HISTORY OF MODERN ART

PAINTING SCULPTURE ARCHITECTURE PHOTOGRAPHY

SIXTH EDITION

HISTORY OF MODERN ART

PAINTING SCULPTURE ARCHITECTURE PHOTOGRAPHY

SIXTH EDITION

H.H. ARNASON

ELIZABETH C. MANSFIELD

New York University

Prentice Hall

Upper Saddle River London Singapore
Toronto Tokyo Sydney Hong Kong Mexico City

For Pearson Education, Inc.:
Editor-in-Chief: Sarah Touborg
Senior Sponsoring Editor: Helen Ronan
Editorial Assistant: Carla Worner
Senior Managing Editor: Mary Rottino
Project Liaison: Barbara Cappuccio
Senior Operations Supervisor: Brian K. Mackey
Director of Marketing: Brandy Dawson
Marketing Manager: Laura Lee Manley

This book was set in 10/13 Galliard.

Credits and acknowledgments borrowed from other sources and
reproduced, with permission, in this textbook appear on pages
825–830.

This book was designed and produced by Laurence
King Publishing Ltd, London
www.laurenceking.co.uk

For Laurence King Publishing:
Development Editor: Kara Hattersley-Smith
Project Editor: Nicola Hodgson
Copy Editor: Elizabeth Ingles
Designer: Ian Hunt
Picture Researcher: Emma Brown
Proofreader: Lisa Cutmore
Indexer: Angela Koo

Printed in China

Front cover: Gerhard Richter, *Vase*, 1984. Oil on canvas, 7' 4½" ×
6' 6¾" (2.2 × 2 m). Museum of Fine Arts, Boston. Juliana Cheney
Edwards Collection.

Library of Congress Cataloging-in-Publication Data

Arnason, H. Harvard.
 History of modern art / H.H. Arnason, Elizabeth C. Mansfield.—6th ed.
 p. cm.
 Includes bibliographical references and index.
 ISBN 0-205-67367-8 (hardback)—ISBN 0-13-606206-7 (pbk.)
 1. Art, Modern—20th century. I. Mansfield, Elizabeth, 1965. II. Title.
 N6490.A713 2009
 709.04—dc22

 2009015436

10 9 8 7 6 5 4 3

(paperbound) ISBN 10: 0-13-606206-7
ISBN 13: 978-0-13-606206-6
(hardcover) ISBN 10: 0-205-67367-8
ISBN 13: 978-0-205-67367-4

Contents

18
Postwar European Art 439

19
Nouveau Réalisme and Pop Art 472

Foreword: A Short History of *History of Modern Art*

Modern art—understood here to include progressive trends in the visual arts from the middle of the nineteenth century to the present day—is an inherently unwieldy and ever-expanding conception. H. Harvard (Harvey) Arnason recognized this, lamenting in his Preface to the first edition of the book that "it is possible to discuss at length only a minority" of relevant artists. The chief criterion by which he admitted artists for consideration was the degree to which they "affected the international stream of modern art." Arnason also recognized that the history of art he presented in 1968 would require regular adjustment in order to accommodate new developments.

Arnason was able to prepare only one of the book's revisions, ceding the task of retooling the third edition to Daniel Wheeler in 1986, the year of his death. Subsequent editions were revised by Marla F. Prather, Michael Bird, and Elizabeth Mansfield. Throughout, the process of revision has been one of updating information as well as revisiting much of Arnason's material in the context of a scholarly and educational environment that has changed significantly from the one in which he wrote. New editions of *History of Modern Art* have offered much new material and interpretative insights, but the book is still essentially Arnason's creation. This Foreword offers a brief investigation into the marathon staying-power of his original endeavor, even though successive revisions have seen the book evolve over the years to take account of new directions in art and art history. After four decades and five new editions, Arnason's vision remains the core of this standard work of art-historical reference.

The Art of Looking

Arnason was Professor and Chairman of the University of Minnesota's art department from 1947 to 1961, and he had a long association with New York's Solomon R. Guggenheim Museum as its Vice President for Art Administration. He embarked on *History of Modern Art* relatively late in life. The project was conceived and intended as a long-term landmark—the first book of its kind—and it drew on the experience of his distinguished career as an art historian. Two deep-rooted convictions underpin Arnason's *History*: first, that understanding art is a matter of fundamental importance; second, that the way to learn about art is to look for yourself. His original Preface unequivocally emphasized his belief in the importance of the individual's face-to-face experience of art—a belief that, as he saw it, gave the book its rationale and its structure:

> The thesis of this book, insofar as it has a thesis, is that in the study of art the only primary evidence is the work of art itself. Everything that has been said about it, even by the artist himself, may be important, but it remains secondary evidence. ... It is for this reason that an effort has been made to reproduce most of the works discussed. For the same reason a large part of the text is concerned with a close analysis of these works of art and with detailed descriptions of them as well. This has been done in the conviction that simple description has an effect in forcing the attention of the spectator on the painting, sculpture, or building itself. If, after studying the object, he disagrees with the commentator, all the better. In the process he has learned something about visual perception.

Encouraging his readers to look at art was Arnason's first objective. But he had a further, more challenging aim in view, which was to get people thinking about what it means to go beyond the realm of words—facts, opinions, descriptions, books (no matter how inspiring or enlightening these may be)—and experience art as a purely visual phenomenon. "The principal emphasis of this book," he wrote,

> revolves around [the] problem of seeing modern art. It is recognized that this involves two not necessarily compatible elements: the visual and the verbal.

Any work of art history and/or criticism is inevitably an attempt to translate a visual into a verbal experience. Since the mind is involved in both experiences, there are some points of contact between them. Nevertheless, the two experiences are essentially different and it must always be recognized that the words of the interpreter are at best only an approximation of the visual work of art.

Arnason's admonition to remain alert to the differences between linguistic and non-linguistic visual phenomena is as relevant today as it was in 1968. We respond differently to images than we do to words; images play differently upon our emotions and our intellects. The study of modern art can help sharpen our ability to discern subtle differences among visual encounters that may, at first glance, seem identical. Why else does Arnason consider looking at modern art so important? The valuation that society places on art, and the reasons for that valuation, change with time, and here again, since *History of Modern Art* first appeared, shifts have occurred in our perception of why art matters.

Experience and Interpretation

The distant roots of Arnason's belief that looking at art is in itself a profoundly worthwhile activity can be traced to the liberal, secular educational ideals of the nineteenth century. These ideals presumed that exposure to the "highest" kind of cultural experiences could make people, whatever their social or ethnic background, better citizens and happier individuals.

More recent generations of scholars and writers have fiercely questioned the foundations of this outlook, but its monuments continue to exert enormous influence on Western cultural life. The conviction that simply looking at paintings and sculptures, or entering a grandly beautiful building, were necessarily uplifting and "ennobling" experiences was an important factor in the nineteenth-century enthusiasm in Europe and North America for establishing public art collections and opening great private collections to the public, a practice Western nations also pursued in the countries they annexed and colonized. As a scholar working in the orbit of major American collections, Arnason was a direct heir to the tradition of promoting contact with art for the general good. These collections, and later ones founded on their model, still provide the public with its most important points of access to art.

His belief in the power of art to work its own magic in our lives marks Arnason as a man very much of his time and background. He was born in 1909 in Canada, where he remained until 1927, when he emigrated to the United States to complete his education at Northwestern University and Princeton. Today art has lost none of its cultural glamour, but the role of interpretation is now regarded as not merely helpful but in certain ways essential for the viewer's own experience. The idea of art history as a unitary field of knowledge has been replaced by the recognition of diverse art histories, each shaped by a particular interpretative approach. Likewise, the old notion of the canon—a roll-call of indisputable masterpieces that set the standard for all artistic achievement—has given way to a far more inclusive view of what constitutes legitimate objects of art-historical attention.

These changes have affected the ways in which art is made, viewed, presented, and taught. Textbooks locate art within contemporaneous social, historical, political, and philosophical themes. Museums, too, which at one time were regarded as palaces or temples for the display of self-evidently significant cultural treasures, now see the interpretation of these treasures as an equally important activity, recognizing that any work of art may well mean quite different things to different viewers. It is not that we look any more carefully or subtly at art than earlier generations did, only that the range of information regarded as relevant to an understanding (or understandings) of art has been vastly extended. Revised versions of *History of Modern Art*, as one would expect, have acknowledged interpretative standpoints more openly and, inevitably, more self-consciously than did Arnason's original text.

A Book That Moves with the Times

Art historians are today much more at home with the concept of the collaborative making of art than in earlier days, when the notion of the lone genius prevailed. In its evolution through successive editions, this book has become a richly collaborative project. But it would also be true to say that *History of Modern Art* holds to its original aim, concisely stated by Arnason in his Preface:

> This book is intended for the general reader and the student of modern art. ... Aside from being a broad, analytical survey of modern art and architecture, the book is conceived as a dictionary in which much factual information is included. This is particularly true of the latter part [which is] intended to suggest the main directions of contemporary art and architecture rather than to pretend completeness.

If we take a mid-nineteenth-century start date, "modern" art is now entering its third century. Sometime, someone will draw the line. But it is a fair bet that serious students of the modern era in art will continue, whatever their critical perspectives or cultural allegiances, to reach for this book on the shelves.

Preface

H. Harvard Arnason insisted that artworks be understood first in terms of their unique formal properties, and his *History of Modern Art* has long been recognized for the acuity of its visual analysis. To neglect the specifically *visual* quality of artworks would be akin to ignoring the use of language in poetry or the quality of sound in music. Only through close formal analysis, Arnason explained, could art and its effect on us be fully understood.

Arnason also directed his readers to consider modern art in terms of "everything that we can learn about the environment that produced it." The current edition of *History of Modern Art* preserves Arnason's sensitive approach to visual analysis while deepening the text's consideration of the social conditions that have affected the production and reception of modern and contemporary art.

Toward this end, the sixth edition retains the book's chronological organization. While not claiming that modernism's birth can be traced to a specific moment, *History of Modern Art* accords particular relevance to the year 1835. Two events in that year anchor the text's account of modernism: the production of the earliest photographs by William Henry Fox Talbot and the publication of Théophile Gautier's novel *Mademoiselle de Maupin*, with its provocative cross-dressing heroine and scandalous endorsement of *l'art pour l'art*. These events announce the conflicting impulses that have catalyzed the development of modern art since the nineteenth century.

Modern art is the cultural expression of a society shaped as much by scientific rationalism as by transcendent idealism. The tension inherent in this social condition propels modernism, through which these competing worldviews are explored and often synthesized. The appearance of photography and the doctrine of Art for Art's Sake in the same year testify to the appeal of both viewpoints at this time. For many, photography promised to document the world accurately and objectively, to deliver absolute visual truth. Partisans of Art for Art's Sake celebrated instead a truth based on subjective aesthetic experiences that transcend lived reality. These two worldviews have continued to collide and commingle to the present day, with moments of resolution and irresolution continually giving rise to new forms of visual culture.

Talbot's photography and Gautier's novel also introduce themes that recur throughout the book. Intersections between art and science, for instance, are noted repeatedly, as is the role of technology in shaping modern art. Other sustained themes include the relationship between modernism and femininity, the influence of criticism on the reception of modern art, the development and effects of the art market, and the persistence of the exotic as an aesthetic ideal. Although these ideas are woven through the whole of *History of Modern Art*, each chapter maintains a distinct focus, addressing a particular movement or concept. New introductions address the social and aesthetic issues particular to each chapter while linking these ideas to the central themes of the text.

Furthering the assertion of modern art's social import is the inclusion of new artists and artworks. These additions are intended to strengthen the central arguments of the book while also broadening its conception of modernism. Among other changes is the integration of women and African-American artists into the main narrative. These important contributors to the history of modernism are not cast as extras in an otherwise male, white, and Eurocentric story. Rather, the main narrative encompasses their work while also addressing issues related to their marginalization in traditional histories of modern art. For instance, the relationship between modern art and women involves more than the history of women's exclusion from the institutions of artmaking and exhibition: it also concerns the significance of the female nude for the history of modernism as well as the decisive influence of women patrons of avant-garde art in the late nineteenth and early twentieth centuries. Likewise, to comprehend the position of African-American artists in this period requires an understanding of contemporary cultural assumptions about race and representation.

History of Modern Art now closes with a chapter devoted to globalization, taking into consideration the

Acknowledgments

economic and political conditions currently affecting artists and audiences internationally. Coupled with this account of social circumstances is a discussion of postcolonial theory. By articulating the causes and consequences of Western imperialism, postcolonial theory has contributed significantly to a reformulation of what it means to be an artist just as it has led some collectors, dealers, and museum professionals to reconsider their practices.

The book concludes with a discussion of Jean Nouvel's controversial Quai Branly Museum in Paris, which opened in 2006. Here, the clarity of postcolonial theory finds itself ensnared in the vexed history of actual colonial practice. As an ethnographic museum, the Quai Branly testifies to France's former imperial status even as it attempts to allow the objects collected there to speak on their own account. But with its crepuscular galleries, interactive video stations, and alcoves animated with piped-in music indigenous to France's old colonial possessions, the museum recreates the fantasy of easy access and compliant natives that has spurred colonial ambitions since the sixteenth century. Such imaginings were as crucial to Paul Gauguin's Tahitian sojourns as to the work of contemporary artists like Emily Jacir or Mona Hatoum, who articulate a visual language of cultural identity and resistance in the face of such imperialist fantasies.

The Quai Branly Museum expresses the same tensions and contradictions that have informed modern art since its inception. In preserving the idea of an ethnographic museum, it endorses a view of culture that privileges acquisition, categorization, documentation, and objectivity. Its galleries, though, are designed to elicit universal, transcendent aesthetic experiences. As has always been the case, it remains to the viewer to succumb to the pleasures of either capitulation or resistance—or each in their turn—in the face of modern art.

Although it is impossible for me to list all of the scholars whose suggestions helped guide this revision of *History of Modern Art*, I am especially grateful to Darsie Alexander, Jay Curley, Susan Dackerman, Helen Molesworth, and Steven Nelson for introducing me to works by artists not previously included in this text. The book's conception of modernism is richer and more complete thanks to their insight. For her well-timed intervention and constant support, I extend my deepest thanks to Helen Ronan. Copyeditor Lis Ingles and image researcher Emma Brown, along with the rest of the staff at Laurence King Publishing, provided the steady assistance essential for the project's realization.

Revising a textbook, especially one as authoritative and enduring as Arnason's *History of Modern Art*, is an inherently collaborative enterprise. This collaborative spirit is epitomized by the sixteen scholars and teachers of modern art whose commentaries on earlier versions of the manuscript strengthened the book's arguments: Susan J. Baker, University of Houston; Randy Becker, Buena Vista University; John X. Christ, University of Massachusetts, Lowell; Carl Goldstein, University of North Carolina at Greensboro; Bonnie Lea Kutbay, Mansfield University of Pennsylvania; Barbara L. Miller, Western Washington University; Elizabeth K. Mix, Butler University; Shari Morin-Pennington, Community College of Vermont; Sarah K. Rich, Pennsylvania State University; Gil Scullion, Manchester Community College; Rita W. Tekippe, University of West Georgia; Shawnee M. Turner, College of Mount Saint Joseph; Damon Willick, Loyola Marymount University; Reva Wolf, State University of New York, New Paltz; James Yood, Art Institute of Chicago; and Robbin Zella, Housatonic Museum of Art.

The anonymity of their comments was maintained throughout the process of revision. It is a great pleasure for me now to acknowledge them and their contribution.

Elizabeth Mansfield
May 2008
New York, NY

What's New: Chapter-by-chapter Revisions

Chapter 1

The famous Whistler vs. Ruskin trial establishes the keynote for a complex history of modern art. Major themes now introduced here include the rising influence of art critics and the art market, the legacies of Romanticism and academic classicism, and the sharpening dispute over art's role in society.

Chapter 2

A style as well as a way of understanding the world, Realism is presented as one of the theoretical foundations of modern art. Discussions of sculpture, photography, prints, and paintings are now integrated, showing Realism's influence across various media. Impressionism is characterized as both indebted to and departing from Realism, a shift explored in relation to contemporary history as well as aesthetics. The significance of the female nude as a persistent subject of modern art is now addressed.

Chapter 3

The diverse styles and practices classified under Post-Impressionism share a tendency to favor subjective artistic responses to the world as opposed to the objectivity often commended by Realism. To convey this effectively, the chapter emphasizes the enduring influence of the Art for Art's Sake doctrine, which attained maturity in the visual arts with Symbolism.

Chapter 4

Modern architecture is seen as emerging from diverse approaches to design. Popular revivalist tendencies in architectural design are addressed, and an expanded account of the Arts and Crafts movement is provided. The chapter concludes by focusing on the technical innovations and aesthetic ambitions that gave rise to the skyscraper.

Chapter 5

This chapter presents Aestheticism and Art Nouveau, linking both to Symbolism. With Aestheticism, the artistic disinterest of Symbolism and Art for Art's Sake is maintained. Art Nouveau attempts to synthesize the aesthetic freedom of Symbolism with functionalism. The synthesis pursued by Art Nouveau is described as exemplary of modernism.

Chapter 6

The exciting formal innovations of Fauvism liberate fully color, line, and form from serving documentary ends. This chapter on Fauvism locates the underpinnings of Fauvist experimentation in the art of Cézanne and other Post-Impressionists as well as in Primitivism. Primitivism is now explained in greater detail as a cultural as well as political phenomenon.

Chapter 7

The sources of German Expressionism are traced through the philosophy of Nietzsche and through the art of Lovis Corinth, Paula Modersohn-Becker, and the Fauves. The political, economic, and cultural conditions particular to Germany in the early twentieth century are also cited as crucial for the character of Expressionist art.

Chapter 8

Cubism is here presented as a movement as responsive to art-historical tradition as it is to contemporary formal experimentation by artists like Cézanne. The intensely collaborative partnership of Braque and Picasso revolutionized modern artists' (and viewers') understanding of representation.

Chapter 9

By focusing on early twentieth-century architecture, this chapter illustrates the degree to which the tension between functionalism and Art for Art's Sake continues to affect the course of modern art. Frank Lloyd Wright's quest for a balance between the decorative and functional qualities of a structure is countered by Adolf Loos' statement on "Ornament and Crime."

Chapter 10

Artistic responses to Cubism are addressed not only in terms of style but also in relation to specific social conditions. The Italian Futurists applied the formal lessons of Cubism to their ideology of ardent nationalism, just as some Russian Constructivists found in the visual language of Cubism a means of expressing a new, revolutionary, and egalitarian aesthetic.

Chapter 11

World War I caused a rupture in the European art world, leading progressive artists to seek new means for expressing their outrage, confusion, and despair through Dada and the New Objectivity. Additional illustrations of works by Duchamp have been included and the work of Käthe Kollwitz now prefaces the account of the New Objectivity.

Chapter 12

The artistic response to World War I is further explored in a chapter devoted to the Paris scene. It is against the backdrop of the war that *Les Maudits* and the classical revival of the "Call to Order" are considered.

Chapter 13

De Stijl is now presented in a single chapter. Theo van Doesburg's ideas about aesthetic unity and the role design should play in social reform are discussed alongside relevant examples of architecture, furniture, painting, and sculpture. This allows for a coherent discussion of de Stijl ideas and how they affected all media.

Chapter 14

Like the de Stijl movement, the Bauhaus was founded on the principle of arts integration in pursuit of a unified aesthetic. This chapter now focuses exclusively on the Bauhaus, taking readers from its inception under the guidance of Walter Gropius, through its rise as a model for arts production and education, to its dissolution under the Nazi regime. The influence of former Bauhaus instructors, especially on the emergence of modernism in the United States, brings the chapter to a close.

Chapter 15

An expanded explanation of Freud's ideas introduces readers to concepts such as dreamwork, fetishism, and castration anxiety—all of which were taken up by Surrealist artists as themes or methods for artmaking. The addition of works by Claude Cahun as well as Magritte's *Le Viol* (*The Rape*) allow for a deeper exploration of gender and sexuality in Surrealist practice.

Chapter 16

Modern art produced in America prior to World War II is considered not only in terms of its relationship to European styles and innovations, but also in relation to contemporary events. The trial of Sacco and Vanzetti, for instance, is now discussed alongside relevant works by Ben Shahn. All artworks discussed at length are now illustrated.

Chapter 17

Mondrian's move to the U.S. now introduces the chapter on the rise of pure abstraction in American art during the 1940s and 50s. The import of Surrealism and its attempt to reveal the workings of the unconscious is also positioned as an important influence for Abstract Expressionism. These formal and theoretical influences are explored in relation to political and economic conditions in postwar America.

Chapter 18

European art of the immediate postwar period has been newly contextualized, giving readers essential information about the region's social and cultural conditions. A description of the plays of Samuel Beckett and the Theater of the Absurd is included to help convey the mood of Europe's avant-garde in this period. All works accorded sustained discussion are illustrated, and works formerly appearing in black and white now appear in color.

Chapter 19

This chapter on Nouveau Réalisme and Pop art has been reorganized to begin with the European material before shifting to the United States. This new arrangement encourages readers to perceive the decidedly European context of Nouveau Réalisme, a point that can be lost when this material is presented after Pop art. Recognition of the social and political relevance of both movements has been strengthened.

Chapter 20

This chapter now comprises Post Painterly Abstraction and Minimalism, allowing readers to see how artists responded to Clement Greenberg's conception of modernism as fundamentally a movement toward pure, disinterested abstraction. New illustrations of works by Joan Mitchell, Helen Frankenthaler, Larry Bell, Frank Stella, and Agnes Martin appear in this chapter along with many new color figures.

Chapter 21

This chapter on the International Style and the expressive, sculptural architecture of modernist designers like Wright, Saarinen and Breuer has been updated and features additional works by Mies, Gropius, Wright, Stirling and Gowan, Terragni, as well as many new color illustrations.

Chapter 22

An entire chapter is now devoted to Conceptual Art. The Art and Language Group leads off the chapter, which offers expanded discussions of Hans Haacke and Fluxus. This chapter also introduces protest and activist art, with an

enhanced section on feminist art. Among artists included in the new edition are Louise Lawler and the Situationists. Works that receive sustained commentary are illustrated whenever documentation exists.

Chapter 23

This chapter on Post-minimalism, like those on Minimalism and Conceptualism, continues the new organization of *History of Modern Art* by presenting contemporary art thematically rather than simply by decade. Here, readers now encounter the various movements through which artists responded to the seemingly antithetical challenges of Minimalism and Conceptualism. More works by Robert Smithson, Eva Hesse, and Neil Jenney are illustrated.

Chapter 24

Postmodernism—in all its myriad forms—has been newly reorganized into a single chapter. To help explicate this movement, ideas such as poststructuralism, deconstruction, and deconstructivism are explained. New works by Norman Foster, Santiago Calatrava, Sherrie Levine, and Mark Tansey have been included to better convey the scope of Postmodernism.

Chapter 25

Although the revised version of *History of Modern Art* generally takes pains to integrate discussions of various media, this chapter now focuses exclusively on painting. The tendency of Minimalism and Conceptualism was to shy away from easel painting; the resurgence of this technique in the 1970s and 80s, therefore, receives special attention. More recent experiments in painting by Lisa Yuskavage and John Currin are likewise presented here to encourage readers to consider their work not only in reference to past works by Rembrandt, Picasso, or Bacon, but also in the context of painting's more recent history.

Chapter 26

Since the critical intervention of Postmodernism, contemporary artists have increasingly taken the art world itself as the subject of their work. This newly reorganized chapter considers how artists are renegotiating modernism through works that confront the various institutions and traditions of avant-garde art production, display, and acquisition.

Chapter 27

Arnason's *History of Modern Art* now concludes with a chapter devoted to globalization. In addition to tracing the effects of postcolonial theory on artists and audiences, this chapter considers how modernism has been decentered. No longer a form of cultural expression dominated by Europe and North America, modernism (and its offshoots, such as Postmodernism) has become a means by which non-Western and developing countries can interrogate Western social and cultural assumptions. The final monument considered in the book is Jean Nouvel's 2006 Quai Branly Museum.

1
The Origins of Modern Art

"I have seen, and heard, much of cockney impudence before now; but never expected a coxcomb to ask two hundred guineas for flinging a pot of paint in the public's face."

John Ruskin, *Fors Clavigera*, 1877

With this affront, John Ruskin (1819–1900) touched off a firestorm in the staid art world of late Victorian Britain. Ruskin was Britain's most influential art critic. The target of his attack: **James McNeill Whistler**'s painting, *Nocturne in Black and Gold: The Falling Rocket* (fig. **1.1**). Ruskin's acidic review—in which he essentially accused the painter of being a charlatan whose only aim was to bilk art collectors of their money—provoked Whistler (1834–1913) to sue the critic for libel. The case went to court in 1878. The trial drew many spectators, eager to watch the eminent critic spar with the famously witty artist. Few observers were disappointed: according to newspaper accounts Whistler's testimony was loaded with irony and sarcasm. For instance, when Ruskin's attorney, John Holker, questioned the success of *Nocturne in Black and Gold*, asking of Whistler: "Do you think you could make me see beauty in that picture?" Whistler replied dryly: "No ... I fear it would be as impossible as for the musician to pour his notes into the ear of a deaf man."

As amusing as these theatrics were, there were nonetheless important issues at stake for the history of modern art. In many ways, the defendant in the case was not simply the art critic John Ruskin, but art—especially modern art—itself. What was in the balance here? One weighty question concerned the role of art in society. Ruskin believed that art possessed the power to improve society. For him, this was accomplished chiefly through an artwork's ability to represent nature faithfully. To encounter nature in its purity and grandeur, for Ruskin, was to contemplate the divine. Artists who adhered to his doctrine of "truth to nature" could, he thought, promote moral virtue as well as aesthetic pleasure. In Whistler's *Nocturne in Black and Gold*, Ruskin found neither the moral nor the pictorial clarity he

desired. Whistler's attempt to capture the dazzling effects of a fireworks display over the Thames through startling, explosive brushwork defied the critic's understanding of nature as a product of divine creation.

Whistler subscribed to a very different understanding of art's purpose. An adherent of the doctrine of "Art for Art's Sake," Whistler believed that true art served no social

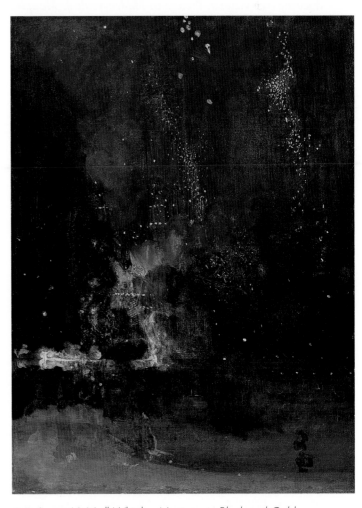

1.1 James McNeill Whistler, *Nocturne in Black and Gold: The Falling Rocket*, c. 1875. Oil on panel, 23 × 18" (60.3 × 46.4 cm). Detroit Institute of Arts, Detroit.

Théophile Gautier
Preface to *Mademoiselle de Maupin* (1835)

The first statement of Art's for Art's Sake appeared in Gautier's preface to a novel. Critics and censors found the preface objectionable for its seeming hedonism.

...Someone has said somewhere that literature and the arts influence morals. Whoever he was, he was undoubtedly a great fool. It was like saying green peas make the spring grow, whereas peas grow because it is spring.... Nothing that is beautiful is indispensable to life. You might suppress flowers, and the world would not suffer materially; yet who would wish that there were no flowers? I would rather give up potatoes than roses.... There is nothing truly beautiful but that which can never be of any use whatsoever; everything useful is ugly, for it is the expression of some need, and man's needs are ignoble and disgusting like his own poor and infirm nature. The most useful place in a house is the water-closet.

purpose whatsoever. Followers of the Art for Art's Sake doctrine (see Gautier, Preface to *Mademoiselle de Maupin*, above) held social utility under suspicion if not contempt, believing that a work's usefulness threatened to detract from its purely aesthetic purpose. "Art," Whistler explained, "has become foolishly confounded with education." For supporters of Art for Art's Sake, beauty was simply the measure of a work's ability to stimulate a pleasing aesthetic sensation. The trial of Whistler vs. Ruskin pitted not just two men against each other, but provided a forum for the debate between those who looked to art as essential to social progress and those who insisted that art transcended social concerns. This debate would continue long after the conclusion of the trial, with various modernist movements allying themselves to one or the other viewpoint.

Making Art and Artists: The Role of the Critic

Ruskin's insistence on the ability of art to improve society led him to develop ways of bringing fine arts education to members of the working class. In addition to sponsoring art exhibitions and lectures for working-class audiences, Ruskin published a newsletter he hoped would appeal to working-class readers. It was in this newsletter, *Fors Clavigera*, that he published his provocative review of Whistler's painting. Ruskin's advocacy for the working class and his efforts to provide laborers with access to forms of culture typically beyond their experience likewise colored the clash between critic and artist. On the one hand, Ruskin's condemnation of Whistler's painting speaks to his interest in supporting art that offers an immediate and accessible social message. On the other hand, Ruskin drew on class-based stereotypes in his denigration of the artist. By attributing to Whistler a "cockney impudence," Ruskin delivers an insult that turns on class differentiation: the adjective "cockney" was used in the nineteenth century to designate a Londoner who lacked the refinement of the gentry. In this way, Ruskin not only tapped into Whistler's well-known sensitivity about his social status but also exposed the persistence of class as a means of differentiating artists from their patrons. As subsequent chapters will show, this divide between artists and patrons, between those who create art and those who consume it, troubled many modern artists.

Along with such artists, many critics of modern art sought to bridge the divide between culture and its diverse potential audiences. Art criticism as a distinct literary or journalistic activity emerged in the eighteenth century in response to the proliferation of public venues for exhibiting art. Prior to that, artworks had remained largely confined to the private galleries of the nobility or other wealthy collectors. For the most part, only religious art was regularly viewed by the general public. By the early eighteenth century, this had changed. Not only were art dealers and even auctioneers beginning to stage public displays of their wares, but large-scale exhibitions were being mounted throughout Western Europe, following the French model of public exhibitions sponsored by the monarchy. In France, these exhibitions were known as "Salons" because of the name of the room in which they were originally held at the Louvre Palace: the Salon Carré or "Square Parlor." The Paris Salon took place regularly, usually every two years, and would feature hundreds of artworks mostly by members of France's Royal Academy of Painting and Sculpture. Works by promising Academy students as well as prominent foreign artists were also shown. An official, public event, the Salon was open to anyone who wished to view the works on display. Other European countries soon followed France's example, leading to a proliferation of regular public exhibitions in all the major European capitals by the early nineteenth century.

In the early years of the Salon, the unprecedented access to artworks brought viewers face to face with an often confusing variety of subjects, styles, and media. To help guide visitors through the exhibitions, self-appointed arbiters of aesthetic quality began to write reviews, which would then be disseminated as pamphlets, in newspapers, or by private subscription. It did not take long for the art critics to have an effect on public taste. Even artists occasionally followed the advice of critics in their pursuit of public approbation.

Of great interest to early critics of the Salon was the specific genre pursued by different artists. "Genre" refers generally to the type of subject represented in a painting. There were five main genres: history (depicting biblical, mythological, or historical subjects), landscape, portrait, still life, and (slightly confusingly) "genre painting" (scenes of everyday life). The French Royal Academy, at the time

of its foundation in 1648, held that history painting was the greatest achievement for a painter because historical subjects demand erudition as well as the highest degree of technical skill. Based on subjects from ancient or modern history, classical mythology, or the Scriptures, history painting required a thorough knowledge of important literary and historical texts. What is more, most history paintings were expected to present one or more heroic figures, often depicted nude, so anatomy and life-drawing were an essential part of a history painter's education. Finally, history paintings are often set in real or imagined towns, on battlefields or in other landscapes, and thus required the ability to execute works in that genre as well. As vaunted as history painting was by the Academy, early critics, such as Denis Diderot, often guided their readers toward other genres such as landscape, still life, and genre painting. Among the most attentive readers of art criticism were art dealers and collectors. This remains the case today.

A Marketplace for Art

As mentioned above, many of the earliest public exhibitions of artwork were organized by dealers and auctioneers. This phenomenon marks an important shift in the role of art in society. Economic changes in Western Europe—the seventeenth-century expansion of mercantilism, which depended on favorable international trade balances and sales of manufactured goods, and the eighteenth-century development of capitalism, which encouraged the further spread of manufacturing beyond the limits of state control to encompass private investment as well—contributed to the ascendance of the bourgeoisie, a class of citizens with newly acquired economic strength and a taste for the fashions and habits of the nobility (see *Modernity and Modernism*, right). Collectors from the middle as well as upper registers of society now sought to fill their homes with beautiful things, including artworks, creating a demand especially for small paintings and table-top sculptures that would fit comfortably in a townhouse or apartment. Thus, during the eighteenth century, a market force was introduced into the art world, leading to a proliferation in the nineteenth century of smaller works with themes suitable to a bourgeois domestic interior. It is precisely this market, in fact, to which Whistler hoped to appeal with the modest scale and striking effects of his *Nocturne in Black and Gold*, a painting that measures less than two feet high and a foot and a half wide.

All of these currents—art's role in society, increasing class tension, proliferating art exhibitions, the growing influence of art critics, and the expanding market for art—converged in the Whistler vs. Ruskin trial. And all of these phenomena contributed to the development of modern art. But perhaps more than any of these pressures, the real issue motivating Whistler's confrontation with Ruskin involves a problem fundamental to modernism: What is art? Whistler in fact offers an answer to this question during the trial. When attorney Holker attempts to clear

> ### CONTEXT
>
> ## Modernity and Modernism
>
> With industrialization in Western Europe and North America came modernity: cities grew as dwindling agricultural jobs prompted workers to seek employment in manufacturing. The population booms in cities such as Paris and London led to an expansion of businesses aimed at serving the needs of these new citizens: restaurants, bars, theaters, music halls, boarding houses, and inns proliferated. These businesses created more jobs while also introducing new social habits and expectations. Rooted in urban culture, where leisure activities as well as daily necessities are available commercially, modernity refers to the condition of post-industrial, capitalist society. Modernism is simply the cultural expression of this form of social organization. Associated with ideas of progress and novelty, modernism reflects the dominant ethos of a society in which consumption—of new forms of entertainment along with the necessities of life—plays a central role in one's daily activities. One of the signal markers of the rise of modernism in the West was the advent of the department store and the idea of shopping as a leisure activity. Just as indicative of modernism was a pervasive ambivalence toward modernity itself. Many welcomed the technological advances and economic prosperity that modernity seemed to foster. Others, however, were wary of its emphasis on change and continual improvement, noting capitalism's tendency to exploit workers murderously and to contribute to the deplorable living conditions of the poor. Modern art, like all forms of modernism, is a response to the diverse political, economic, and cultural pressures of modernity.

his client of libel by indicating that Whistler really was a charlatan committing fraud, he points out that *Nocturne in Black and Gold* could not possibly be a finished artwork because there simply had not been sufficient labor or time invested in the piece. Holker asks, "Did it take you long to paint the *Nocturne in Black and Gold*? How soon did you knock it off?" Whistler replies, "Oh, I knock one off in a couple of days." The barrister then asks Whistler if it's merely "the labour of two days" for which he charges more than £200? To this question Whistler responds, "No, I ask it for the knowledge of a lifetime."

Whistler won the case. Though it was a pyrrhic victory for the painter, whose receipt of only a farthing—less than a penny—in damages cast him into bankruptcy, Whistler's statement nonetheless announces the establishment of one of modernism's central tenets: that art is first and foremost the manifestation of an individual's emotional and intellectual will.

The Modern Artist

The notion that an artwork is fundamentally the expression of a particular artist's thoughts or desires seems obvious

today. But this has not always been the case. The idea that Whistler put forward is rooted—like many sources of modernism—in the eighteenth century. Until the late eighteenth century, artists in the West since the Renaissance had understood their work as part of a tradition going back to classical antiquity. Though each artist was expected to contribute uniquely to this tradition, the practice of emulation remained central to any artist's training. Young artists would learn to create by first copying works acknowledged as superior examples of their genre, style, or medium. Only after a student fully understood the work of earlier artists and was able to reproduce such examples faithfully could he or she go on to create new forms. But even then, new works were expected to contribute to established traditions. This was the method of training used at art academies throughout Western Europe from the seventeenth through the nineteenth centuries. Artists achieved success by demonstrating their inventiveness *within the tradition* in which they worked.

For instance, one of the consummate achievements of eighteenth-century French academic art is **Jacques-Louis David**'s Neoclassical painting *Oath of the Horatii* (fig. **1.2**). The subject is taken from classical sources and had been treated earlier by other painters. For his version, David (1748–1825) looks to the exemplary seventeenth-century French painter **Nicolas Poussin** (1594–1665), emulating his predecessor's crisp linearity, rich colors, and sculptural treatment of figures as seen in the latter's *Holy Family on the Steps* from 1648 (fig. **1.3**). David relies further on Poussin for the clear, geometrical arrangement of figures: the bold pentagon holding old Horatio and his sons, the oval grouping of despondent women on the right. Even the clear, stage-like architectural setting hints at Poussin, though David has radically compressed the space in emulation of ancient relief sculpture. Of course, David's treatment of the theme as well as his rendering of figures and space was heralded for its freshness and novelty at the time of its initial exhibition in 1785. At this time, however, novelty and originality were subsumed within the conventions of artistic tradition.

What Does It Mean to Be an Artist?: From Academic Emulation toward Romantic Originality

The emphasis on emulation as opposed to novelty begins to lose ground toward the end of the eighteenth century when a new weight is given to artistic invention. Increasingly, invention is linked with imagination, that is to say, with the artist's unique vision, a vision uncon-

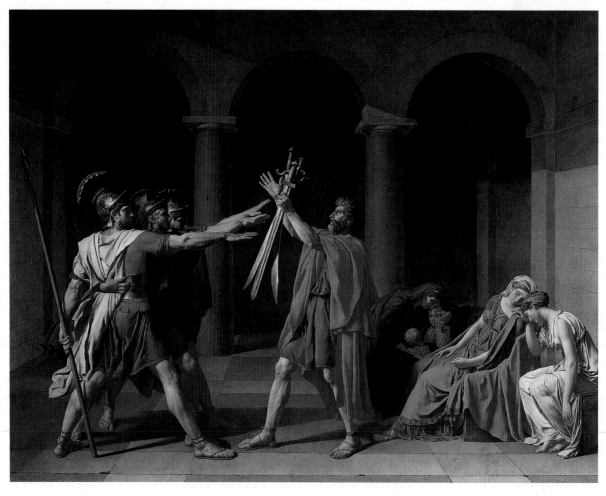

1.2 Jacques-Louis David, *The Oath of the Horatii*, 1784. Oil on canvas, 10' 10" × 14' (3.4 × 4.3 m). Musée du Louvre, Paris.

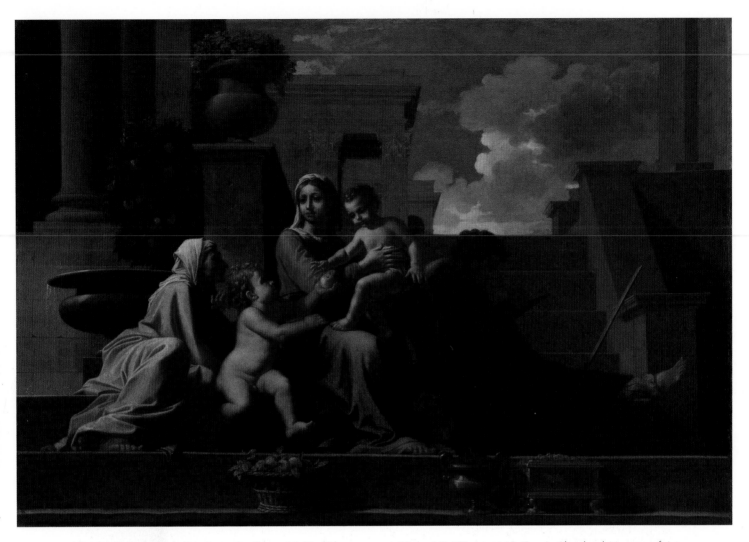

1.3 Nicolas Poussin, *Holy Family on the Steps*, 1648. Oil on canvas, 28 × 44" (72.4 × 111.7 cm). Cleveland Museum of Art. Leonard C. Hanna, Jr., Fund. 1981.18.

strained by academic practice and freed from the pictorial conventions that had been obeyed since the Renaissance. This new attitude underlies the aesthetic interests of Romanticism. Arising in the last years of the eighteenth century and exerting its influence well into the nineteenth, Romanticism exalted humanity's capacity for emotion. In music, literature, and the visual arts, Romanticism is typified by an insistence on subjectivity and novelty. Today, few would argue that art is simply the consequence of creative genius. Romantic artists and theorists, however, understood art to be the expression of an individual's will to create rather than a product of particular cultural as well as personal values. Genius, for the Romantics, is something possessed innately by the artist: it cannot be learned or acquired. To express genius, then, the Romantic artist must resist academic emulation and instead turn inward, toward making pure imagination visible. The British painter and printmaker **William Blake** (1757–1827) typifies this approach to creativity.

Producing prophetic books based in part on biblical texts as well as on his own prognostications, Blake used his training as an engraver to illustrate his works with forceful, intensely emotional images. His depictions of familiar biblical personages, for instance, momentarily evoke for the viewer conventional representations before spinning away from the familiar into a strange new pictorial realm. His rendering of *Nebuchadnezzar* (fig. **1.4**) shows the Babylonian king suffering the madness described in the Book of Daniel. The nudity and robust muscularity of the king might initially remind the viewer of the heroic Old Testament figures who people Michelangelo's Sistine Chapel ceiling, but the grimacing expression and distortions of the figure—which emphasize the king's insanity as he "did eat grass as oxen"—quickly dispel thoughts of classical prototypes or quiet grandeur.

With Jacques-Louis David and William Blake, we have representatives of the two dominant art styles of the late eighteenth century: Neoclassicism and Romanticism. Both of these styles—along with the growing influence of art criticism, a proliferation of public art exhibitions, and the expansion in the number of bourgeois patrons and collectors—will help to lay the foundations of modern art. David's Neoclassicism carries into the nineteenth century an awareness of tradition along with a social conscience that will enable art to assume a place at the center of political as well as cultural life in Europe. Blake's Romanticism

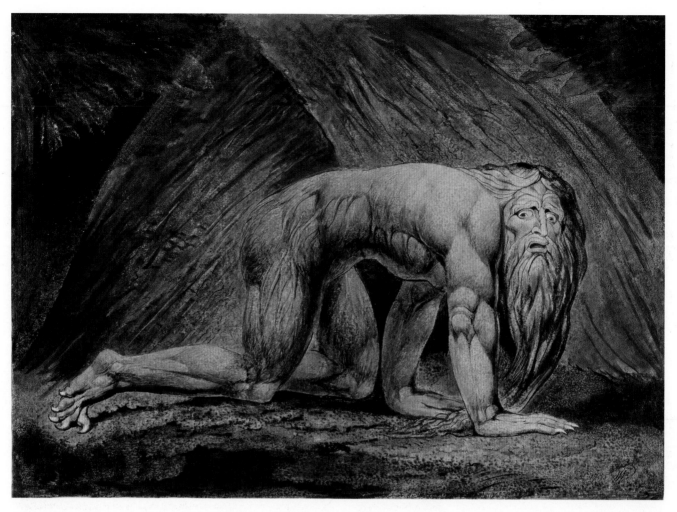

1.4 William Blake, *Nebuchadnezzar*, 1795. Color print finished in ink and watercolor on paper, 21 × 28" (54.3 × 72.5 cm). Tate, London.

pours a different strain into the well from which modern art is drawn. With its insistence that originality is the mark of true genius, Romanticism demands of modern art an unceasing pursuit of novelty and renewal.

Making Sense of a Turbulent World: The Legacy of Neoclassicism and Romanticism

Neoclassicism, which dominated the arts in Europe and America in the second half of the eighteenth century, has at times been called a derivative style that perpetuated the classicism of Renaissance and Baroque art. Yet in Neoclassical art a fundamental Renaissance visual tradition was seriously opposed for the first time—the use of perspective to govern the organization of pictorial space. Perspective refers to a system for representing three dimensions on a two-dimensional surface, creating the illusion of depth. Artists since the Renaissance used two main techniques for accomplishing this: linear perspective and atmospheric perspective. Linear perspective suggests the recession of space through the use of real or implied lines, called "orthogonals," which seem to converge at a point in the distance. Poussin's *Holy Family on the Steps* uses linear

perspective to suggest a single vanishing point just behind the head of the infant Jesus. Atmospheric perspective imitates the tendency of distant objects to appear less distinct to give the illusion of depth. It may be argued that David's manipulation of perspective was crucial in shaping the attitudes that led, ultimately, to twentieth-century abstract art.

David and his followers did not actually abandon the tradition of a pictorial structure based on linear and atmospheric perspective. They were fully wedded to the idea that a painting was an adaptation of classical relief sculpture, such as the *Ara Pacis* (Altar of Peace) in Rome (fig. **1.5**): they subordinated atmospheric effects; emphasized linear contours; arranged their figures as a frieze across the picture plane and accentuated that plane by closing off pictorial depth through the use of such devices as a solid wall, a back area of neutral color, or an impenetrable shadow. The result, as seen in *The Oath of the Horatii*, is an effect of figures composed along a narrow stage behind a proscenium, figures that exist in space more by the illusion of sculptural modeling than by their location within a pictorial space that has been constructed according to principles of perspective.

The clearest formal distinction between Neoclassical and Romantic painting in the nineteenth century may be seen in the approaches to plastic form and techniques of

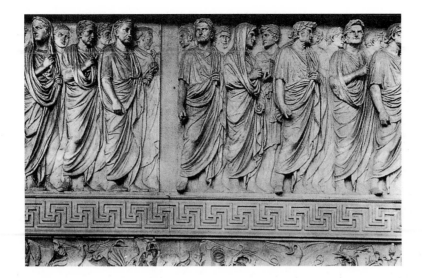

1.5 Detail of the *Ara Pacis* (Altar of Peace), scene of an imperial procession, 13–9 B.C.E. Marble frieze. Rome.

applying paint. Neoclassicism in painting established the principle of balanced frontality to a degree that transcended even the High Renaissance or the seventeenth-century classicism of Nicolas Poussin. Romantic painters relied on diagonal recession in depth and indefinite atmospheric–coloristic effects more appropriate to the expression of the inner imagination than the clear light of reason. The Neoclassicists continued the Renaissance tradition of glaze painting to attain a uniform surface unmarred by the evidence of active brushwork, whereas the Romantics were more experimental, sometimes reviving the richly impastoed surfaces of Baroque and Rococo paintings. During the Romantic era there developed an increasingly high regard for artists' sketches, which were thought to capture

the evanescent touch of the artist, thereby communicating authentic emotion. Such attitudes were later crucial for much abstract painting in America and France following World War II (see chapters 17 and 18).

Printmaking likewise experienced a resurgence. Eager to exploit the capacity of prints to produce multiple copies, Romantic artists sought techniques that would endow prints with the spontaneity of drawings (see *Printmaking Techniques*, below). Blake created experimental relief etchings to pursue this interest. Romantic artists also quickly embraced the new process of lithography in order to achieve their goals. Among the earliest Romantic artists to utilize this medium was **Théodore Géricault** (1791–1824). His *Horse Devoured by a Lion* from

TECHNIQUE

Printmaking Techniques

Prior to the invention of photography, the easiest way to reproduce images was through printmaking. Some artists were particularly drawn to this, often preferring the intimate scale and wide circulation afforded by prints. Two techniques—aquatint and lithography—became especially popular among Romantic artists. Aquatint offered printmakers the ability to create passages of rich tone, ranging from pale grays to rich blacks. Early printmaking techniques—such as engraving—tended to rely on line only, which made it difficult to render shading. Engraving involves incising a line into a metal plate using a sharp instrument called a burin. Once the design is inscribed onto the plate, ink is applied to the surface. The ink settles into the lines and the surface of the plate is wiped clean. A piece of paper is then placed atop the design and, to receive the ink resting in the incised lines, the plate and paper are run through a printing press that exerts enough pressure to force the paper into the line where it receives the ink. But how to reproduce areas of tone, like a wash, rather than just line? With aquatint a fine powdered resin is sprinkled onto the metal printing plate, which is heated so the resin melts and adheres in a

pebbled pattern. By dipping the plate into a pan of acid, the parts of it not covered by the resin are eaten away by the acid. This area, like the line of an engraving, holds ink for transfer onto a print. By using different patterns and thicknesses of resin along with varying strengths of acid, the tonal range of an aquatint can be manipulated. Lithography is a different technique altogether, and does not require the metal plate used in engraving and aquatint. With lithography, the artist uses a crayon or other grease-based medium to draw a design onto a specially prepared block of porous limestone. Water applied to the surface is absorbed by the porous stone but repelled by the greasy ink. An oil-based ink is then applied to the surface: because of the natural repulsion between oil and water, the ink remains only on the areas marked by the artist. This surface can then be covered by a sheet of paper and run through a press using much less pressure than an engraving or an aquatint. Lithography, because it does not require incising into a metal plate or the use of noxious acids, allows artists to work much as they would when drawing, which accounts for the often free and spontaneous character of lithographs.

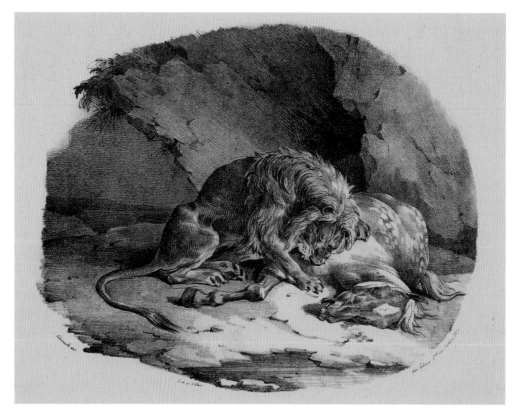

1.6 Théodore Géricault, *Cheval Devoré par un Lion (Horse Devoured by a Lion)*, 1820–21. Lithograph; black lithographic ink on prepared "stone" paper, 10¹³⁄₁₆ × 14⁹⁄₁₆" (27.4 × 37 cm). British Museum, London.

1820–21 (fig. **1.6**) uses lithography to explore a favorite Romantic theme: the nobility of animals in the face of unpitying nature. The immediacy of the lithographic line contributes to the subject's drama, while Géricault's manipulation of tone delivers velvety black passages that recede ominously in the background, framing the terrifying jaws of the lion as he turns away from his prey.

History Painting

David and his followers tended toward history painting, especially moralistic subject matter related to the philosophic ideals of the French Revolution and based on the presumed stoic and republican virtues of early Rome. Yet painters were hampered in their pursuits of a truly classical art by the lack of adequate prototypes in ancient painting. There was, however, a profusion of ancient sculpture. Thus, it is not surprising that Neoclassical paintings such as *The Oath of the Horatii* (see fig. 1.2) should emulate sculptured figures in high relief within a restricted stage, as in the *Ara Pacis* (see fig. 1.5), which David saw in Rome, where he painted *The Oath*. The "moralizing" attitudes of his figures make the stage analogy particularly apt. Though commissioned for Louis XVI, whom David, as a deputy of the Revolutionary government, later voted to send to the guillotine, this rigorous composition of brothers heroically swearing allegiance to Rome came to be seen as a manifesto of revolutionary sentiment.

Of course, not all Neoclassical painters used the style in support of overtly moralizing or didactic themes. **Jean-**

Auguste-Dominique Ingres (1780–1867), a pupil of David who during his long life remained the exponent and defender of the Davidian classical tradition, exploited Neoclassicism for its capacity to achieve cool formal effects, leaving political agitation to others. His style was essentially formed by 1800 and cannot be said to have changed radically in works painted at the end of his life. Ingres represented to an even greater degree than did David the influence of Renaissance classicism, particularly that of Raphael. Although David was a superb colorist, he tended to subordinate his color to the classical ideal. Ingres, on the contrary, used a palette both brilliant and delicate, combining classical clarity with Romantic sensuousness, often in liberated, even atonal harmonies of startling boldness (fig. **1.7**). His *Grande Odalisque*, though not a figure from any specific historical or mythological text, maintains the monumentality and idealization typical of history painting. Ingres' preoccupation with tonal relationships and formal counterpoints led him to push his idealization of the female body to the limits of naturalism, offering abstractions of the models from which he worked.

The sovereign quality that Ingres brought to the classical tradition was that of drawing, and it was his drawing, his expression of line as an abstract entity—coiling and uncoiling in self-perpetuating complications that seem as much autonomous as descriptive—that provided the link between his art and that of Edgar Degas and Pablo Picasso (fig. **1.8**).

One of the major figures of eighteenth- and nineteenth-century Romantic history painting, who had a demonstrable

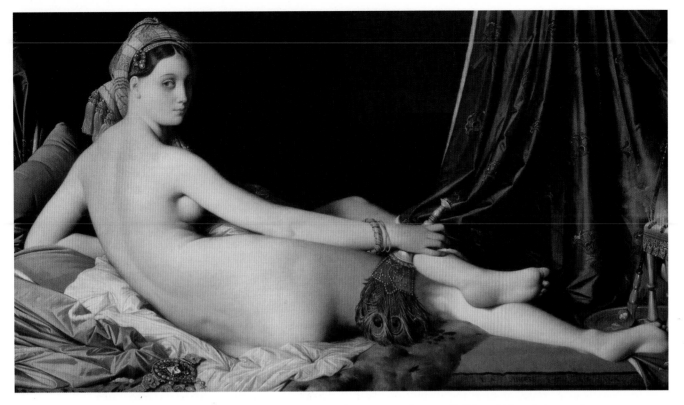

1.7 Jean-Auguste-Dominique Ingres, *Grande Odalisque*, 1814. Oil on canvas, 36 × 64" (91 × 162 cm). Louvre, Paris.

influence on what occurred subsequently, was the Spaniard **Francisco de Goya y Lucientes** (1746–1828). In a long career Goya carried his art through many stages, from penetrating portraits of the Spanish royal family to a particular concern in his middle and late periods with the human propensity for barbarity. The artist expressed this bleak vision in monstrously fantastical scenes of human depravity. Like Géricault and Blake, he pursued printmaking, exploiting the relatively new medium of aquatint to endow his etchings with lush chiaroscuro effects. His

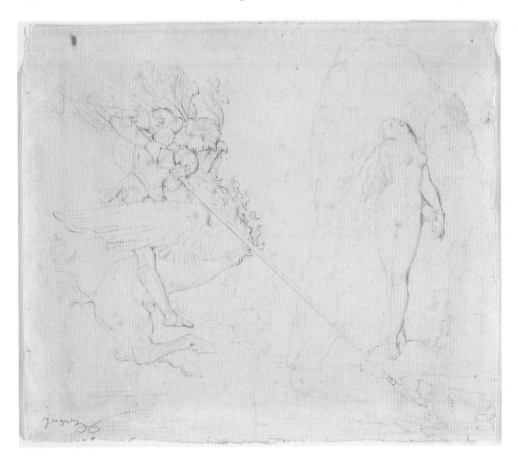

1.8 Jean-Auguste-Dominique Ingres, *Roger Delivering Angelica*, 1818. Graphite on white woven paper, 6¾ × 7¾" (17.1 × 19.7 cm). Harvard University Art Museums, Fogg Art Museum, Cambridge, MA. Bequest of Grenville L. Winthrop.

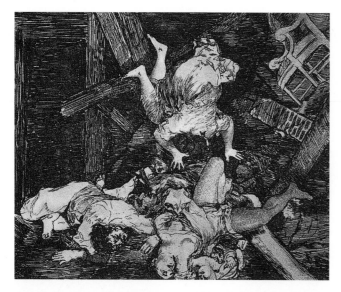

1.9 Francisco de Goya y Lucientes, Plate 30 from *The Disasters of War*, 1810–11. Etching, 1863 edition, image 5 × 6⅛" (12.8 × 15.5 cm). Hispanic Society of America, New York.

brilliant cycle of prints, *The Disasters of War* (fig. **1.9**), depicts the devastating results of Spain's popular uprisings against Napoléon's armies during the Peninsular War (1808–14), triggered by Napoléon's determination to control the ports of Portugal and Spain. Facing certain invasion, the Spanish monarchy agreed to an alliance with the French emperor who nevertheless gave his army free rein to pillage Spanish towns as they marched to Portugal. In one of the most searing indictments of war in the history

of art, Goya described, with reportorial vividness and personal outrage, atrocities committed on both sides of the conflict. While sympathetic to the modern ideas espoused by the great thinkers of the Enlightenment, or the Age of Reason, Goya was simultaneously preoccupied with the irrational side of human nature and its capacity for the most grotesque cruelty. Because of their inflammatory and ambivalent message, his etchings were not published until 1863, well after his death. During his lifetime Goya was not very well known outside Spain, despite his final years in voluntary exile in the French city of Bordeaux. Once his work had been rediscovered by Édouard Manet in the mid-nineteenth century it made a strong impact on the mainstream of modern painting.

The French Romantic movement really came into its own with **Eugène Delacroix** (1798–1863)—through his exploration of exotic themes, his accent on violent movement and intense emotion, and, above all, through his reassertion of Baroque color and emancipated brushwork (fig. **1.10**). He brought the same qualities to more conventional subjects drawn from literature and history. Not surprisingly, Delacroix felt drawn to scenes taken from Shakespeare, whose characters often succumb to their passions for power or love. Delacroix's intensive study of the nature and capabilities of color derived not only from the Baroque but also from his contact with English painters such as John Constable, Richard Bonington, and Joseph Mallord William Turner. His greatest originality, however, may lie less in the freedom and breadth of

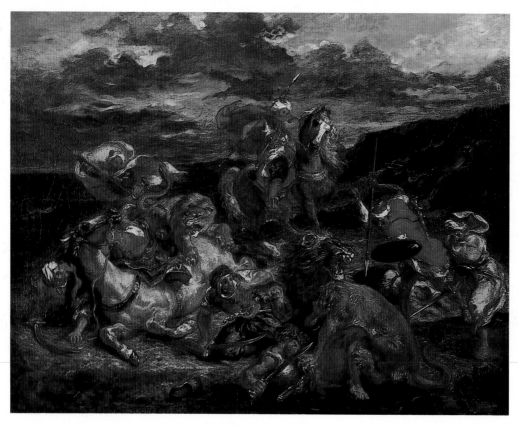

1.10 Eugène Delacroix, *The Lion Hunt*, 1861. Oil on canvas, 30⅛ × 38¾" (76.5 × 98.4 cm). The Art Institute of Chicago.

his touch than in the way he juxtaposed colors in blocks of mutually intensifying complementaries, such as vermilion and blue-green or violet and gold, arranged in large sonorous chords or, sometimes, in small, independent, "divided" strokes. These techniques and their effects had a profound influence on the Impressionists and Post-Impressionists, particularly Vincent van Gogh (who made several copies after Delacroix) and Paul Cézanne.

Landscape Painting

Fascinated with the awesome power of nature, Romantic artists were, not surprisingly, drawn to the genre of landscape painting. For some painters, the landscape offered a manifestation of the sublime, the rational workings of a deity; for others, a symbol of humanity's helplessness in the face of an irrational fate. Either way, the landscape served as a forceful vehicle for Romantic meditations on the limits of human understanding and the fragility of civilization. Landscape paintings were also much sought after by early nineteenth-century patrons, who could accommodate scenes of familiar as well as distant lands in their homes more easily than they could hang large-scale history paintings depicting arcane subjects from classical texts.

Although the main lines of twentieth-century painting are traditionally traced to French art, Romantic treatments of the landscape found their most characteristic manifestation in Germany. Indeed, there were critical contemporary developments in Germany, England, Scandinavia, and the Low Countries throughout much of the nineteenth century. One may, in fact, trace an almost unbroken Romantic tradition in Germany and Scandinavia—a legacy that extends from the late eighteenth century through the entire nineteenth century to Edvard Munch, the Norwegian forerunner of Expressionism, and the later German artists who admired him.

Implicit in this Romantic vision is a sense that the natural world can communicate spiritual and cultural values, at times formally religious, at times broadly pantheistic.

With **Caspar David Friedrich** (1774–1840), the leading German painter of Romantic landscape, the image of nature was by definition a statement of the sublime, of the infinite and the immeasurable. His landscapes are filled with mysterious light and vast distances, and human beings, when they appear, occupy a subordinate or largely contemplative place (fig. **1.11**). In his ghostly procession of monks into the ruined apse of a Gothic church, Friedrich clearly draws formal parallels between the towering forms of the apse and the framing "architecture" of nature.

Although landscape painting in France during the early nineteenth century was a relatively minor genre, by mid-century certain close connections with the English landscapists of the period began to have crucial effects. The painter **Richard Parkes Bonington** (1802–28), known chiefly for his watercolors, lived most of his brief life in France, where, for a short time, he shared a studio with his friend Delacroix. Bonington's direct studies from nature exerted considerable influence on several artists of the Romantic school, including Delacroix, as well as

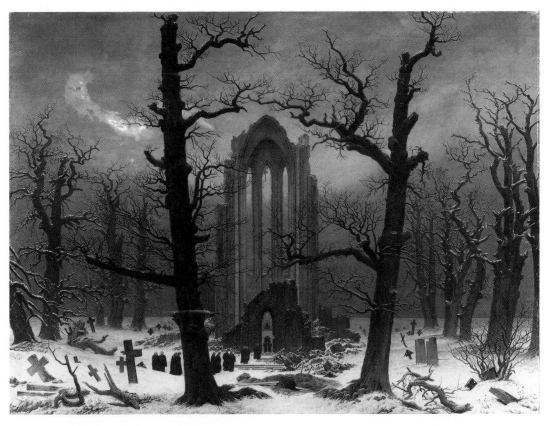

1.11 Caspar David Friedrich, *Cloister Graveyard in the Snow*, 1819. Oil on canvas, 48 × 67" (121.9 × 170.2 cm). Formerly Nationalgalerie, Berlin (destroyed in World War II).

1.12 Richard Parkes Bonington, *A Scene on the French Coast*, c. 1825. Watercolor and pencil on paper, 8¼ × 13⅜" (21.3 × 34.2 cm). Tate, London.

landscape painters like Camille Corot, whose work will be discussed below. Although he painted cityscapes as well as genre and historical subjects, it was the spectacular effects of Bonington's luminous marine landscapes (fig. **1.12**) that directly affected artists such as Johan Barthold Jongkind and Eugène Boudin, both important precursors of Impressionism (see fig. 2.30). Indeed, many of the English landscapists visited France and exhibited in the Paris Salons, while Delacroix spent time in England

and learned from the direct nature studies of the English artists. Foremost among these were **John Constable** (1776–1837) and **Joseph Mallord William Turner** (1775–1851). Constable spent a lifetime recording in paint those locales in the English countryside with which he was intimately familiar (fig. **1.13**). The exhibition of several of his works, including his *Hay Wain*, at the Paris Salon of 1824 brought him greater acclaim in France than he received in Britain. Delacroix, in particular, took

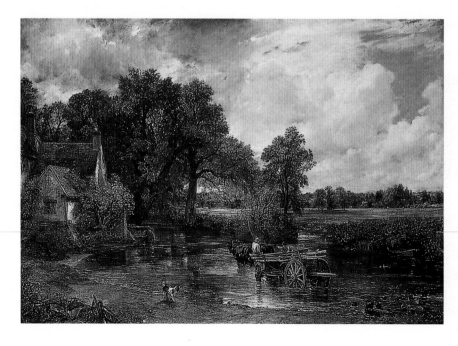

1.13 John Constable, *The Hay Wain*, 1819–21. Oil on canvas, 51¼ × 73" (130.2 × 190 cm). The National Gallery, London.

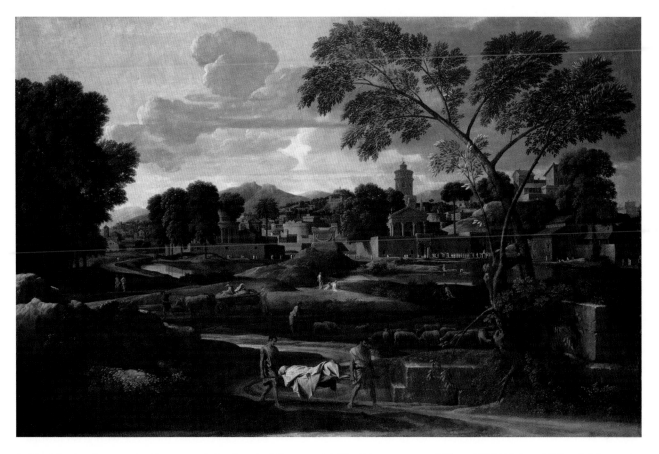

1.14 Nicolas Poussin, *Landscape with the Burial of Phocion*, 1648. Oil on canvas, 44¾ × 68⅞" (114 × 175 cm). National Museum of Wales, Cardiff.

to heart Constable's evocative brushwork and personal engagement with nature.

Though his paintings and the sketches he made from nature were the product of intensely felt emotion, Constable never favored the dramatic historical landscapes, with their sublime vision of nature, for which Turner was justifiably famous in his own day. Ambitious, prolific, and equipped with virtuoso technical skills, Turner was determined to make landscapes in the grand tradition of Claude Lorrain and Poussin, exemplified by the latter's *Landscape with the Burial of Phocion* (fig. **1.14**). Claude's and Poussin's carefully constructed, Italianate landscapes, which often include mythological or biblical figures, defined classical landscape painting for over two centuries. Though both were French, each decided to pursue painting in the *campagna*, or countryside around Rome. Turner's first trip to Italy in 1819 was an experience with profound consequences for his art. In his watercolors and oils he explored his fascination with the often destructive forces of nature and the ever-changing conditions of light and atmosphere in the landscape. His dazzling light effects could include the delicate reflections of twilight on the Venetian canals or a dramatic view across the Thames of the Houses of Parliament in flames (fig. **1.15**). Turner's painterly style could sometimes verge on the abstract, and his paintings are especially relevant to developments in twentieth-century art.

1.15 Joseph Mallord William Turner, *The Burning of the Houses of Parliament*, 1834–35. Oil on canvas, 36½ × 48½" (92.7 × 123.2 cm). The Cleveland Museum of Art. Bequest of John L. Severance. 1942.647.

The degree to which Turner's subjective exploration of nature led him toward abstraction did not deter John Ruskin from heralding the painter as the most significant of "modern" artists. Viewers looking today at Turner's *The Burning of the Houses of Parliament* alongside Whistler's *Nocturne in Black and Gold* might wonder at Ruskin's rejection of the latter. Like Turner, Whistler gives the majority of his canvas to the striking play of light and color against the sky. Both painters appeal to technical experimentation to achieve the dramatic incendiary effects at the center of their paintings. One place where the two differ, however, is in their handling of space. Turner remains true to the classical construction of pictorial space as divided into a clearly discernible fore-, middle- and background. Despite its violent subject, his painting retains the balance and symmetry characteristic of classical works by Claude and Poussin. Whistler, on the other hand, abandons these conventions, plunging the viewer into an uncertain position *vis-à-vis* the flash of fireworks and their reflection on the surface of the river. What is more, Whistler's subject—the regular fireworks display over an amusement park popular among the working as well as middle classes—evokes the cheap and artificial pleasures of urban life. Turner's work instead conveys the awesomeness of nature—here, represented by the fire—which threatens to destroy a consummate symbol of civilization.

The principal French Romantic landscape movement was the Barbizon School, a loose group named for a village in the heart of the forest of Fontainebleau, southeast of Paris. The painters who went there to work drew from the seventeenth-century Dutch landscape tradition as well as that of England. Works by Bonington and Constable rather than Turner, however, had the greatest influence on the Barbizon painters. Thus, the emphasis continued to be on unified, tonal painting rather than on free and direct color. It was the interior of the forest of Fontainebleau, rather than the brilliant sunlight of the seashore, that appealed to them. This in itself could be considered a Romantic interpretation of nature, as the expression of intangibles through effects of atmosphere.

The artist most closely associated with the Romantic landscape of the Barbizon School was **Théodore Rousseau** (1812–67). Instead of following the classical approach by visiting Italy and painting an idealized version of the *campagna*, Rousseau deliberately turned to the French landscape for his subjects. What is more, he refused to endow his landscapes with mythological or other narrative scenes. He painted pure landscapes, believing that nature itself provided more than sufficient thematic content. In the forests around Fontainebleau Rousseau distilled the essence of French culture and nationality; not surprisingly, the period of his greatest popularity coincided with the establishment of France's brief Second Republic (1848–52). In his *Edge of the Forest of Fontainebleau, Sunset* (fig. **1.16**), Rousseau endows the scene with great intimacy by framing the view with trees that appear to bow as if acknowledging the presence of the viewer. The vegetation—especially the lone, backlit tree in the middle ground—seems more animated, more alive than even the cattle who staff the scene.

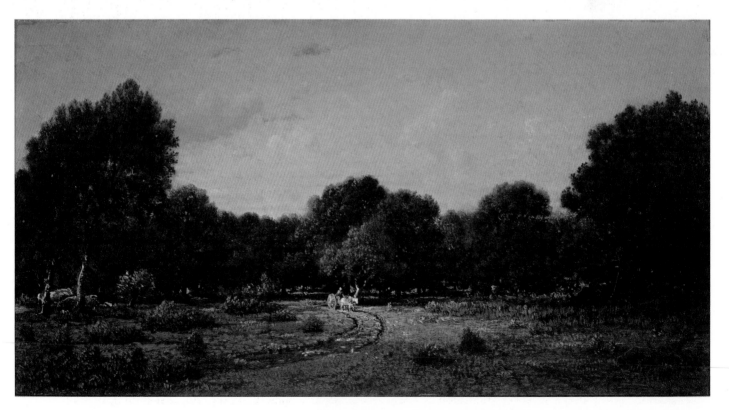

1.16 Théodore Rousseau, *Edge of the Forest of Fontainebleau, Sunset*, 1850. Oil on canvas, 55⅞ × 77⅞" (142 × 198 cm). Louvre, Paris.

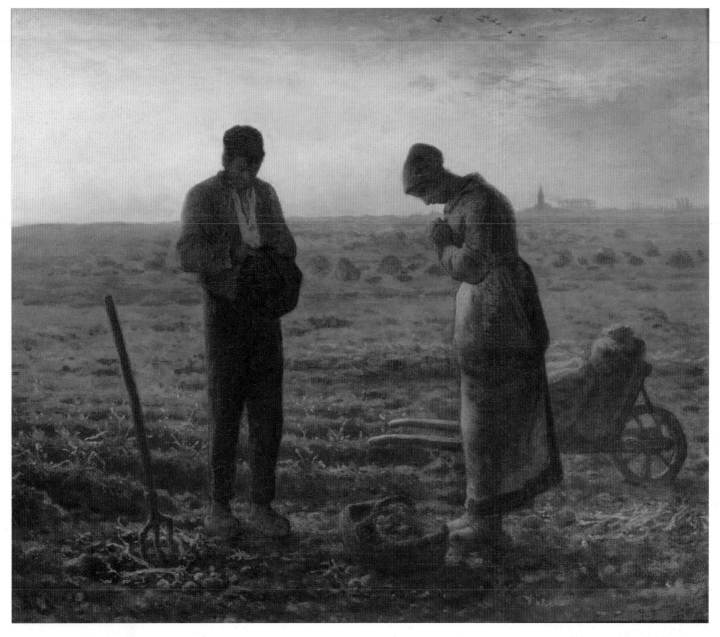

1.17 Jean-François Millet, *The Angelus*, 1857–59. Oil on canvas, 21½ × 25⅞" (55 × 66 cm). Musée d'Orsay, Paris.

Other painters associated with the Barbizon School depended instead on a more literal human presence in order to animate their landscapes. **Jean-François Millet** (1814–75) peopled his landscapes with laborers, often treating them with a grandeur customarily reserved for biblical or classical heroes (fig. **1.17**). As if to redeem the grinding poverty of unpropertied farm life, he integrated his field laborers into landscape compositions of Poussinesque grandeur and calm. Because of this reverence for peasant subjects Millet exerted great influence on Van Gogh (see chapter 3).

The work of **Camille Corot** (1796–1875), a painter only peripherally associated with the Barbizon School, cannot easily be categorized. His studies of Roman scenes have a classical purity of organization comparable to that of Poussin and a limpidity of light and color similar to that of Bonington. Like his English contemporaries, Corot

spent a good deal of his time drawing and painting directly from nature. Beginning in 1825, he spent three years in Italy making open-air studies that in their delicate tonalities capture the special character of southern light. One of his best-known works from this Italian sojourn, *Island and Bridge of San Bartolomeo, Rome* (fig. **1.18**), possesses a classical balance and clarity while demonstrating Corot's striking approach to form. His structures are tightly inter-locking horizontals and verticals, all harmoniously defined within a narrow range of ochers and browns. The strong sense of architectural geometry, of contrasting masses and planes, emerges not by way of conventional modeling, but through a regard for form as a series of nearly abstract volumes. These small landscapes exerted a great influence on the development of the Impressionism and Post-Impressionism of Monet and Cézanne. From the landscapes of his Roman period, Corot turned to a more Romantic

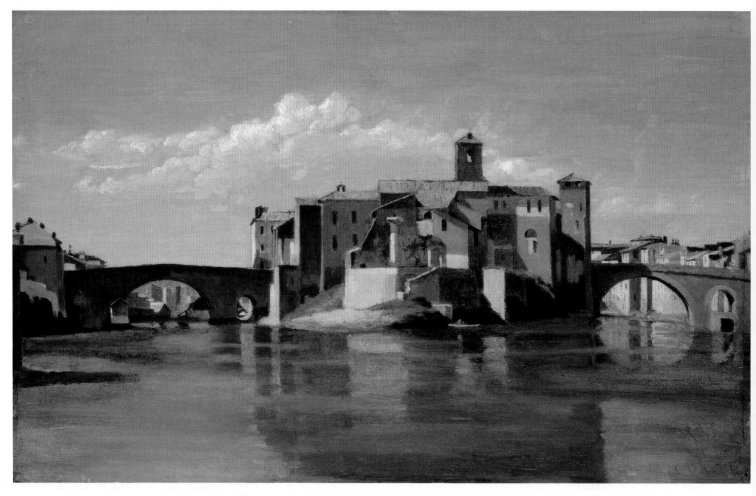

1.18 Camille Corot, *Island and Bridge of San Bartolomeo, Rome*, 1826–28. Oil on paper on canvas, 10⅝ × 16⅞"
(27 × 16.9 cm). National Gallery of Art, Washington. Patrons' Permanent Fund.

mode with delicate woodland scenes in tones of silvery gray, Arcadian landscapes sometimes populated by diminutive figures of nymphs and satyrs (see fig. 2.29). His late portraits and figure studies, on the contrary, are solidly realized and beautifully composed, works that are closely related to the studio scenes and figures of Post-Impressionist, Fauve, and Cubist tradition.

In the end, both Neoclassicism and Romanticism (and, ultimately, modernism) can be seen as products of the Enlightenment. The eighteenth-century valorization of rationality, the faith in reason exhibited by such *philosophes* as Voltaire and Denis Diderot, undergirds the Neoclassical penchant for archeological accuracy, pictorial clarity, and even moral virtue. Through reason, the social as well as the natural order can be understood and, perhaps, even improved. Hence, rigorous academic training with its years of practice and emulation offered the most reliable guide to young painters. Yet, the Enlightenment had another face, a face that turned toward the emotional side of life. The *philosophe* Jean-Jacques Rousseau argued that natural, unpolluted human emotions offered the surest means of understanding truth. For Rousseau, only by *feeling*

something could one truly know it. This strand of the Enlightenment finds itself at the center of Romanticism, where truth is sought by turning inward, where subjective experiences are the surest markers of genius. Just as, for Rousseau, conventional schools offered only corruption and lies, academic practices struck some Romantic artists as similarly contrary to their aims.

What the following chapters will show, however, is that both Neoclassicism and Romanticism nourish the roots of modernism. In fact, modernism might be best understood as a struggle between the forces of objective rationality and subjective expression. At certain points in the history of modern art, one or the other might seem to gain the advantage. But the tension between the two continues to exert its influence, and the other side is never far from revealing itself. This condition makes itself felt early in the nineteenth century with the appearance of another artistic mode of representation that contributed to the evolution of modernism: Realism. A literary as well as visual style, Realism will push the Enlightenment penchant for dispassionate rationality and social improvement to its zenith.

2
The Search for Truth: Early Photography, Realism, and Impressionism

At the start of the nineteenth century, both the Neoclassical and Romantic styles had their partisans. Typified by the work of Ingres, Neoclassicism offered viewers glimpses of an imaginary antique past or an exotic, otherworldly present rendered in a crisp, detached linearity. Romanticism, exemplified by the painting of Delacroix, likewise tended toward subjects drawn from distant cultures or literary fantasies, but depicted with an undisguised subjectivity and passionate colorism. Each offered its brand of escapism to Europeans weary of revolution and wary of the incipient imperialism emerging throughout the West. As European and North American economies grew increasingly reliant on manufacturing, many Western countries seized territories in Africa, South America, Asia, and the Pacific in search of both raw materials and new markets for their goods. Romantic depictions of colonized lands and peoples offered an appealing alternative to the reality of military occupation and economic exploitation sustaining the rise of capitalism.

Dispelling this escapism was an emphatic return to Enlightenment rationality in the form of Realism. The challenges posed by industrial expansion and political upheaval were not to be mastered by a retreat into fantasy but by a renewed search for truth. The truth promised by objective analysis and cold reason appealed to artists and writers as much as to philosophers and scientists. That Positivism—a philosophy that rejects metaphysical considerations in favor of a strictly empirical approach to understanding all forms of human experience—should gain adherents as a popular as well as intellectual movement gives an indication of the widespread craving for certainty, whether scientific, moral, economic, or political. Realism was the cultural response to this need.

New Ways of Seeing: Photography and its Influence

The public taste for visual fact served as an all-important stimulant to the research that finally brought about the invention of the first practical photographic processes. The ingredients had existed, some for centuries. Ancient authors noted the use of the *camera obscura*, a dark chamber with a small aperture that projects external scenes onto the opposite wall. Lenses had likewise been in use for centuries. And the photosensitivity of silver salts—which would be used to record images in early photographs—had been familiar to chemists at least since the eighteenth century, perhaps from as early as the twelfth. So what pressed so many artists, inventors, and scientists to seek in the first decades of the nineteenth century a means of securing an image through photography? Unquestionably, industrialized Europe and North America had developed a cultural desire for the accuracy it promised. And photography would, in its turn, fuel this interest in finding—and documenting—objective truth.

In August 1839, **Louis-Jacques-Mandé Daguerre** (1789–1851) publicly demonstrated a new mechanical technology, the daguerreotype, for permanently fixing upon a flat surface and in minute detail an exact tonal, if not full-color, image of the world. From that time, Western painters would hardly be able to create new imagery without some consciousness of the special conditions introduced by the medium of photography (literally "drawing with light"). Not until the twentieth century, it should be added, would photographers feel altogether free to work without deference to the rival aesthetic standards, qualities, and prestige imposed by the age-old, handwrought image-making processes of painting and drawing.

The most immediate and obvious impact of photography on painting can be seen in the work of artists eager to achieve a special kind of optical veracity unknown until then, a trend often thought to have culminated in the "instantaneity" of some Realist and Impressionist works, and resurgent in the Photorealism of the 1970s (see chapter 23).

Other artists, however, or even the same ones, took the scrupulous fidelity of the photographic image as good reason to work imaginatively or conceptually and thus liberate

2.1 Louis-Jacques-Mandé Daguerre, *An early daguerreotype,
taken in the artist's studio,* 1837. Société Française de
Photographie, Paris.

were absent from the Fine Arts galleries and instead presented in the industrial halls, highlighting their technical rather than aesthetic interest. Regardless of the contested status of photography's aesthetic merit, early photographers found their work relating closely to painting, just as painters were bound up with photography. Buoyed by pride in their technical superiority, photographers even felt compelled to match painting in its artistic achievements. For painters enjoyed the freedom to select, synthesize, and emphasize at will and thus attain not only the poetry and expression thought essential to art but also a higher order of visual, if not optical, truth. In one of the earliest known photographs, Daguerre, who was already famous for his immense, sensationally illusionistic painted dioramas, had sought to emulate art as much as nature. The reality he chose to record was that of a still life arranged in a manner conventional to painting since at least the seventeenth century (fig. **2.1**). This was a daguerreotype, a metal plate coated with a light-sensitive silver solution, which, once developed in a chemical bath, resulted in a unique likeness that could not be replicated, but that recorded the desired image with astonishing clarity.

Simultaneously in England, the photographic process became considerably more versatile. **William Henry Fox Talbot** (1800–77) discovered a way of fixing a light-reflected image on the silver-treated surface of paper, producing what its creator called a calotype. Talbot claimed that his earliest calotype dated to 1835, thus preceding the daguerreotype. Talbot's belated announcement allowed Daguerre to enjoy greater publicity and financial reward from the invention of photography, but the British inventor's process ultimately superseded that of his French rival (see *Daguerreotype versus Calotype*, below). Talbot's technique converted a negative image into a positive one, a procedure that remains core to film-based photography.

their art from the requirement of pictorial verisimilitude. Some saw the aberrations and irregularities peculiar to photography as a source of fresh ideas for creating a whole new language of form. And among painters of the period were some accomplished photographers, such as Edgar Degas and Thomas Eakins. Photography could also serve painters as a shortcut substitute for closely observed preparatory drawings and as a vastly expanded repertoire of reliable imagery, drawn from any exotic-seeming corner of the globe into which adventurous photographers had been able to lug their cumbersome equipment.

Despite the widespread interest in photography by artists, the aesthetic status of photographs remained suspect. Institutional practices contributed to the aesthetic burden of proof placed on photographers. Photographs were not generally included in art exhibitions. For instance, at the Universal Exposition in Paris in 1855, photographs

TECHNIQUE

Daguerreotype versus Calotype

Building upon the earlier experiments of the versatile inventor Nicéphore Niépce (1765–1833), Daguerre developed a photographic process in which an iodized silver plate was placed inside a rudimentary camera. When the lens was directed at the desired scene, an aperture would be manually opened for several minutes. This action would record a "latent" image on the plate, meaning that the image existed on the plate as a chemical reaction though it was not visible to the naked eye. Daguerre discovered he could reveal the latent black and white image by treating the plate with mercury fumes: one of many dangerous processes associated with early photography. The latent image would degrade upon exposure to additional light, however. Daguerre found the final step in the process in 1837 when he realized that a salt solution would fix the image. The resulting daguerreotype remains one of the clearest, most precise modes of photography. The main

drawback of daguerreotypes was their uniqueness: they could not be reproduced. Pursuing the invention of photography at the same time was William Henry Fox Talbot, who was familiar with the *camera obscura* as an aid to drawing. A disappointed amateur draftsman, Talbot developed a technique whereby a scene captured by a *camera obscura* would be projected onto paper coated with silver salt, thereby securing a black and white reproduction of it. These photographs reversed the depicted subject's brightness so that dark areas registered as light and light areas as dark. Talbot resolved this by using them as negatives. By projecting light through one and onto another piece of sensitized paper, he restored the lights and darks of the original, thus paving the way for numerous advances in negative-based photography during the nineteenth and twentieth centuries. Talbot called his process "calotype," meaning "beautiful type."

2.2 Oscar G. Rejlander, *The Two Ways of Life*, 1857. Combination albumen print. Royal Photographic Society, England.

Because the negative made it possible for the image to be replicated an infinite number of times, unlike the daguerreotype, painting-conscious photographers such as **Oscar G. Rejlander** (1813–75) could assemble elaborate, multifigure compositions in stagelike settings. They pieced the total image together from a variety of negatives and then orchestrated them, rather in the way history painters prepared their grand narrative scenes for the Salon (fig. **2.2**). With his combination prints, Rejlander emulated not only the artistic methods and ambitions of academic masters, but also their pretensions to high moral purpose. British photographer **Henry Peach Robinson** (1830–1901) used sketches (fig. **2.3**) to prepare his elaborate exhibition photographs, which he compiled from multiple negatives (fig. **2.4**).

2.3 Henry Peach Robinson, sketch for *Carolling*, 1886–87. Pencil on paper, 13 × 25" (33 × 65.5 cm). Royal Photographic Society, England.

2.4 Henry Peach Robinson, *Carolling*, 1887. Combination albumen print. Royal Photographic Society, England.

2.5 Anna Atkins, *Cystoseira granulata*, from *British Algae*, 1843–44. Cyanotype, 11½ × 8²½" (28.0 × 21.8 cm). Detroit Institute of Arts.

But just as the Realist spirit inspired some progressive painters to seek truth in a more direct and simplifying approach to subject and medium, many enlightened photographers sought to purge their work of the artificial, academic devices employed by Rejlander and instead report the world and its life candidly. One approach to achieving such immediacy is through photograms: objects are placed directly onto photosensitive paper which is then exposed to light. **Anna Atkins** (1799–1871) was a pioneer in this technique, creating richly hued cyanotypes of botanical specimens (fig. **2.5**). Atkins circulated her cyanotypes in volumes such as *British Algae* (1843–53), the first publication to be composed and printed photographically. The striking color of her photograms and their accurate yet ghostly record of plant forms point to both the aesthetic and documentary potential of photography.

For camera-based photography, other strategies could be used to enhance the medium's potential for objectivity and reportage. The practitioners of this kind of documentary photography achieved art and expression through the choice of subject, view, framing, light, and the constantly improving means for controlling the latter—lenses, shutter speeds, plates, and processing chemicals. Even the work of Daguerre and Talbot (figs. **2.6**, **2.7**) shows this taste for creating a straightforward record of the everyday world, devoid of theatrics or sentiment. Their first street scenes already have the oblique angles and random cropping of snapshots, if not the bustling life, which moved in and out of range too rapidly to be caught by the slow photosensitive materials of the 1830s and 40s. Contemporaries called Daguerre's Paris a "city of the dead," since the only human presence registered in images like *Boulevard du*

2.6 Louis-Jacques-Mandé Daguerre, *Boulevard du Temple, Paris*, c. 1838. Daguerreotype. Bayerisches Nationalmuseum, Munich.

2.7 William Henry Fox Talbot, *Trafalgar Square, London, during the erection of the Nelson Column*, London, England, 1843. Salt print from a paper negative, 6¾ × 8⅜" (17.1 × 21.3 cm). The Museum of Modern Art, New York.

Temple was that of a man who stood still long enough for his shoes to be shined and, coincidentally, for his picture to be taken.

Among the first great successes in photography were the portraitists, foremost among them France's **Nadar** (Gaspard-Félix Tournachon; 1820–1910) and England's **Julia Margaret Cameron** (1815–79), whose powerful personalities gave them access to many illustrious people of the age and the vision to render these with unforgettable penetration (fig. **2.8**). A prolific writer, as well as caricaturist, hot-air balloon photographer, and dynamic man about Paris, Nadar wrote in 1856:

> Photography is a marvellous discovery, a science that has attracted the greatest intellects, an art that excites the most astute minds—and one that can be practiced by any imbecile. … Photographic theory can be taught in an hour, the basic technique in a day. But what cannot be taught is the feeling for light. … It is how light lies on the face that you as artist must capture. Nor can one be taught how to grasp the personality of the sitter. To produce an intimate likeness rather than a banal portrait, the result of mere chance, you must put yourself at once in communion with the sitter, size up his thoughts and his very character.

2.9 Julia Margaret Cameron, *Mrs Herbert Duckworth as Julia Jackson*, c. 1867. Albumen print, 13⅜ × 9⅝" (34 × 24.4 cm). International Museum of Photography at George Eastman House, Rochester, New York.

Cameron liked to dress up her friends and family and reenact scenes from the Bible and Tennyson's *Idylls of the King* (a series of poems based on the legends of King Arthur) as photographed costume dramas. She also approached portraiture with an intensity that swept away all staginess but the drama of character and accentuated chiaroscuro (fig. **2.9**). Throughout her work, however, she maintained, like the good Victorian she was, only the loftiest aims. In answer to the complaint that her pictures always appeared to be out of focus, Cameron stated:

> What is focus—who has a right to say what focus is the legitimate focus—My aspirations are to ennoble Photography and to secure for it the character and uses of High Art by combining the real & ideal & sacrificing nothing of Truth by all possible devotion to Poetry & Beauty.

In addition to portraits and lyrical genre scenes, Cameron also participated in another of photography's earliest genres: ethnographic images. The emergence of photography coincided with the expansion of colonialism by European countries, especially Britain and France. This

2.8 Nadar (Gaspard-Félix Tournachon), *Sarah Bernhardt*, 1864. Photograph, 9⅜ × 9⅜" (23.8 × 24.5 cm). Bibliothèque Nationale de France, Paris.

imperialism manifested itself culturally in the form of Orientalism: Western representations—literary and visual—of the Near East, North Africa, and Asia, those regions under heaviest colonization during the mid-nineteenth century. Ethnography and the nascent discipline of anthropology likewise developed in response to national interests, fostering a better understanding of those cultures now under colonial rule. This desire to know the "other"—sometimes for altruistic reasons, sometimes out of simple curiosity, but also motivated by commercial and political considerations—led many photographers to turn their cameras to the landscapes and peoples of colonized regions. When Cameron's husband was appointed to a colonial post in Ceylon, she joined him there with her family and her camera. Unlike many of her contemporaries, Cameron's approach to ethnographic photography maintains much the same sensitivity and subjectivity that she accorded her English sitters (fig. **2.10**).

Quick to become one of documentary photography's most abiding subjects was war. Photography robbed armed conflict of the operatic glamour often given it by traditional painting. This first became evident in the photographs taken by Roger Fenton during the Crimean War of 1853–56, but it had an even more shattering effect in the work of **Mathew Brady** (1823–96) and such associates as Alexander Gardner, who bore cameras onto the body-strewn fields in the wake of battle during the American Civil War (fig. **2.11**). (Because the required length of exposure was still several seconds, the battles themselves could not be photographed.) Now that beautifully particularized, mutely objective—or indifferent—pictures disclosed all too clearly the harrowing calm brought by violence, or the almost indistinguishable likeness of the dead on either side of the conflict, questions of war and peace took on a whole new meaning. When Brady's photograph is compared to a contemporary Civil War scene by one of the greatest American painters of the era, Winslow Homer (see fig. 2.50), it becomes clear that photography brought home the graphic reality of war in a way no painter would.

In America the daguerreotype experienced wild popularity from the moment the first instruction manuals and equipment arrived on the East Coast. The many commercial photographic studios that sprang up, especially in New York and Philadelphia, gave rise to hundreds of amateur photographers. They provided inexpensive portrait services to sitters who could never have afforded a painted portrait. From the countless efforts of anonymous photographers emerge forthright records of ordinary citizens and valuable likenesses of extraordinary personalities, such as the eminent abolitionist writer and orator Frederick Douglass (fig. **2.12**). An escaped slave, Douglass informed his eloquent public protests against slavery with firsthand experience. He was an adviser to President Abraham Lincoln during the Civil War and afterward became the first African-American to hold high office in the United States government. The photograph of Douglass as a young man was taken at the end of a lecture tour he had given in Great Britain and Ireland in order to avoid recapture in America. Like the best daguerreotypes, it possesses tremendous appeal by virtue of its unaffected, straightforward presentation of the sitter.

2.10 Julia Margaret Cameron, *Unknown Girl, Ceylon,* 1875–79. Albumen print. J. Paul Getty Museum, Los Angeles.

2.11 Mathew Brady, *Dead Soldier, Civil War*, c. 1863. Gelatin-silver print. Library of Congress, Washington, D.C.

2.12 Unknown photographer, *Frederick Douglass*, 1847. Daguerreotype, 3¼ × 2¾" (8.3 × 7 cm). Collection William Rubel.

Only the Truth: Realism

Photography offered only one avenue for the exploration and documentation of observed reality. Realism was another. Any art-historical consideration of Realism is inextricably tied to the tumultuous political and social history of this period in France, the country where Realism developed most coherently. Following the final defeat of Napoléon in 1815, a succession of Bourbon monarchs resumed the governance of France. At first tolerant of moderate reforms, the monarchy grew increasingly authoritarian until revolution broke out anew in 1830. A relatively bloodless coup replaced the Bourbons with a king from the Orléans line: Louis-Philippe. The self-styled "Citizen King," Louis-Philippe agreed to govern as a constitutional monarch. Like his predecessors, he found in France's political instability and economic difficulties cause to assume greater authority while limiting the rights of the citizenry and of the press. After he was finally toppled in yet another uprising—during the great revolutionary year of 1848—France's Second Republic was proclaimed. The Republic's president, Napoléon's nephew Louis-Napoléon Bonaparte, staged his own coup late in 1851 and, in 1852, inaugurated the Second Empire over which he would rule as supreme head. Reigning as Napoléon III, he lacked the military acumen of his uncle. His disastrous execution of the Franco–Prussian War resulted in the collapse of the Second Empire in 1870. It is against the backdrop of this tortuous journey away from empire and back again that the development of Realism in France must be understood.

Alongside these historical events, a new kind of journalism and a new kind of critical writing were everywhere evident. Many of the leading authors and critics of France and England wrote regularly for the new popular reviews. This phenomenon is perhaps best seen in the emergence of the caricature—the satirical comment on life and politics, which became a standard feature of journals and newspapers. Although visual attacks on individuals or corrupt economic and political systems have always existed, and artists such as Goya have been motivated by a spirit of passionate invective, drawings that ranged from gentle amusement to biting satire to vicious attack now became a commonplace in every part of Europe and America. These images could be cheaply disseminated through the popular medium of lithography (see p. 7).

France

The greatest of the satirical artists to emerge in this new environment was **Honoré Daumier** (1808–79), who was best known for some 4,000 lithographic drawings that he contributed to French journals such as *La Caricature* and *Le Charivari*, but was also an important sculptor and painter. His small caricatural busts were created between 1830 and 1832 to lampoon the eminent politicians of Louis-Philippe's regime. Daumier's studies of the theater, of the art world, and of politics and the law

courts range from simple commentary to perceptive observation to bitter satire. His political caricatures were at times so biting in their attacks on the establishment that they were censored. The artist was imprisoned for six months for a caricature he did of the king.

Daumier could not resist mocking the apelike features of the Comte de Kératry (fig. **2.13**), for he was not only a government official, but an art critic as well. Daumier's *Ratapoil* ("hairy rat") of 1850–51 is not based on an actual person but is a personification of all the unscrupulous agents of Louis-Napoléon (later Napoléon III) (fig. **2.14**). Their arrogance and tawdry elegance are subtly communicated through the figure's twisting pose and the fluttering flow of clothing, counterpoised by the bony armature of the figure itself. Out of fear that it would be destroyed by the very forces it satirized, the clay figurine was kept hidden until after Daumier's death, when, like the earlier busts, it was cast in bronze.

The sculpture of Daumier, now much admired, was a private art, little known or appreciated until its "discovery" in the late twentieth century. But while Daumier was concerned with all the details of everyday life and politics, he cannot be called only a Realist. His paintings dealing with themes from the writings of Cervantes and Molière place him partly in the Romantic camp, not only for his use of literary subjects but also for the dramatic chiaroscuro he employed to obtain his effects. This drama of light and shade transforms even mundane subjects, such as *The Third-Class Carriage* (fig. **2.15**), from simple illustration to a scene of pathos. The painting is a crucial example of

2.14 Honoré Daumier, *Ratapoil*, 1850–51. Original plaster cast, height 16⅞" (43 cm). Albright Knox Gallery, Buffalo. Elisabeth H. Gates Fund, 1954.

French Realist art in its sympathetic depiction of contemporary working-class life.

The profundity of Daumier's horror at injustice and brutality is perhaps best illustrated in the famous lithograph *Rue Transnonain* (fig. **2.16**), which shows the dead bodies of a family of innocent workers murdered by the civil guard during the republican revolt of 1834. With journalistic bluntness, the title refers to the street where the killings took place. In its powerful exploitation of a black-and-white medium, as well as the graphic description of its gruesome subject, this is a work comparable to Goya's *Disasters of War* (see fig. 1.9).

2.13 Honoré Daumier, *Comte de Kératry (The Obsequious One)*, c. 1833. Bronze, 4⅞ × 5¼ × 3⅝" (12.4 × 13.3 × 8.9 cm). Hirshhorn Museum and Sculpture Garden, Smithsonian Institution, Washington, D.C.

2.15 Honoré Daumier, *The Third-Class Carriage*, c. 1863–65. Oil on canvas, 25¼ × 35½" (64.1 × 90.2 cm). The Metropolitan Museum of Art, New York.

2.16 Honoré Daumier, *Rue Transnonain*, April 15, 1834, published in *L'Association Mensuelle*, July 1834. Lithograph, 11½ × 17½" (29.2 × 44.5 cm). Graphische Sammlung Albertina, Vienna.

Like Daumier, **Gustave Courbet** (1819–77) inherited certain traits from his Romantic predecessors. Throughout his life, he produced both erotic subjects that border on academicism and Romantic self-portraits. But, most important, he created unsentimental records of contemporary life that secure his place as the leading exponent of modern Realism in painting. These works possess a compelling physicality and an authenticity of vision that the artist derived from the observed world. Most notably, Courbet insisted upon the very material with which a painting is constructed: oil paint. He understood that a painting is in itself a reality—a two-dimensional world of stretched canvas defined by the nature and textural consistency of paint—and that the artist's function is to define this world.

A Burial at Ornans (fig. **2.17**) is significant in the history of modern painting for its denial of illusionistic depth, its apparent lack of a formal composition, and an approach to subject matter so radical that it was seen as an insult to everything for which the venerable French Academy stood. In his assertion of paint texture, the artist drew on and amplified the intervening experiments of the Romantics, although with a different end in view. Whereas the Romantics used broken paint surfaces to emphasize the intangible elements of the spirit or sublime natural phenomena (see fig. 1.15), Courbet employed them as a means to make the ordinary world more tangible. *The Burial* documents a commonplace event in Courbet's small provincial hometown in eastern France, but its ambitious size conforms to the

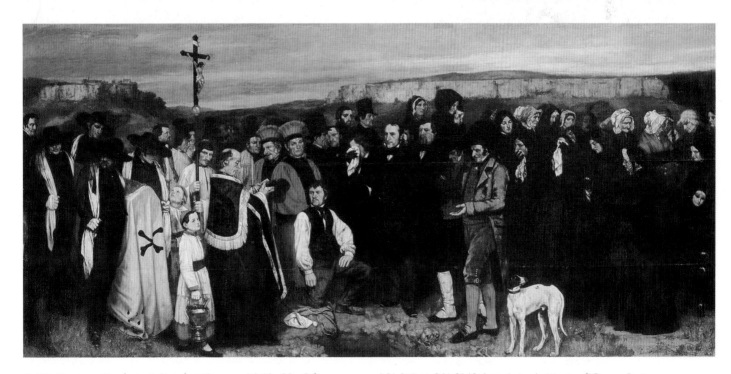

2.17 Gustave Courbet, *A Burial at Ornans*, 1849–50. Oil on canvas, 10' 3½" × 21' 9" (3.1 × 6.6 m). Musée d'Orsay, Paris.

dimensions of history painting, a category reserved for the noblest events from the past. Courbet's casual, frieze-like arrangement of village inhabitants, made up mostly of his friends and relatives, is an accurate depiction of local funerary customs (men and women are segregated, for example), but it carries no particular narrative message. It was not only this lack of compositional hierarchy and pictorial rhetoric that outraged French critics. Courbet's representation of ordinary residents of the countryside did not coincide with established Parisian norms for the depiction of rural folk. These are not the ennobled peasants of Millet (see fig. 1.17) or the pretty, happy maids of traditional academic painting. Rather, they are highly individualized, mostly unattractive, and aggressively real.

Combined with his unorthodox approach to formal matters, Courbet's Realism in his unpolished treatment of working-class subjects was associated with left-wing dissidence. Realism, and Courbet's sharpened political sensibilities, came to the fore during these decades of political turmoil, when republicans, Bonapartists, royalists, and socialists struggled to realign France's government. Courbet pursued his political sympathies on his canvases as he did in life, causing as much uproar with his Realist painting as with his activism. His contempt for the conservatism of official arts institutions spurred him in 1855 to mount a grand exhibition of his works—some of which had been rejected by the Salon jury—in a temporary Pavilion of Realism hastily erected near that year's Universal Exposition in Paris. This gesture encouraged later avant-garde artists, like the Impressionists, to establish similarly independent exhibitions. By the end of the century, the Salon would be displaced entirely as a venue for groundbreaking new art.

For the ardent socialist Courbet, peasant laborers and the rural landscape were the true sources of French identity and, hence, political authority. In a group of landscapes of the 1850s and 60s, *The Source of the Loue* among them (fig. **2.18**), Courbet had experimented with a form of extreme close-up of rocks abruptly cut off at the edges of the painting. A view from the artist's native province of Franche-Comté, *The Source* may owe something to the emerging art of photography, both in its fragmentary impression and in its subdued, almost monochromatic color. Courbet's landscape, however, combined a sense of observed reality with an even greater sense of the elements and materials with which the artist was working: the rectangle of the picture plane and the emphatic texture of the oil paint, which asserted its own nature at the same time that it was simulating the rough-hewn, sculptural appearance of exposed rocks.

Like Courbet, the Realist painter **Rosa Bonheur** (1822–99) largely addressed rural themes. Endowing her subjects with a grandeur akin to that of Millet's peasants, she nevertheless departs from her Barbizon contemporaries in her depiction of landscapes of crystalline clarity and rich color. Thanks to the progressive views of her parents, Bonheur was allowed to study painting and even permitted to visit farms and slaughterhouses disguised as a boy so she could sketch and acquire some knowledge of anatomy. The accuracy and sympathy of her paintings of animals, in particular, earned her fame as well as a fortune. *Ploughing in the Nivernais* (fig. **2.19**) exemplifies her approach to Realism in its respect for agricultural labor, its careful observation of livestock, and its glowing precision.

2.18 Gustave Courbet, *The Source of the Loue*, 1864. Oil on canvas, 39¼ × 56" (99.7 × 142.2 cm). The Metropolitan Museum of Art, New York.

2.19 Rosa Bonheur, *Ploughing in the Nivernais*, 1849. Oil on canvas, 70⅞ × 102⅜" (180 × 260 cm). Musée d'Orsay, Paris.

England

During the early decades of Queen Victoria's long reign (1837–1901), the social and artistic revolution that fueled the Realist movement in France assumed virtually religious zeal, as a group of young painters rebelled against what they considered the decadence of current English art. They called for renewal modeled on the piously direct, "primitive" naturalism practiced in Florence and Flanders prior to the late work of Raphael and the High Renaissance, which they saw as the beginning of what had become a stultifying academic tradition. **William Holman Hunt** (1827–1910), John Everett Millais, and Dante Gabriel Rossetti joined with several other sympathetic spirits to form a secret, reform-minded artistic society, which they called the Pre-Raphaelite Brotherhood. The ardent Pre-Raphaelites determined to eschew all inherited Mannerist and Baroque artifice and to search for truth in worthwhile, often Christian, subject matter presented with naive, literal fidelity to the exact textures, colors, light, and, above all, the outlines of nature.

For *The Hireling Shepherd* (fig. **2.20**) Hunt pursued "truth to nature" in the countryside of Surrey, where he spent the summer and fall of 1851 working *en plein air*, or out-of-doors, to set down the dazzling effect of morning sunlight. Reviving the techniques of the fifteenth-century Flemish masters, Hunt laid—over a white wet ground— glaze after glaze of jewel-like, translucent color and used the finest brushes to detail every wildflower blossom and blade of grass. Late in life, he asserted that his "first object was to portray a real Shepherd and Shepherdess … sheep and absolute fields and trees and sky and clouds instead of the painted dolls with pattern backgrounds called by such names in the pictures of the period." But it seems that he was also motivated to create a private allegory of the need for mid-Victorian spiritual leaders to cease their

2.20 William Holman Hunt, *The Hireling Shepherd*, 1851. Oil on canvas, 30¹/₁₆ × 43⅛" (76.4 × 109.5 cm). Manchester City Art Galleries, England.

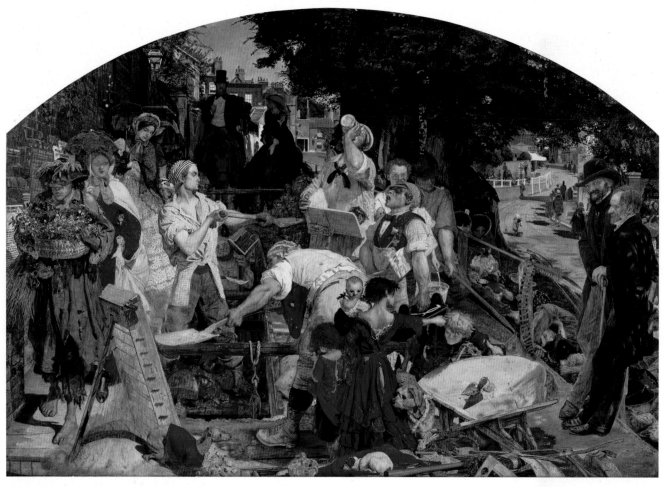

2.21 Ford Madox Brown, *Work*, 1852, 1855–63. Oil on canvas, 4' 5" × 6' 5¹¹⁄₁₆" (1.35 × 2 m). Manchester City Art Galleries, England.

sectarian disputes and become true shepherds tending their distracted flocks. Thus, while the shepherd, ruddy-faced from the beer in his hip keg, pays court to the shepherdess, the lamb on her lap makes a deadly meal of green apples, just as the sheep in the background succumb from being allowed to feed on corn. Gone are the smooth chiaroscuro elisions, rhythmic sweep, and gestural grace of earlier art, replaced by a fresh-eyed naturalism. The critic John Ruskin wrote appreciatively of Holman Hunt's work, lending his influential voice in support of the Pre-Raphaelites.

Although he never became an official member of the Brotherhood, **Ford Madox Brown** (1821–93) was introduced to them by the precocious young poet and painter Rossetti. The large canvas *Work* (fig. **2.21**), which preoccupied him for several years, is Brown's monumental testament to the edifying and redemptive power of hard toil. Like Hunt, he relies on a microscopic accuracy of detail to deliver his moralizing message. At the center of the sun-drenched composition are the muscular laborers who dig trenches for new waterworks in the London suburb of Hampstead. A proliferation of genre vignettes circles around this central action of the painting; these reinforce Brown's theme with emblems of the various social strata that made up contemporary Victorian society. At the far left, for example, is a ragged flower-seller followed by two women distributing temperance tracts. In the shade

of a tree at the right, an indigent couple tends to an infant, while in the background an elegantly dressed couple rides horseback. The two men at the far right are portraits: the philosopher Thomas Carlyle and a leading Christian Socialist, Frederick Denison Maurice, "brainworkers" whose relatively conservative ideas about social reform dovetailed with Brown's own genuine attempts to correct social injustice. His painting is the most complete illustration of the familiar Victorian ethic that promoted work as the foundation of material advancement, national progress, and spiritual salvation.

Seizing the Moment: Impressionism and the Avant-Garde

The various scandals surrounding Courbet's life and work had introduced the French public to the idea of a radical, often shocking, alternative to academic Salon art that was more or less closely identified with left-wing politics. Largely through Courbet's image in the popular imagination, the idea of an artistic avant-garde, or vanguard, became firmly established. Each new wave of avant-garde art was greeted with outrage by conservative public opinion—an outrage that frequently turned to acceptance, and even admiration, with the passing of time and the arrival of newer, yet more shocking, developments in art.

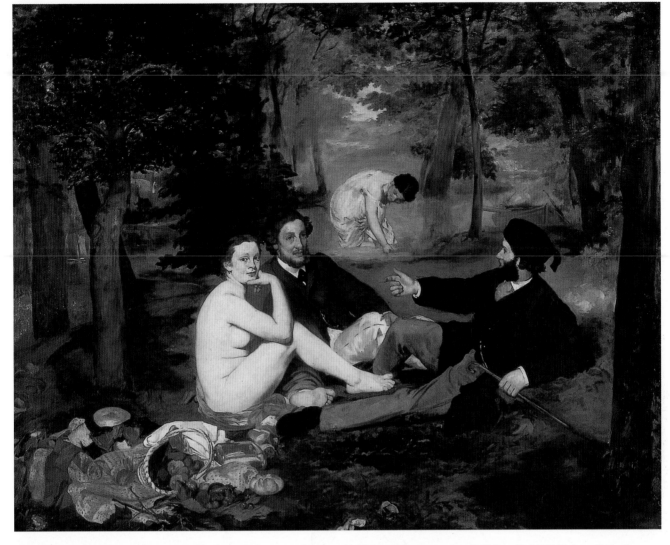

2.22 Édouard Manet, *Déjeuner sur l'herbe* (*Luncheon on the Grass*), 1863. Oil on canvas, 6' 9⅛" × 8' 10¼" (2.1 × 2.7 m). Musée d'Orsay, Paris.

Manet and Whistler

Although sympathetic to left-wing politics, **Édouard Manet** (1832–83) was a realist who nevertheless sought recognition through such conventional venues as the Salon, where he aimed to exhibit his modern depictions of contemporary life. His *Déjeuner sur l'herbe* (fig. **2.22**), rejected by the Salon of 1863, created a major scandal when it was shown in the Salon des Refusés, the exhibition mounted by the state that year to house the large number of works barred by jurors from the main Salon. Although the subject was based on Renaissance academic precedents—Giorgione's *Pastoral Concert* (1510) and an engraving by **Marcantonio Raimondi** (c. 1480–before 1534) of *The Judgment of Paris* (c. 1510–20), after a lost cartoon by Raphael (fig. **2.23**)—few viewers understood Manet's historicizing project and popular indignation arose because the classical, pastoral subject had been translated into contemporary terms. Raphael's goddesses and Giorgione's nymphs had become models, or even prostitutes, one naked, one

2.23 Marcantonio Raimondi, *The Judgment of Paris*, c. 1510–20. Based on a design by Raphael. Engraving, 11½ × 17⅜" (29.2 × 43.6 cm). The Metropolitan Museum of Art, New York. Rogers Fund, 1919.

partially disrobed, relaxing in the woods with two men whom Salon visitors would have recognized by their dress as artists or students. The woman in the foreground is Victorine Meurent, the same model who posed for *Olympia* (see fig. 2.24), and the men are Manet's relations. Manet abided by the convictions of his supporter Charles Baudelaire, the great poet and art critic who exhorted artists to paint scenes of modern life and to invent contemporary contexts for old subjects such as the nude. But in his ironic quotations from Renaissance sources, Manet created what seemed to be a conscious affront to tradition and accepted social convention.

Manet ostensibly adopted the structure of Raphael's original composition, with the bending woman in the middle distance forming the apex of the classical receding triangle of which the three foreground figures serve as the base and sides. However, his broad, abrupt handling of paint and his treatment of the figures as silhouettes rather than carefully modeled volumes tend to collapse space, flatten forms, and assert the nature of the canvas as a two-dimensional surface. Manet's subject, as well as the sketchiness of technique, infuriated the professional critics.

Manet's *Olympia* (fig. **2.24**), painted in 1863 and exhibited in the Salon of 1865, created an even greater furor than the *Déjeuner*. Here, again, the artist's source was exemplary: Titian's *Venus of Urbino*, which Manet had copied as a young man visiting Florence. *Olympia*, however, was a slap in the face to all the complacent academic painters who regularly presented their exercises in scarcely disguised eroticism as virtuous homage to the gods and goddesses of classical antiquity. Venus reclining has become an unidealized, modern woman who, by details such as her ribbon and slippers, as well as her name, would have been recognized as a prostitute. She stares out at the spectator with an impassive boldness that bridges the gap between the real and the painted world in a startling manner, and effectively shatters any illusion of sentimental idealism in the presentation of the nude figure. *Olympia* is a brilliant design in black and white, with the nude figure silhouetted against a dark wall enriched by red underpainting that creates a Rembrandtesque glow of color in shadow. The black maidservant brings flowers offered by a client; the cat clearly reacts to her. The volume of the figure is created entirely through its contours—again, the light-and-dark pattern and the strong linear emphasis annoyed the critics as much as the shocking subject matter.

Beyond the provocatively named figure, the bouquet of flowers, the black maid, and the cat also functioned as symbols of sexual licentiousness. Flowers were a long-standing metaphor for female genitalia. Black Africans were believed by many Europeans to be hyper-sexual. This racial stereotype would have been familiar to many contemporary

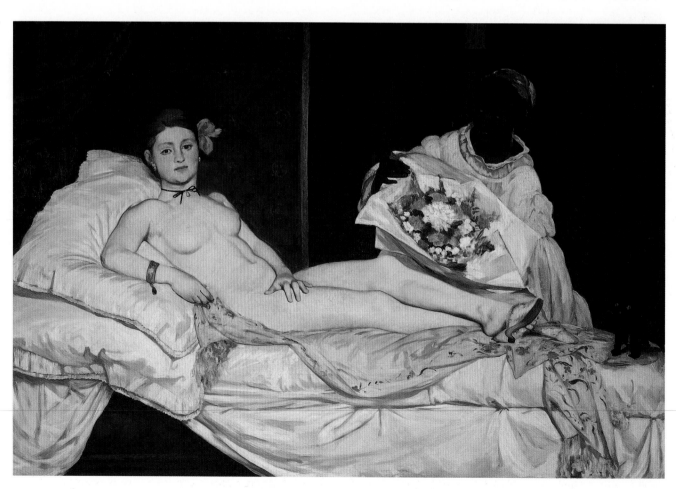

2.24 *Édouard Manet, Olympia, 1863. Oil on canvas, 4′ 3″ × 6′ 2¾″ (1.3 × 1.9 m). Musée d'Orsay, Paris.*

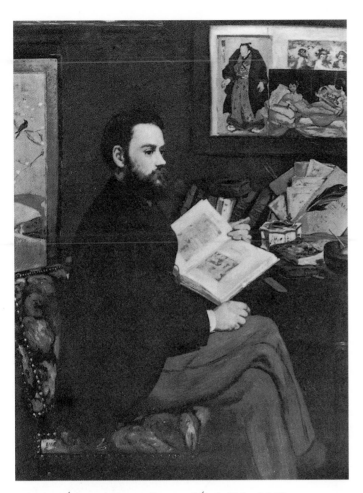

2.25 Édouard Manet, *Portrait of Émile Zola*, 1868. Oil on canvas, 57⅛ × 44⅞" (145.1 × 114 cm). Musée d'Orsay, Paris.

asm for Asian and specifically Japanese art then spreading throughout Europe. In the art of Asia avant-garde French painters found some of the formal qualities they were seeking in their own work.

After photography, the most pervasive influence on the nineteenth-century advance of modernist form came from Asian art, especially the color woodcut prints that began finding their way west shortly after the American naval officer Matthew Perry had forced open the ports of Japan in 1853, ending two centuries of closure to Western vessels. With their steep and sharply angled views, their bold, snapshot-like croppings or near–far juxtapositions, and their flat-pattern design of brilliant, solid colors set off by the purest contour drawing, the works of such masters as Kitagawa Utamaro, Katsushika Hokusai, and **Andō Hiroshige** (1797–1858; fig. **2.26**) struck European eyes as amazingly new and fresh. These prints reinforced the growing belief in the West that pictorial truth lay not in illusion but in the intrinsic qualities of the artist's means and the opaque planarity of the picture surface.

Among the artists to absorb fully the lessons offered by Japanese prints was **Mary Cassatt** (1845–1926). The Philadelphia-born Cassatt, who arrived in Paris with her wealthy family in 1866, reveals her understanding both of the Japanese independence of line and of Manet's interest in quotidian scenes of modern life. Cassatt's print,

viewers, thus heightening the outrage over the image. Finally, poets like Baudelaire had drawn on the association between cats and opportunistic sexual behavior. For Courbet, it was the painting's formal innovations that troubled him the most. He found *Olympia* so unsettling in the playing-card flatness of its forms, all pressed hard against the frontal plane, that he likened the picture to "a Queen of Spades getting out of a bath."

Manet's *Portrait of Émile Zola* (fig. **2.25**), an informal portrait, continues the Realists' critique of the academic concept of the grand and noble subject, carrying the attack several steps further in its emphasis on the plastic means of painting itself. Zola, the great Realist novelist and proponent of social reform, was Manet's friend and supporter. Manet included in the work certain details that are perhaps more revealing of his own credos than of those of the writer who had so brilliantly defended him against his detractors. On the desk, for example, is the pamphlet Zola wrote on Manet. Posted on the wall to the sitter's right is a small print of *Olympia*, behind which is a reproduction of *Bacchus* by the seventeenth-century Spanish master Velázquez. Beside *Olympia* is a Japanese print, and behind Zola's figure is part of a Japanese screen. The Japanese print and screen are symptomatic of the growing enthusi-

2.26 Andō Hiroshige, *Moon Pine at Ueno* from *One Hundred Views of Famous Places in Edo*, 1857. Color woodcut, 13¾ × 8⅝" (34.9 × 21.9 cm). The Brooklyn Museum, New York.

Woman Bathing (fig. **2.27**), presents a humble subject, which she animates through the play of strong contour line and surface patterning. The figure's boldly striped garment energizes the floral pattern of the carpet, with both surfaces merging into a single plane. Traditional perspectival space is here abandoned in favor of color, line, and form arranged for the benefit of visual harmony rather than documentary information.

Likewise fascinated by Asian art as a means of creating a new pictorial reality suitable for "a painter of modern life" was James Whistler (see chapter 1). Whistler, who trained in Paris and resided in London, exhibited a painting at the 1863 Salon des Refusés that caused a critical scandal rivaling the one incited by Manet's *Déjeuner sur l'herbe.* Much more than Manet, however, Whistler transformed Japanese sources into an emphatic aestheticism. *Japonisme,* or the emulation of patterns and forms observed in Japanese or Japanese-inspired prints, textiles, ceramics, and screens, offered Whistler a means to divorce himself from Western pictorial conventions in order to express a fresh, lyrical, and atmospheric sensibility. Even so, in an authentic Realist manner, he consistently painted what he had observed.

2.28 James Abbott McNeill Whistler, *Symphony in White No. II: The Little White Girl,* 1864. Oil on canvas, 30⅛ × 20⅛" (76.5 × 51.1 cm). Tate, London.

2.27 Mary Cassatt, *Woman Bathing,* 1890–91. Drypoint and aquatint, printed in color, 17 × 11¾" (43.2 × 29.8 cm). The Metropolitan Museum of Art, New York. Gift of Paul J. Sachs, 1916. 16.2.2.

Whistler's approach was evident in the early 1860s, when he made pictures like *Symphony in White No. II: The Little White Girl* (fig. **2.28**), where *japonisme* makes its presence felt not only in the obvious décor of an Asian blue-and-white porcelain vase, painted fan, and azalea blossoms, but also in the more subtle, and more important, flattening effects of the nuanced, white-on-white rendering of the model's dress and the rectilinear, screenlike divisions of the architectural framework. Further reinforcing the sense of an overriding formalism is the off-center composition, with its resulting crop of the figure along two edges of the canvas. To emphasize his commitment to the principle of Art for Art's Sake, Whistler gave his pictures musical titles—arrangements, symphonies, and nocturnes—thereby drawing analogies with a more immaterial, evocative, and non-descriptive medium. Such analogies were very much in the spirit of late nineteenth-century Aestheticism, summed up in 1873 in the English critic Walter Pater's

dictum, "All art constantly aspires towards the condition of music." This approach emphasized the formal qualities of art as being more important than subject matter, and indeed Whistler's aim was to create not a duplicate of nature, but rather what he called "an arrangement of line, form, and color first."

From Realism to Impressionism

A great part of the struggle of nineteenth-century experimental painters was an attempt to recapture the color, light, and changeability of nature that had been submerged in the rigid stasis and studio gloom of academic tonal formulas. The color of the Neoclassicists had been defined in local areas but modified with large passages of neutral shadows to create effects of sculptural modeling. The color of Delacroix and the Romantics flashed forth passages of brilliant blues or vermilions from an atmospheric ground. As Corot and the Barbizon School of landscape painters sought to approximate more closely the effects of the phenomenal world with its natural light, they were almost inevitably bent in the direction of the subdued light of the interior of the forest, of dawn, and of twilight. Color, in their hands, thus became more naturalistic, although they did choose to work with those effects of nature most closely approximating the tradition of studio light. However, the increasingly delicate and abstract, almost monochromatic tonality of the post-1850, proto-Impressionist landscapes painted indoors by Corot (fig. **2.29**), so different from the clear colors and structural firmness of his earlier Italian work (see fig. 1.18), may well have been an attempt to imitate the seamless, line-free value range of contemporary photography, a medium that greatly interested him. In their smoky tissues of feathery leaves and branches, the moody, autumnal, park-like scenes painted by the aging Corot seem to be painterly counterparts of the blurred landscape photographs of the period.

Artists had always sketched in the open air and, as we have seen, some such as Corot and the Barbizon painters made compositions entirely *en plein air*, though even these artists usually completed paintings in the studio. The Impressionists were the most consistently devoted to *plein-air* painting, even for some of their most ambitious works, and to capturing on canvas as faithfully as possible the optical realities of the natural world. However, the more the Realist artists of the mid-nineteenth century attempted to reproduce the world as they saw it, the more they understood that reality rested not so much in the simple objective world of natural phenomena as in the eye of the spectator. Landscape in actuality could never be static and fixed. It was a continuously changing panorama of light and shadow, of moving clouds and reflections on the water. The same scene, observed in the morning, at noon, and at twilight, was actually three different realities. Further, as painters moved out of doors from the studio they came to realize that nature, even in its dark shadows, was not composed of black or muddy browns. The colors of nature were the full spectrum—blues, greens, yellows, and whites, accented with notes of red and orange, and often characterized by an absence of black.

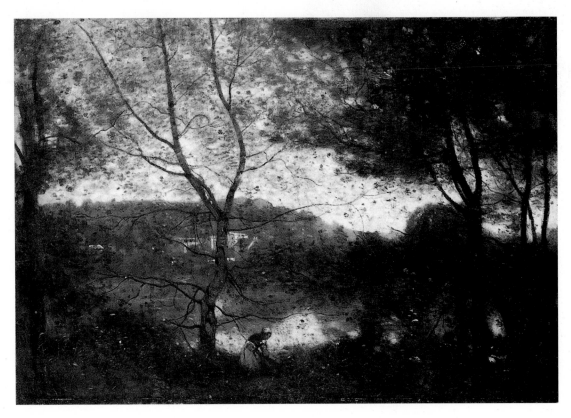

2.29 Camille Corot, *Ville d'Avray*, 1870. Oil on canvas, 21⅝ × 31½" (54.9 × 80 cm). The Metropolitan Museum of Art, New York. Bequest of Catharine Lorillard Wolfe, 1887.

Louis Leroy, the satirical critic for *Le Charivari*, was the first to speak of a school of "Impressionists," a term he derisively based on the title of a painting by **Claude Monet** (1840–1926) (fig. **2.30**) that was included in the first Impressionist exhibition, which opened on April 15, 1874, at the studio of the photographer Nadar. Featuring 163 works by thirty-five artists, the exhibition drew mostly artists, writers, and adventurous viewers along with a clutch of critics. The estimated 3,500 visitors to the month-long show would have seemed quite few when compared with the 400,000 who attended the Salon that year. The show marked a significant historical occasion, for it was organized by a group of artists outside the official apparatus of the Salon and its juries: the first of many independent, secessionist group exhibitions that punctuate the history of avant-garde art in the modern period.

Monet's painting presents a thin veil of light gray-blue shot through with the rose-pink of the rising sun. Reflections on the water are suggested by short, broken brushstrokes, and the ghostly forms of boats and smokestacks are described with loose patches of color, rather than gradations of light and dark tones. *Impression: Sunrise*, for Monet, was an attempt to capture the ephemeral aspects of a changing moment, more so, perhaps, than any of his paintings until the late Venetian scenes or *Waterlilies* of

1905. *The Bridge at Argenteuil* (fig. **2.31**) might be considered a more classic version of developed Impressionism. It represents a popular sailing spot in the Parisian suburb, where Monet settled in 1871. Scenes of contemporary leisure were a mainstay of Impressionist subject matter. The painting glistens and vibrates, giving the effect of brilliant, hot sunlight shimmering on the water in a scene of contemplative stillness. Monet employed no uniform pattern of brushstrokes to define the surface: the trees are treated as a relatively homogeneous mass; the foreground blue of the water and the blue of the sky are painted quite smoothly and evenly, while the tollhouse reflected in the water is conveyed by dabs of thick yellow impasto; the boats and the bridge are drawn in with firm, linear, architectural strokes. The complete avoidance of blacks and dark browns and the assertion of modulated hues in every part of the picture introduce a new world of light-and-color sensation. And even though distinctions are made among the textures of various elements of the landscape—sky, water, trees, architecture—all elements are united in their common statement as paint. The overt declaration of the actual physical texture of the paint itself, heavily brushed or laid on with a palette knife, derives from the broken paint of the Romantics, the heavily modeled impasto of Courbet, and the brush gestures of Manet. But now it has become an

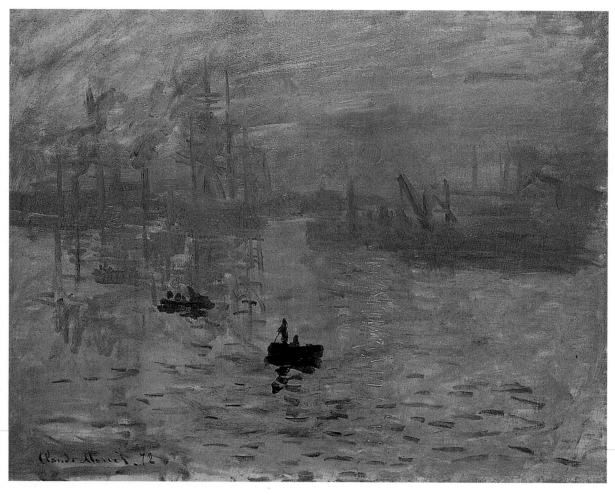

2.30 Claude Monet, *Impression: Sunrise*, 1872. Oil on canvas, 17¾ × 21¾" (45.1 × 55.2 cm). Musée Marmottan, Paris.

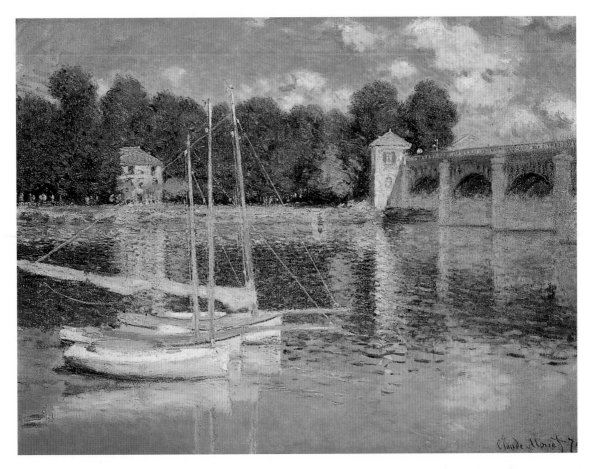

2.31 Claude Monet, *The Bridge at Argenteuil*, 1874. Oil on canvas, 23⅝ × 31½" (60 × 80 cm). Musée d'Orsay, Paris.

overriding concern with this group of young Impressionists. The point has been reached at which the painting ceases to be solely or even primarily an imitation of the elements of nature.

In this work, then, Impressionism can be seen not simply as the persistent surface appearance of natural objects but as a never-ending metamorphosis of sunlight and shadow, reflections on water, and patterns of clouds moving across the sky. This is the world as we actually see it: not a fixed, absolute perspective illusion in the eye of a frozen spectator within the limited frame of the picture window, but a thousand different glimpses of a constantly changing scene caught by a constantly moving eye.

Monet's retreat from the Realists' aim to represent their world as directly and objectively as possible was, of course, motivated not only by different aesthetic interests but by personal and social concerns as well. In 1871, France had suffered a humiliating defeat at the hands of Otto von Bismarck's Prussian army. The terms of peace following the Franco–Prussian War (1870–71) left France in economic straits. So distasteful were the terms of the treaty with the newly established German Empire that an insurrection in Paris soon ignited. An independent, essentially socialist government was formed, known as the Commune. This lasted less than a year and was brutally suppressed by the French army, with huge losses especially among working-class members of the militia. Even those who did not take an active part in the combat suffered terrible privations. Supplies of food and other necessities had been cut off by the national government, leaving Parisians to attempt to feed themselves and their families by any means available. Those who survived the Commune faced further difficulties: thousands were arrested, with deportations and even summary executions following. The war and the ensuing Commune left their marks on Paris and the psyche of its citizens: many buildings, including the Tuileries Palace near the Louvre, were destroyed during the insurrection and thousands were killed; few who remained in Paris emerged unscathed. Among those who lived in the city during the Commune was Courbet, whose socialist sympathies led him to actively support the uprising. Spared execution, he was forced into exile. Among those artists who would form themselves into the Impressionist group, many had served in the war or suffered in its aftermath. A few, like Monet, were able to escape to neutral territory. But none returned to Paris unchanged. The new aesthetic that Monet and the Impressionists developed must be reckoned as much a palliative as an aesthetic response to the formal innovations of their Realist, Romantic, and Neoclassical predecessors.

Monet's departure from the Realist insistence on the unwavering truth of empiricism toward an intuitive grasp of the reality of visual experience becomes particularly evident when a work like *Boulevard des Capucines, Paris*

(fig. **2.32**)—painted from an upstairs window in Nadar's former studio—is compared with contemporary photographs of a similar scene (fig. **2.33**; see fig. **2.6**). Whereas both camera-made images show "cities of the dead," the one because its slow emulsion could record virtually no sign of life and the other because its speed froze every horse, wheel, and human in mid-movement, Monet used his rapidly executed color spotting to express the dynamism of the bustling crowd and the flickering, light- and mist-suffused atmosphere of a wintry day, the whole perceived within an instant of time. Still, far from allowing his broken brushwork to dissolve all form, he so deliberated his strokes that simultaneously every patch of relatively pure hue represents a ray of light, a moment of perception, a molecule of atmosphere or form in space, a tile within the mosaic structure of a surface design. With its decorative clustering of color touches, its firm orthogonals, and its oblique Japanese-style or photographic view, the picture is a statement of the artist's sovereign strength as a pictorial

architect. Monet's is a view of modern Paris, for throughout the Second Empire Napoléon III, through his Prefect of the Seine, Baron Georges-Eugène Haussmann, undertook a major program of urban renewal that called for the construction of wide boulevards and new sewers, parks, and bridges. While the renovations generally improved circumstances for commerce, traffic, and tourism, they destroyed many of the narrow streets and small houses of old Paris. The bustle of these new *grands boulevards*, and the cafés and theaters that lined them, provided fertile subjects for the painters of modern life.

The artists associated with the Impressionist movement were a group of diverse individuals, all united by a common interest, but each intent on the exploration of his or her own separate path. **Auguste Renoir** (1841–1919) was essentially a figure painter who applied the principles of Impressionism in the creation of a lovely dream world that he then transported to the Paris of the late nineteenth century. *Moulin de la Galette* (fig. **2.34**), painted in 1876, epitomizes his most Impressionist moment, but it is an ethereal fairyland in contemporary dress. This scene of a commonplace Sunday afternoon dance in the picturesque Montmartre district of Paris is transformed into a color- and light-filled reverie of fair women and gallant men, who, in actuality, were the painters and writers of Renoir's acquaintance and the working-class women with whom they chatted and danced. The lights flicker and sway over the colors of the figures—blue, rose, and yellow—and details are blurred in a romantic haze of velvety brushwork that softens their forms and enhances their beauty. This painting and his many other comparable paintings of the period are so saturated with the sheer joy of a carefree life that it is difficult to recall the financial problems that Renoir, like Monet, was suffering during these years.

The art of the Impressionists was largely urban. Even the landscapes of Monet had the character of a Sunday in the country or a brief summer vacation. But this

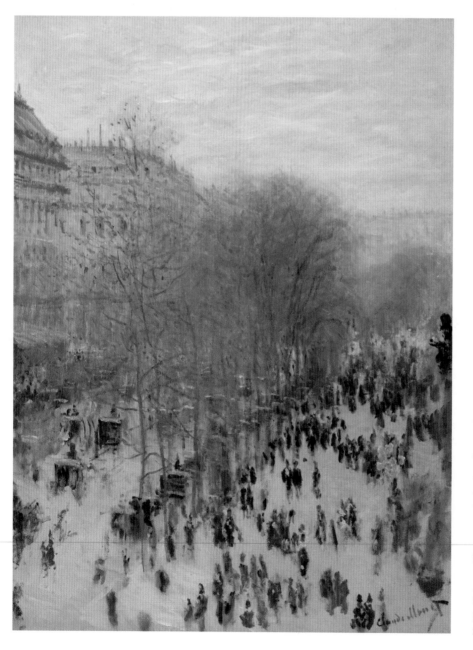

2.32 Claude Monet, *Boulevard des Capucines, Paris (Les Grands Boulevards)*, 1873–74. Oil on canvas, 31¼ × 23¼" (79.4 × 59.1 cm). The Nelson-Atkins Museum of Art, Kansas City, Missouri.

2.33 Edward Anthony, *A Rainy Day on Broadway, New York,* from the series *Anthony's Instantaneous Views,* 1859. One half of a stereograph. International Museum of Photography at George Eastman House, Rochester, New York.

urban art commemorated a pattern of life in which the qualities of insouciance, charm, and good living were extolled in a manner equaled only by certain aspects of the eighteenth century. Now, however, the portrayal of the good life no longer involved the pastimes of the aristocracy but reflected the pleasures available even to poverty-stricken artists. But the moments of relaxation were relatively rare and spaced by long intervals of hard work and privation for those artists who, unlike Cézanne or Degas, were not blessed with a private income.

Though born into a family belonging to the grande bourgeoisie, **Edgar Degas** (1834–1917) was in fact far from financially secure, especially after the death of his father in 1874. He thought of himself as a draftsman in the tradition of Ingres, yet he seems to have had little interest in exhibiting at the Salon after the 1860s or in selling his works. On the contrary, he took an active part in the Impressionist exhibitions between 1874 and 1886, in which he showed his paintings regularly. But, while associated with the Impressionists, Degas did not share their enthusiasm for the world of the out-of-doors. Even his racehorse scenes of the late 1860s and early 1870s, which were open-air subjects, were painted in his studio. Though he produced extraordinary landscapes in his color monotypes,

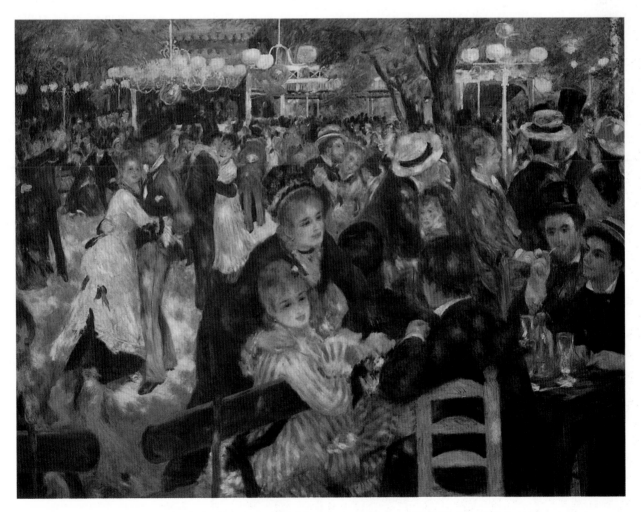

2.34 Auguste Renoir, *Moulin de la Galette,* 1876. Oil on canvas, 51½ × 69" (130.8 × 175.3 cm). Musée d'Orsay, Paris.

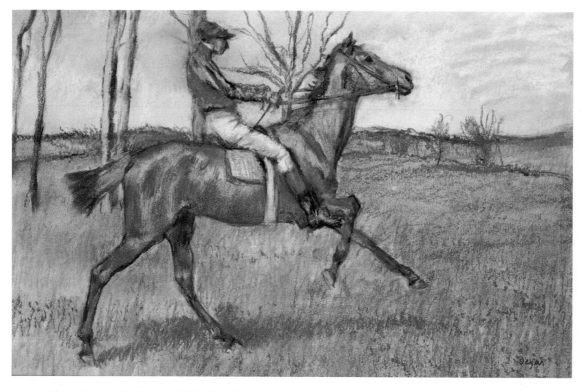

2.35 Edgar Degas, *The Jockey*, 1889. Pastel on paper, 12½ × 19¼" (31.8 × 48.9 cm). Philadelphia Museum of Art.

drawing horses and people remained Degas' primary interest, and his draftsmanship continued to be more precise than that of Manet's comparable racetrack subjects (fig. **2.35**). This was particularly true in later works, where Degas became one of the first artists to exploit the new knowledge of animal movement recorded in the 1870s and 80s by **Eadweard Muybridge** (1830–1904) and others in a series of stop-action photographs (fig. **2.36**). These images made forever obsolete the "rocking-horse" pose—legs stretched forward and backward—long conventional in paintings of running beasts.

In addition to being a skilled draftsman, painter, and photographer, Degas was an accomplished sculptor and printmaker. Like Daumier's, the sculpture of Edgar Degas was little known to the sculptors of the first modern generation, for most of it was never publicly exhibited during

his lifetime. Degas was concerned primarily with the traditional formal problems of sculpture, such as the continual experiments in space and movement represented by his dancers and horses. His posthumous bronze casts retain the immediacy of his original modeling material, a pigmented wax, which he built up over an armature, layer by layer, to a richly articulated surface in which the touch of his hand is directly recorded. While most of his sculptures have the quality of sketches, *Little Dancer Fourteen Years Old* (fig. **2.37**) was a fully realized work that appeared in the 1881 Impressionist exhibition, the only time the artist showed one of his sculptures. By combining an actual tutu and a real satin hair ribbon with more traditional media, Degas created an astonishingly modern object that foreshadowed developments in twentieth-century sculpture (see fig. 23.52).

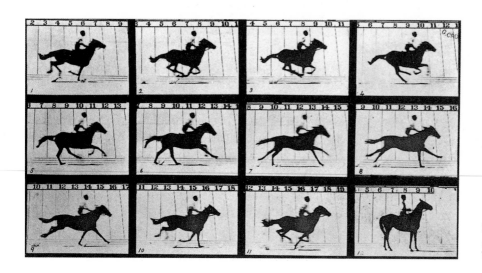

2.36 Eadweard Muybridge, *Horse in Motion*, 1878. Wet-plate photographs.

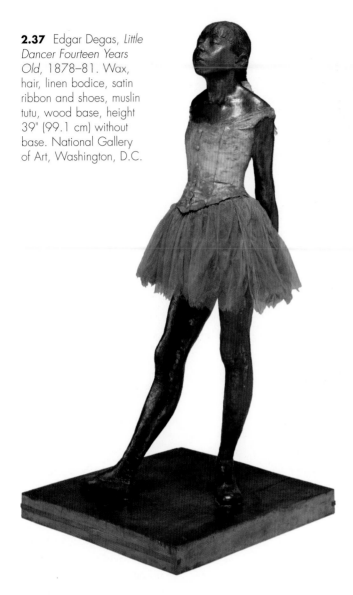

2.37 Edgar Degas, *Little Dancer Fourteen Years Old*, 1878–81. Wax, hair, linen bodice, satin ribbon and shoes, muslin tutu, wood base, height 39" (99.1 cm) without base. National Gallery of Art, Washington, D.C.

Increasingly, during the 1880s and 90s, Degas employed printmaking as well to explore commonplace subjects: milliners in their shops; exhausted laundresses; women occupied with the everyday details of their toilette: bathing, combing their hair, dressing, or drying themselves after the bath. In a work like *The Tub* (fig. **2.38**) Degas goes beyond any of his predecessors in presenting the nude figure as part of an environment in which she fits with unconscious ease. Here the figure is beautiful in the easy, compact sculptural organization, but the routine character of her pose takes away any element of the erotic, while the bird's-eye view and the cut-off edges translate the photographic fragment into an abstract arrangement reminiscent of Japanese prints. When Degas exhibited this work among a group of similar pastels in the last Impressionist exhibition in 1886, many critics responded to them with descriptions, such as comparisons to animals, that betrayed a virulent but commonplace misogyny. In his unflattering, naturalistic depictions of women, Degas had failed to create the eroticized objects of desire that inhabited academic paintings of the nude and that were, as feminist art historians have pointed out, designed for consumption by a predominantly male audience. While Degas' pastels were destined for the same viewers, they transgress accepted norms of "femininity" and, in their monumental simplicity, are among the most moving treatments of the nude in modern art.

The theme of women bathing or dressing was taken up by other Impressionists, most notably Mary Cassatt (see fig. 2.27) and **Berthe Morisot** (1841–95). Morisot's *Woman at Her Toilette* (fig. **2.39**) presents the viewer with an intimate view of a seated woman, seen from behind, arranging her hair. The face is mostly hidden, though

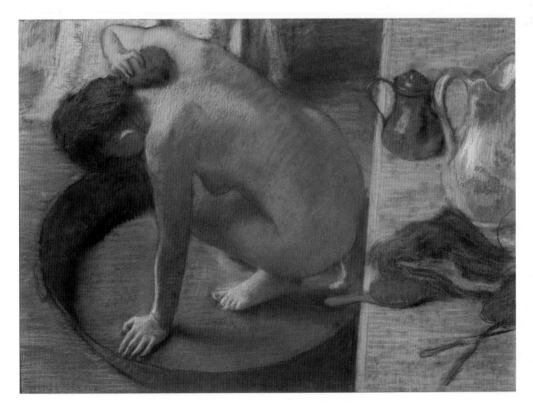

2.38 Edgar Degas, *The Tub*, 1886. Pastel on cardboard, 23⅝ × 32⅝" (60 × 82.9 cm). Musée d'Orsay, Paris.

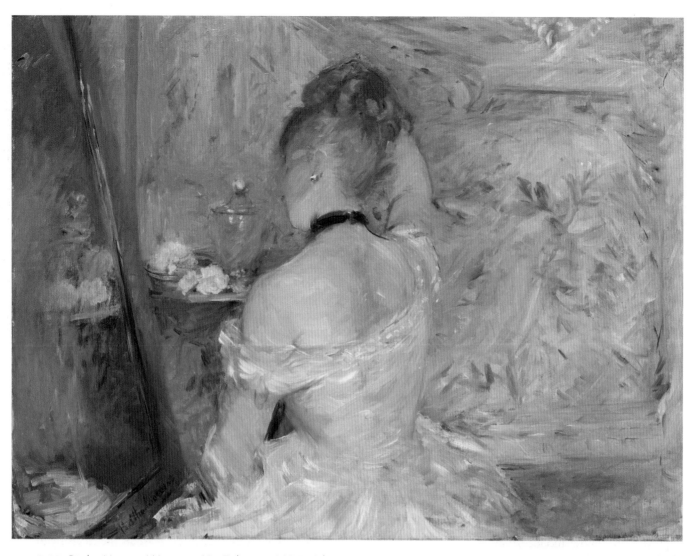

2.39 Berthe Morisot, *Woman at Her Toilette*, c. 1875. Oil on canvas, 23 × 31⅜" (60.3 × 80.4 cm). Art Institute of Chicago. The Stickney Fund, 1924. 127.

one of her softly closed eyes—suggestive of patience and submission—is visible. Morisot's placement of a mirror in the scene allows her to generate multiple sources of light in the room as well as to show reflections of flowers, skin, and silk. Even with the prominent mirror, the artist avoids falling into a clichéd discourse on the subject of vanity—the allegorical theme typically given to depictions of women with mirrors. Morisot's woman is no personification of self-absorption. Her natural gesture and unselfconscious pose generate an intimacy that is underscored by the vibrant brushwork. The rapid, sketchy handling of the wallpaper is matched by the energetic treatment of the dress and skin, inviting the viewer to perceive the scene less as a voyeur than as an active, moving participant in the space depicted. Relieving the viewer of the awkward point of view established in Degas' bather images, Morisot places the onlooker where he or she might stand to assist the woman with the addition of blossoms to her coiffure.

By the mid-1880s, the Impressionists were undergoing a period of self-evaluation, which prompted Monet and his circle to move in various directions to renew their art once again, some by reconsidering aspects of traditional drawing and composition, others by enlarging or refining the premises on which they had been working. Foremost among the latter stood Monet, who remained true to direct visual experience, but with such intensity, concentration, and selection as to push his art toward anti-naturalistic subjectivity and pure decorative abstraction. In series after series he withdrew from the urban and industrial world, once so excitingly consistent with the nineteenth century's materialist concept of progress, and looked to nature, as if to record its scenes quickly before science and technology could destroy them forever. Monet magnified his sensations of the individual detail perceived in an instant of time so that, instead of fragmenting large, complex views like that in *Boulevard des Capucines, Paris* (see fig. 2.32), he broke up simple, unified subjects—poplars, haystacks, the façade of Rouen Cathedral—into representations of successive moments of experience. Each, by its very nature, assumed a uniform tonality and texture that tended to reverse objective analysis into its opposite: subjective synthesis. In a long, final series, painted at his home at Giverny, in the French countryside, Monet retired to an environment of his own creation, a water garden, where

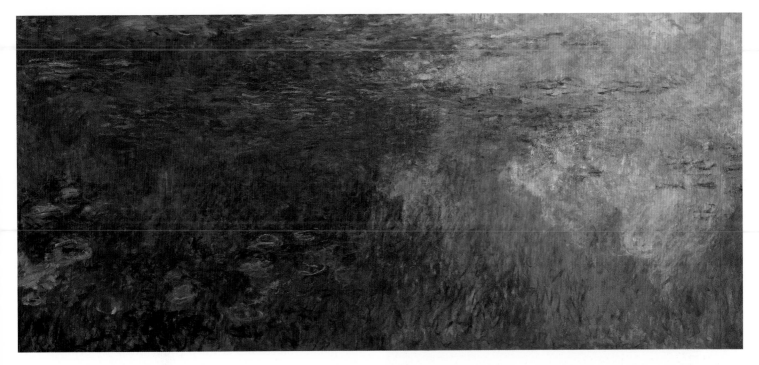

2.40 Claude Monet, *Les Nuages (Clouds)*, 1916–26. Oil on canvas, left panel of three, each panel 6' 6¾" × 13' 11⅜" (2 × 4.3 m). Musée de l'Orangerie, Paris.

he found a piece of the real world—a sheet of clear liquid afloat with lily pads and flowers, and reflections from the sky above—perfectly at one with his conception of the canvas as a flat, mirrorlike surface shimmering with a dynamic materialization of light and atmosphere (fig. **2.40**). Monet's empirical interest in luminary phenomena had become a near-mystical obsession, its lyrical poetry often expressed in almost monochrome blue and mauve. As single, all-over, indivisible images, they point the way toward the Abstract Expressionism of the late 1940s and the 50s, which would produce a similarly "holistic" kind of painting, environmental in its scale but now entirely abstract in its freedom from direct reference to the world outside (see fig. 17.9).

Nineteenth-Century Art in the United States

At the opening of the twentieth century, American painters and sculptors, like their counterparts in Great Britain, had not yet embraced the most progressive developments in continental Europe. American artists historically lacked the critical support systems of established art academies (therefore many studied abroad) and a tradition of government patronage. Despite the limitations of its art apparatus, American culture had generated major figures, such as Benjamin West and John Singleton Copley in colonial times, and the late nineteenth-century expatriates Whistler, Cassatt, and John Singer Sargent (see fig. 2.48), capable of holding their own in the European art capitals. After the Civil War Americans had proved vigorously original in architecture and through this medium (see chapter 4) had made a decisive contribution to the visual arts. But that promising start was brought to a halt by the same academic bias that had held so many painters and sculptors in thrall to outmoded aesthetics inherited from the classical and Romantic past. While the more self-assured and talented European artists grew strong through resistance to the academy, Americans generally felt the need to master tradition rather than innovate against it. American artists were aware that, to progress in their art, it would be necessary to achieve their own artistic identity, assimilating influences from the generative centers in Europe until these had been transformed by authentic native sensibility into something independent and distinctive.

Early American Artists and the Hudson River School

Many American artists of the nineteenth century saw art as a means to define a distinct American national character. American history and culture seemed at this time to be curiously polarized between the material and the mystical. In the colonial period, and for some time after, Americans most consistently expressed their artistic personality—whether Romantic or Realist—through an engagement with nature.

George Catlin (1796–1872) was particularly concerned with national identity. He abandoned a successful practice as a portraitist for wealthy white patrons in Philadelphia to paint the individuals and culture of America's indigenous populations. For six years Catlin traveled west of the Mississippi, executing portraits and scenes of daily life among more than fifty Native American peoples. Then thought to be on the verge of extinction (due to aggressive government policies to "remove" them from United States territories), Native Americans were a source of tremendous curiosity for European Americans. Catlin presented his

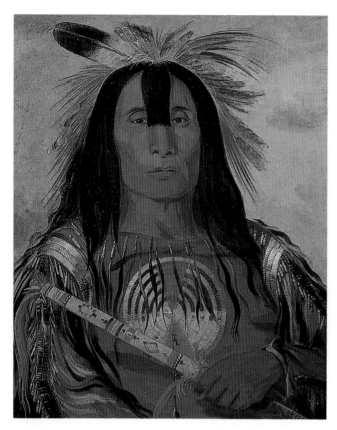

2.41 George Catlin, *Buffalo Bull's Back Fat, Head Chief, Blood Tribe*, 1832. Oil on canvas, 29 × 24" (73.7 × 61 cm). National Museum of American Art, Smithsonian Institution, Washington, D.C.

(most of the seventeen children were named after old-master painters or famous scientists) excelled at portraiture, though he also tried his hand at history painting. His touching and meticulous portrayal of his farsighted younger brother, a botanist who posed with what was purportedly the first geranium specimen to enter the country, delivers not only a compelling portrait but an image of a nineteenth-century faith in knowledge as a modern virtue. The two interests of the Peale family—science and art—are brought together in this freshly conceived composition, just as the two genres of still life and portraiture are seamlessly merged.

An obsessive concern with exactitude, as a means of revealing the true nature of things, emerges dramatically in the *trompe-l'oeil* painters of the late nineteenth century, most notably John Frederick Peto and **William Michael Harnett** (1848–92). The latter's *The Old Violin* (fig. **2.43**) is a *tour de force* of verisimilitude, visual deception, and classical simplicity. While Harnett's still lifes delighted the public, nineteenth-century critics often condemned the work as old-fashioned illusionism bereft of elevating moral content. It was not until the 1930s that Harnett's reputation was resurrected, when a taste for Surrealism and abstraction revised attitudes about his technical wizardry and highly structured formal organization. Harnett's examination of the nature of visual perception re-emerged

paintings, together with actual costumes and artifacts, in a famous "Indian Gallery" that toured the United States and Europe, bringing images of an exotic world to audiences who felt nostalgia for the disappearance of America's native inhabitants while for the most part sanctioning their obliteration. Among Catlin's many paintings of tribal leaders is a striking portrait of the chief of the Blackfoot tribe, *Buffalo Bull's Back Fat* (fig. **2.41**), which was shown in the Paris Salon of 1846 and admired by the poet and critic Charles Baudelaire. While Catlin's paintings stand as important ethnographic sources because of their accurate depictions of Native American dress and custom, they are also powerful examples of the art of portraiture.

The American taste for realism occasionally grew so obsessive in its concern for the integrity of palpable things that reality, once measured and delineated, entered the realm of the ideal. Suggestive of metaphysical ideas or universal emotions, some American realists transcended the particularity of realism to convey poignant feelings or abstract concepts. This tendency is evident in the almost magical illusionism of *Rubens Peale with a Geranium* (fig. **2.42**), painted by **Rembrandt Peale** (1778–1860). Peale was the son of Charles Willson Peale, an enlightened man of many talents, chiefly interested in natural history and painting. Charles helped to found the Pennsylvania Academy of the Fine Arts in Philadelphia and headed an extraordinary dynasty of artists. Like his father, Rembrandt

2.42 Rembrandt Peale, *Rubens Peale with a Geranium*, 1801. Oil on canvas, 28¼ × 24" (71.7 × 61 cm). National Gallery of Art, Washington, D.C.

2.43 William Michael Harnett, *The Old Violin*, 1886. Oil on canvas, 38 × 24" (96.5 × 61 cm). National Gallery of Art, Washington, D.C.

in the later twentieth century in the Superrealist art of Richard Estes and Duane Hanson (see figs. 23.47, 23.52).

America's greatest artistic achievements in the mid-nineteenth century came in the development of a kind of landscape painting that merged elements of scientific Realism with idealized, even religious interpretations of nature owing much to European Romanticism, notably the work of Turner (see fig. 1.15). This occurred particularly in the works of the so-called Hudson River School, a diverse group of artists (not a literal school or association) who worked in New England and upstate New York. For the most part, their landscapes presented the young American republic as a land of pristine wilderness which, by virtue of its majestic scale and untouched beauty, seemed suffused with divine presence. Artists thus invested landscape painting with moral meaning and used it as a vehicle for defining America's national identity as a new "Promised Land." *The Oxbow* (fig. **2.44**), an icon of American art that established a virtual formula for landscapes of the Hudson River School, was painted by its founder, **Thomas Cole** (1801–48). The painting offers a vast panoramic view of a famous bend in the Connecticut River from a stormy promontory where, amid the rocks and tree trunks, Cole has depicted himself at his easel. Symbolically, the storm clouds at left have passed over the fertile, cultivated fields on the banks of the river, signs of a benign human presence in nature where dwell, according to Cole, "freedom's offspring—peace, security, and happiness." More than the artists who followed him, Cole expressed through his paintings serious doubts about the country's expansionist tendencies, which he feared would result in the destruction of wilderness as new frontiers were occupied and settled.

2.44 Thomas Cole, *View from Mount Holyoke, Northampton, Massachusetts, after a Thunderstorm—The Oxbow*, 1836. Oil on canvas, 4' 3" × 6' 4" (1.3 × 1.9 m). The Metropolitan Museum of Art, New York. Gift of Mrs. Russell Sage, 1908.

2.45 Frederic Edwin Church, *Twilight in the Wilderness*, 1860s. Oil on canvas, 40 × 64" (101.6 × 162.6 cm). The Cleveland Museum of Art. Mr. and Mrs. William H. Marlatt Fund. 1965.233.

Cole's chief protégé was **Frederic Edwin Church** (1826–1900), who reinforced his fine-art education by traveling extensively, mostly in North and South America, and by studying the theories of Alexander von Humboldt, a famous German naturalist who called for a "heroic landscape painting" that would bring scientific accuracy to the depiction of nature's grandest scenes. Church was a master of virtuoso, highly theatrical interpretations of those grand scenes, from volcanoes in the Ecuadorian Andes to icebergs in the Arctic north. In *Twilight in the Wilderness* (fig. **2.45**), he translated a blazing sunset into a sublime vision of biblical proportions, implying, as had Cole, a spiritual, pantheistic view of nature. It has also been suggested, however, that the fiery skies of the painting could portend the imminent conflagration of the Civil War. Though it is difficult to imagine in today's art world, *Twilight* caused a sensation when it, like Church's other masterpieces, was exhibited by itself in a New York gallery, where visitors paid an entrance fee to see the artist's newest creation.

Robert Scott Duncanson (1821–72), Church's contemporary, was from Cincinnati, where a thriving landscape tradition in the Hudson River School style had developed. Born into a poor family of free African-American tradespeople, Duncanson was a serious advocate of the abolitionist movement, frequently donating his work in support of anti-slavery causes. In the art of painting he was self-taught, though in nineteenth-century America this was often the case with white artists as well (Cole, for example).

Like his fellow painters in the East, Duncanson took the valleys and rivers of his own region as the subjects for his landscapes (fig. **2.46**). The tranquility of mood in *Blue Hole, Flood Waters, Little Miami River* and the symmetrical organization of its composition suggest a classical vision of landscape in the manner of the seventeenth-century French artist Claude Lorrain.

2.46 Robert Scott Duncanson, *Blue Hole, Flood Waters, Little Miami River*, 1851. Oil on canvas, 29¼ × 42¼" (74.3 × 107.3 cm). Cincinnati Art Museum.

2.47 George Inness, *Sundown*, 1894. Oil on fabric, 45 × 70" (114.3 × 177.8 cm). National Museum of American Art, Smithsonian Institution, Washington, D.C.

By the end of the nineteenth century, the tight, descriptive style of the Hudson River School had been transformed in the hands of artists like **George Inness** (1825–94) into something more subjective and less dependent on the phenomena of the natural world (fig. **2.47**). An admirer of the French Barbizon painters, Inness painted unpretentious subjects in a highly poetic style far from the grandiose statements of Frederic Church. For him, nature is the domesticated landscape, rather than the untamed wilderness, and it is filled with evocative atmosphere and soft harmonies of green and gold. The way in which formal concerns supersede the need for literal transcription in Inness' work has parallels with many American and European artists at the end of the nineteenth century, who were creating the foundation for twentieth-century abstraction.

New Styles and Techniques in Later Nineteenth-Century American Art

Whatever the developments in painting and sculpture back home, no artists had sensed the coming of the new more presciently than expatriates such as Whistler and Cassatt. Similarly immersed in the European cultural milieu was **John Singer Sargent** (1856–1925). Born to American parents living abroad, he spent most of his career in Paris and London, though he received many portrait commissions from leading American families. His flashing, liquid stroke and flattering touch in portraiture made him one of the most famous and wealthy artists of his time. Moreover, in a major work like *Madame X* (fig. **2.48**) Sargent revealed himself almost mesmerized, like a latter-day Ingres (see fig. 1.7), by the abstract qualities of pure line and flat silhouette. At the same time, he so caught the explicit qualities of

2.48 John Singer Sargent, *Madame X (Mme Pierre Gautreau)*, 1883–84. Oil on canvas, 6' 10⅛" × 3' 7" (2.1 × 1.1 m). The Metropolitan Museum of Art, New York. Arthur Hoppock Hearn Fund, 1916.

2.49 Gertrude Käsebier, *Blessed Art Thou Among Women*, c. 1900. Platinum print on Japanese tissue, 9⅜ × 5½" (23.8 × 13.9 cm). The Museum of Modern Art, New York.

photographs and instead emulates the softer lines and atmospheric quality of Impressionist painting (fig. **2.49**). Pictorialism arose in the late nineteenth century in part as a response to critics' charges that photography was not a legitimate art form (see Baudelaire, "*Salon of 1859*," below). Like Cassatt, Käsebier specialized in the mother-and-child theme, while White aligned himself with the elite social content of Sargent's portraiture and the Orientalizing aestheticism of Whistler's musical "arrangements." The camera offered an unparalleled capacity to render the reality so beloved by Americans, but it could also transcend the particular details of a given subject. Using soft focus to infuse emotion and mystery into their images, Käsebier and White tempered the precision of their photographs with an evocative lyricism characteristic of their American peers Whistler and Cassatt.

More exclusively rooted in American experience than Whistler, Cassatt, and Sargent, and thus more representative of the point of departure for American art in the twentieth

surface and inner character that the painting created a scandal when publicly shown at the Salon, for in addition to the figure's already décolleté dress, Sargent had placed the left-hand strap off her shoulder. To placate an offended public, after the Salon closed he adjusted the strap as seen here. The experience prompted the artist to leave Paris and establish his practice in London. In his most painterly works, meanwhile, Sargent carried gestural virtuosity, inspired by Frans Hals and Diego Velázquez, to levels of pictorial autonomy not exceeded before the advent of the Abstract Expressionists after World War II.

Americans who chose photography as their medium of expression stood out in the international Salons organized for exhibiting the new camera-made art, and indeed often won the major prizes and set the standards for both technical mastery and aesthetic vision. Contemporaries of Whistler, Cassatt, and Sargent were the American photographers **Gertrude Käsebier** (1852–1934) and Clarence H. White, both of whom pursued Pictorialism—a style of photography that avoids the exactitude possible with

SOURCE

Charles Baudelaire
from his "Salon of 1859"

Photography came under pointed scrutiny in this review. Though Baudelaire hailed modernity and the technological advantages associated with it, he dismissed the notion of photography as art. Baudelaire believed that an artwork must be the result of the imaginative faculty. Photography, he felt, supplanted human genius with merely mechanical reportage.

Poetry and progress are like two ambitious men who hate one another with an instinctive hatred, and when they meet upon the same road, one of them has to give place. If photography is allowed to supplement art in some of its functions, it will soon have supplanted or corrupted it altogether, thanks to the stupidity of the multitude which is its natural ally. It is time, then, for [photography] to return to its true duty, which is to be the servant of the sciences and arts—but the very humble servant, like printing or shorthand, which have neither created nor supplemented literature. Let it hasten to enrich the tourist's album and restore to his eye the precision which his memory may lack; let it adorn the naturalist's library, and enlarge microscopic animals; let it even provide information to corroborate the astronomer's hypotheses; in short, let it be the secretary and clerk of whoever needs an absolute factual exactitude in his profession—up to that point nothing could be better. Let it rescue from oblivion those tumbling ruins, those books, prints and manuscripts which time is devouring, precious things whose form is dissolving and which demand a place in the archives of our memory—it will be thanked and applauded. But if it be allowed to encroach upon the domain of the impalpable and the imaginary, upon anything whose value depends solely upon the addition of something of a man's soul, then it will be so much the worse for us!

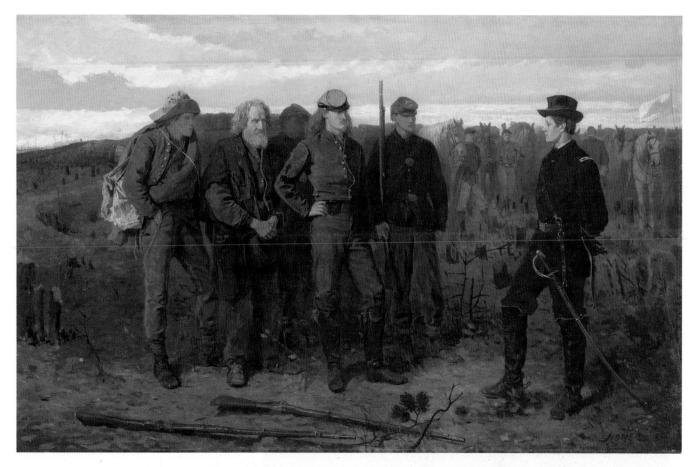

2.50 Winslow Homer, *Prisoners from the Front*, 1866. Oil on canvas, 24 × 38" (60.9 × 96.5 cm). The Metropolitan Museum of Art, New York.

century, were **Winslow Homer** (1836–1910) and Thomas Eakins. As an illustrator for *Harper's Weekly* magazine in New York, Homer, a virtually self-taught artist, was assigned to the front during the Civil War. In his illustrations and in the oil paintings he began to make during the war, Homer tended to focus on the quiet moments of camp life rather than the high drama of battle. A landscape laid waste by those battles is the setting for the artist's early work *Prisoners from the Front* (fig. **2.50**). At the left, three Confederate soldiers—a disheveled youngster, an old man, and a defiant young officer—surrender to a Union officer at the right. Although Homer's painting represents a fairly unremarkable occurrence in the war, it achieves the impact of history painting in the significance of its theme. His subtle characterization of the varying classes and types of the participants in the tragic conflict alludes to the tremendous difficulties to be faced during Reconstruction between these warring cultures.

In 1866 Homer traveled to Paris, where *Prisoners from the Front* was being exhibited. While he shared in the practice of *plein-air* painting and some of the subject matter of the Impressionists, Homer always insisted on the physical substance of things, rarely allowing paint to disintegrate form. Much of his mature work centered on the ocean, either breezy, sun-drenched watercolors made in the Caribbean or dramatic views of the human struggle with the high seas off the coast of Maine, where he settled in

1884. In *The Fox Hunt* (fig. **2.51**), the struggle between the forces of nature plays itself out in a haunting drama featuring a fox, weakened by the deprivations of winter, swooped on by hungry crows. The spareness of this striking composition, with its graceful silhouettes, cropped forms, and slanted perspectives, attests to Homer's interest in *japonisme* as well as his ability to extract great emotional intensity from the simplest of scenes.

In his determination to fuse art and science for the sake of an uncompromising Realism in painting,

2.51 Winslow Homer, *The Fox Hunt*, 1893. Oil on canvas, 38 × 68½" (96.5 × 174 cm). The Pennsylvania Academy of the Fine Arts, Philadelphia.

2.52 Thomas Eakins, *The Champion Single Sculls (Max Schmitt in a Single Scull)*, 1871. Oil on canvas, 32½ × 46¼" (82.6 × 117.5 cm). The Metropolitan Museum of Art, New York. Purchase, Alfred N. Punnett Endowment Fund and George D. Pratt Gift, 1934.

the Philadelphia painter **Thomas Eakins** (1844–1916) all but revived the Renaissance tenets of Leonardo da Vinci. Not only did he dissect cadavers alongside medical students (a traditional method of artistic training) and join Eadweard Muybridge in his studies of motion with stop-action photography (see fig. 2.36), especially those devoted to human movement, but he even had an assistant pose on a cross in full sunlight as the model for a Crucifixion scene and provided a nude male model for his female drawing students, a step that forced his resignation from the august Pennsylvania Academy of the Fine Arts. Eakins' extraordinary early painting *Max Schmitt in a Single Scull* (fig. **2.52**) was his first treatment of an outdoor subject. In the foreground the artist's friend, a celebrated oarsman, pauses momentarily while rowing on Philadelphia's Schuylkill River and looks toward the viewer; in the middle distance, Eakins has depicted himself mid-stroke, also looking at us. A crystalline light and carefully ordered composition lead us into this rational pictorial space, in which each detail is keenly observed and convincingly rendered. Eakins has here produced a Realism that transcends mere illusionism by way of a magical clarity, as if time were momentarily suspended.

Eakins was arguably the greatest American portraitist of the nineteenth century, and his large painting *The Gross Clinic* (fig. **2.53**) is a masterpiece of the genre. The artist looked to the seventeenth-century precedent of Rembrandt's *Anatomy Lesson of Dr. Tulp* for his heroic portrayal of a distinguished surgeon performing an operation before his class. Like Max Schmitt, Dr. Gross looks up during a break in the action. In the midst of the dark, richly hued painting, light falls on his forehead, the intellectual focal point of the scene, and, even more dramatically, on the details of the surgery.

2.53 Thomas Eakins, *The Gross Clinic*, 1875. Oil on canvas, 8' × 6' 6" (2.4 × 2 m). Jefferson Medical College of Thomas Jefferson University, Philadelphia.

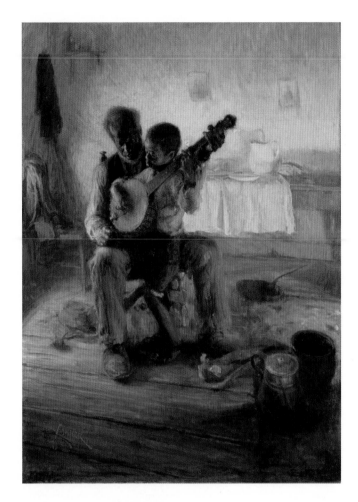

2.54 Henry Ossawa Tanner, *The Banjo Lesson*, 1893. Oil on canvas, 49 × 35½" (124.5 × 90.2 cm). Hampton University Museum, Hampton, Virginia.

banjo-playing, as entertainment for a white audience, and instead focuses on familial intimacy.

In the art of **Albert Pinkham Ryder** (1847–1917) the sense of dream is utterly dominant, even in paintings so overloaded with the material substance of thick paint that, as the critic Lloyd Goodrich has written, "a tiny canvas weighs heavy in the hand." This was the product of years spent in a trial-and-error process of working and reworking a single picture, carried out by a painter who declared that "the artist should fear to become the slave of detail. He should strive to express his thought and not the surface of it. What avails a storm cloud accurate in form and color if the storm is not therein." The storm Ryder wanted was of the sort stirred up by the German composer Richard Wagner, whose sublimely Romantic music deeply touched the artist, as it did many of his contemporaries. Ryder, a solitary figure, was unfortunately a dangerously experimental technician, applying wet paint on wet paint and mixing his oils with what was probably bitumen, so that his pictures did not dry properly, but have gone on "ripening" until they have actually darkened and decayed, a process that has, ironically, destroyed many of the exquisite nuances he had sought in endless modifications. What remains, however, tends to dramatize the extraordinary reductiveness of the final image (fig. **2.55**). With all detail refined away and the whole simplified to an arrangement of broad, dramatically contrasted shapes, a painting by Ryder often evokes the convoluted, emotional rhythms of Rubens and Delacroix as well as the Gothic, visionary world of German Expressionism.

Far from dispassionate in his objectivity, Eakins conveys the human toll of modern medicine through the horrified reaction of the seated female observer, presumably a relative of the patient. She becomes the bearer of emotional content, much as the female members of the Horatii family did in David's painting (see fig. 1.2).

Henry Ossawa Tanner (1859–1937) was an African-American artist who, by the end of the nineteenth century, had achieved significant international distinction. During the so-called Harlem Renaissance of the 1920s, he was recognized as the most important black artist of his generation. Though he studied in Philadelphia with Eakins, whose portrait style profoundly influenced his own, Tanner found a more accepting atmosphere in his adopted city of Paris. He exhibited widely during his lifetime, including at the Paris Salon, and eventually befriended members of the avant-garde circle around Paul Gauguin in the rural artists' communities of Brittany. The French government awarded him the prestigious Légion d'honneur. Tanner's best known work, *The Banjo Lesson* (fig. **2.54**), was probably made during a trip to Philadelphia, when he said he painted "mostly Negro subjects," a genre he felt had been stereotypically cast by white artists. With a loose weave of elongated strokes, Tanner softly defines the central pair of figures, bathing them in a light that imparts a spiritual stillness to the scene, a light not unlike that used in the religious subjects that make up the bulk of his work. The painting overcomes the stereotypical treatment of

2.55 Albert Pinkham Ryder, *Moonlight Marine*, c. 1890s. Oil on panel, 11⅜ × 12" (28.9 × 30.5 cm). The Metropolitan Museum of Art, New York.

2.56 Augustus Saint-Gaudens, *Adams Memorial*, 1886–91. Bronze and granite, height 70" (177.8 cm). Rock Creek Cemetery, Washington, D.C.

American sculpture during the later nineteenth century was nothing if not prolific, especially in public commissions. The expanding economy led to innumerable sculptural monuments and architectural decorations, though these mostly followed the academic traditions of Rome or Paris. **Augustus Saint-Gaudens** (1848–1907) received academic training in New York, Paris, and Rome, though, contrary to most nineteenth-century academic sculptors, European or American, he took fresh inspiration from sculptures of the Renaissance, notably those of Donatello. By infusing the classical tradition with his own brand of naturalism, Saint-Gaudens produced a number of compelling portraits and could enliven the most banal of commemorative or allegorical monuments. But the request he received from the author Henry Adams to create a memorial to his late wife, who had committed suicide, presented quite other challenges (fig. **2.56**). The sculptor's inspired solution, stimulated by Adams' interest in Buddhism, was an austere, mysteriously draped figure that seems to personify a state of spiritual withdrawal from the physical world. With eyes downcast and face shrouded in shadow, the sculpture constitutes an unforgettable image of eternal repose.

Saint-Gaudens' figure bears kinship not only with artworks created during the Renaissance in Italy, but with Northern works as well. The pyramidal composition of the figure and her inward-turning, contemplative quality call to mind **Albrecht Dürer's** (1471–1528) famous engraving, *Melencolia I* (fig. **2.57**). Dürer's dejected figure responds to the futility of the pursuit of knowledge in the face of time and mortality. By conjuring this sentiment, Saint-Gaudens invites comparison between the positivism of the nineteenth century and the humanism of the Renaissance. Both periods looked to learning as the means of bettering society and of finding personal fulfillment. Dürer's personification of Melancholy warns that such intellectual pursuits remain meaningless in the face of death: no amount of empirical study can change this fundamental condition of human existence. Saint-Gaudens was not the only artist to evoke this sentiment. Like many modern artists, he captures the tension between the period's interest in empirical, scientific accounts of human experience and its similarly intense attraction to transcendent, spiritual explanations for events or daily struggles. In the wake of Realism and Impressionism, artists increasingly abandoned the empirical model. Instead of seeking truth through close observation of the natural world, artists began to seek the truth in their own minds, in their own consciences.

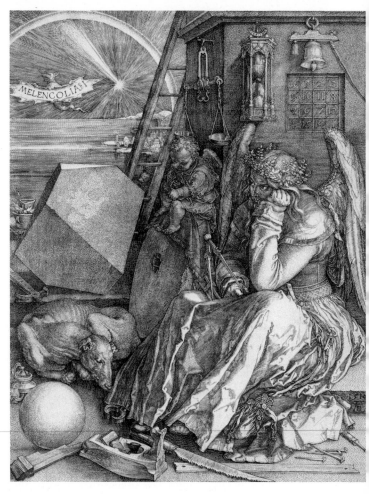

2.57 Albrecht Dürer, *Melencolia I*, 1514. Engraving, 9⁷⁄₁₆ × 7⁵⁄₁₆" (23.9 × 18.5 cm). Fogg Art Museum, Cambridge, MA.

3
Post-Impressionism

Whether through the new technical advantages of photography or the frankness and spontaneity of Realism and Impressionism, many progressive artists of the mid-nineteenth century retained their faith in empiricism. Careful observation coupled with aesthetic discrimination could be relied upon to deliver truths not only about particular moments or experiences but also about the world and humanity more generally. Or could it? Thomas Eakins' *The Gross Clinic* (see fig. 2.53) makes manifest the dilemma posed by such aesthetic empiricism. Offering access to the fundamental, physical nature of human life through his disinterested depiction of Dr. Gross' surgical intervention, Eakins simultaneously acknowledges the limits of this materialism. The intangible forces of emotion and imagination resist easy classification: the human experience cannot be reduced to anatomy or physiology. The violent reaction of the woman who attends the patient emphasizes that experiences are channeled largely through the imagination. Though she is presumably recoiling from the sight of the disconcerting incision in the patient's thigh, her view is, in fact, shielded by the body of Dr. Gross. Her response is a mark of her empathy, of her emotional connection to the patient, and, above all, of the power of her imagination. She responds to what she imagines to be happening.

The work of the Impressionists, too, must be understood as similarly divided between a faith in empiricism and a recognition of its insufficiency. Monet's intense, sustained observations of nature led him to produce dozens of variations on motifs like water lilies (see fig. 2.40), yet, as discussed in the previous chapter, this "truth to nature" must be understood as heavily mediated by each artist's emotional and political sensibilities. Those artists working in the wake of Realism and Impressionism would acknowledge the limits of empiricism, with some choosing to intensify their pursuit of objectivity through new forms of scientific analysis and others abandoning such presumed objectivity and instead turning inward to heed the impulses of imagination. Transformations in the social as well as

physical landscape prompted many artists to wonder whether the world could be best understood by looking outward at nature or by retreating inward to a realm of fantasy. In the closing years of the nineteenth century, the responses to this question were as numerous as the artists addressing it.

By the 1880s, Western society had begun to change in ways that could only distress those imbued with the nineteenth-century positivist belief in ever-accelerating progress driven by science and industry. Change was rapid indeed at this time, but not always progressive. As industrial waste combined with expanding commerce to destroy the unspoiled rivers and meadows so often painted by Monet, he withdrew ever deeper into his "harem of flowers" at Giverny, a "natural" world of his own creation that was inextricably bound up with his late painting. As rising socio-economic expectations throughout industrialized Europe met with a conservative backlash, the clash of ideologies brought anarchist violence. At the same time, science reordered itself with the emergence of new theories of physics, chemistry, and psychology—theories that not only contradicted classical models but often defied even the closest observation of nature. The radical philosopher Friedrich Nietzsche announced the death of God and sharply criticized the moral outlook associated with traditional religion. This in turn provoked new debates concerning the role of religion and even morality. The most advanced artists of the period found little to satisfy their needs in the optimistic utilitarianism that had dominated Western civilization since the Enlightenment. Gradually, therefore, they abandoned the Realist tradition of Daumier, Courbet, and Manet (see chapter 2) that had culminated in Impressionism. Instead, they sought to discover, or recover, a new and more complete reality, one that would encompass the inner world of mind and spirit as well as the outer world of physical substance and sensation.

Inevitably, this produced paintings that seemed even more shocking than Impressionism in their violation of

both academic principles and the polished illusionism desired by eyes now thoroughly under the spell of photography. So various and distinctive were the reactions against the largely sensory nature and supposed formlessness of Impressionism that the English critic Roger Fry, who was among the first to take a comprehensive look at these developments, could do no better than sum them up, in 1910, with the vague designation "Post-Impressionism." The inadequacy of the term is borne out by the fact that, unlike Impressionism, it did not become widely used until a quarter-century after the first appearance of the artistic phenomena it purported to describe. Among other things, it implies that Impressionism was itself a homogeneous style, when in fact it covered a highly diverse range of artistic sensibilities. In reality, the Post-Impressionists were schooled in Impressionism and many of them continued to respect its exponents and share much of their outlook. And so, just as Monet and Renoir were beginning to enjoy a measure of critical and financial success, the emerging painters who inspired the term Post-Impressionist reopened the gap—wider now than ever before—that separated the world of avant-garde art from that of society at large.

The Poetic Science of Color: Seurat and the Neo-Impressionists

Trained in the academic tradition of the École des Beaux-Arts in Paris, **Georges Seurat** (1859–91) was a devotee of classical Greek sculpture and of such classical masters as Poussin (see fig. 1.3 and 1.14), and Ingres (see fig. 1.7). He also studied the drawings of Hans Holbein, Rembrandt, and Millet (see fig. 1.17), and learned principles of mural design from the academic Symbolist Pierre Puvis de Chavannes (see fig. 3.12). He early became fascinated by theories and principles of color organization, which he studied in the writings and paintings of Delacroix, the texts of the critics Charles Blanc and David Sutter, and the scientific treatises of Michel-Eugène Chevreul, Ogden Rood, and Charles Henry. Among the phenomena considered in these texts were the ways in which colors affect one another when placed side by side. According to Chevreul, for example, each color will impose its own complementary on its neighbor: if red is placed next to blue, the red will cast a green tint on the blue, altering it to a greenish blue, while the blue imposes a pale orange on the red. Although the rational, scientific basis

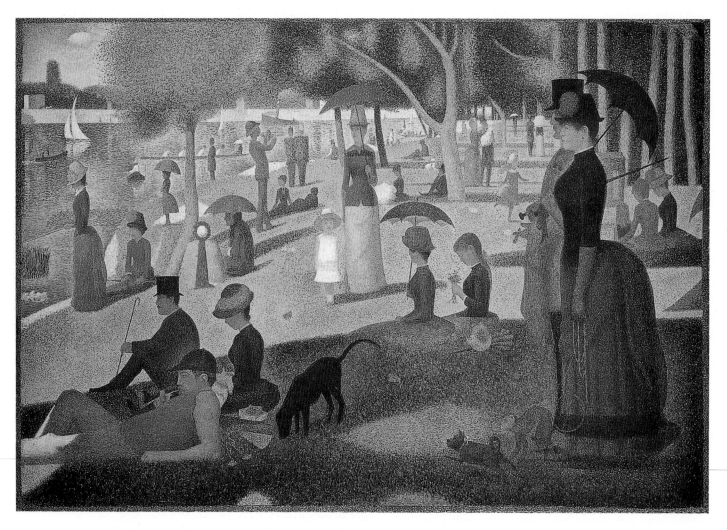

3.1 Georges Seurat, *A Sunday Afternoon on the Island of La Grande Jatte*, 1884–86. Oil on canvas, 6' 9½" × 10' 1¼" (2.1 × 3.1 m). The Art Institute of Chicago.

for such theories appealed to Seurat, he was no cold, methodical theorist. His highly personal form of expression evolved through careful experiments with his craft. Working with his younger friend Paul Signac, he sought to combine the color experiments of the Impressionists with the classical structure inherited from the Renaissance, employing the latest concepts of pictorial space, traditional illusionistic perspective depth, and recent scientific discoveries in the perception of color and light.

It is astonishing that Seurat produced such a body of masterpieces in so short a life (he died at thirty-one in a diphtheria epidemic). One of the landmarks of modern art is his *A Sunday Afternoon on the Island of La Grande Jatte* (fig. **3.1**). Known as *La Grande Jatte*, it was the most notorious item in the last of the eight Impressionist exhibitions, in 1886. Seurat worked for over a year on this monumental painting, preparing it with twenty-seven preliminary drawings (fig. **3.2**) and thirty color sketches. His hauntingly beautiful conté crayon drawings reveal his interest in earlier artists who had similarly exploited black and white, from Rembrandt to Goya. Seurat avoided lines to define contours and depended instead on shading to achieve soft, penumbral effects. In the preparatory works for *La Grande Jatte*, ranging from studies of individual figures to oils that laid in most of the final composition, Seurat analyzed, in meticulous detail, every color relationship and every aspect of pictorial space.

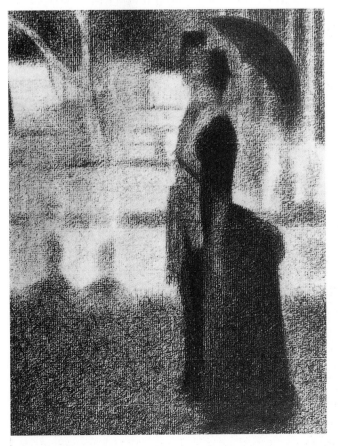

3.2 Georges Seurat, *The Couple*, study for *La Grande Jatte*, 1884. Conté crayon on paper, 12¼ × 9¼" (31.1 × 23.5 cm). The British Museum, London.

Seurat's unique color system was based on the Impressionists' realization that all nature was color, not neutral tone. But the Impressionist painters had generally made no organized, scientific effort to achieve their remarkable optical effects. Their technique involved placing pure, unblended colors in close conjunction on the canvas, perceived by the eye as glowing, vibrating patterns of mixed color. This effect appears in many paintings by Monet, as anyone realizes who has stood close to one of his works, first experiencing it simply as a pattern of discrete color strokes, and then moving gradually away from it to observe all the elements of the scene come into focus.

Building on Impressionism and his own further study of the science of optics, Seurat constructed his canvases with an overall pattern of small, dotlike brushstrokes of generally complementary colors—red and green, violet and yellow, blue and orange—and with white. Various names have been given to his method, including Divisionism (Seurat's own term), Pointillism, and Neo-Impressionism. Despite their apparent uniformity, on close inspection the "dots" vary greatly in size and shape and are laid down over areas where color has been brushed in more broadly. The intricate mosaic produced by Seurat's painstaking technique is analogous to the medium of actual mosaic; its glowing depth of luminosity gives an added dimension to color experience. Unfortunately, some of the pigments he used were unstable, and in less than a decade oranges had turned to brown and brilliant emerald green had dulled to olive, reducing somewhat the original chromatic impact of the painting.

In *La Grande Jatte* Seurat began with a simple contemporary scene of middle-class Parisians relaxing along the banks of the Seine River. What drew him most strongly to the particular scene, perhaps, was the manner in which the figures could be arranged in diminishing perspective along the banks of the river, although delightful inconsistencies in scale abound throughout the composition. At this point in the picture's evolution the artist was concerned as much with the recreation of a fifteenth-century exercise in linear perspective as with the creation of a unifying pattern of surface color dots. Broad contrasting areas of shadow and light, each built of a thousand minute strokes of juxtaposed color-dot complementaries, carry the eye from the foreground into the beautifully realized background. Certainly, Seurat was here attempting to reconcile the classical tradition of Renaissance perspective painting with a modern interest in light, color, and pattern. The immense size of the canvas gives it something of the impact of a Renaissance fresco, and is especially dramatic since it is composed of brushstrokes smaller than a pea. The painting's scale also shows avant-garde art asserting its status relative to the academic tradition (and thus, paradoxically, developing a new "grand tradition" of its own).

More important in the painting than depth or surface pattern is the magical atmosphere that the artist was able to create from the abstract patterns of the figures. The art historian Meyer Schapiro notes that Seurat depicts "a society

at rest and, in accord with his own art, it is a society that enjoys the world in pure contemplation and calm." By placing the figures in strict profile or frontal views, he flattens their forms and endows them with the immobility of stage flats, producing a static atmosphere often described as "Egyptian." In the accumulation of commonplace details, which are filled with amusing vignettes of social caricature, there is an effect of poetry that makes of the whole a profoundly moving experience. The most scientific and objective of all the painters of his time is, curiously, also one of the most poetic and mysterious.

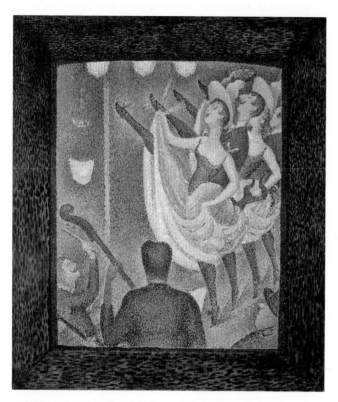

3.3 Georges Seurat; Study for *Le Chahut*, 1889. Oil on canvas, 21⅞ × 18⅜" (55.6 × 46.7 cm). Albright-Knox Art Gallery, Buffalo. General Purchase Funds, 1943.

In a preparatory oil for a later painting, such as the study for *Le Chahut* (fig. **3.3**), the color dots are so large that the figures and their spatial environment are dissolved in color patterns clinging to the surface of the picture. The painting depicts a provocative and acrobatic dance, then popular in Parisian cafés, which Seurat beautifully orchestrates into a series of decorative rhythms, giving form to a theory then current that ascending lines induce feelings of gaiety in the viewer. Seurat was clearly inspired by the colorful posters that were placed around Paris to advertise the dance halls. Around the study for *Le Chahut* he painted a border of multicolored strokes (as he had for *La Grande Jatte*), and he probably painted its wooden frame as well. The relationship between the painting and its frame was of growing concern to progressive painters. No longer content to accept the frame as simply a means of demarcating the borders of a picture, artists such as Seurat and the British Pre-Raphaelites insisted on designing unique frames for each artwork.

Seurat's chief colleague and disciple, **Paul Signac** (1863–1935), strictly followed the precepts of Neo-Impressionism in his landscapes and portraits. Like his colleagues, Signac regarded his revolutionary artistic style as a form of expression parallel to his radical political anarchism. Just as anarchists place the individual at the apex of social organization, Pointillism insists on the formal relevance of each unit of color, showing that harmony emerges by maintaining the integrity of constituent parts. This idea was closely associated with other Neo-Impressionists in France and Belgium who believed that only through absolute creative freedom could art help to bring about social change. In his later, highly coloristic seascapes, Signac provided a transition between Neo-Impressionism and the Fauvism of Henri Matisse and his followers (see chapter 6). Through his book *D'Eugène Delacroix au Néo-impressionnisme* (*From Eugène Delacroix to Neo-Impressionism*), he was also the chief propagandist and historian of the movement. His portrait of the critic Félix Fénéon (fig. **3.4**), who had been the first to use the term Neo-Impressionism, is a fascinating example of the decorative formalism that the artists around Seurat favored. The painting, with its spectacular spiral background inspired by patterns that Signac had found in a Japanese print, contains private references to the critic's ideas and to those of the color theorist Charles Henry, with which Signac was very familiar.

3.4 Paul Signac, *Opus 217. Against the Enamel of a Background Rhythmic with Beats and Angles, Tones and Tints, Portrait of M. Félix Fénéon in 1890*, 1890. Oil on canvas, 29⅛ × 36½" (73.5 × 92.5 cm). The Museum of Modern Art, New York.

Form and Nature: Paul Cézanne

Of all the nineteenth-century painters who might be considered prophets of twentieth-century experiment, the most significant was **Paul Cézanne** (1839–1906). Cézanne struggled throughout his life to express in paint his ideas about the nature of art, ideas that were among the most revolutionary in the history of art. Son of a well-to-do merchant turned banker in Aix-en-Provence in southern France, he had to resist parental disapproval to embark on his career, but once having won the battle, he did not need to struggle for mere financial survival. As we view the splendid control and serenity of his mature paintings (two qualities that, in particular, became touchstones for modernist art), it is difficult to realize that he was an isolated, socially awkward man of a sometimes violent disposition. This aspect of his character is evident in some of his early mythological figure scenes, which were baroque in their movement and excitement. At the same time he was a serious student of the art of the past who studied the masters in the Louvre, from Paolo Veronese to Poussin to Delacroix.

Early Career and Relation to Impressionism

Cézanne's unusual combination of logic and emotion represented the synthesis that he sought in his paintings. Outside of Degas, the Impressionists in the 1870s largely abandoned traditional drawing in an effort to communicate a key visual phenomenon—that objects in nature are not seen as separated from one another by defined contours. In their desire to realize the observed world through color, with both the objects themselves and the spaces between them rendered in terms of color intervals, they tended to destroy objects as three-dimensional entities existing in three-dimensional space. Instead they recreated

solids and voids as color shapes functioning within a limited depth. Because it did not make a clear distinction between three-dimensional mass (objects) and three-dimensional depth (spaces), Impressionism was criticized as formless and insubstantial. Even Renoir felt compelled to restudy the drawing of the Renaissance in order to recapture some of that "form" which Impressionism was said to have lost. And Seurat, Gauguin, and Van Gogh, each in his own way, consciously or unconsciously, were seeking a kind of expression based on, but different from, that of the Impressionists.

Certainly, Cézanne's conviction that Impressionism ignored qualities of Western painting important since the Renaissance prompted his oft-quoted (and frequently misunderstood) remark that he wanted to "make of Impressionism something solid like the art of the museums." By this he did not mean to imitate the old masters. He realized, quite correctly, that artists like Veronese or Poussin had created in their paintings a world similar to but quite distinct from the world in which they lived—that painting, resulting from the artist's various experiences, created a separate reality in itself. It was this kind of reality, the reality of the painting that was neither a direct reflection of life, like a photograph, nor a completely separate entity, that Cézanne sought in his own work. And he felt progressively that his sources must be nature and the objects of the world in which he lived, rather than stories or myths from the past. For this reason he expressed his desire "to do Poussin over again from nature."

Cézanne arrived at his mature position only after extended thought, study, and struggle with his medium. Late in his life, the theoretical position that he tried to express in his idiosyncratic language was probably achieved more through the discoveries he made painting from nature than through his studies in museums. In the art of the museum he found corroboration of what he already instinctively knew. Manet and Courbet are evident as sources, but the forceful temperament of the artist himself differs from that in the work of either predecessor. Throughout the 1860s, Cézanne exorcised his own inner conflict in scenes of murder and rape and, around 1870, he attempted his own *Déjeuner sur l'herbe* (see fig. 2.22) in a strange, heavy-handed variant on Manet's painting. After his exposure to the Impressionists, he returned to the violence of these essays in his *Battle of Love* (fig. **3.5**), a curious recasting of the classic theme of the bacchanal. Here he has moved

3.5 Paul Cézanne, *Battle of Love*, c. 1880. Oil on canvas, 14⅞ × 18¼" (37.8 × 46.2 cm). National Gallery of Art, Washington, D.C.

away from the somber tonality and sculptural modeling of the 1860s into an approximation of the light blue, green, and white of the Impressionists. Nevertheless, this painting is remote from Impressionism in its subject and effect. The artist subdues his greens with grays and blacks, and expresses an obsession with the sexual ferocity he is portraying that is notably different from the stately bacchanals of Titian and even more intense than comparable scenes by Rubens. At this stage he is still exploring the problem of integrating figures or objects and surrounding space. The figures are clearly outlined, and thus exist sculpturally in space. However, their broken contours, sometimes seemingly independent of the cream-colored area of their flesh, begin to dissolve solids and integrate figures with the shaped clouds that, in an advancing background, reiterate the carnal struggles of the bacchanal.

In the 1880s all of Cézanne's ideas on nature and painting came into focus in a magnificent series of landscapes, still lifes, and portraits. During most of this period he was living at Aix, largely isolated from the Parisian art world. *The Bay of Marseilles, seen from L'Estaque* (fig. **3.6**) is today so familiar from countless reproductions that it is difficult to realize how revolutionary it was at the time. Viewed from the hills above the red-tiled houses of the village of L'Estaque and looking toward the Bay of Marseilles, the scene does not recede into a perspective of infinity in the Renaissance manner. Buildings in the foreground are massed close to the spectator and presented as simplified cubes with the side elevation brightly lit. They assert their fluctuating identity, both as frontal color shapes parallel to the picture plane and as the walls of buildings at right angles to it. The buildings and intervening trees are composed in ocher, yellow, orange-red, and green, with little differentiation as objects recede from the eye. Cézanne once explained to a friend that sunlight cannot be "reproduced," but that it must be "represented" by some other means. That means was color. He wished to recreate nature with color, feeling that drawing was a consequence of the correct use of color. In *The Bay*, contours are the meeting of two areas of color. Since these colors vary substantially in value contrasts or in hue, their edges are perfectly defined. However, the nature of the definition tends to allow color planes to slide or "pass" into one another, thus to join and unify surface and depth, rather than to separate

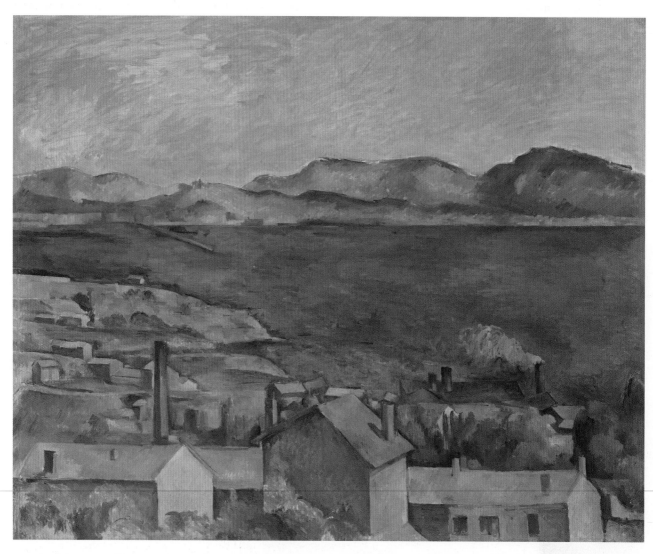

3.6 Paul Cézanne, *The Bay of Marseilles, seen from L'Estaque*, c. 1885. Oil on canvas, 31½ × 39⅝" (80 × 100.6 cm). The Art Institute of Chicago. Mr. and Mrs. Martin A. Ryerson Collection.

them in the manner of traditional outline drawing. The composition of this painting reveals Cézanne's intuitive realization that the eye takes in a scene both consecutively and simultaneously, with profound implications for the construction of the image and the future of painting.

The middle distance of *The Bay* is the bay itself, an intense area of dense but varied blue stretching from one side of the canvas to the other and built up of meticulously blended brushstrokes. Behind this is the curving horizontal range of the hills and, above these, the lighter, softer blue of the sky, with only the faintest touches of rose. The abrupt manner in which the artist cuts off his space at the sides of the painting has the effect of denying the illusion of recession in depth. The blue of the bay asserts itself even more strongly than the ochers and reds of the foreground, with the result that space becomes both ambiguous and homogeneous. The painting must be read simultaneously as a panorama in depth and as an arrangement of color shapes on the surface.

Even at the end of his life, Cézanne never had any desire to abandon nature entirely. When he recommended treating "nature by means of the cylinder, the sphere, the cone, everything brought into perspective so that each side of an object or a plane is directed to a central point," he was not thinking of these geometric shapes as the end result, the final abstraction into which he wanted to translate the landscape or the still life, as has sometimes been assumed. Abstraction for him was a method of stripping off the visual irrelevancies of nature in order to begin rebuilding the natural scene as an independent painting. Thus the end result was easily recognizable from the original motif, as photographs of Cézanne's sites have proved, but it is essentially different: the painting is a parallel but distinct and unique reality.

Later Career

Few artists in history have devoted themselves as intently as Cézanne to the separate themes of landscape, portrait, and still life. It is important to understand that to him these subjects involved similar problems. In all of them he was concerned with the recreation, the realization, of the scene, the object, or the person. The fascination of the still life for Cézanne, as for generations of painters before him and after, lies in the fact that its subject is controllable as no landscape or portrait sitter can possibly be. In *Still Life with Basket of Apples* (fig. **3.7**), he carefully arranged the wine bottle and tilted basket of apples, scattered the other apples casually over the tablecloth, and placed the plate of biscuits at the back of the table, thus setting up the relationships between these elements on which the final painting would be based. The apple obsessed Cézanne as a three-dimensional form that was difficult to control as a distinct object and to assimilate into the larger unity of the canvas. To attain this goal and at the same time to preserve the nature of the individual object, he modulated the circular forms with small, flat brushstrokes, distorted the shapes, and loosened or broke the contours to set up spatial tensions among the objects and unify them as color areas. By tilting the wine bottle out of the vertical, flattening and distorting the perspective of the plate, or changing the direction of the table edge under the cloth, Cézanne was able, while maintaining the appearance of actual objects, to concentrate on the relations and tensions existing among them. As Roger Fry observed, the subtleties through which Cézanne gained his final result "still outrange our pictorial apprehension." However, we can comprehend that he was one of the great constructors and colorists in the history of painting, one of the most penetrating observers, and one of the most subtle minds.

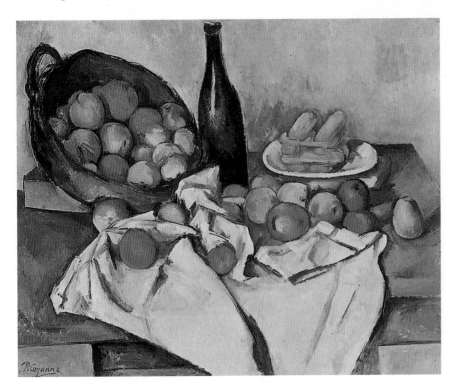

3.7 Paul Cézanne, *Still Life with Basket of Apples*, c. 1893. Oil on canvas, 24⅜ × 31" (61.9 × 78.7 cm). The Art Institute of Chicago. Helen Birch-Bartlett Memorial Collection.

Cézanne usually relied on friends or family members as models, most frequently his patient wife, Hortense Fiquet, but for *Boy in a Red Waistcoat* (fig. **3.8**) he hired a young Italian boy as a model. During a residence in Paris between 1888 and 1890, he painted four portraits of the seemingly melancholy boy in the same white shirt, blue cravat, and brilliant red waistcoat. Only in this composition, however, did the artist situate his subject frontally, to maximize the relaxed contrapposto of the boy's lanky torso. He is centered against a large swag of drapery so variegated by patches of color that its local hue is indeterminate. The painting is constructed as much by its network of broken lines as by the all-over tessellation of its flat, planar strokes. At the same time that the lines contour forms and endow them with an unmistakable fullness, they also intersect and continue from edge to edge, across figure and ground alike, thereby integrating the whole of the field into a kind of asymmetrical armature. A similar equilibrium of volume and plane occurs in the brushwork, where the squarish, "constructive" strokes build up forms while articulating the surface as a mosaic pattern of translucent, painterly slabs.

After 1890 Cézanne's brushstrokes became larger and more abstractly expressive, the contours more broken and dissolved, with color floating across the canvas, sustaining its own identity independent of the objects it defined. These tendencies were to lead to the wonderfully free paintings done at the very end of the artist's life, of which *Mont Sainte-Victoire Seen from Les Lauves* of 1902–06 is one of the supreme examples (fig. **3.9**). Here the brushwork acts the part of the individual musician in a superbly integrated symphony orchestra. Each stroke exists fully in its own right, but each is nevertheless subordinated to the harmony of the whole. This is both a structured and a lyrical painting, one in which the artist has achieved the integration of structure and color, of nature and painting. It belongs to the great tradition of classical landscape (see fig. 1.14), seen, however, as an infinite accumulation of individual perceptions. These are analyzed by the painter into their abstract components and then reconstructed into the new reality of the painting.

To the end of his life, Cézanne held fast to his dream of remaking Poussin after nature, continuously struggling with the problem of how to pose classically or heroically nude figures in an open landscape. For the largest canvas he ever worked, Cézanne painted as Poussin had done—that is, from his imagination—and relied on his years of *plein-air* experience to evoke Impressionist freshness. *The Large Bathers* (fig. **3.10**), in many ways the culmination of thirty years of experiment with the subject of female bathers in an outdoor setting, was painted in the year of Cézanne's death and is unfinished. In it the artist subsumed the fierce emotions expressed in the earlier *Battle of Love* (see fig. 3.5) within the grandeur of his total conception. Thus, while the figures have been so formalized as to seem part of the overall pictorial architecture, their erotic potential now charges the scene. It can be sensed as much in the high-vaulted trees as in the sensuous, shimmering beauty of the brushwork, with its unifying touches of rosy flesh tones and earthy ochers scattered throughout the delicate blue-green haze of sky and foliage. *The Large Bathers*, in its miraculous integration of linear structure and painterly freedom, of form and color, of eye and idea, provided the touchstone model for Fauves and Cubists alike, as well as the immediate antecedent for such landmark, yet disparate, paintings as Matisse's *Bonheur de vivre* (see fig. 6.8) and Picasso's *Les Demoiselles d'Avignon* (see fig. 8.7).

3.8 Paul Cézanne, *Boy in a Red Waistcoat*, 1888–90. Oil on canvas, 35¼ × 28¾" (89.5 × 73 cm). National Gallery of Art, Washington. Collection Mr. and Mrs. Paul Mellon, in honor of the gallery's 50th anniversary.

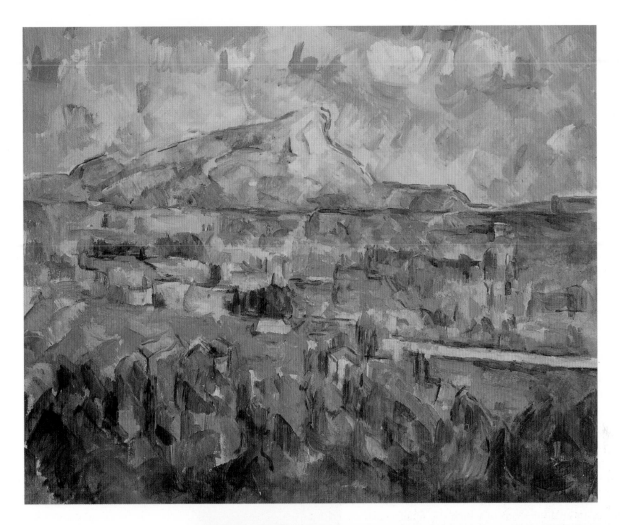

3.9 Paul Cézanne, *Mont Sainte-Victoire Seen from Les Lauves*, 1902–06. Oil on canvas, 25½ × 32" (64.8 × 81.3 cm). Collection Mrs. Louis C. Madeira, Gladwyne, Pennsylvania.

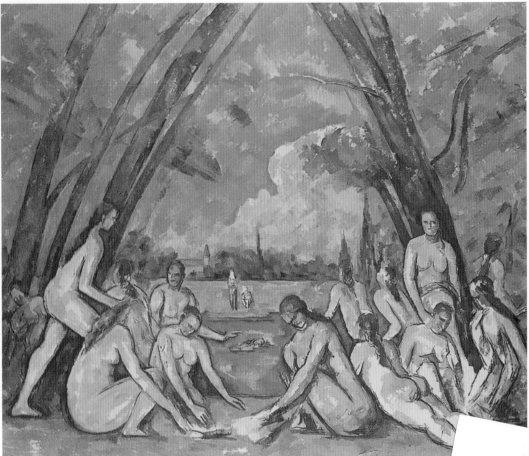

3.10 Paul Cézanne, *The Large Bathers*, 1906. Oil on canvas, 6' 10" × 8' 2" (2.1 × 2.5 m). Philadelphia Museum of Art.

The Triumph of Imagination: Symbolism

Symbolism in literature and the visual arts was a popular—if radical—movement of the late nineteenth century. A direct descendant of Romanticism, Symbolism must also be reckoned a response to the popularization of Art for Art's Sake. With no interest in influencing contemporary beliefs or social policies, Symbolist artists were even freer than their Romantic predecessors to delve into the recesses of their imagination. In literature, Symbolism's founders were mainly poets: Charles Baudelaire and Gérard de Nerval; the leaders at the close of the century were Jean Moréas, Stéphane Mallarmé, and Paul Verlaine. In music, Richard Wagner and Claude Debussy were great influences. Baudelaire had defined Romanticism as "a mode of feeling"—something found within rather than outside the individual—"intimacy, spirituality, color, aspiration toward the infinite." Symbolism arose from the intuitive ideas of the Romantics; it was an approach to an ultimate reality, a pure essence that transcended particular physical experience. The belief that the work of art should spring from the emotions, from the inner spirit of the artist rather than representing observed nature, dominated the attitudes of the Symbolist artists and was to recur continually in the philosophies of twentieth-century art.

For the Symbolists the inner idea, the dream or symbol, was paramount, but could be expressed only obliquely, as a series of images or analogies out of which the final revelation might emerge. Symbolism led some poets and painters back to organized religion, some to mysticism and arcane religious cults, and others to aesthetic creeds that were essentially anti-religious. During the 1880s, at the moment when artists were pursuing the idea of the dream, Sigmund Freud was beginning the studies that were to lead to his theories of the significance of dreams and the workings of the unconscious. Predicated on the understanding that the mind comprises both a sphere of conscious, rational decision-making and a realm of unconscious desires and fears, Freud's research led him to conclude that the unconscious—brimming with emotionally debilitating and, often, socially unacceptable fantasies and urges—could impose itself on the behavior and health of an individual if not properly managed. Unaware of the work of this young scientist, Symbolists nonetheless shared Freud's fascination with the self as an essentially interior experience, a continual renegotiation of reality through fantasy.

Symbolism in painting—the search for new forms, anti-naturalistic if necessary, to express a new content based on emotion (rather than intellect or objective observation), intuition, and the idea beyond appearance—may be interpreted broadly to include most of the experimental artists who succeeded the Impressionists and rejected their reliance on empiricism. The Symbolist movement, while centered in France, was international in scope and had adherents in America, Belgium, Britain, and elsewhere in Europe. These artists had a common concern with problems of personal expression and pictorial structure. They were inspired and abetted by two older academic masters—Gustave Moreau and Pierre Puvis de Chavannes—and also by Odilon Redon, an artist born into the generation of the Impressionists who attained his artistic maturity much later than his exact contemporaries.

Reverie and Representation: Moreau, Puvis, and Redon

Gustave Moreau (1826–98) was appointed professor at the École des Beaux-Arts in 1892 and displayed remarkable talents as a teacher. Inspired by Romantic painters such as Delacroix, Moreau's art exemplified the spirit of the *mal-du-siècle*, an end-of-the-century tendency toward profound melancholy or soul sickness, often expressed in art and literature through decadent and morbid subject matter. In several compositions around 1876, Moreau interpreted the biblical subject of Salome, the young princess who danced for her stepfather Herod, demanding in return the execution of St. John the Baptist. The bloody head of the saint appears in Moreau's painting as if called forth in a grotesque hallucination (fig. **3.11**). He conveys his subject with meticulous draftsmanship and an obsessive profusion of exotic detail combined with jewel-like color and rich paint texture.

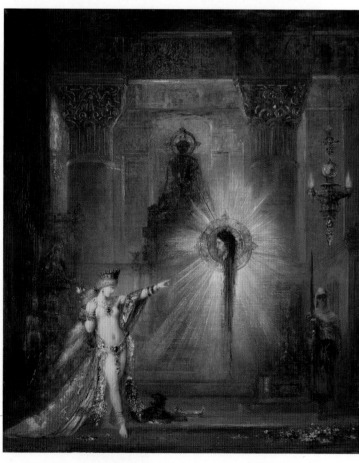

3.11 Gustave Moreau, *The Apparition*, c. 1876. Oil on canvas, 21¼ × 17½" (54 × 44.5 cm). Fogg Art Museum, Harvard University Art Museums, Cambridge, MA.

Moreau's spangled, languidly voluptuous art did much to glamorize decadence in the form of the *femme fatale*, or "deadly woman." The concept of woman as an erotic and destructive force was fostered by Baudelaire's great series of poems *Les Fleurs du Mal* ("The Flowers of Evil") (1857) and the mid-century pessimistic philosophy of Arthur Schopenhauer. Among scores of male artists in the last decades of the nineteenth century, Salome frequently served as the archetype of a castrating female who embodied all that is debased, sexually predatory, and perverse. The *femme fatale* also played a central role in the work of such composers as Wagner and Richard Strauss, such writers as Gustave Flaubert, Joris-Karl Huysmans (who admired Moreau's painting enormously), Stéphane Mallarmé, Oscar Wilde, and Marcel Proust, and a great number of artists. Moreover, the deadly temptress thrived well into the twentieth century, as she resurfaced in Picasso's *Les Demoiselles d'Avignon* (see fig. 8.7), the paintings and drawings of Egon Schiele, and the *amour fou* ("mad love") art of the Surrealists (see chapter 15). Propelling this preoccupation with sexually alluring yet dangerous women was a generalized disorientation arising from changing social mores and gender roles in the late nineteenth and early twentieth centuries. As more women sought—and achieved—political and economic enfranchisement, long-held assumptions about women's physical and mental shortcomings were exposed as myths. The "New Woman," capable of thinking and acting for herself, provoked consternation and confusion as she made her presence felt throughout Western Europe and North America.

Although **Pierre Puvis de Chavannes** (1824–98), with his simple, naive spirit, bleached colors, and near-archaic handling, would seem to have stood at the opposite pole from the elaborate, hothouse art of Moreau, the two painters were alike in a certain academicism and in the curious attraction this held for the younger generation. In Puvis, the reasons for such an anomaly can be readily discerned in his mural painting *Summer* (fig. **3.12**). The allegorical subject and its narrative treatment are highly traditional, but the organization in large, flat, subdued color areas, and the manner in which the plane of the wall is respected and even asserted, embodied a compelling truth in the minds of artists who were searching for a new idealism in painting. Although the abstract qualities of the mural are particularly apparent to us today, the classical withdrawal of the figures—as still and quiet as those in the *Ara Pacis* (see fig. 1.5) and Seurat—transforms them into emblems of that inner light that the Symbolists extolled.

Symbolism in painting found one of its earliest and most characteristic exponents in **Odilon Redon** (1840–1916), called the "prince of mysterious dreams" by the critic and novelist Huysmans. Redon felt Impressionism lacked the ambiguity that he sought in his art, and though he frequently found his subjects in the study of nature, at times observed under the microscope,

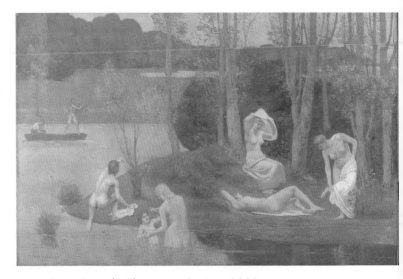

3.12 Pierre Puvis de Chavannes, *Summer*, 1891. Oil on canvas, 4' 11" × 7' 7½" (1.5 × 2.3 m). The Cleveland Museum of Art. Gift of Mr. and Mrs. J. H. Wade, 1916. 1056.

they were transformed in his hands into beautiful or monstrous fantasies.

Redon studied for a time in Paris with the painter Jean-Léon Gérôme, but he was not temperamentally suited to the rigors of academic training. He suffered from periodic depression—what he called his "habitual state of melancholy"—and much of his early work stems from memories of an unhappy childhood in and around Bordeaux, in southwest France. Like Seurat, Redon was a great colorist who also excelled at composing in black and white, and the first twenty years of his career were devoted almost exclusively to monochrome drawing, etching, and lithography, works he referred to as his "noirs," or works in black. His printmaking activity contributed to the rise in popularity of etching in the 1860s, prompted in part by a new appreciation in France of Rembrandt's prints, which Redon especially admired for their expressive effects of light and shadow. Redon studied etching with Rodolphe Bresdin, a strange and solitary artist who created a graphic world of meticulously detailed fantasy based on the work of the northern European masters Dürer (see fig. 2.57) and Rembrandt. Redon later found a closer affinity with the graphics of Francisco Goya (see fig. 1.9). Redon revealed the potential of the medium of lithography, in which he invented a world of dreams and nightmares based not only on the examples of past artists but also on his close and scientific study of anatomy.

Redon's own predilection for fantasy and the macabre drew him naturally into the orbit of the Symbolists. In his drawings and lithographs, where he pushed his rich, velvety blacks to extreme limits of expression, he developed and refined the fantasies of Bresdin in nightmare visions of monsters, or tragic-romantic themes taken from mythology or literature. Redon was close to the Symbolist poets and was almost the only artist who was successful in translating their words into visual equivalences. He dedicated

3.13 Odilon Redon, *Roger and Angelica*, c. 1910. Pastel on paper on canvas, 36½ × 28¾" (92.7 × 73 cm). The Museum of Modern Art, New York.

The Naïve Art of Henri Rousseau

Although **Henri Rousseau** (1844–1910) was almost the same age as Monet, his name tends to be linked with a younger generation of progressive artists, because of the remarkable artistic circles with which he associated, sometimes unwittingly, in Paris. Though Rousseau shared many formal concerns with his Post-Impressionist contemporaries, such as Gauguin and Seurat, he is often regarded as a phenomenon apart from them, for he worked in isolation, admired the academic painters they abhorred, and was "discovered" by several younger avant-garde artists. In its rejection of traditional illusionism and search for a poetic, highly personalized imagery, his work embraces concerns held by many Symbolist artists at the end of the century. For younger artists, however, his work chimed with their growing interest in "primitive" art—whether the prehistoric or folk art of Europe, or the art of other cultures and peoples whose works were untouched by what they saw as the dead hand of Western academic tradition.

In 1893, Rousseau retired from a full-time position as an inspector at a municipal toll station in Paris. He was called "le Douanier" ("the customs agent") by admiring young artists and poets who were more intrigued by his outsider status than by the exact nature of his day job. Once he turned his full energies to painting, Rousseau seems to have developed a native ability into a sophisticated technique and an artistic vision that, despite its ingenuousness, was not without aesthetic sincerity or self-awareness.

Rousseau was a fascinating mixture of naivety, innocence, and wisdom. Seemingly humorless, he combined a strange imagination with a way of seeing that was magical, sharp, and direct. In 1886, he exhibited his first painting, *Carnival Evening* (fig. **3.14**), at the Salon des Indépendants. The black silhouettes of the trees and house are drawn in painstaking detail—the accretive approach typically used by self-taught painters. Color throughout is low-keyed, as befits a night scene, but the lighted bank of clouds beneath the dark sky creates a sense of clear, wintry moonlight, as do the two tiny figures in carnival costumes in the foreground, who glow with an inner light. Despite the laboriously worked surface and the untutored quality of his drawing, the artist fills his painting with poetry and a sense of dreamy unreality.

By 1890 Rousseau had exhibited some twenty paintings at the Salon des Indépendants. His work had achieved a certain public notoriety, thanks to the constant mockery it endured in the press, but it also increasingly excited the interest of serious artists such as Redon, Degas, and Renoir and important writers like the poet and playwright Alfred Jarry and, somewhat later, Guillaume Apollinaire. Despite such recognition, Rousseau never made a significant living from his painting and spent most of his post-retirement years in desperate poverty. Yet to the end of his life he continued his uncritical admiration for the Salon painters, particularly for the technical finish of their works. *The Sleeping Gypsy* (fig. **3.15**) is one of the most entrancing and magical

a portfolio of his lithographs to Edgar Allan Poe, whose works had been translated by Baudelaire and Mallarmé, and he created three series of lithographs inspired by Gustave Flaubert's *Temptation of St. Anthony*, a novel that achieved cult status among Symbolist writers and artists in the 1880s. Huysmans reviewed Redon's exhibitions enthusiastically at the same time that he was himself moving away from Émile Zola's naturalism and into the Symbolist stream with his novel of artistic decadence *Against the Grain*, in which he discussed at length the art of Redon and of Gustave Moreau.

After 1890, Redon began to work seriously in color, almost immediately demonstrating a capacity for exquisite, original harmonies, in both oil and pastel, that changed the character of his art from the macabre and the somber to the joyous and brilliant. Gone are the nightmarish visions of previous decades, replaced by a new enthusiasm for religious and mythological subjects. Yet in *Roger and Angelica* (fig. **3.13**), the subject—the rescue of Angelica by the hero Roger, based on a Renaissance poem—seems almost incidental. We can hardly decipher the two tiny figures, Roger on a winged horse-like hippogriff, at left, and Angelica at right, naked and chained to a rock. They are lost amid clouds of brilliant, amorphous color, where nothing is fixed in space and everything is subsumed in an atmosphere of overpowering sensuality.

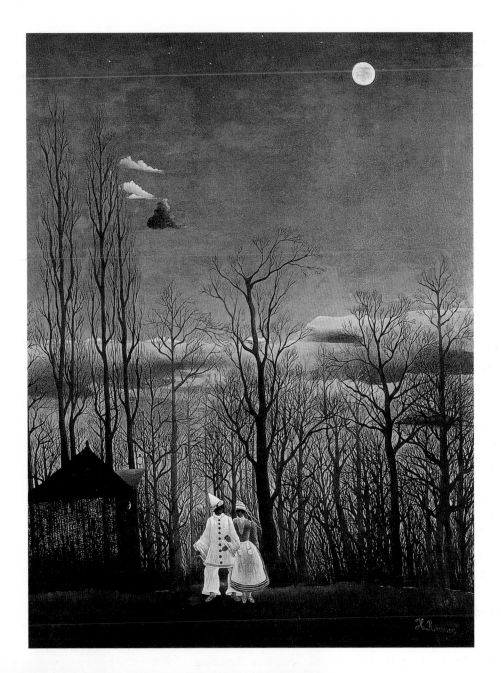

3.14 Henri Rousseau, *Carnival Evening*, 1886. Oil on canvas, 46 × 35⅛" (116.8 × 89.2 cm). Philadelphia Museum of Art.

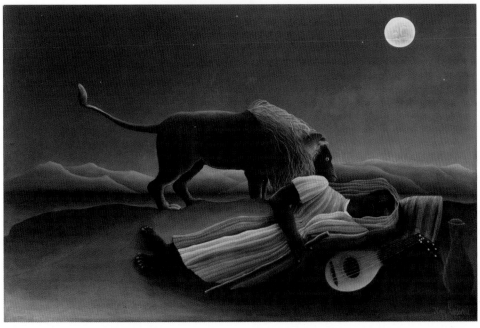

3.15 Henri Rousseau, *The Sleeping Gypsy*, 1897. Oil on canvas, 4' 3" × 6' 7" (1.3 × 2 m). The Museum of Modern Art, New York.

paintings in modern art. By this time he could create mood through a few elements, broadly conceived but meticulously rendered. The composition has a curiously abstract quality, but the tone is overpoweringly strange and eerie— a vast and lonely landscape framing a mysterious scene. This painting was lost for years until it was rediscovered in 1923 in a charcoal dealer's shop by the art critic Louis Vauxcelles. This "discovery" by the critic would further the modernist idea that artistic genius is not always apparent to all viewers; the discriminating eye of a sensitive artist or critic must be relied upon to discern aesthetic achievement, even in the unlikeliest of places. During his later years, Rousseau became something of a celebrity for the new generation of artists and critics. He held regular musical soirées at his studio. In 1908 Picasso, discovering a portrait of a woman by Rousseau at a junk shop (though he no doubt knew Rousseau's work already), purchased it for five francs and gave a large party for him in his studio, a party that has gone down in the history of modern painting. It was partly intended as a joke on the innocent old painter, who took himself so seriously as an artist, but more as an affectionate tribute to a naive man heralded as a genius. In 1910, the year of his death, Rousseau's first solo exhibition was held in New York at Alfred Stieglitz's Gallery 291, thanks to the efforts of the young American painter Max Weber (see fig. 16.13), who had befriended Rousseau in Paris.

An Art Reborn: Rodin and Sculpture at the Fin-de-Siècle

It was the achievement of the French artist **Auguste Rodin** (1840–1917) to rechart the course of sculpture almost singlehandedly and to give the art an impetus that led to a major renaissance. There is no one painter who occupies quite the place in modern painting that Rodin can claim in modern sculpture. He introduced modern ideas into the tradition-bound form of figural public sculpture, depicting bodies that exert the material weight of their physical existence while simultaneously revealing the play of thoughts and emotions that underlie a figure's movement. In this way, Rodin's works show their indebtedness to Realism and Symbolism.

Early Career and *The Gates of Hell*

Rodin began his revolution, as had Courbet in painting (see chapter 2), with a reaction against the sentimental idealism of the academicians. His examination of nature was coupled with a re-examination of the art of the Middle Ages and the Renaissance—most specifically, of Donatello and Michelangelo. Rodin was in possession of the full range of historical sculptural forms and techniques by the time he returned in 1875 from a brief but formative visit to Italy, where he studied firsthand the work of Michelangelo, who, he said, "liberated me from academicism."

The Age of Bronze (fig. **3.16**), Rodin's first major signed work, was accepted in the Salon of 1877, but its scrupulous

realism led to the suspicion that it might have been in part cast from the living model—which became a legitimate technique for making sculpture only in the 1960s (see fig. 19.38). Although Rodin had unquestionably observed the model closely from all angles and was concerned with capturing and unifying the essential quality of the living form, he was also concerned with the expression of a tragic theme, inspired perhaps by his reaction to the Franco–Prussian War of 1870–71, so disastrous for the French. The figure, which once held a spear, was originally titled *Le Vaincu* ("The Vanquished One") and was based firmly on the *Dying Slave* of Michelangelo. By removing the spear,

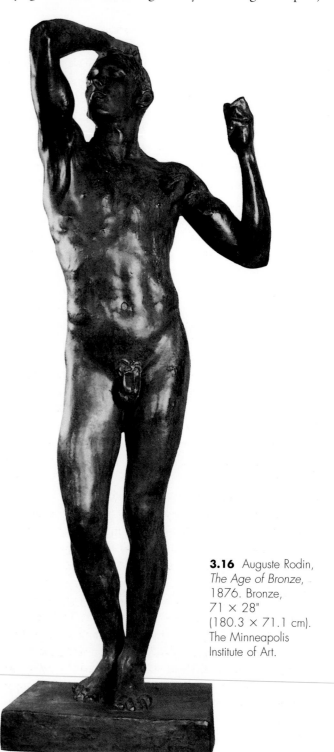

3.16 Auguste Rodin, *The Age of Bronze*, 1876. Bronze, 71 × 28" (180.3 × 71.1 cm). The Minneapolis Institute of Art.

Rodin created a more ambivalent and ultimately more daring sculpture. The suggestion of action, frequently violent and varied, had been an essential part of the repertory of academic sculpture since the Late Renaissance, but its expression in nineteenth-century sculpture normally took the form of a sort of tableau of frozen movement. Rodin, however, studied his models in constant motion, in shifting positions and attitudes, so that every gesture and transitory change of pose became part of his vocabulary. As he passed from this concentrated study of nature to the more expressive later works, even his most melodramatic subjects and most violently distorted poses were given credibility by their secure basis in observed nature.

In 1880 Rodin received a commission, the most important one of his career, for a portal to the proposed Museum of Decorative Arts in Paris. He conceived the idea of a free interpretation of scenes from Dante's *Inferno*, within a design scheme based on Lorenzo Ghiberti's great fifteenth-century gilt-bronze portals for the Florence Baptistry, popularly known as the *Gates of Paradise*. Out of his ideas emerged *The Gates of Hell* (fig. **3.17**), which remains one of the masterpieces of nineteenth- and twentieth-century sculpture. It is not clear whether the original plaster sculpture of *The Gates* that Rodin exhibited at the Exposition Universelle in 1900 was complete, though it is clear that the idea of academic "finish" was abhorrent to the artist. The portal was never installed in the Museum of Decorative Arts, and the five bronze casts that exist today were all made posthumously. Basing his ideas loosely on individual themes from Dante but also utilizing ideas from the poems of Baudelaire, Rodin created isolated figures, groups, or episodes, experimenting with different configurations over more than thirty years.

The Gates contains a vast repertory of forms that the sculptor developed in this context and then adapted to other uses, and sometimes vice versa. For example, he executed the central figure of Dante, a brooding nude seated in the upper panel with his right elbow perched on his left knee, as an independent sculpture and exhibited it with the title *The Thinker; The Poet; Fragment of the Gate*. It became the artist's best-known work, in part because of the many casts that exist of it in several sizes. The work is crammed with a dizzying variety of forms on many different scales, above and across the lintel, throughout the architectural frieze and framework, and rising and falling restlessly within the turmoil of the main panels. To convey the turbulence of his subjects, Rodin depicted the human figure bent and twisted to the limits of endurance, although with remarkably little actual distortion of anatomy. Imprisoned within the drama of their agitated and anguished state, the teeming figures—coupled, clustered, or isolated—seem a vast and melancholy meditation on the tragedy of the human condition, on the plight of souls trapped in eternal longing, and on the torment of guilt and frustration. Like *The Thinker*, many of the figures made for *The Gates of Hell* are famous as individual sculptures, including *The Three Shades*,

who stand hunched atop the gates. The tragedy and despair of the work are perhaps best summarized in *The Crouching Woman*, whose contorted figure, a compact, twisted mass, attains a beauty that is rooted in intense suffering.

The violent play on the human figure seen here was a forerunner of the Expressionist distortions of the figure developed in the twentieth century. An even more suggestive and modern phenomenon is to be found in the basic concept of the Gates—that of flux or metamorphosis, in which the figures emerge from or sink into the matrix of the bronze itself, in the process of birth from, or death and decay into, a quagmire that both liberates and threatens to engulf them. Essential to the suggestion of change in *The Gates* and in most of the mature works of Rodin is the exploitation of light. A play of light and shadow moves over the peaks and crevasses of bronze or marble, becoming analogous to color in its evocation of movement, of growth and dissolution.

Although Rodin, in the sculptural tradition that had persisted since the Renaissance, was first of all a modeler, starting with clay and then casting the clay model in plaster and bronze, many of his most admired works are in marble. These also were normally based on clay and plaster originals, with much of the carving, as was customary, done by assistants. Rodin closely supervised the work and finished the marbles with his own hand. The marbles were handled with none of the expressive roughness of the bronzes (except in deliberately unfinished areas) and without deep undercutting. He paid close attention to the delicate, translucent, sensuous qualities of the marble, which in his later works he increasingly emphasized—inspired by unfinished works of Michelangelo—by contrasting highly polished flesh areas with masses of rough, unfinished stone. In his utilization of the raw material of stone for expressive ends, as in his use of the partial figure (the latter suggested no doubt by fragments of ancient sculptures), Rodin was initiating the movement away from the human figure as the prime medium of sculptural expression. The remarkable portrait of his lover and fellow sculptor Camille Claudel (fig. **3.18**) does away with the torso altogether to personify meditation through the abrupt juxtaposition of a smoothly polished, disembodied head with a coarsely hewn block of marble.

The Burghers of Calais and Later Career

As a somewhat indirect memorial to French losses in the Franco–Prussian War, the city of Calais began formulating plans in 1884 for a public monument in memory of Eustache de Saint-Pierre, who in 1347, during the Hundred Years' War, had offered himself, along with five other prominent citizens, as hostage to the English in the hope of raising the long siege of the city. The commission held particular appeal for Rodin. In the old account of the event, the medieval historian Froissart describes the hostages as delivered barefoot and clad in sackcloth, with ropes around their necks, bearing the keys to the city and fortress; this tale permitted the artist to be historically accurate and yet

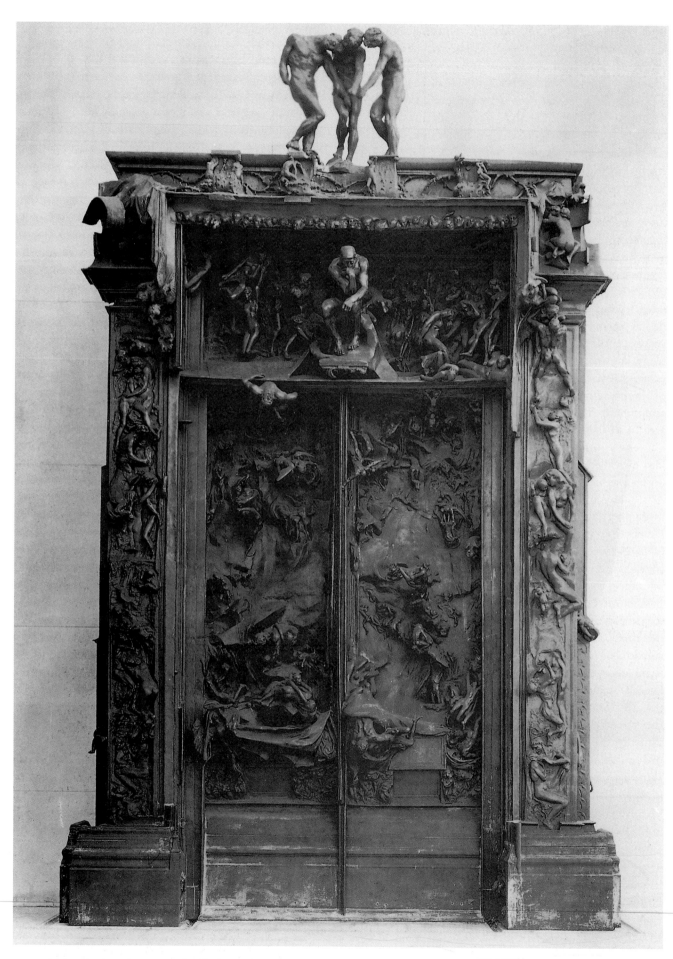

3.17 Auguste Rodin, *The Gates of Hell*, 1880–1917. Bronze, 20' 10" × 13' 1" × 2' 9½" (6.4 × 4 × 0.85 m). Musée Rodin, Paris.

3.18 Auguste Rodin, *Thought (Camille Claudel)*, 1886. Marble, 29½ × 17 × 18" (74.9 × 43.2 × 45.7 cm). Musée d'Orsay, Paris.

avoid the problem of period costumes without resorting to nudity. After winning the competition with a relatively conventional heroic design set on a tall base, Rodin created a group of greater psychological complexity, in which individual figures, bound together by common sacrifice, respond to it in varied ways (fig. **3.19**). So he studied each figure separately and then assembled them all on a low rectangular platform, a non-heroic arrangement that allows the viewer to approach the figures directly. It took some doing for Rodin to persuade Calais to accept the work, for rather than an image of a readily recognizable historical event, he presented six particularized variations on the theme of human courage, deeply moving in their emotional range and thus very much a private monument as well as a public one.

3.19 Auguste Rodin, *The Burghers of Calais*, 1886. Six figures, bronze, 6' 10½" × 7' 11" × 6' 6" at base (2.1 × 2.4 × 2 m). Hirshhorn Museum and Sculpture Garden, Smithsonian Institution, Washington, D.C.

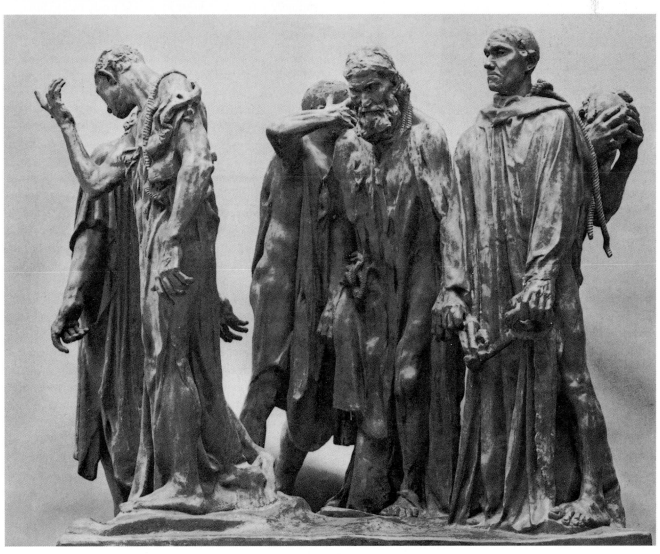

The debt of *The Burghers of Calais* to the fourteenth- and fifteenth-century sculptures of Claus Sluter and Claus de Werve is immediately apparent, but this influence has been combined with an assertion of the dignity of common humanity analogous to that in the nineteenth-century sculptures of the Belgian artist **Constantin Meunier** (1831–1904), whose *The Dock Hand* endows its subject with a heroic bearing and monumentality without sacrificing a Realist's eye for accuracy (fig. **3.20**). The rough-hewn faces, powerful bodies, and the enormous hands and feet transform Rodin's burghers into laborers and peasants and at the same time enhance their physical presence, as do the outsize keys. Rodin's tendency to dramatic gesture is apparent here, and the theatrical element is emphasized by the unorthodox organization, with the figures scattered about the base like a group of stragglers wandering across a stage. The informal, open arrangement of the figures, none of which touches another, is one of the most daring and original aspects of the sculpture. It is a direct attack on the classical tradition of closed, balanced groupings for monumental sculpture. The detached placing of the masses gives the intervening spaces an importance that, for almost the first time in modern sculpture, reverses the traditional roles of solid

and void, of mass and space. Space not only surrounds the figures but interpenetrates the group, creating a dynamic, asymmetrical sense of balance. Rodin's wish that the work be placed not on a pedestal but at street level, situating it directly in the viewer's space, anticipated some of the most revolutionary innovations of twentieth-century sculpture.

Rodin's *Monument to Balzac*, a work he called "the sum of my whole life," was commissioned in 1891 by the French Writers' Association, at the urging of the novelist Émile Zola. Here the artist plunged so deeply into the privacy of individual psychology—his own perhaps even more than the subject's—that he failed to gain acceptance by the patrons. What they and the public perceived was a tall, shapeless mass crowned by a shaggy head so full of Rodin's "lumps and hollows" that it seemed more a desecrating caricature than a tribute to the great novelist Honoré de Balzac, who had died in 1850. Little were they prepared to appreciate what even the artist characterized as a symbolism of a kind "yet unknown." The work provoked a critical uproar, with some proclaiming it a masterpiece and others reviling it as a monstrosity, whereupon it was withdrawn from the Paris Salon in 1898.

Rodin struggled to realize a portrait that would transcend any mere likeness and be a sculptural equivalent of a famously volcanic creative force. He made many different studies over a period of seven years, some of an almost academic exactness, others more emblematic. In the end, he cloaked Balzac in the voluminous "monk's robe" he had habitually worn during his all-night writing sessions. The anatomy has virtually disappeared beneath the draperies, which are gathered up as if to muster and concentrate the whole of some prodigious inspiration, all reflected like a tragic imprint on the deep-set features of the colossal head. The figure leans back dramatically beneath the robe, a nearly abstract icon of generative power.

Exploring New Possibilities: Claudel and Rosso

Until the 1980s, when long overdue retrospectives of her work were held, **Camille Claudel** (1864–1943) was known largely as Rodin's assistant and mistress. She never recovered from her failed relationship with the sculptor and was confined to mental hospitals for the last thirty years of her life. Claudel's work shares many formal characteristics with that of her mentor; nevertheless, hers was a highly original talent in a century that produced relatively few women sculptors of note, and at a time when it was still extremely difficult for women artists to be taken seriously. By the time she entered Rodin's studio at age twenty, she was already exhibiting at the Salon. Though she was an accomplished portraitist—she produced a memorable image of Rodin—Claudel's particular strength lay with inventive solutions to multifigure compositions. An unusual and decidedly unheroic subject for sculpture, *Chatting Women* (fig. **3.21**) presents four seated figures, rapt in discussion, who form a tightly knit group in the corner of a room. An immediacy of expression and the quotidian nature of the subject seem

3.20 Constantin Meunier, *The Dock Hand*, modeled 1885, cast 1905. Bronze, 46¹⁄₁₆ × 18¼ × 18" (117 × 46.3 × 45.7 cm). Museum of Fine Arts, Boston. Helen and Alice Colburn Fund.

3.21 Camille Claudel, *Chatting Women*, 1897. Onyx and bronze, 17¾ × 16⅝ × 15⅜" (45 × 42.2 × 39 cm). Musée Rodin, Paris.

3.22 Medardo Rosso, *The Concierge (La Portinaia)*, 1883. Wax over plaster, 14½ × 12⅜" (36.8 × 32 cm). The Museum of Modern Art, New York.

at odds with the inexplicable nudity of the figures and the use of strongly veined and colored onyx, which serves to underscore the abstract nature of the representation.

Medardo Rosso (1858–1928) was born in Turin, Italy, and worked as a painter until 1880. After being dismissed from the Accademia di Brera in Milan in 1883, he lived in Paris for two years, worked in Dalou's atelier, and met Rodin. After 1889 Rosso spent most of his remaining active career in Paris, and thus was associated more with French sculpture than with Italian. In a sense, he always remained a painter. Rosso extended the formal experiments of Rodin, deliberately dissolving sculptural forms until only an impression remained. His favorite medium, wax, allowed the most imperceptible transitions, so that it becomes difficult to tell at exactly what point a face or figure emerges from an amorphous shape and many-textured surface. "Nothing is material in space," Rosso said. The primacy he gave to the play of light and shadow is evident in the soft *sfumato* that envelops the portrait of his old doorkeeper (fig. **3.22**), a work once owned by Émile Zola. This quality has sometimes led critics to call him an "Impressionist" sculptor. In his freshness of vision and his ability to catch and record the significant moment, Rosso added a new dimension to sculpture, in works that are invariably *intimiste*, small-scale, and anti-heroic, and anticipated the search for immediacy that characterizes so much of the sculpture to follow.

Primitivism and the Avant-Garde: Gauguin and Van Gogh

Gauguin

Paul Gauguin (1848–1903) was unquestionably the most influential artist to be associated with the Symbolist movement. But while he became intimate with Symbolist poets, especially Mallarmé, and enjoyed their support, Gauguin deplored the literary content and traditional form of such artists as Moreau and Puvis. He also rejected the optical naturalism of the Impressionists, while initially retaining their rainbow palette before vastly extending its potential for purely decorative effects. He sought what he termed a "synthesis of form and color derived from the observation of the dominant element." Gauguin advised a fellow painter not to "copy nature too much. Art is an abstraction; derive this abstraction from nature while dreaming before it, but think more of creating than the actual result."

In these statements may be found many of the concepts of twentieth-century experimental painting, from the idea of color used arbitrarily rather than to describe an object visually, to the primacy of the creative act, to painting as abstraction. Gauguin's ideas, which he called "Synthetism," involved a synthesis of subject and idea with form and color, so that his paintings are given their mystery, their visionary quality, by their abstract color patterns. His purpose in creating such an anti-Realist art was to express

invisible, subjective meanings and emotions. He attempted to free himself from the corrupting sophistication of the modern industrial world, and to renew his spirit, by contact with an innocence and sense of mystery that he sought in non-industrial societies. He constantly described painting in terms of an analogy with music, of color harmonies, of color and lines as forms of abstract expression. In his search he was attracted, to a greater degree even than most of his generation, to so-called "primitive" art. In his work we find the expression of modern primitivism, the tendency to understand non-Western or pre-industrial societies as more pure, more authentic than those of the West. Primitivism simultaneously valorizes and denigrates pre-industrial cultures, because their appeal rests in their perceived simplicity and resistance to progress. Only by casting these societies as relatively naive and ineffectual could their potential as sources for aesthetic as well as economic exploitation be justified. Such notions were, of course, forged at a time when European countries were aggressively colonizing the very societies Western artists sought to emulate. For Gauguin, primitivism held appeal as a means of relieving himself of the burden of Western culture, industrialization, and urbanization. Attracted not only to primitive-seeming motifs, Gauguin also cultivated a deliberately naive style. Like the paintings of Henri Rousseau, Gauguin's works convey an immediacy and authenticity generally absent in academic art.

In searching for the life of a "savage," he became, sometimes to the detriment of a serious consideration of his art, a romantic symbol, the personification of the artist as rebel against society. After years of wandering, first in the merchant marine, then in the French navy, he settled down, in 1871, to a prosaic but successful life as a stockbroker in Paris, married a Danish woman, and had five children. For the next twelve years the only oddity in his respectable, bourgeois existence was the fact that he began painting, first as a hobby and then with increasing seriousness. He even managed to show a painting in the Salon of 1876 and to exhibit in four Impressionist exhibitions from 1879 to 1882. He lost his job, probably because of a stock-market crash, and by 1886, after several years of family conflict and attempts at new starts in Rouen and Copenhagen, he had largely severed his family ties, isolated himself, and become involved with the Impressionists.

Gauguin had spent the early years of his childhood in Peru, and he appears almost always to have had a nostalgia for far-off, exotic-seeming places. This feeling ultimately crystalized in the conviction that his salvation, and perhaps that of all contemporary artists, lay in abandoning modern civilization to return to some simpler, more elemental pattern of life. From 1886 to 1891 he moved between Paris and the Breton villages of Pont-Aven and Le Pouldu, with a seven-month interlude in Panama and Martinique in 1887 and a tempestuous but productive visit with Vincent van Gogh in Arles the following year. In 1891 he sailed for Tahiti, returning to France for two years in 1893 before settling in the South Seas for good (see excerpt from *Noa Noa*, below). His final trip, in the wake of years of illness and suffering, was to the island of Hiva-Oa in the Marquesas Islands, where he died in 1903.

The earliest picture in which Gauguin fully realized his revolutionary ideas is *Vision after the Sermon*, painted in 1888 in Pont-Aven (fig. **3.23**). This is a startling and pivotal work, a pattern of red, blue, black, and white tied together by curving, sinuous lines and depicting a Breton peasant's biblical vision of Jacob wrestling with the Angel. The innovations used here were destined to affect the ideas of younger groups such as the Nabis and the Fauves. Perhaps the greatest single departure is the arbitrary use of color in the dominating red field within which the protagonists struggle, their forms borrowed from a Japanese print. Gauguin has here constricted his space to such an extent that the dominant red of the background visually thrusts itself forward beyond the closely viewed heads of the peasants in the foreground. Though the brilliant red hue may have been stimulated by his memory of a local religious celebration that included fireworks and bonfires in the fields, this painting was one of the first complete statements of color as an expressive end in itself.

SOURCE

Paul Gauguin
from *Noa Noa* (1893)

Gauguin arranged for the publication of his journal, which he hoped would stimulate interest in the artworks he had produced there. The title means "beautiful fragrance." It was initially published in a version heavily revised by the poet Charles Morice. This extract comes from Gauguin's original version.

I began to work—notes, sketches of all sorts. Everything in the landscape blinded and dazzled me. Coming from Europe I was always uncertain of a color, unable to see the obvious: yet it was so easy to put a red and a blue on my canvas, naturally. In the streams, golden shapes enchanted me. Why did I hesitate to make all that god and all that sunny rejoicing flow on my canvas? Probably old habits from Europe, all that timidity of expression of our old degenerate races.

In order to understand the secret in a Tahitian face, all the charm of a Maori smile, I had been wanting for a long time to do the portrait of a neighboring woman of pure Tahitian race. One day, when she had been bold enough to come into my hut to look at some pictures and photographs of paintings, I asked her if I could do it.

She was specially interested in the photograph of Manet's *Olympia*. Using the few words I had learned in her language (for two months I'd spoken not a word of French) I questioned her. She told me that this Olympia was very beautiful: I smiled at this opinion and was moved by it. She had a sense of the beautiful (whereas the École des Beaux-Arts finds it horrible).

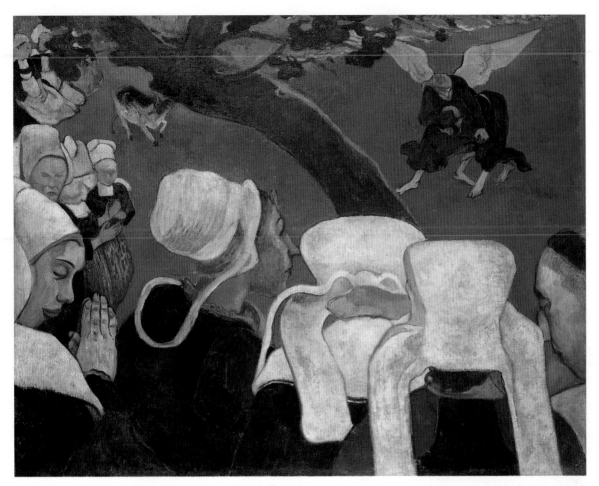

3.23 Paul Gauguin, *Vision after the Sermon*, 1888. Oil on canvas, 28¾ × 36¼" (73 × 92.1 cm). National Gallery of Scotland, Edinburgh.

From the beginning of his life as an artist, Gauguin did not restrict himself to painting. He carved sculptures in marble and wood and learned the rudiments of ceramics to become one of the most innovative ceramicists of the century. (It is a feature of modern art in general that many artists, including Picasso, Matisse, and others, have been less constrained by the boundaries between the academic disciplines of painting and sculpture, or between so-called fine art and craft practice, than artists of earlier post-Renaissance generations.) By the late 1880s Gauguin had ventured into printmaking, another medium to which he brought all his experimental genius. One of his most enigmatic works, made in Brittany during an especially despondent period, is a wooden panel that he carved in low relief, painted, and titled with the cynical admonition *Be in Love and You Will Be Happy* (fig. **3.24**). Here a woman, "whom a demon takes by the hand," faces the forces of temptation, symbolized in part by a small fox. Such themes, the struggle between knowledge and innocence, good and evil, life and death, recur in Gauguin's Tahitian compositions. Among the faces in the relief, the one with its thumb in its mouth, at the upper right, is the artist himself.

3.24 Paul Gauguin, *Soyez amoureuses vous serez heureuses (Be in Love and You Will Be Happy)*, 1889. Carved and painted linden wood, 37½ × 28½" (95.3 × 72.4 cm). Museum of Fine Arts, Boston. Arthur Tracy Cabot Fund.

Gauguin was disappointed, upon his arrival in Tahiti, to discover how extensively Western missionaries and colonials had encroached upon native life. The capital, Papeete, was filled with French government officials, and Tahitian women often covered themselves in ankle-length missionary dresses. Nor was the island filled with the indigenous carvings of ancient gods Gauguin had hoped for, so he set about making his own idols, based in part on Egyptian and Buddhist sculptures that he knew from photographs. One example of this is his largest sculpture, *Oviri* (fig. **3.25**), executed during a visit to Paris between two Tahitian sojourns. The title means "savage" in Tahitian, a term with which Gauguin personally identified, for he later inscribed "Oviri" on a self-portrait. The mysterious, bug-eyed woman crushes a

3.25 Paul Gauguin, *Oviri*, 1894. Partially glazed stoneware, 29½ × 7½ × 10⅜" (74.9 × 19.1 × 27 cm). Musée d'Orsay, Paris.

3.26 Paul Gauguin, *Where Do We Come From? What Are We? Where Are We Going?* 1897–98. Oil on canvas, 4' 6¾" × 12' 3" (1.4 × 3.7 m). Museum of Fine Arts, Boston. Tompkins Collection. Arthur Gordon Tompkins Fund.

wolf beneath her feet and clutches a wolf cub to her side. Whether she embraces the cub or suffocates it is unclear, though Gauguin did refer to her as a "murderess" and a "cruel enigma." The head was perhaps inspired by the mummified skulls of Marquesan chiefs, while the torso derives from the voluptuous figures, symbols of fecundity, on the ancient Javanese reliefs at Borobudur in Southeast Asia, of which Gauguin owned photographs.

Another attempt at inventing suitably "primitive" sculpture on behalf of the Tahitians can be seen at the left in his grand, philosophical painting *Where Do We Come From? What Are We? Where Are We Going?* (fig. **3.26**). Over twelve feet (3.7 m) long, this is the most ambitious painting of Gauguin's career. It presents a summation of his Polynesian imagery, filled with Tahitians of all ages situated at ease within a terrestrial paradise devoid of any sign of European civilization. "It's not a canvas done like a Puvis de Chavannes," Gauguin said, "with studies from nature, then preliminary cartoons etc. It is all dashed off with the tip of the brush, on burlap full of knots and wrinkles, so that its appearance is terribly rough." The multiple forms and deep spaces of this complex composition are tied together by its overall tonalities in green and blue. It was this element—color—that the artist called "a mysterious language, a language of the dream."

Van Gogh

Whereas Gauguin was an iconoclast, caustic in speech, cynical, indifferent, and at times brutal to others, **Vincent van Gogh** (1853–90) was filled with a spirit of enthusiasm for his fellow artists and an overwhelming love for humanity. This love had led him, after a short-lived experience as an art dealer and an attempt to follow theological studies, to become a lay preacher in a Belgian coal-mining area. There, in 1880, he first began to draw. After study in Brussels, The Hague, and Antwerp, he went to Paris in 1886, where he met Seurat, Signac, and Gauguin, as well as members of the original Impressionist group.

In his early drawings, Van Gogh revealed his roots in traditional Dutch landscape, portrait, and genre painting, using the same perspective structures, and depicting the broad fields and low-hanging skies that the seventeenth-century artists had loved. Van Gogh never abandoned perspective even in later years, when he developed a style with great emphasis on the linear movement of paint over the surface of the canvas. For him—and this is already apparent in his early drawings—landscape itself had an expressive, emotional significance.

After his exposure to the Impressionists in Paris, Van Gogh changed and lightened his palette. Indeed, he discovered his deepest single love in color—brilliant, unmodulated color—which in his hands took on a character radically different from the color of the Impressionists. Even when he used Impressionist techniques, the peculiar intensity of his vision gave the result a specific and individual quality that could never be mistaken for any other painter's.

The passion in Van Gogh's art arose from his intense, overpowering response to the world in which he lived and to the people he knew. His mental troubles are, though not well understood, a famous part of his larger-than-life reputation as it developed during the twentieth century. Such episodes as the incident in which he sliced off part of his ear during Gauguin's visit have overshadowed a reasoned understanding of his work. More than any other artist, Van Gogh has come to typify the figure of the lone artist-genius, spurned and misunderstood by society. This legend is only partly borne out by the more complex reality of his life and work. Van Gogh may have suffered from a neurological disorder, perhaps a severe form of epilepsy, that was no doubt exacerbated by physical ailments and excessive drinking. He was prone to depression and suffered acutely during seizures, but he painted during long periods of lucidity, bringing tremendous intelligence and imagination to his work. His letters to his brother Theo, an art dealer who tried in vain to find a market for Vincent's work, are among the most moving and informative narratives by an artist that we have (see *Letter to Theo van Gogh*, p. 74). They reveal his wide knowledge of art and literature, and a highly sensitive perception that is fully equal to his emotional response. He was sharply aware of the extraordinary effects he was achieving through his expressive use of color. "Instead of trying to reproduce exactly what I have before my eyes, I use color more arbitrarily," he wrote, "in order to express myself forcibly." Echoing the Symbolist ideas of Gauguin, Van Gogh told Theo that he "was trying to exaggerate the essential and to leave the obvious vague."

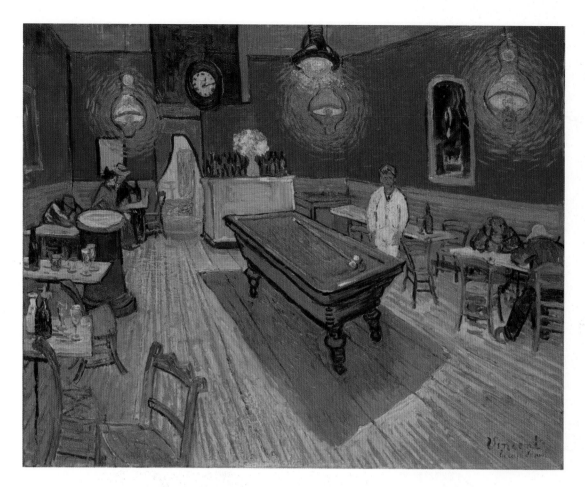

3.27 Vincent van Gogh, *The Night Café*, 1888. Oil on canvas, 27½ × 35" (69.9 × 88.9 cm). Yale University Art Gallery, New Haven. Bequest of Stephen Carlton Clark, B.A. 1903.

Van Gogh could also present the darker side of existence. Thus, of *The Night Café* (fig. **3.27**) he says: "I have tried to express the terrible passions of humanity by means of red and green." *The Night Café* is a nightmare of deep-green ceiling, blood-red walls, and discordant greens in the furniture. The perspective of the brilliant yellow floor is tilted so precipitously that the contents of the room threaten to slide toward the viewer. The result is a terrifying experience of claustrophobic compression that anticipates the Surrealist explorations of fantastic perspective, none of which has ever quite matched it in emotive force.

Vincent van Gogh carried on the great Netherlandish tradition of portraiture, from his first essays in drawing to his last self-portraits, painted a few months before his suicide in 1890. The intense *Self-Portrait* from 1888 was made in Arles and was dedicated to Gauguin (fig. **3.28**). It formed part of an exchange of self-portraits among Van Gogh's artist friends to support his notion of an ideal brotherhood of painters. The beautifully sculptured head (which Van Gogh said resembled that of a Buddhist monk) and the solidly modeled torso are silhouetted against a vibrant field of linear rhythms painted, according to the artist, in "pale malachite," akin to the monochrome backgrounds used by Northern Renaissance portraitists such as Lucas Cranach the Younger. The coloristic and rhythmic integration of all parts, the careful progression of emphases, from head to torso to background, all demonstrate an artist in superb control of his plastic means. "In a picture," he wrote to Theo, "I want to say something comforting as music. I want to paint men and women with that something of the eternal which the halo used to symbolize, and which we seek to give by the actual radiance and vibration of our colorings."

SOURCE

Vincent van Gogh
from a letter to his brother Theo van Gogh, 6 August 1888

Today I am probably going to begin on the interior of the café where I have a room, by gas light, in the evening. It is what they call here a "café de nuit," staying open all night. "Night prowlers" can take refuge there when they have no money to pay for a lodging, or are too drunk to be taken in. All those things—family, native land—are perhaps more attractive in the imaginations of such people as us, who pretty well do without land or family either, than they are in reality. I always feel I am a traveler, going somewhere and to some destination. If I tell myself that the somewhere and the destination do not exist, that seems to me very reasonable and likely enough. The brothel keeper, when he kicks anyone out, has similar logic, argues as well, and is always right, I know. So at the end of my career I shall find my mistake. So be it. I shall find then that not only the Arts, but everything else as well, were only dreams, that one's self was nothing at all.

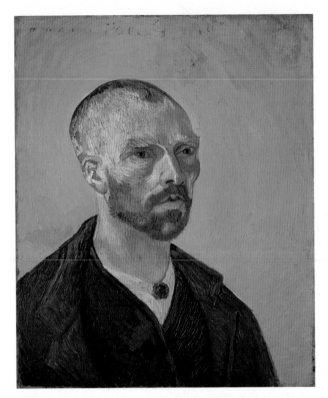

3.28 Vincent van Gogh, *Self-Portrait*, dedicated to Paul Gauguin. 1888. Oil on canvas, 24½ × 20½" (62.2 × 52.1 cm). Fogg Art Museum, Harvard University Art Museums, Cambridge, MA. Bequest from the Maurice Wertheim Collection, Class of 1906.

The universe of Van Gogh is forever stated in *The Starry Night* (fig. **3.29**). This work was painted in June 1889 at the sanatorium of Saint-Rémy, in southern France, where he had been taken after his second breakdown. The color is predominantly blue and violet, pulsating with the scintillating yellow of the stars. *The Starry Night* is both an intimate and a vast landscape, seen from a high vantage point in the manner of the sixteenth-century landscapist Pieter Brueghel the Elder. In fact, the peaceful village, with its prominent church spire, is a remembrance of a Dutch rather than a French town. The great poplar tree in the foreground shudders before our eyes, while above whirl and explode all the stars and planets of the universe. Van Gogh was intrigued by the idea of painting a nocturnal landscape from his imagination. Scholars have tried to explain the content of the painting through literature, astronomy, and religion. Though their studies have shed light on Van Gogh's interests, none has tapped a definitive source that accounts for the astonishing impact of this painting, which today ranks among the most famous works of art ever made. The defining quality of Van Gogh's paintings is that they are supernatural or at least extrasensory experiences evoked with a touch as meticulous as though the artist were painfully and exactly copying what he was observing before his eyes.

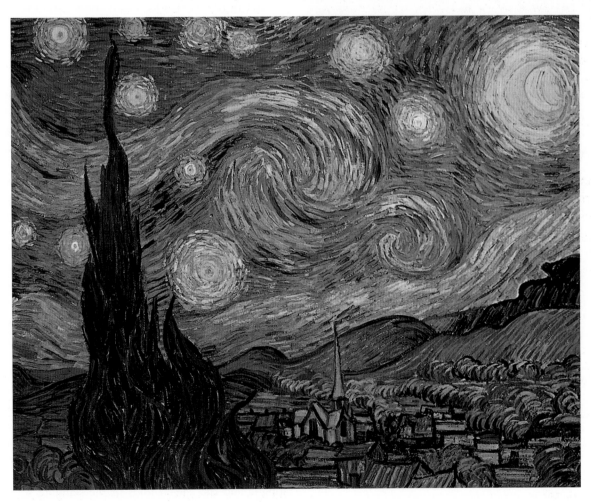

3.29 Vincent van Gogh, *The Starry Night*, 1889. Oil on canvas, 29 × 36¼" (73.7 × 92.1 cm). The Museum of Modern Art, New York.

A New Generation of Prophets: The Nabis

Paul Sérusier (1863–1927), one of the young artists under Gauguin's spell at Pont-Aven, experienced something of an epiphany when the older master undertook to demonstrate his method during a painting session in a picturesque wood known as the Bois d'Amour: "How do you see these trees?" Gauguin asked. "They are yellow. Well then, put down yellow. And that shadow is rather blue. Render it with pure ultramarine. Those red leaves? Use vermilion." This permitted the mesmerized Sérusier to paint a tiny work on a cigar-box cover (fig. **3.30**), which proved so daring in form, even verging on pure abstraction, that the artist and his friends thought it virtually alive with supernatural power. And so they entitled the painting *The Talisman* and dubbed themselves the "Nabis," from the Hebrew name for "prophet." The Nabis were a somewhat eclectic group of artists whose principal contributions—with some outstanding exceptions—lay in a synthesizing approach to masters of the earlier generation, not only to Seurat but also to Cézanne, Redon, and Gauguin, particularly the last, for his art theory as well as the direct example of his painting.

3.30 Paul Sérusier, *The Talisman (Landscape of the Bois d'Amour)*, 1888. Oil on wood cigar-box cover, 10½ × 8⅜" (26.7 × 21.3 cm). Musée d'Orsay, Paris.

Gauguin had been affected by the ideas of his young friend Émile Bernard when the two were working together in Pont-Aven in the summer of 1888. He derived important elements of his style from Bernard's notion of *cloisonnisme*, a style based on medieval enamel and stained-glass techniques. Certainly, the arbitrary, non-descriptive color, the flat areas of color bounded by dark, emphatic contours, the denial of depth and sculptural modeling—all stated by Gauguin in *Vision after the Sermon* (see fig. 3.23)—were congenial to and influential for the Nabis.

The group included Sérusier, Maurice Denis, Pierre Bonnard, Paul Ranson, and later Aristide Maillol, Édouard Vuillard, Félix Vallotton, Ker-Xavier Roussel, and Armand Séguin. The Nabis epitomized the various interests and enthusiasms of the end of the century. Among these were literary tendencies toward organized theory and elaborate celebrations of mystical rituals. Denis and Sérusier wrote extensively on the theory of modern painting; and Denis was responsible for the formulation of the famous phrase, "a picture—before being a warhorse, a female nude, or some anecdote—is essentially a flat surface covered with colors assembled in a particular order." The Nabis sought a synthesis of all the arts through continual activity in architectural painting, the design of glass and decorative screens, book illustration, poster design, and stage design for the advanced theater of Ibsen, Maurice Maeterlinck, Strindberg, Wilde, and notably Alfred Jarry's shocking satirical farce *Ubu Roi* ("King Ubu").

Vuillard and Bonnard

Édouard Vuillard (1868–1940) and Pierre Bonnard exemplify the spirit and aims of the Nabis. Their long working lives linked the art of *fin-de-siècle* France to the mid-twentieth century. Both were much admired; their reputations, however, were for a long time private rather than public. Their world is an intimate one, consisting of corners of the studio, the living room, the familiar view from the window, and portraits of family and close friends. In his early works Vuillard used the broken paint and small brushstroke of Seurat or Signac, but without their rigorous scientific methods. In *Woman in Blue with Child* (fig. **3.31**) he portrayed the Parisian apartment of Thadée Natanson, co-founder of *La Revue Blanche,* and his famously beautiful and talented wife, Misia, who is depicted in the painting playing with her niece. As was often his practice, Vuillard probably used his own photograph of the apartment as an *aide-mémoire* while working up his composition. It is a typical turn-of-the-century interior, sumptuously decorated with flowered wallpaper, figured upholstery, and ornaments. In Vuillard's hands, the interior became a dazzling surface pattern of muted blues, reds, and yellows, comparable to a Persian painting in its harmonious richness. Space may be indicated by the tilted perspective of the chaise longue and the angled folds of the standing screen, but the forms of the woman and child are flattened so as to be virtually indistinguishable from the surrounding profusion

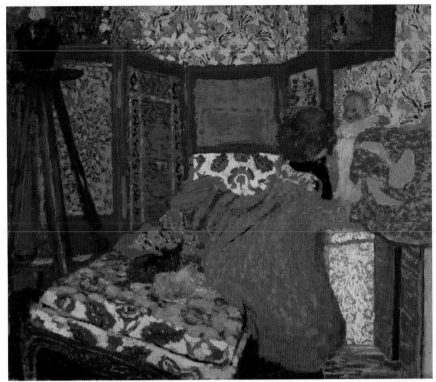

3.31 Édouard Vuillard, *Woman in Blue with Child*, c. 1899. Oil on cardboard, 19⅛ × 22¼" (48.6 × 56.5 cm). Glasgow Art Gallery and Museum, Kelvingrove.

hair, or as a shadowy but ever-present figure seated at the breakfast table, appearing at the window, or boating on the Seine.

After receiving training both in the law and in the fine arts, Bonnard soon gained a reputation making lithographs, posters, and illustrated books. His most important early influences were the work of Gauguin and Japanese prints. The impact of the latter can be seen in his adaptation of the *japoniste* approach to the tilted spaces and decorative linear rhythms of his paintings. But from the beginning Bonnard also evinced a love of paint texture. This led him from the relatively subdued palette of his early works to the full luminosity of high-keyed color rendered in fragmented brushstrokes, a development that may well owe something to both the late works of Monet and the Fauve paintings of Matisse.

of patterns. Such quiet scenes of Parisian middle-class domesticity have been called *intimiste*; in them, the flat jigsaw puzzle of conflicting patterns generates shimmering after-images that seem to draw from everyday life an ineffable sense of strangeness and magic.

Of all the Nabis, **Pierre Bonnard** (1867–1947) was the closest to Vuillard, and the two men remained friends until the latter's death. Like Vuillard, Bonnard lived a quiet and unobtrusive life, but whereas Vuillard stayed a bachelor, Bonnard early became attached to a young woman whom he ultimately married in 1925. It is she who appears in so many of his paintings, as a nude bathing or combing her

The large folding screen *Promenade of the Nursemaids, Frieze of Fiacres* (fig. **3.32**) is made up of four lithographs, based on a similarly painted screen. With its tilted perspectives and abbreviated, silhouetted forms, it shows Bonnard at his most *japoniste* and decorative. At the same time, the figures of mother and children, the three heavily caped nurses, and the marching line of fiacres, or carriages, reveal

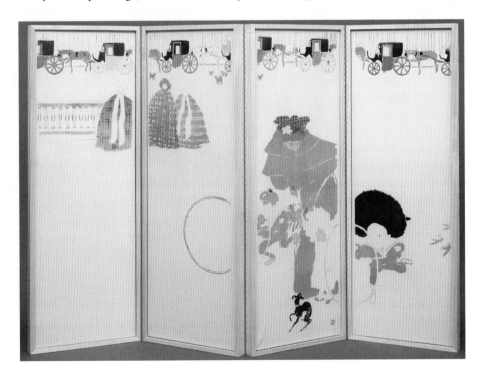

3.32 Pierre Bonnard, *Promenade of the Nursemaids, Frieze of Fiacres*, 1899. Color lithograph on four panels, each 54 × 18¾" (137.2 × 47.6 cm). The Museum of Modern Art, New York.

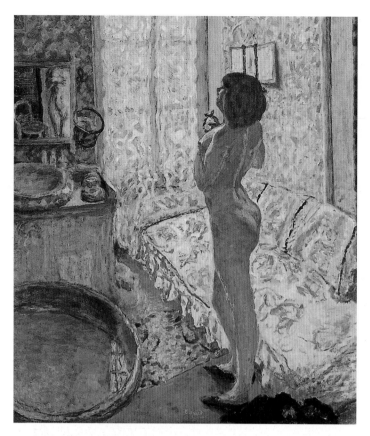

3.33 Pierre Bonnard, *Nu à contre jour (Nude against the Light)*, 1908. Oil on canvas, 49 × 42½" (124.5 × 108 cm). Musées Royaux des Beaux-Arts de Belgique, Brussels.

a touch of gentle satire that well characterizes the penetrating observation Bonnard combined with a brilliant simplicity of design. Like his fellow Nabis, Bonnard believed in eliminating barriers between the popular decorative arts and the high-art traditions of painting and sculpture. He envisioned an art of "everyday application" that could extend to fans, prints, furniture, or, in this case, color litho.

In *Nude against the Light* (fig. **3.33**), Bonnard has moved from the public sphere of Parisian streets to the intimate world of the nude in a domestic interior, a subject he exploited throughout his career as a means to investigate light and color. Bonnard silhouetted the model, his ever-youthful wife Marthe, against the sun-drenched surfaces of her boudoir. Light falls through the tall French windows, strongly illuminating the side of the woman turned from our view but visible in the mirror at left. This use of reflections to enlarge and enrich the pictorial space, to stand as a picture within a picture, became a common strategy of Bonnard's as well as Matisse's interiors (see fig. 12.13). But in its quiet solemnity and complete absence of self-consciousness, Bonnard's nude is deeply indebted to the precedent of Degas' bathers, even to the detail of the round tub (see fig. 2.38). Like those of the older artist, Bonnard's composition is disciplined and complex, carefully structured to return the eye to the solid form of the nude, which he surrounds with a multitude of textures, shapes, and colors. But Bonnard creates an expressive mood all his own. As she douses herself with perfume,

the model seems almost transfixed by the warm, radiant light that permeates the scene.

Bonnard's color became progressively brighter. By the time he painted *Dining Room on the Garden*, in 1934–35 (fig. **3.34**), he had long since recovered the entire spectrum of luminous color, and had learned from Cézanne that color could function constructively as well as sensually. In this ambitious canvas Bonnard tackled the difficult problem of depicting an interior scene with a view through the window to a garden beyond, setting the isolated, geometric forms of a tabletop still life against a lush exterior landscape. Now the model, his wife Marthe, is positioned to one side, an incidental and ghostly presence in this sumptuous display. By the mid-1930s, virtually all the great primary revolutions of twentieth-century painting had already occurred, including Fauvism, with its arbitrary, expressive color, and Cubism, with its reorganization of Renaissance pictorial space. Moreover, painting had found its way to pure abstraction in various forms. Perfectly aware of all this, Bonnard was nonetheless content to go his own way. In the work seen here, for instance, there is evidence that he had looked closely at Fauve and Cubist paintings, particularly the works of Matisse—who was a devoted admirer—and had used what he wanted of the new approaches without at any time changing his basic attitudes.

While some Post-Impressionists like Gauguin and Van Gogh preferred to work in isolation or in the company of one or two like-minded colleagues, others, such as the Nabis, sought to develop new organizations that might provide the practical as well as moral support artists

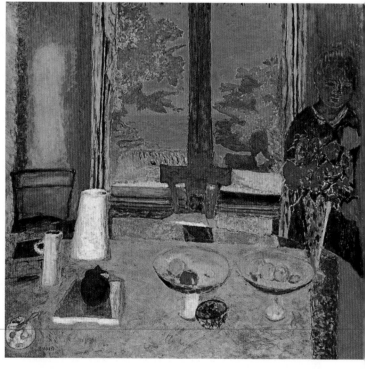

3.34 Pierre Bonnard, *Dining Room on the Garden*, 1934–35. Oil on canvas, 50⅛ × 53½" (127.3 × 135.9 cm). Solomon R. Guggenheim Museum, New York.

enjoyed when affiliated with a traditional academy or guild. Neo-Impressionism, the quasi-scientific handling of color created by Seurat and Signac, made its appearance in 1884, when a number of artists who were to be associated with the movement exhibited together at the Groupe des Artistes Indépendants in Paris. Later that year the Société des Artistes Indépendants was organized through the efforts of Seurat, Henri-Edmond Cross, Redon, and others, and was to become important to the advancement of early twentieth-century art as an exhibition forum. Also important were the exhibitions of Les XX (Les Vingt, or "The Twenty") in Brussels. Van Gogh, Gauguin, Toulouse-Lautrec, and Cézanne exhibited at both the Indépendants and Les XX. James Ensor, Henry van de Velde, and Jan Toorop exhibited regularly at Les XX and its successor, La Libre Esthétique, whose shows became increasingly dominated first by the attitudes of the Neo-Impressionists and then by the Nabis.

La Revue Blanche, a magazine founded in 1891, became one of the chief organs of expression for Symbolist writers and painters, the Nabis, and other artists of the avant-garde. Bonnard, Vuillard, Denis, Vallotton, and Toulouse-Lautrec (who was never officially a Nabi, although associated with the group) all made posters and illustrations for the magazine, which was a meeting ground for experimental artists and writers from every part of Europe, among them Van de Velde, Edvard Munch, Marcel Proust, André Gide, Ibsen, Strindberg, Wilde, Maxim Gorky, and Filippo Marinetti.

Montmartre: At Home with the Avant-Garde

Although **Henri de Toulouse-Lautrec** (1864–1901) may be seen as the heir of Daumier in the field of printmaking, he also served, along with his contemporaries Gauguin and Van Gogh, as one of the principal bridges between nineteenth-century avant-garde painting and the early twentieth-century experiments of Edvard Munch, Pablo Picasso, and Henri Matisse. Lautrec was interested in Goya and the line drawings of Ingres, but he was above all a passionate disciple of Degas, both in his admiration of Degas' draftsmanship and in the disengaged attitude and calculated formal strategies that he brought to the depiction of his own favorite subjects—the theaters, brothels, and bohemian cabarets of Paris.

Because of years of inbreeding in his old, aristocratic family, Lautrec was permanently disfigured from a congenital disease that weakened his bones. Against his family's wishes, he pursued art as a profession after receiving an education in the private Parisian studios of Léon Bonnat and Fernand Cormon, painters who provided students with a more open and tolerant atmosphere than that found in the École des Beaux-Arts. In Cormon's studio Lautrec met Bernard and Van Gogh, both of whom he rendered in early portraits.

Lautrec is best known for his 1890s color lithographs of performers in Montmartre dance halls; his inventive and striking graphic style elevated poster design to the realm of avant-garde art, a shift in the perception of ephemeral works that would influence generations of progressive artists. But before devoting himself largely to graphic works, he had already proved himself to be a sensitive portraitist with paintings and drawings of a colorful cast of characters, including Carmen Gaudin, the woman portrayed in *"À Montrouge"—Rosa La Rouge* (fig. **3.35**). The artist was drawn to the simple clothes, unruly red hair, and tough look of this young working-class woman, who, arms dangling informally, averts her face as she is momentarily silhouetted against the lighted window. Lautrec creates this simplified composition out of his characteristically long strokes of color in warm, subdued tonalities. But the somber mood of the painting has also to do with its subject. Lautrec's painting was inspired by a gruesome song written by his bohemian friend, the famous cabaret singer Aristide Bruant, about a prostitute who conspires to kill her clients.

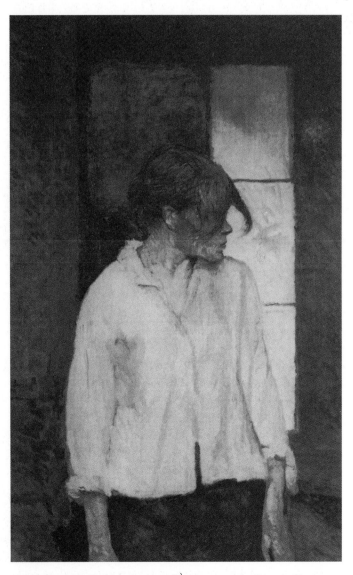

3.35 Henri de Toulouse-Lautrec, *"À Montrouge"—Rosa La Rouge*, 1886–87. Oil on canvas, 28½ × 19¼" (72.4 × 48.9 cm). The Barnes Foundation, Merion, Pennsylvania.

The naturalism of Lautrec's early portraits gave way in the 1890s to the brightly colored and stylized works that make his name synonymous with turn-of-the-century Paris. His earliest lithographic poster, designed for the notorious dance hall called the *Moulin Rouge* (fig. **3.36**), features the scandalous talents of La Goulue ("the greedy one"), a dancer renowned for her gymnastic and erotic interpretations of the *chahut*, the dance that had attracted Seurat in 1889 (see fig. 3.3). Lautrec's superb graphic sensibility is apparent in the eye-catching shapes that, albeit abbreviated, were the result of long observation.

At least as familiar as Toulouse-Lautrec with the district of Montmartre was **Suzanne Valadon** (1867–1939). Born in central France, she was the child of a peasant woman who moved with her infant daughter to Montmartre. As a teenager, Valadon joined the circus as a performer but soon left because of an injury. She became a popular model in a neighborhood filled with artists, posing for Toulouse-Lautrec as well as Puvis, Renoir, and Degas. An instinctive aptitude for drawing enabled this self-taught artist to achieve a remarkable degree of success in the male-dominated art world of the time. By the 1890s, some of her drawings had even been purchased by Degas, who introduced her to the technique of etching. Valadon made still lifes and the occasional landscape, but the bulk of her oeuvre was devoted to portraits and nudes. *Woman at her Toilet* (fig. **3.37**) reveals her familiarity with Degas' images of bathers, yet departs from his treatment of them in her emphatic use of contour line and the unselfconscious intimacy of the two women, one of whom gently combs through the hair of the other. Here, the scene of women bathing avoids falling into the hackneyed territory of

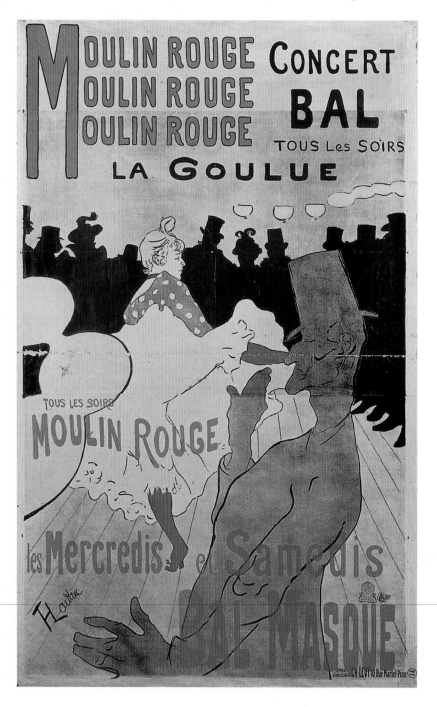

3.36 Henri de Toulouse-Lautrec, *Moulin Rouge—La Goulue*, 1891. Color lithograph, 6' 3¼" × 4' (1.9 × 1.2 m). Victoria and Albert Museum, London.

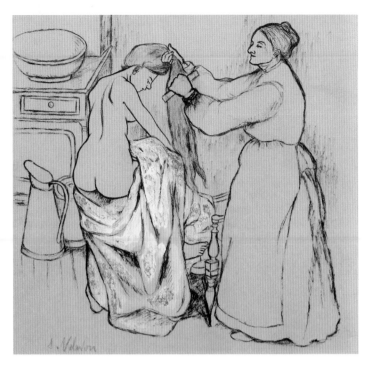

3.37 Suzanne Valadon, *Woman at her Toilet*, 1904–10. Tempera and pastel with white accent on paper, 14⅜ × 14¾" (36.4 × 37.4 cm). National Museum, Belgrade.

voyeuristic fantasy and instead conveys the dignity of its working-class subjects. In her paintings, Valadon embraced the intense color of her Post-Impressionist contemporaries while continuing to explore the body as the locus of physical as well as emotional intensity. The figure in her *Blue Room* (fig. **3.38**) assumes a traditional odalisque pose. But this forthright woman, unconventionally dressed in striped pants, has little in common with the bold courtesans of Manet (see fig. 2.24). Valadon's model follows intellectual pursuits (note the book on the bed), and she smokes a cigarette, hardly the habit of a "respectable" woman, even in 1923 when this work was completed. While her frank representations of a female subject recall depictions of prostitutes by her friend Toulouse-Lautrec, Valadon inventively places her unconventional odalisque in a richly decorative space redolent with the *intimisme* of Vuillard's and Bonnard's scenes of quiet domestic life. She thus confounds the titillation of brothel imagery by merging it with the formal patterns and reassuring domestic imagery of the Nabis. Valadon's conception of the interior as a space where fantasy and reality might collide, commingle, or merge would find a literal counterpart in Art Nouveau architecture and design.

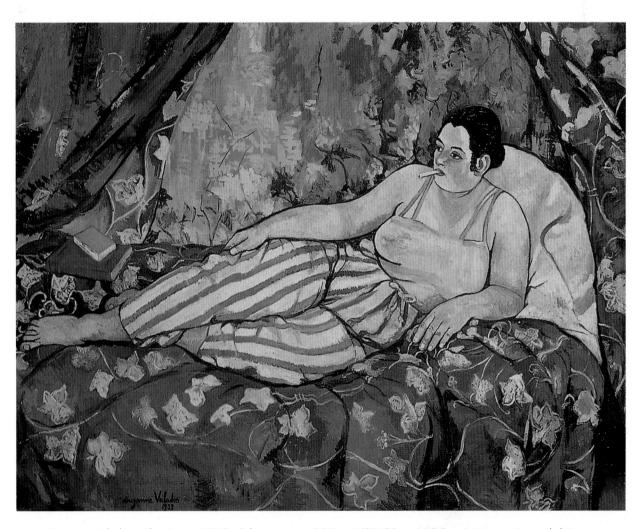

3.38 Suzanne Valadon, *Blue Room*, 1923. Oil on canvas, 35⅜ × 45⅝" (90 × 115.9 cm). Musée National d'Art Moderne, Centre d'Art et de Culture Georges Pompidou, Paris.

4
The Origins of Modern Architecture and Design

Architecture monumentalized the nineteenth century's ambivalence toward modernity and industrialization. For some architects, industrialization was viewed as an assault on Western culture, threatening to obliterate its traditional values and social behavior. Those who held such views tended to embrace revivalism in architectural and interior design. Classical, Gothic, Renaissance, Baroque, and even Rococo styles gained new currency in the industrialized West, permitting architects to articulate reassuringly familiar façades and spaces. How could human dignity be completely trammeled by commerce and industry, such revivalists asked, in an environment punctuated by Greek and Roman temples, Gothic chapels, or Baroque palaces? Other designers viewed industrialization with less suspicion. Moves to large-scale manufacturing and the development of new processes for producing iron and steel were seen by sympathetic architects as boons to design, fueling innovation while damping costs. Progress in society, such designers argued, demanded similar progress in the built environment. Ultimately, modern architecture emerged from the conversation and conflict between those who welcomed industrialization, urbanization, and capitalism and those who wished to hold these forces at bay.

Safeguarding Culture: Revivalist Tendencies in Nineteenth-Century Architecture

American Classicism

A pattern of stylistic revivals had predominated in Europe since the fifteenth century and in the Americas since the sixteenth century, when early settlers brought with them the architectural styles and traditions of different European regions. Throughout the nineteenth century, architects continued to expand this tendency. By the first decades of the century, Neoclassicism was well established in both Europe and America as the dominant style. In America, this Neoclassical style, or classical revival, coincided with the aims of a young republic that regarded itself as the

new Arcadia. The Neoclassical style in architecture, which consisted of endless recombinations of ancient Greek and Roman motifs, symbolized the ideal public virtues of democracy, liberty, and reason.

At the turn of the century, America, with its growing population, burgeoning cities, and expanding economy, was emerging as a world power. The expression of this in public buildings showed a heightened consciousness of historical revivalism, which could encompass Gothic, classical, or colonial styles, among others. More and more American architects received their training at the École des Beaux-Arts in Paris, the international heart of academicism in architecture. For American banks, civic monuments, libraries, capitols, and other public buildings coast to coast, the preferred mode was academic classicism on a grandiose scale. For example, the enormous central mall in Washington, D.C., which runs between the Capitol and the Lincoln Memorial, and which is lined with mostly classical façades, was a product of this period.

While the firm of **McKim, Mead & White** (founded 1879) was in some degree responsible for the hold that academic classicism had on American public architecture during the late nineteenth and early twentieth centuries, the firm's historicism was based less on generic Greek and Roman prototypes than on American eighteenth-century architecture. These prolific architects produced some of the most successful classical public buildings in America, including the Boston Public Library, New York's magnificent Pennsylvania Railroad Station (see fig. 9.7), sadly demolished in 1966, and the influential Rhode Island State Capitol in Providence, which established the model for many state capitols in the early years of the twentieth century. In their domestic architecture, McKim, Mead & White drew on the qualities of American colonial building and were able to select the historical or geographic style that best suited a particular site or commission. The William G. Low House of 1886–87 (fig. **4.1**) is a superb example of the "shingle style," a colonial revival style associated with the firm. Built in Bristol, Rhode Island, the

4.1 McKim, Mead & White, William G. Low House, 1886–87. Bristol, Rhode Island. Demolished 1960s.

Low House evokes comparison with colonial architecture of coastal New England with its shingle siding, horizontally aligned windows and overall symmetry. These associations make perfect sense given the house's site overlooking the Atlantic Ocean. The Low House is revolutionary when viewed in contrast to the enormous revivalist mansions then fashionable in nearby, wealthy Newport. The shingle-covered structure, with its bay windows and extended side porch, is formed of a single triangular gable, and has a striking geometric integrity.

European Eclecticism

During the later eighteenth century, particularly in England, an opposing trend, the Gothic Revival, had also gained considerable momentum and continued to make headway during the first half of the nineteenth. The culmination of this trend in civic architecture was the triumphant Houses of Parliament (fig. **4.2**) by **Charles Barry** (1795–1860) and **Augustus W. N. Pugin** (1812–52), in which the evocation of the Middle Ages reminds visitors of the distinctive, historical character of British government and its roots

4.2 Charles Barry and Augustus W. N. Pugin, Houses of Parliament, 1836–58. London.

in the Magna Carta. The Gothic revival was accompanied by revivals of Renaissance and Baroque classicism, which likewise used styles from the past to convey ideas about the present. These stylistically backward-looking movements characterize much of the monumental civic architecture of the late nineteenth century and the early twentieth.

In European architecture as in American, the latter half of the nineteenth century was a highly eclectic period. The classical and Gothic revivals of the early century had been augmented by elaborate buildings in the Renaissance- and Baroque-revival styles. Of these the Paris Opéra (fig. **4.3**), designed by **Charles Garnier** (1825–98), is perhaps the supreme example. Resting like an elaborate jewel box at the top of the Avenue de l'Opéra, this structure evokes in its exterior the rhythm, movement, and grandeur of the performances anticipated on its stage inside. The façade's recessed classical columns suggest the influence of antiquity, while the swags of garlands along the frieze and the exuberant sculptures atop the cornice speak to the extravagance of the Baroque. A style associated with the Bourbon kings who ruled France just before the Revolution, the Baroque is here revived in the service of the Emperor Napoléon III. The interior of the Opéra is no less grand than its façade, though drawing on the lighter—albeit no less aristocratic—Rococo style of Louis XV. An imperial staircase was included to accommodate the entry of Napoléon III and his retinue. Bronze lamps and even ivory sculptures point the way to the theater boxes.

Whether Rococo, Renaissance, Gothic, or classical, revivalism remained, far into the twentieth century, the preferred style for public and monumental buildings as well as grandiose domestic architecture. Numerous châteaux, mansions and townhouses built by newly wealthy industrialists peppered Western Europe and North America. But not all designers wished to place revival styles at the service of the wealthy and powerful. Some artists and architects delved into historic styles in hopes of finding and restoring a more authentic and reassuring aesthetic in the face of surging industrialization and voracious consumerism.

"A Return to Simplicity": The Arts and Crafts Movement and Experimental Architecture

Skepticism about the consequences of industrialization led some designers toward stylistic revivalism while others sought to interrupt modernization at a more fundamental level. The British critic and philosopher John Ruskin, discussed in chapter 1, was among those who attempted to identify and resist the forces propelling modernity and industrialization. The tremendous expansion of machine production during the nineteenth century resulted in mass consumption of new, more cheaply manufactured products. This growing mass market put the emphasis on cheapness rather than quality or beauty. Thus there arose early in the nineteenth century the profession of modern advertising, which followed the principle that the most ornate, unoriginal products sell best. To a Romantic, progressive nineteenth-century thinker and artist like **William Morris** (1834–96), friend of Ruskin and collaborator of the

4.3 Charles Garnier, The Opéra, 1861–74. Paris.

Pre-Raphaelites (see chapter 2), the machine was destroying the values of individual craftsmanship on which the high level of past artistic achievement had rested. Poet, painter, designer, and social reformer, Morris fought against the rising tide of what he saw as commercial vulgarization, for he passionately believed that the industrial worker was alienated both from the customer and the craft itself and was held hostage to the dictates of fashion and profit.

Like his mentor John Ruskin, Morris believed that a society was reflected in its arts and, furthermore, that artworks contribute directly to the values and organization of society. Of chief importance to Morris was the human, spiritual quality of culture. Factory-produced lace, furnishings, and dinnerware were, for Morris, lacking in both quality and integrity. Using such items in a household—any household—signaled the acceptance that soulless machines now dominated domestic as well as commercial life. Like Ruskin, Morris looked back to the Middle Ages with nostalgia, seeing in medieval society the emphasis on community and spirituality that he found lacking in Victorian Britain, and emulating the forms and ornament of medieval design. This interest in an idealized past was fused with a love of nature, leading Morris to invent vegetal and animal patterns for cloth and wallpaper that remain popular today.

Morris founded an artists' cooperative, called the Firm, which made household furnishings of the highest quality (fig. **4.4**). There he put into practice his admiration for the Middle Ages, producing works based on his and others' organic patterns and organizing skilled laborers as if they were members of a medieval crafts guild. His friend, the artist and designer Walter Crane, summarized their common goals by calling for "a return to simplicity, to sincerity; to good materials and sound workmanship; to rich and suggestive surface decoration, and simple constructive forms." Morris' designs were intended to raise the dignity of craftsperson and owner alike and to enhance the beauty of ordinary homes. The Firm's aesthetic and social sensibilities gave rise to the Arts and Crafts Movement in the British Isles, which exerted tremendous influence in the United States, especially on the oak Mission Style furniture of Gustav Stickley.

Morris asked the architect **Philip Webb** (1831–1915) to design his own home, the Red House, in Kent in 1859 (fig. **4.5**). In accordance with Morris' desires, the house was generally Gothic in design, but Webb interpreted his commission freely. Into a simplified, traditional, red-brick Tudor Gothic manor house, with a steeply pitched roof, he introduced exterior details of classic Queen Anne windows and oculi. The effect of the exterior is of harmony and compact unity, despite the disparate elements. The plan is an open L-shape with commodious, well-lit rooms arranged in an easy and efficient asymmetrical pattern. The interior, from the furniture and stained-glass windows down to the fire irons, was designed by Webb and Morris

4.4 William Morris, Detail of *Pimpernel* wallpaper, 1876. Victoria and Albert Museum, London.

in collaboration with Morris' wife, Jane, and the Pre-Raphaelite artists Rossetti and Burne-Jones. Aware of such English experiments, the influential American architect Henry Hobson Richardson (see p. 89) developed his own style of domestic architecture, which fused American traditions with those of medieval Europe. The Stoughton House, in Cambridge, Massachusetts, is one of his most

4.5 Philip Webb and William Morris, Red House, 1859–60. Bexleyheath, Kent, England.

familiar structures in the shingle style (named for the wooden tiles or shingles used as wall cladding) then rising to prominence on the eastern seaboard. The main outlines recall Romanesque- and Gothic-revival traditions, but these are architecturally less significant than the spacious, screened entry and the extensive windows, which suggest his concern with the livability of the interior. The shingled exterior wraps around the structure of the house to create a sense of simplicity and unity.

Experiments in Synthesis: Modernism beside the Hearth

Not all late nineteenth-century designers shied away from modernism in architecture: far from it. The century witnessed the invention of many new types of structure including railway stations, department stores, and exhibition halls, all presenting radically new spaces and constructed using mass-produced, industrial materials. These were buildings without tradition, however, which made it easier for architects to persuade their patrons to pursue innovative design and construction. The public was generally less receptive to progressive tendencies in traditional structures like churches, houses, or apartment blocks. Despite this conservatism, many of modern architecture's most revolutionary concepts—attention to utility and comfort, the notion of beauty in undecorated forms, and of forms that follow function—were first conceived in modest individual houses and small industrial buildings. The pioneer efforts of Webb in England and of Richardson and McKim, Mead & White in the United States were followed by the important experimental housing of Charles F. A. Voysey, Arthur H. Mackmurdo, and Charles Rennie Mackintosh in the British Isles, and in the United States by the revolutionary house designs of Frank Lloyd Wright. Unlike their Arts and Crafts contemporaries such as William Morris, architects like Voysey and Mackintosh viewed new technologies and industrial materials without suspicion, using the advantages promised by such innovations to map out a middle path between nostalgic historicism and the brand of unapologetic modernism that would eventually give rise to the steel-and-glass-clad skyscraper.

Charles F. A. Voysey (1857–1941), through his wallpapers and textiles, had a more immediate influence on progressive European design than did the Arts and Crafts movement of Morris. The furniture he designed had a rectangular, medievalizing form with a simplicity of decoration and a lightness of proportion that some historians have claimed anticipated later Bauhaus furniture, though Voysey was perplexed by such assertions. Voysey's architecture was greatly influenced by Arthur H. Mackmurdo (1851–1942), who, in structures such as his own house and his Liverpool exhibition hall, went beyond Webb in the creation of a style that eliminated almost all reminiscences of English eighteenth-century architecture. A house by Voysey in Bedford Park, London, dated 1891 (fig. **4.6**), is astonishingly original in its rhythmic groups of windows and door openings against broad white areas of unadorned, starkly vertical walls. While Voysey was a product of the English Gothic Revival, he looked not to the great cathedrals for inspiration, but to the domestic architecture of rural cottages. In his later country houses he returned, perhaps at the insistence of clients, to suggestions of more traditional Tudor and Georgian forms. He continued to treat these, however, in a ruggedly simple manner in which plain wall masses were lightened and refined by articulated rows of windows.

Largely as a result of the work of **Charles Rennie Mackintosh** (1868–1928), Glasgow was one of the most remarkable centers of architectural experiment at the end of the nineteenth century. Mackintosh's most considerable work of architecture, created at the beginning of his career, is the Glasgow School of Art of 1898–99, with its library addition of 1907–09 (fig. **4.7**). The essence of this building is simplicity, clarity, monumentality, and, above all, an organization of interior space that is not only functional but also highly expressive of its function. The huge, rectangular studio windows are imbedded in the massive stone façade, creating a balance of solids and voids. The rectangular heaviness of the walls, softened only by an occasional curved masonry element, is lightened by details of fantasy, particularly in the ironwork, that show a relationship to Art Nouveau, but derive in part from the curvilinear forms of medieval Scottish and Celtic art. The library addition is a large, high-ceilinged room with surrounding balconies. Rectangular beams and columns are used to create a series of views that become three-dimensional, geometric abstractions.

The same intricate play with interior vistas seen in this library is apparent in a series of four public tea rooms, also in

4.6 Charles F. A. Voysey, Forster House, 1891. Bedford Park, London.

4.7 Charles Rennie Mackintosh, Library, Glasgow School of Art, 1907–09.

4.8 Charles Rennie Mackintosh, Willow Tea Rooms, 1903. Glasgow.

Glasgow, commissioned by Catherine Cranston. For the last of these, the Willow Tea Rooms, Mackintosh was able to design the entire building (fig. **4.8**). Most details of the interior design, furniture, and wall painting are the products of both Mackintosh and his wife, Margaret Macdonald. They shared with Morris and the followers of the Arts and Crafts movement the notion that all architectural elements, no matter how small, should be integrated into a total aesthetic experience. In 1900, Mackintosh exhibited with the Vienna Secession, a group of mostly Austrian artists who had decided to leave the Vienna Academy in 1897 in order to advance progressive ideas through exhibitions, a magazine (*Ver Sacrum*), and their teaching. Mackintosh's inventive architectural designs, furniture, glass, and enamels were received more favorably there than they had been in London. He died virtually penniless, and it was not until the 1960s that his reputation was fully revived. Today his furniture and decorative arts are among the most coveted of the modern era.

Where Voysey and Mackintosh offered something of a middle way, taking advantage of innovations in manufacturing and new materials while maintaining traditional expectations about scale and aesthetic utility, some designers adopted with enthusiasm a new approach to architecture that incorporated unapologetically all that industrialization had to offer.

Palaces of Iron and Glass: The Influence of Industry

New ideas in architecture emerged during the nineteenth century in the context of engineering, with the spread of industrialization and the use of novel building materials, notably iron, glass, and hollow ceramic tile. The use of iron for structural elements became fairly common in English industrial building only after 1800, although there are sporadic instances during the eighteenth century. These new materials—developed or improved during the Industrial Revolution—permitted greater flexibility and experimentation in design, as well as larger scale, since iron could be used to span far larger spaces than was possible in stone or wood construction.

During the first half of the nineteenth century, a concealed iron skeleton structure was used in buildings of all types, and exposed columns and decorative ironwork appeared, particularly in non-traditional structures, notably in the Royal Pavilion at Brighton (fig. **4.9**), designed by **John Nash** (1752–1835). Iron was also used extensively in the many new railway bridges built throughout Europe, as the railway system expanded (fig. **4.10**). **Gustave Eiffel** (1832–1923) built his famous 984-foot (300 m) tower for the Paris Universal Exposition of 1889 (see Huysmans'

4.9 John Nash, Royal Pavilion, 1815–23, as remodeled. Brighton, England.

4.10 Gustave Eiffel, Truyère Bridge, 1880–84. Garabit, France.

review in *Le Fer*, opposite). It was the most dramatic demonstration of the possibilities of exposed-metal construction and used iron in a variety of ways. Roofs of iron and glass over commercial galleries or bazaars became popular and ambitious in design at this time, especially in Paris. In greenhouses, iron gradually replaced wood as a frame for glass panes, with a consequent enlargement of scale. The Jardin d'Hiver (Winter Garden) in Paris, designed by Hector Horeau in 1847 and since destroyed, measured 300 by 180 feet (91 by 55 m) in floor plan and rose to a height of 60 feet (18 m)—a remarkable size at the time.

Works such as this gave rise to the concept of the monumental glass-and-metal structure, of which the Crystal Palace, created for the Great Exhibition in London in 1851 by **Sir Joseph Paxton** (1801–65), was the most famous example (fig. **4.11**). The Crystal Palace was erected through modern building methods that are today taken for granted—prefabricated modules that allow for easy assembly. Paxton developed the ridge-and-furrow roof construction while designing greenhouses. Yet the building, an airy barrel-vaulted gallery, also recalls the space and shape of a gigantic, secular cathedral. The Crystal Palace was dismantled and reassembled in Sydenham, south London, where it remained until it was destroyed by fire in 1936.

The sheds of the new railway stations, precisely because they were structures without tradition, provided some of the most daring and experimental buildings in iron and glass. The Gare Saint-Lazare in Paris supplied the painter Monet with a new experience in light, space, and movement, which

SOURCE

Joris-Karl Huysmans
from the review *Le Fer*, 1889

A Symbolist poet, novelist, and critic, Huysmans voiced the disdain that many Parisians felt toward the Eiffel Tower as it was being erected on the Champ de Mars where the 1889 Universal Exposition was held.

In a touching unanimity ... the entire press, flat on its stomach, exalts the genius of M. Eiffel. And yet his tower resembles a factory chimney under construction, a carcass that waits to be filled with cut stone or bricks. One cannot imagine that [it] is finished, that this solitary suppository riddled with holes will remain as it is.... The Eiffel Tower is truly of a disconcerting ugliness, and it is not even enormous! Seen from below, it does not seem to attain the height cited for it.... From afar, from the center of Paris, from the depths of the suburbs, the effect is identical. The emptiness of this cage diminishes it; the lathing and the meshwork make of this trophy of iron a horrible bird cage ... it is 300 meters tall and appears 1,000; it is finished and it appears barely begun.... Finally, one must ask oneself, what is the fundamental purpose for the existence of this tower?

4.12 Henri Labrouste, Reading room, Bibliothèque Sainte-Geneviève, 1843–50. Paris.

architectural element on which much of twentieth-century architecture was based.

"Form Follows Function": The Chicago School and the Origins of the Skyscraper

Modern architecture may be said to have emerged in the United States with the groundbreaking commercial buildings of **Henry Hobson Richardson** (1838–86), an architect who, though eclectic, did not turn to the conventional historicist styles of Gothic pastiche and classical revival. In his Marshall Field Wholesale Store in Chicago (fig. **4.13**), now destroyed, Richardson achieved an effect of monumental mass and stability through the use of graduated rough blocks of reddish Massachusetts sandstone and Missouri granite in a heavily rusticated structure inspired by Romanesque architecture and fifteenth-century Italian Renaissance palaces. The windows, arranged in diminishing arcaded rows that mirror the gradual narrowing of the masonry wall from ground to roof, are integrated with the interior space rather than being simply holes punched at intervals into the exterior wall. The landmark Marshall Field building was constructed with traditional load-bearing walls, columns, and girders (rather than the steel frames of later skyscrapers), but its elemental design, free of picturesque ornament, influenced the later work of the Chicago School, specifically that of Louis Sullivan and, ultimately (though he would never acknowledge it), Frank Lloyd Wright.

Throughout the nineteenth century, continual expansion and improvement in the production of structural iron and steel permitted the height of commercial buildings to be raised, a necessity born of growing urban congestion and rising real-estate costs. At the same time, there were sporadic experiments in increasing the scale of windows beyond the dictates of Renaissance palace façades. A vast proportion of Chicago was destroyed in the great fire of

he painted several times. Exposed iron columns supporting iron-and-glass arches were employed even in some traditional structures, such as the Bibliothèque Sainte-Geneviève (fig. **4.12**) by **Henri Labrouste** (1801–75). Stamped, cast-iron details were very popular, and a substantial industry in their prefabrication developed before 1850. For decades thereafter, however, the structural and decorative use of cast iron declined, largely because of the conservative tastes of revival-oriented theorists in architecture. Only at the very end of the nineteenth century, with the new Art Nouveau style (see chapter 5), did metal emerge once more as the

4.11 Sir Joseph Paxton, Crystal Palace, 1851. London.

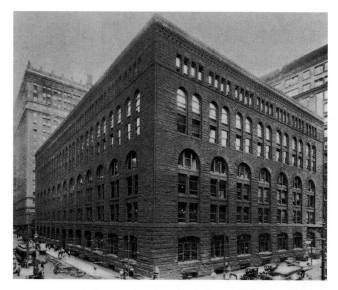

4.13 Henry Hobson Richardson, Marshall Field Wholesale Store, 1885–87. Chicago. Demolished 1931.

1871—an event that cleared the way for a new type of metropolis fully utilizing the new architectural and urban planning techniques and materials developed in Europe and America over the previous hundred years.

The Home Insurance Building in Chicago (fig. **4.14**), designed and constructed between 1884 and 1885 by the architect **William Le Baron Jenney** (1832–1907), was only ten stories high, no higher than other proto-skyscrapers already built in New York (the illustration shown here includes the two stories that were added in 1890–91). Its importance rested in the fact that it embodied true sky-scraper construction, in which the internal metal skeleton carried the weight of the external masonry shell. This inno-vation, which was not Jenney's alone, together with the development of the elevator, permitted buildings to rise to great heights and led to the creation of the modern urban landscape of skyscrapers. With metal-frame construction, architects could eliminate load-bearing walls and open up façades, so that a building became a glass box in which solid, supporting elements were reduced to a minimum. The concept of the twentieth-century skyscraper as a glass-encased shell framing a metal grid was here stated for the first time.

Among the many architects attracted to Chicago from the East or from Europe by the opportunities engen-dered by the great fire was the Dane Dankmar Adler (1844–1900), an engineering specialist. He was joined in 1879 by a young Boston architect, **Louis Sullivan** (1856–1924), and in 1887 the firm of Adler and Sullivan hired a twenty-year-old draftsman, Frank Lloyd Wright. The 1889 dedication of the Adler and Sullivan Auditorium helped stimulate a resurgence of architecture in Chicago after the devastations of the fire. And, like Jenney's Home Insurance Building, it emerged under the influence of Richardson's Marshall Field store (see fig. 4.13). The Auditorium included offices, a hotel, and, most signifi-cantly, a spectacular new concert hall, then the largest in

the country, with a highly successful acoustical system designed by Adler. Shallow concentric arches in the hall made for a majestic yet intimate space, and Sullivan's use of a sumptuous decoration of natural and geometric forms, richly colored mosaics, and painted panels proved that ornament was one of the architect's great strengths as a designer. By the late 1920s, the Chicago Opera Company had moved to new quarters—fortunately, however, the demolition of the Auditorium during the ensuing years of national depression proved too expensive to carry out.

Adler and Sullivan entered the field of skyscraper construction in 1890 with their Wainwright Building in St. Louis. Then, in the Guaranty Building (now the Prudential Building) in Buffalo, New York, Sullivan designed the first masterpiece of the early skyscrapers (fig. **4.15**). Here, as in the Wainwright Building, the architect attacked the prob-lem of skyscraper design by emphasizing verticality, with the result that the piers separating the windows of the top ten stories of the twelve-story structure are uninterrupted through most of the building's height. At the same time, he seemed well aware of the design problem peculiar to the skyscraper, which is basically a tall building consisting of a large number of superimposed horizontal layers. Thus, Sullivan accentuated the individual layers with ornamented bands under the windows, as well as throughout the attic story, and crowned the building with a projecting cornice

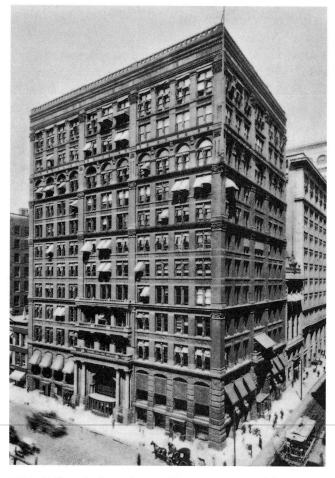

4.14 William Le Baron Jenney, Home Insurance Building, 1884–85. Chicago. Demolished 1929.

4.15 Louis Sullivan, Guaranty Trust Building (now Prudential Building), 1894–95. Buffalo.

that brings the structure back to the horizontal. This tripartite division of the façade—base, piers, and attic—has frequently been compared to the form of a classical column. When compared with the "stacked" effect of superimposed stories in Jenney's Home Insurance Building (see fig. 4.14), however, the vertical emphasis of Sullivan's building has a fundamentally modern, anti-academic character. Meanwhile, the treatment of the columns on the ground floor emphasizes the openness of the interior space. Above them, the slender piers between the windows soar aloft and then join under the attic in graceful arches that tie the main façades together. The oval, recessed windows of the attic, blend into the elegant curve of the summit cornice. Sullivan's famed ornament covers the upper part of the structure in a light, overall pattern, helping to unify the façade while also emphasizing the nature of the terracotta

sheathing over the metal skeleton as a weightless, decorative surface, rather than a weight-bearing element. "It must be every inch a proud and soaring thing," said Sullivan of the tall office building, "rising in sheer exaltation … from bottom to top as a unit without a single dissenting line." In theory, Sullivan felt that a building's interior function should determine its exterior form, hence his famous phrase, "form follows function" (see Sullivan, *The Tall Office Building*, p. 92). But practical experience taught him that function and structure did not always generate the most appealing forms.

The progressive influence of Richardson and the Chicago School was counteracted after his death as more and more young American architects studied in Paris in the academic environment of the École des Beaux-Arts (where, in fact, Richardson had trained). The 1893 World's

SOURCE

Louis Sullivan
"The Tall Office Building Artistically Considered," 1896

Thanks to the mid-nineteenth century inventions of the safety elevator and of cost-effective processes for manufacturing steel, architects could design buildings dozens of stories tall. The proliferation of such "skyscrapers" raised questions about their appearance: what proportions and ornamentation were best suited to these new structures? While some called for classicism, others demanded an organic style based on vegetation. Sullivan instead makes appearance secondary to a building's purpose.

Whether it be the sweeping eagle in his flight, or the open apple-blossom, the toiling work-horse, the blithe swan, the branching oak, the winding stream at its base, the drifting clouds, over all the coursing sun, form ever follows function, and this is the law. Where function does not change form does not change. The granite rocks, the ever-brooding hills, remain for ages; the lightning lives, comes into shape, and dies in a twinkling.

It is the pervading law of all things organic and inorganic, of all things physical and metaphysical, of all things human and all things superhuman, of all true manifestations of the head, of the heart, of the soul, that the life is recognizable in its expression, that form ever follows function. This is the law.

Shall we, then, daily violate this law in our art? Are we so decadent, so imbecile, so utterly weak of eyesight, that we cannot perceive this truth so simple, so very simple? Is it indeed a truth so transparent that we see through it but do not see it? It is really then, a very marvelous thing, or is it rather so commonplace, so everyday, so near a thing to us, that we cannot perceive that the shape, form, outward expression, design, or whatever we may choose, of the tall office building should in the very nature of things follow the functions of the building, and that where the function does not change, the form is not to change?

Columbian Exposition in Chicago, a world's fair celebrating the four-hundredth anniversary of Columbus's voyage, was a vast and highly organized example of quasi-Roman city planning (fig. **4.16**). It was a collaboration among many architects, including McKim, Mead & White, the Chicago firm of Burnham and Root, and Richard Morris Hunt (1827–95), the doyen of American academic architecture. Though modeled on European precedents, the Columbian Exposition set out to assert American ascendancy in industry and particularly the visual arts. Ironically, while international expositions in London and Paris had unveiled such futuristic architectural marvels as the Crystal Palace and the Eiffel Tower, America looked to the classical European past for inspiration. This resulted, in part, from an anxiety that pragmatic Chicago-style architecture might give a provincial appearance to America's first world's fair. The gleaming white colonnades of the buildings, conceived on an awesome scale and arranged around an immense reflecting pool, formed a model for the future American dream city, one that affected a generation of architects and their clients. Thus, although the Chicago School of architecture maintained its vitality into the first decade of the twentieth century, neo-academic eclecticism remained firmly established, with New York architects leading the way.

This eclecticism often fused comfortably familiar revivalist forms with innovative engineering. An exemplary manifestation of this fusion is the Brooklyn Bridge (1869–83), in which the Gothic Revival style clothes a triumph of American technology (fig. **4.17**). It was designed by **John Augustus Roebling** (1806–69), who barely lived to see it begun (his son Washington completed the work with his wife, Emily). Before construction of the bridge, the East River was crossed by up to a thousand ferry trips a day. With its soaring Gothic towers and graceful steel suspension cables, the Brooklyn Bridge forms a dramatic gateway to New York City. No wonder numbers of American painters and photographers were drawn to its grandeur as a pictorial motif.

By 1913 the Woolworth Building (fig. **4.18**), designed by **Cass Gilbert** (1859–1934), loomed 792 feet (241 m) above the streets of New York—fifty-two stories of Late Gothic-style stone sheathing serving mainly to add weight, disguise the metal-case construction frame, and create a sense of soaring verticality. Until 1931, the Woolworth Building was New York's tallest edifice, a Gothic cathedral of the modern age and a shining symbol of American capitalism. It has since been overshadowed by later and taller buildings, but remains one of the most distinguished structures on the New York skyline.

In the early years of the twentieth century, progressive architecture made plain its continuing interest in tradition even as it embraced the support of new patrons and new technologies. The commercial and corporate enterprises that underwrote the construction of early skyscrapers had more or less replaced the royal, noble, or religious patrons of earlier centuries. Yet these new patrons continued to pay homage to the styles of the monumental architecture of the past by commissioning buildings that displayed historical ornament, as the Gothic flourishes of the Woolworth Building do. It is this hesitation between the new and the old, between tradition and innovation, that characterizes modern art and architecture at the turn of the century.

4.16 Richard Morris Hunt; McKim, Mead & White; Burnham and Root; and other architects, World's Columbian Exposition, Chicago, 1893. Demolished.

4.17 John Augustus Roebling, Brooklyn Bridge, 1869–83. New York.

4.18 Cass Gilbert, Woolworth Building, 1911–13. New York.

5
Art Nouveau and the Beginnings of Expressionism

As seen in chapters 3 and 4, the turn of the century was a time of synthesis in the arts, a time when artists sought new directions that in themselves constituted a reaction against the tide of "progress" represented by industrialization. At the same time, the architects discussed in the previous chapter recognized that new patterns of life in the industrial age called for new types of buildings—bridges, railroad stations, and skyscrapers. The great innovators, such as Richardson, Sullivan, or Mackintosh, were able to draw selectively upon older styles without resorting to academic pastiche, and to create from the past something new and authentic for the present. While these architects did not abandon tradition, their work constituted a powerful countercurrent to Beaux-Arts historicism. At the same time, the search of the Symbolist poets, painters, and musicians for spiritual values was part of this reaction. Gauguin used the term "synthetism" to characterize the liberating color and linear explorations that he pursued and transmitted to disciples. This synthesizing spirit became, in the last decades of the nineteenth century and the first of the twentieth, a great popular movement that affected the taste of every part of the population in both Europe and the United States.

What remains especially curious about this taste for synthesis is that it involved the reconciliation of two seemingly incompatible ideas: the complete aesthetic liberty of Art for Art's Sake and the necessity of a social role for art characteristic of the Arts and Crafts Movement. Among the most successful attempts at reconciling these impulses was the movement called Art Nouveau, a French term meaning simply "new art." Art Nouveau draws equally upon the inward-turning, fantastical experiments of Symbolism, the exotic forms and decorative exuberance of *japonisme*, and the innovative experiments with industrial materials undertaken by designers such as Paxton, Labrouste, and Eiffel. Art Nouveau was a definable style that emerged from the experiments of painters, architects, craftspeople, and designers and, for a decade, permeated not only painting, sculpture, and architecture, but also graphic design,

magazine and book illustration, furniture, textiles, glass and ceramic wares, jewelry, and even clothing. As the name implies, Art Nouveau represented a conscious search for new and genuine forms that were capable of expressing modernism at the turn of the century, a period often referred to using the French "*fin-de-siècle*." Meaning literally "end of the century," the French term conveys a sense of decline and uncertainty that is absent in its English counterpart.

With Beauty at the Reins of Industry: Aestheticism and Art Nouveau

Among the British art movements buoyed by Walter Pater's writings in support of Art for Art's Sake was Aestheticism. Encompassing both literary and visual works, Aestheticism did not designate a particular style so much as adhere to the idea that art should not be expected to serve any social purpose. Artists associated with the Aesthetic Movement often represented figures or subjects drawn from literary sources, as did **Frederick Leighton** in his painting of *The Bath of Psyche* (fig. **5.1**). Like his Symbolist contemporaries, Leighton offers a visual response to the classical figure of Psyche as opposed to a direct illustration of a specific text. Leighton's concern here is with the achievement of compositional balance and unity, color harmonies, and seductive counterpoints of texture. The archeological accuracy of his pictures is intended to enhance the attentive viewer's experience and satisfaction with the piece, not to contribute to any narrative or moral significance. What matters is the viewer's pleasure in looking, thematized by Psyche's reverie as she gazes at her own reflection. Highly eroticized, Aestheticist works often vacillate between heterosexual and homosexual readings, as does Psyche with her well-muscled physique. While the shading that defines her torso beneath her raised left arm endows her with a feminine waist, it also subtly disguises a contour line tracing a more masculine transition from chest

to hips. The ambiguity of the figure's gender contributes to the unmooring of the subject, suggestive of the dreamy quality of many works of the Aestheticists.

The drawings of the young English artist **Aubrey Beardsley** (1872–98) were immensely elaborate in their black-and-white stylization and decorative richness (fig. **5.2**). Associated with the so-termed "aesthetic" or "decadent" literature of Oscar Wilde and other *fin-de-siècle* writers, they were admired for their beauty and condemned for their sexual content. Beardsley, like Edgar Allan Poe and certain of the French Symbolists, was haunted by

5.2 Aubrey Beardsley, *Salome with the Head of John the Baptist*, 1893. India ink and watercolor, 10⅞ × 5¾" (27.6 × 14.6 cm). Aubrey Beardsley Collection, Manuscripts Division, Department of Rare Books and Special Collections, Princeton University Library, New Jersey.

5.1 Frederick Leighton, *The Bath of Psyche*, 1890. Oil on canvas, 35⅛ × 24⅜" (89.2 × 62.2 cm). Tate, London.

Romantic visions of evil, of the erotic and the decadent. In watered-down imitations, his style in drawing appeared all over Europe and America in popularizations of Aestheticist book illustrations and posters. Beardsley based one of his illustrations for Wilde's 1894 play *Salome* on this drawing, in which the stepdaughter of Herod holds up the severed head of St. John the Baptist in a gesture of grotesque eroticism.

Less doctrinaire than their continental counterparts, these British adherents to the Art for Art's Sake doctrine accepted that a successful work of art might possess some utility beyond its purely aesthetic function to excite an emotional response in the viewer. James Whistler's famous *Peacock Room* from 1876–77 (fig. **5.3**), made in collaboration with the architect Thomas Jeckyll (1827–81) for the London house of the shipping magnate Frederick Richards Leyland, exemplifies this. Designed to showcase Leyland's Chinese porcelain collection, the Peacock Room was eclectic in style, as was typical of the Aesthetic Movement, but it is generally suffused with an exoticism akin to the *japonisme* discussed in chapter 2. Like his exact contemporary William Morris (and perhaps in response to him), Whistler, known for his paintings and prints (see figs. 1.1 and 2.28), wished to prove his strength as a designer of an integrated decorative environment. The result is a shimmering interior of dark greenish-blue walls embellished with circular abstract patterns and golden peacock motifs, which Whistler called *Harmony in Blue and Gold*. On the south wall of the room he depicted two fighting peacocks, one rich and one poor, which slyly alluded to a protracted quarrel between the artist and his patron. Leyland, who refused to pay Whistler for a great deal of the work on the room that he had never commissioned, finally banned the irascible artist from the house after he invited the public and press to view his creation without Leyland's permission. The room was later acquired intact by an American collector and is now housed in the Freer Gallery of Art in Washington, D.C. With its emphasis on beautiful but useful objects and a decorative style largely shaped by the reigning craze for *japonisme*, the Aesthetic Movement was an important forerunner of Art Nouveau.

Natural Forms for the Machine Age: The Art Nouveau Aesthetic

Art Nouveau grew out of the English Arts and Crafts Movement, whose ideas spread rapidly throughout Europe and found support in the comparable theories of French, German, Belgian, and Austrian artists and writers. A key characteristic of the movement was the concept of a synthesis of the arts based on an aesthetic of dynamic linear movement. Many names were given to this phenomenon in its various manifestations, but ultimately "Art Nouveau" became the most generally accepted, through its use by the Parisian shop and gallery owned by Siegfried Bing, the Maison de l'Art Nouveau, which was influential in propagating the style. In Germany the term *Jugendstil*, or "youth style," after the periodical *Jugend*, was adopted.

In 1890, it must be remembered, large quantities of mainstream painting, sculpture, and architecture were still being produced in accepted academic styles using traditional methods. The Arts and Crafts Movement offered one alternative, advocating organic design, traditional materials, and hand crafting. In contrast to that movement, Art Nouveau made use of new materials and machine technologies both in buildings and in decoration. Moreover, although Art Nouveau artists could not avoid the influence of past styles, they explored those that were less well known and out of fashion with the current academicians. They looked not only to medieval but also to Asian art forms or devices that were congenial to their search for an abstraction based on linear rhythms. Thus the linear qualities and decorative synthesis of eighteenth-century Rococo; the wonderful linear interlace of Celtic and Saxon illumination and jewelry; the bold, flat patterns of Japanese paintings and prints (see fig. 2.26); the ornate motifs of Chinese and Japanese ceramics and jades, were all used as sources for ideas. The Art Nouveau artists, while seeking a kind of abstraction, discovered most of the sources for their decoration in nature, especially in plant forms, often given a

5.3 James Abbott McNeill Whistler, *The Peacock Room*, 1876–77. Panels: oil color and gold on tooled leather and wood. Installed in the Freer Gallery of Art, Washington, D.C.

symbolic or sensuous overtone. They also drew on scientific discoveries, such as the forms of micro-organisms becoming familiar from explorations in botany and zoology. Their willingness to depart from their models in order to achieve suggestive, often fantastical forms testifies to the influence of Symbolism as well.

Painting and Graphic Art

One of the most influential figures in all the phases of Art Nouveau was the Belgian **Henry van de Velde** (1863–1957). Trained as a painter, he eventually produced abstract compositions in typical Art Nouveau formulas of color patterns and sinuous lines (fig. **5.4**). For a time he was interested in Impressionism and read widely on the scientific theory of color and perception. He soon abandoned this direction in favor of the Symbolism of Gauguin and his school, and attempted to push his experiments in symbolic statement through abstract color expression further than had any of his contemporaries. Ultimately, Van de Velde came to believe that easel painting was a dead end and that the solution for contemporary society was to be found in the industrial arts. Though significantly influenced by the theories of the British designer William Morris (discussed in chapter 4), Van de Velde regarded the machine as a potentially positive agent that could "one day bring forth beautiful products." It was finally as an architect and designer that he made his major contributions to Art Nouveau and the origins of twentieth-century art.

In Austria, the ideas of Art Nouveau were given expression in the founding in 1897 of the Vienna Secession and, shortly thereafter, in its publication, *Ver Sacrum* ("Sacred Spring"). This diverse group was so named because it seceded from Vienna's conservative exhibiting society, the Künstlerhaus, and opposed the intolerance toward new, anti-naturalist styles at the Academy of Fine Arts. The major figure of the Secession was **Gustav Klimt** (1862–1918), in many ways the most talented exponent of pure Art Nouveau style in painting. Klimt was well established as a successful decorative painter and fashionable portraitist, noted for the brilliance of his draftsmanship, when he began in the 1890s to be drawn into the stream of new European experiments. He became conscious of Symbolism, Pre-Raphaelitism, and Aestheticism. His style also encompassed a study of Byzantine mosaics. A passion for erotic themes led him not only to the creation of innumerable drawings, sensitive and explicit, but also to the development of a painting style that integrated sensuous nude figures with brilliantly colored decorative patterns of a richness rarely equaled in the history of modern art. He was increasingly drawn to murals. Those he created for the Palais Stoclet in Brussels, designed by Josef Hoffmann between 1905 and 1910 (fig. **5.5**; see also fig. 5.15), are executed in glass, enamel, metal, and semi-precious stones.

5.4 Henry van de Velde, *Tropon*, c. 1899. Advertising poster, 47⅝ × 29⅛" (121 × 74 cm). Museum für Kunst und Gewerbe, Hamburg.

5.5 Gustav Klimt, Detail of dining-room mural, c. 1905–08. Mosaic and enamel on marble. Palais Stoclet, Brussels.

5.6 Gustav Klimt, *Adele Bloch-Bauer I*, 1907. Oil, silver, and gold on canvas, 53¼ × 53¼" (138 × 138 cm). Neue Galerie, New York.

They combined figures conceived as flat patterns (except for modeled heads and hands) with an overall pattern of abstract spirals—a glittering complex of volumetric forms imbedded in a mosaic of jeweled and gilded pattern. Although essentially decorative in their total effect, the Stoclet murals mark the moment when modern painting was on the very edge of non-representation.

The undisguised eroticism and unsettling symbolism of Klimt's large-scale commissions failed to appeal to most institutional or commercial patrons. Portraiture thus served as his primary means of supporting himself. Even in this conventional genre, Klimt exerts his passion for the abstract and decorative. Refusing to be hamstrung by the customary flattery and tired poses endemic to society portraits, he casts his wealthy sitters, such as Adele Bloch-Bauer, as Byzantine royalty who peer out from behind a curtain of shattered golden glass, a cascade punctuated by shards of absinthe green and blood red (fig. **5.6**). In Klimt's portraits those citizens of *fin-de-siècle* Vienna—who so preoccupied Freud in his clinical practice—are seen as the psychoanalyst may have seen them: hovering between the realms of dream and waking existence (see Freud, *The Interpretation of Dreams*, opposite).

SOURCE

Sigmund Freud
from *The Interpretation of Dreams*, 1899

Freud's theories about the influence of childhood experiences on personality development were formulated and tested during the course of his clinical practice in Vienna. Dream interpretation, when conducted under the guidance of a psychoanalyst, could, Freud believed, aid in a patient's treatment.

In the course of [my] psychoanalytic studies, I happened upon the question of dream-interpretation. My patients, after I had pledged them to inform me of all the ideas and thoughts which occurred to them in connection with a given theme, related their dreams, and thus taught me that a dream may be interpolated in the psychic concatenation, which may be followed backwards from a pathological idea into the patient's memory. The next step was to treat the dream itself as a symptom, and to apply to it the method of interpretation which had been worked out for such symptoms.

For this a certain psychic preparation on the part of the patient is necessary. A twofold effort is made, to stimulate his attentiveness in respect of his psychic perceptions, and to eliminate the critical spirit in which he is ordinarily in the habit of viewing such thoughts as come to the surface. For the purpose of self-observation with concentrated attention it is advantageous that the patient should take up a restful position and close his eyes; he must be explicitly instructed to renounce all criticism of the thought-formations which he may perceive. He must also be told that the success of the psychoanalysis depends upon his noting and communicating everything that passes through his mind, and that he must not allow himself to suppress one idea because it seems to him unimportant or irrelevant to the subject, or another because it seems nonsensical. He must preserve an absolute impartiality in respect to his ideas; for if he is unsuccessful in finding the desired solution of the dream, the obsessional idea, or the like, it will be because he permits himself to be critical of them.

Architecture and Design

It is difficult to speak of a single, unified Art Nouveau style in architecture except in the realms of surface ornament and interior decoration. Despite this fact, certain aspects of architecture derive from Art Nouveau graphic art and decorative or applied arts, notably the use of the whiplash line in ornament and a generally curvilinear emphasis in decorative and even structural elements. The Art Nouveau spirit of imaginative invention, linear and spatial flow, and non-traditionalism fed the inspiration of a number of architects in continental Europe and the United States and enabled them to experiment more freely with ideas opened up to them by the use of metal, glass, and reinforced-concrete construction. Since the concept of Art Nouveau involved a high degree of specialized design and craftsmanship, it did not lend itself to the developing field of large-scale mass construction. However, it did contribute substantially to the outlook that was to lead to the rise of a new and experimental architecture in the early twentieth century.

The architectural ornament of Louis Sullivan in the Guaranty Trust Building (see fig. 4.15) or the Carson Pirie Scott store in Chicago was the principal American manifestation of the Art Nouveau spirit in architecture, and a comparable spirit permeated the early work of Sullivan's great disciple, Frank Lloyd Wright (see fig. 9.1). The outstanding American name in Art Nouveau was that of **Louis Comfort Tiffany** (1848–1933), but his expression lay in the fields of interior design and decorative arts, notably his table lamps. These combined the stylized natural forms so typical of Art Nouveau with his patented Favrile glass, which appeared handmade although it was industrially manufactured (fig. **5.7**). Tiffany was not only in close touch with the European movements but himself exercised a considerable influence on them.

In Spain, **Antoni Gaudí** (1852–1926) was influenced as a student by a Romantic and Symbolist concept of the Middle Ages as a golden age, which for him and for other Spanish artists became a symbol for the rising nationalism of Catalonia. Also implicit in Gaudí's architecture was his early study of natural forms as a spiritual basis for architecture. He was drawn to the work of the influential French architect and theorist Eugène Emmanuel Viollet-le-Duc. The latter was a leading proponent of the Gothic Revival and a passionate restorer of medieval buildings who analyzed Gothic architectural structure in the light of modern technical advances. His writings on architecture, notably his *Entretiens* ("Discussions"), which appeared in French, English, and American editions in the 1860s and 70s, were widely read by architects. His bold recommendations on the use of direct metal construction influenced not only

5.7 Louis Comfort Tiffany, Table lamp, c. 1900. Bronze and Favrile glass, height 27" (68.6 cm), shade diameter 18" (45.7 cm). Lilian Nassau Ltd., New York.

Gaudí, but a host of other experimental architects at the end of the nineteenth century. While Gaudí's early architecture belonged in part to the main current of Gothic Revival, it involved a highly idiosyncratic use of materials, particularly in textural and coloristic arrangement, and an even more imaginative personal style in ornamental ironwork. His wrought-iron designs were arrived at independently and frequently in advance of the comparable experiments of mainstream Art Nouveau. Throughout his later career, from the late 1880s until his death in 1926, Gaudí followed his own direction, which at first was parallel to Art Nouveau and later became independent of anything that was being done in the world or would be done until the middle of the twentieth century, when his work was reassessed.

Gaudí's first major commission was to complete the Church of the Sagrada Família (Holy Family) in Barcelona (fig. **5.8**), already begun as a Gothic Revival structure by the architect Francisco de Villar. Gaudí worked intermittently on it from 1883 until his death, leaving it far from complete. The main parts of the completed church, particularly the four great spires of one transept, are only remotely Gothic. Although influences of Moorish and other architectural styles may be traced, the principal effect is of a building without historic style—or rather one that expresses the imagination of the architect in the most personal and powerful sense. The decoration of the church contains a profusion of fantasy in biological ornament flowing into naturalistic figuration and abstract decoration. Brightly colored mosaic embellishes the finials of the spires.

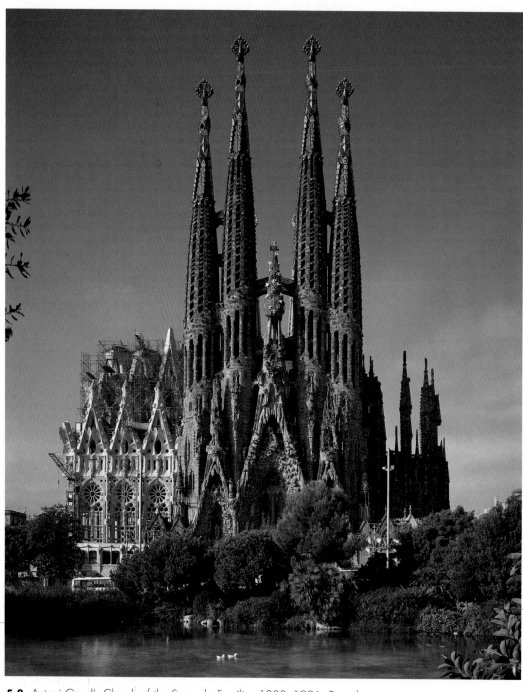

5.8 Antoni Gaudí, Church of the Sagrada Família, 1883–1926. Barcelona.

These forms were not arbitrary; they were tied to Gaudí's structural principles and his often hermetic language of symbolic form, informed by his spiritual beliefs. To complete the church according to the architect's plans, an enormous amount of construction has been undertaken since his death and continues today.

Along with the walls, benches, and other features that he dreamed up for the Güell Park (fig. **5.9**), Gaudí designed the Casa Milá apartment house in Barcelona (fig. **5.10**). This was a large structure around open courts, conceived as a single continuous movement of sculptural volumes. The façade, flowing around the two main elevations, is an alternation of void and sculptural mass. The undulating roof lines and the elaborately twisted chimneypots carry through the unified sculptural theme. Ironwork grows over the balconies like luscious, exotic vegetation. The sense of organic growth continues in the floor plan, where one room or corridor flows without interruption into another.

Walls are curved or angled throughout, to create a feeling of everlasting change, of space without end. In his concept of architecture as dynamic space joining the interior and exterior worlds and as living organism growing in a natural environment, in his daring engineering experiments, in his

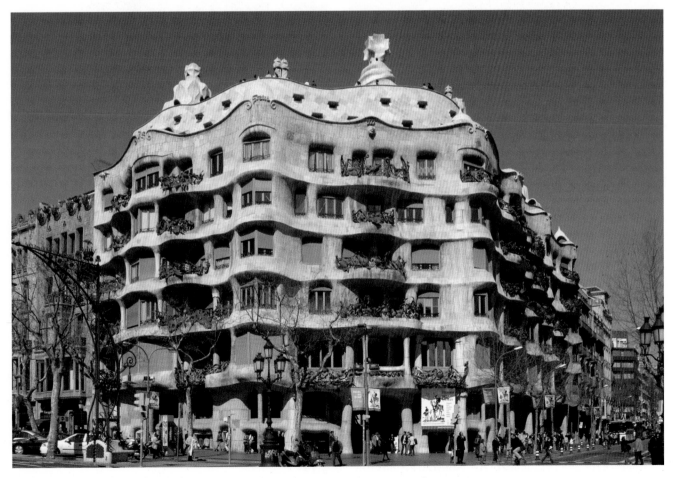

5.10 Antoni Gaudí, Casa Milá, 1905–07. Barcelona.

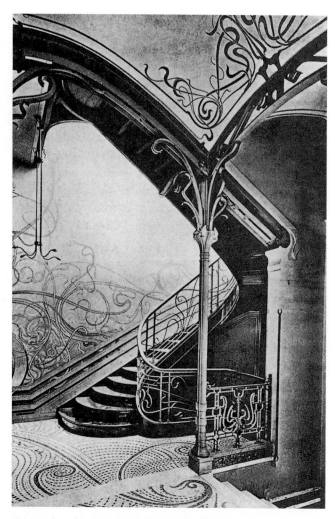

5.11 Victor Horta, Stairwell of interior, Tassel House, 1892–93. Brussels.

similar commercial buildings. The large-scale department store was a characteristic development of the later nineteenth century, superseding the older type of small shop and enclosing the still older form of the bazaar. Thus it was a form of building without traditions, and its functions lent themselves to an architecture that emphasized openness and spatial flow as well as ornate decorative backgrounds. The façade of Horta's department store in Brussels, À l'Innovation (fig. **5.12**), is a display piece of glass and curvilinear metal supports. Such department stores sprang up all over Europe and America at the beginning of the twentieth century. Their utilitarian purpose made them appropriate embodiments of the new discoveries in mass construction: glass and exposed metal structure and decorative tracery. Horta's design was notable for its expression of the interior on the glass skin of the exterior, so that the three floors, with a tall central "nave" and flanking, four-story side aisles, are articulated in the façade.

Many distinguished architects were associated with Art Nouveau in one context or another, but few of their works can be identified with the style to the same degree as Horta's. The stations designed by **Hector Guimard** (1867–1925) for the Paris Métropolitain (subway) can be considered pure Art Nouveau, perhaps because they were

imaginative use of materials—from stone that looks like a natural rock formation to the most wildly abstract color organizations of ceramic mosaic—Gaudí was a visionary and a great pioneer.

If any architect might claim to be the founder of Art Nouveau architecture, however, it is the Belgian **Victor Horta** (1861–1947). Trained as an academician, he was inspired by Baroque and Rococo concepts of linear movement in space, by his study of plant growth and of Viollet-le-Duc's structural theories, and by the engineer Gustave Eiffel (see fig. 4.10).

The first important commission carried out by Horta was the house of a Professor Tassel in Brussels, where he substantially advanced Viollet-le-Duc's theories about the use of metal construction. The stair hall (fig. **5.11**) is an integrated harmony of linear rhythms, established in the balustrades of ornamental iron, the whiplash curves atop the capitals, the arabesque designs on the walls and floor, and the winding steps. Line triumphs over sculptured mass as a multitude of fanciful, tendril-like elements blends into an organic whole that boldly exposes the supporting metal structure.

Many of the chief examples of Art Nouveau architecture are to be found in the designs of department stores and

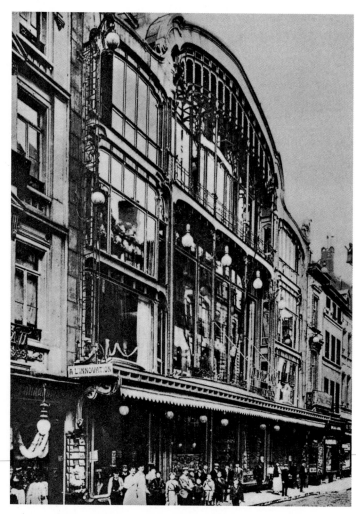

5.12 Victor Horta, À l'Innovation department store, 1901. Brussels. Destroyed by fire 1967.

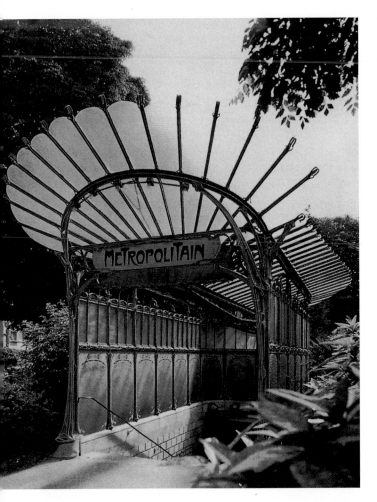

5.13 Hector Guimard, Entrance to the Porte Dauphine Métropolitain station, 1901. Paris.

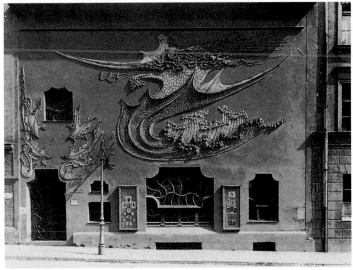

5.14 August Endell, Atelier Elvira, 1897. Munich.

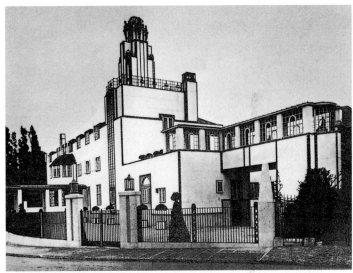

5.15 Josef Hoffmann, Palais Stoclet, 1905–11. Brussels.

not so much architectural structures as decorative signs or symbols. His Métro stations were constructed for the 1900 Universal Exposition out of prefabricated parts of cast iron and glass. At odds with the prevailing taste for classicism, they created a sensation in Paris, causing one critic to compare them to a dragonfly's wings. The entrance to the Porte Dauphine station (fig. **5.13**) is a rare example of an original Guimard canopy still intact.

Aside from the elaborate "sea-horse" ornament on its façade, the Atelier Elvira by **August Endell** (1871–1925) in Munich (fig. **5.14**) is a relatively simple and austere structure. However, details of the interior, notably the stair hall, did continue the delicate undulations of Art Nouveau. The Palais Stoclet in Brussels (fig. **5.15**) by the Austrian architect **Josef Hoffmann** (1870–1955) is a flat-walled, rectangular structure, although the dining-room murals by Klimt (see fig. 5.5) and the interior furnishings and decorations represent a typical Art Nouveau synthesis of decorative accessories. Hoffmann's starkly abstract language is closer to the elegant geometry of the Viennese *Jugendstil* school than to the flourishes of the Belgian Art Nouveau, inviting a reconsideration of his work in the context of the modern German and Austrian architecture discussed in chapter 9.

Toward Expressionism: Late Nineteenth-Century Avant-Garde Painting beyond France

In retrospect it is apparent that *Jugendstil* was as important for the new ideas it evoked in painters of the era as for the immediate impetus given architects and designers working directly in an Art Nouveau style. The Norwegian Edvard Munch, who had a sizable impact on German Expressionism; the Swiss Ferdinand Hodler; the Belgian James Ensor, a progenitor of Surrealism; and the Russian Vasily Kandinsky, one of the first abstract artists, all grew up in the environment of *Jugendstil* or Art Nouveau. Although some of the artists in this section formed their highly individual styles in response to advanced French art, they also drew extensively from their own local artistic traditions.

Scandinavia

By 1880, at the time **Edvard Munch** (1863–1944) began to study painting seriously, Oslo (then Kristiania), Norway, had a number of accomplished painters with a degree of patronage for their work. But the tradition was largely academic, rooted in the French Romantic Realism of the Barbizon School and in German lyrical naturalism, in part because Norwegian painters usually trained in Germany. In Kristiania, Munch was part of a radical group of bohemian writers and painters who worked in a naturalist mode.

Thanks to scholarships granted by the Norwegian government, Munch lived intermittently in Paris between 1889 and 1892, where he had already spent three weeks in 1885. Though it is not certain what art he saw while in France, the Post-Impressionist works he must have encountered surely struck a chord with his incipient Symbolist tendencies. In 1892 his reputation had grown to the point where he was invited to exhibit at the Verein Berliner Künstler (Society of Berlin Artists). His retrospective drew such a storm of criticism that the members of the Society voted to close it after less than a week. Sympathetic artists, led by Max Liebermann, left the Society and formed the Berlin Secession. This recognition—and controversy—encouraged Munch to settle in Germany, where he spent most of his time until 1908.

In evaluating Munch's place in European painting it could be argued that he was formed not so much by his Norwegian origins as by his exposure, first to Paris during one of the most exciting periods in the history of French painting, and then to Germany at the moment when a new and dynamic art was emerging. The singular personal quality of his paintings and prints, however, is unquestionably a

5.17 Christian Krohg, *The Sick Girl*, 1880–81. Oil on wood, 40⅛ × 22⅞" (101.9 × 58.1 cm). Nasjonalgalleriet, Oslo.

result of an intensely literary and even mystical approach, intensified by his own tortured psyche. The painter moved in literary circles in Norway as well as in Paris and Berlin, was a friend of noted writers, among them the playwright August Strindberg, and in 1906 made stage designs for Ibsen's plays *Ghosts* and *Hedda Gabler*.

Although he lived to be eighty years old, the specters of sickness and death hovered over Munch through much of his life. His mother and sister died of tuberculosis while he was still young. His younger brother succumbed in 1895, five years after the death of their father, and Munch himself suffered from serious illnesses. Sickness and death began to appear early in his painting and recurred continually. The subject of *The Sick Child*, related to the illness and death of his sister (fig. **5.16**), haunted him for years. He reworked the painting over and over, and made prints of the subject as well as two later versions of the painting.

Munch's mentor, the leading Norwegian naturalist painter **Christian Krohg** (1852–1925), had earlier explored

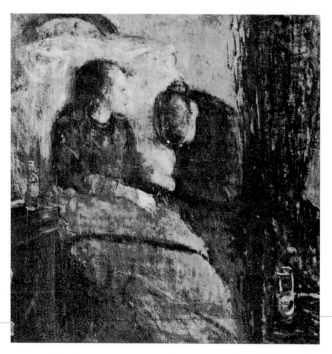

5.16 Edvard Munch, *The Sick Child*, 1885–86. Oil on canvas, 47 × 46⅜" (119.4 × 118.4 cm). Nasjonalgalleriet, Oslo.

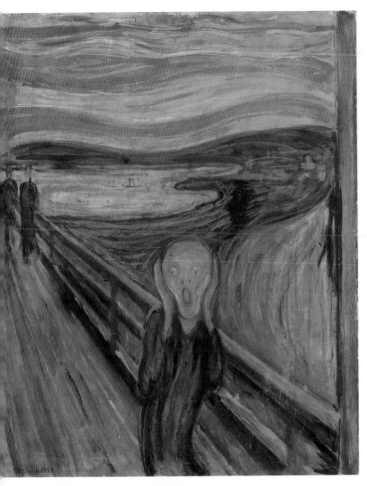

5.18 Edvard Munch, *The Scream*, 1893. Oil and tempera on board, 35¾ × 29" (90.8 × 73.7 cm). Nasjonalgalleriet, Oslo.

treatments of such subjects. While his version could not have predicted the melodrama or painterly handling of Munch's painting, the connection between the two canvases is obvious, though Munch, typically, denied the possibility of influence.

Munch was enormously prolific, and throughout his life experimented with many different themes, palettes, and styles of drawing. The works of the turn of the century, in which the symbolic content is most explicit, are characterized by the sinuous, constantly moving, curving line of Art Nouveau, combined with color dark in hue but brilliant in intensity. Influences from Gauguin and the Nabis are present in his work of this period. The anxieties that plagued Munch were frequently given a more general and ambiguous, though no less frightening, expression. *The Scream* (fig. **5.18**) is an agonized shriek translated into bands of color that echo like sound waves across the landscape and through the blood-red sky. The image has its source in Munch's experience. As he walked across a bridge with friends at sunset, he was seized with despair and "felt a great, infinite scream pass through nature." *The Scream*, the artist's best-known and most widely reproduced image, has become a familiar symbol of modern anxiety and alienation.

Munch was emerging as a painter at the moment when Sigmund Freud was developing his theories of psychoanalysis. Munch's obsessions with sex, death, and woman as a destructive force seem at times to provide classic examples of the problems Freud was exploring. In many works, *The Dance of Life* among them (fig. **5.19**), Munch transformed the moon and its long reflection on the water into a phallic symbol. *The Dance of Life* belongs to a large series Munch called *The Frieze of Life*, which contained most of his major paintings (including *The Scream*), addressing the central themes of love, sexual anxiety, and death. The subject of this painting, based on Munch's troubled personal history of love and rejection, was in step with international trends in Symbolist art.

a similar theme, common in the art and literature of the period, but he did so in an astonishingly direct and exacting style (fig. **5.17**). This sitter confronts the viewer head-on, her pale skin and white gown stark against the white pillow. Krohg, who had also watched his sister die of tuberculosis, avoided the usual sentimentality or latent eroticism that normally pervaded contemporary

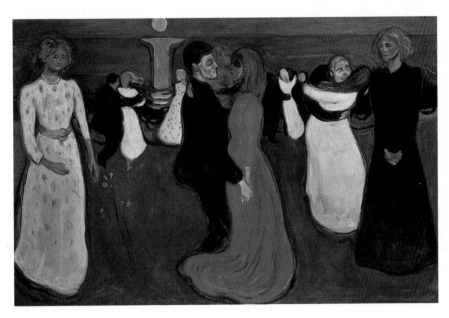

5.19 Edvard Munch, *The Dance of Life*, 1900. Oil on canvas, 4' 1½" × 6' 3½" (1.26 × 1.9 m). Nasjonalgalleriet, Oslo.

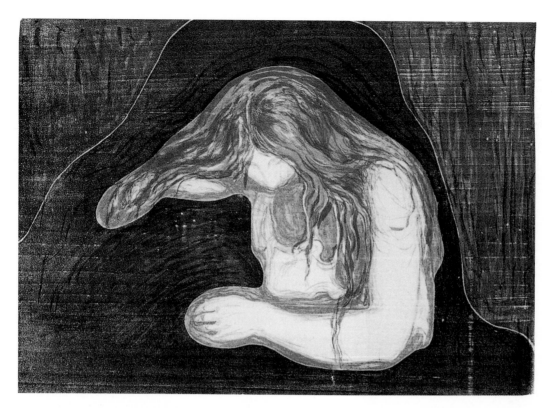

5.20 Edvard Munch, *Vampire*, 1902. Woodcut and lithograph, from an 1895 woodcut, 14⅞ × 21½" (38 × 54.6 cm). Munch-Museet, Oslo.

Munch was one of the major graphic artists of the twentieth century, and like Gauguin, he took a very experimental approach to printmaking and contributed to a revival of the woodcut medium. He began making etchings and lithographs in 1894 and for a time was principally interested in using the media to restudy subjects he had painted earlier. The prints, however, were never merely reproductions of the paintings. In each case he reworked the theme in terms of the new medium, sometimes executing the same subject in drypoint, woodcut, and lithography, and varying each of these just as each was modified from the painting. For *Vampire* (fig. **5.20**), Munch used an ingenious method he had invented for bypassing the tedious printmaking process of color registration, which involves inking separate areas of the woodblock for each color and painstakingly aligning the sheet for every pass (one for each color) through the press. Munch simply sawed his block into sections, inked each section separately, and assembled them like a puzzle for a single printing. In *Vampire*, he actually combined this technique with lithography to make a "combination print." Through these innovative techniques, Munch gained rich graphic effects, such as subtly textured patterns (by exploiting the rough grain of the woodblock), and translucent passages of color. His imagery, already explored in several drawings and paintings made in Berlin, is typically ambiguous. While the redheaded woman could be embracing her lover, the ominous shadow that looms above them and the title of the work imply something far more sinister.

Northern and Central Europe

The Swiss artist **Ferdinand Hodler** (1853–1918) also knew the ravages of sickness and death, and, like Van Gogh, had undergone a moral crisis in the wake of deep religious commitment. In his paintings, he avoided the turbulent drama of earlier Romantic expressions and sought instead frozen stillness, spareness, and purity, the better to evoke some sense of the unity within the apparent confusion and complexity of the world of experience. This can be discerned in the famous *Night* (fig. **5.21**), where the surfaces and volumes of nature have been described in exacting detail, controlled by an equally intense concern for abstract pattern, a kind of rigorously balanced, frieze-like organization the artist called "parallelism." As in Munch's *The Scream*, the imagery in *Night* was an expression of Hodler's own obsessive fears. The central figure, who awakens to find a shrouded phantom crouched above him, is a self-portrait, as is the man at the upper right, while the women in the foreground are depictions of his mistress and ex-wife. The painting was banned from an exhibition in Geneva in 1891 as indecent, but encountered a better reception when it was later shown in Paris.

The Belgian **James Ensor** (1860–1949), whose long life was almost exactly contemporary with Munch's, emerged from a similar political and economic milieu. Both Belgium and Norway were preoccupied with establishing distinctive national identities during the second half of the nineteenth century. Belgium's emphatic claims to a cultural patrimony distinct from its former Dutch governors provided Ensor with an acute appreciation for an artistic lineage that linked him to painters such as Peter Paul Rubens and Pieter Brueghel the Elder. The consciousness of this heritage even compelled him to assume, from time to time, though half satirically, the appearance of Rubens (fig. **5.22**). Outside of a three-year period of study at the Royal Academy of Fine Arts in Brussels, Ensor spent his entire life in his native Ostend, on the coast of Belgium, where his

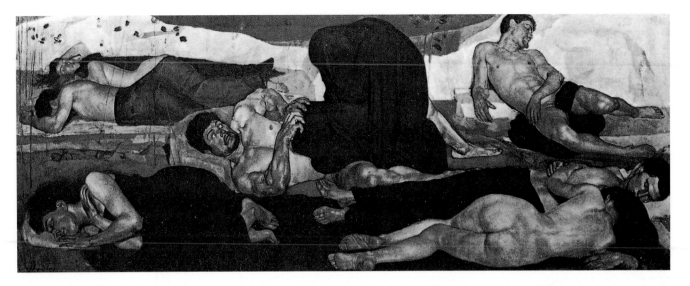

5.21 Ferdinand Hodler, *Night*, 1889–90. Oil on canvas, 3' 9¾" × 9' 9¾" (1.17 × 3 m). Kunstmuseum, Bern.

Flemish mother and her relatives kept a souvenir shop filled with toys, seashells, model ships in bottles, crockery, and, above all, the grotesque masks popular at Flemish carnivals.

By 1881, Ensor could produce such accomplished traditional Realist–Romantic paintings that he was accepted in the Brussels Salon and by 1882 in the Paris Salon. His approach was already changing, however, with the introduction of brutal or mocking subject matter, harshly authentic pictures of miserable, drunken tramps and inexplicable meetings of masked figures.

Ensor's mature paintings still have the capacity to shock. He was something of an eccentric and much affected by nineteenth-century Romanticism and Symbolism, evident in his passionate devotion to the tales of Poe and Balzac, the poems of Baudelaire, and the work of several contemporary Belgian writers. He searched the tradition of fantastic painting and graphic art for inspiration—from the tormented visions of Matthias Grünewald and Bosch to Goya. Ensor was further affected by Daumier and his social commentaries (see figs. 2.16, 2.17), the book illustrator Gustave Doré, Redon, and the decadent-erotic imagery of the Belgian artist Félicien Rops.

During the late 1880s Ensor turned to religious subjects, frequently the torments of Christ. They are not interpreted in a narrowly religious sense, but are, rather, a personal revulsion for a world of inhumanity that nauseated him. This feeling was given its fullest expression in the most important painting of his career, *The Entry of Christ into Brussels in 1889* (fig. **5.23**), a work from 1888–89 that depicts the Passion of Christ as the center of a contemporary Flemish *kermis*, or carnival, symptomatic of the indifference, stupidity, and venality of the modern world. Ensor describes this grotesque tumult of humanity with dissonant color, compressing the crowd into a vast yet claustrophobic space. Given the enormous size of *The Entry of Christ* (it is over 12 feet, or 3.5 m, wide), it has been suggested that Ensor painted it in response to Seurat's *La Grande Jatte* (see fig. 3.1), which had been much heralded at an exhibition in Brussels in 1887. While the French painting was a modern celebration of middle-class life, Ensor's was an indictment of it. The figure of Christ, barely visible far back in the crowd, was probably based on the artist's own likeness. This conceit—the artist as persecuted martyr—had been promoted by the Symbolists, with Gauguin among those who effectively exploited the theme. By extension, Ensor's hideous crowd refers to

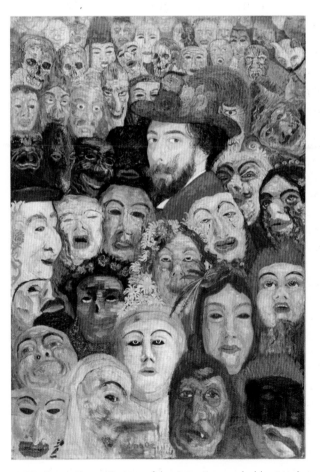

5.22 James Ensor, *Portrait of the Artist Surrounded by Masks*, 1899. Oil on canvas, 47 × 31½" (119.4 × 80 cm). Menard Art Museum, Aichi, Japan.

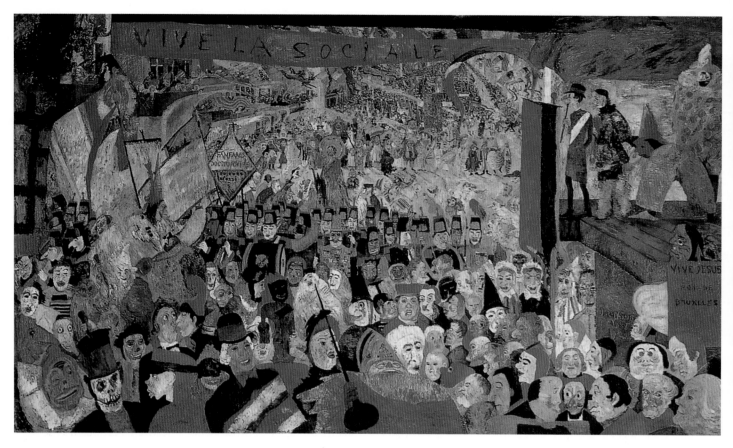

5.23 James Ensor, *The Entry of Christ into Brussels in 1889*, 1888–89. Oil on canvas, 8' 5" × 12' 5" (2.6 × 3.8 m). J. Paul Getty Museum, Los Angeles.

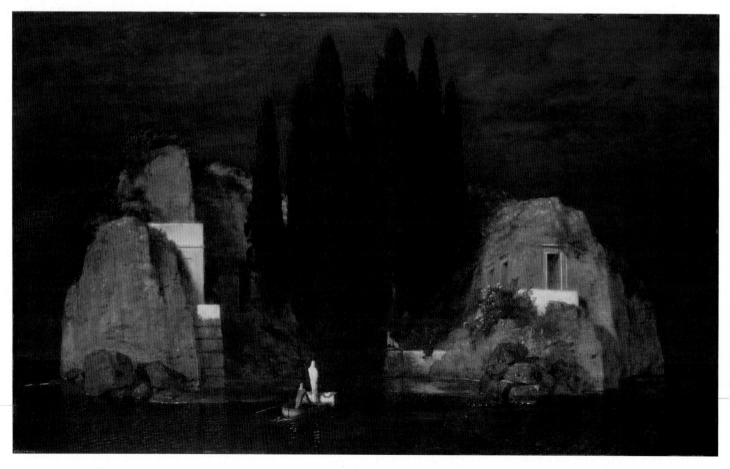

5.24 Arnold Böcklin, *Island of the Dead*, 1880. Oil on wood, 29 × 48" (73.7 × 122 cm). The Metropolitan Museum of Art, New York.

the ignorant citizens of Ostend, who greeted his work with incomprehension.

Even members of a more liberal exhibiting group in Brussels, called L'Essor, were somewhat uneasy about Ensor's new paintings. This led in 1884 to a withdrawal of some members, including Ensor, to form the progressive society Les XX (The Twenty). For many years the society was to support aspects of the new art in Brussels. Although it exhibited Manet, Seurat, Van Gogh, Gauguin, and Toulouse-Lautrec, and exerted an influence in the spread of Neo-Impressionism and Art Nouveau, hostility to Ensor's increasingly fantastic paintings grew even there. *The Entry of Christ* was refused admission and was never publicly exhibited before 1929. The artist himself was saved from expulsion from the group only by his own vote.

During the 1890s Ensor focused much of his talent for invective on the antagonists of his paintings, frequently with devastating results. Some of his most brilliant and harrowing works were produced at this time. The masks reappeared at regular intervals, occasionally becoming particularly personal, as in *Portrait of the Artist Surrounded by Masks* (see fig. 5.22), a painting in which he portrayed himself in the manner of Rubens' self-portraits—with debonair mustache and beard, plumed hat, and piercing glance directed at the spectator. The work is reminiscent of an earlier 1883 self-portrait by Ensor and, in a curious way, of a painting by Hieronymus Bosch of Christ surrounded by his tormentors (here, Ensor's critics): the personification of Good, isolated by Evil but never overwhelmed.

The ancestors of twentieth-century Surrealism can also be found in a trio of artists who emerged in German-speaking Europe during the Symbolist era: Böcklin, Klinger, and Kubin. The eldest of these was **Arnold Böcklin** (1827–1901), born in Basel, educated in Düsseldorf and Geneva, and then resident in Italy until the end of his life. Like so many others within contemporary German culture, Böcklin fell prey to the classical dream, which prompted him to paint, with brutal, almost grotesque academic Realism, such mythical beings as centaurs and mermaids writhing in battle, or some sexual contest between a hapless, depleted male and an exultant *femme fatale*. One of his most haunting images, especially for later painters like Giorgio de Chirico and the Surrealists, came to be called *Island of the Dead* (fig. **5.24**), a scene depicting no known reality but universally appealing to the late Romantic and Symbolist imagination. With its uncanny stillness, its ghostly white-cowled figure, and its eerie moonlight illuminating rocks and the entrances to tombs against the deep, mysteriously resonant blues and greens of sky, water, and tall, melancholy cypresses, the picture provided inspiration not only for subsequent painters but also for numerous poets and composers.

The German artist **Max Klinger** (1857–1920) paid homage to Böcklin by making prints after several of his paintings, including *Island of the Dead*. Klinger is best known for a ten-part cycle of prints entitled *The Glove*

(fig. **5.25**), whose sense of fantasy may owe something to the dark, sinister imaginings of Goya. The Czech artist and illustrator Alfred Kubin (1877–1959) proved capable of phantasms well in excess of those found in the art of either Böcklin or Klinger. Indeed, he may be compared with Redon, though his obsession with woman-as-destroyer themes places him alongside *fin-de-siècle* artists like Rops as well as anticipating the Freudian world of Surrealism. Kubin was to become a member of Kandinsky's Munich circle, and in 1911 he joined a set of brilliant experimental artists in Germany called Der Blaue Reiter (the Blue Rider). Meanwhile, in 1909, he published his illustrated novel entitled *The Other Side*, often regarded as a progenitor of the hallucinatory fictions of Franz Kafka.

As progressive artists working in Scandinavia, Belgium, Germany, and Austria turned inward to explore the realms of private desire and inner struggle, a group of French artists took to heart Cézanne's admonition to focus on the formal character of their work, to achieve new types of visual expression through experiments with color, line, form, and space. Fantasy and reverie, while undoubtedly furnishing fuel for creative work, required a new visual language for expression. The Fauves would finally achieve formal independence of the visual arts without sacrificing the narrative ambiguity and seductive themes that had so entranced the Symbolists.

5.25 Max Klinger, *An Action* from *The Glove*, 1882. Etching, 9⅞ × 7½" (25 × 18.9 cm). Kupferstichkabinett, Staatliche Museen, Berlin.

6
The New Century: Experiments in Color and Form

As the twentieth century dawned, the malaise of the *fin de siècle* subsided and *la belle époque*, "the beautiful age," was under way. The ambivalence toward industrial and commercial expansion gave way to renewed optimism. Stunning new inventions promised to ease the burden of manual labor, to conquer disease, and to enhance leisure. Automobiles, cinemas, even airplanes became part of the imagination if not the everyday experience of the inhabitants of industrialized Europe and America. A willingness to experiment, to attempt what seemed impossible only months earlier, emboldened progressive artists along with their counterparts in industry and science. This zeal for experimentation brought radical new styles to the fore: Fauvism, Cubism, and Expressionism, just to name a few. It also meant that new styles evolved rapidly, with one succeeding another at a dizzying pace. In contrast to earlier periods when an established style would endure for decades or even centuries, the avant-garde styles of the early twentieth century were quickly developed then often immediately modified or abandoned.

As already indicated, this passion for innovation was not unique to the visual arts. Scientists and engineers, for instance, advanced their fields with similar energy. Aside from what might be described as a generally optimistic and progressive milieu at the start of the century, artistic innovation must also be understood as a response to a particular aesthetic demand. Originality had, since the advent of Romanticism in the late eighteenth century, become an increasingly important measure of aesthetic success for progressive artists. Yet even the avant-garde recognized that they were part of an artistic tradition. To remain in conversation with that tradition meant that artists had to retain some of the vocabulary and syntax of its language. How to balance innovation against tradition would remain a central concern for modern artists of the early twentieth century, no matter how radical their work became.

The quest for originality had already led some artists, like Paul Gauguin, to turn away from Western formulas and instead pursue primitivism. This interest in non-Western art peaked in the early twentieth century with a particular focus on African cultures. As was the case with late nineteenth-century primitivism, this preoccupation with African art resulted in large part from European colonization of most of the continent. Though not initially greeted with the same enthusiasm as Asian or Oceanic artworks, by the 1920s sub-Saharan African sculpture, in particular, came to symbolize the "primitive," pre-industrial "other" in the imaginations of many Europeans and North Americans. By extension, African or African-seeming forms and motifs were seen as markers of novelty and, hence, originality. So potent was the link between African art and originality that several artists and critics claimed to have been the "discoverer" of this art. Of course, most Western artists gained familiarity with African works through magazine illustrations or through visits to ethnographic museums, a reminder that the avant-garde's understanding of non-Western cultures was highly mediated by the desires and assumptions of their own societies. These tensions—between Western and non-Western forms, between tradition and innovation—make themselves felt acutely in the work of Henri Matisse and the Fauves.

Fauvism

"*Donatello au milieu des fauves!*" ("Donatello among the wild beasts!") was the ready quip of Louis Vauxcelles, art critic for the review *Gil Blas*, when he entered Gallery VII at Paris' 1905 Salon d'Automne and found himself surrounded by blazingly colored, vehemently brushed canvases in the midst of which stood a small neo-Renaissance sculpture. With this witticism Vauxcelles gave its name to the first French avant-garde style to emerge in the twentieth century. It should be noted, however, that Vauxcelles was generally sympathetic to the work presented by the group of young painters, as were other liberal critics.

The starting point of Fauvism was later identified by Henri Matisse, its sober and rather professorial leader, as "the courage to return to the purity of means." Matisse and

his fellow Fauves—André Derain, Maurice de Vlaminck, Georges Rouault, Raoul Dufy, and others—allowed their search for immediacy and clarity to show forth with bold, almost unbearable candor. While divesting themselves of Symbolist literary aesthetics, along with *fin-de-siècle* morbidity, the Fauves reclaimed Impressionism's direct, joyous embrace of nature and combined it with Post-Impressionism's heightened color contrasts and emotional, expressive depth. Following the example of Post-Impressionists like Gauguin and Van Gogh, they emancipated color from its role of describing external reality and concentrated on the medium's ability to communicate directly the artist's experience of that reality by exploiting the pure chromatic intensity of paint. Fauvism burst on to the Parisian art scene at a time when the heady pace of change in the arts, as in society as a whole, was coming to be seen as part of the new, modern world order. Moreover, as artists from many different countries and backgrounds were drawn to Paris, seeking contact with the exciting new developments there, Fauve paintings made a deep impression on the new generation of avant-garde artists who were also coming to terms with the possibilities for painting opened up by Cézanne.

Inevitably, the Fauves' emphasis on achieving personal authenticity meant that they would never form a coherent movement. But before drifting apart as early as 1907, the Fauves made certain definite and unique contributions. Though none of them attempted complete abstraction, as did their contemporaries Vasily Kandinsky or Robert Delaunay, for example, they extended the boundaries of representation, based in part on their exposure to non-Western sources, such as African art. For subject matter they turned to portraiture, still life, and landscape. In the last, especially in the art of Matisse, they revisualized Impressionism's culture of leisure as a pagan ideal of *bonheur de vivre*, the joy of life. Most important of all, the Fauvist painters practiced an art in which the painting was conceived as an autonomous creation, freed from serving narrative or symbolic ends.

"Purity of Means" in Practice: Henri Matisse's Early Career

Henri Matisse (1869–1954) first studied law, but by 1891 he had enrolled in the Académie Julian, studying briefly with the rigidly academic painter William Bouguereau, who came to represent everything he rejected in art. The following year he entered the École des Beaux-Arts and was fortunate enough to study with Gustave Moreau (see fig. 3.11), a dedicated teacher who encouraged his students to find their own directions not only through individual experiment but also through constant study in museums. In Moreau's studio, Matisse met Georges Rouault, Albert Marquet, Henri-Charles Manguin, Charles Camoin, and Charles Guérin, all of whom were later associated with the Fauves.

Matisse's work developed slowly from the dark tonalities and literary subjects he first explored. By the late 1890s he had discovered the Pointillist paintings of Seurat and his followers, known collectively as Neo-Impressionists, along with artists such as Toulouse-Lautrec and, most importantly, Cézanne. In about 1898 he began to experiment with figures and still lifes painted in bright, non-descriptive color. In 1900, Matisse entered the atelier of Eugène Carrière, a maker of dreamily romantic figure paintings. There he met André Derain, who introduced him to Maurice de Vlaminck the following year, completing the principal Fauve trio. Around that time, Matisse also worked in the studio of the sculptor Antoine Bourdelle, making his first attempts at sculpture and demonstrating the abilities that were to make him one of the great painter–sculptors of the twentieth century.

Earliest Works

Moreau's admonition to copy the Old Masters instilled in Matisse an unflagging concern for artistic tradition and his relationship to it. Among the paintings that Matisse copied in the Louvre during his student days was a still life by the seventeenth-century Dutch painter Jan Davidsz de Heem. Matisse's version was a free copy, considerably smaller than the original. In 1915, he would even make a Cubist variation of the work. At the Salon de la Société Nationale des Beaux-Arts (known as the Salon de la Nationale) of 1897, he exhibited his own composition of a still life, *Dinner Table* (fig. 6.1), which was not favorably received by the conservatives. Though highly traditional on the face of it, this work was one of Matisse's most complicated and carefully constructed compositions to date, and it was his first truly modern work. While it still depended on locally descriptive color, this painting revealed in its luminosity an interest in the Impressionists. The abruptly tilted table that

6.1 Henri Matisse, *La Desserte (Dinner Table)*, 1896–97. Oil on canvas, 39¼ × 51½" (99.7 × 130.8 cm). Private collection.

crowds and contracts the space of the picture anticipated the artist's subsequent move toward radical simplification in his later treatment of similar subjects (see fig. 6.22). *Male Model* of about 1900 (fig. **6.2**) carried this process of simplification and contraction several stages further, even to the point of some distortion of perspective, to achieve a sense of delimited space. Again, Matisse has chosen to experiment with a very conventional subject: a male nude. A single male figure, often clearly in a studio pose, was known as an *académie* and was central to the training of any aspiring academician. The modeling of the figure in abrupt facets of color was a direct response to the paintings of Cézanne, whose influence Matisse here brings to bear on what most progressive painters would perceive as a tired academic exercise. On the contrary, Matisse's fusion of Cézanne's radical treatment of space, pigment, and brushwork with an *académie* announces Matisse's intention of realizing Cézanne's dream to "make of Impressionism something solid and lasting like the art in the museums."

At around the same time, Matisse began working on a related sculpture (fig. **6.3**). *The Serf* was begun in 1900, but not completed until 1904. Although sculpted after the well-known model, Bevilacqua, who had not only posed for Matisse's *Male Model* but also for Rodin, *The Serf*

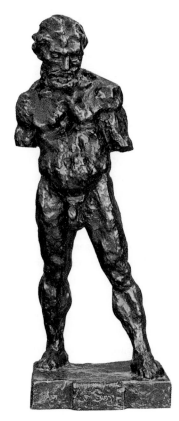

6.3 Henri Matisse, *The Serf*, 1900–04. Bronze, 36 × 13⅞ × 12¼" at base (91.4 × 35.3 × 31.1 cm). Hirshhorn Museum and Sculpture Garden, Smithsonian Institution, Washington, D.C.

was adapted in attitude and concept (although on a reduced scale) from a Rodin sculpture called *Walking Man*. In *The Serf* Matisse carries the expressive modeling of the surface even further than Rodin, and halted the forward motion of the figure by adjusting the position of the legs into a solidly static pose and truncating the arms above the elbow.

Between 1902 and 1905 Matisse exhibited at the Salon des Indépendants and at the galleries of Berthe Weill and Ambroise Vollard. The latter was rapidly becoming the principal dealer for the avant-garde artists of Paris. When the more liberal Salon d'Automne was established in 1903, Matisse showed there, along with the Nabis painter Pierre Bonnard (see figs. 3.32, 3.33, and 3.34) and a fellow alumnus of Moreau's studio, Albert Marquet. But most notorious was the Salon d'Automne of 1905, in which a room of paintings by Matisse, Vlaminck, Derain, and Rouault, among others, is supposed to have occasioned the remark by Vauxcelles that gave the group its permanent name.

Matisse's Fauve Period

The word *fauve* made particular reference to these artists' brilliant, arbitrary color, more intense than the "scientific" color of the Neo-Impressionists and the non-descriptive color of Gauguin and Van Gogh, and to the direct, vigorous brushwork with which Matisse and his friends had been experimenting the previous year at St. Tropez and Collioure on the Riviera in the south of France. The Fauves accomplished the liberation of color toward which, in their different ways, Cézanne, Gauguin, Van Gogh, Seurat, and the Nabis had been experimenting. Using similar means, the Fauves were intent on different ends. They wished to use pure color squeezed directly from the tube, not to describe objects in nature, not simply to set up retinal vibrations, not to accentuate a romantic or mystical subject, but to build new pictorial values apart from all these. For the Fauves, all pictorial elements could be realized through the use of pure color. Even space and the modeling of form could be rendered through color, without

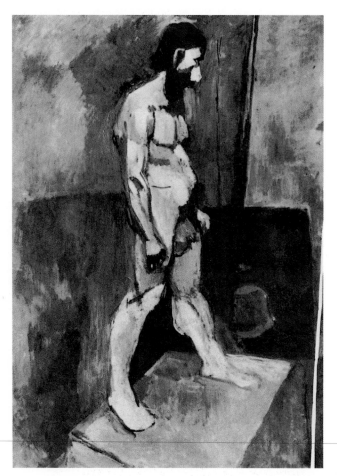

6.2 Henri Matisse, *Male Model (L'Homme Nu; "Le Serf" Académie bleue; Bevilacqua)*, Paris, 1900. Oil on canvas, 39⅛ × 28⅜" (99.3 × 72.7 cm). The Museum of Modern Art, New York.

recourse to Renaissance tricks of perspective or chiaroscuro. Thus, in a sense, they were using the color of Gauguin and Seurat, freely combined with their own linear rhythms, to reach effects similar to those constantly sought by Cézanne, whom Matisse revered.

Earlier in 1905, at the Salon des Indépendants, Matisse had already exhibited his large Neo-Impressionist composition *Luxe, calme et volupté* (fig. **6.4**), a title taken from a couplet in Baudelaire's poem *L'Invitation au voyage* (see Baudelaire, *Invitation to the Voyage*, p. 114). In this important work, which went far along the path to abstraction, he combined the mosaic landscape manner of Signac (who bought the painting) with figure organization that recalls Cézanne's many compositions of bathers (see fig. 3.10), one of which Matisse owned. At the left of this St. Tropez beach scene, Matisse depicted his wife, Amélie, beside a picnic spread. But this mundane activity is transported to a timeless, arcadian world populated by languid nudes relaxing along a beach that has been tinged with dazzling red. With *Luxe*, therefore, Matisse offered a radical reinterpretation of the grand pastoral tradition in landscape painting, best exemplified in France by Claude Lorrain and Nicolas Poussin (see fig. 1.14).

As in many of the paintings that postdate this work, Matisse's idyllic world is exclusively female. The significance of this inclination deserves consideration at this point.

As mentioned earlier, the nude male figure, the subject of countless *académies*, was traditionally considered the most important subject for an ambitious young artist to learn to manage. Decorum as well as a predilection for themes from classical antiquity led academic artists to view the heroic nude male (as opposed to nude female) body as a particularly elevated motif. Nude women were largely confined to the lesser genres: minor classical subjects such as the Loves of the Gods or scenes of everyday life. Avant-garde artists since Courbet, however, tended to address their nude studies to female models. This shift might be explained in terms of the avant-garde's rejection of academic hierarchies. Another, more compelling, factor that contributed to this shift is the long-standing association between femininity and nature. The female body served for many artists as a metaphor for essential, uncorrupted nature. In this way, the nude female figure served the avant-garde much in the same way that non-Western motifs did: as guarantors of aesthetic authenticity. Of course, the erotic character of many avant-garde treatments of the female body also reveals the enduring association between artistic creativity and masculine sexual potency, a link that will come under sharp scrutiny by later, especially feminist, artists.

While Matisse wrestled with the legacy of classicism through his work, the sculptor **Aristide Maillol** (1861–1944) found in classical antiquity a reassuring source for

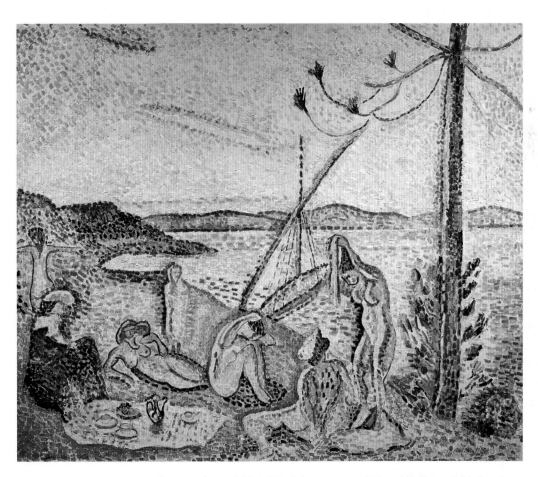

6.4 Henri Matisse, *Luxe, calme et volupté*, 1904–05. Oil on canvas, 37 × 46" (94 × 116.8 cm). Musée d'Orsay, Paris.

his formal experiments. Maillol began as a painter and tapestry designer; he was almost forty when the onset of a dangerous eye disease made the meticulous practice of weaving difficult, and he decided to change to sculpture. He began with wood carvings that had a definite relation to his paintings and to the Nabis and the Art Nouveau environment in which he had been working at the turn of

the century (see chapters 3 and 5). However, he soon moved to clay modeling and developed a mature style that changed little throughout his life. That style is summarized in one of his very first sculptures, *The Mediterranean* (fig. **6.5**), a massive, seated female nude, integrated as a set of curving volumes in space. He developed a personal brand of classicism that simplified the body into idealized, geometric forms and imparted a quality of psychological withdrawal and composed reserve.

Shown at the infamous Salon d'Automne of 1905 (known as the "Fauve Salon"), Maillol's *Mediterranean* would have provided a cool, monumental counterpoint to the flashing scenes mounted on the walls. It was there that Matisse exhibited *The Open Window* (fig. **6.6**), which is perhaps the first fully developed example of a theme favored by him throughout the rest of his life. It is simply a small fragment of the wall of a room, taken up principally with a large window whose casements are thrown wide to the outside world—a balcony with flowerpots and vines, and beyond that the sea, sky, and boats of the harbor at Collioure. It was at this Mediterranean port, during the summer of 1905, that Matisse and Derain produced the first Fauve paintings. In *The Open Window* the inside wall and the casements are composed of broad, vertical stripes of vivid green, blue, purple, and orange, while the outside world is a brilliant pattern of small brushstrokes, ranging from stippled dots of green to broader strokes of pink, white, and blue in sea and sky. This diversity of paint handling, even in adjoining passages within the same picture, was typical of Matisse's early Fauve compositions. Between his painterly marks, Matisse left bare patches of canvas, reinforcing the impact of brushstrokes that have been freed from the traditional role of describing form in order to suggest an intense, vibrating light. By this date, the artist had already moved far beyond any of the Neo-Impressionists toward abstraction.

In Neo-Impressionism, as in Impressionism, the generalized, allover distribution of color patches and texture had produced a sense of atmospheric depth, at the same time that it also asserted the physical presence and impenetrability of the painting surface. Matisse, however, structured an architectural framework of facets and planes that are even broader and flatter than those of Cézanne, suppressing all sense of atmosphere; internal illumination, the play of light within a painting that suggests physical depth, is replaced with a taut, resistant skin of pigment that reflects the light. Rather than allowing the viewer to enter pictorial space, this tough, vibrant membrane of color and pattern draws the eye over and across, but rarely beyond, the picture plane. And even in the view through the window, the handling is so vigorously self-assertive that the scene appears to advance more than recede, as if to turn inside out the Renaissance conception of the painting as a simulacrum of a window open into the infinite depth of the real world. As presented by Matisse, the window and its sparkling view of a holiday marina become a picture within

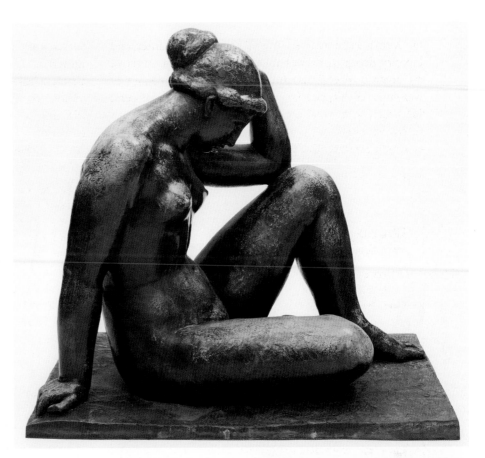

6.5 Aristide Maillol, *The Mediterranean*, 1902–05 (cast c. 1951–53). Bronze, 41 × 45 × 29¾" (104.1 × 114.3 × 75.6 cm). The Museum of Modern Art, New York.

a picture. This is a theme the artist often pursued, transforming it into a metaphor of the modernist belief that the purpose of painting was not to represent the perceptual world but rather to use visual stimuli to take the viewer beyond the perceptual reality—or the illusion of perceptual reality—that was the stock in trade of earlier Western art.

Shortly after exhibiting *The Open Window*, Matisse painted an audacious portrait of his wife. In *Portrait of Madame Matisse/The Green Line* (fig. 6.7), the sitter's face is dominated by a brilliant pea-green band of shadow dividing it from hairline to chin. At this point Matisse and his Fauve colleagues were building on the thesis put forward by Gauguin, the Symbolists, and the Nabis: that the artist is free to use color independently of natural appearance, building a structure of abstract color shapes and lines foreign to

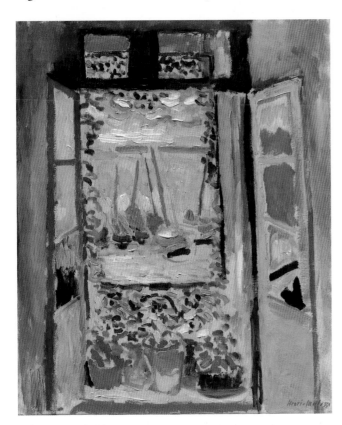

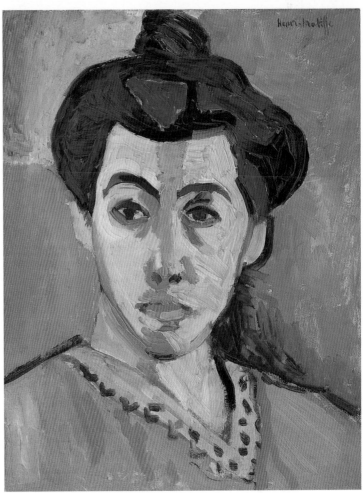

6.6 Henri Matisse, *The Open Window*, 1905. Oil on canvas, 21¾ × 18⅛" (55.2 × 46 cm). National Gallery of Art, Washington. Collection of Mr. and Mrs. John Hay Whitney, 1998. 74.7.

6.7 Henri Matisse, *Portrait of Madame Matisse/The Green Line*, 1905. Oil and tempera on canvas, 15⅞ × 12⅞" (40.3 × 32.7 cm). Statens Museum for Kunst, Copenhagen.

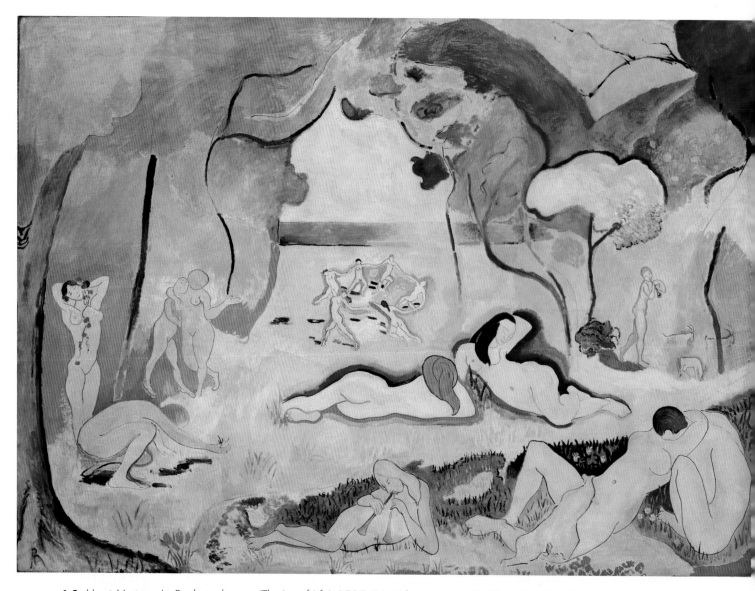

6.8 Henri Matisse, *Le Bonheur de vivre (The Joy of Life)*, 1905–06. Oil on canvas, 5' 8½" × 7' 9¾" (1.74 × 2.4 m). The Barnes Foundation, Merion, Pennsylvania.

the figure, tree, or still life that remains the basis of the structure. Perhaps Matisse's version was more immediately shocking because his subject was so simple and familiar, unlike the exotic scenes of Gauguin or the mystical fantasies of Redon, in which such arbitrary colorism seemed more acceptable. With its heavy, emphatic strokes and striking use of complementary hues, the painting is actually closest to portraits by Van Gogh (see fig. 3.28).

The artist's experiments with Poussinesque arcadian figure compositions climaxed in the legendary *Le Bonheur de vivre* (fig. **6.8**), a painting filled with diverse reminiscences of past art, from *The Feast of the Gods*, by Giovanni Bellini and Titian, to Persian painting, from prehistoric cave paintings to a composition by Ingres (see fig. 1.7). In this large work (it is nearly eight feet, or 2.5 m, wide), the artist has blended all these influences into a masterful arrangement of figures and trees in sinuous, undulating lines reminiscent of contemporary Art Nouveau design (see chapter 5). *Le Bonheur de vivre* is filled with a mood of sensual languor; figures cavort with Dionysian abandon in

a landscape that pulsates with rich, riotous color. Yet the figure groups are deployed as separate vignettes, isolated from one another spatially as well as by their differing colors and contradictory scales. As Matisse explained, *Le Bonheur de vivre* "was painted through the juxtaposition of things conceived independently but arranged together." He made several sketches for the work, basing his vision on an actual landscape at Collioure, which he painted in a lush sketch without figures that still contains some of the broken color patches of Neo-Impressionism. The circle of ecstatic dancers in the distance of *Le Bonheur de vivre*, apparently inspired by the sight of fishermen dancing in Collioure, became the central motif of Matisse's 1909–10 painting, *Dance (II)* (see fig. 6.23). *Le Bonheur de vivre* is an all-important, breakthrough picture; it was bought immediately by the American writer Gertrude Stein and her brother Leo, among the most adventurous collectors of avant-garde art at the time. It was through the Steins, in fact, that Matisse was eventually introduced to Picasso, who admired *Le Bonheur de vivre* in their apartment.

The Influence of African Art

In 1906 Matisse, Derain, and Vlaminck began to collect art objects from Africa, which they had first seen in ethnographic museums, and to adapt those forms into their art. Of all the non-Western artistic source material sought out by European modernists, none proved so radical or so far-reaching as the art of Africa. Modern artists appropriated the forms of African art in the hope of investing their work with a kind of primal truth and expressive energy, as well as a touch of the exotic, what they saw as the "primitive," or, in Gauguin's word, the "savage." Unlike the myriad other influences absorbed from outside contemporary European culture—Asian, Islamic, Oceanic, medieval, folk, and children's art—these African works were not only sculptural, as opposed to the predominantly pictorial art of Europe, but they also embodied values and conventions outside Western tradition and experience. Whereas even the most idealized European painting remained ultimately bound up with perceptual realities and the ongoing history of art itself, African figures did not observe classical proportions and contained no history or stories that Europeans understood. With their relatively large, mask-like heads, distended torsos, prominent sexual features, and squat, abbreviated, or elongated limbs, they impressed Matisse and his comrades with the powerful plasticity of their forms (mostly unbound by the literal representation of nature), their expressive carving, and their iconic force.

An early example of African influence in Matisse's art occurred most remarkably in *Blue Nude: Memory of Biskra* (fig. **6.9**), which, as the subtitle implies, was produced following the artist's visit to Biskra, a lush oasis in the North African desert. The subject of the painting—a reclining female nude—is a dynamic variation of a classic Venus pose, with one arm bent over the head and the legs flexed forward. Matisse had made the reclining nude central to *Le Bonheur de vivre*, and such was the interest it held for him that he then restudied it in a clay sculpture, a variation of which was later cast in bronze (fig. **6.10**). Now, working

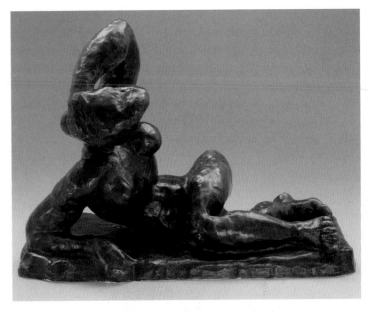

6.10 Henri Matisse, *Reclining Nude, I (Nu couché, I; Aurore)*, Collioure, winter 1906–07. Bronze, 13½ × 19¾ × 11¼" (34.3 × 50.2 × 28.6 cm). The Museum of Modern Art, New York.

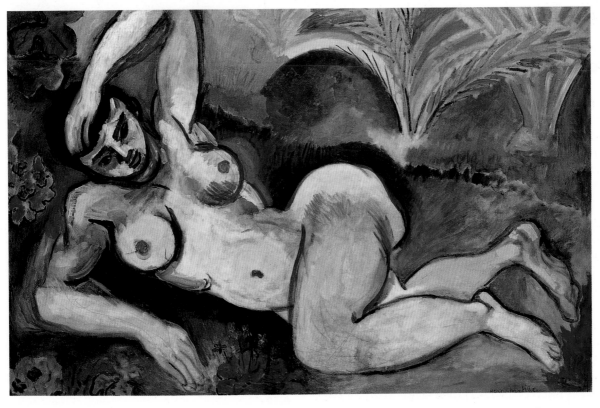

6.9 Henri Matisse, *Blue Nude: Memory of Biskra*, 1907. Oil on canvas, 36¼ × 56⅛" (92.1 × 142.5 cm). The Baltimore Museum of Art.

from memory and his own clay model, and evidently encouraged by the example of African sculpture, he abstracted his image further. These influences produced the bulbous exaggeration of breasts and buttocks; the extreme contrapposto that makes torso and hips seem viewed from different angles, or assembled from different bodies; the scarified modeling, or vigorously applied contouring in a brilliant, synthetic blue; and the mask-like character of the face. But however much these traits reveal the impact of African art, they have been translated from the plastic, freestanding, iconic sculpture of Africa into a pictorial expression by means of the Cézannism that Matisse had been cultivating all along. This can be seen in the dynamic character of the whole, in which rhyming curves and countercurves, images and after-images, and interchanges of color and texture make figure and ground merge into one another.

In its theme, *Blue Nude* belongs to the tradition in nineteenth-century painting of the odalisque, or member of a North African harem (see fig. 1.7). This subject of the exotic, sexually available woman, exploited by Delacroix, Ingres, and countless lesser Salon artists, was destined for visual consumption by a predominantly heterosexual male audience. But the level of abstraction Matisse imposes on his subject, as with Cézanne's bathers, moves the figure beyond the explicitly erotic. Responding to the charges of ugliness made against *Blue Nude*, Matisse said: "If I met such a woman in the street, I should run away in terror. Above all, I do not create a woman, I make a picture." Inspired by the example of what he called the "invented planes and proportions" of African sculpture, Matisse used these sources in his own subtle, reflective fashion, assimilating and synthesizing until they are scarcely discernible. Another example of this experimentation is his small *Two Women* (fig. **6.11**), which consists of two figures embracing, one front view, the other back view. Although it may have some connection with Early Renaissance exercises in anatomy in which artists depicted athletic nudes in front and back views, its blocky, rectangular structure has a closer connection with some frontalized examples of African sculpture. This influence is not surprising, given that Matisse began to collect such sculpture shortly before he made *Two Women*, which is based on a photograph from an ethnographic magazine depicting two Tuareg women from North Africa.

With *Le Luxe II*, a work of 1907–08 (fig. **6.12**), Matisse signaled a move away from his Fauve production of the preceding years. It is a large painting, nearly seven feet (2.1 m) tall, which Matisse elaborately prepared with full-scale charcoal and oil sketches, as was customary for large-scale academic commissions. The oil sketch *Le Luxe I* is much looser in execution, and closer to Fauvism than are the flat, unmodulated zones of color in the final version. Though *Le Luxe II* explores a theme similar to that of *Luxe, calme et volupté* and *Le Bonheur de vivre* (see figs. 6.4, 6.8), the figures are now life-size and dominate the landscape.

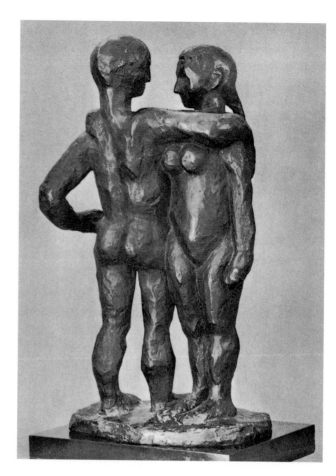

6.11 Henri Matisse, *Two Women*, 1907. Bronze, 18¼ × 10½ × 7⅞" (46.6 × 25.6 × 19.9 cm). Hirshhorn Museum and Sculpture Garden, Smithsonian Institution, Washington, D.C.

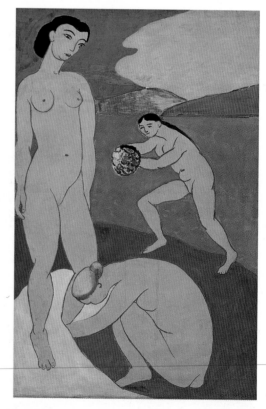

6.12 Henri Matisse, *Le Luxe II*, 1907–08. Casein on canvas, 6' 10½" × 4' 6" (2.1 × 1.38 m). Statens Museum for Kunst, Copenhagen.

Coloristically, *Le Luxe II* is far more subdued, relying on areas of localized color bound by crisp lines. Despite the artist's abandonment of perspective, except for the arbitrary diminution of one figure, and modeling in light and shadow, the painting is not merely surface decoration. The figures, modeled only by the contour lines, have substance; they exist and move in space, with the illusion of depth, light, and air created solely by flat color shapes that are, at the same time, synonymous spatially with the picture plane. The actual subject of the painting remains elusive. The crouching woman, a beautiful, compact shape, seems to be tending to her companion in some way (perhaps drying her feet?), while another rushes toward the pair, proffering a bouquet of flowers. Matisse may have implied a mythological theme, such as Venus' birth from the sea, but, typically, he only hints at such narratives. Even so, the monumentality of the figure, and its evocation of the mythological subjects that characterized Salon art for the previous two centuries, indicate that Matisse perceives his project to be an extension of the French artistic tradition rather than a violent rupture with it. In this way, Matisse's endeavor might be seen as closer to Manet's than that of the Impressionists, in that he is seeking deliberately to enter into a conversation with the chief standard-bearer of French academicism, Nicolas Poussin.

"Wild Beasts" Tamed: Derain, Vlaminck, and Dufy

André Derain (1880–1954) met the older Matisse at Carrière's atelier in 1900, as already noted, and was encouraged by him to proceed with his career as a painter. He already knew Maurice de Vlaminck, whom Derain in turn had led from his various careers as violinist, novelist, and bicycle racer into the field of painting. Unlike Vlaminck, Derain was a serious student of the art of the museums who, despite his initial enthusiasm for the explosive color

of Fauvism, was constantly haunted by a more ordered and traditional concept of painting.

Although Derain's Fauve paintings embodied every kind of painterly variation, from large-scale Neo-Impressionism to free brushwork, most characteristic, perhaps, are works such as *London Bridge* (fig. **6.13**). It was painted during a trip commissioned by the dealer Ambroise Vollard, who wanted Derain to make paintings that would capture the special atmosphere of London (Claude Monet's many views of the city had just been successfully exhibited in Paris). To compare Derain's painting with the Impressionist's earlier work, *Bridge at Argenteuil* (see fig. 2.31), is to understand the transformations art had undergone in roughly thirty years, as well as the fundamental role Impressionism had played in those transformations. While in London, Derain visited the museums, studying especially the paintings of Turner (see fig. 1.15), Claude, and Rembrandt, as well as African sculpture. Unlike Monet's view of the Seine, Derain's painting of the Thames is a brilliantly synthetic color arrangement of harmonies and dissonances. The background sky is rose-pink; the buildings silhouetted against it are complementary green and blue. By reiterating large color areas in the foreground and background and tilting the perspective, Derain delimits the depth of his image. In the summer of 1906, several months after the trip to London, Derain spent time in L'Estaque, the famous site of paintings by Cézanne (see fig. 3.6). But his grand panorama of a bend in the road (fig. **6.14**) takes its cue from Gauguin (see figs. 3.23, 3.26) in its brilliant palette and the evocation of an idealized realm far from the urban bustle of London's waterways. With this work Derain travels to new extremes of intensity and anti-naturalism in his color, a world in which the hues of a single tree can shift dramatically half a dozen times.

The career of **Maurice de Vlaminck** (1876–1958) presents many parallels with Derain's, even though the artists were so different in personality and in their approach to the art of painting. Impulsive and exuberant, Vlaminck was

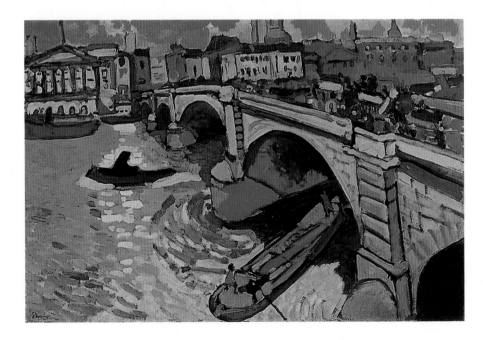

6.13 André Derain, *London Bridge*, 1906. Oil on canvas, 26 × 39" (66 × 99.1 cm). The Museum of Modern Art, New York.

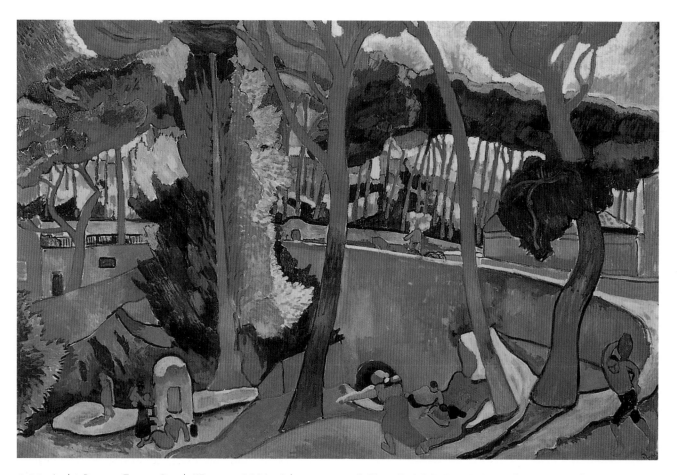

6.14 André Derain, *Turning Road, L'Estaque*, 1906. Oil on canvas, 4' 3" × 6' 4¾" (1.3 × 1.9 m). The Museum of Fine Arts, Houston.

a self-taught artist with anarchist political leanings who liked to boast of his contempt for the art of museums. From the time he met Derain and turned to painting, he was enraptured with color. Thus the Van Gogh exhibition at the Bernheim-Jeune Gallery in Paris in 1901 was a revelation to him. At the Salon des Indépendants in the same year, Derain introduced him to Matisse, but it was not until 1905, after exposure to the work of both artists, that Vlaminck's work reached its full potential, despite his false claims to have been the leader of the Fauves. Van Gogh remained his great inspiration, and in his Fauve paintings Vlaminck characteristically used the short, choppy brushstrokes of the Dutch painter to attain a comparable kind of coloristic dynamism. His small but dramatic *Portrait of Derain* (fig. **6.15**) is one of several likenesses the Fauves made of one another. Vlaminck has here moved to a boldly conceived image in which Derain's face is predominantly an intense, brilliant red with black contours, yellow highlights, and a few strokes of contrasting green shadow along the bridge of the nose, recalling Matisse's *Portrait of Madame Matisse/The Green Line* (see fig. 6.7).

Raoul Dufy (1877–1953) was shocked out of his reverence for the Impressionists and Van Gogh by his discovery of Matisse's 1905 painting *Luxe, calme et volupté*, when, he said, "Impressionist realism lost all its charm." In a sense, he remained faithful to this vision and to Fauve color throughout his life. His *Street Decked with Flags, Le Havre* (fig.

6.15 Maurice de Vlaminck, *Portrait of Derain*, 1906. Oil on cardboard, 10¾ × 8¾" (27.3 × 22.2 cm). The Metropolitan Museum of Art, New York.

6.16) takes up a subject celebrated by the Impressionists, but the bold, close-up view of the flags imposes a highly abstracted geometric pattern on the scene.

After 1908, Dufy experimented with a modified form of Cubism, but he was never really happy in this vein. Gradually he returned to his former loves—decorative color and elegant draftsmanship—and formulated a personal style based on his earlier Fauvism. His pleasurable subjects were the horse races and regattas of his native Le Havre and nearby Deauville, the nude model in the studio, and the view from a window to the sea beyond. He maintained a rainbow, calligraphic style until the end of his life, applying it to fabrics, theatrical sets, and book illustrations as well as paintings.

For Matisse, Fauvism was only a beginning from which he went on to a rich, productive career spanning the first half of the twentieth century. Derain and Vlaminck, however, did little subsequently that had the vitality of their Fauve works. It is interesting to speculate on why these young men should briefly have outdone themselves, but the single overriding explanation is probably the presence of Henri Matisse—older than the others, more mature and, ultimately, more gifted as an artist. But in addition to Matisse and Rouault (see below), there was also Georges Braque, who, after discovering his first brief and relatively late inspiration in Fauvism, went on to restudy Cézanne, with consequences for twentieth-century art so significant that they must await a subsequent chapter on Cubism.

Religious Art for a Modern Age: Georges Rouault

Georges Rouault (1871–1958) exhibited three works in the "Fauve Salon" of 1905 and thus is associated with the work of the group, although his paintings were not actually shown in the room with theirs. Throughout his long and productive career, Rouault remained deeply religious, deeply emotional, and profoundly moralistic. He came from a family of craftsmen, and he himself was first apprenticed to a stained-glass artisan, an experience that would have a lasting effect on his work. In the studio of Gustave Moreau he met Matisse and other future Fauves, and soon became Moreau's favorite pupil, for he followed most closely Moreau's own style and precepts.

By 1903 Rouault's art, like that of Matisse and others around him, was undergoing profound changes, reflecting a radical shift in his moral and religious outlook. Like his friend the Catholic writer and propagandist Léon Bloy, Rouault sought subjects to express his sense of indignation and disgust over the evils that, as it seemed to him, permeated bourgeois society. The prostitute became his symbol of this rotting society. Rouault invited prostitutes to pose in his studio, painting them with attributes such as stockings or corsets to indicate their profession. In many of these studies, done in watercolor, the woman is set within a confined space, to focus attention on the figure (fig. **6.17**). Some of the poses and the predominantly blue hues of

6.16 Raoul Dufy, *Street Decked with Flags, Le Havre*, 1906. Oil on canvas, 31⅞ × 25⅞" (81 × 65.7 cm). Musée National d'Art Moderne, Paris.

6.17 Georges Rouault, *Prostitute before a Mirror*, 1906. Watercolor on cardboard, 27⅝ × 20⅞" (70.2 × 53 cm). Musée National d'Art Moderne, Centre National d'Art et de Culture Georges Pompidou, Paris.

these watercolors stem in part from Rouault's admiration for Cézanne. The women's yellow-white bodies, touched with light-blue shadows, are modeled sculpturally with heavy, freely brushed outlines. Here the mask-like grimace of the face is reflected in the mirror, like a twisted paraphrase of the classical Venus, who contemplates her beauty in a looking glass. Absent from Rouault's treatment of this subject is either the detachment of Degas or the sympathetic complicity of Toulouse-Lautrec. His contortion of the figure and aggressive handling result in a decidedly bleak view of Paris's *demi-monde*.

Rouault's moral indignation further manifested itself, like Daumier's, in vicious caricatures of judges and politicians. His counterpoint to the corrupt prostitute was the figure of the circus clown, sometimes the carefree nomad beating his drum, but more often a tragic, lacerated martyr. As early as 1904 he had begun to depict subjects taken directly from the Gospels—the Crucifixion, Jesus and his disciples, and other scenes from the life of Christ. He represented the figure of Christ as a tragic mask of the Man of Sorrows, deriving directly from a crucified Christ by Grünewald or a tormented Christ by Bosch. Rouault's

religious and moral sentiments are perhaps most movingly conveyed in a series of fifty-eight prints, titled *Miserere*, commissioned by his dealer Vollard (whose heirs the artist later had to sue to retrieve the contents of his studio) (fig. **6.18**). For years, Rouault devoted himself to the production of the etchings and aquatints of *Miserere* (Latin for "Have Mercy"), which were printed between 1914 and 1927, but not published until 1948, when the artist was seventy-seven. Some of the images and accompanying text are forthrightly Christian, while others can be interpreted more broadly as commentaries on contemporary social conditions and World War I, recalling Goya's earlier series *Disasters of War* (see fig. 1.9). Technically, the prints are masterpieces of graphic compression. The black tones, worked over and over again, have the depth and richness of his most vivid oil colors.

The characteristics of Rouault's later style are seen in *The Old King* (fig. **6.19**). The design has become geometrically abstract in feeling, and colors are intensified to achieve the glow of stained glass, a medium with which he was familiar from his early apprenticeship. A thick black outline is used to define the rather Egyptian-style profile

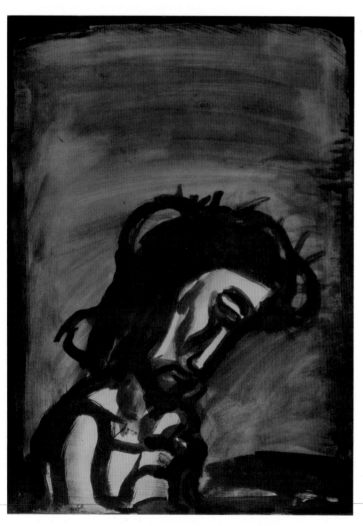

6.18 Georges Rouault, *Jesus Reviled*, from *Miserere*, 1914–27. Aquatint, etching, drypoint. Sewanee: The University of the South Special Collections, Permanent Collection, and University Archives.

6.19 Georges Rouault, *The Old King*, 1916–36. Oil on canvas, 30¼ × 21¼" (76.8 × 54 cm). Carnegie Museum of Art, Pittsburgh.

of the king's head and the square proportions of his torso. Paint is applied heavily with the underpainting glowing through, in the manner of Rembrandt. Rouault also captures some of Rembrandt's mood in this serene image of a world-weary ruler, who clutches a flower in his hand, one of the few traces of white in the entire painting. Although Rouault never entirely gave up the spirit of moral indignation expressed in the virulent satire that marked his early works, the sense of calm and the hope of salvation in the later paintings mark him as one of the few authentic religious painters of the modern world.

The *Belle Époque* on Film: the Lumière Brothers and Lartigue

Developments in photography contemporary with the years of Fauvism include color processes, after one was finally made commercially feasible in 1907 by **Auguste** and **Louis Lumière** (1862–1954; 1864–1948) of Lyons, France (fig. **6.20**). By coating one side of a glass plate with a mixture of tiny, transparent starch particles, each dyed either red, green, or blue (the three primary photographic colors), and the other side with a thin panchromatic emulsion, the Lumières created a light-sensitive plate that, once exposed, developed, and projected on a white ground, reproduced a full-color image of the subject photographed. The Autochromes—as the Lumières called the slides made by their patented process—rendered images in muted tonalities with the look of a fine-grained texture, an effect that simply heightened the inherent charm of the bright subject matter. This was especially true for a Fauve generation still entranced with Neo-Impressionism. Their invention was immediately taken up by professional photographers, especially the so-called Pictorialists (see fig. 2.49), as well as amateurs around the world. (See also the related subject of *Early Motion Pictures*, right.)

Dufy's privileged, Belle Époque world of regattas and racecourses was also celebrated by the French contemporary

Early Motion Pictures

Along with color photography, motion pictures were proliferating during the first decade of the twentieth century. The modern fascination with capturing motion on film led Eadweard Muybridge to develop in the 1870s a means of photographing a rapid sequence of actions (see fig. 2.36). Thomas Edison, following a visit to Muybridge's laboratory, took the idea even further, recording a series of images on a continuous strip of film. This film could then be viewed using Edison's Kinetoscope, through which a single viewer watched the short film. The Kinetoscope made its public debut in 1894; Kinetoscope "parlors" were soon introduced throughout North America and Europe. Among those impressed by the technology—and relieved by Edison's failure to secure an international patent on the device—were the brothers Auguste and Louis Lumière (see fig. 6.20). They felt that the "peep show" experience of the Kinetoscope limited its appeal. The Lumière brothers conceived motion-picture viewing in terms of a tradition of visual spectacle long popular in Europe. Magic lantern shows, which date back to the seventeenth century, used an oil-fueled lamp to project glass slides onto a screen. By moving, interchanging, or superimposing slides, the effect of motion could be simulated. Another popular form of visual spectacle was the diorama, invented by Louis Daguerre in 1822 (see discussion of Daguerre in chapter 2). Dioramas were specially built theaters in which huge paintings executed on scrims were dramatically backlit to create breathtaking scenes that seemed to move and change before the viewers' eyes. With this legacy in mind, in 1895 the Lumière brothers developed a projector based on Edison's Kinetoscope. Quickly copied, the invention led to the opening of permanent movie theaters or cinemas in the first years of the twentieth century. They were known as "nickelodeons" in the United States, since patrons paid five cents to view films that generally lasted from five to fifteen minutes.

6.20 Lumière brothers, *Young Lady with an Umbrella*, 1906–10. Autochrome photograph. Fondation Nationale de la Photographie, Lyons, France.

6.21 Jacques-Henri Lartigue, *In My Room: Collection of My Racing Cars*, 1905. Gelatin silver print, 5⅜ × 7" (13.7 × 17.8 cm).

photographer **Jacques-Henri Lartigue** (1894–1986), once the fast-action handheld camera had been introduced in 1888 and progressively improved. Such developments encouraged experimentation and enabled this affluent child artist (he began making photographs at age seven) to capture not only his family and friends at their pleasures, but also the gradual advent of such twentieth-century phenomena as auto races and aviation. At his death in 1986 Lartigue, who was a painter professionally, left behind a huge number of photographs and journals that document a charmed life of holidays, swimming holes, and elegantly clad ladies and gentlemen. He was eleven when he aimed his camera at the toy cars in his bedroom (fig. **6.21**), and his image adopts a child's angle on the world. The tiny cars, at eye level, take on strange dimensions, the whole compounded by the mysteriously draped fireplace that looms above them. Owing to his view of photography as a pursuit carried on for private satisfaction and delight, Lartigue did not become generally known until a show at New York's Museum of Modern Art in 1963, when his work took an immediate place in the history of art as a direct ancestor of the "straight" but unmistakable vision of such photographers as Brassaï and Henri Cartier-Bresson.

Modernism on a Grand Scale: Matisse's Art after Fauvism

Fauvism was a short-lived but tremendously influential movement that had no definitive conclusion, though it had effectively drawn to a close by 1908. The direction of Matisse's art explored in *Le Luxe II* is carried still further in *Harmony in Red* (fig. **6.22**), a large painting destined for the Moscow dining room of Sergei Shchukin, his important early patron who, along with Ivan Morozov, is the reason Russian museums are today key repositories of Matisse's greatest work. This astonishing painting was begun early in 1908 as *Harmony in Blue* and repainted in the fall, in a radically different color scheme. Here Matisse returned to the formula of *Dinner Table*, which he had painted in 1896–97 (see fig. 6.1). A comparison of the two canvases dramatically reveals the revolution that had occurred in this artist's works—and in fact in modern painting—during a ten-year period. Admittedly, the first *Dinner Table* was still an apprentice piece, a relatively conventional exploration of Impressionist light and color and contracted space, actually more traditional than paintings executed by the Impressionists twenty years earlier. Nevertheless, when submitted to the Salon de la Nationale it was severely criticized by the conservatives as being tainted with Impressionism.

In *Harmony in Red* we have moved into a new world, less empirical and more abstract than anything ever envisioned by Gauguin, much less the Impressionists. The space of the interior is defined by a single unmodulated area of red, the flatness of which is reinforced by arabesques of plant forms that flow across the walls and table surface. These patterns were actually derived from a piece of decorative fabric that Matisse owned. Their meandering forms serve to confound any sense of volumetric space in the painting and to create pictorial ambiguities by playing off the repeated pattern of flower baskets against the "real" still lifes on the table. This ambiguity is extended to the view through the window of abstract tree and plant forms silhouetted against a green ground and blue sky. The red

6.22 Henri Matisse, *Harmony in Red (The Dessert)*, 1908. Oil on canvas, 5' 10⅞" × 7' 2⅝" (1.8 × 2.2 m). The Hermitage Museum, St. Petersburg.

building in the extreme upper distance, which reiterates the color of the room, in some manner establishes the illusion of depth in the landscape, yet the entire scene, framed by what may be a window sill and cut off by the picture edge like other forms in the painting, could also itself be a painting on the wall. In essence Matisse has again—and in an even greater degree than in *Le Luxe II*—created a new, tangible world of pictorial space through color and line.

In two huge paintings of the first importance, *Dance (II)* and *Music*, both of 1909–10 (figs. **6.23**, **6.24**) and both commissioned by Shchukin, Matisse boldly outlined large-scale figures and isolated them against a ground of intense color. The inspiration for *Dance* has been variously traced to Greek vase painting or peasant dances. Specifically, the motif was first used by Matisse, as we have seen, in the background group of *Le Bonheur de vivre*. In *Dance*, the colors have been limited to an intense green for

the earth, an equally intense blue for the sky, and brick-red for the figures, which are sealed into the foreground by the color areas of sky and ground, and by their proximity to the framing edge and their great size within the canvas. They nevertheless dance ecstatically in an airy space created by these contrasting juxtaposed hues and by their own modeled contours and sweeping movements. The depth and intensity of the colors change in different lights, at times setting up visual vibrations that make the entire surface dance. *Music* is a perfect foil for the kinetic energy of *Dance*, in the static, frontalized poses of the figures arranged like notes on a musical staff, each isolated from the others to create a mood of trance-like withdrawal. Matisse's explanation of Fauvism as "the courage to return to a 'purity of means'" still holds true here. In both paintings the arcadian worlds of earlier painters (see fig. 1.14) have been transformed into an elemental realm beyond the

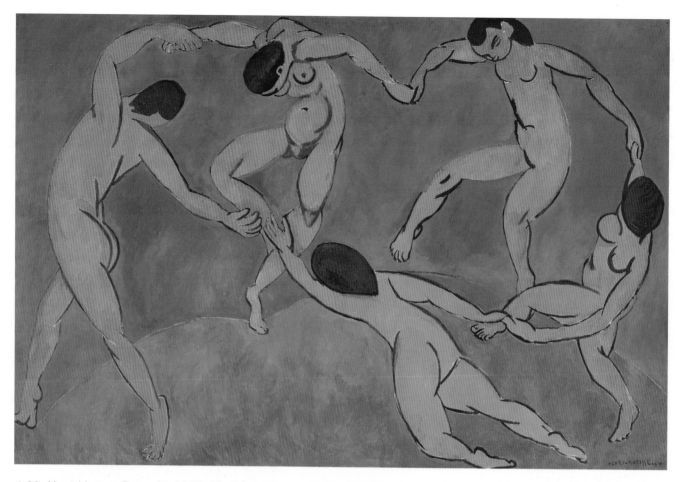

6.23 Henri Matisse, *Dance (II)*, 1909–10. Oil on canvas, 8' 5⅝" × 12' 9½" (2.6 × 3.9 m). The Hermitage Museum, St. Petersburg.

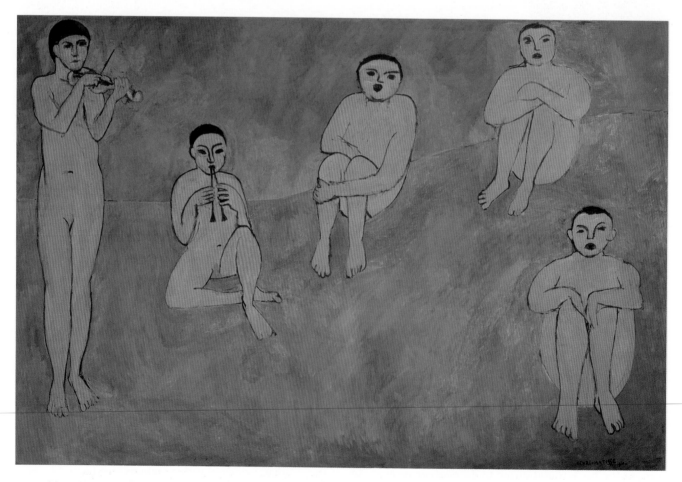

6.24 Henri Matisse, *Music*, 1909–10. Oil on canvas, 8' 5⅝" × 12' 9½" (2.6 × 3.9 m). The Hermitage Museum, St. Petersburg.

specificities of time and place. When they were exhibited in the 1910 Salon d'Automne, these two extraordinary paintings provoked little but negative and hostile criticism, and Shchukin at first withdrew his commission, though he soon changed his mind. These monumental works further show Matisse locating his art in relation to the grand classical tradition. Modernist in conception, they nevertheless aligned him with the elite world of wealthy patronage that had previously sustained (and indeed still continued to sustain) conventional academic art. Other modernist artists—notably Picasso—were to tread a comparable path, simultaneously becoming respected public figures while retaining, at least to a degree, the avant-garde ability to disconcert conventionally minded viewers.

In *The Red Studio* (fig. **6.25**), Matisse returned to the principle of a single, unifying color that he had exploited in *Harmony in Red*. The studio interior is described by a uniform area of red, covering floor and walls. The space is given volumetric definition only by a single white line that indicates the intersection of the walls and floor, and by the paintings and furniture lined up along the rear wall. Furnishings—table, chair, cupboard, and sculpture stands—are dematerialized, ghostlike objects outlined in white lines. The tangible accents are the paintings of the artist, hanging on or stacked against the walls, and (in the foreground) ceramics, sculptures, vase, glass, and pencils. (*Le Luxe II* can be seen at the upper right.)

Matisse's most ambitious excursion in sculpture was the creation of the four great *Backs*, executed between 1909 and c. 1930 (fig. **6.26**). While most of his sculptures are small-scale, these monumental reliefs are more than six feet (1.8 m) high. They are a development of the theme stated in *Two Women*, now translated into a single figure in bas-relief, seen from the back. But Matisse has here resorted to an upright, vertical surface like that of a painting on which to sculpt his form. *Back I* is modeled in a relatively representational manner, freely expressing the modulations of a muscular back, and it reveals the feeling he had for sculptural form rendered on a monumental scale. *Back II* is simplified in a manner reflecting the artist's interest in Cubism around 1913. *Back III* and *Back IV* are so reduced to their architectural components that they almost become abstract sculpture. The figure's long ponytail becomes a central spine that serves as a powerful axis through the

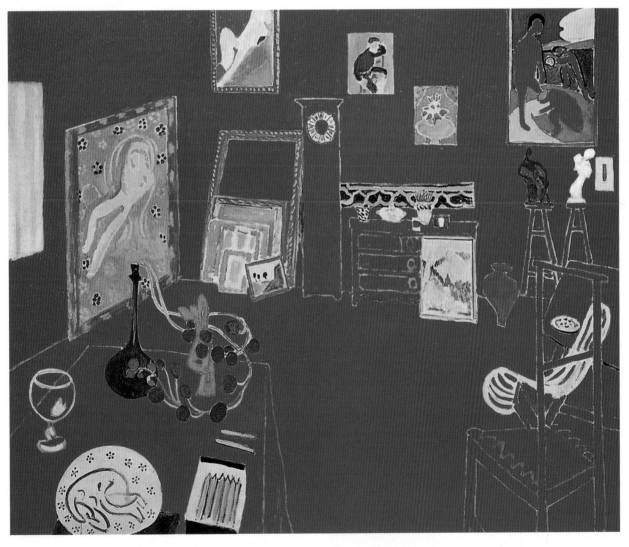

6.25 Henri Matisse, *The Red Studio*, Issy-les-Moulineaux, 1911. Oil on canvas, 5' 11¼" × 7' 2¼" (1.81 × 2.2 m). The Museum of Modern Art, New York.

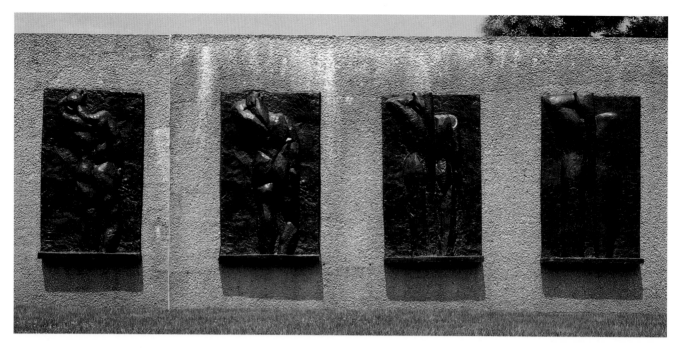

6.26 Henri Matisse, From left to right: *Back I*, 1909. Bronze relief, 74 × 44 × 6½" (188.9 × 113 × 16.5 cm). *Back II*, 1913. Bronze, 74 × 47 × 8" (188.6 × 119.4 × 20.3 cm). *Back III*, 1916–17. Bronze, 74 × 44¼ × 6" (188 × 112.4 × 15.2 cm). *Back IV*, c. 1930. Bronze, 74 × 45 × 7" (188 × 114.3 × 17.8 cm). Hirshhorn Museum and Sculpture Garden, Smithsonian Institution, Washington, D.C.

center of the composition. Here, as in *The Blue Nude*, Matisse has synthesized African and Cézannesque elements, this time, however, in order to acknowledge, as well as resist, the formal discoveries made by the Cubists.

Matisse's other major effort in sculpture was a series of five heads of a woman, done between 1910 and 1916. *Jeannette I* and *Jeannette II* are direct portraits done from life in the freely expressive manner of late Rodin bronzes. But with *Jeannette III*, *Jeannette IV*, and *Jeannette V* (fig. **6.27**), he worked from his imagination, progressively transforming the human head first into an expressive study, exaggerating all the features, and then into a geometric organization of shapes. In Matisse's work, serial sculptures such as the *Backs* and the *Jeannettes* do not necessarily constitute a set of progressive

6.27 Henri Matisse, *Jeannette V* (Jeanne Vaderin, 5th state), Issy-les-Moulineaux, 1916. Bronze, 22⅞ × 8⅜ × 10⅝" (58.1 × 21.3 × 27.1 cm). The Museum of Modern Art, New York.

steps toward the perfection of an idea. Rather, they are multiple but independent states, each version a definitive solution in and of itself.

Forms of the Essential: Constantin Brancusi

Matisse's experimentation with the distillation of form, with the interaction of positive and negative space, and with non-Western influences bears kinship with the work of **Constantin Brancusi** (1876–1957), whose sculpture, like Matisse's post-Fauvist painting, is difficult to link to a particular school or movement. Born to peasants in Romania, he left home at the age of eleven. Between 1894 and 1898 he was apprenticed to a cabinetmaker and studied in the provincial city of Craiova, and then at the Bucharest Academy of Fine Arts. In 1902 he went to Germany and Switzerland, arriving in Paris in 1904. After further studies at the École des Beaux-Arts under the sculptor Antonin Mercié, he began exhibiting, first at the Salon de la Nationale and then at the Salon d'Automne. Impressed by his contributions to the 1907 Salon d'Automne, Rodin invited him to become an assistant. Brancusi stayed only a short time. As he later declared, "Nothing grows under the shade of great trees."

The sculpture of Brancusi is in one sense isolated, in another universal. He worked with few themes, never really deserting the figure, but he touched, affected, and influenced most of the major strains of sculpture after him. From the tradition of Rodin's late studies came the figure *Sleep*, in which the realistic form of a shadowed face appears

6.28 Constantin Brancusi, *Sleeping Muse I*, 1909–10. Marble, 7 × 11½ × 8" (17.8 × 29.2 × 20.3 cm). Hirshhorn Museum and Sculpture Garden, Smithsonian Institution, Washington, D.C.

to sink into the matrix of the marble. The theme of the *Sleeping Muse* was to become an obsession with Brancusi, and he played variations on it for some twenty years. In the next version (fig. **6.28**), and later, the head was transformed into an egg shape, with the features lightly but

sharply cut from the mass. As became his custom with his basic themes, he presented this form in marble, bronze, and plaster, almost always with slight adjustments that turned each version into a unique work.

In a subsequent work, the theme was further simplified to a teardrop shape in which the features largely disappeared, with the exception of an indicated ear. To this 1911 piece he gave the name *Prometheus*. The form in turn led to *The Newborn*, in which the oval is cut obliquely to form the screaming mouth of the infant or, when viewed from another angle, to suggest swaddling clothes. He returned to the polished egg shape in the ultimate version, entitled *The Beginning of the World* (fig **6.29**), closely related to a contemporary work called *Sculpture for the Blind*. In this, his ultimate statement about creation, Brancusi eliminated all reference to anatomical detail. A similar work, as well as *The Newborn*, can be seen at the bottom of Brancusi's photograph of his studio, taken around 1927 (fig. **6.30**). The artist preferred that his work be discovered in the context of his own studio, amid tools, marble dust, and incomplete works. He was constantly rearranging it, grouping the sculptures into a carefully staged environment. Brancusi left the entire content of his studio to the French state; a reconstruction of it is in the Georges Pompidou Center in Paris. The artist took

6.29 Constantin Brancusi, *The Beginning of the World*, c. 1920. Marble, metal, and stone, 29⅝ × 11⅜" (75.2 × 28.9 cm). Dallas Museum of Art.

6.30 Constantin Brancusi, *The Studio*, c. 1927. Photograph, mounted on glass, 23¾ × 19¾" (60.3 × 50.2 cm). Pascal Sernet Fine Art, London.

photographs of his own works (a privilege he rarely allowed others) in order to disseminate their images beyond Paris and to depict his sculptures in varying, often dramatic light. His many pictures of corners of his studio convey the complex interplay of his sculptural shapes and the cumulative effect of his search for ideal form. "Why write [about my sculptures]?" he once said. "Why not just show the photographs?"

This analysis of the egg was only one of a number of related themes that Brancusi continued to follow, with a hypnotic concentration on creation, birth, life, and death. In 1912 he made his first marble portrait of a young Hungarian woman named Margit Pogany, who posed several times in his studio. He portrayed her with enormous oval eyes and hands held up to one side of her face. This form was developed further in a number of drawings and in later variations in marble and polished bronze, in which Brancusi refined and abstracted his original design, omitting the mouth altogether and reducing the eyes to an elegant, arching line of a brow that merges with the nose. *Torso of a Young Man* (fig. **6.31**) went as far as Brancusi ever did in the direction of geometric form. In this polished bronze from 1924, he abstracted the softened, swelling lines of anatomy introduced in his earlier wood versions of the sculpture into an object of machine-like precision. Brancusi was clearly playing on a theme of androgyny here, for while the *Torso* is decidedly phallic, it could also constitute an interpretation of female anatomy.

The subjects of Brancusi were so elemental and his themes so basic that, although he had few direct followers, little that happened subsequently in sculpture seems foreign to him. *The Kiss*, 1916 (fig. **6.32**), depicts with the simplest of means an embracing couple, a subject Brancusi had first realized in stone in 1909. Although this had been the subject of one of Rodin's most famous marbles, in the squat, blockish forms of *The Kiss* Brancusi made his break with the Rodinesque tradition irrefutably clear. He was also aware of developments in Cubist sculpture, as well as works in a primitivist vein, such as the crudely carved wooden or stone figures of Derain (fig. **6.33**).

The artist was particularly obsessed with birds and the idea of conveying the essence of flight. For over a decade he progressively streamlined the form of his 1912 sculpture *Maiastra* (or "master bird," from Romanian folklore), until he achieved the astonishingly simple, tapering form of *Bird in Space* (fig. **6.34**). The image ultimately became less the representation of a bird's shape than that of a bird's trajectory through the air. Brancusi designed his own bases

6.31 Constantin Brancusi, *Torso of a Young Man*, 1924. Polished bronze, 18 × 11 × 7" (45.7 × 28 × 17.8 cm), stone and wood base, height 40⅜" (102.6 cm). Hirshhorn Museum and Sculpture Garden, Smithsonian Institution, Washington, D.C.

6.32 Constantin Brancusi, *The Kiss*, 1916. Limestone, 23 × 13 × 10" (58.4 × 33 × 25.4 cm). Philadelphia Museum of Art.

and considered them an integral part of his sculpture. In *Bird in Space*, the highly polished marble bird (he also made bronze versions) fits into a stone cylinder that sits atop a cruciform stone base. This, in turn, rests on a large X-shaped wooden pedestal. He made several variations on these forms, such as that designed for *Torso of a Young Man*. These bases augment the sense of soaring verticality of the bird sculptures. In addition, they serve as transitions between the mundane physical world and the spiritual realm of the bird, for Brancusi sought a mystical fusion of the disembodied light-reflecting surfaces of polished marble or bronze and the solid, earthbound mass of wood. He said, "All my life I have sought the essence of flight. Don't look for mysteries. I give you pure joy. Look at the sculptures until you see them. Those nearest to God have seen them."

In his wood sculptures, although he occasionally strove for the same degree of finish, Brancusi usually preferred a primitive, roughed-out totem. In *King of Kings* (fig. **6.35**), which he had previously titled *The Spirit of Buddha*, reflecting his interest in Eastern spirituality, the great, regal shape comprises superimposed forms that are reworkings of the artist's wooden pedestals. Brancusi intended this sculpture for a temple of his design in India, commissioned

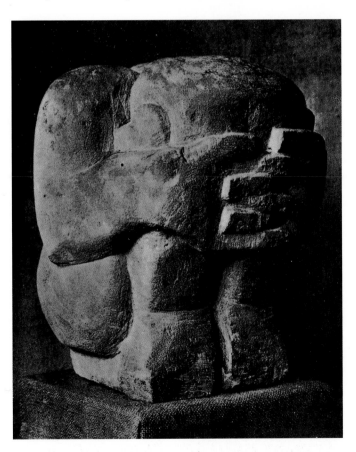

6.33 André Derain, *Crouching Man*, 1907. Stone, 13 × 11" (33 × 27.9 cm). Galerie Louise Leiris, Paris.

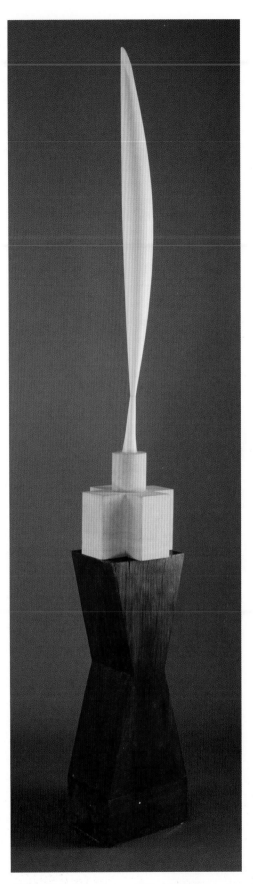

6.34 Constantin Brancusi, *Bird in Space*, 1925. Marble, stone, and wood, 71⅝ × 5⅜ × 6⅜" (181.9 × 13.7 × 16.2 cm), stone pedestal 17⅝ × 16⅜ × 16⅜" (44.8 × 41.6 × 41.6 cm), wood pedestal 7¾ × 16 × 13⅜" (19.7 × 40.6 × 34 cm). National Gallery of Art, Washington, D.C.

by the Maharajah of Indore, who owned three of the artist's *Birds in Space*. The temple was never built. In fact, Brancusi's only outdoor work on a vast scale was a sculptural ensemble installed in the late 1930s in Tîrgu-Jiu, Romania, not far from his native village. This included the immense cast-iron *Endless Column* (fig. **6.36**), which recalls ancient obelisks but also draws upon forms in Romanian folk art. The rhomboid shapes of *Endless Column* also began as socle (pedestal) designs that were, beginning in 1918, developed as free-standing sculptures. Wood versions of the sculpture can be seen in Brancusi's photograph of his studio (see fig. 6.30). *Endless Column* was the most radically abstract of his sculptures, and its reliance upon repeated modules became enormously important for Minimalist artists of the 1960s.

That Brancusi sought to elicit universal, transcendent experiences through his sculpture speaks to a certain optimism about humanity's essential nature. Feelings of "pure joy" are, presumably, accessible to anyone who opens him- or herself up to the experience. Brancusi's hopeful views were not, of course, shared by all artists at this time.

Many viewed the conditions generated by modernity with suspicion or disgust. Some of the most compelling visual manifestations of these concerns would come through the work of the German Expressionists. Just as engaged with non-Western art as Brancusi and just as inclined to attribute essential characteristics to all of humanity, the German Expressionists offered a radically different image of the human condition.

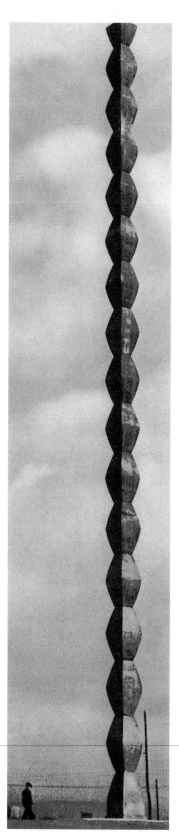

6.35 Constantin Brancusi, *King of Kings*, c. 1930. Oak, height 9' 10" (3 m). Solomon R. Guggenheim Museum, New York.

6.36 Constantin Brancusi, *Endless Column*, 1937–38. Cast iron, height 98' (29.9 m). Tîrgu-Jiu, Romania.

7
Expressionism in Germany

"God is dead." This assertion, put forth by the then little-known German philosopher Friedrich Nietzsche in 1882, succinctly sums up the moral quandary of Western society in the late nineteenth century. With the advent of Positivism earlier in the century, scientific rationalism had gained cachet as a means of understanding and improving all areas of human experience. The fruit of this faith in reason seemed abundant by the early years of the twentieth century: *la belle époque* was in full swing, giving rise to a culture of exuberant experimentation of the sort that led to Fauvism. But Positivism also had some unsettling side effects. One of them, Nietzsche observed, was nihilism— existence outside a certain, unquestioned moral framework. If all human experience could be accounted for through recourse to objective, rational analysis, then what is the basis for morality? Why should individuals embrace one set of values over another? Historically, these questions had been answered by the Church and seconded by the state, typically personified by a sovereign. The spread of secularism and of varying degrees of democracy during the nineteenth century displaced these authorities.

What arose in their place? For some, science promised authoritative guidance. Human nature and cultural values might be best divined through objective study and experimentation. Thus the modern fields of psychology, anthropology, sociology, and even art history were effectively established at this time. For others, only religion could provide a genuine moral framework for life. A resurgence of religiosity characterized the dawn of the new century, with some returning to the traditional faiths of their parents or grandparents, while others adopted Eastern, esoteric, or occult practices such as Buddhism, Theosophy, or animism. Nationalism presented yet another rallying point for those seeking a set of ready values to which they could anchor themselves. With European and American imperialism reaching a crescendo, national pride likewise spiked. Personal identity became an extension of national identity, and native folk cultures were increasingly viewed as "pure" expressions of an authentic national culture.

Subsuming individual identities to a collective national character offered another remedy for the nihilism Nietzsche viewed as nascent in his time. For those unmoved by nationalism, unawed by religion, and uncertain of the motives of science and industry, Nietzsche's flat declaration resonated with the bleak certainty that humanity had only its own basest instincts to guide it. German Expressionism is the visual corollary to Nietzsche's statement.

The term "expressionism" is used generally to refer to artworks with a particular emphasis on emotional content. In such works, strong emotion is conveyed not only thematically but also by means of technique and medium. Thus, Delacroix's *Lion Hunt* (see fig. 1.10) can be characterized as expressionistic insofar as the undulating lines, rich color, and loose brushwork support the violence and chaos of the subject. Likewise, Munch's *The Scream* (see fig. 5.18) exemplifies expressionism in its agitated, disorienting rendering of a theme of desperation and alienation. German Expressionism refers to a specific movement in Northern Europe that flourished in the first few decades of the twentieth century. Its genesis can be found in Romanticism, with its emphasis on intensely personal aesthetic explorations. It also bears a strong kinship to Fauvism. Like the Fauves, German Expressionist painters of the early twentieth century used a vibrant palette that strayed from natural observation. Other points of similarity include the distortion or flattening of perspectival space, the energetic handling of media, and an interest in art-historical tradition. There are some important differences, however. Unlike their Fauve contemporaries, the German Expressionists were largely freed from any lingering academic influence. In fact, many of the leading Expressionists never received the long academic training that informed the work of Fauves such as Matisse and Derain. Perhaps the singular distinction between Fauvism and German Expressionism is the latter's engagement with contemporary social issues. Far from dispassionate analysts like Matisse or his great influence Cézanne, Expressionists used their artworks to provide a rejoinder to the proposition that "God is dead."

From Romanticism to Expressionism: Corinth and Modersohn-Becker

The strong emotional content of Expressionism was not new to German art. Romantic painters like Caspar David Friedrich (fig. 1.11) conveyed intense feelings of loss and longing, of reverence and hope through their work. Even German medieval and Renaissance artists valued emotionalism in artworks in a way that often puzzled their southern contemporaries. German Expressionism draws from these northern sources. Paving the way from Romanticism to Expressionism were such northerners as Van Gogh, Munch, Klimt, Hodler, Ensor, Böcklin, Klinger, and Kubin. However, the young Expressionists in Germany also drew inspiration from their own native folk traditions or children's art, as well as the art of other cultures, especially Africa and Oceania. Among those whose work played a particularly strong role in bridging the divide between earlier northern strains of expressionism and the full-blown Expressionism that appeared in the first decade of the twentieth century were Lovis Corinth and Paula Modersohn-Becker.

The paintings and graphic arts of **Lovis Corinth** (1858–1925) form a clear link between German Romanticism and later German Expressionist art. His lengthy academic training included study in his native

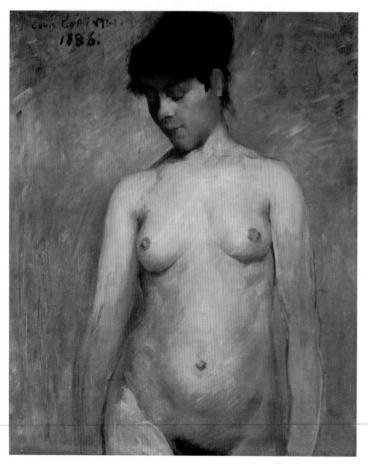

7.1 Lovis Corinth, *Nude Girl*, 1886. Oil on canvas, 30 × 25¼" (76.2 × 64.14 cm). Minneapolis Institute of Arts. Gift of Mr. and Mrs. Donald Winston.

Germany and in France, where he entered the Académie Julian in 1884. One of his professors there was William Bouguereau, the academician whose teaching and methods Matisse would, a few years later, dismiss as moribund. Like Matisse, Corinth rejected the idealism of Bouguereau's style. But Corinth didn't turn to avant-garde art for an alternative to the academic approach. He, in fact, claimed to be unaware of Impressionism during his time in Paris. Instead, he internalized the lessons of the academy, rendering what he saw with exacting draftsmanship and a real colorist's sensitivity to complements and tonal relations. Corinth's is not the dispassionate gaze of a realist, though: the dynamic brushwork, startling yet naturalistic color, and palpable emotional tension of his work call to mind the work of Munch (see figs. 5.16, 5.18, 5.19, 5.20). This equipoise between objective analysis and subjective encounter in works like *Nude Girl* (fig. **7.1**) charge Corinth's work with an internal tension that would later give way to fierce Expressionism.

Paula Modersohn-Becker (1876–1907) was born in Dresden and settled in the artists' colony at Worpswede near Bremen in 1897. Worpswede, like the French town of Pont-Aven in Brittany where Gauguin painted before traveling to Tahiti, appealed to artists interested in a simpler, more authentic-seeming culture. In Worpswede, Modersohn-Becker developed a primitivist style, drawing from folk art and non-Western sources while avoiding the finicky brushwork, smooth blending of pigment, and high finish of academic painting. Although she was not associated with any group outside of the provincial school of painters at Worpswede, Modersohn-Becker was in touch with new developments in art and literature through her friendship with the poet Rainer Maria Rilke (who had been Rodin's secretary), as well as through a number of visits to Paris. In these she discovered successively the French Barbizon painters, the Impressionists, and then, in 1905 and 1906, the works of Van Gogh, Gauguin, and Cézanne. Following this last trip, she embarked on a highly productive and innovative period, distilling and simplifying forms while heightening the expressiveness of color. In her extensive letters and diaries, the artist wrote of her desire for an art of direct emotion, of poetic expression, of simplicity and sensitivity to nature: "Personal feeling is the main thing. After I have clearly set it down in form and color, I must introduce those elements from nature that will make my picture look natural (see Modersohn-Becker, *Letters and journal*, opposite). She worried about the implications of marriage and motherhood for her professional life and died prematurely following the birth of her only child, leaving us with merely a suggestion of what she might have achieved.

What sets Modersohn-Becker's work apart from other primitivists like Gauguin as well as from her Fauve contemporaries is its daring exploration of novel subjects. Her *Self-Portrait on Her Sixth Wedding Anniversary* (fig. **7.2**) fuses the conventional theme of the artist's self-portrait

Paula Modersohn-Becker
Letters and journal

From an undated journal entry, c. August 1897

Worpswede, Worpswede, I cannot get you out of my mind. There was such atmosphere there—right down to the tips of your toes. Your magnificent pine trees! ...And your birch trees—delicate, slender young virgins who delight the eye. With that relaxed and dreamy grace, as if life had not really begun for them yet. They are so ingratiating—one must give oneself to them, they cannot be resisted. But then there are some already masculine and bold, with strong and straight trunks. Those are my "Modern Women."

From a letter to the painter Otto Modersohn (whom she would later marry) written in Paris and dated February 29, 1900:

In several salons, where one trips over the long gowns of elegant Paris, there were many things to be seen, much shallow, sweet, and bad stuff. But I keep thinking that somewhere hidden treasure must lie. There is much beauty and depth in Puvis de Chavannes. He is someone who suddenly stands quite alone among others. ... Do you know Monet? I had heard his name in Germany. I saw a number of paintings by him recently. Even here the concept of nature seemed superficial.

From a letter to the sculptor Bernhard Hoetger written in the summer of 1907:

I have not done much work this summer, and I have no idea if you will like any of the little that I have accomplished. In conception, all the work has probably remained much the same. But the execution, I think, is quite another matter. What I want to produce is something compelling, something full, an excitement and intoxication of color—something powerful ... I wanted to conquer Impressionism by trying to forget it. What happened was that it conquered me. We must work with digested and assimilated Impressionism.

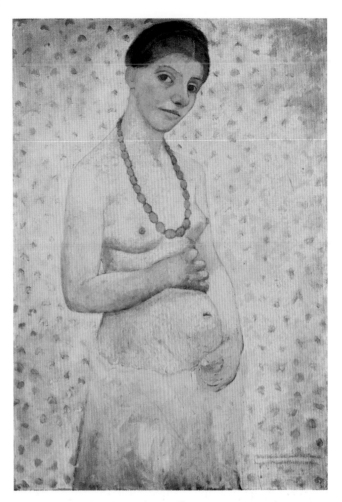

7.2 Paula Modersohn-Becker, *Self-Portrait on Her Sixth Wedding Anniversary*, 1906. Oil on canvas, 39¾ × 27½" (101 × 69.9 cm). Kunstsammlungen Böttcherstrasse/Paula Modersohn-Becker Museum, Bremen.

Fauve experimentation. What is more, like the Expressionists who followed her, Modersohn-Becker acknowledges the necessity of tying the formal attributes of a work of art to its theme. Here, the abstract pattern surrounding her serves to flatten pictorial space, enhancing the planar surface of the canvas. Yet, at the same time, this pattern suggests floral wallpaper, implying that she rests within a domestic space. The muted ocher tones of the work combine with the mask-like rendering of her face and simple amber necklace to endow the work with an earthy primitivism, as if to assert the universal resonance of her highly personal experience of pregnancy.

Spanning the Divide between Romanticism and Expressionism: Die Brücke

In 1905 Ernst Ludwig Kirchner, Erich Heckel, Karl Schmidt-Rottluff, and Fritz Bleyl formed an association they called Die Brücke, or "the bridge," linking "all the revolutionary and fermenting elements." These young architecture students, all of whom wanted to be painters, were drawn together by their opposition to the art that

with the favored modernist motif of the nude woman. Far from treating the nude female form as simply a cipher for formal experimentation—as Matisse claimed to be doing with his *Blue Nude* (fig. 6.9)—Modersohn-Becker presents a body, her own body, redolent with personality, agency, and creativity. She reveals herself frankly in the full bloom of her pregnancy. Artists' self-portraits have long served as a means to represent their claims to authorship. Here, Modersohn-Becker asserts her body as a source for artistic creation and the creation of life itself. With this gesture, she not only invents a genre of portraiture unavailable to male artists, but she also reclaims the female nude as a fully human subject, not simply another formal motif that might just as well be a still life.

Technically, Modersohn-Becker points the way to Expressionism. Simplified areas of color and spatial compression testify to her understanding of Post-Impressionist and

surrounded them, especially academic art and fashionable Impressionism, rather than by any preconceived program. Imbued with the spirit of Arts and Crafts and *Jugendstil* (see chapter 5), they rented an empty shop in a workers' district of Dresden, in eastern Germany, and began to paint, sculpt, and make woodcuts together. The influences on them were many and varied: the art of medieval Germany, of the French Fauves, of Edvard Munch, of non-Western sculpture. For them, Van Gogh was the clearest example of an artist driven by an "inner force" and "inner necessity"; his paintings presented an ecstatic identification or empathy of the artist with the subject he was interpreting. Even more familiar to them was Munch, whose graphic works were widely known in Germany by 1905 (see fig. 5.20), and the artist himself was spending most of his time there. His obsession with symbolic subjects struck a sympathetic chord in the young German artists, and from his mastery of the graphic techniques they could learn much. Among historic styles, the most exciting discovery was art from Africa and the South Pacific, of which notable collections existed in the Dresden Ethnographic Museum.

In 1906 Emil Nolde and Max Pechstein joined Die Brücke. In the same year Heckel, then working for an architect, persuaded a manufacturer for whom he had executed a showroom to permit the Brücke artists to exhibit there. This was the historic first Brücke exhibition, which marked the emergence of twentieth-century German Expressionism. Little information about the exhibition has survived, since no catalogue was issued, and it attracted virtually no attention.

During the next few years the Brücke painters exhibited together and produced publications designed by members and manifestos in which Kirchner's ideas were most evident. The human figure was studied assiduously in the way Rodin had studied the nude: not posed formally but simply existing in the environment. Despite developing differences in style among the artists, a hard, Gothic angularity permeated many of their works.

The Brücke painters were conscious of the revolution that the Fauves were creating in Paris and were affected by their use of color. However, their own paintings maintained a Romantic sense of expressive subject matter and a characteristically jagged, Gothic structure and form. Their subjects, too, strayed from the arcadian landscapes and portraits of friends and family so favored by the Fauves to include stark portrayals of prostitutes and dancers, frankly eroticized depictions of child models, and unsettling scenes of urban leisure and decadence. When Die Brücke artists turned to the landscape, they likewise emphasized tension rather than harmony between humanity and nature. By 1911 most of the Brücke group were in Berlin, where a new style appeared in their works, reflecting the increasing consciousness of French Cubism (see chapter 8) as well as Fauvism, given a Germanic excitement and narrative impact. By 1913 Die Brücke was dissolved as an association, and the artists proceeded individually.

Kirchner

The most creative member of Die Brücke was **Ernst Ludwig Kirchner** (1880–1938). In addition to his extraordinary output of painting and prints, Kirchner, like Erich Heckel, made large, roughly hewn and painted wooden sculptures. These works in a primitivist mode were a result of these artists' admiration for African and Oceanic art. Kirchner's early ambition to become an artist was reinforced by his discovery of the sixteenth-century woodcuts of Albrecht Dürer and his Late Gothic predecessors (fig. **7.3**). Yet his own first woodcuts, done before 1900, were probably most influenced by Félix Vallotton and Edvard Munch. Between 1901 and 1903 Kirchner studied architecture in Dresden, and then, until 1904, painting in Munich. Here he was attracted to Art Nouveau designs and repelled by the retrograde paintings he saw in the exhibition of the Munich Secession. Like so many of the younger German artists of the time, he was particularly drawn to German Gothic art. Of modern artists, the first revelation for him was the work of Seurat. Going beyond Seurat's research, Kirchner undertook studies of nineteenth-century color theories that led him back to Johann Wolfgang von Goethe's essay *History of the Theory of Colors* (1805–10).

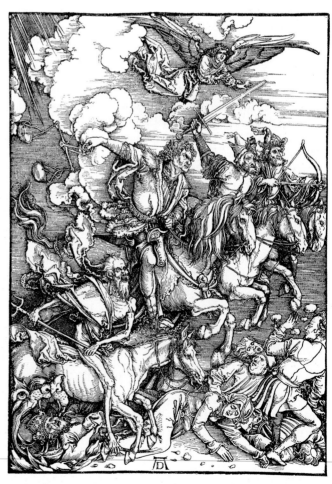

7.3 Albrecht Dürer, *The Four Riders of the Apocalypse*, c. 1497–c. 1498. Woodcut, 15⅜ × 11¹¹⁄₁₆" (39 × 28.1 cm). Harvard University Art Museums, Cambridge, MA. Gift of Paul J. Sachs. M10277.

Kirchner's painting style about 1904 showed influences from the Neo-Impressionists combined with a larger, more dynamic brushstroke related to that of Van Gogh, whose work he saw, along with paintings by Gauguin and Cézanne, in the exhibition of the Munich Artists' Association held that year. His return to Dresden and architecture school in 1904, and his acquaintance with Heckel, Schmidt-Rottluff, and Bleyl, led to the founding of the Brücke group.

For subject matter Kirchner looked to contemporary life, rejecting the artificial trappings of academic studios. In both Dresden and Berlin, where he moved in 1911, he recorded the streets and inhabitants of the city and the bohemian life of its nightclubs, cabarets, and circuses. *Street, Dresden* (fig. **7.4**) of 1908 is an assembly of curvilinear figures who undulate like wraiths, moving toward and away from the viewer without individual motive power, drifting in a world of dreams. Kirchner probably had Munch's street painting *Spring Evening on Karl Johan Street* in mind when he made this work, and, as was frequently his habit, he reworked it at a much later date. In Berlin he painted a series of street scenes in which the spaces are confined and precipitously tilted, and the figures are elongated into angular shards by long feathered

strokes. Kirchner made rapid sketches of these street scenes, then worked up the image in more formal drawings in his studio before making the final paintings.

A frequent subject of Kirchner's art was the girl Fränzi Fehrmann, who, with her siblings, was a favorite model of the Brücke group (fig. **7.5**). Children of a deceased circus performer, they modeled as a way to help their widowed mother support the household. In this painting by Kirchner, Fränzi is represented as an adolescent, neither completely a child nor fully adult. Posed on a bed with a pink flower in her hair and assertively gazing toward the viewer, Fränzi conveys an incipient sexuality. Yet her boxy jumper, small hands, and loose hair testify to her status as a child. The stylized figure against a black background to the left of her is part of an African wall-hanging, serving for Kirchner as a symbol of authenticity and renewal—ideas he here associates with Fränzi's youth. Kirchner's use of color—especially the acidic green of her mask-like face—complicates further the sitter's personality. Formally, Kirchner uses the green-yellow much as a Fauve painter might, to sculpt the sitter's face by juxtaposing complements like red or blue to model her lips and cheekbones. But for Kirchner the Expressionist, his color choices telegraph a mood of uncertainty or even danger. Why isn't

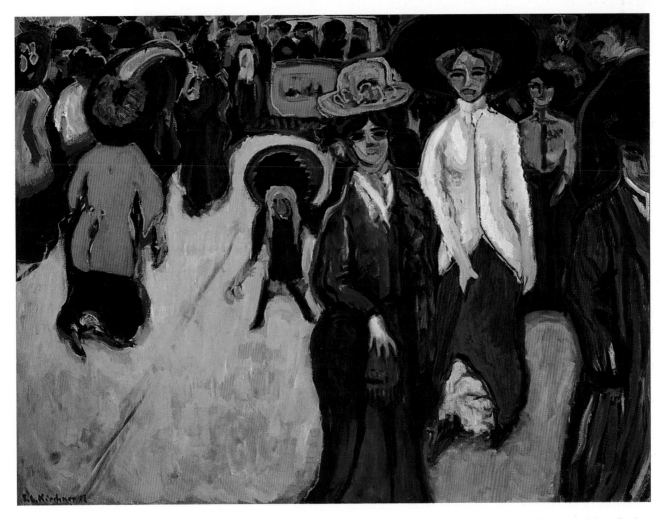

7.4 Ernst Ludwig Kirchner, *Street, Dresden*, 1908 (dated 1907 on painting). Oil on canvas, 4' 11¼" × 6' 6⅞" (1.51 × 2 m). The Museum of Modern Art, New York.

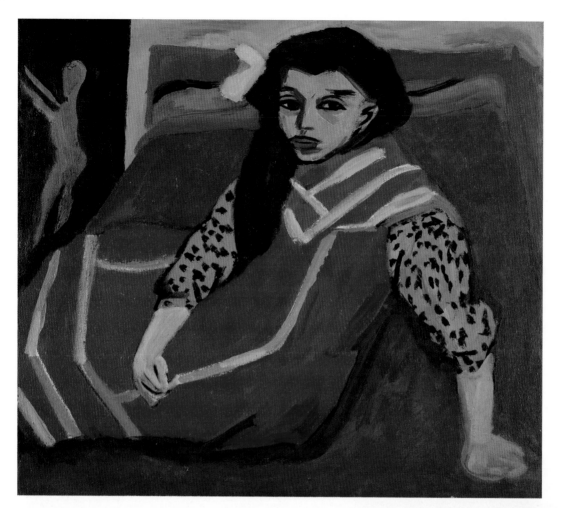

7.5 Ernst Ludwig Kirchner, *Seated Girl (Fränzi Fehrmann)*, 1910; altered 1920. Oil on canvas, 31¾ × 35⅞" (80.6 × 91.1 cm). Minneapolis Institute of Arts. The John R. Van Derlip Fund.

the skin of Fränzi's arms rendered in a similar color? Their placid pink hue heightens the disconcerting intensity of her face, estranging her countenance and reminding the viewer of the impossibility of fully knowing another.

One of the principal contributions of Die Brücke was its revival of printmaking as a major form of art. During the nineteenth century many experimental painters and sculptors had made prints, and toward the end of the century, in the hands of artists like Toulouse-Lautrec (see fig. 3.36), Gauguin, and Redon, printmaking assumed an importance as an independent art form beyond anything that had existed since the Renaissance. In Germany, however, a country with a particularly rich tradition of printmaking, this art form occupied a special place, and its revival contributed to the character of painting and sculpture. It was especially the simplified forms of the woodcut, a form of printmaking with a long and distinguished history in German art, that Expressionists like Kirchner felt conveyed emotion most authentically. The artists of Die Brücke brought about a veritable renaissance of this medium. Kirchner, in both black-and-white and color woodcuts, developed an intricate, linear style that looked back to the woodcuts of Dürer and the earlier Martin Schongauer (see *Woodcuts and Woodblock Prints*, opposite). In a powerful portrait of the Belgian Art Nouveau architect Henry van de Velde, he used characteristic V-shaped gouges to create complex surface patterns (fig. **7.6**).

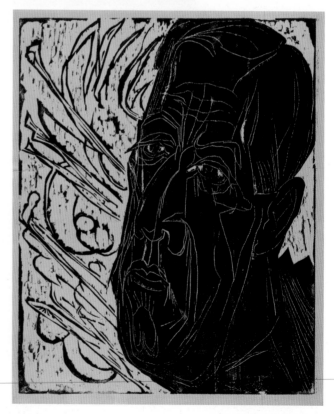

7.6 Ernst Ludwig Kirchner, *Portrait of Henry van de Velde*, 1917. Woodcut, 19½ × 15¾" (49.6 × 40 cm). Harvard University Art Museums, Cambridge, MA. Museum Funds. M13167.

Woodcuts and Woodblock Prints

Using carved wooden blocks to print images onto paper or fabric is one of the oldest printmaking techniques. Developed in China before the first century C.E., the method has been employed in the West since at least the fifteenth century. The technique of woodcut, or woodblock printing, as it is alternately called, is fairly straightforward. A design is drawn onto a block of wood, which is then carved so that the desired image remains in relief. Ink is applied to the raised design and the block pressed onto a flat surface such as paper. No great pressure is needed to transfer the ink to paper, though a press is often used to ensure even, consistent pressure from one impression to the next. The image can also be transferred easily by rubbing a piece of the paper placed over the inked surface of the block. In the hands of Albrecht Dürer, Renaissance woodcuts reached their zenith (see fig. 7.3). Dürer exploits the technique's reliance on line, using bold contour strokes to define figures and fine, parallel lines for shadows and modeling.

Color prints can be produced in a number of ways. An existing print can be colored, or color can be introduced during the printmaking process. One method for color printing involves applying colored inks to the block before printing. Another technique requires two or more blocks, each carved to print a different part of the scene. These blocks are then printed in different hues, adding depth as well as vibrancy to the scene. Japanese *ukiyo-e* prints exemplify this approach (see fig. 2.26). Edvard Munch took an innovative turn to color printing by cutting his woodblocks into pieces, like a jigsaw puzzle, applying different colors of ink to the various pieces, then reassembling them for printing (see fig. 5.20).

Nolde

Emil Nolde (1867–1956) was the son of a farmer from northwestern Germany, near the Danish border. The reactionary, rural values of this area had a profound effect on his art and his attitude toward nature. Strong emotional ties to the landscape and yearning for a regeneration of the German spirit and its art characterized the popular *völkisch* or nationalist tradition. Early in his career, Nolde depicted the landscape and peasants of this region in paintings reminiscent of the French artist Millet (see fig. 1.17). As an adult, he even took as his surname Nolde, the name of his native village (he was born Emil Hansen), to underscore a strong identification with the land.

Nolde studied woodcarving and worked for a time as a designer of furniture and decorative arts in Berlin. His first paintings, of mountains transformed into giants or hideous trolls, drew on qualities of traditional Germanic fantasy. The commercial success of some of these images enabled Nolde to return to school and to take up painting seriously in Munich, where he encountered the work of contemporary artists such as Adolph Menzel and Arnold Böcklin (see fig. 5.24), and then in Paris. While in Paris in 1899–1900, he, like so many art students, worked his way gradually from the study of Daumier and Delacroix to Manet and the Impressionists, and his color took on a new brilliance and violence as a result of his exposure to the latter. In 1906 he accepted an invitation to become a member of Die Brücke. Essentially a solitary person, Nolde left Die Brücke after a year and devoted himself increasingly to a personal form of Expressionist religious paintings and prints.

Among his first visionary religious paintings was *The Last Supper* of 1909 (fig. 7.7). When compared with celebrated old master paintings of Jesus among his disciples, such as Rembrandt's *Christ at Emmaus* or even Leonardo da Vinci's *Last Supper*, Nolde's mood is markedly different

7.7 Emil Nolde, *The Last Supper*, 1909. Oil on canvas, 33⅞ × 42⅛" (86 × 107 cm). Statens Museum for Kunst, Copenhagen.

from their quiet restraint. His figures are crammed into a practically non-existent space, the red of their robes and the yellow-green of their faces flaring like torches out of the surrounding shadow. The faces themselves are skull-like masks that derive from the carnival processions of Ensor (see fig. 5.23). Here, however, they are given intense personalities—no longer masked and inscrutable fantasies but individualized human beings passionately involved in a situation of extreme drama. The compression of the group packed within the frontal plane of the painting—again stemming from Ensor—heightens the sense of impending crisis.

Of the Brücke group, Nolde was already an accomplished etcher by the time he made his first woodcuts. These owe something to Late Gothic German woodcuts as well as the prints of Munch, with their intense black-and-white contrast and bold, jagged shapes that exploit the natural grain of the woodblock. His lithographs, which differ in expression from the rugged forms of his woodcuts, include *Female Dancer* (fig. **7.8**). Nolde appreciated the artistic freedom afforded him by the lithographic medium, which he used in experimental ways, brushing ink directly onto the stone printing matrix to create thin, variable washes of color. He was interested in the body as an expressive vehicle, and had made sketches in the theaters and cabarets of Berlin, as had Kirchner. But the sense of frenzied emotion and wild abandon in *Female Dancer* evokes associations with some imagined primal ritual rather than with the urban dance halls with which he was familiar. Nolde had studied the work of non-European cultures in museums such as the Berlin Ethnographic Museum, concluding that Oceanic and African art possessed a vitality lacking in much Western art. He argued for their study as objects of aesthetic as well as scientific interest and made drawings of objects that were then incorporated into his still-life paintings. In 1913, shortly after making

7.8 Emil Nolde, *Female Dancer*, 1913. Color lithograph, 20⅞ × 27⅛" (53 × 69 cm). Nolde-Stiftung Seebüll, Germany.

this lithograph, Nolde joined an official ethnographic expedition to New Guinea, then a German colony in the South Pacific, and later traveled to East Asia. He made sketches of the landscapes and local inhabitants on his journeys, from which he returned highly critical of European colonial practices.

Heckel, Müller, Pechstein, and Schmidt-Rottluff

Erich Heckel (1883–1970) was a more restrained Expressionist whose early paintings at their best showed flashes of psychological insight and lyricism. After 1920 he turned increasingly to the production of colorful but essentially Romantic–Realist landscapes. A painting such as *Two Men at a Table* (fig. **7.9**) evokes a dramatic interplay in which not only the figures but the contracted, tilted space of the room are charged with emotion. This painting, dedicated "to Dostoyevsky," is almost a literal illustration from the Russian novelist's *Brothers Karamazov* (1880). The painting of the tortured Christ, the suffering face of the man at the left, the menace of the other—all refer to Ivan's story, in the novel, of Christ and the Grand Inquisitor, when the atheist Ivan shares a chillingly nihilistic parable with his brother, who has decided to become a monk. Arguing that most human beings will not willingly lead virtuous lives—even in recognition of Christ's sacrifice—the Inquisitor asserts that "Anyone who can

7.9 Erich Heckel, *Two Men at a Table*, 1912. Oil on canvas, 38⅛ × 47¼" (96.8 × 120 cm). Kunsthalle, Hamburg.

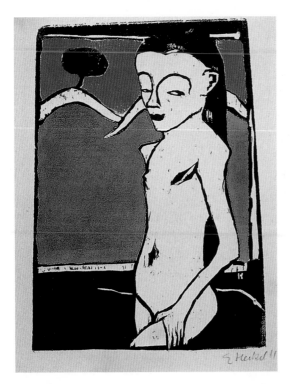

7.10 Erich Heckel, *Standing Child*, 1910. Color woodcut, 14¾ × 10¾" (37.5 × 27.5 cm). Los Angeles County Museum of Art.

appease a man's conscience can take his freedom away from him." True liberty—whether of the soul or the body—is a responsibility few are prepared to manage conscientiously—a foreshadowing of Nietzsche's nihilistic observation. By contrast, Heckel's color woodcut *Standing Child* (fig. **7.10**) involves no narrative. It is a spare composition representing the then twelve-year-old Fränzi Fehrmann, the subject of Kirchner's painting *Seated Girl* (fig. **7.5**). The artist reserved the color of the paper for the model's skin and employed three woodblocks—for black, green, and red inks—in the puzzle technique invented by Munch (see fig. **5.20**) for the brilliant, abstracted landscape behind her. It is a gripping image for its forthright design and the frank, precocious sexuality of the sitter.

Using the most delicate and muted colors of all the Brücke painters, **Otto Müller** (1874–1930) created works that suggest an Oriental elegance in their organization. His nudes are attenuated, awkwardly graceful figures whose softly outlined, yellow-ocher bodies blend imperceptibly and harmoniously into the green and yellow foliage of their setting (fig. **7.11**). He was impressed by ancient Egyptian wall paintings and developed techniques to emulate their muted tonalities. The unidealized, candid depiction of nudes in open nature was among the Brücke artists'

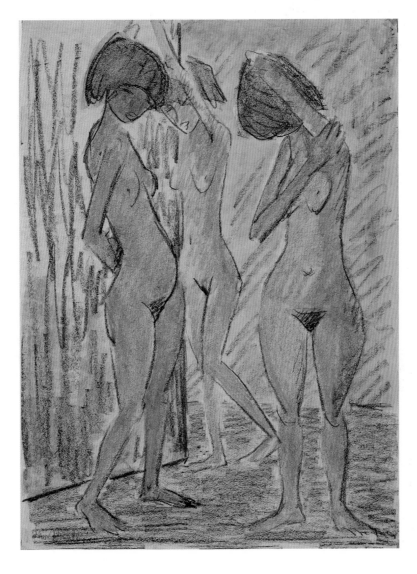

7.11 Otto Müller, *Bathing Women*, 1912. Crayon on paper, 17⅜ × 13⅜" (43.7 × 33.5 cm). Bildarchiv Rheinisches Museum, Cologne.

favorite subjects. They saw the nude as a welcome release from nineteenth-century prudery and a liberating plunge into primal experience. As Nolde proclaimed, echoing the widely shared, if unwittingly patronizing, view of "primitive" peoples that was current at the time, "Primordial peoples live in their nature, are one with it and are a part of the entire universe." The relative gentleness of Müller's treatment of this theme found an echo in the contemporary photographs of the German-born photographer **Heinrich Kühn** (1866–1944), who, like early twentieth-century modernists in painting, sought to flatten space and create a more two-dimensional design—a Pictorial effect, as the photographers would have said—by viewing his subject or scene from above (fig. **7.12**).

Max Pechstein (1881–1953) had a considerable head start in art by the time he joined Die Brücke in 1906. He had studied for several years at the Dresden Academy, and in general enjoyed an earlier success than the other Brücke painters. In 1905 he had seen a collection of wood carvings from the Palau Islands in the Royal Ethnographic Museum in Dresden, and these had a formative influence on his work. In 1914 he traveled to these islands in the Pacific to study the art firsthand. Pechstein was the most eclectic of the Brücke group, capable of notable individual paintings that shift from one style to another. The early *Indian and Woman* (fig. **7.13**) illustrates the interests of the Expressionists with its exotic subject, modeling of the figures, and Fauve-inspired color. Pechstein's drawing is sculptural and curvilinear in contrast to that of Müller or Heckel, and it was not tinged by the intense anxiety that informed so much of Kirchner's work. Like Nolde, Pechstein chose dance as his subject for a color woodcut of 1910 (fig. **7.14**), a work he may have been inspired to make after seeing a Somali dance group perform in Berlin that year. The dancers are portrayed against a colorful

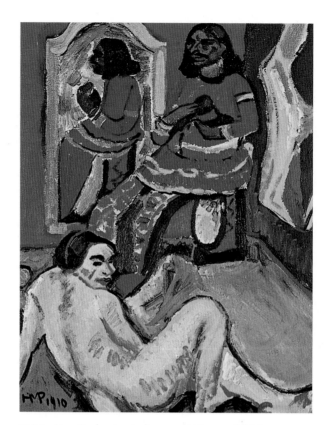

7.13 Max Pechstein, *Indian and Woman*, 1910. Oil on canvas, 32¼ × 26¼" (81.9 × 66.7 cm). The Saint Louis Art Museum.

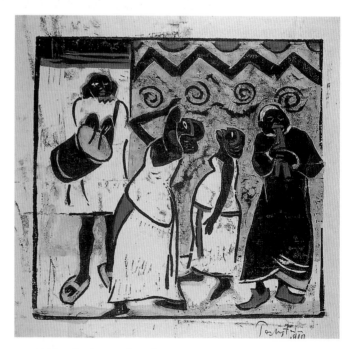

7.14 Max Pechstein, *Somali Dancers*, 1910. Hand-colored woodcut, 12½ × 14⅜" (31.8 × 36.5 cm). Brücke-Museum, Berlin.

7.12 Heinrich Kühn, *Der Malschirm (The Artist's Umbrella)*, 1908. Photogravure on heavy woven paper, 9 × 11⅜" (23 × 28.9 cm). The Metropolitan Museum of Art, New York. The Alfred Stieglitz Collection, 1949.

backdrop that resembles the kind of hangings with which the Brücke artists decorated their studios, like the one just visible on the left side of Kirchner's *Seated Girl* (fig. 7.5). Pechstein sought a deliberately crude execution here, with schematically hewn figures and a surface covered with irregular smudges of ink.

7.15 Karl Schmidt-Rottluff, *Self-Portrait with Monocle*, 1910. Oil on canvas, 33⅛ × 30" (84.1 × 76.2 cm). Staatliche Museen zu Berlin, Preussischer Kulturbesitz, Nationalgalerie.

traumatized by his service in Russia during World War I, was later commissioned to redesign the imperial German eagle, casts of which were placed on buildings throughout Germany. Despite this service to his country, when the Nazis came to power he was dismissed from his position as professor of art in Berlin in 1933 and forbidden to work. In 1937, the Nazis confiscated his *Self-Portrait with Monocle* from the museum that had acquired it in 1924, denigrating his work as unwholesome and 'degenerate' (see discussion in chapter 11 and box 11.3). For his part, Nolde returned to Germany from his expedition during the war and resumed art-making. As critical as he may have been toward colonialism, he nevertheless believed in the ethnic superiority of Nordic people, an attitude that would lead him later to sympathize with the Nazis. The effects of Nazi ideology and policies on the arts in Germany will be discussed in chapter 11.

The Spiritual Dimension: Der Blaue Reiter

The Brücke artists were the first manifestation of Expressionism in Germany but not necessarily the most significant. While they were active, first in Dresden and then in Berlin, a movement of more far-reaching implications was germinating in Munich around one of the great personalities of modern art, Vasily Kandinsky. Calling themselves Der Blaue Reiter ("The Blue Rider"), this group espoused no single style, though their work falls under the heading of Expressionism because of its free use of form, color, and space along with their interest in conveying intense moods and ideas through this formal experimentation. Like Die Brücke, Der Blaue Reiter viewed contemporary, industrialized society with skepticism. But instead of engaging in a direct critique as, for example, Kirchner did with his urban scenes and disquieting portraits, the artists of Der Blaue Reiter tended to retreat from the city and modern life, turning instead to folk culture, an idealized rendering of nature, or a romanticized medieval past. Above all, an attraction to spirituality guided Der Blaue Reiter, as an unblinking confrontation with modern society had guided Die Brücke.

In 1910 **Karl Schmidt-Rottluff** (1884–1976) portrayed himself as the very image of the arrogant young Expressionist—in a green turtleneck sweater, complete with beard and monocle, against a roughly painted background of a yellow doorway flanked by purplish-brown curtains (fig. **7.15**). Aside from Nolde, Schmidt-Rottluff was the boldest colorist of the group, given to vivid blues and crimsons, yellows and greens, juxtaposed in jarring but effective dissonance. Although never a fully abstract painter, he was probably the member of Die Brücke who moved furthest and most convincingly in the direction of abstract structure.

Die Brücke's Collapse

Die Brücke finally dissolved in 1913 after members either drifted away or, at the end, left in deliberate protest at Kirchner's public assertion of his leadership of the group. Most continued to explore the possibilities of Expressionism, but the outbreak of World War I in 1914 interrupted or halted altogether the artistic work of those involved in the movement. Kirchner enlisted in the field artillery; suffering a mental and physical breakdown, he was discharged in 1915. He recuperated in Switzerland, where he continued to live and work near the town of Davos until his suicide in 1938. During this late period Kirchner continued to renew his style, painting many of his older themes along with serene Alpine landscapes and sympathetic portrayals of Swiss peasant life. Schmidt-Rottluff,

Kandinsky

Born in Moscow, **Vasily Kandinsky** (1866–1944) studied law and economics at the University of Moscow. Visits to Paris and an exhibition of French painting in Moscow aroused his interest to the point that, at age thirty, he refused a professorship of law in order to study painting. He then went to Munich, where he was soon caught up in the atmosphere of Art Nouveau and *Jugendstil* then permeating the city.

Since 1890, Munich had been one of the most active centers of experimental art in Europe. Kandinsky was soon taking a leading part in the Munich art world, even while undergoing the more traditional discipline of study at the Academy and with older artists. In 1901 he formed a new artists' association, Phalanx, and opened his own art school. In the same year he was exhibiting in the Berlin Secession, and by 1904 had shown works in the Paris Salon d'Automne and Exposition Nationale des Beaux-Arts. That year the Phalanx had shown the Neo-Impressionists, as well as Cézanne, Gauguin, and Van Gogh. By 1909 Kandinsky was leading a revolt against the established Munich art movements that resulted in the formation of the Neue Künstler Vereinigung (NKV, New Artists' Association). In addition to Kandinsky, the NKV included Alexej von Jawlensky, Gabriele Münter, Alfred Kubin, and, later, Franz Marc. Its second exhibition, in 1910, showed the works not only of Germans but also of leading Parisian experimental painters: Picasso, Braque, Rouault, Derain, and Vlaminck.

During this period, Kandinsky was exploring revolutionary ideas about non-objective or abstract painting, that is, painting without literal subject matter, that does not take its form from the observed world. He traced the beginnings of this interest to a moment of epiphany he had experienced in 1908. Entering his studio one day, he could not make out any subject in his painting, only shapes and colors: he then realized it was turned on its side. In 1911 a split in the NKV resulted in the secession of Kandinsky, accompanied by Marc and Münter, and the formation of the association Der Blaue Reiter, a name taken from a book published by Kandinsky and Marc, in turn named after a painting by Kandinsky. The historic exhibition held at the Thannhauser Gallery in Munich in December 1911 included works by Kandinsky, Marc, August Macke, Heinrich Campendonck, Münter, the composer Arnold Schoenberg, and "Le Douanier" Henri Rousseau, among others. Paul Klee, already associated with the group, showed with them in a graphics exhibition in 1912. This was a much larger show. The entries were expanded to include artists of Die Brücke and additional French and Russian artists: Roger de La Fresnaye, Kazimir Malevich, and the Alsatian Jean Arp.

In his book *Concerning the Spiritual in Art*, published in 1911, Kandinsky formulated the ideas that had obsessed him since his student days in Russia. Always a serious student, he had devoted much time to the question of the relations between art and music. He had first sensed the dematerialization of the object in the paintings of Monet, and this direction in art continued to intrigue him as, through exhibitions in Munich and his continual travels, he learned more about the revolutionary new discoveries of the Neo-Impressionists, the Symbolists, the Fauves, and the Cubists. Advances in the physical sciences had called into question the "reality" of the world of tangible objects, strengthening his conviction that art had to be concerned with the expression of the spiritual rather than the material.

Despite his strong scientific and legal interests, Kandinsky was attracted to Theosophy, spiritism, and the occult. Theosophy, in particular, gained adherents among intellectuals and artists at the turn of the century. A metaphysical formulation that combined elements of eastern religions, especially Buddhism and Hinduism, with mysticism and an esoteric belief in the pursuit of spiritual knowledge, Theosophy was established by Helena Petrovna Blavatsky, who founded the Theosophical Society in New York in 1875. Like others attracted to Theosophy, Kandinsky sought precisely the spiritual transcendence that nineteenth-century Positivism had discounted as useless superstition. There was always a mystical core in Kandinsky's thinking— something he at times attributed to his Russian roots. This sense of an inner creative force, a product of the spirit rather than of external vision or manual skill, enabled him to arrive at an art entirely without representation other than colors and shapes. Deeply concerned with the expression of harmony in visual terms, he wrote, "The harmony of color and form must be based solely upon the principle of the proper contact with the human soul." And so, Kandinsky was one of the first, if not—as traditionally thought—the very first, modern European artist to break through the representational barrier and carry painting into total abstraction.

As Kandinsky was moving toward abstraction, his early paintings went through various stages of Impressionism and Art Nouveau decoration, but all were characterized by a feeling for color. Many also had a fairytale quality of narrative, reminiscent of his early interest in Russian folktales and mythology. Kandinsky pursued this line of investigation in the rural setting of the Bavarian village of Murnau, where he lived for a time with Gabriele Münter. Münter took up *Hinterglasmalerei* (painting behind glass), a form of German folk art in which a painting is done on the underside of a sheet of glass so that the final image can be viewed through the glass. The technique involves starting with foreground elements and highlights and other details meant to be perceived as closer to the viewer. Areas intended to be seen as further away are added subsequently. Münter taught the technique to Kandinsky. The archaism of the style and its spiritual purity forecast the more radical simplifications soon to come. Like his contemporaries in Germany and France, Kandinsky was interested in native Russian art forms and in 1889 had traveled on an ethnographic expedition to study the people of Vologda, a remote Russian province north of Moscow. He was moved by the interiors of the peasants' houses, which were filled

with decorative painting and furniture. "I learned not to look at a picture from outside," he said, "but to move within the picture, to live in the picture."

Because of his wish to associate his work with an image-free art form that spoke directly to the senses in modernist fashion, Kandinsky began using titles derived from music, such as "Composition," "Improvization," or "Impression," a gesture akin to Whistler's practice earlier (see chapter 2). He made ten major paintings titled "Composition," which he considered to be his most complete artistic statements, expressive of what he called "inner necessity" or the artist's intuitive, emotional response to the world. A close examination of *Sketch for Composition II* (fig. **7.16**) reveals that the artist is still employing a pictorial vocabulary filled with standing figures, riders on horseback, and onion-domed churches, but they are now highly abstracted forms in the midst of a tumultuous, heaving landscape of mountains and trees painted in the high-keyed color of the Fauves. Although Kandinsky said this painting had no theme, it is clear that the composition is divided into two sections, with a

scene of deluge and disturbance at the left and a garden of paradise at the right, where lovers recline as they had in Matisse's *Le Bonheur de vivre* (see fig. 6.8). Kandinsky balances these opposing forces to give his all-embracing view of the universe.

In general, Kandinsky's compositions revolve around themes of cosmic conflict and renewal, specifically the Deluge from the biblical Book of Genesis and the Apocalypse from the Book of Revelation. From such cataclysm would emerge, he believed, a rebirth, a new, spiritually cleansed world. In *Composition VII* (fig. **7.17**), an enormous canvas

7.17 Vasily Kandinsky, *Composition VII*, 1913. Oil on canvas, 6' 6¾" × 9' 11⅛" (2 × 3 m). Tretyakov Gallery, Moscow.

from 1913, colors, shapes, and lines collide across the pictorial field in a furiously explosive assembly. Yet even in the midst of this symphonic arrangement of abstract forms, the characteristic motifs Kandinsky had distilled over the years can still be deciphered, such as the glyph of a boat with three oars at the lower left, a sign of the biblical floods. He did not intend these hieroglyphic forms to be read literally, so he veiled them in washes of brilliant color. Though the artist carefully prepared this large work with many preliminary drawings and oil sketches, he preserved a sense of spontaneous, unpremeditated freedom in the final painting.

In 1914 the cataclysm of World War I forced Kandinsky to return to Russia, and, shortly thereafter, another phase of his career began (discussed in chapter 10), a pattern repeated in the careers of many artists at this time. In looking at the work of the other members of Der Blaue Reiter up to 1914, we should recall that the individuals involved were not held together by common stylistic principles but rather constituted a loose association of young artists, enthusiastic about new experiments and united in their oppositions. Aside from personal friendships, it was Kandinsky who gave the group cohesion and direction. In the yearbook *Der Blaue Reiter*, edited by Kandinsky and Marc, which appeared in 1912 and served as a forum for the opinions of the group, the new experiments of Picasso and Matisse in Paris were discussed at length, and the aims and conflicts of the new German art associations were described. In the creation of the new culture and new approach to painting, much importance was attached to the influence of so-called primitive and naive art.

Münter

Gabriele Münter (1877–1962) became acquainted with Kandinsky in 1902 as a student at the Phalanx School, which he had founded in order to teach progressive art precepts in accord with the ideas of the Arts and Crafts Movement and *Jugendstil*. They soon became engaged, but never married, devoting their first few years together to travel and artmaking. Their time in Paris was particularly influential. Münter continued her artistic experimentation during this period, and some of her linocuts were exhibited at the 1907 Paris Salon d'Automne (fig. **7.18**). Once resettled in Munich in 1908, Münter exhibited with the NKV, withdrawing from the group along with Kandinsky in 1911 to help found Der Blaue Reiter. She looked to nature and folk culture for her models, developing a personal style evocative of the *Hinterglasmalerei* technique she had explained to Kandinsky. Her portrait of her friends and fellow artists Alexej von Jawlensky and Marianne von Werefkin (fig. **7.19**) uses thick black outlines to subdivide the scene into discrete areas of vibrant, Fauve color,

7.18 Gabriele Münter, *Aurelie*, 1906. Linocut, 7¼ × 6½" (18.3 × 16.6 cm). Städtische Galerie im Lenbachhaus, Munich.

emulating the surface effects and spatial compression of *Hinterglasmalerei.* Despite its abstraction, the image functions successfully as an Expressionist portrait. Münter conveys through her bravura brushwork the warmth of the sunshine that dapples the grassy bank even as the figures' color and pose suggest a momentary alienation from one another. Only through probing observation can such an economic use of gesture transmit so much feeling.

Werefkin

One of several Russians to join Der Blaue Reiter, **Marianne von Werefkin** (1860–1938) pursued several years of academic study in Moscow and St. Petersburg before relocating to Munich in 1895 with her companion Alexej von Jawlensky. At first devoting herself to supporting Jawlensky's career, she resumed painting in 1902. She helped to found the NKV, but left to show with the more progressive Blaue Reiter artists in 1912. Her 1910 *Self-Portrait* (fig. **7.20**) contrasts fiercely with the pastoral image rendered by her friend Gabriele Münter (see fig. 7.19). While the background hints at an outdoor setting and the pulsating carnation on her hat nods to the standard portrait convention that associates female sitters with nature, Werefkin presents herself as anything but a decorative complement to the landscape. The cylindrical forms of her neck and hat anchor the composition, which vibrates with energetic brushwork and insistent color complements. Modeling her features with alternating strokes of vermilion, ocher, forest green, and even an acidic chartreuse, she engages the viewer with red eyes glowing like two cigarette tips. Here, the Expressionists' frank scrutiny of contemporary society is directed squarely by the artist at herself.

7.20 Marianne von Werefkin, *Self-Portrait,* 1910. Tempera on paper, 20 × 13½" (51 × 34 cm). Städtische Galerie im Lenbachhaus, Munich.

Marc

Of the Blaue Reiter painters, **Franz Marc** (1880–1916) was the closest in spirit to the traditions of German Romanticism and lyrical naturalism. In Paris in 1907 he sought personal solutions in the paintings of Van Gogh, whom he called the most authentic of painters. From an early date he turned to the subject of animals as a source of spiritual harmony and purity in nature. This became for him a symbol of that more primitive and arcadian life sought by so many of the Expressionist painters. Through his friend the painter August Macke, Marc developed, in about 1910, enthusiasms for color whose richness and beauty were expressive also of the harmonies he was seeking.

The great *Blue Horses* of 1911 is exemplary of Marc's mature style (fig. **7.21**). The three brilliant blue beasts are fleshed out sculpturally from the equally vivid reds, greens, and yellows of the landscape. The artist used a close-up view, with the bodies of the horses filling most of the canvas. The horizon line is high, so that the curves of the red hills repeat the lines of the horses' curving flanks. Although the modeling of the animals gives them the effect of sculptured relief projecting from a uniform background, there is no real spatial differentiation between creatures and environment, except that the sky is rendered more softly and less tangibly to create some illusion of distance. In fact, Marc used the two whitish tree trunks and the

7.21 Franz Marc, *The Large Blue Horses*, 1911. Oil on canvas, 41⅝ × 71⁵⁄₁₆" (105.7 × 181.1 cm). Walker Art Center, Minneapolis.

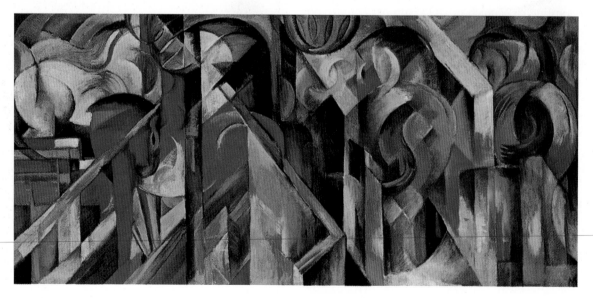

7.22 Franz Marc, *Stables*, 1913–14. Oil on canvas, 29⅛ × 62¼" (74 × 158.1 cm). Solomon R. Guggenheim Museum, New York.

green foliage in front of and behind the horses to tie foreground and background together.

At this time Marc's color, like that of Kandinsky, had a specifically symbolic rather than descriptive function. Marc saw blue as a masculine principle, robust and spiritual; yellow as a feminine principle, gentle, serene, and sensual; red as matter, brutal and heavy. In the mixing of these colors to create greens and violets, and in their proportions one to the other on the canvas, the colors formed abstract shapes and took on spiritual or material significance independent of the subject. His approach to art was religious in a manner that could be described as pantheistic, although it is interesting that in his paintings only animals are assimilated harmoniously into nature—never humans. Unlike Kandinsky's, Marc's imagery was predominantly derived from the material world.

During 1911–12 Marc was absorbing the ideas and forms of the Cubists and finding them applicable to his own concepts of the mystery and poetry of color.

In *Stables* (fig. **7.22**) he combined his earlier curvilinear patterns with a new rectangular geometry. The horses, massed in the frontal plane, are dismembered and recomposed as fractured shapes, dispersed evenly across the surface of the canvas. The forms are composed parallel to the picture plane rather than tilted in depth. Intense but light-filled blues and reds, greens, violets, and yellows flicker over the structurally and spatially unified surface to create a dazzling illusion. Marc's use of color at this stage owed much to Macke, who frequently used the theme of people reflected in shop windows as a means of distorting space and multiplying images. In a group of small compositions from 1914 and in notebook sketches, there was evidence of a move to abstraction.

Macke

Of the major figures in Der Blaue Reiter, **August Macke** (1887–1914), despite his close association with and influence on Franz Marc, created work that was as elegantly controlled as it was expressive. Macke, like Marc, was influenced by Kandinsky and by the color concepts of Gauguin and Matisse.

After some Fauve- and Cubist-motivated exercises in semi-abstraction, Macke began to paint city scenes in high-keyed color, using diluted oil paint in effects close to that of watercolor. *Great Zoological Garden*, a triptych of 1912 (fig. **7.23**), is a loving transformation of a familiar scene into a fairyland of translucent color. Pictorial space is delimited by foliage and buildings that derive from the later watercolors of Cézanne. The artist moves easily from passages as abstract as the background architecture to passages as literally representational as the animals and the foreground figures. The work has a unity of mood that is light and charming, disarming because of the naive joy that permeates it.

Macke occasionally experimented with abstract organization, but his principal interest from 1912 to 1914 continued to be his cityscapes, which were decorative colored impressions of elegant ladies and gentlemen strolling in the park or studying the wares in brightly lit shop windows.

7.23 August Macke, *Great Zoological Garden*, 1912. Oil on canvas, 4' 3⅛ × 7' 6¾" (1.3 × 2.3 m). Museum am Ostwall, Dortmund, Germany.

In numerous versions of such themes, he shows his fascination with the mirror-like effects of windows as a means of transforming the perspective space of the street into the fractured space of Cubism.

Jawlensky

Alexej von Jawlensky (1864–1941) was well established in his career as an officer of the Russian Imperial Guard before he decided to become a painter. After studies in Moscow he took classes in the same studio in Munich as Kandinsky. Although not officially a member of Der Blaue Reiter, Jawlensky was sympathetic to its aims and continued for years to be close to Kandinsky. After the war he formed the group called Die Blaue Vier (The Blue Four), along with Kandinsky and other former members of Der Blaue Reiter.

By 1905 Jawlensky was painting in a Fauve palette, and his drawings of nudes of the next few years are suggestive of Matisse. About 1910 he settled on his primary theme, the portrait head, which he explored thenceforward with mystical intensity. *Madame Turandot* is an early example (fig. **7.24**), painted in a manner that combines characteristics of Russian folk painting and Russo–Byzantine icons—sources that would dominate Jawlensky's work.

Klee

Paul Klee (1879–1940) was one of the most varied, influential, and brilliant talents of the twentieth century. His stylistic development is difficult to trace, since the artist continually re-examined his themes and forms to arrive at a reality beyond the visible world. He developed a visual language seemingly limitless in its invention and in the variety of its formal means. His complex language of personal signs and symbols evolved through private fantasy and a range of interests from plant and zoological life to astronomy and typography. Also interested in music, he wanted to create imagery infused with the rhythms and counterpoint of musical composition, saying that color could be played like a "chromatic keyboard."

Klee was born in Switzerland. The son of a musician, he was initially inclined toward music, but having decided on the career of painting, went to Munich to study in 1898. During the years 1903–06 he produced a number of etchings that in their precise, hard technique suggest the graphic tradition of the German Renaissance, in their mannered linearity Art Nouveau, and in their mad fantasy a personal vision reflecting the influence of the Expressionist printmaker Alfred Kubin. These were also among the first of Klee's works in which the title formed an integral part of his creative work. Klee brought tremendous verbal skill and wit to his paintings, drawings, and prints, using letters and words literally as formal devices in his compositions, which he then gave a literary dimension with poetic and often humorous titles.

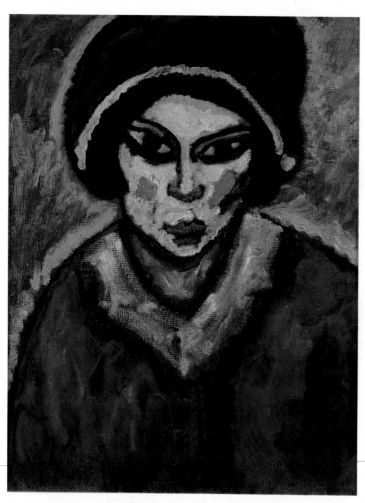

7.24 Alexej von Jawlensky, *Madame Turandot*, 1912. Oil on canvas, 23 × 20" (58.4 × 50.8 cm). Collection Andreas Jawlensky, Locarno, Switzerland.

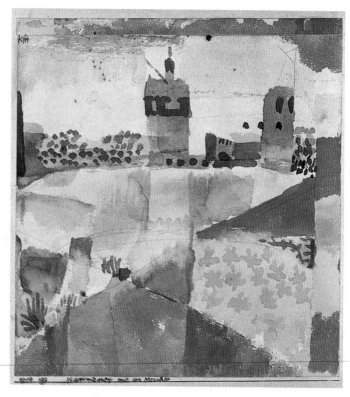

7.25 Paul Klee, *Hammamet mit der Moschee (Hammamet with the Mosque)*, 1914. Watercolor and pencil on paper on cardboard, 8⅛ × 7½" (20.6 × 19.1 cm). The Metropolitan Museum of Art, New York. The Berggruen Klee Collection.

Between 1901 and 1905 Klee traveled extensively in Italy and France and probably saw works by Matisse. Between 1908 and 1910 he became aware of Cézanne, Van Gogh, and the beginnings of the modern movement in painting. In 1911 he had a solo exhibition at the Thannhauser Gallery in Munich and in the same year met the Blaue Reiter painters. Over the next few years he participated in the Blaue Reiter exhibitions, wrote for progressive art journals, and returned to Paris in 1912 when he saw further paintings by Picasso, Braque, and Henri Rousseau.

He took a trip with Macke to Tunis and other parts of North Africa in 1914. Like Delacroix and other Romantics before him, he was affected by the brilliance of the region's light and the color and clarity of the atmosphere. To catch the quality of the scene Klee, like Macke, turned to watercolor and a form of semi-abstract color pattern based on a Cubist grid, a structure he frequently used as a linear scaffolding for his compositions (fig. 7.25). Although he made larger paintings, he tended to prefer small-scale works on paper. Klee had a long and fertile career, the later phases of which will be traced in chapter 14.

Feininger

Although **Lyonel Feininger** (1871–1956) was born an American of German-American parents, as a painter he belongs within the European orbit. The son of distinguished musicians, he was, like Klee, early destined for a musical career. But before he was ten he was drawing his impressions of buildings, boats, and elevated trains in New York City. He went to Germany in 1887 to study music, but soon turned to painting. In Berlin between 1893 and 1905 Feininger earned his living as an illustrator and caricaturist for German and American periodicals, developing a brittle, angular style of figure drawing related to aspects of Art Nouveau, but revealing a very distinctive personal sense of visual satire. The years 1906–08, in Paris, brought him in touch with the early pioneers of modern French painting. By 1912–13 he had arrived at his own version of Cubism, particularly the form of Cubism with which Marc was then experimenting. Feininger was invited to exhibit with Der Blaue Reiter in 1913. In *Harbor Mole* of 1913 (fig. 7.26), he recomposed the scene of a breakwater into a scintillating interplay of color facets, geometric in outline but given a sense of rapid change by the transparent,

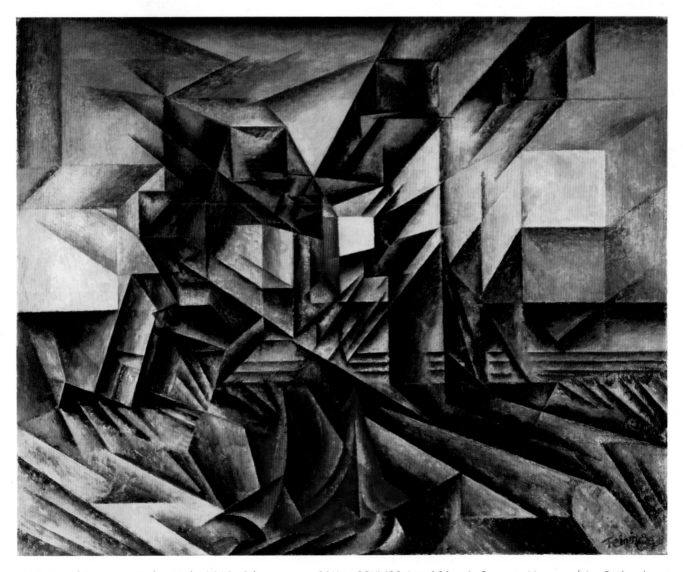

7.26 Lyonel Feininger, *Harbor Mole*, 1913. Oil on canvas, 31¾ × 39¾" (80.6 × 101 cm). Carnegie Museum of Art, Pittsburgh.

delicately graded color areas. In this work Feininger stated in a most accomplished manner the approach he was to continue, with variations, throughout the rest of his long life: that of strong, straight-line structure played against sensuous and softly luminous color. The interplay between taut linear structure and Romantic color, with space constantly shifting between abstraction and representation, created a dynamic tension in his paintings.

Germany's entry into World War I put an end to the exhibitions of Der Blaue Reiter and the publication of their yearbook. The artists dispersed, with German citizens like Klee, Marc, and Macke sent into military service. Macke was killed within weeks; Marc survived until 1916, only to be killed at Verdun. Münter relocated to Sweden, Jawlensky and Werefkin took refuge in Switzerland, and Kandinsky returned to Russia. Even before the war, another center for avant-garde activity had taken its place alongside Die Brücke and Der Blaue Reiter. In 1912, the musician and critic Herwarth Walden opened a gallery in Berlin for avant-garde art, the Sturm Galerie, using the name of the avant-garde art journal *Der Sturm* (The Storm), which he had founded in 1910. At the gallery, he exhibited Kandinsky and Der Blaue Reiter, Die Brücke and the Italian Futurists, and grouped as "French Expressionists" the artists Braque, Derain, Vlaminck, Auguste Herbin, and others. Also shown were Ensor, Klee, and Robert Delaunay. In 1913 came the climax of the Sturm Galerie's exhibitions, the First German Autumn Salon, including 360 works. Henri Rousseau's room contained twenty paintings, and almost the entire international range of experimental painting and sculpture at that moment was shown. Although during and after the war the various activities of Der Sturm lost their impetus, Berlin between 1910 and 1914 remained a rallying point for most of the new European ideas and revolutionary movements, largely through the leadership of Walden.

Expressionist Sculpture

With the exception of such older masters as Maillol, the tradition of Realist or Realist–Expressionist sculpture flourished more energetically outside France than within after 1910. The human figure was so thoroughly entrenched as the principal vehicle of expression for sculptors that it was even more difficult for them to depart from it than for painters to depart from landscape, figure, or still life. It was also difficult for sculptors to say anything new or startlingly different from what had been said before. Expressionist sculptors came closest to investing the subject with new relevance and vigor. In Germany the major figure was **Wilhelm Lehmbruck** (1881–1919). After an academic training, Lehmbruck turned for inspiration first to the Belgian sculptor of miners and industrial workers Constantin Meunier (see fig. 3.20), and then to Rodin (see figs. 3.16, 3.17, 3.18, 3.19). During the four years he spent in Paris, between 1910 and 1914, Lehmbruck became acquainted with Matisse, Brancusi, and Aleksandr

Archipenko. His *Kneeling Woman* (fig. **7.27**) of 1911 reveals the influence of Maillol, as well as classical Greek sculpture. The emotional power of Lehmbruck's work, however, comes not from his studies of the past but from his own sensitive and melancholy personality. His surviving works are few, for the entire oeuvre belongs to a ten-year period. In *Seated Youth* (fig. **7.28**), his last monumental work, the artist utilized extreme elongation—possibly suggested by figures in Byzantine mosaics and Romanesque sculpture—to convey a sense of contemplation and withdrawal. This work represents a departure from Maillol and from a nineteenth-century tradition that emphasized volume and mass. Lehmbruck's figure, with its long, angular limbs, is penetrated by space, and exploits for expressive ends the abstract organization of solid and voids. With its mood of dejection and loss, *Seated Youth* expresses the trauma and sadness Lehmbruck experienced in Germany during World War I—suffering that finally, in 1919, led him to suicide.

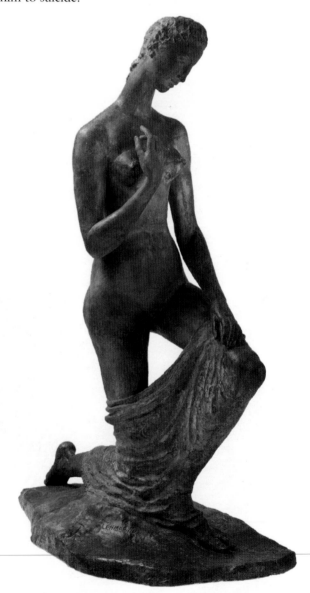

7.27 Wilhelm Lehmbruck, *Kneeling Woman*, 1911. Cast stone, 69½ × 56 × 27" (176.5 × 142.2 × 68.6 cm). The Museum of Modern Art, New York.

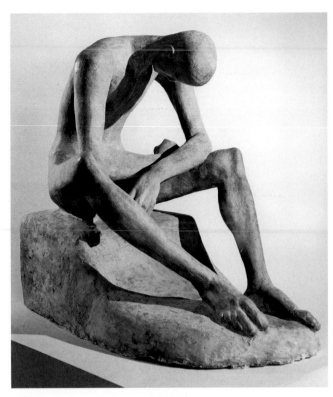

7.28 Wilhelm Lehmbruck, *Seated Youth*, 1917. Composite tinted plaster, 40⅝ × 30 × 45½" (103.2 × 76.2 × 115.5 cm). National Gallery of Art, Washington, D.C.

7.29 Georg Kolbe, *Young Woman*, 1926. Bronze, height 50⅝" (128.6 cm). Walker Art Center, Minneapolis.

Other leading German sculptors of the early twentieth century included **Georg Kolbe** (1877–1941) and Ernst Barlach. Kolbe began as a painter but developed an interest in sculpture during a two-year stay in Rome. His later encounter with Rodin's work in Paris had considerable impact on his work. For his figures or portrait heads, Kolbe combined the formal aspects of Maillol's figures with the light-reflecting surfaces of Rodin's. After some essays in highly simplified figuration, Kolbe settled into a lyrical formula of rhythmic nudes (fig. **7.29**)—appealing, but essentially a Renaissance tradition with a Rodinesque broken surface. His depictions in the 1930s of heroic, idealized, and specifically Nordic figures now seem uncomfortably compatible with the Nazis' glorification of a "master race."

In addition to making sculpture carved from wood or cast in bronze, **Ernst Barlach** (1870–1938) was an accomplished poet, playwright, and printmaker. Although, like Lehmbruck, he visited Paris, he was not as strongly influenced by French avant-garde developments. His early work took on the curving forms of *Jugendstil* and aspects of medieval German sculpture. In 1906 he traveled to Russia, where he was deeply impressed by the peasant population, and his later sculptures often depicted Russian beggars or laborers. Once he was targeted as a "degenerate artist" by the Nazi authorities in the 1930s, Barlach's public works, including monumental sculptures for cathedrals, were dismantled or destroyed. He was capable of works of sweeping power and the integration in a single image of humor, pathos, and primitive tragedy, as in *The Avenger* (fig. **7.30**). His was a storytelling art, a kind of socially conscious Expressionism that used the outer forms of contemporary experiment for narrative purposes.

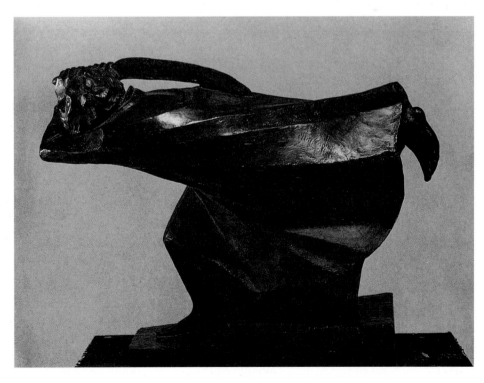

7.30 Ernst Barlach, *The Avenger*, 1914. Bronze, 17¼ × 23 × 8¼" (43.8 × 58.4 × 21 cm). Hirshhorn Museum and Sculpture Garden, Smithsonian Institution, Washington, D.C.

Self-Examination: Expressionism in Austria

To understand the various directions in which Expressionism developed, we may look at two artists who were associated in some degree with Expressionism in Austria, where its practitioners were never formally organized into a particular group. Like Klee and Feininger, the Austrians Egon Schiele and Oskar Kokoschka each had a highly individualized interpretation of the style.

Schiele

Egon Schiele (1890–1918) lived a short and tragic life, dying in the worldwide influenza epidemic of 1918. He was a precocious draftsman and, despite opposition from his uncle (who was his guardian after his father died insane, an event that haunted him), studied at the Vienna Academy of Art. His principal encouragement came from Gustav Klimt (see chapter 5), at his height as a painter and leader of the avant-garde in Vienna when they met in 1907. The two artists remained close, but although Schiele was deeply influenced by Klimt, he did not fully share his inclination toward the decorative.

Schiele's many self-portraits rank among his supreme achievements. They range from self-revelatory documents of personal anguish to records of a highly self-conscious and youthful bravado. *Schiele, Drawing a Nude Model before a Mirror* (fig. **7.31**) demonstrates his extraordinary

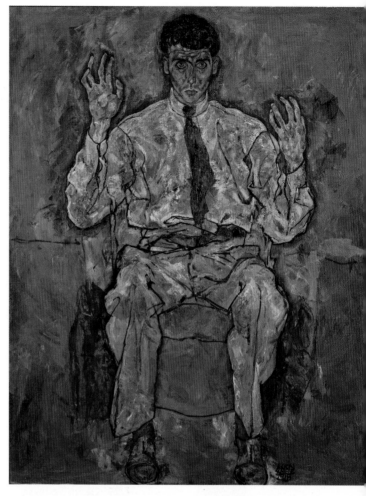

7.32 Egon Schiele, *Portrait of Paris von Gütersloh*, 1918. Oil on canvas, 55⅛ × 43⅞" (140 × 110.3 cm). Minneapolis Institute of Arts. Gift of the P.D. MacMillan Land Company.

natural skill as a draftsman. The intense portrayal, with the artist's narrowed gaze and the elongated, angular figure of the model, differs from even the most direct and least embellished of Klimt's portraits. Here Schiele explores the familiar theme of the artist and model, but does so to create an atmosphere of psychological tension and explicit sexuality. Schiele's models included his sister Gerti, as well as friends, professional models, and prostitutes. But when, albeit innocently, in 1912 he sought out children for models in his small village, he was imprisoned for twenty-four days for "offenses against public morality."

A comparison of paintings by Klimt and Schiele is valuable in illustrating both the continuity and the change between nineteenth-century Symbolism and early twentieth-century Expressionism. Klimt's painting *Adele Bloch-Bauer I* (see fig. 5.6) subsumes its sitter within rich and colorful patterns. Schiele's unfinished *Portrait of Paris von Gütersloh* (fig. **7.32**), painted in 1918, is comparable in subject, but the approach could not be more different. Both portraits give special attention to their sitters' hands: a gesture reminiscent of prayer in the Byzantine-influenced portrait by Klimt and a similarly suggestive gesture of religious ecstasy on the part of Schiele's friend Gütersloh, a painter and writer. Yet in contrast to the still, geometric design that

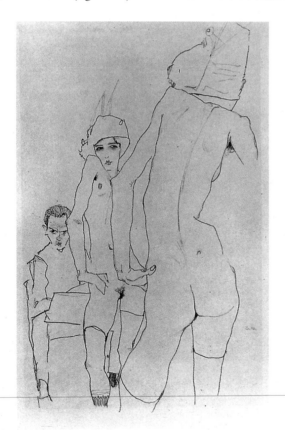

7.31 Egon Schiele, *Schiele, Drawing a Nude Model before a Mirror*, 1910. Pencil on paper, 21¾ × 13⅞" (55.2 × 35.2 cm). Graphische Sammlung Albertina, Vienna.

locks Bloch-Bauer in place, Gütersloh's entire body seems animated by a nervous energy. The paint is built up in jagged brushstrokes of harsh and dissonant tones of ocher, red, and cobalt.

Far from enveloping the sitter, Schiele's background functions as an undulating, animated counterpart to his friend. Thus, the fluid, seemingly timeless monumentality of Klimt's *Adele Bloch-Bauer I* confronts in Gütersloh a frenetic, continuously evolving modern portrait, in which medium and technique are used to reveal psychology as much as physical likeness.

Kokoschka

Oskar Kokoschka (1886–1980), like Schiele, was a product of Vienna, but he soon left the city, which he found gloomy and oppressive, for Switzerland and Germany, embracing the larger world of modern art to become one of the international figures of twentieth-century Expressionism. Between 1905 and 1908 Kokoschka worked in the Viennese Art Nouveau style, showing the influence of Klimt and Aubrey Beardsley (see fig. 5.2).

Even before going to Berlin at the invitation of Der Sturm gallerist Herwarth Walden in 1910, he was instinctively an Expressionist. Particularly in his early "black portraits," he searched passionately to expose an inner sensibility—which may have belonged more to himself than to his sitters. Among his very first images is the 1909 portrait of his friend the architect Adolf Loos (fig. **7.33**), who early on recognized Kokoschka's talents and provided him with moral as well as financial support. The figure projects from its dark background, and the tension in the contemplative face is echoed in Loos' nervously clasped hands. The Romantic basis of Kokoschka's early painting appears in *The Tempest* (fig. **7.34**), a double portrait of himself with his lover, Alma Mahler, in which the two figures, composed with flickering, light-saturated brushstrokes, are swept through a dream landscape of cold blue mountains and valleys lit only by the gleam of a shadowed moon. The painting was a great success when Kokoschka exhibited it in the 1914 New Munich Secession. The year before, he wrote to Alma about the work, then in progress: "I was able to express the mood I wanted by reliving it. ... Despite

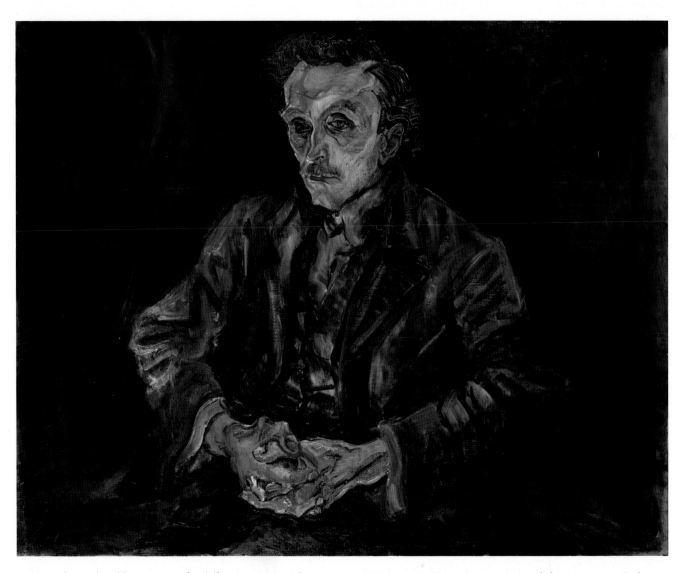

7.33 Oskar Kokoschka, *Portrait of Adolf Loos*, 1909. Oil on canvas, 29⅛ × 35⅞" (74 × 91.1 cm). Staatliche Museen zu Berlin, Preussischer Kulturbesitz, Nationalgalerie.

all the turmoil in the world, to know that one person can put eternal trust in another, that two people can be committed to themselves and other people by an act of faith."

Mahler's decision to end their relationship in 1915 shattered Kokoschka, who, some four years later, commissioned a Munich mannequin- and doll-maker to fabricate a convincing substitute. Despite detailed instructions, the final product was less than satisfying. In trying to emulate the texture of skin, the artisan had applied downy feathers to the doll's exterior, but this only heightened its artificiality. The dejected Kokoschka used the doll as a prop in several paintings (fig. **7.35**), creating a series of works whose eerie quality would not again be matched until the Surrealists began in earnest to elicit states of psychological unease from their viewers. Kokoschka's emotional difficulties were not solely due to his failed relationship with Mahler; service in World War I compounded his fragile emotional state. Seriously wounded in the war, Kokoschka produced little for several years, but his ideas and style were undergoing constant change. In 1924 he abruptly set out on some seven years of travel, during which he explored the problem of landscape, combining free, arbitrary, and brilliant Impressionist or Fauve color with a traditional perspective in which space is organized in clear fore-,

7.35 Oskar Kokoschka, *Woman in Blue*, 1919. Oil on canvas, 30¾ × 40½" (78 × 103 cm). Staatsgalerie Stuttgart.

middle, and background planes. Throughout his long life Kokoschka remained true to the spirit of Expressionism—to the power of emotion and the deeply felt sensitivity to the inner qualities of nature and the human soul. In 1933, in financial difficulties, the painter returned from his long

7.34 Oskar Kokoschka, *The Tempest*, 1914. Oil on canvas, 5' 11¼" × 7' 2⅜" (1.81 × 2.2 m). Öffentliche Kunstsammlung Basel, Kunstmuseum.

travels, going first to Vienna and then to Prague. During this period his works in public collections in Germany were confiscated by the Nazis as examples of "degenerate art." In 1938, as World War II approached, London became his home, and later Switzerland, although whenever possible he continued his restless traveling.

But in the 1910s, when German Expressionism emerged, the calamitous world wars and depression of the next decades were unimaginable. Germany was an empire with expanding territorial claims and a booming industrial economy (see *The German Empire*, below). While many in Germany—including most of the Expressionists—feared the imperial ambitions of their government, artists working in France were experiencing a different cultural atmosphere. Forthrightly political statements had receded from progressive French art since the apogee of Realism in the nineteenth century. Formal questions seemed to propel the work of the Fauves, just as it appeared to many viewers to be the only concern of the Cubists. Yet even in Cubist works the social and cultural conditions of the *fin-de-siècle* can be discerned.

CONTEXT

The German Empire

As disastrous as the Franco–Prussian War had been for Napoléon III of France, it was a well-calculated success for the Prussian prime minister, Otto von Bismarck. Bismarck had counted on Napoléon III's willingness to go to war with his German neighbors, if only to confirm his legitimacy as the successor to his uncle, the famed general Napoléon Bonaparte. Bismarck provoked Napoléon III by maneuvering a relative of the Prussian King Wilhelm I into possible succession to the Spanish throne. When the French ambassador met with Wilhelm to persuade him to withdraw Prussian claims to rule Spain, the king dictated a measured response for his prime minister to convey to France. Bismarck changed Wilhelm's calm language into a fiery, provocative retort and the French emperor declared war. Prussia's mechanized army quickly decimated the French lines, and Napoléon III was captured on August 31, 1870, just six weeks into the war. The resulting victory led to the formation of the German Empire, in which Prussia assumed leadership over a confederation of previously independent German states.

King Wilhelm became Kaiser, or emperor, of the Germans, and Bismarck served as his chancellor. Accelerating even further Northern Europe's industrialization, Bismarck made Germany the wealthiest, most literate, and most urban nation in Europe. To accomplish this, though, he drafted an oppressive constitution, designed to minimize the strength of opposition. Shortly after succeeding to the imperial throne, Wilhelm II dismissed Bismarck, fearing that his authoritarian policies would lead to an insurrection. Even with Bismarck's departure, the German Empire continued its industrial and military growth, but without addressing realistically the demands of its new and enormous working-class population. Political and social tensions mounted until Wilhelm II entered World War I under pressure from his generals, whom he had long mollified by building up the army and navy. Unable to manage any longer the uncertain balance he had achieved among his generals, the working class, political dissidents, wealthy manufacturers, and powerful landowners, Wilhelm II would find that his fate would be decided by war.

8
Cubism

Modern artists rested on the brink of total abstraction in 1910. Whether in pursuit of pure emotion or aesthetic autonomy, progressive artists were abandoning the tradition of naturalism that had guided the visual arts since the Renaissance. Expressionists like Kandinsky sought to trigger emotional or spiritual experiences through their art. The fundamental problem, for Kandinsky, rested with the West's attachment to mimesis, which reproduces aspects of the visible world. Kandinsky wanted his art to prompt viewers to contemplate a higher, spiritual realm, not remind them of their earthly concerns. In music he found an art form free from the shackles of imitation. Thus, Kandinsky treated color, line, and form as visual counterparts to notes, chords, rhythms, and harmonies arranged to elicit a specific emotional response.

In the case of the Fauves, the desire to elevate a work's formal attributes to a footing equal, if not superior, to its subject led painters like Matisse to liberate color, line, form, and space from their status as mere tools for documenting the visible world. One way to understand Matisse's strategy is to compare his approach to that of a poet. Poets choose words as much for their sounds and rhythms as for their meanings. For this reason, poetry can seem abstruse or even incomprehensible without prolonged consideration. Matisse likewise uses each of the formal elements at his disposal to fulfill a specific aesthetic need, allowing visual harmony to take precedence over the naturalism or narrative clarity of his work.

As these examples show, abstraction served a variety of ends. The degree to which an artist moved toward abstraction depended on his or her aesthetic aims. For an artist in search of spiritual transcendence, like Kandinsky, pure or "strong" abstraction ultimately best served his goals. Strong abstraction does not proceed from the observation of a real-world model; it is instead generated wholly by the artist's imagination. For most avant-garde artists working in the early twentieth century, though, abstraction was simply a means of distilling to its essential qualities a form observed in the real world. Referred to as "weak" abstraction, this approach demanded from artists the same level of engagement with nature and visual phenomena required since the Renaissance.

Cubism, more than any other avant-garde movement of the early twentieth century, reveals the degree to which modern artists were conscious of their relationship to artistic conventions born in the Renaissance. A form of weak abstraction, Cubism maintained an emphatic hold on the physical world. Rather than challenging the significance of material reality—as Expressionists such as Kandinsky and Marc were doing—Cubists Georges Braque and Pablo Picasso questioned the means by which this reality was understood and represented. They were not the only ones re-examining conventional accounts of the physical world. In 1905, Albert Einstein published his theory of special relativity, which asserts that neither space nor time is a fixed, stable measure. Both space and time are elastic, changing in relation to the speed and position of an observer. Accounts of a possible fourth dimension—where a body could move through time just as a human being moves through space—were circulated. Though poorly understood by laymen like Picasso and Braque, the notion that space and time were essentially the same was very exciting and certainly motivated some of their thinking.

More accessible were the ideas of the philosopher Henri Bergson, whose theories on the nature of consciousness were published in *Matter and Memory* (1896) and quickly popularized in Europe and North America. Among Bergson's key points was his assertion that consciousness is the accumulation of experiences. In other words, no rational being can ever experience a single instant of time: the past, present and future are not separate moments of awareness but an unbreakable continuum. Perception, Bergson explained, was also an experience of duration, leading artists like the Cubists to create artworks addressed to this model.

The invention of Cubism was truly a collaborative affair, and the close, mutually beneficial relationship between Picasso and Braque was arguably the most significant of

its kind in the history of art. According to Braque, it was "a union based on the independence of each." We have seen how much of the modern movement was the result of collective efforts between like-minded artists, as with the Fauves in France (see chapter 6) or Die Brücke or Der Blaue Reiter in Germany (see chapter 7). But there was no real precedent for the intense level of professional exchange that took place between Picasso and Braque, especially from 1908 to 1912, when they were in close, often daily contact. "We were like two mountain climbers roped together," Braque said. Picasso called him "pard," in humorous reference to the Western novels they loved to read (especially those about Buffalo Bill), or "Wilbur," likening their enterprise to that of the American aviation pioneers Wilbur and Orville Wright. In collaborating, each brought his own experiences and abilities to bear. Whereas Picasso was impulsive, prolific, and anarchic, Braque was slow, methodical, and meditative. Their backgrounds and training were also quite different. Thus, to understand fully the sources of Cubism, their early careers must first be treated individually.

Immersed in Tradition: Picasso's Early Career

Pablo Ruiz Picasso (1881–1973) was born in the provincial town of Málaga in southern Spain. Though an Andalusian by birth (and a resident of France for most of his life), he always identified himself as a Catalan, from the more industrialized, sophisticated city of Barcelona, where the family moved when he was thirteen. Picasso's father was a painter and art teacher who gave his son his earliest instruction. Though Picasso was no child prodigy, by the age of fourteen he was making highly accomplished portraits of his family.

Barcelona and Madrid

In the fall of 1895, when his father took a post at Barcelona's School of Fine Arts, the young Picasso was allowed to enroll directly in the advanced courses. At his father's urging, Picasso next spent eight or nine months in Madrid in 1897, where he enrolled at but rarely attended the Royal Academy of San Fernando, the most prestigious school in the country. He studied Spain's old masters at the great Prado Museum, admiring especially Diego Velázquez, whose work he copied. Several decades later, Picasso made his own highly personal interpretations of the old masters he saw in the museums (see fig. 18.2).

8.1 Pablo Picasso, *Le Moulin de la Galette*, 1900. Oil on canvas, 35½ × 46" (90.2 × 116.8 cm). Solomon R. Guggenheim Museum, New York.

Picasso suffered serious poverty in Madrid and chafed under the strictures of academic education, already setting his sights on Paris. First, however, he returned for a time to Barcelona. As the capital of Catalonia, a region fiercely proud of its own language and cultural traditions, Barcelona was undergoing a modern renaissance. Its citizens were vying to establish their city as the most prosperous, culturally enlightened urban center in Spain. At the same time, poverty, unemployment, and separatist sentiments gave rise to political unrest and strong anarchist tendencies. As in Madrid, the latest artistic trend in Barcelona was *modernista*, a provincial variation on Art Nouveau and Symbolism (see fig. 5.8) practiced by young progressive artists that left its mark on Picasso's early work.

Picasso's work from this period was in step with the pessimistic mood that permeated international Symbolist art toward the end of the century, as seen in the melancholic soul sickness of works by artists such as Aubrey Beardsley (see fig. 5.2) and Edvard Munch (see fig. 5.18). Picasso's preoccupation with poverty and mortality was to surface more overtly in the work of his so-called Blue Period.

Blue and Rose Periods

In 1900 one of Picasso's paintings was selected to hang in the Spanish Pavilion of the Universal Exposition in Paris. At age nineteen he traveled to the French capital for the first time with his friend and fellow painter Carles Casagemas. Picasso, who spoke little French, took up with a community of mostly Catalan artists in Paris and soon found benefactors in two dealers, Pedro Mañach, a fellow Catalan, and Berthe Weill, also an early collector of works by Matisse. She sold the first major painting Picasso made in Paris, *Le Moulin de la Galette* (fig. **8.1**), a vivid study of closely packed figures in the famous dance hall in

Montmartre. Although he no doubt knew Renoir's impressionist rendition of the same subject (see fig. 2.34), Picasso rejected its sun-dappled congeniality in favor of a nocturnal and considerably more sinister view. This study of figures in artificial light relates to the dark, tenebrist scenes typical of much Spanish art at the time, but the seamy ambience recalls the work of Degas or Toulouse-Lautrec, both shrewd chroniclers of Parisian café life.

Picasso's friend Casagemas became completely despondent over a failed love affair after the artists arrived back in Spain. He eventually returned to Paris without Picasso and, in front of his friends, shot himself in a restaurant. Picasso experienced pangs of guilt for having abandoned Casagemas, and he later claimed that it was the death of his friend that prompted the gloomy paintings of his Blue Period. Between 1901 and 1904, in both Barcelona

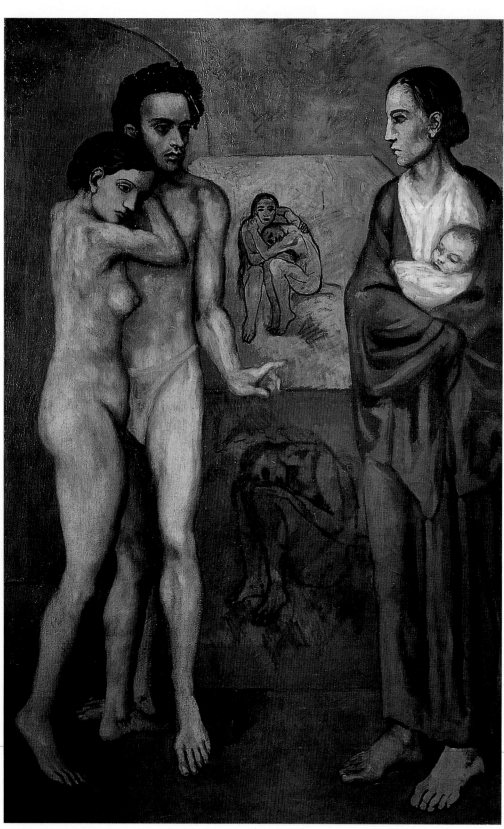

8.2 Pablo Picasso, *La Vie*, 1903. Oil on canvas, 6' 5⅜" × 4' 2⅜" (2 × 1.29 m). The Cleveland Museum of Art. Gift of Hanna Fund. 1945.24.

and Paris, Picasso used a predominantly blue palette in many works for the portrayal of figures and themes expressing human misery—frequently hunger and cold, the hardships he himself experienced as he was trying to establish himself. The thin, attenuated figures of Spain's sixteenth-century Mannerist painter, El Greco, found echoes in these works by Picasso, as did the whole history of Spanish religious painting, with its emphasis on mourning and physical torment.

A signal work of this period is the large allegorical composition Picasso made in Barcelona, *La Vie (Life)* (fig. **8.2**), for which he prepared several sketches. For the gaunt couple at the left Picasso depicted Casagemas and his lover, though X-rays reveal that the male figure was originally a self-portrait. They receive a stern gaze from the woman holding a baby at the right, who emerged from studies of inmates Picasso had made in a Parisian women's prison (where he could avail himself of free models), many of them prostitutes suffering from venereal disease. By heavily draping the woman, he gives her the timeless appearance of a madonna, thus embodying in a single figure the contradictory view of women as either saints or seductresses, a tension likewise stereotyped in Symbolist images of the *femme fatale*. In their resemblance to a shamed Adam and Eve, the lovers (like their equivalent in the painting behind them) also yield a religious reading. The pervasive blue hue of *La Vie* turns flesh into a cold, stony substance while compounding the melancholy atmosphere generated by the figures. In the spring of 1904 Picasso settled in Paris; he was never to live in Barcelona again. He moved into a tenement on the Montmartre hill dubbed by his friends the Bateau Lavoir ("laundry boat," after the ungainly laundry barges docked in the Seine), which was ultimately made famous by his presence there. Until 1909 Picasso lived at the Bateau Lavoir in the midst of an ever-growing circle of friends: painters, poets, actors, and critics, including the devoted Max Jacob, who was to die in a concentration camp during World War II, and the poet Guillaume Apollinaire, who was to become the literary apostle of Cubism.

Among the first works Picasso made upon arriving in Paris in 1904 is a macabre pastel in which a woman with grotesquely elongated fingers and hunched shoulders kisses a raven (fig. **8.3**). The subject evokes Edgar Allan Poe, a favorite writer among *fin-de-siècle* Parisian artists, particularly Odilon Redon, whose own brilliant pastels may have been a source for Picasso's (see fig. 3.13). The model for *Woman with a Crow* was an acquaintance who had trained her pet bird to scavenge crumbs from the floors of the Lapin Agile ("Nimble Rabbit"), a working-class cabaret in Montmartre frequented by the artist and his entourage. Her skeletal form is silhouetted against an intense blue, but the chilly hues and downcast mood of the Blue Period were giving way to the new themes and the warmer tonalities that characterize the next phase of Picasso's work, the Rose Period.

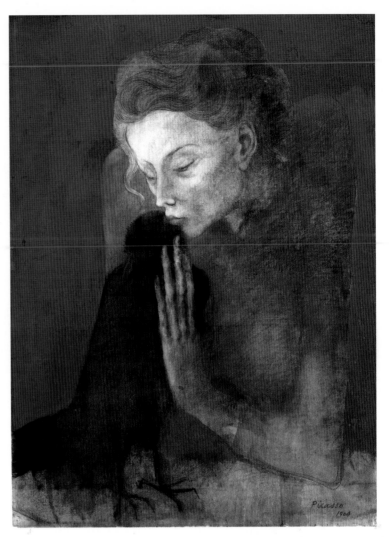

8.3 Pablo Picasso, *Woman with a Crow*, 1904. Charcoal, pastel, and watercolor on paper, 25½ × 19½" (64.7 × 49.5 cm). Toledo Museum of Art.

Between 1905 and 1906 Picasso was preoccupied with the subject of acrobatic performers who traveled from town to town, performing on makeshift stages. Called *saltimbanques*, these itinerant entertainers often dressed as Harlequin and Pierrot, the clownish characters from the Italian tradition of *commedia dell'arte* who compete for the amorous attentions of Columbine. These subjects were popular in France as well as Spain in nineteenth-century literature and painting, and Picasso certainly knew pictorial variations on the themes by artists such as Daumier and Cézanne. His own interest in circus subjects was stimulated by frequent visits to the Cirque Médrano, located near his Montmartre studio.

Like his predecessor Daumier, Picasso chose not to depict the *saltimbanque* in the midst of boisterous acrobatics but during moments of rest or quiet contemplation. His supreme achievement in this genre is *Family of Saltimbanques* (fig. **8.4**); at seven-and-a-half feet tall (2.3 m), it was the largest painting he had yet undertaken and stands as a measure of his enormous ambition and talent in the early years of his career. He made several preparatory studies, and X-rays reveal that at least four

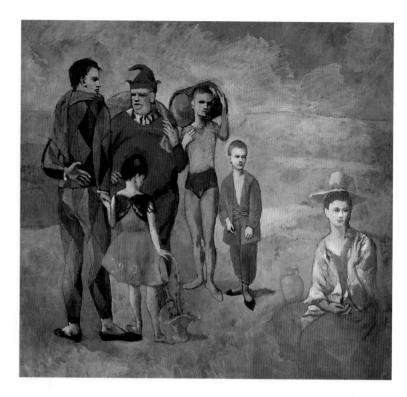

8.4 Pablo Picasso, *Family of Saltimbanques*, 1905. Oil on canvas, 6' 11¾" × 7' 6⅜" (2.1 × 2.3 m). National Gallery of Art, Washington, D.C.

variations on the final composition exist beneath the top paint layer. The painting began as a family scene, with women engaging in domestic chores and Harlequin (the figure seen here at the far left) watching a young female acrobat balance on a ball. But in the end Picasso settled upon an image virtually devoid of activity, in which the characters, despite their physical proximity, hardly take note of one another. Stripped of anecdotal details, the painting gains in poetry and mystery. The acrobats gather in a strangely barren landscape painted in warm brown tones that the artist loosely brushed over a layer of blue paint. An enigmatic stillness has replaced the heavy pathos of the Blue Period pictures, just as the predominant blues of the earlier work have shifted to a delicately muted palette of earth tones, rose, and orange.

The identities of the individual *saltimbanques* have been ascribed to members of Picasso's circle, but the only identification experts agree upon is that of Picasso, who portrayed himself, as he often did, in the guise of Harlequin, easily identifiable by the diamond patterns of his motley costume. These homeless entertainers, who eked out a living through their creative talents, existing on the margins of society, have long been understood as modernist surrogates for the artist. Before completing this large canvas, Picasso

exhibited over thirty works at a Paris gallery, including several *saltimbanque* subjects. Little is known about the sales, if any, that resulted from the show, but subsequently Picasso tended to refrain from exhibiting his work in Paris, except in small shows in private galleries (his favorite venue was his own studio). Although he was still seriously impoverished, his circumstances improved somewhat during these years as his circle of admirers—critics, dealers, and collectors—continued to grow.

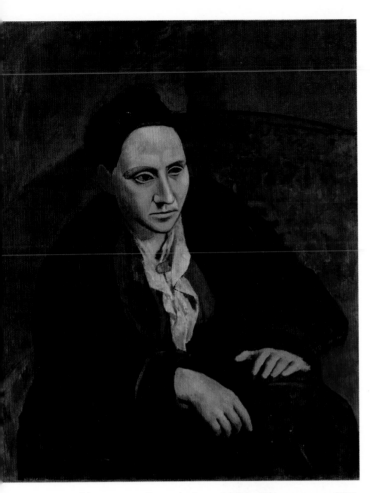

8.5 Pablo Picasso, *Gertrude Stein*, 1906. Oil on canvas, 39¼ × 32" (99.7 × 81.3 cm). The Metropolitan Museum of Art, New York. Bequest of Gertrude Stein, 1946.

One remarkable member of that circle was the American writer Gertrude Stein, who, with her brothers Leo and Michael, had lived in Paris since 1903 and was building one of the foremost collections of contemporary art in the city (see *Women as Patrons of the Avant-Garde*, opposite). She met Picasso in 1905 and introduced him the following year to Matisse, whose work the Steins were collecting. In their apartment Picasso had access to one of the great early Matisse collections, including the seminal *Le Bonheur de vivre* (see fig. 6.8). Gertrude Stein said she sat for Picasso ninety times while he painted her portrait (fig. **8.5**). Her ample frame, characteristically draped in a heavy, loose-fitting dress, assumes an unconventional pose for a female sitter, one that clearly conveys the self-assured nature of a woman who freely proclaimed her own artistic genius. She fills her corner of space like some powerful, massive work of sculpture. Picasso abandoned the portrait over the summer while he vacationed in Spain, and repainted Stein's face from memory upon his return. Its mask-like character, with eyes askew, anticipates the distortions of coming years.

By the end of 1905 Picasso's figures had taken on an aura of beauty and serenity that suggests a specific influence from ancient Greek white-ground vase paintings. This brief classical phase was prompted by several factors, including his studies of antiquities in the Louvre, and the

1905 retrospective of the work of the Neoclassical painter Jean-Auguste-Dominique Ingres (see figs. 1.7 and 1.8). Picasso's subjects during this period were primarily nudes, either young, idealized women or adolescent boys, all portrayed in a restrained terracotta palette evoking the ancient Mediterranean. By the end of 1906, following a trip to the remote Spanish village of Gósol, this classical ideal had evolved into the solid, thick-limbed anatomies of *Two Nudes* (fig. **8.6**), a mysterious composition in which we confront a woman and what is nearly but not quite her mirror reflection. The image is drained of the sentimentalism that inhabited the artist's Blue and Rose Period pictures. Significantly, Picasso was making sculpture around this time and earlier in 1906 had seen a show at the Louvre of Iberian sculpture from the sixth and fifth centuries B.C.E. These works, produced by a people that inhabited the

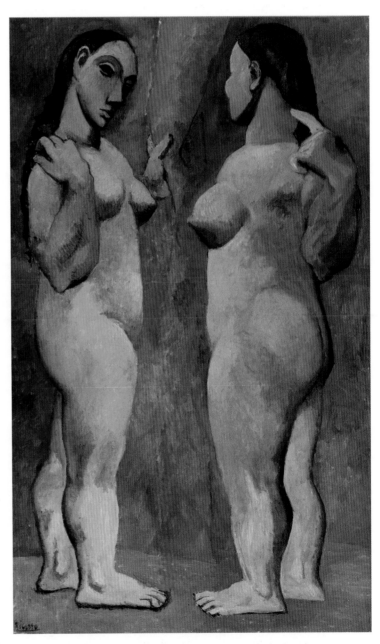

8.6 Pablo Picasso, *Two Nudes*, Paris, late 1906. Oil on canvas, 59⅝ × 36⅝" (151.5 × 93 cm). The Museum of Modern Art, New York.

eastern and southeastern coastal region of Spain during the first millennium B.C.E., were of particular interest to him since they had been excavated fifty miles (80 km) from his hometown. In 1907 he actually purchased two ancient Iberian stone heads, which he returned in 1911, after discovering that they had been stolen from the Louvre. In addition, the 1906 Salon d'Automne had featured a large retrospective of Gauguin's work, including the first important public presentation of his sculpture (see fig. 3.25). As an artist who plundered the art of non-Western and ancient cultures for his own work, Gauguin provided Picasso with a crucial model. Picasso's own preoccupation with sculptural form at this time, his encounter with the blocky contours of the ancient Iberian carvings, and the revelatory encounter with Gauguin's "primitivizing" examples left an indelible mark on paintings such as *Two Nudes*.

Les Demoiselles d'Avignon

Picasso's large canvas *Les Demoiselles d'Avignon* (fig. **8.7**) has been called the single most important painting of the twentieth century. It is an astonishing image that, in the iconoclastic spirit of modernism, virtually shattered every preceding pictorial and iconographical convention. Scholars have generated hundreds of pages scrutinizing its history and pondering its meaning, and the painting still has the

power to assault the viewer with its aggressively confrontational imagery. Long regarded as the first Cubist painting, the *Demoiselles* is now generally seen as a powerful example of expressionist art—an "exorcism painting," Picasso said, in which he did not necessarily initiate Cubism, but rather obliterated the lessons of the past. In fact, this type of multifigure composition did not persist in high Cubism, which was the domain of the single figure, the still life, and, to a lesser degree, the landscape. Nor did this violent, expressive treatment of the subject find a place in a style famous for emotional and intellectual control.

The five *demoiselles*, or young ladies, represent prostitutes from Avignon Street, in Barcelona's notorious redlight district, which Picasso knew well. The title, however, is not his; Picasso rarely named his works. That task he left to dealers and friends. The subject of prostitution, as we saw with Manet's scandalous *Olympia* (see fig. 2.24), had earned a prominent place in avant-garde art of the nineteenth century. Cézanne responded to Manet's painting with his own idiosyncratic versions of the subject. Other French artists, especially Degas and Toulouse-Lautrec, had portrayed the interior life of brothels, attracted as much by the availability of nude or nearly-nude potential models as by the frankly sexualized environs. As discussed in chapter 6, artistic activity was often associated with sexuality

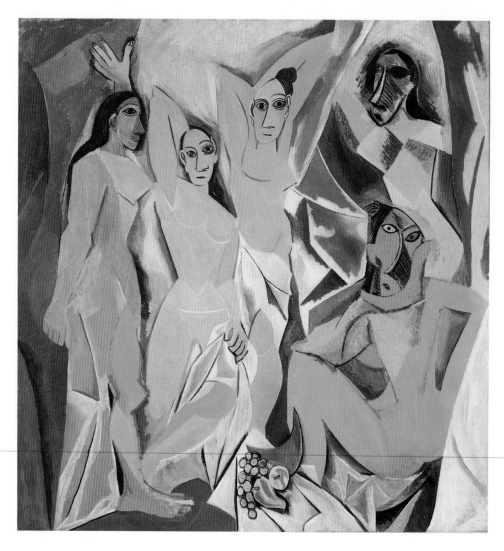

8.7 Pablo Picasso, *Les Demoiselles d'Avignon*, June–July 1907. Oil on canvas, 8' × 7' 8" (2.4 × 2.3 m). The Museum of Modern Art, New York.

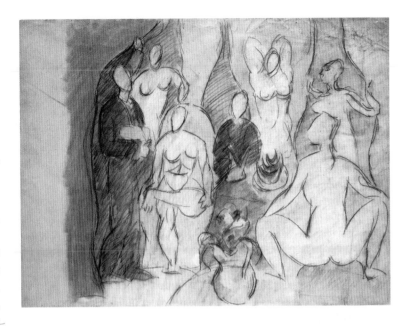

by modern artists and critics, making prostitutes an especially compelling subject. But none of Picasso's modernist predecessors addressed the motif with the vehemence or enormous scale seen here, where the theme of sexuality is raised to an explosive pitch.

When confronted with the *Demoiselles*, it is difficult to recall that the gentle *Saltimbanques* painting (see fig. 8.4) was only two years old. When compared to *Two Nudes* (see fig. 8.6), the anatomies of the *Demoiselles* seem crudely flattened and simplified, reduced to a series of interlocking, angular shapes. Even the draperies—the white cloth that spills off the table in the foreground and the bluish curtains that meander around the figures—have hardened into threatening shards. The composition is riddled with deliberately disorienting and contradictory points of view. The viewer looks down upon the table at the bottom of the canvas, but encounters the nudes head-on. Eyes are presented full face, while noses are in profile. The seated figure at the lower right faces her cohorts but manages to turn her head 180 degrees to address the viewer. The two central figures offer themselves up for visual consumption by assuming classic Venus poses, while their companion to the left strides into the composition like a fierce Egyptian statue. All of the prostitutes stare grimly ahead, with emotions seemingly as hardened as the knife-edge forms themselves. The three women at the left bear the simplified "Iberian" features familiar from *Two Nudes*. Most shocking of all, however, are the harshly painted masks that substitute for faces on the two figures at the right.

The *Demoiselles* evolved over several months in 1907, during which Picasso prepared his work in the manner of a traditional academic artist, executing dozens of drawings (figs. **8.8**, **8.9**). Through these preparatory works we are

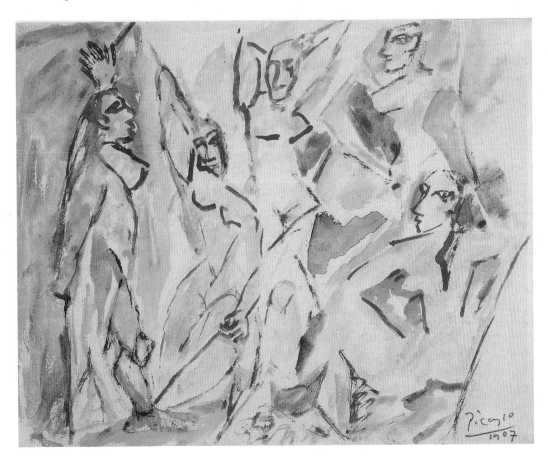

able to observe his progress as he honed his composition from a complex narrative to the startlingly iconic image we encounter today. The first of the drawings shown here, executed in the spring of 1907, reveals Picasso's early idea for the painting. At the far left is a figure the artist identified as a medical student. He holds a book in his right arm (in earlier studies it was a skull) and draws back a curtain with his left. In this curiously draped, stage-like setting, the student encounters a provocative quintet of naked women, one of whom theatrically opens more curtains at the right. They surround a lone sailor, who is seated before a table holding a plate of spiky melons and a phallic *porrón*, a Spanish wine flask. A second still life on a round table projects precipitously into the room at the bottom of the sheet. Even on this small scale the women appear as aggressive, sexually potent beings, compared to their rather docile male clients. For Picasso, a frequenter of brothels in his youth, the threat of venereal disease was of dire concern in an era in which such afflictions could be fatal. The inclusion of a skull-toting medical student (who resembled Picasso in related sketches) probably reflects the artist's morbid conflation of sex and death and his characteristically misogynistic view of women as the carriers of life-threatening disease.

In a tiny watercolor made about two months after the drawing (see fig. 8.9), Picasso transformed the medical student into a woman in a similar pose and eliminated the sailor altogether. The prostitutes, for the most part, have shifted their attention from their clients to the viewer. It is this conception, deprived of the earlier narrative clues, that emerges as the large painting. In this watercolor, executed in delicate washes of pink with jagged, electric-blue contour lines, Picasso also made drastic changes in his formal conception of the subject. The space is compressed, the figures are highly schematized, and rounded contours have given way to sharp, angular forms. Even the table is now a triangle, jutting into the room.

Equipped with a prodigious visual memory and keen awareness of past art, Picasso could have had several paintings in mind as he set to work on his large canvas in June. In 1905 he had seen Ingres' round painting *Turkish Bath* of 1863, a titillating Salon piece that displays intertwined female nudes in myriad erotic poses. While staying in Gósol in 1906 Picasso produced his own version of a harem subject. But in that painting, unlike the *Demoiselles*, the sitters (all likenesses of his lover Fernande Olivier) are represented in conventional bather poses, washing themselves or brushing their hair. Matisse's spectacular painting *Le Bonheur de vivre* (see fig. 6.8) had surely made a great impact on Picasso in the 1906 Salon des Indépendants, the juryless Salon that had been an important showcase for avant-garde art since 1884. The following year he had probably also seen Matisse's *Blue Nude* (see fig. 6.9). It is possible that Picasso undertook the *Demoiselles* partly as a response to these radical compositions. Most important of all for the artist (and for the subsequent development of Cubism) was the powerful example of Cézanne, who died in 1906 and whose work was shown in a retrospective at the 1907 Salon d'Automne. It is important to recall that many of the French master's early depictions of bathers (see fig. 3.5) were fraught with an anxiety and violence that no doubt attracted Picasso, but a major instigating force for the *Demoiselles* was the group of Cézanne's later bather paintings (see fig. 3.10). Indeed, certain figures in Picasso's composition have been traced to precedents in Cézanne. Picasso, however, chose not to cast his models as inhabitants of a timeless pastoral, but as sex workers in a contemporary brothel.

The work of many other painters has been linked to Picasso's seminal painting, from El Greco to Gauguin, but more significant was the artist's visit in June 1907 to Paris's ethnographic museum, where he saw numerous examples of African and Oceanic sculpture and masks. According to Apollinaire (who no doubt embellished the artist's words), Picasso once said that African sculptures were "the most powerful and the most beautiful of all the products of the human imagination." He had already seen such works during studio visits to artists who were collecting African art, including Matisse, Derain, and Vlaminck (see chapter 6). But his encounter at the museum, which took place while he was at work on the *Demoiselles*, provoked a "shock," he said, and he went back to the studio and reworked his painting (though not specifically to resemble anything he had just seen). It was at this time that he altered the faces of the two figures at the right from the "Iberian" countenances to violently distorted, depersonalized masks. Picasso not only introduced dramatically new, incongruous imagery into his painting, but he rendered it in a manner unlike anything else in the picture. When he added the women's mask-like visages at the right he used dark hues and rough hatch marks that have been likened to scarification marks on African masks. By deploying such willfully divergent modes throughout his painting Picasso heightened its disquieting power.

Beyond Fauvism: Braque's Early Career

When the French artist **Georges Braque** (1882–1963) first saw *Les Demoiselles d'Avignon* in Picasso's studio in 1907, he compared the experience to swallowing kerosene and spitting fire. Most of Picasso's supporters, including Apollinaire, were horrified, or at least stymied, by the new painting. Derain ventured that one day Picasso would be found hanged behind his big picture. According to the dealer Daniel-Henry Kahnweiler, the *Demoiselles* "seemed to everyone something mad or monstrous." As more and more visitors saw it in the studio (it was not exhibited publicly until 1916), the painting sent shock waves throughout the Parisian artistic community. For Braque, the painting had direct consequences for his art, prompting him to apply his current stylistic experiments to the human figure.

Just one year younger than Picasso, Braque was the son and grandson of amateur painters. He grew up in Argenteuil, on the River Seine, and the port city of Le Havre in Normandy, both famous Impressionist sites. In Le Havre he eventually befriended the artists Raoul Dufy and Othon Friesz, who, like Braque, became associates of the Fauve painters. As an adolescent Braque took flute lessons and attended art classes in the evening at Le Havre's École des Beaux-Arts. Following his father's and grandfather's trade, he was apprenticed as a house painter and decorator in 1899 and at the end of 1900 he went to Paris to continue his apprenticeship. Some of the decorative and *trompe l'oeil* effects that later entered his paintings and collages were the result of this initial experience. After a year of military service and brief academic training, Braque settled in Paris, but he returned frequently to Le Havre to paint landscapes, especially views of the harbor. Like his artist contemporaries in Paris, he studied the old masters in the Louvre and was drawn to Egyptian and archaic sculpture. He was attracted by Poussin among the old masters, and his early devotion to Corot continued. During the same period he was discovering the Post-Impressionists, including Van Gogh, Gauguin, and the Neo-Impressionist Signac, but it was ultimately the art of Cézanne that affected him most deeply and set him on the path to Cubism.

In the fall of 1905 Braque was impressed by the works of Matisse, Derain, and Vlaminck at the notorious Salon d'Automne where Fauvism made its public debut, and the following year he turned to a bright, Fauve-inspired palette. Unlike Picasso, Braque submitted work regularly to the Salons in the early years of his career. His paintings were included in the 1906 Salon des Indépendants, but he later destroyed all the submitted works. In the company of Friesz and Derain, he spent the fall and winter of 1906 near Marseilles at L'Estaque, where Cézanne had painted (see fig. 3.6). He then entered a group of his new Fauve paintings in the Salon des Indépendants of March 1907 that included Matisse's *Blue Nude*. One of his works was purchased by Kahnweiler, who was to become the most important dealer of Cubist pictures. Though the record is not certain, Braque and Picasso probably met around this time. It was inevitable that their paths should cross, for they had several friends in common, including Derain, Matisse, and Apollinaire.

During his brief exploration of Fauvism, Braque developed his own distinctive palette, beautifully exemplified in the clear, opalescent hues of *Viaduct at L'Estaque* (fig. 8.10). Despite the bright coloration of this landscape, made on the site in the fall of 1907, its palette is tame compared with the radical color experiments of Matisse's Fauve work (see fig. 6.6). Owing largely to lessons absorbed from Cézanne, Braque was not willing to forgo explicit pictorial structure in his landscapes. The composition of *Viaduct at L'Estaque* is rigorously constructed: the hills and houses, though abbreviated in form, retain a palpable sense of volume, created through Cézannist patches of color and blue outlines, rather than through traditional chiaroscuro.

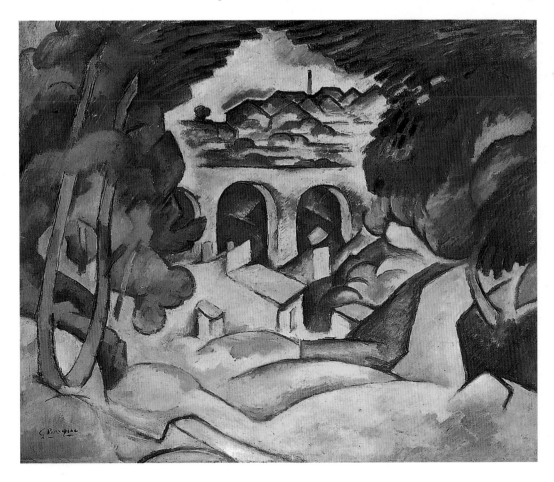

8.10 Georges Braque, *Viaduct at L'Estaque*, 1907. Oil on canvas, 25⅝ × 31¾" (65.1 × 80.6 cm). The Minneapolis Institute of Arts.

Braque built these forms up toward a high horizon line and framed them within arching trees, a favorite device of Cézanne. These tendencies in Braque's work are often referred to as "Cézannism."

At the end of 1907 Braque visited Picasso's studio with Apollinaire, possibly for the first time. By the end of the next year he and Picasso were regular visitors to one another's studios. On this visit Braque saw the completed *Demoiselles* and the beginnings of Picasso's most recent work, *Three Women* (see fig. 8.13). Until this point Braque had rarely painted the human form, but early in 1908 he made a multifigure painting, since lost, which was clearly inspired by *Three Women*. That spring he produced *Large Nude* (fig. **8.11**), a painting that signals his imminent departure from Fauvism. Like Picasso, Braque had seen Matisse's *Blue Nude* the previous fall (see fig. 6.9), and his massively muscular figure, set down with bold brushwork and emphatic black outlines, bears the memory of that work. But Braque repudiated the rich pinks and blues of *Viaduct at L'Estaque* for a subdued palette of ochers, browns, and gray-blue. While the model's simplified facial features and the angular drapery that surrounds her recall the *Demoiselles*, Braque was not motivated by the

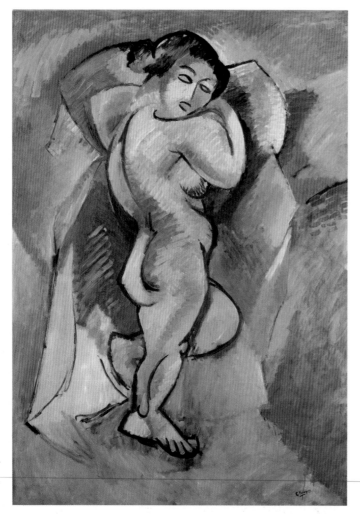

8.11 Georges Braque, *Large Nude*, 1908. Oil on canvas, 55⅛ × 39" (140 × 99.1 cm). Musée National d'Art Moderne, Centre Georges Pompidou, Paris.

sexualized themes of Picasso's painting. With *Large Nude*, he said he wanted to create a "new sort of beauty … in terms of volume, of line, of mass, of weight."

A comparison between *Viaduct at L'Estaque* and Braque's painting from August 1908, *Houses at L'Estaque* (fig. **8.12**), makes clear the transformations that took place in his style after fall 1907. With the suppression of particularizing details, the houses and trees become simplified, geometric volumes experienced at close range and sealed off from surrounding sky or land. Braque explained that in such pictures he wished to establish a background plane while "advancing the picture toward myself bit by bit." Rather than receding into depth, the forms seem to come forward, approximating an appearance of low-relief sculpture, or bas-relief.

Braque's illusion of limited depth is not dependent upon traditional, single-point linear perspective. Cézanne, he later said, was the first to break with that kind of "erudite, mechanicized perspective." Instead, he achieves illusion by the apparent volume of the buildings and trees—their overlapping, tilted, and shifting shapes create the effect of a scene observed from various positions. Despite many inconsistencies (of the sort that abound in Cézanne's work), including conflicting orthogonals and vantage points, or roof edges that fail to line up, or disappear altogether, Braque managed a wholly convincing, albeit highly conceptualized, space—one that exemplifies modernist concerns in being true to sense perceptions rather than to pictorial conventions. Color is limited to the fairly uniform ocher of the buildings, and the greens and blue-green of the trees. Whereas Cézanne built his entire organization of surface and depth from his color, Braque, in this work and increasingly in the paintings of the next few years, subordinates color in order to focus on pictorial structure.

With *Houses at L'Estaque* Braque established the essential syntax of early Cubism. He is generally credited with arriving at this point single-handedly, preliminary to the steady exchanges with Picasso that characterize the subsequent development of high Cubism. These works at L'Estaque confirmed Braque's thorough abandonment of Fauvism. "You can't remain forever in a state of paroxysm," he said. In fact, Fauvism was a short-lived experiment for most of its artists, partly because painters such as Derain, Dufy, and Vlaminck fell increasingly under the spell of Cézanne's work. In the world of the Parisian avant-garde during this remarkably fertile period, there was a growing sense of polarization between the followers of Matisse and the Cézannist and Cubist faction. Gertrude Stein described the competing camps as "Picassoites" and "Matisseites."

In the fall of 1908 Braque showed his new L'Estaque works to Picasso and submitted them to the progressive Salon d'Automne. The jury, which included Matisse, Rouault, and the Fauve painter Albert Marquet, rejected all his entries. According to Apollinaire, who told the story many ways over the years, it was upon this occasion that Matisse referred to Braque's "little cubes." By 1912

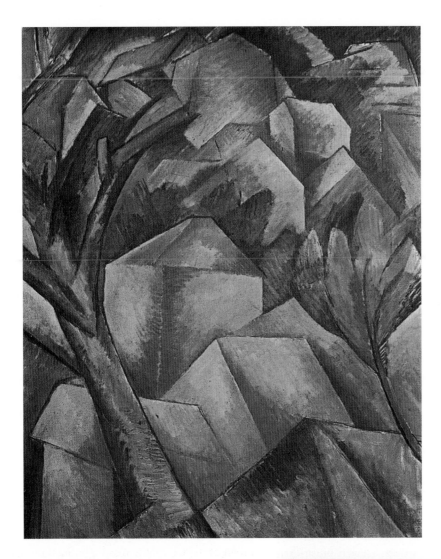

8.12 Georges Braque, *Houses at L'Estaque*, August 1908. Oil on canvas, 28¾ × 23⅝" (73 × 60 cm). Kunstmuseum, Bern.

8.13 Pablo Picasso, *Three Women*, 1907–08. Oil on canvas, 6' 6¾ × 7' 6½" (2 × 2.3 m). The Hermitage Museum, St. Petersburg.

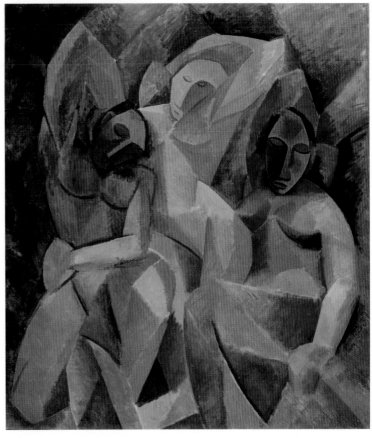

this had become the standard account for the birth of the term "Cubism." Following his rejection, Braque exhibited twenty-seven paintings in November 1908 at the Kahnweiler Gallery, with a catalogue by Apollinaire. Louis Vauxcelles, the critic who had coined the term "Fauve," reviewed the exhibition and, employing Matisse's term, observed that Braque "reduces everything, places and figures and houses, to geometrical schemes, to cubes."

"Two Mountain Climbers Roped Together": Braque, Picasso, and the Development of Cubism

The remarkable artistic dialogue between Braque and Picasso began in earnest toward the end of 1908, when they started visiting one another's studios regularly to see what had materialized during the day. "We discussed and tested each other's ideas as they came to us," Braque said, "and we compared our respective works." At this time Picasso completely revised *Three Women* (fig. **8.13**), a painting he had begun the year before in response to Braque's Cubist paintings from L'Estaque. Those new experiments led Picasso toward a more thorough absorption of "Cézannism," as he developed his own variation on the bas-relief effects he saw in Braque's work. The three

women here seem to be a reprise of the two central figures of the *Demoiselles*, although these mammoth beings seem even less like flesh and blood and appear as though chiseled from red sandstone. In earlier states of the painting, known from vintage photographs, the faces were boldly inscribed with features inspired by African masks, but Picasso altered those features in the final state. The women no longer stare boldly ahead, as in the *Demoiselles*, but seem to hover on the edge of deep slumber. Picasso here employs Cézanne's *passage*, a technique whereby the edges of color planes slip away and merge with adjacent areas. For example, on the proper left leg of the central figure (meaning her left, not ours) is a pale green triangle that dually functions as a facet of her thigh and part of her neighbor's breast. This *passage* mitigates any sense of clear demarcation between the figures and their environment. Such ambiguity of figure and ground, facilitated by an opening up of contours, is a fundamental characteristic of Cubism.

"Analytic Cubism," 1909–11

Cubism is often mistakenly characterized as a complete rejection of artistic conventions in use since the Renaissance. A more accurate way to understand it is as a dialogue with tradition, a recalibration of some of the assumptions motivating Western art since the fifteenth century. For instance, the Cubists recognized that Renaissance linear perspective, in which spatial recession is illusionistically rendered on a two-dimensional surface by means of geometry, was simply one of many ways in which three-dimensional space might be translated into two dimensions. There is nothing natural about the way linear perspective works. Viewers must learn to perceive the illusion of space in a painting using linear perspective just as viewers today must learn how to see the three-dimensional worlds created in "magic eye" posters. Western viewers are simply so accustomed to encountering scenes constructed according to linear perspective that it seems a natural and accurate record of observed reality. With Analytic Cubism, Braque and Picasso sought to develop a new system for depicting space. The same three dimensions rendered in paintings like David's *Oath of the Horatii* (see fig. 1.2) or Poussin's *Landscape with Burial of Phocion* (see fig. 1.14) exist in Cubist works. The difference is that Braque and Picasso use different techniques to represent space and volume: the modeling of a form might be suggested by a few parallel lines; the recession of one plane behind another is signaled by an L- or V-shaped mark, suggestive of two planes intersecting. Picasso and Braque held that a viewer will learn to "read" space and volume within a Cubist work just as he or she learned to perceive space in paintings by David or Poussin. Another characteristic of Cubism that testifies to their concern with artistic tradition is the artists' attraction to some of the most staid genres in Western art: figure studies and still lifes. Both were essential components of academic training. For example, the exquisitely rendered fan and hookah in Ingres' *Grande Odalisque* (fig. 1.7) are essentially still lifes

executed in support of a larger genre scene. Braque and Picasso's attraction to still life derived not only from their engagement with artistic tradition, but also from simple expediency: models are costly and even the best cannot maintain a pose as long as a loaf of bread or a guitar can, an important consideration given Cubists' method of sustained analysis of form and space. Materials drawn from the café and the studio, the milieux most familiar to these artists, became standard motifs in their work. Newspapers, bottles of wine, or food—the objects literally within their reach—were often elliptically coded with personal, sometimes humorous allusions to their private world. Musical instruments, too, appear often in their Cubist still lifes. Not only were they close at hand, but they also evoke the idea of music. A fundamental property of music is duration: music is essentially sound organized in time. Thus, the presence of musical instruments, sheet music, or song lyrics in Cubist works can be seen as a response to Henri Bergson's ideas about perception, an attempt to give visual form to his account of consciousness. But further experimentation was needed before Cubism would fully emerge in its first, analytic form.

Picasso's majestic painting *Bread and Fruit Dish on a Table* (fig. **8.14**) is an especially intriguing example of still life, since the artist initiated it as a figurative composition and then gradually transformed the human figures into bread, fruit, and furniture. We know from small studies that he was planning a painting of several figures seated and

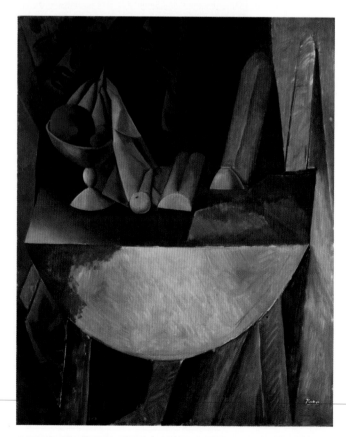

8.14 Pablo Picasso, *Bread and Fruit Dish on a Table*, 1909. Oil on canvas, 64⅜ × 52¼" (164 × 132.5 cm). Öffentliche Kunstsammlung, Kunstmuseum, Basel.

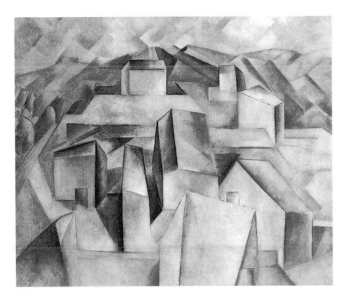

8.15 Pablo Picasso, *Houses on the Hill, Horta de Ebro,* summer 1909. Oil on canvas, 25⅝ × 31⅞" (65 × 81 cm). The Museum of Modern Art, New York.

facing the viewer from behind the drop-leaf table seen here (just like one in his studio). Evacuating the figures' bodies from the scene, he nonetheless retained their legs, thus explaining the strange, plank-like forms under the table. Other shapes from the old composition were retained to take on new identities in the still life. For example, the loaves of bread at the right, mysteriously propped up against a backdrop, were once the arms of a figure. At the opposite end of the table sat a woman, whose breasts were retained as fruit in a bowl. Thus, Picasso makes a sly visual pun on a hackneyed symbol of fecundity and womanhood, while balancing this rounded, feminine form with the phallic loaves at the opposite end of the table.

Picasso spent the summer of 1909 in the Spanish hill town of Horta de Ebro (today Horta de San Juan), where his early Cubist style reached its apogee. Among the landscapes he made that summer is *Houses on the Hill, Horta de Ebro* (fig. **8.15**), in which the stucco houses of the village, seen from above, are piled up into a pyramidal structure of such refinement and delicate coloration that the expressionist intensity of *Demoiselles* seems a distant memory. Painted in facets of pale gold and gray, the highly geometricized houses are presented in multiple, often contradictory perspectives. Rather than creating forms that recede predictably into the distance, Picasso often reversed the orthogonals to project toward the viewer. His juxtaposition of light and dark planes enhances the overall sculptural configuration but fails to convey any single or consistent light source. The result is a shimmering, prismatic world where space and mass are virtually synonymous. Even the sky has been articulated into a crystalline pattern of intersecting planes—realized through subtle shifts in value of light gray or green—that suggests a distant mountain range.

During this crucial summer Picasso also made several paintings and drawings of Fernande Olivier, including portrait studies that articulate the sculptural mass of her

head into a series of curving planes. After returning to Paris in September he worked in the studio of a friend, the Catalan sculptor Manuel Hugué, known as Manolo, and sculpted a head based on his Horta studies of Olivier. Several bronzes were then cast at a later date from the artist's original plaster casts. Picasso, who is arguably one of the most inventive sculptors of all time, had experimented with sculpture intermittently for several years. With *Woman's Head (Fernande)* (fig. **8.16**) he recapitulates in three dimensions the pictorial experiments of the summer by carving Olivier's features into facets as geometric as one of his Horta hillsides. Despite its innovative treatment of plastic form as a ruptured, discontinuous surface, this sculpture still depends upon the conventional methods and materials of modeling clay into a solid mass and making plaster casts (two were made) from the clay model that are then used to cast the work in bronze.

While Picasso was concentrating on his sculpture, Braque spent the winter of 1909 in Paris, composing several still lifes of musical instruments. Braque was an amateur musician, and the instruments he kept in his studio were common motifs in his paintings throughout his career. He preferred violins, mandolins, or clarinets to other objects, for they have, he said, "the advantage of being animated by one's touch." Despite the intensified fragmentation that Braque had by now adopted, the still-life subjects of *Violin and Palette* (fig. **8.17**) are still easily recognizable. Within a long, narrow format he has placed, in descending order, his palette, a musical score propped up on a stand, and a violin. These objects inhabit a shallow, highly ambiguous space. Presumably the violin and music stand are placed on a table, with the palette hanging on

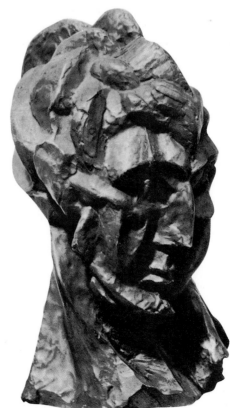

8.16 Pablo Picasso, *Woman's Head (Fernande),* fall 1909. Bronze, 16¼ × 9¾ × 10½" (41.3 × 24.7 × 26.6 cm). The Museum of Modern Art, New York.

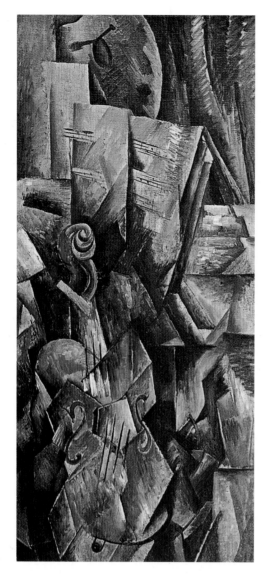

8.17 Georges Braque, *Violin and Palette*, 1909. Oil on canvas, 36⅛ × 16⅞" (91.7 × 42.9 cm). Solomon R. Guggenheim Museum, New York.

under assault since Manet. In its place, Braque offers a conceptual reconfiguration of that world. This kind of artistic legerdemain, in which different systems of representation simultaneously exist within one painting, was soon to be most fully exploited in Cubist collage and *papier collé*.

Picasso also treated musical themes in his early Cubist compositions. One of the best-known examples is his *Girl with a Mandolin (Fanny Tellier)* (fig. **8.18**), made in Paris in the spring of 1910. Still working from nature, Picasso hired a professional model to pose nude in his studio. When this portrait is compared with Braque's *Violin and Palette*, Picasso's style appears somewhat less radical than Braque's. The figure still retains a sense of the organic and, in some areas, is clearly detached from the background plane by way of sculptural modeling, seen especially in the rounded volumes of the model's right breast and arm. Picasso's chromatic range, however, is even more restricted than that of Braque's still life. Employing soft gradations of gray and golden brown, Picasso endowed this lyrical portrait with a beautifully tranquil atmosphere.

By 1910 Picasso and Braque had entered the period of greatest intensity in their collaborative, yet highly competitive, relationship. Over the next two years they

a wall behind them, but their vertical disposition within the picture space makes their precise orientation unclear. Although certain forms, such as the scroll at the top of the violin neck, are rendered naturalistically, for the most part the objects are not modeled continuously in space but are broken up into tightly woven facets that open into the surrounding void. At the same time, the interstices between objects harden into painted shards, causing space to appear as concrete as the depicted objects. It was this "materialization of a new space" that Braque said was the essence of Cubism.

At the top of *Violin and Palette* Braque depicted his painting palette, emblem of his métier, hanging from a carefully drawn nail. The shadow cast by the nail reinforces the object's existence in three-dimensional space. By employing this curious detail of *trompe l'oeil*, Braque calls attention to the ways in which his new system departs from conventional means of depicting volumetric shapes on a flat surface. In so doing, he declares Cubism's challenge to the hegemony of Renaissance conceptions of space, which had been

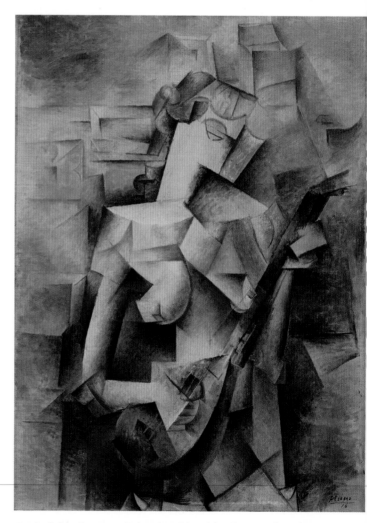

8.18 Pablo Picasso, *Girl with a Mandolin (Fanny Tellier)*, late spring 1910. Oil on canvas, 39½ × 29" (100.3 × 73.7 cm). The Museum of Modern Art, New York.

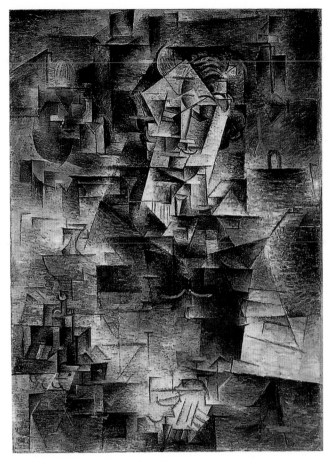

8.19 Pablo Picasso, *Portrait of Daniel-Henry Kahnweiler*, 1910. Oil on canvas, 39½ × 28⅜" (100.6 × 72.8 cm). The Art Institute of Chicago.

linear grid that hovers near the surface of the painting. Planes shift in front of and behind their neighbors, causing space to fluctuate and solid form to dissolve into transparent facets of color. Although he delineated his figure not as an integrated volume but as a lattice of lines dispersed over the visual field, Picasso nevertheless managed a likeness of his subject. In small details—a wave of hair, the sitter's carefully clasped hands, a schematic still life at the lower left—the painter particularized his subject and helps us to reconstruct a figure seated in a chair. Though Picasso kept color to the bare minimum, his canvas emits a shimmering, mesmerizing light, which he achieved by applying paint in short daubs that contain generous admixtures of white pigment. The Italian critic Ardengo Soffici, whose early writings about Picasso and Braque helped bring the Italian Futurists in contact with Cubism, referred to the "prismatic magic" of such works.

The degree to which the pictorial vocabularies of Picasso and Braque converged during the Analytic phase of Cubism can be demonstrated through a comparison of two works from 1911. Picasso's *Accordionist* (fig. **8.20**) dates

produced some of the most cerebral, complex paintings of their careers, working with tremendous concentration and in such proximity that some of their compositions are virtually indistinguishable from one another. For a time they even refrained from signing their own canvases on the front in order to downplay the individual nature of their contributions. "We were prepared to efface our personalities in order to find originality," Braque said. "Analytic Cubism," in which the object is analyzed, broken down, and dissected, is the term used to describe this high phase of their collaboration.

An exemplary work of Analytic Cubism is Picasso's *Portrait of Daniel-Henry Kahnweiler* (fig. **8.19**), made a few months after *Girl with a Mandolin*. The painting belongs to a series of portraits of art dealers that Picasso made in 1910. Kahnweiler was an astute German dealer who had been buying works by Braque and Picasso since 1908. He was also a critic who wrote extensively about Cubist art, producing the first serious theoretical text on the subject, which interprets the style in semiological terms as a language of signs. In this portrait, for which Kahnweiler apparently sat about twenty times, the modeled forms of *Girl with a Mandolin* have disappeared, and the figure, rather than disengaged from the background, seems merged with it. Here the third dimension is stated entirely in terms of flat, slightly angled planes organized within a

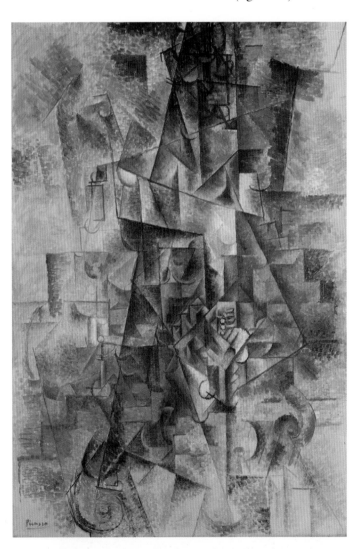

8.20 Pablo Picasso, *Accordionist*, summer 1911. Oil on canvas, 51¼ × 35¼" (130.2 × 89.5 cm). Solomon R. Guggenheim Museum, New York. Solomon R. Guggenheim Museum Founding Collection. Gift, Solomon R. Guggenheim.

from the astonishingly productive summer of that year, which he spent with Braque in Céret, a village in the French Pyrenees. At a nearly identical state of exploration is Braque's *The Portuguese (The Emigrant)* (fig. **8.21**), begun in Céret after Picasso's departure and completed in Paris. Both artists reorder the elements of the physical world within the shallow depths of their respective compositions, using the human figure as a pretext for an elaborate scaffolding of shifting, interpenetrating planes. The presence of the figure is made evident principally by a series of descending diagonal lines that helps concentrate the geometric structure down the center of the picture. That structure opens up toward the edges of the canvas where the pictorial incident diminishes, occasionally revealing the bare, unpainted ground. Both Picasso and Braque at this stage used a stippled, delicately modulated brushstroke so short as to be reminiscent of Seurat, though their color is restricted to muted gray and brown. Variation in values in these hues and in the direction of the strokes creates almost imperceptible change and movement between surface and depth.

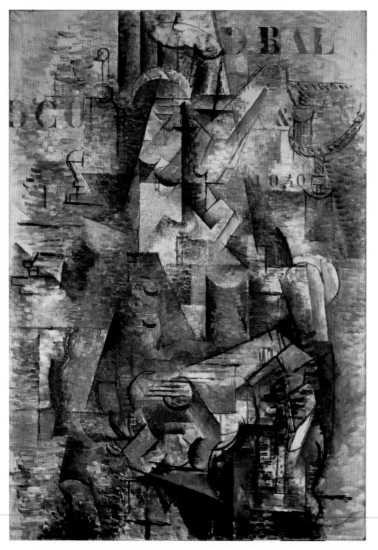

8.21 Georges Braque, *The Portuguese (The Emigrant)*, 1911. Oil on canvas, 46⅛ × 32" (117.2 × 81.3 cm). Öffentliche Kunstsammlung, Kunstmuseum, Basel.

However indecipherable their images, Braque and Picasso never relinquished the natural world altogether, and they provided subtle clues to the apprehension of their obscure subject matter. In the *Accordionist* (which represents a young girl, according to Picasso, not a man, as critics have often presumed) curvilinear elements near the bottom edge of the painting stand for the arms of a chair, while the small circles and step patterns toward the center indicate the keys and bellows of an accordion. *The Portuguese (The Emigrant)*, Braque said, shows "an emigrant on the bridge of a boat with a harbor in the background." This would explain, at the upper right, the transparent traces of a docking post and sections of nautical rope. In the lower portion are the strings and sound hole of the emigrant's guitar. Braque introduced a new element with the stenciled letters and numbers in the painting's upper zone. Like other forms in *The Portuguese*, the words are fragmentary. The letters D BAL at the upper right, for example, may derive from Grand Bal, probably a reference to a common dance-hall poster. While Braque had incorporated a word into a Cubist painting as early as 1909, his letters there were painted freehand as a descriptive local detail. For *The Portuguese* he borrowed a technique from commercial art and stenciled his letters, which here function not as illusionistic representations but as autonomous signs dissociated from any context that accounts for their presence. Inherently flat, the letters and numbers exist "outside of space," Braque said. And because they are congruent with the literal surface of the painting, they underscore the nature of the painted canvas as a material object, a physical fact, rather than a site for an illusionistic depiction of the real world. At the same time, they make the rest of the image read as an illusionistically shallow space. Braque's introduction of words in his painting, a practice soon adopted by Picasso, was one of many Cubist innovations that had far-reaching implications for modern art. Like so many of their inventions, the presence in the visual arts of letters, words, and even long texts is today commonplace (see figs. 19.33, 24.41, 27.31).

"Synthetic Cubism," 1912–14

In May 1912 the Cubists' search for alternative modes of representation led Picasso to adopt collage, a technique previously used mainly by folk artists (see *Collage*, opposite). The result was a small but revolutionary work, *Still Life with Chair Caning* (fig. **8.22**). Within this single composition Picasso combined a complex array of pictorial vocabularies, each imaging reality in its own way. Painted on an oval support, a shape Picasso and Braque had adopted earlier, this still life depicts objects scattered across a café table. The fragment of a newspaper, *Le Journal*, is indicated by the letters JOU, which, given the artist's penchant for puns, could refer to *jouer*, meaning "to play" and implying that all this illusionism is a game. Over the letters Picasso depicted a pipe in a naturalistic style, while at the right he added the highly abstracted forms of a goblet, a knife, and a slice of lemon.

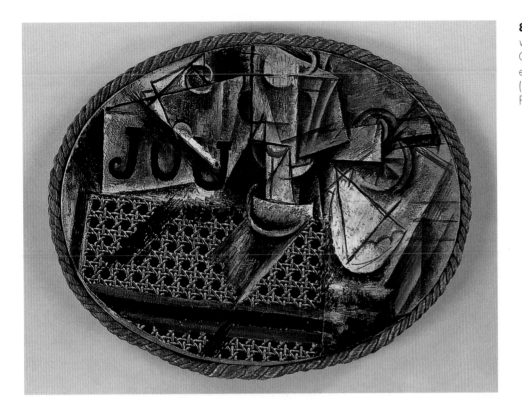

8.22 Pablo Picasso, *Still Life with Chair Caning*, 1912. Oil and oilcloth on canvas, edged with rope, 10⅝ × 14⅝" (27 × 37 cm). Musée Picasso, Paris.

TECHNIQUE

Collage

Generally associated with early twentieth-century modernism, collage had been a technique popular among craft artists and amateurs for centuries. The term "collage" is of modern coinage, derived by Georges Braque from the French verb *coller*, meaning "to stick" or "to paste." Prior to its adoption by the Cubists, it was a domestic pastime pursued in the eighteenth and nineteenth centuries mostly by women who affixed memorabilia, pressed flowers, and other items to a sheet of paper or a board. Bringing diverse items into relation with one another in this way provokes the viewer to discover connections among them, to invent the narrative that joins them. This potential for generating multiple narratives through a kind of free association appealed to avant-garde artists as much as it did to the hobbyists who used the technique to articulate bonds between friends and family members or with nature. The modernist author Virginia Woolf captures both the domestic and avant-garde associations of collage in her novel *To the Lighthouse* (1927), which she begins with the description of a boy seated at his knitting mother's feet, cutting out items advertised in a catalogue. This scene at first conveys a cozy domesticity. But the boy's activity—making cutouts of objects that seem to have no relationship to one another, objects listed repeatedly as if to evoke some hidden connection—alerts the reader to the unconventional, stream-of-consciousness narrative that will structure the novel. A friend of the art critic and avant-garde champion Roger Fry (see chapter 3), Virginia Woolf was well aware of modern artists' use of collage when she wrote the book in the mid-1920s.

The most prominent element here, however, is a section of common oilcloth that has been mechanically printed with a design simulating chair caning. Picasso glued the cloth directly to his canvas. While this *trompe l'oeil* fabric offers an exacting degree of illusionism, it is as much a fiction as Picasso's painted forms, since it remains a facsimile of chair caning, not the real thing. After all, Picasso once said, art is "a lie that helps us understand the truth." But he did surround his painting with actual rope, in ironic imitation of a traditional gold frame. The rope could have been suggested by a wooden table molding (see the table in fig. 8.26, for example) or the kind of cloth edged with upholstery cord that Picasso had placed on a table in his studio. Combined with the oilcloth, a material from the actual world, the rope encourages a reading of the painted surface itself as a horizontal table top, a logical idea, given the presence of still-life objects. Such spatial ambiguity is one of the many ways Picasso challenged the most fundamental artistic conventions. His incorporation of unorthodox materials not associated with "high" or "fine" art offered a radically new connection to the external world and an alternative to the increasingly hermetic nature of his Analytic Cubist compositions. Around the same time he and Braque were reintroducing color to their Cubist paintings with bright, commercial enamel paint.

Following Picasso's adoption of collage, Braque originated *papiers collés* (pasted papers). While this technique also involved gluing materials to a support, it is distinguished from collage in that only paper is used. Collage, on the other hand, capitalized on disparate elements in jarring juxtaposition. Braque made his first *papier collé*, *Fruit Dish and Glass* (fig. **8.23**), in September 1912, during an extended stay with Picasso in Sorgues, in the south

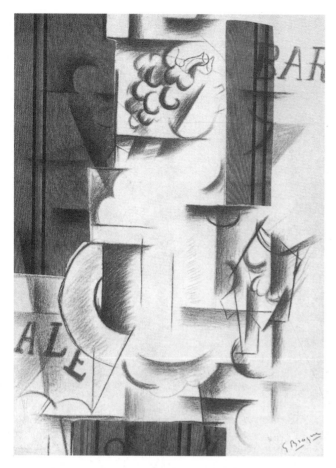

8.23 Georges Braque, *Fruit Dish and Glass*, September 1912. Charcoal and pasted paper on paper, 24⅜ × 17½" (62 × 44.5 cm). Private collection.

of France. It has been proposed that Braque deliberately postponed his experiment until Picasso, who regarded any idea as fair game for stealing, had left Sorgues for Paris. Once he was satisfied with the results, Braque presented them to Picasso. "I have to admit that after having made the *papier collé*," he said, "I felt a great shock, and it was an even greater shock for Picasso when I showed it to him." Picasso soon began making his own experiments with Braque's "new procedure."

The precipitating event behind Braque's invention was his discovery in a store window of a roll of wallpaper printed with a *faux bois* (imitation wood-grain) motif. Braque had already used a house painter's comb to create *faux bois* patterns in his paintings, a technique he passed on to Picasso, and he immediately saw the paper's potential for his current work. Like the oilcloth in *Still Life with Chair Caning*, the *faux bois* offered a readymade replacement for hand-wrought imagery. In *Fruit Dish and Glass* Braque combined the *faux bois* paper with a charcoal drawing of a still life that, judging from the drawn words "ale" and "bar," is situated in the familiar world of the café. With typical ambiguity, the cut-outs of pasted paper play multiple roles, both literal and descriptive. Although their location in space is unclear, the *faux bois* sections in the upper portion of the still life are signs for the wall of the café, while the rectangular piece below represents a wooden table.

In addition, the *faux bois* enabled Braque to introduce color into his otherwise monochrome composition and to enlist its patterns as a kind of substitute chiaroscuro. At this point Braque was thinking of the *papiers collés* in relation to his paintings, for virtually the same composition exists as an oil.

Once Picasso took up the challenge of Braque's *papier collé*, the contrast in sensibility between the two became obvious. While Braque relied on his elegant Cubist draftsmanship to bind the imagery of his *papiers collés* together, Picasso immediately deployed more colorful, heterogeneous materials with greater irony and more spatial acrobatics. In one of his earliest *papiers collés*, *Guitar, Sheet Music, and Wine Glass* of 1912 (fig. **8.24**), a decorative wallpaper establishes the background for his still life (and implies that the depicted guitar is hanging on a wall). Picasso bettered Braque by actually painting a simulated wood-grain pattern on paper, which he then cut out and inserted into his composition as part of a guitar. But the instrument is incomplete; we must construct its shape by decoding the signs the artist provides, such as a section of blue paper for the bridge and a white disk for the sound hole.

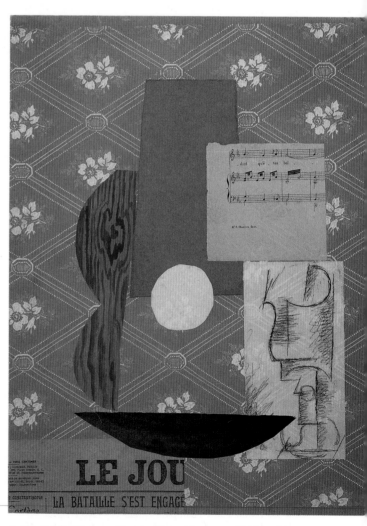

8.24 Pablo Picasso, *Guitar, Sheet Music, and Wine Glass*, fall 1912. Pasted papers, gouache, and charcoal on paper, 18⅞ × 14¾" (47.9 × 37.5 cm). McNay Art Museum, San Antonio, Texas.

As in Picasso's collage *Still Life with Chair Caning*, different signifying systems or languages of representation are here at work, complete with charcoal drawing (the glass at the right) and a guitar-shaped cut-out of painted *faux bois* paper. We have seen the way in which the Cubists represented newspapers in their painted compositions. The next step was to glue the actual newsprint to the surface of a *papier collé*. In this example, even the headline of the Paris newspaper *Le Journal*, LA BATAILLE S'EST ENGAGÉ (the battle is joined), has a dual message. It literally refers to the First Balkan War then being waged in Europe and thus adds a note of contemporaneity. Some specialists have argued that its deeper meaning is personal, that it is Picasso's friendly challenge to Braque on the battlefield of a new medium; others have read it as more directly political, an effort to confront the realities of war. By appropriating materials from the vast terrain of visual culture, even ones as ephemeral as the daily newspaper, and incorporating them unaltered into their works of art, Braque and Picasso undermined definitions of artistic authenticity that made it the exclusive province of drawing and painting, media that capture the immediacy of the individual artist's touch. As always, this was accomplished with irony and humor—here again, JOU implies "game" or "play." It was a challenge that had profound consequences for twentieth-century art, one that in many ways still informs debates in contemporary art.

The inventions in 1912 of collage and *papier collé*, as well as Cubist sculpture (discussed below), essentially terminated the Analytic Cubist phase of Braque and Picasso's enterprise and initiated a second and more extensive period in their work. Called Synthetic Cubism, this new phase lasted into the 1920s and witnessed the adoption and variation of the Cubist style by many new practitioners, whose work is addressed later in this chapter. If earlier Cubist works analyzed form by breaking it down and reconstructing it as lines and transparent planes, the work after 1912 generally constructs an image from many diverse components. Picasso and Braque began to make paintings that were not primarily a distillation of observed experience but, rather, were built up by using all plastic means at their disposal, both traditional and experimental. In many ways, Synthetic Cubist pictures are less descriptive of external reality, for they are generally assembled with flat, abstracted forms that have little representational value until they are assigned one within the composition. For example, the bowl-shaped black form in figure 8.23 is ambiguous, but once inserted in the composition, it stands for part of a guitar.

The dynamic new syntax of Synthetic Cubism, directly influenced by collage, is exemplified by Picasso's *Card Player* (fig. 8.25), from 1913–14. Here the artist has replaced the shimmering brown-and-gray scaffolding of *Accordionist* (see fig. 8.20) with flat, clearly differentiated shapes in bright and varied color. We can make out a mustachioed card player seated at a wooden table, indicated by the *faux bois* pattern, on which are three playing cards.

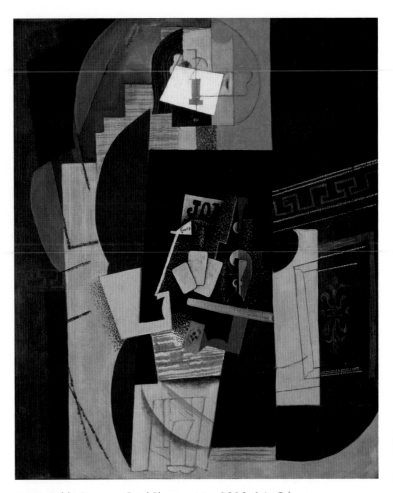

8.25 Pablo Picasso, *Card Player*, winter 1913–14. Oil on canvas, 42½ × 35¼" (108 × 89.5 cm). The Museum of Modern Art, New York.

Below the table Picasso schematically inscribed the player's legs and on either side of the sitter he included an indication of wainscoting on the back wall. Here the cropped letters JOU, by now a signature Cubist conceit, have an obvious relevance. Picasso emulates in oil the pasted forms of collage and *papiers collés* by partially obscuring with a succeeding layer of paint each of the flat shapes that make up the figure.

After 1913 the principal trend in paintings by both Picasso and Braque was toward enrichment of their plastic means and enlargement of their increasingly individual Cubist vocabularies. In Picasso's *Green Still Life* (fig. 8.26), we can easily identify all the customary ingredients of a Cubist still life—compote dish, newspaper, glass, bottle, and fruit. Following the intellectual rigors of Analytic Cubism, the artist seems to delight here in a cheerfully decorative mode. Alfred Barr, an art historian and the first director of The Museum of Modern Art, New York, called this decorative phase in Picasso's work Rococo Cubism. Here Picasso has disposed his still-life objects in an open, tangible space and, using commercial enamels, adds bright dots of color that resemble shiny sequins. The entire ground of the painting is a single hue, a bright emerald green, which Picasso allows to infiltrate the objects themselves. In so doing, he reiterates the flatness of the pictorial

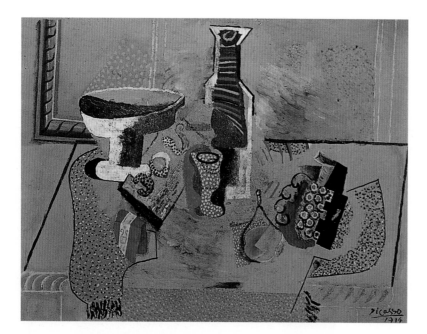

Braque and Picasso

Documents prove that constructed Cubist sculpture was invented by Braque and that it predated the first *papiers collés*. Nevertheless, no such works from his hand exist. Because he did not preserve the works, it is assumed that he thought of them principally as aids to his *papiers collés*, not as an end in themselves. According to Kahnweiler, Braque made reliefs in wood, paper, and cardboard, but the only visual record of his sculpture is a 1914 photograph of a work taken in his Paris studio (fig. **8.27**). This unusual composition represents a familiar subject, a café still life, assembled from paper (including newsprint) and cardboard on which Braque either drew or painted. He installed his sculpture across a corner of the room, thus incorporating the real space of the surrounding studio into his work.

Though constructed sculpture was Braque's invention, it was Picasso, typically, who made the most thorough use of it. His first attempt in the new technique is a guitar made from sheet metal, which he first prepared in October

space and deprives the objects of volume. Picasso painted *Green Still Life* in Avignon during the summer of 1914. Perhaps the optimistic mood of his work at this time reflects the calm domesticity he was enjoying there with Eva Gouel, his companion since 1911. But this sense of wellbeing was soon shattered. In August 1914 war was declared in Europe; by the end of 1915 Eva was dead of tuberculosis.

Braque, who was called up to serve in the French military (along with Guillaume Apollinaire and André Derain), said goodbye to Picasso at the Avignon railroad station, bringing to an abrupt end one of the greatest collaborations in the history of art. Picasso remained in Paris until 1917, when he went to Rome with the writer Jean Cocteau and worked on stage designs for the Ballets Russes. The postwar work of Braque and Picasso is discussed in chapter 12.

Constructed Spaces: Cubist Sculpture

Even in the hands of great modernist innovators such as Constantin Brancusi (see fig. 6.28), sculpture was still essentially conceived as a solid form surrounded by void. Sculptors created mass either through subtractive methods: carving form out of stone or wood; or additive ones: building up form by modeling in wax or clay. By these definitions, Picasso's *Woman's Head (Fernande)* (see fig. 8.16), regardless of its radical reconception of the human form, is still a traditional solid mass surrounded by space. Like collage, constructed sculpture is assembled from disparate, often unconventional materials. Unlike traditional sculpture, its forms are penetrated by void and create volume not by mass, but by containing space. With the introduction of constructed sculpture the Cubists broke with one of the most fundamental characteristics of sculptural form and provoked a rupture with past art equal to the one they fostered in painting.

8.27 Georges Braque, 1914. The artist's Paris studio with a paper sculpture, now lost.

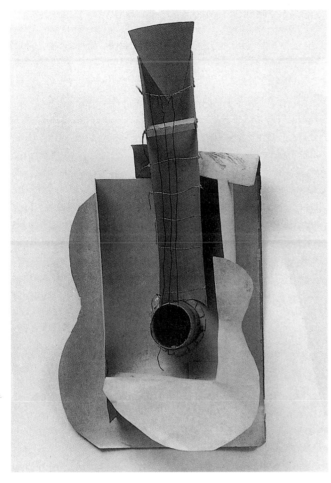

8.28 Pablo Picasso, Maquette for *Guitar*, Paris, October 1912. Construction of cardboard, string, and wire (restored), 25¾ × 13 × 7½" (65.1 × 33 × 19 cm). The Museum of Modern Art, New York.

1912 as a maquette made simply of cardboard, string, and wire (fig. **8.28**). Picasso's use of an industrial material such as sheet metal was highly unorthodox in 1912; in the years since, it has become a common sculptural medium. Clearly, the guitar was a significant impetus behind his *papiers collés*, for photographs taken in the artist's studio show it surrounded by works in this medium. In many ways, Picasso's guitar sculpture is the equivalent in three dimensions of the same motif in his *papier collé Guitar, Sheet Music, and Wine Glass* (see fig. 8.24), made several weeks later.

Through a technique of open construction, the body of the cardboard guitar has largely been cut away. Volume is expressed as a series of flat and projecting planes, resulting in a quality of transparency previously alien to sculpture. Picasso made the guitar sound hole, a void in a real instrument, as a projecting cylinder, just as he designed the neck as a concavity. The morphology of the guitar was directly inspired by a Grebo mask from the Ivory Coast in Africa, in which the eyes are depicted as hollow projecting cylinders. Picasso owned two such examples, one of which he bought in August 1912 during a visit to Marseilles with Braque. *Guitar* was revolutionary in showing that an artist's conceptual inventions of form are signs of or references to reality, not mere imitations of it. They can be

entirely arbitrary and may bear only a passing resemblance to what they actually denote. Thus the sign for the guitar's sound hole was stimulated by a completely unrelated source—the eyes of an African mask.

We know from a 1913 photograph that Picasso inserted his cardboard guitar into a relief still-life construction on the wall of his studio. In an even more fascinating sculptural ensemble, also recorded only in a contemporary photograph, he drew a guitarist on a canvas and gave the figure projecting cardboard arms that held an actual guitar. A real table with still-life props on it completed the composition. In this remarkable tableau Picasso closed the breach that separated painting and sculpture, uniting the pictorial realm with the space of the external world. Much of modern sculpture has addressed this very relationship, in which a sculpture is regarded not as a separate work of art to be isolated on a pedestal, but rather as an object coexisting with the viewer in one unified space. Unlike his constructed sculptures, which were essentially reliefs, Picasso's *Glass of Absinthe* (fig. **8.29**) was conceived in the round and was originally modeled by conventional methods in

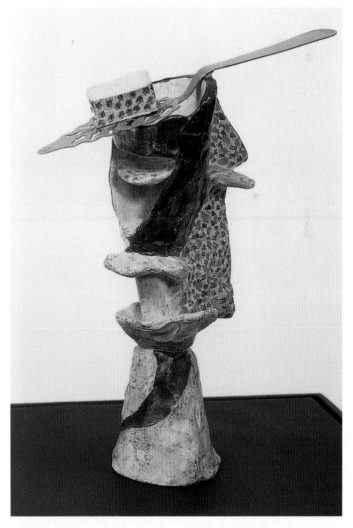

8.29 Pablo Picasso, *Glass of Absinthe*, spring 1914. Painted bronze with silver absinthe spoon, 8½ × 6½ × 3⅜" (21.6 × 16.4 × 8.5 cm); base diameter 2½" (6.4 cm). The Museum of Modern Art, New York.

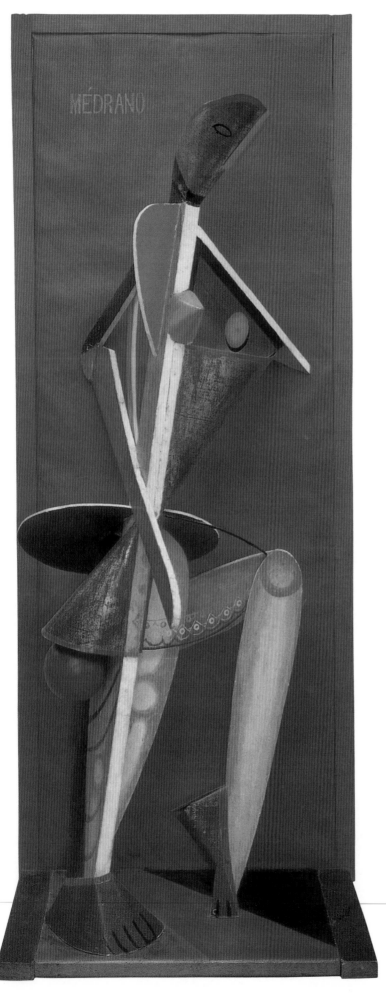

wax. Absinthe is a highly addictive, stupor-inducing liquor, so lethal that by the end of 1914 it was outlawed in France. Upon completion of the wax model of *Glass of Absinthe*, Kahnweiler had the work cast in bronze in an edition of six, to each of which the artist added a "found object," a perforated silver spoon, as well as a bronze sugar cube. He hand-painted five variants and coated one with sand, a substance that first Braque and then he had added to their paint medium. The bright color patterns on this example are similar to those found in the artist's contemporary paintings (see fig. 8.26). Picasso cut deep hollows in the glass to reveal the interior, where, as in the previous *Still Life*, the level of fluid reads as a horizontal plane. In this adaptation of collage methods to the medium of sculpture, Picasso adapts objects from the real world for expressive purposes in the realm of art. This lack of discrimination between the "high" art media of painting and sculpture and the "low" ephemera of the material world remained a characteristic of Picasso's sculpture (see figs. 15.42, 15.43) and proved especially relevant for artists in the 1950s and 60s (see figs. 19.29, 19.70).

Archipenko

Aleksandr Archipenko (1887–1964) has a strong claim to priority as a pioneer Cubist sculptor. Born in Kiev, Ukraine, he studied art in Kiev and Moscow before going to Paris in 1908. Within two years he was exhibiting his highly stylized figurative sculptures, reminiscent of Gauguin's, with the Cubist painters at the Paris Salons. By 1913 he had established his own sculpture school in the French capital, and his works were shown at Berlin's Der Sturm Gallery and in the New York Armory Show (see chapter 16). In 1913–14 Archipenko adapted the new technique of collage to sculpture, making brightly polychromed constructions from a variety of materials. He based some of the figures from this period on performers he saw at the Cirque Médrano, the circus that had also been one of Picasso's favorite haunts. In *Médrano II*, 1913 (fig. **8.30**), Archipenko assembled a dancing figure from wood, metal, and glass, which he then painted and attached to a back panel, creating a stage-like setting. This work was singled out for praise by Apollinaire in his review of the 1914 Salon des Indépendants. In the manner of constructed sculpture, Archipenko articulated volume by means of flat colored planes. Thus, the dancer's entire torso is a single plank of wood to which her appendages are hinged. Her skirt is a conical section of tin joined to a curved pane of glass, on which the artist painted a delicate ruffle. Over the next few years, Archipenko developed this idea of a figure against a backdrop in his so-called sculpto-paintings, which

8.30 Aleksandr Archipenko, *Médrano II*, 1913. Painted tin, wood, glass, and painted oilcloth, 49⅞ × 20¼ × 12½" (133.2 × 51.4 × 31.8 cm). Solomon R. Guggenheim Museum, New York.

are essentially paintings that incorporate relief elements in wood and sheet metal.

Walking Woman, 1918–19 (fig. **8.31**), typifies Archipenko's later free-standing sculptures. In 1915 he began using the void as a positive element in figurative sculpture, effectively reversing the historic concept of sculpture as a solid surrounded by space. He believed that sculptural form did not necessarily begin where mass encounters space, but "where space is encircled by material." Here the figure is a cluster of open spaces shaped by concave and convex solids. Although Picasso's Cubist constructions were more advanced than those of Archipenko, the latter's Cubist figures had more immediate influence, first because they were more widely exhibited at an early date, and second because they applied Cubist principles to the long-familiar sculptural subject of the human figure, which revealed the implications of mass–space reversals more readily.

Duchamp-Villon

The great talents of **Raymond Duchamp-Villon** (1876–1918) were cut short by his early death in the war in 1918. He was one of six siblings, four of whom became artists—the other three are Marcel Duchamp, Jacques Villon (whose work is discussed on p. 192), and Suzanne Duchamp. In 1900 Duchamp-Villon abandoned his studies in medicine and took up sculpture. At first influenced by

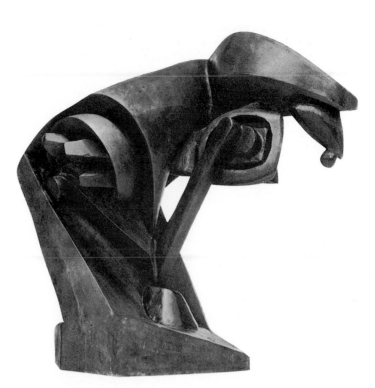

8.32 Raymond Duchamp-Villon, *The Horse*, 1914. Bronze (cast c. 1930–31), 40 × 39½ × 22⅜" (101.6 × 100.1 × 56.7 cm). The Museum of Modern Art, New York.

Rodin, like nearly all sculptors of his generation, he moved rapidly into the orbit of the Cubists. In his most important work, the bronze *Horse*, in 1914 (fig. **8.32**), the artist endows a pre-industrial subject with the dynamism of a new age. Through several versions of this sculpture he developed the image from flowing, curvilinear, relatively representational forms to a highly abstracted representation of a rearing horse. The diagonal planes and spiraling surfaces resemble pistons and turbines as they move, unfold, and integrate space into the mass of the sculpture. "The power of the machine imposes itself upon us to such an extent," Duchamp-Villon wrote, "that we can scarcely imagine living bodies without it." With its energetic sense of forms being propelled through space, *Horse* has much in common with the work of the Italian Futurist Umberto Boccioni, who had visited the studios of Archipenko and Duchamp-Villon in 1912 and whose sculptures (see fig. 10.20) were shown in Paris in 1913.

Lipchitz

Cubism was only one chapter in the long career of **Jacques Lipchitz** (1891–1973), though no other sculptor explored as extensively the possibilities of Cubist syntax in sculpture. Born in Lithuania in 1891 to a prosperous Jewish family, Lipchitz arrived in Paris in 1909 and there studied at the École des Beaux-Arts and the Académie Julian. In 1913 he met Picasso and, through the Mexican artist Diego Rivera, began his association with the Cubists. He also befriended a fellow Lithuanian, Chaim Soutine, as well as Amedeo Modigliani, Brancusi, Matisse, and, in 1916, Juan Gris. During this time he developed an abiding interest in the

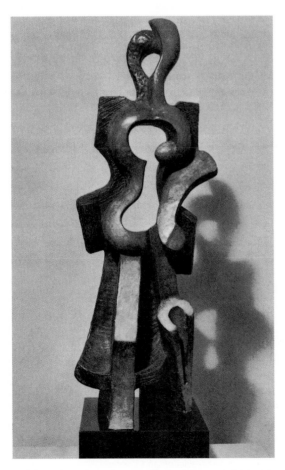

8.31 Aleksandr Archipenko, *Walking Woman*, 1918–19. Bronze, height 26⅜" (67 cm). Courtesy Frances Archipenko Gray.

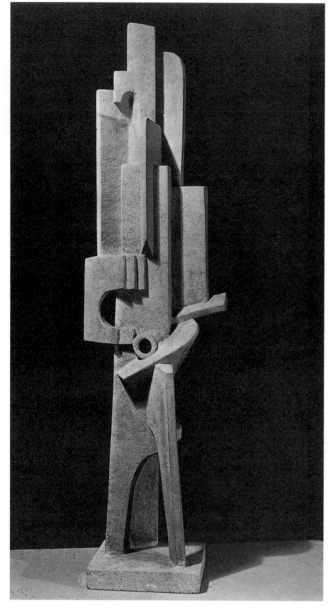

8.33 Jacques Lipchitz, *Man with a Guitar*, 1915. Limestone, 38¼ × 10½ × 7¾" (97.2 × 26.7 × 19.5 cm). The Museum of Modern Art, New York.

totemic forms of African sculpture. In 1913 he introduced geometric stylization into his figure sculptures and by 1915 was producing a wide variety of Cubist wood constructions as well as stone and bronze works. For Lipchitz, Cubism was a means of re-examining the essential nature of sculptural form and of asserting sculpture as a self-contained entity, rather than an imitation of nature.

In a series of vertical compositions in 1915–16, including *Man with a Guitar* (fig. **8.33**), Lipchitz edged to the brink of abstraction. Conceived as a structure of rigid, inter-secting planes, *Man with a Guitar* is an austere rendition of a familiar Cubist theme and was derived from the artist's earlier and more legible wood constructions of detachable figures. Late in life, Lipchitz, who often compared these abstracted sculptures to architecture, wrote about them in his autobiography, *My Life in Sculpture*: "I was definitely building up and composing the idea of a human figure

from abstract sculptural elements of line, plane, and volume; of mass contrasted with void completely realized in three dimensions." Lipchitz preferred modeling in clay to carving in stone, and most of his later sculptures, which gradually increased in scale, were developed as clay models and plaster casts that were then cast in bronze or carved in stone by his assistants. A bronze from 1928, *Reclining Nude with Guitar*, shows how the artist was still producing innovative forms within an essentially Cubist syntax. In the blocky yet curving masses of the sculpture, Lipchitz struck a characteristic balance between representation and abstraction by effecting, in his words, "a total assimilation of the figure to the guitar-object." This analogy between the guitar and human anatomy was one already exploited by Picasso. From the 1930s to the end of his life, expres-siveness became paramount in Lipchitz's sculpture and led to the free, rather baroque modeling of his later works. He moved to the United States to escape World War II in Europe and produced many large-scale public sculptures based on classical and biblical subjects.

Laurens

Henri Laurens (1885–1954) was born, lived, and died in Paris. He was apprenticed in a decorator's workshop and for a time practiced architectural stone carving. By the time of fully developed Analytic Cubism, he was living in Montmartre, immersed in the rich artistic milieu of the expanded Cubist circle in Paris. He was especially close to Juan Gris and Braque, whom he met in 1911. After his initial exposure to Cubism, Laurens absorbed the tenets of the style slowly. His earliest extant construc-tions and *papiers collés* (two media that are closely related in his oeuvre) date to 1915. Like Archipenko, whose Cubist work he knew well, Laurens excelled at polychromy in sculpture, integrating color into his constructions,

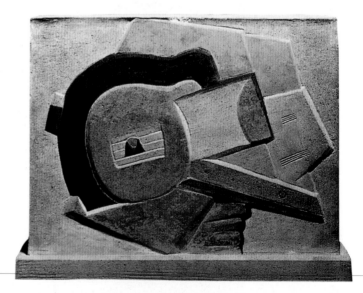

8.34 Henri Laurens, *Guitar and Clarinet*, 1920. Painted limestone, 12⅜ × 14½ × 3½" (36.7 × 36.8 × 8.9 cm). Hirshhorn Museum and Sculpture Garden, Smithsonian Institution, Washington, D.C.

low reliefs, and free-standing stone blocks. Referring to the long tradition of color in sculpture from antiquity to the Renaissance, he emphasized its function in reducing the variable effects of light on sculptural surfaces. As he explained, "When a statue is red, blue, or yellow, it remains red, blue, or yellow. But a statue that has not been colored is continually changing under the shifting light and shadows. My own aim, in coloring a statue, is that it should have its own light."

By 1919 Laurens had abandoned construction and embarked on a series of still-life sculptures in rough, porous stone. Drawing on his background in architectural stone carving and inspired by his love of French medieval sculpture, he carved *Guitar and Clarinet* (fig. **8.34**), 1920, in very low relief and then reinforced these flattened volumes with delicate, mat color. After 1920 Laurens relaxed the geometries of his Cubist style, adopting more curvilinear modes devoted to the depiction of the human figure.

An Adaptable Idiom: Developments in Cubist Painting in Paris

The English critic Roger Fry, an early supporter of the Cubists, stated that "They do not seek to imitate form, but to create form, not to imitate life but to find an equivalent for life." By 1911 the Cubist search for new forms was gaining momentum well beyond the studios of Picasso and Braque, and eventually spawned a large school of Cubist painters in Paris. Of these, Albert Gleizes and Jean Metzinger also became talented critics and expositors

of Cubism. Their book *On Cubism*, published in 1912, was one of the first important theoretical works on the movement. In Paris Gleizes and Metzinger met regularly with Robert Delaunay, Fernand Léger, and Henri Le Fauconnier, all of whom were sympathetic to the possibilities opened up by Cubism. The group convened regularly at the home of the Socialist writer Alexandre Mercereau, at the café Closerie des Lilas and, on Tuesday evenings, at sessions organized by the journal *Vers et prose*. At the café these painters met with older Symbolist writers and younger, enthusiastic critics, such as Guillaume Apollinaire and André Salmon. (They were not, however, close to Cubism's inventors, Braque and Picasso.) In 1911 the group arranged to have their paintings hung together in the Salon des Indépendants. The concentrated showing of Cubist experiments created a sensation, garnering violent attacks from most critics, but also an enthusiastic champion in Apollinaire. That year Archipenko and Roger de La Fresnaye joined the Gleizes–Metzinger group, together with Apollinaire's friend the painter **Marie Laurencin** (1881–1956). Laurencin had portrayed Apollinaire (seated in the center), herself (at the left), Picasso, and his lover Fernande Olivier in her 1908 group portrait (fig. **8.35**), whose naive style is reminiscent of Rousseau.

The three brothers Jacques Villon, Marcel Duchamp, and Raymond Duchamp-Villon, the Czech František Kupka, and the Spaniard Juan Gris were all new additions to the Cubist ranks. In the Salon des Indépendants of 1912 the "Salon Cubists" were so well represented that protests against their influence were lodged in the French

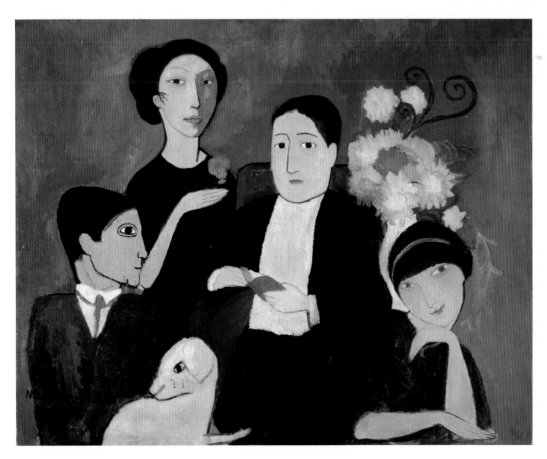

8.35 Marie Laurencin, *Group of Artists*, 1908. Oil on canvas, 25½ × 31⅞" (64.8 × 81 cm). The Baltimore Museum of Art.

parliament. Although Picasso and Braque did not take part in these Salons, their innovations were widely known. By then Cubist art had been shown in exhibitions in Germany, Russia, Britain, Spain, and the United States. In 1912 Kandinsky published works of Le Fauconnier and other Cubists in his yearbook *Der Blaue Reiter*, and Paul Klee visited the Paris studio of the Salon Cubist Robert Delaunay. Marc and Macke soon followed.

As these artists began to push the original Cubist concepts in various directions, testing limits in the process, they demonstrated that Cubism was a highly flexible and adaptable idiom. In a large exhibition at the Parisian gallery La Boëtie, held in October 1912 and entitled (probably by Jacques Villon) "Section d'Or" ("golden section"), entries by Marcel Duchamp, Francis Picabia, and Kupka signaled innovative alternatives to the Cubism of Picasso and Braque.

During 1912 and 1913 Gleizes and Metzinger's *On Cubism* was published, as well as Apollinaire's book *Les Peintres cubistes* and writings by various critics tracing the origins of Cubism and attempting to define it. Even today, when we are accustomed to the meteoric rise and fall of art movements and styles, it is difficult to appreciate the speed with which Cubism became an international movement. Beginning in 1908 with the isolated experiments of Braque and Picasso, by 1912 it was branching off in new directions and its history was already being written.

Gris

Juan Gris (1887–1927) was born in Madrid but moved permanently to Paris in 1906. While Gris was not one of Cubism's inventors, he was certainly one of its most brilliant exponents. Since 1908 he had lived next to his friend Picasso at the old tenement known as the Bateau Lavoir and had observed the genesis of Cubism, although he was then occupied in making satirical illustrations for French and Spanish journals.

Gris was closer to Braque and Picasso than were other members of the Cubist circle, and he was aware of their latest working procedures. Gris' sensibility differed significantly from Picasso's: he was not drawn to the primitive, and his work is governed by an overriding refinement and logic. In fact, he later made compositions based on the classical notion of ideal proportion known as the golden section.

By 1912 he was making distinctive collages and *papiers collés* with varied textural effects, enhanced by his rich color sense. He tended to avoid Picasso's heterogeneous media and subversive approach to representation, preferring to marshal his pasted papers, which he usually applied to canvas, into precise, harmonious arrangements. *The Table*, 1914 (fig. **8.36**), depicting a typical Cubist still-life subject, incorporates Braque's *faux bois*, along with hand-applied charcoal and paper. Although the canvas is rectangular, the objects are contained within an oval format (the table itself is also rectangular) that seems to exist by virtue

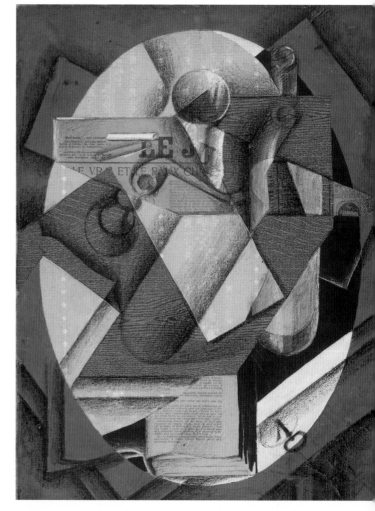

8.36 Juan Gris, *The Table*, 1914. Pasted and printed papers and charcoal on paper, mounted on canvas, 23½ × 17½" (59.7 × 44.5 cm). Philadelphia Museum of Art.

of a bright, elliptical spotlight. To achieve the layered complexity of this composition, Gris reordered the data of the visible world within at least two independent spatial systems. The foreshortened bottle of wine at the far right (which partially disappears under the *faux bois* paper) and the open book at the bottom are described as solid volumetric forms and exist in a relatively traditional space that positions the viewer above the table, looking down. The open book is drawn, but the text is an actual page from one of Gris' favorite detective novels. Toward the center of the work, a glass, bottle, and book, lightly inscribed in charcoal, are virtually transparent. They tilt at a precarious angle on what appears to be a second wooden table, introducing an altogether new space that is synonymous with the flat, upright surface of the painting. Perhaps the headline in the pasted newspaper, LE VRAI ET LE FAUX CHIC (real and false chic), refers not just to French fashion, but to the illusionistic trickery at play here.

Gris ceased making collages after 1914 but continued to expand his Cubist vocabulary in painting and drawing. In *Still Life and Townscape (Place Ravignan)* (fig. **8.37**) he employed a common Cubist device by mixing alternative types of illusionism within the same picture. In the

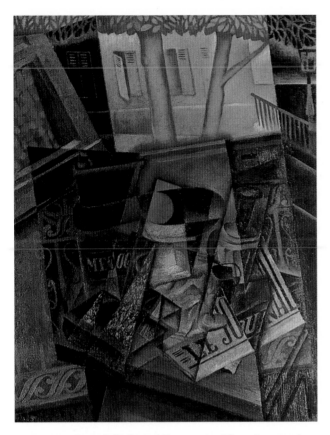

8.37 Juan Gris, *Still Life and Townscape (Place Ravignan)*, 1915. Oil on canvas, 45⅞ × 35⅛" (116.5 × 89.2 cm). Philadelphia Museum of Art.

lower half, a room interior embodies all the elements of Synthetic Cubism, with large, intensely colored geometric planes interlocking and absorbing the familiar collage components: the fruit bowl containing an orange; the newspaper, *Le Journal*; the wine label, "Médoc." However, this foreground pattern of tilted color shapes leads the eye up and back to a window that opens out on a uniformly blue area of simple trees and buildings. Thus the space of the picture shifts abruptly from the ambiguity and multifaceted structure of Cubism to the cool clarity of a traditional Renaissance painting structure: the view through the window.

Gleizes and Metzinger

The contributions of **Albert Gleizes** (1881–1953) and Metzinger to the Cubist movement are usually overshadowed by the reputation of their theoretical writings, specifically the pioneering book *On Cubism*, in which much of its pictorial vocabulary was first elucidated. Gleizes in particular was instrumental in expanding the range of the new art, in both type of subject and attitude toward that subject. His monumental 1912 painting *Harvest Threshing* (fig. **8.38**) opens up to a vast panorama the generally hermetic world of the Cubists. In its suggestions of the dignity of labor and the harmonious interrelationship of worker and nature, Gleizes explores a social dimension foreign to the unpeopled landscapes of Picasso and Braque. Although the

8.38 Albert Gleizes, *Harvest Threshing*, 1912. Oil on canvas, 8' 10" × 11' 7" (2.7 × 3.5 m). National Museum of Western Art, Tokyo.

palette remains within the subdued range—grays, greens, and browns, with flashes of red and yellow—the richness of Gleizes' color gives the work romantic overtones suggestive of Jean-François Millet (see fig. 1.17). In his later works, largely a response to the breakthrough *Simultaneous Disk* paintings of Robert Delaunay (see fig. 8.43), Gleizes turned to a form of lyrical abstraction based on curvilinear shapes, frequently inspired by musical motifs.

The early Cubist paintings of **Jean Metzinger** (1883–1956) are luminous variations on Cézanne, whose posthumous 1907 retrospective in Paris left an indelible impression on countless artists. *The Bathers* (fig. **8.39**), no doubt informed by Gris' immediate example, illustrates Metzinger's penchant for a carefully constructed rectangular design, in which the romantic luminosity of the paint plays against the strict geometry of the linear structure. He received his first solo exhibition in 1919 at Léonce Rosenberg's Galerie de l'Effort Moderne in Paris, which was dedicated to a rigorous form of Cubism dubbed "crystal" Cubism, an apt designation for Metzinger's paintings at that time. Toward the end of World War I he began to assimilate photographic images of the figure

8.39 Jean Metzinger, *The Bathers*, 1913. Oil on canvas, 58¼ × 41⅞" (148 × 106.4 cm). Philadelphia Museum of Art.

or architectural scenes into a decorative Cubist frame. His later style, strongly influenced by Fernand Léger's work of the 1920s, was an idealized realism for which Cubist pattern was a decorative background—a formula that enmeshed many of the lesser Cubists.

Léger

One almost inevitable development from Cubism was an art celebrating the ever-expanding machine world within the modern metropolis, for the geometric basis of much Cubist painting provided analogies to machine forms. In his 1924–25 essay, *The Machine Aesthetic: Geometric Order and Truth*, **Fernand Léger** (1881–1955) wrote: "Each artist possesses an offensive weapon that allows him to intimidate tradition. I have made use of the machine as others have used the nude body or the still life." Léger was not interested in simply portraying machines, for he opposed traditional realism as sentimental. Rather, he said he wanted to "create a beautiful object with mechanical elements."

Léger was from Normandy, in northwest France, where his family raised livestock. This agrarian background contributed to his later identification with the working classes and to his membership in the Communist Party in 1945. Once he settled in Paris in 1900, Léger shifted his studies from architecture to painting and passed from the influence of Cézanne to that of Picasso and Braque. One of his first major canvases, *Nude Figures in a Wood* (fig. **8.40**), is an unearthly habitation of machine forms and wood-chopping robots. Here Léger seems to be creating a work of art out of Cézanne's cylinders and cones, but it is also clear that he knew the work of artists such as Gleizes and Metzinger. The sobriety of the colors, coupled with the frenzied activity of the robotic figures, whose faceted forms can barely be distinguished from their forest environment, creates an atmosphere symbolic of a new, mechanized world. In 1913 Léger began a series of boldly non-objective paintings called *Contrastes de Formes* (contrasts of forms), featuring planar and tubular shapes composed of loose patches of color within black, linear contours. The metallic-looking forms, which interlock in rhythmical arrangements like the gears of some great machine, give the illusion of projecting toward the viewer. At first these shapes were non-referential, but the artist later used the same morphology to paint figures and landscapes.

Other Agendas: Orphism and Other Experimental Art in Paris, 1910–14

Unlike Léger, **Robert Delaunay** (1885–1941) moved rapidly through his apprenticeship to Cubism and by 1912 had arrived at a formula of brilliantly colored abstractions with only the most tenuous roots in naturalistic observation. His restless and inquisitive mind had ranged over the entire terrain of modern art. Delaunay was developing his art of "simultaneous contrasts of color" based on the ideas of the color theorist Michel-Eugène Chevreul, who

8.40 Fernand Léger, *Nude Figures in a Wood*, 1909–10. Oil on canvas, 47¼ × 66⅞" (120 × 169.9 cm). Kröller-Müller Museum, Otterlo, the Netherlands.

had so strongly influenced Seurat, Signac, and the Neo-Impressionists (see chapter 3). Also of interest to Delaunay were the space concepts of Cézanne, Braque, and Picasso. In 1911 and 1912 he exhibited with Der Blaue Reiter in Munich and at Der Sturm Gallery in Berlin in 1912. This early contact with the German avant-garde, and especially the paintings and writings of Kandinsky (see chapter 7), helped to make Delaunay one of the first French artists to embrace abstraction. He also joined the Cubists at the highly controversial Salon des Indépendants of 1911, where Apollinaire declared his painting the most important work in the show. Delaunay avoided the figure and the still life, two of the mainstays of orthodox Cubism, and in his first Cubist paintings took as themes two great works of Parisian architecture: the Gothic church of Saint-Séverin and the Eiffel Tower. He explored his subjects in depth, and made several variations of each. The Eiffel Tower series was begun in 1909. Like a work by Cézanne, the 1910 *Eiffel Tower in Trees* (fig. **8.41**) is framed by a foreground tree, depicted in light hues of ocher and blue, and by a pattern of circular cloud shapes that accentuate the staccato tempo of the painting. The fragmentation of the tower and foliage introduces not only the shifting viewpoints of Cubism, but also rapid motion, so that the tower and its environment seem to vibrate. With his interest in

8.41 Robert Delaunay, *Eiffel Tower in Trees*, 1910. Oil on canvas, 49⅞ × 36½" (126.7 × 92.7 cm). Solomon R. Guggenheim Museum, New York. Solomon R. Guggenheim Museum Founding Collection.

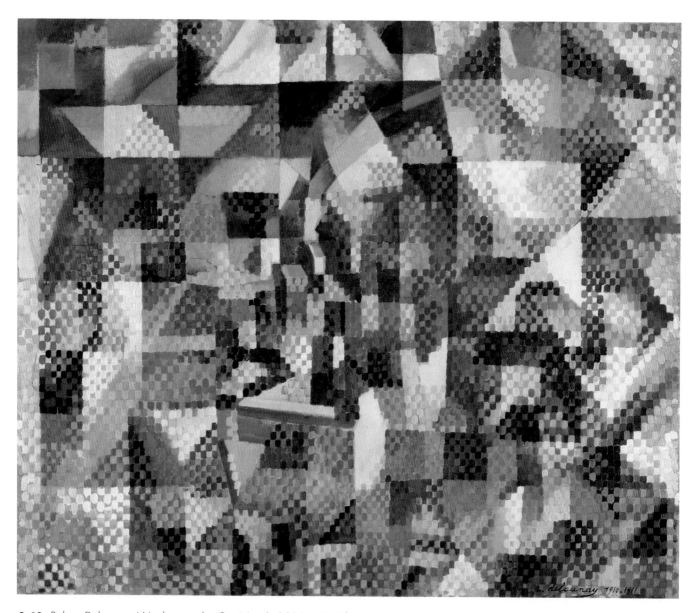

8.42 Robert Delaunay, *Window on the City No. 3*, 1911–12. Oil on canvas, 44¾ × 51½" (113.6 × 130.8 cm). Solomon R. Guggenheim Museum, New York. Solomon R. Guggenheim Museum Founding Collection.

simultaneous views and in the suggestion of motion, Delaunay may be reflecting ideas published by the Futurists in their 1910 manifesto (see chapter 10).

Delaunay called his method for capturing light on canvas through color "simultaneity." In *Window on the City No. 3* (fig. **8.42**), 1911–12, which belongs to a series based on views of Paris, Delaunay applied his own variation of Chevreul's simultaneous contrast of colors. He used a checkerboard pattern of color dots, rooted in Neo-Impressionism and framed in a larger pattern of geometric shapes, to create a dynamic world of fragmented images. This is essentially a work of abstraction, though its origin is still rooted in reality. In the spring of 1912 he began a new series, *Windows*, in which pure planes of color, fractured by light, virtually eliminate any recognizable vestiges of architecture and the observed world. Throughout this period, however, he continued to paint clearly representational works alongside his abstractions.

In his *Disk* paintings of 1913 (fig. **8.43**) Delaunay abandoned even the pretense of subject, creating arrangements of vividly colored circles and shapes. While these paintings, which he grouped under the title *Circular Forms*, have no overt relationship to motifs in nature, the artist did, according to his wife, Sonia Delaunay, observe the sun and the moon for long periods, closing his eyes to retain the retinal image of the circular shapes. His researches into light, movement, and the juxtaposition of contrasting colors were given full expression in these works.

Born Sonia Stern in a Ukrainian village in 1885, the same year as Robert Delaunay, **Sonia Delaunay** (1885–1979) moved to Paris in 1905. She married Robert in 1910 and, like him, became a pioneer of abstract painting. Her earliest mature works were Fauve-inspired figure paintings, and her first abstract work (fig. **8.44**), dated 1911, was a blanket that she pieced together from scraps of material after the birth of her son. This remarkable object, which Delaunay

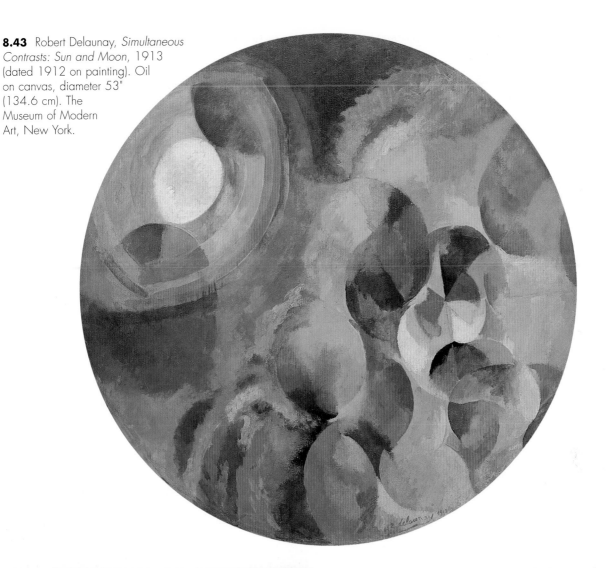

8.43 Robert Delaunay, *Simultaneous Contrasts: Sun and Moon*, 1913 (dated 1912 on painting). Oil on canvas, diameter 53" (134.6 cm). The Museum of Modern Art, New York.

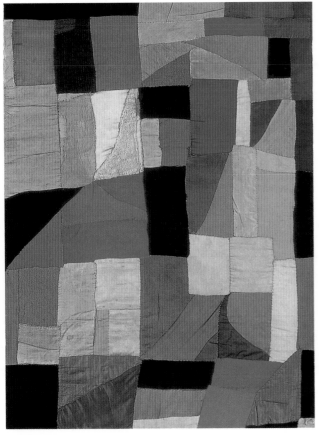

8.44 Sonia Delaunay, *Blanket*, 1911. Appliquéd fabric, 42⅞ × 31⅞" (109 × 81 cm). Musée National d'Art Moderne, Centre National d'Art et de Culture Georges Pompidou, Paris.

said was based on examples made by Russian peasant women (and has much in common with the geometric pieced "crazy quilts" of nineteenth-century America), foreshadowed the abstract paintings she had begun to make by 1913. In those paintings, called *Simultaneous Contrasts*, Delaunay explored the dynamic interaction of brilliant color harmonies. While they had much in common with Robert's work, they gave evidence of a creative personality quite distinct from his. After World War I Sonia Delaunay devoted more time to textile design. When worn, her clothing literally set into motion the geometric patterns she had first explored in 1911. Her highly influential designs were sold throughout America and Europe.

Born in the Czech Republic (then Bohemia, in the Austro-Hungarian Empire), **František Kupka** (1871–1957) attended the art academies of Prague and Vienna. The many forces in those cities that shaped his later art include exposure to the spiritually oriented followers of Nazarene art, decorative Czech folk art and other forms of ornament, knowledge of color theory, an awareness of the art

of the Vienna Secession, and a lifelong involvement with spiritualism and the occult. Settling in Paris in 1896, he discovered chronophotography and the budding art form of cinematography. These, along with the color theory of Chevreul, contributed to his notion of an art, still based on the human figure, that suggested a temporal dimension through sequential movement. In this he shared concerns with the Futurists, though he developed his ideas before he saw their work in Paris in 1912.

Throughout his life Kupka was a practicing medium and maintained a profound interest in Theosophy, Eastern religions, and astrology. The visionary, abstract art he developed in Paris, beginning in 1910, was based on his mystical belief that forces of the cosmos manifest themselves as pure rhythmic colors and geometric forms. Such devotion to the metaphysical realm placed him at odds with most of the Cubist art he encountered in Paris. Though he arrived at a non-objective art earlier than Delaunay, and though he was the first artist to exhibit abstract works in Paris, Kupka was then relatively unknown, and his influence was not immediately felt. In 1911–12, with the painting he entitled *Disks of Newton* (fig. **8.45**), Kupka created an

abstract world of vibrating, rotating color circles. While his prismatic circles have much in common with Delaunay's slightly later *Simultaneous Disks*, it is not entirely clear what these two artists knew of one another's work.

In 1912 Apollinaire named the abstract experiments of Delaunay, Léger, Kupka, and others Orphism, a term that displeased the highly individualistic Kupka. The designation was intended to conjure the image of Orpheus, the doomed musician of Greek legend whose songs could tame wild beasts and soothe the gods. Apollinaire defined the style as one based on the invention of new structures "which have not been borrowed from the visual sphere," though the artists he designated had all relied on the "visual sphere" to some degree. It was, however, a recognition that this art was in its way as divorced as music from the representation of the visual world or literal subject. Kandinsky, it will be recalled, equated his abstract paintings—done at about the same time—with pure musical sensation (see fig. 7.17).

Duchamp

Among the first artists to desert Cubism in favor of a new approach to subject and expressive content was **Marcel Duchamp** (1887–1968), one of the most fascinating, enigmatic, and influential figures in the history of modern art. As previously noted, Duchamp was one of four siblings who contributed to the art of the twentieth century, though none was nearly so significant as Marcel. Until 1910 he worked in a relatively conventional manner drawn from Cézanne and the Impressionists. In 1911 he painted his two brothers in *Portrait of Chess Players* (fig. **8.46**),

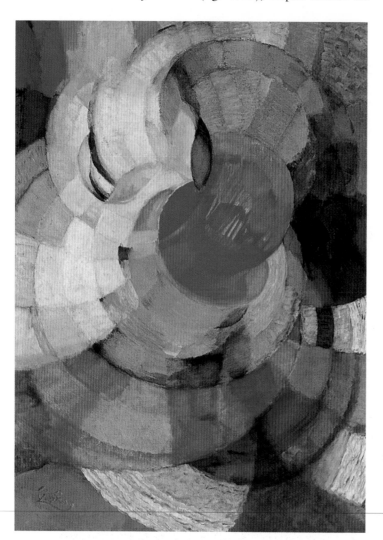

8.45 František Kupka, *Disks of Newton* (Study for *Fugue in Two Colors*), 1911–12. Oil on canvas, 39⅜ × 29" (100 × 73.7 cm). Philadelphia Museum of Art.

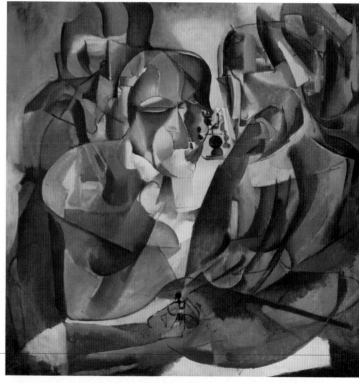

8.46 Marcel Duchamp, *Portrait of Chess Players*, 1911. Oil on canvas, 39¾ × 39¾" (101 × 101 cm). Philadelphia Museum of Art.

8.47 Marcel Duchamp, *Nude Descending a Staircase, No. 2*, 1912. Oil on canvas, 58 × 35" (147.3 × 88.9 cm). Philadelphia Museum of Art.

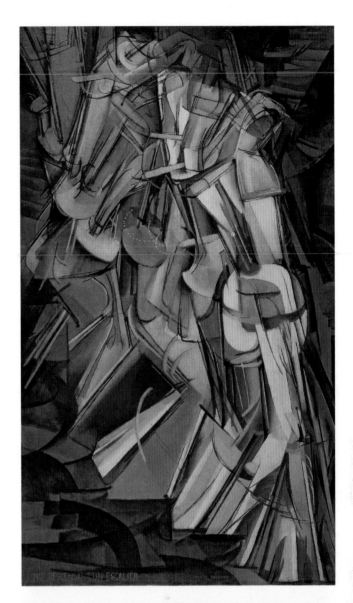

obviously after coming under the influence of Picasso and Braque's Cubist explorations. The space is ambiguous and the color is low-keyed and virtually monochromatic, partly because Duchamp painted it by gaslight rather than daylight. The linear rhythms are cursive rather than rectangular, while the figures are characterized by tense energy and individuality; their fragmentation gives them a fantastic rather than a physical presence. Even at the moment when he was learning about Cubism, Duchamp was already transforming it into something entirely different from the conceptions of its creators, producing what leading Cubists regarded as a creative misreading of its principles. The game of chess is a central theme in Duchamp's work. In his later career, when he had publicly stopped making art, chess assumed a role tantamount to artistic activity in his life.

During 1911 Duchamp also painted the first version of *Nude Descending a Staircase*, a work destined to become notorious as a popular symbol of modern art. In the famous second version, 1912 (fig. **8.47**), the androgynous, mechanized figure has been fragmented and multiplied to suggest a staccato motion. Duchamp was fascinated by the art of cinema and by the nineteenth-century chronophotographs of Étienne-Jules Marey (fig. **8.48**), which studied the body's locomotion through stop-action photographs, similar to those of Eadweard Muybridge and Thomas Eakins (see fig. 2.36). Marey placed his subjects in black clothing with light metal strips down the arms and legs that would, when photographed, create a linear graph of their

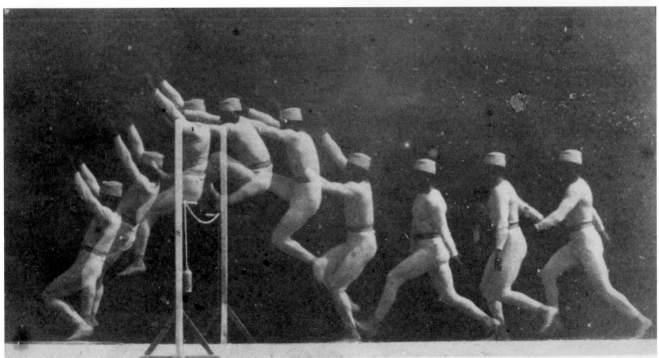

8.48 Étienne-Jules Marey, *A Man Doing a High Jump*, 1892. Chronophotograph.

movement. Duchamp similarly indicated the path of his figure's movement with lines of animation and, at the elbow, small white dots. He borrowed the Cubists' reductive palette, painting the figure in what he called "severe wood colors." Cubists on the selection committee for the 1912 Salon des Indépendants objected to the work for its literal title and traditional subject. Duchamp refused to change the title and withdrew his painting from the show. Throughout his life he used and subverted established artistic modes; in *Nude* he freely adapted Cubist means to a peculiarly personal expressive effect. The rapidly descending

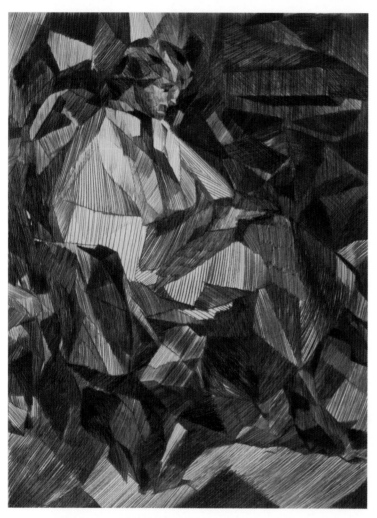

8.49 Jacques Villon, *Yvonne D. in Profile*, 1913. Drypoint in black on woven paper, 21½ × 16¼" (54.6 × 41.3 cm). National Gallery of Art, Washington, D.C.

nude is not a static form analyzed as a grid of lines and planes as is, for example, Picasso's *Portrait of Daniel-Henry Kahnweiler* (see fig. 8.19). Instead, by depicting the figure in several successive moments at once, Duchamp implies movement through space. *Nude Descending a Staircase* was shown in New York at the enormous 1913 Armory Show, the first international exhibition of modern art in the United States. The painting outraged American critics; one derided it as an "explosion in a shingle factory." Thanks to this exhibition, by the time Duchamp came to America in 1915 his reputation was already established. From an attack on Cubism that involved a new approach to subject, he passed, between 1912 and 1914, to an attack on the nature of subject painting, and finally to a personal re-evaluation of the very nature of art. This phase of his career is properly examined in chapter 11.

Duchamp's elder brother Gaston, who took the name **Jacques Villon** (1875–1963), was at the other extreme from Marcel, a committed Cubist. In 1906 he moved to Puteaux, on the outskirts of Paris, where he had a house that adjoined Kupka's. Puteaux, and particularly Villon's studio, became a remarkable nucleus of Cubist activity (the other being Montmartre, where Picasso and Braque worked) that eventually attracted Villon's brothers, Gleizes, Léger, Picabia, and Metzinger, among others. Villon established a personal, highly abstract, and poetic approach to Cubism, one he maintained throughout his long life. In addition to painting, he also made prints, a medium well suited to his particular Cubist idiom. The crystalline structure of jagged triangular shapes in the drypoint print depicting his sister, *Yvonne D. in Profile*, 1913, is indicated solely through parallel lines (fig. **8.49**). They switch directions and densities, creating volumetric rhythms and a sense of shifting light over the surface.

The influence of Cubism spread well beyond France in the years leading up to World War I. Modified to accommodate the aesthetic demands of artists from Britain, Italy, Russia, and the Netherlands, Cubism would serve as a springboard to experiments in pure abstraction, a direction that neither Braque nor Picasso would follow. Differing aesthetic demands were not the only forces reshaping Cubism. Artists like the Futurists and Vorticists, discussed in the next chapter, brought Cubism into line with their political aims as well.

9
Early Twentieth-Century Architecture

In its germinal phase from 1909 to 1914, Cubism was not promoted by either Braque or Picasso as a means of changing society. While Cubist works from this period sometimes divulge an interest in a particular political event or issue, they were generally not created with the aim of serving specific social ends. But many of the artists and architects working in the early twentieth century embraced the possibility that their works might improve society. The belief that art could, and should, serve a salutary social or spiritual purpose had been a guiding principle for the British critic and philosopher John Ruskin, whose disciple William Morris introduced his ideas into modern design through his firm, Morris and Co., a major stimulus for the Arts and Crafts Movement.

Although the Arts and Crafts Movement influenced the development of Art Nouveau in Europe, its principles were adopted more thoroughly by the American architect Frank Lloyd Wright during the first years of the twentieth century. Wright shared Morris' faith in the social benefits of innovative design and careful handcrafting. Following his mentor, Louis Sullivan, he held above all that buildings as well as furnishings must give priority to functionalism. Wright was a pioneer of the international modern movement, and his experiments in architecture as organic space in the form of abstract design antedate those of most of the early twentieth-century avant-garde European architects. His designs were published in Europe in 1910 and 1911, in two German editions by Ernst Wasmuth, and were studied by every major architect on the continent.

Just as Wright was making a name for himself, a very different tendency in avant-garde architecture was gathering momentum in Europe. From the late 1890s the Austrian architect Adolf Loos announced his opposition to the use of ornament in architecture, vehemently expressed in his 1908 article "Ornament and Crime." Emphasizing simple cuboid forms, he eschewed decorative features and even the curved lines so beloved by Art Nouveau. In contrast to the ethic of fine traditional craftsmanship and artistic finish that Art Nouveau had inherited from the Arts and Crafts

Movement, Loos saw the industrial skills of the machine age as better fitted to serve the modern architecture. The tensions between these two approaches to architecture—one based in Arts and Crafts sensibilities, the other derived from Loos' commendation of a modern aesthetic of pure geometry—can be seen particularly clearly in the development of architecture in Austria and Germany during the first three decades of the twentieth century.

Modernism in Harmony with Nature: Frank Lloyd Wright

Frank Lloyd Wright (1867–1959) studied engineering at the University of Wisconsin, where he read the work of John Ruskin and was particularly drawn to rational, structural interpretation in the writings of Eugène-Emmanuel Viollet-le-Duc. In 1887 he was employed by the Chicago architectural firm of Adler and Sullivan, establishing his own practice in 1893. There is little doubt that many of the Sullivan houses built when Wright worked there represented his ideas. Wright's basic philosophy of architecture was expressed primarily through the house form. The 1902–06 Larkin Building in Buffalo, New York (see fig. 9.5) was his only large-scale structure prior to Chicago's Midway Gardens (1914) and the Imperial Hotel in Tokyo (see fig. 9.6) (all three, incidentally, have been destroyed).

Early Houses
At the age of twenty-two Wright designed his own house in Oak Park, Illinois (1889), a quiet community thirty minutes by train from downtown Chicago. His earliest houses, including his own, reflect influences from the shingle-style houses of H. H. Richardson and McKim, Mead & White (see fig. 4.1) and developed the open, free-flowing floor plan of the English architects Philip Webb and Richard Norman Shaw. Wright used the characteristically American feature of the veranda, open or screened, wrapping around two sides of the house, to enhance the sense of outside space that penetrated to the main living rooms.

The cruciform plan, with space surrounding the central core of fireplace and utility areas (kitchen, landing, etc.), also affected Wright's approach to house design as well as to more monumental design projects.

In the 1902–03 Ward Willits House in Highland Park, Illinois (fig. **9.1**), Wright made one of his first individual and mature statements of the principles and ideas that he had been formulating during his apprentice years. The house demonstrates his growing interest in a Japanese aesthetic. He was a serious collector of Japanese prints (about which he wrote a book), and before his trip to Japan in 1905 he probably visited the Japanese pavilions at the 1893 World's Columbian Exposition in Chicago. In the Willits House, the Japanese influence is seen in the dominant wide, low-gabled roof and the vertical striping on the façade. The sources, however, are less significant than the welding together of all the elements of the plan, interior and exterior, in a single integrated unit of space, mass, and surface. From the compact, central arrangement of fireplace and utility areas, the space of the interior flows out in an indefinite expansion carried without transition to the exterior and beyond. The essence of the design in the Willits House, and in the series of houses by Wright and his followers to which the name Prairie Style has been given, is a predominant horizontal accent of rooflines with deep, overhanging eaves echoing the flat prairie landscape of the Midwest. The earth tones of the typical Prairie house were intended to blend harmoniously with the surroundings, while the massive central chimney served both to break the horizontal, low-slung line of the roof and to emphasize the hearth as the spiritual and psychological center of the house.

The interior of the Wright Prairie house (see fig. 9.4) is characterized by low ceilings, frequently pitched at unorthodox angles; a sense of intimacy; and constantly changing vistas of one space flowing into another. The interior plastered walls of the Willits House were trimmed simply in wood, imparting a sense of elegant proportion and geometric precision to the whole. Wright also custom-designed architectural ornaments for his houses, such as light fixtures, leaded glass panels in motifs abstracted from natural forms, and furniture, both built-in and free-standing (fig. 9.2). Though his emphasis on simple design and the honest expression of the nature of materials is dependent in part on Arts and Crafts ideals (see chapter 4), Wright fervently supported the role of mechanized production in architectural design. He regarded the machine as a metaphor of the modern age but did not believe that buildings should resemble machines. Paramount in his house designs was the creation of a suitable habitat, in harmony with nature, for the middle-class nuclear family. Wright understood the way in which his domestic dwellings embodied the collective values and identity of a community. These early residences were designed for Chicago's fast-growing suburbs, where structures could extend horizontally, as opposed to the city, where Victorian town houses were built in several stories to accommodate narrow urban plots.

9.1 Frank Lloyd Wright, Ward Willits House, 1902–03. Highland Park, Illinois.

The culmination of Wright's Prairie Style is the 1909 Robie House in Chicago (figs. **9.3**, **9.4**). The house is centered around the fireplace and arranged in plan as two sliding horizontal sections on one dominant axis. The horizontal roof cantilevers out on steel beams and is anchored at the center, with the chimneys and top-floor gables set at right angles to the principal axis. Windows are arranged in long, symmetrical rows and are deeply imbedded into the brick masses of the structure. The main, horizontally designed lines of the house are reiterated and expanded in the terraces and walls that transform interior into exterior space and vice versa. The elements of this house, combining the outward-flowing space of the interior and the

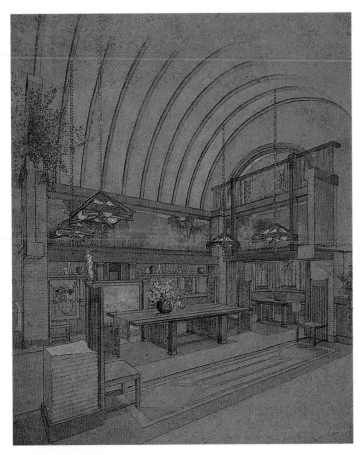

9.2 Frank Lloyd Wright, Susan Lawrence Dana House, 1902–04. Springfield, Illinois. Interior perspective, dining room. Pencil and watercolor on paper, 25 × 20⅜" (63.5 × 51.7 cm). Avery Architectural and Fine Arts Library, Columbia University, New York.

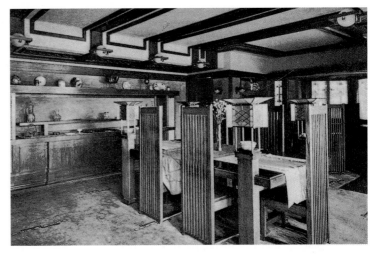

9.4 Frank Lloyd Wright, Dining Room, Robie House. Chicago.

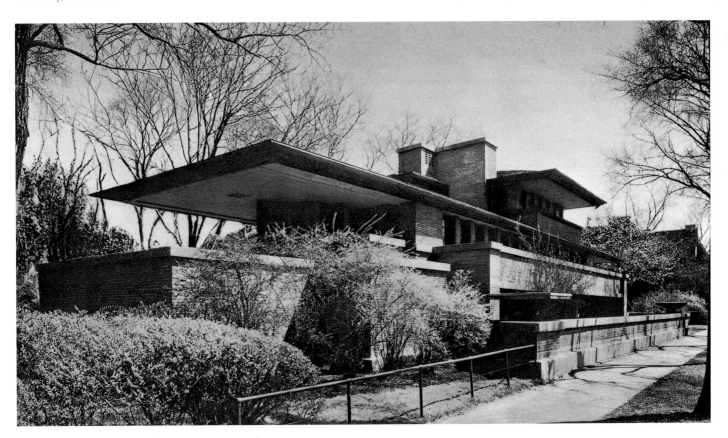

9.3 Frank Lloyd Wright, Robie House, 1909. Chicago.

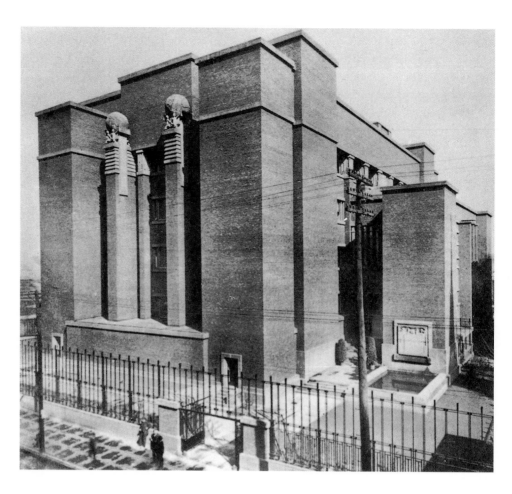

9.5 Frank Lloyd Wright, Larkin Building, 1902–06. Buffalo, New York. Demolished 1950.

linear and planar design of exterior roofline and wall areas with a fortress-like mass of chimneys and corner piers, summarize other experiments that Wright had carried on earlier in the Larkin Building (fig. **9.5**).

The Larkin Building

The Larkin Building represented radical differences from the Prairie house in that it was organized as rectangular elements in which Wright articulated mass and space into a single, close unity. The Larkin Building was, on the exterior, a rectangular, flat-roofed structure, whose immense corner piers protected and supported the window walls that reflected an open interior well surrounded by balconies. The open plan, filled with prototypes of today's "work stations," was Wright's solution for a commodious, light-filled office environment. The Larkin Building literally embodied the architect's belief in the moral value of labor, for its walls were inscribed with mottoes extolling the virtues of honest work. This was an example of the early modern industrial structures that encompassed tremendous possibilities for developing innovative kinds of internal, expressive space in the new tall buildings of America (the economics of industrial building, however, soon destroyed these possibilities).

Mid-Career Crisis

In the years after 1910, just when he was becoming a world figure, Wright experienced a period of neglect and even vilification in his own country. Highly publicized personal problems, among them his decision to leave his wife and six children for another woman, Mamah Cheney, helped to drive him from the successful Midwestern practice he had built up in the early years of the century. In 1914 Cheney, along with her two children and four house-guests, was murdered by a servant who also set fire to Taliesin, the home Wright had built for himself in Wisconsin; he subsequently rebuilt it (the name is that of a mythic Welsh poet and means "shining brow"). Along with these personal factors were cultural and social changes that, by 1915, had alienated the patronage for experimental architecture in the Midwest and increased the popularity of historical revivalist styles. Large-scale construction of mass housing soon led to vulgarization of these styles.

About 1915, Wright began increasingly to explore the art and architecture of ancient cultures, including the Egyptian, Japanese, and Maya civilizations. The Imperial Hotel in Tokyo (fig. **9.6**), a luxury hotel designed for Western visitors, occupied most of his time between 1912 and 1923 and represents his most ornately complicated decorative period, filled with suggestions of Far Eastern and Pre-Columbian influence. In addition, it embodied his most daring and intricate structural experiments to date—experiments that enabled the building to survive the wildly destructive Japanese earthquakes of 1923 (only to be destroyed by the wrecking ball in 1968). For twenty years after the Imperial Hotel, Wright's international reputation continued to grow. Though he frequently had difficulty earning a living, he was indomitable; he wrote, lectured,

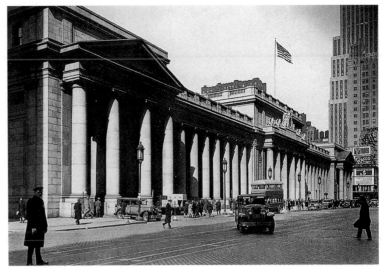

9.7 McKim, Mead & White, Pennsylvania Station, 1906–10. New York. Demolished 1966.

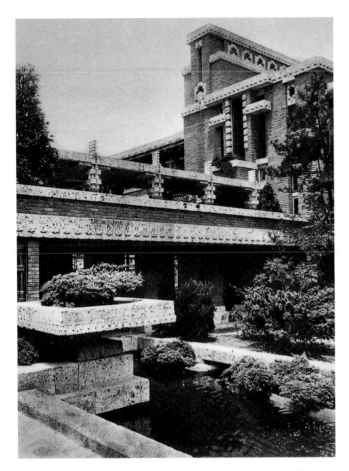

9.6 Frank Lloyd Wright, Imperial Hotel, c. 1912–23. Tokyo. Demolished 1968.

and taught, secure in the knowledge of his own genius and place in history, and he invented brilliantly whenever he received commissions.

Temples for the Modern City: American Classicism 1900–15

Aside from Wright, a number of his followers, and a few isolated architects of talent, American architecture between 1915 and 1940 was largely in the hands of academicians and builders. Nevertheless, two landmark structures were erected during this period. New York City's Pennsylvania Station (fig. **9.7**), built between 1906 and 1910 and demolished in 1966, represents one of the most tragic architectural losses of the twentieth century. "Until the first blow fell," said an editorial in *The New York Times*, "no one was convinced that Penn Station really would be demolished or that New York would permit this monumental act of vandalism." The station was designed by the Beaux-Arts architectural firm of McKim, Mead & White, who designed classically inspired civic buildings throughout

America in the early years of the century. Penn Station was one of the firm's most ambitious undertakings. The exterior, a massive Doric colonnade based on the ancient Baths of Caracalla in Rome, presented a grand modern temple that underscored the power of the railroad as a symbol of progress. Inside, a visitor's first impression upon arrival was the dramatically vaulted spaces in the train concourse, its glass-and-steel construction recalling the crystal palaces of the previous century (see fig. 4.11). In 1966 the city responded to the destruction of Penn Station by establishing the New York City Landmarks Preservation Commission.

At the same time, on the other side of the continent, a remarkable act of preservation was taking place. The Palace of Fine Arts in San Francisco (fig. **9.8**), designed by the architect **Bernard Maybeck** (1862–1957), was originally built in 1915 for the Panama–Pacific International Exposition. Celebrating the opening of the Panama Canal, the San Francisco Exposition was a world's fair that emulated the famous 1893 World's Columbian Exposition (see fig. 4.16). It was visited by nineteen million people during

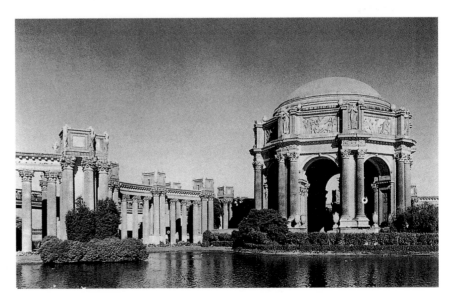

9.8 Bernard Maybeck, Palace of Fine Arts, 1915. San Francisco.

ten months in 1915, providing an economic boost to a city that had experienced the devastating earthquake and fire of 1906. Sited along a lagoon, Maybeck's popular ensemble included an open-air rotunda, a curving Corinthian peristyle, and a large gallery that housed the fair's paintings and sculptures. The unconventional Maybeck turned classicism into his own personal idiom, violating canonical rules and covering his structures with richly imaginative classical-style ornament. He sought a mood of melancholy and past grandeur, for he envisioned the Palace as "an old Roman ruin, away from civilization … overgrown with bushes and trees." It was a mood somehow appropriate for a world in the midst of the carnage of World War I. Though it was the only building not torn down after the fair, the Palace of Fine Arts was never intended as a permanent structure and it soon began to show signs of decay. Between 1962 and 1967 it was completely reconstructed out of concrete. Today it is still used as a city museum.

New Simplicity Versus Art Nouveau: Vienna Before World War I

The capital of the vast, disparate Austro-Hungarian Empire, which was dismembered after World War I, prewar Vienna was a cosmopolitan city characterized by both entrenched official conservatism and culturally progressive tendencies that were highly influential in many spheres, such as the psychoanalytic research being undertaken there by Sigmund

Freud (see chapter 5). In 1897, determined to break away from the stifling academicism of official art, a group of artists had formed the Vienna Secession (see chapter 5). Their new exhibition building, designed in 1898 by **Joseph Maria Olbrich** (1867–1908), combined different strands of Art Nouveau in the geometric lines of its façade and the intertwined foliage of its openwork gilt-bronze cupola. In early twentieth-century Viennese architecture, therefore, the relationship between Art Nouveau decoration and modernist geometric functionalism is far from a clear-cut opposition. Both elements can be found in buildings by major Austrian architects of the period, although the polemical writings of Loos in particular helped to define the austere simplicity he favored as the hallmark of avant-garde architecture.

The founder of Viennese modernism, **Otto Wagner** (1841–1918), was first an academic architect. His stations for the Vienna subway (1896–97) were simple, functional buildings dressed with baroque details. In his 1894 book on modern architecture, however, Wagner had already demonstrated his ideas about a new architecture that used the latest materials and adapted itself to the requirements of modern life. His motto, "Necessity alone is the ruler of art," anticipated later twentieth-century functionalism. In the hall of his 1905 Vienna Post Office Savings Bank (fig. **9.9**) Wagner used unadorned metal and glass to create airy, light-filled, unobstructed space. While there is some stylistic similarity here to the organic designs by Art Nouveau architects like Victor Horta (see chapter 5), Wagner's approach

9.9 Otto Wagner, Post Office Savings Bank, 1905. Vienna.

shows a typically modernist concern for the increasing elimination of structural elements and the creation of a single unified and simple space.

Adolf Loos (1870–1933) was active in Vienna from 1896. After studying architecture in Dresden, he worked in the United States for three years from 1893 (when he attended the World's Columbian Exposition in Chicago), taking various odd jobs while learning about the new concepts of American architecture, particularly the skyscraper designs of Sullivan and other pioneers of the Chicago School (see chapter 4). After settling in Vienna, Loos followed principles established by Wagner and Sullivan favoring a pure, functional architecture, as seen in his 1910 Steiner House in Vienna (fig. **9.10**). Zoning rules allowed for only one story above street level, so Loos employed a barrel-vaulted roof on the front of the house, so deep that it allowed for two more levels facing the garden, which is the view seen here. The garden façade is symmetrical; simple, large-paned windows arranged in horizontal rows are sunk into the planar surfaces of the rectilinear façade. Reinforced concrete appears here in one of its earliest applications in a private house. Although the architecture and ideas of Loos never gained wide appeal, the Steiner House is a key monument in the creation of the new style.

Among the Art Nouveau architects attacked by Loos were Olbrich and Josef Hoffmann (see chapter 5), who, with the painter Gustav Klimt, were the founders of the Vienna Secession. Hoffmann's masterpiece is the Palais Stoclet, a luxurious house that he built for the Stoclet family in Brussels (see fig. 5.15). This splendid mansion is characterized by severe rectangular planning and façades, and broad, clear, white areas framed in dark, linear strips (betraying the influence of Charles Rennie Mackintosh). Its lavish interior design, an expression of the Secessionist belief in a total decorative environment, offers a marked contrast to the sobriety of Loos' Steiner House.

Hoffmann is perhaps more important for his part in establishing the Wiener Werkstätte (Vienna Workshops) than for his achievement as a practicing architect. The workshops, which originated in 1903, continued the craft traditions of William Morris and the English Arts and Crafts movement, with the contradictory new feature that the machine was now accepted as a basic tool of the designer. For thirty years the workshops exercised a notable influence, teaching fine design in handicrafts and industrial objects.

Tradition and Innovation: The German Contribution to Modern Architecture

In Germany before 1930, largely as a result of enlightened governmental and industrial patronage, architectural experimentation, instead of depending only on brilliant individuals, was coordinated and directed toward the creation of a "school" of modern architecture. In this process, the contributions of certain patrons such as Archduke Ernst Ludwig of Hesse and the AEG (German General Electrical Company) were of the greatest importance.

Relations between Austrian and German architecture were extremely close in the early years of the twentieth century. When the Archduke of Hesse wished to effect a revival of the arts by founding an artists' colony at Darmstadt in Germany, he employed Olbrich to design most of the buildings, including the 1907 Hochzeitsturm (Wedding Tower) (fig. **9.11**). The Wedding Tower, which still dominates

9.11 Joseph Maria Olbrich, Hochzeitsturm (Wedding Tower), 1907. Darmstadt, Germany.

9.10 Adolf Loos, Garden view, Steiner House, 1910. Vienna.

Darmstadt, was so named because it commemorated the archduke's second marriage; it was intended less as a functional structure than as a monument and a focal point for the entire project. Although it was inspired by the American concept of the skyscraper, its visual impact owes much to the towers of German medieval churches. Its distinctive five-fingered gable symbolizes an outstretched hand. The manner in which rows of windows below the gable are grouped within a common frame and wrapped around a corner of the building was an innovation of particular significance for later skyscraper design.

At about the same time that Hoffmann set up the Wiener Werkstätte a German cabinetmaker, Karl Schmidt, had started to employ architects and artists to design furniture for his shop in Dresden. Out of this grew the Deutsche Werkstätte (German Workshops), which similarly applied the principles of Morris to the larger field of industrial design. From these and other experiments, the Deutscher Werkbund (German Work or Craft Alliance) emerged in 1907. This was the immediate predecessor of the Bauhaus, one of the most influential schools in the development of modern architecture and industrial design (see chapter 14).

Behrens and Industrial Design

More than any other German architect of the early twentieth century, **Peter Behrens** (1868–1940) forged a link between tradition and experiment. He began his career as a painter, producing Art Nouveau graphics, and then moved from an interest in crafts to the central problems of industrial design for machine production. Behrens turned to architecture as a result of his experience in the artists' collaborative at Darmstadt, where he designed his own house—the only one in the colony not designed by Olbrich. In 1903 Behrens was appointed director of the Düsseldorf School of Art, and in 1907 the AEG company, one of the world's largest manufacturers of generators, motors, and lightbulbs, hired him as architect and coordinator of design for everything from products to publications. This unusual appointment by a large industrial organization of an artist and architect to supervise and improve the quality of all its products was a landmark in the history of architecture and design.

One of Behrens' first buildings for AEG, a landmark of modern architecture, is the Turbine Factory in Berlin, completed in 1909 (fig. **9.12**). Although the building is given a somewhat traditional appearance of monumentality by the huge corner masonry piers and the overpowering visual mass of the roof (despite its actual structural lightness), it is essentially a glass-and-steel structure. Despite the use of certain traditional forms, this building is immensely important in its bold structural engineering, in its frank statement of construction, and in the social implications of a factory built to provide the maximum of air, space, and light. It is functional for both the processes of manufacture and the working conditions of the employees—concerns rarely considered in earlier factories.

9.12 Peter Behrens, AEG Turbine Factory, 1908–09. Berlin.

The hiring of Behrens by AEG and similar appointments by other industrial corporations mark the emergence of some sense of social responsibility on the part of large-scale industry. The established practice had been one of short-sighted and often brutal exploitation of natural and human resources. Certain enlightened industrialists began to realize that well-designed working spaces and products were not necessarily more expensive to produce than badly designed ones and had numerous economic and political advantages (see *The Human Machine*, opposite). In the rapidly expanding industrial scene and the changing political landscape of early twentieth-century Europe, the public image presented by industry was assuming increasing importance. It was becoming evident that industry had a powerful role to play in public affairs and even in promoting a national image. Such ideas may have influenced Behrens' transformation of his functional glass-and-steel Turbine Factory into a virtual monument to the achievements of modern German industry. Behrens is important not only as an architect but as a teacher of a generation that included Gropius, Le Corbusier, and Mies van der Rohe—all of whom worked with him early in their careers.

Expressionism in Architecture

Between 1910 and 1925 the spirit of Expressionism manifested itself in German architecture, as in painting and sculpture (see chapter 7). Expressionist architecture includes works in which specific ideas—often political—are conveyed through a building's form and materials. That a work of architecture can function as an argument on behalf of a particular ideology was already well understood by modern architects. What distinguishes Expressionist architecture is the emphasis on the thematic content of the structure itself, which takes on as much importance as the building's intended function. Although this trend did not result initially in many important buildings, and although Expressionism in architecture was terminated by the rise of Nazism, it did establish the base for a movement that was

The Human Machine: Modern Workspaces

With the proliferation of factories and office buildings in the late nineteenth and early twentieth centuries, architects and engineers grappled with the problems posed by industry's need for such an intense concentration of laborers. Some of the most lasting innovations in industrial architecture were made by Albert Kahn, who designed factories used for the first assembly-line approach to manufacturing at the Ford Motor Co. in Detroit. By creating long, open spaces enclosed by glass curtain walls or covered by a roof with a continuous clerestory, Kahn introduced well-lit spaces that enhanced productivity while also taking safety into consideration. Along with the development of streamlined factory production, known as "Fordism," came the advent of "Taylorism," named for F. W. Taylor who advocated minute analysis of laborers' movements in order to establish practices and work stations that would eliminate all wasted actions. Not surprisingly, the leading metaphor for industrial architecture in the first decades of the twentieth century was the machine, suggesting that laborers—from factory workers to typists—were simply components of a ceaseless engine. This image, which strikes us today as grindingly inhuman, was embraced by many utopian-minded architects, including Le Corbusier, who saw in the seeming objectivity of Fordism, Taylorism, and the machine ideal a model for a new society that would be free of the oppressive economic and political discord fueling World War I.

later realized in the 1950s and 60s, after the austerity and pristine elegance of the International Style (see chapter 21) had begun to pall.

Forerunners of Expressionism in architecture include Gaudí's creations in Barcelona (see figs. 5.8, 5.9, 5.10) and the 1913–14 Werkbund Theater in Cologne (fig. **9.13**) by the Belgian architect Van de Velde (see p. 204), who worked in Germany from 1899 to 1914. The building's strongly sculptural exterior, for which Van de Velde used the molded forms of the façades to define the volume of the interior, has been seen as the definitive break with the essentially linear emphasis of Art Nouveau architecture. Van de Velde's other achievements in Germany include the educational program that he developed at the Weimar School, which he founded in 1906 under the patronage of the Duke of Saxe-Weimar. This program put its emphasis on creativity, free experiment, and escape from dependence on past traditions.

One of the most startling examples of Expressionist architecture is the 1919 Grosses Schauspielhaus (Great Theater) in Berlin (fig. **9.14**), created by **Hans Poelzig** (1869–1936) for the theatrical impresario Max Reinhardt. This was actually a conversion of an old building, originally an enormous covered market that, after 1874, served as the Circus Schumann. Using stalactite forms over the entire ceiling and most of the walls, and filtering light through them, Poelzig created a vast cave-like arena of mystery and fantasy appropriate to Reinhardt's spectacular productions.

Of the architects who emerged from German Expressionism, perhaps the most significant was **Erich Mendelsohn** (1887–1953). Mendelsohn began practice in 1912, but his work was interrupted by World War I.

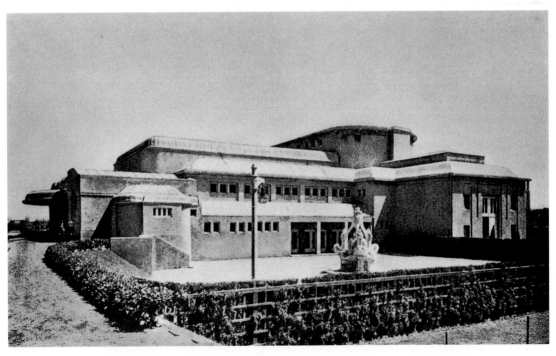

9.13 Henry Clemens van de Velde, Werkbund Theater, 1913–14. Cologne. Demolished 1920.

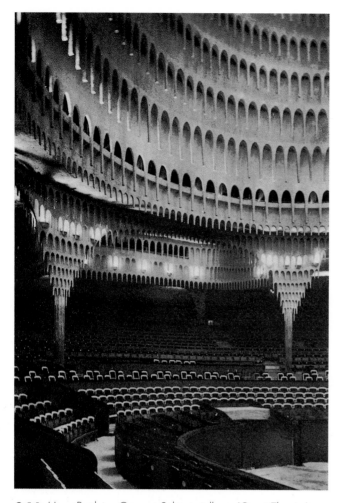

9.14 Hans Poelzig, Grosses Schauspielhaus (Great Theater), 1919. Berlin. Dismantled 1938.

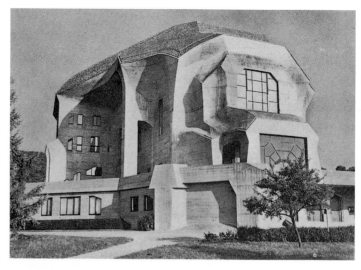

9.16 Rudolf Steiner, Goetheanum II, 1925–28. Dornach, Switzerland.

Following the war, one of his first important buildings was the Einstein Tower in Potsdam (fig. **9.15**). One of the principal works of Expressionist architecture, it was built to study spectroanalytic phenomena, especially Einstein's theory of relativity. Instruments in the cupola reflected light vertically through the tower onto a mirror in the underground laboratory. On the exterior, Mendelsohn emphasized qualities of continuity and flow appropriate to the material of concrete (although the Einstein Tower was actually built of brick and covered with cement to look like cast concrete). The windows flow around the rounded corners, while the exterior stairs flow up and into the cavern of the entrance. The entire structure, designed as a monument as well as a functioning laboratory, has an essentially organic quality, prophetic of the later works of Le Corbusier and Eero Saarinen.

Many other architects, particularly in Germany and Holland, were affected by the spirit of Expressionism during the 1920s. The educator, philosopher, and occultist **Rudolf Steiner** (1861–1925), although not trained as an architect, produced remarkable examples of utopian architecture in his Goetheanum I and II (fig. **9.16**), the latter of which became a tremendous sculptural monument of concrete that looked back to Gaudí and forward to post-World War II *architecture brut*.

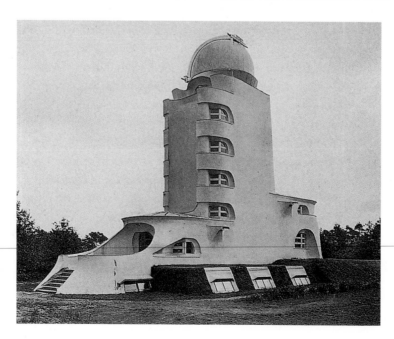

9.15 Erich Mendelsohn, Einstein Tower, 1920–21. Potsdam.

Toward the International Style: The Netherlands and Belgium

Berlage and Van de Velde

Although he considered himself a traditionalist, the Dutch architect **Hendrik Petrus Berlage** (1856–1934) was passionately devoted to stripping off the ornamental accessories of academic architecture and expressing honest structure and function. He characteristically used brick as a building material, the brick that, in the absence of stone and other materials, has created the architectural face of the Low Countries. His best-known building, the Amsterdam Stock Exchange (fig. **9.17**) (now home to the Beurs van Berlage Foundation and the Dutch Philharmonic Orchestra), is principally of brick, accented with details of light stone. The brick is presented, inside and out, without disguise or embellishment, as is the steel framework that supports the glass ceiling. The general effect, with a massive corner tower and the low arcades of the interior, is obviously inspired by Romanesque archi-

tecture, in some degree seen through the eyes of the American architect H. H. Richardson, whose work he knew and admired (see fig. 4.13).

In his writings, Berlage insisted on the primacy of interior space. The walls defining the spaces had to express both the nature of their materials and their strength and bearing function, undisguised by ornament. Above all, through the use of systematic proportions, Berlage sought a total effect of unity analogous to that created by the Greeks of the fifth century B.C.E., whose temples and civic buildings were constructed with the careful application of proportional relationships between all parts of a building. He conceived of an interrelationship of architecture, painting, and sculpture, but with architecture in the dominant role.

Berlage's approach to architecture was also affected by Frank Lloyd Wright, whose work he discovered first through publications and then at first hand on a trip to the United States in 1911. He was enthusiastic about Wright and particularly about the Larkin Building (see fig. 9.5),

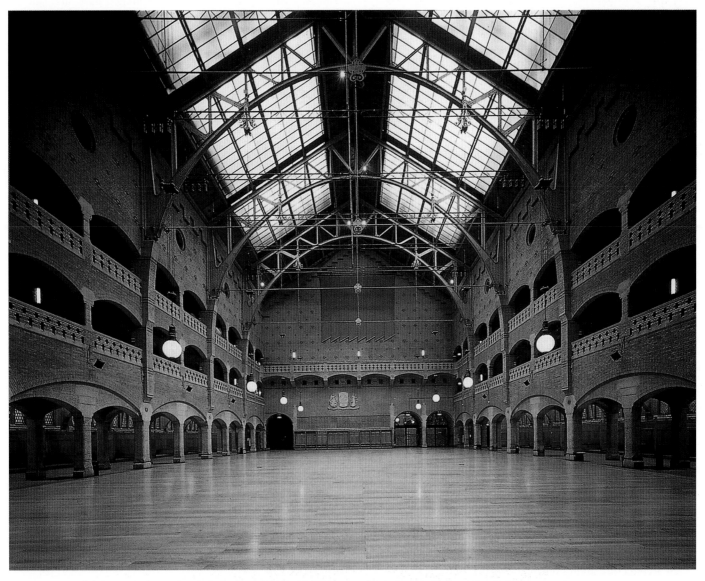

9.17 Hendrik Petrus Berlage, Stock Exchange, 1898–1903. Amsterdam.

Modern Materials

Louis Sullivan's dictate that "form ever follows function" could not have been fully expressed in modern architecture without the new materials developed for industry in the late nineteenth century. The construction of high-rises depended upon the availability of strong but relatively light steel girders that could be assembled into a sort of skeleton. Without such an internal structure, the walls required to support a building over seven stories tall would be so thick that its lower floors would be largely useless. In 1855, the English inventor Henry Bessemer patented a process for mass-producing high-grade steel, expanding the availability of the material while lowering its cost. Even without steel, high-rises could only ascend as far as people were willing to climb. Elisha Otis' 1853 introduction of the safety elevator, which has side brakes that deploy should the cable snap, led to steam- and electric-powered passenger elevators, making it possible for people to work, shop, or even live comfortably dozens of stories above ground. Even greater flexibility in design was afforded by ferro-concrete, likewise developed in the mid-nineteenth century. With wire mesh or iron bars as internal reinforcement, concrete could be poured into irregular, even curving forms. It could also be used to create larger spans, making it an inexpensive and flexible alternative to masonry.

with its analogies to his own Amsterdam Stock Exchange. What appealed to Berlage and his followers about Wright was his rational approach—his efforts to control and utilize the machine and to explore new materials and techniques in the creation of a new society.

Nearly every turn-of-the-century art or design movement, from Impressionism to Arts and Crafts, nourished the fertile career of the Belgian Henry Clemens van de Velde (see also chapter 5). Van de Velde was a painter, craftsman, industrial designer, architect, and critic who had an extensive influence on German architecture and design. He was a socialist who wanted to make his designs available to the working classes through mass production. Trained as a painter, first in Antwerp and then in Paris, he was in touch with the Impressionists and was interested in Symbolist poetry. Back in Antwerp, painting in a manner influenced by Seurat, he exhibited with Les XX, the avant-garde Brussels group (see chapter 3). Through them he discovered Gauguin, Morris, and the English Arts and Crafts movement. As a result, he enthusiastically took up the graphic arts, particularly poster and book design (see fig. 5.4), and then, in 1894, turned to the design of furniture. All the time, he was writing energetically, preaching the elimination of traditional ornament, the assertion of the nature of materials, and the development of new, rational principles in architecture and design.

New Materials, New Visions: France in the Early Twentieth Century

French architecture during the period 1900–14 was dominated by the Beaux-Arts tradition, except for the work of two architects of high ability, Auguste Perret and Tony Garnier. Both were pioneers in the use of reinforced concrete (see *Modern Materials*, left). In his 1902–03 apartment building (fig. **9.18**) **Auguste Perret** (1874–1954) covered a thin reinforced-concrete skeleton with glazed terracotta tiles decorated in an Art Nouveau foliate pattern. The structure is clearly revealed and allows for large window openings on the façade. The architect increased daylight illumination by folding the façade around a front wall and then arranging the principal rooms so that all had outside windows. The strength and lightness of the material also substantially increased openness and spatial flow.

Perret's masterpiece in ferro-concrete building is probably his Church of Notre Dame at Le Raincy, near Paris, built in 1922–23 (fig. **9.19**). Here he used the simple form of the Early Christian basilica—a long rectangle with only a slightly curving apse, a broad, low-arched nave, and side aisles just indicated by comparably low transverse arches.

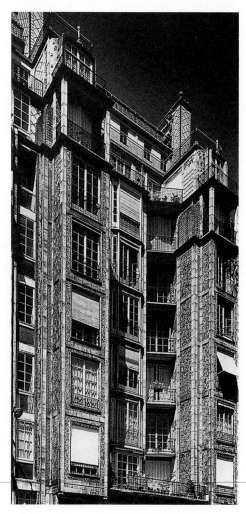

9.18 Auguste Perret, Apartment house, 25 Rue Franklin, 1902–03. Paris.

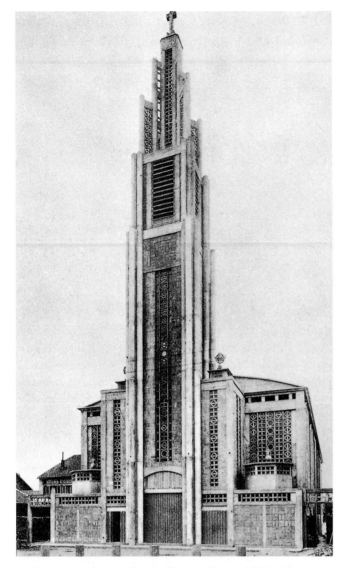

9.19 Auguste Perret, Church of Notre Dame, 1922–23. Le Raincy, France.

Construction in reinforced concrete permitted the complete elimination of structural walls. The roof rests entirely on widely spaced slender columns, and the walls are simply constructed of stained glass (designed by the painter Maurice Denis) arranged on a pierced screen of precast-concrete elements. The church at Le Raincy remains a landmark of modern architecture, not only in the effective use of ferro-concrete but also in the beauty and refinement of its design.

While working in Rome around 1900, **Tony Garnier** (1869–1948) developed a radically new approach to urban planning that overturned the traditional academic approach based on symmetry and monumentality. In Garnier's model town, residential areas, industrial sites, transport infrastructure, and civic facilities are all rationally interrelated. From 1905, his designs as municipal architect for his native city of Lyons explored the architectural possibilities of steel and reinforced concrete. His 1913 hall for the city's cattle market and abattoirs (fig. **9.20**) achieved a steel span of 262 feet (80 m).

World War I interrupted many experiments in architecture, as well as in painting and sculpture, begun in the first years of the twentieth century. During the war years a new generation of architects emerged—Gropius and Mies van der Rohe in Germany; Le Corbusier in France; Oud and Rietveld in Holland; Eliel Saarinen and Alvar Aalto in Finland. Together with Frank Lloyd Wright in the United States, these architects built on the foundations of the pioneers discussed in this chapter to create one of the great architectural revolutions of history.

9.20 Tony Garnier, Lyons Market Hall, 1913. Lyons, France.

10
European Responses to Cubism

As the buoyant first decade of the twentieth century came to a close, the glittering *belle époque* faded. The years leading up to World War I were marked by tragic reminders of the limits of human ingenuity, the cost of industrialization, and the terrible consequences of colonization. By the end of 1912, the mood in Europe and North America had darkened. Accounts of the Belgian King Leopold's rapacious exploitation of the central African colony of the Congo Free State from 1885 to 1908 were now circulating in the popular press. Treating the region's inhabitants as virtual slaves, Leopold unleashed a ruthless army of overseers bent on achieving the greatest profit possible through trade in commodities like rubber and ivory. Millions of Africans were killed or maimed: it was common practice for rubber harvesters' hands to be cut off when quotas were not met. It was also in 1912 that the "unsinkable" ship *Titanic* slipped majestically from its berth at Southampton, England, with great fanfare, only to founder after hitting an iceberg four days later. More than 1,500 were killed in the disaster.

While the *Titanic*'s fate illustrated the consequences of overestimating new fabrication techniques and advances in industrial engineering, there were chilling demonstrations of the capacity of machines to perform exactly as designed. Aerial bombing, used first by Italy against Turkish troops in 1911, added a terrifying new dimension to warfare. The bombing of a Turkish railway station by Bulgarian pilots the following year demonstrated the potential for airplanes to target buildings accurately, enhancing the anonymity of attacks on soldiers as well as civilians. The conflict that prompted the development of bombers and tanks was the Balkan Wars, in which the contracting Ottoman Empire came under assault from a number of its former states, including Bulgaria, Montenegro, Greece, and Serbia.

For most Europeans and Americans, territorial disputes between the waning Ottoman Empire and its neighbors seemed far away and scarcely relevant. Some saw these conflicts as evidence of a coming shift in the European balance of power. Ardent nationalists in Italy, France, Germany,

and Britain supported engagement in the conflict in order to expand the political and economic influence and possibly even the borders of their countries. Such extreme nationalism manifested itself culturally in the Futurist and Vorticist movements. Most artists, however, viewed events in southeastern Europe with either detachment or suspicion. For instance, even though Picasso's *Guitar, Sheet Music, and Wine Glass* of 1912 (fig. 8.24) includes a fragment of a newspaper headline, LA BATAILLE S'EST ENGAGÉ, taken from a story about the Balkan conflict, this representation of the images, conversations, and music animating a Paris café is anything but a call to arms.

The ambiguity of space and matter as well as content characteristic of prewar Cubism made it an unreliable vehicle for ideology. Many of the artists influenced by Cubism adapted its formal and thematic abstruseness to create fantastical and suggestive works. Such painters as Marc Chagall and Giorgio De Chirico, for instance, adapted Cubist innovations to enhance their dreamily naturalistic imagery. Yet many artists who found themselves under the spell of Cubism did not share this ideological circumspection, instead using Cubist-inspired artworks to promote specific political viewpoints. These impassioned artists show that abstraction—both weak abstraction like Cubism and strong abstraction in which no reference to observed reality is made—can be yoked to the service of a particular ideology, or set of political beliefs, whether these beliefs lean toward capitalism and nationalism, as in the case of Futurism, or toward socialism and collectivism, as in Russian Constructivism.

Fantasy Through Abstraction: Chagall and the Metaphysical School

Cubism emboldened even figurative artists to reconsider their assumptions about pictorial space. Among those most receptive to incorporating Cubist ideas into their art were descendants of Romanticism and Symbolism like

Marc Chagall and Giorgio De Chirico. As Romanticism grew and spread in the nineteenth century, visions of imagined worlds appeared in many forms in painting, sculpture, and architecture. The dreamworlds of Moreau (fig. 3.11), Redon (3.13), Ensor (fig. 5.22), Böcklin (fig. 5.24), Klinger (fig. 5.25), and Rousseau (fig. 3.15) provided the initial transition from nineteenth-century Romanticism to twentieth-century fantasy. Abstraction expanded the boundaries of these realms of fantasy.

Chagall

The paintings of **Marc Chagall** (1887–1985) do not fit neatly into a category or movement, but their sense of fantasy testifies to the persistent legacy of Symbolism. Chagall was born to a large and poor Jewish family in Vitebsk, Russia. He acquired a large repertoire of Russian-Jewish folktales and a deep attachment to the Jewish religion and traditions, from which his personal and poetic visual language emerged. He attended various art schools in St. Petersburg, but derived little benefit until 1908, when he enrolled in an experimental school directed by the theater designer Léon Bakst, who was influenced by the new ideas emanating from France. In 1910, after two years of study, Chagall departed for Paris.

There he entered the orbit of Guillaume Apollinaire and the leaders of the new Cubism (see chapter 8). Chagall's Russian paintings had largely been intimate genre scenes, often enriched by elements of Russian or Jewish folklore. His intoxication with Paris fueled his experimentation with Fauve color and Cubist space, and his subjects became filled with a lyricism that, within two years of his arrival, emerged in mature and uniquely poetic paintings.

Homage to Apollinaire (fig. **10.1**) was shown for the first time at Herwarth Walden's Der Sturm Gallery in Berlin in 1914. That show had an impact on the German Expressionists that extended well beyond World War I. Chagall's painting is a homage to four people he admired, including Walden and Apollinaire, whose names are inscribed around a heart at the lower left. The artist included his own name in Roman and Hebrew letters at the top of the canvas. A circular pattern of color shapes, inspired by the paintings of his friend Robert Delaunay (see fig. 8.43), surrounds the bifurcated figure of Adam and Eve. The esoteric symbolism of *Homage to Apollinaire* has been variously interpreted. Beyond the traditional biblical meanings are references to alchemy and other mystical schools of thought. The bodies of Adam and Eve emerge from one pair of legs to symbolize the union and opposition of male and female, derived from medieval representations of the Fall from Grace. The numbers on the left arc of the outer circle introduce the notion of time. In fact, the figures themselves read like the hands of a clock. Such themes of lovers irrevocably joined extend throughout Chagall's work, as do references to both Jewish and Christian spirituality.

During the next years in Paris, Chagall continued to create new forms to express his highly personal vision.

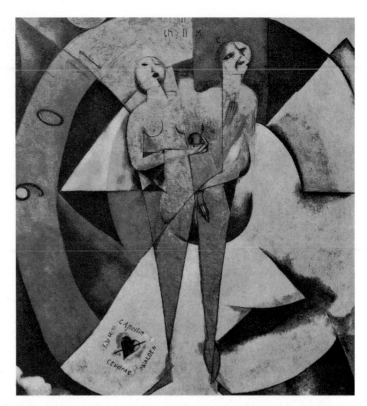

10.1 Marc Chagall, *Homage to Apollinaire*, 1911–12. Oil, gold and silver powder on canvas, 6' 6¾" × 6' 3⅜" (2 × 1.9 m). Stedelijk van Abbe Museum, Eindhoven, the Netherlands.

In *Paris Through the Window* (fig. **10.2**), the double-faced Janus figure (the Roman god of doorways) in the lower right corner, with its two profiles in contrasting light and shadow, suggests a double nature for the painting—the romantic yet real Paris, and the Paris transformed in the poet's dreams—with trains floating upside down, pedestrians promenading parallel to the sidewalks, and an aviator supported by a triangular kite. The window, with its frame of red, yellow, blue, and green, and its human-headed cat acting as a domesticated Cerberus (the mythical three-headed dog who guards the underworld), becomes a partition between the two realms. The composition of the sky in large geometric areas and the animated buildings, particularly the somewhat tilted Eiffel Tower (which could not be seen from Chagall's studio), suggest Robert Delaunay's dynamic method (see fig. 8.43) imposed upon a dream of gentle nostalgia. Many of Chagall's contemporaries, including Delaunay, did not favor this strong imaginative element. It was the poet André Breton, the principal theorist of Surrealism, who would recognize the significance of Chagall's "liberation of the object from the laws of weight and gravity."

Chagall returned to Vitebsk in 1914 and, caught by the outbreak of war in Russia, stayed there until 1922. After his reunion with his beloved Bella, whom he married in 1915, he commemorated his feeling for her in a group of paintings of lovers. *Birthday* (fig. **10.3**) is a 1923 copy of a composition originally painted in 1915 (Chagall occasionally made copies of his paintings to keep for his own use).

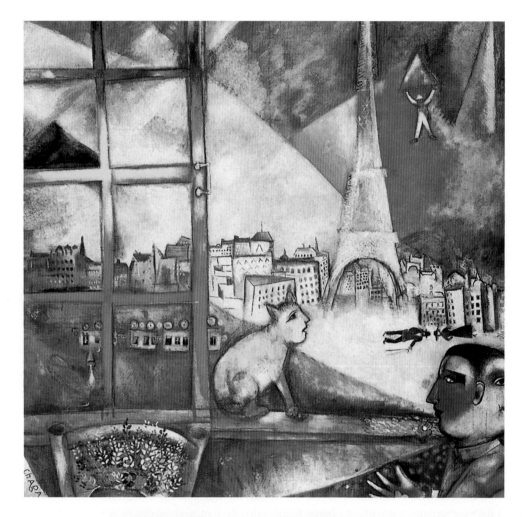

10.2 Marc Chagall, *Paris Through the Window*, 1913. Oil on canvas, 52⅜ × 54¾" (133 × 139.1 cm). Solomon R. Guggenheim Museum, New York.

10.3 Marc Chagall, *Birthday*, 1923. Oil on canvas, 31⅞ × 39⅜" (81 × 100 cm). Private collection.

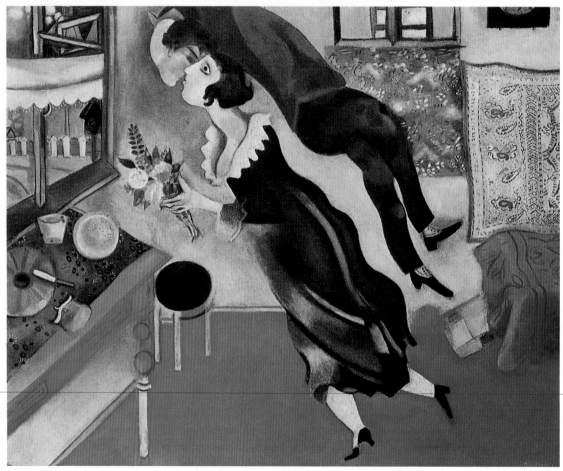

This canvas commemorates Bella's surprise visit to the artist's studio with a bouquet of flowers for his birthday. Chagall floats ecstatically through the air and, with delicious absurdity, twists his head for a kiss.

After the 1917 Russian Revolution, Chagall, like other avant-garde artists, served for a time as a commissar of fine arts and formed a free art academy. Perhaps his most fruitful work was for the State Yiddish Chamber Theater in Moscow, where he painted murals and designed sets and costumes. This opportunity to work on a large scale in the theater continued to fascinate him and to inspire some of his most striking paintings. *The Green Violinist* (fig. **10.4**), painted after his return to Paris in 1923, is also a replica of an earlier work. It is based on one of the paintings Chagall made for the Yiddish Theater, studies for which he brought to Paris. The violinist, a subject frequently depicted by Chagall, refers to the traditional form of music that was performed in Russian-Jewish villages. Here the purple-frocked fiddler is seen floating above the brown and gray roofs of his village.

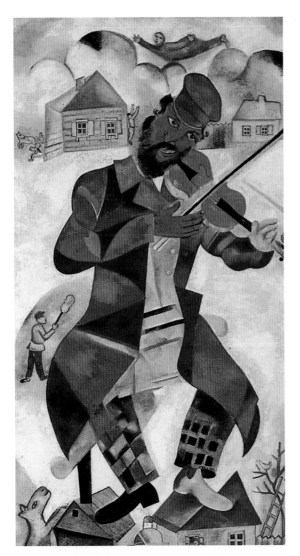

10.4 Marc Chagall, *The Green Violinist*, 1923–24. Oil on canvas, 6' 5¾" × 3' 6¾" (1.9 × 1.1 m). Solomon R. Guggenheim Museum, New York.

In Paris, Chagall became increasingly active in the graphic arts, especially for the dealer Ambroise Vollard. Over the years he continued to move from project to project with undiminished energy and enthusiasm. In 1945 he designed sets and costumes for Igor Stravinsky's ballet *Firebird*. He made color lithographs; produced sculptures and ceramics; designed a ceiling for the Paris Opéra in 1963 and murals for the Metropolitan Opera at the Lincoln Center in New York in 1966. He also designed many characteristically vibrant stained-glass windows in which he was able to indulge his love of rich, translucent color.

De Chirico and the Metaphysical School

Working in Italy from around 1913 to 1920, the Metaphysical painters retained the forms of Renaissance reality, linear perspective, recognizable environments, and sculptural figures and objects, but used various juxtapositions to produce surprise and shock, and to create an atmosphere of strangeness, sometimes even of fear and horror. The naturalism and seemingly habitable landscapes of most Metaphysical images do not immediately divulge a debt to Cubism, but in both schools there is a conception of space as a formal element capable of conveying mood or meaning. Not simply an environment for figures or objects, space functions as part of a complex pictorial message.

The work of **Giorgio De Chirico** (1888–1978), in particular, links nineteenth-century Romantic fantasy with twentieth-century Surrealism. Born in Greece of Italian parents, De Chirico learned drawing in Athens. After the death of his father, the family moved to Munich in order to advance the artistic or musical leanings of their children. In Munich, De Chirico was exposed to the art of Böcklin (see fig. 5.24) and Klinger (see fig. 5.25). What impressed him about Böcklin was his ability to impart "surprise": to make real and comprehensible the improbable or illusory by juxtaposing it with normal everyday experience. De Chirico's concept of a painting as a symbolic vision was also affected by his readings of the philosophical writings of Nietzsche. For example, Nietzsche's insistence that art expresses deep-seated motivations within the human psyche led De Chirico to his metaphysical examination of still life.

While De Chirico was in Germany, from 1905 to 1909, Art Nouveau (see chapter 5) was still a force, and the German Expressionists (see chapter 7) were beginning to make themselves known. Ideal or mystical philosophies and pseudophilosophies were gaining currency among artists and writers everywhere, and modern Theosophy was an international cult. As discussed in chapter 7, Kandinsky found a basis for his approach to abstraction in Theosophy, and his mystical concepts of an inner reality beyond surface appearance would later affect artists as divergent as Mondrian and Klee. De Chirico constantly referred to the "metaphysical content" of his paintings, using the word "metaphysical" (which in philosophy refers to broad questions of the nature of causality, being, and time) loosely or inaccurately to cover various effects of strangeness, surprise, and shock.

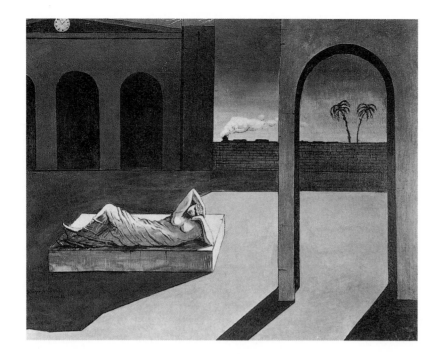

10.5 Giorgio De Chirico, *The Soothsayer's Recompense,* 1913. Oil on canvas, 53½ × 71" (135.9 × 180.3 cm). Philadelphia Museum of Art.

De Chirico's approach to art during his early and most influential phase—up to 1920—was to examine a theme as though wringing from it its central mystery. In 1912 and 1913, while living in Paris, he painted a group of works incorporating a Hellenistic sculpture of a reclining Ariadne. One of these works, *The Soothsayer's Recompense* (fig. **10.5**),

10.6 Giorgio De Chirico, *The Melancholy and Mystery of a Street,* 1914. Oil on canvas, 34¼ × 28⅛" (87 × 71.4 cm). Private collection.

presents the darkened arches of a classical façade beneath a large clock. On the distant horizon a moving train introduces another modern element into a seemingly ancient context. Such anomalies are commonplace in Italian cities—a palazzo may become a nineteenth-century railway station. De Chirico used these anachronisms to suggest the melancholy of departure, a melancholy that saturates the shadowed square where deserted Ariadne mourns her departed lover Theseus. At times, the strange, sad loneliness of De Chirico's squares takes on dimensions of fear and isolation in a vast, empty space.

It was while in Paris and in close proximity to Apollinaire and the work of the Cubists that De Chirico restructured the depiction of space in his compositions, fragmenting and destabilizing some planes in order to enhance the viewer's disorientation. *The Melancholy and Mystery of a Street* of 1914 (fig. **10.6**) is one of his finest examples of deep perspective used for emotional effect. On the right, an arcaded building in deep browns and grays casts a shadow filling the foreground; a lower white arcade on the left sweeps back toward infinity; the sky is threatening. Into the brightly lit space between the buildings emerges a little girl rolling her hoop inexorably toward a looming black specter of a figure standing behind the dark building. In the foreground of the palazzo on the right is an empty, old-fashioned freight car or carnival van whose open doors add another suggestive and disturbing element. The scene may be described matter-of-factly: an Italian city square with shadows lengthening in a late autumn afternoon; an arcade of shops closed for the day; railway tracks in the lower left corner; the shadow of a heroic nineteenth-century statue; a little girl hurrying home. But from these familiar components the artist has created an ominous mood.

Upon Italy's entry into World War I, De Chirico left Paris, where he had attracted considerable attention among the avant-garde, and returned home to Italy. In Ferrara,

from 1915 to 1919, he summed up his explorations of the previous years in a fully developed mature style. The haunting, dream-like fusion of reality and unreality in his paintings was aptly termed Metaphysical, leading to the formation of the Scuola Metafisica, or Metaphysical School. *The Great Metaphysician* (fig. **10.7**) is a key work of this time, the climax of the artist's visions of loneliness and nostalgia, his fear of the unknown, his premonitions of the future, and his depiction of a reality beyond the physical realm. *The Great Metaphysician* combines the architectural space of the empty city square and the developed mannequin figure. The deep square is sealed in with low classical buildings. The buildings to the right and left are abstract silhouettes extending dark, geometric shadows over the brown area of the square. Only the rear buildings and the foreground monument are brightly lit. This monument on a low base is a looming construction of elements from the studio and drafting table, crowned by a blank mannequin head. It is clear from these paintings that the Metaphysical School sought an elegiac and enigmatic expression, one that, unlike their Italian contemporaries the Futurists, did not reject the art of the Italian past.

10.7 Giorgio De Chirico, *The Great Metaphysician*, 1917. Oil on canvas, 41⅛ × 27½" (104.5 × 69.8 cm).

"Running on Shrapnel": Futurism in Italy

It was left to the Italian Futurists to demonstrate how Cubist ideas could be deployed in the service of overt political goals. In their paintings and sculptures the Futurist artists sometimes verged on total abstraction, but for the most part they, like the Cubists, drew upon imagery derived from the physical world. Futurism was first of all a literary concept, born in the mind of the poet and propagandist Filippo Tommaso Marinetti (1876–1944) in 1908 and announced in a series of manifestos in 1909, 1910, and subsequently. From this point onward, the manifesto was to play a prominent and recurring role in modern art—indeed, it has been described as one of its most characteristic productions (see *The Founding and Manifesto of Futurism*, below).

Futurism began as a rebellion of young intellectuals against the cultural torpor into which Italy had sunk during the nineteenth century, when Renaissance and Neoclassical artistic values continued to dominate painting and sculpture, despite the avant-garde developments in neighboring France. Strongly nationalistic, the Futurists advocated the expansion of Italian industry and territory, which they believed could only be accomplished by crushing nostalgia and any reverence for the past. As so frequently happens in such movements, the Futurists' manifestos initially focused on what they had to destroy before new ideas could flourish. The first manifesto, written by Marinetti, demanded the destruction of the libraries, museums, academies, and cities of the past, which he called mausoleums. In its wholesale assault on conventional values, it extolled the beauties of revolution, of war, and of the speed and dynamism of machine technology: "A roaring motorcar, which looks as though running on shrapnel, is more beautiful than the *Victory of Samothrace*." Much of the spirit of Futurism reflected the flamboyant personality of Marinetti himself; rooted in the anarchist and revolutionary fervor of the day, it attacked the ills of an aristocratic and bourgeois society and celebrated progress, energy, and change. By the 1930s, unfortunately, such impulses would have dire political consequences.

In late 1909 or early 1910 the painters Umberto Boccioni and Carlo Carrà along with the artist and composer Luigi Russolo joined Marinetti's movement. Later it also included Gino Severini, who had been working in Paris since 1906, and Giacomo Balla. The group drew up a second manifesto in 1910. This again attacked the old institutions and promoted the artistic expression of motion, metamorphosis, and the simultaneity of vision itself. The painted moving object was to merge with its environment, so that no clear distinction could be drawn between the two:

> Everything is in movement, everything rushes forward, everything is in constant swift change. A figure is never stable in front of us but is incessantly appearing and disappearing. Because images persist on the retina, things in movement multiply, change form, follow one another like vibrations within the space they traverse. Thus a horse in swift course does not have four legs: It has twenty, and their movements are triangular.

The targets of the Futurists' critique included all forms of imitation, concepts of harmony and good taste, all art critics, all traditional subjects, tonal painting, and that perennial staple of art, the painted nude.

At this point, the paintings of the various Futurists had little in common. Many of their ideas still came from the unified color patterns of the Impressionists and even more explicitly from the Divisionist techniques of the Neo-Impressionists (see chapter 3). But unlike Impressionism, Fauvism, and Cubism, all of which were generated by a steady interaction of theory and practice, Futurism emerged as a full-blown and coherent theory, the illustration of which the artists then set out to realize in paintings. The Futurists were passionately concerned with the problem of establishing empathy between the spectator and the painting, "putting the spectator in the center of the picture." In this they were close to the German Expressionists (see chapter 7), who also sought a direct appeal to the emotions. Futurist art extolled metropolitan life and modern industry. This did not, however, result in a machine aesthetic in the manner of Léger, since the Italians were concerned with the unrestrained expression of individual ideals, with mystical revelation, and with the articulation of action. This is exemplified by Russolo's Futurist musical compositions, which utilized the aggressive sounds of urban, industrial life to create a cacophonous celebration of modernity. Russolo even invented a new set of instruments to replace those used by classical orchestras in order to perform his "Art of Noises." Though Russolo and the other Futurists held in common their sense of purpose, Futurist art cannot be considered a unified style.

The Futurist exhibition in Milan in May 1911 was the first of the efforts by the new group to make its theories concrete. In the fall of that year, Carrà and Boccioni visited Paris. Severini took them to meet Picasso at his studio, where they no doubt saw the latest examples of Analytic Cubist painting. What they learned is evident in the repainted version of Boccioni's *The Farewells* (fig. **10.8**), a 1911 work that is the first in a trilogy of paintings titled *States of Mind*, about arrivals and departures at a train station. Within a vibrating, curving pattern the artist introduces a Cubist structure of interwoven facets and lines designed to create a sense of great tension and velocity. Boccioni even added the shock of a literal, realistic collage-like element in the scrupulously rendered numbers on the cab of the dissolving engine. It will be recalled that in 1911 Braque and Picasso first introduced lettering and numbers

10.8 Umberto Boccioni, *States of Mind I: The Farewells*, 1911. Oil on canvas, 27¾ × 37⅞" (70.5 × 96.2 cm). The Museum of Modern Art, New York.

into their Analytic Cubist works (see figs. 8.21, 8.24). Boccioni's powerful encounter with Cubism reinforced his own developing inclinations, and he adapted the French style into his own dynamic idiom.

An exhibition of the Futurists, held in February 1912 at the gallery of Bernheim-Jeune in Paris, was widely noticed and reviewed favorably by Guillaume Apollinaire himself. It later circulated to London, Berlin, Brussels, The Hague, Amsterdam, and Munich. Within the year, from being an essentially provincial movement in Italy, Futurism suddenly became a significant element in international experimental art.

Balla

The oldest of the group and the teacher of Severini and Boccioni, **Giacomo Balla** (1871–1958) had earlier painted realistic pictures with social implications. He then became a leading Italian exponent of Neo-Impressionism and in this context most influenced the younger Futurists.

Balla's painting *Street Light* (fig. **10.9**) is an example of pure Futurism in the handling of a modern, urban subject. Using V-shaped brushstrokes of complementary colors radiating from the central source of the lamp, he created an optical illusion of light rays translated into dazzling colors so intense that they appear to vibrate. Balla, working in Rome rather than Milan, pursued his own distinctive experiments, particularly in rendering motion through simultaneous views of many aspects of objects. His *Dynamism of a Dog on a Leash* (fig. **10.10**), with its multiplication of legs, feet, and leash, has become one of the familiar and delightful creations of Futurist simultaneity. The little dachshund scurries along on short legs accelerated and multiplied to the point where they almost turn into wheels. This device for suggesting rapid motion or physical activity later became a cliché of comic strips and animated cartoons. Balla eventually returned to more traditional figure painting.

10.9 Giacomo Balla, *Street Light (Lampada—Studio di luce)*, dated 1909 on canvas. Oil on canvas, 68¾ × 45¼" (174.7 × 114.5 cm). The Museum of Modern Art, New York.

10.10 Giacomo Balla, *Dynamism of a Dog on a Leash (Leash in Motion)*, 1912. Oil on canvas, 35 × 45½" (88.9 × 115.6 cm). Albright-Knox Art Gallery, Buffalo, New York.

Bragaglia

Also at work within the ambience of Futurist dynamism was the Italian photographer and filmmaker **Antonio Giulio Bragaglia** (1889–1963), who, like Duchamp and Balla, had been stimulated by the stop-action photographs of Muybridge (see fig. 2.36), Eakins, and Marey (see fig. 8.48). Bragaglia, however, departed from those and shot time exposures of moving forms (fig. **10.11**), creating fluid, blurred images of continuous action. These, he thought, constituted a more accurate, expressive record than a sequence of discrete, frozen moments. In 1913 Bragaglia published a number of his "photodynamic" works in a book entitled *Fotodinamismo Futurista*.

10.11 Antonio Giulio Bragaglia, *The Cellist*, 1913. Gelatin-silver print.

Severini

Living in Paris since 1906, **Gino Severini** (1883–1966) was for several years more closely associated than the other Futurists with the growth of Cubism, serving as a link between his Italian colleagues and French artistic developments. His approach to Futurism is summarized in *Dynamic Hieroglyphic of the Bal Tabarin* (fig. **10.12**), a lighthearted and amusing distillation of Paris nightlife. The basis of the composition lies in Cubist faceting put into rapid motion within large, swinging curves. The brightly dressed chorus girls, the throaty chanteuse, the top-hatted, monocled patron, and the carnival atmosphere are all presented in a spirit of delight, reminding us that the Futurists' revolt was against the deadly dullness of nineteenth-century bourgeois morality. This work is a *tour de force* involving almost every device of Cubist painting and collage, not only the color shapes contained in the Cubist grid, but also elements of sculptural modeling that create effects of advancing volumes. Additionally present are the carefully lettered words "Valse," "Polka," "Bowling," while real sequins are added as collage on the women's costumes. The color has Impressionist freshness, its arbitrary distribution a Fauve boldness. Many areas and objects are mechanized and finely stippled in a Neo-Impressionist manner. Severini

10.12 Gino Severini, *Dynamic Hieroglyphic of the Bal Tabarin*, 1912. Oil on canvas with sequins, 63⅜ × 61½" (161.6 × 156.2 cm). The Museum of Modern Art, New York.

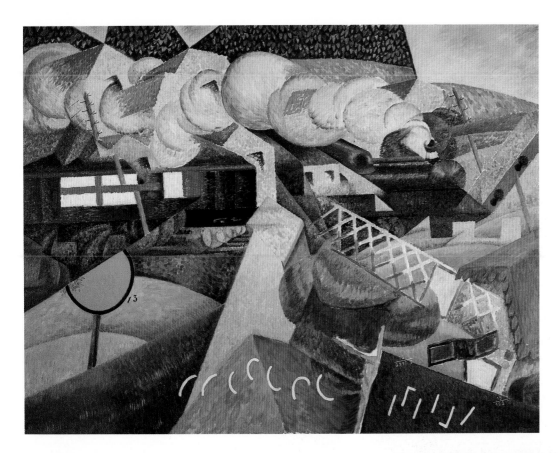

10.13 Gino Severini, *Red Cross Train Passing a Village*, 1915. Oil on canvas, 35¼ × 45¾" (89.5 × 116.2 cm). Solomon R. Guggenheim Museum, New York.

even included one or two passages of literal representation, such as the minuscule Arab horseman (upper center) and the tiny nude riding a large pair of scissors (upper left).

The sense of fragmented but still dominating reality that persisted in Severini's Cubist paintings between 1912 and 1914 found its most logical expression in a series of works on the subject of transportation, which began with studies of the Paris Métro. With the coming of the war, the theme of the train flashing through a Cubist landscape intrigued Severini as he watched supply trains pass by his window daily, loaded with weapons or troops. *Red Cross Train Passing a Village* (fig. **10.13**), one of several works from the summer of 1915 on this theme, is his response to Marinetti's appeal for a new pictorial expression for the subject of war "in all its marvelous mechanical forms." *Red Cross Train* is a stylization of motion, much more deliberate in its tempo than *Bal Tabarin*. The telescoped but clearly recognizable train, from which balloons of smoke billow, cuts across the middle distance. Large, handsome planes of strong color (in contrast to the muted palette of Analytic Cubism), sometimes rendered with a Neo-Impressionist brushstroke, intersect the train and absorb it into the painting's total pattern. The effect is static rather than dynamic and is surprisingly abstract in feeling. During these years Severini moved toward a pure abstraction stemming partly from the influence of Robert Delaunay. In *Dinamismo di Forme* (fig. **10.14**) he organized what might be called a Futurist abstract pattern of triangles and curves, built up of Neo-Impressionist dots. For some of the works in this series Severini extended the exuberant color dots onto his wooden frame.

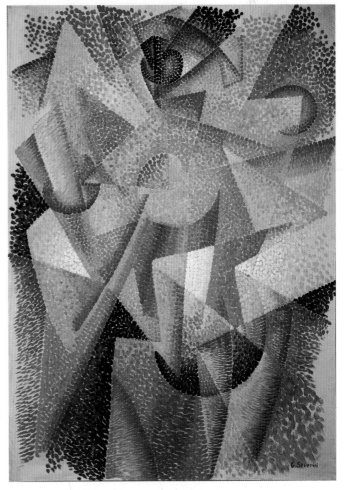

10.14 Gino Severini, *Dinamismo di Forme*, 1912. Oil on canvas. Galleria d'Arte Moderna, Rome.

Carrà

The capacity for Futurist artwork to express political messages in a dazzling and novel way is demonstrated by **Carlo Carrà** (1881–1966), whose propagandistic collage *Patriotic Celebration* (fig. **10.15**) employs radiating colors, words, and letters, Italian flags, and other lines and symbols to extol the king and army of Italy, and to simulate the noises of sirens and mobs. The spiraling composition with its radiating spokes of text suggests an automobile's spinning wheel, an airplane's propeller or a gear or turbine from a machine or factory—all subjects of delight to Futurists. Using "free words," as Marinetti did, to affect and stimulate the spirit and imagination directly through their visual associations, Carrà summons the tumult of a parade or demonstration where party slogans and patriotic songs commingle. A similar approach to text and imagery was being developed among Russian Futurist poets and artists. Carrà was also important in bridging the gap between Italian Futurism and the Metaphysical School. The war-weary Carrà eventually abandoned Futurism to join De Chirico in forming the Metaphysical School when the two met in 1917 (fig. **10.16**).

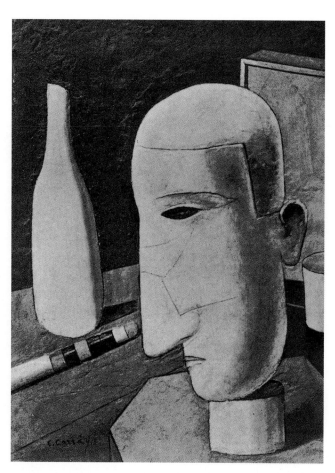

10.16 Carlo Carrà, *The Drunken Gentleman*, 1917 (dated 1916 on canvas). Oil on canvas, 23⅝ × 17½" (60 × 44.5 cm). Collection Carlo Frua de Angeli, Milan.

Boccioni

Umberto Boccioni (1882–1916) was perhaps the most visually inventive of the Futurists. In his monumental work *The City Rises* (fig. **10.17**) he sought his first "great synthesis of labor, light, and movement." Dominated by the large, surging figure of a horse before which human figures fall like ninepins, it constitutes one of the Futurists' first major statements: a visual essay on the qualities of violent action, speed, the disintegration of solid objects by light, and their reintegration into the totality of the picture by that very same light.

The greatest contribution of Boccioni during the last few years of his short life was the creation of Futurist sculpture. During a visit to Paris in 1912, he went to the studios of Archipenko, Brancusi, and Duchamp-Villon and saw sculpture by Picasso. Immediately upon his return to Milan he wrote the *Technical Manifesto of Futurist Sculpture* (1912), in which he called for a complete renewal of this "mummified art." He began the manifesto with the customary attack on all academic tradition. The attack became specific and virulent on the subject of the nude, which still dominated the work not only of the traditionalists but even of the leading progressive sculptors, Rodin, Bourdelle, and Maillol. Only in the Impressionist sculpture of Medardo Rosso (see fig. 3.22), then Italy's leading sculptor, did Boccioni find exciting innovations. Yet he recognized that,

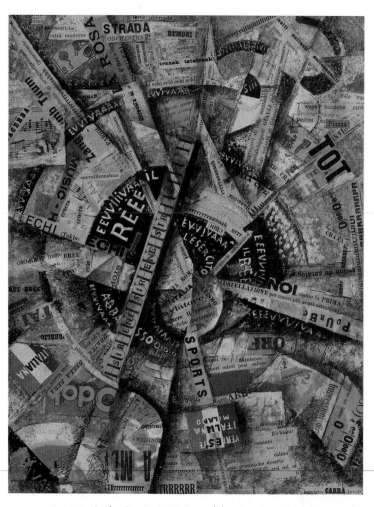

10.15 Carlo Carrà, *Patriotic Celebration (Free-Word Painting)*, 1914. Pasted paper and newsprint on cloth, mounted on wood, 15¼ × 12" (38.7 × 30.5 cm). Private collection.

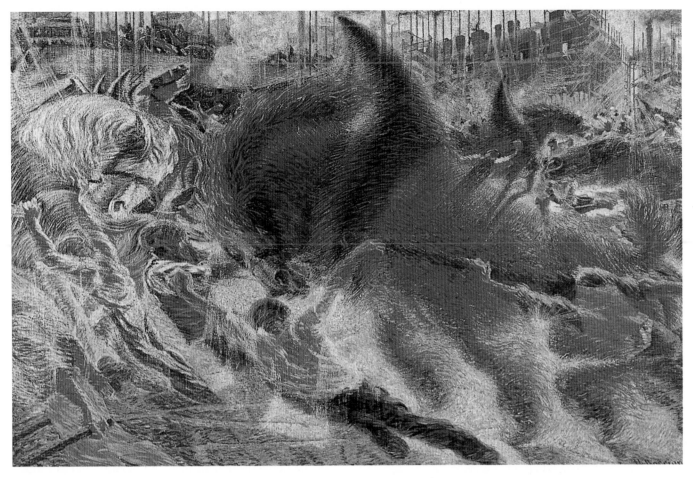

10.17 Umberto Boccioni, *The City Rises*, 1910. Oil on canvas, 6' 6½" × 9' 10½" (2 × 3 m). The Museum of Modern Art, New York.

in his concern to capture the transitory moment, Rosso was bound to represent the subject in nature in ways that paralleled those of the Impressionist painters.

Taking off from Rosso, Boccioni sought a dynamic fusion between his sculptural forms and surrounding environment. He emphasized the need for an "absolute and complete abolition of definite lines and closed sculpture. We break open the figure and enclose it in [an] environment." He also asserted the sculptor's right to use any form of distortion or fragmentation of figure or object, and insisted on the use of every kind of material—"glass, wood, cardboard, iron, cement, horsehair, leather, cloth, mirrors, electric lights, etc., etc."

Boccioni's Futurist sculpture and his manifesto were the first of several related developments in three-dimensional art, among them Constructivist sculpture. *Development of a Bottle in Space* (fig. **10.18**) enlarged the tradition of the analysis of sculptural space. The bottle is stripped open, unwound, and integrated with an environmental base that makes the homely object, only fifteen inches high, resemble a model for a vast monument. In a related

10.18 Umberto Boccioni, *Development of a Bottle in Space*, 1912. Silvered bronze (cast 1931), 15 × 23¾ × 12⅞" (38.1 × 60.3 × 32.7 cm). The Museum of Modern Art, New York.

10.19 Umberto Boccioni, *Table + Bottle + House*, 1912. Pencil on paper, 13⅛ × 9⅜" (33.4 × 23.9 cm). Civico Gabinetto dei Disegni, Castello Sforzesco, Milan.

10.20 Umberto Boccioni, *Unique Forms of Continuity in Space*, 1913. Bronze (cast 1931), 43⅞ × 34⅞ × 15¾" (111.2 × 88.5 × 40 cm). The Museum of Modern Art, New York.

drawing (fig. **10.19**), possibly made in preparation for the sculpture, the forms of a bottle and glass are opened up, set in motion with rotational, curving lines, and penetrated by the flat planes of the table on which they sit.

Boccioni's most impressive sculpture, *Unique Forms of Continuity in Space* (fig. **10.20**), was also his most traditional and the one most specifically related to his paintings. The title suggests that, although the human body may lie at its foundation, the impetus behind the sculpture is the coincidence of abstract form. The figure, made up of fluttering, curving planes of bronze, moves essentially in two dimensions, like a translation of his painted figures into relief. It has something in common with the ancient Greek Victory of Samothrace so despised by Marinetti: the stances of both figures are similar—a body in dramatic mid-stride, draperies flowing out behind, and arms missing.

Sant'Elia

At the First Free Futurist Exhibition, held in Rome in 1914, the founders of Futurism were joined by a number of younger artists, including the architect **Antonio Sant'Elia** (1888–1916). Sant'Elia's *Manifesto of Futurist Architecture* was no doubt written with the ever-present assistance of Marinetti, who later published Sant'Elia's text again with his own modifications. In his text and drawings, Sant'Elia conceived of cities built of the newest materials, in terms of the needs of modern men and women, and as expressions of the dynamism of the modern spirit. His visionary ideas remained on the drawing board, for his renderings were not plans for potentially functioning buildings. They were rather more like dynamic architectural sculpture. His drawings for the *Città Nuova* (*New City*) (fig. **10.21**)

10.21 Antonio Sant'Elia, Train and plane station for project for *Città Nuova*, 1914. Probably black ink on paper. Musei Civici, Como.

gave visual form to his ideas about a modern metropolis built with the technology of the future. His city contained imaginary factories and power stations on multilevel highways and towers of fantastic proportions. Though his buildings never materialized, Sant'Elia's belief in an authentic architecture based on industrial mechanization epitomized Futurist ideas. Like Boccioni and so many other talented experimental artists, Sant'Elia died in World War I.

"Our Vortex is Not Afraid": Wyndham Lewis and Vorticism

The most radical element in English art to emerge before World War I was the group calling themselves Vorticists (from "vortex"), founded in 1914 and led by the painter, writer, and polemicist **Percy Wyndham Lewis** (1886–1957). In its debt to Cubism and interest in representing movement and power, Vorticism exhibits a formal kinship with Futurism. Vorticism also promoted nationalism—even fascism—though, of course, in support of British rather than Italian interests. In the catalogue of the only exhibition of Vorticism, at the Doré Galleries in 1915, Lewis described the movement with all the zealous rhetoric typical of the early twentieth-century avant-garde:

> By vorticism we mean (a) Activity as opposed to the tasteful Passivity of Picasso; (b) Significance as opposed to the dull and anecdotal character to which the Naturalist is condemned; (c) Essential Movement and Activity (such as the energy of a mind) as opposed to the imitative cinematography, the fuss and hysterics of the Futurists.

Of particular significance for Vorticism was the association of the American poet Ezra Pound, then living in England. He gave the movement its name and with Lewis founded the periodical *Blast*, subtitled *Review of the Great English Vortex* (fig. **10.22**). For the Vorticists, abstraction was the optimal artistic language for forging a link between art and life. As Lewis stated in *Blast*, they believed that artists must "enrich abstraction until it is almost plain life." Lewis was a literary man by character, and much of his contribution lay in the field of criticism rather than creation. He was early drawn to Roger Fry's experiments in arts organizations (see *The Omega Workshops*, right). He was influenced by Cubism from a very early date and, despite his polemics against it, by Futurism. In one of his few surviving pre-World War I paintings (fig. **10.23**), Lewis composed a dynamic arrangement of rectilinear forms that arch through the composition as though propelled by an invisible energy force. This adaptation of a Cubist syntax to metallic, machine-like forms has much in common with Léger's paintings around this date. Lewis was primarily attempting, by every means in his power, to attack and break down the academic complacency that surrounded him in England. In the vortex he was searching for an art

The Omega Workshops

Though remembered today chiefly as an art critic and champion of avant-garde art, Roger Fry also exercised influence in his native Britain as an arts administrator and reformer. His most ambitious experiment in these areas was the Omega Workshops, a design firm he founded in 1913 along with the artists Vanessa Bell and Duncan Grant. The aims of the Omega Workshops were twofold: to provide a means for progressive artists to make a living through their art and to make Continental experiments in abstraction accessible to the British public, which showed little interest in avant-garde art. Many artists—and even some enthusiastic amateurs—were associated with the company from its inception until its collapse due to insolvency in 1920. Fry was less concerned with craft perfection than with promulgating a spirit of avant-garde experimentation. Omega artists worked collaboratively and anonymously, designing furnishings such as screens, rugs, ceramics, furniture, and even clothing, many decorated with bright colors and abstract figures evocative of Fauve paintings; all were signed simply with the firm's mark: Ω. Wyndham Lewis was affiliated with the group at its start, but soon withdrew his support, publicly denouncing the Omega Workshops as "a pleasant tea party" that lacked both "masculine" genius and political commitment.

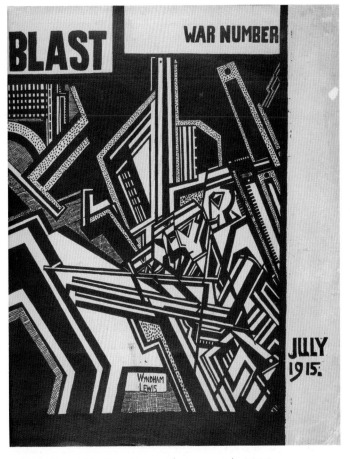

10.22 Percy Wyndham Lewis, *Blast* cover, July 1915. Harvard University Art Museums, Cambridge, MA.

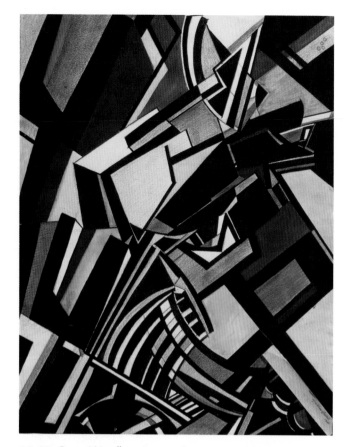

10.23 Percy Wyndham Lewis, *Composition*, 1913. Watercolor drawing on paper, 13½ × 10½" (34.3 × 26.7 cm). Tate, London.

10.24 Alvin Langdon Coburn, *Ezra Pound*, 1917. Vortograph. Private collection.

of "activity, significance, and essential movement, and a modernism that should be clean, hard, and plastic."

Vorticism was a short-lived phenomenon. Nevertheless, it was of great importance in marking England's involvement in the new experimental art of Europe. As with other artists associated with the movement, few of Lewis' early Vorticist paintings survive. After the war he abandoned abstraction in favor of a stylized figurative art. He made portraits of Edith Sitwell, Ezra Pound, and other literary figures, giving them, through a suggestion of Cubist structure, an appearance of modernism.

Another Vorticist to experiment with Cubist-inspired portraiture was the photographer **Alvin Langdon Coburn** (1882–1966). Though born in the United States, Coburn spent much of his mature career in Britain after moving there in 1912. He was involved with Vorticism from its foundation, producing faceted photographs that present objects as if shattered and reassembled, much like Picasso and Braque's early experiments in Cubism (fig. 8.17). Coburn called these photographs Vortographs and produced them using a "Vortoscope," a pyramidal assemblage of mirrors attached to the camera's lens. His Vortographic portrait of Ezra Pound (fig. **10.24**) pulsates with energy and intensity. The rhythm of the image is conveyed not only by the illusion of a sequence of photographs taken at different moments, but also through the play of geometric shapes as the stark white triangles of his shirt collar oscillate beneath the circles formed by the rims of his glasses.

A World Ready for Change: The Avant-Garde in Russia

In the attempt to evaluate the Russian achievement in the early twentieth century, a number of points must be kept in mind. Since the eighteenth century of Peter and Catherine the Great, Russia had maintained a tradition of royal patronage of the arts and had close ties with the West. Russians who could afford to traveled frequently to France, Italy, and Germany, and through books and periodicals they were aware of new developments in European art. Russian literature and music attained great heights during the nineteenth century, as did theater and ballet, which began to draw on the visual arts in interesting collaborations. Art Nouveau and the ideas of French Symbolists and Post-Impressionist Nabis made themselves widely felt in the late 1880s through the movement known as the World of Art (*Mir Iskusstva*); Russian artists mingled these influences with Byzantine and Russian painting and decorative traditions. There was constant, often heated, debate as to whether Russia should modernize on the Western European model or search its own history and folklore for a distinctively Russian route to reform. This division was to inform the development of Russian modernism in its turn.

In 1890, World of Art was joined by Sergei Diaghilev, destined to become perhaps the greatest of all ballet impresarios as well as an enthusiast for modern art in general.

A few years later Diaghilev launched his career arranging exhibitions, concerts, theatrical and operatic performances, and ultimately the Ballets Russes, which opened in Paris in 1909 and went from success to success. From then on, Diaghilev drew on many of the greatest names in European painting to create his stage sets.

After the *World of Art* periodical, first published in 1898, came other avant-garde journals. Reading these journals was yet another way that Russian artists could watch and absorb the progress of Fauvism, Cubism, Futurism, and their offshoots. Great collections of the new French art were formed by the enlightened collectors Sergei Shchukin and Ivan Morozov in Moscow. By 1914, Shchukin's collection contained more than 200 works by French Impressionist, Post-Impressionist, Fauve, and Cubist painters, including more than fifty by Picasso and Matisse. Morozov's collection included Cézannes, Renoirs, Gauguins, and many works by Matisse. Both Shchukin and Morozov were generous in opening their collections to Russian artists, and the effect of the Western avant-garde on these creative individuals was incalculable. Through such modern art collections and the exhibitions of the Jack of Diamonds group, an alternative exhibition society founded in 1910 in Moscow, Cubist experiments were known in St. Petersburg and Moscow almost as soon as they were inaugurated. By the time Marinetti, whose Futurist manifesto had long been available there, visited Russia in 1914, the Futurist movement in that country was in full swing.

Only since the 1980s, and especially following the dissolution of the Soviet Union in 1991, has scholarship on early twentieth-century Russian avant-garde art really come into its own. Before then, it was restricted and some-times suppressed; Western scholars in particular were often denied access to archival materials and works of art during the Cold War. Official hostility to modernism dated back to the government of the Soviet leader Joseph Stalin, who, in 1932, decreed that Socialist Realism (naturalistic art that celebrated the worker) was the only acceptable form of art. The kinds of small, independent art groups that had until then flourished in Russia, particularly among the avant-garde, were proscribed, and paintings by many of the greatest artists were relegated to storerooms or even destroyed. Such was the fate of the works of Kazimir Malevich, for example, who, unlike many of his contemporaries, chose not to leave the country after Stalin's rise to power. Though known in the West through works acquired by foreign collectors and institutions, his paintings had not been seen in Russia for decades when they were at last exhibited there in 1988.

Larionov, Goncharova, and Rayonism

Lifelong companions and professional collaborators **Mikhail Larionov** (1881–1964) and **Natalia Goncharova** (1881–1962) are among the earliest proponents of the Russian avant-garde. Larionov was a founding member of the Jack of Diamonds group in 1910, but by the following year he and Goncharova had left it and formed a rival organization, the Donkey's Tail, claiming the need for a contemporary Russian art that drew less from Western Europe (since the Jack of Diamonds exhibitions included work by Western European artists) and more from indigenous artistic traditions. (Nevertheless, in 1912 they both participated in the second Blaue Reiter exhibition in Munich, as well as in a historic Post-Impressionist show in London.) They turned to Russian icons and *lubok* (folk) prints for inspiration and made works in what they termed a Neo-Primitive style.

In 1912 Larionov created Rayonism, based on his studies of optics and theories about how intersecting rays of light reflect off the surface of objects (fig. **10.25** is a work from 1916). Rayonist works were first shown in

10.25 Mikhail Larionov, *Rayonist Composition*, 1916. Gouache on paper, 21¼ × 17⅝" (54 × 45 cm). Private collection.

December 1912 and then in a 1913 exhibition called The Target. Although Rayonism was indebted to Cubism, and also related to Italian Futurism in its emphasis on dynamic, linear forms, Larionov and his circle emphasized its Russian origins. His paintings were among the first non-objective works of art made in Russia. In them he sought to merge his studies of nineteenth-century color theories with more recent scientific experiments (such as radiation). His 1913 manifesto titled *Rayonism*, which extolled this style as "the true liberation of painting," was the first published discourse in Russia on non-objectivity in art.

Like Larionov, Goncharova was drawn to ancient Russian art forms. In addition to icons and *lubok* prints, she studied traditional examples of embroidery. This non-hierarchical distinction between craft and "high" art is a key characteristic of the Russian avant-garde and is perhaps one of the reasons why so many women were at the artistic forefront along with their male colleagues. After her Neo-Primitive phase, Goncharova produced paintings in a Futurist and Rayonist vein. Her colorful 1912 canvas *Linen* (fig. **10.26**) reveals a knowledge of Cubist painters such as Gleizes and Metzinger, but the cyrillic letters add a distinctively Russian touch. She also continued to make paintings in a folk style, as can be seen in *Icon Painting Motifs* (fig. **10.27**). The conceptual nature of such images explains, to some degree, how an ancient heritage of icons and flat-pattern design prepared Russians to accept total abstraction.

10.27 Natalia Goncharova, *Icon Painting Motifs*, 1912. Watercolor on cardboard, 19½ × 13⅜" (49.5 × 34.6 cm). State Tretyakov Gallery, Moscow.

Larionov and Goncharova left Russia in 1915 to design for Diaghilev. They settled in Paris, became French citizens in 1938, and married in 1955. Neither artist produced more than a few significant Rayonist paintings, but their ideas were instrumental for an art that synthesized Cubism, Futurism, and Orphism and that contained "a sensation of the fourth dimension." This pseudo-scientific concept of a fourth spatial dimension, popularized by scientists, philosophers, and spiritualists, gained currency among the avant-garde across Europe and in the United States in the early twentieth century.

Popova and Cubo-Futurism

One of the strongest artists to emerge within the milieu of the pre-revolutionary Russian avant-garde was the tragically short-lived **Lyubov Popova** (1889–1924), whose sure hand and brilliant palette are evident even in her earliest work. The daughter of a wealthy bourgeois family, Popova was able to travel extensively throughout her formative years, visiting Paris in 1912 and studying under the Cubists Le Fauconnier and Metzinger. In 1913 she began working in the studio of the Constructivist Vladimir Tatlin (see figs. 10.37, 10.38). She also knew

10.26 Natalia Goncharova, *Linen*, 1912. Oil on canvas, 35 × 27½" (89 × 70 cm). Tate, London.

Goncharova and Larinov and like them was interested in Russian medieval art. Unlike Tatlin, she was not concerned with the construction of objects in space, but rather found her expressive mode in painting. She developed a mature Cubo-Futurist style (the term is Malevich's, see below), showing a complete assimilation of Western pictorial devices into her own dynamic idiom. Her still life *Subject from a Dyer's Shop* (fig. **10.28**) contains a rich chromatic scheme that probably reflects her study of Russian folk art. Here the Cubist-derived language of integrated, pictorialized form and space may have received its most authoritative expression outside the oeuvre of the two founding Cubists themselves. In late 1915 or early 1916, partly in response to Malevich's Suprematist canvases, Popova began to compose totally abstract paintings that she called Painterly Architectonics. In these powerful compositions she paid increasing attention to building up her paint surfaces with strong textures.

In the aftermath of the 1917 October Revolution, Russian artists were involved in serious debate about the appropriate nature of art under the new communist regime. Constructivist artists abandoned traditional media such as painting and dedicated themselves to "production art." Their intention was to merge art with technology in products that ranged from utilitarian household objects to textile design, propagandistic posters, and stage sets for political rallies. Popova, who renounced easel painting in 1921, made designs for the theater, including a 1922 set for *The Magnanimous Cuckold* (fig. **10.29**), a play staged by Vsevolod Meyerhold, one of the leading figures of avant-garde theater. The set was organized according to the principles that informed Popova's abstract paintings. Like a large Constructivist environment, it consisted of arrangements of geometric shapes within a structure of horizontal and vertical elements.

10.28 Lyubov Popova, *Subject from a Dyer's Shop*, 1914. Oil on canvas, 27¾ × 35" (70.5 × 88.9 cm). The Museum of Modern Art, New York.

Malevich and Suprematism

More than any other individual, even Delaunay or Kupka, it was **Kazimir Malevich** (1878–1935) who took Cubist geometry to its most radical conclusion. Malevich studied art in Moscow, where he visited the collections of Shchukin and Morozov. He was painting outdoors in an Impressionist style by 1903 and for a brief time experimented with the Neo-Impressionist technique of Seurat. In 1910 he exhibited with Larionov and Goncharova in the first Jack of Diamonds show in Moscow and subsequently joined their rival Donkey's Tail exhibition, in which he exhibited Neo-Primitivist paintings of heavy-limbed peasants in bright Fauvist colors. By 1912 he was painting in a

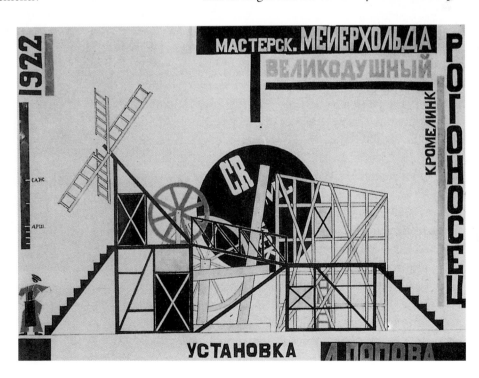

10.29 Lyubov Popova, Stage design for Vsevolod Meyerhold's *The Magnanimous Cuckold*, 1922. India ink, watercolor, paper collage, and varnish on paper, 19¾ × 27¼" (50.2 × 69.2 cm). State Tretyakov Gallery, Moscow.

Cubist manner. In *Morning in the Village after a Snowstorm* (fig. **10.30**) cylindrical figures of peasants move through a mechanized landscape, with houses and trees modeled in light, graded hues of red, white, and blue. The snow is organized into sharp-edged metallic-looking mounds. The resemblance to Léger's earlier machine Cubism is startling (see fig. 8.40), but it is questionable whether either man saw the other's early works for, unlike some of his colleagues, Malevich never traveled to Paris.

For the next two years Malevich explored different aspects and devices of Cubism and Futurism, and called his highly personalized amalgamation of the two Cubo-Futurism. In 1913 he designed Cubo-Futurist sets and costumes for *Victory over the Sun*, an experimental performance billed as the "First Futurist Opera." The actors were mostly amateurs who recited or sang their lines, accompanied by an out-of-tune piano. The non-narrative texts of *Victory over the Sun* were called *zaum*, meaning "transrational" or "beyond-the-mind," and were intended to divest words of all conventional meaning. In 1913–14 Malevich created visual analogues to these semantic experiments in a num-ber of paintings, labeling the style Transrational Realism. Through the juxtaposition of disparate elements in his compositions, he mounted a protest "against logic and philistine meaning and prejudice." In certain paintings of 1914, autonomous colored planes emerge from a matrix of Cubo-Futurist forms. In Malevich's abstract work of the following year, these planes came to function as entirely independent forms suspended on a white ground. "In the year 1913," the artist wrote, "in my desperate attempt to free art from the burden of the object, I took refuge in the square form and exhibited a picture which consisted of nothing more than a black square on a white field."

Like Larionov (and a number of modern artists, for that matter), Malevich had a tendency to date his paintings retrospectively and assign them impossibly early dates. It was not until 1915 that he unveiled thirty-nine totally non-representational paintings, whose style he called Suprematism, at a landmark exhibition in Petrograd (now St. Petersburg) called 0, 10 (Zero–Ten): The Last Futurist Exhibition (fig. **10.31**). Included in the exhibition was the painting *Black Square*, hung high across the corner

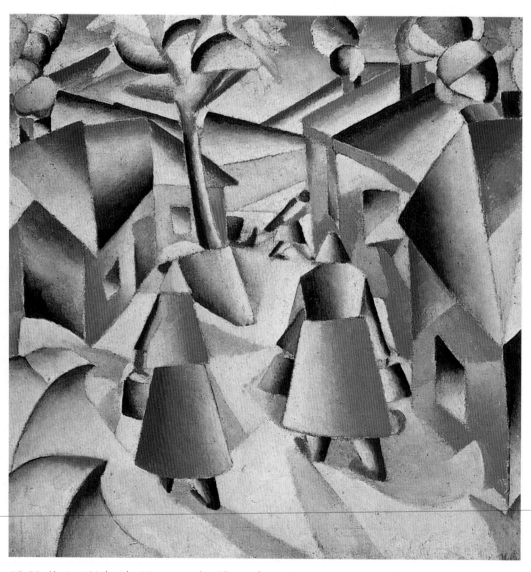

10.30 Kazimir Malevich, *Morning in the Village after a Snowstorm*, 1912. Oil on canvas, 31¾ × 31⅞" (80.6 × 80.9 cm). Solomon R. Guggenheim Museum, New York.

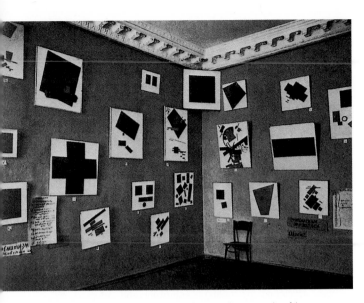

10.31 Kazimir Malevich, Installation photograph of his paintings in 0, 10 (Zero–Ten): The Last Futurist Exhibition in Petrograd (St. Petersburg), December 1915.

of the room in the traditional place of a Russian icon. This emblem of Suprematism, the most reductive, uncompromisingly abstract painting of its time, represented an astonishing conceptual leap from Malevich's work of the previous year. In his volume of essays entitled *The World of Nonobjectivity*, the artist defined Suprematism as "the supremacy of pure feeling in creative art." "To the Suprematist," he wrote, "the visual phenomena of the objective world are, in themselves, meaningless; the significant thing is feeling, as such, quite apart from the environment in which it is called forth."

As with Kandinsky and his first abstract paintings (see fig. 7.17), the creation of this simple square on a plain ground was a moment of spiritual revelation to Malevich. For the first time in the history of painting, he felt, it had been demonstrated that a painting could exist completely independent of any reflection or imitation of the external world—whether figure, landscape, or still life. Actually, of course, he had been preceded by Delaunay, Kupka, and Larionov in the creation of abstract paintings, and he was certainly aware of their efforts, as well as those of Kandinsky, who moved to largely non-objective imagery in late 1913. Malevich, however, can claim to have carried abstraction to an ultimate geometric simplification—the black square. Here, he taught, was a new beginning that corresponded to the social transformation occurring around him in the years leading up to the Russian Revolution. It is noteworthy that the two dominant wings of twentieth-century abstraction—the painterly Expressionism of Kandinsky and the hard-edged geometric purity of Malevich—should have been founded by two Russians. And each of these men had a conviction that his discoveries were spiritual visions rooted in the traditions of Old Russia.

In his attempts to define this new Suprematist vocabulary, Malevich tried many combinations of rectangle, circle, and cross, oriented vertically and horizontally. His passionate

curiosity about the expressive qualities of geometric shapes next led him to arrange clusters of colored rectangles and other shapes on the diagonal in a state of dynamic tension with one another. This arrangement of forms implied continuous motion in a field perpetually charged with energy. Malevich established three stages of Suprematism: the black, the red or colored, and the white. In the final phase, realized in monochromatic paintings of 1917 and 1918 (fig. 10.32), the artist achieved the ultimate stage in the Suprematist ascent toward an ideal world and a complete renunciation of materiality, for white symbolized the "real concept of infinity." This example displays a tilted square of white within the canvas square of a somewhat different shade of white—a reduction of painting to the simplest relations of geometric shapes.

Malevich understood the historic importance of architecture as an abstract visual art and in the early 1920s, when he had temporarily abandoned painting, he experimented with drawings and models in which he studied the problems of form in three dimensions and crafted visions of Suprematist cities, planets, and satellites suspended in space. His abstract three-dimensional models, called Arkhitektons, were significant to the growth of Constructivism in Russia and, transmitted to Germany and western Europe by his disciples, notably El Lissitzky, influenced the design teachings of the Bauhaus (see chapter 14).

In the 1920s Malevich's idealist views were increasingly at odds with powerful conservative artistic forces in the Soviet Union who promoted Socialist Realism as the only genuine proletarian art. Eventually, this style was officially established as the only legitimate form of artistic expression.

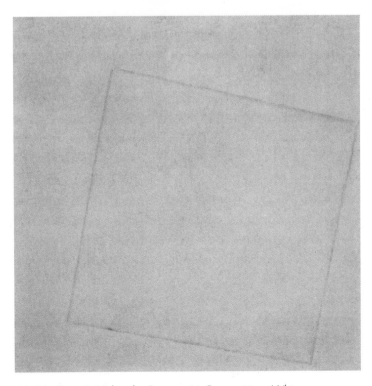

10.32 Kazimir Malevich, *Suprematist Composition: White Square on White*, 1918. Oil on canvas, 31¼ × 31¼" (79.4 × 79.4 cm). The Museum of Modern Art, New York.

By the end of 1926 Malevich was dismissed from his position as director of Inkhuk, the Institute of Artistic Culture, and in 1930 he was even imprisoned for two months and interrogated about his artistic philosophy. In his late work Malevich returned to figurative style, though in several works between 1928 and 1932 he combined echoes of his early Cubo-Futurist work with Suprematist concepts. Perhaps the empty landscapes and faceless automaton figures of the last years express, as one discerning critic wrote in 1930, "the 'machine' into which man is being forced—both in painting and outside it."

El Lissitzky's Prouns

Of the artists emerging from Russian Suprematism the most influential internationally was **El (Eleazar) Lissitzky** (1890–1941), who studied architectural engineering in Germany. On his return to Russia at the outbreak of World War I, Lissitzky took up a passionate interest in the revival of Jewish culture, illustrating books written in Yiddish and organizing exhibitions of Jewish art. Like Marc Chagall, he was a major figure in the Jewish Renaissance in Russia around the time of the 1917 Revolution that brought about the fall of the Czarist regime. In 1919 Chagall appointed

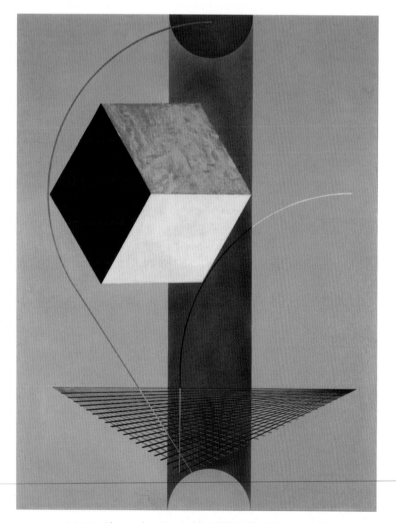

10.33 El Lissitzky, *Proun 99*, 1924–25. Water-soluble and metallic paint on wood, 50½ × 38¾" (128.3 × 98.4 cm). Yale University Art Gallery, New Haven. Gift of Société Anonyme.

Axonometry

The search for ways of representing three-dimensional space on a two-dimensional surface occupied scientists and designers as well as artists. Renaissance linear perspective, in which literal or implied orthogonal lines converge to give the illusion of spatial recession, follows a system codified by Leon Battista Alberti in the fifteenth century. The problem with using Renaissance linear perspective in designs for a structure or piece of equipment is that the system relies on distortion to achieve illusionism. While this poses no difficulties for artists and their patrons, it causes great problems for someone trying to build an exact replica of something rendered in this way. Axonometry, which was developed by military engineers and adopted by cartographers and architects in the nineteenth century, uses a different approach. Axonometric projections preserve the scale of an object and its constituent, mapping out accurately the relationships between forms. Such diagrams can be disorienting to viewers accustomed to renderings in linear perspective, just as Cubist representations of familiar objects can be difficult to read. Constructivists, such as El Lissitzky (see fig. 10.33), found in axonometry a means of overcoming the conventions of Renaissance pictorial space. Its associations with engineering endowed axonometry with a quality of objectivity and accuracy that further appealed to artists seeking to find new, stable truths about society through art.

Lissitzky to the faculty of an art school in Vitebsk that he headed. There Lissitzky, much to the disappointment of Chagall, became a disciple of the art of another faculty member, Malevich, developing his own form of abstraction, which he called Prouns (fig. **10.33**). The exact origin of this neologism is unclear, but it may be an acronym for "Project for the Affirmation of the New" in Russian. Lissitzky's Prouns are diverse compositions made up of two- and three-dimensional geometric shapes floating in space. The forms, sometimes depicted axonometrically, represent the artist's extension of Suprematist theories into the realm of architecture (see *Axonometry*, above). Indeed, Lissitzky extended the Proun literally into the third dimension in 1923 with his *Prounenraum* (*Proun Room*) (fig. **10.34**), consisting of painted walls and wood reliefs in a room that the viewer was to walk through in a counterclockwise direction. The artist wanted the walls to dissolve visually to allow the Proun elements to activate the space. The room was destroyed, but was reconstructed from Lissitzky's original documents for an exhibition in the Netherlands in 1965.

Lissitzky left Moscow in 1921 for Berlin. He was one of the key artists who brought Russian Suprematism and Constructivism together with related experiments being undertaken in Western Europe. In 1925 he resettled permanently in Moscow, where in the 1930s he became

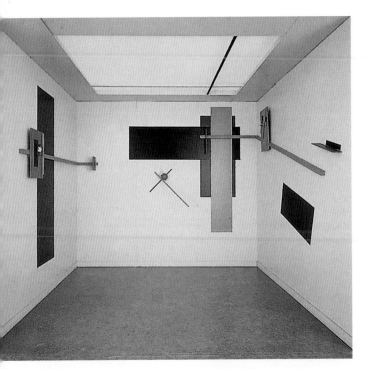

10.34 El Lissitzky, *Prounenraum* (*Proun Room*), created for Berlin Art Exhibition, 1923, reconstructed 1965. Wood, 9' 10⅛" × 9' 10⅛" × 8' 6⅜" (3 × 3 × 2.6 m). Stedelijk Van Abbemuseum, Eindhoven, the Netherlands.

an effective propagandist for the Stalinist regime. Once he abandoned abstraction, he made photographs as well as typographic, architectural, and exhibition designs. Among his most memorable images is a photographic self-portrait from 1924, *The Constructor* (fig. **10.35**). In a double exposure, the artist's face is superimposed on an image of his hand holding a compass over grid paper—a reminder of his role as an architect.

Kandinsky in the Early Soviet Period

As we saw in our discussion of Der Blaue Reiter (see chapter 7), Vasily Kandinsky was a great force in the transmission to the West of Russian experiments in abstraction and construction. Compelled by the outbreak of war to leave Germany, he went back to Russia in 1914. In the first years after the Revolution, the new Soviet government actively encouraged experimentalism and new forms in the arts to go with the new society communism was attempting to construct. In 1918 Kandinsky was invited to join the Department of Visual Arts (IZO) of Narkompros (NKP, the People's Commissariat for Enlightenment) in Moscow, and subsequently helped to reorganize Russian provincial museums. He remained in revolutionary Russia for seven years but eventually found his spiritual conception of art coming into conflict with the utilitarian doctrines of the ascendant Constructivists. In 1921 he left the Soviet Union for good, conveying many of his and his colleagues' innovations to the new Bauhaus School in Weimar, Germany.

Meanwhile, until 1920, Kandinsky continued to paint in the manner of free abstraction that he had first devised during the period 1910–14 (see figs. 7.16, 7.17). That year he began to introduce, in certain paintings, regular shapes and straight or geometrically curving lines. During 1921 the geometric patterns began to dominate, and the artist moved into another major phase of his career. There can be no doubt that Kandinsky had been affected by the geometric abstractions of Malevich, Rodchenko, Tatlin, and the Constructivists. Despite the change from free forms to color shapes with smooth, hard edges, the tempo of the paintings remained rapid, and the action continued to be the conflict of abstract forms. *White Line, No. 232*

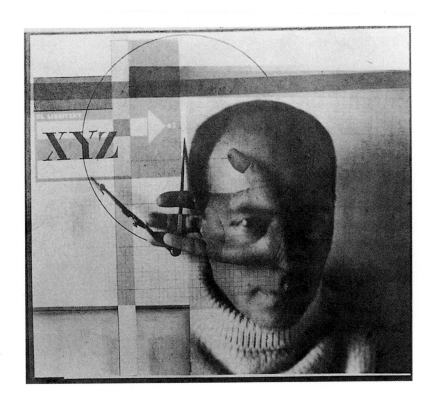

10.35 El Lissitzky, *The Constructor (Self-Portrait)*, 1924. Gelatin-silver print, 4½ × 4⅞" (11.3 × 12.5 cm). Stedelijk van Abbemuseum, Eindhoven, the Netherlands.

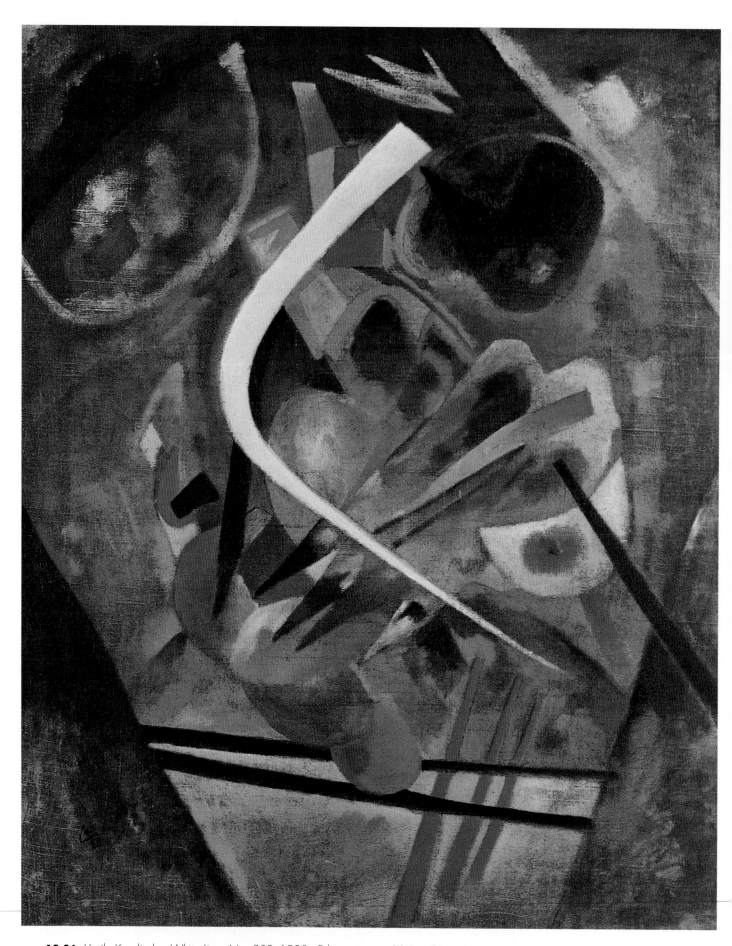

10.36 Vasily Kandinsky, *White Line, No. 232*, 1920. Oil on canvas, 38⅝ × 31½" (98.1 × 80 cm). Museum Ludwig, Cologne.

(fig. **10.36**) is a transitional work: the major color areas are still painted in a loose, atmospheric manner, but they are accented by sharp, straight lines and curved forms in strong colors.

Utopian Visions: Russian Constructivism

The word *Konstruktivizm* (Constructivism) was first used by a group of Russian artists in the title of a small 1922 exhibition of their work in Moscow. It is a term that has been applied broadly in a stylistic sense to describe a Cubist-based art developed in many countries. In general, that art is characterized by abstract, geometric forms and a technique in which various materials, often industrial in nature, are assembled rather than carved or modeled. But Constructivism originally referred to a movement of Russian artists after the 1917 Revolution who enlisted art in the service of the new Soviet system. These artists believed that a full integration of art and life would help foster the ideological aims of the new society and enhance the lives of its citizens. Such utopian ideals were common to many modernist movements, but only in Russia were the revolutionary political regime and the revolution in art so closely linked. The artists not only made constructed objects, but were major innovators in such areas as typography, textiles, furniture, and theatrical design. The 1917 Revolution initially gave a huge boost to modernism in Russia as experimental art and the new social order seemed for a time to be marching in step. The head of the new People's Commissariat for Enlightenment, Anatoly Lunacharsky—a man described by Lenin as possessing "a sort of French brilliance"—eagerly involved avant-garde artists at every level of the revolutionary cultural program.

Innovations in Sculpture

Constructivism was one of the significant new concepts to develop in twentieth-century sculpture. From the beginning of its history, sculpture had involved a process of creating form by taking away from the amorphous mass of the raw material (the carving of wood or stone), or by building up the mass (modeling in clay or wax, later to be cast in metal). These approaches presuppose that sculpture is mainly an art of mass rather than of space. Traditional techniques persisted well into the twentieth century, even in the work of so revolutionary a figure as Brancusi (see chapter 6). The first Cubist sculpture of Picasso, the 1909 *Woman's Head* (see fig. 8.16), with its deep faceting of the surface, still respected the central mass.

True constructed sculpture, in which the form is assembled from elements of wood, metal, plastic, and other materials such as found objects, was a predictable consequence of the Cubists' experiments in painting. Even before Picasso, Braque had made Cubist constructions from pieces of paper and cardboard. Though Braque's works have not survived, an early photograph shows a constructed still life mounted across a corner of the artist's studio (see fig. 8.27). Picasso's 1912 *Guitar* (see fig. 8.28) and 1913 *Mandolin and Clarinet* preserve some idea of the Cubist approach to sculpture.

Tatlin may have seen these works by Braque and Picasso during his trip to Paris, before embarking on his Counter-Reliefs. The subsequent development of constructed sculpture, particularly in its direction toward complete abstraction, took place outside France. Boccioni's Futurist sculpture manifesto of 1912 recommended the use of unorthodox materials, but his actual constructed sculpture remained tied to literal or Cubist subjects. Archipenko's constructed Médrano figures (see fig. 8.30), executed between 1912 and 1914, were experiments in space–mass reversals, but the artist never deserted the subject—figure or still life—and soon reverted to a form of Cubist sculpture modeled in clay for casting in bronze.

In France and Italy the traditional techniques of sculpture—modeling, carving, bronze casting—were probably too powerfully imbedded to be overthrown, even by the leaders of the modern revolution. Sculptors who had attended art schools—Brancusi and Lipchitz, for example—were trained in technical approaches unchanged since the eighteenth century. Modern sculpture emerged from the Renaissance tradition more gradually than modern painting. Possibly as a consequence of this evolutionary rather than revolutionary process, even the experimentalists continued to utilize traditional techniques. The translation of Cubist collage into three-dimensional abstract construction was achieved in Russia first, then in Holland and Germany.

Tatlin

The founder of Russian Constructivism was **Vladimir Tatlin** (1895–1953). In 1914 he visited Berlin and Paris, where he saw Cubist paintings in Picasso's studio, as well as the constructions in which Picasso was investigating the implications of collage for sculpture. The result, on Tatlin's return to Russia, was a series of reliefs constructed from wood, metal, and cardboard, with surfaces coated with plaster, glazes, and broken glass. His exhibition of these works in his studio was among the first manifestations of Constructivism, just as the reliefs were among the first complete abstractions, constructed or modeled, in the history of sculpture. Tatlin's constructions, like Malevich's Suprematist paintings, were to exert a profound influence on the course of Constructivism in Russia.

Most of Tatlin's first abstract reliefs have disappeared, and the primary record of them is a number of drawings and photographs that document his preoccupation with articulating space. The so-called Counter-Reliefs, begun in 1914, were released from the wall and suspended by wires across the corner of a room (again, the location in Russian homes for icons), as far removed from the earthbound tradition of past sculpture as the technical resources of the artist permitted. One of these reliefs

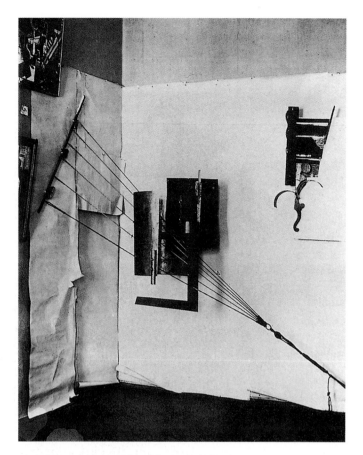

10.37 Vladimir Tatlin, *Counter-Relief*, 1915. Iron, copper, wood, and rope, 28 × 46½" (71 × 118 cm). Reconstruction. State Russian Museum, St. Petersburg.

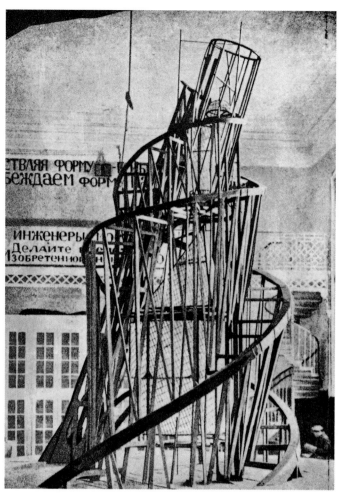

10.38 Vladimir Tatlin, Model for *Monument to the Third International*, 1919–20. Wood, iron, and glass, 20' (6.09 m). State Russian Museum, St. Petersburg.

(fig. **10.37**) has been assembled from Tatlin's original parts in St. Petersburg's State Russian Museum. Because the reliefs are made from ordinary materials, rather than traditional sculptural media such as bronze or marble, and because they are not isolated on a base, they tend to inhabit the space of the viewer more directly than conventional sculpture.

Tatlin developed a repertoire of forms in keeping with what he believed to be the properties of his chosen materials. According to the principles of what he called the "culture of materials" and "truth to materials," each substance, through its structural laws, dictates specific forms, such as the flat geometric plane of wood, the curved shell of glass, and the rolled cylinder or cone of metal. For a work of art to have significance, Tatlin came to believe that these principles must be considered in both the conception and the execution of the work, which would then embody the laws of life itself.

Like many avant-garde artists, Tatlin embraced the Russian Revolution. Thereafter, he cultivated his interest in engineering and architecture, an interest that saw its most ambitious result in his twenty-foot-high (over 6 m) model for a *Monument to the Third International* (fig. **10.38**), which was exhibited in Petrograd (St. Petersburg) and Moscow in December 1920. Had the full-scale project been built, it would have been approximately 1,300 feet high, much taller than the Eiffel Tower and the biggest

sculptural form ever conceived at that time. It was to have been a metal spiral frame tilted at an angle and encompassing a glass cylinder, cube, and cone. These glass units, housing conferences and meetings, were to revolve, making a complete revolution once a year, once a month, and once a day, respectively. The industrial materials of iron and glass and the dynamic, kinetic nature of the work symbolized the new machine age. The tower was to function as a propaganda center for the Communist Third International, an organization devoted to the support of world revolution, and its rotating, ascending spiral form was a symbol of the aspirations of communism and, more generally, of the new era. It anticipated, and in scale transcended, all subsequent developments in constructed sculpture encompassing space, environment, and motion, and has come to embody the ideals of Constructivism.

After the consolidation of the Soviet system in the 1920s, Tatlin readily adapted his nature-of-materials philosophy to the concept of production art, which held that in the classless society art should be rational, utilitarian, easily comprehensible, and socially useful, both aesthetically and practically. At its best this idealist doctrine inspired artists to envision a world in which even the most mundane objects would be beautifully designed. But as the Soviet

authorities grew intolerant of the radical artistic idealism that had flourished in the early years of the new order, and Socialist Realism became the official style, the ideals of production art turned to dogma. Socialist Realism worked tragically against such spiritually and aesthetically motivated artists as Malevich and Kandinsky, driving the latter out of Russia altogether. Tatlin, dedicated to Constructivist principles, went on to direct various important art schools and enthusiastically applied his immense talent to designing workers' clothing, furniture, and even a Leonardesque flying machine called the Letatlin.

Rodchenko

By 1915–16, **Aleksandr Rodchenko** (1891–1956) had become familiar with the work of Malevich and Tatlin and he soon began to make abstract paintings and to experiment with constructions. By 1920 he, like Tatlin, was turning more and more to the idea that the artist could serve the revolution through a practical application of art in engineering, architecture, theater, and industrial and graphic design. His *Hanging Construction* (fig. **10.39**) is a nest of concentric circles, which move slowly in currents of air. The shapes, cut from a single piece of plywood, could be collapsed after exhibition and easily stored. Rodchenko also made versions (none of which survives) based on a triangle, a square, a hexagon, and an ellipse. This creation of a three-dimensional object with planar elements reveals the Constructivists' interest in mathematics and geometry. It is also one of the first works of constructed sculpture to use actual movement, in a form suggestive of the fascination with space travel that underlay many of the ideas of the Constructivists. Apparently Rodchenko liked to shine lights on the constructions so that they would reflect off the silver paint on their surfaces, enhancing the sense of dematerialization in the work.

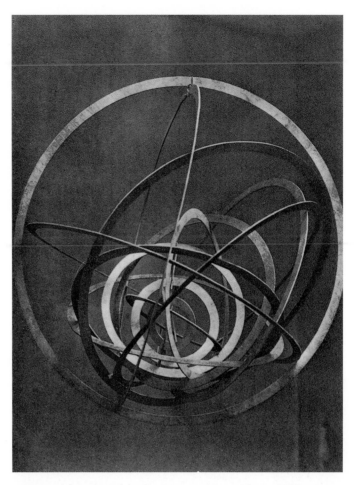

10.39 Aleksandr Rodchenko, *Hanging Construction*, 1920. Wood. Location unknown.

Rodchenko was ardently committed to the Soviet experiment. After 1921 he devoted himself to graphic, textile, and theater design. His advertising poster from 1924 (fig. **10.40**) typifies the striking typographical innovations of the Russian avant-garde. Rodchenko also excelled at

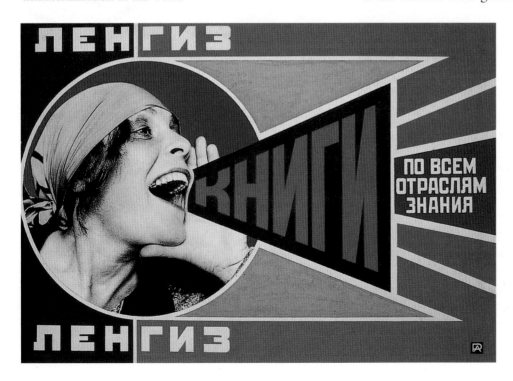

10.40 Aleksandr Rodchenko, Untitled advertising poster, 1924. Gouache and photomontage on paper, 27½ × 33⅞" (69.7 × 86.1 cm). Rodchenko-Stepanova Archive, Moscow.

photography. Commenting on images like the one reproduced here, he wrote in 1928:

> In photography there is the old point of view, the angle of vision of a man who stands on the ground and looks straight ahead or, as I call it, makes "bellybutton" shots. ... The most interesting angle shots today are those "down from above" and "up from below," and their diagonals.

By 1928 artists had long since discovered the value of the overhead perspective as a device for realizing a more abstract kind of image (see figs. 8.14, 14.7). In the vertiginous view of *Assembling for a Demonstration* (fig. **10.41**) Rodchenko constructed a composition of sharp diagonals, light–dark contrasts, and asymmetrical patterns. Given the time and the place in which it was made, Rodchenko's photograph seems a metaphor for a new society where outdated perspectives have given way to dramatic new ones.

Stepanova and Rozanova

Like her husband, Rodchenko, **Varvara Fedorovna Stepanova** (1894–1958) gave up painting (at least until the 1930s) in order to devote herself to production art. This did not mean traditional decorative arts but rather functional materials manufactured in an equal partnership between artist and industrial worker. Within their utopian framework, these new art forms were intended to aid in the creation of a new society. Tatlin's phrase "Art into Life" was the rallying cry of the Constructivists. Stepanova, who made designs for the state textile factory in Moscow, created striking fabrics in repetitive, geometric patterns suitable for industrial printing methods. She designed clothing, as did Rodchenko and Tatlin, for the new man and woman (fig. **10.42**), with an emphasis on comfort and ease of movement for the worker. The severe economic crisis that crippled Russia during the years of civil war following the Revolution thwarted the implementation of many Constructivist goals. Not surprisingly, Stepanova's sophisticated designs, grounded as they were in a modernist sensibility, were received with greater enthusiasm when exhibited in Paris in 1925 than among the working people of Moscow.

10.41 Aleksandr Rodchenko, *Assembling for a Demonstration*, 1928. Gelatin-silver print, 19½ × 13⅞" (49.5 × 35.3 cm). The Museum of Modern Art, New York.

10.42 Varvara Fedorovna Stepanova, Design for sportswear, 1923. Gouache and ink on paper, 11⅞ × 8½" (30.2 × 21.7 cm). Collection, Alexander Lavrentiev.

10.43 Olga Rozanova, *Untitled (Green Stripe)*, 1917–18. Oil on canvas, 28 × 20⅞" (71 × 53 cm). Rostovo-Yaroslavskij Arkhitekturno-Khudozhestrennyj Muzej-Zapovednik, Rostovo-Yaroslavskij, Russia.

The artists who adopted the name Constructivist in 1921 worked in three-dimensional form, but the origin of the aesthetic in Tatlin's philosophy of materials was in the *faktura* (texture of paint) and the paint surface—its thickness, glossiness, and technique of application. *Faktura* could be considered and treated as autonomous expression, as texture that generates specific forms. In this way the narrative function of figurative art was replaced by a self-contained system. As early as 1913 **Olga Rozanova** (1886–1918) had asserted that the painter should "speak solely the language of pure plastic experience." In 1917, as if to illustrate the principle, she painted a remarkable picture (fig. **10.43**), its composition simply a wide, lavishly brushed green stripe running up, or down, the center and cutting through a creamy white field of contrasted but equally strong scumbled texture. The result seems to reach across the decades to the 1950s and Barnett Newman's more monumental but scarcely more radical Zip paintings (see fig. 17.27).

Pevsner, Gabo, and the Spread of Constructivism

The Constructivist experiments of Tatlin, Rodchenko, and Stepanova came to an end in the early 1930s, as the Soviet government began to discourage abstract experi-ment in favor of practical enterprises useful to a struggling economy. Many of the Suprematists and Constructivists left Russia in the early 1920s. The most independent contributions of those who remained, including Tatlin and Rodchenko, were to be in graphic and theatrical design. After the pioneering work in Russia, Constructivism developed elsewhere. The fact that artists like Kandinsky, Naum Gabo, and Anton Pevsner left Russia and carried their ideas to Western Europe was of primary importance in the creation of a new International Style in art and architecture.

The two leading Russian figures in the spread of Constructivism were the brothers Anton (Antoine) Pevsner (1886–1962) and **Naum Gabo** (1890–1977). Pevsner was first of all a painter whose history summarized that of many younger Russian artists. His exposure to non-academic art first came about through his introduction to traditional Russian icons and folk art. He then discovered the Impressionists, Fauves, and Cubists in the Morozov and Shchukin collections. In Paris between 1911 and 1914, he knew and was influenced by Archipenko and Modigliani. Between 1915 and 1917 he lived in Norway with his brother Naum and on his return to Russia after the Revolution taught at the Moscow Academy.

Naum Gabo (Naum Neemia Pevsner), who changed his name to avoid confusion with his elder brother, went to Munich in 1910 to study medicine but turned to mathematics and engineering. There he became familiar with the scientific theories of Albert Einstein, among others, attended lectures by the art historian and critic Heinrich Wölfflin, and read Kandinsky's *Concerning the Spiritual in Art*. He left Germany when war broke out and settled for a time in Norway. There, in the winter of 1915–16, he began to make a series of heads and whole figures of pieces of cardboard or thin sheets of metal, figurative constructions transforming the masses of the head into lines or plane edges framing geometric voids. The interlocking plywood shapes that make up *Constructed Head No. 1* establish the interpenetration of form and space without the creation of a surface or solid mass.

In 1917, after the Russian Revolution, Gabo returned to Russia with Pevsner. In Moscow he was drawn into the orbit of the avant-garde, meeting Kandinsky and Malevich and discovering Tatlin's constructions. He abandoned the figure and began to make abstract sculptures, including a motor-propelled kinetic object consisting of a single vibrating rod, as well as constructions of open geometric shapes in wood, metal, and transparent materials such as *Column* (fig. **10.44**). Originally conceived in 1920–21, these tower-shaped sculptures, like Tatlin's *Monument* (see fig. 10.38), were part of Gabo's experiments for a visionary architecture.

Between 1917 and 1920 the hopes and enthusiasms of the Russian experimental artists were at their peak. Most of the abstract artists were initially enthusiastic about the Revolution, hoping that from it would come the liberation and triumph of progressive art. By about 1920, however, Tatlin and the group around him had become increasingly doctrinaire in their insistence that art should serve the Revolution in specific, practical ways. Under government pressure, artists had to abandon or subordinate pure experiment in painting and sculpture and turn their energies to engineering, industrial, and product design.

Gabo's reaction to these developments was recorded in the *Realistic Manifesto*. It was signed by Gabo and Pevsner and distributed in August 1920 at a Moscow exhibition of their work, but Gabo drafted it and was principally responsible for the ideas it contained. In many ways the manifesto was the culmination of ideas that had been fermenting in the charged atmosphere of Russian abstract art over the previous several years. At first a supporter of the revolutionary regime, Gabo found himself increasingly at odds with those members of the avant-garde who denounced art in favor of utilitarian objects to aid in the establishment of the socialist state. In the *Realistic Manifesto*, in which the word "realistic" refers to the creation of a new, Platonic reality more absolute than any imitation of nature, Gabo distinguished between his idealistic though "politically neutral" art and the production art of Tatlin, Rodchenko, and others. With revolutionary fervor, he proclaimed that

10.44 Naum Gabo, *Column*, c. 1923, reconstructed 1937. Wood, painted metal, and glass (later replaced with Perspex), 41½ × 29 × 29" (105.3 × 73.6 × 73.6 cm). Solomon R. Guggenheim Museum, New York.

the art of the future would surpass what he regarded as the limited experiments of the Cubists and Futurists. He called on artists to join forces with scientists and engineers to create a sculpture whose powerful kinetic rhythms embodied "the renascent spirit of our time." Gabo later wrote:

> The most important idea in the manifesto was the assertion that art has its absolute, independent value and a function to perform in society whether capitalistic, socialistic, or communistic—art will always be alive as one of the indispensable expressions of human experience and as an important means of communication.

Until 1921 avant-garde artists were allowed the freedom to pursue their new experiments. But as civil war abated, the Soviet state began to impose its doctrine of Socialist Realism. The result was the departure from Russia of Kandinsky, Gabo, Pevsner, Lissitzky, Chagall, and many other leading spirits of the new art throughout the 1920s who, as we shall see in chapter 14, continued to develop their ideas in the West.

11
Picturing the Wasteland: Western Europe during World War I

No single event influenced the development of modern art as profoundly as World War I. Sparked by the ongoing conflict in the Balkans, the war rapidly escalated to the point where not only most of Europe but, through international alliances and colonization, much of the world was involved. Most observers assumed that the war would be only "a brief storm." Even the British Foreign Secretary declared to the House of Commons in 1914 that "If we engage in war, we shall suffer little more than we shall suffer even if we stand aside."

But the war was neither brief nor easy: industrialization had enabled rapid manufacture of continuously evolving war machines. Increasingly powerful artillery, along with tanks and airplanes, was brought into service. Most terrifying, though, was the use of poison gas, introduced into combat in 1915. So effective were these weapons—used by both sides during the war—that troops had difficulty advancing across contested ground, thus prolonging battles and deferring decisive victories. Well before the conclusion of the war in 1918, wounded troops were returning home with terrible stories of the conditions at the front (especially those involved in trench warfare) and disabling injuries to testify to the experience. Plastic surgery emerged as a medical specialty in consequence of the disfiguring wounds caused by fragmentation grenades or land mines (see *The Art of Facial Prosthetics*, right). In addition to the more than ten million soldiers killed and twenty million physically wounded, there were further millions who returned from battle with profound psychological injuries, leading to a new understanding of the emotional consequences of war and to novel methods for treating those diagnosed with "shell shock."

Artistic responses to these events were stylistically and thematically diverse. Some, like the Futurists and Vorticists discussed in the previous chapter, welcomed war, what Marinetti called "the world's only hygiene," as the best means of pursuing their nationalist ideas. Others observed with horror as a conflict over territorial claims that few understood (much less supported) escalated into a bloodbath of unprecedented proportions. Many sought to escape the war, moving to neutral countries like Switzerland or even to the United States, which entered the war in 1917 but remained geographically insulated from the devastation unfolding in Europe. A number of

CONTEXT

The Art of Facial Prosthetics

The unprecedented number and types of facial wounds inflicted on soldiers during World War I prompted numerous medical innovations. Plastic surgery had not been widely attempted before the war: it was rarely thought necessary and the large breathing masks required to deliver anesthesia made facial surgery difficult if not impossible. Now, with hundreds of patients who had survived terrible wounds but whose injuries—often involving missing noses, cheeks, ears, eyes, or chins and jaws—rendered them unrecognizable even to family members, army surgeons attempted a host of new procedures. The most successful innovator was Harold Gillies, who developed techniques for grafting or stretching skin over nasal, chin, or cheek implants. These early efforts produced uneven outcomes, and Gillies would vastly improve his techniques during World War II. But for those injured in World War I, plastic surgery might leave them at least as disfigured as had their original injuries. Social alienation and even suicide were too often the consequence, so doctors encouraged the (usually temporary, though sometimes permanent) use of facial prostheses: galvanized copper or tin masks, enameled to approximate the soldier's skin, hair, or eye color. Artists worked with physicians and dentists to produce these masks. Among the most noted was Anna Coleman Ladd (1881–1950), an American sculptor married to a physician. Both joined the Red Cross during the war, serving in France. There she used her knowledge of mold-making, modeling, and anatomy to create masks that were more lifelike than most then available. The clumsiness of many facial prostheses is satirized by Neue Sachlichkeit artists like Otto Dix (see fig. 11.33).

artists were killed, including Blaue Reiter painters Franz Marc and August Macke and the Futurist Umberto Boccioni. Those who survived gave visual expression to their reactions, drawing alternately on the new language of abstraction and on figurative or naturalistic styles. The movements born of World War I would contribute decisively to the directions modern art would take in the coming decades.

The World Turned Upside Down: The Birth of Dada

Zurich, in neutral Switzerland, was the first important center in which an art, a literature, and even a music and a theater of the fantastic and the absurd arose. In 1915 a number of artists and writers, almost all in their twenties and in one way or another displaced by the war, converged on this city. This international group included the German writers Hugo Ball and Richard Huelsenbeck, the Romanian poet Tristan Tzara, the Romanian painter and sculptor Marcel Janco, the Alsatian painter, sculptor, and poet Jean (Hans) Arp, the Swiss painter and designer Sophie Taeuber, and the German painter and experimental filmmaker Hans Richter. Many other poets and artists were associated with Zurich Dada, but these were the leaders whose demonstrations, readings of poetry, "noise concerts," art exhibitions, and writings assaulted the traditions and preconceptions of Western art and literature. Thrown together in Zurich, these young men and women expressed their reactions to the spreading hysteria of a world at war in forms that were intended as negative, anarchic, and destructive of all conventions. Dada was a means of expressing outrage at the war and disaffection for the materialist and nationalist views that promoted it. In Dada there was a central force of wildly imaginative humor, one of its lasting delights—whether manifested in free-word-association poetry readings drowned in the din of noise machines, in absurd theatrical or cabaret performances (see fig. 11.2), in nonsense lectures, or in paintings produced by chance or intuition uncontrolled by reason. Nevertheless, it had a serious intent: the Zurich Dadaists were engaging in a critical re-examination of the traditions, premises, rules, logical bases, even the concepts of order, coherence, and beauty that had guided the creation of the arts throughout history and remained central to the enterprise of high-minded, utopian modernism.

The Cabaret Voltaire and Its Legacy

Hugo Ball, a philosopher and mystic as well as a poet, was the first actor in the Dada drama. In February 1916, with the nightclub entertainer Emmy Hennings, he founded the Cabaret Voltaire in Zurich as a meeting place for these free spirits and a stage from which existing values could be attacked. Interestingly enough, across the street from the Cabaret Voltaire lived Vladimir Ilyich Lenin, who would stand at the forefront of the Russian Revolution the

following year. Ball and Hennings were soon joined by Tzara, Janco, Arp, and Huelsenbeck.

The term "Dada" was coined in 1916 to describe the movement then emerging from the seeming chaos of the Cabaret Voltaire, but its origin is still doubtful. The popular version advanced by Huelsenbeck is that a French–German dictionary opened at random produced the word "dada," meaning a child's rocking horse or hobbyhorse. Richter remembers the *da, da, da, da* ("yes, yes") in the Romanian conversation of Tzara and Janco. *Dada* in French also means a hobby, event, or obsession. Other possible sources are in dialects of Italian and Kru African. Whatever its origin, the name Dada is the central, mocking symbol of this attack on established movements, whether traditional or experimental, that characterized early twentieth-century art. The Dadaists used many of the formulas of Futurism in the propagation of their ideas—the free words of Marinetti, whether spoken or written; the noise-music effects of Luigi Russolo to drown out the poets; the numerous manifestos. But their intent was antithetical to that of the Futurists, who extolled the machine world and saw in mechanization, revolution, and war the rational and logical means, however brutal, to the solution of human problems.

Zurich Dada was primarily a literary manifestation, whose ideological roots were in the poetry of Arthur Rimbaud, in the theater of Alfred Jarry, and in the critical ideas of Max Jacob and Guillaume Apollinaire. In painting and sculpture, until the Cubist Francis Picabia arrived, the only real innovations were the free-form reliefs and collages "arranged according to the laws of chance" by Jean Arp (see fig. 11.3). With few exceptions, the paintings and sculptures of other artists associated with Zurich Dada broke little new ground. In abstract and Expressionist film—principally through the experiments of Hans Richter and Viking Eggeling—and in photography and typographic design, however, the Zurich Dadaists made important innovations.

The Dadaists' theatrical activity was anything but stale, however, and paved the way for later forms of performance art that developed after World War II (see figs. 19.36, 19.37), particularly that of the Fluxus group. Arp described a typical evening at the Cabaret Voltaire thus:

> Tzara is wiggling his behind like the belly of an Oriental dancer. Janco is playing an invisible violin and bowing and scraping. Madame Hennings, with a Madonna face, is doing the splits. Huelsenbeck is banging away nonstop on the great drum, with Ball accompanying him on the piano, pale as a chalky ghost. We were given the honorary title of Nihilists.

The performers may have been wearing one of the masks created by **Marcel Janco** (1895–1984) made of painted paper and cardboard (fig. **11.1**). Ball said these masks not only called for a suitable costume but compelled the wearer

coherent group. Nevertheless, three factors shaped their creative efforts. These were *bruitisme* (noise-music, from *le bruit*—"noise"—as in *le concert bruitiste*), simultaneity, and chance. *Bruitisme* came from the Futurists, and simultaneity from the Cubists via the Futurists. Chance, of course, exists to some degree in any act of artistic creation. In the past the artist had normally attempted to control or to direct it, but it now became an overriding principle. All three, despite the artists' avowed negativism, soon became the basis for their revolutionary approach to the creative act, an approach still found in poetry, music, drama, and painting.

The year 1916 witnessed the first organized Dada evening at a public hall in Zurich and the first issue of the magazine *Collection Dada*, which Tzara would eventually take over and move to Paris. The following year, the first public Dada exhibitions were held at the short-lived Galerie Dada. Such activities ushered in a new, more constructive phase for Zurich Dada, broadened from the spontaneous performances of the Cabaret Voltaire. But with the end of World War I, Zurich Dada too was drawing to an end. The initial enthusiasms were fading; its participants were scattering. Ball abandoned Dada, and Huelsenbeck, who had opposed attempts to turn it into a conventional, codified movement, left for Berlin. Tzara remained for a time in Zurich and oversaw the last Dada soirée in 1919,

11.1 Marcel Janco, *Mask*, 1919. Paper, cardboard, string, gouache, and pastel, 17¾ × 8⅝ × 2" (45 × 22 × 5 cm). Musée National d'Art Moderne, Centre d'Art et de Culture Georges Pompidou, Paris.

to act unpredictably, to dance with "precise, melodramatic gestures, bordering on madness." Dada theater of this kind had precedents in Russian Futurist performances, such as the 1913 *Victory over the Sun*, for which Malevich designed costumes.

Hugo Ball introduced abstract poetry at the Cabaret Voltaire with his poem *O Gadji Beri Bimba* in June 1916. Wrapped in a cardboard costume (fig. **11.2**), he recited his "sound poem," *Karawane*, from the two flanking music stands. Ball's thesis—that conventional language had no more place in poetry than the outworn human image in painting—produced a chant of more or less melodic syllables without meaning such as "zimzim urallala zimzim zanzibar zimlalla zam...." Despite the frenzied reactions of the audience to this experiment, its influence—like much else presented at the Cabaret Voltaire—affected the subsequent course of twentieth-century poetry.

The Zurich Dadaists were violently opposed to any organized program in the arts, or any movement that might express the common stylistic denominator of a

11.2 Hugo Ball reciting the poem *Karawane* at the Cabaret Voltaire, Zurich, 1916. Photograph, 28⅛ × 15¾" (71.5 × 40 cm). Kunsthaus, Zurich.

after which he moved to Paris. The painter Francis Picabia arrived in 1918, bringing contact with similar developments in New York and Barcelona. Picabia, together with Marcel Duchamp and Man Ray, had contributed to a Dada atmosphere in New York. Returning to Paris at the end of the war, he became a link, as did Tzara, between the postwar Dadaists of Germany and France. Dada, which was perhaps more a state of mind than an organized movement, left an enormous legacy to contemporary art, particularly the Neo-Dada art of the 1950s and early 1960s (see figs. 19.28, 19.33).

Arp

Jean (Hans) Arp (1887–1966) was the major visual artist to emerge from Zurich Dada. He was born in Strasbourg, then a German city in the disputed region of Alsace but subsequently recovered by France. He studied painting and poetry, and in Paris in 1904 he discovered modern painting, which he then pursued in studies at the Weimar School of Art and the Académie Julian in Paris. He also wrote poetry of great originality and distinction throughout his life. The disparity between his formal training and the paintings he was drawn to brought uncertainty, and he spent the years 1908–10 in reflection in various small villages in Switzerland. The Swiss landscape seems to have made a lasting impression on him, and the abstraction to which he eventually turned was based on nature and organic shapes.

In Switzerland Arp met Paul Klee, and after his return to Germany he was drawn into the orbit of Kandinsky and the Blaue Reiter painters (see figs. 7.16, 7.17). In 1912 he exhibited in Herwarth Walden's first Autumn Salon, and by 1914, back in Paris, he found himself in the circle of Picasso, Modigliani, Apollinaire, Max Jacob, and Delaunay.

Arp took an unusually long time finding his own direction. Since he destroyed most of his pre-1915 paintings, the path of his struggle is difficult to trace. He experimented with geometric abstraction based on Cubism, and by 1915, in Zurich, he was producing drawings and collages whose shapes suggest leaves and insect or animal life but which were actually abstractions. With **Sophie Taeuber** (1889–1943), whom he met in 1915 and married in 1922, he jointly made collages, tapestries, embroideries, and sculptures. Through his collaboration with her, Arp further clarified his ideas:

> These pictures are Realities in themselves, without meaning or cerebral intention. We ... allowed the elementary and spontaneous to react in full freedom. Since the disposition of planes, and the proportions and colors of these planes seemed to depend purely on chance, I declared that these works, like nature, were ordered according to the laws of chance, chance being for me merely a limited part of an unfathomable *raison d'être*, of an order inaccessible in its totality.

11.3 Jean Arp, *Collage Arranged According to the Laws of Chance*, 1916–17. Torn and pasted paper, 19⅛ × 13⅝" (48.6 × 34.6 cm). The Museum of Modern Art, New York.

Also emerging at this time was the artist's conviction of the metaphysical reality of objects and of life itself—some common denominator belonging to both the lowest and the highest forms of animals and plants. It may have been his passion to express his reality in the most concrete terms possible, as an organic abstraction (or, as he preferred to say, an organic concretion), that led him from painting to collage and then to relief and sculpture in the round.

In 1916–17 Arp produced collages of torn, rectangular pieces of colored papers scattered in a vaguely rectangular arrangement on a paper ground (fig. **11.3**). The story is that he tore up a drawing that displeased him and dropped the pieces on the floor, then suddenly saw in the way they landed the solution to the problems with which he had been struggling. Arp continued to experiment with collages created in this manner, just as Tzara created poems from words cut out of newspapers, shaken and scattered on a table. Liberated from rational thought processes, the laws of chance, Arp felt, were more in tune with the workings of nature. By relinquishing a certain amount of control, he was distancing himself from the creative process. This kind of depersonalization, already being explored by Marcel Duchamp in Paris, had profound consequences for later art.

The shift in emphasis from the individual artist and the unique artistic creation allowed for fruitful collaboration between Taeuber and Arp, who dubbed their joint productions "Duo-Collages." Partly as a result of Taeuber's training in textiles, the couple did not restrict themselves to traditional fine art media. In their desire to integrate art and life they shared an outlook with contemporaries in Russia and artists such as Sonia Delaunay (see fig. 8.44). Taeuber developed a geometric vocabulary in her early Zurich compositions (fig. **11.4**). These rigorous abstractions, organized around a rhythmical balance of horizontals and verticals, had a decisive influence on Arp's work. He said that when he met Taeuber in 1915, "she already knew how to give direct and palpable shape to her inner reality. … She constructed her painting like a work of masonry. The colors are luminous, going from rawest yellow to deep red." Between 1918 and 1920 Taeuber made four remarkable heads in polychromed wood, two of which are portraits of Arp (fig. **11.5**). These heads, humorously reminiscent of hat stands, are among the few works of Dada sculpture made in Zurich. At the same time, Raoul Hausmann was creating similar mannequin-like constructions in Berlin (see fig. 11.19).

By 1915, Arp was devising a type of relief consisting of thin layers of wood shapes. These works, which he called "constructed paintings," represent a medium somewhere between painting and sculpture. They give evidence of Arp's awareness of Cubist collage and constructions, which he would have seen in Paris in 1914–15 (see figs. 8.24, 8.27, 8.28). To make his reliefs, Arp prepared drawings and gave them to a carpenter who cut them out in wood. While not executed by the same aleatory methods employed for the collages, the relief drawings sprang from Arp's willingness to let his pencil be guided unconsciously, without a set goal in mind. The curving, vaguely organic forms that resulted, which evoked the body and its processes or some other highly abstracted form in nature, have been called "biomorphic," a term used to describe the abstract imagery of Arp's later work as well as that of many Surrealists who followed his lead. Arp developed a vocabulary of biomorphic shapes that had universal significance. An oval or egg shape, for example, was for him a "symbol of metamorphosis and development of bodies." A viola shape suggested a female torso, and then an accent was provided by a cut-out circle that became a navel. Arp's later painted reliefs suggested plants, exotic vegetables,

11.4 Sophie Taeuber, *Rythmes Libres*, 1919. Gouache and watercolor on vellum, 14¾ × 10⅞" (37.6 × 27.5 cm). Kunsthaus, Zurich.

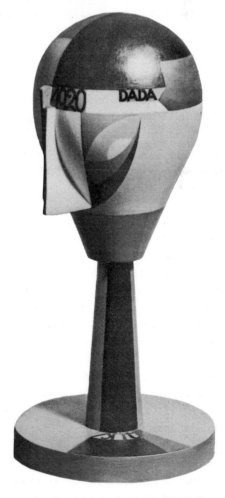

11.5 Sophie Taeuber, *Dada Head*, 1920. Painted wood, height 13⅜" (34 cm). Foundation Arp, Clamart, France.

crustaceans, or swarming amoebae, strongly implying life, growth, and metamorphosis. He used the term "*Formes terrestres*" or "earthly forms" to describe these reliefs. A particular shape might suggest a specific object and thus give the relief its name, as in *Fleur Marteau (Hammer Flower)* (fig. **11.6**). Although the origin of the shapes was initially intuitive (a line doodled on a piece of paper), the contour lines were as organic as the living organism that inspired them.

Although he was one of the founders of Zurich Dada who exerted tremendous influence on subsequent art, Arp did not perform in the theatrical presentations at the Cabaret Voltaire (unlike Taeuber, who danced in the Dada performances). "He never needed any hullabaloo," said Huelsenbeck, "Arp's greatness lay in his ability to limit himself to art." He also contributed drawings and poems to Dada publications between 1916 and 1919. In Arp's later, free-standing sculptures in marble or bronze (see chapter 15), the suggestion of head or torso became more frequent and explicit. When asked in 1956 about a 1953 piece entitled *Aquatic*—which, reclining, suggests some form of sea life, and standing on end, a sensuous female torso—he commented, "In one aspect or another, my sculptures are always torsos." In the same way that De Chirico influenced the use by some Surrealists of illusionistic techniques and recognizable images, Arp's

work would contribute to the different artistic tendency within Surrealism to employ abstract biomorphic shapes and arbitrary, non-descriptive color to create a world of fantasy. His work later influenced such artists as Joan Miró, André Masson, and Alexander Calder (see figs. 15.13, 15.15, 20.30).

"Her Plumbing and Her Bridges": Dada Comes to America

During World War I, Marcel Duchamp and Francis Picabia had both come to New York and found a congenial environment at 291, the avant-garde gallery founded by Alfred Stieglitz, who had introduced the American public to such European masters as Rodin, Toulouse-Lautrec, Henri Rousseau, Matisse, and Picasso. (The "Stieglitz circle" of American artists is discussed in chapter 16.) In 1915, assisted by Duchamp and Picabia, Stieglitz founded the periodical *291* to present the revolutionary convictions about modern art held by these artists. Thus, ideas comparable to those that would define Zurich Dada one year later were fermenting independently in a small, cohesive group in New York. Aside from the two Europeans, the most important figure in the group was the young American artist Man Ray. In addition, the remarkable collectors Louise and Walter Arensberg, whose salons regularly

attracted many of the leading artists and writers of the day, were important patrons of Marcel Duchamp, the artist of greatest stature and influence in the group.

Duchamp's Early Career

The enormous impact made on twentieth-century art by **Marcel Duchamp** (1887–1968) is best summarized by the British Pop artist Richard Hamilton: "All the branches put out by Duchamp have borne fruit. So widespread have been the effects of his life that no individual may lay claim to be his heir, no one has his scope or his restraint." Duchamp, a handsome, charismatic man of great intellect, devoted a lifetime to the creation of an art that was more cerebral than visual. By the beginning of World War I he had rejected the works of many of his contemporaries as "retinal" art, or art intended to please only the eye. Although a gifted painter, Duchamp ultimately abandoned conventional methods of making art in order, as he said, "to put art back at the service of the mind." He lived a simple but peripatetic existence, traveling between Europe and America for most of his adult life.

Duchamp's inquiry into the very nature of art was first expressed in such paintings as *Nude Descending a Staircase, No. 2* (see fig. 8.47), which used Cubist faceting to give,

he said, "a static representation of movement." The Paris exhibition of the Futurists in February 1912 had helped the artist to clarify his attitudes, although his intention was at the opposite extreme from theirs. Futurist dynamism, with its "machine aesthetic," was an optimistic, humorless exaltation of the new world of the machine, with progress measured in terms of speed, altitude, and efficiency. Duchamp, though he used some of Futurism's devices, expressed disillusionment through satirical humor.

Duchamp spent the summer of 1912 painting machines of his own creation. While still in France, he made *The King and Queen Traversed by Swift Nudes* in which the figures are not only mechanized but are conceived as machines in operation, pumping some form of sexual energy from one to another. Subsequently in Munich the artist pursued his fantasies of sexualized machines in a series of paintings and drawings, including *The Passage from Virgin to Bride* (fig. **11.7**) and the initial drawing for the important painting on glass, *The Bride Stripped Bare by Her Bachelors, Even* or *The Large Glass* (see fig. 11.12). Though these works suggest anatomical diagrams of the respiratory, circulatory, digestive, or reproductive systems of higher mammals, in each Duchamp abandoned the physicality of the human body. The organic becomes

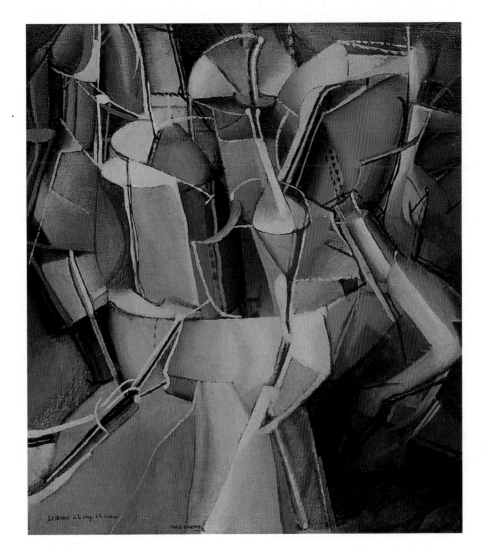

11.7 Marcel Duchamp, *The Passage from Virgin to Bride*, Munich, July–August 1912. Oil on canvas, 23⅜ × 21¼" (59.4 × 54 cm). The Museum of Modern Art, New York.

mechanized, and human flesh is supplanted by tubes, pistons, and cylinders. The term "mechanomorphic" was eventually coined to describe Duchamp's distinctive grafting of machine forms onto human activity. Thus, while he restored traditional symbols of inviolable purity and sanctified consummation (i.e., the virgin and the bride), he destroyed any sense of convention by presenting them as elaborate systems of anatomical plumbing. Doubting the validity of traditional painting and sculpture as appropriate modes of contemporary expression, and dissatisfied with Cubism, Duchamp still created beautifully rendered, visually seductive works of art. His recognition of this fact no doubt contributed to his decision to abandon painting at the age of twenty-five. "From Munich on," Duchamp said, "I had the idea of *The Large Glass.* I was finished with Cubism and with movement—at least movement mixed up with oil paint. The whole trend of painting was something I didn't care to continue."

During 1912 the so-called Armory Show was being organized in New York, and the American painters Walt Kuhn and Arthur B. Davies and the painter and critic Walter Pach were then in Paris selecting works by French artists. Four paintings by Duchamp were chosen, including *Nude Descending a Staircase* and *The King and Queen Traversed by Swift Nudes.* When the Armory Show opened in February 1913, Duchamp's paintings, and most particularly the *Nude,* became the *succès de scandale* of the exhibition. Despite attacks in the press, all four of his works were sold, and he suddenly found himself notorious.

Duchamp was meanwhile continuing with his experiments toward a form of art based on everyday subject matter—with a new significance determined by the artist and with internal relationships proceeding from a relativistic mathematics and physics of his own devising. Although he had almost ceased to paint, Duchamp worked intermittently toward a climactic object: *The Large Glass* (see fig. 11.12), intended to sum up the ideas and forms he had explored in *The Passage from Virgin to Bride* and related paintings. For this project, he made, between 1913 and 1915, the drawings, designs, and mathematical calculations for *Bachelor Machine* and *Chocolate Grinder, No. 1,* later to become part of the male apparatus accompanying the bride in *The Large Glass.*

Duchamp's most outrageous and far-reaching assault on artistic tradition by far was his invention in 1913 of the "readymade," defined by the Surrealist André Breton as "manufactured objects promoted to the dignity of art through the choice of the artist." Duchamp said his selection of common "found" objects, such as a bottle rack (fig. **11.8**), was guided by complete visual indifference, or "anaesthesia," and the absence of good or bad taste. The readymades demonstrated, in the most irritating fashion to the art world of Duchamp's day, that art could be made out of virtually anything, and that it required little or no manipulation by the artist. Within Duchamp's vocabulary, his famously irreverent addition of a mustache and goatee to a reproduction of the *Mona Lisa* was a "rectified" readymade. An "assisted" readymade also required some

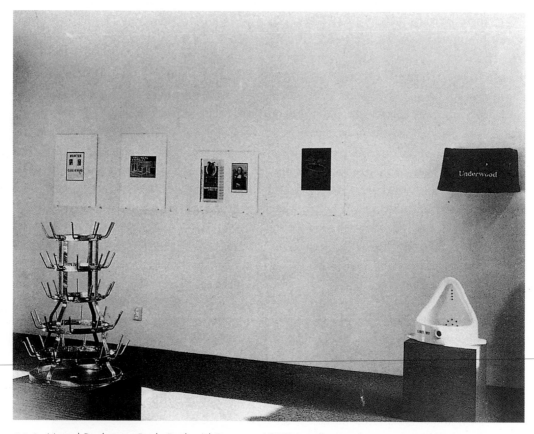

11.8 Marcel Duchamp, *Bottle Rack* and *Fountain,* 1917. Installation photograph, Stockholm, 1963.

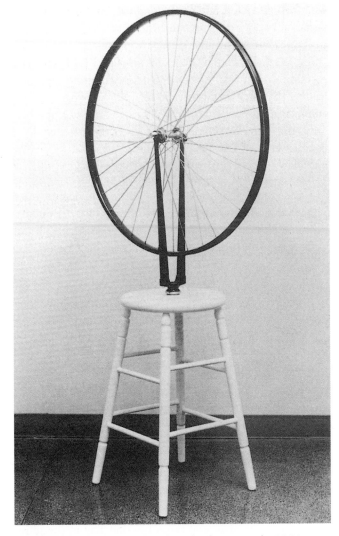

11.9 Marcel Duchamp, *Bicycle Wheel*, New York, 1951 (third version, after lost original of 1913). Assemblage: metal wheel, 25½" (63.8 cm) diameter, mounted on painted wood stool, 23¾" (60.2 cm) high; overall 50½ × 25½ × 16⅝" (128.3 × 64.8 × 42.2 cm). The Museum of Modern Art, New York.

intervention by the artist, as when Duchamp mounted an old bicycle wheel on an ordinary kitchen stool (fig. **11.9**).

Because the readymade could be repeated indiscriminately, Duchamp decided to make only a small number yearly, saying, "for the spectator even more than for the artist, art is a habit-forming drug and I wanted to protect my readymade against such contamination." He stressed that it was in the very nature of the readymade to lack uniqueness, and since readymades are not originals in the conventional sense, a "replica will do just as well." To extend the perversity of this logic, Duchamp remarked: "Since the tubes of paint used by an artist are manufactured and readymade products we must conclude that all paintings in the world are assisted readymades." He limited the number of readymades so that their original concept would not lose its impact.

For Duchamp, the conception, the "discovery," was what made a work of art, not the uniqueness of the object. One glimpses in the works discussed so far the complex

process of his thought—the delight in paradox, the play of visual against verbal, and the penchant for alliteration and double and triple meanings. In a deliberate act of provocation, Duchamp submitted a porcelain urinal, which he turned ninety degrees and entitled *Fountain* (see fig. 11.8), to the 1917 exhibition of the New York Society of Independent Artists. The work was signed "R. Mutt," a pun on the plumbing fixture manufacturer J. L. Mott Iron Works. Needless to say, the association with the popular *Mutt and Jeff* cartoons did not escape Duchamp. Although the exhibition was in principle open to any artist's submission without the intervention of a jury, the work was rejected. Duchamp resigned from the association, and *Fountain* became his most notorious readymade (see "The Richard Mutt Case," below).

In 1913–14 Duchamp had carried out an experiment in chance that resulted in *3 Standard Stoppages* (fig. **11.10**) and was later applied to *The Large Glass*. In a spirit that mocked the notion of standard, scientifically perfect measurement, Duchamp dropped three strings, each one meter in length, from a height of one meter onto a painted canvas. The strings were affixed to the canvas with varnish in the shape they assumed to "imprison and preserve forms obtained through chance." These sections of canvas and screen were then cut from the stretcher and laid down on glass panels, and three templates were cut from wooden rulers in the profile of the shapes assumed by the strings. The idea of the experiment—not the action itself—was

SOURCE

Anonymous (Marcel Duchamp)
"The Richard Mutt Case"

This defense of Fountain's *admission into the Society of Independent Artists exhibition of 1917 appeared later that year in the magazine* The Blind Man.

They say that any artist paying six dollars may exhibit.

Mr. Richard Mutt sent in a fountain. Without discussion this article disappeared and never was exhibited.

What were the grounds for refusing Mr. Mutt's fountain:

1. Some contended that it was immoral, vulgar.

2. Others, it was a plagiarism, a plain piece of plumbing.

Now Mr. Mutt's fountain is not immoral, that is absurd, no more than a bathtub is immoral. It is a fixture that you see every day in plumbers' store windows.

Whether Mr. Mutt with his own hands made the fountain or not has no importance. He CHOSE it. He took an ordinary article of life, placed it so that its useful significance disappeared under the new title and point of view—created a new thought for that object.

As for plumbing, that is absurd. The only works of art America has given are her plumbing and her bridges.

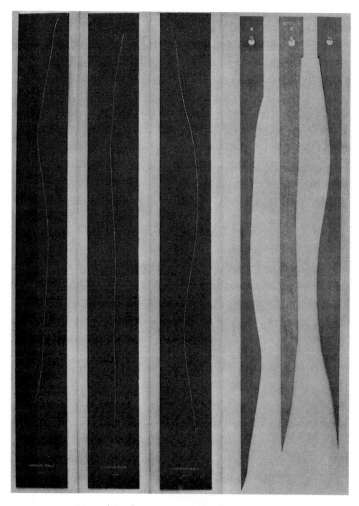

11.10 Marcel Duchamp, *3 Standard Stoppages (3 Stoppages Étalon)*, 1913–14. Assemblage: three threads glued to three painted canvas strips, each mounted on a glass panel; three wood slats, shaped along one edge to match the curves of the threads; the whole fitted into a wooden box, three painted canvas strips, each 5¼ × 47¼" (13.3 × 120 cm); each mounted on a glass panel, 7¼ × 49⅜ × ¼" (18.4 × 125.4 × 0.6 cm); three wood slats, 2½ × 43 × ⅛" (6.2 × 109.2 × 0.2 cm), 2½ × 47 × ⅛" (6.1 × 119.4 × 0.2 cm), 2½ × 43¼ × ⅛" (6.3 × 109.7 × 0.2 cm); overall, fitted into wood box, 11⅛ × 50⅞ × 9" (28.2 × 129.2 × 22.7 cm). The Museum of Modern Art, New York.

11.11 Marcel Duchamp, *Tu m'*, 1918. Oil on canvas, with bottle brush, three safety pins, and one bolt, 2' 3½" × 10' 2¾" (0.69 × 3.2 m). Yale University Art Gallery, New Haven. Gift from the Estate of Katherine S. Dreier.

what intrigued Duchamp. *3 Standard Stoppages* is thus a remarkable document in the history of chance as a controlling factor in the creation of a work of art.

In 1918, Duchamp made *Tu m'* (fig. **11.11**), his last painting on canvas, for the collector Katherine Dreier, a leading spirit in American avant-garde art. The painting has an unusually long and horizontal format, for it was destined for a spot above a bookcase in Dreier's library. It includes a compendium of Duchampian images: cast shadows, drawn in pencil, of a corkscrew and two readymades, *Bicycle Wheel* and *Hat Rack*; a pyramid of color samples (through which an actual bolt is fastened); a *trompe l'oeil* tear in the canvas "fastened" by three real safety pins; an actual bottle brush; a sign painter's hand (rendered by a professional sign painter), as well as the outlines at the left and right of *3 Standard Stoppages*. Together with Dreier and Man Ray, Duchamp eventually founded the Société Anonyme, an important organization that produced publications, gave lectures, and put on exhibitions while building an important collection of modern art.

Duchamp's Later Career

When the United States entered World War I in 1917, Duchamp relocated for several months to Argentina and then to Europe. In 1920 he returned to New York, bringing a vial he called *50 cc of Paris Air* as a gift for the art collector Walter Arensberg. During this period he invented a female *alter ego*, Rrose Sélavy, which when pronounced in French sounds like "Eros, c'est la vie" or "Eros, that's life." Duchamp inscribed works with this pseudonym and was photographed several times by Man Ray in the guise of his feminine persona. Such gestures were typical of his tendency to break down gender boundaries, and they demonstrate the degree to which Duchamp's activities and his personality were as significant, if not more so, than any objects he made.

In 1922, after yet another round of travel, Duchamp settled in New York and continued working on *The Large Glass* (fig. **11.12**). He finally ceased work on it in 1923. This painting on glass, which was in gestation for several years, is the central work of his career. The glass support dispensed with the need for a background since, by virtue of its transparency, it captured the "chance environment" of its surroundings. *The Large Glass* depicts an elaborate and

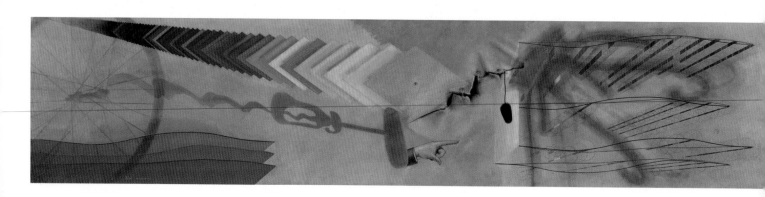

unconsummated mating ritual between the bride in the upper half of the glass, whose machine-like form we recognize from *The Passage from Virgin to Bride* (see fig. 11.7), and the uniformed bachelors in the lower half. These forms are rendered with a diagrammatic precision that underscores the pseudoscientific nature of their activities. Despite their efforts, the bachelors fail to project their "love gasoline" (the sperm gas or fluid constantly ground forth by the rollers of the chocolate machine) into the realm of the bride, so the whole construction becomes a paradigm of pointless erotic activity. Breton described it as "a mechanistic and cynical interpretation of the phenomenon of love." To annotate

and supplement this cryptic work, Duchamp assembled his torn scraps of notes, drawings, and computations in another work titled *The Green Box*. This catalogue of Duchampian ideas was later published by the artist in a facsimile edition. Duchamp allowed New York dust to fall on *The Large Glass* for over a year and then had it photographed by Man Ray, calling the result *Dust Breeding*; then he cleaned everything but a section of the cones, to which he cemented the dust with a fixative. The final touch came when the *Glass* was broken while in transit and was thereby webbed with a network of cracks. Duchamp is reported to have commented with satisfaction, "Now it is complete."

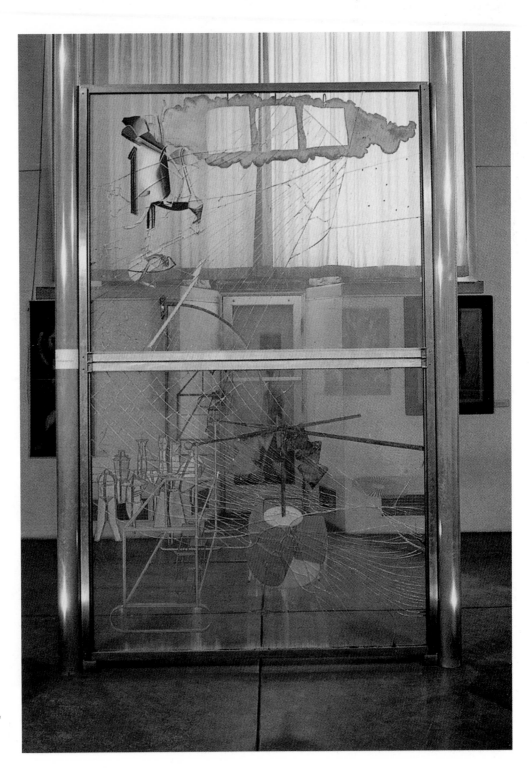

11.12 Marcel Duchamp, *The Bride Stripped Bare by Her Bachelors, Even* or *The Large Glass*, 1915–23. Oil, lead wire, foil, dust, and varnish on glass, 8' 11" × 5' 7" (2.7 × 1.7 m). Philadelphia Museum of Art.

11.13 Marcel Duchamp, *Boîte en valise (Box in a Valise)*, 1941. Leather valise containing miniature replicas, photographs, and color reproductions of works by Duchamp. Philadelphia Museum of Art.

11.14 Marcel Duchamp, *Étant Donnés 1. La Chute d'Eau, 2. Le Gaz d'Éclairage. (Given 1. The Waterfall, 2. The Illuminating Gas)*, 1946–66. Mixed-media assemblage: wooden door, bricks, velvet, wood, leather stretched over an armature of metal, twigs, aluminum, iron, glass, Plexiglas, linoleum, cotton, electric lights, gas lamp (Bec Auer type), motor, etc., 7' 11½" × 5' 10" (2.42 × 1.78 m). Philadelphia Museum of Art.

Back in Paris in the mid-1930s, Duchamp devised a work of art that made all of his inventions easily portable. The *Boîte en valise (Box in a Valise)* (fig. **11.13**) was a kind of leather briefcase filled with miniature replicas of his previous works, including all the aforementioned objects. It provided a survey of Duchamp's work, like a traveling retrospective. When, like so many other European artists, Duchamp sought final refuge in America from World War II, he came equipped with his "portable museum." Friends such as the American artist Joseph Cornell, who also made art in box form (see fig. 17.47), helped him assemble the many parts of *Boîte*. Like *The Green Box*, it was made into a multiple edition. Duchamp intended that the viewer participate in setting up and handling the objects in the valise. In this way, the viewer completes the creative act set in motion by the artist.

Although Duchamp let it be rumored that he had ceased all formal artistic activity in order to devote himself to chess (at which he excelled), he worked in secret for twenty years on a major sculptural project, completed in 1966. *Étant Donnés 1. La Chute d'Eau, 2. Le Gaz d'Éclairage (Given 1. The Waterfall, 2. The Illuminating Gas)* (fig. **11.14**) is one of the most disturbing and enigmatic works of the century, but it came to light only after the artist's death, when it was installed in the Philadelphia Museum of Art, which owns most of Duchamp's major works. A mixed-media assemblage built around the realistic figure of a nude woman sprawled on the ground, *Étant Donnés* can only be viewed by one person at a time through a peephole in a large wooden door. Duchamp's secret considerations of realism and voyeurism, coupled with the mysterious title, provide a challenging complement to the mechanical sexuality and person symbolism of *The Large Glass*.

Picabia

Francis Picabia (1879–1953) was born in Paris of wealthy Cuban and French parents. Between 1908 and 1911 he moved from Impressionism to Cubism. He joined the Section d'Or briefly and then experimented with Orphism and Futurism. In New York in 1915, he collaborated with Marcel Duchamp in establishing the American version of proto-Dada and, in the spirit of Duchamp, took up machine imagery as an emblematic and ironic mode of representation. "Almost immediately upon coming to America," Picabia said, "it flashed on me that the genius of the modern world is in machinery, and that through machinery art ought to find a most vivid expression." In this "mechanomorphic" style, Picabia achieved some of his most distinctive work, particularly a series of *Machine Portraits* of himself and his key associates in New York. Thus, he saw Stieglitz (fig. **11.15**) as a broken bellows camera, equipped with an automobile brake in working position and a gear shift in neutral, signifying the frustrations experienced by someone trying to present experimental art in philistine America. Both the Gothic letters and the title, *Ideal*, confirm the

11.15 Francis Picabia, *Ideal*, 1915. Pen and red and black ink on paper, 29⅞ × 20" (75.9 × 50.8 cm). The Metropolitan Museum of Art, New York.

conceptual or heraldic form of the portrait, while also establishing a witty contrast between the commonplace, mechanical imagery and the ancient, noble devices of traditional heraldry. Made for publication in Stieglitz's journal *291*, Picabia's 1915 portraits are modest in size, materials, and ambition, but in other works the artist developed his machine aesthetic—his "functionless" machines—into splendidly iconic paintings. They are tongue-in-cheek, however, in their commentary on the seriocomic character of human sexual drives, and have many parallels, both thematic and formal, with Duchamp's *The Large Glass*, then under way in New York.

Returning to Europe in 1916, Picabia founded his journal *391* in Barcelona and published it intermittently in New York, Zurich, and Paris until 1924. After meeting the Zurich Dadaists in 1918, he was active in the Dada group in Paris. He reverted to representational art and, after the emergence of Surrealism, painted a series of *Transparencies* in which he superimposed thin layers of transparent imagery delineating classically beautiful male and female images, sometimes accompanied by exotic flora and fauna.

Though the *Transparencies*, and the greater part of Picabia's later work, were long dismissed as decadently devoid of either content or formal interest, they have assumed new importance among the acknowledged prototypes of 1980s Neo-Expressionism (see chapter 25).

Man Ray and the American Avant-Garde

Relatively unburdened by tradition, some American artists who met Duchamp and Picabia in New York had little difficulty entering into the Dada spirit. Indeed, one of the most daring of all Dada objects was made by Philadelphia-born Morton Schamberg, who mounted a plumbing connection on a miter box and sardonically titled it *God*. Though known primarily for this work, Schamberg was actually a painter and photographer who made a number of abstract, machine-inspired compositions in oil before his life was cut short by the massive influenza epidemic of 1918.

No less ingenious in his ability to devise Dada objects than to photograph them was Man Ray (1890–1976) (born Emmanuel Radnitsky), also from Philadelphia, who went on to pursue a lengthy, active career in the ambience of Surrealism. He gathered with Duchamp and Picabia at the Arensbergs' home and by 1916 had begun to make paintings inspired by a Dada machine aesthetic and three-dimensional constructions made with found objects. By 1919, Man Ray, who was always looking for ways to divest himself of the "paraphernalia of the traditional painter," was creating the first paintings made with an airbrush, which he called "Aerographs." Normally reserved for commercial graphic work, the airbrush made possible the soft tonalities in the dancing fans and cones of *Seguidilla* (fig. **11.16**). The artist was delighted with his new discovery. "It was wonderful," he said, "to paint a picture without touching the canvas."

11.17 Man Ray, *Gift*, replica of lost original of 1921. Flatiron with nails, height 6½ × 3⅝ × 3¾" (16.5 × 9.2 × 9.5 cm). Collection Morton G. Neumann Family, Chicago.

In 1921, disappointed that Dada had failed to ignite a full-scale artistic revolution in New York, Man Ray moved to Paris. His exhibition in December of that year was a Dada event. The gallery was completely filled with balloons that viewers had to pop in order to discover the art. *Gift* (fig. **11.17**), which exists today as a replica of the 1921 original, was made in the spirit of Duchamp's slightly altered or "assisted" readymades. With characteristic black

11.16 Man Ray, *Seguidilla*, 1919. Airbrushed gouache, pen and ink, pencil, and colored pencil on paper board, 22 × 27⅞" (55.9 × 70.8 cm). Hirshhorn Museum and Sculpture Garden, Smithsonian Institution, Washington, D.C.

humor, Man Ray subverted an iron's normal utilitarian function by attaching fourteen tacks to its surface, transforming this familiar object into something alien and threatening. The work was made for the avant-garde French composer Erik Satie, hence its title.

Man Ray, who had taken up photography in 1915 through his association with Stieglitz, invented cameraless photographic images that he called "Rayographs." These were made by placing objects on or near sensitized paper that was then exposed directly to light, technically akin to Anna Atkins' cyanotypes of the previous century (see fig. 2.5). In the proper Dada manner, the technique was discovered accidentally in the darkroom. By controlling exposure and by moving or removing objects, the artist used this "automatic" process to create images of a strangely abstract or symbolic character (fig. **11.18**).

Man Ray became an established figure in the Parisian avant-garde, gaining fame with his Dada films, with his experimental photographs, his portrayals of artists and art, and his fashion photography (see fig. 15.56). By the mid-1920s, he was a central figure of the Surrealist circle (see chapter 15). Several of his assistants became important photographers in their own right: Berenice Abbott (see fig. 16.51), Bill Brandt (see fig. 15.64), and Lee Miller (see fig. 17.50).

11.18 Man Ray, *Untitled*, 1922. Gelatin-silver print (Rayograph), 9⅜ × 7" (23.8 × 17.78 cm). The Museum of Modern Art, New York.

"Art is Dead": Dada in Germany

In 1917, with a devastating war, severe restrictions on daily life, and rampant inflation, the future in Germany seemed completely uncertain. This atmosphere, in which highly polarized and radical politics flourished, was conducive to the spread of Dada. Richard Huelsenbeck, returning to Berlin from Zurich, joined a small group including the brothers Wieland and Helmut Herzfelde (who changed his name to John Heartfield as a pro-American gesture), Hannah Höch, the painters Raoul Hausmann, George Grosz, and, later, Johannes Baader. Huelsenbeck opened a Dada campaign early in 1918 with speeches and manifestos attacking all phases of the artistic status quo, including Expressionism, Cubism, and Futurism. A Club Dada was formed, to which Kurt Schwitters, later a major exponent of German Dada, was refused membership because of his association with Der Sturm Gallery, regarded by Huelsenbeck as a bastion of Expressionist art and one of Dada's chief targets.

After the war and the fall of the German Empire came a period of political chaos, which did not end with the establishment of the Weimar Republic (1918–33) and democratic government under the moderate socialist president Friedrich Ebert. Experimental artists and writers were generally leftwing, hopeful that from chaos would emerge a more equable society, but disillusionment among members of the Dada group set in as they realized that the so-called socialist government was actually in league with business interests and the old imperial military. From their disgust with what they regarded as a bankrupt Western culture, they turned to art as a medium for social and political activity. Their weapons were mostly collage and photomontage. Berlin Dada, especially for Heartfield and Grosz, quickly took on a leftwing, pacifist, and communist direction. The Herzfelde brothers' journal, *Neue Jugend*, and their publishing house, Malik-Verlag, utilized Dada techniques for political propaganda (see figs. 11.21, 11.31). George Grosz made many savage social and political drawings and paintings for the journal. One of the publications financed by the Herzfelde brothers was *Every Man Is His Own Football*. Although the work was quickly banned, its title became a rallying cry for German revolutionists. In 1919 the first issue of *Der Dada* appeared, followed in 1920 by the first international Dada-Messe, or Dada Fair, where the artists covered the walls of a Berlin gallery with photomontages, posters, and slogans like "Art is dead. Long live the new machine art of Tatlin." The rebellious members of Dada never espoused a clear program, and their goals were often ambiguous and sometimes contradictory: while they used art as a means of protest, they also questioned the very validity of artistic production.

Hausmann, Höch, and Heartfield

The Zurich Dada experiments in noise-music and in abstract phonetic poetry were further explored in Berlin.

Raoul Hausmann (1886–1971), the chief theoretician and writer of the group (nicknamed "the Dadasoph"), claimed the invention of a poetic form involving "respiratory and auditive combinations, firmly tied to a unit of duration," expressed in typography by "letters of varying sizes and thicknesses which thus took on the character of musical notations." In his *Spirit of Our Time (Mechanical Head)* (fig. **11.19**), 1919, Hausmann created a kind of three-dimensional collage. To a wooden mannequin head he attached real objects, including a metal collapsing cup, a tape measure, labels, and a pocketbook. Through his use of common found objects, Hausmann partook of the iconoclastic spirit of Duchamp's readymades and implied that human beings had been reduced to mindless robots, devoid of individual will.

In the visual arts, a major invention or discovery was photomontage, created by cutting up and pasting together photographs of individuals and events, posters, book jackets, and a variety of typefaces in new and startling configurations—anything to shock. The source material was supplied by the tremendous growth in the print media in Germany. Hausmann and Höch (who were lovers and

11.19 Raoul Hausmann, *The Spirit of Our Time (Mechanical Head)*, 1919. Wood, leather, aluminum, brass, and cardboard, 12⅝ × 9" (32.1 × 22.9 cm). Musée National d'Art Moderne, Centre d'Art et de Culture Georges Pompidou, Paris.

occasional collaborators), along with Grosz, claimed to have originated Dada photomontage, although the technique had existed for years in advertising and popular imagery. Precedent can also be identified in Cubist collage of *papier collé* and Futurist collage (see fig. 10.15). Photomontage, with its clear integration of images of modern life into works of art, proved to be an ideal form for Dadaists and subsequently for Surrealists.

A large photomontage of 1919–20 by **Hannah Höch** (1889–1978), with a typically sardonic title, *Cut with the Kitchen Knife Dada Through the Last Weimar Beer Belly Cultural Epoch of Germany* (fig. **11.20**), was included in the Dada-Messe, despite the efforts of Grosz and Heartfield to exclude her work. The dizzying profusion of imagery here demonstrates how photomontage relies on material appropriated from its normal context, such as magazine illustration, and introduces it into a new, disjunctive context, thereby investing it with new meaning. Höch here presents a satirical panorama of Weimar society. She includes photographs of her Dada colleagues, communist leaders, dancers, sports figures, and Dada slogans in varying typefaces. The despised Weimar government leaders at the upper right are labeled "anti-Dada movement." At the very center of the composition is a photo of a popular dancer who seems to toss her out-of-scale head into the air. The head is a photo of Expressionist printmaker Käthe Kollwitz (see discussion p. 255 and figs. 11.27–11.29). Although the Dadaists reviled the emotive art of the Expressionists, it seems likely that Höch respected this leftwing woman artist. Throughout the composition are photographs of gears and wheels, both a tribute to technology and a means of imparting a sense of dynamic, circular movement. One difference between Höch and her colleagues is the preponderance of female imagery in her work, indicative of her interest in the new roles of women in postwar Germany, which had granted them the vote in 1918, two years before the United States.

John Heartfield (1891–1968) made photomontages of a somewhat different variety. He composed images from the clippings he took from newspapers, retouching them in order to blend the parts into a facsimile of a single, integrated image. These images were photographed and made into photogravures for mass reproduction. Beginning in 1930, as the rise of Nazism began to dominate the political landscape, Heartfield contributed illustrations regularly to the leftwing magazine *AIZ* or *Workers' Illustrated Newspaper*. For one of his most jarring images of protest, made in 1934 after Hitler had become German chancellor (and had assumed dictatorial powers), he altered the words of a traditional German Christmas carol and twisted the form of a Christmas tree into a swastika tree (fig. **11.21**). "O Tannenbaum im deutschen Raum, wie krumm/sind deine Äste!" ("O Christmas tree in German soil, how crooked are your branches!") the heading reads. The text below states that in the future all trees must be cut in this form.

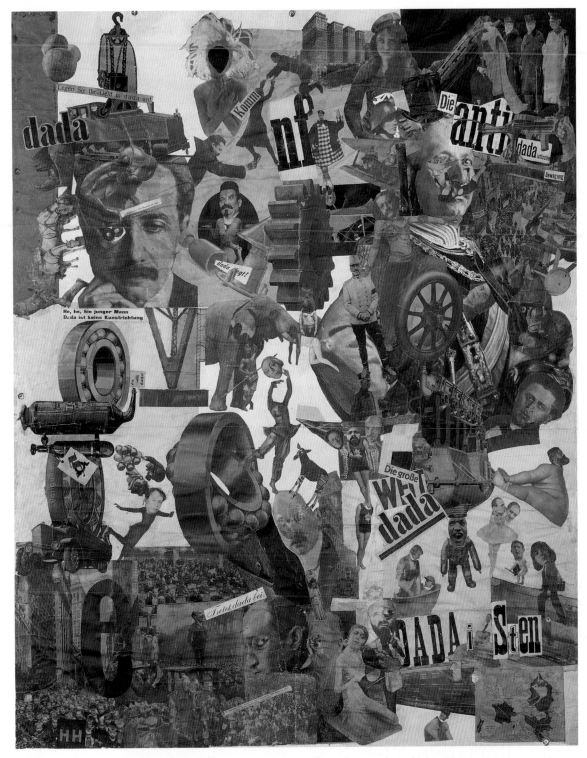

11.20 Hannah Höch, *Cut with the Kitchen Knife Dada Through the Last Weimar Beer Belly Cultural Epoch of Germany*, 1919–20. Photomontage, 44⅞ × 35½" (114 × 90.2 cm). Staatliche Museen zu Berlin, Preussischer Kulturbesitz, Nationalgalerie.

Schwitters

Somewhat apart from the Berlin Dadaists was the Hanoverian artist **Kurt Schwitters** (1887–1948), who completed his formal training at the Academy in Dresden and painted portraits for a living. He quarreled publicly with Huelsenbeck and was denied access to Club Dada because of his involvement with the apolitical and pro-art circle around Walden's Der Sturm Gallery. He was eventually reconciled with other members of the group, however,

and established his own Dada variant in Hanover under the designation "Merz," a word in part derived from the word "Commerzbank" included in one of his collages. "At the end of 1918," he wrote, "I realized that all values only exist in relationship to each other and that restriction to a single material is one-sided and small-minded. From this insight I formed Merz, above all the sum of individual art forms, Merz-painting, Merz-poetry." Schwitters was a talented poet, impressive in his readings and deadly

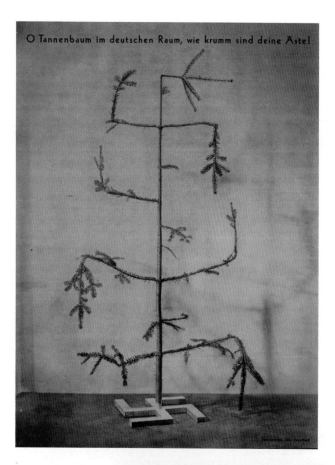

O Tannenbaum im deutschen Raum, wie krumm sind deine Ästel

11.21 John Heartfield, *Little German Christmas Tree*, 1934. Photomontage, 10¼ × 7⅞" (26 × 20 cm). The Metropolitan Museum of Art, New York.

serious about his efforts in painting, collage, and construction. These always involved a degree of deadpan humor delightful to those who knew him, but disturbing to unfamiliar audiences.

Schwitters' collages were made of rubbish picked up from the street—cigarette wrappers, tickets, newspapers, string, boards, wire screens, and whatever caught his fancy. In these so-called *Merzbilder* or *Merzzeichnungen* (Merz-pictures or Merz-drawings) he transformed the detritus of his surroundings into strange and wonderful beauty. In *Picture with Light Center* (fig. **11.22**) we see how Schwitters could extract elegance from these lowly found materials. He carefully structured his circular and diagonal elements within a Cubist-derived grid, which he then reinforced by applying paint over the collage, creating a glowing, inner light that radiates from the picture's center. For his 1920 assemblage, *Merzbild 25A (Das Sternenbild) (Stars Picture)* (fig. **11.23**), Schwitters did not restrict himself to the two-dimensional printed imagery we have seen in the photomontages of Heartfield and Höch. He incorporates rope, wire mesh, paint, and other materials

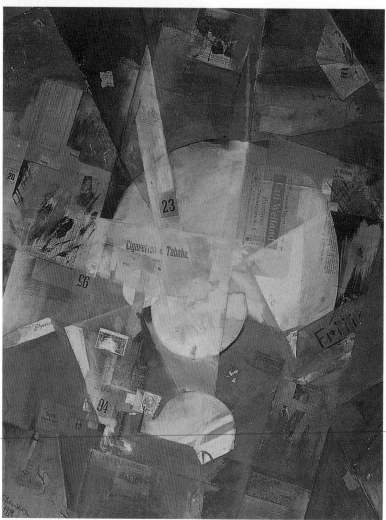

11.22 Kurt Schwitters, *Picture with Light Center*, 1919. Collage of cut-and-pasted papers and oil on cardboard, 33¼ × 25⅞" (84.5 × 65.7 cm). The Museum of Modern Art, New York.

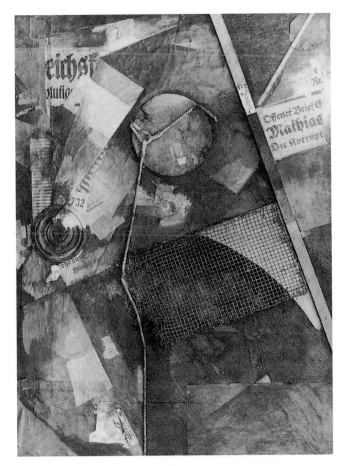

11.23 Kurt Schwitters, *Merzbild 25A (Das Sternenbild) (Stars Picture)*, 1920. Assemblage, 41 × 31⅛" (104.1 × 79.1 cm). Kunstsammlung Nordrhein-Westfalen, Düsseldorf.

11.24 Kurt Schwitters, *Hanover Merzbau*, destroyed. Photo taken c. 1931.

indicating a strong concern for physicality in his surfaces. But his are not accidental juxtapositions or ones made purely for formal effect. The snatches of text from German newspapers in this Merzbild can be decoded as referring to recent political events in Germany.

Schwitters introduced himself to Raoul Hausmann in a Berlin café in 1918 by saying, "I am a painter and I nail my pictures together." This description applies to all his relief constructions, since he drew no hard-and-fast line between them and *papiers collés*, but most specifically to the series of great constructions that he called *Merz-Column* or *Merzbau* (fig. **11.24**), the culmination of his attempts to create a *Gesamtkunstwerk*, or total work of art. He began the first one in his house in Hanover around 1920 as an abstract plaster sculpture with apertures dedicated to his Dadaist and Constructivist friends and containing objects commemorating them: Mondrian, Gabo, Arp, Lissitzky, Malevich, Richter, Mies van der Rohe, and Van Doesburg. The *Merzbau* grew throughout the 1920s with successive accretions of every kind of material until it filled the room. Having no place to go but up, he continued the environmental construction with implacable logic into the second story. "As the structure grows bigger and bigger," Schwitters wrote, "valleys, hollows, caves appear, and these lead a life of their own within the overall structure. The juxtaposed surfaces give rise to forms twisting in every direction, spiraling upward." When he was driven from Germany by the Nazis and his original *Merzbau* was destroyed, Schwitters started another one in Norway. The Nazi invasion forced him to England, where he began again for the third time. After his death in 1948, the third *Merzbau* was rescued and preserved in the University of Newcastle. The example of Schwitters was crucial for later artists who sought to create sculpture on an environmental scale. They include figures as diverse as Louise Nevelson (see fig. 17.48), Red Grooms (see fig. 19.37), and Louise Bourgeois (see fig. 17.45).

Ernst

When **Max Ernst** (1891–1976) saw works by modern artists such as Cézanne and Picasso at the 1912 Sonderbund exhibition in Cologne, he decided to forgo his university studies and take up art. He went to Paris in 1913, and his works were included that year in the First German Autumn Salon at Der Sturm in Berlin, when the artist was only twenty-two years old. In 1919–20, Jean Arp established contact with Ernst in Cologne, and the two were instrumental in the formation of yet another wing of international Dada. The two had met in Cologne in 1914, but Ernst then served in the German army. At the end of the war, he discovered Zurich Dada and the paintings of De Chirico (see figs. 10.5–10.7) and Klee (fig. 7.25). Ernst's early paintings

were rooted in a Late Gothic fantasy drawn from Dürer, Grünewald, and Bosch. The artist was also fascinated by German Romanticism in the macabre forms of Klinger and Böcklin. This "gothic quality" (in the widest sense) remained a consistent characteristic of Ernst's fantasies. In 1919–20, a staggeringly productive period, he produced collages and photomontages that demonstrated a genius for suggesting the metamorphosis or double identity of objects, a topic later central to Surrealist iconography. In an ingenious work from 1920 (fig. **11.25**), Ernst invented his own mechanistic forms as stand-ins for the human body. As he frequently did during this period, the artist took a page from a 1914 scientific text illustrating chemistry and biology equipment and, by overpainting certain areas and inserting his own additions, he transformed goggles and other laboratory utensils into a pair of hilarious creatures before a landscape. The composition bears telling comparison with Picabia's mechanomorphic inventions (see fig. 11.15).

During the winter of 1920–21, Ernst and Arp collaborated on collages entitled *Fatagagas*, short for *Fabrication des Tableaux Garantis Gasométriques*. Ernst usually provided the collage imagery while Arp and other occasional collaborators provided the name and accompanying text. In the *Fatagaga* titled *Here Everything Is Still Floating*, an anatomical drawing of a beetle becomes, upside-down, a steamboat floating through the depths of the sea. Some of the *Fatagagas* were sent to Tristan Tzara in Paris for illustration in his ill-fated publication *Dadaglobe*. Ernst had been in close contact with the Parisian branch of Dada and many of the artists who would develop Surrealism. By the time he moved to Paris in 1922, he had already created the basis for much of the Surrealist vocabulary.

Despite the close friendship between Ernst and Arp, their approaches to painting, collage, and sculpture were different. Arp's was toward abstract, organic Surrealism in which figures or other objects may be suggested but are rarely explicit. Ernst, following the example of De Chirico and fortified by his own "gothic" imagination, became a principal founder of the wing of Surrealism that utilized Magic Realism—that is, precisely delineated, recognizable objects, distorted and transformed, but nevertheless presented with a ruthless realism that throws their newly acquired fantasy into shocking relief. *Celebes* (fig. **11.26**) is a mechanized monster whose trunk-tail-pipeline sports a cowskull-head above an immaculate white collar. A headless classical torso beckons to the beast with an elegantly gloved hand. The images are unrelated on a rational level; some are threatening (the elephant), while others are less explicable (the beckoning torso). The rotund form of the elephant was actually suggested to Ernst by a photograph of a gigantic communal corn bin made of clay and used by people in southern Sudan. While not constructed as a collage, *Celebes*, with its many disparate motifs, is informed by a collage aesthetic as well as by the early paintings of De Chirico; it appeals to the level of perception below consciousness. Ernst, who worked in a remarkably broad range of media and styles, became a major figure of Surrealism (see figs. 15.5–15.8).

11.25 Max Ernst, *1 Copper Plate 1 Zinc Plate 1 Rubber Cloth 2 Calipers 1 Drainpipe Telescope 1 Pipe Man*, 1920. Gouache, ink, and pencil on printed reproduction, 9½ × 6½" (24.1 × 16.7 cm). Whereabouts unknown.

11.26 Max Ernst, *Celebes*, 1921. Oil on canvas, 51⅛ × 43¼" (129.9 × 109.9 cm). Tate, London.

Idealism and Disgust: The "New Objectivity" in Germany

Immediately following Germany's defeat in World War I and the abdication of Kaiser Wilhelm II, some of the leaders of German Expressionism formed the November Group and were soon joined by Dadaists. In 1919, under the newly established Weimar Republic, the Workers' Council for Art was organized to seek more state support, more commissions from industry, and the reorganization of art schools. Its artists included many of the original Expressionists as well as leading poets, musicians, and critics. Many of the aims of the November Group and the Workers' Council were incorporated into the program of the Weimar Bauhaus.

In their exhibitions, the November Group re-established contact with France and other countries, and antagonisms among the various new alignments were submerged for a time to present a common front. The Expressionists were exhibited, as well as representatives of Cubism, abstraction, Constructivism, and Dada, while the new architects showed projects for city planning and large-scale housing. Societies similar to the November Group sprang up in many parts of Germany, and their manifestos read like a curious blend of socialist idealism and revivalist religion.

Among the artists associated with the November Group was the Expressionist printmaker and sculptor **Käthe Kollwitz** (1867–1945), who devoted her life and her art to a form of protest or social criticism. She was the first of the German Social Realists who developed out of Expressionism during and after World War I. Essentially a Realist, and powerfully concerned with the problems and sufferings of the underprivileged, she stands somewhat aside from other Expressionists such as the members of Die Brücke or Der Blaue Reiter. When she married a doctor, his patients, predominantly the industrial poor of Berlin, became her models.

As a woman, Kollwitz had been prevented from studying at the Academy, so she attended a Berlin art school for women. There she was introduced to the prints and writings of Max Klinger (see chapter 5) and decided to take up printmaking rather than painting. The graphic media appealed to Kollwitz for their ability to convey a message effectively and to reach a wide audience, because each image could be printed many times. Like Klinger, she produced elaborate print cycles on a central theme, such as the portfolio of woodcuts entitled *War*, executed from 1922 to 1923. The second image from this series of seven scenes shows a group of young men following Death, who beats out the march to battle on a drum (fig. **11.27**). With their gaunt faces contorted by expressions of fear, regret, and even hope, the youths attend to the crooked hand of Death urging them on. Already, though, an arc fills the space above the figures, suggesting a rainbow or halo: the harbinger of their fate as martyrs for a pointless cause. Kollwitz' youngest son had been killed just days after

11.27 Käthe Kollwitz, *The Volunteers (Die Freiwilligen)*, Plate 2 from *Der Krieg (War)*, 1922–23. Woodcut, 35 × 49" (47.5 × 65.2 cm).

entering into the war in 1914, an event that only sharpened her activism. Although best known for her black-and-white prints and posters of political subjects, Kollwitz could be an exquisite colorist. Her lithograph of a nude woman (fig. **11.28**), with its luminous atmosphere and quiet mood, so unlike her declarative political prints, demonstrates her extraordinary skill and sensitivity as a printmaker.

11.28 Käthe Kollwitz, *Female Nude with Green Shawl Seen from Behind*, 1903. Color lithograph, sheet 23½ × 18½" (59.7 × 47 cm). Staatliche Kunstsammlungen, Dresden.

11.29 Käthe Kollwitz, *Lamentation: In Memory of Ernst Barlach (Grief)*, 1938. Bronze, height 10¼" (26 cm). Hirshhorn Museum and Sculpture Garden, Smithsonian Institution, Washington, D.C.

Kollwitz was capable of an equally intense expression in sculpture, with which she was increasingly involved throughout her last years. Given the intrinsically sculptural technique of carving and gouging a block of wood to make a woodcut, it is not surprising that a printmaker might be drawn to sculpture, though Kollwitz never actually made sculpture in wood. Like Lehmbruck, she learned of Rodin's work on a trip to Paris and admired the sculpture of Constantin Meunier, whose subjects of workers struck a sympathetic chord. But perhaps the most significant influence on her work in three dimensions was that of her friend Ernst Barlach. The highly emotional tenor of her work, whether made for a humanitarian cause or in memory of her dead son, arose from a profoundly felt grief that transmitted itself to her sculpture and prints. *Lamentation: In Memory of Ernst Barlach (Grief)* (fig. **11.29**) is an example of Kollwitz's relief sculpture, a moving, close-up portrait of her own grieving.

The November Group's common front of socialist idealism did not last long. The workers whom the artists extolled and to whom they appealed were even more suspicious of the new art forms than was the capitalist bourgeoisie. It was naturally from the latter that new patrons of art emerged. By 1924 German politics was shifting inexorably to the right, and the artists' utopianism was in many cases turning into disillusionment and cynicism. There now emerged a form of Social Realism in painting to which the name "The New Objectivity" (*Die Neue Sachlichkeit*) was given. Meanwhile, the Bauhaus, the design school run by Gropius since 1919 at Weimar, had tried to apply the ideas of the November Group and the Workers' Council to create a new relationship between artist and society. In 1925 it was forced by the rising tide of conservative opposition to move to Dessau. Its faculty members still clung to postwar Expressionist and socialist ideas, although by 1925 their program mostly concerned the training of artists, craft workers, and designers for an industrial, capitalist society.

Grosz

The principal painters associated with the New Objectivity were **George Grosz** (1893–1959), Otto Dix, and Max Beckmann—three artists whose style touched briefly at certain points but who had essentially different motivations. Grosz studied at the Dresden Academy from 1909 to 1911 and at the Royal Arts and Crafts School in Berlin off and on from 1912 to 1916, partially supporting himself with drawings of the shady side of Berlin nightlife. These caustic

works prepared him for his later violent statements of disgust with postwar Germany and humankind generally. In 1913 he visited Paris and, despite later disclaimers, was obviously affected by Cubism and its offshoots, particularly Robert Delaunay and Italian Futurism. After two years in the army (1914–16), Grosz resumed his caricatures while convalescing in Berlin. They reveal an embittered personality, now fortified by observations of autocracy, corruption, and the horrors of a world at war. Recalled to the army in 1917, Grosz ended his military career in an asylum on whose personnel and administration he made devastating comment.

After the war Grosz was drawn into Berlin Dada and its overriding leftwing direction. He made stage designs and collaborated on periodicals, but continued his own work of political or social satire. *Dedication to Oskar Panizza* of 1917–18 (fig. **11.30**) is his most Cubist-inspired work. The title refers to a writer whose work had been censored at the end of the nineteenth century. But the larger subject, according to Grosz, was "Mankind gone mad." He said that the dehumanized figures represent "Alcohol, Syphilis, Pestilence." Showing a funeral turned into a riot, the painting is flooded with a blood or fire red. The buildings lean crazily; an insane mob is packed around the black coffin on which Death sits triumphantly, swigging at a bottle; the faces are horrible masks; humanity is swept into

11.31 George Grosz, *Fit for Active Service (The Faith Healers)*, 1916–17. Pen, brush, and India ink, sheet 20 × 14⅜" (50.8 × 36.5 cm). The Museum of Modern Art, New York.

a hell of its own making; and the figure of Death rides above it all. Yet the artist controls the chaos with a geometry of the buildings and the planes into which he segments the crowd.

The drawing *Fit for Active Service (The Faith Healers)* (fig. **11.31**) was used as an illustration in 1919 for *Die Pleite (Bankruptcy)*, one of the many political publications with which Grosz was involved. The editors, Herzfelde, Grosz, and Heartfield, filled *Die Pleite* with scathing political satire, which occasionally got them thrown into prison. This work shows Grosz' sense of the macabre and his detestation of bureaucracy, with a fat complacent doctor pronouncing his "O.K." of a desiccated cadaver before arrogant Prussian-type officers. The spare economy of the draftsmanship in Grosz's illustrations is also evident in a number of the artist's paintings done in the same period. *Republican Automatons* (fig. **11.32**) applies the style and motifs of De Chirico and the Metaphysical School to political satire, as empty-headed, blank-faced, and mutilated automatons parade loyally through the streets of a mechanistic metropolis on their way to vote as they are told. In such works as this, Grosz comes closest to the spirit of the Dadaists and Surrealists. But he expressed his most passionate convictions in drawings and paintings that continue an Expressionist tradition of savagely denouncing a decaying Germany of brutal profiteers and obscene prostitutes, and of limitless gluttony and sensuality in the face of abject poverty, disease, and death. Normally Grosz worked in a

11.30 George Grosz, *Dedication to Oskar Panizza*, 1917–18. Oil on canvas, 55⅛ × 43¼" (140 × 109.9 cm). Staatsgalerie, Stuttgart.

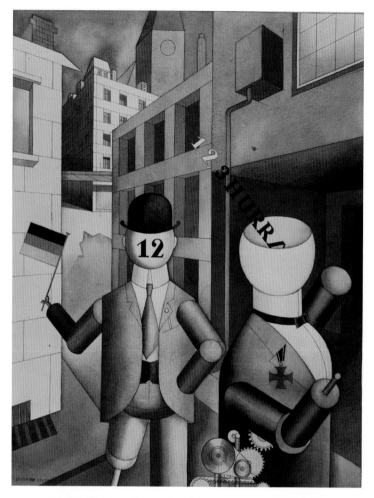

11.32 George Grosz, *Republican Automatons*, 1920. Watercolor and pencil on paper, 23⅝ × 18⅝" (60 × 47.3 cm). The Museum of Modern Art, New York.

style of spare and brittle drawing combined with a fluid watercolor. In the mid-1920s, however, he briefly used precise realism in portraiture, close to the New Objectivity of Otto Dix (see below).

Grosz was frequently in trouble with the authorities, but it was Nazism that caused him to flee. In the United States during the 1930s, his personality was quite transformed. Although he occasionally caricatured American types, these portrayals were relatively mild, even affectionate. America for him was a dream come true, and he painted the skyscrapers of New York or the dunes of Provincetown in a sentimental haze. His pervading sensuality was expressed in warm portrayals of Rubenesque nudes.

The growth of Nazism rekindled his power of brutal commentary, and World War II caused Grosz to paint a series expressing bitter hatred and deep personal disillusionment. In the later works, sheer repulsion replaces the passionate convictions of his earlier statements. He did not return to Berlin until 1958, and he died there the following year.

Dix

The artist whose works most clearly define the nature of the New Objectivity was **Otto Dix** (1891–1969). Born of

working-class parents, he was a proletarian by upbringing as well as by political conviction. Dix's combat experience made him fiercely anti-militaristic. His war paintings, gruesome descriptions of unaccountable horrors, are rooted in the expressive realism of German late medieval and Renaissance art. Dix responded to the war and its consequences with unblinking honesty, rendering brutal battlefield scenes as well as depictions of wounded and destitute veterans. *The Skat Players—Card Playing War Invalids* (fig. **11.33**) shows a trio of veterans engaged in a tragi-comic game of cards. War injuries have left them all as amputees, forced to hold their cards between their toes or with a mangled hand. Faces, too, have been damaged, along with ears, eyes, and skulls, leaving the men to cope with poorly fitting facial and scalp prostheses. Simultaneously horrifying, pathetic, and ridiculous, Dix's treatments of the war refuse to let the viewer settle into a single, easy response. His images are as angry and fatalistic as they are wrenching. The bright, lurid colors he often uses lend an intensity evocative of the bright pigments of commercial imagery such as posters and popular prints. His paintings initially seduce with their candy store hues before slapping the viewer with their shocking realism. His painting *The Trench* (fig. **11.34**) traveled throughout Germany as part of

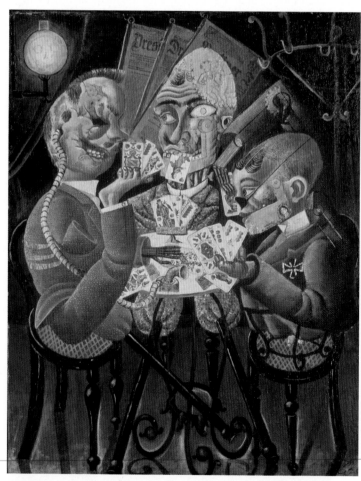

11.33 Otto Dix, *The Skat Players—Card Playing War Invalids,* 1920. Oil and collage on canvas, 43⁵⁄₁₆ × 34¼" (110 × 87 cm). Staatliche Museen zu Berlin, Preussischer Kulturbesitz, Nationalgalerie.

11.34 Otto Dix, *The Trench*, 1923. Destroyed 1943–45. Oil on canvas.

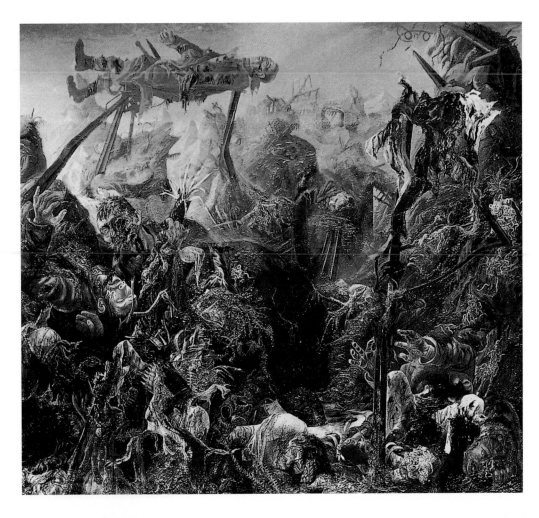

11.35 Otto Dix, *Dr. Mayer-Hermann*, 1926. Oil and tempera on wood, 58¾ × 39" (149.2 × 99.1 cm). The Museum of Modern Art, New York.

an exhibition mounted by a group called No More War. It was stored for a time by Ernst Barlach (see fig. 7.30), but it was eventually destroyed, perhaps when the Nazis set fire to works of "degenerate" art in Berlin toward the end of World War II.

Like Grosz, Dix was exposed to diverse influences from Cubism to Dada, but from the beginning he was concerned with uncompromising realism. This was a symptom of the postwar reaction against abstraction, a reaction most marked in Germany but also evident in most of Europe and in America. Even many of the pioneers of Fauvism and Cubism were involved in it. However, the superrealism of Dix was not simply a return to the past. In his portrait of the laryngologist Dr. Mayer-Hermann (fig. **11.35**), the massive figure is seated frontally, framed by the vaguely menacing machines of his profession. Although the painting includes nothing bizarre or extraneous, the overpowering confrontation gives a sense of the unreal. For this type of superrealism (as distinct from Surrealism) the term Magic Realism was coined: a mode of representation that takes on an aura of the fantastic because commonplace objects are presented with unexpectedly exaggerated and detailed forthrightness. Dix remained in Germany during the Nazi regime, although he was forbidden to exhibit or teach and was imprisoned for a short time. After the war he turned to a form of mystical, religious expression.

The Photography of Sander and Renger-Patzsch

The portraiture of artists like Dix may very well have been influenced by the contemporary photographs of **August Sander** (1876–1964), a German artist and former miner who became a powerful exponent of the New Objectivity. Sander set out to accomplish nothing less than a comprehensive photographic portrait of "People of the Twentieth Century." He was convinced that the camera, if honestly and straightforwardly employed, could probe beneath appearances and dissect the truth that lay within. Sander photographed German society in its "sociological arc" of occupations and classes, mostly presenting cultural types in the environments that shaped them (fig. **11.36**). In 1929 he published a preview of his magnum opus—one of the most ambitious in the history of photography—under the title *Antlitz der Zeit (Face of Our Time)*, only to see the book suppressed and the plates (but not the negatives) destroyed in 1936 by the Nazis, who inevitably found the photographer's ideas contrary to their own pathological views of race and class. For his part, Sander wrote: "It is not my intention either to criticize or to describe these people, but to create a piece of history with my pictures."

The German photographer most immediately identified with the New Objectivity was **Albert Renger-Patzsch** (1897–1966). Like Paul Strand in the United States (see fig. 16.22), Renger-Patzsch avoided the double exposures and photographic manipulations of Man Ray (see fig. 11.18) and Moholy-Nagy (see fig. 14.6), as well as the artificiality and soulfulness of the Pictorialists, to practice "straight" photography closely and sharply focused on objects iso-

11.37 Albert Renger-Patzsch, *Irons Used in Shoemaking, Fagus Works*, c. 1925. Gelatin-silver print. Galerie Wilde, Cologne.

lated, or abstracted, from the natural and manmade worlds (fig. **11.37**). But for all its stark realism, such an approach yielded details so enlarged and crisply purified of their structural or functional contexts that the overall pattern they produce borders on pure design. Still, Renger-Patzsch insisted upon his commitment to factuality and his "aloofness to Art for Art's Sake."

Beckmann

Max Beckmann (1884–1950) was the principal artist associated with the New Objectivity but could only briefly be called a precise Realist in the sense of Dix. Born of wealthy parents in Leipzig, he was schooled in the Early Renaissance art of Germany and the Netherlands, and the great seventeenth-century Dutch painters. After studies at the Weimar Academy and a brief visit to Paris, Beckmann settled in 1903 in Berlin, then a center of German Impressionism and Art Nouveau. Influenced by Delacroix and by the German academic tradition, he painted large religious and classical murals and versions of contemporary disasters such as the sinking of the *Titanic* (1912), done in the mode of Géricault's bleak masterpiece commemorating an 1816 shipwreck, *Raft of the "Medusa"*. By 1913 Beckmann was a well-known academician. His service in World War I brought about a nervous breakdown and, as

11.36 August Sander, *Circus Artistes (Zirkusartisen)*, from the series *People of the 20th Century (Menschen des 20 Jahrhunderts)*, from the portfolio *Traveling People—Fair and Circus*, Düren (Cologne), Germany. 1926–32. Gelatin-silver print, 8¼ × 10" (21 × 25.5 cm). The Museum of Modern Art, New York.

he later said, "great injury to his soul." The experience turned him toward a search for internal reality. Beckmann assumed many guises in over eighty-five self-portraits made throughout his life. The *Self-Portrait with Red Scarf* of 1917 (fig. **11.38**) shows the artist in his Frankfurt studio, haunted and anxious. Beckmann's struggle is apparent in a big, unfinished Resurrection, on which he worked sporadically between 1916 and 1918. Here he attempted to join his more intense and immediate vision of the war years to his prewar academic formulas. This work liberated him from his academic past. In two paintings of 1917, *The Descent from the Cross* and *Christ and the Woman Taken in Adultery*, he found a personal expression, rooted in Grünewald, Bosch, and Brueghel, although the jagged shapes and delimited space also owed much to Cubism. Out of this mating of Late Gothic, Cubism, and German Expressionism emerged Beckmann's next style.

Although he was not politically oriented, Beckmann responded to the violence and cruelty of the last years of the war by painting dramas of torture and brutality—sympto-matic of the lawlessness of the time and prophetic of the state-sponsored genocide of the early 1940s. Rendered in pale, emotionally repulsive colors, the figures could be twisted and distorted within a compressed space, as in late medieval representations of the tortures of the damned (in Beckmann's work, the innocent), the horror heightened by explicit and accurate details. Such works, which impart symbolic content through harsh examination of external appearance, were close to and even anticipated the New Objectivity of Grosz and Dix.

In *Self-Portrait in Tuxedo* from 1927 (fig. **11.39**), Beckmann presents a view of himself quite different from the one ten years earlier. Now a mature figure, he appears serious and self-assured, debonair even. The composition is striking in its elegant simplicity, with deep blacks, for which Beckmann is understandably admired, set against the blue-gray wall and the artist's stark white shirt. In the later 1920s, as is clear from this image, Beckmann, moving from success to success, was regarded as one of Germany's leading artists. Yet the isolation of the figure—dressed

11.38 Max Beckmann, *Self-Portrait with Red Scarf*, 1917. Oil on canvas, 31½ × 23⅜" (80 × 60 cm). Staatsgalerie, Stuttgart.

11.39 Max Beckmann, *Self-Portrait in Tuxedo*, 1927. Oil on canvas, 55½ × 37¾" (141 × 96 cm). Busch-Reisinger Museum, Harvard University Art Museums, Cambridge, MA.

formally as if attending a party or other social affair—and his stony gaze testify to a continuing estrangement from society. When the Nazis came to power in 1933, Beckmann was stripped of his teaching position in Frankfurt, and 590 of his works were confiscated from museums throughout Germany. On the opening day of the 1937 Degenerate Art show in Munich, which included several of his works (including fig. 11.38), the artist and his wife fled to Amsterdam (see *Degenerate Art*, below). In 1947, after years of hiding from the Nazis (he never returned to Germany), Beckmann accepted a teaching position at Washington University, St. Louis, Missouri, where he filled a position vacated by the Abstract Expressionist painter Philip Guston (see fig. 17.18) and became a highly influential teacher. He remained in the United States for the rest of his life.

CONTEXT

Degenerate Art

As the Nazis gained power in Germany during the late 1920s, the party sought to bring all areas of society into line with its policies. The visual arts were no exception. By the time the Nazis assumed control of the government in 1933, a campaign to rid the country of artworks deemed *entartete* or "degenerate" was already underway. Any art that did not accord with Nazi ideology—which advocated German cultural primacy and Teutonic racial and ethnic superiority—was seized from public museums. In its early stages, the Nazi campaign against degenerate art was directed largely at Expressionism, which was considered too sympathetic toward "negro culture." As the campaign gained ground in the mid-1930s, anything seen as avant-garde, as "cosmopolitan and Bolshevik," or as somehow representing "Jewish influence" (an expansive category under this violently anti-Semitic regime) was denounced as "impure" and dangerous. Overseen by Adolf Hitler's minister of propaganda, Josef Goebbels, the program against degenerate art culminated in the seizure of 16,000 works, some of which were exhibited in 1937 at the Degenerate Art (*Entartete Kunst*) show, staged first in Munich before touring the country. The point of the exhibition was to defame not only suspect artists but also the curators who had acquired their work. The deliberately chaotic installation (see fig. **11.40**) included labels indicating how much each work cost, condemning the use of public funds for the purchase of, as Hitler put it, "putrefaction." The Degenerate Art exhibition included works by Gauguin, Van Gogh, Nolde, Kirchner, Lehmbruck, Kandinsky, Klee, and Marc. Goebbels initially announced that all of the seized art would be burned, but in the end a public bonfire consumed 4,829 artworks while the rest were auctioned in Switzerland.

11.40 Room 3 including Dada wall in Degenerate Art Exhibition, Munich, 1937.

Throughout the 1930s and 40s, Beckmann continued to develop his ideas of coloristic richness, monumentality, and complexity of subject. The enriched color came from visits to Paris and contacts with French artists, particularly Matisse and Picasso. However, his emphasis on literary subjects with heavy symbolic content reflected his Germanic artistic roots. The first climax of his new, monumental–symbolic approach was the large 1932–33 triptych *Departure* (fig. **11.41**). Beckmann made nine paintings in the triptych format, obviously making a connection between his work and the great ecclesiastical art of the past: church altarpieces typically comprised two or more panels, which, when taken together, address a particular Christian theme or recount episodes from the life of Jesus or one of the saints. The right wing of *Departure* shows frustration, indecision, and self-torture; in the left wing, sadistic mutilation, and the torture of others. Beckmann said of this triptych in 1937:

On the right wing you can see yourself trying to find your way in the darkness, lighting the hall and staircase with a miserable lamp dragging along tied to you as part of yourself, the corpse of your memories, of your wrongs, of your failures, the murder everyone commits at some time of his life—you can never free yourself of your past, you have to carry the corpse while Life plays the drum.

In addition, despite his disavowal of political interests, the lefthand panel must refer to the rise of dictatorship that was driving liberal artists, writers, and thinkers underground.

The darkness and suffering in the wings are resolved in the brilliant sunlight colors of the central panel, where the king, the mother, and the child set forth, guided by the veiled boatman. It is important to emphasize that Beckmann's allegories and symbols were not a literal iconography, to be read by anyone given the key. The spectator had to participate actively, and the allusions could mean something different to each. In addition, the allusions in Beckmann's work could be very complex. He said of *Departure*: "The King and Queen have freed themselves of the tortures of life—they have overcome them. The Queen carries the greatest treasure—Freedom—as her child in her lap. Freedom is the one thing that matters—it is the departure, the new start."

11.41 Max Beckmann, *Departure*, 1932–33. Oil on canvas, triptych, center panel 7' ¾" × 3' 9⅜" (2.2 × 1.15 m); side panels each 7' ¾" × 3' 3¼" (2.2 × 1 m). The Museum of Modern Art, New York.

12
Art in France after World War I

Not all artists responded to World War I with the cynicism and ferocity of the New Objectivity or Dada movements. Artists working in France immediately following the war gave visual form to other emotions: despair, nostalgia, even hope. Years of warfare had dampened enthusiasm for artistic experimentation, and cultural movements tended away from "scandalous" avant-gardism toward an art based on the values of the classical tradition. "After the war," said the former Fauve painter André Derain, "I thought I would never be able to paint—that after all that—no one would be interested." By the end of the war, Derain had himself turned from his earlier innovative work to a classicizing style, and in the 1920s the general trend toward classicism in all the arts gathered momentum. It was characterized by poet and playwright Jean Cocteau as a "call to order." Avant-garde experiments with radical abstraction, such as Cubism, were set aside in favor of styles and themes more easily understood as extensions of the French tradition of classicism that traced its lineage back through Ingres and David to the clarity of Poussin and the serenity of Claude. Like everyone else in France at the time, artists were seeking to regain their bearings and make sense of losses inflicted by the war.

Even with its tempered enthusiasm for avant-garde experimentation, Paris resumed its prewar status as a center for progressive art. A number of gifted artists in retreat from revolution in Russia, economic hardship in Germany, and provincialism in America were thus lured to Paris, assuring the continuing status of the city as the glittering, cosmopolitan capital of world art. These émigré artists were labeled—sometimes xenophobically—as the School of Paris, to distinguish them from French-born modernists like Matisse. Suspicion of foreigners was a sad fact not only of French culture but of Western societies generally as isolationism gained currency. Even Picasso suffered insults on the streets of Paris during the war, because he appeared to be an able-bodied young man shirking his military duty or because he was recognized as a foreigner. The label "School of Paris" has lost its xenophobic associations and is now used to describe art produced by artists living in the city from 1919 into the 1950s.

Eloquent Figuration: *Les Maudits*

The School of Paris embraced a wide variety of artists between the two world wars who shared common ground not only through their base in France but also in their independence from narrowly defined aesthetic categories. While distinctly modernist in their willingness to distort imagery for expressive purposes, they nonetheless regarded figurative imagery as fundamental to the meaning of their work. This diverse and distinguished group included Braque, Léger, Matisse, and Picasso. Perhaps even more representative of the polyglot School of Paris than those major figures, however, is a subgroup known as *les maudits*—Modigliani from Italy, Soutine from Lithuania, Suzanne Valadon (see figs. 3.37, 3.38), and her son, Maurice Utrillo. *Les maudits* means "the cursed"—an epithet that alluded not only to these artists' poverty and alienation but also to the picturesque, ultimately disastrous, bohemianism of their disorderly lifestyles. Much of this gravitated around the sidewalk cafés of Montparnasse and Saint-Germain-des-Prés, the quarters on the Left Bank of the Seine favored by the Parisian avant-garde since before the war, when Picasso and his entourage had abandoned Montmartre to the tourists.

Modigliani

Amedeo Modigliani (1884–1920) was born of well-to-do parents in Livorno, Italy. His training as an artist was often interrupted by illness, but he managed to get to Paris by 1906. Although he was essentially a painter, in around 1910, influenced by his friend Brancusi (see chapter 6), he began to experiment with sculpture. Modigliani's short life has become the quintessential example of bohemian artistic existence in Paris, so much so that the myths and anecdotes surrounding his biography have tended to undermine serious understanding of his work. For fourteen years he worked in Paris, ill from tuberculosis (from which he eventually

12.1 Amedeo Modigliani, *Head*, c. 1911–13. Limestone, height 25 × 6 × 8½" (63.5 × 15.2 × 21 cm). Solomon R. Guggenheim Museum, New York.

it is difficult to speak of a stylistic development, although a gradual transition can be seen from work inspired by the Symbolist painters (see chapter 3), in which the figure is securely integrated in the space of an interior, toward a pattern of linear or sculptural detachment. Modigliani knew Picasso and occasionally visited his studio, but he never really succumbed to the lure of Cubism.

Although all of his portraits resemble one another through their elegantly elongated features or their reference to forms deriving from Archaic art, the portraits of his friends, who included notable artists and critics of the early twentieth century, are sensitive records of specific personalities, eccentricities, and foibles. Modigliani's closest friend in Paris was his fellow painter Chaim Soutine (fig. **12.2**). His portrayal of this Lithuanian peasant, with his disheveled hair and clothes and narrow, unfocused eyes, conveys a psychological presence lacking in many of his other likenesses.

Modigliani also painted anonymous students or children—anyone who would pose for him without a fee. For his paintings of nudes, however, he frequently relied on

died), drugs, and alcohol, but drawing and painting obsessively. He quickly spent what little money he had, and he tended to support himself by making drawings in cafés that he sold for a few francs to the sitter.

With very few exceptions, the experiments that Modigliani carried out in sculpture between approximately 1910 and 1914 (he rarely dated his works) are carved stone heads (fig. **12.1**). He believed that modern sculpture should not be modeled in clay but should result only from direct carving in stone. Beyond the powerful example of Brancusi, the sculptural sources that appealed to him were rooted in European medieval art and the art of a diverse range of cultures including Africa, Egypt, Archaic Greece, and India. Most of the heads have highly abstracted, geometricized features, with the characteristic long nose, almond eyes, and columnar neck. As we see here, Modigliani sometimes left the block of stone only roughed in at the back, making the sculptures strictly frontal in orientation. This tendency may be related to his apparent intention to group the heads into some kind of decorative ensemble. It has been suggested that he abandoned the demanding métier of sculpture because of his frail health and the expense of the materials. While both of these factors may have played a role in his decision, it seems likely that he wanted to be a painter first and foremost.

In subject, Modigliani's paintings rarely departed from the depiction of single portrait heads, torsos, or full figures against a neutral background. His career was so short that

12.2 Amedeo Modigliani, *Chaim Soutine*, 1916. Oil on canvas, 36⅛ × 23½" (91.8 × 59.7 cm). National Gallery of Art, Washington, D.C.

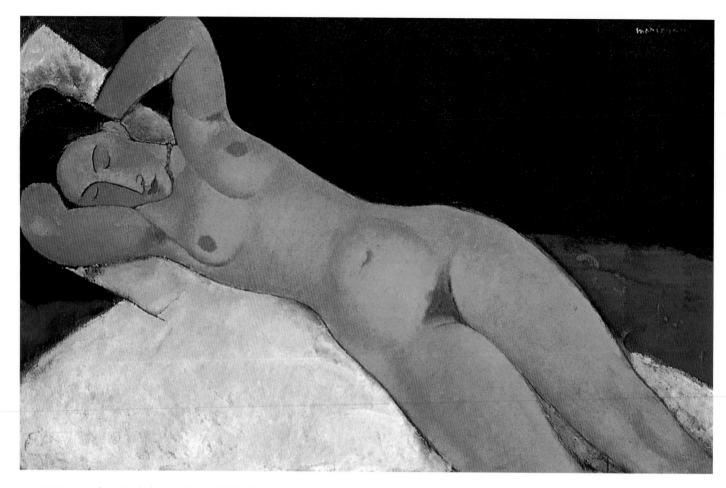

12.3 Amedeo Modigliani, *Nude*, 1917. Oil on canvas, 28¾ × 45¾" (73 × 116.2 cm). Solomon R. Guggenheim Museum, New York.

professional models. Modigliani developed a fairly standard formula for his compositions of reclining nudes (fig. **12.3**). The attenuated figure is normally arranged along a diagonal and set within a narrow space, her legs eclipsed by the edge of the canvas. The figure is outlined with a flowing but precise line, while the full volumes are modeled with almost imperceptible gradations of flesh tones. The artist was fond of contrasting draped white sheets against deep Venetian red, as seen in this 1917 example. The influence here of Titian is unmistakable, particularly that of his *Venus of Urbino*, in the Uffizi, which Modigliani frequented during his student days in Florence. His friend and fellow Italian, the Futurist Gino Severini, detected a "Tuscan elegance" in the work of Modigliani, who kept reproductions of old-master paintings on the walls of his Paris studio. For his paintings of nudes, he frequently assumed a point of view above the figure, thus establishing a perspective that implies the subject's sexual availability to the artist and (presumably male) viewers. With their blatant sexuality and coy, flirtatious expressions, Modigliani's nudes present a modernized version of a long-standing genre of eroticized female nudes, a subject of particular interest to modern artists (see discussion in chapter 2). In Modigliani's day, his paintings of nude women were deemed indecent enough to be confiscated from an exhibition by the police for their excessive exposure of pubic hair.

Soutine

Chaim Soutine (1894–1943), the tenth of eleven children from a poor Lithuanian-Jewish family, developed an early passion for painting and drawing. He managed to attend some classes in Minsk and Vilna (Vilnius), a center of Jewish cultural activity, and, through the help of a patron, arrived in Paris before the war's outbreak. He studied at the École des Beaux-Arts, but it was through the artists who he met at an old tenement known as La Ruche (The Beehive), where Chagall also lived around this time, that he began to find his way. Modigliani in particular took the young artist under his wing. He showed him Italian paintings in the Louvre and helped refine Soutine's manners and improve his French. "He gave me confidence in myself," Soutine said.

Soutine constantly destroyed or reworked his paintings, so it is difficult to trace his development from an early to a mature style. An early formative influence was Cézanne, an artist likewise greatly admired by Modigliani. Van Gogh also provided a crucial example, although the energy and vehemence of Soutine's brushstroke surpassed even that of the Dutch artist. The essence of Soutine's Expressionism lies in the intuitive power and the seemingly uncontrolled but immensely descriptive brush gesture (see fig. 12.5). In this quality he is closer than any artist of the early twentieth century to the Abstract Expressionists of the

1950s, especially De Kooning (see fig. 17.6), who greatly admired Soutine.

From 1919 Soutine spent three years in Céret in the French Pyrenees. The mountain landscape inspired him to a frenzy of free, Expressionist brush paintings that rivaled in exuberance anything produced by the Fauves or the German Expressionists. In *Gnarled Trees* (fig. **12.4**), he conveys a sense of immersion in the landscape with this composition, in which the buildings on the heaving hillside are barely decipherable through the trees and writhing coils of paint. Soutine painted furiously during this period. After his return to Paris in 1922, a large number of his canvases were bought by the American collector Albert C. Barnes, providing the artist with his first major public success and a steady income.

In Soutine's portraits and figure paintings of the 1920s there is frequently a predominant color—red, blue, or white—around which the rest of the work is built. In *Woman in Red* (fig. **12.5**) the sitter is posed diagonally across an armchair over which her voluminous red dress flows. The red of the dress permeates her face and hands; it is picked up in her necklace and in the red-brown tonality of the ground. Only the deep blue-black of the hat stands out against it. Soutine endows the static figure

12.4 Chaim Soutine, *Gnarled Trees*, c. 1920. Oil on canvas, 38 × 25" (96.5 × 63.5 cm). Private collection, New York.

12.5 Chaim Soutine, *Woman in Red*, c. 1924–25. Oil on canvas, 36 × 25" (91.4 × 63.5 cm). Private collection.

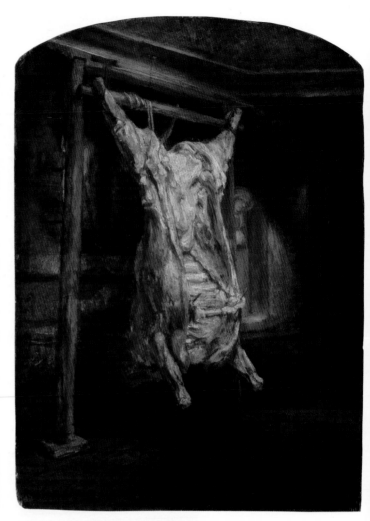

12.6 Chaim Soutine, *Carcass of Beef*, c. 1925.
Oil on canvas, 55¼ × 42⅜" (140.3 × 107.6 cm).
Albright-Knox Art Gallery, Buffalo, New York.

12.7 Rembrandt van Rijn, *Butchered Ox*, 1655.
Oil on panel, 37 × 27" (94 × 69 cm). Louvre, Paris.

with tremendous vitality and movement, as the undulating surface rhythms swerve back and forth across the canvas. The hands are distorted as though from arthritis, and the features of the face are twisted into a slight grin. As in many of Soutine's portraits, the first impression is of a cruel caricature. Then one becomes aware of the sitter's highly individual, and in this case ambiguous, personality. *Woman in Red* appears at once comic, slightly mad, and knowingly shrewd.

Soutine's passion for **Rembrandt** (1606–69) was commemorated in a number of extraordinary paintings that were free adaptations of the Dutch master's compositions. In *Carcass of Beef* (fig. **12.6**) Soutine transcribed Rembrandt's 1655 *Butchered Ox*, in the Louvre, with gruesome, bloody impact (fig. **12.7**). Unlike Rembrandt, Soutine isolated his subject, stripped it of any anecdotal context, and pushed it up to the surface. The story of the painting is well known—Soutine poured blood from the butcher's shop to refurbish the rapidly decaying carcass while his assistant fanned away the flies, and nauseated neighbors clamored for the police. Oblivious to the stench, Soutine worked obsessively before his subject, recording every detail in vigorously applied, liquid color. In this and

in many other paintings, Soutine demonstrated how close are the extremes of ugliness and beauty, a phenomenon that would intrigue his Surrealist peers.

Utrillo

Maurice Utrillo (1883–1955) was the child of artist and model Suzanne Valadon, whose work is discussed alongside that of the Post-Impressionists who hired her to model and also supported her turn to artmaking (see chapter 3). Valadon's son provides perhaps the greatest paradox among *les maudits*. He was given the family name of the Spanish art critic Miguel Utrillo, who wished to help the boy (his actual father was rumored to be Puvis de Chavannes). As a youngster, Utrillo began to drink heavily, was expelled from school, and by the age of eighteen was in a sanatorium for alcoholics. During his chaotic adolescence—probably through his mother's influence—he became interested in painting. Like his mother, he was self-trained, but his art is hardly reminiscent of hers. Although his painting was technically quite accomplished and reveals stylistic influences from the Impressionists and their successors, his work is closer to the purposely naive or primitive type of painting inspired by Henri Rousseau (see fig. 3.15).

12.8 Maurice Utrillo, *Street in Asnières*, 1913–15. Oil on canvas, 29 × 36¼" (73.7 × 92.1 cm). Private collection.

The first paintings that survive are of the suburb of Montmagny where Utrillo grew up, and of Montmartre, where he moved. Painted between approximately 1903 and 1909, they have coarse brush texture and sober colors. In about 1910 Utrillo began to focus obsessively and almost exclusively on the familiar scenes of Montmartre, which he painted street by street. On occasional trips away from Paris, he painted churches and village scenes that were variations on his basic theme (fig. **12.8**). Asnières, the village depicted here, was one of the sites along the Seine favored by the Impressionists. Utrillo admired the work of Sisley and Pissarro, but unlike them, he preferred the unremarkable village streets to the banks of the river. The composition of *Street in Asnières* typifies his preferred format. Buildings along a narrow street devoid of pedestrians disappear into a long perspective. To emulate the rough texture of the chalky, whitewashed buildings, he frequently added plaster to his zinc white oil paint. In fact, this period is often referred to as his "white" period. His favorite scenes recur over and over again, his memory refreshed from postcards. Around the end of the war, following the white period, his color brightened and figures occurred more frequently. From 1930 until his death in 1955, Utrillo, now decorated with the Legion of Honor, lived at Le Vésinet outside Paris. During these twenty-five years of rectitude, he did little but repeat his earlier paintings.

Dedication to Color: Matisse's Later Career

As discussed in the context of Fauvism in chapter 6, the culmination of **Henri Matisse's** (1869–1954) prewar exploration of color may be seen in his 1911 painting *Red Studio* (see fig. 6.25). When compared with works of a similar date by Braque and Picasso (see figs. 8.20, 8.21), which have the typically muted palette of Analytical Cubism, its reliance on the power of a single strong color is particularly striking. Just as the Cubists used multiple viewpoints to undermine the conventional illusionism of single-point perspective, Matisse placed objects in relation to each other in terms not of spatial recession but of color. As he said of the *Red Studio* (which in real life was an airy, white-walled room), "I find that all these things, flowers, furniture, the chest of drawers, only become what they are to me when I see them together with the color red."

Despite his very different approach to painting, and the fact that he was considerably older than most members of the Cubist circle (he was in his mid-forties at the outbreak of war in 1914 and so did not serve in the military), Matisse shared some of their concerns, including an enthusiasm for non-Western art. The influence of Cubism can be felt in his work during the war years, although subsequent phases of his career—from his "rococo" decorative

idiom of the 1920s to the sharply defined and supremely graceful simplicity of his late cut-outs—reassert the primacy of color.

The careers of Matisse and Picasso followed quite different courses through the mid-twentieth century. At the same time, the development of Matisse's art from around 1914 onward presents numerous points of comparison with Picasso's. Extending over decades of their long working lives, the more-or-less cordial rivalry between them fueled the popular view of these two great artists as "mighty opposites" in the history of modernism.

Response to Cubism, 1914–16

Being thoroughly immersed in the art of Cézanne, Matisse inevitably found himself responding to the structured interpretation of Cézanne's style realized by Braque and Picasso. One of Matisse's most austere interpretations of a Cubist mode is *Piano Lesson* of 1916 (fig. **12.9**). This work is a large, abstract arrangement of geometric color planes—grays and greens compressed by shots of orange and pink.

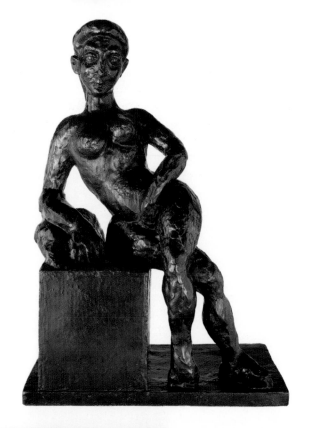

12.10 Henri Matisse, *Decorative Figure*, 1908. Bronze, 29½ × 20 × 11¾" (72 × 51 × 30 cm). Hirshhorn Museum and Sculpture Garden, Smithsonian Institution, Washington, D.C. Gift of Joseph H. Hirshhorn, 1966.

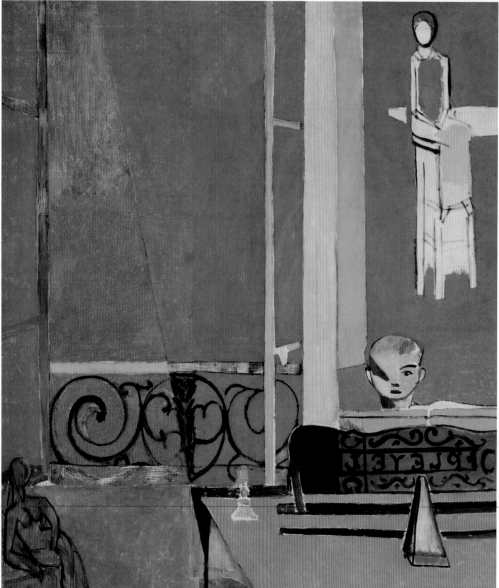

12.9 Henri Matisse, *Piano Lesson*, late summer 1916. Oil on canvas, 8' ½" × 6' 11¾" (2.45 × 2.13 m). The Museum of Modern Art, New York.

A tilted foreground plane of rose pink constitutes the top of the piano, on which a gray metronome sits; its triangular shape is echoed in the angled green plane that falls across the window. The planes are accented by decorative curving patterns based on the iron grille of the balcony and the music stand of the piano. The environment is animated by the head of the child sculpturally modeled in line evoking Matisse's 1908 sculpture *Decorative Figure* (fig. 12.10), which appears in so many of his paintings. Another of his works, the painting *Woman on a High Stool*, 1914, is schematically indicated in the upper right, but its nature, as a painting or a figure in the room, remains unclear, heightening the sense of spatial ambiguity. The stiff figure seems to preside over the piano lesson like a stern instructor. Here again, Matisse's interpretation of Cubism is intensely personal, with none of the shifting views and fractured forms that mark the main line of Picasso, Braque, and Juan Gris. Its frontality and its dominant uniform planes of geometric color areas show that Matisse could assimilate Cubism in order to achieve an abstract structure of space and color.

Renewal of Coloristic Idiom, 1917–c. 1930

The following year Matisse undertook another version of this theme with *Music Lesson* (fig. 12.11), a painting almost identical in size to *Piano Lesson*, which depicts the same room in the artist's house at Issy-les-Moulineaux, southwest of Paris. Matisse has transformed that room into a pleasant domestic setting for a portrait of his family. The three children are in the foreground while Madame Matisse sews in the garden. Everyone is self-absorbed and takes little heed of the artist or the beautiful garden view. The artist implies his own presence through his open violin case on the piano, his painting on the wall in the upper right corner, and his sculpture, *Reclining Nude 1/Aurora* (see fig. 6.10), here enlarged and flesh-colored, which sits by the pond before a lush landscape. In the wake of *Piano Lesson*, Matisse replaced his previous Cubist austerity with a lush indulgence in color and decorative forms. The tranquil, orderly family scene holds at bay the destruction and privations still weighing on Western Europe. Indeed, little of Matisse's artistic production during or immediately after the war speaks directly to the conflict.

In late 1917 Matisse moved to Nice, in the south of France, where he spent much time thereafter. In spacious, seaside studios, he painted languorous models, often in the guise of exotic "odalisques," under the brilliant light of the Riviera. These women reveal little in the way of individual psychologies; they are objects of fantasy and visual gratification in a space seemingly sealed off from the rest of the world. Matisse, no doubt like many others living in Europe at this time, found such escapist fantasies far more appealing than either the shocking realism of New Objectivity or the nihilism of Dada. Throughout most of the 1920s, Matisse supplanted heroic abstraction with intimacy,

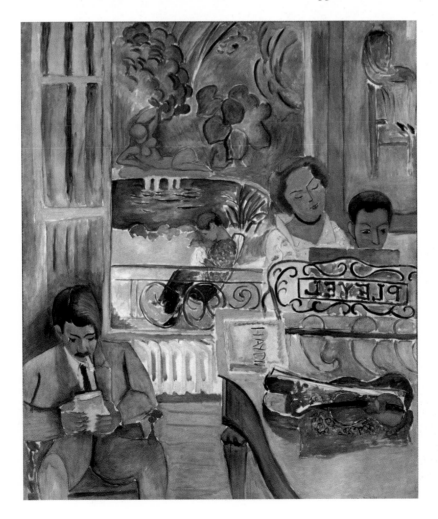

12.11 Henri Matisse, *Music Lesson*, 1917. Oil on canvas, 8' ⅛" × 6' 7" (2.4 × 2 m). The Barnes Foundation, Merion, Pennsylvania.

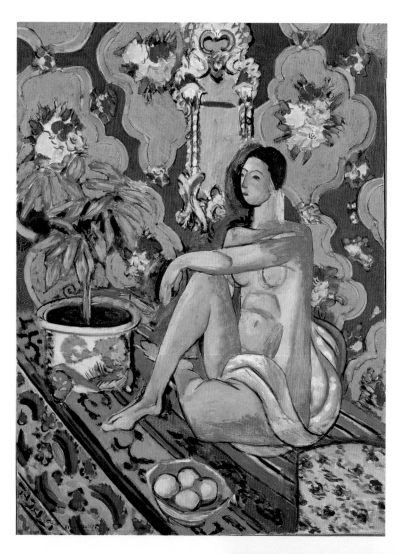

12.12 Henri Matisse, *Decorative Figure Against an Ornamental Background*, 1925–26. Oil on canvas, 51⅛ × 38½" (129.9 × 97.8 cm). Musée National d'Art Moderne, Centre d'Art et de Culture Georges Pompidou, Paris.

12.13 Henri Matisse, *Interior with a Phonograph*, 1924. Oil on canvas, 39¾ × 32" (101 × 81.3 cm). Private collection.

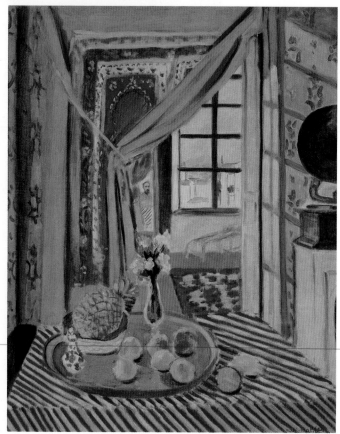

charm, and a mood of sensual indulgence, all suffused with color as lavish as an Oriental carpet and with a sense of line and pattern that owed much to Islamic art. Yet, even within this deceptively relaxed manner, the artist produced images and compositions of grand, even solemn magnificence. The *Decorative Figure Against an Ornamental Background* of 1925–26 (fig. **12.12**) epitomizes this most rococo phase of Matisse's work. Through the highly sculptural quality of his model, he manages to set the figure off against the patterned Persian carpet, which visually merges with a background wall decorated with the repetitive floral motif of French Baroque wallpaper and the elaborate volutes of a Venetian mirror. Such solidly modeled figures appear in his sculptures of this period and in lithographs.

During the 1920s Matisse revived his interest in the window theme, first observed in the 1905 Fauve *The Open Window* (see fig. 6.6) and often with a table, still life, or figure set before it. Through this subject, in fact, one may follow the changing focus of his attention from Fauve color to Cubist reductiveness and back to the coloristic, curvilinear style of the postwar years. In *Interior with a Phonograph* (fig. **12.13**), a painting of 1924, Matisse gave full play to his brilliant palette, while at the same time constructing a richly ambiguous space, created through layers of rectangular openings.

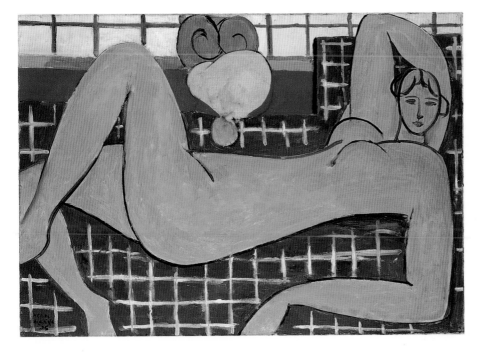

12.14 Henri Matisse, *Large Reclining Nude (The Pink Nude)*, 1935. Oil on canvas, 26 × 36½" (66 × 92.7 cm). The Baltimore Museum of Art.

but also color, until the latter consisted of little more than rose, blue, black, and white. The odalisque thus rests within a pure, rhythmic flow of uninterrupted curves. While this cursive sweep evokes the simplified volumes of the figure, it also fixes them into the gridded support of the chaise longue. Here is the perfect antithetical companion to the Fauve *Blue Nude* of 1907 (see fig. 6.9), a sculptured image resolved by far less reductive means than those of the *Large Reclining Nude*.

An Art of Essentials, c. 1930–54

Matisse had once expressed (in 1908) his desire to create "an art of balance, of purity and serenity devoid of troubling or depressing subject matter, an art which would be … something like a good armchair in which to rest from physical fatigue." Indulgent as this may seem, Matisse was earnest in his self-effacing and unsparing search for the ideal. Thus, in the wake of his 1920s luxuriance, the sixty-six-year-old artist set out once again to renew his art by reducing it to essentials. The evidence of this prolonged and systematic exercise has survived in a telling series of photographs, made during the course of the work—state by state—that he carried out toward the ultimate realization of his famous *Large Reclining Nude* (formerly called *The Pink Nude*) of 1935 (fig. **12.14**). He progressively selected, simplified, and reduced—not only form

Like artists in the grand French tradition of the decorative that preceded him—from Le Brun at Versailles through Boucher and Fragonard in the eighteenth century to Delacroix, Renoir, and Monet in the nineteenth— Matisse had ample opportunity to be overtly decorative when, in 1932, he began designing and illustrating special editions of great texts, the first of which was *Poésies* by Stéphane Mallarmé, published by Albert Skira. In the graphics for these volumes, Matisse so extended the aesthetic economy already seen in the *Large Reclining Nude* that, even when restricted to line and black-and-white, he could endow the image with a living sense of color and volume.

Matisse's most extraordinary decorative project during the 1930s was his design for a large triptych on the subject of dance (fig. **12.15**) commissioned by the American

12.15 Henri Matisse, *Merion Dance Mural*, 1932–33. Oil on canvas: left 11' 1¾" × 14' 5¾" (3.4 × 4.4 m), center 11' 8⅛" × 16' 6⅛" (3.6 × 5 m), right 11' 1¾" × 14' 5¾" (3.4 × 4.4 m). The Barnes Foundation, Merion, Pennsylvania.

Matisse in Merion, Pennsylvania

Among the most dedicated American collectors of European avant-garde art was Albert C. Barnes, a chemist who amassed a fortune at the start of the twentieth century creating patent medicines. His interest in art led him first to collect Barbizon School paintings before the artist William Glackens, a childhood friend, advised him instead to pursue Impressionist and Post-Impressionist works. Barnes adopted this recommendation with gusto, compiling an enormous collection of works by artists such as Monet, Renoir, Degas, Van Gogh, Gauguin, and Cézanne. Through Gertrude and Leo Stein, Barnes became acquainted with Picasso and Matisse in 1912 and began collecting their work as well. His support for avant-garde artists continued to gain momentum. Relying increasingly on his own instincts, he was the first serious collector of paintings by Chaim Soutine.

Barnes' collection eventually comprised over 2,000 artworks, many by leading members of the European and American avant-garde. He assembled the collection in a limestone mansion outside Philadelphia in suburban Merion, Pennsylvania. Inspired by the educational theories of John Dewey, Barnes invited schoolchildren and laborers to the house-museum, in which he had carefully arranged his collection to highlight formal correspondences. Intermingled with the avant-garde artworks were examples of African sculpture, folk art, and ironwork. Thus, a visitor might consider the design of an ornamental hinge alongside a painting by Seurat. Barnes felt his collection was more valuable to students and the working class than to members of the social elite, whom he regularly refused to admit. His will stipulated that the collection, held in trust by the Barnes Foundation, could never be rearranged or relocated even temporarily, thus preserving for decades after his death the eccentricity as well as the intimacy of his galleries. Barnes' experiment came to an end in 2004 when the Foundation's board successfully challenged the terms of his will, paving the way for the collection's relocation to Philadelphia where a new Barnes Center for Arts Education is planned.

collector Albert C. Barnes, the man who had bought the works of Soutine (see *Matisse in Merion, Pennsylvania*, above). The triptych would occupy three lunettes in the Barnes Foundation at Merion, which already housed more works by Matisse than any museum. Matisse began to paint the murals in Nice, only to discover well into the project that he was using incorrect measurements. So he began anew. (In 1992, in an amazing discovery, this unfinished but splendid composition was found rolled up in Matisse's studio in Nice.) When he returned to work on the second version, he discovered that his usual technique of brushing in every color himself was enormously time-consuming. In order to expedite his experiments with form and color arrangements, he cut large sheets of painted paper and pinned them to the canvas, shifting them, drawing on them, and, ultimately, discarding them once he decided on the final composition. This method of cutting paper, as we shall see, became an artistic end in itself during the artist's later years.

For both compositions, Matisse turned to his own previous treatment of the dance theme (see fig. 6.23). In the final murals, the dancing figures are rendered in light gray, to harmonize with the limestone of the building, and are set against an abstract background consisting of broad, geometric bands of black, pink, and blue. The limbs of the figures are dramatically sliced by the curving edges of the canvas, which somehow enhance rather than inhibit their ecstatic movements. Matisse, of course, understood that his image had to be legible from a great distance, so the forms are boldly conceived, with no interior modeling to distract from their simplified contours. The result is one of the most successful mergings of architecture and painting in the twentieth century. Fortunately, Matisse felt the need to paint a third version of the murals, which now belongs, as does the first, to the Musée National d'Art Moderne in Paris.

Celebrating the Good Life: Dufy's Later Career

Raoul Dufy (1877–1953) joined Matisse in remaining true to the principles of Fauve color but, in the years following the "Wild Beast" episode (see fig. 6.16), refined them into a sumptuous signature style. Even more than Matisse, he was a decorator with a connoisseur's taste for the hedonistic joys of the good life. During the 1920s and 30s, Dufy achieved such popularity—not only in paintings, watercolors, and drawings, but also in ceramics, textiles, illustrated books, and stage design—that his rainbow palette and stylish, insouciant drawing seem to embody the spirit of the period. *Indian Model in the Studio at L'Impasse Guelma* (fig. **12.16**) shows many of the characteristics of the artist's mature manner. The broad, clear area of light blue that covers the studio wall forms a background to the intricate pattern of rugs and paintings whose exotic focus is an elaborately draped Indian girl. The use of descriptive line and oil color laid on in thin washes is such that the painting—and this is true of most of Dufy's works—seems like a delicately colored ink drawing.

Dufy combined influences from Matisse, Rococo, Persian and Indian painting, and occasionally modern primitives such as Henri Rousseau, transforming all these into an intimate world of his own. The artist could take a panoramic view and suggest, in minuscule touches of color and nervous

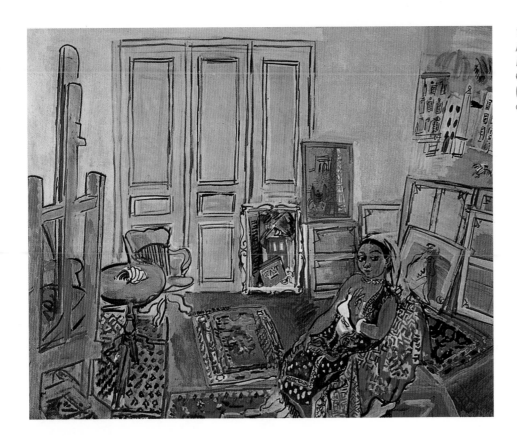

12.16 Raoul Dufy, *Indian Model in the Studio at L'Impasse Guelma*, 1928. Oil on canvas, 31⅞ × 39⅜" (81 × 100 cm). Private collection.

arabesques of line, the movement and excitement of his world—crowds of holidaymakers, horse races, boats in sun-filled harbors, the circus, and the concert hall.

Eclectic Mastery: Picasso's Career after the War

"I paint objects as I think them, not as I see them," said **Pablo Picasso** (1881–1973). This statement emphasizes the strong conceptual element that lies behind both his lifelong readiness to experiment with new kinds of visual language and his capacity to assimilate the essence of a diverse range of artistic styles and techniques. Unlike Matisse, whose "art of balance," like a comfortable armchair, sought to relax and refresh the viewer, Picasso came to see art as "an instrument of war against brutality and darkness." His work during the interwar years reflects intellectual currents of the times, from the classical "call to order" that followed the war to his involvement with Surrealism and communism, and the passionate political statement of *Guernica*.

In 1914, like other European avant-garde movements, Cubism had lost momentum as artists and writers, including Braque, Léger and Apollinaire, enlisted in the armed forces. As a foreigner, Picasso was able to remain in Paris, but he worked more now in isolation. After the period of discovery and experiment in Analytic Cubism, collage, and the beginning of Synthetic Cubism (1908–14), there was a pause during which the artist used Cubism for decorative ends (see figs. 8.26, 8.29). Then, suddenly, during a sojourn in Avignon in 1914, he began a series of realistic portrait drawings in a sensitive, scrupulous linear technique that recalls his longtime admiration for the drawings of Ingres. But works such as the portrait of Picasso's dealer *Ambroise Vollard* (fig. **12.17**) were in the minority during 1915–16, when the artist was still experimenting with painting and constructions in a Synthetic Cubist vein.

12.17 Pablo Picasso, *Ambroise Vollard*, 1915. Pencil on paper, 18⅜ × 12⁹⁄₁₆" (46.7 × 31.9 cm). The Metropolitan Museum of Art, New York.

The war years and the early 1920s saw a return to forms of realism on the part of other French painters—Derain, Vlaminck, Dufy—originally associated with Fauvism or Cubism. In Picasso's case, however, the drawings and, subsequently, paintings in a realist mode contributed to a re-examination of the nature of Cubism. He obviously felt confident enough of his control of the Cubist vocabulary to attack reality from two widely divergent vantage points. With astonishing agility, he pursued Cubist experiments side by side with realistic and classical drawings and paintings in the early 1920s. Picasso's facility with an eclectic range of styles—in itself one of the most extraordinary phenomena of twentieth-century art—is interesting in several ways. It shows how the artist was able to take full advantage of the experimental freedoms that were an integral part of modernism. But at the same time it shows him moving away from modernist notions of authenticity (for example, Cubism's truth to the fragmented nature of visual perception as it is actually experienced) toward modes of parody or pastiche, strategies similarly exploited by the Dadaists.

Parade and Theatrical Themes

In 1917 Picasso agreed, somewhat reluctantly because he hated travel or disruption of his routine, to go to Rome as part of a group of artists, including the poet and dramatist Jean Cocteau, the composer Erik Satie, and the choreographer Léonide Massine, to design curtains, sets, and costumes for a new ballet, *Parade*, being prepared for Diaghilev's *Ballets Russes* (Russian Ballet Company).

CONTEXT

Diaghilev's *Ballets Russes*

Serge Diaghilev's *Ballets Russes* exemplify the profitable tension between traditional and avant-garde culture around World War I. Diaghilev was a Russian impresario who, in 1909, formed a touring troupe of dancers classically trained at the Imperial Ballet in St. Petersburg. By 1911, the successful *Ballets Russes* had settled in Paris, where Diaghilev invited avant-garde artists to collaborate with his director, composers, and dancers in designing innovative costumes and sets. One of the most infamous of Diaghilev's productions was the "realist ballet" *Parade* (see fig. 12.19). At its première in Paris the ballet provoked outrage. There was no single problem: Picasso's Cubist sets and costumes, Erik Satie's music (which included conventional instruments along with sounds produced by typewriters, a foghorn, and milk bottles), and Jean Cocteau's anti-capitalist story all had a share in eliciting the critics' gall. Diaghilev recognized that postwar tastes in culture were returning to reassuringly traditional forms. Subsequent productions by the *Ballets Russes* retreated from the avant-garde experimentation of *Parade* and instead pursued folk themes animated by more conventional instrumentation.

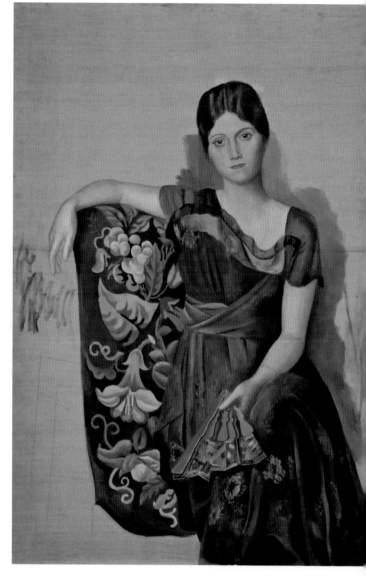

12.18 Pablo Picasso, *Olga Seated in an Armchair*, 1917. Oil on canvas, 51⅛ × 35" (130 × 88.8 cm). Musée Picasso, Paris.

The stimulus of Italy, where Picasso stayed for two months visiting museums, churches, and ancient sites like Pompeii, contributed to the resurgence of classical style and subject matter in his art. He also met and married a young dancer in the *corps de ballet*, Olga Koklova, who became the subject of many portraits in the ensuing years, including the Ingresesque *Olga Seated in an Armchair* (fig. **12.18**). Even in its unfinished state, this portrait testifies to Picasso's interest in the classical tradition of French painting, a reassuring reminder of the capacity for cultures to endure even in the somber world of postwar Europe.

Picasso's contributions to *Parade*, however, reveal his enduring commitment to progressive art. *Parade* brought the artist back into the world of the theater, which, along with the circus, had been an early love and had provided him with subject matter for his Blue and Rose Periods (see chapter 8). Dating back to the late eighteenth century, a traditional "parade" was a sideshow performance enacted outside a theater to entice the spectators inside. The ballet was built around the theme of conflict: on the one hand,

12.19 Pablo Picasso, *The American Manager*, 1917. Reconstruction. Realized by Kermit Love for The Museum of Modern Art, 1979. Paint on cardboard, fabric, paper, wood, leather, and metal, 11' 2¼" × 8' × 3' 8½" (3.4 × 2.4 × 1.1 m). The Museum of Modern Art, New York.

the delicate humanity and harmony of the music and the dancers; on the other, the commercialized forces of the mechanist–Cubist managers (fig. **12.19**) and the deafening noise of the sound effects. Cocteau, who saw the scenario as a dialogue between illusion and reality, the commonplace and the fantastic, intended these real sounds—sirens, typewriters, or trains—as the aural equivalent of the literal elements in Cubist collages (see fig. 8.22). The mixture of reality and fantasy in *Parade* led Apollinaire in his program notes to refer to its *sur-réalisme*, one of the first recorded uses of this term to describe an art form. *Parade* involved elements of shock that the Dadaists were then exploiting in Zurich (see chapter 11). Picasso designed a backdrop for it that is reminiscent of his 1905 circus paintings (see fig. 8.4) in its tender, romantic imagery and Rose Period coloring. Like Satie's soothing prelude, it reassured the audience, which was expecting Futurist cacophony. But they were shocked out of their complacency once the curtain rose. When *Parade* was first performed in Paris on May 18, 1917, the audience included sympathetic viewers like Gris and Severini. Most of the theatergoers, however, were outraged members of the bourgeoisie. The reviews were

devastating, and *Parade* became a *succès de scandale*, marking the beginning of many fruitful collaborations between Picasso, as well as other artists in France, with the ballet company (see *Diaghilev's Ballets Russes*, opposite).

During this period, Picasso's early love of the characters from the Italian *commedia dell'arte* and its descendant, the French circus, was renewed. Pierrots, Harlequins, and musicians again became a central theme. The world of the theater and music took on a fresh aspect that resulted in a number of brilliant portraits, such as that of the Russian composer Igor Stravinsky, and figure drawings done in delicately sparse outlines.

Postwar Classicism

In the early postwar period Picasso experimented with different attitudes toward Cubism and representation. In the latter, the most purely classical style was manifested before 1923 in drawings that have the quality of white-ground Greek vase paintings of the fifth century B.C.E. By 1920 such drawings embodied a specifically Greek or Roman subject matter that Picasso continued to explore thereafter. *Nessus and Dejanira* (fig. **12.20**), for example, depicts a story from Ovid's *Metamorphoses* in which the centaur Nessus tries to rape Dejanira, the wife of Herakles. Picasso said that his trips to the Mediterranean inspired such ancient mythological themes. This subject so intrigued the artist that he made versions in pencil, silverpoint, watercolor, and etching. The representational line drawings also revived his interest in the graphic arts, particularly etching and lithography. He produced prints at the beginning of his career and during the earlier Cubist phase and the war years. From the early 1920s, printmaking became a major phase of his production, so much so that Picasso must be regarded as one of the great printmakers of the twentieth century.

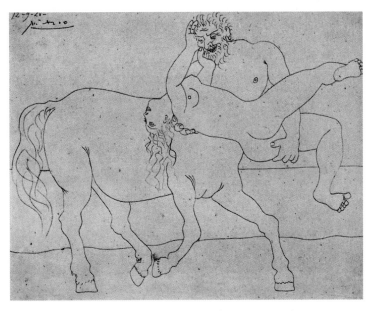

12.20 Pablo Picasso, *Nessus and Dejanira*, 1920. Pencil on paper, 8¼ × 10¼" (21 × 26 cm). The Museum of Modern Art, New York.

During 1920, Picasso also began to produce paintings, frequently on a large scale, in which his concept of the classical is in a different and monumental vein. He pursued this style for the next four years in painting and then continued in sculpture in the early 1930s. The years of working with flat, tilted Cubist planes seemed to build up a need to go to the extreme of sculptural mass. The faces are simplified in the heavy, coarse manner of Roman rather than Greek sculpture, and when Picasso placed the figures before a landscape, he reduced the background to frontalized accents that tend to close rather than open the space. Thus, the effect of high sculptural relief is maintained throughout. While the stone giantesses of *Three Women at the Spring* (fig. **12.21**), which have been compared with Michelangelo's sibyls (prophetesses) in the Sistine Chapel, do not embody the traditional proportions of the classical canon, they are endowed with a classical sense of dignity and timelessness. Picasso prepared his compact, rigorously constructed image with several studies. The compositional elements rotate around the central placement of a jug and the women's enormous hands, which are extended in slow, hieratic gestures. Occasionally, Picasso put his figures into lumbering activity, as in *Two Women Running on the Beach (The Race)* (fig. **12.22**). The colors of this painting, in accordance with its classical mood, are light and bright—blues and reds, with raw pink flesh tones. Despite their massive limbs, these ecstatic women bound effortlessly across the landscape. We should recall that such massive

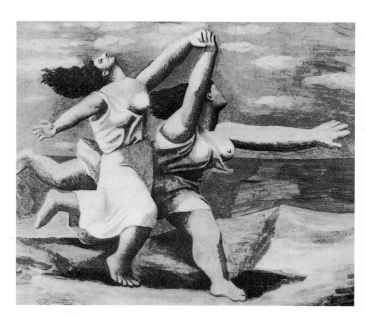

12.22 Pablo Picasso, *Two Women Running on the Beach (The Race)*, 1922. Gouache on plywood, 13⅜ × 16¾" (34 × 42.5 cm). Musée Picasso, Paris.

figures were not new in Picasso's career, for during his proto-Cubist period (1906–08) he had produced a number of comparably substantial and primitivizing renditions of the nude (see fig. 8.6).

Picasso continued to paint for two or three more years in a classical vein, but now with more specific reference to the spirit of Athens in the fifth century B.C.E. One of

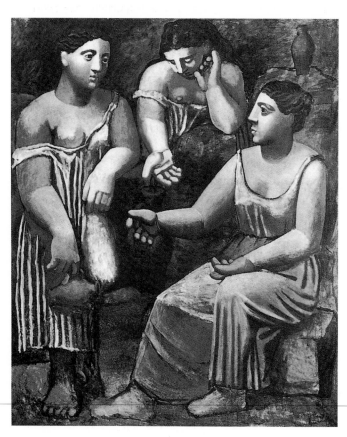

12.21 Pablo Picasso, *Three Women at the Spring*, Fontainebleau, summer 1921. Oil on canvas, 6' 8¼" × 5' 8½" (2.03 × 1.74 m). The Museum of Modern Art, New York.

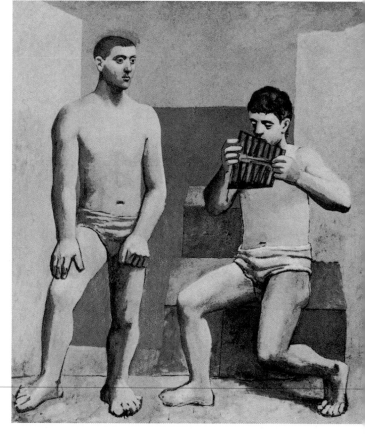

12.23 Pablo Picasso, *The Pipes of Pan*, 1923. Oil on canvas, 6' 6½" × 5' 8½" (2 × 1.74 m). Musée Picasso, Paris.

the outstanding works of this phase is *The Pipes of Pan* (fig. **12.23**). The two youths are presented as massive yet graceful athletes, absorbed in their own remote and magical world. The rectilinear forms of the background deny any sense of spatial recession, turning the whole into a kind of Mediterranean stage set.

Cubism Continued

The remarkable aspect of Picasso's art during this ten-year period (1915–25) is that he was also producing major Cubist paintings. He explained this stylistic dichotomy in a 1923 interview: "If the subjects I have wanted to express have suggested different ways of expression I have never hesitated to adopt them." After the decorative enrichment of the Cubist paintings around 1914–15 (see fig. 8.26), including pointillist color and elaborate, applied textures, the artist moved back, in his Cubist paintings of 1916–18, to a greater austerity of more simplified flat patterns, frequently based on the figure (fig. **12.24**). Simultaneously, he made realistic versions of this subject, a favorite with him.

12.24 Pablo Picasso, *Harlequin with Violin (Si tu veux)*, 1918. Oil on canvas, 56 × 39½" (142.2 × 100.3 cm). The Cleveland Museum of Art. Purchase, Leonard C. Hanna, Jr. 1975.2.

From compositions involving figures, there gradually evolved the two versions of the *Three Musicians* (fig. **12.25**), both created in 1921, the same year Picasso made *Three Women at the Spring*. One version is in The Museum of Modern Art, New York; the other is in the Museum of Art, Philadelphia. The three figures in both versions are seated frontally in a row, against an enclosing back wall, and fixed by the restricted foreground, but the version in New York is simpler and more somber. The paintings are a superb summation of the Synthetic Cubist style up to this point, but they also embody something new. The figures are suggestive not so much of exuberant musicians from the *commedia dell'arte* as of some mysterious tribunal. It has been persuasively argued that the three musicians represent covert portraits of Picasso's friends—the writer Max Jacob (the monk at the right), who had recently withdrawn from the world and taken up residence in a monastery, and Apollinaire (Pierrot, the "poet" at the left), who had died in 1918. Picasso portrays himself, as he often did, in the guise of Harlequin, situated in the middle between his friends. The somber, somewhat ominous mood of the painting is thus explained as the work becomes a memorial to these lost friends.

The other direction in which Picasso took Cubism involved sacrifice of the purity of its Analytic phase for the sake of new exploration of pictorial space. The result was, between 1924 and 1926, a series of the most colorful and spatially intricate still lifes in the history of Cubism. *Mandolin and Guitar* (fig. **12.26**) illustrates the artist's superb control over the entire repertory of Cubist and perspective space. The center of the painting is occupied by the characteristic Cubist still life—the mandolin and guitar twisting and turning on the table, encompassed in mandorlas of abstract color-shapes: vivid reds, blues, purples, yellows, and ochers against more subdued but still rich earth colors. The tablecloth is varicolored and patterned, while the corner of the room with the open window is a complex of tilted wall planes and receding perspective lines. These create a considerable illusion of depth, which, however, seems constantly to be turning back upon itself, shifting and changing into flat planes of color. The whole is infiltrated by an intense Mediterranean light, made palpable by the deeply colored shadow that falls across the red tile floor at the right.

It is interesting to recall the extent to which the subject of the open window, often with a table, still life, or figure before it, had also been a favorite of Matisse (see fig. 12.13). Certain relationships between Matisse's work and Picasso's contemporary paintings of similar subjects indicate that Picasso may have been looking at his colleague and great rival's work.

In some Cubist still lifes of the mid-1920s, Picasso introduced classical busts as motifs, suggesting the artist's simultaneous exploration of classic idealism and a more expressionist vision. In *Studio with Plaster Head* (fig. **12.27**), the Roman bust introduces a quality of mystery analogous

12.25 Pablo Picasso, *Three Musicians,* summer 1921. Oil on canvas, 6' 7" × 7' 3¾" (2 × 2.2 m). The Museum of Modern Art, New York.

12.26 Pablo Picasso, *Mandolin and Guitar,* 1924. Oil and sand on canvas, 56⅛ × 67¾" (142.6 × 200 cm). Solomon R. Guggenheim Museum, New York.

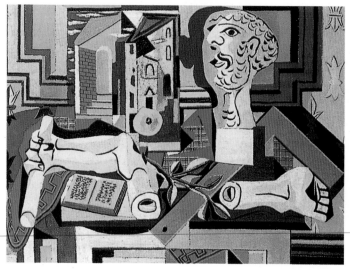

12.27 Pablo Picasso, *Studio with Plaster Head,* summer 1925. Oil on canvas, 38⅝ × 51⅝" (97.9 × 131.1 cm). The Museum of Modern Art, New York.

to De Chirico's use of classical motifs (see fig.10.5). While the trappings of classicism are here, the serenity of Picasso's earlier classical paintings has vanished. The work belongs to a tradition of still lifes representing the attributes of the arts (including the prominent architect's square at the right), but the juxtapositions become so jarring as to imbue the composition with tremendous psychological tension. At the back of the still life, fragments of Picasso's small son's toy theater imply that the entire still life is an ancient Roman stage set. The head is almost a caricature, which Picasso manages to twist in space from a strict profile view at the right to a fully frontal one in the deep blue-gray shadow at the left. The broken plaster arm at the left grips a baton so intensely that it feels animated.

Sensuous Analysis: Braque's Later Career

Georges Braque (1882–1963) and Picasso had parted company in 1914, never to regain the intimacy of the formative years of Cubism. After his war service and slow recovery from a serious wound, Braque returned to a changed Paris in the fall of 1917. Picasso was in Italy, and other pioneers of Cubism or Fauvism were widely scattered. However, Juan Gris and Henri Laurens (see chapter 8) were still in Paris, working in a manner that impressed Braque and inspired him to find his own way once more. By 1918–19 a new and personal approach to Synthetic Cubism began to be apparent in a series of paintings, of which *Café-Bar* (fig. **12.28**) is a document for Braque's style for the next twenty years. The painting is tall and relatively narrow, a shape which Braque had used during his first essays in Cubism (see fig. 8.17) and which he now began to utilize on a more monumental scale. The subject is a still life of guitar, pipe, journal, and miscellaneous objects piled vertically on a small, marble-topped pedestal table, or *guéridon*. This table was used many times in subsequent paintings. The suggested elements of the environment are held together by a pattern of horizontal green rectangles patterned with orange-yellow dots, placed like an architectural framework parallel to the picture plane.

Compared with Braque's prewar Cubist paintings, *Café-Bar* has more sense of illusionistic depth and actual environment. Also, although the colors are rich, and Braque's feeling for texture is more than ever apparent, the total effect recalls, more than Picasso's, the subdued, nearly monochrome tonalities that both artists worked with during their early collaboration (see figs. 8.20, 8.21). This is perhaps the key to the difference between their work in the years after their collaboration. Whereas the approach of Picasso was experimental and varied, that of Braque was conservative and intensive, continuing the first lessons of Cubism. Even when he made his most radical departures into his own form of classical figure painting during the 1920s, the color remained predominantly the grays, greens, browns, and ochers of Analytic Cubism. The principal

characteristic of Braque's style emerging about 1919 was that of a textural sensuousness in which the angular geometry of earlier Cubism began to diffuse into an overall fluid pattern of organic shapes.

This style manifested itself in the early 1920s in figure paintings in which the artist seems to have deserted Cubism as completely as Picasso did in his classical figure paintings. The difference again lay in the painterliness of Braque's oils and drawings, as compared with Picasso's Ingres-like contour drawings and the sculptural massiveness of his classical paintings. In Braque's paintings and figure drawings of

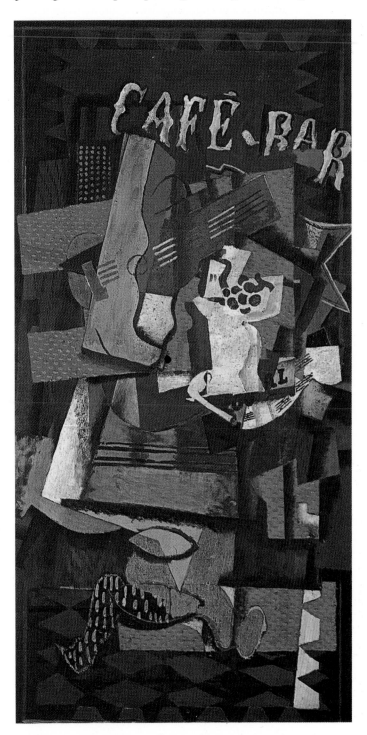

12.28 Georges Braque, *Café-Bar*, 1919. Oil on canvas, 63¼ × 31⅞" (160.7 × 81 cm). Öffentliche Kunstsammlung Basel, Kunstmuseum.

this period, the artist effected his personal escape from the rigidity of his earlier Cubism and prepared the way for his enriched approach to Cubist design of the later 1920s and 30s. The sobriety of Braque's palette and the purposefulness of his devotion to Cubism—the style that promised such formal liberty in the years between 1909 and 1914—must be reckoned at least in part a consequence of his wartime experiences.

The most dramatic variation on his steady, introspective progress occurred in the early 1930s when, under the influence of Greek vase painting, Braque created a series of line drawings and engravings with continuous contours. This flat, linear style also penetrated to his newly austere paintings of the period: scenes of artist and model or simply figures in the studio. These works exhibit some of the most varied effects of Braque's entire career. The dominant motif of *Woman with a Mandolin* (fig. **12.29**) is a tall, dark silhouette of a woman seated before a music stand. Behind her, a profusion of patterns on the wall recalls the wallpaper patterns of Braque's earlier *papiers collés*. Because the woman's profile, very similar to ones in related compositions, is painted a deep black-brown, she becomes a shadow, less material than the other richly textured elements in the room. She plays the role of silent muse

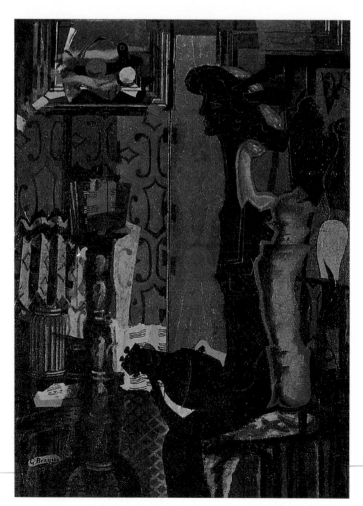

12.29 Georges Braque, *Woman with a Mandolin*, 1937. Oil on canvas, 51¼ × 38¼" (130.2 × 97.2 cm). The Museum of Modern Art, New York.

in this monumental painting, which represents Braque's meditation on art and music. It was probably inspired by Corot's treatment of the same subject, painted around 1860, which shows a young woman before an easel, holding a mandolin.

Austerity and Elegance: Léger, Le Corbusier, and Ozenfant

In his paintings of the 1920s and 30s, **Fernand Léger** (1881–1955) took part in the so-called "call to order" that characterized much French art after World War I, in which he had served. One of his major figure compositions from the postwar period is *Three Women (Le Grand Déjeuner)* (fig. **12.30**). The depersonalized figures, who stare fixedly and uniformly at the spectator, are machine-like volumes modeled out from the rigidly rectangular background. Léger labored over *Three Women*, the largest of three very similar versions of the same composition, and even repainted the figure at the right, who was originally the same marble-like gray color of her companions. He regarded the subject as timeless and eternal and said that his artistic sources were David, Ingres, Renoir, and Seurat. Although *Three Women* reflects Léger's engagement with classicism, it is also resolutely modern. In the abstract, rectilinear forms of the background one detects an awareness of the contemporary paintings of Mondrian, who was then living in Paris (see fig. 13.3). With its elements of austere, Art Deco elegance, Léger's art of this period also had much in common with the 1920s Purism (see below) of Amédée Ozenfant and Le Corbusier (see figs. 12.32, 12.33). Léger remained very close to these artists after their initial meeting in 1920.

During the last twenty years of his life, Léger revisited a few basic themes through which he sought to sum up his experiences in the exploration of humanity and its place in a contemporary industrial society. It was a social as well as a visual investigation of his world as an artist, a final and culminating assessment of his plastic means for presenting it. In *The Great Parade* of 1954 (fig. **12.31**), Léger brought to culmination a series in which figure and environment are realistically drawn in heavy black outline on a white ground, over which float free shapes of transparent red, blue, orange, yellow, and green. This huge work also reflects a lifelong obsession with circus themes, as well as an interest in creating a modern mural art. Léger worked on the large canvas for two years. "In the first version," he recalled, "the color exactly fitted the forms. In the definitive version one can see what force, what vitality is achieved by using color on its own." Despite his increased interest in illustrative subject and social observation, these late works are remarkably consistent with Léger's early Cubist paintings based on machine forms (see fig. 8.40). The artist was one of a few who never really deserted Cubism but demonstrated, in every phase of his prolific output, its potential for continually fresh and varied expression.

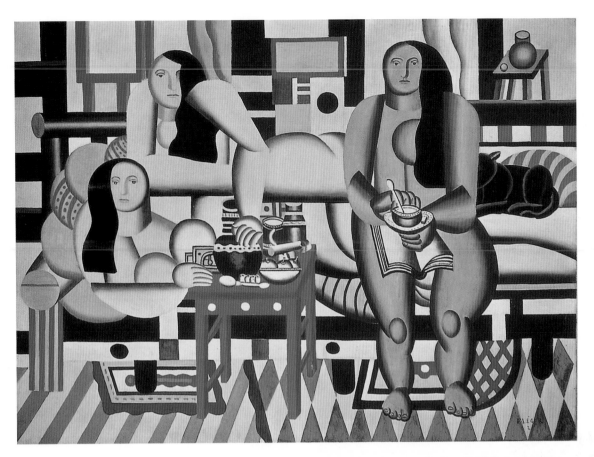

12.30 Fernand Léger, *Three Women (Le Grand Déjeuner)*, 1921. Oil on canvas, 6' ¼" × 8' 3" (1.8 × 2.5 m). The Museum of Modern Art, New York.

12.31 Fernand Léger, *The Great Parade*, 1954. Oil on canvas, 9' × 13' 1" (2.7 × 4 m). Solomon R. Guggenheim Museum, New York.

The variant on Cubism called Purism was developed around 1918 by the architect and painter Charles-Édouard Jeanneret, who in 1920 began to use the pseudonym **Le Corbusier** (1887–1965), and the painter **Amédée Ozenfant** (1886–1966). Unlike Picasso and Braque, who were not theoretically inclined, many later Cubist-inspired artists were prone to theorizing, and they published their ideas in journals and manifestos. In their 1918 manifesto *After Cubism*, Ozenfant and Jeanneret attacked the then current state of Cubism as having degenerated into a form of elaborate decoration. In their painting they sought a simple, architectural structure and the elimination of decorative ornateness as well as illustrative or fantastic subjects. To them the machine became the perfect symbol for the kind of pure, functional painting they hoped to achieve— just as, in his early, minimal architecture, Le Corbusier

thought of a house first as a machine for living. Purist principles are illustrated in two still-life paintings by Ozenfant (fig. **12.32**) and Le Corbusier (fig. **12.33**). Executed in 1920, the year that Purism reached its maturity, both feature frontally arranged objects, with colors subdued and shapes modeled in an illusion of projecting volumes. Symmetrical curves move across the rectangular grid with the antiseptic purity of a well-tended, brand-new machine. Le Corbusier continued to paint throughout his life, but his theories gained significant expression in the great architecture he produced (see chapter 21). Ozenfant had enunciated his ideas of Purism in *L'Élan*, a magazine published from 1915 to 1917, before he met Le Corbusier, and in *L'Esprit nouveau*, published with Le Corbusier from 1920 to 1925. Ozenfant, who eventually settled in the United States, later turned to teaching and mural painting.

12.32 Amédée Ozenfant, *Guitar and Bottles*, 1920. Oil on canvas, 31⅞ × 39¼" (81 × 99.7 cm). Solomon R. Guggenheim Museum, New York.

12.33 Le Corbusier (Charles-Édouard Jeanneret), *Still Life*, 1920. Oil on canvas, 31⅞ × 39¼" (81 × 99.7 cm). The Museum of Modern Art, New York.

13
Clarity, Certainty, and Order: de Stijl and the Pursuit of Geometric Abstraction

As much of Europe girded itself for war, artists living in neutral countries like Switzerland and the Netherlands continued their work, largely unimpeded. It was thanks to Dutch neutrality in World War I that the movement called de Stijl ("the style") was able to take root in the 1910s. Led by Theo van Doesburg and Piet Mondrian, de Stijl embraced geometric abstraction and Constructivist ideas, free from the resurgence in classicism that led so many French avant-garde artists to retreat from abstraction. Constructivism in the hands of Western European artists like Van Doesburg and Mondrian must be understood as related but not identical to Russian Constructivism, which promoted a specific, Soviet-style socialism. Constructivism more generally can be understood as a movement in early twentieth-century modernism in which strong abstraction with a geometric basis is a defining element. Other characteristics of this more diffuse category of Constructivism include the avoidance of overt narrative and emotional content as well as a tendency to minimize facture. Facture—the evidence of an artist's manipulation of his or her medium through brushstrokes in the case of painting, or hand-modeling in clay sculpture—was suppressed by many Constructivists, who felt such traces to be vestiges of an outdated, even dangerous, Romantic sensibility. In the hands of artists like Van Doesburg and Mondrian, geometric abstraction was in part an attempt to create a scientifically based, universal language of the senses that would transcend the cultural, political, and economic divisions compounded by the war. Mainly Dutch but also including artists from Belgium and Hungary, the members of de Stijl sought a universal aesthetic that would unify all forms of visual art while also unifying humanity.

The de Stijl Idea

Theo van Doesburg was the leading spirit in the formation and promotion of the group and the creation of its influential journal, also called *de Stijl*, devoted to the art and theory of the group and published from 1917 to 1928, the dates by which the movement is generally bounded, though its influence persists even today (see *De Stijl "Manifesto 1"*, below). De Stijl was dedicated to

the "absolute devaluation of tradition ... the exposure of the whole swindle of lyricism and sentiment." The artists involved emphasized "the need for abstraction and simplification": mathematical structure as opposed to Impressionism and all "baroque" forms of art. They created art "for clarity, for certainty, and for order." Their works began to display these qualities, transmitted through the straight line, the rectangle, or the cube, and eventually through colors simplified to the primaries red, yellow, and blue and the neutrals black, white, and gray. For Van Doesburg these simplifications had symbolic significance based on Eastern philosophy and the mystical teachings of Theosophy, a popular spiritual movement that was known among de Stijl artists partly through Kandinsky's book *Concerning the Spiritual in Art* (see chapter 7). Despite Van Doesburg's efforts to present de Stijl as a unified and coherent entity, it included many individual talents who did not strictly adhere to a single style. Nevertheless, the artists, designers, and architects of the movement shared ideas about the social role of art in modern society, the integration of all the arts through the collaboration of artists and designers, and an abiding faith in the potential of technology and design to realize new utopian living environments based on abstract form. Together they developed an art based rigorously on theory, dedicated to formal purity, logic, balance, proportion, and rhythm.

The de Stijl artists were well aware of avant-garde developments in modern art in France, Germany, and Italy—Fauvism, Cubism, German Expressionism, and Italian Futurism. But they recognized as leaders only a few pioneers, such as Cézanne in painting and Frank Lloyd Wright and Hendrik Berlage in architecture. They had little or no knowledge of the Russian experiments in abstraction until the end of the war, when international communications were re-established. At that time, contact developed between the Dutch and Russian avant-garde, especially through El Lissitzky.

Mondrian: Seeking the Spiritual Through the Rational

In evaluating the course of geometric abstraction from its beginnings, in about 1911, to the present, an understanding of Piet Mondrian's role is of paramount importance and will, therefore, be treated at some length. He was the principal figure in the evolution of geometric abstraction during World War I, for the ideas of de Stijl and their logical development were primarily his achievement. Mondrian's influence extended not only to abstract painting and sculpture but also to the forms of the International Style in architecture. During the 1920s and 30s in Paris it was probably the presence and inspiration of Mondrian more than any other single person that enabled abstraction to survive and gradually to gain strength—in the face of the "call to order" and the 1920s return to figuration, as well as economic depression, threats of dictatorship, and war.

Mondrian also played a central part in the rise of abstraction in American art during the 1940s and 50s.

Early Work

A transition from fairly conventional naturalistic paintings to a revolutionary modern style during and after World War I can be traced in the career of **Piet Mondrian** (1872–1944). Born Pieter Mondriaan, he was trained in the Amsterdam Rijksacademie and until 1904 worked primarily as a landscape painter. He then came under the influence of Jan Toorop and for a time painted in a Symbolist manner. His early work evinces a tendency to work in series—which proved central to the development of his abstract work—and to focus on a single scene or object, whether a windmill, a thicket of trees, a solitary tree, or an isolated chrysanthemum. Early landscapes adhered to a principle of frontality and, particularly in a series of scenes with windmills, to cut-off, close-up presentation.

By 1908 Mondrian was becoming aware of some of the innovations of modern art. His color blossomed in Fauve-inspired blues, yellows, pinks, and reds. In forest scenes he emphasized the linear undulation of saplings; in shore- and seascapes, the intense, flowing colors of sand dunes and water. For the next few years he painted motifs such as church façades presented frontally, in nearly abstract planes of arbitrary color or in patterns of loose red and yellow spots deriving from the Neo-Impressionists and the brushstrokes of Van Gogh. With any of his favorite subjects—the tree, the dunes and ocean, the church or windmill, all rooted in the familiar environment of the Netherlands—one can trace his progress from naturalism through Symbolism, Impressionism, Post-Impressionism, Fauvism, and Cubism to abstraction. In *Blue Tree* (fig. **13.1**), an image to which he devoted several paintings and drawings, Mondrian employed expressive, animated brushwork reminiscent of Van Gogh's, causing the whole scene to pulsate with energy.

In early 1912 Mondrian moved to Paris. Though he had seen early Cubist works by Picasso and Braque in Holland, he became fully conversant with the style in the French capital. It is in the wake of this experience that he emerges as a major figure in modern art. He himself came to regard the previous years as transitional. During his first years in Paris, Mondrian subordinated his colors to grays, blue-greens, and ochers under the influence of the Analytic Cubism of Picasso and Braque (see figs. 8.20, 8.21). But he rarely attempted the tilted planes or sculptural projection that gave the works of the French Cubists their defined, if limited, sense of three-dimensional spatial existence; his most Cubist paintings still maintained an essential frontality. Mondrian was already moving beyond the tenets of Cubism to eliminate both subject and three-dimensional illusionistic depth.

As early as 1912 the tree had virtually disappeared into a linear grid that covered the surface of the canvas.

13.1 Piet Mondrian, *Apple Tree, Pointillist Version*, 1908–09. Oil on composition board, 22⅜ × 29½" (56.8 × 75 cm). A673. Dallas Museum of Art. Gift of the James H. and Lillian Clark Foundation. © 2009 Mondrian/Holtzman Trust c/o HCR International, Warrenton, Virginia, 20186, USA.

Mondrian at this time favored centralized compositions, which involve greater density in the center with gradual loosening toward the edges. His occasional adoption of the oval canvas (inspired by the Cubists) allowed him to emphasize further the ideas of center and periphery. As his experiments continued, the linear structure of his paintings became more rectangular and abstract. By 1914 the artist had begun to experiment with a broader but still subtle range of colors, asserting their identity within a structure of horizontal and vertical lines.

In Paris Mondrian was profoundly affected by the example of Cubism, but he gradually began to feel that the style "did not accept the logical consequences of its own discoveries: it was not developing abstraction toward its ultimate goal, the expression of pure reality. I felt that this could only be established by pure plastics (plasticism)." In this statement, made in 1942, he emphasized the two words that summarize his lifelong quest—"plastic" and "reality." To him "plastic expression" referred to capacity of colors and forms to assert their presence, to affect the viewer. "Reality" or "the new reality" was the reality of plastic expression, or the reality of forms and colors in the painting. Thus, the new reality was the presence of the painting itself, as opposed to the painted imitation of nature or the romantic evocation of the artist's emotions.

Neoplasticism

Gradually, as the artist tells it, Mondrian became aware that "(a) in plastic art reality can be expressed only through the equilibrium of dynamic movements of form and color; (b) pure means afford the most effective way of attaining this." These ideas led him to develop a set of organizational principles in his art. Chief among them were the balance of unequal opposites, achieved through the right angle, and the simplification of color to the primary hues plus black and white. It is important to recall that Mondrian did not arrive at his final position solely through theoretical speculation, but through long and complex development.

In 1914 Mondrian returned to Holland to visit his ailing father; he was forced to stay when the war broke out. Between 1914 and 1916 he eliminated all vestiges of curved lines, so that the structure became predominantly vertical and horizontal. The paintings were still rooted in subject—a church façade, the ocean, and piers extending into the ocean—but these were now simplified to a pattern of short, straight lines, like plus and minus signs, through which the artist sought to suggest the underlying structure of nature. During 1917 and later he explored another variation (fig. **13.2**)—rectangles of flat color of varying sizes, suspended in a sometimes loose, sometimes precise rectangular arrangement. The color rectangles sometimes touch, sometimes float independently, and sometimes overlap. They appear positively as forms in front of the light background. Their interaction creates a surprising illusion of depth and movement, even though they are kept rigidly parallel to the surface of the canvas. It was in 1917 that Mondrian began contributing essays to *de Stijl*, embarking on a fertile association with Van Doesburg and the group's other members that would last until 1925. Mondrian's presence in Paris, where he lived again from 1919 until 1938, made him the de facto spokesman for de Stijl, a movement still largely unknown among French avant-garde artists until the early 1920s. Mondrian soon realized that these detached color planes created both a tangible

13.2 Piet Mondrian, *Composition in Color A*, 1917. Oil on canvas, 19⅞ × 17⅞" (50.3 × 45.3 cm). B84. Kröller-Müller Museum, Otterlo, the Netherlands. © 2009 Mondrian/Holtzman Trust c/o HCR International, Warrenton, Virginia, 20186, USA.

sense of depth and a differentiation of foreground and background; this interfered with the pure reality he was seeking. This discovery led him during 1918 and 1919 to a series of works organized on a strict rectangular grid. In the so-called "checkerboards," rectangles of equal size and a few different colors are evenly distributed across the canvas. By controlling the strength and tone of his colors, Mondrian here neutralized any distinction between figure and ground, for the white and gray rectangles do not recede behind the colored ones or assume a subordinate role as support. Mondrian did not develop this compositional solution further, for he felt the modular grid was too prominent. Finally, therefore, he united the field of the canvas by thickening the dividing lines and running them through the rectangles to create a linear structure in tension with the color rectangles. In 1920, after returning to Paris, Mondrian came to the fulfillment of his Neoplastic artistic ideals. His paintings of this period express abstract, universal ideas: the dynamic balance of vertical and horizontal linear structure and simple, fundamental color. Mondrian's ultimate aim was to express a visual unity through an "equivalence of opposites"; this in turn expressed the higher mystical unity of the universe.

In 1920, with his first full-fledged painting based on the principles of Neoplasticism (meaning roughly "new image" or "new form"), Mondrian had found his solution to a long unsolved problem—how to express universals through a dynamic and asymmetrical equilibrium of vertical and horizontal structure, with primary hues of color disposed in rectangular areas. These elements gave visual expression to Mondrian's beliefs about the dynamic opposition and balance between the dual forces of matter and spirit, theories that grew out of his exposure to Theosophy and the dialectical theories of the early nineteenth-century German philosopher Georg Wilhelm Friedrich Hegel. It was only through the pure "plastic" expression of what Mondrian called the "inward" that humans could approach "the divine, the universal."

In his painting, Mondrian was disturbed by the fact that, up to this point, in most of his severely geometric paintings—including the floating color-plane compositions and the so-called grid or "checkerboard" paintings—the shapes of red, blue, or yellow seemed to function visually as foreground forms against a white and gray background (see fig. 13.2) and thus to interfere with total unity. The solution, he found, lay in making the forms independent of color,

with heavy lines (which he never thought of as lines in the sense of edges) moving through the rectangles of color. By this device he was able to gain a mastery over color and space that he would not exhaust for the next twenty years.

A mature example of Neoplasticism is seen in the *Composition, 1921/Tableau No. II 1921–25, with Red, Blue, Yellow, and Gray* (fig. **13.3**). Here is the familiar palette of red, blue, yellow, black, and two shades of gray. The total structure is emphatic, not simply containing the color rectangles but functioning as a counterpoint to them. Both red and gray areas are divided into larger and smaller rectangles with black lines. The black rectangles, since they are transpositions of lines to planes, act as further unifying elements between line and color. The edges of the painting are left open. Along the top and in the lower left corner, the verticals do not quite go to the edge, with the conse-quence that the grays at these points surround the ends of the lines. Only in the lower right does the black come to the edge, and this is actually a black area through which the line moves slightly to the left of the edge. In all other parts a color, principally gray, but red and yellow at the upper left, forms the outer boundary. The result that Mondrian sought—an absolute but dynamic balance of vertical and horizontal structure, using primary hues and black and white—is thus achieved. Everything in the painting holds its place. By some purely visual phenomenon, caused by the structure and the subtle disposition of color areas, the grays are as assertive as the reds or yellows; they advance as well as recede. The painting is not flat. Everything is held firmly in place, but under great tension.

The open composition with emphasis on large white or light-gray areas predominated in Mondrian's production

13.3 Piet Mondrian, *Composition, 1921/Tableau No. II 1921–25, with Red, Blue, Black, Yellow, and Gray*, 1921–25. Oil on canvas, 29⅜ × 25⅝" (75 × 65 cm). B121/154. Private collection, Zurich. © 2009 Mondrian/Holtzman Trust c/o HCR International, Warrenton, Virginia, 20186, USA.

during the 1920s and, in fact, for the rest of his life. He usually worked on several pictures at once and often developed a single idea by working in series, devoting as many as eight paintings to variations on a single theme. He made several variations within a square format, including *Composition with Red, Blue, and Yellow* (1930), in which a large color square of red, upper right, is joined point to point with a small square of comparably intense blue by intersecting black lines. Surrounding them, equally defined by heavy black lines, are rectangles of off-white. In the lower right corner is one small rectangle of yellow. The white areas, combined with the subordinate blue and yellow, effectively control and balance the great red square. Although Mondrian did not ascribe symbolic meaning to colors in the way that, for example, Kandinsky did, he told a collector that his paintings with a predominant red were "more real" than paintings with little or no color, which he considered "more spiritual."

The Break with de Stijl

Mondrian resigned from de Stijl in 1925 after disagreements with Van Doesburg about the nature of de Stijl architecture (though the artists were reconciled in 1929). While Mondrian envisioned, like his de Stijl colleagues, the

13.4 Piet Mondrian, *Lozenge Composition with Four Yellow Lines*, 1933. Oil on canvas, diagonal 44¼" (112.9 cm); sides 30⅝ x 30½" (80.2 x 79.9 cm). B241. Gemeentemuseum, The Hague, the Netherlands. © 2009 Mondrian/Holtzman Trust c/o HCR International, Warrenton, Virginia, 20186, USA.

integration of all the arts, he fervently believed in the superiority of painting, another point of departure from a tenet of de Stijl. A prolific writer and theoretician, Mondrian fully formulated his mature ideas during the 1920s.

Despite this break with Van Doesburg, Mondrian continued working in the Constructivist vein commended by the de Stijl group. His studio in Paris was a spartan living space but a remarkable artistic environment that was famous throughout the European art world. For his ideal Neoplastic environment, the artist created geometric compositions on the studio walls with arrangements of colored squares. The easel was more for viewing than working (he preferred to paint on a horizontal surface). In 1930 Mondrian was visited by Hilla Rebay, an artist and zealous supporter of abstract art who was to help found the Museum of Nonobjective Painting in New York, eventually to become the Solomon R. Guggenheim Museum. "He lives like a monk," she observed, "everything is white and empty, but for red, blue, and yellow painted squares that are spread all over the room of his white studio and bedroom. He also has a small record player with Negro music." Second only to painting was the artist's abiding passion for American jazz.

Lozenge Composition with Four Yellow Lines (fig. **13.4**) is among Mondrian's most beautiful so-called lozenge or diamond paintings. In this format, first used by him in 1918, the square painting is turned onto its corner but the horizontal and vertical axes are maintained internally. The shape inspired some of Mondrian's most austere designs, in which his desire to transgress the frame, to express a sense of incompleteness, was given tangible expression. *Lozenge Composition with Four Yellow Lines* represents an ultimate simplification in its design of four yellow lines, delicately adjusted in width and cutting across the angles of the diamond. Mondrian's fascination with the incomplete within the complete, the tension of lines cut off by the edge of the canvas that seek to continue on to an invisible point of juncture outside it, is nowhere better expressed than here. The viewer's desire to rejoin and complete the lines, to recover the square, is irresistible. The fascination of this magnificently serene painting also lies in another direction—the abandonment of black. Mondrian would fully develop this aspect in his very last works (see fig. 17.1). It is important to note that he also designed his own frames out of narrow strips of wood that he painted white or gray and set back from the canvas. He wished to emphasize the flat, non-illusionistic nature of his canvases, "to bring the painting forward from the frame ... to a more real existence."

In 1932 Mondrian introduced a dramatic new element in one of his Neoplastic compositions when he divided a black horizontal into two thin lines. With this "double line" he set out to replace all vestiges of static form with a "dynamic equilibrium." This innovation brought a new, vibrant opticality to the work, with Mondrian multiplying the number of lines until, by the late 1930s, the paintings contained irregular grids of black lines with only one or a few planes of color. A midway point in this development is *Composition in White, Black, and Red* of 1936, a structure of vertical and horizontal black lines on a white ground, with a small black rectangle in the upper left corner and a long red strip at the bottom. The lines, however, represent intricate proportions, both in the rectangles they define and in their own thickness and distribution. In the right lower corner, horizontal lines, varied subtly in width, create a grid in which the white spaces seem to expand and contract in a visual ambiguity.

Only the commencement of the bombing of Paris by the Germans in World War II persuaded Mondrian to abandon his studio and emigrate to the United States, where he had friends and collectors eager to help him. There he would join a diverse group of artists displaced from Europe by the war (he would also find an audience tentatively appreciative of avant-garde trends). The influence of these émigrés is discussed in chapter 17.

Van Doesburg, de Stijl, and Elementarism

As already noted, **Theo van Doesburg** (1883–1931) was the moving spirit in the formation and development of de Stijl, though Mondrian's greater celebrity in Paris and, especially, in New York made him a prominent symbol of the movement. During his two years of military service (1914–16) Van Doesburg studied the new experimental painting and sculpture and was particularly impressed by Kandinsky's essay, *Concerning the Spiritual in Art*. In 1916 he experimented with free abstraction in the manner of Kandinsky, as well as with Cubism, but was still searching for his own path. This he found in his composition *Card Players* (fig. **13.5**), based on a painting by Cézanne, but simplified to a complex of interacting shapes based on rectangles, the colors flat and reduced nearly to primaries. Fascinated by the mathematical implications of his new

13.5 Theo van Doesburg, *Card Players*, 1916–17. Tempera on canvas, 46½ × 58" (118.1 × 147.3 cm). Private collection.

13.6 Theo van Doesburg, *Composition IX (Card Players)*, 1917. Oil on canvas, 45⅝ × 41¾" (115.9 × 106 cm). Gemeente Museum, The Hague, the Netherlands.

abstraction, Van Doesburg explored its possibilities in linear structures, as in a later version of *Card Players* (fig. **13.6**).

Even Mondrian was affected by the fertility of Van Doesburg's imagination. When artists work together as closely as the de Stijl painters did during 1917–19, it is extremely difficult and perhaps pointless to establish absolute priorities. Van Doesburg, Mondrian, and their colleague Bart Van der Leck for a time were all nourished by one another. However, each went in his own direction in the 1920s, when Van Doesburg's attention turned toward architecture. He followed de Stijl principles until he published his *Fundamentals of the New Art* in 1924. He then began to abandon the rigid vertical–horizontal

formula of Mondrian and de Stijl and to introduce diagonals. This heresy, as well as fundamental differences over the nature of Neoplastic architecture, contributed to Mondrian's resignation from de Stijl. Though by 1918 Mondrian himself made lozenge-shaped paintings with diagonal edges (see fig. 13.4), a development he discussed at length with Van Doesburg, the lines contained within his compositions always remained strictly horizontal and vertical.

In a 1926 manifesto in *de Stijl*, Van Doesburg named his new departure Elementarism, and argued that the inclined plane reintroduced surprise, instability, and dynamism. In his murals at the Café l'Aubette, Strasbourg (fig. **13.7**)—decorated in collaboration with Jean Arp and Sophie Taeuber (see figs. 11.3, 11.4)—Van Doesburg made his most monumental statement of Elementarist principles. He tilted his colored rectangles at forty-five-degree angles and framed them in uniform strips of color. The tilted rectangles are in part cut off by the ceiling and lower wall panels. Across the center runs a long balcony with steps at one end that add a horizontal and diagonal to the design. Incomplete rectangles emerge as triangles or irregular geometric shapes. In proper de Stijl fashion, Van Doesburg designed every detail of the interior, down to the ashtrays. Here he realized his ideals about an all-embracing, total work of abstract art, saying that his aim was "to place man within painting instead of in front of it and thereby enable him to participate in it."

In the richly diverse and international art world of the 1920s, Van Doesburg provided a point of contact between artists and movements in several countries. He even maintained a lively interest in Dada. His Dada activities included his short-lived magazine *Mecano*, his poems written under the pseudonym of I. K. Bonset, and a Dada cultural tour of Holland with his friend Kurt Schwitters.

13.7 Theo van Doesburg, Sophie Taeuber, and Jean Arp, Interior, Café l'Aubette, 1926–28, Strasbourg, destroyed 1940.

Until his death in 1931, Van Doesburg promoted de Stijl abroad, traveling across Europe and seeking new adherents to the cause as older members defected. His efforts contributed to the establishment of de Stijl as a movement of international significance. With its belief in the integration of the fine and applied arts, the de Stijl experiment paralleled that of the Bauhaus in many ways. Van Doesburg was in Weimar in the early 1920s, lecturing and promoting de Stijl ideas at the Bauhaus, and fomenting dissent among the school's younger members. Although he was not a member of the faculty, he probably contributed to an increased emphasis at the Bauhaus on rational, machine-based design.

De Stijl Realized: Sculpture and Architecture

Although the most influential theorists of de Stijl—Van Doesburg and Mondrian—are known primarily for their painting, one of the central tenets of the movement was the assertion that artworks cannot be conceived of individually, as unconnected objects of aesthetic fascination. On the contrary, artistic production should be harnessed to a program of aesthetic and social integration. For this reason it is not surprising that some of the most convincing manifestations of de Stijl thinking appear in three-dimensional works such as architecture, interior design, and sculpture. Few de Stijl buildings remain standing. Their plans—and the ideas motivating them—were widely disseminated in the years immediately following the war, contributing significantly to the international development of modern architecture.

The formative influences on de Stijl architects were H. P. Berlage and Frank Lloyd Wright (see chapter 9). J. J. P. Oud, Robert van 't Hoff, and Gerrit Rietveld, three of its principal architects, were also acquainted with the early modernists in Germany and Austria—Behrens, Loos, Hoffmann, and Olbrich—but their association with Mondrian and Van Doesburg had considerable influence on the forms that their architecture would take. Another important influence is to be found in the writings of M. H. J. Schoenmaekers, which also provided a philosophical base for Mondrian's painting and theorizing before 1917. Schoenmaekers propounded a mystical cosmology based on the rectangle. Inspired by Theosophy, his *Elements of Expressive Mathematics* (1916) sought to uncover the hidden relationships between natural forms. From such ideas arose an architecture of flat roofs, with plain walls arranged according to definite systems that create a functional and harmonious interior space.

In their aesthetic, the architects and artists of de Stijl were much concerned with the place of the machine and its function in the creation of a new art and a new architecture. They shared this concern with the Italian Futurists, with whom Van Doesburg corresponded (Severini was a regular corresponding member of de Stijl), but they departed from the emotional exaltation of the machine in favor of enlisting its power to create a new collective order. From this approach arose their importance for subsequent experimental architecture. Van Doesburg called architecture the "synthesis of all the arts" and said that it would "spring from human function" rather than from historical building types developed in a time when the patterns of domestic life had little in common with modern lifestyles.

Vantongerloo

Free-standing sculpture, like architecture, guides a viewer's experience of space and time as well as of form and color. Sculpture refuses to divulge its content completely to a viewer who remains static. Experiments in sculpture by de Stijl artists generally engage many of the same principles and problems addressed by architecture. In sculpture the achievements of de Stijl were concentrated principally in the works of the Belgian **Georges Vantongerloo** (1886–1965). He was not only a sculptor but also a painter, architect, and theoretician. His first abstract sculptures (fig. **13.8**), executed in 1921, were conceived in the traditional sense as masses carved out of the block, rather than as constructions built up of separate elements. They constitute notable transformations of de Stijl painting into three-dimensional design. Later, Vantongerloo turned to open construction, sometimes in an architectural form and sometimes in free linear patterns. In his subsequent painting and sculpture he frequently deserted the straight line in favor of the curved, but throughout his career he maintained an interest in a mathematical basis for his art, to the point of deriving compositions from algebraic equations.

13.8 Georges Vantongerloo, *Construction of Volume Relations*, 1921. Mahogany, 16⅛ × 5⅝ × 5¾" (41 × 14.4 × 14.5 cm), including base. The Museum of Modern Art, New York.

13.9 Robert van 't Hoff, Huis ter Heide, 1916. Utrecht, the Netherlands.

Van 't Hoff and Oud

The actual buildings created by these architects before 1921 were not numerous. A house built by **Robert van 't Hoff** (1852–1911) in Utrecht in 1916 (fig. **13.9**) antedated the formation of de Stijl and was almost entirely based on his firsthand observations of Wright's work in Chicago, as may be seen in the cantilevered cornices, the grouping of windows, the massing of corners, as well as the severe rectangularity of the whole. Van 't Hoff was an adventurous designer, at least in his theories. He was the first member of de Stijl to discover the Futurist architect Sant'Elia, about whose unfulfilled projects (see fig. 10.21) he wrote in *de Stijl*. The unrealized project that **J. J. P. Oud** (1890–1963) prepared for seaside housing on the Strand Boulevard at Scheveningen, the Netherlands, in 1917 displays the future International Style housing strategy in a flat-roofed, terraced row of repeated individual rectangular units. A 1919 project by Oud for a small factory was a combination of cubic masses alternating effectively with vertical chimney pylons and horizontal windows in the Wright manner. Instead of the typical early Wright pitched roof, however, these architects, almost from the beginning, opted for a flat roof, thus demonstrating a relationship to de Stijl painters. In the best-known and in many ways most influential of his early buildings, the 1924–27 housing project for workers at Hook of Holland (fig. **13.10**), Oud employed wraparound, curved corners on his façades and solidly expressed brickwork in a manner that suggested a direct line of influence from Berlage, despite the rectangularity and openness of the fenestration and the flat roofs. The workers' houses had an importance beyond their stylistic influence as an early example of enlightened planning for well-designed, low-cost housing. In the façade design of the Café de Unie in Rotterdam (fig. **13.11**), Oud almost literally translated a 1920s Mondrian painting into architectural terms, at the same time illustrating the possibilities of de Stijl for industrial, poster, and typographic design. The café was destroyed in the bombing of Rotterdam in 1940 during World War II.

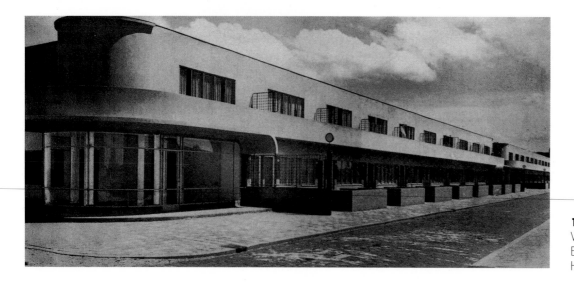

13.10 J. J. P. Oud, Workers' Housing Estate, 1924–27. Hook of Holland.

Rietveld

The most complete statement of de Stijl architecture is Schröder House (fig. **13.12**), designed by **Gerrit Rietveld** (1888–1964) as a commission from Mrs. Truus Schröder-Schräder, who collaborated closely with Rietveld on its design. Mrs. Schröder lived in the house for sixty years and, toward the end of her life, initiated the Rietveld Schröder House Foundation, which oversaw its complete renovation between 1974 and 1987. Rietveld used detached interlocking planes of rectangular slabs, joined by unadorned piping, to break up the structure, giving the whole the appearance of a Constructivist sculpture. The large corner and row windows give ample interior light; cantilevered roofs shelter the interior from the sun; and, according to Mrs. Schröder's requirements, sliding partitions created open-plan spaces for maximum flexibility of movement. The rooms are light, airy, and cool, thus planned to create a close relationship between the interior spaces and exterior nature.

Trained as a cabinetmaker, Rietveld also designed furniture, which assumed a role much like functional sculpture within de Stijl interiors. His 1923 *Red and Blue Chair*

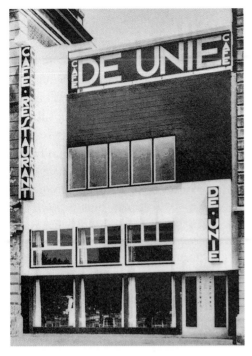

13.11 J. J. P. Oud, Café de Unie, 1925. Destroyed 1940. Rotterdam, the Netherlands.

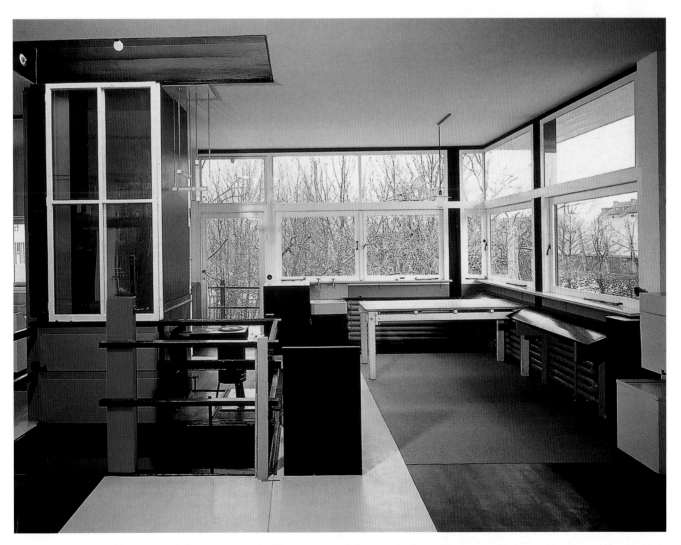

13.12 Gerrit Rietveld, Living and dining area, Schröder House, with furniture by Rietveld.

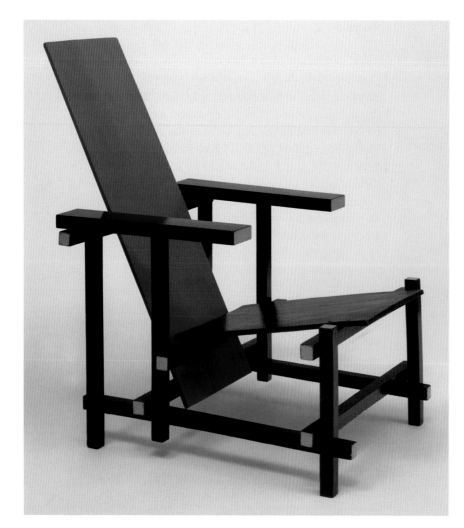

13.13 Gerrit Rietveld, *Red and Blue Chair*, 1917. Painted wood, height 34½" (87.6 cm). The Museum of Modern Art, New York.

classical balance than of dynamic equilibrium. "The construction," the artist wrote, "is attuned to the parts to insure that no part dominates or is subordinate to the others. In this way the whole stands freely and clearly in space, and the form stands out from the material." Fundamental to de Stijl philosophy was this sense of the integral relationship between the whole and its constituent parts. Rietveld's influence was keenly felt at the Bauhaus art school, whose director Walter Gropius shared his commitment to aesthetic unity and pointed to his designs as exemplary models for students. Until his death in 1964, Rietveld remained one of the masters of Dutch architecture, receiving many major commissions, of which the last was the Van Gogh Museum in Amsterdam, begun in 1967.

Van Eesteren

Cornelis van Eesteren (1897–1988) collaborated with Van Doesburg on a number of architectural designs during the 1920s, including a project for a house that was one of the most monumental efforts in de Stijl domestic architecture attempted to that date. In contrast with Rietveld's approach, the palatial edifice of the projected Rosenberg House (fig. **13.14**) emphasized the pristine rectangular masses of the building, coordinated as a series of wings spreading out from a central core, defined by the strong vertical accent of the chimney pier in the mode of Wright. In the central mass they opened up the interior space with cantilevered terraces. Van Eesteren was also an influence on Gropius, who would likewise use cantilevered terraces in his design for the Bauhaus campus, discussed in the next chapter.

(fig. **13.13**) is among the most succinct statements of de Stijl design. Rietveld first constructed the chair in plain wood in 1917, and painted it in 1923. The seat is blue, the back is red, and the sections of the frame are black with yellow ends. The simple, skeleton-like frame clearly discloses its structure, which, like all of Rietveld's furniture, eschews any sense of the luxurious or highly crafted object, for it was intended for mass production (which never took place). The tilted planes of the seat and back, which have parallels in the linear structures of some of Van Doesburg's paintings (see figs. 13.5, 13.6), convey less a sense of

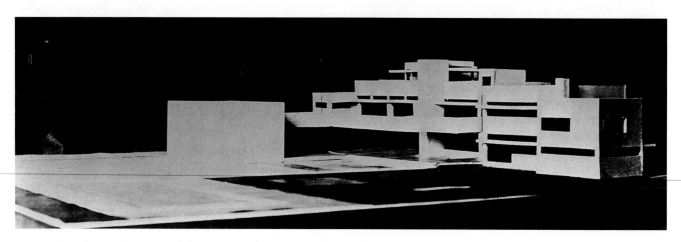

13.14 Cornelis van Eesteren and Theo van Doesburg, Project for Rosenberg House, 1923.

14
Bauhaus and the Teaching of Modernism

By 1918, progressive artists had introduced radical innovations to all areas of artistic production. Formal arts education, however, remained rooted in academic practices dating back to the seventeenth century. Since that time, specialization in a particular technique had been codified into the academic approach, a method that tended to maintain strict divisions between painting, sculpture, and architecture. Other forms of artistic production, including decorative or "applied" arts along with print-making and photography, were typically excluded from academy programs, which taught only "fine art." By the late nineteenth century, modern artists increasingly eschewed these narrow categories, demonstrating an eagerness to explore diverse media and techniques. Paul Gauguin, for instance, employed painting, carving, and printmaking in an effort to give shape to his aesthetic aims. Such experimentation had only become more frequent in the early twentieth century.

Another convention maintained by arts academies was the focus on nature as model. Life classes, in which students draw a nude model posed in the studio, remained a staple in arts education, even though the history paintings and the heroic or mythological sculptural programs for which life drawing formerly prepared students were no longer in great demand. Many avant-garde artists, such as Matisse and Picasso, received prolonged academic training before turning to new influences such as African sculpture or popular prints in an effort to shake loose academic habits. At the other extreme, artists like Henri Rousseau or Theo van Doesburg were largely self-taught, thus less encumbered by academic conventions.

One of the earliest experiments in progressive arts education unfolded in Russia during the early years of the Soviet Union. Narkompros (the People's Commissariat for Enlightenment) initiated an arts education division in 1920 called Inkhuk (the Institute of Artistic Culture). Administered and staffed by some of the leading lights of the Russian avant-garde including Malevich, Lissitzky, and Kandinsky, Inkhuk was closely monitored by the Soviet government for doctrinal orthodoxy (see chapter 10). Such tight oversight as well as the diverse views of the artists involved made it difficult to establish and adhere to a coherent curriculum.

A more successful program for progressive arts education, the Bauhaus, opened in 1918 in Weimar, capital of an unsteady postwar Germany. The new art school encountered a challenging proving ground in the nascent Weimar Republic (1918–33). Traumatized by the war, beset by financial difficulties imposed by their victorious enemies, threatened by an influenza epidemic, and riven by political factions, Germans were confronting an uncertain future. The brutal suppression of socialist and communist opposition to the new government signaled the regime's desperation. Growing popular resentment over the settlement of the peace and fear of accelerating economic privations soured much of the initial enthusiasm for a republican system of government. These conditions facilitated the rise of the National Socialist (Nazi) Party, whose leader Adolf Hitler assumed dictatorial powers in 1933. It was against this tumultuous backdrop that the Bauhaus transformed modern arts education, creating a system that endures today.

From its inception until 1928, the Bauhaus was under the direction of the architect Walter Gropius. Gropius provided the Bauhaus with the strong—some even felt autocratic—leadership and coherent vision missing from the Russian Constructivists' program at Inkhuk. It was Gropius' commitment to functionalism, his sympathy for Constructivist ideas, and his belief that art could improve society that launched this unparalleled institution. Any serious discussion of the Bauhaus must begin with a consideration of Gropius' work and career.

Audacious Lightness: The Architecture of Gropius

Many German artists who emerged from World War I resolved to place their art in the service of social

betterment, to develop a new culture that would guide society toward political harmony and prosperity. **Walter Gropius** (1883–1969) not only epitomizes this attitude, but he put his beliefs into practice with a determination that few could match. This resoluteness emerged early in his career. Gropius was not naturally gifted at drafting. While many would have accepted this shortcoming as an insurmountable barrier to becoming a professional architect, Gropius turned the deficit to his advantage. Throughout his career, he relied on draftsmen to render his designs, a practice that left him with more time for creative thinking and teaching. His training included two years (1908–10) in the office of Peter Behrens (see chapter 9), where he adopted the view that industry and design could benefit through integration. Thanks to Behrens' influence, Gropius maintained an unwavering commitment to the belief that modern technologies and manufacturing practices could be used to serve aesthetic ends. During his time with Behrens, Gropius became acquainted with other young architects with whom he would maintain long associations, including **Adolph Meyer** (1881–1929) and Ludwig Mies van der Rohe.

Gropius left Behrens' firm in 1910 to establish a practice with Meyer in Berlin. The following year, they designed a factory for the Fagus Shoe Company at Alfeld-an-der-Leine (fig. **14.1**). The Fagus building represents a sensational innovation in its utilization of complete glass sheathing, even at the corners. In effect, Gropius here had invented the curtain wall that would play such a visible role in the form of subsequent large-scale twentieth-century architecture.

Gropius and Meyer were commissioned to build a model factory and office building in Cologne for the 1914 Werkbund Exhibition of arts and crafts and industrial

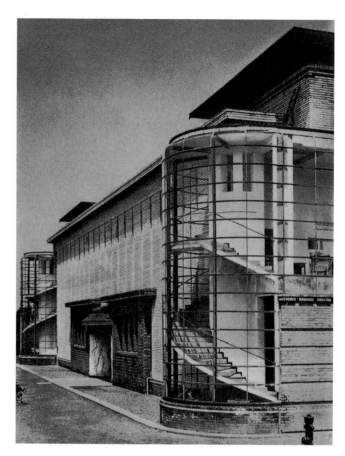

14.2 Walter Gropius and Adolph Meyer, Model Factory at the Werkbund Exhibition, 1914. Cologne.

objects (fig. **14.2**). Gropius felt that factories should possess the monumentality of ancient Egyptian temples. For one façade of their "modern machine factory," the architects combined massive brickwork with a long, horizontal expanse of open glass sheathing, the latter most effectively used to encase the exterior spiral staircases at the corners (clearly seen in the view reproduced here). The pavilions at either end have flat overhanging roofs derived from Frank Lloyd Wright (see fig. 9.3), whose work was known in Europe after 1910, and the entire building reveals the elegant and disciplined design that became a prototype for many subsequent modern buildings.

World War I temporarily prevented further collaborations between Gropius and Meyer. Accepting an officer's commission, Gropius served on the front lines. In 1915, he married Alma Mahler, whose intense affair with the Expressionist painter Oskar Kokoschka had recently ended. With the conclusion of the war in 1918, Gropius was called to revive and direct one of the many cultural institutions neglected during the war, including the School of Industrial Art (Kunstgewerbeschule Sachsen) that Henry van de Velde had organized in Weimar in 1904. The school had been founded on Arts and Crafts principles of social utility and unity of the arts. Gropius shared these ideas, but would modify radically the curriculum and organization of the school, which he renamed Bauhaus.

During his years as director of the Bauhaus, Gropius continued his own architectural practice in collaboration

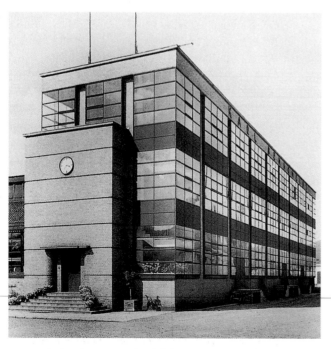

14.1 Walter Gropius and Adolph Meyer, Fagus Shoe Factory, 1911–25. Alfeld-an-der-Leine, Germany.

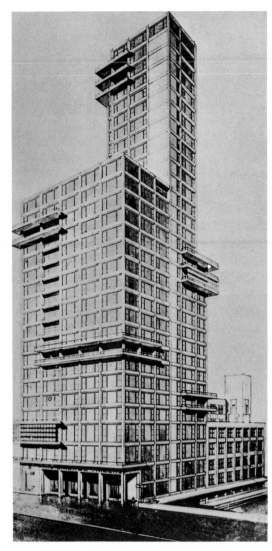

14.3 Walter Gropius and Adolph Meyer, Design for the Chicago Tribune Tower, 1922.

with Meyer. One of their unfulfilled projects was the design for the Chicago Tribune Tower in 1922 (fig. **14.3**). The highly publicized competition for the design of this tower, with over 250 entries from architects worldwide, provides a cross-section of the eclectic architectural tendencies of the day, ranging from strictly historicist examples based on Renaissance towers to the modern styles emerging in Europe. The traditionalists won the battle with the neo-Gothic tower designed by the American architect Raymond Hood (probably in collaboration with John Mead Howells). The design of Gropius and Meyer, with the spare rectangularity of its forms, its emphasis on skeletal structure, and its wide tripartite windows, was based on the original skyscraper designs of Sullivan and the Chicago School (see fig. 4.14, 4.15) and also looked forward to the skyscrapers of the mid-twentieth century.

The Building as Entity: The Bauhaus

Upon taking charge of the Weimar School of Industrial Art, Gropius immediately set about reorganization. The institution had become moribund due to the war and

the resulting dismissal of Van de Velde, a Belgian and, therefore, subject to expulsion as a foreigner. As was the case with the Arts and Crafts and the Deutscher Werkbund traditions, which had informed Van de Velde's program of teaching in workshops rather than studios, Gropius was convinced of the need for the creations of architect, artist, and craftsman to form a unified whole. His program was innovative, not in its insistence that the architect, the painter, and the sculptor should work with the craftsperson, but in specifying that they should *be* craftspeople first of all. The concepts of learning by doing, of developing an aesthetic on the basis of sound craft skills, and of breaking down barriers between "fine art" and craft were fundamental to the Bauhaus philosophy, as was a reconciliation between craft and industry (see Gropius, *Bauhaus Manifesto*, below).

As he wrote in 1923, "The Bauhaus believes the machine to be our modern medium of design and seeks to come to terms with it." This shift toward a machine aesthetic was no doubt due in part to the influence of Constructivism and the presence in Weimar by 1921 of the de Stijl artist Theo van Doesburg.

The first proclamation of the Bauhaus declared:

Architects, painters, and sculptors must recognize anew the composite character of a building as an entity. … Art is not a "profession." There is no essential difference between the artist and the craftsman. The artist is an exalted craftsman. … Together let us conceive and create the new building of the future, which will embrace architecture and sculpture and painting in one unity and which will rise one day toward heaven from the hands of a million workers like the crystal symbol of a new faith.

This initial statement reflected a nostalgia for the medieval guild systems and collective community spirit that lay behind the building of the great Gothic cathedrals, as well as expressing the socialist idealism current in Germany during the infancy of the Weimar Republic, as it was throughout much of postwar Europe. But as Germany—and especially the conservative city of Weimar—grew more reactionary, suspicion of this political attitude caused antagonism toward the school, an antagonism that in 1925 drove the Bauhaus to its new home in Dessau.

Bauhaus Dessau

The growing industrial town of Dessau offered Gropius the perfect site for relocation. Not only would Dessau facilitate his desire to knit the aims of industry and art, the region also was less conservative than Weimar, thus more tolerant of the Bauhaus' socialist leanings. With the move to Dessau, Gropius closed his Weimar office in 1925, ending his partnership with Meyer. He could now focus his attention on giving full expression to his ideas through his design for the new campus at Dessau (fig. **14.4**). Here, Gropius was able to realize one of the clearest statements of functionalism. These buildings, finished in 1926, incorporated a complex of classrooms, studios, workshops, library, and living quarters for faculty and students. The workshops consisted of a glass box rising four stories and presenting the curtain wall, the glass sheath or skin, freely suspended from the structural steel elements. The form of the workshop wing suggests the uninterrupted spaces of its interior. On the other hand, in the dormitory wing, the balconies and smaller window units contrasting with clear expanses of wall surface imply the broken-up interiors of individual apartments.

The asymmetrical plan of the Bauhaus is roughly cruciform, with administrative offices concentrated in the broad, uninterrupted ferro-concrete span of the bridge linking workshops with classrooms and library. In every way, the architect sought the most efficient organization of interior space. At the same time he was sensitive to the abstract organization of the rectangular exterior—the relation of windows to walls, concrete to glass, verticals to horizontals, lights to darks. The Bauhaus combined functional organization and structure with a geometric, de Stijl-inspired design. Not only were the buildings revolutionary in their versatility and in the application of abstract principles of design based on the interaction of verticals and horizontals, but they also embodied a new concept of architectural space. The flat roof of the Bauhaus and the long, uninterrupted planes of white walls and continuous window voids create a lightness that opens up the space of the structure. The interior was furnished with designs by Bauhaus students and faculty, including Gunta Stölzl's tapestries and Marcel Breuer's tubular-steel furniture (see p. 310). The building was seriously damaged in World War II and underwent limited renovation in the 1960s. It was finally restored to its original appearance in the 1970s. Since the reunification of

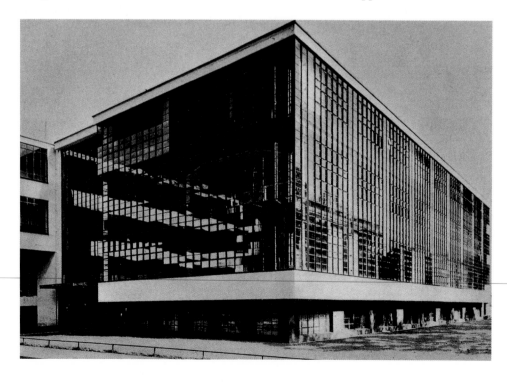

14.4 Walter Gropius, Workshop wing, Bauhaus, 1925–26. Dessau, Germany.

Germany in 1990, this landmark building has become the focus of new studies and a site for historical exhibitions related to the Bauhaus.

The move to Dessau coincided with increased funding from the state and the elevation of some former Bauhaus students to positions as teachers. The latter helped to integrate the curriculum, bringing the school closer into line with Gropius' original plan. It was also in Dessau that the accent on craft declined, while the emphasis on architecture and industrial design substantially increased. The architecture students were expected to complete their training in engineering schools. Gropius said:

> We want to create a clear, organic architecture, whose inner logic will be radiant and naked, unencumbered by lying façades and trickeries; we want an architecture adapted to our world of machines, radios, and fast motor cars, an architecture whose function is clearly recognizable in the relation of its form. … [W]ith the increasing strength of the new materials—steel, concrete, glass—and with the new audacity of engineering, the ponderousness of the old methods of building is giving way to a new lightness and airiness.

Gropius' theories were disseminated in Bauhaus publications, including the influential *Bauhausbücher* (Bauhaus books). Designed in the school's advertising and typography studios, the Bauhaus books included essays and reproductions of artworks, helping to propagate the school's aesthetic and social principles. In addition to its theoretical publications, the Bauhaus produced catalogues of furniture and other household items for sale. Gropius was intent on bridging the divide between artisan and consumer that had undermined Morris and Company's attempt to bring finely crafted furnishings into middle- and working-class households in the previous century. With the adoption of mechanized production methods, Bauhaus products were generally more affordable than Morris and Company's.

The *Vorkurs*: Basis of the Bauhaus Curriculum

The Bauhaus curriculum was initially divided into two broad areas: problems of craft and problems of form. Each course had a "form" teacher and a "craft" teacher. This division was necessary because, during the school's early years in Weimar, it was not possible to assemble a faculty who were collectively capable of integrating the theory and practice of painting, sculpture, architecture, design, and crafts—although in practice several instructors taught both the *Vorkurs*, or foundation course, and workshop courses. The Swiss painter and textile artist Johannes Itten designed the *Vorkurs* as a six-month introduction to design principles as well as to a variety of media and techniques. Itten, like subsequent instructors of the foundation course,

exerted a particularly strong influence on the program and students through the integration of design and social theory in the *Vorkurs*. Itten's personal emphasis on spirituality and on developing personal responses to design problems conflicted with Gropius' interest in subordinating individual genius to a communal approach. After Itten left in 1923, the foundation course was given by László Moholy-Nagy and Josef Albers, each teaching in accordance with his own ideas. Paul Klee and Vasily Kandinsky also taught the course. Each of these artists left his mark on the Bauhaus curriculum, just as each influenced the development of modern art and pedagogy.

Moholy-Nagy

László Moholy-Nagy (1895–1946) was an important educator and advocate for abstract art, Constructivism, functional design, architecture, and, especially, experimental photography. A Hungarian trained in law, Moholy-Nagy was wounded on the Russian front during World War I, when Austria–Hungary fought—and was ultimately defeated—as part of the Central Powers. During his long convalescence, Moholy-Nagy became interested in painting. In the tumultuous years following the war, the political Left gained momentum in Hungary, resulting in a short-lived revolutionary government until 1919. By the end of that year, with the restoration of a counter-revolutionary regime intolerant of intellectual dissent, Moholy-Nagy left Budapest, first for Vienna, then for Berlin. He soon became a significant force in the remarkably diverse artistic environment of postwar Berlin, which during the 1920s was an international crossroads for members of the avant-garde. In Berlin, Moholy-Nagy met the de Stijl artist Theo van Doesburg, as well as the Dadaist Kurt Schwitters and other artists associated with Der Sturm Gallery. His encounter with the work of avant-garde Russian artists, including Malevich (see fig. 10.31) and El Lissitzky (see figs. 10.33–10.35), triggered an immediate response in his own work, as did his discovery of Naum Gabo's *Realistic Manifesto*, which had been published in a Hungarian communist journal (see chapter 10).

By 1921 Moholy-Nagy's interests had begun to focus on elements that dominated his creative expression for the rest of his life—light, space, and motion. He explored transparent and malleable materials, the possibilities of abstract photography, and the cinema. Beginning in 1922, Moholy-Nagy pioneered the creation of light-and-motion machines built from reflecting metals and transparent plastics. The first of these kinetic, motor-driven constructions, which he named "light–space modulators," was finally built in 1930 (fig. **14.5**). When the machines were set in motion, their reflective surfaces cast light on surrounding forms. During the 1920s, Moholy-Nagy was one of the chief progenitors of mechanized kinetic sculpture, but a number of his contemporaries, including Gabo, Tatlin (see fig. 10.37), and Rodchenko (see fig. 10.39), were also exploring movement in sculpture.

14.5 László Moholy-Nagy, *Light–Space Modulator*, 1922–30. Kinetic sculpture of steel, plastic, wood, and other materials with electric motor, 59½ × 27½ × 27½" (151.1 × 69.9 × 69.9 cm). Busch-Reisinger Museum, Harvard University Art Museums, Cambridge, MA.

Moholy-Nagy met Gropius in 1922 at Der Sturm. He made such an impression that Gropius invited him to become a teacher at the Weimar Bauhaus. A student, the photographer Paul Citroën (see p. 311), described Moholy-Nagy's arrival: "Like a vigorous, eager dog, Moholy burst into the Bauhaus circle, ferreting out with unfailing scent the still unsolved, still tradition-bound problems in order to attack them." In sharp contrast to the intuitive, mystical teaching methods of his predecessor Johannes Itten, Moholy-Nagy, a committed exponent of the Constructivist alliance of art and technology, stressed objectivity and scientific investigation in the classroom.

During his time at the Bauhaus Moholy-Nagy made abstract paintings, clearly influenced by El Lissitzky and Malevich, produced three-dimensional constructions, and worked in graphic design. Always alert to ways of exploring the potential of light for plastic expression, Moholy-Nagy also became an adventurous photographer. Apparently unaware of Man Ray's technically identical Rayograms, Moholy-Nagy developed his own cameraless images in 1922, just a few months after Ray. Both artists' discoveries attest to the highly experimental nature of photography in the 1920s. Moholy-Nagy and his wife Lucia, who collaborated with him until 1929, called their works "photograms" (fig. **14.6**). However, unlike Man

Ray, with his interest in the surreality of images discovered by automatic means, Moholy-Nagy remained true to his Constructivist aesthetic and used the objects placed on light-sensitive paper as "light modulators"—materials for exercises in light. As in the example illustrated, the overlapping, dematerialized shapes of the photogram form abstract compositions that are set in motion purely by the manipulation of light. Moholy-Nagy regarded the camera as an instrument for extending vision and discovering forms otherwise unavailable to the naked eye. In the "new vision" of the world presented in his 1925 Bauhaus book *Malerei Fotografie Film* ("Painting Photography Film"), the artist included not only his own photographic works but also scientific, news, and aerial photographs, all of them presented as works of art. In addition to the abstract photograms, he made photomontages and practiced straight photography. Like Rodchenko (see fig. 10.41), he was partial to sharply angled, vertiginous views that bring to mind the dynamic compositions of Constructivist painting. About his 1928 aerial view taken from Berlin's Radio Tower (fig. **14.7**), itself a symbol of new technology, Moholy-Nagy wrote: "The receding and advancing values of the black and white, grays and textures, are here reminiscent of the photogram." To him, the camera was a graphic tool equal to any as a means of rendering reality and disclosing its underlying purity of form. And so he wrote in a frequently quoted statement: "The illiterate of the future will be ignorant of camera and pen alike."

14.6 László Moholy-Nagy, *Untitled*, c. 1940. Photogram, silver bromide print, 20 × 16" (50 × 40 cm). The Art Institute of Chicago. Gift of George and Ruth Barford.

14.7 László Moholy-Nagy, *Untitled* (looking down from the Radio Tower, Berlin), c. 1928. Gelatin-silver print, 14¼ × 10" (36.2 × 25.6 cm). The Art Institute of Chicago, Julien Levy Collection.

Moholy-Nagy was, until 1928, a principal theoretician in applying the Bauhaus concept of art to industry and architecture. Following Gropius' resignation that year, and the ensuing emphasis at the Bauhaus on practical training and industrial production over art and experimentation, Moholy-Nagy left the school.

Josef Albers

After studying widely in Germany, **Josef Albers** (1888–1976) entered the Bauhaus in 1920 as a student and, in 1923, was appointed to the faculty. While at the Bauhaus he met and married Anni Fleischmann, a gifted textile artist. In addition to his work in the foundation course, Albers taught furniture design and headed the glass workshop.

Albers' early apprenticeship in a stained-glass workshop contributed to his lifelong interest in problems of light and color within geometric formats. Returning to the medium of glass at the Bauhaus, Albers pointed to a means of making geometric abstraction part of a functional environment. Just as tapestry weaving or furniture crafting can be incorporated into an architectural work, so can colored glass windows. In his flashed glass pieces of the 1920s one can observe the transition from organic, free-form compositions of glass fragments to grid patterns, as in *City* (fig. **14.8**), in which the relations of each color strip to all the others are meticulously calculated. To create these compositions, Albers invented a painstaking technique of sand-blasting and painting thin layers of opaque glass, which he then baked in a kiln to achieve a hard, radiant surface. The title of this work highlights its resemblance to an

14.8 Josef Albers, *City*, 1928. Sand-blasted colored glass, 11 × 21⅜" (27.9 × 54.9 cm). Kunsthaus, Zurich.

International Style skyline. In fact, Albers adapted this composition in 1963 for a fifty-four-foot-wide (16.4 m) mural, which he called *Manhattan*, that was commissioned for New York's Pan Am Building (now the MetLife Building). Albers' time in the United States will be discussed later in this chapter.

Klee

Introduced earlier in the context of Der Blaue Reiter (see chapter 7), **Paul Klee** (1879–1940) served in the German army in World War I immediately after the breakup of the group in 1914. In 1920 Gropius invited him to join the staff of the Bauhaus at Weimar, and he remained affiliated with the school from 1921 to 1931, an enormously productive period for him. Becoming a teacher prompted the artist to examine the tenets of his own painting. It also strengthened his resolve to discover and elaborate rational systems for the creation of pictorial form. He recorded his theories in his copious notes and in publications of great significance for modern art, including his 1925 Bauhaus book, *Pedagogical Sketchbook*.

Klee's art, as differentiated from that of Mondrian or even of Kandinsky in his later phase, was always rooted in nature and was seldom completely abstract. His abstract works mainly date from his Bauhaus years, when he was especially close to Kandinsky (whose Bauhaus years are discussed below) and to the traditions of Russian Suprematism and Constructivism and Dutch de Stijl. He drew upon his great storehouse of naturalistic observations as his raw material, but his paintings were never based on immediately observed nature except in his early works and sketchbook notations. Yet even his abstract paintings have a pulsating energy that appears organic rather than geometric, seemingly evolved through a natural process of dynamic growth and transformation.

In both his teaching and his art, Klee wanted to bring about a harmonious convergence of the architectonic and the poetic. With their heightened emphasis on geometric structure and abstract form, his paintings and drawings (he saw no need to distinguish between the two) from the Bauhaus years reveal formal influences from his Constructivist colleagues. Yet Klee was above all an individualist. However much he absorbed from the Bauhaus Constructivists, his poetic and intuitive inventions provided a counterweight to the more scientific and objective efforts at the school.

Like Mondrian and Kandinsky, Klee was concerned in his teachings and his painting with the geometric elements of the work of art—the point, the line, the plane, the solid. To him, however, these elements had a primary basis in nature and growth. It was the process of change from one to the other that fascinated him. To Klee, a painting continually grew and changed in time as well as in space. In the same way, color was neither a simple means of establishing harmonious relationships nor a method of creating space in the picture. Color was energy. It was emotion that established the mood of the painting within which the line established the action.

Klee saw the creative act as a magical experience in which the artist was enabled in moments of illumination to combine an inner vision with an outer experience of the world, to create an image that was parallel to and capable of illuminating the essence of nature. Although it grew out of the traditions of Romanticism and specifically of Symbolism (see chapter 3), Klee's art represented a new departure. He believed that his inner truth, his inner vision, was revealed not only in the subject, the color, and the shapes as defined entities, but even more in the very process of creation. To start the creative process, Klee, a consummate draftsman, would begin to draw like a child; he said children, like the insane and "primitive" peoples, had the "power to see." He let the pencil or brush lead him until the image began to emerge. As it did, of course, his conscious experience and skills came back into play in order to carry the first intuitive image to a satisfactory conclusion. At this point, some other association, recollection, or fantasy would result in the poetic and often amusing titles that then became part of the total work. Because he placed such value on inner vision and the intuitive process of drawing, Klee's methods and theories had affinities with the automatist techniques of the Surrealists, who claimed him as a pioneer and included his work in their first exhibition in Paris in 1925 (see chapter 15). When two leading Surrealists, Masson and Miró, discovered Klee's art in 1922, they regarded the experience as one of great importance for their own work.

Klee discovered much of his iconography through teaching. As he used arrows to indicate lines of force for his students, these arrows began to creep into his work, where they are both formal elements and mysterious vectors of emotion. Color charts, perspective renderings, graphs,

14.9 Paul Klee, *Aum den Fisch (Around the Fish)*, 1926. 124. Oil and tempera on primed muslin on cardboard; original frame, 18⅜ × 25⅛" (46.7 × 63.8 cm). The Museum of Modern Art, New York. Abby Aldrich Rockefeller Fund.

rapidly drawn heads, plant forms, linear patterns, checker-boards—elements of all descriptions became part of that reservoir of subconscious visual experience, which the artist then would transform into magical imagery. Usually working on a small scale in a deliberately naive rendition, Klee scattered or floated these elements in an ambiguous space composed of delicate and subtle harmonies of color and light that add mystery and strangeness to the concept.

During the 1920s, Klee produced a series of black pictures in which he used oils, sometimes combined with watercolor. Some of these were dark underwater scenes where fish swam through the depths of the ocean surrounded by exotic plants, abstract shapes, and sometimes strange little human figures. These works, including *Around the Fish* (fig. **14.9**), embody an arrangement of irrelevant objects, some mathematical, some organic. Here the precisely delineated fish on the oval purple platter is surrounded by objects: some machine forms, some organic, some emblematic. A schematic head on the upper left grows on a long stem from a container that might be a

machine and is startled to be met head-on by a red arrow attached to the fish by a thin line. A full and a crescent moon, a red dot, a green cross, and an exclamation point are scattered throughout the black sky—or ocean depth—in which all these disparate signs and objects float. This mysterious, nocturnal still life typifies Klee's personal language of hieroglyphs and his use of natural forms merely as a point of departure into a fantastic realm. "The object grows beyond its appearance through our knowledge of its inner being," he wrote, "through the knowledge that the thing is more than its outward aspect suggests."

Made during Klee's Bauhaus years, *In the Current Six Weirs* (fig. **14.10**) is an arrangement of vertical and horizontal rectangles, in which gradations of deep color are contained within precisely ruled lines. Yet the total effect is organic rather than geometric, dynamic rather than static, with the bands continuing to divide as they move leftward. This and several similar abstract compositions of brilliantly colored strata were inspired by Klee's trip to Egypt in 1928–29 and are a response to the vast expanse and intense

14.10 Paul Klee, *In der Strömung sechs Schwellen (In the Current Six Weirs)*, 1929, 92. Oil and tempera on canvas; original frame, 16⅝ × 16⅝" (42.2 × 42.2 cm). Solomon R. Guggenheim Museum, New York.

14.11 Paul Klee, *Ad Parnassum*, 1932, 274. Oil and casein paint on canvas; original frame, 39⅜ × 49⅝" (100 × 126 cm). Kunstmuseum Bern, Dauerleihgabe des Vereins der Freunde des Kunstmuseums Bern (Society of Friends of Kustmuseum Bern).

light of the desert landscape. Most of Klee's paintings were in combinations of ink and watercolor, media appropriate to the delicate quality of fluidity that he sought; but this particular work combines oil and tempera, media used to obtain effects of particular richness and density.

Desiring more time for his art and frustrated by the demands of teaching and the growing politicization within the Dessau Bauhaus, Klee left the school in 1931 and took a less demanding position at the Düsseldorf Academy. During the early 1930s, he applied his own variety of Neo-Impressionism in several compositions, culminating in a monumental painting from 1932, *Ad Parnassum* (fig. **14.11**). Klee covered the canvas with patterns of thick, brightly colored daubs of paint. These are marshaled into distinctive forms by way of a few strong lines that conjure up a pyramid beneath a powerful sun. Like Kandinsky, Klee believed that pictorial composition was analogous to music and that sound can "form a synthesis with the world of appearances." Both he and his wife were musicians, and he applied the principles of musical composition, with all its discipline and mathematical precision, to his paintings and to his teaching. The title of this majestic work derives from a famous eighteenth-century treatise on musical counterpoint called, in Latin, *Gradus ad Parnassum* ("Stairway to Parnassus"), Parnassus being a mountain sacred to the Greek god Apollo and the Muses. Klee orchestrated color and line in his painting according to his own system of pictorial polyphony, creating a luminous, harmonious vision aimed at elevating the viewer into a higher, Parnassian realm.

In 1933, the year Hitler assumed power in Germany, Klee was dismissed from his position at the Düsseldorf Academy and returned to his native Bern in Switzerland. Figures, faces (sometimes only great peering eyes), fantastic landscapes, and architectural structures (sometimes menacing) continued to appear in his art during the 1930s. Perhaps the principal characteristic of Klee's late works

was his use of bold and free black linear patterns against a colored field. One of his last works, *Death and Fire* (fig. **14.12**), 1940, is executed with brutal simplicity, thinly painted on an irregular section of rough burlap. The rudimentary drawing, like the scrawl of a child, delineates a harrowing, spectral image, expressive perhaps of the burdens of artistic isolation, debilitating illness, and the imminent threats of war and totalitarianism. Klee died later that year.

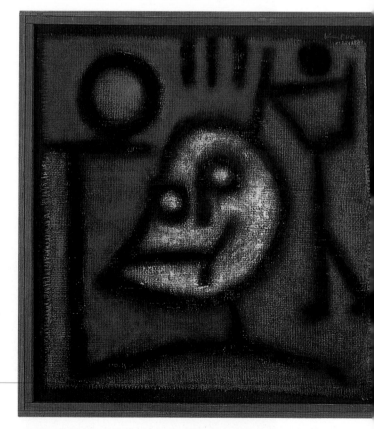

14.12 Paul Klee, *Tod und Feuer (Death and Fire)*, 1940, 332. Oil and colored paste on burlap; original frame, 18⅜ × 17½" (46.7 × 44.6 cm). Zentrum Paul Klee, Bern.

Kandinsky

Vasily Kandinsky (1866–1944) renewed his friendship with Klee when he returned to Germany from Russia in 1921, and in 1922 he joined the Weimar Bauhaus. One of the school's most distinguished faculty members, he taught a course called Theory of Form and headed the workshop of mural painting (regarded as superior to traditional easel painting at the school). Kandinsky's style underwent significant changes during his tenure at the Bauhaus. While he still adhered to the mystical Theosophical beliefs expressed in his seminal book from 1911, *Concerning the Spiritual in Art*, he had come to value form over color as a vehicle for expression, and his paintings evolved toward a more objective formal vocabulary. Even before coming to the Bauhaus, under the influence of Russian Suprematism and Constructivism, Kandinsky's painting had turned gradually from free Expressionism to a form of geometric abstraction. This evolution is evident in *White Line, No. 232* (see fig. 10.36), a painting he made in 1920 while still in Russia, which, despite expressive brushwork, contains clearly defined geometric and organic forms.

By 1923, in *Composition VIII* (fig. **14.13**), hard-edged shapes had taken over. As discussed in chapter 7, Kandinsky regarded the works that he named *Compositions* as the fullest expression of his art. Ten years had elapsed between *Composition VII*, 1913 (see fig. 7.17) and *Composition VIII*, and a comparison of the two paintings elucidates the changes that had taken place during this period. The deeply saturated colors and tumultuous collision of painterly forms in the 1913 picture are here replaced by clearly delineated shapes—circles, semicircles, open triangles, and straight lines—that float on a delicately modulated background of blue and creamy beige. The emotional climate of the later painting is far less heated than that of its predecessor, and its rationally ordered structure suggests that harmony has superseded the apocalyptic upheavals inhabiting the artist's prewar paintings.

Kandinsky fervently believed that abstract forms were invested with great significance and expressive power, and the spiritual basis of his abstract forms set him apart from Bauhaus teachers like Moholy-Nagy. "The contact of the acute angle of a triangle with a circle," he wrote, "is no less powerful in its effect than that of the finger of God with the finger of Adam in Michelangelo's [Creation of Man] painting." The circle, in particular, was filled with "inner potentialities" for the artist, and it took on a prominent

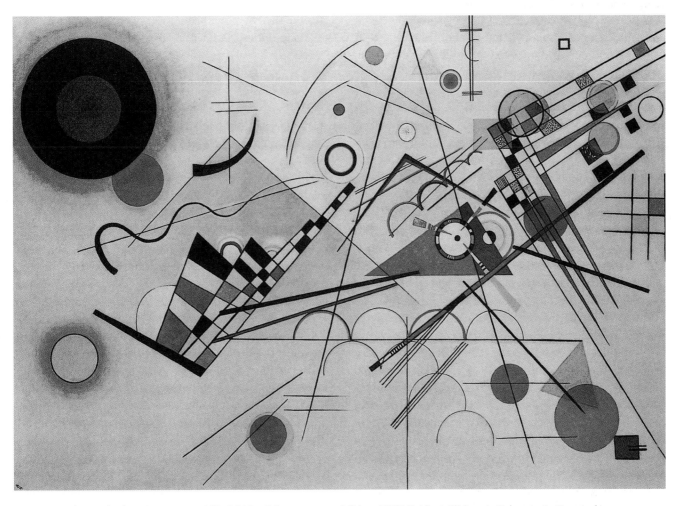

14.13 Vasily Kandinsky, *Composition VIII*, 1923. Oil on canvas, 55⅛ × 79⅛" (140 × 201 cm). Solomon R. Guggenheim Museum, New York.

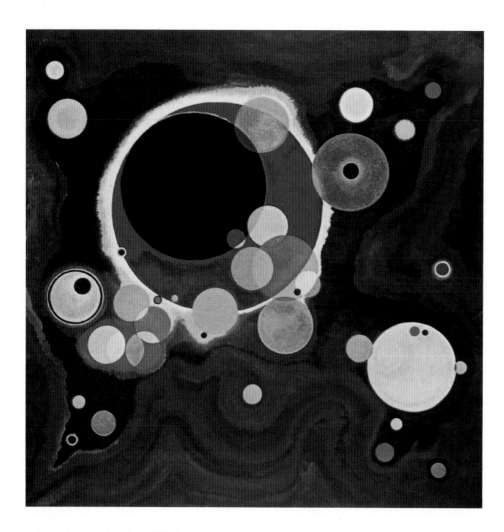

14.14 Vasily Kandinsky, *Several Circles, No. 323*, 1926. Oil on canvas, 55⅛ × 55⅛" (140 × 140 cm). Solomon R. Guggenheim Museum, New York.

role in his work of the 1920s. In *Several Circles, No. 323* (fig. **14.14**), the transparent color circles float serenely across one another above an indeterminate, gray-black ground, like planets orbiting through space. It is hardly surprising that the artist revered the circle as a "link with the cosmic" and as a form that "points most clearly to the fourth dimension."

In 1926 Kandinsky published, as a Bauhaus book, *Point and Line to Plane*, his textbook for a course in composition. As compared with Klee's *Pedagogical Sketchbook* of the previous year, Kandinsky's book attempts a more absolute definition of the elements of a work of art and their relations to one another and to the whole. Here the artist affirmed the spiritual basis of his art, and his correspondence of the time reveals a combination of the pragmatic and the mystical.

Kandinsky continued his association with the Bauhaus until the school was closed in 1933. At the end of that year he moved permanently to Paris, where he was soon involved in the Abstraction-Création group, organized in 1931 by artists hoping to promote the pursuit of pure abstraction. Through Abstraction-Création he became friendly with Miró, Arp, and Pevsner. This new environment heightened Kandinsky's awareness of the Surrealist activities of the 1920s, and one senses certain qualities akin to abstract Surrealism in the many works created after his move to France.

Die Werkmeistern: Craft Masters at the Bauhaus

Over the years the Bauhaus attracted one of the most remarkable art faculties in history. In addition to their duties teaching the *Vorkurs*, Klee and Kandinsky also taught painting, as did Lyonel Feininger and Georg Muche, among others. Herbert Bayer taught graphic arts, including advertising, typography, and book design. Oskar Schlemmer introduced students to innovations in stage design. Josef Albers ran the glass studio, and Gunta Stölzl directed the weaving workshop. The architect Marcel Breuer gave instruction in furniture design and fabrication. Pottery was taught by Gerhard Marcks, who was also a sculptor and graphic artist. In addition to the star-studded faculty, the Bauhaus frequently attracted distinguished foreign visitors, such as, in 1927, the Russian Suprematist painter Kazimir Malevich. As mentioned above, when the Bauhaus moved to Dessau, several former students joined the faculty, including Breuer and Bayer. These artist–teachers gained international renown for their innovative pedagogy as well as for their own creative production.

Schlemmer

German artist **Oskar Schlemmer** (1888–1943) taught design, sculpture, and mural painting at the Bauhaus from 1920 to 1929. During his years there, Schlemmer's real

passion was theater. In 1923 he was appointed director of theater activities at the school. When he moved to the new Dessau location in 1925 he set up the experimental Theater Workshop. Schlemmer's art—whether painting, sculpture, or the costumes he designed for his theatrical productions—was centered on the human body. While he applied the forms of the machine to the figure, he emphasized the need to strike a balance between humanist interests and the growing veneration at the Bauhaus for technology and the machine.

For his best-known production, *The Triadic Ballet*, Schlemmer encased the dancers in colored, geometric shapes made from wood, metal, and cardboard. Designed to limit the range of the dancers' movements, the costumes transformed the performers into abstracted, kinetic sculptures. Indeed, for exhibition purposes, Schlemmer mounted his "spatial–plastic" costumes as sculptures. As can be seen in his collage *Study for The Triadic Ballet* (fig. **14.15**), he envisioned the stage as an abstract, gridded space through which the performers moved according to mathematically precise choreography. The deep perspective space depicted

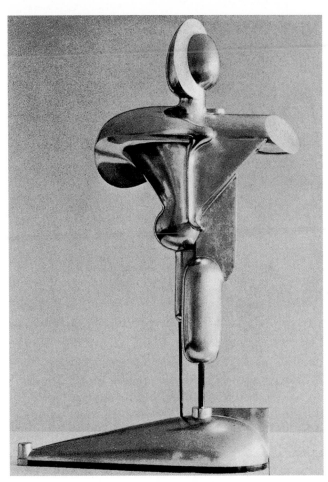

14.16 Oskar Schlemmer, *Abstract Figure*, 1923. Bronze (cast 1962 from original plaster), 42⅛ × 26⅜" (107 × 67 cm). Collection Frau Tut Schlemmer, Stuttgart.

here is similar to that of Schlemmer's paintings from this period. *The Triadic Ballet* was first performed in 1922 in the artist's native Stuttgart and was subsequently presented in several European cities.

Most of Schlemmer's sculptures were polychromed relief constructions, but in 1923 he made two free-standing sculptures, one of which was the original plaster for *Abstract Figure* (fig. **14.16**). For this large, imposing torso, Schlemmer sought the same clarity of form and geometric precision that he brought to his theatrical designs. With its gleaming surfaces and streamlined forms, the sculpture shines like the chassis of a new automobile.

Stölzl

The weaving workshop at the Bauhaus produced works that balanced perfectly the school's commitment to progressive design and utility. From 1925, the studio was directed by **Gunta Stölzl** (1897–1983), who had studied under Itten at the Bauhaus in Weimar. While Itten directed her to pursue a personal aesthetic vision through her weaving, she adapted to the functionalist vision of Gropius, expanding her practice to accommodate industrial materials. The rhythmic play of bands of color enlivens her abstract pieces as they embody an aesthetic integrity perhaps unique to weaving: the rhythm of moving the shuttle back and

14.15 Oskar Schlemmer, *Study for The Triadic Ballet*, c. 1921–23. Gouache, brush and ink, incised enamel, and pasted photographs on paper, 22⅝ × 14⅜" (57.5 × 37.1 cm). The Museum of Modern Art, New York.

14.17 Gunta Stölzl, *Tapestry*, 1922–23. Cotton, wool, and linen, 100¹³⁄₁₆ × 74" (256 × 188 cm). Harvard Art Museum, Busch-Reisinger Museum, Association Fund. BR49.669.

14.18 Marcel Breuer, Armchair, Model B3, Dessau, Germany. Late 1927 or early 1928. Chrome-plated tubular steel with canvas slings, 28⅛ × 30¼ × 27¾" (71.4 × 76.8 × 70.5 cm). The Museum of Modern Art, New York.

14.19 Herbert Bayer, Bauhaus Dessau, 1926. Letterpress, 8½ × 5⅞" (21.6 × 14.9 cm). The Museum of Modern Art, New York.

forth finds its echo in the pattern woven into the tapestry (fig. **14.17**). In this way, tapestry weaving offers one of the clearest expressions of the unity between artisan and work that theorists such as William Morris, Aleksandr Rodchenko, and Theo van Doesburg had urged artists to pursue. Until her resignation in 1931, Stölzl was the only woman in charge of a Bauhaus workshop. Though initially women were to be given equal status at the Bauhaus, Gropius grew alarmed at the number of women applicants and restricted them primarily to weaving, a skill he deemed suitable for female students.

Breuer and Bayer

The greatest practical achievements at the Bauhaus were probably in interior, product, and graphic design. For example, **Marcel Breuer** (1902–81) created many furniture designs at the Bauhaus that have become classics, including the first tubular-steel chair (fig. **14.18**). He said that, unlike heavily upholstered furniture, his simple, machine-made chairs were "airy, penetrable," and easy to move. Through Breuer's influence, a new vocabulary of simple, functional shapes was established in metal design. The courses in display and typographic design under **Herbert Bayer** (1900–85), along with Moholy-Nagy, Jan Tschichold, and others, revolutionized the field of type. Bayer developed a distinctive typography used in most Bauhaus publications (fig. **14.19**). Presented always

in lower case, Bayer's sans-serif type became synonymous with mid-century modernism. Bauhaus designs have passed so completely into the visual language of the modern age that it is now difficult to appreciate how revolutionary they were on first appearance. Certain designs, such as Breuer's tubular chair and his basic table and cabinet designs, Gropius' designs for standard unit furniture, and designs by other faculty members and students for stools, stacking chairs, dinnerware, lighting fixtures, textiles, and typography so appealed to popular tastes that they are still manufactured today (see *Industry into Art into Industry*, below).

"The Core from which Everything Emanates": International Constructivism and the Bauhaus

The Bauhaus, as envisioned by Gropius, can be understood as a blend of three major influences: the Arts and Crafts movement, with its integration of the arts and its insistence on the social role of art; the medieval guild system, which emphasized a collaborative, community-minded approach to artmaking over the Romantic emphasis on individual genius; and the aesthetic principles of Constructivism. Constructivist ideas reached the Bauhaus through a variety of sources, principally de Stijl—in the form of Theo van

14.20 Paul Citroën, *Metropolis*, 1923. Collage, printed matter, and postcards, 30 × 23" (76.5 × 58.5 cm). Printroom of the University of Leiden, the Netherlands.

Doesburg and the *de Stijl* magazine, the influence of teachers like Kandinsky, who had had firsthand experience with Russian Constructivism, and Moholy-Nagy. Students, such as **Paul Citroën** (1896–1983), made Constructivism central to their work, as evidenced by his iconic 1923 photomontage *Metropolis* (fig. **14.20**). Achieved by cutting and pasting, the image conveys the dynamism and chaos of modern urban life. Within the large thirty-by-twenty-three-inch format, Citroën crushed together such a towering mass of urban imagery that Moholy-Nagy called it "a gigantic sea of masonry," stabilized, however, by Constructivism's controlling principle of abstract design. Artists like Naum Gabo, Anton Pevsner, and Willi Baumeister, though neither students nor faculty members at the Bauhaus, nonetheless contributed to the school's engagement with Constructivism and, through associations with the Bauhaus faculty, helped to spread the school's ideas to an international audience.

Gabo

Following his departure from Russia in 1922, where the abstract art he had helped to evolve (see chapter 10) proved incompatible with the utilitarian policies of the Soviet regime, **Naum Gabo** (1890–1977) lived in

Germany until 1932, perfecting his Constructivist sculpture and contributing significantly, though indirectly, to Moholy-Nagy's ideas on light, space, and movement at the Bauhaus. Though not a member of the Bauhaus faculty, Gabo lectured there in 1928, published an important article in *Bauhaus* magazine, and was in contact with several Bauhaus artists. In 1922 eight of his sculptures were included in a huge exhibition of Russian art that traveled to Berlin and Amsterdam, helping to bring his work and that of other Russian abstract artists to an international audience. Like Moholy-Nagy, Gabo was a major practitioner of Constructivism in many media. At the same time, both artists demonstrated how the formal aspects of Constructivism were assimilated in the West without its political associations with the early, idealistic phase of communist revolution. As we saw in chapter 10, while Gabo sympathized with the initial aims of the revolution in Russia, he did not harness his art to specific ideas of collectivism and utilitarianism. Nevertheless, he shared Moholy-Nagy's utopian belief in the transformative powers of art. He encouraged modern artists to look to technology and the machine for forms and materials to express appropriately the aims of the new social order.

In Germany, Gabo continued the research he had begun in Russia. He explored the possibilities of new artistic media, particularly glass and recently developed plastic materials such as celluloid, to exploit a sense of planar transparency in his sculpture. For Diaghilev's 1927 ballet *La Chatte*, Gabo and his brother Anton Pevsner (see opposite) designed a set filled with large geometric sculptures in a transparent material that shone, in the words of one observer, with "quicksilver radiance." In 1931, Gabo took part in the international competition for the Palace of Soviets, a never-realized building that was to be a proud symbol in Moscow of the new Soviet Union. Several architects from the West also took part, including Le Corbusier and Gropius. Gabo, who had been searching for a form of architectural expression through his constructed sculpture, proposed a daring, winged structure of reinforced concrete.

In 1932, after Nazi stormtroopers came to his studio, Gabo left Germany for Paris, where he was active in the Abstraction-Création group, organized partly as an antidote to the influence of Surrealism, which will be addressed in the following chapter. His next move was to England, where between 1936 and 1946 he was active in the circle of abstract artists centering on Herbert Read, Ben Nicholson, Barbara Hepworth (see fig. 18.51), and Henry Moore (see fig. 18.50). Thereafter Gabo lived in the United States until his death in 1977.

Gabo's principal innovation of the 1940s was a construction in which webs of taut nylon string were attached to interlocking sheets of lucite, a clear plastic (fig. **14.21**). Over many years, Gabo made several versions of *Linear Construction in Space, No. 1* on different scales. In these he attained a transparent delicacy and weightlessness unprece-

14.21 Naum Gabo, *Linear Construction in Space, No. 1 (Variation)*. Lucite with nylon thread, 24½ × 24½" (62.2 × 62.2 cm). The Phillips Collection, Washington, D.C.

14.22 Naum Gabo, Construction for the Bijenkorf department store, 1956–57. Pre-stressed concrete, steel ribs, stainless steel, bronze wire, and marble, height 85' (25.9 m). Rotterdam, the Netherlands.

dented in sculpture. Like a drawing in space, the nylon filaments reflect light and gracefully articulate the void as positive form, transforming the space, according to Gabo, into a "malleable material element."

After emigrating to the United States in 1946, Gabo was able to realize his ambition to create large-scale public sculpture. His major architectural–sculptural commission was his 1956–57 monument for the new Bijenkorf department store in Rotterdam (fig. **14.22**), designed by the Bauhaus architect Marcel Breuer. The store was part of a massive postwar campaign to rebuild the city, which had been devastated by German bombs in 1940. Gabo's solution for the busy urban site was a soaring, open structure consisting of curving steel shafts that frame an inner abstract construction made of bronze wire and steel. Gabo likened the sculpture, with its tremendous weight anchored in the ground, to the form of a tree.

Pevsner

Unlike his younger brother Gabo, **Anton Pevsner** (1886–1962) never taught at the Bauhaus, although he did, like Gabo, work within the Constructivist tradition. Pevsner left Russia in 1923 and settled permanently in Paris, where he exhibited with his brother in 1924. At this time he began to work seriously in abstract constructed sculpture. Commissioned by the Société Anonyme in 1926 (see chapter 11), his *Portrait of Marcel Duchamp* is an open plastic construction with obvious connections to Gabo's *Constructed Head No. 1* of 1915. By the end of the

1920s, however, Pevsner had nearly abandoned construction in transparent plastics in favor of abstract sculpture in bronze or copper. In 1932 he joined the Abstraction-Création group in Paris and, like Gabo, contributed to their journal.

In his 1938–39 *Projection into Space* (fig. **14.23**), Pevsner realized his idea of "developable surface" or sculpture realized from a single, continuously curving plane. *Projection into Space* is polished bronze, not cast but hammered out to machine precision. Despite the geometric precision of his work, Pevsner denied any mathematical basis in its organization. The structure of *Projection into Space* invites viewing from multiple vantage points, carrying the eye of the spectator around the perimeter, while the dynamic, spiraling planes give the illusion of movement in a static design. This quality was explored in such Futurist sculptures as Boccioni's *Development of a Bottle in Space* (see fig. 10.18), but the elimination of all representation in Pevsner's work heightens the sense of dynamism.

Pevsner carried out several large architectural commissions. The *Dynamic Projection in the 30th Degree* at the University of Caracas, Venezuela, enlarged from a smaller bronze version, is more than eight feet (2.43 m) high. This sculpture centers around a sweeping diagonal form that thrusts out from the center at a thirty-degree angle from the compressed waist of the vertical, hourglass construction. In this form, Pevsner combines solidity of shape with the freedom of a vast pennant seemingly held rigid by the force of a tornado wind.

14.23 Anton Pevsner, *Projection into Space*, 1938–39. Bronze and oxidized copper, 21½ × 15¾ × 19½" (54.6 × 40 × 50.2 cm). Private collection, Switzerland.

Baumeister

Like Schlemmer, **Willi Baumeister** (1889–1955) was a pupil of Adolf Hoelzel at the Stuttgart Academy. He collaborated with both artists on a mural project in 1914 and frequently exhibited with Schlemmer in Germany. Throughout the interwar years, he was in contact with an international group of artists ranging from Le Corbusier and Léger to Malevich and Moholy-Nagy. He exhibited in Paris in the 1920s, and became a member of Cercle et Carré and Abstraction-Création during 1930 and 1931. Although he never served on the Bauhaus faculty, he associated with several artists at the school and contributed to its magazine.

Baumeister's mature work was affected by Cubism and Purism as well as by Schlemmer's machine-based figurative style. Following World War I, during which he served in the German army, Baumeister made a series of shallow relief constructions called *Mauerbilder* (wall pictures). In one example from 1923 (fig. **14.24**), geometric forms surround a highly schematized figure. While some of these forms are painted directly on the wooden support, others are sections of wood applied to the surface. A decade earlier, Archipenko, whose work was no doubt known to Baumeister, was experimenting with similar techniques in Paris (see fig. 8.30). By the early 1930s, organic shapes

appeared among the artist's machine forms, evidence of his interest in Surrealism and the paintings of Paul Klee. In such works as *Stone Garden I*, Baumeister added a textural element by building up his surfaces sculpturally with sand and plaster. During the Nazi regime, when he was branded a "degenerate artist," Baumeister painted in secret, advancing his own ideas toward freer abstraction—ideograms with elusive suggestions of figures. These signs came from the artist's imagination, but were based on his studies of the art of ancient civilizations, such as Mesopotamia.

From Bauhaus Dessau to Bauhaus U.S.A.

Gropius resigned as director of the Bauhaus in 1928 to work full-time in his architectural practice. He was succeeded by Hannes Meyer, a Marxist who placed less emphasis on aesthetics and creativity than on rational, functional, and socially responsible design. Meyer increasingly politicized the curriculum at the Bauhaus and stressed practical, industrial training over artistic production. This trend eventually led to Schlemmer's resignation. Meyer was forced to leave the Bauhaus in 1930, and Ludwig Mies van der Rohe (Gropius' first choice in 1928) assumed the directorship.

Mies van der Rohe

The spare, refined architecture of **Ludwig Mies van der Rohe** (1886–1969), built on his edict that "Less is more," is synonymous with the modern movement and the International Style. He has arguably had a greater impact on the skylines of American cities than any other architect. His contribution lies in the ultimate refinement of the basic forms of the International Style, resulting in some of its most famous examples. Some of the major influences on Mies were: his father, a master mason from whom he initially gained his respect for craft skills; Peter Behrens (see chapter 9), in whose atelier he worked for three years; and Frank Lloyd Wright. From Wright, Mies gained his appreciation for the open, flowing plan and for the predominant horizontality of his earlier buildings. He was affected not only by Behrens' famous turbine factory (see fig. 9.12), but also by Gropius' 1911 Fagus Factory (see fig. 14.1), with its complete statement of the glass curtain wall. Gropius had worked in Behrens' office between 1907 and 1910, and the association between Gropius and Mies that began there, despite a certain rivalry, continued. Mies' style remained almost conventionally Neoclassical until after World War I. Then, in the midst of the financial and political turmoil of postwar Germany, he plunged into the varied and hectic experimentation that characterized the Berlin School.

In 1921 and 1922 Mies completed two designs for skyscrapers, which, although never built, established the basis of his reputation. The first was triangular in plan, the second a free-form plan of undulating curves (fig. **14.25**).

14.24 Willi Baumeister, *Wall Picture with Circle II*, 1923. Oil and wood on wood panel, 46½ × 27⅛" (118 × 69 cm). Kunsthalle, Hamburg.

14.25 Ludwig Mies van der Rohe, Model for a glass skyscraper, 1922.

In these he proposed the boldest use yet envisaged of a reflective, all-glass sheathing suspended on a central core. As Mies wrote:

> Only in the course of their construction do skyscrapers show their bold, structural character, and then the impression made by their soaring skeletal frames is overwhelming. On the other hand, when the façades are later covered with masonry, this impression is destroyed and the constructive character denied. ... The structural principle of these buildings becomes clear when one uses glass to cover non-load-bearing walls. The use of glass forces us to new ways.

No comparably daring design for a skyscraper was to be envisaged for thirty or forty years. Because there was no real indication of either the structural system or the disposition of interior space, these projects still belonged in the realm of visionary architecture, but they were prophetic projections of the skyscraper.

Mies' other unrealized projects of the early 1920s included two designs for country houses, both in 1923, in brick (fig. **14.26**) and in concrete. The brick design so extended the open plan made famous by Frank Lloyd Wright that the free-standing walls no longer enclose rooms but instead create spaces flowing into one another. Mies fully integrated the interior and exterior spaces. The plan of this house, drawn with the utmost economy and elegance, and the abstract organization of planar slabs in the elevation exemplify Mies' debt to the principles of de Stijl (it has often been compared to the composition of a 1918 painting by Mies' friend Theo van Doesburg).

One of the last works executed by Mies in Europe was the German Pavilion for the Barcelona International Exposition in 1929 (fig. **14.27**)—Mies was in charge of Germany's entire contribution. The Barcelona Pavilion, destroyed at the end of the exhibition, has become one of the classics of his career and is perhaps the pre-eminent example of the International Style. Here was the most complete statement to date of all the qualities of refinement, simplification, and elegance of scale and proportion that Mies, above all others, brought to modern architecture. In this building he contrasted the richness of highly polished marble wall slabs with the chrome-sheathed slender columns supporting the broad, overhanging flat roof. Thus, the walls are designed to define space rather than support the structure. In a realization of the open plan that he had designed for the brick country house, the marble and glass interior walls stood free, serving simply to define space. But in contrast to the earlier work, the architect put limits on the space of pavilion and court by enclosing them in end walls. This definition of free-flowing interior space within a total rectangle was to become a signature style for Mies in his later career. The pavilion was furnished with chairs (the "Barcelona chair"), stools, and glass tables also designed by Mies. In the Barcelona Pavilion, he demonstrated that the International Style had come to a maturity

14.26 Ludwig Mies van der Rohe, Elevation for brick country house, 1923.

14.27 Ludwig Mies van der Rohe, German Pavilion, International Exposition, 1929. Barcelona, Spain. Reconstructed 1986.

permitting comparison with the great styles of the past. In 1986, to celebrate the centenary of the architect's birth, the pavilion was completely reconstructed in Barcelona according to the original plans.

Although Mies became director of the Bauhaus in 1930 he had little opportunity to advance its program. After moving from Dessau to Berlin in that year, the school suffered increasing pressure from the Nazis until it was finally closed in 1933. In 1937, with less and less opportunity to practice, Mies left for the United States, where in the last decades of his life he was able to fulfill, in a number of great projects, the promise apparent in the relatively few buildings he actually created in Europe (see chapter 21).

At its best, the uncompromising rationalism of Mies' architecture could produce compelling examples of pristine, streamlined form. In lesser hands, as is apparent in skylines across the United States, his minimalist forms could become impersonal glass and steel monuments to consumer capitalism or drab apartment dwellings. In the words of architecture critic Ada Louise Huxtable, "Mies' reductive theories, carried to their conceptual extreme, contained the stuff of both sublimity and failure, to which even he was not immune." By the early 1970s, the modern movement, and particularly the International Style as represented above all by Mies and Le Corbusier, would encounter a protracted backlash, opening the door to the era of Postmodernism (see chapter 24).

Bauhaus U.S.A.

Mies was one of many artists associated with the Bauhaus to emigrate to the United States in the 1930s. These artists carried the Bauhaus curriculum and ethos with them, establishing new art programs based on its model throughout North America.

Walter Gropius, who left his post as director in 1928 to resume his private practice, continued to produce work deemed degenerate, leading to his expulsion from Germany by the Nazis in 1934. Initially he settled in Britain, but moved to the United States in 1937 upon accepting a position at Harvard University's Graduate School of Design. Much of the work he produced between his departure from the Bauhaus and his arrival in the U.S. was low- or middle-cost housing. He would continue his efforts in this vein, developing, in a collaboration with Konrad Wachsmann, another German émigré architect, a system for producing inexpensive prefabricated housing. In his pioneering European and American works, Gropius helped provide the foundation of what would later be dubbed the International Style.

Josef Albers likewise emigrated, becoming one of the most important art teachers in the United States, first at the remarkable school of experimental education, Black Mountain College in North Carolina, and subsequently at Yale University. Throughout the 1940s, Albers developed his increasingly reductive vocabulary with remarkable assiduity, exploring issues of perception, illusionism, and the often ambiguous interaction of abstract pictorial elements. Beginning in 1950 he settled on the formula that he entitled *Homage to the Square*, where he relentlessly explored the relationships of color squares confined within squares, devoting his own studio practice to the lessons on color theory he taught so famously at Yale. For the next twenty-five years, in a seemingly endless number of harmonious color combinations, Albers employed the strict formula of *Homage to the Square* in paintings and prints of many sizes. Within this format, the full, innermost square is, in the words of one observer, "like a seed; the heart of the matter, the core from which everything emanates."

As *Apparition*, a 1959 *Homage to the Square* subtitle, suggests (fig. **14.28**), Albers' goal was to expose the "discrepancy between physical fact and psychic effect." The interior square is not centered, but rather positioned near the bottom of the canvas. According to a predetermined asymmetry, the size of the color bands at the bottom is doubled on each side of the square and tripled at the top. By restricting himself to this format, Albers sought to demonstrate the subtle perceptual ambiguities that occur when bands of pure color are juxtaposed. Colors may advance or recede according to their own intrinsic hue and in response to their neighbor, or they may even appear to mix optically with adjacent colors. And by the painted miter effect, seen here on the outermost corners, the artist creates a sense of illusionistic depth on a flat surface.

Marcel Breuer, principally active at the Bauhaus as a furniture designer, ultimately joined Gropius in 1937 on the faculty of Harvard University and practiced architecture with him. After Breuer left this partnership in 1941, his reputation steadily grew to a position of world renown (see figs. 21.25, 21.41). Moholy-Nagy, through his books *The New Vision* and *Vision in Motion* and his directorship of the New Bauhaus, founded in Chicago in 1937 (now the Institute of Design of the Illinois Institute of Technology), greatly influenced the teaching of design in the United States. He eventually resided in Amsterdam and London, painting, writing, and making art in all media. His stylistic autobiography, *Abstract of an Artist* (added to the English edition of *The New Vision*), is one of the clearest statements of the modern artist's search for a place in technology and industry.

14.28 Josef Albers, *Homage to the Square: Apparition*, 1959. Oil on board, 47½ × 47½" (120.7 × 120.7 cm). Solomon R. Guggenheim Museum, New York.

15
Surrealism and Its Discontents

Surrealism made visible a new, modern consciousness. Europe was changed by the time the armistice was signed in 1918. Feeling alienated, unable to imagine themselves as part of a society that had plunged more or less heedlessly into the catastrophe of World War I, artists responded in different ways. As seen in the previous chapters, some adopted the oppositional, anti-aesthetic of Dada while others affirmed Western cultural traditions by resuming the classicism of earlier generations. The aesthetic posture showing the greatest resilience and optimism was probably that staked out by Constructivists, such as those allied with the Bauhaus, who believed that Western civilization could redeem itself with the help of art. Surrealism charted a completely different tack. Neither rejecting entirely Western aesthetic traditions nor promising a cure for society's ills, Surrealism responded to this moment by reasserting the invincibility of artistic genius.

What Surrealists understood to be the source of artistic creativity departed from previous conceptions. Renaissance artists understood genius to be an innate capacity, a divine spark that animated only a very few. Academic artists of the eighteenth and nineteenth centuries conceived of genius in terms of emulation and intellectual attainment. Romantic artists reintroduced the idea of genius as something inborn but rare, a creative faculty that gave rise to originality. Surrealism shares the Romantic notion of genius as exceptional and marked by originality, but traces its source to the mind's unconscious. Artistic genius, for Surrealism, depends on the ability to tap into the raw impulses, desires, and fears that Freud claimed were seated in the unconscious. Only by giving form to the unconscious could an artist achieve the authenticity and originality essential for a work of aesthetic genius. This, like all conceptions of genius, privileged some individuals while rendering it virtually impossible for others to lay claim to it. Grounded in Freudian psychology, the Surrealist theory of genius endowed masculinity with particular creative resonance, undoubtedly contributing to the movement's dearth of women participants.

By 1920, Freud's ideas had become popularized throughout Europe and North America. Psychoanalysis promised to explain—maybe even cure—human aggression and deviance. The possibility of accounting for the irrational by rational, scientific means was especially appealing in the wake of the war. Central to Freudian psychoanalysis is the assertion that personalities develop in early childhood, largely in response to thwarted and repressed sexual desires. Freud's theories tend to address male subjects, leaving women to serve largely as triggers for unfulfilled erotic impulses or feelings of shame and inadequacy (see *Fetishism*, opposite). The Surrealists' loose appropriation of psychoanalytic theory carried with it this perception of women as objects to desire or fear, reviving forcefully the *femme fatale* so prevalent in Symbolist art.

Surrealism, like Symbolism, began as a literary movement, widening to accommodate the visual arts. In 1917 French writer Guillaume Apollinaire referred to his own drama *Les Mamelles de Tirésias (The Breasts of Tiresias)*, and also to the ballet *Parade* produced by Diaghilev, as "surrealist." The term was commonly used thereafter by the poets André Breton and Paul Éluard, as well as other contributors to the Paris journal *Littérature*. The concept of a literary and art movement formally designated as Surrealism, however, did not emerge until after the demise of Dada in Paris in the early 1920s.

Breton and the Background to Surrealism

In the years immediately after World War I, French writers had been trying to formulate an aesthetic of the non-rational stemming variously from the writings of Arthur Rimbaud, the Comte de Lautréamont (see p. 320), Alfred Jarry, and Apollinaire. By 1922 Breton was growing disillusioned with Dada on the ground that it was becoming institutionalized and academic, and led the revolt that broke up the Dada Congress of Paris. Together with Philippe Soupault, he explored the possibilities of

Fetishism

Freudian psychoanalysis offered two theories especially appealing to Surrealist artists: dream work and fetishism. Both are described in terms of their sensory appeal: dreams as visual projections of the unconscious (see *Interpretation of Dreams*, chapter 5) and fetishes as objects of particular tactile or optical interest. Fetishism, according to Freud, can arise during the process of psycho-sexual maturation, which begins at birth and continues into young adulthood. Traumatic experiences can affect the outcome of this process. For Freud, certain events were especially prone to trigger anxiety in children, who repress memories of such episodes, confining them to their unconscious. Sometimes the unconscious cannot retain difficult memories, allowing them to enter the conscious mind as unwanted (and seemingly groundless) phobias or desires. One event that Freud believed could tax the unconscious was a male child's recognition that women do not possess a penis. This revelation would be difficult to comprehend by a young boy, who naturally assumes that all humans are anatomically like him. The lack of a penis could only be accounted for by assuming the woman had somehow lost hers due to an injury or terrible punishment, raising the possibility that he might lose his penis, too. Typically, the "castration anxiety" caused by this event is minimized thanks to the child's ability to repress all memory of the event in his unconscious. But if repression is not entirely successful, the boy (and, later, the man) might employ a fetish to assuage the anxiety released by the unconscious. A fetish is typically an object linked by the unconscious to the traumatic event. Fetishes provide comfort by allowing the unconscious to revisit the trauma safely, with the security of an object that is a substitute for the thing lost or injured. Thus, in the case of castration anxiety, a shoe or stocking (something seen at the same time the boy realized that there was no penis where he expected to see one) compensates for the lack, providing pleasure by erasing anxiety. Although Freud's explanation of the source of fetishism precludes a female fetishist, some Surrealist artists like Claude Cahun explored fetishism in terms of feminine sexuality and pleasure.

automatic writing in his 1922 Surrealist texts called *The Magnetic Fields*. Pure psychic automatism, one of the fundamental precepts of Surrealism, was defined by Breton as "dictation of thought, in the absence of any control exercised by reason, and beyond any aesthetic or moral preoccupation." While this method of composing without any preconceived subject or structure was designed for writing, its principles were also applied by the Surrealists to drawing.

After 1922 Breton assumed the principal editorship of *Littérature* and gradually augmented his original band of writers with artists whose work and attitudes were closest to his own: Francis Picabia, Man Ray, and Max Ernst.

One of the exercises in which the artists engaged during their gatherings was the so-called "exquisite corpse." The practice was based on an old parlor game in which one participant writes part of a sentence on a sheet of paper, folds the sheet to conceal part of the phrase, and passes it to the next player, who adds a word or phrase based on the preceding contribution. Once the paper makes it around the room in this manner, the provocative, often hilarious, sentence is read aloud. One such game produced "The exquisite corpse will drink the young wine," hence the name. When this method was adapted for collective drawings (fig. **15.1**), the surprising results coincided with the Surrealist love of the unexpected. The elements of chance, randomness, and coincidence in the formation of a work of art had for years been explored by the Dadaists. Now it became the basis for intensive study for the Surrealists, whose experience of four years of war made them attach much importance to their isolation, their alienation from society and even from nature.

From the meetings between writers and painters emerged Breton's *Manifesto of Surrealism* in 1924, containing this definition:

> SURREALISM, noun, masc., pure psychic automatism by which it is intended to express, either verbally or in writing, the true function of thought. Thought dictated in the absence of all control exerted by reason, and outside all aesthetic or moral preoccupations. ENCYCL. Philos. Surrealism is based on the belief in the superior reality of certain forms of association heretofore neglected, in the omnipotence of the dream, and in the disinterested play of thought. It leads to the permanent destruction of all other psychic mechanisms and to its substitution for them in the solution of the principal problems of life.

15.1 André Breton, Valentine Hugo, Greta Knutson, and Tristan Tzara, *Exquisite Corpse*, c. 1930. Ink on paper, 9¼ × 12¼" (23.5 × 31.1 cm). Morton G. Neumann Family Collection.

This definition emphasizes words rather than plastic images, literature rather than painting or sculpture. Breton was a serious student and disciple of Freud, from whose teachings he derived the Surrealist position concerning the central significance of dreams and the unconscious, as well as the use of free association (allowing words or images to suggest other words or images without imposing rational connections or structures) to gain access to the unconscious. Breton conceived of the Surreal condition as a moment of revelation in which are resolved the contradictions and oppositions of dreams and realities. In the second manifesto of Surrealism, issued in 1930, he said: "There is a certain point for the mind from which life and death, the real and the imaginary, the past and the future, the communicable and the incommunicable, the high and the low cease being perceived as contradictions."

Two nineteenth-century poets had irresistible appeal to the Surrealists: Isidore Ducasse, known as the Comte de Lautréamont (1846–70), and Arthur Rimbaud (1854–91). Unknown to each other, both lived almost in isolation, wandered from place to place, and died young; they wrote transformative poetry while still adolescents, tearing at the foundations of Romantic verse. The idea of revolt permeates Lautréamont's poetry: revolt against tradition, against the family, against society, and against God. The ideas of Rimbaud at seventeen years of age seemed to define for the Surrealists the nature of the poet and poetry. Rimbaud believed that the poet, like a Christian mystic, must attain a visionary state through rigid discipline—but here a discipline of alienation, monstrosities of love, suffering, and madness. Like the Surrealists later, Rimbaud was concerned with the implications of dreams, the unconscious, and chance.

An influential and charismatic figure, Breton was the self-appointed but generally acknowledged leader of Surrealism. He was ruthless in the role as he invited artists to join the group only to exclude them when they failed to toe the party line. As Breton formulated a dogma of Surrealist principles, schisms and heresies inevitably appeared, for few of its exponents practiced Surrealism with scrupulous literalness. In fact, the works of the major Surrealists have little stylistic similarity, aside from their departure from traditional content and their rejection of journalistic approaches to art. The first group exhibition of Surrealist artists was in 1925 at the Galerie Pierre. It included Arp, De Chirico, Ernst, Klee, Man Ray, Masson, Miró, and Picasso. In that year Yves Tanguy joined the group. A Surrealist gallery was opened in 1927 with an exhibition of these artists joined by Marcel Duchamp and Picabia. Except for René Magritte, who joined later that year, and Salvador Dalí, who did not visit Paris until 1929, this was the roster of the first Surrealist generation.

The Two Strands of Surrealism

From its inception, Surrealism in painting tended in two directions. The first, represented by Arp, Ernst, Miró,

André Masson, and, later, Matta, is biomorphic or abstract Surrealism. In this tendency, automatism—"dictation of thought without control of the mind"—is predominant, and the results are generally close to abstraction, although some degree of recognizable imagery is normally present. Its origins were in the experiments in chance and automatism carried on by the Dadaists and the automatic writing of Surrealist poets. The other direction is associated with Salvador Dalí, Yves Tanguy, and René Magritte. It presents, in meticulous detail, recognizable scenes and objects that are taken out of natural context, distorted and combined in fantastic ways as they might be in dreams. Its sources are the art of Henri Rousseau, Chagall, Ensor, De Chirico, and nineteenth-century Romantics. These artists attempted to use images of the unconscious, defined by Freud as uncontrolled by conscious reason (although Dalí, with his "paranoiac–critical methods," claimed to have control over his unconscious). Freud's theories of the unconscious and of the significance of dreams were, of course, fundamental to all aspects of Surrealism. To the popular imagination it was the naturalistic Surrealism associated with Dalí, Tanguy, and others of that group that signified Surrealism, even though it has had less influence historically than the abstract biomorphism of Miró, Masson, and Matta.

Both strands of Surrealism differed from Dada in their essentially Romantic emphasis on the unconscious (rather than the forms and rhythms of the machine). Like Dada, however, Surrealism delighted in the exploration of unconventional techniques and in discovering creative potential in areas that lay outside the conventional territory of art.

Political Context and Membership

Surrealism was a revolutionary movement not only in literature and art but also in politics. The Surrealist period in Europe was one of deepening political crisis, financial collapse and the rise of fascism, provoking moral anxiety within the avant-garde. Under Breton's editorship (1925–29) the periodical *La Révolution surréaliste* maintained a steady communist line during the 1920s. The Dadaists at the end of World War I were anarchists, and many future Surrealists joined them. Feeling that government systems guided by tradition and reason had led humankind into the bloodiest conflict in history, they insisted that government of any form was undesirable, and that the irrational was preferable to the rational in art and in all of life and civilization. The Russian Revolution and the spread of communism provided an alternative channel for Surrealist protests during the 1920s. Louis Aragon and, later, Paul Éluard joined the Communist Party, while Breton, after exposure to the reactionary bias of Soviet communism or Stalinism in art and literature (discussed in chapter 10), took a Trotskyist position in the late 1930s (see *Trotsky and International Socialism between the Wars*, opposite). Picasso, who made Surrealist work in the 1930s, became a communist in protest against the fascism of

Trotsky and International Socialism between the Wars

Socialism attracted many adherents after World War I, with numerous artists and intellectuals among those drawn to the idea of a government managed for the economic benefit of all of its citizens. This was probably the only idea shared by the diverse organizations referred to as "socialist" that arose in Europe and North America during the 1910s and 20s. Labor unions were perhaps the most visible manifestation of socialism in Western Europe and North America between the wars. Strong unionists, or syndicalists, believed that workers needed to seize control (violently, if necessary) of production in order to alleviate economic disparity. The writings of Karl Marx and Friedrich Engels provided the basis for much socialist activity, most notably the Bolshevik Revolution in Russia. Far from monolithic, the Russian socialists directing the revolution held disparate views. Leon Trotsky, for instance, famously challenged Vladimir Lenin's and especially Joseph Stalin's advocacy of a powerful, central government controlled by intellectuals and bureaucrats drawn from the bourgeoisie. Trotsky's endorsement of a government managed by the working class itself was rejected, as was his adherence to the idea that socialism had to be an international phenomenon to succeed; he was eventually sent into exile by Stalin in 1924. Living first in Turkey, then France, Norway, and finally Mexico, Trotsky became a symbol of democratic communism and international workers' solidarity. Many artists and intellectuals, including most of the Surrealists, subscribed to Trotskyism. He was assassinated in Mexico by a Stalinist agent in 1940.

Franco. By 1930, although schisms were occurring among the original Surrealists, new artists and poets were being recruited by Breton. Dalí joined in 1929, the sculptor Alberto Giacometti in 1931, and René Magritte in 1932. Other later recruits included Paul Delvaux, Henry Moore, Hans Bellmer, Oscar Dominguez, and Matta. The list of writers was considerably longer. Surrealist groups and exhibitions were organized in Britain, Czechoslovakia, Belgium, Egypt, Denmark, Japan, the Netherlands, Romania, and Hungary. Despite this substantial expansion, infighting resulted in continual resignations, dismissals, and reconciliations. In addition, artists such as Picasso were adopted by the Surrealists without joining officially.

During the 1930s the major publication of the Surrealists was the lavish journal *Minotaure*, founded in 1933 by Albert Skira and E. Tériade. The last issue appeared in 1939. Although emphasizing the role of the Surrealists, the editors drew into their orbit any of the established masters of modern art and letters who they felt had made significant contributions. These included artists as diverse as Matisse, Kandinsky, Laurens, and Derain.

"Art is a Fruit": Arp's Later Career

One of the original Zurich Dadaists (see chapter 11), **Jean (Hans) Arp** (1886–1966) was active in Paris Dada during its brief life, showing in the International Dada Exhibition of 1922 at the Galerie Montaigne, and contributing poems and drawings to Dada periodicals. When official Surrealism emerged in 1924, Arp was an active participant. At the same time, he remained in close contact with German and Dutch abstractionists and Constructivists. He also contributed to Theo van Doesburg's *De Stijl* and with El Lissitzky edited *The Isms of Art*. He and his wife and fellow artist Sophie Taeuber eventually made their home in Meudon, outside Paris.

During the 1920s Arp's favorite material was wood, which he made into painted reliefs. He also produced paintings, some on cardboard with cut-out designs making a sort of reverse collage. Although Arp had experimented with geometric abstractions between 1915 and 1920 (see fig. 11.3), frequently collaborating with Sophie Taeuber, he abandoned geometric shapes after 1920. His art would increasingly depend on the invention of biomorphic, abstract forms, based on his conviction that "art is a fruit that grows in man, like a fruit on a plant, or a child in its mother's womb." Yet Arp championed the geometric work of Van Doesburg and Sophie Taeuber (see figs. 13.6, 11.5) and collaborated with these two artists in decorating ten rooms of the Café l'Aubette in his native city, Strasbourg (see fig. 13.7). His murals for the café (now destroyed) were the boldest, most free, and most simplified examples of his biomorphic abstraction. They utilized his favorite motifs: the navel and mushroom-shaped heads, sometimes sporting a mustache and round-dot eyes. *Rising Navel and Two Heads* was simply three flat, horizontal, scalloped bands of color, with two color shapes suggesting flat mushrooms floating across the center band. *Navel-Sun* was a loosely circular white shape floating on a blue background (though most of the actual color scheme is lost). There are no parallels for these large, boldly abstracted shapes until the so-termed Color Field painters of the 1950s and 60s.

Of particular interest among Arp's reliefs and collages of the late 1920s and early 30s were those entitled or subtitled *Objects Arranged According to the Laws of Chance*, or *Navels* (fig. **15.2**). These continued the 1916–17 experiment in *Collage with Squares Arranged According to the Laws of Chance* (see fig. 11.3), although most of the forms were now organic rather than geometric. Arp made several versions of this wooden relief in 1930–31; he often employed the oval shapes seen here, which were for him variations on a navel, his universal emblem of human life. He also produced string reliefs based on chance— loops of string dropped accidentally on a piece of paper and seemingly fixed there. It seems, however, that he may have given the laws of chance some assistance, for which he had a precedent in Duchamp's *3 Standard Stoppages* (see fig. 11.10).

15.2 Jean (Hans) Arp, *Objects Arranged According to the Laws of Chance*, or *Navels*, 1930. Varnished wood relief, 10⅜ × 11⅛ × 2¼" (26.3 × 28.3 × 5.4 cm). The Museum of Modern Art, New York.

Arp's great step forward in sculpture occurred at the beginning of the 1930s, when he began to work completely in the round, making clay and plaster models for later bronze or marble sculptures. Arp shared Brancusi's devotion to mass rather than space as the fundamental element of sculpture (see fig. 6.28). He thus stands at the opposite pole from the Constructivists Tatlin or Gabo (see figs. 10.37, 10.44). In developing the ideas of his painted reliefs, he had introduced seemingly haphazard detached forms that hovered around the matrix-like satellites. *Head with Three Annoying Objects* (fig. **15.3**) was originally executed in plaster, Arp's preferred medium for his first sculptures in the round. On a large biomorphic mass rest three objects, identified as a mustache, a mandolin, and a fly. The three strange forms were named in Arp's earliest title for the work, derived from one of his stories in which he describes himself waking up with three "annoying objects" on his face. The objects were not secured to the "head," for Arp intended that they be moved around by the spectator, introducing yet another element of chance in his work. Arp applied titles to his works after he had made them, with the intention of inspiring associations between images and ideas or, as he said, "to ferret out the dream." Thus, the meaning of the work, like the arrangement of the forms themselves, was open-ended. Like many of Arp's plasters, *Head with Three Annoying Objects* was not cast in bronze until much later, in this case not until 1950.

To his biomorphic sculptural forms Arp applied the name "human concretion," for even forms that are not derived from nature, he said, can still be "as concrete and sensual as a leaf or a stone." In 1930 Van Doesburg had proposed the name "concrete art" as a more accurate description for abstract art. He contended that the term "abstract" implied a taking away from, a diminution of, natural forms and therefore a degree of denigration. What could be more real, he asked, more concrete than the fundamental forms and colors of non-representational or non-objective art? Although Van Doesburg's term did not gain universal recognition, Arp used it faithfully, and as "human concretions," it has gained a specific, descriptive connotation for his sculptures in the round. Arp said:

> Concretion signifies the natural process of condensation, hardening, coagulating, thickening, growing together. Concretion designates the solidification of a mass. Concretion designates curdling, the curdling of the earth and the heavenly bodies. Concretion designates solidification, the mass of the stone, the plant, the animal, the man. Concretion is something that has grown.

The art of Jean Arp took many different forms between 1930 and 1966, the year of his death. Abstract (or concrete) forms suggesting sirens, snakes, clouds, leaves, owls, crystals, shells, starfish, seeds, fruit, and flowers emerged continually, suggesting such notions as growth, metamorphosis, dreams, and silence. While developing his freestanding sculpture, Arp continued to make reliefs and collages. To make his new collages, Arp tore up his own work (fig. **15.4**). In this example from 1937, he essentially recomposed the work by connecting the new forms with curvilinear lines drawn in pencil. This new collage technique, a liberating release from the immaculateness of the sculptures, was described by Arp:

15.3 Jean Arp, *Head with Three Annoying Objects*, 1930 (cast 1950). Bronze, 14⅛ × 10¼ × 7½" (35.9 × 26 × 19.1 cm). Estate of Jean Arp.

15.4 Jean Arp, *Composition*, 1937. Collage of torn paper, India ink wash, and pencil, 11¾ × 9" (29.8 × 22.9 cm). Philadelphia Museum of Art.

I began to tear my papers instead of curving them neatly with scissors. I tore up drawings and carelessly smeared paste over and under them. If the ink dissolved and ran, I was delighted. ... I had accepted the transience, the dribbling away, the brevity, the impermanence, the fading, the withering, the spook-ishness of our existence. ... These torn pictures, these *papiers déchirés* brought me closer to a faith other than earthly.

Many of these torn-paper collages found their way to the United States and offered a link between organic Surrealism and postwar American Abstract Expressionism.

Hybrid Menageries: Ernst's Surrealist Techniques

The career of **Max Ernst** (1891–1976) as a painter and sculptor, interrupted by four years in the German army, began when he moved to Paris from Cologne in 1922. At the end of 1921, the Dadaist Ernst had resumed painting after having devoted himself to various collage techniques since 1919 (see fig. 11.25). The manner of *Celebes*, the

15.5 Max Ernst, *Two Children Are Threatened by a Nightingale*, 1924. Oil on wood with wood construction, 27½ × 22½ × 4½" (69.8 × 57.1 × 11.4 cm). The Museum of Modern Art, New York.

chief painting of his pre-Paris period (see fig. 11.26), is combined with the technique of his Dada assemblages in *Two Children Are Threatened by a Nightingale* (fig. **15.5**), a 1924 dream landscape in which two girls—one collapsed on the ground, the other running and brandishing a knife—are frightened by a tiny bird. The fantasy is given peculiar emphasis by the elements attached to the panel— the house on the right and the open gate on the left. A figure on top of the house clutches a young girl and seems to reach for the actual wooden knob on the frame. Contrary to Ernst's usual method of working, the title of this enigmatic painting (inscribed in French on the frame) preceded the image. Ernst himself, speaking in the third person, noted:

> He never imposes a title on a painting. He waits until a title imposes itself. Here, however, the title existed before the picture was painted. A few days before, he had written a prose poem which began: *à la tombée de la nuit, à la lisière de la ville, deux enfants sont menacés par un rossignol* (as night falls, at the edge of town, two children are threatened by a nightingale).... He did not attempt to illustrate this poem, but that is the way it happened.

In 1925, Ernst became a full participant in the newly estab-lished Surrealist movement. That year he began to make

drawings that he termed *frottage* (rubbing), in which he used the child's technique of placing a piece of paper on a textured surface and rubbing over it with a pencil. The resulting image was largely fortuitous, but Ernst consciously reorganized the transposed textures in new contexts, creating new and unforeseen associations. Not only did *frottage* provide the technical basis for a series of unorthodox drawings, it also intensified Ernst's perception of the textures in his environment—wood, cloth, leaves, plaster, and wallpaper.

Ernst applied this technique, combined with *grattage* (scraping), to his paintings of the late 1920s and the 30s. The 1927 canvas *The Horde* (fig. **15.6**) expresses the increasingly ominous mood of his paintings. The monstrous, tree-like figures are among the many frightening premonitions of the conflict that would overtake Europe in the next decade. In 1941, Ernst escaped World War II in Europe and settled in New York City, where his presence, along with other Surrealist refugees, would have tremendous repercussions for American art. Ernst's antipathy toward the rise of fascism was given fullest expression in *Europe after the Rain* (fig. **15.7**), which has been aptly described as a requiem for the war-ravaged continent. In this large painting Ernst employed yet another technique, which he called "decalcomania." Invented by the Spanish Surrealist Oscar Dominguez, this technique involved placing paper or glass on a wet painted surface, then pulling it away to achieve surprising textural effects. It appealed to Ernst and other Surrealists for the startling automatic forms that could be created.

Of all the menageries and hybrid creatures that Ernst invented, he most closely identified with the image of the bird, eventually adopting one of his inventions, named Loplop, as a kind of surrogate self-image. The 1942 painting *Surrealism and Painting* (fig. **15.8**), also the title of a book by Breton, shows a bird-like beast made of smoothly rounded sections of human anatomy, serpents, and birds' heads. The monster, painted in delicate hues, is composing an abstract painting, perhaps "automatically." In fact, Ernst engaged in a partially automatic process to create the painting—he swung paint over the canvas from a hole in a tin can. The full implications of this "drip" technique would be explored by Jackson Pollock to make his revolutionary, mural-sized abstract paintings in the 1950s (see fig. 17.9).

15.6 Max Ernst, *The Horde*, 1927. Oil on canvas, 44⅞ × 57½" (114 × 146.1 cm). Stedelijk Museum, Amsterdam.

15.7 Max Ernst, *Europe after the Rain*, 1940–42. Oil on canvas, 21½ × 58⅛" (54.6 × 147.6 cm). Wadsworth Atheneum, Hartford, Connecticut.

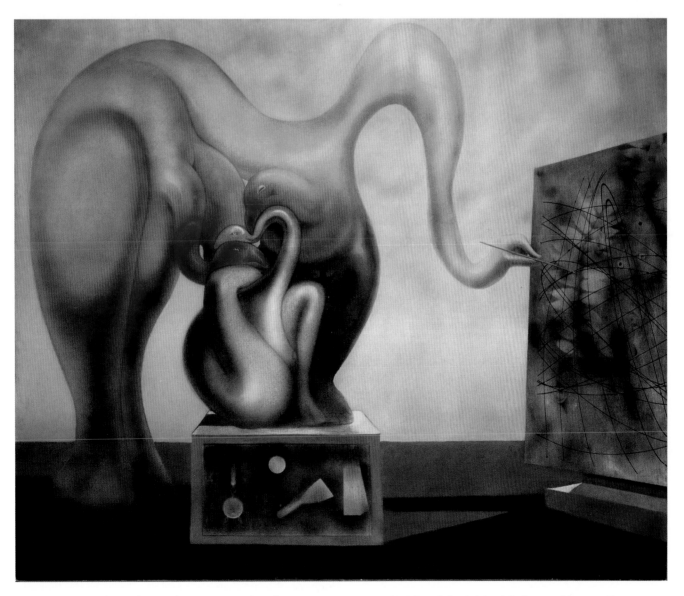

15.8 Max Ernst, *Surrealism and Painting*, 1942. Oil on canvas, 77 × 92" (1.95 × 2.3 m). Menil Collection, Houston, Texas.

"Night, Music, and Stars": Miró and Organic–Abstract Surrealism

Although active for many years in Paris, the Spanish artist **Joan Miró** (1893–1983) constantly returned to his native country, and his Catalan roots remained a consistent force in his art throughout his life. In art schools in Barcelona, where he was born, he was introduced to French art, and his first mature paintings, executed in 1915–16, show the influence of Cézanne. But he also admired more contemporary masters, especially Matisse and his fellow Spaniard Picasso. Though never a Cubist, he freely adapted aspects of the style to suit his own purposes.

Nude with Mirror (fig. **15.9**), begun in the spring of 1919, combines Cubist faceting, flat-color areas, and geometric pattern with a sculptural figure. Painted from a live model, the nude is set against a spare, terracotta-colored background that contrasts sharply with the highly decorative patterns of the stool and rug on which she sits. Despite the Cubist fracturing of certain parts of the anatomy, the figure has a strong three-dimensional presence of rounded volumes. In the monumental simplicity of *Nude with Mirror* there is evidence of Miró's admiration for Henri Rousseau (see fig. 3.15). A hint of the unreality to come in Miró's work emerges as we realize that the model gazes at herself in the mirror with nearly closed eyes.

In 1920 Miró began to spend winters in Paris and summers in Montroig, Spain. He was drawn to the work of the Dadaists as well as Paul Klee and, by 1923, was working from his imagination rather than from nature. He became friendly with Breton and the other poets in Paris who were soon to launch the Surrealist revolution. Yet these encounters, as well as Miró's natural inclination to fantasy, do not entirely account for the richly imaginative imagery that he said was "always born in a state of hallucination."

Carnival of Harlequin, 1924–25 (fig. **15.10**), is one of the first Surrealist pictures where Miró's playful sense of caprice has been given full rein. His space, the suggested confines of a grayish-beige room, teems with life of the strangest variety. At the left is a tall ladder to which an ear has been attached along with, at the very top, a tiny, disembodied eye. Animating the inanimate was a favorite Surrealist theme. To the right of the ladder is a man with a disk-shaped head who sports a long-stemmed pipe beneath a tendriled mustache and stares sadly at the spectator. At his side, an insect with blue and yellow wings pops out of a box. Surrounding this group is every sort of hybrid organism, all having a fine time. Miró's unreal world is painstakingly rendered and remarkably vivid; even his inanimate objects have an eager vitality. He derived his imagery from many sources beyond his own fertile imagination. While some are based on forms in nature, others may stem from medieval art or the paintings of his fellow Surrealists. As they float in the air or cavort on the ground, his creatures are spread equally across the entire surface of the painting, so our eyes do not alight in one central place. In this picture, as well as in a number of others around this time, Miró mapped out his compositional organization with red lines arranged in a diagonal grid that can still be detected through the paint layer.

The second half of the 1920s was an especially prolific period for Miró. His first solo show was held in Paris in 1925, and in November of that year he took part in the first exhibition of Surrealist painting, which included *Carnival of Harlequin*. Much of the work of this period is marked by a reduction of means, moving from the complexity of *Carnival of Harlequin* to the magic simplicity of a painting such as *Dog Barking at the Moon* (fig. **15.11**). Again we find the ladder, for Miró a symbol of transcendence and a bridge to another, unearthly realm. But it is now a player in a depopulated nocturnal landscape, a dark and alien place that resembles a scene from a dream.

In 1933 Miró made a remarkable group of eighteen paintings based on collages of realistic details torn from newspapers and pasted on cardboard. The motifs—tools, machines, furniture, and dishes—suggested to him organic–abstract shapes, sometimes with implied faces or figures. The predominantly abstract intent of these paintings is indicated by their neutral titles. One of the paintings that resulted from this process is *Painting* (fig. **15.12**). Although this work appears completely non-figurative, many observers have found a resemblance between the mysterious forms and animals, such as a seated dog at the upper left. These organic–abstract shapes are perhaps closest to the biomorphic inventions of Arp.

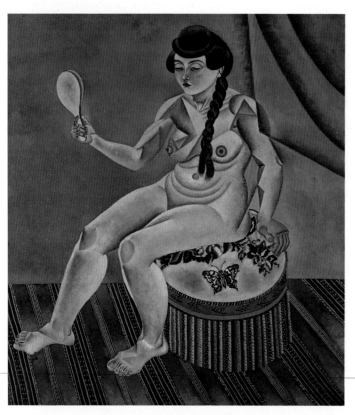

15.9 Joan Miró, *Nude with Mirror*, 1919. Oil on canvas, 44½ × 40⅛" (113 × 102 cm). Kunstsammlung Nordrhein-Westfalen, Düsseldorf.

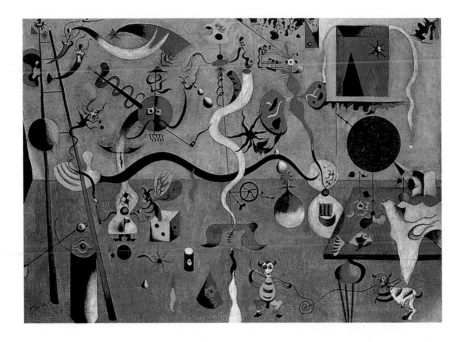

15.10 Joan Miró, *Carnival of Harlequin*, 1924–25. Oil on canvas, 26 × 36⅝" (66 × 93 cm). Albright-Knox Art Gallery, Buffalo, New York.

A classic example of the Surrealist "object" that proliferated in the movement in the 1930s is Miró's sculpture that takes this very word for its title (fig. **15.13**). The object consists of a wood cylinder that holds in its cavity a high-heeled, doll-sized leg, the fetishistic nature of which typifies Surrealist eroticism. The cylinder is surrounded by other found objects, including a stuffed parrot from whose perch is suspended a little cork ball. The whole construction sits on a base made of a derby hat; in its brim "swims" a red plastic fish. The Surrealist juxtaposition of disparate objects was meant to evoke surprise and trigger further associations in the mind of the viewer. The notion of found objects was introduced by Duchamp (see fig. 11.8), but Miró did not adopt that artist's attitude of aesthetic indifference in this whimsical, carefully composed object.

With the outbreak of World War II, Miró had to flee from his home in Normandy and go back to Spain, where a rightwing government under General Franco had been established in 1939 following Franco's victory, with support from Nazi Germany, in the Spanish Civil War of 1936–39. The isolation of the war years and the need for contemplation and re-evaluation led Miró to read mystical literature and to listen to the music of Mozart and Bach. "The night, music and stars," he said, "began to play a major role in suggesting my paintings." While fleeing from the Nazis in France to Franco's Spain, Miró, in contrast to his inclination—in response to the Spanish Civil War—to revisit representation, committed himself to an abstract art consistent with his evocative Surrealist compositions of the 1920s. Between January 1940 and September 1941 he

15.11 Joan Miró, *Dog Barking at the Moon*, 1926. Oil on canvas, 28¾ × 36¼" (73 × 92 cm). Philadelphia Museum of Art.

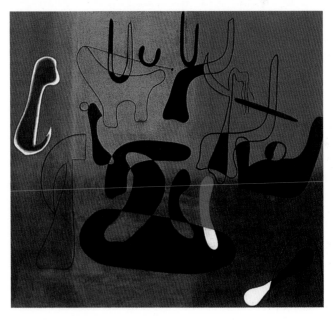

15.12 Joan Miró, *Painting*, 1933. Oil on canvas, 5' 8½" × 6' 5¼" (1.74 × 2 m). The Museum of Modern Art, New York.

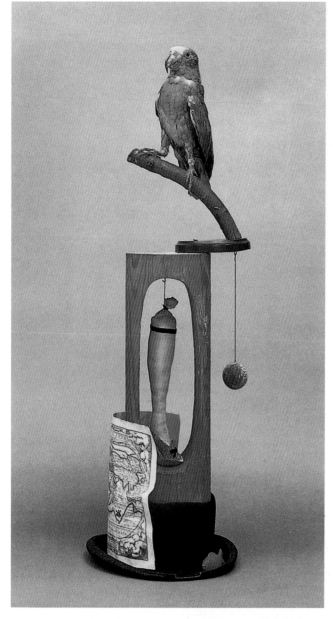

15.13 Joan Miró, *Object*, 1936. Assemblage: stuffed parrot on wood perch, stuffed silk stocking with velvet garter and doll's paper shoe suspended in hollow wood frame, derby hat, hanging cork ball, celluloid fish, and engraved map, 31⅞ × 11⅞ × 10¼" (81 × 30.1 × 26 cm). The Museum of Modern Art, New York.

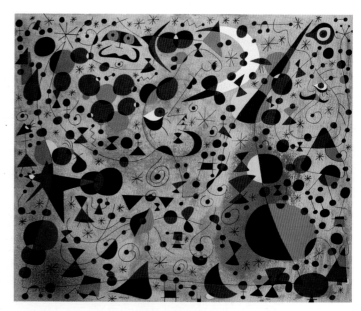

15.14 Joan Miró, *The Poetess* from the series *Constellations*, December 31, 1940. Gouache and oil wash on paper, 15 × 18" (38.1 × 45.7 cm). Private collection.

Methodical Anarchy: André Masson

One of the Surrealist artists who would eventually emigrate from Paris to New York was **André Masson** (1896–1987). Among the first Surrealists, Masson was the most passionate revolutionary, a man of vehement convictions who had been deeply spiritually scarred by his experiences in World War I. Almost fatally injured, he was hospitalized for a long time, and after partially recovering, he continued to rage against the insanity of humankind and society until he was confined for a while to a mental hospital. Masson was by nature an anarchist, whose convictions were fortified by his experience. He joined the Surrealist movement in 1924, though his anti-conformist temperament caused him to break with the controlling Breton. Masson first left the group in 1929, rejoined it in the 1930s, and left again in 1943.

Masson's paintings of the early 1920s reveal his debt to Cubism, particularly that of Juan Gris (see chapter 8). In 1925 Masson was regularly contributing automatic drawings to *La Révolution surréaliste*. These works directly express his emotions and contain various images relating to the sadism of human beings and the brutality of all living things. *Battle of Fishes* (fig. **15.15**) is an example of Masson's sand painting, which he made by freely applying adhesive to the canvas, then throwing sand over the surface and brushing away the excess. The layers of sand would suggest forms to the artist, "although almost always irrational ones," he said. He then added lines and small amounts of color, sometimes directly from the paint tube, to form a pictorial structure around the sand. Here the imagery is aquatic, though the artist described the fish as anthropomorphic. As in the *frottage* technique used by Ernst (see fig. 15.6), Masson here allows chance to help

worked on a series of twenty-three small gouaches entitled *Constellations* (fig. **15.14**), which are among his most intricate and lyrical creations. In the sparkling compositions the artist was concerned with ideas of flight and transformation as he contemplated the migration of birds, the seasonal renewal of butterfly hordes, and the flow of constellations and galaxies. Miró dispersed his imagery evenly across the surface. In 1945 the *Constellations* were shown at New York's Pierre Matisse Gallery, where they affected the emerging American Abstract Expressionist painters then seeking alternatives to Social Realism and Regionalism (see figs. 17.4, 17.31). As the leader of the organic–abstract tendency within Surrealism, Miró had a major impact on younger American painters.

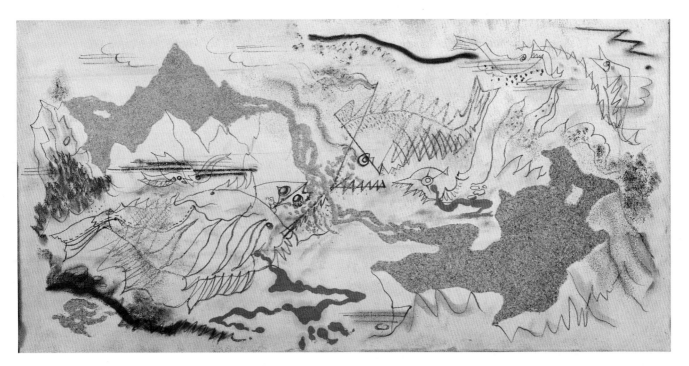

15.15 André Masson, *Battle of Fishes*, 1926. Sand, gesso, oil, pencil, and charcoal on canvas, 14¼ × 28¾" (36.2 × 73 cm). The Museum of Modern Art, New York.

determine his composition, though his firm belief that art should be grounded in conscious, aesthetic decisions eventually led him away from this method.

In the late 1930s, after living principally in Spain for three years, Masson temporarily painted in a style closer to the more naturalistic wing of Surrealism. He painted monstrous, recognizable figures from mythological themes in a manner influenced by Picasso and possibly Dalí. To escape World War II, Masson lived for a time in the United States,

where, he said, "Things came into focus for me." He exhibited regularly in New York, influencing some of the younger American painters, particularly Jackson Pollock. Masson would later say that Pollock carried automatism to an extreme that he himself "could not envision." Living in rural Connecticut, Masson reverted to a somewhat automatist, Expressionist approach in works such as *Pasiphaë* (fig. **15.16**). The classical myth of the Minotaur provided one of his recurrent themes in the 1930s and 40s.

15.16 André Masson, *Pasiphaë*, 1943. Oil and tempera on canvas, 39¾ × 50" (101 × 127 cm). Private collection.

(It was he who named the Surrealist review after this part-man, part-bull beast from Greek mythology.) Because she displeased the sea god Poseidon, Pasiphaë was made to feel a passionate, carnal desire for a beautiful white bull. Following her union with the bull she gave birth to the monstrous Minotaur. Masson said he wanted to represent the violent union of woman and beast in such a way that it is impossible to tell where one begins and the other ends. This subject, which had become a major theme in Picasso's work (see fig. 15.40), also appealed to the young Pollock, who made a painting of Pasiphaë in the same year as Masson.

Enigmatic Landscapes: Tanguy and Dalí

To capture the simultaneous familiarity and strangeness of dreams—believed to be a link to the unconscious—some Surrealists worked in a highly naturalistic style. Using the illusionism of Renaissance perspective along with intense colors and highly finished surfaces, artists like Yves Tanguy and Salvador Dalí attempted to picture the desires and fears contained in the unconscious, an endeavor that Freud would dismiss as both pointless and impossible.

Yves Tanguy (1900–55) had literary interests and close associations with the Surrealist writers Jacques Prévert and

15.17 Yves Tanguy, *Mama, Papa Is Wounded!* (*Maman, Papa est blessé!*), 1927. Oil on canvas, 36¼ × 28¾" (92.1 × 73 cm). The Museum of Modern Art, New York.

Marcel Duhamel in Paris after 1922. With Prévert he discovered the writings of Lautréamont and other prophets of Surrealism. In 1923, inspired by two De Chirico paintings in the window of the dealer Paul Guillaume, he decided to become a painter. Entirely self-taught, Tanguy painted in a naive manner until 1926, at which time he destroyed many of these canvases. After meeting André Breton, Tanguy began contributing to *La Révolution surréaliste* and was adopted into the Surrealist movement. His subsequent progress was remarkable, in both technique and fantastic imagination. *Mama, Papa Is Wounded!* (fig. **15.17**) was the culmination of this first stage and exhibited all the obsessions that haunted him for the rest of his career. The first of these was an infinite-perspective depth, rendered simply by graded color and a sharp horizon line—a space that combines vast emptiness and intimate enclosure, where ambiguous organic shapes, reminiscent of Arp's biomorphic sculptures, float in a barren dreamscape.

Dalí

The artist who above all others symbolizes Surrealism in the public imagination is the Spaniard **Salvador Dalí** (1904–89). Not only his paintings, but his writings, his utterances, his actions, his appearance, his mustache, and his genius for publicity have made the word "Surrealism" a common noun in all languages, denoting an art that is irrational, erotic, mad—and fashionable. Dalí's life was itself so completely Surrealist as to appear contrived, leading some—including many Surrealists—to question his integrity along with his pictorial accomplishments. The primary evidence must be the paintings themselves, and no one can deny the technical facility, the power of imagination, or the intense conviction that they display.

Dalí was born at Figueras, near Barcelona. Like Picasso, Miró, and, before them, the architect Gaudí (see chapter 5), he was a product of the rich Catalan culture. A substantial part of the iconography of Dalí refers to real or imagined episodes from his childhood and adolescence. The landscape of these early years appears constantly in his paintings, which are marked by the violence of his temperament—ecstatic, filled with fantasy, terror, and megalomania. Dalí encountered Italian and French art, Impressionism, Neo-Impressionism, and Futurism before he went to Madrid's Academy of Fine Arts in 1921. He followed the normal academic training, developing a highly significant passion for nineteenth-century academicians and artists such as Millet (fig. 1.17), Böcklin (fig. 5.24), and particularly the meticulous narrative painter Ernest Meissonier. His discoveries in modern painting during the early 1920s were Picasso, De Chirico, Carrà, and the Italian Metaphysical School, whose works were reproduced in the periodical *Valori Plastici*. More important for his development was the discovery of Freud, whose writings on dreams and the subconscious seemed to answer the torments and erotic fantasies he had suffered since childhood. Between 1925 and 1927 he explored several styles and often worked in

SOURCE

Georges Bataille
from *The Cruel Practice of Art* (1949)

The philosopher Georges Bataille was, along with André Breton, a chief theoretician of Surrealism. By 1929, Breton's political intransigence led many artists and writers to form an alternative Surrealist group around Bataille.

The painter is condemned to please. By no means can he transform a painting into an object of aversion. The purpose of a scarecrow is to frighten birds from the field where it is planted, but the most terrifying painting is there to attract visitors. Actual torture can also be interesting, but in general that can't be considered its purpose. Torture takes place for a variety of reasons. In principle its purpose differs little from that of the scarecrow: unlike art, it is offered to sight in order to repel us from the horror it puts on display. The painted torture, conversely, does not attempt to reform us. Art never takes on itself the work of the judge. When horror is subject to the transfiguration of an authentic art, it becomes a pleasure, an intense pleasure, but a pleasure all the same....

The paradox of emotion is that it wants to have much more sense that it does have. Emotion that is not tied to the opening of a horizon but to some nearby object, emotion within the limits of reason only offers us a compressed life. Burdened by our lost truth, the cry of emotion rises out of disorder, such as it might be imagined by the child contrasting the window of his bedroom to the depths of the night. Art, no doubt, is not restricted to the representation of horror, but its movement puts art without harm at the height of the worst and, reciprocally, the painting of horror reveals the opening onto all possibility. That is why we must linger in the shadows which art acquires in the vicinity of death.

them simultaneously: the Cubism of Picasso and Gris, the Purism of Le Corbusier and Ozenfant, the Neoclassicism of Picasso, and a precise realism derived from the seventeenth-century Dutch master Vermeer.

In 1929 Dalí visited Paris for several weeks and, through his friend Miró, met the Surrealists. He moved to the French capital for a time the following year (though his main residence was Spain) to become an official member of the movement. Breton regarded the dynamic young Spaniard as a force for renewal in the group, which was plagued by endless ideological conflict (see Bataille, *The Cruel Practice of Art*, left). Dalí became deeply involved with Gala Éluard, the wife of the Surrealist writer Paul Éluard, and he married her in 1934. He had by now formulated the theoretical basis of his painting, described as "paranoiac–critical": the creation of a visionary reality from elements of visions, dreams, memories, and psychological or pathological distortions.

Dalí developed a precise miniaturist technique, accompanied by a discordant but luminous color. His detailed *trompe l'oeil* technique was designed to make his dream-world more tangibly real than observed nature (he referred to his paintings as "hand-painted dream photographs"). He frequently used familiar objects as a point of departure—watches, insects, pianos, telephones, old prints or photographs—imparting to them fetishistic significance. He declared his primary images to be blood, decay, and excrement. From the commonplace object Dalí set up a chain of metamorphoses that gradually or suddenly dissolved and transformed the object into a nightmare image, given conviction by the exacting technique. He was determined to paint as a madman—not in an occasional state of receptive somnambulism, but in a continuous frenzy of induced paranoia. In collaboration with Luis Buñuel, Dalí turned to the cinema and produced two classics of Surrealist film, *Un Chien andalou (An Andalusian Dog)* (1929) and *L'Age d'or (The Golden Age)* (1930). The cinematic medium held infinite possibilities for the Surrealists, in the creation of dissolves, metamorphoses, and double and quadruple images, and Dalí made brilliant use of these.

The microscopic brand of realism that Dalí skillfully deployed to objectify the dreamworld reached full maturity in a tiny painting from 1929, *Accommodations of Desire* (fig. **15.18**). The work is actually

15.18 Salvador Dalí, *Accommodations of Desire*, 1929. Oil and collage on panel, 8⅝ × 13¾" (22 × 34.9 cm). Private collection.

a collage, created using two illustrations of lions' heads that Dalí cut from a book and placed on what appear to be stones. These strange forms cast dark shadows in the desolate landscape and serve as backdrops to other imagery, including an army of ants. In one of the most disturbing images in *Un Chien andalou*, which had been made earlier the same year, ants swarm over a hand. They appear again, this time over a pocket watch, in one of Dalí's later paintings (see fig. 15.19). His own painted incarnations of a lion's head appear at the upper left of *Accommodations* and with the group of figures at the top of the composition. In his mostly fictional autobiography of 1942, *The Secret Life of Salvador Dalí*, the artist said that he undertook this painting during his courtship of Gala (who was then still married to Paul Éluard). The experience of intense sexual anxiety led him to paint this work, in which "desires were always represented by the terrorizing images of lions' heads."

In his book *La Femme visible (The Visible Woman)* (1930), Dalí wrote: "I believe the moment is at hand when, by a paranoiac and active advance of the mind, it will be possible (simultaneously with automatism and other passive states) to systematize confusion and thus to help discredit completely the world of reality." By 1930 Dalí had left De Chirico's type of metaphysical landscape for his own world of violence, blood, and decay. He sought to create in his art a specific documentation of Freudian theories applied to his own inner world. He started a painting with the first image that came into his mind and went on from one association to the next, multiplying images of persecution or megalomania like a true paranoiac. He defined his paranoiac–critical method as a "spontaneous method of irrational knowledge based upon the interpretative–critical association of delirious phenomena."

Dalí shared the Surrealist antagonism to art that defined itself in terms of formal qualities rather than content. *The Persistence of Memory* of 1931 (fig. **15.19**) is a denial of every twentieth-century experiment in abstract organization. Its miniaturist technique (the painting is only just over a foot wide) goes back to fifteenth-century Flemish art, and its sour greens and yellows recall nineteenth-century chromolithographs. The space is as infinite as Tanguy's (see fig. 15.17), and rendered with hard objectivity. The picture's fame comes largely from the presentation of recognizable objects—watches—in an unusual context, with unnatural attributes, and on an unexpected

15.19 Salvador Dalí, *The Persistence of Memory (Persistance de la mémoire)*, 1931. Oil on canvas, 9½ × 13" (24.1 × 33 cm). The Museum of Modern Art, New York.

15.20 Salvador Dalí, *Gala and the Angelus of Millet Immediately Preceding the Arrival of the Conic Anamorphoses*, 1933. Oil on panel, 9⅜ × 7⅜" (23.8 × 18.7 cm). National Gallery of Canada, Ottawa.

scale. Throughout his career Dalí was obsessed with the morphology of hard and soft. Here, lying on the ground, is a large head in profile (which had appeared in several previous paintings) seemingly devoid of bone structure. Drooped over its surface, as on that of a tree and shelf nearby, is a soft pocket watch. Dalí described these forms as "nothing more than the soft, extravagant, solitary, paranoic–critical Camembert cheese of space and time." He painted the work one night after dinner, when, after all the guests were gone, he contemplated the leftover Camembert cheese melting on the table. When he then

looked at the landscape in progress in his studio—with shoreline cliffs and a branchless olive tree—the image of soft watches came to him as a means of representing the condition of softness. This pictorial metamorphosis, in which matter is transformed from one state into another, is a fundamental aspect of Surrealism.

Dalí's painting during the 1930s vacillated between outrageous fantasy and a strange atmosphere of quiet achieved less obviously. *Gala and the Angelus of Millet Immediately Preceding the Arrival of the Conic Anamorphoses* (fig. **15.20**) exemplifies the first aspect.

15.21 Salvador Dalí, *Soft Construction with Boiled Beans: Premonitions of Civil War*, 1936. Oil on canvas, 39¼ × 39" (100 × 99 cm). Philadelphia Museum of Art.

In the back of a brilliantly lighted room is Gala, grinning broadly, as though snapped by an amateur photographer; in the front sits an enigmatic male, actually a portrait of Vladimir Lenin. Over the open doorway is a print of Millet's *Angelus* (fig. 1.17), a painting that, in Dalí's obsessive, Freudian reading, had become a scene about predatory female sexuality. Around the open door a monstrous comic figure (the Russian writer Maxim Gorky) emerges from the shadow, wearing a lobster on his head. There is no rational explanation for the juxtaposition of familiar and phantasmagoric, but the nightmarish effect is undeniable. Dalí painted *Soft Construction with Boiled Beans: Premonitions of Civil War* (fig. **15.21**) in Paris in 1936, on the eve of the Spanish Civil War. It is a horrific scene of psychological torment and physical suffering. A gargantuan figure with a grimacing face is pulled apart, or rather pulls itself apart ("in a delirium of auto-strangulation" said the artist), while other body parts are strewn among the excretory beans along the ground. Despite the anguish expressed in his painting, Dalí reacted to the civil war in his native country—as he did to fascism in general—with characteristic self-interest (he had quarreled bitterly with the Surrealists in 1934 over his refusal to condemn Hitler).

In 1940 Dalí, like so many of the Surrealists, moved to the United States where he painted society portraits and flourished in the role of Surrealist *agent provocateur*.

His notoriety and fashionable acceptance reached their height with designs for the theater, jewelry, and objets d'art. In 1941 came a transition in his painting career. He announced his determination to "become Classic," to return to the High Renaissance of Raphael, though his paintings still contained a great deal of Surrealist imagery. He and Gala resettled permanently in Spain in 1948. After 1950 Dalí's principal works were devoted to Christian religious art, exalting the mystery of Christ and the Mass.

Surrealism beyond France and Spain: Magritte, Delvaux, Bellmer, Matta, and Lam

In contrast to Dalí, **René Magritte** (1898–1967) has been called the invisible man among the Surrealists. Thanks perhaps to the artist's comparatively low-key personality, due in part to Breton's lukewarm support of his art, the works of Magritte have had a gradual but powerful impact. In particular, his exploration of how we "read" visual images as part of a code, or system of signs, coincided with the linguistic and philosophical investigations that led to the modern field of semiotics.

After years of sporadic study at the Brussels Academy of Fine Arts, Magritte, like Tanguy, was shocked into realizing his destiny when in 1923 he saw a reproduction

15.22 René Magritte, *The Treachery (or Perfidy) of Images*, 1928–29. Oil on canvas, 23¼ × 31½" (60 × 80 cm). Los Angeles County Museum of Art.

of De Chirico's 1914 painting *The Song of Love*. In 1926 he emerged as an individual artist with his first Surrealist paintings, inspired by the work of Ernst and De Chirico. Toward the end of that year, Magritte joined other Belgian writers, musicians, and artists in an informal group comparable to the Paris Surrealists. He moved to a Paris suburb in 1927, entering one of the most highly productive phases of his career, and participated for the next three years in Surrealist affairs. Wearying of the frenetic, polemical atmosphere of Paris after quarreling with the Surrealists, and finding himself without a regular Parisian dealer to promote his work, Magritte returned to Brussels in 1930 and lived there quietly for the rest of his life.

Because of this withdrawal from the art centers of the world, Magritte's paintings did not initially receive much attention. In Europe he was seen as a marginal figure among the Surrealists, and in the United States, in the heyday of painterly abstraction after World War II, his meticulous form of realism seemed irrelevant to many who were drawn instead to the work of Masson or Miró. But subsequent generations, such as that of the Pop artists, appreciated Magritte's capacity for irony,

uncanny invention, and deadpan realism. The perfect symbol for his approach is the painting entitled *The Treachery (or Perfidy) of Images* (fig. **15.22**). It portrays a briar pipe so meticulously that it might serve as a tobacconist's trademark. Beneath, rendered with comparable precision, is the legend *Ceci n'est pas une pipe* ("This is not a pipe"). This delightful work confounds pictorial reality and underscores Magritte's fascination with the relationship of language to the painted image. It undermines our natural tendency to speak of images as though they were actually the things they represent. A similar idea is embodied in *The Human Condition* (fig. **15.23**), where we encounter a pleasant landscape framed by a window. In front of this opening is a painting on an easel that "completes" the very landscape it blocks from view. The problem of real space versus spatial illusion is as old as painting itself, but it is imaginatively treated in this picture within a picture. Magritte's classic play on illusion implies that the painting is less real than the landscape, when in fact both are painted fictions. The tree depicted here, as the artist explained (somewhat

15.23 René Magritte, *The Human Condition*, 1933. Oil on canvas, 39⅜ × 31⅞" (100 × 81 cm). National Gallery of Art, Washington, D.C.

confusingly, in view of the illusory nature of the "real" landscape, as he defines it), exists for the spectator "both inside the room in the painting, and outside in the real landscape. Which is how we see the world: we see it as being outside ourselves even though it is only a mental representation of it that we experience inside ourselves."

Magritte drew freely on the Freudian repertoire of sexual anxiety, occasionally creating works that foil a male heterosexual viewer's erotic interests. In the case of *The Rape (Le viol)* of 1934 (fig. **15.24**), the instability of the image causes disorientation as it vacillates between a woman's limbless nude torso and an androgynous face. As the breasts of the figure morph into eyes and the pubic area resolves into a mouth, the work becomes a lesson in the uncanny: the unsettling loss of confidence in one's ability to discern one form from another. In the case of *The Rape*, this disorientation becomes threatening. The title

announces sexual violence, normally committed against women. The image raises the specter of another sort of sexual violence, the unconscious fear of castration, signaled by the fusion of mouth with *mons veneris*, evoking the "vagina dentata" or toothed vagina that functioned, along with the praying mantis, as a common Surrealist symbol of the psychic threat posed by women. The absence of legs, arms, or a head also conjures associations with the famed *Venus de Milo*, inviting further consideration of the modernist association between art and sexuality as well as Western Europe's history of pillaging the artworks of other cultures.

Paul Delvaux (1897–1994), like Magritte a longtime resident of Brussels, came to Surrealism slowly. Beginning in 1935, he painted women, usually nude but occasionally clothed in chaste, Victorian dress. Sometimes lovers appear, but normally the males are shabbily dressed scholars, strangely oblivious to the women. *Entrance to the City*

15.24 René Magritte, *The Rape (Le viol)*, 1934. Oil on canvas, 28¾ × 21¼" (73 × 54 cm). Menil Collection, Houston, Texas.

(fig. **15.25**) gives the basic formula: a spacious landscape; nudes wandering about, each lost in her own dreams; clothed male figures, with here a partly disrobed young man studying a large plan; here also a pair of embracing female lovers and a bowler-hatted gentleman (reminiscent of Magritte) reading his newspaper while walking. The chief source seems to be fifteenth-century painting, translated into Delvaux's peculiar personal fantasy. Delvaux's dreamworld is filled with a nostalgic sadness that transforms even his erotic nudes into something elusive and unreal.

Another artist who, like Delvaux, belonged to a later, second wave of Surrealism is **Hans Bellmer** (1902–75). In 1923–24 this Polish-born artist trained at the Berlin Technical School, studying drawing with George Grosz (see chapter 11) and establishing contact with other figures related to German Dada. In the 1930s, he began assembling strange constructions called "dolls" (fig. **15.26**), adolescent female mannequins whose articulated and ball-jointed parts—heads, arms, trunks, legs, wigs, glass eyes—could be dismembered and reassembled in every manner of erotic or masochistic

posture. The artist then photographed the fetishistic objects, whose implied sadism appealed to the Surrealists. This led to publication of Bellmer's photographs in a 1935 issue of *Minotaure*; a career for the artist in the Surrealist milieu of Paris; and a place for his camera-made images in the history of photography. Bellmer also expressed his rather Gothic imagination in a number of accomplished, if sometimes disturbing, drawings.

15.26 Hans Bellmer, *Doll*, 1935. Wood, metal, and *papier mâché*. Manoukian Collection, Paris.

Matta and Lam

Surrealism in the 1940s was also enriched by the contributions of the Chilean artist Matta and the Cuban Wifredo Lam, both of whom traveled to Europe and participated in Parisian Surrealist circles before returning to the Americas. Their long careers provide links between the later phases of Surrealism and other art movements of the postwar period.

Born in Chile as Roberto Sebastiano Antonio Matta Echaurren, **Matta** (1911–2002) studied architecture in the Paris office of Le Corbusier until, in 1937, he showed some of his drawings to Breton, who immediately welcomed him into the Surrealist fold. When he emigrated to the United States in 1939 (on the same boat as Tanguy), Matta was relatively unknown, despite his association with the Surrealists in Paris. His 1940 one-man show at the Julien Levy Gallery, the most important commercial showcase for Surrealist art in New York, had a momentous impact on American experimental artists. Although Matta—the last painter, along with Arshile Gorky (see chapter 17), claimed for Surrealism by André Breton—was much younger than most of his better-known expatriate European colleagues, his paintings marked the step that American artists were seeking.

Over the next few years, together with the American painter Robert Motherwell, Matta, who unlike many émigré artists from Europe spoke English fluently, helped to forge a link between European Surrealism and the American movement to be called Abstract Expressionism. Matta's painting at that point is exemplified in the 1942 *Disasters of Mysticism* (fig. **15.27**). Although this has some roots in the work of Masson and Tanguy, it is a powerful excursion into uncharted territory. In its ambiguous, automatist flow, from brilliant flame-light into deepest shadow, it suggests the ever-changing universe of outer space.

Wifredo Lam (1902–82) brought a broad cultural background to his art and, once he arrived in Paris in 1938, to the Surrealist milieu. Born in Cuba to a Chinese father and a European–African mother, he studied art first in Havana and, in 1923, in Madrid. In Spain he fought on the side of the Republicans during the Civil War, a fact that endeared him to Picasso when he moved to Paris. Through Picasso, Lam was introduced to members of the Parisian Surrealist circle, including Breton. In his paintings he explored imagery that was heavily influenced by Picasso, Cubism, and a continuing interest in African art. Lam left Paris because of World War II, eventually traveling with Breton to Martinique, where they were joined by Masson. The Frenchmen moved on to New York while Lam returned to Cuba in 1942. His rediscovery of the rich culture of his homeland helped to foster the emergence of his mature style: "I responded always to the presence of factors that emanated from our history and our geography, tropical flowers, and black culture."

While in Cuba, Lam made the large, sumptuously colored painting *The Jungle* (fig. **15.28**). Based in part on the Cuban religion of Santería, which blends mystical and ritualistic traditions from Africa with old-world Catholicism, *The Jungle* presents a dense tropical landscape populated by odd, long-limbed creatures whose disjointed heads resemble African masks. These human–animal hybrids, who assemble in a lush dreamscape, give evidence of the artist's Surrealist background. Lam returned to France in 1952, though he continued to travel widely and visit Cuba. His art was especially important to postwar European and American artists, especially the CoBrA painters of northern Europe (see chapter 18).

15.27 Matta, *Disasters of Mysticism*, 1942. Oil on canvas, 38¼ × 51¾" (101.6 × 152.4 cm). Private collection.

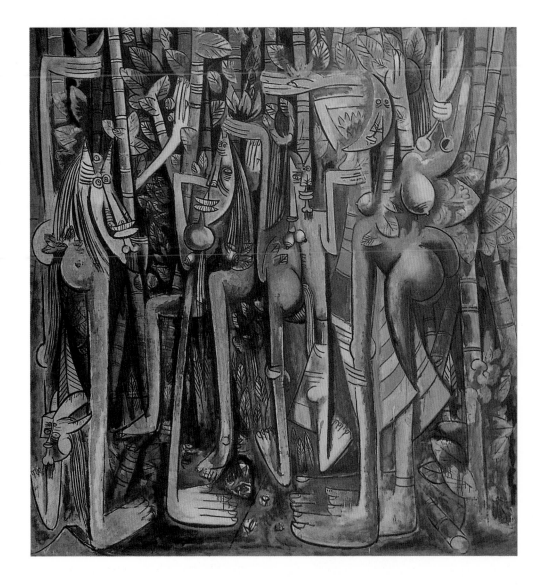

Women and Surrealism: Oppenheim, Cahun, Tanning, and Carrington

As a movement, Surrealism was not particularly hospitable to women, except as a terrain onto which male artists projected their erotic desires and psychic fears. Nevertheless, several women advanced decidedly innovative work in a Surrealist idiom. **Meret Oppenheim** (1913–85), a native of Berlin, arrived in Paris as an art student in 1932 when she was not yet twenty years old and was soon introduced to members of the Surrealist circle. She began to take part in the group's exhibitions in 1935 and modeled for a number

of photographs by Man Ray. Although she produced a large body of work—paintings, drawings, sculpture, and poetry—Oppenheim was known primarily for her notorious *Object (Le Déjeuner en fourrure) (Luncheon in Fur)* (fig. **15.29**), a cup, plate, and spoon covered with the fur of a Chinese gazelle. The idea for this "fur-lined tea cup,"

15.29 Meret Oppenheim, *Object (Le Déjeuner en fourrure) (Luncheon in Fur)*, 1936. Fur-covered cup, diameter 4⅜" (10.9 cm); saucer, diameter 9⅜" (23.7 cm); spoon, length 8" (20.2 cm). Overall height 2⅞" (7.3 cm). The Museum of Modern Art, New York.

which has become the very archetype of the Surrealist object, germinated in a café conversation with Picasso about Oppenheim's designs for jewelry made of fur-lined metal tubing. When Picasso remarked that one could cover just about anything with fur, she quipped, "even this cup and saucer." In Oppenheim's hands, this emblem of domesticity and the niceties of social intercourse metamorphosed into a hairy object that is both repellent and eroticized, the consummate fetish. Conjuring both desire and dread, Oppenheim's *Object* revels in Freudian erotic ambivalence and sexual anxiety.

Claude Cahun (1894–1954) confronted directly the psychological as well as physical significance of sexual identity in her photographs, many of which are self-portraits (fig. **15.30**). The nature of gender was of particular interest to Cahun, born Lucy Schwob, who adopted a gender-neutral name and made no secret of either her lesbianism or her romantic partnership with her stepsister and collaborator Suzanne Malherbe. Her self-portraits capture an uncannily androgynous figure, often sporting the costume and accoutrements of a decidedly masculine occupation: sailor, pilot, circus strongman, or dandy. Another series of self-images presents Cahun as a lifeless mannequin or doll, challenging the viewer to discern reality from representation. Cahun exhibited regularly with the Surrealists and shared their commitment to a politically engaged art. The depth of this commitment became clear during World War II, when Cahun and Malherbe were living on the

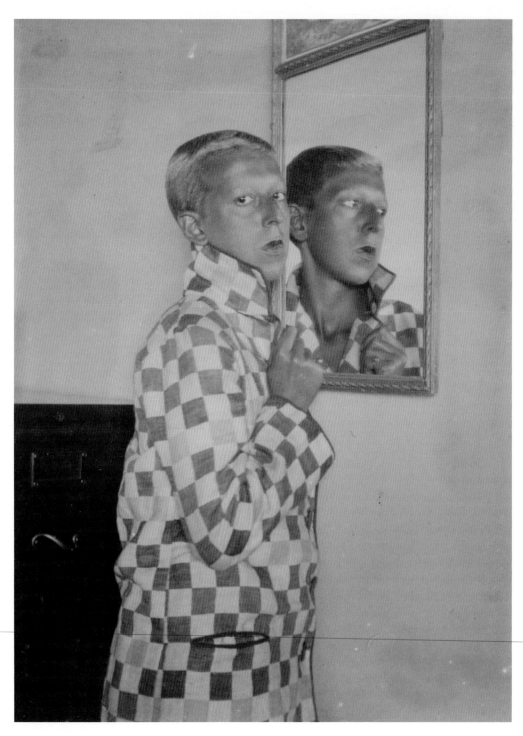

15.30 Claude Cahun (Lucy Renée Mathilde Schwob), *Self-Portrait*, c. 1928. Gelatin silver print, 3⅜ × 2⅜" (8.2 × 5.7 cm). San Francisco Museum of Modern Art.

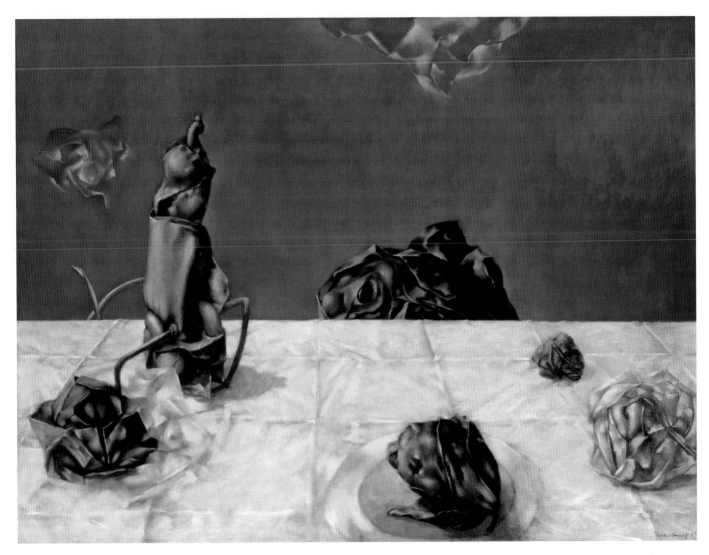

15.31 Dorothea Tanning, *Some Roses and Their Phantoms*, 1952. Oil on canvas, 29⅞ × 40" (75.9 × 101.6 cm). Tate, London. Gift of Robert Shapazian.

German-occupied island of Jersey. They distributed anti-war tracts on thin tissue paper, which they stuffed into the pockets of German soldiers. In 1944, the pair were arrested and condemned to death, but the liberation prevented the sentence from being carried out. The Nazis repeatedly sacked her home and studio, though, destroying most of the work she had made before and during the war.

The career of American artist **Dorothea Tanning** (b. 1910) was somewhat overshadowed by that of her husband, Max Ernst, whom she married in 1946. Tanning had met Ernst in New York, where she moved after her brief art studies in Chicago. Like so many American artists, she was deeply moved by the experience of the important exhibition Fantastic Art, Dada, and Surrealism, held at The Museum of Modern Art in 1936. She came into contact with Surrealist refugee artists from Paris, including Ernst and Breton. By the early 1940s, Tanning had produced her first mature paintings, and in 1944 she was given a solo exhibition at the Julien Levy Gallery. In 1946, she moved with Ernst to Sedona, Arizona, and later settled in France. Tanning's skills as a painter and her penchant for the bizarre are given rich expression in the 1952 still life *Some*

Roses and Their Phantoms (fig. **15.31**). Across a table covered with strange, rose-hybrid formations and a tablecloth marked by grid-shaped folds, a monstrous creature raises its head. Tanning's meticulous style intensifies the hallucinatory quality of the scene. As she claimed, "It's necessary to paint the lie so great that it becomes the truth."

Slightly younger than Tanning was British-born **Leonora Carrington** (b. 1917), who distinguished herself both as a writer and a painter. Carrington scandalized her wealthy Catholic parents by moving to Paris with Max Ernst at the age of twenty and becoming an associate of the Surrealists. During the war, when Ernst was interned by the French as an enemy alien (and imprisoned for a time in a cell with Hans Bellmer), Carrington suffered a mental collapse, about which she wrote eloquently in the book *En bas (Down There)* of 1943. After living in New York for two years, she settled in Mexico in 1942. The enigmatic imagery that surrounds the artist in her *Self-Portrait (The White Horse Inn)* (fig. **15.32**) is closely tied to Celtic mythology and memories of her childhood. These are themes that she explored in her literary works: in two of her short stories the protagonists befriend, respectively,

15.32 Leonora Carrington, *Self-Portrait (The White Horse Inn)*, 1936–37. Oil on canvas, 25½ × 32⅛" (65 × 81.5 cm). Private collection.

a hyena and a rocking horse, both of which have magical powers. Carrington, who apparently kept a rocking horse in her Paris apartment, created a lead character in one of the stories who is capable of transforming herself into a white horse. In the painting, Carrington, wearing her white jodhpurs, reaches out to a hyena-like creature heavy with milk, while at the same time a hobby-horse levitates inexplicably above her head. Given the subject of Carrington's own fable, the galloping white horse seen through the window becomes a kind of liberated surrogate self. In a larger context, this arresting painting abounds with classic Freudian dream imagery, in which horses are symbols of sexual desire. After she moved to Mexico, Carrington cast her mystical subjects of alchemy and the occult in imagery reminiscent of the late fifteenth-century Netherlandish painter Hieronymus Bosch.

Never Quite "One of Ours": Picasso and Surrealism

In 1925, André Breton claimed **Pablo Picasso** (1881–1973) as "one of ours," but sensibly exempted the great artist (at least for a time) from adopting a strict Surrealist regime. Picasso was never a true Surrealist. He did not share the group's obsession with the unconscious

and the dreamworld, though his paintings could certainly plumb the depths of the psyche and express intense emotion. The powerful strain of eroticism and violence in Picasso's art also helped ally him to the Surrealist cause. He had considerable sympathy for the group, exhibiting with them and contributing drawings to the second number of *La Révolution surréaliste* (January 15, 1925). In the fourth number of the magazine (July 15, 1925) Breton, the editor, included an account of *Les Demoiselles d'Avignon* (see fig. 8.7) and reproduced collages and a new painting by Picasso.

Painting and Graphic Art, mid-1920s to 1930s

We have already seen in *Studio with Plaster Head* (see fig. 12.27) how a new emotionalism was entering Picasso's work in the mid-1920s. Now, violence and anxiety (a favorite emotional coupling of the Surrealists) have been introduced, permeating *Large Nude in Red Armchair* (fig. 15.33), 1929. It is a timeless subject—a figure seated in a red chair draped in fabric and set against green flowered wallpaper (these saturated hues persisted in Picasso's work of the 1930s). But the woman's body is pulled apart as though made of rubber. With knobs for hands and feet and black sockets for eyes, she throws her head back not in sensuous abandon but in a toothy wail, resulting in what

15.33 Pablo Picasso, *Large Nude in Red Armchair*, May 5, 1929. Oil on canvas, 6' 4¾" × 4' 3¼" (1.9 × 1.3 m). Musée Picasso, Paris.

Breton called "convulsive" beauty. While he did it to rather different effect, the photographer André Kertész subjected the female body to a similar kind of elasticity in the 1930s (see figs. 15.57, 15.58). In many ways, Picasso's paintings can be read as running commentaries on his relationships, and his paintings of the late 1920s, when his marriage was disintegrating, were filled with women as terrifying monsters. As the poet Paul Éluard observed, "He loves with intensity and kills what he loves."

One of Picasso's favorite subjects was the artist in his studio. He returned to it periodically throughout his career, often exploring the peculiarly voyeuristic nature of the painter's relationship to the model. His interest may have been aroused by a commission from the dealer Ambroise Vollard to provide drawings for an edition of Honoré de Balzac's novel *The Unknown Masterpiece*. The illustrated edition was published in 1931. This story concerns an obsessive painter who worked for ten years on a painting of a woman and ended with a mass of incomprehensible scribbles, which the painter asserts is a nude of surpassing beauty, his crowning achievement. Picasso's interpretation (fig. **15.34**) may illustrate his mistrust in

15.34 Pablo Picasso, *Painter and Model Knitting* (executed in 1927) from *Le Chef-d'oeuvre inconnu*, by Honoré de Balzac, Paris, Ambroise Vollard, 1931. Etching, printed in black, plate 7⁹⁄₁₆ × 10⅞" (19.2 × 27.6 cm). The Museum of Modern Art, New York.

15.35 Pablo Picasso, *Painter and Model*, 1928. Oil on canvas, 51⅛ × 64¼" (130 × 163.2 cm). The Museum of Modern Art, New York.

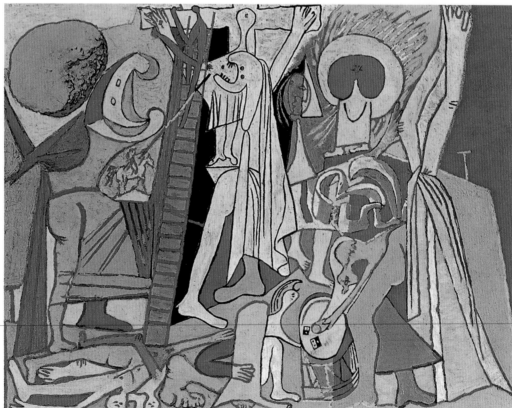

15.36 Pablo Picasso, *Crucifixion*, 1930. Oil on plywood, 20⅛ × 26" (51.1 × 66.1 cm). Musée Picasso, Paris.

complete abstraction as a means of representing an ideal, for he had already warned against trying "to paint the invisible." In a highly geometric composition of 1928 (fig. **15.35**), reality and illusion as presented in the drawing are reversed. The painter and model are highly abstracted, Surrealist ciphers, while the "painted" portrait on the artist's canvas is a more "realistic" profile.

Picasso rarely painted religious subjects, but the small, brilliant *Crucifixion* (fig. **15.36**) testifies to his interest in Christian themes. The artificial palette of bright reds, yellows, and greens seems unsuited to the somber subject, but Picasso's is hardly a conventional treatment. Into a small canvas he manages to cram a crowd of disjointed figures in such a dizzying variety of scales and styles that it is extremely difficult to read the picture. We can recognize certain familiar aspects of the story. For example, a tiny red figure at the top of the ladder nails Christ's hand to the cross. The mourning Virgin is located just before the cross, her face distorted in the same grimace we encountered in *Large Nude in Red Armchair*. In the foreground two soldiers throw dice for Christ's clothes, but the anatomies of the figures are drastically distorted by unexpected shifts in scale. The *Crucifixion* is a highly personal version of this sacred subject, one that drew on many sources, including ancient legends and rituals. What is clear is its sense of

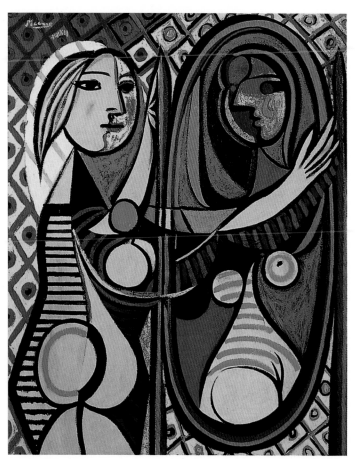

15.38 Pablo Picasso, *Girl Before a Mirror*, Boisgeloup, 1932. Oil on canvas, 64 × 51¼" (162.3 × 130.2 cm). The Museum of Modern Art, New York.

tortured agony, which looks back to the German Gothic and Northern Renaissance art with which Picasso was then preoccupied. His drawings after Matthias Grünewald's iconic *Isenheim Altarpiece* were published in 1933 in the first issue of *Minotaure*, for which he designed the cover.

In 1928 Picasso made sketches of the figure compartmentalized into strange bone-like forms. Variations on these highly sexualized "bone figures" continued into the 1930s. One startling example is *Seated Bather* (fig. **15.37**), which is part skeleton, part petrified woman, and all monster, taking her ease in the Mediterranean sun. *Seated Bather* simultaneously has the nonchalance of a bathing beauty and the predatory countenance of a praying mantis, one of the Surrealists' favorite insect images. Because the female praying mantis sometimes devours the male after mating, it was seen as a particularly apt metaphor for the threatening feminine of Freudian theory. Careful inspection of the righthand portion of *Crucifixion* (see fig. 15.36) proves that this strange head first made an appearance in that work, suggesting the formal compression of the menacing Roman soldier who rolls dice for Christ's clothes with the nude bather posing seductively on the sun-drenched shore.

Picasso reveals some interest in the unconscious as a source of creativity and of truth in the 1932 painting *Girl Before a Mirror* (fig. **15.38**), for which his mistress

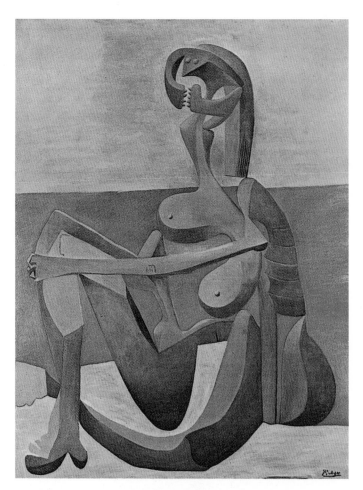

15.37 Pablo Picasso, *Seated Bather*, early 1930. Oil on canvas, 64¼ × 51" (163.2 × 129.5 cm). The Museum of Modern Art, New York.

Marie-Thérèse Walter served as model. Picasso here assimilates classical repose with Cubist space in a key painting of the 1930s. Such moments of summation for Picasso alternate with cycles of fertile and varied experiment. *Girl Before a Mirror* brings together brilliant color patterns and sensual curvilinear rhythms. Rapt in contemplation of her mirror image, the girl sees not merely a reversed reflection but some kind of mysterious alter ego. In the mirror her clear blonde features become a disquieting series of dark, abstracted forms, as though the woman is peering into the depths of her own soul.

Guernica and Related Works

Picasso's major painting of the 1930s and one of the most recognizable works of the twentieth century is *Guernica* (fig. **15.39**). Executed in 1937, it was inspired by the atrocities of the Spanish Civil War—specifically, the destruction of the Basque town of Guernica by German bombers in the service of the Spanish fascists. In January 1937, Picasso, who supported the Republicans in their fight against the fascist General Francisco Franco, created two etchings, each composed of a number of episodes, and accompanied by a poem, *Dream and Lie of Franco*. General Franco is shown as a turnip-headed monster, and the bull as the symbol of resurgent Spain. The grief-stricken woman in the painting who shrieks over the body of her dead child first appeared in this etching. In May and June 1937 Picasso painted *Guernica* for the Spanish Republican Pavilion of the Paris World's Fair. It is a huge painting in black, white, and gray, a scene of terror and devastation. Although Picasso used motifs such as the screaming horse or agonized figures derived from his Surrealist distortions of the 1920s, the structure is based on the Cubist grid and returns to the more stringent palette of Analytical Cubism (see fig. 8.18). With the exception of the fallen warrior at the lower left, the human protagonists are women, but the central victim is the speared horse from *Minotauromachy*. *Guernica* is Picasso's most powerfully expressionist application of Cubism and one of the most searing indictments of war ever painted.

Though *Guernica* was created in response to current events, elements in the painting can be traced back to Picasso's work of the 1920s. The figure of the Minotaur first appeared in a collage of 1928. In 1933 he made a series of etchings, collectively known as the *Vollard Suite*, in which the Minotaur is a central character. During 1933 and 1934 Picasso also drew and painted bullfights of particular savagery. These explorations climaxed in the etching *Minotauromachy* of 1935 (fig. **15.40**). It presents a number of elements reminiscent of Picasso's life and his Spanish past, including: recollection of the prints of Goya; the women in the window; the Christ-like figure on the ladder; the little girl holding flowers and a candle (a symbol of innocence); the screaming, disemboweled horse (which becomes the central player in *Guernica*) carrying a dead woman (dressed as a toreador); and the Minotaur groping his way. The place of the Minotaur (or the bull) in Picasso's iconography is ambiguous. It may be a symbol of insensate, brute force, sexual potency and aggression, a symbol of Spain, or of the artist himself.

Sculpture, late 1920s to 1940s

In 1928 Picasso's Surrealist bone paintings revived his interest in sculpture, which, except for a few sporadic assemblages, he had abandoned since 1914. In broader terms, sculpture can be seen to gain greater importance around

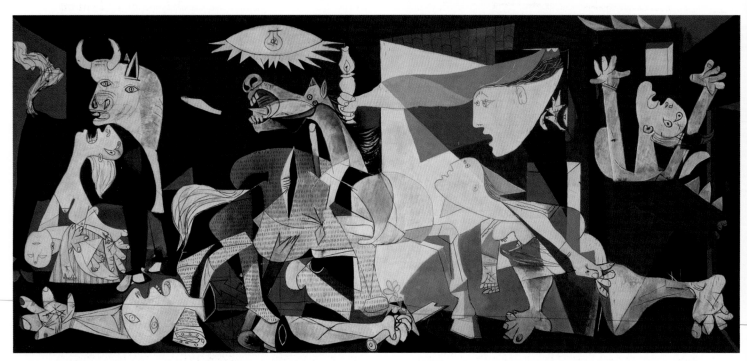

15.39 Pablo Picasso, *Guernica*, 1937. Oil on canvas, 11' 6" × 25' 8" (3.5 × 7.8 m). Museo Nacional Centro de Arte Reina Sofía, Madrid.

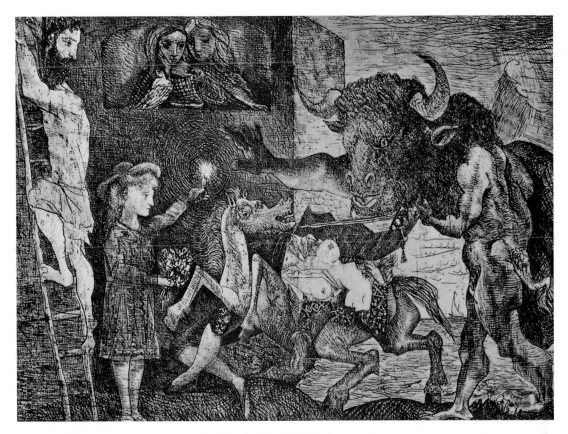

15.40 Pablo Picasso, *Minotauromachy*, March 23, 1935. Etching and engraving on copper plate, printed in black; plate 19½ × 27⅜" (49.6 × 69.6 cm). The Museum of Modern Art, New York.

1930 as part of a movement away from modernism's earlier emphasis on individual, experimental enquiry toward more public forms of expression, of which *Guernica* is a powerful example.

With the technical help of his old friend Julio González (see p. 348), a skilled metalworker, Picasso produced welded iron constructions that, together with González' similar creations of the period, marked the emergence of direct-metal sculpture as a major, modern medium. Picasso's *Woman in the Garden* (fig. **15.41**), a large, open construction in which the figure consists of curving lines and organic-shaped planes, is one of the most intricate and monumental examples of direct-metal sculpture produced to that date. The woman's face is a triangle with strands of windswept hair and the by-now familiar gaping mouth. The bean-shaped form in the center stands for her stomach, while the disk below it is one of Picasso's familiar signs for female genitalia. The original version of this work was made of welded and painted iron. Picasso commissioned González to make a bronze replica.

Carried away by enthusiasm, Picasso modeled in clay or plaster until by 1933 his studio at Boisgeloup was full. His work included massive heads of women, reflecting his contemporaneous curvilinear style in painting and looking back in some degree to his Greco-Roman style; torsos

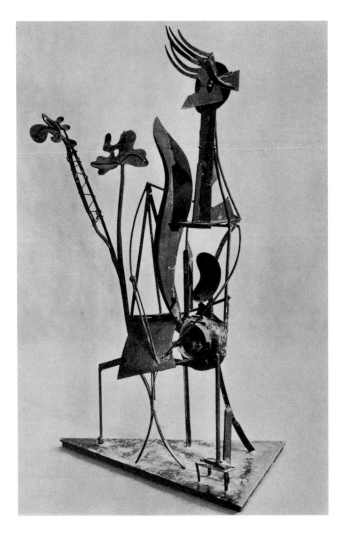

15.41 Pablo Picasso, *Woman in the Garden*, 1929–30. Bronze after welded and painted iron original, height 6' 10¾" (2.1 m). Musée Picasso, Paris.

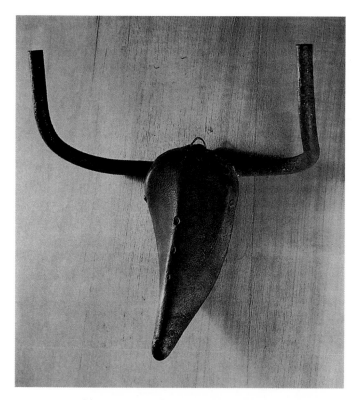

15.42 Pablo Picasso, *Bull's Head*, 1943. Bicycle saddle and handlebars, 13¼ × 17⅛ × 7½" (33.5 × 43.5 × 19 cm). Musée Picasso, Paris.

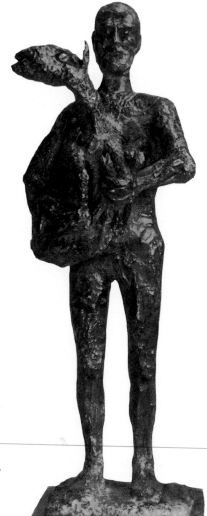

15.43 Pablo Picasso, *Man with a Sheep*, 1943. Bronze, height 7' 3" (2.2 m). Musée Picasso, Paris.

transformed into anthropomorphic monsters; surprisingly representational animals including a cock and a heifer; and figures assembled from found objects organized with humor and delight. Of the found-object sculptures perhaps the most renowned is the *Bull's Head* of 1943 (fig. **15.42**), which consists of an old bicycle seat and handlebars—a wonderful example of the way Picasso remained alert to the formal and expressive potential of the most commonplace objects.

The full range of Picasso's experiments in sculpture becomes clear when we realize that *Bull's Head* was made shortly before *Man with a Sheep* (fig. **15.43**). This work, which was created through the more conventional medium of plaster for bronze, is one of the artist's most moving conceptions. On the one hand the figure could refer to the Early Christian figure of the Good Shepherd, Christ the protector of the oppressed, a figure that may be traced back to classical pagan religions as well as to the Old Testament. On the other, it could recall ancient rituals of animal sacrifice. Picasso insisted, "There is no symbolism in it. It is just something beautiful." This sculpture stood prominently in the artist's Paris studio at the time of the liberation of France in 1944 by the Allied forces where, in the words of one Picasso scholar, it "came to epitomize an act of faith in humanity."

Pioneer of a New Iron Age: Julio González

Julio González (1876–1942), another son of Barcelona, had been trained in metalwork by his father, a goldsmith, but he practiced as a painter for many years. In Paris by 1900, he came to know Picasso and Brancusi, but after the death of his brother Jean in 1908, he lived in isolation for several months. In 1910 González began to make masks in a metal repoussé technique. In 1918, he learned the technique of oxyacetylene welding, and by 1927 he was producing his first sculptures in iron. In the late 1920s he made a series of masks (fig. **15.44**) from sheets of flat metal. The sharp, geometric contours in the mask, as González's drawings make clear, are derived from the strong, angular shadows cast over faces in the hot sun. Their openwork construction had no real precedents in figural sculpture. In 1928, Picasso asked González for technical help in constructed sculpture, Picasso's new interest. It may be said that González began a new age of iron for sculpture, which he described in his most famous statement:

The age of iron began many centuries ago by producing very beautiful objects, unfortunately for a large part, arms. Today, it provides as well, bridges and railroads. It is time this metal ceased to be a murderer and the simple instrument of a supermechanical science. Today the door is wide open for this material to be, at last, forged and hammered by the peaceful hands of an artist.

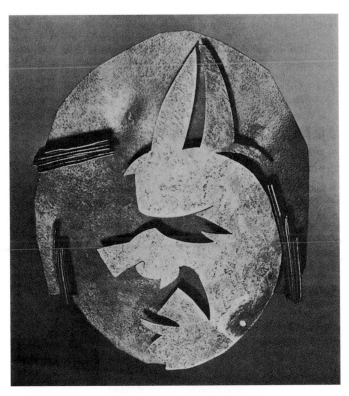

15.44 Julio González, *Mask of Roberta in the Sun*, c. 1929. Iron, height 7⅛" (18.1 cm). Collection Roberta González, Paris.

By 1931 González was working in direct, welded iron, with a completely open, linear construction in which the solids were merely contours defining the voids. The difference between these constructions and the earlier ones of Gabo and the Russian Constructivists (see figs. 10.39, 10.44) lies not only in the technique—which was to have such far-reaching effects on younger sculptors—but also in the fact that, however abstract his conceptions, González was always involved with the figure. Side by side with these openwork, direct-metal constructions, González continued to produce naturalistic heads and figures, such as his large wrought-iron and welded *Montserrat* (fig. **15.45**), a heroic figure of a Spanish peasant woman, symbol of the resistance of the Spanish people against fascism. Montserrat is the name of the mountain range near Barcelona, epitomizing Catalonia. This work was commissioned by the Spanish Republic for the 1937 World's Fair in Paris, where it was shown with murals by Miró and Picasso's *Guernica*. Dating from 1939, *Monsieur Cactus I (Cactus Man I)* (fig. **15.46**), as the name implies, is a bristly and aggressive individual, suggesting a new authority in the artist's work. The original version of this work was made of welded iron; it was then cast in bronze in an edition of eight. Scholars have posited that the angry, aggressive forms of *Monsieur*

15.45 Julio González, *Montserrat*, 1937. Wrought iron, 65 × 18½ × 18½" (165 × 47 × 47cm). Stedelijk Museum, Amsterdam.

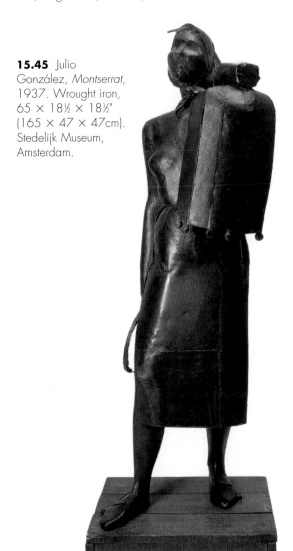

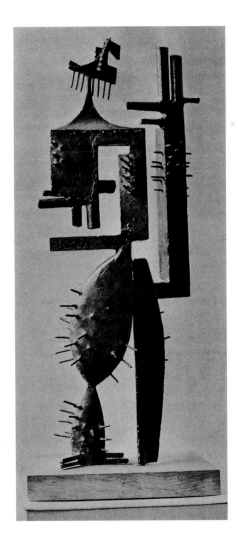

15.46 Julio González, *Monsieur Cactus I (Cactus Man I)*, 1939. Bronze (cast from original iron), height 26" (66 cm). Private collection.

Cactus I may embody the artist's reactions to the recent fascist defeat of resistance forces in his beloved Barcelona, signaling the end of civil war in Spain.

The sculpture of Picasso and González after the 1920s has had a special relevance to contemporary sculpture for its exploration of the techniques of direct metal and the use of the found object. For example, when American sculptor David Smith came upon González's work in the early 1930s, he was inspired to make welded metal sculpture (see fig. 17.36).

Surrealism's Sculptural Language: Giacometti's Early Career

If González was the pioneer of a new iron age, in which the medium would be used to forge artworks instead of weapons, **Alberto Giacometti** (1901–66) inaugurated a bronze age that would give form to the human psyche in all its exultation and depravity. After studies in Geneva and a long stay with his father, a painter, in Italy, where he saturated himself in Italo-Byzantine art and became acquainted with the Futurists, Giacometti moved to Paris in 1922. Here he studied with Émile-Antoine Bourdelle, who had been trained at the École des Beaux-Arts and by Rodin. After three years with Bourdelle, Giacometti set up a studio with his brother Diego, an accomplished technician who continued to be his assistant and model to the end of his life. His first independent sculptures reflected awareness of the Cubist sculptures of Lipchitz and Laurens and, more importantly, of African, Oceanic, and prehistoric art. Giacometti's *Femme cuillère (Spoon Woman)* of 1926 (fig. **15.47**) is a frontalized, Surrealist–primitive totem, probably inspired by a Dan spoon from West Africa that the artist saw in the Paris ethnographic museum. Evincing a spiritual if not a stylistic affinity with the work of Brancusi, *Femme cuillère* has the totemic presence of an ancient fertility figure.

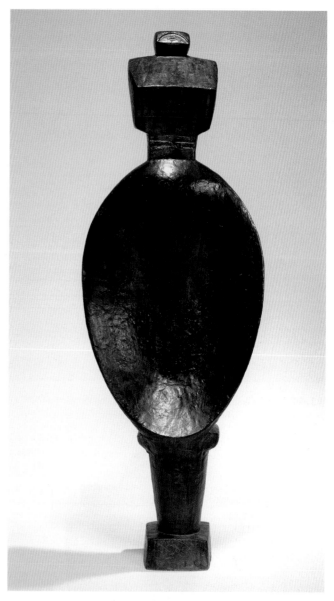

15.47 Alberto Giacometti, *Femme cuillère (Spoon Woman)*, 1926 (cast 1954). Bronze, 56¾ × 20 × 9" (144.1 × 50.8 × 22.9 cm). Raymond and Patsy Nasher Collection, Dallas.

15.48 Alberto Giacometti, *No More Play*, 1931–32. Marble, wood, bronze, 1⅝ × 22⅞ × 17¾" (4.1 × 58 × 45.1 cm). National Gallery of Art, Washington, D.C.

15.49 Alberto Giacometti, *Woman with Her Throat Cut (Femme égorgée)*, 1932 (cast 1949). Bronze, 8 × 34½ × 25" (20.3 × 87.6 × 63.5 cm). The Museum of Modern Art, New York.

At the end of the 1920s Giacometti was drawn into the orbit of the Paris Surrealists. For the next few years he made works that reflected their ideas, exhibiting with Miró and Arp at the Galerie Pierre until 1935 (when he was expelled by the movement). The sculptures he produced during these years are among the masterpieces of Surrealist sculpture. *No More Play* (fig. **15.48**) is an example of his tabletop compositions. Here the base becomes the actual sculpture on which movable parts are deployed like pieces in a board game (as the title implies). In two of the rounded depressions carved in the lunar-like surface are tiny male and female figurines in wood. Between them are three cavities, like coffins with movable lids. One of these contains an object resembling a skeleton. The viewer can interact with the work, moving aside the lids of the "tombs" to discover their contents and crossing over the usually inviolable space between object and viewer.

Woman with Her Throat Cut (fig. **15.49**), a bronze construction of a dismembered female corpse, bears a family resemblance to Picasso's 1930 *Seated Bather* (see fig. 15.37). The spiked, crustacean form of the sculpture suggests the splayed and violated body of a woman. According to the artist, the work should be placed directly on the floor, without a base. From a high vantage point, looking down, the Surrealist preoccupation with sexual violence is undisguised. The avant-garde's focus on the female nude, always more than a mere formal concern, has moved well beyond Manet's modernization of the reclining Venus (see chapter 2) to investigate more troubling themes of sexual subjugation and fetishization. The fatal wound's rupture of the figure's phallic neck makes only too clear the Freudian displacement of castration fears onto the female body. The work's fetishistic quality is enhanced by its portability: it can, like *No More Play*, be moved by the viewer, though the phallic-shaped form should be placed in the leaf-like "hand" of the figure, for Giacometti related the sculpture to the common nightmare of being unable to move one's hand.

In a number of his Surrealist sculptures Giacometti experimented with the format of an open cage structure, a series that climaxed in *The Palace at 4 a.m.* of 1932–33 (fig. **15.50**), a structure of wooden rods defining the outlines

15.50 Alberto Giacometti, *The Palace at 4 a.m.*, 1932–33. Construction in wood, glass, wire, and string, 25 × 28¼ × 15¾" (63.5 × 71.8 × 40 cm). The Museum of Modern Art, New York.

of a house. At the left a woman in a long dress (the artist's recollection of his mother) stands before three tall rectangular panels. She seems to look toward a raised panel on which is fixed a long, oval spoon shape with a ball on it. To the right, within a rectangular cage, is suspended an object resembling a spinal column, and in the center of the edifice hangs a narrow panel of glass. Above, floating in a rectangle that might be a window, is a sort of pterodactyl—"the skeleton birds that flutter with cries of joy at four o'clock." This strange edifice was the product of a period in the artist's life that haunted him and about which he has written movingly:

For six whole months hour after hour was passed in the company of a woman who, concentrating all life in herself, made every moment something marvelous for me. We used to construct a fantastic palace in the night (days and night were the same color as if everything had happened just before dawn; throughout this time I never saw the sun), a very fragile palace of matchsticks: at the slightest false move a whole part of the minuscule construction would collapse: we would always begin it again.

Whatever the associations and reminiscences involved, *The Palace at 4 a.m.* was primarily significant for its wonderful, haunting quality of mystery.

Invisible Object (Hands Holding a Void) of 1934 (fig. **15.51**) is one of Giacometti's last Surrealist sculptures. The elongated female personage half sits on a cage/chair structure that provides an environment and, when combined with the plank over her legs, pins her in space. With a hieratic gesture, she extends her hands to clasp an unseen object, as though participating in some mysterious ritual. The work has been connected to sources in Oceanic and ancient Egyptian art. The form of a single, vertical, attenuated figure is significant for Giacometti's later work (see chapter 18).

Surrealist Sculpture in Britain: Moore

Although **Henry Moore** (1898–1986) did not begin to assume a genuinely international stature before 1945, he was a mature artist by the early 1930s, in touch with the main lines of Surrealism and abstraction on the Continent, as well as all the new developments in sculpture, from Rodin through Brancusi to Picasso and Giacometti. By 1935 he had already made original statements and had arrived at many of the sculptural figurative concepts that he was to build on for the rest of his career.

15.51 Alberto Giacometti, *Mains Tenant le Vide (Hands Holding the Void)*, 1934. Plaster, height 61½" (156.2 cm). Yale University Art Gallery, New Haven. Anonymous gift.

15.52 Henry Moore, *Reclining Figure*, 1929. Hornton stone, height 22½" (57.2 cm). Leeds City Art Galleries, England.

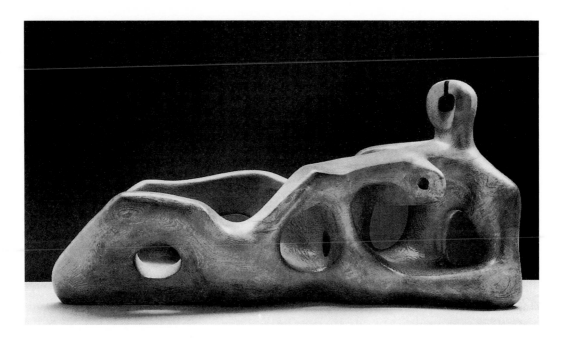

15.53 Henry Moore, *Reclining Figure*, 1939. Elm wood, 3' 1" × 6' 7" × 2' 6" (0.94 × 2 × 0.76 m). The Detroit Institute of Arts.

The son of a coal miner, Moore studied at the Royal College of Art in London from 1921 until 1925. The greatest immediate influence on him was the range of works he studied in English and European museums, particularly the classical, pre-classical, African, and pre-Columbian art he saw in the British Museum. He was also attracted to English medieval church sculpture and to artists in the Renaissance tradition—Masaccio, Michelangelo, Rodin, Maillol—who had a particular feeling for the monumental.

Between 1926 and 1930 the dominant influence on Moore was pre-Columbian art. The 1929 *Reclining Figure* (fig. **15.52**) is an example of the artist's mature sculpture, a piece that may owe its original inspiration to a chacmool (with overtones of Maillol). Chacmools are a distinctive type of stone sculpture, associated with the tenth–twelfth-century Toltec culture of central Mexico, that represents a reclining warrior holding an offering dish. The massive blockiness of Moore's figure stems from a passionate devotion to the principle of truth to materials; that is, the idea that stone should look like stone, not flesh. In this and other reclining figures, torsos, and mother-and-child groups of the late 1920s, Moore staked out basic themes that he then used throughout his life.

In the early 1930s, the influence of Surrealist sculpture, notably that of Picasso, became evident. Moore began to explore other materials, particularly bronze, and his figures took on a fluidity and sense of transparent surface appropriate to what was for him a new material. Similar effects were achieved in carved wood in which he followed the wood grain meticulously, as in *Reclining Figure* from 1939 (fig. **15.53**), his largest carved sculpture to date. Less angular than the 1929 figure, this sculpture consists of a series of holes piercing the undulating solids, transforming the body into a kind of landscape filled with caves and tunnels. A characteristic of the figures of the 1930s is this opening up of voids, frequently to the point where the solids function as space-enclosing frames.

In the mid-1930s Moore turned to abstract forms, and by opening up masses and creating dispersed groups, he studied various kinds of space relationships. This began a continuing concern with a sculpture of tensions between void and solid, of forms enclosed within other forms. These experiments were then translated back into the figures. The interest in spatial problems led Moore during the 1940s and 50s to an ever greater use of bronze and other metals in which he could enlarge the voids of the figures. These developments in his work during and after World War II are pursued in chapter 18.

Bizarre Juxtapositions: Photography and Surrealism

Paris in the 1920s and 30s was especially fertile ground for photography. From many countries, several of the medium's greatest practitioners came together with painters and sculptors in an era of remarkably fruitful exchange among the arts. The 1920s, in particular, was a highly experimental period for photography that witnessed, among other related media, the explosion of cinema. The Surrealists valued photography for its ability to capture the bizarre juxtapositions that occur naturally in daily experience. The Surrealist sense of dislocation could be made even more shocking when documented in a photograph than in, for example, a literally rendered painting by Dalí. The Surrealists regularly featured photography, ranging from Bellmer's constructed "dolls" (see fig. 15.26) to vernacular snapshots by amateurs, in their various journals. Their embrace of the medium, however, was not unequivocal. Breton viewed photography as a threat to what he regarded as the more important activity of painting, and mistrusted its emphasis on the external world rather than internal reality. Nevertheless, photography was even used by artists in the Surrealist movement who were not necessarily photographers. Max Ernst, for example, incorporated

photographs into his collages; Bellmer's creations, as we have seen, were wholly dependent upon photography; and Magritte took photographs of his family and friends, quite separately from his paintings. Others, who were not card-carrying Surrealists but who shared a kindred vision with its official practitioners, were claimed by the movement. Its lasting legacy extended beyond still photography to film, and to other media, notably literature, that are outside the scope of this account.

Atget's Paris

By no means a practicing Surrealist, **Eugène Atget** (1857–1927) was one of the artists embraced by the group through Man Ray, who sensed that his vision lay as much in fantasy as in documentation. After having failed at the military and at acting, Atget taught himself photography and began a business providing photographs, on virtually any subject, for use by artists. By 1897, he had begun to specialize in images of Paris and conceived what a friend called "the ambition to create a collection of all that which both in Paris and its surroundings was artistic and picturesque. An immense subject." Over the next thirty years Atget labored to record the entire face of the French capital, especially those aspects of it most threatened by "progress." Although he was often commissioned by various official agencies to supply visual material on Paris,

Atget proceeded with a single-minded devotion to transform facts into art. His unforgettable images go beyond the merely descriptive to evoke a dreamlike world that is also profoundly real, though infused with a mesmerized nostalgia for a lost and decaying classical past.

Among the approximately 10,000 pictures by Atget that survive—images of streets, buildings, historic monuments, architectural details, parks, peddlers, vehicles, trees, flowers, rivers, ponds, the interiors of palaces, bourgeois apartments, and ragpickers' hovels—are a series of shop fronts (fig. **15.54**) that, with their grinning dummies and superimposed reflections from across the street, would fascinate the Surrealists as "found" images of dislocated time and place. Man Ray was so taken with *Magasin* that he arranged for it to be reproduced in *La Révolution surréaliste* in 1926. The sense it evokes of a dreamworld, of a strange "reality," of threatened loss, could only have been enhanced by equipment and techniques that were already obsolescent when Atget adopted them, and all but anachronistic by the time of his death.

Man Ray, Kertész, Tabard, and the Manipulated Image

The photographer who was most enduringly liberated by Surrealism was the one-time New York Dadaist **Man Ray** (1890–1976) (see figs. 11.17, 11.18), who after 1921

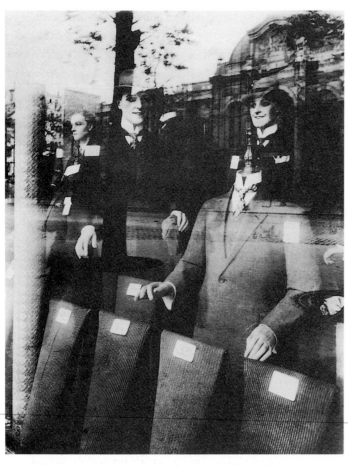

15.54 Eugène Atget, *Magasin, avenue des Gobelins*, 1925. Albumen-silver print, 9⅜ × 7" (24 × 18 cm). The Museum of Modern Art, New York.

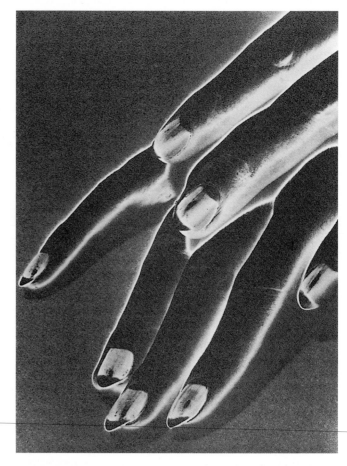

15.55 Man Ray, *Fingers*, 1930. Solarized gelatin-silver print from negative print, 11½ × 8¾" (29.2 × 22.2 cm). The Museum of Modern Art, New York.

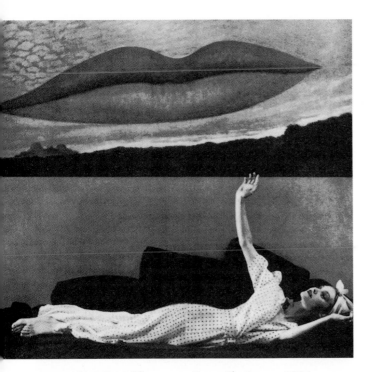

15.56 Man Ray, *Observatory Time—The Lovers*, 1936. Halftone reproduction. Published in *Harper's Bazaar*, November 1936.

lived in Paris and became a force within the circle around André Breton. In the course of his long career, Man Ray worked not only in photography but also in painting, sculpture, collage, constructed objects, and film. Despite his preference for the art of painting, it was through photography and film that he found the most successful expression of his aesthetic goals. From 1924 through the 1930s he contributed his photographs regularly to the Surrealist journals as well as to books by Surrealist writers.

In Paris Man Ray continued to experiment with unorthodox methods in the darkroom. In his Sabattier prints (so named for the early inventor of the technique but generally known as "solarizations"), a developed but unfixed print is exposed to light and then developed again, producing a reversal of tones along the edges of forms and transforming the mundane into something otherworldly (fig. **15.55**). Regarding one of his most famous paintings, *Observatory Time—The Lovers*, executed in 1930–32, Man Ray wrote:

> One of these enlargements of a pair of lips haunted me like a dream remembered: I decided to paint the subject on a scale of superhuman proportions. If there had been a color process enabling me to make a photograph of such dimensions and showing the lips floating over a landscape, I would certainly have preferred to do it that way.

To support himself while carrying out such ambitious painting projects, Man Ray made fashion photographs and photographic portraits of his celebrated friends in art, literature, and society. For *Harper's Bazaar* in 1936 he posed a model wearing a couture beach robe against the

backdrop of *Observatory Time—The Lovers* (fig. **15.56**), thereby grafting on to this elegant scene of high fashion a hallucinatory image of eroticism and Freudian association so revered by the Surrealists.

A lyrical, life-affirming *joie de vivre*, tethered to a rigorous, original sense of form, characterizes the work of **André Kertész** (1894–1985), who was already a practicing photographer when he arrived in France from Budapest in 1925. It was in Paris, however, that he became a virtuoso of the 35mm camera, the famous Leica introduced in 1925, and emerged as a pioneer of modern photojournalism. Though the hand-held camera had been used for years by amateurs, the desire for spontaneity among professionals meant that, by the 1930s, the Leica became the preferred camera of photojournalists. In his personal work, Kertész used the flexible new equipment not so much for analytical description, which the large-format camera did better, as for capturing the odd, fleeting moment or elliptical view when life is most, because unexpectedly, revealed. Photographed in the studio of a sculptor friend, Kertész's image of a woman in a pose like a human pinwheel (fig. **15.57**) playfully mimics the truncated limbs of the nearby sculpture.

The kind of elastic distortion achieved by Picasso through sheer force of imagination opened a rich vein of possibilities for photography, equipped as this medium was with every sort of optical device. Kertész created his funhouse effects (what he called "Distortions") by

15.57 André Kertész, *Satiric Dancer*, Paris, 1926. Gelatin-silver print.

photographing nude models reflected in a special mirror (fig. **15.58**). Despite the visual affinities with Surrealist-inspired imagery, Kertész never claimed any allegiance with the Surrealists and was not asked by Breton to enlist in their ranks. In 1936 he emigrated to America, where he freelanced for the leading illustrated magazines, with the exception of *Life*. The editors of that publication, one crucial to the development of American photography in the 1930s (see fig. 16.49), told him his photographs "spoke too much."

Maurice Tabard (1897–1984) was born in France but came to the United States in 1914. After studying at the New York Institute of Photography and establishing himself as a portrait photographer in Baltimore, Tabard returned to Paris in 1928 to make fashion photographs. He soon came to know photographers Man Ray, Henri Cartier-Bresson (see p. 358), and Kertész, as well as the painter Magritte, and became a well-known figure in Parisian avant-garde circles. Like Man Ray, he made solarized photographs and continued his creative photography alongside his more commercial fashion work. The methods by which Tabard obtained his Surrealistic imagery differed significantly from those of Kertész or Cartier-Bresson. While these artists found their images by chance or, in the case of Kertész's *Distortions*, a special mirror, Tabard engaged in the elaborate manipulation of his craft in the darkroom. His haunting photographs involve double exposures and negative printing, sometimes combining several techniques

15.59 Maurice Tabard, *Untitled*, 1929. Gelatin-silver print. Collection Robert Shapazian, Fresno, California.

within the same image. In an untitled work (fig. **15.59**), he locked the figure into place with a ladder-shaped shadow pattern slyly mimicking the frames that surround each exposure in a roll of film. Other superimposed imagery, including what appears to be the shadow of a tennis racket at the lower left, contributes to an overall sense of disorienting complexity.

The Development of Photojournalism: Brassaï, Bravo, Model, and Cartier-Bresson

Brassaï (Gyula Halász) (1899–1984) took his pseudonym from his native city, Brasso, in the Transylvanian region of Romania. Following his days as a painting student in Budapest and Berlin, Brassaï arrived in the French capital in 1924 and promptly fell in love with its streets, bars, and brothels, its artists, poets, and writers, even its graffiti. He sought out these subjects nightly and slept throughout the day. Once introduced to the small-format camera by his friend Kertész, Brassaï proceeded to record the whole of the Parisian human comedy, doing so as faithfully and objectively as possible (fig. **15.60**). That desire for objectivity prompted him to turn down an invitation from Breton to join the Surrealists. He watched for the moment when character seemed most naked and most rooted in time and place. Brassaï published the results of his nocturnal Parisian forays in the successful book *Paris de*

15.58 André Kertész, *Distortion No. 4*, 1933. Gelatin-silver print.

15.60 Brassaï, *Dance Hall*, 1932. Gelatin-silver print, 11½ × 9¼" (29.2 × 23.5 cm). The Museum of Modern Art, New York.

nuit (*Paris by Night*, 1933). In a more Surrealist vein, he produced images of *sculptures involontaires* ("involuntary sculptures"), close-up photographs of the bizarre shapes formed by discarded tickets, cigarette ends, and other throwaway objects.

Born in Mexico City, **Manuel Álvarez Bravo** (1902–2002) was a self-taught photographer whose work contributed to the artistic renaissance flourishing in Mexico during the 1930s. He befriended many of Mexico's leading avant-garde artists during this period, including the muralists Diego Rivera, David Alfaro Siqueiros, and José Clemente Orozco, whose work, often recorded in Álvarez Bravo's photographs, is discussed in chapter 16. His work represents a distinctive blend of cultural influences, fusing imagery and traditions indigenous to Mexico with current ideas imported from Europe and America, including those of the Surrealists. His work was illustrated in the last issue of *Minotaure*. Like Cartier-Bresson, Álvarez Bravo's penchant for discovering the visual poetry inherent in the everyday world could result in delightful and mysterious found images. He happened upon a group of mannequins, which he captured in a photograph of an outdoor market from the early 1930s (fig. **15.61**). Mannequins were a favorite Surrealist subject thanks to their uncanny resemblance to human beings, a resemblance that can trigger momentary but dizzying disorientation. The smiling cardboard mannequins in Álvarez Bravo's image, themselves merely mounted photographs, repeat the same woman's face, which, unlike its real counterparts below, meets the viewer's gaze.

15.61 Manuel Álvarez Bravo, *Laughing Mannequins*, c. 1932. Gelatin-silver print, 7⁵⁄₁₆ × 9⁹⁄₁₆" (18.6 × 24.3 cm). The Art Institute of Chicago.

Perhaps closer in spirit to the Austrian Expressionists than to the Surrealists is the work of **Lisette Model** (1901–83), a photographer born in turn-of-the-century Vienna to an affluent family of Jewish and Catholic descent. Model wanted first and foremost to become a concert pianist. In Vienna, she studied music with the composer Arnold Schoenberg and through his circle became aware of the activities of the Viennese avant-garde. In 1926, following the loss of the family's fortune during the war, she moved to France with her mother. It was in Paris, in 1933, that she decided to abandon music and become a professional photographer, learning the rudiments of the technique from her younger sister, her friend Florence Henri, and Rogi André, a photographer (and former wife of Kertész) who advised her to photograph only those things that passionately interested her. Model was, above all, interested in people. She regarded the world as a vast cast of characters from which she constructed her own narratives. With her twin-lens Rolleiflex in hand, during a visit to Nice to see her mother, she photographed wealthy vacationers soaking up the Riviera sun along that city's Promenade des Anglais (fig. **15.62**). Model wielded her camera like an invasive tool. Catching her wary subjects off-guard, she approached them closely, sometimes squatting to record their reactions at eye level. She then cropped her images in the darkroom, augmenting the confrontational

15.62 Lisette Model, *Promenade des Anglais*, 1934. Gelatin-silver print on paper, mounted on pasteboard, 13½ × 10⅞" (34.2 × 27.6 cm). The National Gallery of Canada, Ottawa.

nature of the close-up effect. In 1935 her photographs from Nice were published in the leftwing journal *Regards* as disparaging examples of a complacent middle class, "the most hideous specimens of the human animal." While it is not clear whether Model intended this interpretation, she did allow the photographs to be published again in 1941 in the weekly *PM*, one of the American publications for which she worked after she settled in New York in 1938. *PM* used the photos to demonstrate the French characteristics that, in its opinion, led to the country's capitulation in World War II. This photograph was reproduced under the heading "Cynicism." By the 1950s Model had become an influential teacher; her students included the American photographer Diane Arbus (see fig. 19.80).

With its power to record, heighten, or distort reality—a power vastly increased with the invention of the small, hand-held 35mm Leica—photography proved a natural medium for artists moved by the Surrealist spirit. One of the most remarkable was France's **Henri Cartier-Bresson** (1908–2004), who, after studying painting with the Cubist André Lhote, took up photography and worked as a photojournalist covering such epochal events as the Spanish Civil War (1936–39). His is a photojournalism broadly defined, however, for his magical images, especially those made before World War II, have little to do with a discernible narrative or straight reportage of visual fact. From a very young age Cartier-Bresson was powerfully influenced by the Surrealist theories of André Breton. He matured quickly as a photographer, and in the first half of the 1930s, in photographs made in France, Spain, Italy, and Mexico, he created some of the most memorable images of the twentieth century.

The photographer, freed from the encumbrance of a tripod, could exploit new opportunities, pursuing the action as it unfolded. Cartier-Bresson said of his practice:

> I prowled the streets all day feeling very strung up and ready to pounce, determined to "trap" life—to preserve life in the act of living. Above all, I craved to seize the whole essence, in the confines of a single photograph, of some situation that was in the process of unrolling itself before my eyes.

Citing Man Ray, Atget, and Kertész as his chief influences, Cartier-Bresson allowed his viewfinder to "discover" a composition within the world moving about him. Once this had been seized upon, the photographer printed the whole uncropped negative, an image that captured the subject in "the decisive moment" (the title of his 1952 book). *Córdoba, Spain* (fig. **15.63**) is a witty juxtaposition of art and life, as in the collages of his friend Max Ernst. A woman clasps a hand to her bosom, unconsciously repeating the gesture in the corset advertisement behind her. The woman squints into the photographer's lens while the eyes of the poster model are "blinded" by an advertisement pasted over them. In this deceptively simple image, the

15.63 Henri Cartier-Bresson, *Córdoba, Spain*, 1933. Gelatin-silver print.

1960, he photographed nudes with a special Kodak camera that had an extremely wide-angle lens and a tiny aperture. The distortions transformed the nudes into Surreal dream landscapes. He exploits the same distorted perspective in *Portrait of a Young Girl, Eaton Place, London* from 1955 (fig. **15.64**). The dreamlike effect is enhanced by the artist's characteristically high-contrast printing style, where portions of the room disappear into blackness. Brandt also continued to make portraits after the war, recording the likenesses of luminaries in the world of literature and art, including leading Surrealists such as Magritte, Arp, Miró, and Picasso.

Surrealism provided a crucial platform for continuing avant-garde investigations into the sources and meanings of visual art. Among those who would feel its influence most intensely were contemporary American artists eager to explore for themselves the ideas generated by the European avant-garde. Although artists like Man Ray and Duchamp provided a link between the European Surrealists and progressive American artists during the 1930s, it would not be until the conclusion of World War II that Surrealist ideas entered fully into American avant-garde practice. Prewar art in America addressed itself to different concerns.

15.64 Bill Brandt, *Portrait of a Young Girl, Eaton Place, London*, 1955. Gelatin-silver print, 17 × 14¾" (43.2 × 37.5 cm).

artist sets up a complex visual dialogue between art and life, illusion and reality, youth and old age. Cartier-Bresson's pictures, with their momentary equipoise among form, expression, and content, served as models of achievement to photographers for well over half a century.

An English Perspective: Brandt

Although England's **Bill Brandt** (1904–83) was trained as a photographer in the late 1920s in Paris, where he worked in the studio of Man Ray, he made mostly documentary photographs in the 1930s, including a famous series on the coal miners in the North of England during the depression. After World War II, he rediscovered his early days in Surrealist Paris and gave up documentation in favor of re-exploring the "poetry" of optical distortion, or what he called "something beyond reality." Between 1945 and

16
American Art Before World War II

In the years leading up to World War I, the American realist tradition was given new life within the ranks of the so-called "Ashcan School." The name was invented by critics in the 1930s to describe a group of artists active between 1905 and 1913 in New York who enlisted colors that looked as if they had been scraped from a furnace to depict commonplace subjects emphasizing the seedy aspects of daily urban life. Like all Americans, artists were adjusting to life in their burgeoning industrialized society. The vitality of the city provided many themes, with artists sometimes documenting the lives of urban inhabitants with a literalness that shocked viewers accustomed to the bland generalizations of academic art. The frank naturalism of these innovations contrasted with contemporary European trends toward geometric abstraction, classicism, and Surrealism. Far from seeking through art a retreat from the world, the first wave of American modernism confronted society with an unblinking directness. In this way, American art of the first decades of the twentieth century exhibits a kinship with the nineteenth-century European realist tradition. While European modernists had moved away from strict naturalism to explore Symbolism and various types of abstraction, an analogous avant-garde movement had not yet taken hold in the United States.

Despite this persistence of naturalism in American art, the academic spirit had become anathema to many young American painters, even as professional survival remained largely contingent on membership in the National Academy of Design, the American equivalent of the French Academy of Arts. Although it merged with the more tolerant Society of American Artists in 1907, the National Academy remained steadfastly unreceptive to new developments and young artists were forced to look elsewhere for support.

Meanwhile, important venues in New York, particularly Alfred Stieglitz's 291 gallery and the gigantic, 1913 exhibition of modern art known as the Armory Show, helped to introduce European modernists to American audiences and nurtured a number of American artists who were committed to experimental art. But even those who embraced modernism tended to be preoccupied with asserting a clearly American cultural identity. This led to a readiness, when economic and social troubles hit during the 1930s, to exalt a spirit of nationalism. During the years of the Great Depression, this desire to articulate a uniquely American visual culture gave rise to new varieties of naturalistic art based on themes that many artists felt were intrinsically American. This strategy was practiced by the so-called Regionalists, famous for presenting the rural life of the Midwest, and the more politically engaged Social Realists, who documented the consequences of extreme economic change.

America Undisguised: The Eight and Social Criticism

In response to the National Academy's rejection of their work for the 1907 spring exhibition, eight painters participated in a historic exhibition at the Macbeth Gallery in New York City in February 1908. The painter Robert Henri, who had moved to New York from Philadelphia in 1900, was the intellectual leader of this loosely constituted group, called "The Eight." Since 1905, Henri had been a member of the Academy, but in 1907 he found himself so at odds with his colleagues there that he organized an alternative exhibition.

Henri was joined by four Philadelphia artists—John Sloan, Everett Shinn, William Glackens, and George Luks—all illustrators who provided on-the-spot pictorial sketches for newspapers, a practice soon to be superseded as the technology for reproducing newsprint photographs was developed. As a result of this vocation, they came to painting first as draftsmen who portrayed the transient and everyday realities of American life. Three other artists also joined the ranks—the landscape painters Ernest Lawson and Maurice Prendergast, and the Symbolist Arthur B. Davies—and "The Eight" was christened by a New York journalist.

The exhibition of The Eight was a milestone in the history of modern American painting. Although the participating artists represented diverse styles and varying points of view, they were united by their hostility to the academy with its rigid jury system and by their conviction that artists had the right to paint subjects of their own choosing. The show received mixed reviews. Some criticized it for its "inappropriate" recording of the uglier aspects of the New York scene. Several of the exhibiting artists were to become leading members of the Ashcan School.

Henri, Sloan, Prendergast, and Bellows

Robert Henri (1865–1929) was a dedicated teacher and artistic leader who instinctively rebelled against the clichés of the American academic tradition. He had studied at the Pennsylvania Academy with Thomas Anschutz, a pupil of Eakins, and at the Académie Julian in Paris, where the spontaneous sketching techniques he had learned under Anschutz displeased his teachers. In 1900 Henri settled in New York, where he eventually joined the faculty at the New York School of Art. He exhibited widely and, by 1905, was highly enough regarded to be elected as a member of the National Academy of Design.

Henri is primarily admired for the forthright expression and painterly freedom of his portraits, including *Laughing Child* (fig. **16.1**), which was among the works he exhibited with The Eight. He made the portrait during a visit with some of his students to Haarlem in the Netherlands, home

of the seventeenth-century painter Frans Hals. Like the Dutch master, Henri favored immediacy of expression over academic finish in his portraits. During the trip he painted several informal half-length portraits of children against dark backgrounds, skillfully capturing the fresh enthusiasm of his young subjects.

Following the exhibition of The Eight, Henri established his own independent art school, becoming one of the most influential teachers in the early years of the century. Among those he mentored was **John Sloan** (1871–1951), a friend and protégé rather than a student in the conventional sense. Sloan was already a professional illustrator when Henri encouraged him to take up painting and portray what was most familiar to him—the streets and sidewalks of the American urban landscape. In fact, Sloan happened upon the scene depicted in *Hairdresser's Window* (fig. **16.2**) on his way to visit Henri at his New York studio. He was so taken with the spectacle of a crowd gathering beneath the window of a hairdresser's shop that he returned home to paint it from memory and, in his words, "without disguise." In the signs adorning the façade, Sloan introduced amusing puns such as one announcing the shop of "Madame Malcomb." Sloan offered an alternative to the teeming life of city streets in *The Wake of the Ferry II*, 1907 (fig. **16.3**), which depicts a solitary passenger looking out over New York Harbor from the stern of a commuter ferryboat. The painting's delicately brushed passages describing a misty sky and blue-green water recall not only Henri but also Manet and Whistler. New York's waterways provided subjects rich with possibilities for other American painters, including Henri and Glackens, as well as for poets such as Walt Whitman, whose 1856 poem *Crossing Brooklyn Ferry* contributed to Sloan's choice of subject (see Whitman, *Crossing Brooklyn Ferry*, below). And in the year Sloan's picture appeared, American photographer Alfred Stieglitz captured a related subject with his camera (see fig. 16.10).

16.1 Robert Henri, *Laughing Child*, 1907. Oil on canvas, 24 × 20" (61 × 50.8 cm). Whitney Museum of American Art, New York.

SOURCE

Walt Whitman
first stanza of *Crossing Brooklyn Ferry* (1856)

FLOOD-TIDE below me! I watch you face to face;
Clouds of the west! sun there half an hour high! I see you
　　also face to face.

Crowds of men and women attired in the usual costumes!
　　how curious you are to me!
On the ferry-boats, the hundreds and hundreds that cross,
　　returning home, are more curious to me than you
　　suppose;
And you that shall cross from shore to shore years hence, are
　　more to me, and more in my meditations, than you
　　might suppose.

16.2 John Sloan, *Hairdresser's Window*, 1907. Oil on canvas, 31⅞ × 26" (81 × 66 cm). Wadsworth Atheneum, Hartford, Connecticut.

16.3 John Sloan, *The Wake of the Ferry II*, 1907. Oil on canvas, 26 × 32" (66 × 81.3 cm). Phillips Collection, Washington, D.C.

16.4 Maurice Prendergast, *The Idlers*, c. 1918–20. Oil on canvas, 21 × 23" (53.3 × 58.4 cm). Maier Museum of Art, Randolph-Macon Women's College, Lynchburg, Virginia.

Although the terms The Eight and Ashcan School are often used interchangeably, not all of the participants in the 1908 Macbeth Gallery show qualify as Ashcan artists. A case in point is the Boston artist **Maurice Prendergast** (1858–1924), who had trained in Paris in the 1890s and closely followed the developments of the French avant-garde. Prendergast chronicled the lighter side of contemporary life—the pageantry of holiday crowds, city parks, or seaside resorts (fig. **16.4**). He recorded these scenes in a distinctive, highly decorative style consisting of brightly colored patches of paint, reflecting his interest in Japanese prints and the French Nabis painters (see chapter 3).

George Bellows (1882–1925), one of Henri's most accomplished students and an exemplar of the Ashcan School, developed a bold, energetic painting style that he deployed for subjects ranging from inner city street scenes to tense,

ringside views of boxing matches, or socialites at leisure. His *Cliff Dwellers*, 1913 (fig. **16.5**), is a classic Ashcan depiction of daily life in Manhattan's Lower East Side. Forced from their apartments by stifling summer heat, the residents carry on their lives on stoops and sidewalks, seemingly trapped within the walls of the tenement walk-ups. Bellows published a preparatory drawing for this work in *The Masses*, a radical socialist magazine for which Sloan also

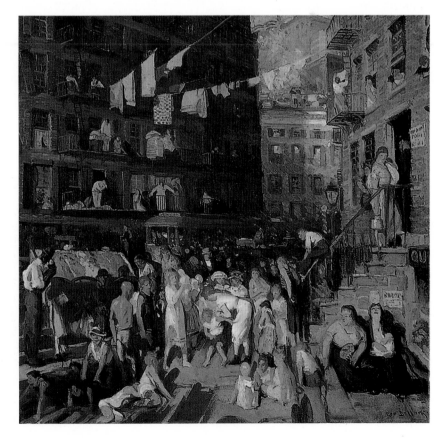

16.5 George Bellows, *Cliff Dwellers*, 1913. Oil on canvas, 39½ × 41½" (100.3 × 105.4 cm). Los Angeles County Museum of Art.

worked, and assigned it a satirical caption, "Why don't they all go to the country for vacation?"

Two Photographers: Riis and Hine

The social criticism inherent in Ashcan School art was even more explicit in the photographic work of **Jacob August Riis** (1849–1914), a Danish immigrant who took his camera into alleys and tenements on the Lower East Side to document the wretched conditions he found there (fig. **16.6**). Originally a newspaper police reporter, Riis said of his camera, "I had use for it and beyond that I never went." To the dismay of New York society, he used his pictures to expose the poverty and starvation that he felt were direct results of the industrial revolution. His book *How the Other Half Lives: Studies Among the Tenements of New York*, published in 1890, became a classic reference for subsequent social documentary photographers (see figs. 19.78, 19.79).

Riis' counterpart in the industrial landscape was **Lewis W. Hine** (1874–1940), who also used photography as an instrument of social reform. After an initial series devoted to immigrants on Ellis Island, Hine spent the years 1908–16 as the staff photographer for the National Child Labor Committee visiting factories to photograph and expose child-labor abuses (fig. **16.7**). Like Riis, Hine used the camera to produce "incontrovertible evidence" that helped win passage of laws protecting children against industrial exploitation. Hine, like documentary photographers before him, including most notably Mathew Brady in his Civil War images (see fig. 2.11), often directed his subjects and skillfully composed his images the better to make his case.

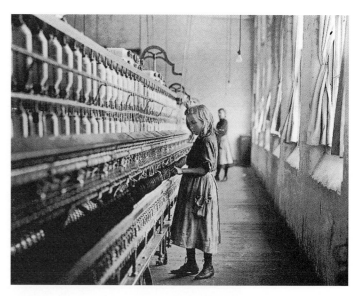

16.7 Lewis W. Hine, *Child in Carolina Cotton Mill*, 1908. Gelatin-silver print on masonite, 10½ × 13½" (26.7 × 34.3 cm). The Museum of Modern Art, New York.

Brooks

Although the American painter **Romaine Brooks** (1874–1970) was a contemporary of the Ashcan artists, she lived in Europe for most of her adult life and her work therefore developed independently of trends in New York. Brooks was a painter of considerable reputation in the 1920s, only to fall into almost total obscurity by the 1940s. As an adult she lived a peripatetic life in Europe, settling finally in Paris in 1905. Her paintings, mostly portraits, were shown at the Parisian gallery Durand-Ruel in 1910. In Paris, Brooks met American poet Natalie Clifford Barney, whose literary salon attracted such illustrious

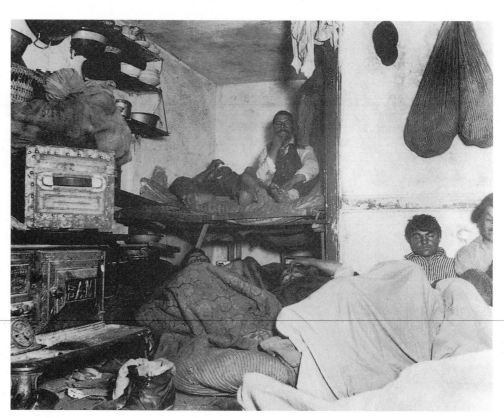

16.6 Jacob A. Riis, *"Five Cents a Spot" Lodging House, Bayard Street*, c. 1889. Gelatin-silver print. Museum of the City of New York.

talents as Marcel Proust, Colette, and André Gide. Brooks conducted an open lesbian relationship with Barney and adopted a masculine manner of dress. In her arresting *Self-Portrait* (fig. **16.8**), shown at the 1923 Salon des Indépendants, she projects herself as a stark silhouette with deeply shadowed eyes against an urban backdrop. The striking contrast of the white collar and cuffs of her shirt against the pure black of her coat recalls Manet's use of unmixed color, while the muted background evokes Whistler's *Nocturnes*. But the effect created by Brooks departs from their example. By articulating her form with such a strong contour line and intense, flattening contrast, she endows herself with an emphatic presence against an indistinct background. This is the closest modern artists have come to realizing a female *flâneur*—a *flâneuse*—a social idler who moves comfortably and confidently through any urban milieu.

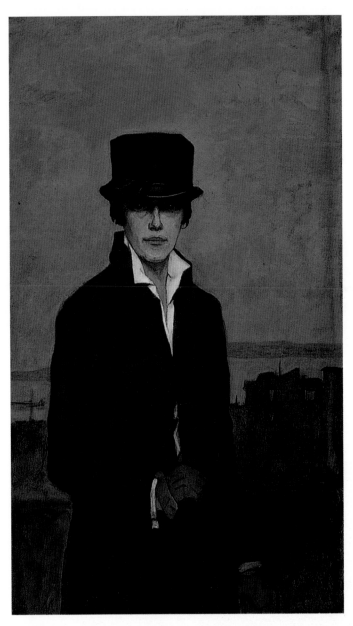

16.8 Romaine Brooks, *Self-Portrait*, 1923. Oil on canvas, 46¼ × 26⅞" (117.5 × 68.3 cm). National Museum of American Art, Washington, D.C.

291 Gallery and the Stieglitz Circle

In 1905, at the Little Galleries of the Photo-Secession at 291 Fifth Avenue in New York, the photographers **Alfred Stieglitz** (1864–1946) and Edward Steichen began to hold exhibitions of photography, and shortly thereafter of modern European paintings and sculpture, as well as African art. The artists whose work was exhibited at the gallery known as 291 were more cosmopolitan than the Henri group: they were in closer contact with current events and artists in Europe, and less chauvinistic about Americanism in art. Moreover, Stieglitz and Steichen were in touch with avant-garde leaders in Paris.

The 291 gallery would serve as a rallying place for American pioneers of international modernism. The gallery was a focal point for the New York Dada movement (see chapter 11), and *291* was also the title of a short-lived Dada magazine. Between 1908 and 1917, works by many of the greatest European modernists were exhibited there, among them Cézanne, Toulouse-Lautrec, Brancusi, Matisse, and Braque, as well as members of the American avant-garde, including John Marin, Charles Sheeler, Charles Demuth, Georgia O'Keeffe, and Elie Nadelman. At the same time, Stieglitz edited an important quarterly magazine on photography called *Camera Work*.

After 291 closed in 1917, Stieglitz continued to sponsor exhibitions at various New York galleries. In 1925 he opened the Intimate Gallery, which was succeeded by An American Place in 1929. Stieglitz directed this gallery until his death in 1946, featuring exhibitions by America's leading modernists. The impact of Stieglitz and his exhibitions at 291 was enormous. The miscellaneous group of Americans shown by him constituted the core of experimental art in the United States in the first half of the twentieth century.

Stieglitz and Steichen

Well before he became a central figure in the American avant-garde, Stieglitz lived in Berlin. Here he began his long and distinguished career as a photographer and launched his crusade to establish photography as a fine art. He was an ardent advocate of Pictorialism in photography. The Pictorialists deplored the utilitarian banality of sharp-focus, documentary photography, as well as the academic pretension of Rejlander and Robinson (see figs. 2.2, 2.4). Instead, they insisted upon the artistic possibilities of camera-made imagery, but held that these could be realized only when art and science had been combined to serve both truth and beauty. Many Pictorialists tried to emulate painting and prints through soft-focus or darkroom manipulation. Too often, however, these attempts to create a heightened sense of poetry resulted in murky, sentimentalized facsimiles of etchings or lithographs.

Because Stieglitz maintained a strict "truth to materials" position, creating highly expressive images without the aid of darkroom enhancement, he was an important forerunner of so-called "straight" photography. The straight

16.9 Alfred Stieglitz, *The Street, Fifth Avenue*, 1896. Gravure, 12 × 9" (30.5 × 22.9 cm). Albright-Knox Art Gallery, Buffalo, New York.

photographer exploits the intrinsic properties of the camera to make photographs that look like photographs instead of imitations of paintings or fine-art prints. Stieglitz joined the Pictorialists in maintaining that their works should be presented and received with the same kind of regard accorded other artistic media. In pursuit of this goal, progressive photographers initiated an international secession movement that provided spaces for meetings and exhibitions, stimulated enlightened critical commentary, and published catalogues and periodicals devoted to photography. The most distinguished and far-reaching in its impact was New York's Photo-Secession group, established by Stieglitz in 1902 to promote "the serious recognition of photography as an additional medium of pictorial expression."

Stieglitz achieved his pictorial goals through his choice of subject, light, and atmosphere in the world about him, allowing natural fog or snow, for instance, to produce the desired effects of atmosphere and mystery (fig. **16.9**). As this image of a snow-covered New York street illustrates, Stieglitz, like the Ashcan painters, drew inspiration from the spectacle of the modern metropolis. But rather than the noisy clutter of humanity envisioned by Sloan or Bellows, Stieglitz was drawn to a lone cloaked figure silhouetted beneath the bare branches of a towering tree.

16.10 Alfred Stieglitz, *The Steerage*, 1907. Gelatin-silver print, 4⁵⁄₁₆ × 3⅝" (11 × 9.2 cm). The Art Institute of Chicago. Alfred Stieglitz Collection, 1949.

In 1907, during a voyage to Europe, Stieglitz discovered little of social or visual interest among his fellow first-class passengers and wandered over to steerage, where the cheapest accommodation was located. As he later explained, he was struck by the combination of forms he witnessed among the crowds on deck—"a round straw hat, the funnel leaning left, the stairway leaning right, the white draw-bridge with its railings made of circular chains, white suspenders crossing on the back of a man." Stieglitz fetched his camera and took what he came to regard as one of his most successful photographs, *The Steerage* (fig. **16.10**). Avoiding even the slightest Pictorialist sentiment or anecdote, Stieglitz provided a straight document of the scene, which he said was not merely a crowd of immigrants but "a study in mathematical lines … in a pattern of light and shade."

Stieglitz's longtime associate in New York's Photo-Secession group, 291 gallery, and *Camera Work* magazine was **Edward Steichen** (1879–1973), whom Rodin commissioned in 1908 to photograph the original plaster cast of his *Balzac* (fig. **16.11**). Rodin proposed that Steichen try working by moonlight. Not only did this technique avoid the flattening effect that direct sunlight would have had on the white material, but the long exposure that the dim light required invested the pictures with a sense of timelessness totally unlike the stop-action instantaneity normally associated with the camera. The resulting photograph summarizes the aesthetic aims of Pictorialism. After World War I, during which he worked as an aerial photographer, Steichen abandoned his soft-focus Pictorialism to practice and promote straight, unmanipulated photography (see *Style through Medium*, p. 368). Steichen became chief photographer for *Vogue* and *Vanity Fair*, publications in which his celebrity portraits and fashion photos, both

16.11 Edward Steichen, *Balzac—The Open Sky*, 1908. Photogravure from *Camera Work*, no. 34–35, 1911, 8 × 6⅛" (20.3 × 15.6 cm). The Museum of Modern Art, New York.

revealing the artist's acute sensitivity to abstract pattern and composition, appeared regularly from 1923 to 1938, exerting tremendous influence on photographers on both sides of the Atlantic (fig. **16.12**). In 1947 Steichen was

16.12 Edward Steichen, *Gloria Swanson*, 1924. Gelatin-silver print, 16⁹⁄₁₆ × 13½" (42.1 × 34.2 cm). The Museum of Modern Art, New York.

Style through Medium
Photogravure and Gelatin-Silver Prints

Attempts to emulate the appearance of prints and drawings led Pictorialist photographers to prefer certain processes over others. Photogravure, which combines photography with printmaking, was among the most popular media for creating "fine art" photographic prints. A light sprinkling of bitumen dust is sprinkled on a copper plate, which is then heated so the dust particles melt and adhere to the surface. This will provide a fine, grainy wash when the plate is eventually printed. Next, a photo-sensitive coating is applied to the plate. This coating hardens when exposed to light, permitting the transfer of the image recorded in a photographic negative onto the surface of the plate. The plate is then placed in an acid bath. The acid's action on the plate corresponds to the depth and hardness of the protective coating. This results in the creation of an etched version of the photographic image, and the plate can then be run through a printing press (see *Printmaking Techniques,* chapter 1). Printed onto luxury papers normally used for fine drawings or prints, photogravures have a soft, rich appearance and were seen by many artists and collectors as preferable to photographs printed directly onto paper that had been treated with emulsion, which has a distinctive, shiny surface. Straight photographers preferred the sharper images and greater tonal range offered by gelatin-silver prints, which use paper coated with a gelatin emulsion in which silver salts are suspended.

appointed director of the Department of Photography at New York's Museum of Modern Art, a position he held until his retirement in 1962. In this capacity, he continued to exert enormous influence on the American reception of avant-garde art.

Weber, Hartley, Marin, and Dove

In a 1910 group show at 291, Stieglitz included works by **Max Weber** (1881–1961), a painter who had recently returned from three years in Paris. For an American, Weber was unusually knowledgeable about recent developments in French art and, by the time of Stieglitz's show, had begun to develop his own highly individual Cubist style. The 1915 *Chinese Restaurant* (fig. **16.13**) is his response to a friend's suggestion that he make a painting about the conversations they had had over dinners in New York City's Chinatown. The wealth of colorful patterns suggests fragments of curtains, tile floors, and figures—colliding visual recollections of a bustling, urban interior and analogues for the rapid exchange of new ideas. Toward the end of World War I, the artist abandoned Cubism for a form of expressionist figuration related to that of Chagall and Soutine.

American painter **Marsden Hartley** (1877–1943) came to Stieglitz's attention with the Post-Impressionist land-scapes he made in Maine in 1907–09. His works were shown for the first time at 291 in 1909. From 1912 to 1915, Hartley lived abroad, first in Paris and then in Berlin. In Germany he was drawn to the mystically based art of Der Blaue Reiter (see chapter 7), and the first works he made there are clearly inspired by Kandinsky. Among the

16.13 Max Weber, *Chinese Restaurant*, 1915. Oil on canvas, 40 × 48" (101.6 × 121.9 cm). Whitney Museum of American Art, New York.

16.14 Marsden Hartley, *Portrait of a German Officer*, 1914. Oil on canvas, 68¼ × 41⅜" (173.3 × 105.1 cm). The Metropolitan Museum of Art, New York.

his interest in the Orphist paintings of Delaunay (see fig. 8.41). In 1916, as war raged in Europe, Hartley's German works were shown at 291, where they were regarded by some reviewers as treacherously pro-German.

Among the artists that Stieglitz promoted, **John Marin** (1870–1953) is known for his superb skill as a water-colorist. Following his art studies in Philadelphia and New York, Marin spent most of the period from 1905 to 1910 in Europe. His introduction to Stieglitz in 1909 marked the beginning of a long and fruitful relationship. The late watercolors of Cézanne were an important source of inspiration for him, and Cubist structure remained a controlling force in the cityscapes and landscapes he painted throughout his life.

During the 1920s and 30s he carried his interpretations of New York close to a form of expressionist abstraction in which his subject is almost always discernible. In the 1922 *Lower Manhattan (Composition Derived from Top of Woolworth Building)* (fig. **16.15**), an explosion of buildings erupts from a black circular form containing a sunburst center, a cut-out form that Marin attached to the paper with thread. He reinforced the transparent, angular strokes of the watercolor with charcoal, creating a work of graphic force that vibrates with the clamor and speed of the city.

Arthur G. Dove (1880–1946) temporarily abandoned a career as an illustrator to go to Paris in 1907 in hopes of becoming a full-time painter. With astonishing speed, he seems to have absorbed much of the course of European modernism. The group of pastels that he exhibited at 291 in 1912 were even closer to non-objectivity than contemporaneous paintings by Kandinsky, whose work Dove knew, and were probably the earliest and most advanced

Blaue Reiter group, Hartley found enthusiastic supporters, notably Franz Marc, who helped him locate venues to exhibit his work, and he quickly came to regard Berlin, the capital of imperial Germany, as the most vital urban center in Europe. In 1914–15 he made a series of paintings in which the imagery is derived from German flags, military insignia, and all the regalia of the imperial court. The works were not a celebration of German nationalism but rather Hartley's response to the lively pageantry of the city. *Portrait of a German Officer* (fig. **16.14**) contains coded references to Marsden's friend and probable lover Karl von Freyburg, a German officer who was killed on the Western Front. Along with the initials "K v. F" in the lower left, the painting features a number 4, which was Freyburg's regiment. The checkerboard pattern evokes his love of chess. Like Weber, Hartley began with motifs from the visible world, broke them up, and reorganized them into a largely abstract composition. The exuberant energy, brilliant colors, and bold arrangement of forms are evidence of

16.15 John Marin, *Lower Manhattan (Composition Derived from Top of Woolworth Building)*, 1922. Watercolor and charcoal with paper cut-out attached with thread on paper, 21⅝ × 26⅞" (54.9 × 68.3 cm). The Museum of Modern Art, New York.

16.16 Arthur G. Dove, *Nature Symbolized No. 2*, c. 1911. Pastel on paper, 17⅞ × 21½" (45.8 × 55 cm). Alfred Stieglitz Collection, 1949. 533. Art Institute of Chicago.

statements in abstract art by an American artist (fig. **16.16**). Throughout his life, Dove was concerned more with the spiritual forces of nature than its external forms, and the curving shapes of his pastels were inspired by the natural world. He later called his group of abstract pastels

16.17 Arthur G. Dove, *Goin' Fishin'*, 1925. Assemblage of bamboo, denim shirtsleeve buttons, wood and oil on wood panel, 19½ × 24" (49.5 × 61 cm). The Phillips Collection, Washington, D.C.

The Ten Commandments, as if together they constituted his spiritual and artistic credo.

Between 1924 and 1930, Dove produced a remarkable group of multimedia assemblages, including *Goin' Fishin'* (fig. **16.17**), composed of fragmented fishing poles and denim shirtsleeves. The artist was aware of the evolution of Cubist collage, but his own efforts have more in common with nineteenth-century American folk art, *trompe l'oeil* painting, and Dada collage, though Dove never adopted the subversive, anti-art stance of the first Dadaists. His own collages range from landscapes made up literally of their natural ingredients—sand, shells, twigs, and leaves—to delicate and magical *papiers collés*. During the 1930s, Dove continued to paint highly abstracted landscapes in which concentric bands of radiating color and active brushwork express both a quality of intense light and the artist's sense of spiritual energy in nature.

O'Keeffe

The last exhibition at 291, held in 1917, was the first solo show by **Georgia O'Keeffe** (1887–1986). Marsden Hartley said that O'Keeffe was "modern by instinct," although she had been exposed, especially through exhibitions at 291, to the work of the major European modernists. The biomorphic, Kandinsky-like abstractions in charcoal that she made in 1915–16 so impressed Stieglitz that he soon gave her an exhibition. The two artists married in 1924. Before he put away his camera for good

16.18 Alfred Stieglitz, *O'Keeffe Hands and Thimble*, 1919, printed 1947 by Lakeside Press, Chicago. Photomechanical (halftone) reproduction, 7¾ × 6" (19.7 × 15.3 cm). George Eastman House, Rochester.

in 1937, Stieglitz made more than 300 photographs of O'Keeffe (fig. **16.18**), contributing to her almost cult status in the art of the twentieth century.

Whether her subjects were New York skyscrapers, enormously enlarged details of flowers, bleached cow skulls, or adobe churches, they have become icons of American art. Her paintings involve such economy of detail and such skillful distillation of her subject that, however naturalistically precise, they somehow become works of abstraction. Alternatively, her abstractions have such tangible presence that they suggest forms in nature. *Music—Pink and Blue, II* (fig. **16.19**) is a breathtaking study in chromatic relationships and organic form. The title suggests the lingering influence of Kandinsky's equation of color with music and, ultimately, with emotion. Typically ambivalent, the forms resemble an enlarged close-up of the flowers that O'Keeffe painted in the 1920s, although some have interpreted them as implicitly sexual. The persistence of interpretations linking O'Keeffe's abstractions to female genitalia or sexuality speaks to the distinctions critics and

16.19 Georgia O'Keeffe, *Music—Pink and Blue, II*, 1919. Oil on canvas, 35½ × 29" (90.2 × 73.7 cm). Whitney Museum of American Art, New York.

art historians have drawn between O'Keeffe's work and that of her male contemporaries, whose works are rarely subjected to such biological essentialism. The artist rejected such readings of her imagery, and, partly in response to such interpretations, her work became more overtly representational in the 1920s, as in her tightly rendered views of New York skyscrapers made from the window of her Manhattan apartment (fig. **16.20**). In 1929 O'Keeffe visited New Mexico for the first time and thereafter divided her time between New York and the Southwest, settling permanently in New Mexico in 1949. The desert motifs that she painted there are among her best-known images (fig. **16.21**). Despite the variety of her strategies for exploring abstraction, O'Keeffe remains best known for the colorful paintings suggestive of flowers, and critics still tend to focus on their supposed sexual connotations as opposed to the enormous influence O'Keeffe exerted on the first wave of American abstract artists. She, perhaps more than any of her contemporaries, pointed the way to a distinctively American approach to abstraction.

16.20 Georgia O'Keeffe, *Radiator Building—Night, New York,* 1927. Oil on canvas, 48 × 30" (121.9 × 76.2 cm). Carl van Vechten Gallery of Fine Arts, Fisk University, Nashville, Tennessee.

16.21 Georgia O'Keeffe, *Cow's Skull with Calico Roses,* 1931. Oil on canvas, 35⅞ × 24" (91.2 × 61 cm). The Art Institute of Chicago. Alfred Stieglitz Collection, Gift of Georgia O'Keeffe, 1947.712.

Straight Photography: Strand, Cunningham, and Adams

Three important American photographers associated, like O'Keeffe, with the West are Paul Strand, Imogen Cunningham, and Ansel Adams. Photographer and filmmaker **Paul Strand** (1890–1976) studied in his native New York City with Lewis Hine. He officially entered the Stieglitz circle in 1916, when his photographs were reproduced in *Camera Work* and he exhibited at 291 for the first time. By now Strand had abandoned the Pictorialism of his early work and was making photographs directly inspired by Cubist painting. In 1917 he contributed an essay to the last issue of *Camera Work* in which he called for photography as an objective art "without tricks of process or manipulation." In 1930–32 Strand worked in New Mexico and photographed the same church that his friends O'Keeffe and Adams had already depicted (fig. **16.22**). All three artists were drawn to the desert sun's ability to accentuate the abstract qualities and dignified monumentality of the adobe structure.

16.22 Paul Strand, *Ranchos de Taos Church, New Mexico,* 1931. Gelatin-silver print.

From her origins in soft-focus Pictorialism, **Imogen Cunningham** (1883–1976), like Strand, shifted to straight photography, producing a series of plant studies (fig. **16.23**), in which blown-up details and immaculate lighting yield an image analogous to the near-abstract flower paintings of Georgia O'Keeffe. In 1932, along with Ansel Adams, Edward Weston, and other photographers in the San Francisco Bay area, Cunningham helped found Group f.64, a loosely knit organization devoted to "straight" photography as an art form. Their name refers to the smallest aperture on a large-format camera, producing sharp focus and great depth of field.

Ansel Adams (1902–84) discovered his passion for nature at the age of fourteen during a visit to California's Yosemite Valley, but it was his initial meeting with Paul Strand in 1930 that decided his career in photography. Three years later he met and engaged the support of Alfred Stieglitz. A masterful technician, Adams revealed himself to be an authentic disciple of Stieglitz when he wrote:

> A great photograph is a full expression in the deepest sense, and is, thereby, a true expression of what one feels about life in its entirety. And the expression of what one feels should be set forth in terms of simple devotion to the medium—a statement of the utmost clarity and perfection possible under the conditions of creation and production.

Adams' art is synonymous with spectacular unspoiled vistas of the West. An image taken in the Sequoia National Park, California, in 1932 (fig. **16.24**) shows the wintry landscape from a close-up angle, so that it fills the frame to reveal the textures of the earth. An experienced mountaineer and dedicated conservationist, Adams was an active member of the Sierra Club by the late 1920s. He helped establish the Department of Photography at New York's Museum of Modern Art in 1940 and the Center for Creative Photography at the University of Arizona, Tucson, in 1975.

16.24 Ansel Adams, *Frozen Lakes and Cliffs, The Sierra Nevada, Sequoia National Park, California,* 1932. Gelatin-silver print.

16.23 Imogen Cunningham, *Two Callas,* 1929. Gelatin-silver print.

Coming to America: The Armory Show

In the early part of the twentieth century, an important catalyst affecting the subsequent history of American art was the International Exhibition of Modern Art, held in New York at the 69th Regiment Armory on Lexington Avenue at 25th Street between February 17 and March 15, 1913. Known simply as The Armory Show, it was organized by the Association of American Painters and Sculptors, who aimed to show a large number of European and American artists and to compete with the regular exhibitions of the National Academy of Design. Arthur B. Davies, a member of The Eight respected by both the Academy and the independents and highly knowledgeable in the international art field, was chosen as chairman and, with the painter Walt Kuhn, did much of the selection. They were assisted in several European cities by the painter and critic Walter Pach. William Glackens, another member of The Eight, oversaw the choice of American works. The Armory Show proved to be a monumental though uneven exhibition focusing on the nineteenth- and early twentieth-century painting and sculpture of Europe (fig. **16.25**). The artists shown ranged from Goya and Delacroix to Daumier, Courbet, Manet, the Impressionists, Van Gogh, Gauguin, Cézanne, Redon, the Nabis, and Seurat and his followers. Matisse and the Fauves were represented, as were Picasso, Braque, and the Cubists. German Expressionists were slighted, while the Orphic Cubists and the Italian Futurists withdrew. Stieglitz purchased the only Kandinsky in the show. Among sculptors, the Europeans Rodin, Maillol, Brancusi, Nadelman, and Lehmbruck, as well as the American Gaston Lachaise, were included, although sculpture was generally far less well represented than painting. American painting of all varieties and quality dominated the show in sheer numbers, but failed in its impact relative to that of the exotic imports from Europe.

The Armory Show created a sensation, and while the popular press covered it extensively (at first with praise), it was savagely attacked by critics and American artists. Matisse was singled out for abuse, as were the Cubists, while Duchamp's *Nude Descending a Staircase* (see fig. 8.47), it will be recalled, enjoyed a *succès de scandale* and was likened to a "pile of kindling wood."

As a result of the controversy, an estimated 75,000 people attended the exhibition in New York. At Chicago's Art Institute, where the European section and approximately half the American section were shown, nearly 200,000 visitors crowded the galleries. Here the students of the Art Institute's school, egged on by members of their faculty, threatened to burn Matisse and Brancusi in effigy. In Boston, where some 250 examples of the European section were displayed at Copley Hall, the reaction was more tepid.

The Armory Show, an unprecedented achievement in America, was a powerful impetus for the advancement of modernism there. Almost immediately, there was evidence of change in American art and collecting. New galleries dealing in modern painting and sculpture began to appear. Although communications were soon to be interrupted by World War I, more American artists than ever were inspired to go to Europe to study. American museums began to buy and to show modern French masters, and a small but influential new class of collectors, which included Dr. Albert Barnes, Arthur Jerome Eddy, Walter Arensberg, Lillie P. Bliss, Katherine Dreier, and Duncan Phillips, arose. From their holdings would come the nuclei of the great American public collections of modern art.

16.25 Postcard showing The Armory Show, 1913. The Museum of Modern Art Archives, New York.

Sharpening the Focus on Color and Form: Synchromism and Precisionism

Synchromism

In the year of The Armory Show, two Americans living in Paris, **Stanton Macdonald-Wright** (1890–1973) and **Morgan Russell** (1886–1953), launched their own movement, which they called Synchromism. The complicated theoretical basis of Synchromism began with the principles of French color theorists such as Chevreul, Rood, and Blanc (see chapter 3). The color abstractions, or Synchromies, that resulted were close to the works of Delaunay, although the ever-competitive Americans vehemently differentiated their work from his. Their 1913 exhibitions in Munich and Paris were accompanied by brash manifestos, followed by a show the next year in New York. Macdonald-Wright, whose *Abstraction on Spectrum (Organization, 5)* (fig. **16.26**) clearly owes much to Delaunay's earlier disk paintings (see fig. 8.43), wrote in 1916, "I strive to divest my art of all anecdote and illustration and to purify it to the point where the emotions of the spectator will be wholly aesthetic, as when listening to good

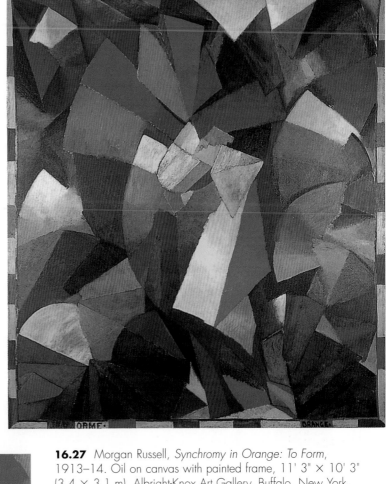

16.27 Morgan Russell, *Synchromy in Orange: To Form*, 1913–14. Oil on canvas with painted frame, 11' 3" × 10' 3" (3.4 × 3.1 m). Albright-Knox Art Gallery, Buffalo, New York.

music." Macdonald-Wright returned to the United States in 1916 and showed his work at 291 the following year. He moved to California in 1918, the year that more or less witnessed the end of Synchromism; although he largely returned to figuration after 1920, his subsequent work was still informed by his early Synchromist experiments.

Russell, on the other hand, spent most of his life in France after 1909. His most important Synchromist work is the monumental *Synchromy in Orange: To Form* (fig. **16.27**), which was included in the 1914 Salon des Indépendants in Paris. Although the densely packed, curving planes of brilliant color seem to construct a wholly abstract composition, the central planes actually contain the forms of a man, possibly Michelangelo's *Dying Slave* in the Louvre, after which Russell—always interested in sculpture—had made drawings. By virtue of juxtaposed advancing and receding colors, the painting has a distinctive sculptural appearance, an aspect that sets his work apart from that of Delaunay.

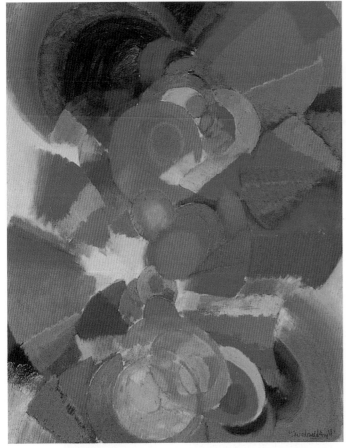

16.26 Stanton Macdonald-Wright, *Abstraction on Spectrum (Organization, 5)*, c. 1914. Oil on canvas, 30⅛ × 24³⁄₁₆" (76.5 × 61.4 cm). Des Moines Art Center, Iowa.

Precisionism

A major manifestation of a new spirit in American art was the movement called Precisionism, which originated during the 1920s, though the term was not itself coined until the 1940s. Never organized into a coherent group with a common platform, the artists involved have also been labeled "Cubo-Realists" and even "the Immaculates." All these terms refer to an art that is basically descriptive, but guided by geometric simplification stemming partly from Cubism. Precisionist paintings tend to be stripped of detail and are often based on sharp-focus photographs. The movement is in some ways the American equivalent of Neue Sachlichkeit or New Objectivity, the realist style practiced in Germany after the war (see chapter 11). The Germans, who had witnessed the horrors of war first-hand, tended to focus on politically charged images of the human figure, while the Americans preferred the more neutral subjects of still life, architecture, and the machine. Given their hard-edge style and urban theme, Georgia O'Keeffe's New York views of the 1920s could be considered Precisionist (see fig. 16.20), but Charles Demuth and, especially, Charles Sheeler were the key formulators of the style.

Charles Sheeler (1883–1965), a Philadelphia-born and trained artist, began working as a professional photographer around 1910, making records of new houses and buildings for architectural firms. In 1919 he moved to New York, where he had already befriended Stieglitz and Strand, and continued to participate in the salons organized by the collectors Walter and Louise Arensberg. There he met Duchamp, Man Ray, Picabia, and other artists associated with New York Dada. Sheeler photographed skyscrapers—double exposing, tilting his camera, and then transferring these special effects and the patterns they produced to his paintings. In 1920 he collaborated with Strand on a six-minute film entitled *Manhatta*, which celebrated the dizzying effect of life surrounded by a dense forest of skyscrapers. Sheeler's 1920 painting *Church Street El* (fig. **16.28**), representing a view looking down from a tall building in Lower Manhattan, was based on a still from the film. In its severe planarity and elimination of details, *Church Street El* is closer to geometric abstraction than to the shifting viewpoints of Cubist painting. By cropping the photographic image, Sheeler could be highly selective in his record of the details provided by reality, thus creating arbitrary patterns of light and shadow and flat color

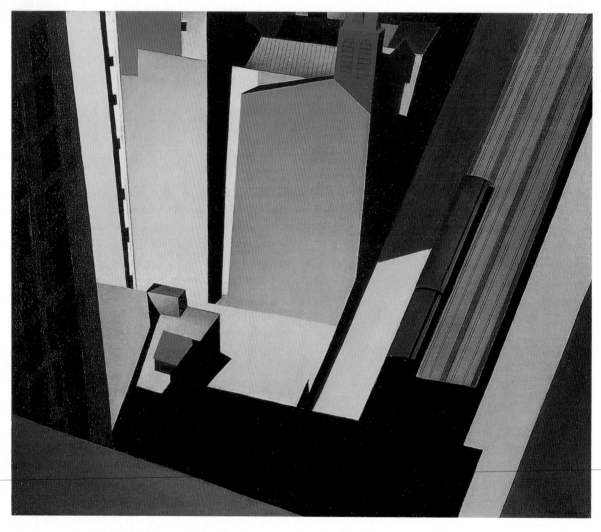

16.28 Charles Sheeler, *Church Street El*, 1920. Oil on canvas, 16 × 19⅛" (40.6 × 48.6 cm). Cleveland Museum of Art. Mr. and Mrs. William H. Marlatt Fund 1977.43.

16.29 Charles Sheeler, *Drive Wheels*, 1939. Gelatin-silver print, 6¹¹⁄₁₆ × 9¹⁄₁₆" (17 × 24.5 cm). Smith College Museum of Art, Northampton, MA.

16.30 Charles Sheeler, *Rolling Power*, 1939. Oil on canvas, 15 × 30" (38.1 × 76.2 cm). Smith College Museum of Art, Northampton, MA.

that transform themselves into abstract relationships. At the right in *Church Street El*, amidst the deep shadows and bright, geometric patches of sun, an elevated train moves along its tracks.

The relationship between Sheeler's camera work (he stopped making strictly commercial photographs in the early 1930s) and his canvases seems to have been virtually symbiotic, as can be seen in a comparison of the photograph entitled *Drive Wheels* and the painting known as *Rolling Power* (figs. **16.29**, **16.30**). At first glance, the work in oil comes across as an almost literal transcription of the photograph, which the artist took in preparation for the painting. But Sheeler altered the

16.31 Charles Demuth, *Rooftops and Trees*, 1918. Watercolor and graphite on paper, 10 × 14" (25.4 × 35.6 cm). Corcoran Gallery of Art, Washington, D.C. Bequest of George Biddle.

composition and suppressed such details as the grease on the engine's piston box, all in keeping with Precisionism's love of immaculate surfaces and purified machine imagery. Sheeler made this painting for *Fortune* magazine as part of a commissioned series called *Power*, consisting of six "portraits" of power-generating machines. Much of Sheeler's work in the 1930s and 40s was a celebration of the modern industrial age, with majestic views of factories, power plants, and machines.

Charles Demuth (1883–1935), also a Pennsylvanian, was the other major figure of Precisionism. He completed his studies at the Pennsylvania Academy in 1910 and, during a trip to Paris in 1912, befriended Hartley, who became an important mentor. Demuth's first mature works were book illustrations and imaginative studies of dancers, acrobats, and flowers, free and organic in treatment, and seemingly at the other extreme from a Precisionist style. The work of Cézanne was an important guiding force during these years. Like Marin, Demuth was a consummate watercolorist, but where Marin used the medium for great drama and expressive purpose, Demuth applied his delicate washes of color with restraint. "John Marin and I drew our inspiration from the same sources," he once said. "He brought his up in buckets and spilled much along the way. I dipped mine out with a teaspoon but I never spilled a drop." Beginning in 1917, Demuth began producing landscapes executed in watercolor, using interpenetrating and shifting planes and suggestions of multiple views (fig. **16.31**). With these works, Demuth began his experiments with abstract lines of force, comparable to those used by the Futurists.

In the 1920s, Demuth produced a series of emblematic portraits of American artists. Made up of images, words, and letters, these "posters," as he called them, were related to some of the Dadaists' symbolic portraits, including Picabia's (see fig. 11.15). They led to *The Figure 5 in Gold*

(fig. **16.32**). The work, a tribute to his friend the poet William Carlos Williams, is based on *The Great Figure*, a poem Williams wrote after seeing a roaring red fire engine emblazoned with a golden number 5:

> Among the rain
> and lights
> I saw the figure 5
> in gold
> on a red
> fire truck
> moving
> tense
> unheeded
> to gong clangs
> siren howls
> and wheels rumbling
> through the dark city.

Like other artists in the postwar era, Demuth was searching for intrinsically American subjects and became interested in the advertising signs on buildings and along highways, not as blemishes on the American landscape but as images with a certain abstract beauty of their own. Demuth's work influenced that of somewhat younger artists, such as Stuart Davis, who avowed his debt to the older artist, as well as that of future generations, including Jasper Johns and, quite specifically, Robert Indiana (see fig. 19.64).

The Harlem Renaissance

In the 1920s in the Harlem neighborhood of New York City arose the first overtly race-conscious cultural movement in America. The Harlem Renaissance grew out of the ideas of thinkers like W. E. B. du Bois, who helped to found the New Negro movement earlier in the century. Fundamental to the movement was the insistence that any conception of "the negro" had to be formulated by blacks themselves; the characterizations of African-Americans by whites, which often relied on denigrating stereotypes, had to be eliminated from black consciousness and replaced with a positive self-image. The Harlem Renaissance saw an explosion of cultural responses to the ideas put forth by the concept of the New Negro: the poetry of Langston Hughes, the blues of Bessie Smith, the philosophy and art criticism of Alain Locke, the novels and stories of Nella Larsen, to name just a few. The influence of the Harlem Renaissance was felt throughout the twentieth century, particularly during the Civil Rights Movement. But its energy was curtailed in 1929 when the stockmarket crash of that year brought a close to the so-called Jazz Age in the United States.

There was no particular style associated with the Harlem Renaissance, whether in music, literature, or the visual arts. Some artists, like **Palmer Hayden** (1890–1964), worked in a strongly naturalistic and sometimes satirical mode. Hayden studied at Cooper Union in New York City, later spending time in Paris where he made contact with members of the European avant-garde. His painting *A Janitor Who Paints* (fig. **16.33**) exemplifies his powers of observation and expression as well as his frustration with narrow-minded perceptions of African-Americans. The painting depicts his friend and fellow artist Cloyde Boykin, who, like Hayden, often picked up odd jobs to support himself. Hayden represents the artist at work in his small apartment, executing a portrait of a woman and her baby.

16.32 Charles Demuth, *The Figure 5 in Gold*, 1928. Oil on composition board, 36 × 29¾" (91.4 × 75.6 cm). The Metropolitan Museum of Art, New York.

16.33 Palmer Hayden, *A Janitor Who Paints*, c. 1930. Oil on canvas, 39⅛ × 32⅞" (99.3 × 83.6 cm). Smithsonian American Art Museum, Washington D.C.

A trashcan rests near the painter, its lid echoing the shape of Boykin's palette, linking him to the labor he needs to perform in order to survive. Hayden said of the work, "I painted it because no one called Cloyde a painter; they called him a janitor," echoing the ideas of Du Bois and other champions of the New Negro movement who recognized that stereotypes and the perceptions of others function as insidious, invisible bonds.

While earning his living as a portrait photographer, **James Van Der Zee** (1886–1983) created a visual portrait of Harlem at the time (fig. **16.34**), documenting places and events such as weddings, funerals, anniversaries, and graduations. With his background in art and music, Van Der Zee took occasion to manipulate his photographs, even to the point of painting his own studio backdrops and retouching his prints. During a period of mass migration of African-Americans from the rural south to northern industrial centers, Van Der Zee's studio portraits captured the aspirational dreams of his sitters, striking a balance between rich fantasy and confident modernity.

16.34 James Van Der Zee, *Harlem Billiard Room*, n.d. Gelatin-silver print, 11 × 14" (27.9 × 35.6 cm). Curtis Galleries, Minneapolis.

Painting the American Scene: Regionalists and Social Realists

The 1930s, the decade that opened after the Wall Street crash of 1929 and closed with the onset of war in Europe, was a period of economic depression and political liberalism in the United States. Reflecting the spirit of isolationism that dominated so much of American thought and action after World War I, art became socially conscious, nationalist, and regionalist. One of the seminal books of the decade was John Steinbeck's *Grapes of Wrath* (1939), a Pulitzer Prize-winning novel celebrating the quiet heroism of Oklahoma Dust Bowl victims during their migration to California. The so-called American Scene refers to those artists who, like Steinbeck, turned their attention to naturalistic depictions of contemporary American life. For the most part, American Scene painters became the guardians of conservatism, fighting a rearguard battle against modernist abstraction. These artists concentrated on intrinsically "American" themes in their painting, whether chauvinistic praise of the virtues of an actually declining agrarian America, or bitter attacks on the political and economic system that had produced the sufferings of the Great Depression.

A crucial event of this decade—indeed, a catalyst for the development of American art transcending even the 1913 Armory Show—was the establishment in 1935, by the United States government, of a Federal Art Project, a subdivision of the WPA (Works Progress Administration). Just as the WPA provided jobs for the unemployed, the Art Project enabled many of the major American painters to survive during these difficult times. A large percentage of the younger artists who created a new art in America after World War II might never have had a chance to develop had it not been for the government-sponsored program of mural and easel painting.

The decade, however, witnessed little of an abstract tendency in American art. There were many artists of talent, and many interesting directions in American art, some of them remarkably advanced. Those who claimed the most attention throughout the era were, however, the painters of the American Scene, an umbrella term covering a wide range of realist painting, from the more reactionary and nationalistic Regionalists to the generally leftwing Social Realists. Divergent as their sociopolitical concerns may have been, the factions merged in their common preference for illustrational styles and their contempt for "highbrow" European formalism.

Benton, Wood, and Hopper

Dominant among the American Scene artists were the Regionalists such as **Thomas Hart Benton** (1889–1975) and Grant Wood. Of these artists, Missouri-born Benton was the most ambitious, vocal, and ultimately influential. Benton moved in modernist circles in New York in the 1910s and 20s, and even made abstract paintings based on his experiments with Synchromism in Paris. By 1934, however, when his fame was such that his self-portrait was reproduced on the cover of *Time* magazine, the artist had vehemently rejected modernism. "I wallowed," he once said, "in every cockeyed ism that came along, and it took me ten years to get all that modernist dirt out of my system." Benton was the darling of the rightwing critic Thomas Craven, who promoted the Regionalists as the great exemplars of artistic nationalism, and an object of scorn among leftist artists such as Stieglitz.

In 1930 Benton executed a cycle of murals on the theme of modern technology for the New School for Social Research in New York. Called *America Today*, the series presents a cross-section of working America through images based on the artist's travel sketches. Benton presented his vast subject by means of compositional montage, as in *City Building* (fig. **16.35**), where heroic workers are seen against a backdrop of New York construction sites. Benton turned to the sixteenth-century art of Michelangelo and El Greco for the sinewy anatomies and mannered poses of his figures.

Although he studied in Paris for a time in 1923, the Iowan **Grant Wood** (1892–1942) was never tempted by European modernist styles as was Benton. More formative was his trip in 1928 to Munich, where he discovered the art of the fifteenth-century Flemish and German primitives. The art from this historical period was also experiencing a resurgence of interest among some German painters, whose work had much in common with Wood's. Adapting this stylistic prototype to the Regionalist concerns he shared with Benton, Wood produced his most celebrated painting, *American Gothic* (fig. **16.36**), which soon became a national icon. Wood was initially drawn to the nineteenth-century "Carpenter Gothic" house that is depicted in the portrait's background. The models for the farmer couple (not husband and wife but two unrelated individuals) were actually Wood's sister and an Iowan dentist. The marriage of a miniaturist, deliberately archaizing style with contemporary, homespun, Puritan content drew immediate attention to the painting, though many wondered if Wood intended to satirize his subject. The artist, who was certainly capable of pictorial satire, said the subjects were painted out of affection rather than ridicule.

By contrast with the Midwestern Regionalists, **Edward Hopper** (1882–1967) was a mainly urban, New York artist. He rejected any association with Benton and his fellow Regionalists, who, he said, caricatured America in their paintings. Hopper, a student of Henri, made several long visits to France between 1906 and 1910, at the time of the Fauve explosion and the beginnings of Cubism. Seemingly unaffected by either movement, Hopper early on established his basic themes of hotels, restaurants, or theaters, as well as their lonely inhabitants.

Much of the effect of Hopper's paintings is derived from his sensitive handling of light—the light of early morning or of twilight; the dreary light filtered into a hotel

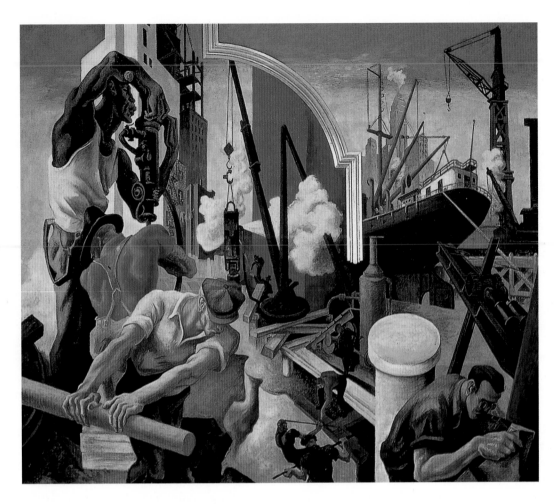

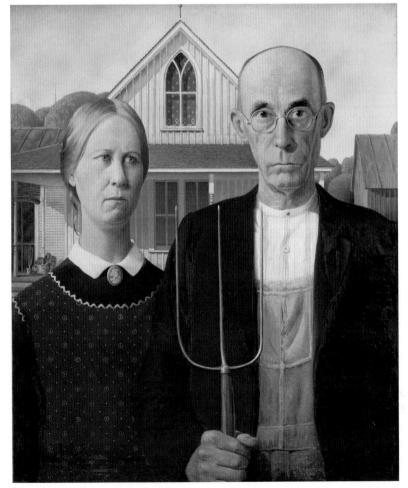

16.35 Thomas Hart Benton, *City Building*, from the mural series *America Today*, 1930. Distemper and egg tempera on gessoed linen with oil glaze, 7' 8" × 9' 9" (2.3 × 3 m). Originally in the New School for Social Research, New York. Relocated in 1984. Collection the Equitable Life Assurance Society of the United States.

16.36 Grant Wood, *American Gothic*, 1930. Oil on beaverboard, 29⅞ × 24⅞" (75.9 × 63.2 cm). Friends of American Art Collection. The Art Institute of Chicago.

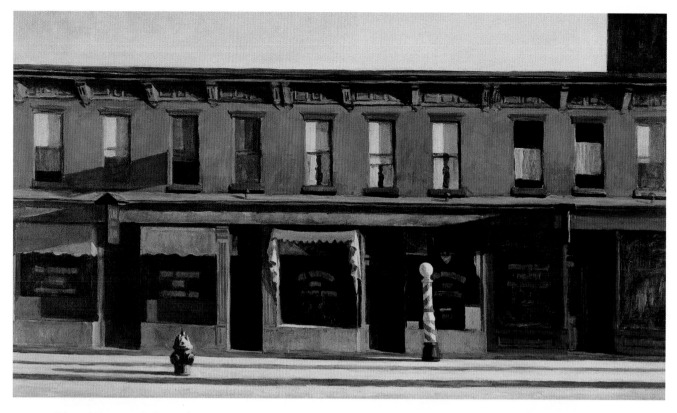

16.37 Edward Hopper, *Early Sunday Morning*, 1930. Oil on canvas, 35 × 60" (88.9 × 152.4 cm). Whitney Museum of American Art, New York.

room or office; or the garish light of a lunch counter isolated within the surrounding darkness. He could even endow a favorite landscape motif—the lighthouses of Cape Cod or Maine—with a quiet eeriness. One of his finest works, *Early Sunday Morning* (fig. **16.37**), depicts a row of buildings on a deserted Seventh Avenue in New York, where a sharp, raking light casts deep shadows and a strange stillness over the whole. The flat façade and dramatic lighting have been linked to Hopper's interest in stage-set design.

Despite his reputation as one of America's premier realist painters, Hopper brought a rigorous sense of abstract design to his compositions. In a late work from 1955, *Carolina Morning* (fig. **16.38**), a woman in a red dress and hat stands in a shaft of intense light. Beyond her the seemingly endless landscape is described with great economy in almost geometric terms. The mood of introspective isolation that pervades many of Hopper's works has affinities with European Surrealist art.

Likewise drawn to urban scenes was the African-American painter **Romare Bearden** (1914–88), who was born in North Carolina but grew up in the thriving artistic milieu of the Harlem Renaissance. In a 1934 essay, *The Negro Artist and Modern Art*, Bearden called on fellow African-American artists to create art based on their own unique cultural experiences. He became involved with the 306 Group, an informal association of African-American artists and writers who met in studios at 306 West 141st Street. In 1936 he studied for a time with the German artist George Grosz (see fig. 11.31) at the city's Art Students

League, no doubt drawn to the artist's reputation as a political satirist. *Folk Musicians* (fig. **16.39**) is characteristic of Bearden's early work. With its simple modeling and consciously "folk" manner, the painting coincides with the prevailing Social Realist trends. The sophistication of Bearden's approach is nevertheless conveyed by his manipulation of space. The loosely modeled figures appear flattened against the wall behind them, while the juxtaposition of strong complementary colors creates a sense of spatial expansion and movement. The spatial dynamism is further enhanced through Bearden's competing backgrounds:

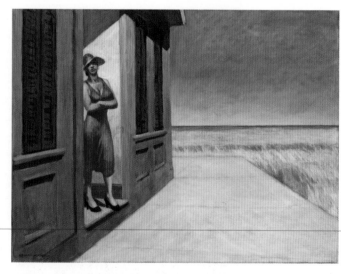

16.38 Edward Hopper, *Carolina Morning*, 1955. Oil on canvas, 30 × 40⅛" (76.2 × 102 cm). Whitney Museum of American Art, New York.

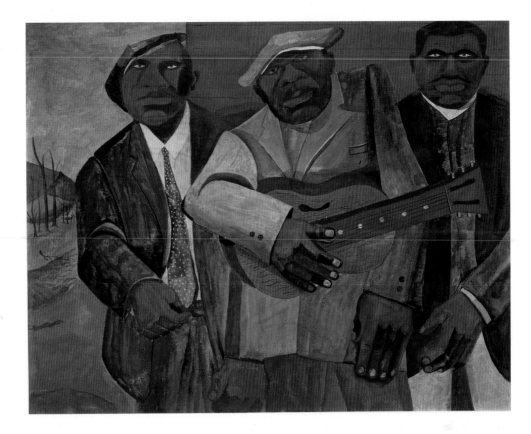

16.39 Romare Bearden, *Folk Musicians*, c. 1941–42. Gouache and casein on Kraft paper, 35½ × 45½" (90 × 114 cm). Bearden Foundation © 1997 Romare Bearden Foundation Inc./Licensed by VAGA, New York, NY.

the brick wall suggestive of urban life gives way to reveal an expansive, rural landscape. This juxtaposition suggests the interchange between urban and rural in the lives and culture of African-Americans, many of whom left their small southern hometowns in the late nineteenth and early twentieth centuries to seek opportunities in northern cities.

Like Bearden, **Jacob Lawrence** (1917–2000) took the African-American experience as his subject, but with a preference for recounting black history through narrative series. In 1940–41 he made sixty panels on the theme of the migration by black men and women from the rural South to the industrial North during and after World War I (fig. **16.40**). Lawrence thoroughly researched his subject and attached his own texts to each of the paintings, outlining the causes for the migration and the difficulties encountered by the workers in the new labor force as they headed for steel mills and railroads in cities like Chicago, Pittsburgh, and New York. Lawrence visually unified his panels by establishing a common color chord of red, green, yellow, and black and a style of boldly delineated silhouettes. The year after its creation, Lawrence's epic cycle went on a national museum tour organized by The Museum of Modern Art. By 1967, when he made a series on the life of black abolitionist Harriet Tubman, Lawrence had earned an international reputation and had begun a distinguished university career in teaching.

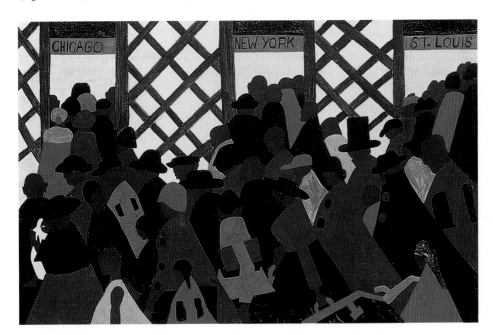

16.40 Jacob Lawrence, *The Migration* series, *Panel No. 1: During World War I there was a great migration north by Southern African Americans*, 1940–41. Casein tempera on hardboard, 12 × 18" (30.5 × 45.7 cm). The Phillips Collection, Washington, D.C.

Grandma Moses and Horace Pippin

Two self-taught artists whose portrayals of American life, albeit from very different perspectives, found common ground with American Scene painting are Anna Mary Robertson Moses, known as **Grandma Moses** (1860–1961), and Horace Pippin. The quintessential untutored artist whose work was steeped in the strong tradition of American folk art, Grandma Moses graduated to oil painting after making pictures in yarn. Her innate gift for creating charming, nostalgic landscapes eventually attracted collectors and critics, and in 1939 she was included in the exhibition Contemporary Unknown American Painters at The Museum of Modern Art. Ironically, her work (fig. **16.41**) began to attract considerable attention in the 1940s and 50s, just as the abstract art of the New York School came to dominate the international scene. This proves that there was a large sector of the American public that preferred this art to the more radical statements of the avant-garde. By her death at the age of 101, her name had long been a household word.

Like Grandma Moses, **Horace Pippin** (1888–1946) took up painting late in life. A black artist from West Chester, Pennsylvania, Pippin worked in isolation until his work was first exhibited in the late 1930s. He drew recognition at a time of growing interest in the work of self-taught artists, arising in part from the avant-garde's quest for an art of authenticity and immediacy. This interest had propelled Henri Rousseau to prominence among the Parisian avant-garde just as it fueled the Surrealists' fascination with the art of children. Pippin's range of subjects was broad, including portraits, landscapes, genre themes, and a series on the life of the abolitionist John Brown. He also painted scenes based on his experiences as an infantryman in World War I, when his right arm, with which he later painted, was permanently injured. *Domino Players* (fig. **16.42**), based on Pippin's childhood memories, shows the artist seated at a table between his female relatives. In such domestic scenes, Pippin offered a rare glimpse into an African-American household in the North around the turn of the century. Although he does not exclude the less picturesque aspects from his painting, he orchestrates the composition around stylized silhouettes and decorative color.

Bishop, Shahn, and Blume

Also active in American Scene painting were such confirmed urban realists as **Isabel Bishop** (1902–88), who portrayed and dignified Depression-wracked New York and its unemployed or overworked and underpaid masses. Bishop, who had studied at the Art Students League while still a teenager, worked for a time on the Federal Art Project, which employed many women artists. She made keenly observed sketches of secretaries and stenographers relaxing during their breaks in Union Square, which she worked into paintings in her studio. Through a technically complex method of oil and tempera, which she built up layer upon layer, she brought to her humble subjects the mood and gravity of a Holy Family by Rembrandt (fig. **16.43**). Bishop's words of tribute to her friend the painter Reginald Marsh could easily apply to her own work. She said he portrayed "little people, in unheroic situations" that are "modeled in the grand manner."

Foremost among the Social Realist painters of the 1930s was **Ben Shahn** (1898–1969), whose work as an artist was inextricably tied to his social activism and who was, in his day, one of the most popular of all American painters.

16.41 Grandma Moses, *Checkered House*, 1943. Oil on canvas, 36 × 45" (91.4 × 114.3 cm). IBM Corporation, Armonk, New York.

16.42 Horace Pippin, *Domino Players*, 1943. Oil on composition panel, 12¾ × 22" (32.4 × 55.9 cm). The Phillips Collection, Washington, D.C.

16.43 Isabel Bishop, *Waiting*, 1938. Oil and tempera on gesso panel, 29 × 22½" (73.7 × 57.2 cm). Newark Museum, New Jersey.

His paintings, murals, and posters inveighed against fascism, social injustice, and the hardships endured by the working-class poor. An accomplished photographer, Shahn often based his paintings on his own photographs, although the mat, thinly brushed tempera surfaces of his canvases have little to do with the photographic realism of Sheeler, for example. Shahn gained recognition in the early 1930s through his paintings on the notorious case of Sacco and Vanzetti (see *The Sacco and Vanzetti Trial*, right). These were bitter denunciations of the American legal system, which had condemned these two men to death in 1927 despite official doubts about their guilt (fig. **16.44**). With the title *The Passion of Sacco and Vanzetti*, Shahn obviously meant to draw a connection to Christian martyrdom. Addressing the theme again around twenty years later but

The Sacco and Vanzetti Trial

In the spring of 1920, two employees of a Boston shoe factory were murdered during a robbery of the company's payroll. A couple of weeks later, two Italian immigrants active in anarchist politics, Nicola Sacco and Bartolomeo Vanzetti, were arrested for the crime. They were convicted in a jury trial and sentenced to death. The pair's conviction quickly galvanized supporters who believed that Sacco and Vanzetti had been arrested simply because of their political sympathies. The evidence that led to the conviction was weak enough to prompt the governor of Massachusetts to assemble an advisory council to review the case, but the recommendation was to retain the verdict. At the time, many laborers as well as artists, intellectuals, and professionals embraced leftist or socialist ideas (see *Trotsky and International Socialism between the Wars*, chapter 15), and Sacco and Vanzetti were seen as symbols of the government's suppression of political opposition. Demonstrations—even riots and bombings—occurred around the country. Despite this, the pair were executed in 1927.

in a different medium—Shahn often explored the same subject through multiple media—the artist uses a poster to appeal to the economic but powerful visual language of street protest (fig. **16.45**).

The Russian-born Social Realist **Peter Blume** (1906–92) painted fantastic imagery in a clearly delineated style that invites comparison with the work of the Surrealist Salvador Dalí (see fig. 15.21). But the term Magic Realism, referring to an art that produces bizarre effects through the depiction of reality, is perhaps a more suitable description of Blume's art. Most American artists greeted Surrealism and all the concomitant theories of the unconscious with great circumspection during the 1930s. It was not until the following decade, when European artists escaping fascism emigrated to the United States, that Surrealism, and

16.44 Ben Shahn, *The Passion of Sacco and Vanzetti*, 1931–32. Tempera on canvas, 7' ½" × 4' (2.1 × 1.2 m). Whitney Museum of American Art, New York.

16.45 Ben Shahn, *The Passion of Sacco and Vanzetti*, 1952. Drawing for poster. Fogg Art Museum, Cambridge, MA.

16.46 Peter Blume, *The Eternal City*, 1934–37 (dated 1937 on painting). Oil on composition board, 34 × 47⅞" (86.4 × 121.6 cm). The Museum of Modern Art, New York.

particularly the automatist, abstract style of Miró, made major inroads into American art. Blume, who denounced Surrealism in print, nevertheless created a style that resonated with Surrealist experiments. His excoriation of the evils of Italian fascism, *The Eternal City* (fig. **16.46**), evokes unconscious wanderings through worlds of psychological as well as physical horror. He had traveled to Italy in 1932 on a Guggenheim grant and said that the idea for this work came to him while he was standing in the Roman forum as a strange light illuminated the scene. The bilious green head of a jack-in-the-box Mussolini looms over the ruins of classical civilization, while the Man of Sorrows continues his eternal mourning on the right.

Documents of an Era: American Photographers Between the Wars

The stalled economy, as well as the failed banks and crops, catalyzed American documentary photographers, many of whom were sponsored by the Federal Farm Security Administration (FSA). Established in 1935, the FSA aimed to educate the population at large about the drastic toll that the Great Depression had taken upon the country's farmers and migrant workers. The moving force behind the project was the economist Roy Stryker, who hired photographers, including Ben Shahn, Dorothea Lange, and Walker Evans, to travel to the hard-pressed areas and document the lives of the residents.

Following studies at Columbia University under Clarence H. White, **Dorothea Lange** (1895–1965) opened a photographic studio for portraiture in San Francisco. However, she found her most vital themes in the life of the streets, and this prepared her for the horrors of the Depression, which she encountered firsthand when she joined Stryker's FSA project. With empathy and respect toward her subjects, Lange photographed a tired, anxious, but stalwart mother with three of her children in a migrant worker camp (fig. **16.47**). This unforgettable and often reproduced image has been called "The Madonna of the Depression." Considered the first "documentary" photographer, Lange redefined the term

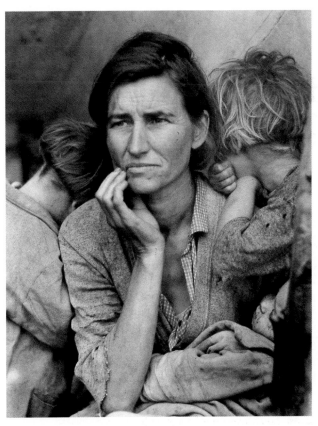

16.47 Dorothea Lange, *Migrant Mother*, 1936. Gelatin-silver print. Library of Congress, Washington, D.C.

by saying, "a documentary photograph is not a factual photograph per se … it carries with it another thing, a quality [in the subject] that the artist responds to." In fact, Lange often staged her images, which allowed her to convey with force and clarity a scene of contemporary American life that may not have been captured had she relied only on chance encounters.

Walker Evans (1903–75) studied in Paris, albeit literature rather than art, and like Lange, was hired by the FSA, making work, he later said, "against salon photography, against beauty photography, against art photography." In the summer of 1936 he and the writer James Agee lived in Alabama with sharecropper families. The result, a 1941 book called *Let Us Now Praise Famous Men*, containing Evans' photographs and Agee's writings, is one of the most moving documents in the history of photography. The straightest of straight photographers, Evans brought such passion to his work that in his images the simple, direct statement ends up being almost infinitely complex—as metaphor, irony, and compelling form. His portrait of a West Virginia miner's home tells volumes about the life of its inhabitants. The cheerful middle-class homemakers and the smiling Santa that cover the walls are sadly incongruent in this stark environment (fig. **16.48**).

Another student of Clarence H. White and a hard-driven professional was **Margaret Bourke-White** (1904–71). As fellow photographer Alfred Eisenstaedt wrote, she "would get up at daybreak to photograph a bread crumb." Really a photojournalist, Bourke-White was the first staff photographer recruited for Henry Luce's *Fortune* magazine, and when the same publisher launched *Life* in 1936, Bourke-White's photograph of Fort Peck Dam appeared on the cover of the first issue (fig. **16.49**), for which she also wrote the lead article. As this image indicates, Bourke-White

16.49 Margaret Bourke-White, *Fort Peck Dam, Montana,* Photograph for the first cover of *Life* magazine, November 23, 1936. *Life* magazine.

favored the monumental in her boldly simplified compositions of colossal, mainly industrial, structures. While emphasizing the accomplishments of the country in a time of faltering confidence—her first major body of work documented the construction of the New York City skyscrapers in the early 1930s as the Depression began—she also focused her camera on human subjects. Some of her most compelling images depict farmers in the drought-stricken Midwest during the Depression; soldiers in the war zones and prison camps of the early 1940s; and black South Africans in the 1950s.

The German-born **Alfred Eisenstaedt** (1898–1995) was one of the first four staff photographers hired for *Life* magazine and another pioneer in the field of pictorial journalism. His photograph of the hazing of a West Point cadet appeared on the cover of the second issue of the magazine. He began his career as an Associated Press photographer in Germany but emigrated to the United States in 1935 when prewar politics made it difficult to publish his frank pictures. Though he produced many pictorial narratives, he was a firm believer in the single image that presented the distillation, the essential statement, of an event. This photograph of a sailor kissing a nurse in New York City's Times Square on Victory Day, 1945 (fig. **16.50**), sums up all the feelings of joy and relief at the end of World War II; but there is some controversy as to whether or not this image was staged.

16.48 Walker Evans, *Miner's Home, West Virginia,* 1935. Gelatin-silver print, 7⁹⁄₁₆ × 9½" (19.2 × 24.1 cm). National Gallery of Art, Washington, D.C.

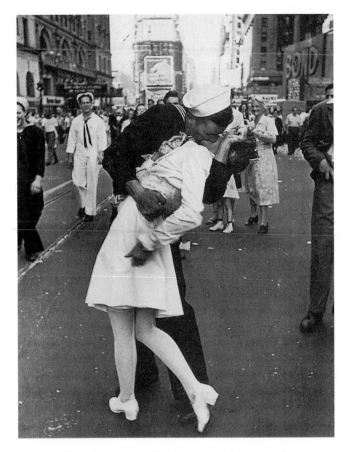

16.50 Alfred Eisenstaedt, *The Kiss (Times Square)*, 1945. *Life* magazine.

Berenice Abbott (1898–1991) returned to New York in 1929 from Paris, where she had learned photography as an assistant to Man Ray. One of the first to appreciate the genius of Atget (see fig. 15.54), and the only photographer ever to make portrait studies of the aged French photographer, Abbott fell in love with Manhattan upon her rediscovery of the city, much as Atget had with Paris. First working alone and then for the WPA, she set herself the task of capturing the inner spirit and driving force of the metropolis, as well as its outward aspect. Though utterly straight in her methods, Abbott, thanks to her years among the Parisian avant-garde, inevitably saw her subject in modernist, abstract terms (fig. **16.51**).

Weegee (b. Arthur Fellig) (1899–1968), another advocate of straight photography, exploited the voyeuristic side of taking pictures. He worked primarily as a freelance newspaper photographer and published his sensational and satiric images of criminal arrests, murder victims, and social events in the tabloids of the day. Like Lisette Model (see fig. 15.62), with whom he worked at *PM* magazine, he captured events by surprising his subjects, often through the use of startling flash. *The Critic* (fig. **16.52**) is an ironic image of two women going to the opera. They stare at the camera and are in turn stared at by the woman to the right who ogles their jewelry, flowers, and furs, all in marked contrast to her own disheveled appearance. In 1945, Weegee published *Naked City*, a book containing many images of New York's underworld.

16.51 Berenice Abbott, *New York at Night*, 1933. Gelatin-silver print on masonite, 10½ × 12¾" (26.7 × 32.4 cm). The Museum of Modern Art, New York.

16.52 Weegee, *The Critic*, 1943. Gelatin-silver print, 10⅝ × 13³⁄₁₆" (27 × 33.5 cm). The Art Institute of Chicago.

Social Protest and Personal Pain: Mexican Artists

While many artists in the United States were looking to indigenous traditions and subject matter between the two world wars, a number of like-minded artists in Mexico turned to their own history and artistic heritage, contributing to a veritable renaissance of Mexican painting. The years 1910–20 were a time of armed revolution in Mexico. This was the era of Emiliano Zapata and Pancho Villa, which began with the ousting of the longtime president Porfirio Díaz and ended with a new constitution that swept in major land and labor reforms. Beginning in the 1920s and continuing to mid-century, Mexican artists covered the walls of the country's schools, ministerial buildings, churches, and museums with vast murals, depicting subjects drawn from ancient and modern Mexico that celebrated a new cultural nationalism. The leading muralists were Diego Rivera, José Orozco, and David Siqueiros. Each of these also worked in the United States, where their work inspired American artists to turn away from European modernism and helped them, through the reintroduction of mural art, to rekindle the social dimensions of art. This was partially because they utilized the classical tradition of fresco painting and partially because theirs was an art of social protest with an obvious appeal to the leftwing, a dominant force in American cultural life throughout the Depression decade. The muralists were enormously influential throughout Latin America as well as the United States.

Rivera

Following his artistic education in Mexico City, **Diego Rivera** (1886–1957) studied and lived in Europe between 1907 and 1921. There he met many of the leading avant-garde artists, including Picasso and Gris, and was developing his own Cubist style by 1913. He went to Italy near the end of his European sojourn and was particularly impressed by Renaissance murals. Upon his return to his native country, Rivera began to receive important commissions for monumental frescoes from the Mexican government. He attempted to create a national style reflecting both the history of Mexico and the socialist spirit of the Mexican revolution. In the murals, Rivera turned away from the abstracting forms of Cubism to develop a modern Neoclassical style consisting of simple, monumental forms and bold areas of color. This style can also be seen in his occasional easel paintings, such as *Flower Day*, 1925 (fig. **16.53**). While the subject of this work relates to an enormous mural project that Rivera undertook for the Ministry of Education in Mexico City, the massive figures and classically balanced composition derive from Italian art, as well as the Aztec and Mayan art that he consciously emulated.

In 1930 Rivera, a committed communist, came to the United States, where he carried out several major commissions that were, ironically, made possible by capitalist industry. Political differences between artist and patrons did lead to problems, however. Most notably, in 1931, Rivera's mural at Rockefeller Center, New York, was destroyed as a result of the inclusion of the Soviet leader Lenin in a scene celebrating the achievements of humanity (Rivera invited the exiled communist leader Leon Trotsky to live with him during his exile—see *Trotsky and International Socialism between the Wars*, chapter 15). Foremost among his surviving works in the United States is a narrative fresco cycle for the Detroit Institute of Arts on the theme of the evolution of technology, culminating in automobile manufacture (fig. **16.54**). Rivera toured the Ford motor plants for months, observing the workers and making preparatory sketches for his murals. The result is a *tour de force* of mural painting in which Rivera orchestrated man and machine into one great painted symphony. "The steel industry itself," he said, "has tremendous plastic beauty … it is as beautiful as the early Aztec or Mayan sculptures." In Rivera's vision, there is no sign of the unemployment or economic depression then crippling the country, nor the violent labor strikes at Ford that had just preceded his arrival in Detroit. At the same time, Rivera reveals criticism of capitalism's potential effects. Even though he portrays the workers with dignity, it is important to note that they are rendered in a dehumanized fashion.

16.53 Diego Rivera, *Flower Day*, 1925. Oil on canvas, 58 × 47½" (147.4 × 120.6 cm). Los Angeles County Museum of Art.

16.54 Diego Rivera, *Detroit Industry*, 1932–33. Fresco, north wall. The Detroit Institute of Arts.

Orozco

José Clemente Orozco (1883–1949), like Rivera and Siqueiros, received his training in Mexico City, at the Academy of San Carlos. Orozco lived in the United States between 1927 and 1934, when he also gained important fresco commissions, notably from Dartmouth College in Hanover, New Hampshire. There, in the Baker Library, he created a panorama of the history of the Americas. Orozco was not a proselytizer in the same vein as Rivera, and he hardly shared his compatriot's faith in modern progress and technology. In his complex of murals for Dartmouth, Orozco showed the viewer the human propensity for greed, deception, or violence. The murals begin with the Aztec story of the deity Quetzalcoatl, continue with the coming of the Spaniards and the Catholic Church, and conclude with the self-destruction of the machine age, climaxing in a great Byzantine figure of a flayed Christ, who, upon arriving in the modern world before piles of guns and tanks, destroys his own cross (fig. **16.55**). All of this is rendered in Orozco's fiery, expressionist style, with characteristically long, striated brushstrokes and brilliant color.

Siqueiros

The third member of the Mexican triumvirate of muralists, **David Alfaro Siqueiros** (1896–1974), executed fewer

16.55 José Orozco, *The Epic of American Civilization: Modern Migration of the Spirit*, 1932–34. Mural, fourteenth panel. Baker Library, Dartmouth College, Hanover, New Hampshire.

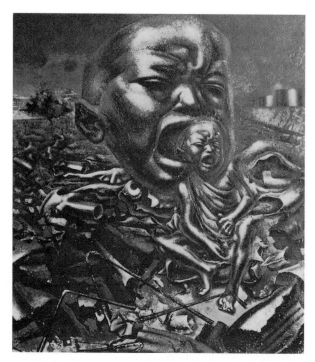

16.56 David Siqueiros, *Echo of a Scream*, 1937. Enamel on wood, 48 × 36" (121.9 × 91.4 cm). The Museum of Modern Art, New York.

public murals throughout the 1930s than his countrymen, partly because his radical political activities kept him on the move. Siqueiros maintained a lifelong interest in adopting the means of modern technology for art. In 1932 he came to the United States, to experience a "technological civilization," and taught at a Los Angeles art school where he executed murals using innovative materials and methods. Siqueiros' first major mural project came in 1939 for the Electricians' Syndicate Building in Mexico City.

The 1937 *Echo of a Scream* (fig. **16.56**), painted the year that Siqueiros joined the anti-fascist Republican Army in the Spanish Civil War, illustrates his vigorous pictorial attack. Beginning with an actual news photograph of a child in the aftermath of a bombing in the contemporaneous Sino–Japanese war, Siqueiros portrayed the "echo" of the child's cries as an enormous disembodied head above a field of ruins, creating a wrenching image of despair.

In 1936 Siqueiros established an experimental workshop in New York that attracted young artists from Latin America and the United States (including Jackson Pollock). The workshop was dedicated to modernizing the methods and materials of art production and to promoting the aims of the Communist Party of the United States. One participant described the use of new industrial paints in the workshop:

> We sprayed [it] through stencils and ... embedded wood, metal, sand, and paper. We used it in thin glazes or built up into thick gobs. We poured it, dripped it, splattered it, hurled it at the picture surface. ... What emerged was an endless variety of accidental effects.

Using such experimental methods, Siqueiros hoped to establish bold new ways of creating modern propagandistic murals. In general, the tradition of mural painting in the 1930s, of both the Mexicans and WPA artists like Benton, was crucial for the coming of age of Abstract Expressionist artists during the ensuing decades.

Kahlo

In the life of Mexican painter **Frida Kahlo** (1907–54), the defining moment came in 1925, when her spine, pelvis, and foot were crushed in a bus accident. During a year of painful convalescence, Kahlo, already a victim of childhood polio, took up painting. Through photographer Tina Modotti she met Diego Rivera, whom she married in 1929. She was with Rivera in Detroit when he painted the murals at the Institute of Arts, but Kahlo never adopted the monumental scale or public themes of mural art. She found her way outside the dominant, masculine mode, which in her circle was mural painting, by turning instead to the creation of an intimate autobiography through an astonishing series of self-portraits. In an early example (fig. **16.57**), she envisions herself in a long pink dress surrounded at the left by the cultural artifacts of Mexico and, at the right, the industrial trappings of the North. The hieratic and miniaturist technique she employs in this small painting on metal is in the folk tradition of Mexican votive paintings, which depict religious figures often surrounded by fantastic attributes.

When André Breton visited Kahlo and Rivera in Mexico in 1938, he claimed Kahlo as a Surrealist and arranged for her work to be shown, with considerable success, in New York. Breton also promised Kahlo a Paris show, which opened in 1939 thanks to Duchamp's intervention. Soon thereafter she and Rivera divorced (they remarried a year later), and Kahlo made several self-portraits documenting

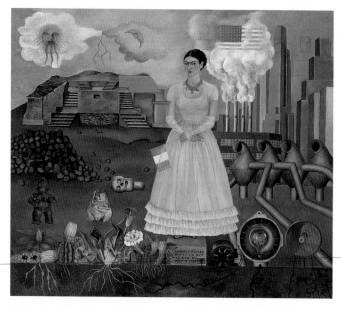

16.57 Frida Kahlo, *Self-Portrait on the Border Between Mexico and the United States*, 1932. Oil on sheet metal, 12¼ × 13¾" (31.1 × 34.9 cm). Private collection.

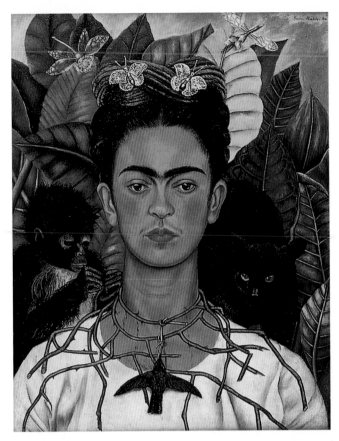

16.58 Frida Kahlo, *Self-Portrait with Thorn Necklace*, 1940. Oil on canvas, 24 × 18¾" (61 × 47.6 cm). Art Collection, Harry Ransom Humanities Research Center, University of Texas, Austin.

her grief. In *Self-Portrait with Thorn Necklace* (fig. **16.58**) she assumes the role of martyr, impaled by her necklace from which a dead hummingbird (worn by the lovelorn) hangs.

Tamayo

Rufino Tamayo (1899–1991), a native of Oaxaca of Zapotec Indian descent, was another Mexican artist who came to prominence around the 1930s. He lived in New York in the late 1920s and again from 1936 to 1948, teaching and working for a time for the WPA, until the government banned foreign artists from the program. Although he occasionally received mural commissions, Tamayo differed from the three leading Mexican muralists in that his aim was never to create a public art based on political ideologies: instead, he preferred themes of a more universal nature. His style was informed both by modernist modes, such as Cubism and Surrealism, and by Mexico's pre-Hispanic art. In the early 1940s, he made a series of animal paintings (fig. **16.59**), whose forms were inspired by popular Mexican art, but whose implied violence seems to register the traumas of war.

Modotti's Photography in Mexico

Closely associated with the artist-reformers of Mexico was Italian-born photographer **Tina Modotti** (1896–1942), who, with her longtime companion the photographer Edward Weston, arrived in Mexico in the early 1920s.

She joined the Communist Party in 1927 and worked in Mexico until her expulsion in 1930 for political activism. She was commissioned by the muralists to document their works in photographs that were circulated internationally and contributed to their celebrity. Her sharp-focus, unmanipulated images, such as her elegant close-ups of plants, bear the influence of Weston. But Modotti used her camera largely for socially relevant subjects, as when she photographed the hands and marionettes of a friend who used his craft for political ends (fig. **16.60**). With a sure eye for the telling image, Modotti built a remarkable corpus of photographs until she gave up the profession to live a nomadic existence in pursuit of her political goals. After periods in Moscow and Spain, she returned to Mexico, where she died in suspicious circumstances in 1942.

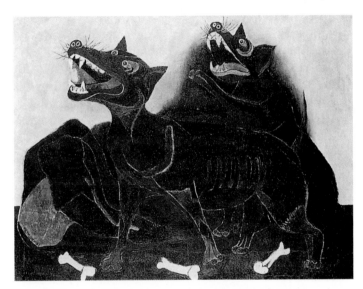

16.59 Rufino Tamayo, *Animals*, 1941. Oil on canvas, 30⅛ × 40" (76.5 × 101.6 cm). The Museum of Modern Art, New York.

16.60 Tina Modotti, *Number 29: Hands of Marionette Player*, n.d. Gelatin-silver print, 7½ × 9½" (19.1 × 24.1 cm). The Museum of Modern Art, New York.

The Avant-Garde Advances: Toward American Abstract Art

As we have seen in both the United States and Mexico, during the 1930s modernism, particularly Cubism and abstraction, seemed to have been driven underground. Nevertheless, while figuration and representation found wide public appeal, artists, many supported by the Federal Art Project, were laying the groundwork for a revival of abstract art. Thus the seeds were sown that would germinate, after World War II, in the transformation of the United States from the position of a provincial follower to that of a full partner in the creation of new art and architecture.

Exhibitions and Contact with Europe

A number of other events and developments of the 1920s and 30s also helped to strengthen the presence of avant-garde art in New York. As we saw in chapter 11, Katherine Dreier, the painter and collector advised by Marcel Duchamp, had organized the Société Anonyme in 1920 for the purpose of buying and exhibiting examples of the most advanced European and American art and holding lectures and symposia on related topics. In 1927 A. E. Gallatin, another painter-collector, put his personal collection of modern art on display at New York University as The Gallery of Living Art. It remained on exhibition for fifteen years. (This collection, now at the Philadelphia Museum together with that of Walter C. Arensberg, includes examples by Brancusi, Braque, Cézanne, Kandinsky, Klee, Léger, Matisse, Miró, Mondrian, and many others.)

The Gallery of Living Art was, in effect, the first museum with a permanent collection of exclusively modern art to be established in New York City. Shortly afterward came the opening of The Museum of Modern Art in 1929, which followed its initial series of exhibitions by modern masters with the historic shows Cubism and Abstract Art and Fantastic Art, Dada, Surrealism, both in 1936. In 1935 the Whitney Museum held its first exhibition of American abstract art, and in 1936 the American Abstract Artists (AAA) group was organized. By 1939 Solomon R. Guggenheim had founded the Museum of Non-Objective Painting, which would eventually be housed in the great Frank Lloyd Wright building on Fifth Avenue (see fig. 21.5).

During the 1930s, a few progressive European artists began to visit or emigrate to the United States. Léger made three visits before settling at the outbreak of World War II. Duchamp, Ozenfant, Moholy-Nagy, Josef Albers, and Hans Hofmann were all living in the United States before 1940. The last four were particularly influential as teachers. The group as a whole represented the earliest influx of European artists who spent the war years in the United States and who helped to transform the face of American art. Conversely, younger American painters continued to visit and study in Paris during the 1930s. Throughout the late 1930s and the 40s, the AAA held annual exhibitions dedicated to the promotion of every form of abstraction, but with particular emphasis on experiments related to the Constructivist and Neo-Plasticist abstraction being propagated in Paris by the Cercle et Carré and Abstraction-Création groups. These close contacts with the European modernists were of great importance for the subsequent course of modern American art.

Davis

The professional career of **Stuart Davis** (1894–1964) encompassed five decades of modern art in the United States. Although Davis was deeply committed to socialist reforms, unlike his Mexican contemporaries or Americans like Ben Shahn he did not exploit painting as a public platform for his political beliefs. Davis was committed to art with a broad, popular appeal, and he negotiated the vast territory between pure abstraction and the conservative realism of the Regionalists. After leaving Robert Henri's School of Art, Davis exhibited five watercolors in the 1913 Armory Show and was converted to modernism as a result of seeing the European work on display. Davis' collages and paintings of the early 1920s are explorations of consumer-product packaging as subject matter, and demonstrated his assimilation of Synthetic Cubism as well as his recollection of nineteenth-century American *trompe l'oeil* painting.

16.61 Stuart Davis, *Egg Beater #4*, 1928. Oil on canvas, 27 × 38¼" (68.6 × 97.2 cm). The Phillips Collection, Washington, D.C.

But his emphatically two-dimensional, deadpan treatment of imagery borrowed from popular culture, as well as his use of modern commercial lettering in his paintings, made Davis an important forerunner of 1960s Pop art.

In his *Egg Beater* series of 1927–28, Davis attempted to rid himself of the last illusionistic vestiges of nature, painting an eggbeater, an electric fan, and a rubber glove again and again until they had ceased to exist in his eyes and mind except as color, line, and shape relations (fig. **16.61**). Throughout the 1930s, Davis continued the interplay of clearly defined, if fragmented, objects with geometric abstract organization. His color became more brilliant, and he intensified the tempo, the sense of movement, the gaiety, and the rhythmic beat of his works through an increasing complication of smaller, more irregular, and more contrasted color shapes.

The culmination of these experiments may be seen in a 1940 work, *Report from Rockport* (fig. **16.62**). Although more abstract than most paintings of the 1930s, *Report from Rockport*, inspired by the main square of Rockport, Massachusetts, includes recognizable features such as buildings and gas pumps. There is a suggestion of depth, achieved by a schematic linear perspective, but the graphic shapes that twist and vibrate across the surface, with no clear representational role to play, reaffirm the picture plane.

Diller and Pereira

One of the artists who exhibited with the AAA was **Burgoyne Diller** (1906–65), the first American to develop an abstract style based on Dutch de Stijl. Once enrolled at the Art Students League in 1929, Diller very rapidly assimilated influences from Cubism, German Expressionism, Kandinsky, and Suprematism, much of which he knew only through reproductions in such imported journals as *Cahiers d'art*. Finally, toward the end of 1933, he had his first direct experience of a painting by Mondrian, whose Neoplastic principles became the main source of Diller's interests. But far from servile in his dependence on Neoplasticism, he went his own way by integrating color and line, so that lines became overlapping color planes (fig. **16.63**). Thus he created a complex sense of space differing from that of Mondrian.

16.63 Burgoyne Diller, *Second Theme*, 1937–40. Oil on canvas, 30⅛ × 30" (76.5 × 76.2 cm). The Metropolitan Museum of Art, New York. George A. Hearn Fund, 1963.

Irene Rice Pereira (1907–71) was another pioneer American abstractionist to appear in the 1930s. Taking her inspiration primarily from the Bauhaus, Pereira sought to fuse art and science, or technology, in a new kind of visionary image grounded in abstract geometry, but aspiring, like the Suprematist art of Malevich, toward an even more rarefied realm of experience. Boston-born and professionally active in New York, Pereira developed a seasoned style compounded of sharply rectilinear hard-edge and crystalline planes, often rendered as if floated or suspended one in front of the other, with transparent tissues giving visual access to the textured, opaque surfaces lying below (fig. 16.64). The resulting effect is that of a complex, many-layered field of color and light.

Avery and Tack

Born and schooled in Hartford, Connecticut, **Milton Avery** (1885–1965) moved to New York in 1925. He characteristically worked in broad, simplified planes of thinly applied color deriving from Matisse but involving an altogether personal poetry. His subjects were his family and friends, often relaxing on holiday, as in his 1945 canvas *Swimmers and Sunbathers* (fig. 16.65). In his later years he turned more to landscape, which, though always recognizable, became more and more abstract in organization. Avery was a major source for the American Color

16.64 Irene Rice Pereira, *Abstraction*, 1940. Oil on canvas, 30 × 38" (76.2 × 96.5 cm). Honolulu Academy of Arts.

Field painters of the 1950s and 60s, such as Mark Rothko (see fig. 17.23). In a memorial service for his friend, Rothko said, "Avery had that inner power which can be achieved only by those gifted with magical means, by those born to sing."

16.65 Milton Avery, *Swimmers and Sunbathers*, 1945. Oil on canvas, 28 × 48⅛" (71.1 × 122.2 cm). The Metropolitan Museum of Art, New York.

Augustus Vincent Tack (1870–1949) may have been the most maverick and removed of all the progressive American painters between the wars. He alone managed to integrate modernism's non-objective and figural modes into organic, sublimely evocative, wall-size abstractions. His work formed a unique bridge between an older pantheistic tradition of landscape painting, last seen in the work of Ryder (see fig. 2.55), and its new, brilliant flowering in the heroic abstractions of the postwar New York School, especially in the paintings of Clyfford Still (see fig. 17.29). Duncan Phillips, Tack's faithful patron throughout the 1920s and 30s, foresaw it all when he declared, in commenting on one of Tack's paintings: "We behold the majesty of omnipotent purpose emerging in awe-inspiring symmetry out of thundering chaos. ... It is a symbol of a new world in the making, of turbulence stilled after tempest by a universal God."

Tack was trained in the 1890s by the American Impressionist John Twachtman, and his early work consisted largely of landscapes in the style of late-nineteenth-century American symbolism. In 1920, when he made his first paintings of the Rocky Mountains, Tack discovered in the majestic Western landscape motifs capable of expressing his mystical feelings about nature. These he gradually transformed into the dramatic, nature-inspired abstractions of his mature work. Paintings such as *Night, Amargosa Desert*, 1935 (fig. **16.66**), represent American Romanticism in the most advanced form it would take during the period, a view of the material world examined so intensely that it dissolved into pure emblem or icon, an aesthetic surrogate for the divine, ordering presence sensed within the disorder of raw nature. Tack's paintings exhibit uncanny affinities with the allover abstractions of the New York School of the 1950s.

16.66 Augustus Vincent Tack, *Night, Amargosa Desert*, 1935. Oil on canvas mounted on plywood panel, 7' × 4' (2.1 × 1.2 m). The Phillips Collection, Washington, D.C.

Sculpture in America Between the Wars

American sculpture during the first four decades of the twentieth century lagged behind painting in quantity, quality, and originality. Throughout this period the academicians predominated, and such modernist developments in sculpture as Cubism or Constructivism were hardly visible. Archipenko, who had lived in the United States since 1923 and who had taught at various universities, finally opened his own school in New York City in 1939. Alexander Calder was the best-known American sculptor before World War II, but largely in a European context, since he had worked in Paris since 1926. His influence grew in America in the following years. During the 1930s, in sculpture as in painting, despite the predominance of the academicians and the isolation of the progressive artists, a number of sculptors were emerging who helped to change the face of American sculpture at the end of World War II.

Lachaise and Nadelman

Among the first generation of modern American sculptors, two important practitioners were Europeans, trained in Europe, who emigrated to the United States early in their careers. These were **Gaston Lachaise** (1882–1935) and Elie Nadelman. Lachaise was born in Paris and trained at the École des Beaux-Arts. By 1910 he had begun to experiment with the image that was to obsess him during the rest of his career, that of a female nude with enormous breasts and thighs and delicately tapering arms and legs (fig. **16.67**). This form derives from Maillol (see fig. 6.5), but in Lachaise's versions it received a range of expression from pneumatic elegance to powerfully primitivizing works that recall the ancient sculpture of India, as well as prehistoric female fertility figures.

Elie Nadelman (1882–1946) received his European academic training at the Warsaw Art Academy. Around 1909 in Paris, where he made the acquaintance of artists including Picasso and Brancusi, Nadelman was reducing the sculpted human figure to almost abstract curvilinear patterns. After his move to the United States in 1914, he was given an exhibition by Stieglitz at 291 gallery. He progressively developed a style that might be described as a form of sophisticated primitivism (he was an avid collector of folk art), marked by simplified surfaces employed in the service of a witty and amusing commentary on contemporary life. His *Man in the Open Air* (fig. **16.68**) is an early example of his work in this manner.

16.67 Gaston Lachaise, *Standing Woman*, 1912–27. Bronze, height 70" (177.8 cm). Albright-Knox Art Gallery, Buffalo, NY.

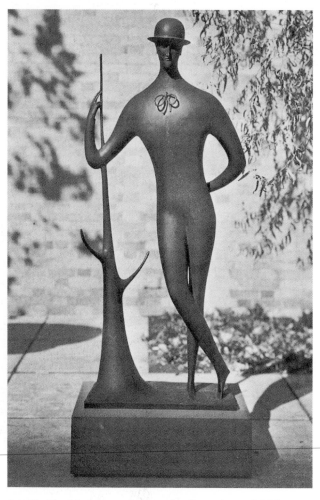

16.68 Elie Nadelman, *Man in the Open Air*, c. 1915. Bronze, 54½" (138.4 cm) high; at base 11¾ × 21½" (29.9 × 54.6 cm). The Museum of Modern Art, New York.

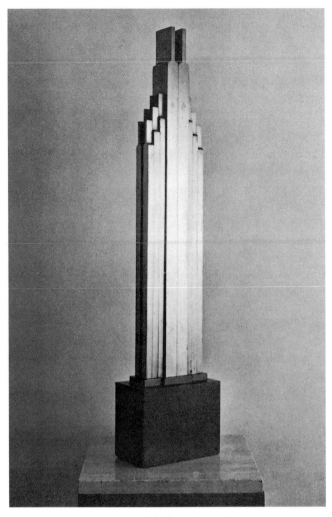

16.69 John Storrs, *Forms in Space #1*, 1927. Steel and copper, 20½ × 4 × 1⅝" (52.1 × 10.2 × 4.1 cm). The Metropolitan Museum of Art, New York. Purchase Francis Lathrop Fund, 1967.

Storrs and Roszak

Son of a Chicago architect, sculptor **John Storrs** (1885–1956) studied in Chicago, Boston, New York, and Paris and, beginning in 1915, made geometricized figurative sculptures in stone. Their streamlined forms, partly inspired by the Native American art Storrs admired and collected, was at one with the prevailing Art Deco style in architecture and decorative arts. During the 1920s, Storrs began to make sculpture directly inspired by modern architectural forms, initially those created by Frank Lloyd Wright. His later celebrations in sculpture of the modern skyscraper (fig. **16.69**) parallel those of Stella, O'Keeffe, Sheeler, and Marin. Such works led to commissions for monumental sculpture to decorate actual buildings. Because of the artist's long expatriation to France, Storrs' achievement remained largely forgotten until the 1960s.

Although in the minority, sculpture in a Constructivist vein thrived in the hands of a few American artists in the 1930s, among them Polish-born **Theodore Roszak** (1907–81). Having arrived in Chicago with his family as a young child, Roszak was trained as a conventional painter at that city's school of the Art Institute, but underwent a change in his outlook during a trip to Europe from 1929 to 1931. Upon returning to the United States he settled in New York, working eventually for the WPA. He made De Chiricoesque figure paintings with Cubist overtones in the early 1930s and, at the same time, began making Cubist sculptures and reliefs. By the middle of the decade, he was experimenting with abstract constructed sculpture as a result of his interest in machines and industrial design. *Construction in White* (fig. **16.70**) is a whitewashed plywood box in which Roszak cut a circle and inserted intersecting sheets of plastic and wooden blocks. He said

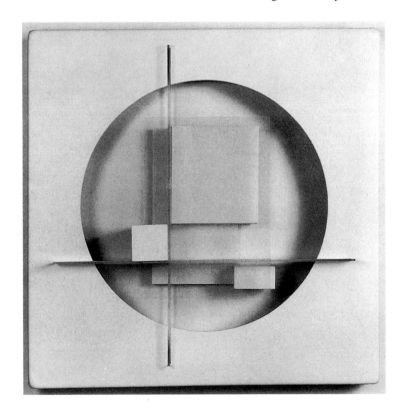

16.70 Theodore Roszak, *Construction in White*, 1938. Painted wood and plastic, 49½ × 49½" (125.7 × 125.7 cm). Estate of Theodore Roszak.

he wanted such works to stand as utopian symbols for perfection. Critical to him were the teachings of the Bauhaus, particularly those of Moholy-Nagy, who had come to Chicago in 1937 to head the New Bauhaus. In the aftermath of World War II, Roszak became disenchanted with technology and began to make welded sculpture in steel. The rough surfaces and aggressive forms of these works reflected the violence and terror of war, situating his work in the arena of Abstract Expressionism (see chapter 17).

Calder

It was a formative encounter with Mondrian's art in 1930 that prompted American **Alexander Calder** (1898–1976) to become an abstract artist. Born in Philadelphia, Calder was the son and grandson of sculptors. After studying engineering, a training that would have direct consequences for his art, he was gradually drawn into the field of art, studying painting at New York's Art Students League and working as an illustrator. Calder's early paintings of circus or sports scenes reflect the styles of his teachers, such as John Sloan (see fig. 16.2). By the time of his first visit to Paris in 1926, Calder had begun to make sculptures in wire and wood. In the French capital he eventually attracted the attention of avant-garde artists and writers (especially the Surrealists) with his *Circus*, a full-fledged, activated environment made up of tiny animals and performers that he assembled from wire and found materials and then set into motion. At the same time he made wooden sculptures and portraits and caricatures constructed from wire. The wire sculptures are early demonstrations of Calder's marvelous technical ingenuity and playful humor. They could be quite large, such as the ten-foot (3 m) *Romulus and Remus* of 1928 (fig. **16.71**). Here Calder bent and twisted wire into a composition of such economy that the entire "torso" of the she-wolf is one continuous stretch of wire. The whole is like a three-dimensional line drawing (Calder made drawings related to the wire sculpture at the same time).

In 1930, during a subsequent sojourn in Paris, Calder visited Mondrian's rigorously composed studio, which deeply impressed him. "This one visit gave me a shock that started things," he said. "Though I had heard the word 'modern' before, I did not consciously know or feel the term 'abstract.' So now, at thirty-two, I wanted to paint and work in the abstract." He began to experiment with abstract painting and, more significantly, abstract wire constructions that illustrated an immediate mastery of constructed space sculpture. These early abstract sculptures, which were exhibited in a 1931 solo exhibition in Paris, consisted of predominantly austere, geometric forms like open spheres; but they also contained a suggestion of subject—constellations and universes.

In 1931, at Arp's suggestion, Calder joined Abstraction-Création and began to introduce motion into his constructions. At first he induced movement by hand cranks or small motors, but eventually the sculptures were driven merely by currents of air and Calder's carefully calibrated systems of weights and balances. There were precedents for this kineticism in sculpture, as we have seen, in the work of Gabo, Rodchenko, and Moholy-Nagy, but no artist developed the concept as fully or ingeniously as Calder. His first group of hand and motor "mobiles" was exhibited in 1932 at the Galerie Vignon, where they were so christened by Marcel Duchamp. When Arp heard the name "mobile," he asked, "What were those things you did last year—stabiles?" Thus was also born the word that technically might apply to any sculpture that does not move but that has become specifically associated with Calder's works.

Calder's characteristic works of the 1930s and 40s are wind-generated mobiles, either standing or hanging, made of plates of metal or other materials suspended on strings or wires, in a state of delicate balance. The earliest mobiles were relatively simple structures in which a variety of objects, cut-out metal or balls and other forms in wood moved slowly in the breeze. A far greater variety of motion was possible than in the mechanically driven mobiles. For one thing, the element of chance played an important role. Motion varied from slow, stately rotation to a rapid staccato beat. In the more complex examples, shapes rotated, soared, changed tempo, and, in certain instances, emitted alarming sounds. In *Object with Red Disks (Calderberry Bush)* (fig. **16.72**), a standing mobile from 1931 (the second title, by which the work is best known, was not

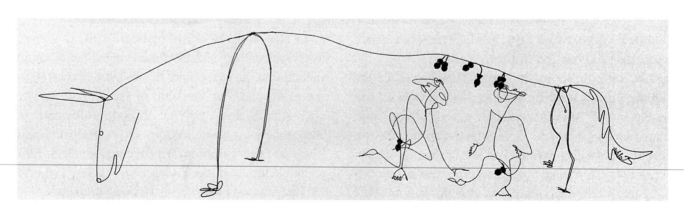

16.71 Alexander Calder, *Romulus and Remus*, 1928. Wire and wood, 30½ × 124½ × 26" (77.5 × 316.2 × 66 cm). Solomon R. Guggenheim Museum, New York.

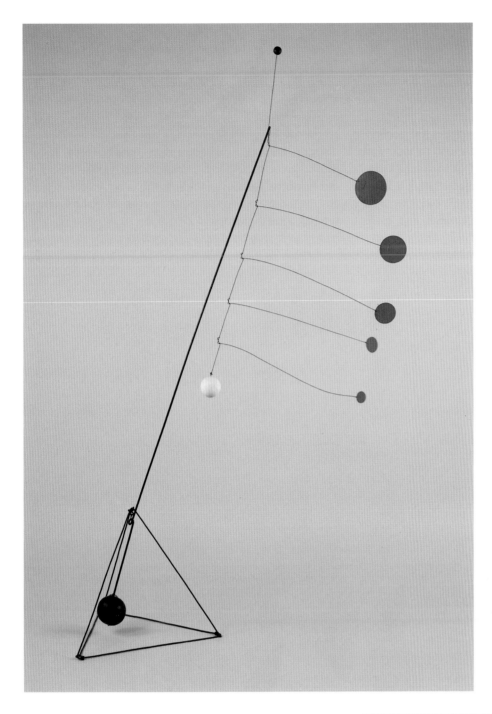

16.72 Alexander Calder, *Object with Red Disks (Calderberry Bush)*, 1931. Painted steel rod, wire, wood, and sheet aluminum, 88½ × 33 × 47½" (224.8 × 83.8 × 120.7 cm). Whitney Museum of American Art, New York.

16.73 Alexander Calder, *The White Frame*, 1934. Painted wood, sheet metal, wire, 7' 5" × 9' (2.1 × 2.7 m). Moderna Museet, Stockholm.

Calder's), the artist counterbalanced five flat red disks with wooden balls and perched the whole on a wire pyramidal base. When set in motion by the wind or a viewer's hand, this abstract construction moves through space in pre-planned yet not entirely predictable ways.

Among Calder's motorized mobiles were also reliefs, with the moving parts on a plane of wooden boards or within a rectangular frame. One of the earliest on a large scale is *The White Frame* of 1934 (fig. **16.73**). In this, a few elements are set against a plain, flat background: a large, suspended disk at the right, a spiral wire at the left, and between them, suspended on wires, a white ring and two small balls, one red and one black. Put into motion, the large disk swings back and forth as a pendulum, the spiral rotates, and the balls drop unexpectedly and bounce from their wire springs. Whereas *The White Frame* (with the

exception of the spiral) still reflects Mondrian, geometric abstraction, and Constructivism, Calder also used free, biomorphic forms reflecting the work of his friends Miró and Arp. From this point onward, his production moved easily between geometric or Neoplastic forms and those associated with organic Surrealism.

By the end of the 1930s, Calder's mobiles had become extremely sophisticated and could be made to loop and swirl up and down, as well as around or back and forth. One of the largest hanging mobiles of the 1930s is *Lobster Trap and Fish Tail* (fig. **16.74**), a work commissioned for The Museum of Modern Art. Although it is quite abstract, the subject association of the Surrealist-inspired, biomorphic forms is irresistible. The torpedo-shaped element at top could be a lobster cautiously approaching the trap, represented by a delicate wire cage balancing at one end of a bent rod. Dangling from the other end is a cluster of fan-shaped metal plates suggestive of a school of fish. The delicacy of the elements somewhat disguises the actual size, some nine and a half feet (2.9 m) in diameter. After World War II, Calder would pursue an international career, expanding the abstract art he had already formulated in the 1930s to an architectural scale of unprecedented grandeur.

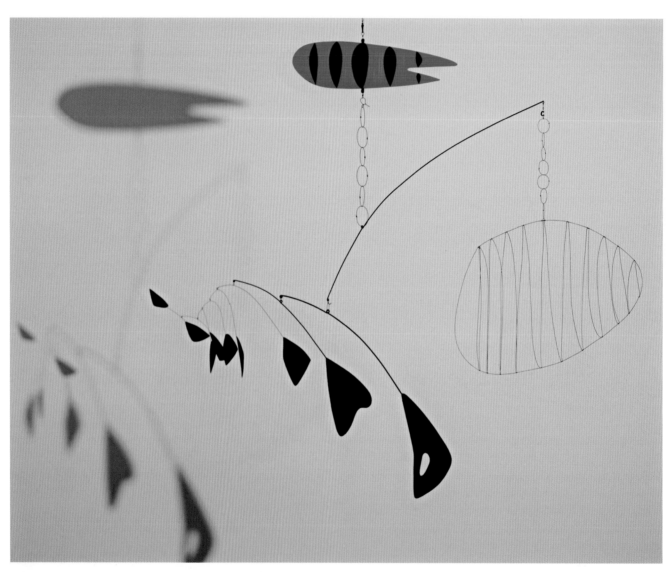

16.74 Alexander Calder, *Lobster Trap and Fish Tail*, 1939. Hanging mobile: painted steel wire and sheet aluminum, approximately 8' 6" high × 9' 6" diameter (2.6 × 2.9 m). The Museum of Modern Art, New York.

17
Abstract Expressionism and the New American Sculpture

Looking back on the 1940s, the American painter Barnett Newman recalled that artists of his generation:

felt the moral crisis of a world in shambles, a world devastated by a great depression and a fierce world war, and it was impossible at that time to paint the kind of paintings that we were doing—flowers, reclining nudes, and people playing the cello. … This was our moral crisis in relation to what to paint.

In 1942, immediately after the United States' entry into World War II, the dominant styles of painting were still Social Realism and Regionalism (see chapter 16). These styles—conservative in their naturalism, unapologetic in their nationalism and nostalgia—were seen by many progressive artists as insufficient for registering the outrage and desperation provoked by World War II. The scale of the war's many fronts along with the unprecedented role played by technology (the firebombings of London, Dresden, and Tokyo, for instance, and the introduction of nuclear warfare) left even citizens of the victorious United States struggling to imagine a safe, peaceful future. The almost immediate mobilization of the Soviet Union's war industry only compounded the confusion and wariness.

This ferment contributed to the creation of Abstract Expressionism, or, as it is more generically called, the New York School. Attitudes conditioned by the war—a sense of alienation and a loss of faith in old systems and old forms of expression—led artists to explore a broad range of intellectual thought from existentialism to the theories of Sigmund Freud and Carl Jung. Expressionism, Cubism, Constructivism, and Surrealism served as guideposts for new aesthetic explorations.

Many associated with New York's burgeoning art world understood early on the true aims of Hitler's anti-Semitic campaign, described by the many émigré artists who had fled Central Europe during the 1930s. As the scope of Nazi atrocities became clear during and, especially, after the war, American artists struggled to find a means of expressing

not only their horror but also a sense of helplessness. Most of the painters who contributed decisively to the development of Abstract Expressionism did not serve in the military, because of age, sex, infirmity, or national origin. While this may have insulated these progressive American artists from direct experience of the war, it also contributed to the sense of moral, even aesthetic, duty described by Newman. In this way, the Abstract Expressionists can be seen as responding to philosopher Theodore Adorno's 1945 declaration that "to write poetry after Auschwitz is barbaric." Art could never—should never—be the same. As Adorno stated in clarifying his dictum: "perennial suffering has as much right to expression as the tortured have to scream."

Social and economic conditions following the war also contributed to the ability of American artists to respond as immediately and radically as they did (see *Artists and Cultural Activism*, p. 405). The devastation of Europe's cultural centers by the second major war in three decades crippled established arts institutions. Many major European dealers and collectors of avant-garde art had been killed, their collections stolen and dispersed; museums and galleries were struggling to regain financial support and social relevancy. It was at this point that New York City assumed a new cultural prominence. By the early twentieth century, the city had become a refuge for progressive American artists as well as recent émigrés like Piet Mondrian, Marcel Duchamp, André Masson, and Hans Hofmann. This, coupled with its status as the financial center of the booming postwar US economy, made New York the new capital of modernism.

Mondrian in New York: The Tempo of the Metropolis

In 1938, with the war approaching, **Piet Mondrian** (1872–1944) left Paris, first for London then New York, where he spent his final four years. Manhattan became the last great love of his life, perhaps because of the Neoplastic effect created by skyscrapers rising from the narrow canyons

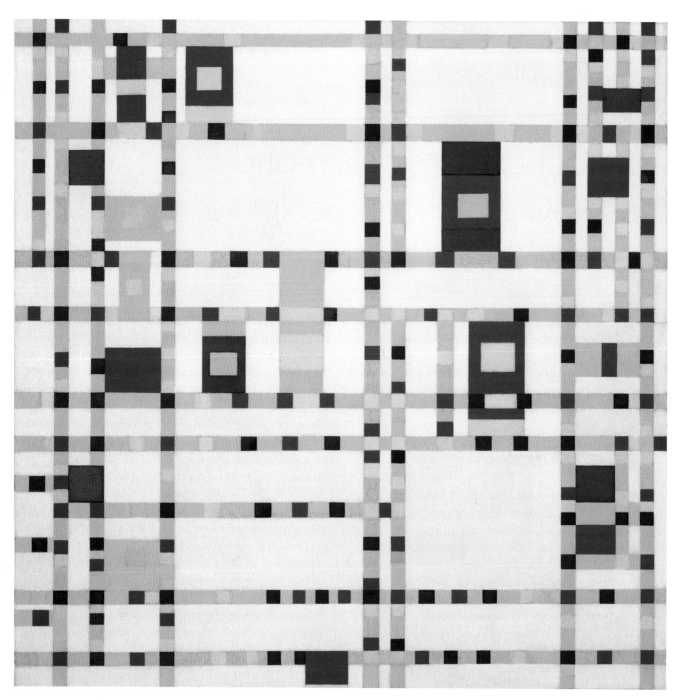

17.1 Piet Mondrian, *Broadway Boogie Woogie*, 1942–43. Oil on canvas, 50 × 50" (127 × 127 cm). B323. Museum of Modern Art, NY. Anonymous gift. © 2009 Mondrian/Holtzman Trust c/o HCR International, Warrenton, Virginia, 20186, USA.

of the streets and the rigid grid of its plan. As early as 1917 Mondrian had said, "The truly modern artist sees the metropolis as abstract life given form: it is closer to him than nature and it will more easily stir aesthetic emotions in him." A major stimulus to the artist was that of lights at night, when the skyscrapers were transformed into a brilliant pattern of light and shadow, blinking and changing. Mondrian also loved the tempo, the dynamism, of the city—the traffic, the dance halls, the jazz bands, the excitement of movement and change. He felt driven to translate these rhythms into his late paintings, where the earlier grid of black lines (see fig. 13.3) is replaced by a complex weave of colored lines.

The impact of the city and music is most evident in *Broadway Boogie Woogie*, painted in 1942–43 (fig. **17.1**). Here the artist departed radically from the formula that had occupied him for more than twenty years. There is still the rectangular grid, but the black, linear structure balanced against color areas is gone. In fact, the process is reversed: the grid itself is the color, with the lines consisting of little blocks of red, yellow, blue, and gray. The ground is a single plane of off-white, and against it vibrate the varicolored lines as well as larger color rectangles.

In New York, Mondrian devised a method of composing with commercially available colored tapes that he could easily shift around until he was satisfied enough to commit

Artists and Cultural Activism

As academies grew less and less relevant for American artists working in the 1930s and 40s, new organizations appeared to take their place. In 1936, several of Hans Hofmann's students helped to establish American Abstract Artists (AAA), an organization dedicated to promoting the progressive art of its members through exhibitions, lectures, and publications. The group rejected European Expressionism and Surrealism along with the Social Realism of their contemporaries, supporting instead the geometric abstraction associated with artists like Mondrian. Early members of AAA included Willem de Kooning, Krasner, Diller, Reinhardt, and Smith. Also convened in 1936 was the American Artists' Congress, whose aims and membership (which included Stuart Davis along with many Ashcan and Social Realist artists) differed from that of the AAA. The Congress was communist in its orientation, advocating, for social justice and government, arts programs such as the Federal Art Project, of which the Works Progress Administration (WPA) was one branch. Support for communism receded during World War II, and the Congress disbanded in 1943. The Artists Equity Association, established in 1947, promoted American art and artists without regard to style or ideology. The group, led by painter Yasuo Kuniyoshi, adopted the model of a labor union, an approach that had succeeded during the Depression when the Artists' Union (founded 1934) demonstrated that picket lines could influence hiring practices and legislation. The conditions faced by artists in the postwar years differed from those of the 1930s, though. With the closure of the FAP in 1943, an economy geared toward industrial rather than cultural expansion, and a population much less sympathetic to socialist-seeming ideas, many artists found themselves in difficult straits. Artists Equity proved successful in increasing government patronage for the arts and finding other financial, legal, and even medical assistance for some unemployed artists.

paint to canvas. This kind of experimental and intuitive approach had always governed Mondrian's working process. Although his art was guided by certain firmly held principles, it was far from formulaic. His paintings are filled with subtle textural effects and give evidence of repeated revisions as the artist painted layer upon layer, widening or narrowing his lines and experimenting with alternative colors. Even his whites are rarely the same hue. Although most art suffers in reproduction, the physical presence of Mondrian's paintings is especially difficult to capture, even in the best photographs.

Mondrian was a legendary figure in the United States, inspiring not only the geometric abstractionists, who had been carrying on a minority battle against Social Realism and Regionalism, but also a number of younger artists who were to create a major revolution in American art. Almost without exception, the emerging Abstract Expressionists

of the early 1940s had great respect for Mondrian, even though their painting took directions that would seem diametrically opposed to everything he believed in.

Entering a New Arena: Modes of Abstract Expressionism

The diverse group of artists involved were opposed to all forms of Social Realism and any art form that smacked of nationalism. Much as they admired Mondrian, they also rejected as trivial the pure geometric abstraction, promoted within the ranks of the American Abstract Artists (AAA), that his art had engendered in America. On the other hand, the relationship of the new movement to the European Surrealists, some of whom also sought refuge from the war in New York, was critical. The Americans were particularly drawn to the organic, abstract, automatist Surrealism of Matta, Miró, and Masson (see chapter 15). Matta, who was in New York from 1939 to 1948, helped introduce the idea of psychic automatism to the Abstract Expressionists. The Americans were less concerned with the new method as a means of tapping into the unconscious than as a liberating procedure that could lead to the exploration of new forms.

The art world of the 1940s was far from a coherent community. The experience of the Federal Art Project of the WPA had provided a degree of camaraderie among artists, and the artists of, largely, the New York School gathered informally in their studios and in the cafeterias and taverns of Greenwich Village to discuss—and sometimes to battle over—the burning artistic issues of the day. Peggy Guggenheim's gallery, Art of This Century, featured European Surrealists but also became a venue for young artists like Clyfford Still, Robert Motherwell, and, especially, Jackson Pollock. A handful of other dealers and a few critics, notably the formalist critic Clement Greenberg, as well as Harold Rosenberg and Thomas Hess, eventually championed the new movement. Greenberg's conception of modernism, in particular, was highly influential (see *Modernist Painting*, p. 406).

Although Abstract Expressionism is as diverse as the artists involved, in a very broad sense two main tendencies may be noted. The first is that of the so-called gestural painters, concerned in different ways with the spontaneous and unique touch of the artist, his or her "handwriting," and the emphatic texture of the paint. It included such major artists as Pollock, Willem de Kooning, and Franz Kline. The other group consisted of the Color Field painters, concerned with an abstract statement in terms of a large, unified color shape or area. Here one can include Mark Rothko, Barnett Newman, Still, and Adolph Gottlieb, as well as, to a degree, Motherwell and Ad Reinhardt. Some of the ideas these artists shared were presented in a short manifesto written by Newman, Rothko, and Gottlieb and published as an open letter in *The New York Times* in 1943, which stated, among other things: "There is no such thing as a good painting about nothing."

"We assert that the subject is crucial," they wrote, "and only that subject matter is valid which is tragic and timeless." In 1948 several of these painters founded an informal school called the "Subjects of the Artist." They were united by their belief that abstract art could express universal, timeless themes. Even at its most abstract, art could convey a sense of the whole range of human emotional experiences.

The Picture as Event: Experiments in Gestural Painting

In 1952 Harold Rosenberg coined the phrase "action painting" to describe the process by which the spontaneous gesture was enacted on the canvas. He wrote:

At a certain moment, the canvas began to appear to one American painter after another as an arena in which to act—rather than as a space in which to reproduce, re-design, analyze or "express" an object, actual or imagined. What was to go on the canvas was not a picture but an event.

What the term "action painting" failed to account for was the balance that these artists struck between forethought and spontaneity; between control and the unexpected.

Hofmann

The career of **Hans Hofmann** (1880–1966) encompassed two worlds and two generations. Born in Bavaria, Hofmann lived and studied in Paris between 1903 and 1914, experiencing the range of new movements from Neo-Impressionism to Fauvism and Cubism. He was particularly close to Robert Delaunay (see chapter 8), whose ideas on color structure were a formative influence. In 1915 Hofmann opened his first school in Munich. In 1932 he moved to the United States to teach, first at the University of California, Berkeley, then at New York's Art Students League, and finally at his own Hans Hofmann School of Fine Arts in New York and in Provincetown, Massachusetts. Hofmann's greatest concern as a painter, teacher, and theoretician lay in his concepts of pictorial structure, which were based on architectonic principles

17.2 Hans Hofmann, *The Gate*, 1959–60. Oil on canvas, 6' 2⅜" × 4' ¼" (1.9 m × 1.23 m). Solomon R. Guggenheim Museum, New York.

17.3 Arshile Gorky, *The Artist and His Mother*, c. 1929–36. Oil on canvas, 60 × 50" (152.4 × 127 cm). National Gallery of Art, Washington, D.C.

rooted in Cubism. This did not prevent him from attempting the freest kinds of automatic painting. A number of such works executed in the mid-1940s, although on a small scale, preceded Pollock's drip paintings.

During the last twenty-six years of his life, Hofmann made abstractions of amazing variety, ranging from a precise but painterly geometry to a lyrical expressionism. In his best-known works, he used thick, rectangular slabs of paint and aligned them with the picture's edge (fig. **17.2**), demonstrating his ideas about color as a space-creating device. While the rectangles of color affirm the literal flatness of the picture, they also appear to advance and recede spatially, creating what Hofmann called a "push and pull" effect. Like his fellow German émigré Josef Albers, Hofmann was one of the premier art educators and theoreticians in the United States, and his influence on a generation of younger artists such as Lee Krasner (see fig. 17.10) and critics including Clement Greenberg was enormous.

Gorky

Armenian-born **Arshile Gorky** (1905–48) was a largely self-taught artist whose work constituted a critical link between European Surrealism and American Abstract Expressionism. Gorky arrived in the United States in 1920, a refugee from the Turkish campaign of genocide against the Armenians, which gave him firsthand experience of the brutality of which militarized, nationalist regimes are capable. His work often addresses—literally or metaphorically—these experiences. His early experiments with both figuration and abstraction were deeply influenced by Cézanne and then Picasso and Miró. He achieved a distinctive figural mode in *The Artist and His Mother* (fig. **17.3**), a haunting portrait based on an old family photograph in which the artist posed beside his mother, well before she died of starvation in his arms.

By the early 1940s, Gorky was evolving his mature style, a highly original mode of expression that combined strange hybrid forms with rich, fluid color. One of his most ambitious paintings, *The Liver is the Cock's Comb*, 1944 (fig. **17.4**), is a large composition that resembles both a wild and vast landscape and a microscopically detailed internal anatomy. Gorky combined veiled but recognizable shapes, such as claws or feathers, with overtly sexual forms, creating an erotically charged atmosphere filled with softly brushed, effulgent color. His biomorphic imagery owed much to Kandinsky (fig. 14.14) and Miró (fig. 15.12), whose works he knew well, and to the

17.4 Arshile Gorky, *The Liver is the Cock's Comb*, 1944. Oil on canvas, 6' 1¼" × 8' 2" (1.9 × 2.5 m). Albright-Knox Art Gallery, Buffalo, New York.

Surrealist automatism of Masson (fig. 15.16) and Matta (fig. 15.27), who were both in New York in the 1940s. The year he made this painting, Gorky met André Breton, the self-appointed leader of the Surrealists, who took a strong interest in his work and arranged for it to be shown at a New York gallery in 1945.

Willem de Kooning

Willem de Kooning (1904–97) was a central figure of Abstract Expressionism, even though he was not one of the first to emerge in the public eye during the 1940s. Born in the Netherlands, De Kooning underwent rigorous artistic training at the Rotterdam Academy. He came to the United States in 1926, where, throughout the 1930s, he slowly made the transition from house painter, commercial designer, and Sunday painter to full-time artist. Of the utmost importance was his early encounter with Stuart Davis (see fig. 16.61), Gorky, and the influential Russian-born painter John Graham, "the three smartest guys on the scene," according to De Kooning. They were his frequent companions to The Metropolitan Museum of Art, where it was possible to see examples of ancient and old-master art. Although he did not exhibit until 1948, De Kooning was an underground force among younger experimental painters by the early forties.

One of the most remarkable aspects of De Kooning's talent was his ability to shift between representational and abstract modes, which he never held to be mutually exclusive. He continued to make paintings of figures into the 1970s, but even many of his most abstract compositions contain remnants of or allusions to the figure. "Even abstract shapes must have a likeness," he said. In the late

1940s he made a bold group of black-and-white abstractions in which he had fully assimilated the tenets of Cubism, which he made over into a dynamic, painterly idiom. Using commercial enamel paint, he made a largely black composition, *Painting*, through which he spread a fluid network of white lines, occasionally allowing the medium to run its own course down the surface (fig. **17.5**). Certain recognizable forms—a hat and glove at the upper right—can be detected. Elsewhere in the picture, De Kooning subsumed figurative references within rhythmically flowing lines, creating vestigial forms that function

17.5 Willem de Kooning, *Painting*, 1948. Enamel and oil on canvas, 42⅝ × 56⅛" (108.3 × 142.5 cm). The Museum of Modern Art, New York.

as his characteristic shorthand for the human body. After *Painting* was shown in his first solo show in New York, it was acquired by The Museum of Modern Art, and De Kooning thus emerged publicly as one of the pioneers of a new style.

While he was making his black-and-white compositions, De Kooning was also working on large paintings of women (fig. **17.6**). This monumental image of a seated woman in a sundress is his simultaneously repellent and arresting evocation of woman as sex symbol and fertility goddess. Although the vigorous paint application appears entirely improvisatory, the artist labored over the painting for eighteen months, scraping the canvas down, revising it, and, along the way, making countless drawings—he was a consummate draftsman—of the subject. When his paintings of women were exhibited in 1953, De Kooning, who once said his work was "wrapped in the melodrama of vulgarity," was dismayed when critics failed to see the humor in them, reading them instead as misogynist. Akin to the Surrealists, De Kooning perceived a relationship between the comic and the terrifying, a relationship he, like the Surrealists, projected onto the female body. He said his images had to do with "the female painted through all the ages, all those idols," by which he could have meant a Greek Venus, a Renaissance nude, a Picasso portrait, a Surrealist *femme fatale*, or a curvaceous American movie star, with her big, ferocious grin. Over the years when he was questioned about his paintings of women, De Kooning emphasized the dual nature of their sexual identity, claiming they derived partly from the feminine within himself. By the mid-1950s the women paintings gave way to compositions sometimes called "abstract urban landscapes,"

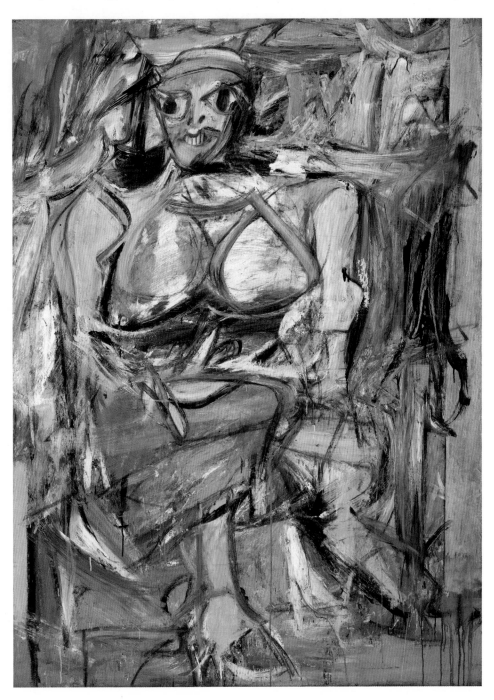

17.6 Willem de Kooning, *Woman, I*, 1950–52. Oil on canvas, 6' 3⅞" × 4' 10" (1.9 × 1.47 m). The Museum of Modern Art, New York.

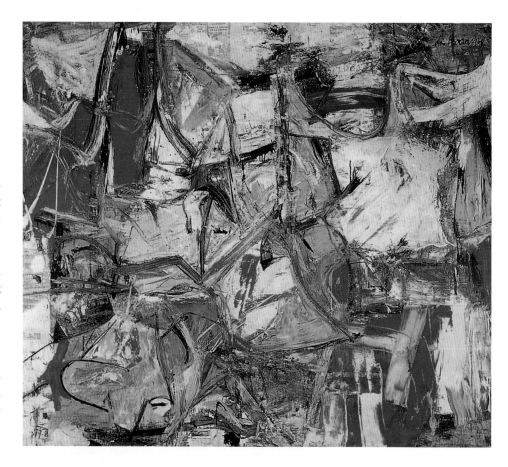

17.7 Willem de Kooning, *Gotham News*, 1955. Oil on canvas, 5' 9" × 6' 7" (1.75 × 2 m). Albright-Knox Art Gallery, Buffalo, New York.

which, with their slashing lines and colliding forms, reflect the lively, gritty atmosphere of New York City streets. In *Gotham News* (fig. **17.7**) De Kooning dragged charcoal through wet paint, churning up the surface to create a heated atmosphere that pulsates with an intense, metropolitan beat. This is a quintessential example of gestural Abstract Expressionism, with the hand of the artist, the emotion-packed "gesture," everywhere apparent.

Pollock

According to De Kooning, it was **Jackson Pollock** (1912–56), with the radical "drip" paintings he began to make in the late 1940s, who "broke the ice." Hailing from the West, Pollock became a huge force on the New York art scene, until his alcoholism led to a fatal car wreck. His identity as a Westerner—a sort of cowboy, even—was cultivated by the artist and his admirers who saw in his work a uniquely American self-reliance and independence. Pollock embodied an American expression of the alienated, misunderstood, and tragic Romantic genius. He achieved a stature of mythic proportions. By the 1950s, he was an international symbol of the new American painting and remains an icon of the post-World War II artist. Pollock came to New York from Cody, Wyoming, by way of Arizona and California. Until 1932 he studied at the Art Students League with Thomas Hart Benton (see fig. 16.35), who represented, Pollock said, "something against which to react very strongly, later on." Nevertheless, there is a relation between Pollock's abstract arabesques and Benton's rhythmical figurative patterns. The landscapes of Ryder (see fig. 2.55) as well as the work of the Mexican muralists (see figs. 16.54, 16.55) were important sources for Pollock's violently expressive early paintings, as were the automatic methods of Masson and Miró. In 1939 The Museum of Modern Art mounted a large Picasso exhibition, a catalyst for artists like De Kooning and Pollock, who were then struggling to come to terms with his work, learn from his example, and forge their own independent styles out of Cubism.

Pollock's paintings of the mid-1940s, usually involving some degree of actual or implied figuration, were coarse and heavy, suggestive of Picasso, but filled with a nervous, brutal energy all their own. In *Guardians of the Secret*, 1943 (fig. **17.8**), schematic figures stand ceremonially at either end of a large rectangle, perhaps a table, an altar, or a funeral bier. A watchdog, with possible affinities to Tamayo's animals (see fig. 16.59), reclines below. Pollock, who covered his canvas with calligraphic, cryptic marks like some private hieroglyphic language, apparently began with legible forms that he gradually obscured. As he later told his wife, the painter Lee Krasner, "I chose to veil the imagery." That imagery has been analyzed within the broad spectrum of Pollock's visual interests, including ritual Navaho sand painting, African sculpture, prehistoric art, and Egyptian painting. Some have seen evidence of Jungian themes in the powerfully psychic content of the artist's early work. Carl Jung's theories of the collective unconscious as a repository for ancient myths and universal archetypes were a frequent topic of discussion in Abstract Expressionist circles. Pollock underwent psychoanalysis with Jungian analysts beginning in 1939.

By 1947 Pollock had begun to experiment with "allover painting," a labyrinthine network of lines, splatters, and paint drips from which emerged the great drip or poured paintings of the next few years. *Number 1, 1950 (Lavender Mist)* (fig. **17.9**) is one of his most visually seductive drip paintings, with its intricate web of oil colors mixed with black enamel and aluminum paint. One can trace the movements of the artist's arm, swift and assured, as he

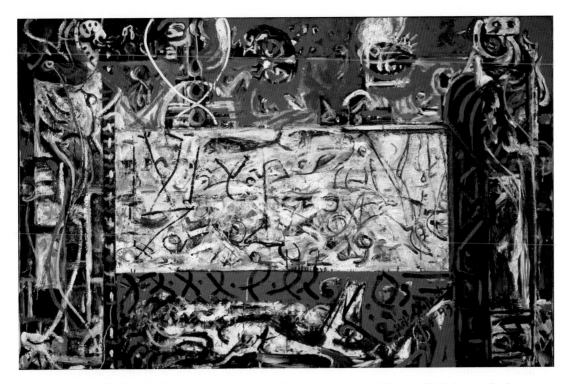

17.8 Jackson Pollock, *Guardians of the Secret*, 1943. Oil on canvas, 4' ¾" × 6' 3" (1.2 × 1.9 m). San Francisco Museum of Modern Art. Albert M. Bender Bequest Fund. Purchase.

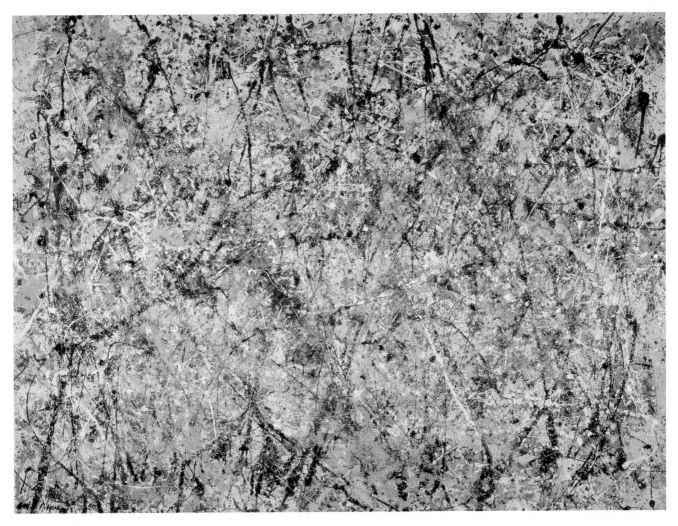

17.9 Jackson Pollock, *Number 1, 1950 (Lavender Mist)*, 1950. Oil, enamel, and aluminum on canvas, 7' 4" × 9' 11" (2.2 × 3 m). National Gallery of Art, Washington, D.C.

deployed sticks or dried-out brushes to drip paint onto the surface. His lines are divorced from any descriptive function and range from string-like thinness to coagulated puddles, all merging into a hazy, luminous whole that seems to hover above the picture plane rather than illusionistically behind it. These paintings, generally executed on a large canvas laid out on the floor, are popularly associated with so-called action painting. It was never the intention of the critic Harold Rosenberg, in coining this term, to imply that action painting was limited to a kind of athletic exercise, but rather that the process of painting was as important as the completed picture (see *The American Action Painters*, below). Despite the furious and seemingly haphazard nature of his methods, Pollock's painting was not a completely uncontrolled, intuitive act. There is no question that, in his paintings and those of other Abstract Expressionists, the elements of intuition and accident play a significant part—this was indeed one of the principal contributions of Abstract Expressionism, which had found its own inspiration in Surrealism's psychic automatism. The presence of bits of studio detritus—cigarette butts, ashes, pastry wrapping, even insects whose struggle left frantic marks—embedded in his paintings (deliberately or by accident is impossible to know) suggests that Pollock

was giving form to the unconscious, with its capacity for sublime longing as well as abject fear. At the same time, however, Pollock's works are informed by skills honed by years of practice and reflection, just as the improvisatory talents of jazz musicians are paradoxically enhanced by regimented training.

Pollock's spun-out skeins of poured pigment contributed other elements that changed the course of modern painting. There was, first, the concept of the allover painting where no part of the composition is given formal precedence over another; it is non-hierarchical, with zones of pictorial interest evenly distributed over the surface. This "holism," together with the large scale of the works, introduced another concept—that of wall painting different from the tradition of easel painting. In 1946 Pollock, who had worked on mural projects for the WPA, said he wanted to paint pictures that "function between the easel and the mural." This was the final break from the Renaissance idea of painting detached from spectator, to be looked at as a self-contained unit. The painting became an environment that encompassed the spectator. Pollock referred to being "in" his paintings when he worked, and in *No. 1, 1950 (Lavender Mist)* tracks of his literal presence are recorded in his own handprints, especially at the upper left edge. In many ways, Pollock departed from the tradition of Renaissance and modern painting before him, and although he had no direct stylistic followers, he significantly affected the course of experimental painting after him.

Krasner

Brooklyn-born **Lee Krasner** (1908–84) received academic training at several New York art schools before joining the Mural Division of the WPA in 1935. From 1937 to 1940 she was a student of Hans Hofmann, from whom she said she "learned the rudiments of Cubism." Subsequently, she joined the AAA, devoted to non-objective art in the tradition of Mondrian, and exhibited Cubist abstractions in their group shows. Krasner became acquainted with Pollock in 1942, when John Graham included their work in a show of young artists he felt showed promise. Krasner and Pollock began to share a studio in 1942, married in 1945, and relocated to Long Island. Unlike Pollock, Krasner felt a general antipathy toward the Surrealists and their automatic methods, due in part to the fundamentally misogynist attitudes of the European Surrealist émigrés (compounded by the general marginalization of women within Abstract Expressionist circles). Throughout the 1940s and 50s, she gradually moved away from Cubist-based forms to a concern for spontaneous gesture and large-scale allover compositions, while remaining committed to a Mondrianesque sense of structure. A painting from 1949 (fig. **17.10**) shows a web of elusive forms whose vertical organization suggests a deliberate, readable order, leading the viewer to anticipate decoding the marks as some form of language. The promised linguistic coherence

SOURCE

Harold Rosenberg

from *The American Action Painters* (first published in 1952)

With a few important exceptions, most of the artists of this vanguard found their way to their present work by being cut in two. Their type is not a young painter but a reborn one. The man may be over forty, the painter around seven. The diagonal of a grand crisis separates him from his personal and artistic past.

Many of the painters were "Marxists" (WPA unions, artists' congresses); they had been trying to paint Society. Others had been trying to paint Art (Cubism, Post-Impressionism)—it amounts to the same thing.

The big moment came when it was decided to paint ... just to PAINT. The gesture on the canvas was a gesture of liberation, from Value—political, aesthetic, moral.

If the war and the decline of radicalism in America had anything to do with this sudden impatience, there is no evidence of it. About the effects of large issues upon their emotions, Americans tend to be either reticent or unconscious. The French artist thinks of himself as a battleground of history; here one hears only of private Dark Nights. Yet it is strange how many segregated individuals came to a dead stop within the past ten years and abandoned, even physically destroyed, the work they had been doing. A far-off watcher unable to realize that these events were taking place in silence might have assumed they were being directed by a single voice.

17.10 Lee Krasner, *Untitled*, 1949. Oil on composition board, 48 × 37" (121.9 × 93.9 cm). The Museum of Modern Art, New York.

fails to materialize, though, and the forms maintain their manic mystery. The rhythm of colors and lines endows the piece with a dynamism as the figures appear to struggle against the grid underlying the composition.

Between 1959 and 1962, following the traumas of Pollock's death and that of her mother, Krasner made a series of *Umber* paintings, so-called for their predominantly brownish hues, which the artist once referred to as "colorless." In *Polar Stampede* (fig. **17.11**) she approached the canvas with a loaded brush, allowing the medium to splash

and explode across the canvas until it resembled a vast glacial landscape that has been stirred up, as the title suggests, by the pounding hooves of wild animals. Krasner did not allow herself improvisational freedom to the degree practiced by Pollock, for even in such a boldly gestural abstraction, her strokes have a regular, rhythmical beat, and a sense of imposed structure.

Krasner had employed the collage medium throughout her career, focusing closely on it beginning in the mid-50s. In 1955 she cut up some discarded canvases that she and

17.11 Lee Krasner, *Polar Stampede*, 1960. Oil on cotton duck, 7' 9⅝" × 13' 3¾" (2.4 × 4 m). Collection Pollock Krasner Foundation.

Pollock had painted and assembled the sliced images into new compositions. The sharp cut-out forms of *Milkweed* (fig. **17.12**) overlap and interpenetrate one another, ironically functioning like the Cubist shards in her original drawings. By first destroying then combining her and Pollock's work in this way, Krasner offers a metaphor for collaborative artmaking in which individual artists must suppress their own personalities and aims in order to enter fully into an artistic partnership. Her choice of collage here calls to mind the earlier collaboration by Braque and Picasso, whose collaborative exploration of Cubism introduced collage to modernist artistic practice (see fig. 8.24).

Kline

Franz Kline (1910–62) was as fascinated with the details and tempo of contemporary America as was Mondrian, and he was also deeply immersed in the tradition of Western painting, from Rembrandt to Goya. Kline studied art at academies in Boston and London and, throughout the 1940s, painted figures and urban scenes tinged with Social Realism. A passion for drawing manifested itself during the 1940s, particularly in his habit of making little black-and-white sketches, fragments in which he studied single motifs, structure, or space relations. One day in 1949, according to the painter and critic Elaine de Kooning, Kline was looking at some of these sketches enlarged through an opaque projector and saw their implications as large-scale, free abstract images. Although this moment of revelation has no doubt been exaggerated, and although Kline's

17.12 Lee Krasner, *Milkweed*, 1955. Oil, paper and canvas collage on canvas, 82⅜ × 57¾" (209.23 × 146.68 cm). Albright Knox Art Gallery, Buffalo, New York.

17.13 Franz Kline, *Nijinsky*, 1950. Enamel on canvas, 46 × 35¼" (116.8 × 89.5 cm). Collection Muriel Kallis Newman, Chicago.

shared Pollock's interest in myth or Rothko's interest in the sublime, and he tended to gamble less with spontaneous gesture than his friend De Kooning. Instead he worked out his compositions in advance, with preliminary sketches, usually on pages torn from the telephone book. *Nijinsky* (fig. **17.13**) is an abstract meditation on his own figurative representations of the subject, based on a photograph of the great Russian dancer as Petrushka in Stravinsky's ballet.

In later works such as *Mahoning* (fig. **17.14**), named for a town in his native Pennsylvania, curved forms give way to straight, girder-like strokes that hurtle across the full breadth of the eight-and-a-half-foot (2.5 m) canvas. Using house-painter brushes on unstretched canvases tacked to his studio wall, Kline shaped rugged but controlled brushstrokes into powerful, architectural structures that have affinities with motifs in the industrial landscape he admired, such as trains, cranes, and bridges. In the paint texture as well as in the shaping of forms, there is an insistence on the equivalence of the whites that prevents the work from becoming simply a blown-up black drawing on a white ground, for, as Kline said, he also painted the white areas, sometimes on top of the black.

A number of artists in this period had pared their art down to the essentials of black and white. Both De Kooning and Pollock, as we have seen, renounced color for a time, as did Newman, Motherwell, Tomlin, and a number of other artists associated with the New York School. Kline reintroduced color to his compositions in the late 1950s, but sadly died in the midst of these new experiments. Like De Kooning's, Kline's painted structures had an enormous impact on younger artists. Their art fostered a veritable school of gestural painters in the late 1950s, the so-called second generation of Abstract Expressionists, the best of whom forged their own individual styles from the pioneers' examples.

mastery of abstraction was gradual rather than instantaneous, he did formulate his new Abstract Expressionist vocabulary with astonishing speed. Even the first works in his new mode have nothing tentative about them.

In 1950, when he made his first large-scale black-and-white abstractions, Kline was well aware of the experiments of the pioneer Abstract Expressionists, although he never

17.14 Franz Kline, *Mahoning*, 1956. Oil on canvas, 6' 8" × 8' 4" (2 × 2.5 m). Whitney Museum of American Art, New York.

Tomlin and Tobey

Until the mid-1940s, **Bradley Walker Tomlin** (1899–1953) was one of the most sensitive and accomplished Americans working in an abstract Cubist style. Toward the end of the decade he completed a group of pictographic compositions related to those of Adolph Gottlieb, including *All Souls Night* (fig. **17.15**), where he superimposed signs resembling ancient hieroglyphs over loosely brushed and delicately colored backgrounds. In 1948 he began to experiment with a form of free calligraphy, principally in black and white, which derived from his interest in automatism, Zen Buddhism, and Japanese brush painting. From this moment, Tomlin returned during the last three or four years of his life to painterly abstractions in which delicate and apparently spontaneous dabs of paint create shimmering, allover compositions. In these so-called "petal paintings," Tomlin discovered some of the lyricism and luminosity of Impressionist landscapes, but he subjected his strokes to the pictorial discipline of a loosely implied grid.

Mark Tobey (1890–1976) moved to Seattle from New York in 1922, and, though he worked far from the artistic mainstream, he produced a unique body of work in step with the most advanced tendencies in New York at that time. Tobey was drawn by a profound inner compulsion to a personal kind of abstract expression with strongly religious overtones. He was a convert to the Bahá'í faith, which, as he said, stresses "the unity of the world and the oneness of mankind." Just as Theosophy and mysticism had gained adherents in Europe during the "mal de siècle" following the Franco–Prussian War, many Americans sought to make sense of a world shattered by war by turning to non-Western spiritual practices.

Tobey began studying Chinese brush painting in 1923 and in the 1930s studied Zen Buddhism in China and Japan. In *Broadway* (fig. **17.16**) he applied the lessons of calligraphy to communicate his vivid memories of New York. His animated line, with its intricate, jazzy rhythms—he called it "white writing"—captures the lights, noise, and frenetic tempo of the city. Like De Kooning or Pollock,

17.16 Mark Tobey, *Broadway*, c. 1935. Tempera on masonite, 26 × 19¼" (66 × 48.9 cm). The Metropolitan Museum of Art, New York.

Tobey moved between figurative and abstract modes throughout the 1940s. In his best-known pictures, such as *Universal Field* (fig. **17.17**), the "white writing" becomes a kind of non-referential calligraphy that is a small-scale, wrist-painted version of the broader, arm-gestured, allover surfaces poured by Pollock. Tobey, who actually composed paintings from linear arabesques and fluid color before Pollock's allover drip paintings, here creates a field charged with energy and light, as his drawn lines zip and dart through a shallow, electrified space.

17.15 Bradley Walker Tomlin, *All Souls Night*, 1947. Oil on canvas, 42½ × 64" (106.7 × 162.6 cm).

17.17 Mark Tobey, *Universal Field*, 1949. Pastel and tempera on cardboard, 28 × 44" (73.9 × 116.2 cm). Whitney Museum of American Art, New York.

Guston

Philip Guston (1913–80) was expelled from Manual Arts High School in Los Angeles along with his classmate Jackson Pollock for lampooning the conservative English department in their own broadside. Pollock was readmitted, but Guston set off on his own, working at odd jobs, attending art school briefly as well as meetings of the Marxist John Reed Club. He followed Pollock to New York and, in 1936, signed up for the mural section of the WPA. By the mid-1940s, drawing on his diverse studies of Cubism, the Italian Renaissance, and the paintings of De Chirico and Beckmann, he was painting mysterious scenes of figures in compressed spaces, works that earned him a national reputation.

Guston taught painting for a time in Iowa City and St. Louis and, in the late 1940s, began to experiment with loosely geometric abstractions. After many painful intervals of doubt, he made his first abstract gestural paintings in 1951. These contained densely woven networks of short strokes in vertical and horizontal configurations (fig. **17.18**) that reveal an admiration for Mondrian. The heavy impasto, serene mood, and subtle, fluctuating light in his

17.18 Philip Guston, *Zone*, 1953–54. Oil on canvas, 46 × 48" (116.8 × 122.2 cm). The Edward R. Broida Trust, Los Angeles.

muted reds, pinks, and grays caused some to see these works as lyrical landscapes, earning Guston the label "Abstract Impressionist." But Guston, who had negligible interest in the Impressionists, explained, "I think of painting more in terms of the drama of this process than I do of 'natural forces.'"

Throughout the 1950s, Guston employed larger and more emphatic gestures in his abstractions, with a tendency to concentrate centralized color masses within a light and fluid environment. In 1962 the Guggenheim Museum mounted a major Guston retrospective, as did New York's Jewish Museum in 1966. But despite these external successes, Guston was experiencing a crisis in his art, with concerns about abstraction's limited potential for expressing the full gamut of human experience. In the late 1960s, he returned to recognizable imagery, astonishing the art world with intensely personal, sometimes nightmarish, images in a crude, cartoonish style. "I got sick and tired of all that purity," he said, "[I] wanted to tell stories."

Elaine de Kooning and Grace Hartigan

Elaine de Kooning (1918–89) is probably best known for the figurative paintings she made in the 1950s. However, at her death a group of abstractions from the 1940s was discovered among her belongings that reveals her early experiments within an Abstract Expressionist mode. She spent the summer of 1948 at Black Mountain College in North Carolina with her husband, Willem de Kooning (they had married in 1943). At the invitation of Josef Albers, Willem had joined the distinguished faculty at the experimental school as a visiting artist. Elaine de Kooning always acknowledged the importance of her husband's paintings as well as those of their friend Arshile Gorky to her own work: "Their reverence and knowledge of their

17.19 Elaine de Kooning, *Harold Rosenberg #3*, 1956. Oil on canvas, 6' 8" × 4' 10⅞" (2 × 1.5 m). National Portrait Gallery, Smithsonian Institution, Washington, D.C.

materials, their constant attention to art of the past and to everything around them simultaneously, established for me the whole level of consciousness as the way an artist should be." Following the summer at Black Mountain, De Kooning began to write on contemporary art for *ARTnews*. Her keen perceptions, as well as her vantage point as a practicing artist who knew her subject firsthand, endowed her writing with authority. In the 1950s and 60s, De Kooning displayed expressive tendencies in a group of male portraits (including several of John F. Kennedy). Her portrayal of art critic Harold Rosenberg (fig. **17.19**), one of the champions of Abstract Expressionism, shows how she brought the gesturalism of the New York School to bear on figurative subjects.

Grace Hartigan (b. 1922) was an even younger member of the New York School than Elaine de Kooning, but one who also witnessed the critical artistic developments in New York at close range.

17.20 Grace Hartigan, *Giftwares*, 1955. Oil on canvas, 5' 3" × 6' 9" (1.6 × 2.1 m). Neuberger Museum of Art, College at Purchase, State University of New York.

A so-called second-generation Abstract Expressionist, Hartigan was deeply affected as a young artist by her encounter with Pollock's drip paintings and Willem de Kooning's black-and-white paintings, both shown in New York in 1948. Like De Kooning, whose famous perambulations through downtown New York were fodder for his strident "urban landscapes" (see fig. 17.7), Hartigan found inspiration in the most mundane aspects of city life. In *Giftwares*, 1955 (fig. **17.20**), she depicted the tawdry offerings of a storefront window, transforming them into a glowing still life in which the loosely brushed but legible forms are pulled up to the picture plane and dispersed evenly across the canvas. While Hartigan's rich palette is a kind of homage to Matisse, her banal subject matter speaks to the ubiquity of consumerism in the wake of America's postwar economic boom. In the late 1950s, Hartigan embarked on a series of distinctive gestural abstractions before resuming a highly abstracted brand of figuration the following decade.

Complex Simplicities: Color Field Painting

Although the divisions between gestural and Color Field painting are somewhat artificial, there were both formal and conceptual differences between artists such as Kline and De Kooning on the one hand and Mark Rothko and Barnett Newman on the other. In 1943, as we saw earlier, Rothko, Newman, and Adolph Gottlieb stated their purpose in a letter to *The New York Times*, which also said: "We favor the simple expression of the complex thought. We are for the large shape because it has the impact of the unequivocal. We wish to reassert the picture plane. We are for flat forms because they destroy illusion and reveal truth." These artists fervently believed that abstract art was not "subjectless" and that, no matter how reductive, it could communicate the most profound subjects and elicit a deep emotional response in the viewer. There is even something polemical in their painting: "It is our function as artists to make the viewer see the world our way—not his way." That, presumably, had been the standard before the war. But now, painting after Auschwitz, such self-delusion

could no longer be tolerated. In their search for "symbols," as Rothko said, "of man's primitive fears and motivations," the artists looked to many sources, including Jungian theory, Surrealist practice, and the art of non-European societies.

Rothko

Mark Rothko (1903–70) emigrated to the United States with his Russian-Jewish family in 1913 and moved ten years later to New York, where he studied with Max Weber at the Art Students League. Throughout the 1930s he made figurative paintings on mostly urban themes and in 1935 formed an independent artists' group with Gottlieb called "The Ten." In 1940, in search of more profound and universal themes and impressed by his readings of Nietzsche and Jung, Rothko began to engage with ancient myths as a source of "eternal symbols." In their letter to *The New York Times*, Rothko, Newman, and Gottlieb proclaimed their "spiritual kinship with primitive and archaic art." Rothko first made compositions based on classical myths and then, by the mid-1940s, painted biomorphic, Surrealist-inspired, hybrid creatures floating in primordial waters. These forms began to coalesce at the end of the decade into floating color shapes with loose, undefined edges within larger expanses of color (fig. **17.21**). By 1949

17.21 Mark Rothko, *No. 1 (No. 18, 1948)*, 1948–49. Oil on canvas, 67¹¹⁄₁₆ × 55¹⁴⁄₁₆" (170.8 × 141.9 cm). The Frances Lehman Loeb Art Center, Vassar College, Poughkeepsie, NY.

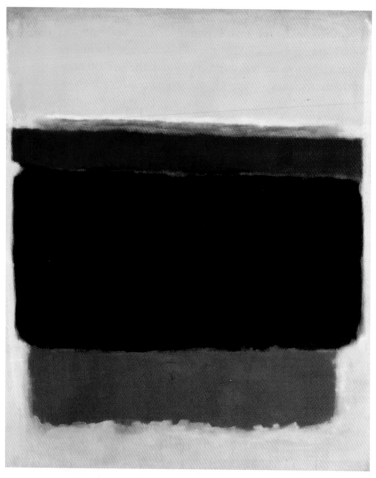

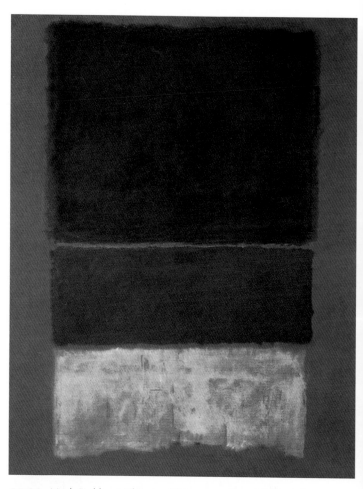

17.22 Mark Rothko, *Untitled (Rothko number 5068.49)*, 1949. Oil on canvas, 6' 9⅜" × 5' 6⅜" (2.1 × 1.7 m). National Gallery of Art, Washington, D.C.

17.23 Mark Rothko, *White and Greens in Blue*, 1957. Oil on canvas, 8' 4" × 6' 10" (2.5 × 2.1 m). Private collection.

Rothko had refined and simplified his shapes to the point where they consisted of color rectangles floating on a color ground (fig. **17.22**). He applied thin washes of oil paint containing considerable tonal variation and blurred the edges of the rectangles to create luminous color effects and

a shifting, ambiguous space. Over the next twenty years, he explored this basic compositional type with infinite and subtle variation. By the sheer sensuousness of their color areas and the sense of indefinite outward expansion without any central focus, the paintings are designed to absorb

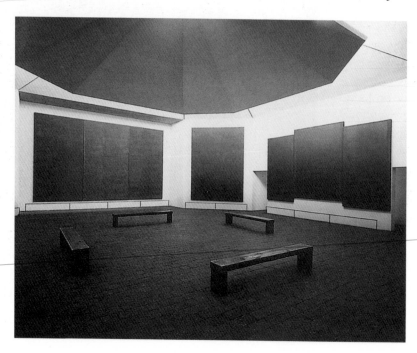

17.24 Mark Rothko, North, Northeast, and East wall paintings in the Rothko Chapel, 1965–66 (opened in 1971). Oil on canvas. Houston, Texas.

and engulf the spectator. Eventually, Rothko was painting on a huge scale, something that contributed to the effect of enclosing, encompassing color.

At the end of the 1950s, Rothko began to move away from bright, sensuous color toward deeper, more somber hues (fig. 17.23). He received commissions for large public spaces, including a restaurant in the Seagram Building in New York; a dining room at Harvard University; and in a chapel in Houston, Texas (fig. 17.24). This last series consists of fourteen large panels, almost uniform in their deep black and red-brown, almost filling the entire available space. The canvases are designed to be homogenous with the octagonal building (designed by Philip Johnson) and the changing light of the chapel interior. Thus, the forms have a less amorphous, harder-edge appearance than Rothko's earlier abstractions. They represent a total architectural–pictorial experience in a sense analogous to that attempted by the religious muralists of the Baroque seventeenth century. Rothko, who even adopted the triptych format long associated with religious subjects, never intended his abstractions as mere formal experiments, but rather wanted to provoke emotional and even transcendental experiences in the viewer. By the late 1960s, the mood of his work had darkened still further, expressing his conviction that, even at its most abstract, art could convey a sense of "tragedy, ecstasy, and doom," a shift in his work that some have linked to his eventual suicide.

Newman

Like Rothko, **Barnett Newman** (1905–70) studied at the Art Students League in the 1920s, but his artistic career did not begin in earnest until 1944, when he resumed painting after a long hiatus and after he had destroyed his early work. By the mid-1950s, he had received nowhere near the attention that Pollock, De Kooning, or Rothko had attracted, although it could be argued that, in the end, his work had the greatest impact on future generations. His mature work, in its radical reductiveness and its denial of painterly surface, differed from that of the Abstract Expressionists discussed so far. As the group's most thoughtful and most polemical theorist, Newman produced an important body of critical writing on the work of his contemporaries as well as on subjects such as pre-Columbian art.

In his early mythic paintings Newman, who had studied botany and ornithology, explored cosmic themes of birth and creation, of primal forms taking shape. Those works share many traits with Rothko's biomorphic paintings. By 1946, however, in canvases such as *Genesis—The Break* (fig. 17.25), the forms become more abstract and begin to shed their biological associations, although the round shape here is a recurring seed form. Thomas Hess, a leading champion of the Abstract Expressionists, said that this painting (as the title implies) was about "the division between heaven and earth." In 1948 Newman made

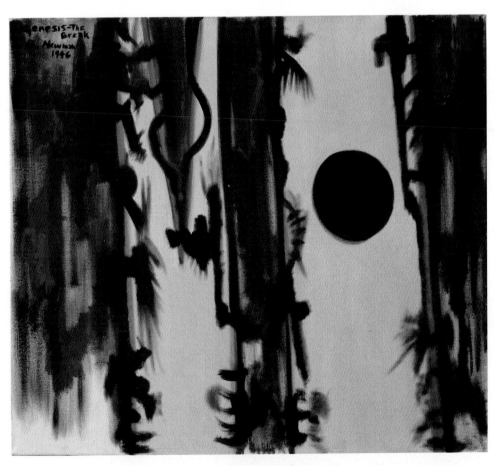

17.25 Barnett Newman, *Genesis—The Break*, 1946. Oil on canvas, 24 × 27" (61 × 68.6 cm). Collection DIA Center for the Arts, New York.

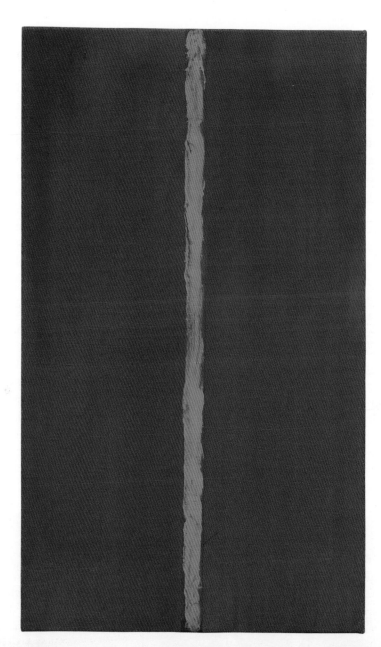

17.26 Barnett Newman, *Onement, I,* 1948. Oil on canvas and oil on masking tape on canvas, 27¼ × 16¼" (69.2 × 41.2 cm). The Museum of Modern Art, New York.

17.27 Barnett Newman, *Vir Heroicus Sublimis,* 1950–51. Oil on canvas, 7' 11⅜" × 17' 9¼" (2.4 × 5.1 m). The Museum of Modern Art, New York.

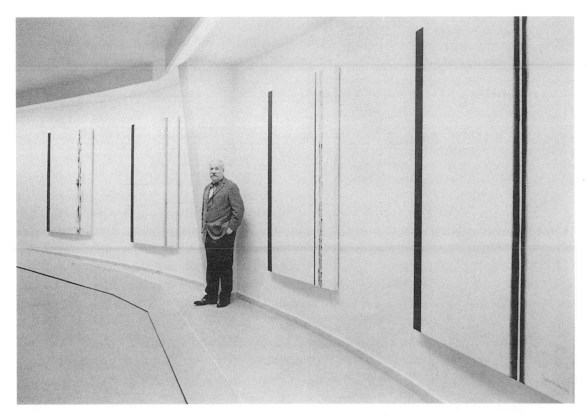

17.28 Barnett Newman in front of *The Stations of the Cross* at the Solomon R. Guggenheim Museum, New York, April 1966. Now at the National Gallery of Art, Washington, D.C.

Onement, I (**17.26**), which he regarded as the breakthrough picture that established his basic formula: a unified color field interrupted by a vertical line—a "Zip" as he called it—or, rather, a narrow, vertical contrasting color space that runs the length of the canvas. The nature of the Zip varied widely, from irregular hand-brushed bands to uninflected, straight edges made possible with the use of masking tape, but the impression is usually of an opening in the picture plane rather than simply a line on the surface. While Newman did not seek out the atmospheric effects that Rothko achieved in his mature works, he was capable of brushed surfaces of tremendous beauty and nuance.

Vir Heroicus Sublimis (fig. **17.27**) is a mature, mural-size painting where the multiple Zips differ in hue and value, sometimes in stark contrast to the brilliant monochrome field, sometimes barely distinguishable from it. Newman wanted to maintain a human scale for his essentially life-affirming, humanist art. Indeed, his title for this work means "Heroic Sublime Man," and his ubiquitous Zip has been read as a sign for the upright human being. Between 1958 and 1964, Newman painted a series of fourteen canvases on the Passion of Christ called *The Stations of the Cross—Lema Sabachthani*, the first four of which are shown in figure **17.28** with the artist at the Guggenheim Museum. He orchestrated his Zip across the series, restricting himself to black and white on unprimed canvas, but varying his medium (Magna, oil, and acrylic) as well as the thickness and character of his Zips. Newman said that the theme of the series was "the unanswerable question

of human suffering," underscored by Jesus' words on the cross, in the Hebrew subtitle, meaning "Why did you forsake me?"

Still

Clyfford Still (1904–80) differed from the other Abstract Expressionists in that virtually all of his training and early artistic development took place outside of New York City. He had, however, exhibited at Peggy Guggenheim's Art of This Century gallery beginning in 1945, thanks to Rothko, and at the Betty Parsons Gallery in 1947. In 1950 he moved to New York from San Francisco, where he had been teaching at the progressive California School of Fine Arts (now the San Francisco Art Institute). He remained in New York until 1961, when he took up residence in the Maryland countryside. Generally contemptuous of the "art world," Still preferred to exhibit infrequently and live at a considerable distance from the nexus of the art establishment in New York.

Since the late 1930s, Still had painted in a freely abstract manner (which contained some vestigial figuration) involving large, flowing images executed in heavy, even coarse, paint textures that he realized with brushes and palette knives. He repeatedly disavowed any interest in Surrealism or the "mythmaking" of his New York contemporaries and refused to give titles to his works (other than neutral letters or a date) to prevent any association with a specific subject. By 1947 he was working on a huge scale, sometimes eight by ten feet (2.4 × 3 m), with immense, crusty areas of

17.29 Clyfford Still, *Number 2*, 1949. Oil on canvas, 7' 8" × 5' 7" (2.3 × 1.7 m). Collection June Lang Davis, Medina, Washington.

color in a constant state of fluid though turgid movement (fig. **17.29**). These abstractions have been described as awesome landscapes that combine the drama and vastness of the West—its mesas, canyons, and rivers—and the Romantic landscape imagery of Albert Pinkham Ryder (see fig. 2.55). Although the artist resisted any direct association between his compositions and landscape, he once said his work reflected "man's struggle and fusion with nature." Over the next twenty years Still persisted in his basic image, a predominant color varying in value and shot through with brilliant or somber accents.

Reinhardt

Ad Reinhardt (1913–67), as he wrote in a prominent art magazine in 1962, was for "art-as-art," elaborating that such art, necessarily abstract, has nothing to do with the issues of either daily life or existential doubt. "The one thing to say about art and life is that art is art and life is life. ... Art that is a matter of life and death is neither fine nor free," he wrote. Reinhardt regarded the talk of myth and tragedy among the Abstract Expressionists as histrionic and objected to any association of his art with the ideals of the group. After abstract experiments in the 1940s, Reinhardt began in the early 1950s to simplify his palette to a single

color. The first groups of such paintings were all red or all blue (fig. **17.30**), and the final group, on which he worked for the rest of his life, was all black. One first observes these later paintings simply as monochrome fields. With time, however (and especially with the black paintings), there begins to emerge a second, inner image—a smaller rectangle, square, or central cross consisting of a slightly different value or tone of the color. These paintings are static, symmetrical, and, according to the artist, timeless. They reward slow looking and are powerfully hypnotic in their effect. Although Reinhardt applied his colors with brushes, he did so without leaving the slightest trace of his implement on the surface. His stated purpose was the elimination of all associations, all extraneous elements, all symbols and signs, and the refinement of paintings to a single dominant experience.

17.30 Ad Reinhardt, *Abstract Painting, Blue*, 1952. Oil on canvas, 6' 3" × 2' 4" (1.9 × 0.71 m). Carnegie Museum of Art, Pittsburgh.

Gottlieb

Adolph Gottlieb (1903–74) studied at the Art Students League with John Sloan and Robert Henri (see figs. 16.1, 16.2). While visiting Europe in 1921–22, he became aware of experiments there in Cubism, abstraction, and Expressionism. The friendships he formed with Rothko, Newman, and Milton Avery in the 1920s were crucial for his future development. During a stay in Arizona in 1937–38, Gottlieb made a number of curious paintings of objects picked up from the desert and arranged within rectangular compartments. These anticipated the *Pictographs*, irregular painted grids filled with two-dimensional ideograms, which occupied the artist between 1941 and 1953 (fig. **17.31**). Gottlieb composed his paintings intuitively, drawing on automatist methods as well as on his interest in ancient myth and ritual. The *Pictographs*—the term itself implies prehistoric cave paintings—had a number of sources, from the European Mondrian, Miró, and Klee to the Cubist grids of the Uruguayan artist Joaquín Torres-García. However, it was also African and Native American art, notably that of the Northwest Coast Kwakiutl (Kwakwaka´waku) people, that provided Gottlieb with a powerful lexicon of mysterious signs, which he assembled to form what he believed to be a new, universal language. Their ominous mood may reflect the dark realities of war, as Gottlieb himself seemed to suggest: "Today when our aspirations have been reduced to a desperate attempt to escape from evil ... our obsessive, subterranean, and pictographic images are the expression of the neurosis which is our reality."

Gottlieb's principal development of the late 1950s and the 60s was the series called *Bursts* (fig. **17.32**), a sort of cosmic landscape usually consisting of an upper circular or ovoid element suggestive of a burning sun, below which is a broken, exploding element, open and dynamic in contrast with the closed form above. The *Burst* paintings combined aspects of gestural painting along with the expansive color of the Color Field painters. In general terms, the *Bursts* seem to underscore life's fundamental dualities and conjure up landscapes at the dawn of civilization. More specifically, they carry the inescapable and recent memory of the atomic bombs dropped by America on the Japanese cities of Hiroshima and Nagasaki in August 1945.

Motherwell

Robert Motherwell (1915–91) was the youngest of the artists originally associated with Abstract Expressionism. He received his early training in literature, art history, and philosophy at Stanford, Harvard, and Columbia. Motherwell's erudition made him an eloquent spokesman for Abstract Expressionism as well as a leading theorist of modern art. As a painter, he was largely self-trained, with the exception of some formal study as a young man in California and later with the Surrealist Kurt Seligmann in New York. In 1941 Motherwell made the acquaintance of several European Surrealists in New York, including Ernst, Tanguy, Masson, and Matta. The aspect of Surrealism that most intrigued him was automatism, the concept of the intuitive, the irrational, and the accidental in the creation of a work of art. In many ways, his early paintings represent an attempt to resolve the seeming contradictions between Mondrian (whom he had also met in New York) and the abstract Surrealists. Motherwell provided American artists with their most thorough introduction to Dada in the 1951 collection of essays *The Dada Painters and Poets*, still an essential sourcebook for Dada writing.

In 1943, at Matta's suggestion, Motherwell began to experiment with collage, introducing automatist techniques in roughly torn pieces of paper. One of the earliest examples is *Pancho Villa, Dead and Alive*, 1943 (fig. **17.33**). Motherwell, who had traveled to Mexico with Matta, had been struck by a photograph of the revolutionary figure, dead and covered with blood. The stick figures representing Villa relate directly to a painting by Picasso from the 1920s, but other forms in the collage were to become signature Motherwell images, such as the ovoid shapes held in tension between vertical, architectural elements. Motherwell's involvement with the collage medium was more extensive than that of any of his Abstract Expressionist colleagues. In the many examples he continued to make throughout his career, he used postcards, posters, wine labels, or musical scores that constitute a visual day-by-day autobiography.

17.31 Adolph Gottlieb, *Voyager's Return*, 1946. Oil on canvas, 37⅞ × 29⅞" (96.2 × 75.9 cm). The Museum of Modern Art, New York.

17.32 Adolph Gottlieb, *Orb* from the *Bursts* series, 1964. Oil on canvas, 7' 6" × 5' (2.3 × 1.52 m). Dallas Museum of Art.

17.33 Robert Motherwell, *Pancho Villa, Dead and Alive*, 1943. Gouache and oil with cut-and-pasted papers on cardboard, 28 × 35⅞" (71.7 × 91.1 cm). The Museum of Modern Art, New York.

In 1948 Motherwell made the first work of his great series of abstract paintings entitled *Elegy to the Spanish Republic No. 34* (fig. **17.34**), inspired by his profound reaction to its defeat by fascist forces in early 1939. Until his death in 1991, he painted more than 150 variants of the *Elegy* theme. These works stand in contrast to his brilliantly coloristic collages and paintings created during the same period, for they were executed predominantly in stark black and white. "Black is death; white is life," the artist said. It is no coincidence that Picasso's monumental painting of protest against the Spanish Civil War, *Guernica* (see fig. 15.39), was black, white, and gray. The *Elegies* consisted for the most part of a few large, simple forms, vertical rectangles holding ovoid shapes in suspension. The scale increased as the series progressed, with some works on a mural scale. While the loosely brushed, organic shapes have been read literally by some, who have suggested that they might represent male genitalia with reference to Spanish bullfights, Motherwell said he invented the forms as emblems for universal tragedy.

17.34 Robert Motherwell, *Elegy to the Spanish Republic No. 34*, 1953–54. Oil on canvas, 6' 8" × 8' 4" (2 × 2.5 m). Albright-Knox Art Gallery, Buffalo, New York.

Baziotes

A friend of Motherwell and Matta from the early 1940s, **William Baziotes** (1912–63) explored with them aspects of Surrealist automatism and was respected enough by the European Surrealists to be included in their group shows in New York. Automatism for Baziotes was not a matter of improvisational gesture, with all its implications of emotion and angst. Rather, it guided a slow and meditative process during which allusive, biomorphic forms emerged as the painting proceeded. Devoted to fantastic, mythic subject matter, Baziotes was a cofounder in 1948 of the Subjects of the Artist school, one of the intellectual meeting places of the New York School. His painting was characterized by shifting, fluid, diaphanous color into which were worked biomorphic shapes drawn with great sensitivity and suggestive of microcosmic or marine life. The strange forms in *Dusk* (fig. **17.35**) may have something in common with prehistoric fossils, the kind the artist might have seen on one of his many visits to New York's American Museum of Natural History. Like a number of his fellow Abstract Expressionists, Baziotes was fascinated by paleontology and primitive life forms.

17.35 William Baziotes, *Dusk*, 1958. Oil on canvas, 60⅜ × 48¼" (153.4 × 122.6 cm). Solomon R. Guggenheim Museum, New York.

Drawing in Steel: Constructed Sculpture

Constructed sculpture—as contrasted with sculpture cast in bronze or modeled in stone—and, particularly, welded metal sculpture, constituted a major direction taken by American artists after World War II.

Smith and Dehner

David Smith (1906–65), a pioneer sculptor of his generation working in welded steel, said of his medium: "The material called iron or steel I hold in high respect. … The metal itself possesses little art history. What associations it possesses are those of this century: power, structure, movement, progress, suspension, brutality." Smith was born in Decatur, Illinois, and between 1926 and 1932 he studied painting, initially with John Sloan (fig. 16.2), at the Art Students League in New York (he was never formally trained as a sculptor). In the early 1930s, intrigued by reproductions of Picasso's welded-steel sculptures of 1929–30 (see fig. 15.41) as well as the works of Julio González (see fig. 15.44) that he saw in John Graham's collection, Smith began to experiment with constructed metal sculpture. He first learned to weld in an automobile plant in the summer of 1925, and in 1933 he established a studio in Brooklyn at Terminal Iron Works, a commercial welding shop. During World War II he worked in a locomotive factory, where he advanced his technical experience in handling metals, and the sheer scale of locomotives suggested to him possibilities for the monumental development of his metal sculpture. Moreover, these experiences established the kinship that he felt with skilled industrial laborers.

During the 1930s and 40s, Smith endowed his sculpture with a Surrealist quality, derived from Picasso, González, and Giacometti. In *The Royal Bird* (fig. **17.36**), he suggests the viciously aggressive skeleton of some great airborne creature of prey. Smith and his wife, the sculptor Dorothy Dehner, had purchased a photograph of the fossilized remains of a prehistoric flying creature, and both made use of the image in their work. His works of the early 1950s are like steel drawings in space, as in *The Letter* (fig. **17.37**), whose metal glyphs recall Gottlieb's pictographic paintings (see fig. 17.31). Yet even when the sculptures were composed two-dimensionally, the natural setting, seen through the open spaces, introduced ever-changing suggestions of depth, color, and movement.

Toward the end of the war, Smith established a studio in Bolton Landing in upstate New York. The studio was a complete machine shop, and during the 1950s and 60s he populated the surrounding fields with his sculptures, which were becoming more monumental in scale and conception. During much of his career Smith worked on sculpture in series, with different sequences sometimes overlapping chronologically and individual sculptures within series varying widely in form. The *Agricola* (Latin for "farmer")

17.36 David Smith, *The Royal Bird*, 1947–48. Steel, bronze, and stainless steel, 21¾ × 59 × 9" (55.2 × 150 × 22.9 cm). Walker Art Center, Minneapolis.

constructions (1952–59) continued the open, linear approach (with obvious agrarian overtones), while the *Sentinels* (1956–61) were usually monolithic, figurative sculptures, at times employing elements from farm or industrial machinery. *Sentinel I* (fig. **17.38**), for example, includes a tire rod and industrial steel step, while the "head" of the sculpture resembles street signs. In contrast with

17.37 David Smith, *The Letter*, 1950. Welded steel, 37⅝ × 22⅞ × 9¼" (95.6 × 58.1 × 23.5 cm). Munson-Williams-Proctor Institute Museum of Art, Utica, New York.

17.38 David Smith, *Sentinel I*, 1956. Painted steel, 89⅝ × 16⅞ × 22⅜" (227.6 × 42.9 × 57.5 cm). National Gallery of Art, Washington, D.C.

17.39 David Smith, left: *Cubi XVIII*, 1964. Stainless steel, height 9' 8" (2.95 m). Museum of Fine Arts, Boston. Center: *Cubi XVII*, 1963. Stainless steel, height 9' (2.74 m). Dallas Museum of Art. Right: *Cubi XIX*, 1964. Stainless steel, height 9' 5" (2.87 m). Tate, London.

17.40 Dorothy Dehner, *Nubian Queen*, 1960. Bronze, 56 × 14 × 8" (142.2 × 35.6 × 20.3 cm). Richard L. Eagan Fine Arts, New York.

most sculptors who used found objects in the 1960s, Smith integrated such objects in the whole structure so that their original function was subordinated to the totality of the new design. This was Constructivist sculpture in the original sense of Naum Gabo's *Realistic Manifesto* (see chapter 10), in which voids do not merely surround mass but are articulated by form. Significant for future developments in sculpture is the fact that *Sentinel I* is not isolated on a pedestal but occupies the viewer's actual space.

In his last monumental series, begun in 1961 with the generic name of *Cubi*, Smith assembled monumental, geometric volumes in stainless steel (fig. **17.39**). Always sensitive to the surfaces of his sculptures, Smith had often painted them in bright, flat color or with distinctive painterly textures. In the *Cubi* series he exercised particular care in polishing to create effects of brilliant, allover calligraphy out of the highly reflecting, light-saturated surfaces. The work communicates an intimate sense of the artist's touch. Smith only rarely employed assistants and even the works of the *Cubi* series, with their machine-like precision, were constructed and finished by the artist. Despite this concern for the personal, his art was critical to the development of the more impersonal creations of Minimalist artists in the 1960s.

Dorothy Dehner (1901–94) was overshadowed as an artist by her famous husband, Smith, yet for nearly forty years she produced a distinguished body of sculpture whose origins should be considered within the Abstract Expressionist milieu. She met Smith while studying painting at the Art Students League in 1926 and later became acquainted with Davis, Gorky, and Avery. Dehner worked in various figurative styles until the late 1940s, when she also began to exhibit her work publicly. Although many of her early abstract paintings and drawings demonstrate a sculptor's sensibility with their depiction of forms that seem to unfold and turn in space, Dehner did not start

making sculpture until 1955, five years after she and Smith had separated. *Nubian Queen* (fig. **17.40**), a bronze from 1960, is an open-frame, totemic construction containing mysterious, pictographic signs. Like her contemporaries in the New York School, Dehner sought to develop a private language with universal implications, and, like them, as her title implies, she liked to tap the art of ancient civilizations for forms and meaning. "I am an archeologist of sorts," she said. "I tamper with the past."

17.41 Mark di Suvero, *Hankchampion*, 1960. Wood and chains, nine wooden pieces, overall 6' 5¼" × 12' 5" × 8' 9" (2 × 3.8 × 2.7 m). Whitney Museum of American Art, New York.

Di Suvero and Chamberlain

Mark di Suvero (b. 1933), much younger than the other artists discussed in this chapter, was still studying art at college in California when the Abstract Expressionists reached the pinnacles of fame in the mid-1950s. But only three years after arriving in New York in 1957, Di Suvero was translating the bold gestures of Kline and De Kooning into a dynamic sculptural idiom. *Hankchampion*, 1960 (fig. **17.41**), consists of massive, rough timbers that project in a precarious, even threatening manner. These early wood pieces sometimes incorporated chain, rope, and found objects, such as barrels or tires, scavenged from the industrial landscape. Although Di Suvero admired Rodin and Giacometti, the most meaningful and immediate artistic example for him was Smith, who changed sculpture, Di Suvero said, from an "objet d'art type of thing to something that is really strong, American industrial art." Despite a serious accident in 1960, when he was nearly crushed to death in an elevator, by the mid-1960s Di Suvero was making works in steel so large that they required a crane. Although he has made many small-scale works, he is best known for the monumental outdoor sculptures he has created since that time, including *Aurora* (fig. **17.42**), which is named after a poem about New York City by

17.42 Mark di Suvero, *Aurora*, 1992–93. Steel, 16' 4" × 19' 6" × 26' (5 × 5.9 × 7.9 m). National Gallery of Art, Washington, D.C.

Federico García Lorca. These works, which enter the realm of architecture by virtue of their scale and I-beam construction, are as much at home in the urban environment as in a natural landscape. In the spirit of Constructivism, Di Suvero's jutting, angled girders shape the void with energy-charged forms that have no sense of central mass. And in the spirit of Calder, some of his mammoth sculptures have moving parts that invite audience participation.

John Chamberlain (b. 1927) began to make sculpture in the early 1960s, works that seemed like three-dimensional embodiments of Abstract Expressionism's explosive, painterly styles and that imply at times an almost violent approach to the medium. Chamberlain has used parts of junked automobiles, with their highly enameled, colored surfaces, to create allover, abstract constructions of surprising beauty. Like Di Suvero, he uses industrial tools, cutting and crushing shapes that he then pieces together, like an assemblage, through a trial-and-error process. The works can be either free-standing sculptures or, as in *Dolores James* (fig. **17.43**), wall-mounted reliefs.

Chamberlain's spontaneous, not entirely predictable methods parallel the Abstract Expressionists' balance of control and accident but share Di Suvero's generally lighter, less emotionally charged spirit. "There's no formula," he said. For example, one night, when he was nearing completion of *Dolores James*, he returned late to his studio and heaved an eight-pound sledgehammer at the sculpture, achieving exactly the final touch he sought. Like Ad Reinhardt, Chamberlain avoided ascribing profound meaning to his works.

Textures of the Surreal: Biomorphic Sculpture and Assemblage

Noguchi

Isamu Noguchi (1904–88) was born in Los Angeles of a Japanese father and an American mother, and then lived in Japan from the age of two to fourteen before returning to the United States. In 1927, following some academic training and his decision to become a sculptor, Noguchi went to Paris, where he saw the work of the Cubists, Surrealists, and Constructivists. He quickly became acquainted with the American expatriate artistic community there, occasionally assisting Calder and, most significantly, Brancusi, from whom he learned direct carving methods. On visits to China and Japan during the 1930s, he studied brush painting and ceramic sculpture.

As an American of Japanese ancestry, Noguchi's experience of World War II differed from that of the Abstract Expressionist artists alongside whom he had worked in the late 1930s and early 40s. Japanese-Americans residing near the Pacific coast were interned after the bombing of Pearl Harbor for fear that they would aid the Japanese. As a resident of New York, Noguchi was not required to report

17.43 John Chamberlain, *Dolores James*, 1962. Welded and painted automobile parts, 6' 4" × 8' 1" × 3' 3" (1.9 × 2.5 × 0.99 m). Solomon R. Guggenheim Museum, New York.

17.44 Isamu Noguchi, *Kouros*, 1944–45. Pink Georgia marble on slate base, 117 × 34⅛ × 42" (297 × 87 × 107 cm). The Metropolitan Museum of Art, New York.

to an internment camp, but he volunteered to live at the detention center in Poston, Arizona, in order to conduct research that might help the campaign against detention. For a time, he was not permitted to leave despite initial assurances that he could return home whenever he wished. Eventually he was released in November of 1942. It was at this point that he made his first thoroughly original works, Surrealistic carvings in marble or slate. In these sculptures, he explored the human psyche as alternately exalted and debased. In *Kouros* (fig. **17.44**) he evoked the human form, not only by the Greek title, but also by the Miróesque biomorphism of the eyeholed and crossed, bone-like forms, all interlocked and arranged in the vertical orientation of a standing figure. The idea for sculptures of this type had originated with Noguchi's 1944 set design for *Herodiade*, a ballet by the leading American choreographer Martha Graham. In the ballet, Salome dances before her mirror, in which she sees, according to Noguchi, "her bones, the potential skeleton of her body." This evocation of the *vanitas* motif—a meditation on the transience of life and the futility of earthly accomplishments, popular in Renaissance and Baroque painting—speaks to the anxiety of the 1940s, when millions were imprisoned or killed merely because of their ancestry, a circumstance as subject to fate as any.

Bourgeois

French-born **Louise Bourgeois** (b. 1911), best known as a sculptor, is hard to classify because of her active work in a variety of media. She began as a painter–engraver in the milieu of Surrealism. Early in her artistic career, when she was struggling with the multiple roles of mother, wife, and artist, she made a disquieting group of paintings that rendered women literally as houses or *Femmes-Maisons*. Bourgeois turned to carved sculpture in the late 1940s, creating roughly hewn, vertical forms in wood that she called *Personages*. Their closest historical analogue is perhaps the Surrealist sculptures of Giacometti. The *Personages*, Bourgeois said, are each endowed with individual personalities and are best experienced as a group. Indeed, the five vertical elements of *Quarantania I* (fig. **17.45**) were originally separate sculptures that she later decided to unite on a single base. Like all of Bourgeois' work, the *Personages* have powerful psychic associations rooted in her own biography.

Cornell

Also rooted in Surrealism is the work of **Joseph Cornell** (1903–72), a highly cultivated American who brought great distinction to the tradition of assemblage. In the early 1930s, Cornell became acquainted with the Julien Levy Gallery in New York, a center for the display of European Surrealism. His first experiments with collage were inspired by the works of Max Ernst, and soon Levy was exhibiting his small constructions along with the works of the Surrealists. By the mid-1930s, Cornell had settled on his

17.45 Louise Bourgeois, *Quarantania I*, 1947–53. Painted wood on wood base, 62⅜ × 11¾ × 12" (158.4 × 29.8 × 30.5 cm). The Museum of Modern Art, New York.

formula of a simple box, usually glass-fronted, in which he arranged found objects such as cork balls, photographs, and maps. Cornell read widely, especially French nineteenth-century literature, but his interests were broad, from poetry and ballet to astronomy and other natural sciences. He haunted the penny arcades, libraries, dime stores, souvenir shops, art galleries, and movie houses of New York, searching out the ephemera that became the content of his enchanting assemblages. In his boxes Cornell, who lived reclusively and rarely spoke about his work, created a personal world filled with nostalgic associations—of home, family, childhood, and of all the literature he had read and the art he had seen. As one critic has noted, "He treated the ephemeral object as if it were the rarest heirloom of a legendary prince or princess."

Medici Slot Machine of 1942 (fig. **17.46**) centers around reproductions of a Renaissance portrait, multiple images taken from the early cinema, and symbols suggesting relations between past and present. Everything is allusion or

17.46 Joseph Cornell, *Medici Slot Machine*, 1942. Construction, 13½ × 12 × 4¼" (34.3 × 30.5 × 10.8 cm). Private collection.

romantic reminiscence gathered together, as one idea or image suggested another, to create intimate and magical worlds. Produced shortly after the U.S. entered World War II, Cornell's assemblage offered an appealing emotional refuge. As in all his creations, he carefully organized his imagery within a loosely geometric format.

To enhance their quality of nostalgia, Cornell often deliberately distressed his surfaces, sometimes leaving his boxes out in the elements to achieve a weathered, time-battered appearance. In *Untitled (The Hotel Eden)* (fig. **17.47**), the ad for the hotel is tattered and the paint on the box is cracked and worn. Cornell usually built a number of boxes around specific themes, such as the *Aviaries* of the 1940s, which include images of exotic birds. As is typical of his work, this composition is rich with associations. The *Hotel Eden* ad suggests the garden of paradise, while the spiral form at the upper left probably refers to a work by Cornell's friend Marcel Duchamp. Cornell was included in the historic 1936 exhibition at The Museum of Modern Art in New York, *Fantastic Art, Dada, and Surrealism*, where his works were installed next to Miró's Surrealist *Object* from 1936 (see fig. 15.13). Although the affinities between *Untitled (Hotel Eden)* and Miró's sculpture are obvious, Cornell objected to being classified with the Surrealists, saying that while he admired their art, he had no interest in the dream world and the subconscious and preferred to focus on "healthier possibilities."

17.47 Joseph Cornell, *Untitled (The Hotel Eden)*, c. 1945. Mixed-media construction, 15⅛ × 15¾ × 4¾" (38.4 × 40 × 12.1 cm). National Gallery of Canada, Ottawa.

Nevertheless, the carefully chosen or wrought objects suggest fetishes (see *Fetishism*, chapter 15), giving his assemblages the kind of therapeutic potential that many Surrealists ascribed to their work.

Nevelson

Louise Nevelson (1899–1988) also worked in a tradition of assemblage, but with results quite different from Cornell's. She studied voice, dance, and art in New York in the late 1920s. In 1931 she went to Europe, studying painting for a time with Hans Hofmann in Munich and playing small roles in movies in Berlin and Vienna. Nevelson always maintained a flair for the theatrical in her eccentric dress and flamboyant manner, and her mature work as a sculptor also manifested a distinctively theatrical sensibility. She liked to control the light and space within which the viewer experienced her work, which, like that of contemporary painters such as Pollock and Rothko, was environmental in its effect. In the early 1940s, Nevelson began to make Surrealist-inspired assemblage sculptures

from found objects and had her first solo exhibition in New York. Her characteristic works of the 1950s were large wooden walls fitted with individual boxes filled with scores of carefully arranged found objects—usually sawn-up fragments of furniture or woodwork rescued from old, demolished houses. (It is not inconsequential that her Russian father was a builder who ran a lumberyard.) Nevelson then painted her sculpture a uniform mat black, white, or, in her later work, reflective gold. *Dawn's Wedding Chapel I* formed part of a large installation at The Museum of Modern Art in 1959 called *Dawn's Wedding Feast* (fig. **17.48**). It included free-standing, totemic constructions as well as wall pieces, all suggesting a site for ancient ceremony and ritual. The shallow boxes were filled with assemblages of whitewashed balusters, finials, posts, moldings and other architectural remnants. Despite their composition from junk, they achieve a quality of decayed elegance, reminiscent of the graceful old houses from which the elements were mined.

Expressive Vision: Developments in American Photography

Depression, political upheaval, and war shaped the vision of photographers in the 1940s just as much as that of painters. By World War II, photography had become central to news agencies' coverage of battle, and in combat some straight photographers found strong subjects for their work. But not all photographers followed this path. New York School painting had exerted a great deal of influence on all art forms, leading many contemporary photographers to explore abstraction.

Capa and Miller

Some of the field pictures made by the Hungarian-American photographer **Robert Capa** (1913–54), during the Spanish Civil War and World War II (fig. **17.49**), seemed to find a parallel in Abstract Expressionism's fluid

17.48 Louise Nevelson, *Dawn's Wedding Chapel I*, 1959. Painted wood, 7' 6" × 4' 3" (2.3 × 1.3 m). Private collection.

17.49 Robert Capa, *Normandy Invasion, June 6, 1944*. Gelatin-silver print.

17.51 Minor White, *Sun in Rock, Devil's Slide, 1947,* October 12, 1947. Gelatin-silver print, 7⅜ × 9⅝" (18.7 × 24.5 cm). The Museum of Modern Art, New York.

17.50 Lee Miller, *Dead SS Guard in the Canal at Dachau,* 1945. Modern gelatin-silver print, 1988. Lee Miller Archives, England.

organization and its conception of the picture as an expression of personal, tragic experience universalized through abstract gesture. It was as if photojournalism, scientific aerial photography, and microphotography helped prepare the human eye for the pictorial formulations of Abstract Expressionism. Capa was deeply committed to the process of the photojournalistic essay as the means for expressing his intended content and felt it could be done only by being as close to the subject matter as possible. He was killed by a landmine while photographing the war in Indo-China.

Another photographer who witnessed the carnage of war firsthand was **Lee Miller** (1907–77), an American who spent most of her adult life in Europe, first in the Parisian circle of Man Ray between 1929 and 1932 and, after 1942, as an official U.S. forces war correspondent. She was present in 1945 at the liberation of Dachau and Buchenwald concentration camps, and the harrowing scenes she recorded there are among the most painfully revelatory images of the war (fig. **17.50**). Some of them were soon featured in *Vogue* magazine, where her work had been published since the late 1920s, with the heading "Believe It." The ironic contrast between photography's ability to capture moments of extreme human misery and the use of such images to lend impact to glossy publications is a paradox particularly evident from the postwar period onward.

White, Siskind, Porter, and Callahan

While some artists used photography to confront directly the reality of war and its aftermath, others adopted the metaphorical visual language of Abstract Expressionism, conjuring the dynamic forms and expansive spaces of New York School painting in photographs of the American landscape. The grandeur and metaphor of Abstract Expressionist painting encouraged photographers to reinvestigate the potential of both straight and manipulated procedures for creating abstract imagery. Among the photographers who used straight photography to discover imagery capable of yielding abstract forms potent with mystical feeling was **Minor White** (1908–76). In works like the one seen here (fig. **17.51**), White's vision paralleled stylistic developments in the art of Abstract Expressionism's gestural painters, as did his devotion to photography as a form of self-expression. "I photograph not that which is," he said, "but that which I AM." As a teacher and writer, and founder, as well as a longtime editor, of *Aperture* magazine, White had a vast and enduring influence on a whole generation of younger photographers.

17.52 Aaron Siskind, *Chicago 1949.* Gelatin-silver print.

Aaron Siskind (1903–91), too, lost interest in subject matter as a source of emotive content and turned instead toward flat, richly textured patterns discovered on old weathered walls, segments of advertising signs, graffiti, and peeling posters (fig. 17.52). In his preoccupation with the expressive qualities of two-dimensional design, Siskind found himself in sympathetic company among painters like Kline and Willem de Kooning, whose influence he acknowledged.

Another photographer whose work might look at home with New York gestural paintings was **Eliot Porter** (1901–90). Porter portrayed nature in the tradition of Ansel Adams (see fig. 16.24), but, unlike most non-commercial photographers of his generation, he worked in color (fig. 17.53). To attain such quality, Porter, unusually for a color photographer, made his own color-separation negatives and dye transfers.

Harry Callahan (1912–99), a friend and colleague of Siskind's, generated photographs of such uncompromising spareness and subtlety that they often bordered on abstraction. His principal influence came from Ansel Adams and the former Bauhaus faculty at the Institute of Design in Chicago, where he taught from 1946. He later founded the photography department at the Rhode Island School of Design. Callahan worked continuously with three deeply felt personal themes—his wife, Eleanor; the urban scene; and simple, unspoiled nature. His study of a spindly

17.54 Harry Callahan, *Weed Against the Sky, Detroit*, 1948. Gelatin-silver print.

weed (fig. **17.54**) is entirely straightforward, yet making sense of the form requires close scrutiny. In his later Cape Cod landscape, Callahan shifted from the isolated close-up of a motif in nature to seemingly limitless space (fig. **17.55**). This distilled view of the world, with its emphatic horizontality and nearly monochrome tonality, recalls late works by Rothko. "I think that every artist continually wants to reach the edge of nothingness," Callahan said.

17.53 Eliot Porter, *Dark Canyon, Glen Canyon*, 1965. Dye imbibition print, 10³⁄₁₆ × 7⅞" (25.9 × 20 cm). The Art Institute of Chicago. Anonymous gift in honor of Hugh Edwards.

17.55 Harry Callahan, *Cape Cod*, 1972. Gelatin-silver print, 9⅝ × 9¾" (24.4 × 24.8 cm).

Levitt and DeCarava

Obviously, not all photographers active in the 1940s and 50s were combing the landscape for abstract forms of expression. New York photographer **Helen Levitt** (b. 1913) began recording ordinary street life with her hand-held Leica camera in the late 1930s. Crucial to her was the discovery of the work of Henri Cartier-Bresson (see fig. 15.63), and her magically complex image of children playing with a broken mirror in the street (fig. **17.56**) is more reminiscent of the Frenchman's "decisive moment" than the social indictments of documentary photographers such as Lewis Hine (see fig. 16.7). Levitt included this and other scenes from Spanish Harlem in a book called *A Way of Seeing*, 1965. It included an essay by James Agee, the writer who had already collaborated on a book with Levitt's friend Walker Evans (see chapter 16).

Self-taught photographer **Roy DeCarava** (b. 1919) grew up in the midst of the Harlem Renaissance, a flourishing of urban African-American culture that was recorded by his older contemporary James Van Der Zee (see fig. 16.34).

By 1952 his photographs had earned him a prestigious Guggenheim grant, the first ever awarded to an African-American. "I want to photograph Harlem through the Negro people," he wrote in his proposal, "Morning, noon, night, at work, going to work, at play, in the streets, talking, kidding, laughing, in the home, in the playground, in the schools. … I want to show the strength, the wisdom, the dignity of the Negro people." One of the resulting photographs is a tender and moving portrait of an embracing couple (fig. **17.57**), which seems to sum up in a single image all the humanity the artist experienced in an entire community. In 1955 DeCarava, like Levitt, joined forces with a noted writer, in this case the poet Langston Hughes, to publish his Harlem photographs as a book, aptly titled *The Sweet Flypaper of Life*.

As the visual arts took on new resonance and avant-garde trends were on the ascendant in the United States in the years following World War II, Europeans found themselves in a very different situation. The physical devastation of the war, the horrific reality of the Holocaust, and years of privations had created less than hospitable conditions for the arts in general and for the avant-garde in particular. Nonetheless, as the next chapter will explain, many members of the avant-garde found in the devastation of the war an even greater need to give visual expression to their experiences.

17.56 Helen Levitt, *New York*, c. 1940. Gelatin-silver print. Courtesy Fraenkel Gallery, San Francisco.

17.57 Roy DeCarava, *Shirley Embracing Sam*, 1952. Gelatin-silver print, 12¹⁵⁄₁₆ × 10¹⁄₁₆" (32.9 × 28.1 cm). Collection The DeCarava Archive.

18
Postwar European Art

The critic Harold Rosenberg described Abstract Expressionism as "a gesture of liberation, from Value—political, aesthetic, moral." American artists working after World War II supported this idea to varying degrees. Many expressed ambivalence if not disdain toward the idea that art should engage social issues. While American artists and critics may have been able to imagine maintaining such aesthetic distance, European artists generally could not. Many of Europe's great cities, including London, Warsaw, Stalingrad, Rotterdam, Berlin, and Rome, had been severely damaged by sustained aerial bombing. Dresden was virtually laid waste. Tens of millions had been killed during the war, including six million Jews systematically murdered as part of the Nazis' campaign of genocide. Other groups subjected to summary execution included homosexual men, disabled adults and children, and Roma (gypsy) peoples.

Just as unnerving was the existence of atomic weapons, used to such devastating effect in the Japanese cities of Hiroshima and Nagasaki where a quarter of a million civilians were either instantly incinerated or killed by radiation poisoning within days, months, or years. Americans, likewise, contemplated with revulsion the effects of "the bomb." But residents of the United States, which was, for the time being, the only nation capable of wielding such power, were spared for a while the possibility of such an attack on American soil.

After World War I, many progressive European artists redoubled their commitment to reason, to the pursuit of pure rationalism in art and architecture. De Stijl and the Bauhaus, discussed in chapters 13 and 14, arose in part from this impulse. But few retained such faith in reason following World War II. Instead, Existentialism became the dominant philosophical response to the madness and pointless violence seemingly endemic to Western civilization. An allied cultural movement was the Theater of the Absurd, a movement in dramatic literature and performance that overturned conventional narrative features, with characters who deliver irrational dialogue in the context of unstable or dreamlike plots and settings (see *Samuel Beckett and the Theater of the Absurd*, below).

European visual artists likewise revisited the conventions of their métiers, finding new materials and novel means

CONTEXT

Samuel Beckett and the Theater of the Absurd

The predominant philosophical outlook in Europe after World War II was Existentialism, which insisted that human consciousness was simply the awareness of emotional, intellectual, and physical being. Attempts to endow this awareness with greater import by imagining an all-powerful source of creation were just distractions from the finiteness of consciousness. Scientific explorations into the nature of consciousness were similarly dismissed by Existentialists as engaging but ultimately pointless endeavors, serving only to provide a reassuring but false coherence to life. Once the simple truth of consciousness was understood and accepted, a great deal of humor could be found in the situation. Humor abounds in the texts of Existentialist writers like Jean-Paul Sartre, Albert Camus, and Simone de Beauvoir. Dramatic authors perceived the comic potential of Existentialism, finding in it a link to the tradition of catharsis in Western drama. Called the "Theater of the Absurd," plays responding to Existentialist ideas first appeared in the late 1940s. Samuel Beckett's *Waiting for Godot* (originally written in French, 1948–49) exemplifies the Theater of the Absurd. The play presents two days in the life of Vladimir and Estragon, a pair of men waiting by a tree for the arrival of someone named Godot. Godot's identity is never explained, though many interpret him as a metaphor for God. Action is limited, and nothing is resolved by the play's end. Another of Beckett's plays, *Happy Days* (1961), opens with one of its two characters, Winnie, buried up to her chest. She is accompanied by her largely silent husband, Willie, to whom she directs a constant stream of chatter and trivialities. The second act has Winnie buried up to her chin as she still claims it to be "another happy day."

of deploying them. Some, like Picasso and Giacometti, chose to confront their thoughts and experiences through figurative means, while others, like the painters Nicolas de Staël and Antoni Tàpies, turned to abstraction as the best vehicle through which to manifest an aesthetic response to a world turned upside down.

Revaluations and Violations: Figurative Art in France

The School of Paris in the postwar years hosted the continuing activity of the older-established artists such as Picasso and Matisse. Returning from the United States were Léger, Chagall, Ernst, Masson, Picabia, and others, including Duchamp, who, after 1945, commuted between Paris and New York. With Giacometti and Jean Dubuffet, figuration received a new impetus in the years immediately following World War II. The debate between figuration and abstraction, which had first emerged in the early twentieth century, continued to resurface throughout the postwar decades, transcending national boundaries.

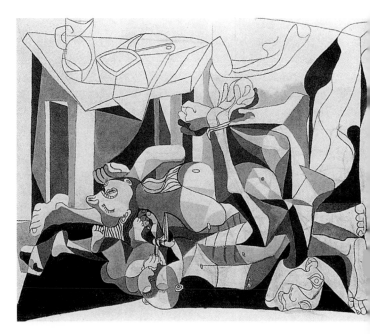

18.1 Pablo Picasso, *The Charnel House*, Paris 1944–45; dated 1945. Oil and charcoal on canvas, 6' 6⅝" × 8' 2½" (2 × 2.5 m). The Museum of Modern Art, New York.

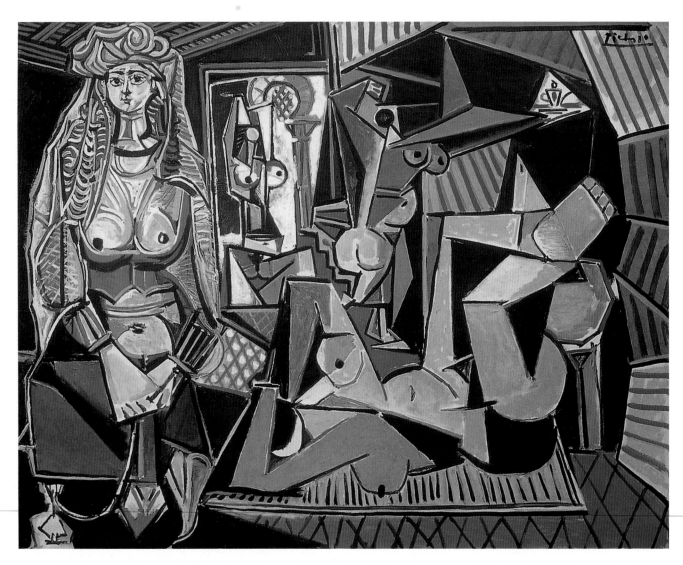

18.2 Pablo Picasso, *Women of Algiers, after Delacroix*, February 11, 1955. Oil on canvas, 45 × 57½" (114.3 × 146.1 cm). Collection Mrs. Victor Ganz, New York.

Picasso

Pablo Picasso (1881–1973), who had joined the Communist Party in 1944, summed up his feelings about the war in *The Charnel House* (fig. **18.1**), 1944–45, a painting that, like *Guernica* (see fig. 15.39), consists of a grisaille palette of black, white, and gray. A tabletop still life, rendered in a late Cubist style and left as an open line drawing, indicates a domestic setting. Beneath it, the twisting, anguished forms of a family massacred in their home could be the twentieth-century echo of Daumier's *Rue Transnonain* (see fig. 2.16).

Picasso's postwar career included an extended dialogue with several great artists of the past, including Velázquez, Courbet, Manet, and Delacroix, through his own variations on their best-known works. In the several versions he made of Delacroix's *Women of Algiers*, a painting he knew in the Louvre, Picasso may have been paying tribute not only to France's leading Romantic painter, but also to Matisse. The latter, famous for his Orientalist themes and languid odalisques, had died a few months before Picasso embarked on this sumptuously colored and highly subjective interpretation of Delacroix's masterpiece (fig. **18.2**).

Giacometti

Alberto Giacometti (1901–66) was Surrealism's most important sculptor (see chapter 15). In 1934, however, he broke with the Surrealists, convinced that his abstracted constructions were carrying him too far from the world of actuality. He returned to a study of the figure, working from the model, with the intention of rendering the object and the space that contained it exactly as he saw them. In 1939 he decided to make a new start:

> I began to work from memory. ... But wanting to create from memory what I had seen, to my terror the sculptures became smaller and smaller, they had a likeness only when they were small, yet their dimensions revolted me, and tirelessly I began again, only to end several months later at the same point. A large figure seemed to me false and a small one equally unbearable, and then often they became so tiny that with one touch of my knife they disappeared into dust. But head and figures seemed to me to have a bit of truth only when small. All this changed a little in 1945 through drawing. This led me to want to make larger figures, but then to my surprise, they achieved a likeness only when tall and slender.

When Giacometti returned to Paris from Switzerland after the war, his long struggle, during which he finished few works, was reaching resolution. The 1947 *Head of a Man on a Rod* (fig. **18.3**) presents a human head, tilted back with mouth agape and impaled on a metal rod. The violence and sense of anguish in the head, which seems to utter a silent scream, are related to the artist's earlier Surrealist works (see fig. 15.49), but the peculiar format

may have been aided by his recollection of a painted human skull from New Ireland (in the western Pacific Ocean) that he had seen displayed on a rod in an ethnographic museum in Basel, Switzerland. Typical of the artist's postwar sculpture, the surface retains all the bumps and gouges formed by his hand in the original wet plaster, thus resembling both a horrible laceration of the flesh and a rugged, rocky landscape.

Giacometti's characteristic sculptural type in the postwar period was the tall, extremely attenuated figure that appeared singly or in groups, standing rigid or striding forward like an Egyptian deity. The figures ranged in scale from a few inches high to fully life-size, as in *Man Pointing* (fig. **18.4**). Giacometti first conceived this work, distinctive for its active gesture, as half of a pair of male figures, so that the man seemed to be pointing out the direction for his companion. The artist may have disliked the implied narrative and decided to isolate the pointing figure.

Early on Giacometti had developed (perhaps from his studies of ancient sculpture) a passion for color in sculpture, and one of the most striking aspects of the later works is the patinas he used on his bronzes. *Chariot* (fig. **18.5**), which suggests an ancient Etruscan bronze, was originally designed as a commemorative public sculpture in Paris, but was ultimately rejected. Giacometti said the idea came from watching nurses wheel medicine carts about while he was hospitalized in 1938. Even when placed in groups, such as in environments evoking city squares, his figures still

18.3 Alberto Giacometti, *Head of a Man on a Rod*, 1947. Bronze, height 21¾" (55.2 cm). Private collection.

18.4 Alberto Giacometti, *Man Pointing*, 1947. Bronze, height 70½" (179.1 cm). The Museum of Modern Art, New York.

maintain a sense of the individual's isolation (fig. **18.6**). Giacometti insisted that his sculptures were not embodiments of modern anguish and alienation and rejected the Existentialist readings of his postwar work by such illustrious figures as Jean-Paul Sartre and Samuel Beckett. Yet Sartre's description of one of Giacometti's sculptures seems very apt here: "Emptiness filters through everywhere, each creature secretes his own void."

From the 1940s Giacometti also drew and painted with furious energy. He sought to pin down space, which could only be suggested in the sculptures. Like them, every painting was a result of constant working and reworking. In their subordination of color and emphasis on the action of line, the paintings have the appearance of drawings or even engravings. In *The Artist's Mother* (fig. **18.7**), the figure is almost completely assimilated into the network of linear details of the conventional living room.

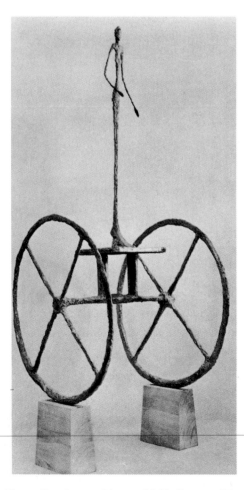

18.5 Alberto Giacometti, *Chariot*, 1950. Bronze, 57 × 26 × 26⅛" (144.8 × 65.8 × 66.2 cm). The Museum of Modern Art, New York.

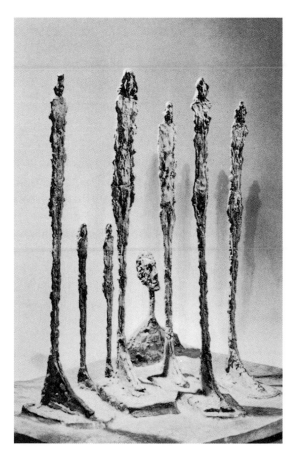

18.6 Alberto Giacometti, *The Forest (Composition with Seven Figures and One Head)*, 1950. Painted bronze, 22 × 24 × 19¼" (55.9 × 61 × 48.9 cm). The Reader's Digest Collection.

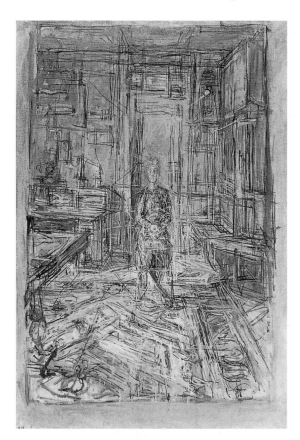

18.7 Alberto Giacometti, *The Artist's Mother*, 1950. Oil on canvas, 35⅜ × 24" (89.9 × 61 cm). The Museum of Modern Art, New York.

Richier

Germaine Richier (1904–59) received her training from two sculptors who had studied with Rodin: Louis-Jacques Guiges and Émile-Antoine Bourdelle. Her earliest surviving sculptures of the late 1930s and early 40s are sensitive portrait heads in the Rodin tradition. But the macabre quality of her mature works, fully formulated in *Praying Mantis* (fig. **18.8**), is uniquely her own. This strangely humanoid creature resembles a seated figure while maintaining all the predatory traits of the insect seen by the Surrealists as a metaphor for threatening femininity. In Richier's hands, the praying mantis becomes a totem of survival. Produced around the same time, *The Hurricane* (fig. **18.9**) is characteristic of Richier's race of uncertain but powerful beings created in postwar France. This is a wounded but heroic figure who exerts resolve despite her pitted, torn, and lacerated flesh. Richier experimented with the bronze technique, using paper-thin plaster models, into the surface of which she pressed every sort of organic object. Sometimes she placed her figures in front of a frame, the background of which is either worked in relief or, in some larger works, painted by a friend such as Maria Elena Vieira da Silva (see fig. 18.22). There are relations

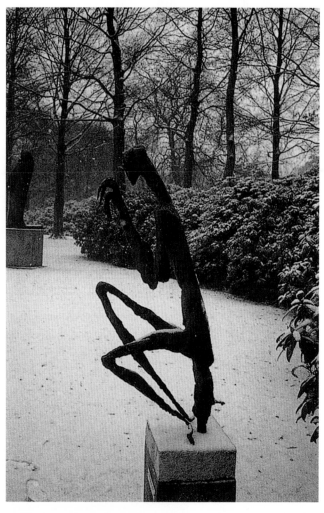

18.8 Germaine Richier, *Praying Mantis*, 1949. Bronze, height 47¼" (120 cm). Middelheim Sculpture Museum, Antwerp.

18.9 Germaine Richier, *The Hurricane*, 1948–49. Bronze, height 70⅛" (178.1 cm). Musée National d'Art Moderne, Centre d'Art et de Culture Georges Pompidou, Paris.

in her encrusted surfaces both to Giacometti's postwar sculpture, which was being formulated at exactly the same time, and to Dubuffet's contemporary figure paintings (see opposite).

Balthus

A notoriously reclusive painter closely allied to Giacometti since the early 1930s was Balthasar Klossowski, Count de Rola, known by his childhood nickname **Balthus** (1908–2001). He was born into a distinguished Polish family and raised in Paris, Geneva, and Berlin. His father was a painter and an art historian; his mother was also a painter; and the poet Rainer Maria Rilke was a close family friend. Balthus settled in the French capital in 1924. He copied the old masters in the Louvre but did not undergo any formal artistic training. Although he exhibited in 1934 at the Galerie Pierre, a Parisian gallery associated with the Surrealists, and was intrigued by the sexual implications of dreams, Balthus was not seduced by the Surrealist love of the irrational. From the 1930s onward, he painted figures in enigmatic narrative compositions, especially semi-aware pubescent girls, whom he placed in situations of riveting mystery, uncomfortable eroticism, and a light that transfixes time (fig. **18.10**). The warm glow of *The Golden Days* illuminates a diorama-like scene, leaving the viewer to contemplate the stagy peepshow and wonder whether the girl's dishevelment denotes that she is in familiar surroundings with a brother or father attending the fire or involved in a clandestine seduction from which she pauses to look in the mirror for a last glimpse of her childhood. The atmosphere of these lavishly brushed paintings seems all the more charged for being contained within an architectonic structure as

18.10 Balthus, *Les Beaux Jours* (The Golden Days), 1944–46. Oil on canvas, 4' 10¼" × 6' 6¾" (1.48 × 2 m). Hirshhorn Museum and Sculpture Garden, Smithsonian Institution, Washington, D.C.

classically calm and balanced as that of Poussin (see figs. 1.3, 1.14). The result is an eerie sense of the anxiety and ambivalent nostalgia that haunted postwar Europe.

Dubuffet

After a brief period of study at the Académie Julian in 1918, which he found uncongenial, **Jean Dubuffet** (1901–85) continued to draw and paint privately, though much of his time was taken up with music, the study of languages, experimental theater, and puppetry. He had his first one-man exhibition at the Galerie René Drouin in Paris in 1944, when he was forty-three years old. Of singular importance to the artist's development at this time was Dr. Hans Prinzhorn's 1922 book *Bildnerei der Geisteskranken (Artistry of the Mentally Ill)*. Here Dubuffet found a brutal power of expression that seemed to him much more valid than the art of the museums or even the most experimental new art. The art of the mentally ill and of children became the models on which he built his approach. He admired Paul Klee, who had also used as sources works by people with no formal artistic training.

After 1944, Dubuffet became an exceptionally prolific painter and concurrently carried on an impressive program of writing on, cataloguing, and publishing his own work. The first of the new paintings, close in spirit to Klee, were panoramic views of Paris and Parisians: the buses, the Métro, the shops, and the backstreets (fig. **18.11**). The colors are bright and lively; the people drawn in a childlike manner; and the space composed as in primitive or archaic painting. "Remember," Dubuffet wrote, "that there is only one way to paint well, while there are a thousand ways to paint badly: they are what I'm curious about; it's from them that I expect something new, that I hope for revelations."

In his *Corps de Dame (Chateau d'Étoupe)* series (**18.12**), the female body is presented frontally and two-dimensionally, as if run over by a cement roller. Dubuffet rejected out of hand the Western tradition of the nude, and his paintings are an assault on "normal" standards of beauty. He observed that women's bodies had "long been

18.12 Jean Dubuffet, *Corps de Dame—Château d'Étoupe*, 1950. Oil on canvas, 45⅟₁₆ × 34⅞₁₆" (114.4 × 87.5 cm). Allen Memorial Art Museum, Oberlin College, Ohio.

18.11 Jean Dubuffet, *View of Paris: The Life of Pleasure*, 1944. Oil on canvas, 35 × 45¾" (88.9 × 116.2 cm). Private collection.

associated (for Occidentals) with a very specious notion of beauty (inherited from Greeks and cultivated by the magazine covers); now it pleases me to protest against this aesthetic, which I find miserable and most depressing. Surely I aim for a beauty, but not that one." Picasso had offered a similar challenge to the conventions of the nude in 1907 with his *Demoiselles d'Avignon* (fig. 8.7).

Dubuffet had explored the variations of graffiti images and the textural effects of Paris walls with their generations of superimposed posters. The scratched, mutilated surface, built up in combinations of paint, paper, and sand, particularly appealed to him. Dubuffet's characteristic technique, what he called *haute pâte*, was based on a thick ground made of sand, earth, fixatives, and other elements into which the pigment was mixed. Figures were incised into this ground, accidental effects were embraced, and the whole—scratched and scarred—worked in every way to give the picture a tangible, powerful materiality. Dubuffet also made pictures out of leaves, tinfoil, or butterfly wings, and his sculptures could be formed of slag, driftwood, sponges, or other found materials. In one of his most ingenious inventions, *L'Âme du Morvan (The Soul of Morvan)* (fig. **18.13**), he managed to coax a strange little figure, who stands before a bush on a base of slag, out of found grapevines (Morvan is a wine-producing district in France).

One of Dubuffet's main sources of inspiration was the great collection he began in 1945 of *art brut* or "raw art."

18.13 Jean Dubuffet, *L'Âme du Morvan (The Soul of Morvan)*, May 1954. Grape wood and vines mounted on slag base, with tar, rope, wire, twine, nails, and staples, 18⅜ × 15⅜ × 12¾" (46.7 × 39.1 × 32.4 cm). Hirshhorn Museum and Sculpture Garden, Smithsonian Institution, Washington, D.C.

18.14 Jean Dubuffet, *The Exemplary Life of the Soil (Texturology LXIII) (Vie exemplaire du sol (Texturologie LXIII))*, 1958. Oil on canvas, 51¼ × 63¾" (130 × 161 cm). Tate, London.

Numbering thousands of works in all media, the collection, today in the Collection de L'Art Brut in Lausanne, Switzerland, contained the art of the mentally disturbed, the "primitive," and the "naive"—"anyone," Dubuffet said, "who has never learned to draw." To him these works had an authenticity, an originality, a passion, even a frenzy, that were utterly lacking in the works of professional artists.

It was Dubuffet's habit to work on a single theme or a few related themes for an extended period. In the 1950s he turned to landscape imagery, but his landscapes are hardly conventional views of nature. Rather, they are representations of the soil, of the earth itself, like close-up views of geological formations, barren of any vegetation. His works through the 1950s were predominantly in close-keyed browns, dull ochers, and blacks, verging toward monochrome and, in a series called *Texturologies*, complete abstraction (fig. **18.14**). Beyond his marvelous corpus of painting and sculpture, Dubuffet has left a body of writings filled with humor and keen observations that apply not only to his work but to art in a larger, universal sense. "What I expect from any work of art," he wrote, "is that it surprises me, that it violates my customary valuations of things and offers me other, unexpected ones."

A Different Art: Abstraction in France

The emergence of postwar French abstraction coincided in time, if not in forms, with the origins of Abstract Expressionism in the United States (see chapter 17).

Although artists on both sides of the Atlantic developed their highly individual styles independently of one another, there was a shared sense of the need to reject geometric abstraction and to create a spontaneous art that was guided by emotion and intuition rather than by rational systems of composition. *Art Informel* (literally "formless art") is a term devised in 1950 by the French critic Michel Tapié to describe this new type of expression. He coined another term, *Art Autre*—"another art," or "a different art," the essence of which is creation with neither desire for, nor preconceptions of, control, geometric or otherwise. *Tachisme* (from the French word *tache*, and meaning the use of the "blot," the "stain," the "spot," or the "drip"), a term also coined in the 1950s by a French critic, refers specifically to European versions of gestural painting.

Fautrier, Van Velde, Hartung, and Soulages

Jean Fautrier (1898–1964) was one of the leading pioneers of *Art Informel*. After painting representationally through the 1920s and 30s, he produced a moving series of small paintings on paper during World War II that he called *Hostages*. Incited by war atrocities that he had witnessed firsthand, the *Hostage* paintings were built-up masses of paint centralized on a neutral ground that resembled decayed human heads served on platters. These were followed by a series called *Naked Torsos*, whose shapes, albeit abbreviated and abstracted, emerge from a heavy paste of clay, paint, glue, and other materials built up in a thick relief. *Nude* (fig. **18.15**), 1960, was made the year

18.15 Jean Fautrier, *Nude*, 1960. Oil on canvas, 35 × 57½" (88.9 × 146.1 cm). Collection de Montaigu, Paris.

Fautrier won the grand prize at the prestigious Venice Biennale. "No art form," the artist said, "can produce emotion if it does not mix in a part of reality."

Though Dutch by birth, **Bram van Velde** (1895–1981) spent most of his professional life in France, where, after World War II, he became especially close to the Irish playwright Samuel Beckett, who wrote about his work. His paintings exhibit a remarkable consistency from the late 1940s until the end of his career. They tend to be composed around loosely delineated triangular, round, and ovoid forms that are situated in allover compositions and accentuated with patterns of dripping paint, as in his *Painting* of 1955 (fig. **18.16**). Though he developed his art without knowledge of American action painting, Van Velde was the European artist closest to aspects of his fellow Dutchman, Willem de Kooning, who was one of the few to exhibit any interest in Van Velde's art when it was first shown in New York in 1948.

Hans Hartung (1904–89) fled Nazi oppression in his native Germany in the early 1930s and settled in Paris, via Spain, in 1935. He experimented with free abstract drawings and watercolors as early as 1922, well before his exact contemporary De Kooning was formulating his Abstract Expressionist mode in America (see chapter 17). Hartung's brittle, linear style owes something to the work of Kandinsky, whom he met in 1925. During the 1930s he explored abstract Surrealism as derived from Miró and Masson, but always with an emphasis on the spontaneous, gestural stroke. He also produced Surrealist collages as well as constructed sculpture in the tradition of his father-in-law, Julio González (see figs. 15.44–15.46).

In the late 1940s, Hartung developed his mature style of brisk graphic structures, usually networks of bold black slashes played against delicate, luminous washes of color. His improvisational marks, combined with his statement in 1951 that he "acted on the canvas" out of a desire to record the trace of his personal gesture, allied him in the minds of some with action painting (see *The American Action Painter*, chapter 17). In 1954, his work underwent a shift after his exposure to Abstract Expressionism, especially the work of Franz Kline (see figs. 17.13 and 17.14), in which he perceived in the latter's paintings "tremendously enlarged details whose feelings and meaning were something totally different from their point of departure." This account couples the disorientation of grossly distorted scale with the expectation that a recognizable object might be perceived, if only the viewer could gain the proper distance. He experimented with precisely the same visual experience in his *T-1954-20* (fig. **18.17**).

18.16 Bram van Velde, *Painting*, 1955. Oil on canvas, 4' 3" × 6' 5" (1.3 × 2 m). Stedelijk Museum, Amsterdam.

18.17 Hans Hartung, *T-1954-20*, 1954. Oil on canvas, 57½ × 38⅜" (145.9 × 97.5 cm). National Gallery of Australia, Canberra.

18.18 Pierre Soulages, *Painting*, 1953. Oil on canvas, 6' 4¾" × 4' 3⅛" (1.9 × 1.3 m). Solomon R. Guggenheim Museum, New York.

Pierre Soulages (b. 1919) first went to Paris in 1938 but did not settle there until 1946, whereupon he arrived at what was to become his signature style by crafting assertive abstract structures based on studies of tree forms. The architectural sense and the closely keyed color range that characterize his abstract style (fig. **18.18**)—with its sense of physical, massive structure in which the blacks stand forth like powerful presences—may have been inspired originally by the dolmens (prehistoric stone monuments made of large stones forming two upright posts supporting a lintel) found in his native Auvergne, as it certainly was by the Romanesque sculpture of the area. Soulages consistently maintained a subdued palette, feeling that "the more limited the means, the stronger the expression." His great sweeping lines or color areas are usually black or of a dark color. Heavy in impasto, they were applied with a palette knife or large, housepainter's brushes. Soulages

thus achieved an art of power and elegance, notable not only in his forms but in the penetrating, encompassing light that unifies his paintings.

Wols, Mathieu, Riopelle, and Vieira da Silva

Berlin-born Alfred Otto Wolfgang Schulze, known by his pseudonym **Wols** (1913–51), was raised in Dresden, where he soon excelled at many things, including music and photography. Interested primarily in drawing and painting, however, the precocious Wols moved to Paris in 1932 at the age of nineteen. There he briefly met members of the international Surrealist circle such as Arp and Giacometti. For part of the war he was, like other expatriate Germans, interned by the French. While detained, he made bizarre watercolors and drawings of hybrid creatures that somewhat resemble Surrealist "exquisite corpse" drawings (see fig. 15.1).

Following the war, Wols developed an abstract style with some analogies to that of Fautrier. In such works as *Bird*, 1949, he built up his paint in a heavy central mass shot through with flashes of intense colors and automatic lines and dribbles (fig. **18.19**). Wols' abstractions create the impact of magnified biological specimens—he had been interested in biology and anthropology from an early age— or encrusted, half-healed wounds. Wols never fully recovered from his war-induced traumas. He drank heavily and died at the age of thirty-eight.

After World War II, **Georges Mathieu** (b. 1921) developed a calligraphic style that owes something to Hartung. His calligraphy (fig. **18.20**), however, consists of sweeping patterns of lines squeezed directly from the tube in slashing, impulsive gestures. To him, speed of execution was essential for intuitive spontaneity. Typically, Mathieu turned to elaborate titles taken from battles or other events of French history, reflecting his insistence that he was a traditional history painter working in an abstract means.

He occasionally painted before an audience, dressed in armor and attacking the canvas as though he were the hero Roland and the canvas were the enemy Saracen from the medieval French romance *The Song of Roland*. During such performances, Mathieu painted with great rapidity, as if to emphasize the centrality of intuition and instinct in his process. The idea of artmaking as a performance would be taken up by other European and American artists during the second half of the twentieth century. Early on, Mathieu recognized the revolutionary quality of *Art Informel* and worked hard to promote it as an alternative to geometric abstraction.

Born and educated in Montreal, **Jean-Paul Riopelle** (1923–2002) settled in Paris in 1947. He soon became part of the circle around the dealer Pierre Loeb (a leading supporter of Surrealism in the 1930s) that included Mathieu and Vieira da Silva. Between 1955 and 1979, he was the companion of the second-generation American Abstract Expressionist Joan Mitchell (see fig. 20.4).

18.19 Wols, *Bird*, 1949. Oil on canvas, 36¼ × 25⅜" (92.1 × 64.5 cm). Menil Collection, Houston, Texas.

The individual mode he achieved in the 1950s, for example in *Blue Knight*, 1953 (fig. **18.21**), is essentially a kind of controlled chance, an intricate, allover mosaic of small, regular daubs of jewel-like color, applied directly from tubes, shaped with palette knives, and held together by directional lines of force.

A Parisian artist difficult to classify but one of great sensitivity was the Lisbon-born **Maria Elena Vieira da Silva** (1908–92). By the forties she was preoccupied with the interaction of perspective and non-perspective space in paintings based on architectural views of the city or deep interior spaces. By 1950 these views became abstract,

18.21 Jean-Paul Riopelle, *Blue Knight*, 1953. Oil on canvas, 3' 8⅞" × 6' 4½" (1.1 × 1.9 m). Solomon R. Guggenheim Museum, New York.

18.22 Maria Elena Vieira da Silva, *The Invisible Stroller*, 1951. Oil on canvas, 52 × 66" (132.1 × 167.6 cm). San Francisco Museum of Modern Art.

18.23 Nicolas de Staël, *Untitled*, 1951. Oil on canvas, 63 × 29" (160 × 73.7 cm). Private collection.

grid-based compositions. *The Invisible Stroller* (fig. **18.22**) is related to Picasso's Synthetic Cubist paintings of the 1920s in its fluctuations of Renaissance perspective and the Cubist grid. From this point forward Da Silva gradually flattened the perspective while retaining a rigid, rectangular, architectural structure. The view of the city, seen from eye level, eventually became the view from an airplane—as one rises higher and higher, details begin to blur and colors melt into general tonalities.

De Staël

Nicolas de Staël (1914–55) was an independent-minded painter who abjured figurative painting during the war, becoming one of the first European abstract painters to gain international renown. He maintained an interest in art-historical tradition, seeing his own work as an extension of the painting of Poussin, Matisse, and Braque, with whom he enjoyed a close friendship. De Staël was born an aristocrat in Russia but forced to flee during the Bolshevik Revolution. Orphaned, he and his siblings grew up in Belgium, where he attended the Royal Academy of Fine Arts before moving to Paris in 1938. In the 1940s he was painting abstractly, but as his work developed, he became more and more concerned with the problem of nature versus abstraction. De Staël seems to have been increasingly desirous of asserting the subject while maintaining abstract form. "A painting," he said, "should be both abstract and figurative: abstract to the extent that it is a flat surface, figurative to the extent that it is a representation of space." He began to paint with palette knives in 1949, building up his abstract compositions with thick, loosely rectangular patches of paint that he scraped into the desired form with a knife (fig. **18.23**). In 1953 he traveled to Sicily and was struck by the intense quality of the light. He made

18.24 Nicolas de Staël, *Agrigente*, 1954. Oil on canvas, 34¾ × 50½" (88.3 × 128.3 cm). The Museum of Contemporary Art, Los Angeles.

landscapes in brilliant hues (fig. **18.24**)—in this example reds, oranges, and yellows—in which the forms are simplified to large planes of flat color accented by a few contrasting color spots. In the last year of his life he began painting even more literal scenes of boats, birds, and oceans, in thin, pale colors. In 1955 De Staël, who had achieved a considerable reputation on both sides of the Atlantic, jumped to his death from the terrace of his studio.

"Pure Creation": Concrete Art

Geometric abstraction was not entirely abandoned in these years. The concept of Concrete art, a term first used by Theo van Doesburg in 1930, was revived in 1947. That was the year of the Salon des Réalités Nouvelles. Another important venue was the gallery of Denise René, which became an international center for the propagation of Concrete art. Among the leaders outside of France was Josef Albers, who went to the United States in 1933 and whose influence there helped the spread of geometric abstraction (see chapter 14). He exhibited regularly with the American Abstract Artists group (see *Artists and Cultural Activism*, chapter 17), as well as with Abstraction-Création in Paris. Many aspects of postwar Constructivism, Color Field painting, Systemic painting, and Op art stem from the international tradition of de Stijl and Concrete art.

Bill and Lohse

Important for the spread of Concrete art in Europe were developments in Switzerland, particularly in the work of **Max Bill** (1908–94) and Richard Paul Lohse. Though he was making non-objective art by the late 1920s, Bill first began applying the term "concrete" to his work in 1936. He defined it as follows: "Concrete painting eliminates all naturalistic representation; it avails itself exclusively of the fundamental elements of painting, the color and form of the surface. Its essence is, then, the complete emancipation of every natural model; pure Creation."

Bill studied at the Dessau Bauhaus between 1927 and 1929 when Josef Albers was teaching there. Subsequently, he developed into one of the most prolific and varied exponents of Bauhaus ideas as a painter, sculptor, architect, graphic and industrial designer, and writer. He was associated with Abstraction-Création in Paris and organized exhibitions of Concrete art in Switzerland. Bill insisted that painting and sculpture have always had mathematical bases, whether arrived at consciously or unconsciously. In the forms of Concrete art he found rationalism, clarity, and harmony—qualities symbolic of certain universal ideas.

In sculpture, the form that intrigued Bill the most and on which he played many variations is the endless helix or spiral (fig. **18.25**). The metal ribbon form turns back upon itself with no beginning and no end and is, therefore, in a constant state of movement and transformation.

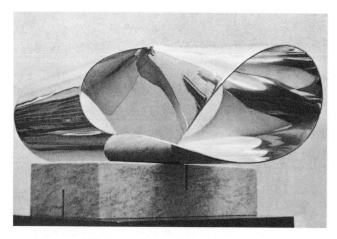

18.25 Max Bill, *Endless Ribbon from a Ring I*, 1947–49, executed 1960. Gilded copper on crystalline base, 14½ × 27 × 7½" (36.8 × 68.6 × 19.1 cm). Hirshhorn Museum and Sculpture Garden, Smithsonian Institution, Washington, D.C.

In his paintings, Bill, like Albers, systematically experimented with color, particularly the interaction of colors upon one another (fig. **18.26**). Much as his square and diamond-shaped paintings owe to the example of Mondrian, Bill's pristine forms and regular grids have more to do with geometry than with Mondrian's intuitive and painterly approach to picturemaking.

Like Bill, **Richard Paul Lohse** (1902–88) made mathematics the basis of his painting. He sought the simplest possible unit, such as a small color-square. Using not more than five color hues but a great range of color values, Lohse built his units into larger and larger complexes through a mathematically precise distribution of hues and values in exact and intellectually predetermined relationships (fig. **18.27**). This resulted in a composition or color structure

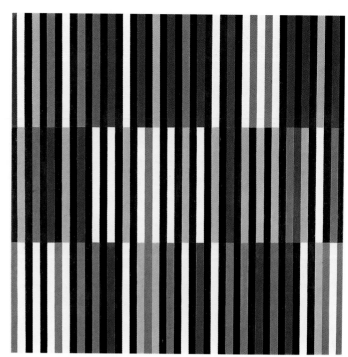

18.27 Richard Paul Lohse, *Pure Elements Concentrated in Rhythmic Groups*, 1949–56. Oil on canvas, 35⅜ × 35⅜" (90 × 90 cm). Kunsthaus Zurich.

that spreads laterally and uniformly, with no single focus, to the edges of the canvas, with the implication and the potential of spreading to infinity beyond the edges. Despite the rigidity of Lohse's system, the subtlety and richness of his colors and the shimmering quality deriving from their infinitely varied relationships give his works a lyrical, poetic feeling. His art would be important for the development of Op art, which was also supported by the Denise René gallery (see fig. 20.28).

18.26 Max Bill, *Nine Fields Divided by Means of Two Colors*, 1968. Oil on canvas, 47 × 47" (119.4 × 119.4 cm). Albright-Knox Art Gallery, Buffalo, New York.

Postwar Juxtapositions: Figuration and Abstraction in Italy and Spain

In post-fascist Italy, art underwent a period of intense debate in major urban centers, such as Milan, Bologna, and Rome, with artistic concerns rarely divorced from political ones. A strong realist movement existed, particularly among communist artists who wielded painting as a political weapon. But alternatives arose among younger artists who proposed radical abstraction as an antidote to Italy's time-honored classical tradition. In the late 1950s various forms of *Art Informel* spread throughout the country, supplanting more Cubist-based forms of abstraction. Despite the Italian proclivity for forming groups and issuing manifestos, *Art Informel* was never a uniform movement in that country, and figuration, particularly in sculpture, remained a viable artistic force.

In Spain during the postwar decades under the dictatorship of General Franco, abstraction was a powerful metaphorical dimension in the work of Antoni Tàpies, who came to rely on his materials and suggestive, organic forms to convey a solemn respect for human endurance and a resistance to oppression.

Morandi

An artist who seemed to exist outside of the political and artistic fray was **Giorgio Morandi** (1890–1964), who emerged as the leading figurative painter in Italy in the years after the war. Despite his forays into landscape and, occasionally, figure painting, Morandi's primary subject throughout his long career was still life. At odds with much of the large-scale, highly emotive, and abstract art being produced after the war, this artist's quiet and modestly scaled still lifes drew as much upon Italian Renaissance traditions as on contemporary developments. Old enough

to have been exposed to Futurism (though his work was never truly Futurist), Morandi was included in the First Free Futurist Exhibition in Rome in 1914. In 1918–19, after discovering the works of Carlo Carrà and Giorgio de Chirico, he made enigmatic still lifes that allied him with the Metaphysical School. Morandi lived quietly in his native Bologna, teaching, painting, and traveling only rarely. It was not until after World War II that he was acknowledged as Italy's leading living painter. The unremarkable elements of his postwar still lifes (fig. **18.28**)—bottles, jars, and boxes—are typically massed together against a neutral ground to form a kind of miniature architecture, with an emphasis on abstract organization and subdued, closely valued tones. There is a meditative, serialized aspect to the artist's work, for he often cast similar arrangements in slightly altered light conditions. Morandi's still lifes, in which humble objects are reduced to their essence, continue the tradition of ascetic Spanish still lifes by seventeenth-century painters like Juan Sánchez Cotán, whose spare, humble arrangements insist upon the importance of spiritual rather than material attainment.

Marini and Manzù

The Italian contribution in postwar figuration came chiefly in sculpture, especially in the work of **Marino Marini** (1901–80) and Giacomo Manzù. The sculpture of Marini, a native of Tuscany, was deeply rooted in history. For Italians, he said, "the art of the past is part and parcel of our daily life in the present." Besides ancient Roman and Etruscan art, he was interested in the sculpture of Archaic Greece and Tang dynasty China. He also traveled widely and was knowledgeable about modernist developments in Italy and elsewhere in Europe. Marini was a mature artist by the 1930s, already experimenting with his favorite themes, including the horse and rider. During the war,

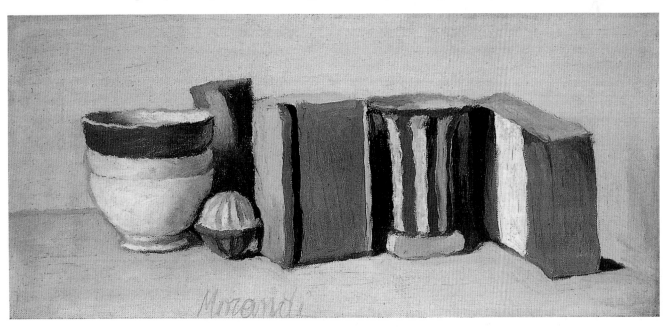

18.28 Giorgio Morandi, *Still Life*, 1951. Oil on canvas, 8⅞ × 19⅝" (22.5 × 50 cm). Kunstsammlung Nordrhein-Westfalen, Düsseldorf.

18.29 Marino Marini, *Horse and Rider*, 1952–53. Bronze, height 6' 10" (2.1 m). Hirshhorn Museum and Sculpture Garden, Smithsonian Institution, Washington, D.C.

the equestrian subject, traditionally employed to commemorate noblemen or celebrate war heroes in city squares, became for Marini a symbol for suffering and disillusioned humanity. His horse, with elongated, widely stretched legs and upthrust head (fig. **18.29**), screams in agony, in a manner that recalls Picasso's *Guernica* (see fig. 15.39). The rider, with outflung stumps for arms, falls back in a violent gesture of despair. "My equestrian figures," the artist said, "are symbols of the anguish that I feel when I survey contemporary events. Little by little, my horses become more restless, their riders less and less able to control them." By 1952, when he won the grand prize for sculpture at the Venice Biennale, Marini was recognized internationally as one of Europe's most significant sculptors.

Giacomo Manzù (1908–91) was influenced by Medardo Rosso (see fig. 3.22), but his real love was the sculpture of the Italian Renaissance. In 1939, deeply affected by the spread of fascism and the threat of war, he made a series of relief sculptures around the subject of the Crucifixion that was his not-so-veiled antifascist statement.

18.30 Giacomo Manzù, *Large Standing Cardinal*, 1954. Bronze, height 66½" (168.9 cm). Hirshhorn Museum and Sculpture Garden, Smithsonian Institution, Washington, D.C.

18.31 Giacomo Manzù, *Death by Violence*, 1952–64. Bronze, from "Doors of Death" at St. Peter's, Vatican City.

The *Cardinal* series, begun in 1938 but represented here by a version from 1954 (fig. **18.30**), took a conventional subject and created from it a mood of withdrawal and mystery. At the same time, Manzù utilized the heavy robes for a simple and monumental sculptural volume. In the Renaissance tradition, Manzù carried out a number of religious commissions, notably the bronze door panels for St. Peter's Basilica in the Vatican at Rome and for Salzburg Cathedral. He received the commission for St. Peter's in 1952 and the doors were consecrated in 1964. Manzù solved the daunting task of designing doors for St. Peter's—he was, after all, entering the realm of Bramante, Michelangelo, and Bernini—with a series of low-relief sculptures on the general theme of death. Each door contains a large vertical panel on a biblical theme above four smaller ones. In these lower panels Manzù chose to depict not the deaths of Christian martyrs but those of common people. In *Death by Violence* (fig. **18.31**), a man succumbs to a tortuous death observed by a compassionate female onlooker.

Afro

Italian *Art Informel* found an advocate in **Afro** (1912–76), as Afro Basaldella is generally known, though his work was never as radical as that of Lucio Fontana or Alberto Burri (see below). It was central to the Italian *Astratto–Concreto* (Abstract–Concrete) movement at mid-century, led by the influential Italian critic Lionello Venturi. During the 1950s, Afro created an atmospheric world of light and shadows, with subdued, harmonious colors and shapes in a constant state of metamorphosis (fig. **18.32**). Of Italian postwar painters, Afro was closest to his American contemporaries, having lived in the United States in 1950 and admired the work of Gorky, Kline, and De Kooning. His later work of the 1960s took on a painterly appearance close to that of these gestural painters.

18.32 Afro, *For an Anniversary*, 1955. Oil on canvas, 4' 11" × 6' 6⅜" (1.5 × 2 m). Solomon R. Guggenheim Museum, New York.

Fontana

Among abstract artists in Italy in the years after the war, **Lucio Fontana** (1899–1968) was the leading exemplar. Born in Argentina and trained as a sculptor in Italy, he was producing abstract sculpture by the early 1930s (though he also continued to work figuratively into the 1950s). He joined the Paris-based Abstraction-Création group in 1935, the same year he signed the *First Manifesto of Italian Abstract Artists*. During World War II he returned to Argentina, where he published *The White Manifesto*, outlining his idea of a dynamic new art for a new age made with such modern materials as neon light and television—media whose potential would not be tapped again for art until the 1960s and 70s. *The White Manifesto*, modeled in many ways on Futurist prototypes, anticipated the theory of what would be known as *Spazialismo* or Spatialism (laid out in five more manifestos between 1947 and 1952), a concept that rejected the illusionistic or "virtual" space of traditional easel painting in favor of the free development of color and form in literal space (see *Fontana, The White Manifesto*, below). The Spatialist program was designed to emancipate art from past preconceptions, to create an art that would "transcend the area of the canvas, or the volume of the statue, to assume further dimensions and become … an integral part of architecture, transmitted into the surrounding space and using discoveries in science and technology."

SOURCE

Lucio Fontana
from *The White Manifesto* (1946)

Plastic art developed from its original base of natural shapes. The manifestation of the unconscious adapted easily to natural forms as a consequence of the idealized conception of existence.

Our material consciousness, that is, our need for things which are easily verifiable, demands that art forms should flow directly from the individual and that they should assume natural form. An art based on forms created by the subconscious and balanced by reason, constitutes a true expression of existence that is the synthesis of a moment in time.

The position of the rational artists is false. In their effort to privilege reason and to deny the workings of the subconscious, they succeed only in rendering them less visible. We can see this process at work in their every endeavor.

Reason does not create. In creating shapes, it is subordinate to the subconscious. In all of his activities, man uses all of his creative faculties. Their free development is fundamental for creating and interpreting a new kind of art. Analysis and synthesis, meditation and spontaneity, construction and sensation, are all values which come together to work in union; and their development in experience is the only way to achieve a complex demonstration of being.

Fontana also became a pioneer of environments in 1949 when he used free forms and black light to create vast Spatialist surrounds, experiments followed in the 1950s by designs made in collaboration with the architect Luciano Baldessari. In his desire to break down categories of painting, sculpture, and even architecture, Fontana described his works as *Concetti Spaziale* (CS), or "Spatial Concepts," thus inaugurating Conceptualism, a movement that would not actually take hold in Western art until the 1970s.

Beginning in 1949, Fontana perforated the canvas with *buchi* (holes) in abstract but not haphazard patterns, thereby breaking through the picture plane that had been the point of departure for painting throughout much of its history. In 1963 he made a series of egg-shaped canvases called *Spatial Concept: The End of God* (fig. **18.33**), in which holes are torn in a brightly painted canvas to reveal another colored canvas below, all resembling a strange, extraterrestrial landscape. During the 1950s he experimented with materials, as did his fellow countrymen Afro and Alberto Burri, building up his penetrated surfaces with heavy paint, paste, canvas fragments, or pieces of glass. It was in 1958 that, feeling he was complicating and embellishing the works too much, Fontana slashed a spoiled canvas. He realized that with this simple act, he could achieve the integration of surface with depth that he had been seeking. These monochrome, lacerated canvases, called *Tagli* (slashes) (fig. **18.34**), were subtitled *Attese*, which translates as "expectations," and are the works for which

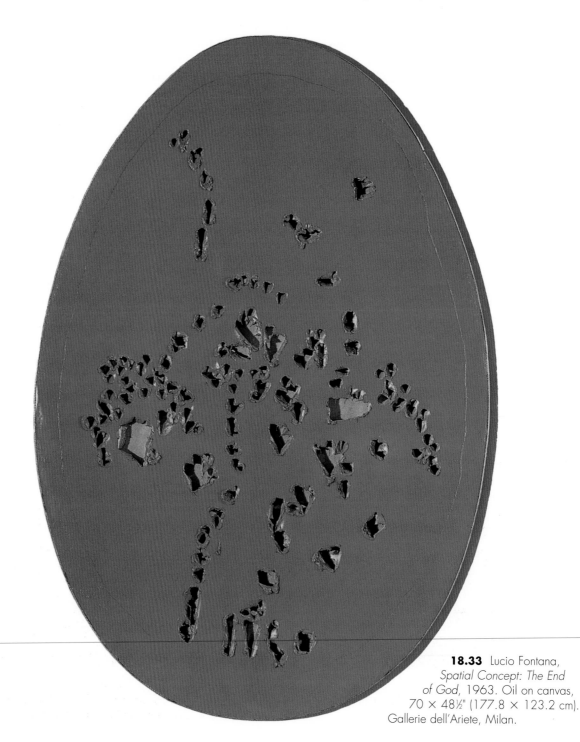

18.33 Lucio Fontana, *Spatial Concept: The End of God*, 1963. Oil on canvas, 70 × 48½" (177.8 × 123.2 cm). Gallerie dell'Ariete, Milan.

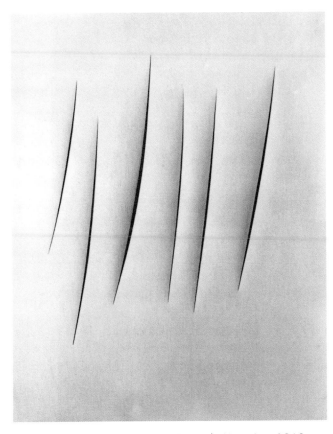

18.34 Lucio Fontana, *Concetto Spaziale (Attese)*, c. 1960. Oil on canvas, 36 × 28¾" (91.4 × 73 cm). Folkwang Museum, Essen, Germany.

18.35 Lucio Fontana, *Nature*, 1959/60. Bronze, 24 × 28¾" (61 × 73 cm). Tate, London.

he is best known. Although Fontana's abstract art was tied to the general trends of *Art Informel*, instead of making a positive gesture that adds medium to the painted surface, his incisions in a sense remove medium and transform the normally taut and inviolable surface of the canvas into a soft, malleable form that opens to a mysteriously dark interior. For Fontana, the gesture was less about creating a record of the individual artist's emotion—as with Mathieu or De Kooning—than it was an exploration of the physical properties of a work of art and the emotions that those properties evoke. Shortly after he made his first *Tagli*, Fontana applied his *Spatial Concepts* to bronze sculptures (as he had already to ceramics), creating roughly textured, rounded forms that are sliced and punctured (fig. **18.35**).

Burri

Alberto Burri (1915–95) was a doctor in the Italian army in North Africa when he was captured by the British. Later he was turned over to the Americans, who interned him as a prisoner of war in Texas, and there he began drawing and painting. Abandoning medicine after his release, he continued his creative activities free of formal artistic training, and developed a style indebted at first to Mondrian and Miró. Burri eventually evolved a method with a strong emphasis on texture and materiality, incorporating thick paint, pastes, and tar into his paintings. He received his first exhibition in a Roman gallery in 1947 and in 1950 began to make *Sacchi* (fig. **18.36**), paintings made of old sacks roughly sewn together and heavily splashed with paint. The results were often reminiscent of bloodstained bandages, torn and scarred—devastating commentaries on war's death and destruction. They have been related to

18.36 Alberto Burri, *Composition*, 1953. Oil, gold paint, and glue on canvas and burlap, 34 × 39⅜" (86.4 × 100 cm). Solomon R. Guggenheim Museum, New York.

Schwitters' collages (see fig. 11.22), but their impact is much more brutal. For a period in the mid-1950s Burri burned designs on thin wood panels like those used in orange crates. In them, as in the earlier works, there is a strange juxtaposition: on the one hand, the ephemeral material coupled with a sense of destruction and disintegration (the material sometimes disintegrates visibly when moved from place to place); on the other hand, the elegance and control with which the artist arranges his elements. Burri also worked in metal and plastics, melting and reforming these media with a blowtorch to achieve results of vivid coloristic beauty combined with effects of disease and decay. His influence has been strong, particularly on the young Robert Rauschenberg (see fig. 19.28), who visited his studio in 1953.

Tàpies

Coming of age following the devastation of the Spanish Civil War and in the wake of the great twentieth-century Spanish painters—Picasso, Miró, Dalí—**Antoni Tàpies** (b. 1923) emerged as an important artist in Spain after World War II. By the early 1960s his reputation had spread well beyond Spain's borders and was bolstered by important exhibitions in Europe and the United States. Tàpies was a native of Barcelona, a gifted draftsman, and a man of broad erudition who drew from many sources, such as Catalan mysticism and Zen Buddhism. His early paintings, which incorporate collage and depict fantastic subjects, are reminiscent of Klee and Miró. Then, in the mid-1950s, profound changes took place in his outlook and his art. "Suddenly, as if I had passed through the looking-glass," he wrote, "a whole new perspective opened up before me, as if to tell the innermost secret of things. A whole new geography lit my way from one surprise to the next." He began to make abstract compositions distinctive for their emphasis on thick, rough textures (fig. **18.37**). He built up the surfaces of his paintings in a variety of ways, with combinations of paint, varnish, sand, and powdered

marble, to create an effect of textured relief. His colors are generally subdued but rich, with surfaces worked in many ways—punctured, incised, or modeled in relief. These highly tactile surfaces became analogous to walls for the artist into which he crudely scratched lines or onto which he applied other materials. As such, they were metaphors for the struggles and sufferings of the artist and his fellow Spaniards during the war years, which he said, "seemed to inscribe themselves on the walls around me" (*tàpies*, in fact, is a form of the verb *tapiar*, meaning "to wall something in"). Like many of his contemporaries, Tàpies has used "poor" materials—weathered wood, rope, burlap, cardboard, and found objects—to create crusty, battered surfaces expressive of his deeply spiritual, anti-materialistic values.

"Forget It and Start Again": The CoBrA Artists and Hundertwasser

In the postwar Netherlands—in the very home of Mondrian and de Stijl—a desire for expressionistic liberation from the constraints of anything rational, geometric, or Constructivist became particularly urgent. Inspired by the Danish painter Asger Jorn, three Dutch artists—Karel Appel, Cornelis Corneille, and George Constant—established the Experimental Group in 1948. They sought new forms of elemental expression, as much opposed to Mondrian and de Stijl as to the Academy. Through contacts with similar groups in Copenhagen and Brussels, this association evolved into the international group CoBrA (standing for Copenhagen, Brussels, and Amsterdam), led by Jorn and the Belgian poet Christian Dotrement. Most of the painters associated with the CoBrA group employed some sort of subject or figuration, often informed by their interests in the art of the untutored—what Dubuffet called *art brut*. The most important unifying principles among these divergent artists were their doctrine of unconstrained formal experimentation; their emphasis on brush gesture;

and their rejection of rationalism and geometric abstraction. In the words of one artist, "The gallery had become a temple dedicated to the right angle and the straight line." In this, they were allied to Dubuffet and Fautrier in France, for both of whom the artists of CoBrA had great respect, although the latter's means of expression were generally more violent, colorful, and dynamic. CoBrA, which lasted as a united movement from 1948 to 1951, was a critical artistic phenomenon for its internationalism. It also infused tremendous energy into abstract painting when an exhausted Europe was just emerging from the war.

Jorn

The Dane **Asger Jorn** (1914–73) represents the most extreme reaction against Concrete art's principles of order and harmony. Jorn spent several formative years in Paris, where he received disciplined training at Léger's academy. Important for his future development was his exposure to the biomorphic Surrealism of Arp and Masson (see figs. 15.2, 15.15), memories of which remained a constant theme in his art. Like the American Abstract Expressionists, who learned from similar Surrealist examples, Jorn was interested in mythic subject matter, which he drew from specifically Nordic folkloric traditions.

Jorn produced paintings that could be an illustration of Ruskin's famous epithet about Whistler—a pot of paint flung in the face of the public (see chapter 1). Yet Jorn's art still has its roots in figuration. Using largely undiluted primary colors with blacks, whites, and greens, Jorn smeared, slashed, and dripped the paint in a seemingly uncontrolled frenzy. Yet the control, established in large, swinging, linear movements, and asymmetrically balanced color-shapes, remains sufficient to bring a degree of order out of chaos while not diminishing the explosive fury of the abstract expression (fig. **18.38**).

Appel

Karel Appel (b. 1921) consistently painted figures and portraits with heavy impasto and brilliant color, as in his 1956 portrait of Willem Sandberg, then director of Amsterdam's Stedelijk Museum, which specializes in modern art (fig. **18.39**). Sandberg was a heroic figure to young artists in Holland both for his support of experimental

18.38 Asger Jorn, *The Enigma of Frozen Water*, 1970. Oil on canvas, 63¾ × 51⅛" (162 × 130 cm). Stedelijk Museum, Amsterdam.

18.39 Karel Appel, *Willem Sandberg*, 1956. Oil on canvas, 51¼ × 31⅞" (130.2 × 81 cm). Museum of Fine Arts, Boston. Tompkins Collection, Arthur Gordon Tompkins Fund.

art—he championed CoBrA against intensely negative public sentiment—and for his efforts to save Dutch Jews from deportation by the Nazis during the war. Appel, like Dubuffet, whose work he first saw in 1947 during a trip to Paris, was drawn to the intuitive and the spontaneous, especially in the art of children, and he achieved a wonderful childlike quality in his own work (fig. **18.40**). He was also inspired by Van Gogh, Matisse, Schwitters, and Picasso. "You have to learn it all," he said, "then forget it and start again like a child. This is the inner evolution." Appel established a certain control over this process through his representation of an explicit face or figure.

Alechinsky

The Belgian **Pierre Alechinsky** (b. 1927) was a latecomer to the CoBrA group. When he first encountered their paintings at a 1949 exhibition in Brussels, he detected in them "a total opposition to the calculations of cold abstraction, the sordid or 'optimistic' speculations of socialist realism, and to all forms of division between free thought and the action of painting freely." By comparison with Appel or Jorn, particularly in his earlier works of the 1950s, Alechinsky produced an allover structure of tightly interwoven elements with a sense of order deriving from microcosmic organisms (fig. **18.41**). His later works, on the other hand, have a curvilinear morphology that stems partly from Belgian Art Nouveau as well as from the artist's automatist practices.

Hundertwasser

An artist who continued the traditions of Austrian Art Nouveau and Expressionism was the Viennese Friedrich Stowasser, or **Hundertwasser** (1928–2000). Impossible to classify through allegiance to any particular artistic group or cause, Hundertwasser traveled extensively, living at different times in France, Italy, and Austria. Though he arrived in Paris at the dawn of *Art Informel*, he developed a style directly at odds with it, preferring instead to forge a visual language based on specific forms derived largely from the Austrians Gustav Klimt and Egon Schiele (see figs. 5.5, 7.31). His early work carries strong overtones of Paul Klee, and he shared Klee's interest in art produced by children. The most distinctive feature of Hundertwasser's art is its jewel-like color, as in the self-portrait shown here (fig. **18.42**), a brilliant pastiche of Art Nouveau decoration. Despite his harrowing years in Nazi Germany, where the Jewish Hundertwasser remained in disguise, he maintained a utopian vision that led him later in life to design progressive urban architecture, including an ecological housing complex in Vienna.

18.40 Karel Appel, *Angry Landscape*, 1967. Oil on canvas, 51¼ × 76¾" (130 × 190 cm). Private collection.

18.41 Pierre Alechinsky, *Ant Hill*, 1954. Oil on canvas, 4' 11½" × 7' 9⅞" (1.5 × 2.4 m). Solomon R. Guggenheim Museum, New York.

18.42 Hundertwasser, *House which was born in Stockholm, died in Paris, and myself mourning it,* 1965. Mixed media, 32 × 23⅔" (81.3 × 60.1 cm). Private collection.

18.43 Francis Bacon, *Painting*, 1946. Oil on canvas, 6' 6" × 4' 4" (2 × 1.32 m). The Museum of Modern Art, New York.

Figures in the Landscape: British Painting and Sculpture

In British art after the war a strong emphasis on the figure reasserted itself. For sculptors Barbara Hepworth and Henry Moore, the relationship between the figure, or sculpture, and its surroundings was of crucial importance. Both artists paid close attention to the siting of their works in rural or urban settings so as to achieve an effect of strong presence and often serene poise. In the paintings of Francis Bacon and Lucian Freud, by contrast, the human subjects inhabit comfortless spaces that highlight their vulnerability.

Bacon

Irish-born **Francis Bacon** (1909–92) was a figurative painter of disquieting subject matter. After the war, he achieved international stature on a par with that of Giacometti and Dubuffet. A wholly self-taught artist, Bacon left his native Dublin as a teenager, traveling in Europe and settling eventually in London. He painted grim, violent, and grotesquely distorted imagery in the most seductive painterly style, producing what one writer described as "a terrible beauty." Bacon's devotion to the monstrous has been variously interpreted as a reaction to the plight of the world, or as a nihilistic or existential attitude toward life's meaninglessness.

In *Painting* (fig. **18.43**), 1946 (he destroyed most of his prewar work), Bacon created a horrific montage of images that, according to his explanation, emerged by accident. The artist said:

> I was attempting to make a bird alighting on a field, but suddenly the lines that I'd drawn suggested something totally different, and out of this suggestion arose this picture. I had no intention to do this picture; I never thought of it in that way. It was like one continuous accident mounting on top of another.

From the deep shadows cast by an umbrella emerges the lower half of a head with a hideously grimacing mouth topped by a bloody mustache. The figure, whose torso virtually disappears into long strokes of paint, is enclosed within a round tubular structure (related to the artist's own earlier furniture designs); hunks of meat seem to be skewered on it. The sense of formal disjunction compounds the imagery's disturbing effect. At the figure's feet is what

appears to be a decorative Oriental carpet, as though this creature, who wears a yellow corsage, is sitting for a conventional formal portrait. Presiding over the entire scene is a gigantic beef carcass, reminiscent of Rembrandt's *Butchered Ox* (fig. 12.7), a work also evoked in Chaim Soutine's *Carcass of Beef* (fig. 12.6). Bacon has it strung up like a crucifixion beneath a grotesquely incongruous festoon of decorative swags. Some have detected in the figure a resemblance to despots of the day, such as Mussolini. Although *Painting* was made just after the war, it transcends any particular association to become a terrifying and universal depiction of ruthless, predatory power.

Bacon's sense of tradition extended from Giotto to Rembrandt and Van Gogh. He used paintings of the past as the basis of his works but transformed them through his own inward vision and torment. Beginning in 1949 he made a series of paintings after Velázquez's *Portrait of Pope Innocent X* in the Doria Pamphili Gallery in Rome (which he knew only through reproductions). In these works, the subject is usually shown seated in a large, unified surrounding space. The figure is blurred as though seen through a veil, while the perspective lines delineate a glass box within which the figure is trapped. *Head VI* (fig. **18.44**) is the first of these papal images and the last of a series of six heads that Bacon made in 1948–49. Typically, the pope's mouth is wide open, as if uttering a horrendous scream. The artist, who said he wanted to "make the best

18.44 Francis Bacon, *Head VI*, 1949. Oil on canvas, 36⅝ × 30⅛" (93.2 × 76.5 cm). Arts Council Collection, London.

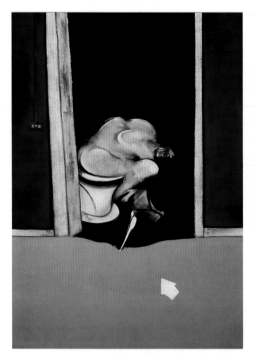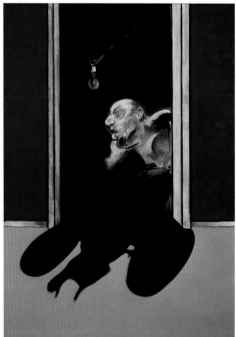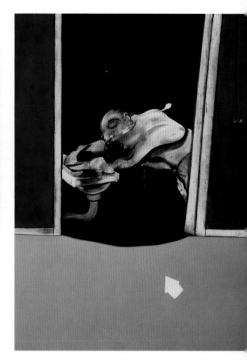

18.45 Francis Bacon, *Triptych—May–June 1973*, 1973. Oil on canvas, each panel 6' 6" × 4' 10" (1.9 × 1.5 m). Private collection.

painting of the human cry," conflated the papal image with a famous still from the Russian film *The Battleship Potemkin*, 1925, directed by Sergei Eisenstein. The still is a close-up of one of the women of Odessa who have come to show support for the sailors engaged in a mutiny against their cruel officers. She has been wounded in the eye and her pince-nez glasses shattered by soldiers of the Imperial Army who met the supporters on the broad steps leading to the harbor, slashing indiscriminately with their swords and firing their rifles into the peaceful gathering. The exact meaning of Bacon's *Pope* series is deliberately obscured by the artist (as are his intentions in referring to the Velázquez and Eisenstein works), but there is no question of the horrifying impact and beauty of the painting.

Bacon's subject was almost exclusively the human face or figure—especially the male nude, which he portrayed in states of extreme, sometimes convulsive effort. Like Max Beckmann (see fig. 11.41), he frequently made triptychs, a format he had employed for scenes related to human suffering. In *Triptych—May–June 1973* (fig. **18.45**), Bacon created a harrowing yet touching posthumous portrait of his companion, George Dyer, during the latter's fatal illness. In three separate images, cinematic in their sense of movement and sequential action, Dyer's ghostly white figure is seen through darkened doorways. In the central canvas, where Dyer lurches toward the sink, the blackness spills out onto the floor as an ominous shadow. This is life at its most fundamental, when the human protagonist is stripped of all pretense and decorum.

Sutherland

The English artist **Graham Sutherland** (1903–80), Bacon's contemporary, also explored agonized expressions of human suffering. During the 1920s he made visionary, meticulously representational landscapes of rural England, mostly in etching, that reveal his passion for the works of the nineteenth-century English painter Samuel Palmer. In the mid-1930s his work became increasingly abstract and imaginative, partly as a result of his discovery of Surrealism. He made paintings based on forms found in nature— rocks, roots, or trees—that were divorced from their landscape context and, in the artist's words, "redefined the mind's eye in a new life and a new mould." He eventually transformed these found forms into monstrous figures that suggest some of Picasso's Expressionist–Surrealist work of the 1930s. The war years, when he worked as an official war artist, led to a certain reversion, when he represented devastated, bombed-out buildings and industrial scenes. By the end of World War II, Sutherland had arrived at his characteristically jagged, thistle-like totems, frequently based quite literally on plant forms but transformed into menacing beasts or chimeras. A commission for the painting of a Crucifixion in St. Matthew's Church, Northampton, led him back to Grünewald's Isenheim Altarpiece. In Grünewald's torn, lacerated figures he found a natural affinity (fig. **18.46**). Along with his expressionist works, he carried on a successful career as a portraitist, painting many of the great figures of his time in literal but penetrating interpretations.

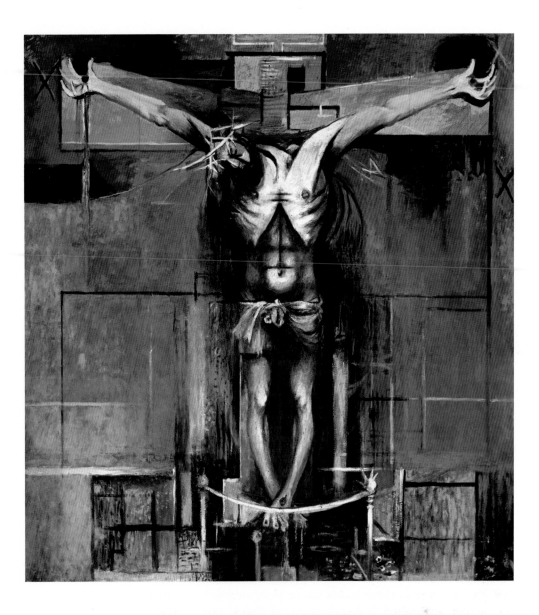

18.46 Graham Sutherland, *Crucifixion*, 1946. Oil on hardboard, 8' × 7' 6" (2.4 × 2.3 m). Church of St. Matthew, Northampton, England.

Freud

An important European heir to the tradition of truth to visual fact is the Berlin-born British artist **Lucian Freud** (b. 1922), the grandson of the pioneering psychoanalyst Sigmund Freud. The artist, whose Jewish family left Berlin for England when Hitler came to power in 1933, showed an aptitude for drawing at a young age and was producing remarkably accomplished work by the time he reached his early twenties. His uncompromising devotion to the physical presence of the sitter is such that the resulting portrait, realized with an obsessive command of line and texture, can seem the product of a clinically cold and analytical mind (fig. **18.47**). Still, in their very "nakedness," models whom the artist has revealed in excruciatingly close-up detail confront the viewer with an unmistakable presence. Not since Germany's Neue Sachlichkeit painting of the 1920s was the human figure examined with such an unflinching eye and such tight,

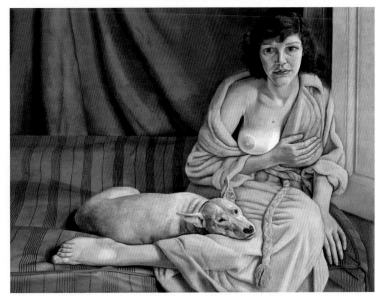

18.47 Lucian Freud, *Girl with White Dog*, 1951–52. Oil on canvas, 30 × 40" (76.2 × 101.6 cm). Tate, London.

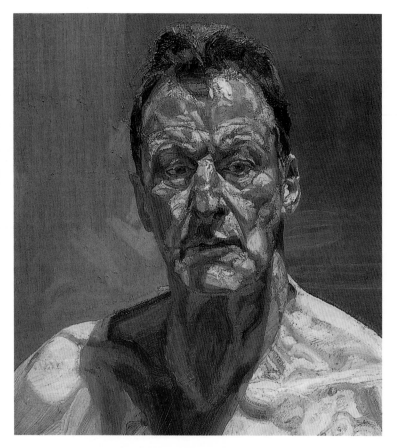

18.48 Lucian Freud, *Reflection (Self-Portrait)*, 1983–85. Oil on canvas, 22⅛ × 20⅛" (56.2 × 51.2 cm). Private collection.

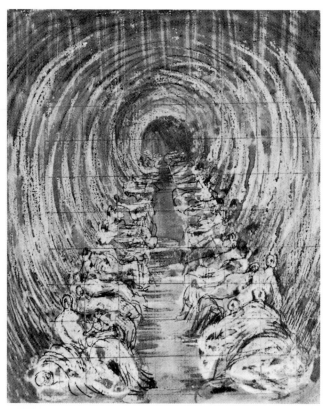

18.49 Henry Moore, Study for *Tube Shelter Perspective*, 1940–41. Pencil, wax crayon, colored crayon, watercolor wash, pen and ink, 10⅓ × 6½" (26.4 × 16.5 cm). Collection Mrs. Henry Moore, England.

linear precision. In the late 1950s, Freud's paint handling began to loosen, although the empiricism of his gaze was undiminished. Many of his works are nudes—friends and family, never professional models—who assume strange and revealing poses, whose bodies are far from idealized, and whose unidealized flesh is tinged with blood and swollen with the muscle and fat that lie beneath the surface. Throughout his career, Freud made close-up portraits,

even turning his unsparing gaze on himself (fig. **18.48**). In his self-portrait from 1983–85, skin becomes a harsh terrain of myriad hues, with deep pink crevices and thick white highlights. When experiencing a painting by Freud "in the flesh," one is aware of pigment, yet never loses the sense of depicted flesh as a living, mutable substance that painfully documents, in the words of Shakespeare's Hamlet, "the thousand natural shocks that flesh is heir to."

Moore

Stylistically and temperamentally, **Henry Moore** (1896–1986), like Barbara Hepworth, contemplated the human condition in calmer philosophical terms than such contemporaries as Bacon and Dubuffet. While faithful to his origins in abstraction, he continued to work in a biomorphic mode, which even at its most reductive was on the brink of evoking the human presence. During World War II he made thousands of drawings of the underground air-raid shelters in London (fig. **18.49**). As huge numbers of people sought

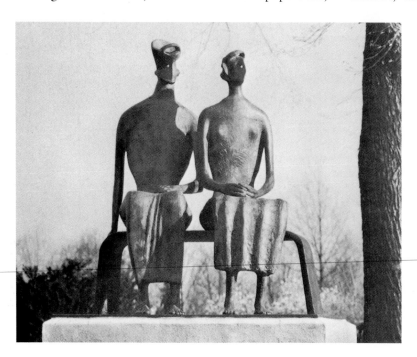

18.50 Henry Moore, *King and Queen*, 1952–53. Bronze, height 63½" (161.3 cm). Hirshhorn Museum and Sculpture Garden, Smithsonian Institution, Washington, D.C.

refuge from German bombs in the tunnels of the London Underground, Moore was able to study reclining figures and figural groups that gave him many ideas for sculpture. During and after the war he continued to develop his theme of recumbent figures composed as an intricate arrangement of interpenetrating solids and voids (see fig. 15.53). The early 1950s also brought forth new experiments in more naturalistic, albeit attenuated figures, such as *King and Queen* (fig. **18.50**). First inspired by an ancient Egyptian sculpture of a royal couple, Moore's king and queen have masks for faces and flattened-out, leaf-like bodies, yet maintain a sense of regal dignity. They have nothing to do with "present-day Kings and Queens," Moore said, but with the "archaic or primitive idea of a King."

Hepworth

Barbara Hepworth (1903–75), the other British sculptor of international stature before and after World War II, was a student at the same time as Henry Moore at Leeds School of Art. The two remained close through much of their careers. Throughout the 1920s, she made highly accomplished figurative sculptures in wood and stone that reflected her admiration for Egyptian, Cycladic, and Archaic Greek art. Hepworth's sculpture began to shed its semblance to the real world after 1931, when she carved *Pierced Form* (destroyed). In this alabaster sculpture, the stone is penetrated in the center by a large hole to make, in the artist's words, "an abstract form and space." This crucial rupture with the notion of carved sculpture as a solid,

closed form was one of Hepworth's major contributions to modern sculpture, and the discovery would inform her subsequent work as well as that of Moore. Her exposure to the work of Arp (who had previously made his own penetrated sculptures) prompted Hepworth to make biomorphic, multipart sculptures in the early 1930s, but by 1934 she adopted a more geometric syntax and eliminated, at least for a time, the remaining vestiges of naturalism from her work.

In one of her best-known works, *Two Segments and Sphere* (fig. **18.51**), 1935–36, Hepworth heightens the tension between the geometric forms, with their smooth, perfected finish, through the precarious positioning of the sphere. In the late 1930s Hepworth produced some of her most severely simplified sculptures, a number of them consisting of a single marble column, gently rounded or delicately indented to emphasize their organic, figurative source.

For a period after World War II, the sense of a naturalistic subject re-emerged in Hepworth's sculptures when she discovered a promising new direction through a series of so-called *Groups* in white marble (fig. **18.52**), small in scale and magical in their impact. She was inspired to make them after watching people stroll through the Piazza San Marco during a 1950 trip to Venice, where her work was featured at the Biennale. The *Groups* were related to her early compositions and to her continuing interest in ancient art, specifically the Cycladic art of prehistoric Greece. In modern terms they recall both Giacometti's groups of walking figures and the biomorphs that inhabit Tanguy's Surrealist landscapes (see fig. 15.17). Much of Hepworth's sculpture of the 1950s was a direct response to the landscape—the rocks, caves, cliffs, and sea—surrounding her home in Cornwall, along with the monumental Neolithic stone menhirs that populate the landscape. She preferred carving in wood or stone to modeling in clay and continued to work with wood and stone on both small and large scales after the war.

18.51 Barbara Hepworth, *Two Segments and Sphere*, 1935–36. Marble, 10½ × 10½ × 8½" (26.7 × 26.7 × 21.6 cm). Private collection.

18.52 Barbara Hepworth, *Group III (Evocation)*, 1952. Marble, height 9" (23 cm). Private collection.

Marvels of Daily Life: European Photographers

Almost every imaginable facet of twentieth-century life was captured by photography, to the extent that the nature—and limits—of the photographic medium came to shape people's responses to visual experience. Although experimental photographers after the war explored photography's immense potential to combine different ways of seeing, as in Siskind's "Abstract-Expressionist" close-ups of wall surfaces or Callahan's botanically precise yet Miróesque *Weed* (see fig. 17.54), it was still some years before photography became a generally accepted art medium on a par with painting, printmaking, or drawing. Nevertheless, photography succeeded in conveying every bit as effectively the era's sense of the fragility as well as the absurdity of modern life. Among the European photographers who produced memorable images of life in the immediate postwar period, Robert Doisneau in France and Josef Sudek in Czechoslovakia both revealed, in highly distinct and individual ways, a poetry in austere or ordinary settings, while the Swiss Werner Bischof documented the effects of six years of conflict across Europe.

Sudek

The Czech **Josef Sudek** (1896–1976) was a leading photographer in Central Europe. Called the "Poet of Prague," Sudek, who lost an arm while serving in World War I, established a successful photographic business in that city in the 1920s and at first made photographs in a Romantic, Pictorialist style. Once German troops occupied Prague in 1939, Sudek retreated into his studio, focusing his

18.53 Josef Sudek, *The Window of My Studio*, 1954. Gelatin-silver print.

18.54 Werner Bischof, *Cologne*, 1946.

camera on whatever caught his eye through the window. He continued his habit of photographing still lifes on his windowsill or views into the garden or the city streets into the 1950s (fig. **18.53**). He said:

> I believe that photography loves banal objects. I am sure you know the fairytales of Andersen: when the children go to bed, the objects come to life, toys, for example. I like to tell stories about the life of inanimate objects, to relate something mysterious: the seventh side of a dice.

Bischof

After studying photography at Zurich's School of Applied Arts, **Werner Bischof** (1916–54) worked as an advertising photographer while also producing beautifully lit images of natural forms and the human figure. From 1942, as a contributor to the cultural magazine *Du*, he turned more toward socially aware photojournalism. When war ended in 1945, Bischof left his neutral country and crossed the continent recording "the face of human suffering" in its many incarnations from France to Romania and Greece.

Images such as the ruined Reichstag (German parliament) building in Berlin, rising out of a shattered city in which people scavenge for firewood or clear rubble with their bare hands, speak eloquently of human resilience and the struggle to create a new beginning. Bischof's desolate cityscapes (fig. **18.54**) find a poetry in the unconscious poise of his human subjects amid this destruction. His photographs of children—including those orphaned and displaced by war—are especially moving documents of this period.

Bischof's photographic record of European cities in the late 1940s makes it graphically clear that, whatever larger shifts in the cultural landscape were taking place, these historic centers of Western culture were in no state to match the vitality and confidence of the American art scene at this time. After working on assignments in India, Japan, and Indo-China (Vietnam) for the Magnum photographic agency, whose founding members included Capa and Cartier-Bresson, Bischof traveled to New York in 1954. Eight months later, photographing in South America, he died in an automobile accident in the Andes.

Doisneau

Something of Dubuffet's serious whimsy was shared by **Robert Doisneau** (1912–94), who, like Brassaï (see fig. 15.60), roamed the streets of Paris seeking and finding what he called "the unimaginable image" within "the marvels of daily life." Having discovered that nothing is more bizarre or amusing than the banal, Doisneau managed to brighten a depressed, existential age with his witty, but never snide, photographic commentary on the foibles, misadventures, and daily pursuits of the human—and particularly Parisian—race. In 1949 he made a series of photographs in the shop of an antique dealer in the city (fig. **18.55**), capturing the varied responses of passersby to a provocative painting of a nude hanging in the window. Such a playful response to postwar Paris was not limited to the work of Doisneau. A group of European artists who coalesced in Paris around 1960 likewise turned to the comic and the absurd as a means of responding to the seemingly precarious status of the society that had emerged from two world wars. The movement promoted by this group, known as *Nouveau Réalisme*, begins the following chapter.

18.55 Robert Doisneau, From the series *The Sideways Glance*, 1949. Gelatin-silver print.

19
Nouveau Réalisme and Pop Art

As the previous chapter makes clear, the European avant-garde mobilized diverse approaches to artmaking in the postwar years. By 1960, though, this diffusion of aesthetic responses coalesced for some of Europe's most daring and ambitious artists in the *Nouveau Réalisme* or New Realism movement. With more than a decade's distance between them and the war, these artists were now able to confront directly what they believed to be its sources: materialism, consumerism, militarism, and nationalism. As the chief postwar symbol of all of these qualities, the United States provided a source of alternating fascination and distress (see *The Marshall Plan and the "Marilyn Monroe Doctrine*," right). Hollywood films, American automobiles, and New York City all provided literal or metaphorical subjects for the New Realists. Yet the U.S. was also seen as Europe's liberator and provider, making the avant-garde's reception of American culture all the more vexed. *Nouveau Réalisme* encompassed a variety of styles and techniques, from the monochrome canvases of Yves Klein to the crushed automobile sculptures of Arman. Humor, particularly irony, was the only unifying characteristic.

Irony likewise motivated the engagement with American consumer culture by American and British Pop artists during the 1950s and 60s. Embracing precisely the frank naturalism and mass-media imagery despised by the Abstract Expressionists, Pop artists engaged in a simultaneous critique of the pretensions of "high art" and the empty materialism of consumer culture. As Andy Warhol said, "The Pop artists did images that anybody walking down Broadway could recognize in a split second—comics, picnic tables, men's trousers, celebrities, shower curtains, refrigerators, Coke bottles—all the great modern things that the Abstract Expressionists tried so hard not to notice." Many artists of the younger generation viewed the legacy of Abstract Expressionism as an oppressive mantle that had to be lifted. They were no longer concerned with the heroic "act" of painting, in self-revelatory gestures and "private Dark Nights." Rather, they found subjects within the immediate environment of their popular culture and sought to incorporate them into their art through depersonalized, often mass-produced means. New Realism and Pop art, Happenings, environments, assemblage began to emerge simultaneously in several American and European cities.

CONTEXT

The Marshall Plan and the "Marilyn Monroe Doctrine"

As devastating as World War II was for Europe and parts of Asia, the cessation of hostilities brought only limited relief. Infrastructures were badly damaged, millions of people were displaced, and economies had collapsed. General George C. Marshall had served as the U.S. Army chief of staff in Europe during the war, assuming the post of Secretary of State in 1947. Marshall believed that the precarious condition of America's wartime allies and enemies would wreak further disaster. Along with humanitarian concerns, he also worried that these vulnerable countries might be prey to Soviet communist expansionism. He proposed providing American financial and technical support, with the stipulation that participating countries would need to generate matching funds and eventually repay some of the aid. Also mandated were trade agreements favorable to the U.S. The Marshall Plan, as it was dubbed, went into effect in 1947. The Plan included an aggressive cultural program, with touring exhibitions of American art and a film-production arm charged with making pro-democracy movies. Most cinemas were, in fact, limited to screening Marshall Plan propaganda reels or Hollywood films, which countries enrolled in the program were required to import. This flood of American consumer goods and culture was both welcomed and scorned. But it could not be ignored. Some European artists looked to Americanization for metaphorical as well as literal sources for their art. In addition to American motifs like cowboys and movie stars, some New Realist artists made works out of imported American goods and abandoned U.S. Army surplus.

In 1961 The Museum of Modern Art mounted The Art of Assemblage, a show that surveyed modern art involving the accumulation of objects, from two-dimensional Cubist *papiers collés* and photomontages, through every sort of Dada and Surrealist object, to junk assemblage sculpture, to complete room environments. Its organizer, William C. Seitz, described such works as follows: "(1) They are predominantly assembled rather than painted, drawn, modeled, or carved; (2) Entirely or in part, their constituent elements are pre-formed natural or manufactured materials, objects, or fragments not intended as art materials." In 1962 the Sidney Janis Gallery's New Realists exhibition opened. The show included a number of the recognized British and American Pop artists, representatives of the French New Realism, and artists from Italy and Sweden working in related directions. Although the American Pop artists had been emerging for several years, Janis' show was an official recognition of their arrival. The European participants seemed closer to the tradition of Dada and Surrealism; the British and Americans more involved in contemporary popular culture and representational, commercial images. But Pop was not embraced by everyone. Proponents of abstract painting decried the arrival of commercialism in art as rampant vulgarity, a youthful attack on high culture.

"Extroversion is the Rule": Europe's New Realism

Nouveau Réalisme developed in the 1950s when the prevailing trend in Europe was geometric abstraction and *Art Informel* (see chapter 18). New Realism was officially founded in 1960 by the French critic Pierre Restany in the Paris apartment of artist Yves Klein. A manifesto was issued and exhibitions were held in Milan in 1960 and at Restany's Gallery J in Paris the following year. The latter was labeled 40 Degrees Above Dada, indicating a kinship, at least according to Restany, with the earlier movement. The original members of the group included Klein, Martial Raysse, Arman, Jean Tinguely, Daniel Spoerri, Raymond Hains, Jacques de la Villeglé, and François Dufrêne. All of these, with the exception of Klein, were included in The Art of Assemblage exhibition in New York, and in the New Realists show at Sidney Janis. In the catalogue for the latter, Pierre Restany is quoted as saying:

In Europe, as well as in the United States, we are finding new directions in nature, for contemporary nature is mechanical, industrial and flooded with advertisements. ... The reality of everyday life has now become the factory and the city. Born under the twin signs of standardization and efficiency, extroversion is the rule of the new world....

Klein

A central figure of *Nouveau Réalisme* was **Yves Klein** (1928–62), who was concerned with the dramatization of ideas beyond the creation of individual works of art; the mystical basis of his art set his work apart from his American Pop contemporaries. He was a member of an obscure spiritual sect, the Rosicrucian Society, and held an advanced black belt in judo. He even opened his own judo school in Paris in 1955, the year of his first public exhibition there. In his blue monochrome abstractions (fig. **19.1**), paintings that caused an uproar when first shown in Milan in 1957, he covered the canvas with a powdery, eye-dazzling, ultramarine pigment that he patented

19.1 Yves Klein, *Blue Monochrome*, 1961. Dry pigment in synthetic polymer medium on cotton over plywood, 6' 4⅞" × 4' 7⅛" (2 × 1.4 m). The Museum of Modern Art, New York.

as IKB ("International Klein Blue"). For Klein, this blue embodied unity, serenity, and, as he said, the supreme "representation of the immaterial, the sovereign liberation of the spirit." These flat, uninflected paintings carried no indication of the artist's hand on their surface and were a radical alternative to gestural abstraction, though Klein cheekily differentiated the works by pricing each one differently. Klein's assertion of the futility of quantifying aesthetic experience in monetary terms appeared again in a 1959 project for which he printed certificates of authenticity for "immaterial pictorial sensibility" that he sold at a price tied to the current value of gold. He even insisted on payment in gold dust. Meeting the buyer along the Seine, Klein would exchange his certificate for the gold, throwing half of the metal into the river. The buyer was then required to burn the certificate of authenticity.

In 1958 Klein attracted audiences to an exhibition of nothingness—*Le Vide (The Void)*—nothing but bare walls in a Parisian gallery. In 1960 he had himself photographed leaping off a ledge in a Paris suburb as a "practical demonstration of levitation" (fig. **19.2**). The photograph was doctored to remove the judo experts holding a tarpaulin below, but Klein, a serious athlete, was obsessed with the notion of flight or self-levitation. In this altered image he presents less a prankish demonstration of levitation than an artistic leap of the imagination. He wrote:

> Today the painter of space ought actually to go into space to paint, but he ought to go there without tricks or fraud, not any longer by plane, parachute or rocket: he must go there by himself, by means of individual, autonomous force, in a word, he should be capable of levitating.

The artist's blue *Anthropometries* (a term invented by Restany) of 1960 were realized with nude models, his "living brushes," who were covered with blue paint and instructed to roll on canvases to create imprints of their bodies (fig. **19.3**). In the *Cosmogonies*, he experimented with the effects of rain on canvas covered with wet blue paint. To make his fire paintings, he used actual flames to burn patterns into a flame-retardant surface and, in later works, added red, blue, and yellow paint (fig. **19.4**). With his passion for a spiritual content comparable to that preached by Kandinsky, Mondrian, and Malevich, Klein was moving against the trend of his time with its insistence on impersonality, on the painting or sculpture as an object, and on the object as an end in itself.

19.2 Yves Klein, *Leap into the Void*, Fontenay-aux-Roses, October 23, 1960. Photograph by Harry Shunk.

19.3 Yves Klein, *Shroud Anthropometry 20, "Vampire,"* c. 1960. Pigment on canvas, 43 × 30" (109.2 × 76.2 cm). Private collection.

Tinguely and Saint-Phalle

For Swiss artist **Jean Tinguely** (1925–94), a friend and collaborator of Klein's, mechanized motion was the primary medium. "The machine allows me," he said, "above anything, to reach poetry." After the formulation of metamechanic reliefs and what he called "metamatics," which permitted the use of chance and sound in motion machines, he introduced painting machines in 1955, another attempt at debunking the assumptions surrounding so-called Action Painting or French *Tachisme*. By 1959 he had perfected the metamatic painting machines, the most impressive of which was the *metamatic-automobile-odorante-et-sonore* for the first biennial of Paris. It produced some 40,000 paintings in an Abstract Expressionist style on a roll of paper that was then cut by the machine into individual sheets.

In 1960 Tinguely came to New York, where he and his companion, the artist Niki de Saint-Phalle, sought like-minded American artists with whom to collaborate. Tinguely's 1960 *Homage to New York* (fig. **19.5**), created in the garden of New York's Museum of Modern Art out of refuse and motors gathered from around the city, was a machine designed to destroy itself. An invited audience watched for about half an hour as the machine smoked and sputtered, finally self-destructing with the aid of the New York Fire Department. A remnant is in the museum's collection.

19.5 Jean Tinguely, *Homage to New York*, 1960. Mixed media. Self-destructing installation in the garden of The Museum of Modern Art, New York.

Parisian-born **Niki de Saint-Phalle** (1930–2002) lived in New York from 1933 to 1951 and exhibited with the New Realists from 1961 to 1963. In the early 1960s she began to make "Shot-reliefs," firing a pistol at bags of paint placed on top of assemblage reliefs. As the punctured bags leaked their contents, "drip" paintings were created by chance methods (fig. **19.6**). These works were both a parodic comment on Action Painting and a ritualistic kind of Performance art. Occasionally titled with references to corporate businessmen or her father, her shooting paintings also delivered strong political and personal messages (she recounted her father's sexual abuse of her in an autobiography, *Mon secret*). Saint-Phalle is best known for her *Nana* or woman figures, which came to represent the archetype of an all-powerful woman. These are rotund, highly animated figures made of *papier-mâché* or plaster and painted with bright colors (fig. **19.7**). SHE ("*hon*" in Swedish) (fig. **19.8**), an eighty-two-foot, six-ton (25 m, 6.09 tonne) reclining *Nana*, was made in collaboration with Tinguely and a Swedish sculptor named Per-Olof Ultvedt for the Moderna Museet in Stockholm, where it was exhibited. Visitors entered the sculpture on a ramp between the figure's legs. Inside this giant womb they encountered a vast network of interconnected compartments with several installations, including a bottle-crunching machine, a planetarium, and a cinema showing Greta Garbo movies. The work was destroyed after three months, although the head remains in the permanent collection of the Moderna Museet.

19.6 Niki de Saint-Phalle, *Shooting Picture*, 1961. Plaster, paint, string, polythene and wire on wood, 56¼ × 30¾ × 3⅛" (143 × 78 × 8 cm). Tate, London.

19.7 Niki de Saint-Phalle, *Black Venus*, 1965–67. Painted polyester, 9' 2¼" × 2' 11" × 2' (2.8 × 0.89 × 0.61 m). Whitney Museum of American Art, New York.

19.8 Niki de Saint-Phalle, *SHE—A Cathedral*, 1966. Mixed-media sculptural environment, 20 × 82 × 30' (6.1 × 25 × 9.1 m). Moderna Museet, Stockholm (fragmentary remains).

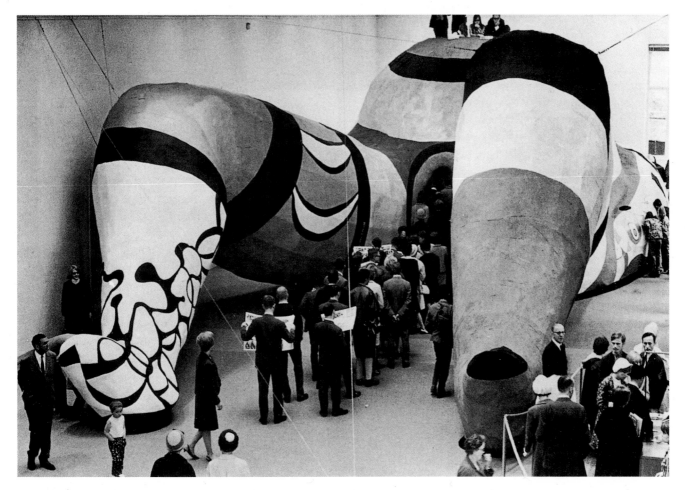

Arman

Arman (Armand Fernández) (1928–2005) was a friend and in some degree a competitor of Klein's. In 1960 he filled a Parisian gallery with refuse, calling it *Le Plein (Fullness)*, thus countering Klein's exhibition of nothingness in *Le Vide*. Arman either fractured objects such as violins into many slivers or made assemblages, which he called "accumulations," consisting of reiterated objects—such as old sabres, pencils, teapots, or eyeglasses. He placed these

19.9 Arman, *La Couleur de mon amour*, 1966. Polyester with imbedded objects, 35 × 12" (88.9 × 30.5 cm). Collection Philippe Durand-Ruel, Paris.

19.10 Arman, *Long-Term Parking*, 1982. Sixty automobiles embedded in cement, 60 × 20 × 20' (18.3 × 6.1 × 6.1 m). Centre d'Art de Montcel, Jouy-en-Josas, France.

objects under vitrines or imbedded them in transparent, quick-setting polyester. Later he created clear plastic figures to act as containers for them. Thus a transparent nude torso (fig. **19.9**) contains a cluster of inverted paint tubes that pour brilliantly colored streamers of paint down into the belly and groin.

Arman called one group of his assemblages "*poubelles*" (trash cans), a term that comments on the prodigal waste inherent in contemporary consumerism while also alluding to the potential for visual poetry in life's recycled detritus, as we have seen in the art of Schwitters (see chapter 11). In 1982 Arman realized a work on a grand scale with *Long-Term Parking* (fig. **19.10**), a sixty-foot (18.3 m) concrete tower with some sixty complete automobiles imbedded in it. The park-like setting outside Paris affirms the artist's contention that, far from expressing the anti-art bias present in Duchamp's original use of found objects, *Long-Term Parking* reflects a desire to restructure used or damaged materials into new, aesthetic forms as a metaphor for the hope that modern life may yet prove salvageable.

César

César Baldaccini, known as **César** (1921–98), created comparable effects from the assemblage of old iron scraps and machine fragments. His work developed independently of trends in the United States but paralleled that of certain American sculptors, notably John Chamberlain (see fig. 17.43). In his constructions, César tended toward

19.11 César, *The Yellow Buick*, 1961. Compressed automobile, 59½ × 30¾ × 24⅞" (151.1 × 78.1 × 63.2 cm). The Museum of Modern Art, New York.

abstraction but often returned to the figure. (Paradoxically the figure is also implicit in many of the abstract works.) His 1958 *Nude* is a pair of legs with lower torso, eroded and made more horrible by the sense of life that remains. During the late 1950s and early 60s (and with variants in new materials into the 90s) he made what he called "compressions"—assemblages of automobile bodies crushed under great pressure and then pressed into massive blocks of varicolored materials, as they are in auto junkyards when the metal is processed for reuse (fig. **19.11**).

Raysse

The work of **Martial Raysse** (b. 1936) perhaps has the most in common with British and American Pop artists, though his beach scenes are more reminiscent of his native Côte d'Azur than Coney Island (fig. **19.12**). In 1962, for an exhibition at Amsterdam's Stedelijk Museum, the artist created an installation called *Raysse Beach*. Using life-size, photographic cut-outs of bathing beauties set in an actual environment of sand and beach balls, he achieved a synthetic recreation of an expensive watering place, a kind of artificial paradise for the Pop generation. Central to *Raysse Beach* are the stereotypical images of women drawn from advertising. After participating in Janis' New Realists exhibition in 1962, Raysse spent time in both New York and Los Angeles and associated with American artists such as Claes Oldenburg and Robert Rauschenberg, whom he had already met in Paris. Their work is discussed later in this chapter.

Christo and Jeanne-Claude

Though never formally associated with *Nouveau Réalisme*, the art of **Christo** (Christo Vladimirov Javacheff) (b. 1935) and **Jeanne-Claude** (Jeanne-Claude Denat de Guillebon) (b. 1935) shares the group's fascination with everyday objects and their capacity for cultural transformation and aesthetic transcendence. Christo was born in Bulgaria, which had become a Soviet satellite state after World War II. Travel outside the "Eastern bloc," as the Soviet Union and the countries under its domination were known, was rarely permitted. Christo escaped from the Eastern bloc by way of Prague in 1957, studying for a semester at the Vienna Fine Arts Academy before relocating the following year to Paris. There he met his future wife Jeanne-Claude, who became his artistic collaborator in 1961. By then, Christo had already begun to wrap quotidian objects—initially studio refuse or household items as well as objects purchased at flea markets—in cloth. These wrapped forms ranged from more recognizable shapes like a chair, a woman, or a Volkswagen automobile, to unidentified objects, which present themselves as abstract, highly enigmatic sculptures (fig. **19.13**). The artistic collaboration of Christo and Jeanne-Claude focuses on large-scale, outdoor

19.12 Martial Raysse, *Tableau dans le style français*, 1965. Assemblage on canvas, 7' 1⅞" × 4' 6⅜" (2.2 × 1.4 m). Collection Runquist.

19.13 Christo, *Package 1962*, 1962. Fabric and rope mounted on board, 36⅝ × 26¾ × 12¼" (93 × 68 × 31 cm).

19.14 Christo and Jeanne-Claude, *Wrapped Kunsthalle*, 1968. Bern, Switzerland. Photo in collection of Christo and Jeanne-Claude.

works such as the 1961 project Dockside Packages, in which a stack of 55-gallon oil drums resting on the busy quay at Cologne Harbor was shrouded in fabric. Most of their early site-specific projects, however, were carried out only in drawings and collages. But in 1968, they actually wrapped their first building, the Kunsthalle in Bern, Switzerland (fig. **19.14**). Here, the urban environment is transformed by the simultaneous absence and presence of the building: the exterior is hidden, but the volume and materiality of the museum asserts themselves even more emphatically thanks to the wrapping. Read as a veil, the fabric summons associations with disguise and mystery. As a shroud, the wrap instead suggests the ritual and memorial functions of the museum as a tomb for culture. Banded with rope, the building also resembles a consumer object, packaged for delivery. With this, the artistic practice of Christo and Jeanne-Claude not only alerts the viewer to the particularities of the urban and rural landscape but also raises questions about the commodification of culture in the postwar era.

Rotella, Manzoni, and Broodthaers

The Italian artist **Mimmo Rotella** (1918–2006) was an early practitioner of the New Realist technique known as décollage, which he began to use in 1953 (fig. **19.15**). The antithesis of collage, which involves layering materials, décollage is a reductive process in which layers are removed by tearing to reveal what lies beneath. A familiar feature of any urban landscape is the layers of half-torn posters—modern urban palimpsests—that decorate billboards, kiosks, and walls. Rotella stripped these posters, often promoting Italian films, from city walls and mounted them on canvas only to tear them off layer by layer. With traces of several posters visible, the finished work evokes a variety of meanings. No longer a clear advertisement for a particular

product or event, the image becomes a lyrical record of an ever-changing urban culture. "What a thrill, what fantasy, what strange things happen," he said, "clashing and accumulating between the first and last layer." Sometimes, Rotella used *grattage* (scraping) along with peeling and tearing to arrive at a work of complete abstraction that

19.15 Mimmo Rotella, *Untitled*, 1963. Décollage, 47¼ × 39⅜" (120 × 100 cm). Location unknown.

resembles Abstract Expressionist paintings in its seeming spontaneity and record of gesture.

The idiosyncratic art of the Italian **Piero Manzoni** (1933–63) ushered in much of the conceptually based work of the 1960s and 70s that would follow his death. A significant event in Manzoni's career, which was even more short-lived than Klein's, was the 1957 exhibition in Milan of the French artist's monochrome paintings. The young Manzoni was an *agent provocateur* in the Dada tradition, as when he offered for sale balloons that would become sculptures once inflated. He charged significantly more for balloons filled with his own breath, thereby playfully addressing the Romantic concept of artistic genius. Inspiration—derived from the Greek word for "breath"—can be collected along with paintings and sculptures. Manzoni pushed this commentary on the artist's capacity to embody genius even further when, in 1961, he signed cans purportedly containing his own excrement. He also made "living sculpture" by signing the bodies of friends or nude models and providing certificates of authenticity, resulting in a kind of "living readymade."

Manzoni was involved with the Italian group *Arte nucleare* (Nuclear Art), which denounced the idea of personal style and, like latter-day Futurists, called for an art of explosive force in the postnuclear age. Klein also exhibited with this group in Milan in 1957. That year, after seeing Klein's show, Manzoni ceased to make tar-based paintings and began his series of *Achromes*, monochrome works with neutral surfaces that were emphatically devoid of any imagery. The *Achromes* consisted of a whole range of media, including plaster or cotton balls, or pebbles mounted on canvas. *Achrome* of 1959 (fig. **19.16**) is reminiscent of the work of an older Italian artist, Fontana (see fig. 18.33), for Manzoni simply manipulated the canvas by folding it into pleats.

One of the "living sculptures" that Manzoni signed in 1962 was the Belgian **Marcel Broodthaers** (1924–76), a poet who began to make art objects in 1964. Like many of his contemporaries discussed in this chapter, Broodthaers staged performances and drew the materials for his reliefs and assemblages from the artifacts of everyday life. He also took part in exhibitions that included work by New Realist as well as Pop artists. Yet his was a highly individual and hermetic form of expression, one shaped just as much by the Surrealist climate that dominated postwar Brussels, thanks largely to the example of his fellow countryman René Magritte (see chapter 15). A case in point is *La Tour visuelle* (fig. **19.17**), a mysterious construction of small glasses covered with magazine reproductions of an eye that recalls Surrealist objects of the 1930s.

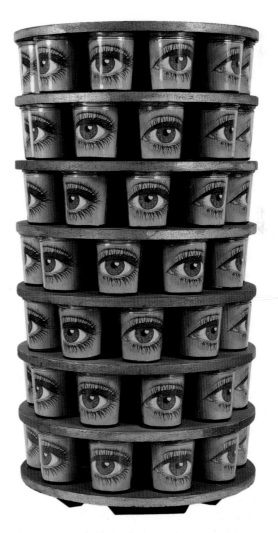

19.16 Piero Manzoni, *Achrome*, 1959. Kaolin on pleated canvas, 55⅛ × 47¼" (140 × 120 cm). Musée National d'Art Moderne, Centre d'Art et de Culture Georges Pompidou, Paris.

19.17 Marcel Broodthaers, *La Tour visuelle*, 1966. Glass, wood, and magazine reproductions, 33½ × 31½" (85 × 80 cm). The Scottish National Gallery of Modern Art, Edinburgh.

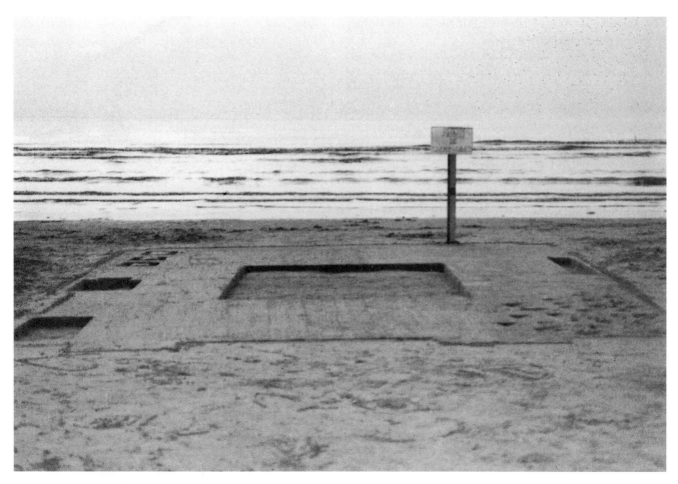

19.18 Marcel Broodthaers, *Ground plan of Musée d'Art Moderne* at Le Coq, on the North Sea coast of Belgium. View of the ground plan of the *Section Documentaire*, August 1969.

Broodthaers, who detested commercialism and what he saw as fashion trends in art, accused the New Realists of acquiescing in the "industrial accumulations that our era produces." Much of his activity centered on Dada-inspired inquiries into the nature of art and subversive alternatives to traditional art institutions. In 1968 he designated his own fictitious Musée d'Art Moderne whose various "sections" were manifested in differing venues, from his house to temporary exhibitions. In 1969 he created his virtual museum on a Belgian beach on the North Sea coast, by tracing its grand plan in the sand. Wearing "museum" hats, he and a colleague set up signs warning visitors not to touch the objects, only to have it all washed away by the tide (fig. **19.18**).

"This is Tomorrow": Pop Art in Britain

Although Pop art has often been regarded as an American phenomenon, it was first introduced in Britain in the mid-1950s. The term was first used in print in 1958 by the English critic Lawrence Alloway, but in a somewhat different context than its subsequent use. Late in 1952, calling themselves the Independent Group, Alloway, the architects Alison and Peter Smithson, the artist Richard Hamilton, the sculptor Eduardo Paolozzi, the architectural historian Reyner Banham, and others met in London at the Institute of Contemporary Arts. The discussions focused around popular (thus, Pop) culture and its implications—such entities as Western movies, science fiction, billboards, and machines. In short, they concentrated on aspects of contemporary mass culture and were centered on its current manifestations in the United States.

After a period of postwar austerity, 1950s Britain began to experience a prosperity that created a mass market for consumer and cultural products. American popular culture was embraced as a liberating, egalitarian force by a new generation who had little time for the restricting exclusivity of "high culture," a notion that included not only aristocratic classicism but also the essentially minority pleasures of modernist abstraction.

Hamilton and Paolozzi

Richard Hamilton (b. 1922) defined Pop art in 1957 as "Popular (designed for a mass audience), Transient (short-term solution), Expendable (easily forgotten), Low cost, Mass produced, Young (aimed at youth), Witty, Sexy, Gimmicky, Glamorous and Big Business." A pioneer Pop work is his small collage made in 1956 and entitled *Just what is it that makes today's homes so different, so appealing?*

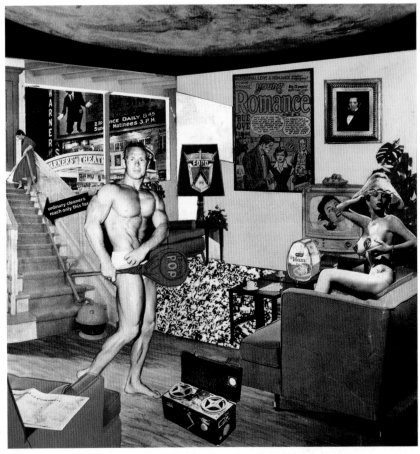

19.19 Richard Hamilton, *Just what is it that makes today's homes so different, so appealing?* 1956. Collage on paper, 10¼ × 9¾" (26 × 24.8 cm). Kunsthalle Tübingen, Sammlung Zundel.

(fig. **19.19**). A poster of this work was used in a multimedia exhibition held at London's Whitechapel Art Gallery in 1956, entitled This is Tomorrow. Hamilton was a disciple of and respected authority on Marcel Duchamp, whose influence on Pop art cannot be overestimated. Hamilton's collage shows a "modern" apartment inhabited by a pin-up girl and her muscle-man mate, whose Tootsie Pop barbell prophesies the Pop movement on its label. Like Adam and Eve in a consumers' paradise, the couple have furnished their apartment with products of mass culture: television, tape recorder, an enlarged cover from a comic book, a Ford emblem, and an advertisement for a vacuum cleaner. Through the window can be seen a movie marquee featuring Al Jolson in *The Jazz Singer*. The images, all culled from contemporary magazines, provide a kind of inventory of visual culture.

An important point about Hamilton's, and subsequent Pop artists', approach to popular culture is that their purpose was not entirely satirical or antagonistic. They were not Expressionists like George Grosz and the Social Realists of the 1930s who attacked the ugliness and inequities of urban civilization. In simple terms, the Pop artists looked at the world in which they lived and examined the objects and images around them with intensity and penetration, frequently making the viewer conscious of that omnipresence for the first time. This is not to say that the artists, and especially Hamilton, were unaware of the ways in which consumer mass culture is communicated to the public—its clichés, its manipulations. On the contrary, his work is often rich with irony and humor.

From the 1960s onward, Hamilton was deeply involved with photographic experiments that broke down the barriers between "fine art" practices and photography. His painting, *I'm dreaming of a white Christmas* (fig. **19.20**),

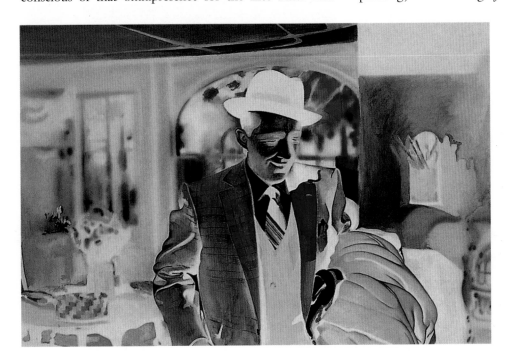

19.20 Richard Hamilton, *I'm dreaming of a white Christmas*, 1967–68. Oil on canvas, 42 × 63" (106.7 × 160 cm). Öffentliche Kunstsammlung Basel, Kunstmuseum.

and a subsequent screenprint, *I'm dreaming of a black Christmas*, were based on a film still of Bing Crosby in the 1954 movie *White Christmas*. By effecting in paint the kind of chromatic reversal found in a photographic negative he creates not only a magical, looking-glass world, but pointedly transforms the protagonist of *White Christmas* into a black man.

The sculptor **Eduardo Paolozzi** (1924–2005), an original member of the Independent Group, produced collages in the early 1950s made from comic strips, postcards, and magazine clippings that are today regarded as important forerunners of Pop art. Originally influenced by Giacometti, Dubuffet, and Surrealism, Paolozzi became interested in the relation of technology to art and emerged as a serious spokesman for Pop culture. In the mid-1950s he began to make bronze sculptures whose rough surfaces were cast from found objects, resulting in creatures that resemble towering, battered robots. Searching for forms and techniques consistent with his growing interest in machine technology, Paolozzi produced welded sculptures in the 1960s that vary from austere, simplified forms in polished aluminum to elaborate polychromed constructions. While the snake-like tubular forms of *Medea* (fig. **19.21**) may have been inspired by the ancient Hellenistic sculpture *Laocoön*, which shows the mythical Greek prophet and his sons battling sea-serpents, Paolozzi's humanoid machine seems to have materialized from the science fiction screen.

Blake and Kitaj

Of the other English Pop artists, **Peter Blake** (b. 1932) took subjects of popular idolatry, such as Elvis Presley, the Beatles, or pin-up girls, and presented them in an intentionally naive style. His early painting *On the Balcony* (fig. **19.22**) was inspired by a Social Realist painting he saw in New York's Museum of Modern Art of working-class people holding masterpieces of modern art that they could never afford to own. In his own variation on the theme, Blake's young people hold paintings, including, at the left, Manet's *On the Balcony*. But they are also surrounded by images from popular media and advertising, as well as by paintings by Blake and his contemporaries.

An ambiguous but crucial figure in the development of British Pop is the American **R. B. Kitaj** (1932–2007), who studied at Oxford and at London's Royal College of Art under the GI Bill that gave services personnel access to college education after the war. He subsequently lived mainly in England. Kitaj painted everyday scenes or modern historical events and personalities in broad, flat color areas combined with a strong linear emphasis and a sense of fragmentation that is consistent with the style of most Pop art. His subject matter, however, diverges from that of his peers.

19.21 Eduardo Paolozzi, *Medea*, 1964. Welded aluminum, 6' 9" × 6' (2.1 × 1.8 m). Rijksmuseum Kröller-Müller, Otterlo.

19.22 Peter Blake, *On the Balcony*, 1955–57. Oil on canvas, 47¾ × 35¾" (121.3 × 90.8 cm). Tate, London.

19.23 R. B. Kitaj, *The Autumn of Central Paris (After Walter Benjamin)*, 1972–73. Oil on canvas, 60 × 60" (152.5 × 152.5 cm). Private collection.

Unique to Kitaj is an emphatic disinterest in popular culture, counterbalanced by a serious, wide-ranging commitment to political and literary themes. His paintings often contain evocative combinations of images derived from sources too complex to yield a clear or specific message. The characteristic work seen here (fig. **19.23**) shows a Parisian café scene in which Kitaj's hero, the leftwing German Jewish philosopher Walter Benjamin, can be identified, juxtaposed with a man wielding a red pick, as if to announce the calamities of 1940 that would drive Benjamin to suicide

as he fled the Nazi troops occupying France. Kitaj's eloquent description of Benjamin's kaleidoscopic accounts of modernity seems to pertain equally to his own work: "His wonderful and difficult montages, pressing together quickening tableaux from texts and from a disjunct world, were called citations by a disciple of his who also conceded that the picture-puzzle distinguished everything he wrote."

Hockney

David Hockney (b. 1937), a student of Kitaj's at the Royal College, was so gifted and productive that he had already gained a national reputation by the time of his graduation. Emerging within the same period as the Beatles, Hockney—with his peroxide hair, granny glasses, gold lamé jacket, and easy charm—became something of a media event in his own right, a genial exponent of the go-go, hedonistic style of the 1960s. Although Hockney projected a self-image that drew on pop culture, his art did not; instead, he used his own life and the lives of his friends and lovers—their faces and figures, houses, and interiors. These he rendered in a manner sometimes inspired by Picasso and Matisse, but often influenced by Dubuffet, in the delicate *faux naïf* manner of children.

Hockney has long maintained a residence in southern California. There the swimming pool became a central image in his art, complete with its cool, synthetic hues. *A Bigger Splash* (fig. **19.24**) combines his signature equilibrium of elegant Matissean flat-pattern design and luxurious mood with a painterly virtuosity for the splash itself. One critic described this sense of suspended animation as the "epitome of expectant stillness," which is due partly to the artist's habit of working from photographs. Infatuated with the Polaroid and, later, with 35mm cameras, Hockney

19.24 David Hockney, *A Bigger Splash*, 1967. Acrylic on canvas, 8' ⅛" × 8' ⅛" (2.4 × 2.4 m). Tate, London.

19.25 David Hockney, *The Brooklyn Bridge, Nov. 28th 1982*, 1982. Photographic collage, 42¹⁵⁄₁₆ × 22¹³⁄₁₆" (109.1 × 57.9 cm). Private collection.

has used photography to re-explore the riches of the space–time equation investigated by Braque and Picasso in Analytic Cubism. In his large collage of the Brooklyn Bridge, dozens of smaller sequential photographs compose a single motif, simulating the scanning sensation of actual vision (fig. **19.25**). Hockney termed his composite photographic images "joiners."

Such treatments of subject matter infiltrated Hockney's paintings as well, including the 1984 *A Visit with Christopher and Don, Santa Monica Canyon* (fig. **19.26**). This panoramic composition recreates a visit to the house of the artist's friends, the painter Don Bachardy and the writer Christopher Isherwood. The viewer's eye is carried through the fractured spaces of the house, where we see the residents at work at either end and where we periodically encounter the same fractured view of the Santa Monica Canyon.

Signs of the Times: Pop Art in the United States

Pop art, especially during the 1960s, had a natural appeal to American artists, who were living in the midst of an even more blatant industrial and commercial environment than that found in Great Britain. Once they realized the tremendous possibilities of their everyday surroundings in the creation of new subject matter, the result was generally a bolder and more forthrightly aggressive art than that of their European counterparts.

Toward the end of the 1950s, as we have already noted, there were many indications that American painting was moving away from the heroic rhetoric and grand painterly gestures of Abstract Expressionism. (For example, De Kooning had parodied the gleaming smiles and exaggerated cleavage of American movie starlets in his paintings of women, one of which even included a cut-out mouth from a popular magazine advertisement.) American art had a long tradition of interest in the commonplace that extended from the *trompe l'oeil* paintings of the nineteenth century (see fig. 2.43) through the Precisionist painters of the early twentieth (see fig. 16.30). Marcel Duchamp's anti-art program led younger painters back to Dada and most specifically to Kurt Schwitters (see fig. 11.22), who was a crucial model for several young artists. Two leading American artists, Robert Rauschenberg and Jasper Johns, were the most obvious heirs to Duchamp and Schwitters. The art of these important forerunners to Pop art has been referred to as Neo-Dada.

19.26 David Hockney, *A Visit with Christopher and Don, Santa Monica Canyon*, 1984. Oil on canvas, 6 × 20' (1.8 × 6.1 m). Collection the artist.

Rauschenberg

Robert Rauschenberg (1925–2008), one of the most important artists in the establishment of American Pop's vocabulary, came of age during the Depression in Port Arthur, Texas. "Having grown up in a very plain environment," he once said, "if I was going to survive, I had to appreciate the most common aspects of life." After serving in the U.S. Navy in World War II and with the help of the GI Bill, Rauschenberg studied at the Kansas City Art Institute and at the Académie Julian in Paris. In 1948, feeling the need for a more disciplined environment, he made the first of several visits to Black Mountain College, an experimental school in North Carolina, to study with Josef Albers. Rauschenberg learned not so much a style as an attitude from the disciplined methods of this former Bauhaus professor, for the young artist's rough, accretive assemblages could hardly be further from the pristine geometry of Albers' abstractions. Even more important in his development was the presence at Black Mountain College in the early 1950s of John Cage, a composer, writer, and devotee of Duchamp, whom Rauschenberg had met in New York, and the choreographer-dancer Merce Cunningham. Cage was an enormously influential figure in the development of Pop art, as well as offshoots such as Happenings, Environments, and innumerable experiments in music, theater, dance, and the remarkably rich combinative art forms that merged all of these media. Rauschenberg would later join Cage and Cunningham in several collaborative performances, designing sets, costumes, and lighting.

Rauschenberg used the world as his palette, working in nearly every corner of the globe and accepting

19.28 Robert Rauschenberg, *Bed*, 1955. Combine painting: oil and pencil on pillow, quilt, and sheet on wood supports, 75¼ × 31½ × 8" (190 × 80 × 20.3 cm). The Museum of Modern Art, New York.

19.27 Robert Rauschenberg and Susan Weil, *Untitled (Double Rauschenberg)*, c. 1950. Monoprint: exposed blueprint paper, 8' 9" × 3' (2.7 × 0.91 m). Collection Cy Twombly, Rome.

virtually any material as fodder for his art. This element of eclectic pastiche is typical of the postmodern approach to culture. It differs from the singular, purist voice of modernism, while owing much to modernism's determined expansion of the media and subject matter available to art. Rauschenberg always used photographic processes in one way or another and, in 1950, collaborating with his former wife Susan Weil, achieved an otherworldly beauty simply by placing figures on paper coated with cyanotype and exposing the paper to light (fig. **19.27**), transforming the intimate botanical specimens of Anna Atkins (fig. 2.5) into a similarly ghostly record of a human subject. He made radically reductive abstractions, including the all-white and all-black paintings he began while at Black Mountain College in the early 1950s, as well as paintings and constructions out of almost anything except conventional materials. An artist who valued inclusivity, multiplicity, and constant experimentation, Rauschenberg scavenged his environment for raw materials for his art, excluding little and welcoming detritus of every sort. He once remarked, "Painting relates to both art and life. Neither can be made. (I try to act in that gap between the two.)"

After settling in New York, Rauschenberg became increasingly involved with collage and assemblage in the 1950s. By 1954 he had begun to incorporate such objects as photographs, prints, or newspaper clippings into the structure of the canvas. In 1955 he made one of his most notorious "combine" paintings, as he called these works, *Bed* (fig. **19.28**). This one included a pillow and quilt over which paint was splashed in an Abstract Expressionist manner, a style Rauschenberg never completely abandoned. His most spectacular combine

19.29 Robert Rauschenberg, *Monogram*, 1959. Combine painting: oil and collage with objects, 42 × 63½ × 64½" (106.7 × 161.3 × 163.8 cm). Moderna Museet, Stockholm.

painting, the 1959 *Monogram* (fig. **19.29**), with a stuffed Angora goat encompassed in an automobile tire, includes a painted and collage-covered base—or rather a painting extended horizontally on the floor—in which free brush painting acts as a unifying element. Whereas *Bed* still bears a resemblance to the object referred to in its title, *Monogram* is composed of disparate elements that do not, as is true of Rauschenberg's work as a whole, coalesce into any single, unified meaning or narrative. The combine paintings clearly had their origin in the collages and constructions of Schwitters and other Dadaists (see fig. 11.23). Rauschenberg's work, however, is different not only in its great spatial expansion, but in its desire to take not so much a Dada, anti-art stance as one that expands our very definitions of art.

In 1962, Rauschenberg began using a photo silkscreen process. Collecting photographs from magazines or newspapers, he had the images commercially transferred onto silkscreens, first in black and white and, by 1963, in color, and then set to work creating a kaleidoscope of images (fig. **19.30**). In the example shown here, the subjects range from traffic signs to the Statue of Liberty to a photograph of Michelangelo's Sistine Ceiling. They collide and overlap but are characteristically arranged in a grid configuration and are bound together by a matrix of the artist's gestural brushstrokes. In 1964, after Rauschenberg had won the grand prize at the Venice Biennale, and as a guarantee against repeating himself, he called a friend in New York and asked him to destroy all the silkscreens he had used to make the works.

19.30 Robert Rauschenberg, *Estate*, 1963. Oil and silkscreen ink on canvas, 8' × 5' 10" (2.4 × 1.78 m). Philadelphia Museum of Art.

Throughout the 1960s, Rauschenberg, like many of the original Pop artists, was involved in a wide variety of activities, including dance and performance. His natural inclination toward collaboration drew him to theater and dance. *Pelican*, a dance he actually choreographed, was performed in 1963 as part of a Pop festival in Washington, D.C. The event took place in a roller-skating rink, and Rauschenberg planned a cast of three—himself, another man on roller skates, and Carolyn Brown, a professional from Merce Cunningham's company who danced on point. The men trailed large parachutes that floated like sails behind them during the performance, which Rauschenberg dedicated to his heroes, the Wright brothers.

In 1984 Rauschenberg launched a seven-year project called ROCI (Rauschenberg Overseas Culture Inter-change), during which he traveled to foreign and often politically sensitive countries to work for the cause of world peace. Collaborating with local artisans and drawing upon indigenous traditions and motifs, Rauschenberg created a body of work in each of the ten countries he visited, including the former Soviet Union, Cuba, China, Tibet, Chile, and Mexico. He completed the series with ROCI USA, for which images were deposited through complex techniques onto a brightly polished surface of stainless steel. The artist then attached a crumpled section of the stainless steel that projects awkwardly from the main support. Typically, chance and accident are welcome, for the highly reflective surface records the activities of the viewers in the gallery.

Johns

Jasper Johns (b. 1930), a native of South Carolina, appeared on the New York art scene in the mid-1950s at the same moment as Rauschenberg, with whom, after 1954, he developed a very close and supportive relationship. Johns' paintings were entirely different but equally revolutionary. At first, he painted targets and American flags in encaustic (an ancient medium of pigment mixed with heated wax), with the paint built up in sensuous, translucent layers (fig. **19.31**). In addition to targets and flags, he took the most familiar items—numbers, letters, words, and maps of the United States—and then painted them with such precision and neutrality that they appear to be objects in themselves rather than illusionistic depictions of objects.

Johns, who destroyed all of his previous work, said the subject of the flag was suggested by a dream in which he was painting an American flag. Because a flag, like a target or numbers, is inherently flat, Johns could dispense with the illusionistic devices that suggest spatial depth and the relationship between figure and ground. At the same time, the readymade image meant that he did not have to invent a composition in the traditional sense. "Using the design of the American flag took care of a great deal for me because I didn't have to design it," he said. "So I went on to similar things like targets—things the mind already knows. That gave me room to work on other levels." This element of impersonality, this apparent withdrawal of the artist's individual invention, became central to many of the

19.31 Jasper Johns, *Flag*, 1954–55 (dated 1954 on reverse). Encaustic oil and collage on fabric mounted on plywood, 42¼ × 60⅜" (107.3 × 153.8 cm). The Museum of Modern Art, New York.

painters and sculptors of the 1960s. Despite their resemblance to actual flags, Johns' flags are clearly paintings, but with his matter-of-fact rendering he introduces the kind of perceptual and conceptual ambiguity with which Magritte had toyed in his painting *The Treachery (or Perfidy) of Images* (see fig. 15.22). Johns' flags and targets exemplify Pop art's concern with signs. They are unique, not mass-produced, objects. And yet, to paint a target is to make a target, not merely a depiction of a target, which in its essentials resembles any other target. Such ambiguities were often exploited in Pop art.

One of the artist's most enigmatic works is *Target with Plaster Casts* (fig. **19.32**), another encaustic painting of a flat, readymade design, but this time the canvas is surmounted by nine wooden boxes with hinged lids, which can either remain closed or be opened to reveal plaster-cast body parts. A strange disjunction exists between the neutral image of a target and the much more emotion-laden body parts, each a different color, just as it does between the implied violence of dismembered anatomical parts and their curious presentation as mere objects on a shelf.

In one of his best-known sculptures, *Painted Bronze*, Johns immortalized the commonplace by taking two Ballantine Ale cans and casting them in bronze (fig. **19.33**). Yet upon close examination it becomes clear that Johns has painted the labels freehand, so what at first appears

19.33 Jasper Johns, *Painted Bronze*, 1960. Painted bronze, 5½ × 8 × 4¾" (14 × 20.3 × 12.1 cm). Museum Ludwig, Cologne.

mass-produced, like a Duchamp readymade, is paradoxically a unique, handwrought form. Moreover, although the cans look identical, one is in fact "open" and cast as a hollow form; the other is closed and solid.

From the end of the 1950s, Johns' paintings were marked by the intensified use of expressionist brushstrokes and by the interjection of actual objects among the flat signs. In *Field Painting* (fig. **19.34**), for example, the Ballantine Ale can reappears, this time as itself. The can is

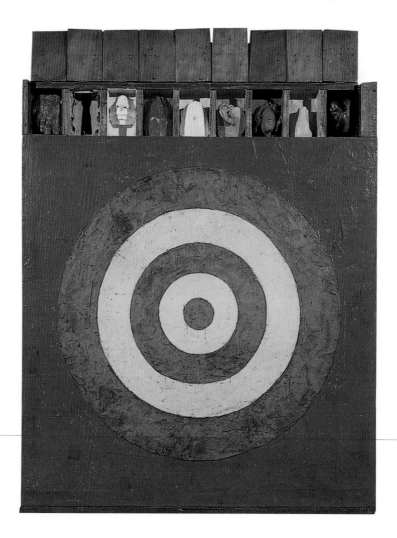

19.32 Jasper Johns, *Target with Plaster Casts*, 1955. Encaustic and collage on canvas with wood construction and plaster casts, 51 × 44 × 3½" (129.5 × 111.8 × 8.9 cm). Collection David Geffen.

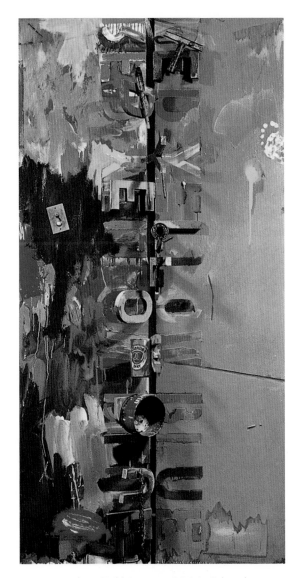

19.34 Jasper Johns, *Field Painting*, 1964. Oil and canvas on wood with objects, 6' × 3' ¾" (180 × 93 cm). Collection the artist.

19.35 Jasper Johns, *Untitled*, 1972. Oil, encaustic, and collage on canvas with objects, 6 × 16' (1.8 × 4.9 m). Museum Ludwig, Cologne.

magnetically attached along with other objects—ones we might find around the artist's studio—to three-dimensional letters that are hinged to the center of the painting. These metal letters spell out "RED," "YELLOW," and "BLUE," although, like their flat counterparts painted on the canvas, they do not necessarily signify the color we read. Johns frequently presents alternative forms of representation in a single painting, for in addition to these signs, he includes color in a welter of Abstract Expressionist paint strokes. One of the foremost printmakers of the postwar era, Johns invoked the names of the primary colors again in a color lithograph titled *Souvenir*, where they encircle his portrait. His drawings and prints usually relate closely to his paintings and sculptures. In *Souvenir*, the various images— the back of a canvas, a flashlight, and a rearview bicycle mirror—are present as actual objects in a painting of the same name. As they often do in Johns' works, the themes here revolve around issues of perception, of looking, and of being looked at.

In the 1970s Johns made paintings that suggest a continuing dialogue between figuration and abstraction, as well as a penchant for complex, hermetic systems of representation. In 1972, in the large, four-panel painting *Untitled* (fig. **19.35**), he introduced a pattern of parallel lines in the far left panel, so-called crosshatches, that have played a role in his work ever since. Johns has said that the crosshatch motif was not one he invented but one he spotted on a passing car, just as he said the flagstone pattern in the two center panels was something he glimpsed on a Harlem wall while riding to the airport in the late 1960s. These flagstone-pattern panels—one in oil, one in encaustic—recreate two slightly different sections of the same panel from an earlier painting called *Harlem Light*. If one panel is superimposed on the other so they match up, the panels form an "imagined square," as Johns described it in his typically enigmatic "Sketchbook Notes." At the far right, in startling contrast to these flat, abstract forms, are three-dimensional casts made from a woman's and a man's body that Johns painted and attached with wing-nuts to strips of wood.

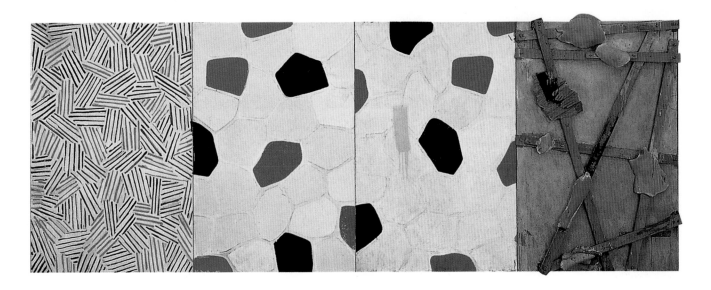

Getting Closer to Life: Happenings and Environments

The concept of mixing media and, more importantly, integrating the arts with life itself was a fundamental aspect of the Pop revolution. A number of artists in several countries were searching for ways to extend art into a theatrical situation or a total environment. A leading spokesman for this attitude was Allan Kaprow, who explained:

A Happening, unlike a stage play, may occur at a supermarket, driving along a highway, under a pile of rags, and in a friend's kitchen, either at once or sequentially. If sequentially, time may extend to more than a year. The Happening is performed according to plan but without rehearsal, audience, or repetition. It is art but seems closer to life.

Happenings may have had their ultimate origins in the Dada manifestations held during World War I (see chapter 11). They might even be traced to the improvisations of the *commedia dell'arte* (a genre of Italian comedy) of the eighteenth century. The post-World War II years saw a global interest in Happening-like performance. The Japanese Gutai Group of Osaka staged such performances as early as 1955, and from 1957 onward they were held in Tokyo as well as Osaka. In Düsseldorf, the Zero Group was founded in 1957 with the aim of narrowing the gap between art and life, while similar ideas were being pursued by artists like Piero Manzoni and Yves Klein. Many of the terms, images, and ideas of Pop art and Happenings found instant popular acceptance, if not always complete comprehension, with the mass media—television, films, newspapers, and magazines. Even television and newspaper advertisements, fashion, and product design were affected, resulting in a fascinating cycle in which forms and images taken from popular culture and translated into works of art were then retranslated into other objects of popular culture. Closely linked to Happenings through the concept of directly involving the viewer—as a participant in art rather than a spectator—was Environment art, in which the artist creates an entire three-dimensional space.

Kaprow, Grooms, and Early Happenings

The first public Happening staged by **Allan Kaprow** (1927–2006), entitled *18 Happenings in 6 Parts*, was held at New York's Reuben Gallery in 1959. This, along with the Hansa and Judson galleries, was an important experimental center where many of the leading younger artists of the 1960s first appeared. Among those who showed at the Reuben Gallery, aside from Kaprow, were Jim Dine, Claes Oldenburg, George Segal, and Lucas Samaras. For Kaprow, the role of Abstract Expressionism was significant. He regarded Pollock's large drip paintings as environmental works of art that implied an extension beyond the edge of the canvas and into the viewer's physical space. Pollock, said Kaprow, "left us at the point where we must become preoccupied with and even dazzled by the space and objects of our everyday life." Pollock's contemporary, the composer John Cage, taught Kaprow at the New School for Social Research in New York City in the late 1950s. Cage helped to bridge art and life by experimenting with musical forms that involved unplanned audience participation and by welcoming chance noises as part of his music. His famous composition *4'33"* consisted of the pianist David Tudor lifting the lid of the piano and sitting for four minutes and thirty-three seconds without playing. The random sounds that occurred during the performance constituted the music.

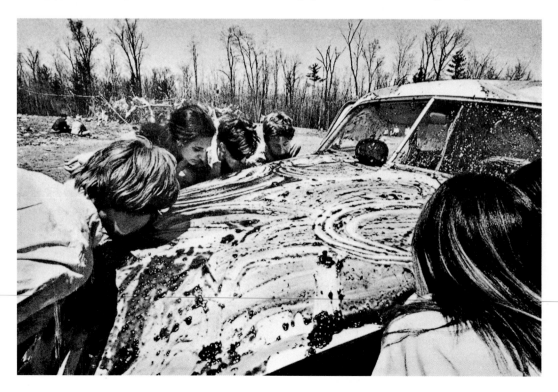

19.36 Allan Kaprow, Photograph from *Household*, a Happening commissioned by Cornell University, 1964.

19.37 Red Grooms, Photograph from *The Burning Building*, a performance at the Delancey Street Museum, New York, 1959.

Happenings (a term that was not embraced by all of those involved) could vary greatly in each instance and with each artist. They were not simply spontaneous, improvisational events but could be structured, scripted, and rehearsed performances. Sometimes they were performed for an audience, which participated to varying degrees according to the artist; sometimes for a camera; and sometimes for no one at all. Because the instigators were for the most part visual artists, visual concerns tended to override dramatic or more conventionally theatrical ones, such as plot or character development. In the moment shown here from Kaprow's 1964 Happening *Household* (fig. **19.36**), the participants are licking strawberry jam from the hood of a car that is soon to be set on fire.

Two months after Kaprow's first Happening at the Reuben Gallery, the artist **Red Grooms** (b. 1937) staged—and performed in—*The Burning Building*, his most famous "play," as he called his version of Happenings, at another New York venue (fig. **19.37**). Grooms, a native of Nashville, Tennessee, settled in New York in 1957, the year he met Kaprow. In *The Burning Building* he played the Pasty Man who, in search of love's secret, pursues the Girl in the White Box into a firemen's den. In the still shown here, he has been knocked out by a fireman, who carries him behind the curtain.

From his early work as a painter and performance artist, Grooms began to make multimedia works on an environmental scale, peopling entire rooms with cut-out figures and objects painted in brilliant and clashing colors. He has continually enlarged his scope to embrace constructions such as the famous *Ruckus Manhattan*, a gargantuan environment he first built in the lobby of a New York office building. With a team of helpers, Grooms created a walk-in map of Lower Manhattan in a spirit of wild burlesque, manic, big-city energy, and broad, slapstick humor (fig. **19.38**).

19.38 Red Grooms and the Ruckus Construction Company, Detail from *Ruckus Manhattan* (World Trade Center, West Side Highway), 1975–76. Mixed media. Installation view Grand Central Station, New York, 1993. Courtesy MTA and Marlborough Gallery, New York.

19.39 George Segal, *The Diner*, 1964–66. Plaster, wood, chrome, laminated plastic, Masonite, fluorescent lamp, glass, and paper, 8' 6" × 9' × 7' 3" (2.6 × 2.7 × 2.2 m). Walker Art Center, Minneapolis.

19.40 George Segal, *Girl Putting on Scarab Necklace*, 1975. Plaster, wood, metal, and glass, 7' × 3' 9" × 3' 9" (2.1 × 1.1 × 1.1 m). Private collection.

Segal

George Segal (1924–2000) began as a painter of expressive, figurative canvases, but feeling hampered by the spatial limitations of painting, he began to make sculpture in 1958. For a number of years he was closely associated with Allan Kaprow (who had staged his first Happening at Segal's New Jersey farm), a connection that stimulated his interest in sculpture as a total environment. By 1961 Segal was casting figures from live models, both nude and fully clothed. He wrapped his subjects in bandages, which he covered in plaster, allowed to dry, and then cut open and resealed, a process that records quite literally the details of anatomy and expression, but retains the rough textures of the original bandages. The figure—or, as is often the case, the group of figures—is then set in an actual environment—an elevator, a lunch counter, a movie ticket booth, or the interior of a bus—with the props of the environment retrieved from junkyards (fig. **19.39**). Although Segal painted the figures in many of his later sculptures, he left them white in the early works, producing the effect of ghostly wraiths of human beings existing in a tangible world. The qualities of stillness and mystery in Segal's sculpture are comparable to the desolate psychological mood of Edward Hopper's paintings (see figs. 16.37, 16.38), while his many treatments of the female nude, including *Girl Putting on Scarab Necklace* (fig. **19.40**), are reminiscent of Degas' paintings of bathers engaged in private moments (see fig. 2.38). In the mid-1970s Segal altered his technique and began to use the body casts as molds from which either plaster or bronze casts could be made. As a result, he was able to make sculpture suitable for outdoor public display.

Oldenburg

Claes Oldenburg (b. 1929), a native of Sweden who was brought to the United States as an infant, created a brilliant body of work based on lowly common objects ranging from foodstuffs to clothespins and matchsticks. Through his exquisitely rendered drawings or through the sculpture he executed in diverse media and scales, Oldenburg transformed the commonplace into something extraordinary. "Art," he said, "should be literally made of the ordinary world; its space should be our space; its time our time; its objects our ordinary objects; the reality of art will replace reality."

Oldenburg's most important early work consisted of two installations made in New York: *The Street*, 1960, and *The Store*, 1961. The former was created of little more than common urban detritus—newspaper, burlap, and cardboard—that the artist tore into fragmented figures or other shapes and covered with graffiti-like drawing. Leaning against the walls or hanging from the ceiling, these ragged-edged objects collectively formed, according to the artist, a "metaphoric mural" that mimicked the "damaged life forces of the city street." Given Oldenburg's willingness to make art from the most common materials, it is no surprise that a crucial early model for him was Jean Dubuffet's *art brut*. In its fullest manifestation, *The Store* (fig. **19.41**) was literally presented in a storefront in Manhattan's Lower East Side, where the artist both made his wares and sold them to the public, thus circumventing the usual venue of a commercial gallery. He filled *The Store* floor to ceiling with sculptures inspired by the tawdry merchandise he saw regularly in downtown cafeterias and shop windows. They were made of plaster-soaked muslin placed over wire frames, which was then painted and attractively priced for such amounts as $198.99. Items from *The Store* depicted everything from lingerie to fragments of advertisements, to food such as ice-cream sandwiches or hamburgers—all roughly modeled and garishly painted in parody of cheap urban wares. Within the installations of *The Street* and *The Store*, Oldenburg staged several Happenings between 1960 and 1962. Situating objects within an environment and sometimes using that environment as a context for Performances—a term he preferred to Happenings—was characteristic of Oldenburg's art for decades.

The stuffed-fabric props that Oldenburg designed for some of these performances, with his first wife, Patricia Muschinski Oldenburg (now Mucha), doing much of the sewing, led to his first independent soft sculptures. Among his earliest examples were stuffed and painted canvas objects such as the nine-and-a-half-foot-long (2.9 m) *Floor Cake* (fig. **19.42**). Soon he was using canvas as well as shiny colored vinyl to translate hard, rigid objects, such as bathroom fixtures, into soft and collapsing versions. These familiar, prosaic toilets, typewriters, or car parts collapse in

19.42 Claes Oldenburg, *Floor Cake (Giant Piece of Cake)*, 1962. Installation view, Sidney Janis Gallery, New York, 1962. Synthetic polymer paint and latex on canvas filled with foam rubber and cardboard boxes, 4' 10⅜" × 9' 6¼" × 4' 10⅜" (1.5 × 2.9 × 1.5 m). The Museum of Modern Art, New York.

19.43 Claes Oldenburg, *Geometric Mouse, Scale A*, 1969–71. Aluminum, steel, and paint, height 12' (3.7 m). Walker Art Center, Minneapolis.

violation of their essential properties into pathetic, flaccid forms that have all the vulnerability of sagging human flesh. Oldenburg, who described his work as "the detached examination of human beings through form," essentially modeled his soft sculptures through direct manipulation, but also allowed gravity to act upon their pliant forms. Thus, the works exist in a state of constant flux.

One of Oldenburg's images, the *Geometric Mouse*, is so synonymous with his name that it has come to represent a kind of surrogate self-portrait. Just as soft sculptures paradoxically metamorphosed hard forms into soft, the

Geometric Mouse, originally derived from the shape of an old movie camera, is a hard (and highly abstracted) version of an organic subject. Oldenburg executed the *Geometric Mouse* on several scales ranging from small tabletop versions to an eighteen-foot-high (5.5 m) outdoor sculpture. *Geometric Mouse, Scale A* (fig. **19.43**), made of steel and aluminum, consists of a few interlocked metal planes but still bears an eerie resemblance to its namesake.

In the mid-1960s, Oldenburg began to make drawings of common objects to be built to the scale of monuments for the city: a pair of giant moving scissors to replace the Washington Monument, a colossal peeled banana for Times Square, or an upside down Good Humor bar to straddle Park Avenue (with a bite removed to allow for the passage of traffic) (fig. **19.44**). These proposals challenged traditional notions of public sculpture as heroic and commemorative in nature and replaced them with irreverent and often hilarious solutions. Oldenburg later realized his fantastic proposals with large-scale projects that have been built around the globe (see figs. 23.21, 23.22). Most of these were conceived with his wife and collaborator Coosje van Bruggen.

"Just Look at the Surface": The Imagery of Everyday Life

Pop artists share an attachment to the everyday, commonplace, or vulgar image of modern industrial America. Often appropriating subjects wholesale from their sources, they also treat their images in an impersonal, neutral manner. They do not comment on the scene or attack it like Social Realists, nor do they exalt it like advertisers. They seem to be saying simply that this is the world we live in, this is the urban landscape, these are the symbols, the interiors, the still lifes that make up our own lives. As opposed to assemblage artists who create their works

19.44 Claes Oldenburg, *Proposed Colossal Monument for Park Avenue, New York: Good Humor bar*, 1965. Crayon and watercolor on paper, 23½ × 17½" (59.7 × 44.5 cm). Collection of Carroll Janis, New York.

from the refuse of modern industrial society, the Pop artists deal principally with the new, the "store-bought," the idealized vulgarity of advertising, of the supermarket, and of television commercials.

Dine

Jim Dine (b. 1935), a gifted graphic artist and painter originally from Cincinnati, was also one of the organizers of the first Happenings, but he gave up this aspect of his work, he said, because it detracted from his painting. Like Rauschenberg, Johns, Kaprow, and others, Dine's art has roots in Abstract Expressionism, although he seems to treat it with a certain irony, combining gestural painting with actual objects, particularly tools (fig. **19.45**). His objects recall both Duchamp's readymades and contemporaneous works by Johns (see fig. 19.33). In Dine's paintings the tools are not only physically present but are also frequently reiterated in painted

images or shadows and are then referred to again through lettered titles. For Dine, the son and grandson of hardware store merchants, the tools as well as the painted image of the palette are self-referential signs, just as his many images of neckties and bathrobes are surrogate self-portraits (fig. **19.46**).

19.46 Jim Dine, *Double Isometric Self-Portrait (Serape)*, 1964. Oil with metal rings and hanging chains on canvas, 4' 8⅞" × 7' ½" (1.5 × 2.14 m). Whitney Museum of American Art, New York.

Samaras and Artschwager

Lucas Samaras (b. 1936), a native of Greece who came to America in 1948, participated in early Happenings at the Reuben Gallery, where he had his first one-man show in 1960. Since then Samaras has worked in a broad range of media, including boxes and other receptacles. In his containers, plaques, books, and table settings, prosaic elements are given qualities of menace by the inclusion of knives, razor blades, or thousands of ordinary but outward-pointing pins. The objects are meticulously made, with a perverse beauty embodied in their implied threat. They are not easily classified as Neo-Dada or Pop art; rather, they are highly expressionist works that carry with them a Surrealist brand of disturbance. Samaras sees in everyday objects a combination of menace and erotic love, and it is this sexual horror, yet attraction, that manifests itself in his work. Two chairs—one covered with pins and leaning back, the other painted and leaning forward—create the effect of a grim dance of the inanimate and commonplace (fig. **19.47**). To touch one of his objects is to be mutilated. Yet the impulse to touch it, the tactile attraction, is powerful.

In the mid-1960s Samaras began to construct full-scale rooms where every surface has been covered with mirrors (fig. **19.48**). Upon entering these reflective environments the viewer is dazzled and disoriented as his or her image is infinitely multiplied in every direction. Such optical experiments have led Samaras to a series of what he calls "photo-transformations" in which his own Polaroid image, placed within his familiar environment, is translated into monstrous forms (fig. **19.49**).

Like Samaras, **Richard Artschwager** (b. 1923) resists easy classification, for the work of both artists bridges several trends in the 1960s, from Pop to Minimalism to Conceptualism. In 1953, after spending three years in the army, earning a degree in physical science at Cornell

University, and studying painting for a year in New York, Artschwager began to make commercial furniture. This technical experience, combined with a growing commitment to art over science that was kindled by an admiration for the work of Johns, Rauschenberg, and Oldenburg, led

19.48 Lucas Samaras, *Mirrored Room*, 1966. Wood and mirrors, 8 × 10 × 8' (2.4 × 3 × 2.4 m). Albright-Knox Gallery, Buffalo, New York.

19.47 Lucas Samaras, *Untitled*, 1965. Pin chair: wood, pins, glue; wood chair: wood, yarn, glue; chairs, 35 × 19¼ × 35¾" (90.2 × 49 × 91 cm). Walker Art Center, Minneapolis.

19.49 Lucas Samaras, *Photo Transformation*, 1973–74. SX-70 Polaroid, 3 × 3" (7.6 × 7.6 cm). Private collection.

Artschwager to the fabrication of hybrid objects occupying a realm somewhere between furniture and sculpture.

Chair (fig. **19.50**) is fabricated in the artist's favorite medium, Formica (here in an elaborately marbleized pattern he used in the mid-1960s). Though it superficially resembles a chair, it would be difficult to use it as such. "I'm making objects for non-use," the artist once said, recalling Duchamp's use-deprived readymades, which transformed everyday objects into works of art. With its rigid, unforgiving surfaces, the geometricized *Chair* seems to share qualities with the abstract sculptures that Minimalist artists were making at the same time (see fig. 20.50), yet its resemblance to a functional object runs entirely counter to their aims.

Artschwager was also making representational paintings based on black-and-white photographs. For these he used acrylic paint on Celotex, a commercial composite paper that is used for inexpensive ceilings. It has a fibrous texture or tooth and is embossed with distinct patterns, providing a prefabricated "gesture" for the painter. Building façades as well as architectural interiors figure prominently among the subjects of Artschwager's paintings. A large diptych from 1972, *Destruction III* (fig. **19.51**), belongs to a series depicting the demolition of the grand Traymore Hotel in Atlantic City. Like his sculptures, Artschwager's painting presents a distant facsimile of its subject, removed from reality more than once by way of the intermediary photographic source that is then translated into the grainy textures of the Celotex support. This tension between illusion and reality is a central theme of Artschwager's art.

19.50 Richard Artschwager, *Chair*, 1966. Formica and wood, 59 × 18 × 30" (149.9 × 45.7 × 76.2 cm). Private collection, London.

19.51 Richard Artschwager, *Destruction III*, 1972. Acrylic on Celotex with metal frames, two panels, 6' 2" × 7' 4" (1.9 × 2.2 m). Private collection.

Rivers

Although the same age as Artschwager, **Larry Rivers** (1923–2002) had very different beginnings as an artist in New York. He came of age artistically during the height of Abstract Expressionism, but always remained committed to figuration in one form or another. Originally trained as a musician, Rivers studied painting at Hans Hofmann's school in the late 1940s and made paintings in the manner of Pierre Bonnard (see fig. 3.34) and Henri Matisse (see fig. 12.13). By the mid-1950s he had developed a style of portraiture remarkable for its literal and explicit character, particularly striking in nude studies of his mother-in-law (fig. **19.52**). After 1960 Rivers began to incorporate into his paintings stenciled lettering and imagery from commercial sources, both of which signaled a departure from the naturalistic conventions that guided his early work. The Dutch Master cigar box, reproducing a painting by Rembrandt, became the subject of several works (fig. **19.53**). In the 1963 version shown here, he appropriated the printed image but altered it by means of his characteristically schematic rendering and loose patches of paint. Rivers shares Pop art's concern for the everyday image, but he differs in his continued interest in painterly handling of images.

19.52 Larry Rivers, *Double Portrait of Berdie*, 1955. Oil on canvas, 5' 10¾" × 6' 10½" (1.8 cm × 2.1 m). Whitney Museum of American Art, New York.

19.53 Larry Rivers, *Dutch Masters and Cigars II*, 1963. Oil and collage on canvas, 8' × 5' 7⅜" (2.4 × 1.7 m). Collection Robert E. Abrams, New York.

Lichtenstein

Roy Lichtenstein (1923–97) may have defined the basic premises of Pop art more precisely than any other American painter. Beginning in the late 1950s, he took as his primary subject the most banal comic strips or advertisements and enlarged them faithfully in his paintings, using limited, flat colors (based on those used in commercial printing) and hard, precise drawing. The resulting imagery documents, while it gently parodies, familiar images of modern America. When drawing from comic strips, Lichtenstein preferred those representing violent action and sentimental romance and even incorporated the Benday dots used in photomechanical reproduction. *Whaam!* (fig. **19.54**) belongs to a group of paintings that he made in the early 1960s. By virtue of its monumental scale (nearly fourteen feet, or 4 m, across) and dramatic subject (one based on heroic images in the comics of World War II battles), *Whaam!* became a kind of history painting for the Pop generation. The artist's depictions of giant, dripping brushstrokes, meticulously constructed and far from spontaneous, are a comedic Pop riposte to the heroic individual gestures of the Abstract Expressionists (fig. **19.55**).

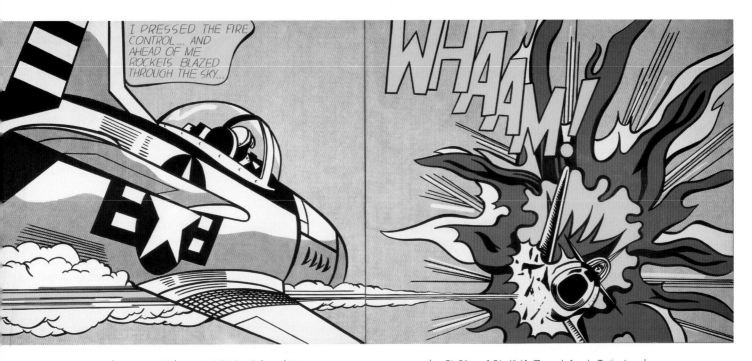

19.54 Roy Lichtenstein, *Whaam!*, 1963. Oil and Magna on two canvas panels, 5' 8" × 13' 4" (1.7 × 4.1 m). Tate, London.

19.55 Roy Lichtenstein, *Big Painting No. 6*, 1965. Oil and Magna on canvas, 7' 8" × 10' 9" (2.3 × 3.3 m). Kunstsammlung Nordrhein-Westfalen, Düsseldorf.

19.56 Roy Lichtenstein, *Artist's Studio: The Dance*, 1974. Oil and Magna on canvas, 8' × 10' 8" (2.4 × 3.3 m). Collection Mr. and Mrs. S.I. Newhouse, Jr., New York.

Lichtenstein frequently turned his attention to the art of the past and made free adaptations of reproductions of paintings by Picasso, Mondrian, and other modern artists. In *Artist's Studio: The Dance* (fig. **19.56**), he borrowed an image from Matisse's *Dance (II)* (see fig. 6.23) as a background for his own studio still life. In 1909 Matisse had depicted his own painting *Dance I* in a similar fashion positioned behind a tabletop still life. Although some of the imagery here may have originated with Matisse, the final effect is unmistakably Lichtenstein's.

Warhol

The artist who more than any other stands for Pop in the public imagination, through his paintings, objects, underground movies, and personal life, is **Andy Warhol** (1928–87). As was the case with several others associated with Pop, Warhol was first a successful commercial artist. Initially, like Lichtenstein, he made paintings based on popular comic strips, but he soon began to concentrate on the subjects derived from advertising and commercial products for which he is best known—Coca-Cola bottles

19.57 Andy Warhol, *210 Coca-Cola Bottles*, 1962. Silkscreen ink on synthetic polymer paint on canvas, 6' 10½" × 8' 9" (2.1 × 2.7 m). Collection Martin and Janet Blinder.

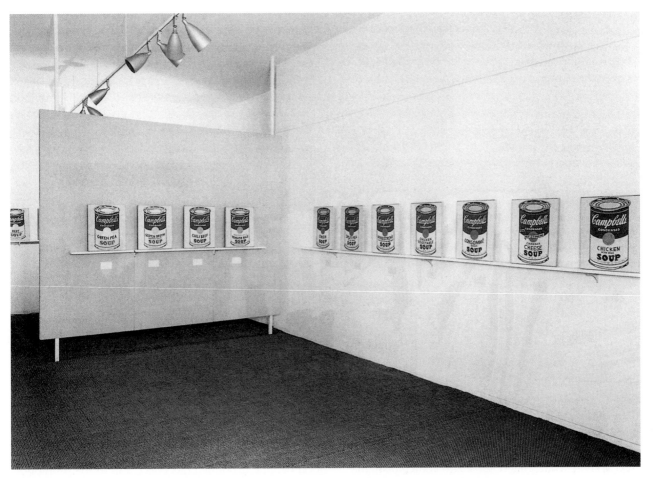

19.58 Andy Warhol, Installation view of *Campbell's Soup Cans*, Ferus Gallery, Los Angeles, 1962.

(fig. **19.57**), Campbell's soup cans, and Brillo cartons. His most characteristic manner was repetition within a grid—endless rows of Coca-Cola bottles, literally presented, and arranged as they might be on supermarket shelves or an assembly line (Warhol appropriately dubbed his studio "The Factory"). "You can be watching TV and see Coca-Cola," he wrote in his 1975 autobiography, "and you can know that the President drinks Coke, Liz Taylor drinks Coke, and just think, you can drink Coke, too. A Coke is a Coke and no amount of money can get you a better Coke than the one the bum on the corner is drinking." Warhol's signature image is the Campbell's soup can, a product he said he ate for lunch every day for twenty years, "over and over again." When he exhibited thirty-two paintings of soup cans in 1962 at the Los Angeles Ferus Gallery, the number was determined by the variety of flavors then offered by Campbell's, and the canvases were monotonously lined up around the gallery on a white shelf like so many grocery goods (fig. **19.58**).

From these consumer products he turned to the examination of contemporary American folk heroes and glamorous movie stars, including Elvis Presley, Elizabeth Taylor, and Marilyn Monroe (fig. **19.59**). He based these early paintings on appropriated images from the media; later he photographed his subjects himself. From 1962 on, Warhol used a mechanical photo-silkscreen process that further emphasized his desire to eliminate the personal signature of

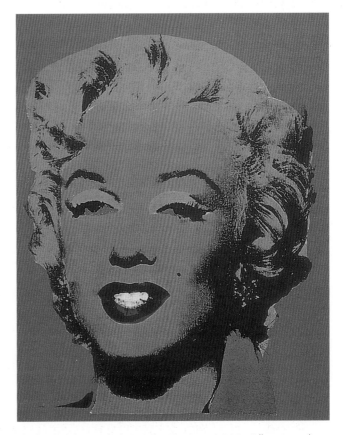

19.59 Andy Warhol, *Marilyn Monroe*, 1962. Silkscreen ink on synthetic oil, acrylic, and silkscreen enamel on canvas, 20 × 16" (50.8 × 40.6 cm).

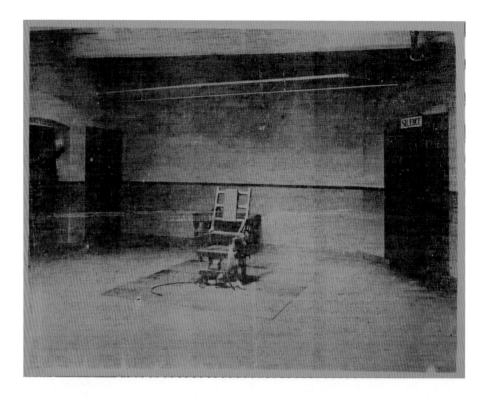

19.60 Andy Warhol, *Little Electric Chair*, 1964–65. Acrylic and silkscreen ink on linen, 22 × 28" (55.9 × 71.1 cm). Founding Collection, Andy Warhol Museum, Pittsburgh.

the artist and to depict the life and the images of his time (see *Screenprinting*, opposite). As in his portrait of Monroe, Warhol allowed the layers of silkscreen colors to register imperfectly, thereby underscoring the mechanical nature of the process and encouraging observers to contemplate the fate of the then recently deceased Monroe.

At the same time that he was beginning his portraits, Warhol created a series of canvases that applied his disturbing sense of impersonality to press photographs of death and disaster scenes. In doing so he suggested that familiarity breeds indifference, even to such disturbing aspects of contemporary life. In his gruesome pictures of automobile wrecks, for example, the nature of the subject makes the attainment of a neutral attitude more difficult. *Little Electric Chair* (fig. **19.60**), taken from an old photograph, shows the grim, barren death chamber with the empty seat in the center and the sign SILENCE on the wall. Presented by the artist either singly, in monotonous repetition, or even paired with a monochrome painting of the same size, the scene becomes a chilling image, as

much through the abstract austerity of its organization as through its associations.

In the later 1960s, Warhol increasingly turned to the making of films, where his principle of monotonous repetition became hypnotic in its effect, and to the promotion of the rock band The Velvet Underground. At the same time, he made himself and his entourage the subject of his art. Equipped with his famous silver-sprayed wig and an attitude of studied passivity, Warhol achieved cult status in New York, especially after he nearly died in 1968 from gunshot wounds inflicted by Valerie Solanas, the sole member of S.C.U.M. (the Society for Cutting Up Men). Throughout the 1970s, he worked primarily as a society portraitist, making garishly colored silkscreen paintings of friends, art world figures, and celebrities.

Rosenquist, Wesselmann, and Indiana

For a period, **James Rosenquist** (b. 1933) was a billboard painter, working on the scaffolding high over New York's Times Square. The experience of painting commercial

19.61 James Rosenquist, Portion of *F-111*, 1965. Oil on canvas with aluminum, overall 10 × 86' (3 × 26.2 m). Private collection.

Screenprinting

Developed as a commercial sign-making technique at the turn of the twentieth century, screenprinting requires little in the way of specialized equipment or materials, making it less expensive and easier than traditional printmaking techniques like engraving, etching, or lithography. Thin fabric, often silk, is stretched across a wood frame. The design is introduced by affixing a stencil onto the silk screen. At this point, the apparatus functions like a sieve: after placing it atop a sheet of paper, section of cloth, or piece of board, ink can be easily pushed through the exposed silk using a squeegee, leaving blank the area covered by a stencil. Multiple colors can be created through the use of additional stencils, by either inking previously screened-out passages or layering successive colors. Stencils can be made out of paper or more durable materials like celluloid or plastic. They can also be produced photo-mechanically by covering the screen with photo-sensitive emulsion that hardens when exposed to light, transferring a photographic negative onto the screen. Early on, commercially-made stencils included celluloid sheets punctured by tiny dots that created the effect of shading or a tonal wash. This means of introducing shading to printed images was invented by Benjamin Day and became known as "Ben Day" or "Benday" dots, a technique associated with Pop artist Roy Lichtenstein. Artists began to use screenprinting by the 1920s to create prints and fabrics. In 1940, American artists coined the term "serigraphy" (literally, "silk drawing") to describe the technique when used for the production of fine art prints. Used by many American and European abstract artists, screenprinting is most closely linked to Pop art. Its commercial origins as well as its ease of use and bold, graphic appearance appealed to artists like Richard Hamilton and Andy Warhol.

images on an enormous scale was critical for the paintings he began to produce in the early 1960s. His best-known and most ambitious painting, *F-111*, 1965, is ten feet high and eighty-six feet long (3 × 26.2 m), capable of being organized into a complete room to surround the spectator (fig. **19.61**).

Named after an American fighter-bomber whose image traverses the entire eighty-six feet, *F-111* also comprises a series of fragmented images of destruction, combined with prosaic details including a lightbulb, a plate of spaghetti, and, most jarring of all, a little girl who grins beneath a bullet-shaped hairdryer. Surrounded by this environment of canvas, visitors experienced the visual jolt of the painting's garish, Technicolor-like palette, augmented by reflective aluminum panels at either end, and its barrage of imagery on a colossal scale. Between 1965, when it was first unveiled at the Leo Castelli Gallery in New York, and 1968, *F-111* traveled to several countries, gaining notoriety not only as an aggressive indictment of war, but as one of the seminal works of the Pop era.

Tom Wesselmann (1931–2004) parodied American advertising in his 1960s assemblages, which combined real elements—clocks, television sets, air conditioners—with photomontage effects of window views, plus sound effects. In works such as *Interior No. 2* (fig. **19.62**), the literal

19.62 Tom Wesselmann, *Interior No. 2*, 1964. Mixed media, including working fan, clock, and fluorescent light, 60 × 48 × 5" (152.4 × 121.9 × 12.7 cm). Private collection.

19.63 Tom Wesselmann, *Great American Nude #57*, 1964. Acrylic and collage on board, 48 × 65" (121.9 × 165.1 cm). Whitney Museum of American Art, New York.

19.65 Robert Indiana, *LOVE*, 1972. Polychrome aluminum, 6 × 6 × 3' (1.8 × 1.8 × 0.9 m). Multiple, formerly Galerie Denise René, Paris.

19.64 Robert Indiana, *The Demuth Five*, 1963. Oil on canvas, diagonal measurements 68 × 68" (172.7 × 172.7 cm). Private collection.

presence of actual objects dissolves the barriers between depicted forms and reality itself. Wesselmann's most obsessive subject was the female nude, variations on which comprise a series he called *Great American Nude* (fig. **19.63**). For decades, he painted this faceless American sex symbol, whose pristine and pneumatic form mimics the popular conventions of pin-up magazines. Wesselmann's *Great American Nude* series should also be understood within the context of modern artists' utilization of the female body as a vehicle for aesthetic exploration. Matisse's declaration in the face of criticism regarding his *Blue Nude* (fig. 6.9) that he sought only to "make a picture" suggested that his choice of subject was irrelevant. Wesselmann's series overturns this assumption, exposing the aesthetic as well as financial commerce conducted via the female body whether through fine art or centerfolds.

Robert Indiana (b. 1938) could be considered the Pop heir to early-twentieth-century artists such as Charles Demuth and Stuart Davis (see figs. 16.32, 16.61). He painted a figure five in homage to the former (fig. **19.64**) and, like Davis, he has painted word-images, in his case attaining a stark simplicity that suggests the flashing words of neon signs—EAT, LOVE, DIE. These word-paintings are composed of stenciled letters and precise, hard-edge color-shapes that relate Indiana to much abstract art of the 1960s.

Unlike most Pop art, which manifests little or no overt comment on society, Indiana's word-images are often bitter indictments, in code, of modern life, and sometimes even a devastating indictment of brutality, as in his *Southern States* series. However, it was with his classic rendering of "LOVE" that Indiana assured a place for himself in the history of the times (fig. **19.65**). He continued to produce, among other new images, many LOVE variations on an ever-increasing scale, as in the aluminum sculpture seen here.

Lindner, Marisol, and Sister Corita

Richard Lindner (1901–78), the son of German Jews, emigrated first to France (where he was temporarily interned in a concentration camp after the outbreak of World War II), and later, in 1941, to New York. There, he first gained a reputation as an illustrator and teacher during the 1950s. Because the paintings he began to make in the early 1960s, with their figurative subject matter, slick finish, and urban imagery, bore a superficial resemblance to Pop art, his name has been associated with that movement. But his work is rooted in European literary and artistic traditions and is more appropriately related to the machine Cubism of Léger as well as to the work of earlier German artists such as Oskar Schlemmer. He created a bizarre and highly personal dreamworld of metallic, tightly corseted mannequins who at times seem to be caricatures of erotic themes, with bright, flat, even harsh colors (fig. **19.66**). These fetishistic images, which are filled with personal and literary associations (his mother had run a custom-fitting corset business in Germany), recapitulate the artist's past.

From the early 1960s, **Marisol** (Marisol Escobar) (b. 1930), a Paris-born Venezuelan artist active in New York, created life-size assemblages made of wood, plaster, paint, and found objects, which she sometimes arranged in environments. These are primarily portraits of famous personalities such as President Lyndon Johnson, Andy Warhol,

19.66 Richard Lindner, *Hello*, 1966. Oil on canvas, 70 × 60" (177.8 × 152.4 cm). Collection Robert E. Abrams, New York.

19.67 Marisol, *The Family*, 1962. Painted wood and other materials in three sections, overall 6' 10⅜" × 5' 5½" × 1' 3½" (2.2 × 1.66 × 0.39 m). The Museum of Modern Art, New York.

and the movie star John Wayne. Marisol based her more anonymous sitters in *The Family* on a photograph of a poor American family from the South (fig. **19.67**). Their features are painted on planks of wood, but the artist added three-dimensional limbs and actual shoes for some of the figures to create her peculiar hybrid of painting and sculpture. Reminiscent of photographs by Walker Evans (see fig. 16.48), *The Family* contains a pathos alien to most Pop art.

Marisol is one of the few women artists associated with the Pop movement. The commonplace, consumerist subjects depicted in Pop works would seem as accessible to women as men. But the adoption of commercial techniques and media—a challenge to fine art hierarchies, which privilege traditional easel painting and handmade rather than "found" sculpture—is a gesture meaningful only to those who already have access to the realm of fine art. Women were prevented by social norms from pursuing professional or artistic careers; such expectations only increased after World War II in a general backlash against the role they had played in industry and culture during the war. Those women who were able to become artists tended during the 1950s and early 60s to pursue established techniques and genres.

A provocative exception was Corita Kent (1918–2006), known as **Sister Corita**, who studied art in Los Angeles before taking Catholic religious vows and joining the Order of the Immaculate Heart of Mary in 1936. She ran the art program at Immaculate Heart College, becoming particularly expert in the production of screenprints. Her work changed dramatically after seeing the 1962 exhibition of Warhol's silkscreen paintings of Campbell's soup cans at the Ferus Gallery in Los Angeles, where she took her students to see current trends in art. Not only did the bold colors, graphic simplicity, and commonplace themes of Pop art begin to appear in her work, but she adapted the style to serve her social and religious aims. The Second Vatican Council, which sat from 1962 to 1965, mandated an effort to make Catholicism more relevant and accessible to ordinary people. Corita pursued this through her art, designing hundreds of screenprints that could be inexpensively produced and distributed around the city. For instance, her 1965 print *Enriched Bread* (fig. **19.68**) echoes the appearance of a package of Wonder Bread but delivers a message about the wonder of faith in a world shattered by war and plagued by injustice. Like her Pop contemporaries, she often used text in her work. The last line of *Enriched Bread* reads "Camus helps build strong bodies 12 ways standard large loaf no preservatives added."

19.68 Sister Corita, *Enriched Bread*, 1965. Serigraph.

Poetics of the "New Gomorrah": West Coast Artists

The Pop ethos had also begun to emerge from the distinctive culture of California by the early 1960s, although the four California artists discussed here—Wayne Thiebaud, Edward Kienholz, Jess, and Ed Ruscha—made work that is only tangentially related to Pop.

Thiebaud

One of the most distinguished artists to emerge in California in the 1960s is the painter **Wayne Thiebaud** (b. 1920). He located his work as part of a long realist tradition in painting that includes such artists as Chardin, Eakins, and Morandi, and he was not comfortable with attempts to tie his work to the Pop movement. When his distinctive still lifes of mass-produced American foodstuffs were first exhibited in New York in 1962, however, they were regarded as a major manifestation of West Coast Pop and were seen by many as ironic commentaries on the banality of American consumerism. Thiebaud specialized in still lifes of carefully arranged, meticulously depicted, lusciously brushed and colored, singularly perfect but unappetizing bakery goods (fig. **19.69**), the kind one would find illuminated under harsh fluorescent lights on a cafeteria counter or in a bakery window. Thomas Hess, who had been an advocate of the Abstract Expressionist painters, wrote of Thiebaud's East Coast debut:

> Looking at these pounds of slabby New Taste Sensation, one hears the artist screaming at us from behind the paintings urging us to become hermits: to leave the new Gomorrah where layer cakes troop down air-conditioned shelving like cholesterol angels, to flee to the desert and eat locusts and pray for faith.

Nevertheless, Thiebaud insisted that these works reflected his nostalgia and affection for the subject, rather than any indictment of American culture. While the repetitive nature of the motif generated compositions as ostensibly

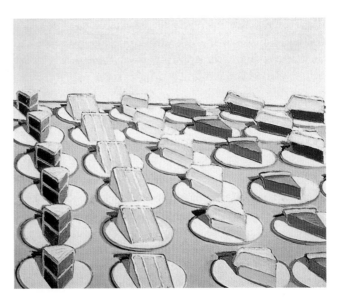

19.69 Wayne Thiebaud, *Pie Counter*, 1963. Oil on canvas, 30 × 36" (76.2 × 91.4 cm). Whitney Museum of American Art, New York.

monotonous as Warhol's grids and series, the paint handling has little in common with the flat, deadpan surfaces favored by the East Coast Pop artists. Thiebaud used the oil medium to recreate the very substance it depicts, whether cake frosting or mustard or pie meringue, building up his colorful paint layers into a thick, delectable impasto. From the 1960s onward, he also produced landscapes that often elicit marvelous chromatic and spatial effects from the vertiginous streets of San Francisco.

Kienholz

In strong contrast to Thiebaud's traditional oil paintings is the subversive art of Los Angeles artist **Edward Kienholz** (1927–94). Like George Segal, he created elaborate tableaux, but where Segal's work is quietly melancholic, Kienholz's constructions embody a mordant, even gruesome, view of American life. For his famous bar, *The Beanery* (fig. **19.70**), he produced a life-size environment, one where the viewer can actually enter and mingle with the customers. The patrons are created mostly from life casts of

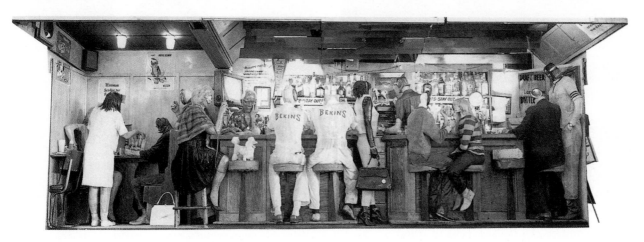

19.70 Edward Kienholz, *The Beanery*, 1965. Mixed-media tableau, 7 × 6 × 22' (2.1 × 1.8 × 6.7 m). Stedelijk Museum, Amsterdam.

the artist's friends. Kienholz filled the tableau, as he called this and similar works, with such grotesque invention and such harrowing accuracy of selective detail that a sleazy neighborhood bar-and-grill becomes a scene of nightmarish proportion. The seedy customers, who smoke, converse, or stare off into space, wear clocks for faces, all frozen at ten minutes after ten. "A bar is a sad place," Kienholz once said, "a place full of strangers who are killing time, postponing the idea that they're going to die." *The State Hospital* (fig. **19.71**) is a construction of a cell with a mental patient and his self-image, both modeled with revolting realism and placed on filthy mattresses beneath a single glaring lightbulb. The man on the upper mattress is encircled by a neon cartoon speech bubble, as though unable to escape reality even in his thoughts. The two effigies of the same creature—one with goldfish swimming in his glassbowl head—make one of the artist's most horrifying works. Though he could not have known Duchamp's late work, *Étant Donnés* (see chapter 11), Kienholz adopted a very similar format for *The State Hospital*, which can be viewed only through a barred window in the cell, thus implicating the viewer as a voyeur in this painfully grim scene.

Jess

The West Coast artist Burgess Collins, known as **Jess** (1923–2004), came to public attention in 1963 when his comic-strip collage was included in Pop Art U.S.A., an exhibition at the Oakland Art Museum. But the reclusive Jess felt no kinship with the Pop artists who were his contemporaries, and most of his mature work is so saturated with romanticism, nostalgia, and fantasy that it seems a far cry from the cool detachment of Pop. After earning a degree in chemistry at the California Institute of Technology, Jess began to study painting in San Francisco under a number of prominent Bay area artists, including Clyfford Still, who, he said, taught him the "poetics of materials." The abstract paintings he made in the first half of the 1950s bear the imprint of this leading Abstract Expressionist. Jess's longtime companion and frequent collaborator was the Beat poet Robert Duncan, who died in 1988.

In 1959 Jess began a series of paintings that he called *Translations,* for which he took pre-existing images, usually old photographs, postcards, or magazine illustrations, and "translated [them] to a higher level emotionally and sometimes spiritually." The *Translations,* which he continued to make until 1976, are painstakingly crafted, built up into thick, bumpy layers of oil paint where the impasto resembles a kind of painted relief (fig. **19.72**). They usually feature an accompanying text. The words at the top of the canvas here come from a text by Gertrude Stein in which a boy learns from his father about the cruelty of collecting butterflies as specimens. The hauntingly tender image, painted in pastel colors in a deliberately anti-naturalistic, paint-by-numbers style, is based on an engraving from an 1887 children's book titled *The First Butterfly in the Net.*

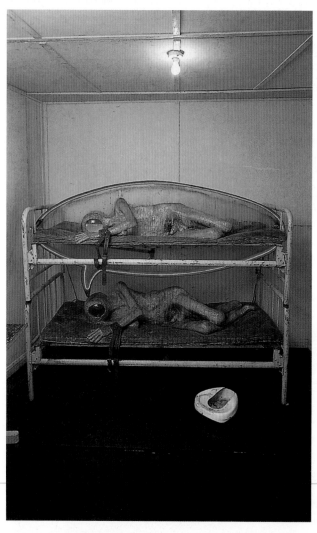

19.71 Edward Kienholz, *The State Hospital,* 1966. Mixed-media tableau, 8 × 12 × 10' (2.4 × 3.7 × 3 m). Moderna Museet, Stockholm.

19.72 Jess, *Will Wonders Never Cease: Translation #21,* 1969. Oil on canvas mounted on wood, 21 × 28⅛" (53.3 × 71.4 cm). Hirshhorn Museum and Sculpture Garden, Smithsonian Institution, Washington, D.C.

Ruscha

The work of **Edward Ruscha** (b. 1937), who settled in Los Angeles in 1956, is not easily classified. His hard-edge technique and vernacular subject matter allied him with California Pop art in the 1960s, while his fascination with words and typography, exemplified by his printed books and word paintings, corresponded to certain trends in Conceptual art that surfaced in the following decade. In 1963 Ruscha, who had already worked as a graphic designer of books, published *Twenty-six Gasoline Stations*, a book containing unremarkable photographs of the filling stations on Route 66, a road he had frequently traveled,

between Oklahoma City, his birthplace, and Los Angeles. He based his large painting *Standard Station, Amarillo, Texas* (fig. **19.73**) on one of those images, though he transformed the mundane motif into a dramatic composition, slicing the canvas diagonally, turning the sky black, and transforming the station into a sleek, gleaming structure that recalls Precisionist paintings of the 1930s.

Another of Ruscha's books, *Every Building on the Sunset Strip* (fig. **19.74**), documents exactly what its title indicates in a series of deadpan photographs. "I want absolutely neutral material," he told one interviewer. "My pictures are not that interesting, nor the subject matter. They are simply a

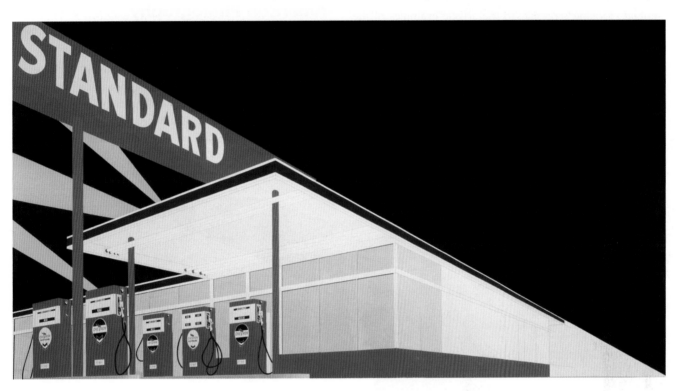

19.73 Edward Ruscha, *Standard Station, Amarillo, Texas*, 1963. Oil on canvas, 5' 5" × 10' (1.65 × 3 m). Hood Museum of Art, Dartmouth College, Hanover, New Hampshire.

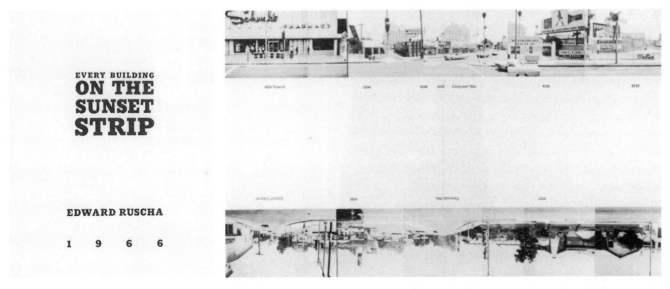

19.74 Edward Ruscha, Title page (above left) and opening pages (above right) of *Every Building on the Sunset Strip*, 1966. Artist's book.

collection of 'facts'; my book is more like a collection of readymades." Ruscha's citation of Duchamp is a reminder that the latter's first major retrospective was held in 1963 at the Pasadena Art Museum. In the 1980s Ruscha began to make tenebrous paintings, in which mysterious objects float, like the words of his earlier paintings, in a nebulous space.

Jiménez

Luis Jiménez (1940–2006), a Mexican-American artist from El Paso, Texas, was not associated specifically with California, but rather the southwestern region of the United States where Mexican and American cultures meet and sometimes clash. Jiménez drew from his Mexican heritage, looking especially to the artistic examples of the Mexican muralists (see chapter 16), as well as the myths, technologies, and mass media of "el Norte." He shared certain concerns with Pop artists for, as he said, "I am making what I would consider people's art and that means that the images are coming from popular culture and so is the material." Jiménez, who learned sign painting techniques in his father's El Paso shop, used fiberglass for his sculpture, a material that, he pointed out, is used to make canoes, cars, and hot tubs. He then applied a jet aircraft acrylic urethane finish with an airbrush, giving his surfaces a hard plastic, autobody glow that is repellent and seductive at the same time. It is a finish that, the artist said, "the critics love to hate." His dramatic *Man on Fire* (fig. **19.75**), a subject previously treated by Orozco, is based on the heroic figure of Cuauhtémoc, the last Aztec emperor, whom the Spaniards tortured by fire.

Personal Documentaries: The Snapshot Aesthetic in American Photography

As the vernacular sources and the mixed media of Pop artists would suggest, photography had become an even more dominant element in Western culture by the early 1960s. A number of artists discussed in this chapter used photography in their art, including Hamilton, Hockney, Rauschenberg, Warhol, Samaras, Ruscha, and the partnership of Christo and Jeanne-Claude. At the same time, a

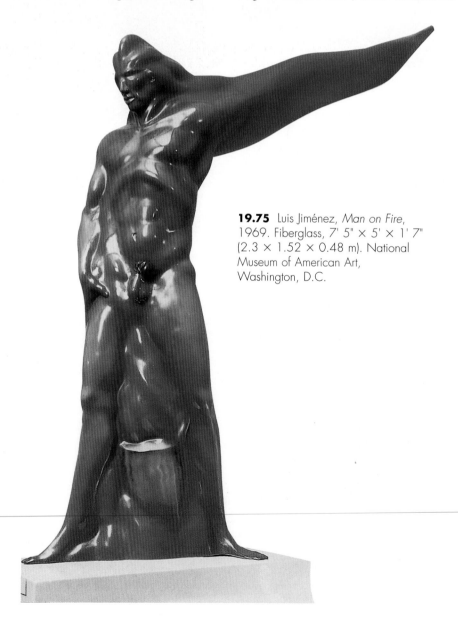

19.75 Luis Jiménez, *Man on Fire*, 1969. Fiberglass, 7' 5" × 5' × 1' 7" (2.3 × 1.52 × 0.48 m). National Museum of American Art, Washington, D.C.

growing number of young professional photographers were attracted to the common activities and artifacts of everyday life and conveyed them in seemingly casual compositions devoid of pictorial convention and overt commentary. Their goal was not an exquisitely crafted and designed print but rather an authentic, directly communicated image. Photographers of the period tended to deheroicize the mystical pretensions and technical perfection sought by, for instance, Strand, Weston, and White. In place of such elevated straight photography came the "snapshot aesthetic," with its subject matter derived from the most banal urban and suburban landscapes and its procedures deceptively haphazard.

These new attitudes were most fully realized in the work of the Swiss-American **Robert Frank** (b. 1924). Aided by a Guggenheim grant, in 1955 Frank set out on a journey of discovery throughout the United States, using his 35mm Leica camera to take a fresh, detached, but ultimately critical—if not absolutely damning—look at postwar American society consumed by violence, conformity, and racial and social division (fig. **19.76**). "Criticism," said Frank, "can come out of love." Frank published eighty-three of his photographs, selected from the original 20,000, in book form, first in France and then in the United States as *The Americans* (1958), with an introduction by novelist Jack Kerouac. When judged by conventional standards, Frank's photographs look harsh, informal, blurred, and grainy, more like glimpses than concentrated views of a subject. Their individual strengths build within the cumulative effect of the book as a whole, the sequential nature of which led the artist to filmmaking.

In the 1960s, *The Americans* became a celebrated icon of American photography and a model for young photographers who shared Frank's outlook. Frank retained a sequential format in much of his later still photography, including the triptych *Moving Out* from 1984 (fig. **19.77**).

19.76 Robert Frank, *Political Rally, Chicago, 1956*, from *The Americans*, 1958. Gelatin-silver print.

From the streets of America he turned inward to haunting meditations on his own life, as shown here with depictions of three abandoned rooms from different moments in his past. The text the artist attached to these images includes the words, "Just accept lost feelings—Shadows in empty room—Silence on TV."

19.77 Robert Frank, *Moving Out*, 1984. Silver-gelatin developed-out prints with acrylic paint, 19¹⁵⁄₁₆ × 47¹³⁄₁₆" (50.6 × 121.4 cm). National Gallery of Art, Washington.

19.78 Gary Winogrand, *Peace Demonstration, Central Park, New York,* 1969. Gelatin-silver print.

American-born **Gary Winogrand** (1928–84) said he took photographs in order to see what the things that interested him would look like as photographs, implying that his artistic vision was something discovered in the course of making pictures. This partly explains the look of his photographs, which record scenes so bluntly real, so familiar, that they are usually absorbed into the scanning process of normal vision. Winogrand was working as a photojournalist and commercial photographer when he encountered the work of Walker Evans and Frank, whose approach to the medium helped shape his mature work. In 1969 he abandoned commercial photography to focus on his personal work and received his second Guggenheim grant, this one to explore the "effect of media on events." A number of the prints made under the grant eventually formed a catalogue and an exhibition called Public Relations (1977). Given the years Winogrand worked on the project

(1969–73), it is no surprise that the Vietnam War played a central role in this group of photographs (fig. **19.78**). Winogrand forgot few of the aesthetic principles learned while a painting student at Columbia University, for however informal *Peace Demonstration* may appear, as in the tipping of the camera, the resulting image is a marvel of conflicting patterns contained with great rigor.

Like Frank, **Lee Friedlander** (b. 1934) found telling imagery among the vast array of visual accident available in America's streets, whether it was a jazz band's procession in a New Orleans neighborhood, or abruptly cropped views of anonymous pedestrians in New York City. Friedlander, who said he wanted to record "the American social landscape and its conditions," exploited the layered reflections of shop windows, often including his own image in such works in a kind of deliberate appropriation of a standard mistake of amateur photography (fig. **19.79**).

19.79 Lee Friedlander, *Washington, D.C.,* 1962. Gelatin-silver print.

Even at their most banal, his photographs, such as this shot of a tawdry restaurant window featuring a portrait of President and Jacqueline Kennedy the year before the assassination, could possess a strange poignancy.

The work of Winogrand and Friedlander was featured in a 1967 exhibition at The Museum of Modern Art called New Documents. According to John Szarkowski, the show's curator, such artists represented a new generation of photographers who were directing "the documentary approach toward more personal ends. Their aim has been not to reform life, but to know it." Also included in the show was the work of New Yorker **Diane Arbus** (1923–71), whose startling photographs issued from her enormous curiosity about human nature in all its manifestations. Her primary mentor was Lisette Model (see fig. 15.62), but Arbus probed the psyche of her subjects even more deeply than her teacher. In the 1950s she made grainy 35mm photographs of anonymous subjects whom she encountered in Coney Island or on the streets of New York City.

From 1960 until her death Arbus made photographs for magazines such as *Esquire* and *Harper's Bazaar*. Her best-known photographs are the portraits she made in the 1960s, often of traditionally taboo subjects, of people existing on the fringes of society, including transvestites, nudists, circus performers, or residents in a home for people with mental disabilities. Arbus' ability to gain the trust of her subjects resulted in sometimes painfully honest images (fig. **19.80**). Her photographs are simultaneously disquieting and wondrous, for she captured a world at which we are not allowed to stare. As her daughter Doon Arbus has written, "She was determined to reveal what others had been taught to turn their back on."

Frank's book *The Americans* provided a critical example for New York photographer **Bruce Davidson** (b. 1933), who was working for *Life* magazine by the late 1950s. Davidson favored gritty subjects drawn from New York's subways or Coney Island and sometimes worked in series such as the one following the teenage members of a Brooklyn street gang (fig. **19.81**). The *Brooklyn Gang* photo-essay was published in *Esquire* magazine in 1960

19.81 Bruce Davidson, *Coney Island* from the series *Brooklyn Gang*, 1959. Gelatin-silver print.

19.82 Duane Michals, *Paradise Regained*, 1968. Series of gelatin-silver prints.

with an accompanying text by Norman Mailer extolling the rebelliousness of youth. Davidson's grainy snapshot presents the subject, teenagers primping before vending machines, without criticism. His explanation that he "force-developed the film to increase the harsh contrast that reflected the tension in their lives" reveals a willingness to manipulate the photographic process to convey the drama and pathos of his subject.

The serial arrangements, narrative content, and even the narcissism found in Warhol's art appeared in the photography of **Duane Michals** (b. 1932), who acquired such traits from the same source as Warhol—Madison Avenue, where Michals worked as a commercial photographer. Convinced that a single image offers little more than the record of a split second cut from the ongoing flow of time, Michals constructed "photostories," or playlets, to expose or symbolize the reality behind our perceptions of it. His 1968 *Paradise Regained* coolly transforms a young couple in a neutral contemporary interior into a version of the biblical Garden of Eden (fig. **19.82**). "I use photography," the artist said, "to help me explain my experience to myself. ... I believe in the imagination. What I cannot see is infinitely more important than what I can see."

Richard Avedon (1923–2004) spent time as a street photographer both in his native city of New York and in Italy (fig. **19.83**). But he is known for his elaborately staged fashion photographs from the 1950s that appeared in *Harper's Bazaar*, a magazine that attracted some of the best talents in photography, including Model, Brandt, Brassaï, and Frank. At the age of nineteen Avedon served in the merchant marines, where he had to take thousands of head shots for ID photos, a fact that may have determined a preference in later years for photographing his subjects straight on, at excruciatingly close range, and against a stark white background. From the early 1950s Avedon photographed many of the most celebrated personalities of his era, from Marilyn Monroe to Giacometti to the Beatles. In 1969 he switched from a Rolleiflex to a much less maneuverable eight-by-ten-inch view camera, sometimes printing in a square format. The images that Avedon produced with the larger camera have installed a sense of imposing beauty upon a spectrum of humanity from fashion models to vagrants.

The 1940s and 50s were the heyday of American photojournalism, with picture magazines such as *Life*, *Harper's*, and *Vogue*, among others, supporting the work of many of photography's leading practitioners. Some

19.83 Richard Avedon, *Zazi, Street Performer, Piazza Navona, Rome, July 27, 1946.* Gelatin-silver print.

of the most memorable photographs of the 1960s came from professional photojournalists, including this gripping image from the war in Vietnam of the execution of a suspected communist sympathizer that was captured by the Associated Press photographer **Eddie Adams** (1933–2004) (fig. **19.84**). So powerful was the response as this photograph was circulated across American newspapers that it served to escalate opposition to the war and to raise questions about the role of photographers who witness violent events and may even encourage them by their presence.

The frank and, at times, even graphic naturalism of Pop art and photography of the 1960s distinguished itself from the cool abstraction pursued by many progressive artists at the time. Often just as committed to social critique as their counterparts working in naturalism, abstract artists of the 1960s conveyed meaning through the formal restraint often associated with Clement Greenberg's ideas about modernism. But this new generation of abstract artists took Greenbergian ideas about formal purity into new directions, exploring novel media and introducing the distinct visual language of Minimalism.

19.84 Eddie Adams, *Vietnamese General Executing Vietcong,* 1968. Gelatin-silver print.

20
Playing by the Rules: Sixties Abstraction

Artists involved in the Pop art, Assemblage, and *Nouveau Réalisme* movements discussed in the previous chapter reveled in breaking the rules. Everything was to be contested in the postwar period, from the nature of fine art media to the role of the audience. While some Abstract Expressionist painters abandoned oil paint for acrylic or even house paint, Pop artists went a step further and created paintings mechanically using screenprinting. The use of industrial materials like steel I-beams by abstract sculptors like Mark di Suvero appears rather staid when compared with the Formica, fiberglass, and acres of synthetic fabric employed by Pop artists. Chance operations and ephemeral works such as performances and Happenings called into question the traditional understanding of a work of visual art as an enduring record of artistic genius. The Romantic conception of the artist as a lone, struggling individual compelled by inner necessity to create was shattered once and for all as Andy Warhol allowed others to produce "his" works at The Factory.

But rules were not always to be broken. Some artists working in the 1950s and 60s were fascinated by formulas and protocols, attracted to the order that rules seem to bring out of the chaos of creation. Mathematics and logic promised a reassuringly rational means of negotiating problems as World War II was supplanted by the Cold War. Constructivists had already explored the composition of artworks through geometric systems and formulas, but now a new generation of abstract artists made such objective-seeming design strategies central to their work.

The notion of "formulas" had also taken on an ominous resonance by 1950. Determined to meet the nuclear capability of the United States, the Soviet Union had assembled a team to build an atomic bomb in 1946. Three years later, they executed their first successful detonation. The speed with which the Soviets achieved a nuclear weapon was aided by espionage, and newspapers in the 1950s and 60s were rife with stories about the danger of losing more "secret formulas" to America's Cold War foe. The idea quickly entered the popular imagination, and

wayward secret formulas became a common plot device in the expanding genre of spy novels and movies.

Formulas and rules also figure in a number of less threatening activities: games as well as religious practices demand adherence to a system. For artists, one formula that had affected their work directly was the account of modernism issued by the enormously influential American critic Clement Greenberg. As discussed in chapter 17, Greenberg discerned several characteristics in a successful piece of modernist art, including the tendency toward abstraction, truth to materials, and the need for each art form to follow its own, internal logic. Originality and authenticity were also highly prized under the terms of Greenbergian modernism. The Abstract Expressionists seemed to have fulfilled completely Greenberg's expectations, leaving the next generation of progressive artists to wonder how they might advance modernism further. Though it was never Greenberg's intention for his ideas to function prescriptively, many artists and critics treated his writings as doctrine.

Pop and Assemblage artists responded to this problem by rejecting entirely the modernist rubric derived from Greenberg. Others, a group of artists working in a style Greenberg christened Post Painterly Abstraction, found new means of fulfilling the demands of modernism. Yet another movement, Minimalism, takes Greenberg's ideas to such an extreme as to seem parodic, though many of the artists associated with the movement claim instead to be taking his ideas to their zenith.

Drawing the Veil: Post Painterly Abstraction

A number of exhibitions held in the 1960s drew attention to certain changes that were occurring in American painting. Among these shows were American Abstract Expressionists and Imagists at New York's Guggenheim Museum in 1961; Toward a New Abstraction at New York's Jewish Museum in 1963; Post Painterly Abstraction, organized in 1964 by Clement Greenberg for the Los Angeles County

Museum of Art; and Systemic Painting, curated in 1966 by Lawrence Alloway at the Guggenheim Museum.

These exhibitions illustrated that many young artists were attempting to break away from what they felt to be the tyranny of Abstract Expressionism, particularly in its emphasis on the individual brush gesture. Among all the painters working against the current of gestural Abstract Expressionism in the late 1950s there was a general move (as Greenberg pointed out) to openness of design, by which he meant that elements of the composition seem to extend beyond the bounds of the artwork, suggesting limitlessness (a closed composition is clearly bounded and contained). Many of the artists turned to the technique of staining raw canvas and moved toward a clarity and freshness that differentiated their works from those of the Abstract Expressionists, which were characterized by compression

and brushwork. The directions and qualities suggested in the work of these artists—some already well established, some just beginning to appear on the scene—were to be the dominant directions and qualities in abstract painting during the 1960s (see *Clement Greenberg, Post Painterly Abstraction*, left).

Francis and Mitchell

Greenberg's inclusion of **Sam Francis** (1923–94) among his Post Painterly artists may seem somewhat surprising, since Francis during the 1950s was associated with American Abstract Expressionism and *Art Informel* in Paris, where he lived until 1961. As Greenberg explained in the introduction to the exhibition catalogue of Post Painterly Abstraction, Abstract Expressionism was characterized by its "painterly" quality, a term inspired by the use of the German word *malerisch* by the Swiss art historian Heinrich Wölfflin to describe Baroque art, where he observed such free and exuberant use of media that absolute narrative clarity was sacrificed for the sake of bravura handling. Just as Wölfflin contrasted the painterly quality of the Baroque with the crisp linearity of High Renaissance art, so Greenberg identified Post Painterly Abstraction with more sharply defined compositions and less emphasis on evidence of the artist's gesture. According to Greenberg: "By contrast with the interweaving of light and dark gradations in the typical Abstract Expressionist picture, all the artists in this show move towards a physical openness of design, or towards linear clarity, or towards both."

Despite Francis' association with Abstract Expressionism or painterly art, the direction of his painting had been toward that compositional openness and formal clarity of which Greenberg spoke. *Shining Back* (fig. 20.1), 1958, presents an open structure that is animated, but not

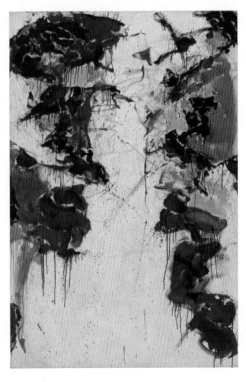

20.1 Sam Francis, *Shining Back*, 1958. Oil on canvas, 6' 7⅜" × 4' 5⅛" (2 × 1.35 m). Solomon R. Guggenheim Museum, New York.

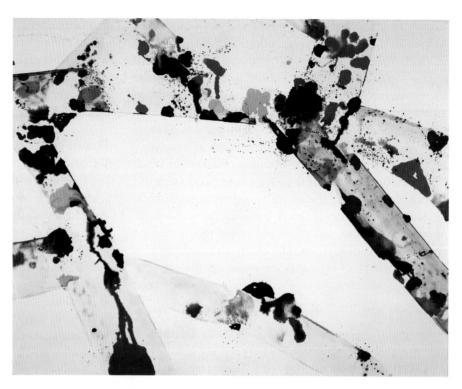

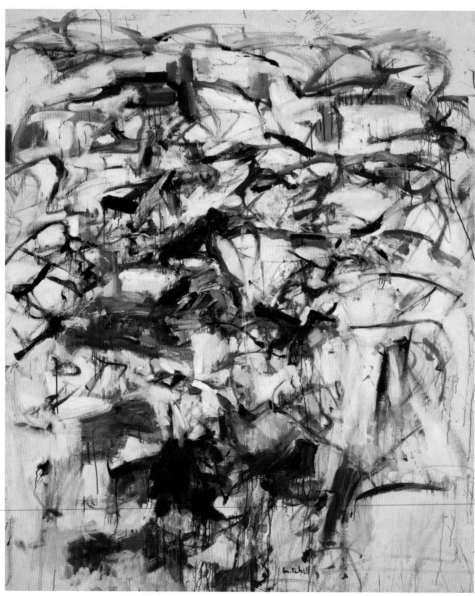

20.3 Joan Mitchell, *August, Rue Daguerre*, 1957. Oil on canvas, 82 × 69" (208 × 175 cm). Phillips Collection, Washington, D.C.

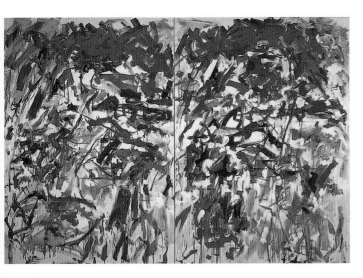

20.4 Joan Mitchell, *Land*, 1989. Oil on canvas, 9' 2¼" × 13' 1½" (2.8 × 4 m). National Gallery of Art, Washington, D.C.

obscured, by Francis' continued use of brush gesture, the drip, and the spatter. In later works, despite lingering vestiges of spatters, the essential organization is that of a few free but controlled color-shapes—red, yellow, and blue—defining the limits of a dominant white space. Francis' paintings of the early 1970s (fig. **20.2**) increasingly emphasized the edge to the point where his paint spatters at times surround a clear or almost clear center area of canvas. At times he used a precise linear structure as a control for his free patterns of stains and spatters, and created an elegant and lyrical form of abstract art.

One of the younger artists who was associated with Abstract Expressionism during the 1950s, **Joan Mitchell**

(1926–92) quickly demonstrated a particular interest in evoking her relationship to landscape, initially referring to both natural and urban environments, often in terms of a remembered time and place, as in *August, Rue Daguerre* (1957) (fig. **20.3**). Mitchell moved permanently to France in 1959, living first in Paris and then in Vétheuil, where she continued to pursue her own directions in painting, undeterred by the popularity of Pop and Op art. In the mid-1960s, she expunged references to urban settings from her work and from then on turned predominantly to nature for inspiration (fig. **20.4**).

Frankenthaler, Louis, and Olitski

An important figure in the transition between Abstract Expressionism and Color Field painting is **Helen Frankenthaler** (b. 1928). Frankenthaler was the first American painter after Jackson Pollock to see the implications of the color staining of raw canvas to create an integration of color and ground in which foreground and background cease to exist. And, like Pollock, she enjoyed the support of Clement Greenberg, who encouraged her formal and technical experiments. Her technique differed significantly from that of Pollock, whose dripped and spattered marks rested on top of the canvas. Frankenthaler poured thinned oil-based paint onto her canvas, allowing it to soak into the support. This produced effects of irresistible movement and flow as the pigment and oil leeched into the support. Frankenthaler's "staining" technique also allowed the weave of the canvas to reveal itself through the pigment, alerting her viewer to her process and the unique properties of her materials. *Mountains and Sea* (fig. **20.5**),

20.5 Helen Frankenthaler, *Mountains and Sea*, 1952. Oil and charcoal on canvas, 86 × 117" (218.4 × 297 cm). Collection of the artist, on loan to National Gallery of Art, Washington, D.C.

20.6 Helen Frankenthaler, *Interior Landscape*, 1964. Acrylic on canvas, 8' 8¾" × 7' 8¾" (2.7 × 2.4 m). San Francisco Museum of Modern Art.

1952, her first stained painting, marked a turning point in her career. Having just returned from a vacation in Nova Scotia, the artist found herself experimenting with composition and consistency of paint. She recounted:

> Before, I had always painted on sized and primed canvas—but my paint was becoming thinner and more fluid and cried out to be soaked, not resting. In *Mountains and Sea*, I put in the charcoal line gestures first, because I wanted to draw in with color and shape the totally abstract memory of the landscape. I spilled on the drawing in paint from the coffee cans. The charcoal lines were original guideposts that eventually became unnecessary.

Frankenthaler employed an open composition, frequently building around a free-abstract central image and also stressing the picture edge (fig. **20.6**). The paint is applied in uniformly thin washes. There is little, sometimes no, sense of paint texture—a general characteristic of Post Painterly Color Field painting—although there is some gradation of tone around the edges of color-shapes, giving them a sense of detachment from the canvas. The irregular central motifs float within a rectangle, which, in turn, is surrounded by irregular light and dark frames. These frames create the feeling that the center of the painting is opening up in a limited but defined depth.

In 1960 Frankenthaler made her first prints. Since then, she worked with a variety of printmaking techniques in addition to painting, using each of these media to explore

pictorial space through the interaction of color and line on a particular surface. One of her most successful prints is *Essence Mulberry*, executed in 1977 (fig. **20.7**). Inspired by an exhibit of medieval prints at The Metropolitan Museum of Art, Frankenthaler combined the shades of mulberry, blue, yellow, and brown. The effect of the blended colors is as delicate and luminescent as that of her paintings.

Morris Louis (1912–62) lived in Washington, D.C., somewhat apart from the New York scene. He and a group of artists that included Kenneth Noland were central to the development of Color Field painting (see chapter 17). The basic point about Louis' work and that of other Color Field painters, in contrast to most of the other new approaches of the 1960s, is that they continued a tradition of painting exemplified by Pollock, Newman, Still, Motherwell, and Reinhardt (see chapter 17). All of these artists were concerned with the classic problems of pictorial space and the statement of the picture plane. During a visit to Frankenthaler's studio in 1953 arranged by Clement Greenberg, Morris Louis was so affected by *Mountains and Sea* that he and Kenneth Noland began to stain

20.7 Helen Frankenthaler, *Essence Mulberry*, 1977. Woodcut, edition of 46, 39½ × 18½" (100.3 × 47 cm). Printed and published by Tyler Graphics Ltd.

20.8 Morris Louis, *Kaf*, 1959–60. Acrylic on canvas, 8' 4" × 12' (2.5 × 3.7 m). Collection Kimiko and John G. Powers, New York.

canvases themselves, establishing their own staining techniques. Louis characteristically applied extremely runny paint to an unstretched canvas, allowing it to flow over the inclined surface in effects sometimes suggestive of translucent color veils. Even more so than Frankenthaler, Louis eliminated the brush gesture, although the flat, thin pigment is at times modulated in billowing tonal waves (fig. **20.8**). His "veil" paintings consist of bands of brilliant, curving color-shapes submerged in translucent washes through which they emerge principally at the edges. Although subdued, the resulting color is immensely rich. In another formula, the artist used long, parallel strips of pure color arranged side by side in rainbow effects. Although the separate colors here are clearly distinguished, the edges are soft and slightly interpenetrating (fig. **20.9**).

Jules Olitski (1922–2007) might be seen as a man of romantic sensibility expressing himself through the sensuousness of his large, assertive color areas. In earlier works he, like so many of his contemporaries, explored circle forms, but his were generally irregular, off-center, and interrupted by the frame of the picture to create vaguely organic effects reminiscent of Jean Arp. Moving away from these forms, Olitski began, in about 1963, to airbrush paint onto the canvas, over which he rolled additional

20.9 Morris Louis, *Moving In*, 1961. Acrylic on canvas, 7' 3½" × 3' 5½" (2.2 × 1.05 m). André Emmerich Gallery, New York.

20.10 Jules Olitski, *High a Yellow*, 1967. Acrylic on canvas, 7' 8½" × 12' 6" (2.3 × 3.8 m). Whitney Museum of American Art, New York.

colors. In later works, such as *High a Yellow*, 1967 (fig. **20.10**), he sprayed on successive layers of pigment in an essentially commercial process that still admitted a considerable degree of accident in surface drips and spatters. The dazzling, varied areas of paint are defined by edges or corners and perhaps internal spots of roughly modeled paint that control the seemingly limitless surfaces. Sometimes apparently crude and coloristically disturbing, Olitski's flamboyant works are nevertheless arresting.

Poons

In the 1960s, **Larry Poons** (b. 1937) created an intriguing form of Systemic painting with optical-illusionistic implications. Systemic art involves a highly organized, often repetitive or even mechanical-seeming approach. In the case of Poons, the system he developed required him to apply dots at specific intervals on a sheet of graph paper to create a pattern that he would then transfer to canvas. Reliance on *a priori* rules or restrictions allows the artist to divert attention away from choosing subject matter or other compositional elements such as color, size of the work, etc. Such strategies by artists to limit their creative freedom were adopted for a variety of reasons during the 1950s and 60s. Some artists, like Poons, found that such an approach enabled them to focus on their medium. Others felt that a rubric could aid in eliminating any vestiges of narrative or romantic sentimentality from their work.

In *Nixes Mate*, 1964 (fig. **20.11**), Poons' small, brightly colored ellipses vibrate against their highly saturated background. This painting, created through a process of staining, was simultaneously identified as Color Field painting by Greenbergian formalists and as Optical art by other critics. Poons subsequently placed more emphasis on the painterly surface of his work. His heavily textured canvases frequently have long, vertically dragged brushstrokes, densely arranged in rich color patterns. Like Olitski and the other Color Field painters, Poons created large-scale works that would envelop the visual field of the viewer, provoking a purely optical response to the image—the Greenbergian ideal for modernist painting.

20.11 Larry Poons, *Nixes Mate*, 1964. Acrylic on canvas, 5' 10" × 9' 4" (1.78 × 2.8 m). Formerly collection Robert C. Scull, New York.

At an Oblique Angle:
Diebenkorn and Twombly

As the trend toward progressively more radical abstraction intensified throughout the 1960s, urged on by doctrinaire critical support, commercial hype, and media exposure, only exceptionally strong artists could maintain their aesthetic independence from the dominant mode. Several of the most interesting figures to emerge during this period enjoyed the advantage—in relation to their autonomy—of regular residence remote from the competitive New York art scene.

In the course of his career, which began in the 1940s, California artist **Richard Diebenkorn** (1922–93) moved through three distinct artistic phases. During the first he worked in an Abstract Expressionist vein, guided by the examples of Clyfford Still and Mark Rothko (see chapter 17), who both taught at the California School of Fine Arts (now the San Francisco Art Institute). While the outward forms of his style would change, the artist early on discovered his most fundamental concern: to abstract from his perception of things seen in order to realize painterly, atmospheric distillations of the western American landscape. From the outset, he learned to translate sensuous, visual experience into broad fields of color structured in relation to the flatness and rectilinearity of the picture

20.12 Richard Diebenkorn, *Berkeley No. 22*, 1954. Oil on canvas, 59 × 57" (149.8 × 144.9 cm). Hirshhorn Museum and Sculpture Garden, Smithsonian Institution, Washington, D.C.

plane by a framework of firm but painterly geometry (fig. 20.12). Even as an Abstract Expressionist, Diebenkorn was, like most of his generation, a cool formalist, and in the context of his art he eschewed private, autobiographical associations in favor of meanings more generally evocative of the interaction between inner and outer worlds. This can be seen to particular advantage in *Man and Woman in Large Room* (fig. **20.13**), executed after the artist shifted from abstraction to figuration, a change that occurred in 1954 while he was in close contact with two other California painters, David Park and Elmer Bischoff. The picture functions almost as a visual metaphor because the figures, despite the expressionist potential of their juxtaposition and handling, participate in the overall structure of the total image while also enriching its sober, contemplative mood with an undercurrent of emotional pressure.

20.13 Richard Diebenkorn, *Man and Woman in Large Room*, 1957. Oil on canvas, 71 × 62½" (180.3 × 158.8 cm). Hirshhorn Museum and Sculpture Garden, Smithsonian Institution, Washington, D.C. Gift of the Joseph H. Hirshhorn Foundation, 1966.

In the early 1960s Diebenkorn moved on from this second, or figurative, phase and, in 1967, following his relocation to Santa Monica, began his third mode, devoted to a series of majestic non-figurative abstractions known as the *Ocean Park* paintings (fig. **20.14**). In variation after variation, and with Matisse as a primary source (see fig. 12.9), in addition to Mondrian, Monet, and of course Abstract Expressionism, Diebenkorn purified and monumentalized his personal vocabulary of mist- and light-filled color planes emanating from but rigorously contained within a softly drawn architectural scaffolding. *Pentimenti* (passages of paint through which earlier paint layers, marks, or corrections are visible), odd and oblique angles in the structural borders, and the expansiveness and close harmony of the luminous colors work without benefit of human images to generate a sense of tension within the pervasive calm, a sense of presence within figuratively empty fields.

After World War II and following a semester of study at Black Mountain College, the slightly younger **Cy Twombly** (b. 1928) established a more or less permanent base in Rome, where he too succeeded in calmly pivoting his art on the convergence point of freedom and control, lucidity and opacity. A poet as well as a painter and sculptor, Twombly found his characteristic image in a slate-gray ground covered with white graffiti, drawings intermingled with words and numbers, reminiscent of classroom lessons or mathematical formulas half-erased from a blackboard (fig. **20.15**). Sometimes snatches of personal verse, often brief quotations from a classical source, always legible at first sight, though never quite complete or entirely coherent on close examination, Twombly's scribbles and scrawls activate the surface with gestures as decisive as Pollock's, but, unlike those of the Abstract Expressionists, they remain indeterminate.

20.15 Cy Twombly, *Untitled*, 1969. Crayon and oil on canvas, 6' 6" × 8' 7" (2 × 2.6 m). The Whitney Museum of American Art, New York.

Forming the Unit: Hard-Edge Painting

The term "Hard-Edge" was first used by the California critic Jules Langsner in 1959, and then given its current definition by Lawrence Alloway in 1959–60. According to Alloway, Hard-Edge was defined in opposition to geometric art in the following way:

The "cone, cylinder, and sphere" of Cézanne fame have persisted in much 20th-century painting. Even where these forms are not purely represented, abstract artists have tended toward a compilation of separable elements. Form has been treated as discrete entities ... [whereas] forms are few in hard-edge and the surface immaculate. ... The whole picture becomes the unit; forms extend the length of the painting or are restricted to two or three tones. The result of this sparseness is that the spatial effect of figures on a field is avoided.

The important distinction drawn here between Hard-Edge and the older geometric tradition is the search for a total unity in which there is generally no foreground or background, no "figures on a field." During the 1950s, Ellsworth Kelly, Ad Reinhardt, Leon Polk Smith, Alexander Liberman, Sidney Wolfson, and Agnes Martin (most of them exhibiting at the Betty Parsons Gallery in New York) were the principal pioneers. Barnett Newman (also showing at Parsons) was a force in related but not identical space and color explorations (see fig. 17.27).

Ellsworth Kelly (b. 1923), who matured artistically in Paris following World War II, came to be considered a leader of the Hard-Edge faction within Color Field painting, although he himself expressed some discomfort with this label. He explained to curator Henry Geldzahler in 1963, "I'm interested in the mass and color, the black and white—the edges happen because the forms get as quiet as they can be." Despite the abstract appearance of much of Kelly's painting, the artist drew extensively on his observation of the natural forms around him, as in *Window, Museum of Modern Art, Paris* of 1949 (fig. **20.16**). In 1954 the artist returned to the States, settling in New York among a group of artists, including Jasper Johns, Robert Rauschenberg, Jack Youngerman, and Agnes Martin, who, like him, resisted the dominance of Abstract Expressionism. In New York, Kelly experimented with collage and continued to develop his interest in shape and color and the relationship of figure to ground. The influence of Arp was evident at times, not only in his sometimes organic-seeming forms but also in his willingness to relinquish some control in composing his work. Although he experimented with chance operations akin to Arp's approach with his *Collage Arranged According to the Laws of Chance* (fig. 11.3), Kelly preferred to limit his compositional freedom by adopting motifs and patterns

found in his environment: window frames, awnings, shadows cast by trees.

His paintings of the early 1960s frequently juxtaposed fields of equally vibrant color, squeezing expansive forms within the confines of a rectangular canvas (fig. **20.17**).

20.16 Ellsworth Kelly, *Window, Museum of Modern Art, Paris*, 1949. Oil on wood and canvas, two joined panels, 50½ × 19½ × ¾" (128.7 × 49.5 × 1.9 cm). Private collection.

20.17 Ellsworth Kelly, *Orange and Green*, 1966. Liquitex (mat varnish) on canvas, 7' 4" × 5' 5" (2.2 × 1.65 m). Collection Robert and Jane Meyerhoff, Phoenix, Maryland.

20.18 Ellsworth Kelly, *Untitled (Mandorla)*, 1988. Bronze, 8' 5" × 4' 5½" × 1' 9" (2.6 × 1.36 × 0.53 m). Private collection.

But just as the tension in these canvases suggests, these forms frequently exploded from the rectangular frame, giving rise to works of various shapes. These shaped canvases undermined the distinction between painting and sculpture. Kelly continued to work in a similar vein; he did not differentiate between his paintings and his sculptures, and some of his works are difficult to classify. Thus *Untitled (Mandorla)* of 1988 (fig. **20.18**), a bronze distillation of a form common in medieval painting, gains much of its effect from its relief projection. Kelly also created freestanding sculptures, works that use forms similar to those of his paintings, although projected on an environmental scale and constructed industrially of Cor-Ten steel.

Like Kelly, **Jack Youngerman** (b. 1926) developed his art in Paris during the postwar years, courtesy of the GI Bill, before returning to join the New York School in the 1950s. He then became known for bringing a special Matisse-like rhythm and grace to the Constructivist tradition by rendering leaf, flower, or butterfly forms with the brilliantly colored flatness and clarity of Hard-Edge painting (fig. **20.19**). In such work, he looked back not only to Arp and Matisse, but also to the rhapsodic, nature-focused art of painters who worked in the United States, such as Dove, O'Keeffe, and Gorky (see figs. 16.16, 16.21, 17.4). For a while, he designed his undulant silhouettes so that figure and ground appear to reverse, with negative and positive switching back and forth.

20.19 Jack Youngerman, *Roundabout*, 1970. Acrylic on canvas, diameter 8' (2.4 m). Albright-Knox Art Gallery, Buffalo, New York. Gift of Seymour H. Knox. Jr., 1971.

20.20 Kenneth Noland, *A Warm Sound in a Gray Field*, 1961. Acrylic on canvas, 6' 10½" × 6' 9" (2.1 × 2.06 m). Private collection, New York.

20.21 Kenneth Noland, *Sarah's Reach*, 1964. Acrylic on canvas, 93¾ × 91⅝" (238.2 × 232.8 cm). Smithsonian American Art Museum, Washington, D.C.

Although **Kenneth Noland** (b. 1924) was close to Louis during the 1950s and, like him, sought through Color Field painting an essential departure from the brush-gesture mode of De Kooning or Kline (see figs. 17.7, 17.13), his personal solutions were quite different. Using the same thin pigment to stain unsized canvas, Noland made his first completely individual statement when, as he said, he discovered the center of the canvas. From this point, between the mid-1950s and 1962, his principal image was the circle or a series of concentric circles exactly centered on a square canvas (fig. **20.20**). Since this relation of circle to square was necessarily ambiguous, in about 1963 Noland began to experiment with different forms, first ovoid shapes placed above center, and then meticulously symmetrical chevrons starting in the upper corners and coming to a point just above the exact center of the bottom

edge (fig. **20.21**). The chevrons, by their placement as well as their composition, gave a new significance to the shape of the canvas and created a total, unified harmony in which color and structure, canvas plane and edges, are integrated.

In 1964 Noland was a featured painter at the United States pavilion of the Venice Biennale, and in 1965 he was given a solo exhibition at the Jewish Museum. It was about this time that Noland, working within personally defined limits of color and shape relationships, systematically expanded his vocabulary. The symmetrical chevrons were followed by asymmetrical examples. Long, narrow paintings with chevrons only slightly bent led to a series in which he explored systems of horizontal strata, sometimes with color variations on identical strata, sometimes with graded horizontals, as in *Graded Exposure* (fig. **20.22**). In the next few years the artist moved from the solution of *Graded*

20.22 Kenneth Noland, *Graded Exposure*, 1967. Acrylic on canvas, 7' 4¾" × 19' 1" (2.3 × 5.8 m). Collection Mrs. Samuel G. Rautbord, Chicago.

20.23 Al Held, *The Big N.* 1964. Synthetic polymer paint on canvas, 9' ⅜" x 9' (2.76 × 2.75 m). The Museum of Modern Art, New York.

Exposure to a formula of vertical or horizontal canvases in which his use of the grid allowed a dominant emphasis to fall on the framing edge. In his subsequent work, Noland continued to explore the relationship of form and color to the edge of the canvas itself, manipulating the shape of the canvas as well as the painted surface.

Al Held (1928–2005) approached Color Field painting differently, building up his paint to create a texture that added to the total sense of weight and rugged power. He worked over his paint surfaces, sometimes layering them to a thickness of an inch, although, from 1963, he sanded down the surface to a machine precision. For a period in the 1960s, Held based paintings on letters of the alphabet (fig. **20.23**), abjuring, like Kelly, some control over the ostensible subject of his work. In these, again, the open portions of the letters were subordinated, both to hold the edges of the canvas and to establish a sense of great scale. Held focused on the powerful presence of colored forms on the canvas, rather than on the less tangible, more self-consciously optical effect of stained color preferred by artists such as Louis and Noland.

In the later 1960s, Held rebelled against the modernist rejection of illusionism and resisted the pervasive reductive trend in contemporary painting. He introduced complex, apparently three-dimensional shapes into his paintings.

The insistent exploration of a version of rigid geometric abstraction led him through the refinement of his means, to a black-and-white structure. In a group of paintings of 1974 and early 1975 he presented an architecture of box-like structures outlined in white against a uniform black ground (fig. **20.24**). The title "Flemish" in the series suggests that Held, like many of his contemporaries in the 1970s, had been looking at old master paintings, in this instance conceivably the works of Jan van Eyck or Rogier van der Weyden, whose minutely rendered scenes depend on the use of empirical perspective. Unlike Renaissance mathematical perspective, which uses geometry to map out a consistent viewpoint, empirical perspective is based simply on observation, resulting in slight inconsistencies and different lines of sight within a single painting.

When Held reintroduced color, he did so with a vengeance, adopting a high-keyed intensity combined with an expanded scale to give his newer paintings an almost overwhelming impact, as in his fifty-five-foot-long (16.8 m) mural *Mantegna's Edge* at the Southland Center, Dallas (fig. **20.25**). Again, this title refers to earlier experiments in perspective: the Italian Renaissance painter Andrea Mantegna was particularly renowned for his daring use of foreshortening. In one famous painting, he used the technique to impart to the viewer of his *Dead Christ* the

20.24 Al Held, *Flemish IX*, 1974. Acrylic on canvas, 6' × 5' (1.8 × 1.52 m). Sable-Castelli Gallery, Toronto.

20.25 Al Held, *Mantegna's Edge*, 1983. Mural, acrylic on canvas, length 55' (16.8 m). Southland Center, Dallas.

sensation of standing over the supine figure. Here, Held offers the twentieth-century viewer a variation on this encounter with the infinite. The color combined with his handling of line produces the paradoxical effect of clarity and ambiguity. Images constantly fail to conform to what experience and tradition have prepared us to anticipate in Held's apparently logical spatial structures. And so, as within the perpetual movement of Pollock's calligraphic complexity, the eye gives up trying to sort out the irresolutions and accepts the experience of the total configuration, as is the case in works rendered using empirical perspective by Netherlandish painters like Van Eyck and Van der Weyden.

Seeing Things: Op Art

Several broadly related tendencies in the painting of the 1960s may be grouped under the heading of Optical (or Retinal) painting. "Optical" in this context should not be confused with the quality of opticality that Greenbergian formalists attributed to modernist painting. For them, opticality meant the sense of a flat, non-illusionistic image that seemed to deny the necessity of physical support. By contrast, the optical stimulation of Op art implied the presence of an illusion generated by the stimulation of the retina. It shares aspects of Color Field painting in its use of brilliant, unmodulated color in retinally stimulating combinations, especially as seen in the art of Larry Poons. Op art came to the forefront of the New York art world in 1965 with William C. Seitz's exhibition, The Responsive Eye, at The Museum of Modern Art. Although the show included some Color Field painters and Hard-Edge abstractionists, it was immediately clear that Op art represented something new. Op art actively engaged the physiology and psychology of seeing with eye-teasing arrangements of color and pattern that seemed to pulsate. Such works generated strong associations with science and technology. Interestingly, although Op art enjoyed much popular interest in the United States, it generated more serious critical acclaim in Europe, with light sculptor Julio Le Parc claiming first prize at the Venice Biennale in 1966.

Optical illusion is not new in the history of art; nor is the overlap it implies between artistic rendition and scientific theories of vision. Examples from the last 500 years include the discovery, or rediscovery, of linear and atmospheric perspective in the fifteenth century; the interest of Impressionist and Post-Impressionist painters such as Georges Seurat in nineteenth-century theories of color and perception; and the experimentation of several Bauhaus artists, like László Moholy-Nagy and Josef Albers, with similar questions. This examination of the Optical and related kinetic art of the 1960s surveys some of the approaches taken by artists during this period to forms of art involving optical illusion or some other specific aspect of perception (of course, as we have already seen, such concerns were not limited to Op and kinetic artists alone).

Vasarely

The Hungarian-born French painter **Victor Vasarely** (1908–97) was the most influential figure in the realm of Op art. Although his earlier paintings belonged in the general tradition of Concrete art (see chapter 18), in the 1940s he devoted himself to Optical art and theories of perception. Vasarely's art theories, first presented in his 1955 *Yellow Manifesto*, involved the replacement of traditional easel painting by what he called "kinetic plastics." To him, "painting and sculpture become anachronistic terms: it is more exact to speak of a bi-, tri-, and multi-dimensional plastic art. We no longer have distinct manifestations of a creative sensibility, but the development of a single plastic sensibility in different spaces." Vasarely sought the abandonment of painting as an individual gesture, the signature of the isolated artist. In a modern, technological society, he believed that art had to have a social context; he saw the work of art as the artist's original idea rather than as an object consisting of paint on canvas. This idea, realized in terms of flat, geometric-abstract shapes mathematically organized, with standardized colors, flatly applied, could then be projected, reproduced, or multiplied into different forms—murals, books, tapestries, glass, mosaic, slides, films, or video. For the traditional concept of the work of art as a unique object produced by an isolated artist, Vasarely substituted the concept of social art, produced by the artist in full command of modern industrial communication techniques for a mass audience.

Vasarely was a pioneer in the development of almost every optical device for the creation of a new art of visual illusion. His *Photographismes* are black-and-white line drawings or paintings. Some of these were made specifically for reproduction, and in them Vasarely frequently covered the drawing with a transparent plastic sheet having the same design as the drawing but in a reverse, negative-positive relationship. When the two drawings—on paper and on plastic—are synchronized, the result is simply a denser version. As the plastic is drawn up and down over the paper, the design changes tangibly before our eyes. Here, literal movement creates the illusion. This and many further devices developed by Vasarely and other Op artists produced refinements of processes long familiar in games of illusion or halls of mirrors.

In his *Deep Kinetic Works*, Vasarely translated the principle of the plastic drawings into large-scale glass constructions, such as the 1953 *Sorata-T* (fig. **20.26**), a standing triptych, six-and-a-half by fifteen feet (2 × 4.6 m) in dimension. The three transparent glass screens may be placed at various angles to create different combinations of the linear patterns. Such art lends itself to monumental statements that Vasarely was able to realize in murals, ceramic walls, and large-scale glass constructions. What he called his "Refractions" involve glass or mirror effects with constantly changing images.

20.26 Victor Vasarely, *Sorata-T*, 1953. Triptych, engraved glass slabs, 6' 6" × 15' (2 × 4.6 m). Private collection.

Since Vasarely was aware of the range of optical effects possible in black and white, a large proportion of his work is limited to these colors, which he referred to simply as "B N" (*blanche noir*: white black). It was, nevertheless, in color that the full range of possibilities for Optical painting could be realized, and Vasarely was well aware of this. In the 1960s, his color burst out with a variety and brilliance unparalleled in his career. Using small, standard color-shapes—squares, triangles, diamonds, rectangles, circles, sometimes frontalized, sometimes tilted, in flat, brilliant colors against equally strong contrasting color grounds—he set up retinal vibrations that dazzle the eye and bewilder perception (fig. **20.27**).

Riley and Anuszkiewicz

The British artist **Bridget Riley** (b. 1931) and the American **Richard Anuszkiewicz** (b. 1930) have created highly acclaimed examples of Op art. Initially working primarily in black and white and different values of gray, with repeated, serial units frontalized and tilted at various angles, Riley produced extremely effective illusions, seemingly making the picture plane weave and billow before our eyes. Her use of variations in tone (which Vasarely rejected) accentuates the illusion (fig. **20.28**). By contrast,

20.27 Victor Vasarely, *Vega Per*, 1969. Oil on canvas, 64 × 64" (162.6 × 162.6 cm). Honolulu Academy of Arts.

20.28 Bridget Riley, *Drift No. 2*, 1966. Emulsion on canvas, 7' 7½" × 7' 5½" (2.31 × 2.26 m). Albright-Knox Art Gallery, Buffalo, New York.

20.29 Richard Anuszkiewicz, *Inflexion*, 1967. Liquitex on canvas, 60 × 60" (152.4 × 152.4 cm). Collection the artist.

Anuszkiewicz, a student of Josef Albers, often used color and straight lines to achieve pulsating visual effects in his painting—frequently defying our ability to distinguish background and foreground in his works or to identify whether a given plane is moving forward or receding. In *Inflexion* (fig. **20.29**) he skillfully reversed the direction of the radiating lines on each side of the square, thus making what at a quick glance looks like a traditional perspective box suddenly begin to turn itself inside out.

New Media Mobilized: Motion and Light

Two directions explored sporadically since early in the twentieth century gained new impetus in the 1960s. These are motion and light used literally, rather than as painted or sculptured illusions. Duchamp's and Gabo's pioneering experiments in motion and Moholy-Nagy's in motion and light have already been noted (see fig. 14.5). Before World War II, Calder was the one artist who made a major art form of motion (see fig. 16.74). Except for further explorations carried on by Moholy-Nagy and his students during the 1930s and 40s, the use of light as a medium was limited to variations on "color organs," in which programmed devices of one kind or another produced shifting patterns of colored lights. These originated in experiments carried on in 1922 at the Bauhaus by Ludwig Hirschfeld-Mack (1893–1965) and by the American Thomas Wilfred (1889–1968), inventor of the color organ. The late 1960s saw a revival in the use of light as an art form and in so-called mixed media, where the senses are engaged by live action, sound, light, and motion pictures at the same time.

During the late 1950s and 60s, exhibitions of light and motion proliferated throughout the world, as did new artists' organizations and manifestos. It was in 1955, in connection with the Movement exhibition at the Denise René Gallery in Paris, that Victor Vasarely issued his *Yellow Manifesto*, outlining his theories of perception and color. Another important theoretician was Bruno Munari (1907–98), who was producing kinetic works in Italy as early as 1933. Active in Spain, Equipo 57 (founded in 1957) represented a group of artists who worked as an anonymous team in the exploration of motion and vision. This anonymity, deriving from concepts of the social implications of art and also, perhaps, from the examples of scientific or industrial research teams, was evident at the outset in the Group T in Milan, founded in 1959; Group N in Padua, Italy, founded in 1960; and Zero Group in Düsseldorf, Germany, founded in 1957 by the kinetic artist Otto Piene. In most cases the theoretical passion for anonymity soon dimmed, and the artists began to emerge as individuals.

Mobiles and Kinetic Art

Although not usually labeled as a 1960s kinetic artist, **Alexander Calder** (1898–1976), whose prewar career was discussed in chapter 16, merits further discussion here for his important example and continued influence in the area of kinetic sculpture. From the late 1940s he had developed a growing interest in monumental forms, and in the transformation of the mobile to a great architectural–sculptural wind machine whose powerful but precisely balanced metal rods, tipped with large, flat, organically shaped disks, encompass and define large areas of architectural space. Since the mobile, powered by currents of air, could function better outdoors than indoors, Calder began early to explore the possibilities for outdoor mobiles. Critical to the development of these works was his reconceptualization of the mobile as something that could function as an autonomous, standing structure, combining interrelated stable and mobile forms in an organic whole. In the late 1950s and 60s, Calder created many large, standing mobile units that rotate in limited but impressive movement over a generally pyramidal base.

As *La Spirale* (fig. **20.30**) suggests, the development of Calder's moving sculptures bore an important relationship to the development of non-moving elements in his structures. One of his signal achievements of the 1960s occurred in his great "stabiles"—his large-scale, non-moving, metal-plate constructions, usually painted black. Of these, one of the most impressive is the glowing red *La Grande Vitesse* (fig. **20.31**) in Grand Rapids, Michigan: an expansive work with which Calder filled an otherwise sterile public space with Miró-like charm and radiant splendor. While suggesting a great exotic flower in its prime or the expressive movements of a dancer, the assemblage of red biomorphic planes boldly displays the structure of its rivets and struts and testifies to the forces involved in creating it.

20.30 Alexander Calder, *La Spirale*, 1958. Standing mobile, sheet metal, rods, bolts, and paint, height 30' (9.1 m). UNESCO, Paris.

20.31 Alexander Calder, *La Grande Vitesse*, 1969. Sheet metal, bolts, and paint, 43 × 55 × 25' (13.1 × 16.8 × 7.7 m). Calder Plaza, Vandenberg Center, Grand Rapids, Michigan.

20.32 George Rickey, *Four Lines Up*, 1967.
Stainless steel, height 16' (4.9 m). Collection
Mr. and Mrs. Robert H. Levi, Lutherville, Maryland.

Among the makers of mobiles, one of
the most interesting to emerge in the United
States since World War II was **George Rickey**
(1907–2002). He composed long, tapering
strips or leaf clusters of stainless steel in a state
of balance so delicate that the slightest breeze or
touch of the hand sets them into a slow, stately
motion or a quivering vibration (fig. **20.32**).
During the 1970s, he enlarged his vocabulary
with the introduction of large-scale rectangu-
lar, circular, and triangular forms in aluminum,
so precisely balanced that they maintain the
possibility of imperceptible and increasingly
intricate patterns in movement. His was an art
of motion entirely different from that of Calder.

Jesus Rafaël Soto (1923–2005) is a motion
artist in the sense that his constructions,
consisting of exquisitely arranged metal rods,
are sensitive to the point that even a change in
atmosphere will start an oscillation (fig. **20.33**).
A Venezuelan who resided in Paris, Soto began
as an illusionistic painter and then moved
to a form of linear construction during the
1960s. He developed a personal idiom of great
elegance, sometimes translated into a form
of large-scale architecture involving spectator
participation. In exhibitions at the Solomon R.
Guggenheim Museum in New York and the
Hirshhorn Museum and Sculpture Garden in
Washington, D.C., he created out of his typical
plastic strings entire room environments that
the spectator could enter.

20.33 Jesus Rafaël Soto, *Petite Double Face*,
1967. Wood and metal, 23⅝ × 15"
(60 × 38.1 cm). Marlborough Gallery, New York.

Artists Working with Light

Of the light experimentalists, the Argentine **Julio Le Parc** (b. 1928) was one of the most imaginative and varied in his employment of every conceivable device of light, movement, and illusion (fig. **20.34**). The awarding to him of the painting prize at the 1966 Venice Biennale was not only a recognition of his talents but also an official recognition of new artistic media. From 1958 Le Parc lived in Paris where, in 1960, he was a founder of the Groupe de Recherche d'Art Visuel (GRAV). With its home base at the Denise René Gallery, this group carried on research in light, perception, movement, and illusion. Le Parc became an important link between various overlapping but normally separate tendencies in the art of the 1960s: not only light and movement, but also different forms of optical, illusionistic painting, and programmed art.

The Greek artist **Chryssa** (b. 1933) bridged the gap between Pop art and light sculpture. She first explored emblematic or serial relief forms composed of identical, rhythmically arranged elements of projecting circles or rectangles. Then, in the early 1960s, she made lead reliefs derived from the type forms used to print newspapers. From this Chryssa passed to a type of found-object sculpture in which she used fragments of neon signs. The love of industrial or commercial lettering, whether from newspapers or signs, became a persistent aspect of her works. In this she was recording the American scene in a manner analogous to the Pop artists or to the earlier tradition of Stuart Davis and Charles Demuth (see figs. 16.61, 16.32). Soon her fascination with the possibilities of light, mainly neon tube light, completely took over her construction of elaborate light machines so that they came to resemble contemporary American industrial objects (fig. **20.35**).

20.35 Chryssa, *Ampersand III*, 1966. Neon lights in Plexiglas, height 30¼" (76.8 cm). Collection Robert E. Abrams Family.

20.34 Julio Le Parc, *Continuel-Lumière avec Formes en Contorsion*, 1966. Motorized aluminum and wood, 6' 8" × 4' ½" × 8" (2 × 1.23 × 2 m). Howard Wise Gallery, New York.

Perhaps the most significant group effort in the United States was EAT—Experiments in Art and Technology—which developed from a series of performances involving Robert Rauschenberg, the engineer Billy Klüver, and the composer John Cage. Presented in 1966, 9 *Evenings: Theater and Engineering* involved dance, electronic music, and video projection. These presentations may be traced back to experiments carried on by Cage since the 1940s as well as a collaborative exhibition held at the Denise René Gallery in Paris in 1955. Experiments by GRAV, sponsored by the René Gallery during the 1950s and 60s, may also be seen as forebears to the EAT group in the utilization of sophisticated technology and effects of light and movement. EAT perhaps extended the collaborative effort furthest in its attraction of large-scale financial support, particularly for its Pepsi-Cola Pavilion at the Osaka World's Fair of 1970.

A number of artists, including **Dan Flavin** (1933–96), **Larry Bell** (b. 1939), and **Robert Irwin** (b. 1928), combined their fascination with technology and light with other concerns arising from the negotiation of Greenbergian modernism in the 1960s. Among these concerns was an interest in materials, leading to a general unwillingness to disguise in any way the nature of their medium. Another preoccupation derived from Greenberg's aesthetic was the environment in which an artwork was installed: to what extent is the space around the work also part of the work?

These issues would be central to Minimalism, to be discussed at greater length in the next section of this chapter. But these are also problems addressed by Flavin, Bell, and Irwin, who have been linked in varying degrees with Minimalism.

Dan Flavin exploited the fluorescent fixtures with which he worked for their luminosity, but also took advantage of their status as objects themselves. In his works, the glass tubes of fluorescent light functioned as sculpture both when illuminated and when unlit, creating different effects. In turn, he recognized that light itself could transform an environment, as his 1992 installation (a reworking of an earlier version from 1971) at the newly renovated Guggenheim demonstrated (fig. **20.36**). In a spirit similar to that of Dan Flavin, Larry Bell produced large tinted-glass boxes that both intrigue viewers with their shimmering iridescence and force their audience to confront them as objects, rather than as pure visual effect (fig. **20.37**). The art of Robert Irwin transforms the environment of the viewer even more radically. Working with tightly stretched semi-transparent textile scrims, lighted from behind, he creates an eerie, isolated environment with a hypnotic effect (fig. **20.38**). One is drawn toward what appears to be an impenetrable void that, upon contemplation, increasingly surrounds the spectator. Irwin's interest in the void may have its roots in the empty gallery of Yves Klein, but Irwin greatly developed the earlier concept.

20.36 Dan Flavin, *Untitled (to Tracy to celebrate the love of a lifetime)*, 1992, expanded version of *Untitled (to Ward Jackson, an old friend and colleague who, during the Fall of 1957 when I finally returned to New York from Washington and joined him to work together in this museum, kindly communicated)*, 1971. A system of two alternating modular units in fluorescent light, sixteen white bulbs, each 2' (0.6 m) long, four each of pink, yellow, green, and blue, each 8' (2.4 m) long. Solomon R. Guggenheim Museum, New York.

20.37 Larry Bell, *Untitled*, 1967. Glass, coatings and metal, 14¼ × 14¼ × 14¼" (36.2 × 36.2 × 36.2 cm). Tate, London.

20.38 Robert Irwin, *Untitled*, 1965–67. Acrylic automobile lacquers on prepared, shaped aluminum with metal tubes, four 150 watt floodlights, 60" diameter × 3½" (152.4 × 8.9 cm). Walker Art Center, Minneapolis.

The Limits of Modernism: Minimalism

It will be clear by now that several trends characterize the painting and sculpture of the 1960s, with a number of artists blurring the distinction between these two media. What has been discussed less explicitly is the ideological background to the various approaches to artmaking, particularly sculpture, during this decade. With the publication of Clement Greenberg's collection of essays *Art and Culture* in 1961, and the continued success of the Abstract Expressionist artists whose work he had championed since the 1940s, Greenberg's influence was at its height. However, just when his modernist viewpoint prevailed, artists began to question the basis for his valuations of excellence. According to Greenberg, the best modern art continued the historical trajectory of painting since the time of Manet, which he understood to involve a progressive evolution toward flatness as artists became increasingly effective at exploiting those qualities specific to the medium of paint. For Greenberg, even sculpture was to be judged by the same criterion of displaying opticality rather than illusionistic volume.

The most serious, protracted questioning of these ideas was undertaken by artists who came to be known as Minimalists. If Pop, Op, and kinetic art can be considered departures from the priorities of Greenbergian modernism, Minimalism offered a particularly poignant alternative. The term "Minimalism" was coined in 1965 to characterize an art of extreme visual reduction, but many Minimalist artists resisted its application to their work. Although the pronounced simplicity of their art was ostensibly in keeping with Greenbergian principles of truth to the medium and the evolution of flatness—that is, the elimination of the illusion of depth on a two-dimensional surface—Minimalism also served to undermine this version of modernism. Minimalist artists discussed their ideas in print, providing an intellectual justification for their dissatisfaction with modernist criticism. With Greenberg and his followers advocating that painting should embrace those qualities unique to the medium (flatness, pictorial surface, and the effect of pure opticality) and that sculpture should

20.39 Anthony Caro, *Midday*, 1960. Painted steel, 7' 7¾" × 2' 11⅞" × 12' 1¾" (2.3 × 0.91 × 3.7 m). The Museum of Modern Art, New York.

aspire to similar goals (an emphasis on surface and optical effect), Minimalist artists began agitating against the supremacy of painting and, above all, to stress the primacy of the object itself. Here, the legacy of Marcel Duchamp and his readymades can be discerned, a legacy made all the more important for American artists by the 1963 retrospective of his work at the Pasadena Art Museum (now the Norton Simon Museum) in California. Yet, Minimalist artists denied the modernist belief that works of art should be autonomous—that they should exist in their own terms irrespective of context—and instead considered the importance of a work's environment. They often took into account theories of the psychology of perception and emphasized the importance of the audience's interaction with their pieces, arguing that art need not be absorbed from a single viewpoint in a purely optical fashion. Minimalist art considered not only the eyes of the spectator, but also the body.

Caro

In order to understand the relationship between modernism and Minimalism, it is helpful to consider the work of a key 1960s modernist, the British sculptor **Anthony Caro** (b. 1924). His work has been discussed in opposition to Minimalism by the critic Michael Fried, who acknowledges his sympathy with Greenberg's ideas. For Fried, Caro exemplifies modernism while the Minimalists are dismissed as anti-modernist.

Caro was particularly influenced by the example of Henry Moore (see figs. 15.52, 15.53, 18.50), for whom he worked as an assistant between 1951 and 1953. Subsequently,

he began to experiment with new materials and with the production of welded metal sculpture. He was encouraged to pursue this direction by a lengthy trip in 1959 to the United States, where he met Clement Greenberg, David Smith, and Kenneth Noland (see figs. 17.36–17.39, 20.20–20.22).

On returning to England, Caro worked actively in a modernist vein, producing sculptures that stressed their presence as physical objects less than their dematerialized optical appearance. Greenberg's 1961 essay on the sculpture of David Smith clarified the goal toward which Caro's work strived:

> To render substance entirely optical, and form, whether pictorial, sculptural or architectural, as an integral part of ambient space—this brings anti-illusionism full circle. Instead of the illusion of things, we are now offered the illusion of modalities: namely, that matter is incorporeal, weightless and exists only optically like a mirage.

In similar fashion, Caro's works often seem to dematerialize in front of the eye, registering their surfaces rather than any sense of bulk. The bright planes of *Midday* (fig. **20.39**) appear almost to float. Similarly, elements of *Riviera* (fig. **20.40**) seem to hover effortlessly in the air. Thus, the opticality of Caro's sculptures—their appeal to a purely visual experience—along with their emphasis on compositional unity, on the harmonious balance of discrete elements brought together as a whole, place them squarely in the modernist camp.

20.40 Anthony Caro, *Riviera*, 1971–74. Rusted steel, 10' 7" × 27' × 10' (3.2 × 8.2 × 3 m). Collection Mr. and Mrs. Bagley Wright, Seattle.

Stella

The art of **Frank Stella** (b. 1936) straddled the line between Minimalism and the modernism advocated by Greenberg. Stella first gained wide recognition in 1960 with a number of works exhibited by New York's Museum of Modern Art during one of its periodic group shows of American artists, on this occasion entitled Sixteen Americans. The "black" paintings shown there were principally large, vertical rectangles, with an absolutely symmetrical pattern of light lines forming regular, spaced rectangles (fig. **20.41**). These lines were not formed by adding white pigment to the canvas—rather, they marked the areas where Stella had not laid paint down. In their balanced symmetry and repetition of identical motifs, his paintings had a compelling power of their own, which led modernist critics to praise their optical qualities (fig. **20.42**). Over the next few years, using copper or aluminum paint, Stella explored different shapes for the canvas, suggested by variations on his rectilinear pattern. In these, he used deep framing edges, which gave a particular sense of solidity to the painting. In 1964 the artist initiated a series of "notched V" compositions, whose shapes resulted from the joining of large chevrons. After some explorations of more coloristic rectangular stripe patterns, at times with optical effects, about 1967 Stella turned to brilliantly chromatic shapes, interrelating protractor-drawn semicircles with rectangular or diamond effects. These "protractor" works (fig. **20.43**) sometimes suggest abstract triptychs, with their circular tops recalling late Renaissance altarpieces. The apparent stress that these works placed on their qualities as objects—as opposed to a strictly optical character—was extremely appealing to Minimalists. At the same time, two friends and former schoolmates of Stella's, Greenbergian critic Michael Fried and Minimalist artist Carl Andre, both struggled for his allegiance. Fried repeatedly claimed that

20.41 Frank Stella, *Die Fahne Hoch!*, 1959. Enamel on canvas, 121½ × 73" (308.6 × 185.4 cm). Whitney Museum of American Art, New York.

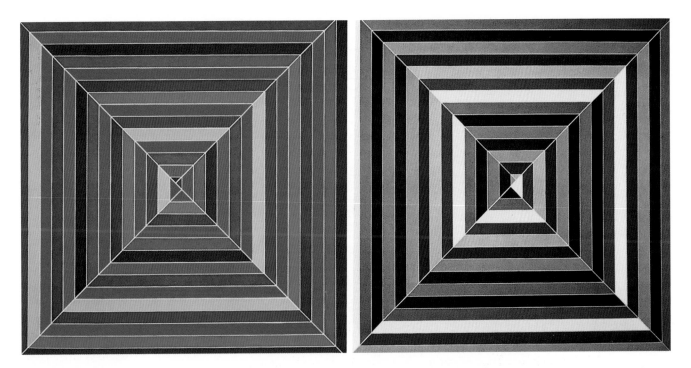

20.42 Frank Stella, *Jasper's Dilemma*, 1962–63. Alkyd on canvas, 6' 5" × 12' 10" (2 × 3.9 m). Collection Alan Power, London.

Stella represented modernist principles; Andre worked closely with him and, when Stella's *Black* paintings were included in the Sixteen Americans exhibition, he wrote a statement about them at the artist's request. Although Stella refused to connect himself firmly with one group or the other, his work continued to undermine any strict division between painting and sculpture. To understand the difficulty in placing his works of the 1960s into a ready category—modernist or Minimalist—the aesthetic concerns motivating Minimalism must be addressed.

20.43 Frank Stella, *Agbatana III*, 1968. Fluorescent acrylic on canvas, 9' 11⅞" × 14' 11⅞" (3 × 4.6 m). Allen Memorial Gallery, Oberlin College, Oberlin, Ohio.

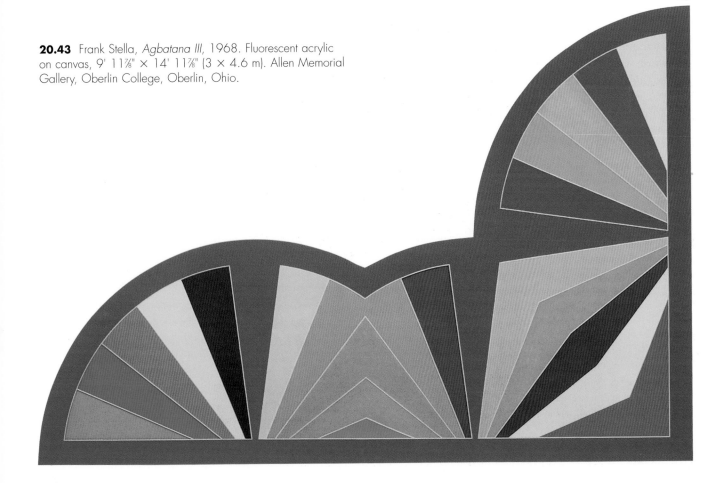

20.44 Tony Smith, *Cigarette*, 1961–66. Plywood model to be made in steel, 15 × 26 × 18' (4.6 × 7.9 × 5.5 m).

Smith, Judd, Bladen, and Morris

Minimalism's clearest early statements came in the form of sculpture. Despite the fact that the sculptor **Tony Smith** (1912–80) matured artistically during the 1940s and 50s, his most important impact was felt during the 1960s. He came to be celebrated by other Minimalists for pronouncements about the nature of art in general (see *Tony Smith Interview*, below), and about his art in particular, which helped to define the new approach of the group as a whole.

Smith's belief that one had to experience art, not merely imbibe its significance by standing in front of it, manifested itself in his large, abstract pieces, which subvert traditional categories of sculpture and experience. *Cigarette*, 1961–66, demands a physical interaction with the viewer (fig. **20.44**); as he or she moves around the structure, certain aspects of it appear as others fade from sight. Both memory and movement are required for the appreciation of the work. Despite its association with an everyday, disposable object,

SOURCE

Tony Smith
from a 1966 interview in *Artforum*

When I was teaching at Cooper Union in the first year or two of the fifties, someone told me how I could get on to the unfinished New Jersey Turnpike. I took three students and drove from somewhere in the Meadows to New Brunswick. It was a dark night and there were no lights or shoulder markers, lines, railings, or anything at all except the dark pavement moving through the landscape of the flats, rimmed by hills in the distance, but punctuated by stacks, towers, fumes, and colored lights. This drive was a revealing experience. The road and much of the landscape was artificial, and yet it couldn't be called a work of art. On the other hand, it did something for me that art had never done. At first I didn't know what it was, but its effect was to liberate me from many of the views I had had about art. It seemed to me that there had been a reality there which had not had any expression in art.

The experience on the road was something mapped out but not socially recognized. I thought to myself, it ought to be clear that that's the end of art. Most painting looks pretty pictorial after that. There is no way you can frame it, you just have to experience it. Later I discovered some abandoned airstrips in Europe—abandoned works, Surrealist landscapes, something that had nothing to do with any function, created worlds without tradition. Artificial landscapes without cultural precedent began to dawn on me. There is a drill ground in Nuremberg, large enough to accommodate two million men. The entire field is enclosed with high embankments and towers. The concrete approach is three sixteen-inch steps, one above the other, stretching for a mile or so.

20.45 Tony Smith, *Die*, 1962. Steel, edition of three, 6 × 6 × 6' (1.8 × 1.8 × 1.8 m). Private collection.

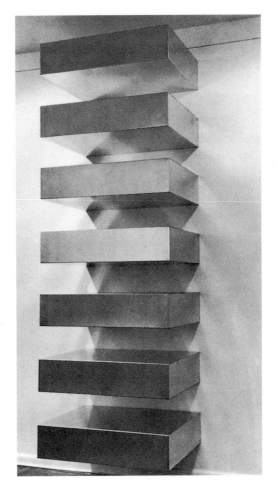

20.46 Donald Judd, *Untitled*, 1965. Galvanized iron, seven boxes, each 9 × 40 × 31" (22.9 × 101.6 × 78.7 cm); 9" (22.9 cm) between each box. Moderna Museet, Stockholm.

the sculpture is by no means pictorial; nor can it be easily cast aside or discarded.

Smith's *Die* of 1962 (fig. **20.45**) has still more obvious affiliations with the common object its name evokes. However, its scale has been radically increased and the cube bears none of a die's traditional markings. *Die* is not an object that can be thrown thoughtlessly by a human hand. Indeed, the sculpture's dimensions—6 feet cubed (1.8 m)—recall the depth of a grave, lending an ominous pall to the object's association with games of chance.

Donald Judd (1928–94) was one of Minimalism's most important sculptors and theorists. With his art criticism and, in particular, his 1965 essay *Specific Objects*, he helped to define the convictions behind the Minimalist questioning of the traditional categories of painting and sculpture. As he wrote in 1965, "A work can be as powerful as it can be thought to be. Actual space is intrinsically more powerful and specific than paint on a flat surface. … A work need only be interesting." For Judd, the "specific

object" could not be classified as either a painting or a sculpture, or even precisely described prior to its making, except in principle. The specific object was less about creating particular structures and more about an attitude toward artmaking.

Through his sculpture, Judd carried the objective attitude to a point of extreme precision. He repeated identical units, often quadrangular, at regular intervals (figs. **20.46**, **20.47**). These are made of galvanized iron or aluminum, occasionally with Plexiglas. Although Judd sometimes painted the aluminum in strong colors, he at first used the galvanized iron in its original unpainted form, something that seemed to emphasize its neutrality. Progressively, however, he used color more frequently in his work, which he began to have professionally manufactured in the mid-1960s.

20.47 Donald Judd, *Untitled (Progression)*, edition of seven, 1965. Red lacquer on galvanized iron, 5 × 69 × 8½" (12.7 × 175.3 × 21.6 cm). The Saint Louis Art Museum, Missouri.

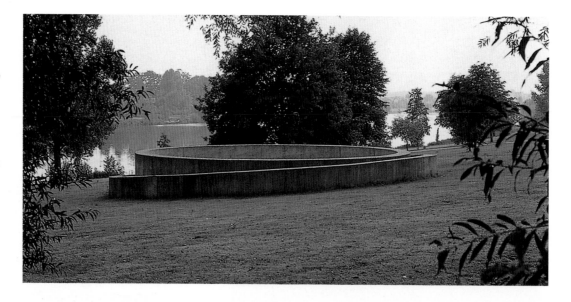

20.48 Donald Judd, *Untitled*, 1977. Concrete, outer ring diameter 49' 3" (15 m), height 2' 11" (0.89 m); inner ring diameter 44' 3" (13.5 m), height 2' 11"–6' 10" (0.89–2.1 m). Collection the City of Münster, Germany.

Judd vehemently insisted that Minimal sculpture—most specifically his own—constituted a direction essentially different from earlier Constructivism or rectilinear abstract painting. The difference, as he saw it, lay in his search for an absolute unity or wholeness through repetition of identical units in absolute symmetry. Even Mondrian "composed" a picture by asymmetrical balance of differing color areas.

Judd's works raise fundamental questions concerning the nature and even the validity of the work of art,

the nature of the aesthetic experience, the nature of space, and the nature of sculptural form. Like those of most Minimalist sculptors, his works progressively expanded in scale. In 1974 he introduced spatial dividers into his sculptures. Three years later he began to construct large-scale works in cement to be installed in the landscape, creating structures that resonate with their environment as they impose order on the movement and experience of a visitor to the site (fig. **20.48**).

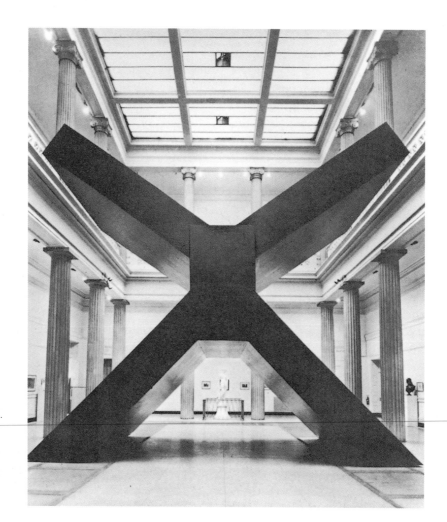

20.49 Ronald Bladen, *The X*, 1967. Painted wood model to be made in metal, 22' 8" × 24' 6" × 12' 6" (6.9 × 7.5 × 3.8 m). Fischbach Gallery, New York.

20.50 Robert Morris, Exhibition, Green Gallery, New York, 1964. Left to right: *Untitled (Cloud)*, 1964, painted plywood; *Untitled (Boiler)*, 1964, painted plywood; *Untitled (Floor Beam)*, 1964, painted plywood; *Untitled (Table)*, 1964, painted plywood.

Ronald Bladen (1918–88), a Canadian, used monumental, architectural forms, frequently painted black, that loom up like great barriers in the space they occupy (fig. **20.49**). Like Tony Smith, Bladen made his mock-ups in painted wood, since the cost of executing these vast structures in metal would be exorbitant. Very often Minimalist artists envisioning large-scale structures must await patrons for the final realization of their projects.

Robert Morris (b. 1931), who during the 1960s was associated with Minimal sculpture, later became a leader in a wide variety of sculptural and environmental art forms. A student of Tony Smith, Morris, like Donald Judd, proved to be a persuasive advocate of Minimal art. His *Notes on Sculpture* provided an important statement about the heritage to which the Minimalists felt themselves heir—a tradition marked by the Constructivists, the work of David Smith, and the paintings of Mondrian—but perhaps even more important, also about the "*Gestalt*" principles he believed to be crucial to Minimal sculpture. *Gestalt* (German for shape or form) theory focuses on human perception, describing our ability to understand certain visual relationships as shapes or units. To ascribe *Gestalt* to an artwork is to recognize its possession of meaningful, compelling form. Through his familiarity with these theories, Morris posited that one's body has a fundamental link to one's perception and experience of sculpture. According to Morris, "One knows immediately what is smaller and what is larger than himself. It is obvious, yet important, to take note of the fact that things smaller than ourselves are seen differently than things larger." Morris' sensitivity to the impact of scale and the corresponding implications of publicness or privateness led to his pioneering work in the organization of entire rooms into a unity of sculptural mass and space.

During the 1960s and 70s, the monumental size of much Minimal sculpture led inevitably to the concept of sculpture designed for a specific space or place. This in turn resulted in ideas such as the use of the gallery space itself as an element in an architectural–sculptural organization. An early experiment in this direction was Morris' 1964 exhibition at the Green Gallery in New York, where large, geometric sculptural modules were integrated within the room, whose space became an element of the total sculpture (fig. **20.50**).

The idea, of course, had been explored earlier by such varied sculptural environments as Schwitters' *Merzbau* (see fig. 11.24) of the 1920s and Yves Klein's *Le Vide* exhibition of the late 1950s, in which the spectators provided the sculptural accents for the empty, white-walled gallery. The implications of sculpture in place were explored and expanded enormously during the 1970s and extended to environments based on painting, Conceptualism, and Earthworks.

LeWitt, Andre, and Serra

Sol LeWitt (1928–2007) produced Minimalist sculptures and paintings. His early sculpture consisted of open, identical cubes integrated to form proportionately larger units. These cubes increase in scale until they dominate the architectural space that contains them (fig. **20.51**). In such works, the physical essence is only the outline of the cubes, while the cubes themselves are empty space. Like Judd and Morris, LeWitt made important theoretical contributions to artistic practice during the later 1960s. His *Paragraphs on Conceptual Art*, published in 1967, reiterated the discomfort of Minimalist artists with Greenbergian standards of quality and set the stage for the recognition of yet another digression from the modernism endorsed by Greenberg—Conceptual art (see chapter 22). LeWitt's essay argued that the most important aspect of a work of art was the idea behind it rather than its form: "The idea becomes a machine that makes the art." LeWitt's 1968 *Box in the Hole* put his thesis into practice. Created in the Netherlands, this work consisted of a metal cube that the artist buried, covered over, and preserved in a series of recorded photographs.

During the early 1970s, LeWitt exploited gallery space in another way—by drawing directly on the walls. These drawings—frequently destroyed at the close of each exhibition—were generally accumulations of rectangles, drawn with a ruler and pencil, toned to various degrees of gray, and accompanied by written specifications, which ensured that a given work could be executed by assistants in the artist's stead. Following LeWitt's conception, the internal lines of each rectangle, creating the tones, might be diagonal as well as vertical or horizontal, and the result was frequently a geometric abstraction of considerable beauty. LeWitt continued his practice of creating wall installations

20.51 Sol LeWitt, *Sculpture Series "A,"* 1967. Installation view, Dwan Gallery, Los Angeles.

(fig. **20.52**). Even if the walls are repainted, the piece is not destroyed; it continues to exist as a well-specified idea and can be reinstalled by following the artist's instructions. The practice of leaving the execution of an artwork to others is common in Minimalist practice, which aims to eliminate all vestiges of the Romantic "hand of the artist" in order to concentrate interest in the work itself.

The early work of **Carl Andre** (b. 1935), influenced by the ideas of his friend Frank Stella and the sculptor Brancusi (see figs. 6.34–6.36), consisted of vertical wooden sculptures, given form by the use of a saw. By the early 1960s, Andre had moved away from carving to the construction of sculptures using identical units. The arrangement of the wooden units in *Pyramid* (fig. **20.53**), first created in 1959 and later reconstructed in 1970, suggests

20.52 Sol LeWitt, *Wall Drawing No. 652, on Three Walls, Continuous Forms with Color in Washes Superimposed,* 1990. Color-ink wash on wall, approx. 30 × 60' (9.1 × 18.3 m). Shown here as installed temporarily at the Addison Gallery, Andover, MA, 1993. Now in the Indianapolis Museum of Art.

a carved form, although the undulations of the surface were not created by the use of a saw.

Other pieces from the early 1960s, like *Well* (also seen in fig. 20.53), are more literal in their arrangement. This shift can be, at least in part, attributed to Andre's experience as a brakeman on a freight train, where he developed an interest in industrial materials and in a populist approach, through which art might spark an aesthetic or even somatic response regardless of the education or cultural background of the audience. After 1965, when he ended his four-year stint with the railroad, Andre began to make horizontally oriented sculptures, known as floorpieces. *Lever* (also seen in fig. 20.53), of 1966, initiated this new phase in his work. These pieces were made out of rugged, industrial materials not traditionally used in fine art. Combined timbers extended horizontally, bricks, styrofoam units, or identical metal squares assembled on the floor were sculptures intended to be walked on. This direct interaction between the audience and the artwork sharpens awareness of the environment, making the piece as much about one's physical orientation as about the visual pattern created by the tiles.

Since the mid-1960s, Andre's sculpture has mostly been constructed in the exhibition space itself. The idea behind the pieces need only be realized where they are intended for display. One of his most intricate floorpieces, *37 Pieces of Work*, was executed in 1969 on the occasion of his solo show at the Guggenheim (fig. **20.54**). The work consisted of a combination of tiles made from six metals: aluminum, copper, steel, magnesium, lead, and zinc. The tiles were a foot square (30.5 cm) and three-quarters of an inch (19 mm) thick. Each metal piece was placed first into

20.53 Carl Andre, Background, *Pyramid*, 1959/70, wood; middle ground, *Well*, 1964/70, wood; foreground, *Lever*, 1966, firebrick. Installation view. Exhibition at the Solomon R. Guggenheim Museum, New York, 1970.

20.54 Carl Andre, *37 Pieces of Work*, Fall 1969. Aluminum, copper, steel, lead, magnesium, and zinc, 1,296 units (216 of each metal), each unit 12 × 12 × ¾" (30.5 × 30.5 × 1.9 cm), overall 36 × 36' (11 × 11 m). Installation view in the rotunda of the Solomon R. Guggenheim Museum, New York, 1970. Now in the Crex Collection, Hallen für neue Kunst, Schaffhausen, Switzerland.

20.55 Richard Serra, *Belts*, 1966–67. Vulcanized rubber, blue neon, 18' 1¾" × 6' 2⅞" × 1' 5⅜" (5.5 × 1.9 × 0.4 m). Solomon R. Guggenheim Foundation, New York.

a six-by-six-foot (1.8 m) square and then used to create accompanying squares by being alternated with one other metal until every combination had been achieved. The title for the piece comes from the thirty-six-square pattern the metals formed, plus the square that encompassed the whole. The work was particularly appropriate for the Guggenheim, where viewers could gaze down on it as they ascended or descended the museum's spiral ramp.

After experimenting with different materials, such as vulcanized rubber, **Richard Serra** (b. 1939) created sculptures consisting of enormously heavy sheets of steel or lead that balanced against or on top of one another. Despite the various forms that his work takes, it consistently exploits the natural form of the material itself. Rather than manipulate his media, Serra looks to their own physical properties for inspiration. His *Belts*, for example, take their form from the simple act of hanging the rubber loops on the wall (fig. **20.55**). The incorporation of a neon tube into the work heightens the viewer's awareness of the intricacies of the forms created by the draped rubber. *One Ton Prop (House of Cards)* (fig. **20.56**) balances four 500-lb. lead sheets against one another. The seemingly casual arrangement of these slabs paradoxically accentuates their weight and communicates a sense of dangerous but exciting precariousness—heightened by the title's reference to the ephemeral, practically weightless house of cards that it emulates.

Serra has also been interested in a form of "scatter sculpture," in which series of torn lead sheets are scattered on the floor or molten lead is splashed along the base of a wall. Throughout the 1970s and 80s, Serra progressively

enlarged the scale of his sculptures, took them out of doors, and combined his sheets of steel (see *Minimalist Materials: Cor-Ten Steel*, opposite) with a landscape environment, thus effecting the inevitable transition from sculpture

20.56 Richard Serra, *One Ton Prop (House of Cards)*, 1969. Lead antimony, four plates, 48 × 48 × 1" (122 × 122 × 2.54 cm). The Museum of Modern Art, New York.

Minimalist Materials: Cor-Ten Steel

Sculptors have always adopted materials in support of a particular aesthetic. Marble, for instance, offers a medium soft enough for subtle modeling but hard enough to be durable and retain a smooth, polished finish. It was a medium particularly well suited to sculptors of classical antiquity who sought to conjure the appearance of idealized athletes and divinities with flawless skin drawn taut over flexed muscles and seductive curves. Minimalist sculptors sought different effects. Avoiding for the most part materials and techniques that make evident the artist's touch (such as hand-worked clay or wax), Minimalists often turned to rough-hewn wood or industrial materials and machine manufacturing in order to eliminate traces of hand-crafting. The object and its materials should be the chief elements of interest, according to Minimalist practice. One of the most popular media to emerge in the mid-twentieth century was self-weathering steel. This form of steel has added to it an alloy of chromium, nickel, copper, and manganese that allows continuous surface oxidization. No surface treatment such as polishing or finishing is required: within a short time (usually a few years), this type of steel will develop a textured surface with a rich, dark brown appearance due to rust. The structural integrity of the steel is in no way compromised by this surface oxidization. Because of slight differences in alloys and differing environmental conditions, no two surfaces will weather in the same way. This form of steel is generally known by the brand name Cor-Ten and is closely associated with the Minimalist sculpture of Richard Serra.

20.57 Agnes Martin, *Night Sea*, 1963. Oil and gold leaf on canvas, 6 × 6' (1.8 × 1.8 m). Private collection.

aspire to the heroics of the Abstract Expressionists. When she felt that she had lost her clarity of vision in 1967, she ceased painting and left New York, returning to New Mexico in 1968. After a period of solitude and contemplation, she resumed painting in the early 1970s. Her images retained their subtle, geometric character, but her colors became even softer and more luminous, making visible the artist's sense of life's essence as a timeless, shadowy emanation (fig. **20.58**). "When I cover the square with rectangles," she explained in 1967, "it lightens the weight of the square, destroys its power."

placed in an interior environment to sculpture that becomes part of a landscape (see fig. 23.23).

Minimalist Painters

Agnes Martin (1912–2004) refined her art over many years, progressing from rather traditional still lifes to Gorky-like biomorphic abstractions, before arriving in the early 1960s at her mature distillations of pure style. Martin honed her means until they consisted of nothing but large, square canvases gridded all over with lines so delicately defined and subtly spaced as to suggest not austere, cerebral geometry but trembling, spiritual vibrations, what Lawrence Alloway characterized as "a veil, a shadow, a bloom" (fig. **20.57**). Declaring their physical realities and limitations yet mysteriously intangible, intellectually derived but romantic in feeling and effect, the paintings of Agnes Martin are the product of a mind and a sensibility steeped in the meditative, holistic forms of Reinhardt, Rothko, and Newman, as well as the paintings of Paul Klee and the historic landscapes and poetry of China. While using Hard-Edge structure in a visually self-dissolving or contradicting manner, Martin had no interest whatever in the retinal games played by Op artists. Nor did she ever

20.58 Agnes Martin, *Untitled Number 5*, 1975. Synthetic polymer paint and pencil on synthetic polymer gesso on canvas, 71⅞ × 72¼" (182.6 × 183.2 cm). The Museum of Modern Art, New York. Gift of the American Art Foundation.

20.59 Robert Ryman, *Untitled*, 1962. Oil on linen canvas, 69½ × 69½" (176.5 × 176.5 cm). Collection the artist.

Since the beginning of his career, **Robert Ryman** (b. 1930) has been interested in "how paint worked." His fascination with paint extended from the way in which it was applied to its interaction with its support and the way in which various types of paint worked together. In his earliest work, Ryman explored a range of colors, gradually giving way to an exclusive use of white paint. *Untitled* of 1962 (fig. **20.59**) represents one of the last instances of color in his work. Here multiple white strokes are layered over a background

20.61 Robert Ryman, *Paramount*, 1981. Oil on linen with metal fasteners and square bolts, 84 × 84" (213.4 × 213.4 cm). Private collection.

of blue and red, literally suppressing the bright hues while simultaneously reacting to them.

By the mid-1960s Ryman had dedicated himself to the use of white, believing that this color more than any other could highlight his manipulation of paint itself. By way of elucidating his "silent" all-white paintings (fig. **20.60**), Ryman said in a frequently quoted statement, "It's not a question of what to paint but how to paint." With these words he declared his commitment to pure painting. "To make" has often figured in Ryman's conversation, for he considers "making" a matter of knowing the language of his materials—canvas, steel, cardboard, paper, wood, fiberglass, Mylar interacting with oil, tempera, acrylic, epoxy, enamel—and of exploiting its syntax so that his paintings come alive with their own story. In *Classico III*, Ryman applied white polymer paint in an even film to twelve rectangles of handmade Classico paper precisely assembled to form a larger rectangle gridded by shadows between the smaller units. With these positioned slightly off-center on a white ground, three types of rectangles in different scales and relationships echo and interact with one another. In *Paramount* (fig. **20.61**), Ryman left the margins, the edges, of the canvas unpainted, drawing attention simultaneously to the paint and to the linen surface upon which it rests. His attention to detail is such that even the metal

20.60 Robert Ryman, *Classico III*, 1968. Polymer on paper, 7' 9" × 7' 5" (2.4 × 2.3 m). Stedelijk Museum, Amsterdam.

fasteners joining the painting to the wall are considered part of the work. He takes into account the relationship of the painting to the wall, carefully considering the height at which it is hung and the distance at which it projects forward. By such rigorous attention to material detail and to issues of optical perception, as well as through his painterly touch, Ryman invests his pictures with a lyrical presence, while pursuing a stern Minimalist program of precision and purification.

In his reaction against the perceived excess of Abstract Expressionism, **Robert Mangold** (b. 1937), a student of Al Held, stressed the factuality of art by creating surfaces so hard, so industrially finished, and so eccentrically shaped that the object quality of the work could not be denied. This assertion of the painting as an object in space was emphasized in several works in which the artist joined canvases, drawing attention to the importance of edges and creating a play between the real line formed by the junction of the two (or more) parts and the drawn line laid down by the artist.

In paintings of the late 1960s and early 70s, he used decorative color to accentuate neutral, monotone grounds, while an "error" in the precise, mechanical drawing subverted the geometric overall shape of the canvas from within (fig. **20.62**). Here, destabilized by elusive color and the imperfect internal pattern, stringent formalism gave way to spreading openness and unpredictability, evoking the outside world of nature and humanity. And so Mangold too struck a balance between impersonality and individualism, bringing a welcome warmth to the pervasive cool of Minimalist aesthetics.

The precocious **Brice Marden** (b. 1938) had hardly graduated from the Yale School of Art, where he too worked with Al Held, when he created his signature arrangement of rectangular panels combined in often symbolic order and painted with dense monochrome fields of beeswax mixed with oil (fig. **20.63**). During his career,

20.62 Robert Mangold, *Untitled*, 1973. Acrylic and pencil on Masonite, 24 × 24" (61 × 61 cm). John Weber Gallery, New York.

Marden became a virtuoso in his ability to balance color, surface, and shape throughout an extended series of variations, developed within a set of purposeful restrictions.

In the late 1970s, Marden began to introduce a combination of vertical and horizontal planes within his paintings. Despite the abstract quality of his images, however, Marden continues to negotiate an underlying relationship between his painting and nature, later introducing a curving, calligraphic line. His study of Chinese calligraphy and corresponding interest in Asian culture inform his *Cold Mountain* paintings, honoring the ninth-century Chinese

20.63 Brice Marden, *The Dylan Painting*, 1966. Oil and wax on canvas, 5 × 10' (1.52 × 3 m). San Francisco Museum of Modern Art.

poet whose name comes from his sacred dwelling spot (fig. **20.64**). The layering and interplay of lines and pigment comment on the process of painting itself. The rhythmic, allover disposition of the calligraphic marks produces a sense of balance, harmony, and precision much in keeping with his earlier painting. Here again, then, is the Minimalist paradox of an extreme simplicity that is capable of rewarding

sustained contemplation with revelations of unsuspected spiritual complexity or sheer aesthetic pleasure.

Drawing directly on the wall or attaching to it a flattened, geometric shape created merely by folding brown wrapping paper (fig. **20.65**), **Dorothea Rockburne** (b. 1921) might seem to have so reduced her means as to take Minimalism over the line into *Arte povera*, an Italian

20.64 Brice Marden, *Cold Mountain 5 (Open)*, 1988–91. Oil on linen, 9 × 12' (2.7 × 3.7 m). Collection Robert and Jane Meyerhoff, Phoenix, Maryland.

20.65 Dorothea Rockburne, *Indication Drawing Series: Neighborhood* from the wall series *Drawing Which Makes Itself*, 1973. Wall drawing: pencil and colored pencil with vellum, 13' 4" × 8' 4" (4.1 × 2.5 m). The Museum of Modern Art, New York.

20.66 Dorothea Rockburne, *The Glory of Doubt, Pascal*, 1988–89. Watercolor and gold leaf on prepared acetate and watercolor on museum board, 3' 8¹³⁄₁₆" × 6' 1¾" (1.14 × 1.9 m).

movement characterized by its use of humble materials (see chapter 23). However, the direction proved quite different, fixed by the artist's preoccupation with the mathematics of set theory as an intellectually pure strategy for creating an intricate interplay of simple geometric forms and real space.

So dependent was this art on process itself that Rockburne created it directly on the gallery wall, thereby condemning her pieces to a poignant life of fragility and impermanence. She subsequently worked in more durable materials and installations, as well as with richer elements, such as color and texture (fig. **20.66**). Nevertheless, Rockburne remained loyal to her fundamental principle of "making parts that form units that go together to make larger units." In the end, the logical yet unexpected way in which her scientifically derived but imaginative folding produces flat, prismatic shapes seduces the eye while engaging the mind. It also reveals why the challenge of working within Minimalism's puritanically self-denying regimen appealed to some of the most gifted artists to emerge in the 1960s.

During that decade, **Jo Baer** (b. 1929) eliminated the brushwork and painterly texture of her earlier work to create pieces whose smooth surfaces showed little evidence of the artist's hand. By reducing the visual interest of the surface itself, Baer believed that the spectator could focus on the image as a whole. Like Robert Morris, she incorporated the principles of *Gestalt* psychology into her work, using her images to test the limits of human perception, and thus drawing attention to the object nature of the canvas itself. In 1969, Baer began her *Wraparound* series, which involved wrapping a painted black band outlined in color around the edge of the stretcher (fig. **20.67**). Looking at the work from a certain angle, the viewer can perceive the whole band, but upon closer inspection it becomes evident

20.67 Jo Baer, *Untitled (Wraparound Triptych— Blue, Green, Lavender)*, 1969–74. Oil on canvas, each panel 48 × 52" (122 × 132 cm). Collection the artist.

that the perceived flat solid is actually painted on two adjacent surfaces. The canvas is no longer purely surface, but a three-dimensional entity, relying upon all of its surfaces to produce its particular effect. The colored bands in *Untitled (Wraparound Triptych—Blue, Green, Lavender)* play an important role, for it is the borders of an image that first signal the presence of a shape to the human brain.

Complex Unities: Photography and Minimalism

Minimalism's visual achievements can also be associated with photography. Serialism, an interest in process as a key source of content, and a search for the complex within the simple, unified image are all fundamental to the Minimalist aesthetic, and can be found in the field-like collages created by **Ray K. Metzker** (b. 1931), a former student of Harry Callahan (see figs. 17.54, 17.55) at the Institute of Design in Chicago. But, like most photographers in the "straight" tradition, Metzker begins with a real-life subject. Having photographed this, not as a single, fixed image but rather as a series of related moments, he then combines, repeats, juxtaposes, and superimposes the shots until he has achieved a composite, grid-like organization reminiscent of Minimalist painting, a single visual entity in which the whole is different and more rewarding than its parts (fig. **20.68**). Metzker says of his work, "Where photography has been primarily a process of selection and extraction, I wish to investigate the possibilities of synthesis."

Bernd Becher (1931–2007) and **Hilla Becher** (b. 1934), German photographers who married in 1961, together developed the documentary style for which they became known. The Bechers turned their attention to the industrial transformation of the Western world, taking stark,

closely cropped photographs of its hallmark architectural structures. Their photographs are frequently arranged into series of visually similar buildings and hung together in the format of a grid (fig. **20.69**). Within these typological studies, each photograph functions as an independent unit, but the virtually uniform lighting and the similarity in form and viewpoint produce an effect of serial repetition that could be compared to the sculptures of Judd or Andre. Such interest in the individuality of units within similar types has a history in German photography that extends to the work of August Sander (see fig. 11.36). As teachers, the Bechers influenced several generations of photographers in Germany and abroad.

The Bechers' photographs resist conveying a sense of the scale or function of the structures they depict. This endows the buildings with a sculptural quality, as if they exist primarily as objects rather than as productive, utilitarian components of the modern landscape. Of course, the dual nature of architecture as something both to be seen and to be used has challenged modern architects since Louis Sullivan declared that "form should ever follow function." The degree to which a work of architecture should answer aesthetic rather than purely utilitarian impulses is a concern that architects negotiated throughout the twentieth century.

20.69 Bernd and Hilla Becher, *Water Towers*, 1980. Black-and-white photographs, 61¼ × 49¼" (155.6 × 125.1 cm). Courtesy Sonnabend Gallery, New York.

20.68 Ray K. Metzker, *Untitled (Wanamaker's)*, 1966–67. Multiple printing, 32¼ × 34¾" (82 × 89.3 cm). The Museum of Modern Art, New York.

21
Modernism in Architecture at Mid-Century

Histories of modern art—including this one—tend to trace modernism's origins to innovations in pictorial arts such as painting or photography. Yet the course of architecture's development from the late nineteenth through the twentieth centuries charts this history just as accurately. In fact, architecture may make even clearer many of the characteristics, aims, and problems fundamental to modernism.

Of course, the story of modern art changes depending on who is recounting it. Art critic Clement Greenberg, whose account of modernism is discussed in chapters 17 and 20, understood it to be the expression of a cultural tendency toward self-criticality, the pursuit of a purity of means and expression that presents itself most convincingly through abstraction. For Greenberg, modern art's social utility rests mainly in its ability to convey an ideal form. In this way, Greenberg's ideas might be seen in accord with those of the ancient Greek philosopher Plato, who believed that the main value of art (if there is one) is to lead the viewer to contemplate the highest realms of spiritual as opposed to material existence. Along with Plato, Greenberg's position is also inflected by the "Art for Art's Sake" doctrine. First articulated in the nineteenth century, Art for Art's Sake held that "everything useful is ugly": only disinterested works of purely aesthetic interest could be considered art, an idea that fueled much experimentation by modern artists associated with Symbolism and Post-Impressionism.

Where does this leave architecture? As the consummate form of useful art, architecture finds itself in an awkward position *vis-à-vis* Greenberg and Art for Art's Sake. Yet the significance of architecture as the signal manifestation of modernism was championed early on by progressive artists like William Morris, Hector Guimard, Theo van Doesburg, and Walter Gropius. Their insistence that modern art could not remain on the margins of society, that art was not only a reflection of society but a stimulus for social behavior and attitudes, contributed to some of the most influential modern art movements: Arts and Crafts, Art Nouveau, and de Stijl as well as the Bauhaus.

Architecture, then, has been left with the task of negotiating the two main impulses motivating modern art from its origins. On the one hand, modernism arose from the desire for an aesthetic expression unshackled by academic or social demands; on the other, it also derives from an Enlightenment sense of social conscience that shifted the burden of human welfare from God to humanity. Modern architecture has been acutely responsive to both of these impulses as designers have sought to merge aesthetic integrity with functionalism and social relevance.

Of course, architecture faces another problem, more practical than theoretical: to realize a building requires far more material and financial resources than does the production of a painting, sculpture, or work of graphic art. Economic depression followed by World War II meant that there was little innovative large-scale architecture in America and Europe in the 1930s and 40s. When the first great wave of new buildings came, it was the International Style that dominated (see chapter 14 for an introduction to this movement). The acceptance of International Style architecture in postwar America, where many key members of the prewar European avant-garde had settled, in turn led to its being re-exported to other nations intent on modernization, as in Latin America, or reconstruction, as in Europe.

Booming economies around the world during the 1950s and 60s led to numerous commissions in which architects employed new structural systems or used older methods, such as ferro-concrete, in novel ways. Besides the skyscraper and other urban office buildings, some of the areas in which architects worked on an unprecedented scale included industrial plants and research centers; university campuses; religious structures; cultural centers, including museums, theaters, and concert halls; and airports.

"The Quiet Unbroken Wave": The Later Work of Wright and Le Corbusier

Throughout the early 1930s, Frank Lloyd Wright continued to critique modernism and the International Style through his writings and new building designs. While he was aware of Art Deco revivalism, which had a tremendous influence in the United States, as well as the extreme austerity of the International Style in Europe, his sympathies lay elsewhere. In a manner parallel to the late style of Wright, that of Le Corbusier was characterized by the exploration of free, organic forms and the statement of the materials of construction.

Wright During the 1930s

During the 1930s, despite the Great Depression, **Frank Lloyd Wright** (1867–1959) began to secure important commissions and also to make a contribution to the field of low-cost, prefabricated housing with his Usonian houses, as well as to city planning. During the first half of the 1930s, when commissions were scarce, he developed his plan for Broadacre City, his concept for an integrated and self-sufficient community of parks, farms, schools, and detached homes made of prefabricated materials to be assembled by each family. Like most such projects, Broadacre City was never realized, but it did enable Wright to clarify his alternatives to current city planning. He felt the modern city destroyed the social fabric, calling it a "parasite of the spirit." While Wright's reformist side motivated him to envision low-cost, prefabricated designs, many of the individual homes he built were for wealthy customers.

His most important realized structures of the 1930s were Fallingwater, the country house that he built for Edgar J. Kaufmann at Bear Run, Pennsylvania (fig. **21.1**), and the Administration Building of the S. C. Johnson & Son Company, Racine, Wisconsin. Fallingwater, sited dramatically on a hillside over a waterfall, is one of Wright's most stunning conceptions. Designed as a vacation home for the family of a wealthy merchant and art patron from Pittsburgh, Fallingwater was voted the best building in the United States in 1991 by members of the American Institute of Architects.

In the use of ferro-concrete for the cantilevered terraces and the sense of planar abstraction, Fallingwater has a superficial affinity to the International Style. It is a basic Wright conception, however, for he was scornful of much of the machine-inspired architecture of the European modernists

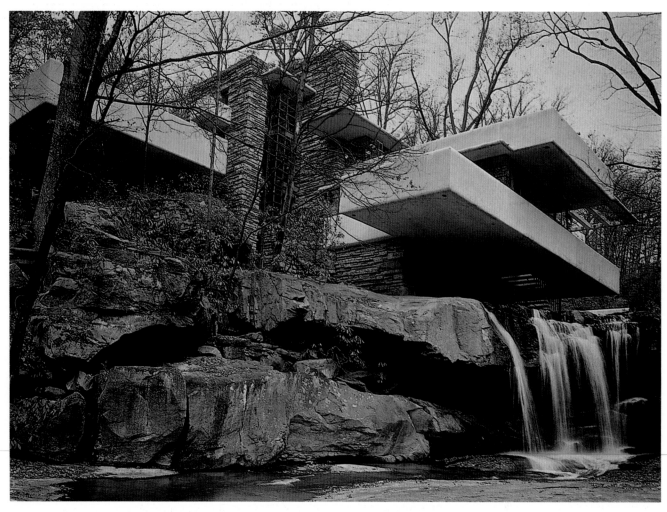

21.1 Frank Lloyd Wright, Edgar J. Kaufmann House (Fallingwater), 1934–37. Bear Run, Pennsylvania.

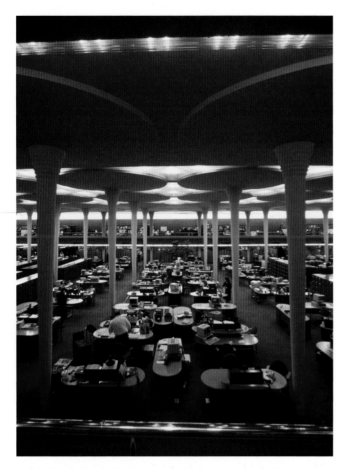

21.2 Frank Lloyd Wright, Interior, Administration Building, S. C. Johnson & Son, Inc., 1936–39.

The Johnson Administration Building (fig. **21.2**) inaugurated a new phase in Wright's style and introduced an original solution to the design of the modern workplace. As in his Larkin Building in Buffalo (see fig. 9.5), Wright's goal in Racine was to seal off the interior from the surrounding industrial environment and provide a workspace that was, as he said, "as inspiring a place to work in as any cathedral ever was in which to worship." Light floods the large interior space from skylights and a clerestory through tubes of Pyrex glass. From the floor, the magical effect of this top illumination has often been likened to being underwater. The interior is a forest of slender columns tapering at the base like those at the ancient Palace of Minos in Crete. The columns terminate at the top in broad, shallow "lily-pad" capitals that repeat the circular motif throughout. As was the case at Fallingwater, the building authorities mistrusted Wright's calculations; they doubted that the columns could carry the necessary load. It was no surprise to the architect when structural tests proved they could withstand several times the regulated weight. Encouraged by the now sympathetic patron, Wright was able to design all details including desks and office chairs. In the 1940s, he was commissioned to add a research tower to the complex. The fourteen-story structure is built of the same kind of glass and brick as the main building, with the addition of elegantly rounded corners. At night, the illuminated building, with its broad bands of translucent glass, also made of Pyrex tubes, takes on an ethereal glow (fig. **21.3**).

who had shaped the International Style (many of whom had been influenced by him). According to Wright, their modern houses "manage to look as though cut from cardboard with scissors … glued together in box-like forms—in a childish attempt to make buildings resemble steamships, flying machines or locomotives." Though he embraced the machine and modern materials and technology, Wright designed a house to be, as he said, a "natural feature of the environment."

The house was almost literally what Wright called an "extension of the cliff," for it is constructed around several large boulders. The boulders, which act as fulcrums helping to secure the house to the hillside, actually penetrate the walls and were incorporated by Wright as internal design features. The central, vertical mass of utilities and chimneys is made of rough, local stone courses (used inside the house as well). It anchors the suspended horizontal forms and contrasts with the smooth, beige-colored concrete of the parapets. The building is particularly effective in its integration of the exterior natural world with the living quarters inside. For example, a glass panel in the living room slides back to access a stairway that leads directly to the stream below the house. With its open plan, low ceilings, and polished flagstone flooring, the interior of Fallingwater is like a welcoming cave in the middle of the woods. Wright designed virtually every interior detail, including most of the furnishings, both built-in and free-standing.

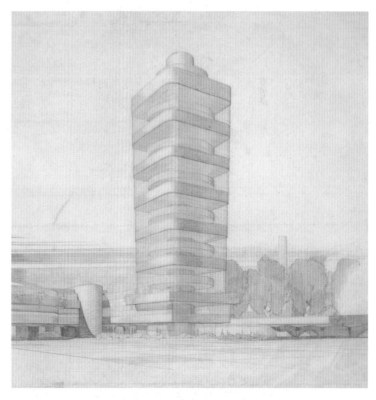

21.3 Frank Lloyd Wright, S. C. Johnson Research Tower presentation drawing, 1936. Sepia, 31¼ × 36" (79.4 × 91.4 cm). The Frank Lloyd Wright Foundation, Scottsdale, Arizona.

Several of Wright's plans for tall buildings, such as his mile-high skyscraper for Chicago, were never realized. But following the research tower for Racine, he began work on the Price Tower in Bartlesville, Oklahoma (fig. **21.4**), which is actually based on his 1929 design for an apartment building in New York, St. Mark's Tower. It was, for its time, a daring concept: a cruciform "airplane propeller" structural unit sheathed in a glass shell and supporting cantilevered floors. Wright's notion of organic architecture was expressed through the central supporting core with its radiating, cantilevered platforms (as opposed to the standard box-frame construction), a structural scheme he likened to that of a tree. The boldly protruding terraces and soaring utility pylons gave the skyscraper the stylistic signature of its author.

The climax of Wright's investigation into the sculptural possibilities of architecture is the Solomon R. Guggenheim Museum (fig. **21.5**). First conceived in 1943, it was not completed until 1959, just after Wright's death. The Guggenheim Museum, sited on Fifth Avenue across from Central Park, is the only building that this leading American architect was ever commissioned to do in Manhattan, and it was many years before he could obtain the necessary

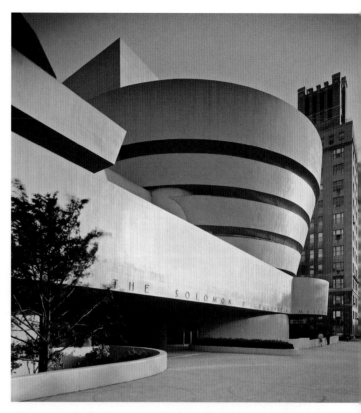

21.5 Frank Lloyd Wright, Solomon R. Guggenheim Museum, 1957–59; addition 1989–92. New York.

building permits for so revolutionary a structure. As designed by Wright, it consisted of two parts: the main exhibition hall and a small administration wing (known as the monitor building), both circular in shape. A smooth, unbroken white band that stretches across the museum's Fifth Avenue façade connects the two sections, giving the appearance of seamless unity. The gallery proper is a continuous spiral ramp around an open central well. The building radiates outward toward the top, the ramps broadening as the building rises, in order to provide ample light and space. A skylight dome on graceful ribs provides natural, general lighting, and continuous strip-lighting around the ramps provides additional illumination. Permanent fins divide the exhibition areas of the ramps into equal bays, where the art is shown. Wright believed that architecture should essentially involve movement, not just be a fixed enclosure of space, and the Guggenheim's spiral form was the ultimate expression of his effort to get beyond the box. Explaining his concept to a skeptical public, Wright noted that his design provided "a greater repose, the atmosphere of the quiet unbroken wave: no meeting of the eye with abrupt changes of form."

As a museum, the Guggenheim offers easy and efficient circulation in one continuous spiral, in contrast to the traditional museum with galleries consisting of interconnected, rectangular rooms. Some of Wright's detractors have criticized the design of the Guggenheim's slanting walls and ramps for competing too strongly with the artwork for the viewer's attention. On the other hand, supporters argue that this museum succeeds in what few others even attempt:

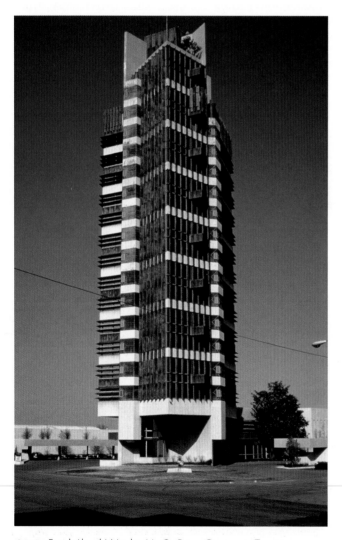

21.4 Frank Lloyd Wright, H. C. Price Company Tower, 1952–56. Bartlesville, Oklahoma.

to be more than a passive site for curatorial activities and to actively engage the viewer's experience of the art, which can be seen across the rotunda as well as at close range.

In 1982, the architectural firm of Gwathmey Siegel was commissioned to renovate the museum in order to accommodate the need for expanded gallery, storage, and administrative space. The restoration provoked almost as much controversy and publicity as had Wright's original design, and some critics have argued that a major icon of American architecture has been tragically compromised. The new addition (see also fig. **21.5**) consists of a thin rectangular slab whose beige limestone façade is ornamented with a gridded pattern. Four new floors of galleries, three of which have double-height ceilings, make it possible to show large-scale works for the first time. In its present renovated state, which was opened to the public in 1992, the great spiral—a monumental sculpture in its own right—was opened all the way to the re-exposed dome, where new ultraviolet-filtering glass was installed. Formerly unused roof space was converted into a sculpture terrace providing sweeping views of Central Park, invoking the intrinsic connection between Wright's architecture and nature.

Le Corbusier

Among the generation of architectural pioneers who rose to prominence during the 1920s, **Le Corbusier** (1887–1965), the artistic pseudonym of the Swiss Charles-Édouard Jeanneret, was a searching and intense spirit, a passionate but frustrated painter (see chapter 12), a brilliant critic, and studied in the tradition of the Vienna Workshops (Wiener Werkstätte), learned the properties of ferro-concrete with Perret in Paris, and worked for a period with Peter Behrens in Berlin (where he no doubt met Gropius and Mies van der Rohe). Le Corbusier's principal exploration throughout much of his career was the reconciliation of human beings with nature and the modern machine. This was addressed largely through the question of the house, to which he applied his famous phrase, "a machine for living." By exploiting the lightness and strength of ferro-concrete, his aims were to maximize the interpenetration of inner and outer space and create plans of the utmost freedom and flexibility.

Le Corbusier's *Five Points of a New Architecture*, published in 1926, were (1) the pilotis—supporting narrow pillars to be left free to rise through the open space of the house; (2) the free plan—composing interior space with non-bearing interior walls to create free flow of space and also interpenetration of inner and outer space; (3) the free façade—the wall as a non-supporting skin or sheath; (4) the horizontal strip window running the breadth of a façade; and (5) the roof garden—the flat roof as an additional living area. These points could provide an elementary outline of the International Style.

The defining work among Le Corbusier's early houses was the Villa Savoye at Poissy (fig. **21.6**), thirty miles (48 km) from Paris. Along with Mies' German Pavilion (see fig. 14.27), the Villa Savoye is generally regarded as a paradigm of the International Style. The three-bedroom house, beautifully sited in an open field, is almost a square in plan, with the upper living area supported on delicate piers or pilotis. The enclosed ground level has a curved-glass end wall containing garage and service functions, set under the hovering second story. The Savoye family, arriving from Paris, would drive right under the house—the curve of the ground floor was determined by the turning radius of a car. Although today's suburban homes are loosely designed around the automobile, in 1929 this design concept was based on the notion of the car as the ultimate machine and the idea that the approach up to and through the house carried ceremonial significance.

In the main living area on the second level, the architect brilliantly demonstrated his aim of integrating inside and outside space. The rooms open onto a terrace, which is protected by half-walls or windbreaks above horizontal openings that continue the long, horizontal line of the strip windows. The horizontal elements are tied together in sections by a central ramp that moves through each level and in and out of doors. The complex of volumes and planes in the Villa Savoye relates to Le Corbusier's own Purist painting (see fig. 12.33). One historian declared, "It was like entering the fantasy world behind the picture plane of a Purist still life."

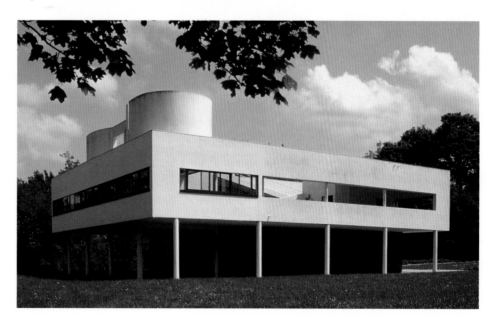

21.6 Le Corbusier, Villa Savoye, 1928–30. Poissy, France.

Le Corbusier, like Wright, had few major commissions during the 1920s, but he continually advanced his ideas and his reputation through his writings and through his urban planning projects. These large-scale housing projects, a response to the growing urban populations and housing shortages of postwar France, were never actually built. In 1922 Le Corbusier drew up a plan for a contemporary city (the *Ville Contemporaine*) of three million inhabitants, involving rows of gleaming glass skyscrapers placed on stilts to allow for pedestrian passage. They were connected by vast highways and set in the midst of parks. In his 1925 *Plan Voisin* for Paris, Le Corbusier envisioned an enormous urban-renewal project that would have replaced the historic buildings north of the Seine with a complex of high-rise buildings. Like the *Ville Contemporaine*, this radiant modern city was the architect's drastic antidote to the traffic-congested streets of modern Paris and the soot-filled slums of the nineteenth-century city. It was based on the utopian notion common among the modern pioneers that, armed with the right city planning and the appropriate faith in technology, architecture could revolutionize patterns of living and improve the lives of modern city dwellers on a physical, economic, and even spiritual level.

In the face of today's massive and eclectic urban centers, Le Corbusier's faith that a uniform strategy for urban planning would create cities where "the air is clean and pure" and "there is hardly any noise" seems naively idealistic. Nevertheless, his urban schemes were prophetic in the way they anticipated elements of today's cityscapes. Le Corbusier's writings have also been tremendously influential in modern world architecture. His trenchant book *Vers une architecture (Towards a New Architecture)* (1923) was immediately translated into English and other languages and has since become a standard treatise. In it he extolled the beauty of the ocean liner, the airplane, the automobile, the turbine engine, bridge construction, and dock machinery—all products of the engineer, whose designs had to reflect function and could not be embellished with non-essential decoration. Le Corbusier dramatized the problems of modern architecture through incisive comparisons and biting criticisms and, in effect, spread the word to a new generation.

The enormous 1947–52 building in Marseilles, France, known as the Unité d'Habitation (fig. **21.7**), an apartment complex designed primarily for blue-collar workers, both carries out Le Corbusier's town-planning ideas and asserts its rough-surfaced concrete structure as if it is a massive sculpture. The building is composed of 337 small duplex apartments, each with a two-story living room, developed in Le Corbusier's earlier housing schemes. It includes shops, restaurants, and recreation areas, to constitute a self-contained community (community facilities are provided on the roof). Unités were also built in the French town of Nantes and in Berlin. In them, Le Corbusier abandoned the concept of concrete as a precisely surfaced machine-age material and presented it in its rough state, as it came from the molds. In doing so, he inaugurated a new style—almost a new age—in modern architecture, to which the name Brutalism was later given. Possibly related to the French word *brut* (uncut, rough, raw), the term has taken many forms, but fundamentally involves the idea of "truth to materials" and the blunt statement of their nature and essence. Brutalism most characteristically manifests itself in reinforced concrete, not only because of its texture but even more because of its innate sculptural properties.

Le Corbusier's seminal pilgrimage chapel of Notre-Dame-du-Haut at Ronchamp in France (figs. **21.8**, **21.9**), built in 1950–54, is a brilliant example of his new sculptural style. Sensitively and elegantly attuned to its hilltop site, the structure is molded of white concrete topped by the dark, floating mass of the roof and accented by towers (inspired by the Roman emperor Hadrian's villa at Tivoli, near Rome), which together serve as a geometric counterpoint to the main mass. The interior is lit by windows of varying sizes and shapes that open up from small apertures to create focused tunnels of light, evoking a rarefied spirituality. Its external, curvilinear forms and the mystery of its interior recall prehistoric grave forms.

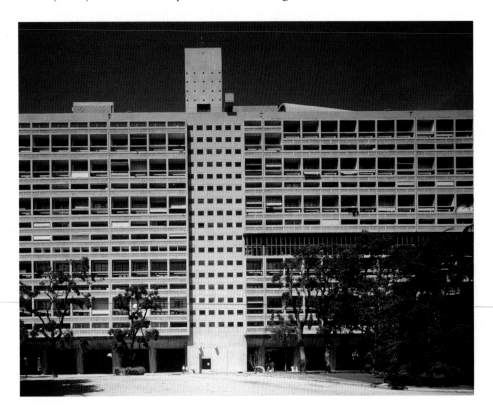

21.7 Le Corbusier, Unité d'Habitation, 1947–52. Marseilles, France.

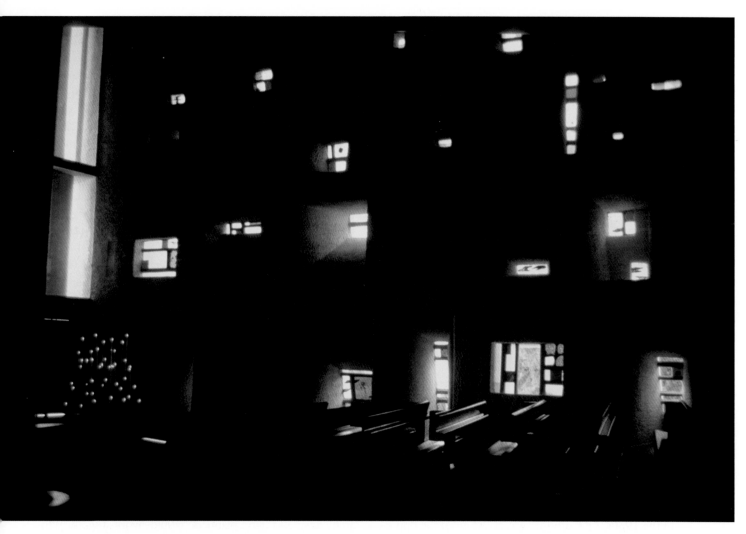

21.8 Le Corbusier, Interior, Notre-Dame-du-Haut, 1950–54. Ronchamp, France.

21.9 Le Corbusier, Notre-Dame-du-Haut, 1950–54. Ronchamp, France.

21.10 Le Corbusier, Assembly Building, 1959–62. Chandigarh, India.

Since Ronchamp, form, function, symbolism, and plasticity have all taken on new meaning. This structure succeeded in relaxing architects' formerly traditional attitudes toward form and space; the "box" was finally exploded.

In the 1950s, Le Corbusier was at last given the opportunity to put into effect his lifelong ideas on total city planning in the design and construction at Chandigarh, a new capital for the Punjab in India, on which he worked into the 1960s. The city of Chandigarh is situated on a plain at the edge of hills, and the government buildings, comprising the Secretariat, the Assembly, and the High Court, rise to the north in the foothills, with the three

buildings arranged in an arc around a central area incorporating terraces, gardens, and pools. The Court Building was conceived as a giant umbrella beneath which space was made available for court functions and for the general public. Access roads to the city are largely concealed, while changing vistas are achieved through ingeniously placed manmade mounds. The Assembly Building (fig. **21.10**) is the most impressive of the three, with its ceremonial entrance portico and upward-curving roof set on pylons, the whole reflected in the pool and approached by a causeway. Le Corbusier's achievement is embodied not only in the individual buildings but also in their subtle visual relationships to one another. The total complex constitutes a fitting climax to his career; it fulfilled the request of the client, Prime Minister Jawaharlal Nehru, that the city be "symbolic of the freedom of India, unfettered by the traditions of the past," in its new era of independent statehood following the end of British rule in 1947.

Purity and Proportion: The International Style in America

The Influence of Gropius and Mies van der Rohe

Shortly after his 1937 arrival in the U.S., **Walter Gropius** (1883–1969) put into effect his principles of collaboration, a "team approach" to design, and his ideas concerning the social responsibilities of the architect (see chapter 14). For Gropius, who had founded the Bauhaus in 1919 on these ideas, collaboration meant that architects, landscape architects, and city planners would work together to create a cohesive vision of the modern world. In 1945, with some of his students, Gropius formed The Architects' Collaborative (TAC) to design buildings in the United States and elsewhere. At Harvard he continued his design of school structures with the Harvard Graduate Center of 1950 (fig. **21.11**). Here he had the problem of placing a modern building among traditional structures dating from

21.11 Walter Gropius, Harvard Graduate Center, 1950. Cambridge, MA.

21.12 Walter Gropius, Project for City Center for Boston Back Bay, 1953.

the eighteenth to the twentieth centuries. He made no compromises with tradition but used stone and other materials to enrich and give warmth and variety to his modern structure. He also commissioned artists such as Miró, Arp, and Albers to design murals, thus introducing to Harvard the Bauhaus concept of the integration of the arts. In his later years with TAC, Gropius moved again into full-scale architectural production. Perhaps the most ambitious of the later designs was the 1953 Boston Back Bay Center (fig. **21.12**), unfortunately never constructed. This was a large-scale project comprising office buildings, a convention hall, a shopping center, an underground parking lot, and a motel. It involved two slab structures set in a T form, raised on stilts above intricate, landscaped pedestrian walks and driveways. The façades were to have been richly textured, and the entire complex represented a superior example of recent American experiments in the creation of total industrial, mercantile, or cultural centers—social and environmental experiments with which Gropius himself had been concerned in Germany during the 1920s.

Having completed relatively few buildings before leaving Germany in 1937, **Ludwig Mies van der Rohe** (1886–1969) was finally able to put his ideas into practice in the United States. With the end of the Depression, big institutions were eager to put up new buildings and to

develop a new architecture. In the skyscrapers he created, as well as in the new campus for the Illinois Institute of Technology (IIT), Mies' solutions had an incalculable influence on younger architects everywhere. The plan of the Institute, as drawn by Mies in 1940, has an abstract quality characterized by rectangular complexes. Located in a deteriorating area on the south side of Chicago, the school complex, with its conception of architecture geared to industrialization and standardization, became a model of efficient organization and urban planning. In fact, it inspired large-scale slum clearance in the area, a process that was intended to, but ultimately did not, eliminate overcrowding and physical deterioration of older buildings there. Of steel-and-glass construction, the IIT buildings are organized on a modular principle. Each unit in itself and in relation to others exemplifies Mies' sensitivity to every aspect of proportion and detail of construction (fig. **21.13**).

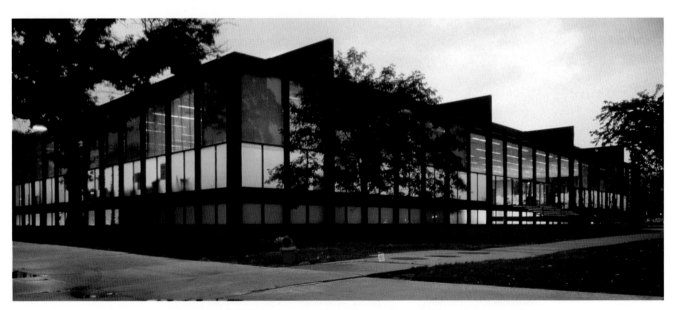

21.13 Ludwig Mies van der Rohe, Crown Hall, 1950–56. Chicago.

Skyscrapers

In 1947, an international group of architects (including Le Corbusier and Oscar Niemeyer—see p. 576) met in New York under the general direction of **Wallace K. Harrison** (1895–1981) to design the permanent headquarters of the newly formed United Nations organization (fig. **21.14**). Situated at the edge of New York's East River and built between 1947 and 1950, this building was the first monument of the postwar renaissance in American architecture. Symbolically the most important building to be constructed in the aftermath of World War II, the headquarters complex represents the epitome of modern functionalism and mid-century optimism. Aesthetically, it attempted to replace diverse national traditions with a design appropriate to the universal concept of the new world organization. The thirty-nine-story Secretariat, a glass-and-aluminum curtain-wall building, introduced to the United States a concept of the skyscraper as a tall, rectangular slab; in this case the sides are sheathed in glass and the ends are clad in marble. Le Corbusier was principally responsible for the main forms of the Secretariat, but its simplified, purified structure embodies the Bauhaus tradition of Gropius and Mies van der Rohe.

After having envisioned (but not built) two highly advanced skyscraper designs in around 1920 (see fig. 14.25), Mies was finally able to carry out some of his ideas in his 1951 apartments on Lake Shore Drive in Chicago

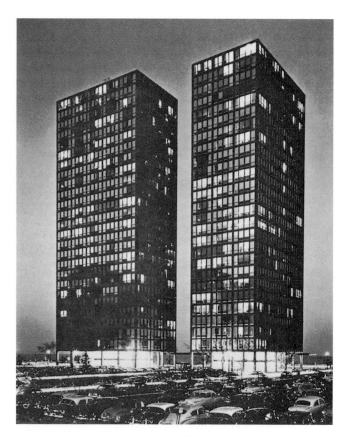

21.15 Mies van der Rohe, Lake Shore Drive Apartments, 1951. Chicago.

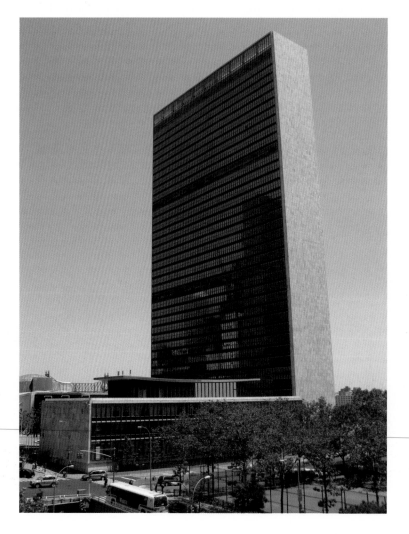

21.14 Wallace K. Harrison, United Nations Headquarters, 1947–50. New York.

(fig. **21.15**). The skyscrapers of Louis Sullivan and the Chicago School fascinated him and drew him to study the skyscraper form. The basic problems—of steel structure, its expression, and its sheathing—were of long-standing interest. The twin Lake Shore apartment buildings consist of two interrelated twenty-six-story vertical blocks set at right angles to each other. The steel structural members accent the verticality. As is customary with Mies, the structures are built on a module and have floor-to-ceiling windows.

The inspiration of Mies and the United Nations building led immediately to the first large office building of the 1950s, Lever House (fig. **21.16**), completed in 1952 by the architectural firm of **Skidmore, Owings & Merrill**, with Gordon Bunshaft as chief architect. Lever House, which was intended as a monument/symbol for an international corporation, is a tall rectangular slab, occupying only a small part of a New York city block. It is raised on pylons that support the first enclosed level—the principal public areas—thus giving the total structure a vertical L-shape. The building is one of the first to have an all-glass-clad façade and windows of alternating horizontal ribbons of opaque green and light green tinted glass.

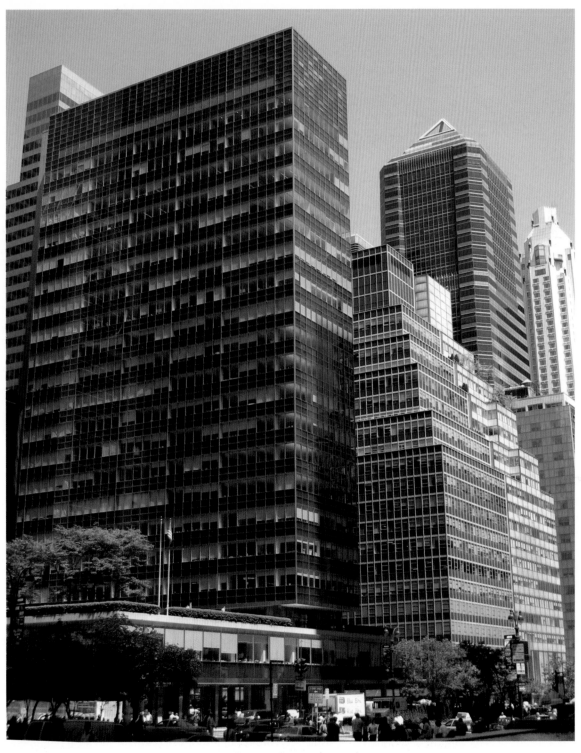

21.16 Skidmore, Owings & Merrill, Lever House, 1951–52. New York.

21.17 Mies van der Rohe and Philip Johnson, Seagram Building, 1958. New York.

Across Park Avenue from Lever House is a signal example of skyscraper architecture: Mies van der Rohe's 1958 Seagram Building (fig. **21.17**). In it Mies and his collaborator Philip Johnson were given an unparalleled opportunity to create a monument to modern industry, comparable to the Gothic cathedrals that had been monuments to medieval religious belief. The building is a statement of the slab principle, isolated with absolute symmetry within a broad plaza lightened by balanced details of fountains. The larger skeleton structure is clearly apparent within the more delicate framing of the window elements that sheathe the building. The materials of bronze and amber glass lend the exterior an opaque solidity that does not interfere with the total impression of light filling the interior. The building is perhaps the consummate expression of Mies' emphasis on "the organizing principle of order as a means of achieving the successful relationship of the parts to each other and to the whole." In addition to its dramatic utilization of International Style principles of design, the Seagram Building is noted also for its detachment from the surrounding city streets. A deeply set plaza pushes the building away from the busy traffic, while the abrupt termination of the glass curtain—one floor above the plaza—appears to raise the building on stilts, creating an impression of lightness, as if the structure is hovering above the street.

Domestic Architecture

After World War II, as roads and highways made outlying areas more accessible than ever, and as a war-based economy was replaced by peacetime values and normalization of life, the market for single-family houses exploded. The variations on the theme of the detached house in the International Style were endless and varied slightly from country to country in response to climate and local building materials. Much of the early American architecture of Gropius and

21.18 Marcel Breuer, House II, 1951. New Canaan, Connecticut.

Breuer consisted of homes following Bauhaus principles. For Gropius, standardization satisfied the needs of the masses for economical housing. **Marcel Breuer**'s (1902–81) own second house at New Canaan, Connecticut, built in 1951, illustrates his ability to use materials that blend with the local environment. In this case, Breuer selected principally concrete and fieldstone, with weathered wood beams used for the ceilings (fig. **21.18**).

Mies van der Rohe built only one house in the United States—the Farnsworth House in Plano, Illinois—but **Philip Johnson**'s (1906–2005) own home, Glass House,

in New Canaan, Connecticut (1949) (fig. **21.19**), is a classic extension of Miesian principles of uninterrupted interior space. Few "boxes" have reached the level of rationalism and sophistication of the main house, which is a transparent glass box. With its supreme structural clarity, the main house provides protection yet dissolves the boundaries between nature and interior space, while the guesthouse, at the other extreme, is an enclosed structure.

Richard Neutra (1892–1970), an émigré from Austria, developed his practice on the basis of the American preoccupation with building houses. A winter home in

21.19 Philip Johnson, Glass House, 1949. New Canaan, Connecticut.

21.20 Richard Neutra, Kaufmann House, 1947. Palm Springs, California.

Palm Springs, California, for Edgar Kaufmann—the same client who in the 1930s had commissioned Wright's Fallingwater—was designed for a desert site by Neutra, who had been an employee of Wright in the 1920s. Set against a spectacular backdrop, the Kaufmann House (1947) (fig. **21.20**) is pristine and cool in its elegant rectilinearity. Glass is used generously, and the plan is arranged so that the space flows from interior to exterior with unfettered freedom. Walls can be pulled back to allow the interior to become part of the wide outdoor courtyard spaces. Neutra combined glass, stucco, and natural rock in this house, which is cross-shaped with two intersecting axes. In his work and writing, Neutra advocated the link between architecture and the general health of the human nervous system. His physiological concerns addressed the beneficial impact of well-designed architecture and thoughtful siting. Though his buildings could function independently of their site, Neutra, like Wright, felt that landscape was more important than stylistic precedent.

Internationalism Contextualized: Developments in Europe, Latin America, Asia, and Australia

Finland

Alvar Aalto (1898–1976) created architecture that is characterized by a warmth and humanity in his use of materials; by buildings that are individualized; and by a harmony with human scale. Aalto never abandoned the timeless quality of the traditional architecture of his Finnish homeland. His structures seem to grow out of the site and to solve particular design problems, whether of factory, house,

school, or town plan. Aalto was also a leading furniture designer known for his bentwood chairs and tables.

Aalto made his debut in 1937 with the interior of the Savoy Restaurant in Helsinki, where he introduced his perforated plywood screen and free-form furnishings, quite different in style from the understated luxury of the Villa Mairea (1939) in Noormarkku, Finland (fig. **21.21**), designed for patrons Harry and Maire Gullichsen. The villa anticipates Aalto's own words of the following year, when he wrote that the function of architecture is to "bring the material world into harmony with human life." Villa Mairea is highly compatible with natural materials and clearly harmonizes with the fir forest that surrounds it. Aalto employed polished teak and other woods and rough masonry throughout in order to soften the modernist rigor of his design. Warm-toned wood is used inside in the paneled flooring and slatted ceilings, the columns, and in his own birchwood furniture.

Aalto's was a creative rather than reactionary response against the machine aesthetic. In non-residential buildings, traditional rectangular windows replaced the "orthodox" glass curtain wall. He expanded the vocabulary of avant-garde architecture to the point where the original sources of the new style all but vanished, and he established a distinctly personal alternative. Irregular, even picturesque, shapes and masses dominate his work, but the very informality of his buildings defies comparison with Mies or Le Corbusier. There are affinities in Aalto's work with the organic, site-specific forms of Wright, the exuberant expressionism of Erich Mendelsohn, and the cool rationality of Gropius. But his free-form brick and glass-brick walls and undulating wood vaults made fresh use of natural materials. Even his

21.21 Alvar Aalto,
Villa Mairea, 1939.
Noormarkku, Finland.

grandest structures have a human scale. His versatility helped establish a distinctive brand of modernism that still flourishes in Finland and indeed all over Scandinavia.

As the leading architect of Scandinavia, Aalto had opportunities to experiment with public buildings, churches, and

21.22 Alvar Aalto, Town Hall, c. 1950–53.
Säynätsalo, Finland.

town planning, and he achieved one of his most personal expressions in the Town Hall at Säynätsalo (fig. **21.22**). This, a center for a small Finnish town, includes a council room, library, offices, shops, and residences for officials. The brick structure with broken, tilted rooflines merges with the natural environment. Heavy timbers, beautifully detailed, are used for ceilings to contrast with the brick walls inside. Somewhat romantic in concept, this center illustrates the combination of effective planning and respect for the natural environment characteristic of Aalto and the best northern European architecture.

Great Britain

After the pioneering work of the late nineteenth century by William Morris, Philip Webb, Charles Voysey, and Charles Rennie Mackintosh (see chapter 4), there was little experimental architecture in Great Britain during the first decades of the twentieth century. The arrival in Britain in the 1930s of Gropius, Breuer, Mendelsohn, and the Russian Serge Chermayeff stimulated new thinking, though none of them stayed past 1940. World War II interrupted any new work and, after the war, budgetary limitations prevented large-scale architectural development. Although few ambitious individual structures were built in Britain in the mid-twentieth century, progress was made in two areas: town and country planning, and the design of schools and colleges.

The work of **James Stirling** (1926–92), one of the most imaginative and influential British architects of the postwar period, is associated with the tradition of Le Corbusier. Stirling had a masterly ability to combine all sorts of materials—glass, masonry, and metal—in exciting new contexts. His early buildings are not so much functional,

21.23 James Stirling and James Gowan, Ham Common, 1957. London.

in the original International Style sense, as they are expressive and personal. With James Gowan he designed the low-cost housing complex of Ham Common in England in 1957 (fig. **21.23**), when he was studying the later ideas of Le Corbusier and exploring the possibilities of ready-made products in new architectural contexts. In the 1968 Cambridge University History Faculty (fig. **21.24**), Stirling

21.24 James Stirling, History Faculty, Cambridge University, 1968. Cambridge, England.

used a cohesive approach to achieve a dense and complex spatial integration. Although he was an important teacher and thinker in his field, he was often pessimistic about the state of modern architecture. This is ironic because his own accomplishments continually demonstrated its possibilities, especially, as we shall see, in his Postmodern work (see chapter 24).

France

With the exception of works by the titanic figure of Le Corbusier and earlier ones by Auguste Perret (see figs. 9.18, 9.19), French architecture of the twentieth century had comparatively few moments of inspiration. This was in part the result of the continuing academic system of training for architects and the persistence of a bureaucratic old guard. The Swiss-born Le Corbusier produced a number of important buildings in France, but he ultimately achieved greater standing elsewhere.

The most ambitious postwar structure erected in Paris was that of the Y-shaped building for the United Nations Educational, Scientific, and Cultural Organization (UNESCO), designed by an international team of architects that included the Hungarian Breuer and the French Bernard Zehrfuss with the Italian architect-engineer Pier Luigi Nervi. The total complex is excellently adapted to a difficult site and is adorned by a large number of sculptures, paintings, and murals by artists such as Miró, Calder, Picasso, Noguchi, and Henry Moore. Breuer expanded the ideas and plan of the UNESCO building into his work on a research center for IBM–France at La Gaude, Var (fig. **21.25**). This is a huge structure of a comparable, double-Y plan, with windows set within deep, heavy, concrete frames, the whole on concrete supports. The effect is of openness and airiness combined with massive, rugged detail.

As a result of an important postwar international competition, the most sensational and hotly debated building to be designed in the 1960s (erected in Paris during the early 1970s) was the high-tech extravaganza officially known as Le Centre National d'Art et de Culture Georges Pompidou designed by **Renzo Piano** (b. 1937) and **Richard Rogers** (b. 1933). (It is referred to as the Pompidou Center after the then-president of France, and also as the Beaubourg after the old market district on which it stands.) The Pompidou Center (fig. **21.26**) houses France's national museum of modern art, a public library, an audiovisual center, a rooftop restaurant, and, added later, an internet café. In its time, the design achieved a new standard in open-space flexibility. The structural and service functions were channeled along the outer walls, leaving the interior open to be freely subdivided, and suitable for a multitude of changeable institutional and public uses. By making visible all the building's mechanical and structural elements, the Pompidou Center would seem to fulfill the modernist preference for truth to materials and formal integrity. The Pompidou Center takes Bauhaus pragmatism and technology as its point of departure, only to transform them into a

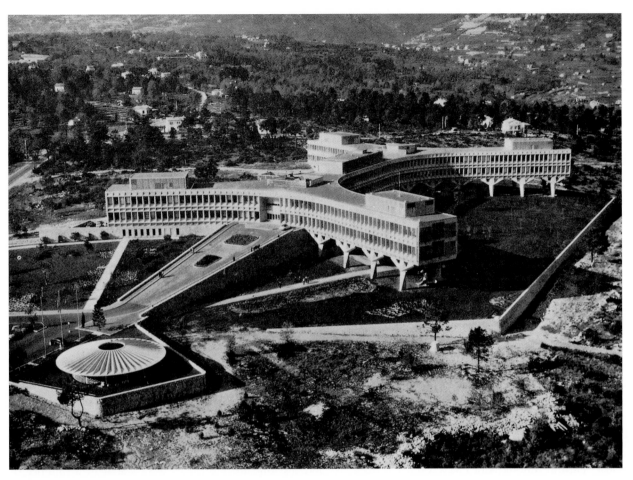

21.25 Marcel Breuer, IBM–France Research Center, 1960–62. La Gaude, Var, France.

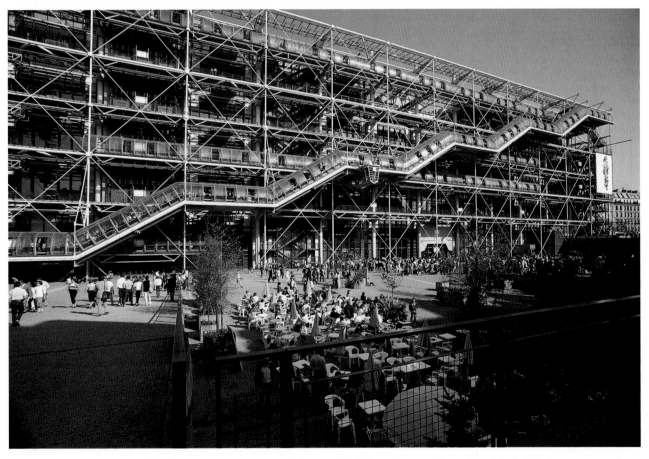

21.26 Renzo Piano and Richard Rogers, Centre National d'Art et de Culture Georges Pompidou, 1971–78. Paris.

surreal dream of pipes and trusses, marine funnels and vents, most of which festoon the exoskeleton. Despite a gargantuan appetite for fuel and difficult-to-manage, barnlike galleries, the Pompidou Center is a great popular success, partly because of a five-story outside escalator, whose transparent plastic tubes offer riders a moving, spectacular view of Paris and the immense, open plaza below. The latter has become a forum—like the *parvis* of a medieval cathedral (the open space in front of and around the building)—for the whole human carnival, from artists displaying their works to jugglers and, of course, tourists and Parisians going about their daily business.

Germany and Italy

As we have seen, Germany until 1930 was a world leader in developing new architecture. During the Nazi regime, German architecture declined from its position of world leadership to academicism and fascist bombast. After the war, morale was low for those architects and artists who had remained in Germany through the war years. While America was enjoying prosperity, Germany underwent a slow, traumatic period of rebuilding, and it took a full decade for the country to recover the principles forcibly surrendered to the Nazis.

In Italy, modern architecture made a somewhat belated arrival, perhaps because the sense of the past was so strong. The visionary Futurist Antonio Sant'Elia was killed in World War I at the age of twenty-eight, before he had a chance to execute his concepts for cities of the future (see fig. 10.21). His ideas faded along with Futurism, and his influence was diffused principally through publications that inspired

pioneers outside of Italy, importantly Le Corbusier and the architects of de Stijl and the Bauhaus.

The official governmental style looked back to showy, nationalistic monumentalism, of which the nineteenth-century monument to Victor Emmanuel II in Rome is the most conspicuous example. In 1933 a group of younger architects, gruppo 7, banded together and called for a functional and rational architecture that would value form over surface in modern architecture. A few outstanding, though isolated, buildings resulted from this and other aspects of Italian rationalism between the wars, notably the aesthetically pure 1936 Casa del Fascio (now the Casa del Popolo, or House of the People) at Como, designed by **Giuseppe Terragni** (1904–42) and commissioned by the local fascist party as its headquarters (fig. **21.27**). Originally conceived as a building wrapped around an open courtyard (since enclosed), the structure is a simple half-cube. After World War II, Italy expanded its experiment beyond progressive architecture, moving into a position of European and even world leadership in many aspects of industrial, product, and fashion design.

The most influential of Italy's prewar design giants was the engineer-architect **Pier Luigi Nervi** (1891–1979). Nervi had a resounding ability to translate engineering structure into architectural forms of beauty. Chronologically he belongs with the pioneers of modern architecture, and his fundamental theses were stated in a number of important buildings executed during the 1930s. His main contribution was the creation of new shapes and spatial dimensions with reinforced concrete. As in the work of Mies van der Rohe, Nervi's buildings show a subtle fusion

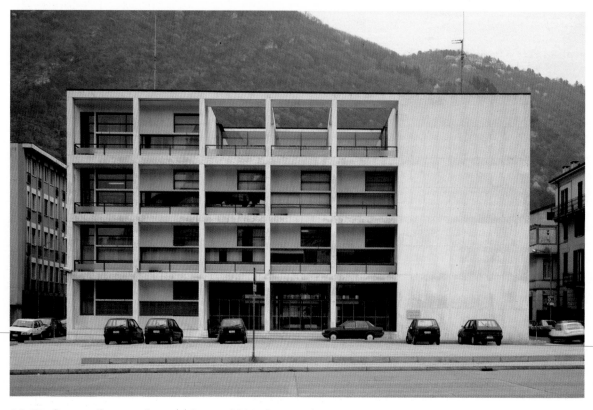

21.27 Giuseppi Terragni, Casa del Fascio, 1936. Como, Italy.

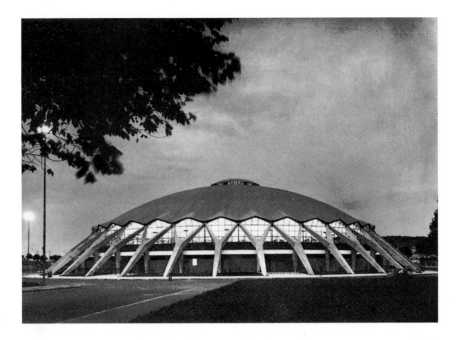

21.28 Pier Luigi Nervi and Annibale Vitellozzi, Sports Palace, 1956–57. Rome, Italy.

of structure and space. But while Mies searched for free internal space, Nervi's aesthetic was dependent on an energetic display of the structural parts of a building. One of the most important commissions of his career was the design of an aircraft hangar in 1935, the first of a number of variants that he built for the military from 1936 to 1941. These hangars, which involve vast, uninterrupted concrete roof spans, led him to study different ways to create such spans. He learned how to lighten and strengthen his materials and to integrate aesthetic and structural variations in his designs. In 1948–49, his Exhibition Hall was built in Turin, using prefabricated concrete units to create a vault spanning 312 feet (95 m).

In the 1950s, Nervi developed the technique of hydraulic pre-stressing of ferro-concrete, which made it possible to lighten the support of buildings. Two of the dramatic applications of his experiments with this material are the small and large sports palaces built for the 1960 Olympic Games in Rome (fig. **21.28**). The smaller one, seen here, meant to hold 4,000–5,000 spectators, was built in 1956–57, in collaboration with the architect Annibale Vitellozzi. The building is essentially a circular roof structure in which the enclosed shell roof, 197 feet (60 m) in diameter, rests lightly on thirty-six Y-shaped concrete supports. The edge of the roof is scalloped, both to accentuate the points of support and to increase the feeling of lightness. A continuous window band between this scalloped edge and the outside wall provides uniform daylight and adds to the floating quality of the ceiling. On the interior, the ceiling, a honeycomb of radiating, interlaced curves, floats without apparent support. The shell domes of the small and large sports palaces became prototypes for other such structures.

During the 1950s and 60s, Nervi collaborated with architects all over the world, including Italy's own **Gio Ponti** (1891–1979). The distinguished Ponti was the chief architect of the Pirelli Tower in Milan (fig. **21.29**),

the result of a close collaboration between architects and engineers. Ponti developed slowly but consistently from Neoclassical beginnings toward an elaborate modernism. The Pirelli Tower, for which Nervi was the structural engineer, remains Ponti's signature building, one of the

21.29 Gio Ponti, Pier Luigi Nervi, and others, Pirelli Tower, 1956–59. Milan, Italy.

most lucid and individual interpretations of the skyscraper yet achieved. In contrast to most American skyscrapers built before the 1950s, it is a separate building surrounded by lower structures, designed to be seen from all sides. The architect was concerned with making it a total, finite, harmonious unit. A boat shape, rather than the customary rectangular slab, was used. The thirty-two-story building is carried on tapering piers, resulting in the enlargement of the spaces as the piers become lighter toward the top. The entire building, with the diagonal areas at the ends enclosed and framing the side walls of glass, has a sculptural quality, a sense of solidity and mass unusual in contemporary skyscraper design.

Latin America, Australia, and Japan

A spectacular example of the spread of the International Style occurred in Latin America after 1940. Le Corbusier's participation in the design of the Ministry of Education and Health in Rio de Janeiro between 1937 and 1943 provided the spark that ignited younger Latin American architects, among them **Oscar Niemeyer** (b. 1907) in Brazil. Le Corbusier's influence is apparent in most of the subsequent development of Brazilian architecture, but Niemeyer and his contemporaries added expressionist and baroque elements—such as curving shapes and lavish use of color, reflecting the Latin American tradition—to plans and façades. In his Pampulha buildings of the early 1940s, Niemeyer hinted at an integration of painting and architecture and effectively introduced a wilder interplay of forms and levels into his buildings.

One of the most dramatic commissions in the history of architecture was the design of the entire city of Brasília, the new federal capital of Brazil (fig. **21.30**). The general plan of the city was laid out by Lúcio Costa, who won the competition sponsored by Brazil's president in 1956. Niemeyer, as chief architect for the project, was entrusted

21.30 Oscar Niemeyer, Palace of the Dawn, 1959. Brasília, Brazil.

with the principal public buildings. Costa's lucid plan was essentially cruciform. Niemeyer designed large-scale civic buildings for the top of the cross, with residential sites along the two arms of the horizontal axis, incorporating places for work and recreation. The idea of building an ideal city far removed from any of the principal centers of commerce and industry probably doomed Brasília to its role as sterile city of government officials, devoid of the cultural diversity and activity of Brazil's other major urban centers. At a time in the history of architecture when very little attention was being paid to concepts of total urban planning, such a project must be seen as important, despite its deficiencies and failures.

In Australia, too, there was a comparable development of new architectural forms, from the slab skyscraper to the integrated educational institution and advanced experiments in housing and urban planning. The most spectacular modern structure is the sail-form, free-standing Sydney Opera House of 1972 on Bennelong Point (fig. **21.31**),

21.31 Jørn Utzon and Hall, Todd, and Littleton, Sydney Opera House, 1972. Bennelong Point, Sydney Harbor, Australia.

21.32 Kenzo Tange, Aerial view, The National Gymnasiums, 1964. Tokyo.

jutting out into Sydney Harbor. The architectural firm of Hall, Todd, and Littleton succeeded the Danish architect **Jørn Utzon** (b. 1918), who made the original design. This cultural center includes an opera hall, a theater, an exhibition area, a cinema, and a chamber music hall.

Modern architecture in Japan, despite a long history of sporadic progressive examples extending back to Frank Lloyd Wright's Imperial Hotel (see fig. 9.6), was only at its inception after World War II. While assimilating the powerful influence of Le Corbusier, the tradition of Japanese architecture (which for centuries embodied so many elements that today are called modern) helped to turn contemporary influences into something distinct.

One of the most significant later twentieth-century Japanese architects is **Kenzo Tange** (1913–2005), whose work in the 1950s and 60s combined rationalist and traditional directions in Japanese aesthetics. Like most Japanese architects of his generation, Tange was a disciple of Le Corbusier, particularly of his later, Brutalist style. Tokyo City Hall, a work of 1952–57, is a rather thin version of Le Corbusier's Unité d'Habitation (see fig. 21.7), but with the Kasagawa Prefecture Office at Takamatsu (1955–58), Tange used a combination of massive, direct concrete treatment and horizontally accentuated shapes reminiscent of traditional Japanese architecture. Perhaps Tange's most striking achievement is the pair of gymnasiums that he designed for the Olympic Games held in Tokyo in 1964 (fig. **21.32**). Both steel-sheeted roofs, somewhat resembling seashells, are suspended from immense cables, and their structure is at once daring and graceful. The larger roof hangs from two concrete masts, while the smaller is ingeniously suspended from a cable spiraling down from a single mast. The Brutalism of the buildings themselves, with their rough surface texture and frank structure, gives

the complex—set as it is on a huge platform of undressed stone blocks—a sense of enduring drama.

Tange's Yamanashi Press Center in Kofu (fig. **21.33**) is a fantastically monumental structure in which immense pylons provide for elevators and other utilities and act visually as tower supports for the horizontal office areas. The total impact is like that of a vast Romanesque fortified castle. The interior, however, is open and flexible, with spaces defined by movable *shoji* screens that allow occupants easily to adapt their space to changing needs. Reminiscent of traditional timber post-and-beam constructions, the press building is one of the earliest examples of a reaction against the abstract, homogeneous trends of modern architecture. Its very "uncompletedness" is an important aspect of its design; it is open-ended and not confined by more traditional architectural approaches that rely on finite elevations and concise imagery.

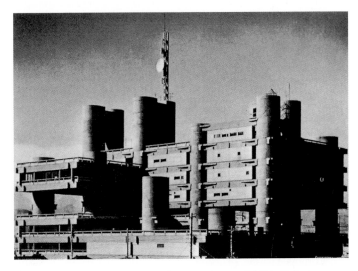

21.33 Kenzo Tange, Yamanashi Press Center, 1967. Kofu, Japan.

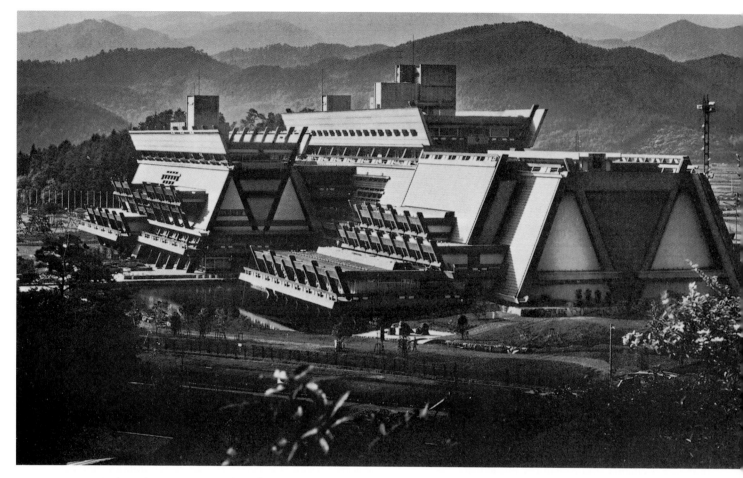

21.34 Sachio Ohtani, International Conference Building, 1955. Kyoto, Japan.

Another Japanese architect who followed the late Le Corbusier line is Takeo Sato, whose City Hall in Iwakuni merges the design of a traditional Japanese pagoda with modern building materials including concrete and glass. Similarly, **Sachio Ohtani**'s (b. 1924) International Conference Building in Kyoto (fig. **21.34**) is a massive structure that houses meeting and exhibition rooms, restaurants, administrative offices, shops, and recreation areas. Employing old trapezoidal and triangular design elements, it represents one of the most spectacular attempts yet to combine on a vast scale ancient Japanese motifs and concepts with modern architectural forms.

Breaking the Mold: Experimental Housing

Of great significance to working architects were some unbuilt visionary house designs such as the Endless House (fig. **21.35**) designed by **Frederick Kiesler** (1890–1965), whom Philip Johnson called "the greatest non-building architect of our time." As early as 1925, Kiesler had conceived of a city in space built on a bridge structure, and an Endless Theater. From these, in 1934, he developed a "space house" and, after years of experiment, the so-termed Endless House, proposed many times in various versions but never built. The idea for an Endless Structure was to

short-circuit any traditional divisions between floor, wall, and ceiling and to offer the inhabitant an interior that could be modified at will. In doing this, Kiesler abandoned the rectangle and turned to egg-shapes freely modeled from plastic materials and proffering a continuously flowing interior space.

Such experiments represented an attempt not only to find new forms based on natural, organic principles but also to utilize new technical and industrial developments while potentially cutting building costs. Among such projects is a 1961 house and studio in Scottsdale, Arizona, built by **Paolo Soleri** (b. 1919). Literally a cave, it is the forerunner of Soleri's Dome House in Cave Creek, Arizona (1950). Born in Turin, Italy, Soleri came to the United States in 1947 and spent a year and a half working with Frank Lloyd Wright. His compact prototype city, Arcosanti (fig. **21.36**), located in the high desert of Arizona in a 4,060-acre (1643-hectare) preserve and now a National Landmark, has been under construction since 1970. For some forty years, it has been an experiment, or "urban laboratory," to demonstrate his theory of arcology. An "arcology" is an integration of architecture, ecology, and urban planning. It involves a whole new concept of urban environment that would eliminate the automobile from within the city (walking would be the main way of getting around), develop renewable energy systems (solar and

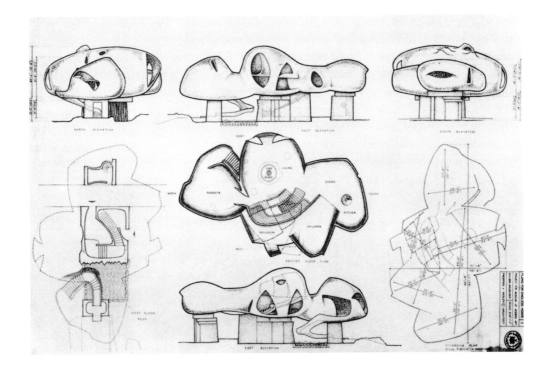

wind), utilize recycling, and allow access to and interaction with the surrounding natural environment. Using rounded concrete structures, this miniaturization of the city allows for the radical conservation of land, energy, and resources. The arcology concept proposes a highly integrated and compact three-dimensional urban form that is the opposite of the wasteful consumption of land, energy, time, and human resources in urban sprawl. (Only about two percent as much land as a typical city of similar population is needed.) Therefore, it presents a new solution to the ecological, economic, spatial, and energy problems of cities.

Less utopian than arcology is prefabrication—the mass manufacturing and pre-construction of individual parts. Although relatively few, there are instances of successful,

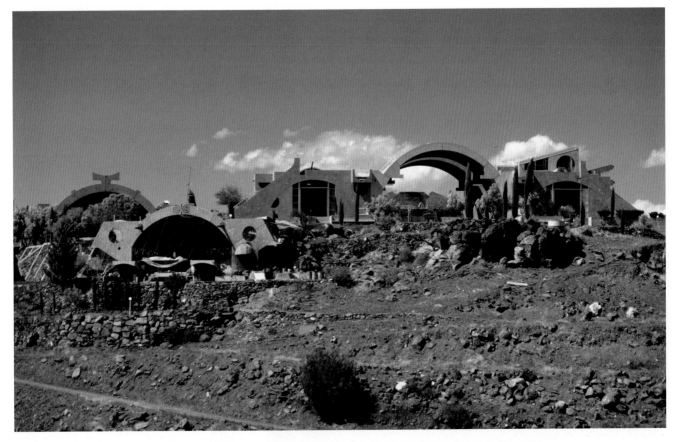

21.36 Paolo Soleri, Arcosanti, begun 1970. Scottsdale, Arizona.

large-scale prefabrication in the twentieth century, such as Nervi's 1948–49 Turin exhibition hall (see p. 575). Some manufacturers in the United States offer partially prefabricated small houses. In a number of California houses, including their own in Santa Monica (1949) (fig. **21.37**), the husband-and-wife team of architect-designers **Charles** (1907–78) and **Ray Eames** (1916–88) set out to prove that modern architecture could be both accessible and economical. Using prefabricated materials purchased through catalogues, the Eameses constructed residences consisting of light steel-skeleton cores covered with fitted plastic, stucco, or glass panels, as well as stock doors, windows, and accessories. These mass-produced materials were chosen for both economic appeal and industrial aesthetic and represent a utilitarian domestic architectural style (see *Women in Architecture*, right).

One of the most distinctive examples of prefabricated housing design is by Israeli architect **Moshe Safdie** (b. 1938). His megastructure, Habitat '67, commissioned for Expo '67, the 1967 World's Fair in Montreal, Canada, was conceived to provide fresh air, sunlight, privacy, and suburban amenities to residents of an urban location (fig. **21.38**). It was designed as a permanent settlement of 158 dwellings made up of fifteen types of independent, interlocking prefabricated boxes. The boxes are staggered in order to provide open-deck space for each unit and to ensure versatile visual and spatial combinations. It is possible to add more prefabricated, mass-produced units to such a structure, rather than constructing them on site.

Further refinement of the modernist aesthetic can be seen in the work of five architects who, in 1969, were recognized as the New York School (not to be confused with the Abstract Expressionist painters known as the New

CONTEXT

Women in Architecture

Architecture remained a field accessible almost exclusively to men well into the second half of the twentieth century. Like other areas of artistic endeavor, women's access to architecture was blocked by long-standing prejudices and social expectations. The first thing they had to overcome—if they were to pursue seriously any of the so-called "high arts" of painting, sculpture, or architecture—was the assumption that their primary duties were domestic: maintaining a home and raising children. Women wishing to study architecture first had to complete the equivalent of a college-level program of courses in mathematics and, at the very least, rudimentary physics and engineering, not to mention drafting. Prior to the mid-twentieth century, few women were permitted (much less encouraged) to follow such a path. Among those who did overcome such obstacles was Julia Morgan (1872–1957), whose successful San Francisco practice focused primarily on domestic architecture, really the only specialty open to women practitioners. Morgan first studied at the University of California before gaining entry in 1898 into the École des Beaux-Arts in Paris. At first refused admission by the French institution (which had never conceived of matriculating a woman into its architecture program), she proved her abilities by entering—and mostly winning—a number of European architecture competitions. Although most of her commissions were in the prevailing Mission or Arts and Crafts styles, she is perhaps best remembered as the architect of William Randolph Hearst's fantastical home at San Simeon, California, known as Hearst Castle, under continuous construction from 1919 to 1947.

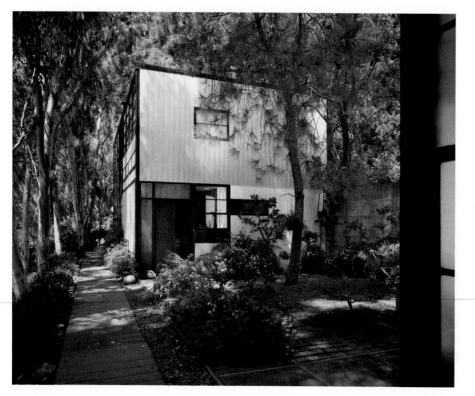

York School). Also called the New York Five, the group included Peter Eisenman, John Hejduk, Michael Graves, Charles Gwathmey, and Richard Meier. The most heavily commissioned of these was **Richard Meier** (b. 1934), whose glistening, white structures—supersophisticated exploitations of the modernist vocabulary—have proved irresistible to wealthy private clients, corporations, and cultural institutions. In Douglas House in Harbor Springs, Michigan (fig. **21.39**), one sees Purist or de Stijl classicism so wittily elaborated as to become a new Mannerism, reversing simple closed forms and ribbon windows into intricate, openwork abstractions with double- and triple-height interiors and vast expanses of glass.

21.37 Charles and Ray Eames, Eames Residence, 1949. Santa Monica, California.

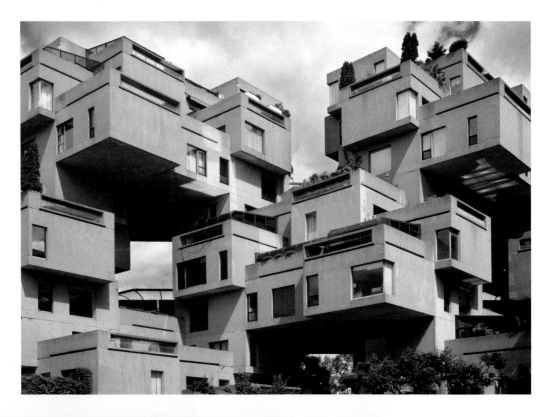

21.38 Moshe Safdie, Habitat '67, 1967. Montreal, Canada.

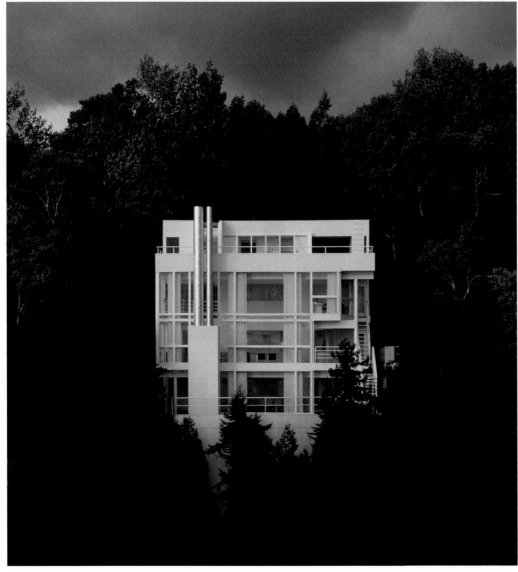

21.39 Richard Meier, Douglas House, 1971–73. Harbor Springs, Michigan.

Arenas for Innovation: Major Public Projects

Cultural Centers, Theaters, and Museums in America

The most elaborate center to date in the United States is the Lincoln Center for the Performing Arts in New York City (fig. **21.40**), which opened in 1962 and represented a spectacular return to architectural formalism. The classical origins of its layout are not disguised. The focus of the principal structures on three sides of a monumental plaza is a fountain, designed by Philip Johnson. In addition to **Max Abramovitz**'s (1908–2004) Philharmonic Hall (1962) (renamed Avery Fisher Hall), the Center comprises Johnson's New York State Theater (1964), **Eero Saarinen**'s (1910–61) Vivian Beaumont Theater (1965), Skidmore, Owings & Merrill's Library-Museum of the Performing Arts (1965), and Wallace K. Harrison's Metropolitan Opera House (1966). A large subterranean garage lies beneath this group. Adjunct structures include a midtown branch of Fordham University and a home for the Juilliard School, completed in 1969 by Pietro Belluschi with Catalano and Westermann.

The buildings created by this notable assemblage of talent exemplify a new monumental classicism characteristic of public and official architecture in the 1960s. The project is impressive, despite the criticisms leveled against individual structures. The chief complaints, aside from problems of acoustics and sightlines, are focused on the Lincoln Center's barren monumentality, its colossal scale unrelieved by ornamental detail that would provide a human reference.

We saw earlier in this chapter, in the discussion about the renovation of Frank Lloyd Wright's Guggenheim Museum (see fig. 21.5), that an art museum is actually a complicated design problem, involving basic questions of efficient circulation, adequate light—natural, artificial,

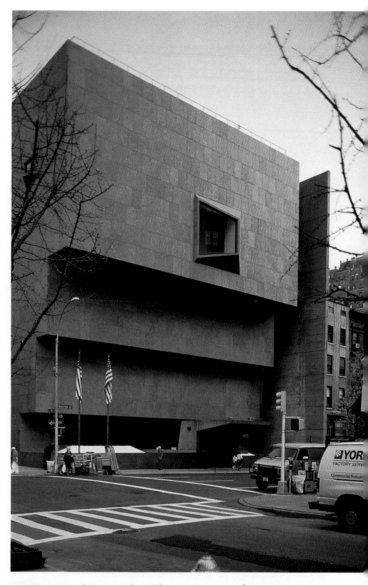

21.41 Marcel Breuer, The Whitney Museum of American Art, 1966. New York.

21.40 Lincoln Center, from left: New York State Theater, by Philip Johnson, 1964; Metropolitan Opera House, by Wallace K. Harrison, 1966; Philharmonic (now Avery Fisher) Hall, by Max Abramovitz, 1962. New York.

21.42 Louis I. Kahn, Interior, west gallery and bookstore, Kimbell Art Museum, 1972. Fort Worth, Texas.

or both—sufficient work and storage space, and, in most cases, rooms for other events, such as concerts, theatrical performances, and receptions. The Whitney Museum of American Art (fig. **21.41**) designed by Marcel Breuer is another important museum design. Breuer's building, illustrative of his later Brutalism, is a development of the forms he used earlier for St. John's Abbey Church in Collegeville, Minnesota (1953–61) and for the lecture hall of New York University's uptown campus in the Bronx (1956–61). The Whitney is a stark and impressive building, in which heavy, dark granite and concrete are used inside and out. The main galleries are huge, uninterrupted halls capable of being divided in almost any way by movable yet solid partitions and representing the utmost flexibility in installation space and artificial lighting. Natural daylight has been ignored except for that emanating from a few trapezoidal-shaped windows functioning as relief accents.

The architect **Louis I. Kahn** (1901–74) was responsible for the design of two important art buildings. Like Wright, Kahn initiated a new American architecture, but while Wright's work developed in the late nineteenth and early twentieth centuries, Kahn matured amidst the uncertainty and loss of idealism of the 1930s and 40s. Born in Estonia, Kahn emigrated with his family to Philadelphia in 1905. He received architectural training in the Beaux Arts tradition at the University of Pennsylvania. There followed a year in Europe, where he was impressed both by the monuments of classical antiquity and by his discovery of Le Corbusier. His later work would reflect a fusion of modernism's passion for technology and abstract form along with a profound awareness of history and its role in architecture.

For a number of years, Kahn taught at Yale University, where he designed the Yale Art Gallery (1951–53), the university's first modern building and one of the first contemporary approaches to the design challenges of the art museum.

Perhaps the most visionary and completely realized of all of Kahn's buildings is his Kimbell Art Museum in Fort Worth, Texas, completed in 1972 (figs. **21.42, 21.43**)—one of the most dramatic as well as functionally effective art museums in the world. The design is based upon a parallel series of self-supporting cycloidal vaults that eliminate the need for interior supports and facilitate an unobstructed and very flexible use of the spacious interior. Indoor and outdoor spaces are integrated through the inclusion of a sculpture garden that creates a fluid interchange between the museum and its environment, thereby altering the traditional notion of a museum as a place that cloisters works of art. The architect is also noted for the close attention paid to the issues of lighting and display. By combining artificial and natural light, and breaking up the cavernous heights of gallery space with low-hanging lights and shorter partitioning walls, the Kimbell becomes both a practical space for the display and conservation of art, and an aesthetically pleasing environment that is at once monumental and intimate to the gallery visitor.

21.43 Louis I. Kahn, Kimbell Art Museum, 1972. Fort Worth, Texas.

The challenge of successfully designing a visitor center and museum for a highly specific and localized American community shows Meier's versatility and his evolution as an architect. The differences between his rationalist Douglas House (fig. 21.39) and the three-story Atheneum at Historic New Harmony in Indiana (fig. **21.44**) are revealing. Now a living museum, New Harmony was a vigorous nineteenth-century American religious and utopian community established by the Harmony Society in 1814. The 1975–79 Atheneum is a gleaming white metal structure set on a green lawn: a visual dialogue of solid and void, projecting terraces, recessive spaces, and folded stairs that proclaim its modernity. The commission required a 180-seat auditorium, four exhibition galleries, observation terraces, and visitor and administrative facilities. Meier's work fulfills the program and stands in great contrast to the log cabins and brick buildings of the historic settlement. There is something detached in the way the building relates to the site of one of the most intriguing social experiments

in American history, but its very detachment offers a completely unbiased vantage point.

I. M. Pei's (Ieoh Ming Pei, b. 1917) East Wing extension to the National Gallery of Art in Washington, D.C. (fig. **21.45**), inaugurated in 1978, ten years after its initial conception, is an extraordinary venue for a broad range of museum activities. It is not only a site for temporary exhibitions and the museum's collection of twentieth-century art, but also houses museum offices, a library, and the Center for Advanced Studies in the Visual Arts (CASVA). The awkward trapezoidal site posed several challenges for the architect, as did the need to integrate the new structure with the extant Beaux-Arts style West Building (designed by John Russell Pope). Pei resolved these problems by dividing the plot into triangular forms that became the building blocks of his design—reiterated throughout the building in floor tiles, skylights, stairs, and tables—and then connecting the entire construction to the West Building via an underground passage. The entrance to the East Building opens to an expansive, light-filled atrium with skylighted ceilings that provide the backdrop for several works of art commissioned especially for the building, including a monumental mobile by Alexander Calder (fig. **21.46**). In contrast to the atrium's open, soaring space, the intimate interior is composed of individual galleries made from smaller rooms and lowered walls that provide a quiet space for the contemplation of the exhibited art. Viewed from outside, the East Building—dramatically set against the view of the Capitol

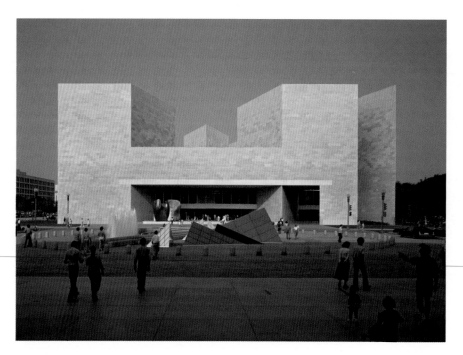

21.45 I. M. Pei, National Gallery of Art, East Wing, 1978. Washington.

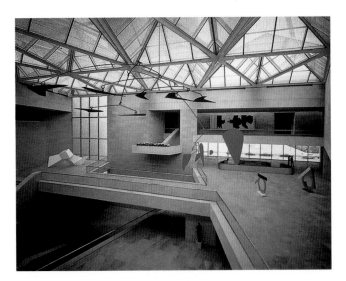

21.46 I. M. Pei, East Building, National Gallery of Art, 1968–78. Washington, D.C. At center, Alexander Calder, *Untitled*, 1976. Aluminum and steel, 29' × 10" × 76' (8.8 × 0.25 × 23.2 m).

Building—is easily recognized by its H-shape design, which is formed by the stocky towers that extend from each of three vertices. Associated in his early years with both Gropius and Breuer, Pei is the consummate modernist, combining and refining the best principles of modern architecture in a continually inventive stream of eloquent commercial and public buildings, including the glass pyramid for the renovated Musée du Louvre in Paris in 1989 (see fig. 24.21).

Urban Planning and Airports

City planning has been a dream of architects since antiquity, and has only occasionally been realized, as in the Hellenistic cities built after the conquests by Alexander the Great, Roman forums, Renaissance and Baroque piazzas, the Imperial Forbidden City of Peking, and Baron Haussmann's rebuilding of Paris in the nineteenth century. Although Le Corbusier was one of the visionaries of European planning in his designs for a new Paris, it was only at Chandigarh (fig. 21.10) that he was able to realize some of his ideas. Brasília was perhaps the most complete realization of a new city plan in the twentieth century (see fig. 21.30).

One opportunity for a distinctly modern kind of urban planning was offered by the airports that proliferated in the 1950s and 60s. Unfortunately, very few of these were successfully realized. With some exceptions, the architecture proved routine and its solutions for such problems as circulation were found to be inadequate. New York's John F. Kennedy International Airport is a vast mix of miscellaneous architectural styles illustrating the clichés of modern architecture. A few individual buildings rise above the norm. One is Eero Saarinen's TWA Terminal (fig. **21.47**), with its striking airplane-wing profile and interior spaces, clearly suggestive of the ideal of flight. In 1961–62, Saarinen had the opportunity to design a complete terminal at the Dulles Airport near Washington, D.C. (fig. **21.48**). The main building—with its upturned floating roof and the adjoining related traffic tower—incorporates an exciting

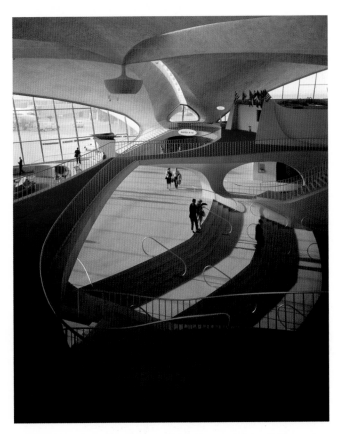

21.47 Eero Saarinen, Interior, TWA Terminal, John F. Kennedy International Airport, 1962. New York.

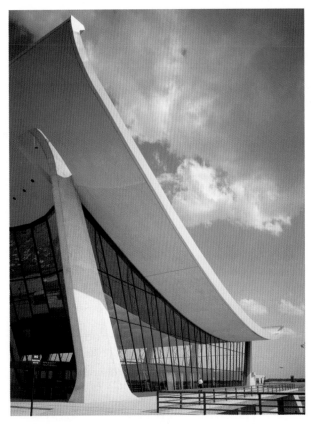

21.48 Eero Saarinen, Dulles Airport, 1961–62. Chantilly, Virginia.

and unified design concept. Saarinen here also resolved practical problems, such as transporting passengers directly to the plane through mobile lounges. Because of the increase in air traffic, Dulles was expanded in the mid-1990s to more than double its original size, reminding us that architectural form often derives from changing functions. In the 1960s Saarinen had predicted such an expansion, and hence left behind explicit architectural plans for future use. The final design, completed by the firm Skidmore, Owings & Merrill, remained loyal to Saarinen's original plans; the building's design was extended by 320 feet (97.5 m) at either end, thereby altering the airport's proportions but leaving the basic form undisturbed.

Architecture and Engineering

To many students of urban design, the solutions for the future seemed to lie less in the hands of the architects than in those of the engineers. Architects themselves were closely following new engineering experiments, particularly such new principles of construction as those advanced by **Richard Buckminster Fuller** (1895–1983). Fuller was the universal man of modern engineering. As early as 1929 he

The Dymaxion House

Visionary designer R. Buckminster Fuller proposed a new type of prefabricated structure as an answer to widespread housing shortages, especially among families with low incomes, in the 1920s. It was called the Dymaxion House, its name derived from three terms associated with his design philosophy: **dy**namic **max**imum tens**ion**. Dynamism relates to Fuller's interest in energy, especially a maximum use of energy that eliminates waste. The notion of tension related to his interest in the suspension principles used in the construction of modern bridges and radio towers. Fuller harnessed these ideas in the design of the Dymaxion House, a round structure with a domed roof surmounted by a passive ventilator that would provide fresh, cool air year-round. The shell of the hive-like house was constructed of lightweight aluminum and the whole structure was suspended on a central core, what Fuller called a "mast," which not only provided the main support but also enclosed all plumbing and wiring, allowing for flexible, modular spaces around it. The interior of the house was segmented into four or five pie-shaped wedges to accommodate different domestic activities: cooking, socializing, sleeping, hygiene, etc. The house was estimated to cost $6,500, then the price of a luxury Cadillac automobile and considerably less than conventional houses. It could be shipped easily in an aluminum tube, then assembled by its owner. No single component weighed over 10 lb., making it possible for two persons of moderate strength to erect it. Although the house first appeared in 1929—shown in Chicago's Marshall Field department store (see fig. 4.13)—it was never mass-produced as Fuller envisioned it would be.

designed a Dymaxion House, literally a machine for living that realized Le Corbusier's earlier concept in its use of automobile and aircraft construction techniques (see *The Dymaxion House*, left). In the early 1930s he built a practical three-wheeled automobile, which was recognized as one of the few rational steps toward solving the problem of city traffic congestion, but which was never put into production. These and many other inventions led ultimately to his geodesic dome structures, based on tetrahedrons, octahedrons, or icosahedrons. These domes, which can be created in almost any material and built to any dimensions, have been used for greenhouses, covers for industrial shops, and mobile, easily assembled living units for the American Army. Although Fuller's genius had long been widely recognized, it was only in the second half of the twentieth century that he had an opportunity to demonstrate the tremendous flexibility, low cost, and ease of construction of his domes. Many innovative structures were constructed for Expo '67, including Safdie's *Habitat* (fig. 21.38), but Fuller's geodesic dome (fig. **21.49**) dominated the whole exposition. The structure was a prototype of what he called an "environmental valve," which encloses sufficient space for whole communities to live within a physical microcosm. The American Pavilion at Expo '67 was a triumphant vindication of this engineer-architect, whose ideas of construction and design promised to make most modern architecture obsolete.

Fuller's projects demonstrate as clearly as any that modern architecture involved diverse styles and philosophies, showing that there is no single form to answer a particular function. The same political, economic, and cultural influences that contributed to the heterogeneity of responses to World War II, the Cold War, and the expansion of industrialism around the world by visual artists express themselves through the utopian projects of Le Corbusier, the triumphant purity of Mies' skyscrapers, and the optimistic dynamism of Fuller's geodesic dome.

21.49 Buckminster Fuller, American Pavilion, Expo '67, 1967. Montreal, Canada.

22
Conceptualism and Activist Art

"A work needs only to be interesting." Donald Judd's declaration, pronounced in 1965, summed up one of the central aims of Minimalism: to create artworks capable of provoking intense awareness. Whether this awareness was directed to a particular object, material or environment or even to the viewer's own body depended on the artwork. Tony Smith's imposing six-foot-square steel cube, *Die*, elicited one experience from the viewer while one of Judd's smaller but highly finished series of Plexiglas boxes generated quite another. The one thing most Minimalist artists shared, though, was a singular concern for form. Seeking to articulate unified, coherent, and seemingly inevitable forms, many contemporary artists have continued to explore the formal possibilities of Minimalism into the twenty-first century.

Just as the Minimalists were defining their project in the 1960s, other progressive artists concluded that form was not necessary to express aesthetic interest or expressive intent. Conceptualism holds that the idea *is* the work of art. Any painting, sculpture, drawing, print, photograph, or building created in response to that idea is simply a piece of documentation, a record of aesthetic expression as opposed to aesthetic expression itself. While Dada is looked to generally as a source for Conceptualism, it is Marcel Duchamp who provided the most influential model for art as idea (see chapter 11). His readymades (see fig. 11.8) destabilized the very notion of art, demanding that artists and viewers alike recognize that the concept of "art" must always precede the appearance of the work. When Duchamp's *The Large Glass* (see fig. 11.12) was shattered in transit, the artist declared that the piece had not been destroyed but rather completed by this accident, asserting the futility faced by any artist of trying to give form to an idea.

The notion that the aesthetic idea rather than the resulting object holds primacy was current even in the Renaissance. For instance, Leonardo da Vinci's habit of leaving projects unfinished was explained by his biographer Giorgio Vasari as a consequence of the artist's ability to imagine forms so perfect that they could not be realized materially. Though of little comfort to Leonardo's frustrated patrons, Vasari's explanation classed the artist's numerous incomplete works as a mark of genius rather than failure. While Conceptual artists may not have shared Vasari's preoccupation with proofs of artistic genius, they did hold that ideas—whether ultimately realized or not—were the most authentic form of art.

It is, perhaps, no surprise that an art movement that actively contests the relevance of most art objects arose in the 1960s. A decade of political upheaval culminated in 1968 with widespread demonstrations in Europe and the United States as students, laborers, and civil rights organizations protested against economic, social, and military policies. Among the focal points of protest were the Vietnam War, civil rights for black Americans, and full economic and social enfranchisement for women. The 1968 assassinations of civil rights leader Martin Luther King, Jr. and anti-war presidential candidate Robert F. Kennedy darkened reformers' hopes in the United States. The Soviet Union's violent suppression of Czechoslovakia's "Prague Spring"—when reform-minded leaders resolved to break with Soviet policy and effect significant social and economic reforms, with broad popular support—cast a similar pall over Central Europe.

Just as the avant-garde had rejected traditional Western artistic ideals in response to World War I, progressive artists working in the 1960s began to question the basis for their own aesthetic values. Their responses to this questioning expressed themselves in myriad ways, with some artists abandoning the production of conventional artworks altogether and instead turning to Performance, Body art, or other ephemeral media such as mail art or graffiti.

Art as Language

In 1970, The Museum of Modern Art in New York mounted an exhibition called simply Information. As the title suggests, the show acknowledged that ideas had come to the fore in art and, for many younger as well as older

artists, taken precedence over concrete form. Already in 1967, the Minimalist sculptor Sol LeWitt had defined his own grid and cube works (see fig. 20.51) as Conceptualist, while reinforcing his position with theoretical statements that had a vast influence on artists of kindred spirit. "In Conceptual Art," LeWitt wrote in 1967, "the idea or concept is the most important aspect of the work ... all planning and decision[s] are made beforehand and the execution is a perfunctory affair. The idea becomes the machine that makes the art." Among the many questions raised by LeWitt's pronouncement is the fairly straightforward query: what, exactly, *is* an idea?

Art & Language, Kosuth

For many artists working in the early phases of Conceptualism, the most essential process by which an idea takes form was through language. The impossibility of separating language from thought has vexed philosophers since antiquity; for some Conceptual artists, language seemed the closest approximation for pure thought. Among those interested in the expressive as well as social dimensions of language were the British artists Terry Atkinson, Michael Baldwin, David Bainbridge, and Harold Hurrell, who formed the Art & Language group in 1968. Their influential journal *Art—Language* was published from 1969 to 1985. United in their skepticism toward Greenbergian modernism, the Art & Language group would soon include the American **Joseph Kosuth** (b. 1945), who had long been wrestling with alternative models for understanding and making art.

An artist as well as a writer and theorist, Kosuth was co-curator of the Information exhibition. His 1965 piece *One and Three Chairs* (fig. **22.1**) presents one of the earliest Conceptual explorations of language as a means of representation. The piece consists of an actual chair accompanied

by a full-scale photograph of it and a dictionary definition of "chair." These three representations of "chairness" evoke Plato's Theory of Forms, which holds that the true form of something exists only in the idea of that thing—all representations of the idea are degraded versions. To illustrate his point, Plato described a couch in three forms: the ideal "couch" that one can only imagine; the actual couch one can rest upon; and a picture of a couch. For Plato, the pictorial representation of the couch is the most degraded version, possessing neither the use value of the real couch nor the perfection of the ideal "couch." In a deliberate evocation of Plato, Kosuth uses a piece of furniture to show that each representation of the chair conveys a slightly different idea: all sign systems (including language) are inherently imprecise, inevitably producing as much misapprehension as understanding (see *Semiotics*, below). This was

22.1 Joseph Kosuth, *One and Three Chairs*, 1965. Wooden folding chair, photographic copy of a chair, and photographic enlargement of a dictionary definition of a chair; chair, 32⅜ × 14⅞ × 20⅞" (82 × 37.8 × 53 cm); photo panel, 36 × 24⅛" (91.5 × 61.1 cm); text panel, 24⅛ × 24½" (61.3 × 62.2 cm). The Museum of Modern Art, New York.

the problem that Plato attributed to visual representation, leading him to imagine his perfect Republic as better off without artists. Kosuth's cheeky reference to Plato here seems to suggest that modern society has finally achieved the state of Plato's utopian Republic and has no further need for artists.

Weiner, Huebler, and Barry

"Without language, there is no art," declared Lawrence Weiner, who maintained that he cared little whether his "statements," a series of tersely phrased proposals, such as *A 36 × 36" Removal to the Lathing or Support of Plaster or Wallboard from a Wall*, were ever executed, by himself or anyone else. Fundamentally, he left to the "receiver" of the work the decision to implement the idea. "Once you know about a work of mine," he wrote, "you own it. There's no way I can climb into somebody's head and remove it." Meanwhile, Douglas Huebler made the Conceptualists' attitude toward form stunningly clear in a famous pronouncement published in 1968: "The world is full of objects, more or less interesting; I do not wish to add any more. I prefer, simply, to state the existence of things in terms of time or of space." In *Location Piece #14* Huebler proposed that photographs be taken over a twenty-four-hour period at twenty-four locations on the 45° parallel north of the Equator. The piece would then be constituted of the photographs, a map of the world, and the artist's statement, which concluded: "The owner of the work will assume the responsibility for fulfilling every aspect of its physical execution." But even if the "owner" assumed that responsibility, the photographs would have been indistinguishable from one another, leaving the viewer to make sense of them and bringing to bear issues of individual identity and personal response. Yet more ephemeral, but touched with the charm of whimsy, were such proposals as the following by Robert Barry, offered as serious artistic commentary:

> All the things I know
> But of which I am not
> At the moment thinking—
> 1:36 PM, June 1969.

While the Conceptualists may have denied the sensory delights offered by traditional painting and sculpture, they discovered new possibilities within the relatively restricted field of language and linguistically analogous systems. Books, newspapers, magazines, catalogues, advertising, postal and telegraphic messages, charts, and maps were all seized upon and exploited as resources for information and opinions about art and almost anything else of world interest in the early 1970s.

Keeping Time: Baldessari, Kawara, and Darboven

Language not only conveys meaning, but it also structures time. Whether oral or written, speech cannot be comprehended instantaneously: meaning becomes clear through time. A number of Conceptual artists have adopted narrative or even systems of timekeeping as the basis for their work.

John Baldessari (b. 1931) composed brief but trenchant tales about art itself, usually accompanied by a reproduction of some key monument from the art-historical canon (fig. **22.2**). In later works such as the photomontage

22.2 John Baldessari, "Art History" from the book *Ingres and Other Parables*, 1972. Photograph and typed text, 8½ × 10⅞" (21.6 × 27.6 cm).

22.3 John Baldessari, *Heel*, 1986. Black-and-white photographs with oil tint, oil stick, and acrylic, mounted on board, 8' 10½" × 7' 3" (2.7 × 2.2 m). Los Angeles County Museum of Art.

Heel (fig. **22.3**), however, the narrative element became extremely elliptical. The viewer may notice that almost all of the individuals shown in the side photographs have injured feet, suggesting that the title may perhaps refer to the idea of an Achilles' heel, the mythical Greek hero's one vulnerable point. And we may also note that the individuals on the periphery could easily gather in the crowd depicted in the central image. But in order to grasp the connection that the artist apparently had in mind, it helps to know that he had been reading Elias Canetti's book

22.4 On Kawara, *The Today Series of Date Paintings*, 1966. Installation view.

Crowds and Power, on the relationship between crowds and individuals. In superimposing a unifying red line on the people who are drifting away from the main group, Baldessari was identifying what might be seen as the mob's Achilles' heel: its vulnerable point is that its members may wander off, one by one, dissipating its power to act.

Books, like verbal communication, offer a sequential, cumulative experience, as opposed to the plastic art of traditional painting that, being static, has the potential for providing a total, all-at-once experience at the very instant of perception. Freed from the tedium of material restraints, the Conceptualists could now move even beyond the third dimension offered by sculpture to explore the fourth dimension of time. **On Kawara** (b. 1933), a Japanese artist resident in New York, made the passage of time itself the all-important subject by each day starting a small black painting that simply set forth the current date in white block letters (fig. **22.4**). With every panel an equal component in the series, the work can reveal its full meaning only as a total conception. The German artist **Hanne Darboven** (b. 1941) recorded the passage of time and her experience of it by filling an enormous number of pages with a kind of abstract calligraphy and mysterious permutating numeration, derived in part from the days, weeks, and months of the calendar. As the artist's digits add up, multiply, and interweave, they eventually cover whole walls of gallery space, finally becoming a complete environment given over to a trance-like involvement with time's steady, inexorable advance (fig. **22.5**).

22.5 Hanne Darboven, *Ein Jahrhundert 00-99*, 1971–73. Installation view. Ink and typewriter on paper, 112 sheets. Courtesy the artist and Elisabeth Kaufmann, Zurich.

Conceptual Art as Cultural Critique

Since its first articulation in LeWitt's statements, Conceptual art has been a form of critical investigation into what drives the making, exhibiting, and selling of art. Many Conceptual artists felt that the qualities that had distinguished modern art—originality, novelty, rarity—were precisely the qualities that fueled modern commerce. Their views were prescient: by the mid-1980s, artworks had replaced precious metals and other commodities among some investors as favored vehicles for speculation. It is estimated that Japanese corporations invested trillions in artworks purchased with an eye toward their future monetary worth rather than their aesthetic interest. Never exhibited, thousands of works remain secured in bank vaults. The practices of the art market as well as those of collectors and museums provided a source for a number of Conceptual projects.

Haacke and Asher

The German-American artist **Hans Haacke** (b. 1936) brought to Conceptual art a moral conscience. On being invited to exhibit at the Solomon R. Guggenheim Museum in New York, Haacke created *Shapolsky et al., Manhattan Real Estate Holdings, a Real-Time Social System, as of May 1, 1971* (fig. **22.6**). In this *Real Estate* series, the artist captioned photographs of tenements, among other kinds of buildings, with business information about ownership, acquisition, and property values. Presented with all the order and logic of a minimalist grid, *Shapolsky et al.* described a system in which a small group of property owners were making money out of under-maintained buildings. Right away, the *Real Estate* pieces were seen as being so inflammatory that the Guggenheim canceled the show. While the cancellation may have preserved the political "neutrality" essential to a tax-free educational institution, it also guaranteed the very kind of public interest that could serve Haacke's overriding purpose—to jolt complacent viewers into helping to correct social injustice. What it could have achieved had it been viewed in the rotunda of the Guggenheim is, of course, impossible to know.

Haacke brought a similar mode of inquiry to a 1975 installation at the John Weber Gallery in New York called *Seurat's "Les Poseuses—Small Version," 1888–1975.* Here, a color reproduction of Seurat's 1888 pointillist painting is accompanied by fourteen panels documenting its ownership history. Haacke focuses attention on the painting's role as a commodity, its monetary value reassessed with each transfer. The installation made clear that the painting's cultural import has become inextricably bound with its commercial value, thus asserting that aesthetic disinterest is an experience unavailable to those living in the age of high capitalism. The fact that this piece was installed in an art gallery lent it further power as well as irony.

Michael Asher (b. 1943) took the exposure of the museum and gallery to extremes by making his art out

22.6 Hans Haacke, *Shapolsky et al., Manhattan Real Estate Holdings, a Real-Time Social System, as of May 1, 1971* (detail), 1971. 142 photographs, 2 maps, 6 charts. Edition of two.

of the physical spaces of sale and display. His 1974 *Situational Work* consisted of removing the wall that divided the exhibition and office space of a gallery. The work made the economic context of aesthetic experiences visible, thus undermining the purity of art praised by formalist critics. Moreover, there was no aesthetic or economic potential in the work itself. Photography and text served to preserve the idea and the event, but Asher's conceptual critique left nothing to buy or even observe.

22.7 Louise Lawler, *Pollock and Tureen, Arranged by Mr. and Mrs. Burton Tremaine, Connecticut,* 1984. Silver dye bleach print; 28 × 39" (71.1 × 99.1 cm). The Metropolitan Museum of Art, New York. Purchase, The Horace W. Goldsmith Foundation Gift through Joyce and Robert Menschel and Jennifer and Joseph Duke Gift, 2000.

Lawler and Wilson

Beginning in the late 1970s, **Louise Lawler** (b. 1947) redirected the institutional critiques of Haacke and Asher to show how museums and galleries articulate cultural authority and assert economic, racial, and sexual hierarchies. In her installations, Lawler reorganizes objects already contained within a particular museum collection (fig. **22.7**). Through her unexpected juxtapositions she makes clear the narratives and assumptions that underlie most organized displays of cultural artifacts. **Fred Wilson** (b. 1954) likewise developed a practice of intervention in the "sacred" cultural spaces such as museums (see fig. **22.8**). His installations, such as *Mining the Museum*, pointedly examine how

the circulation and accumulation of objects document—sometimes quite subtly—the exercise of cultural power, in this case the American involvement in the slave trade. Wilson's interventions reveal the ability of objects to perpetuate racist ideologies, even when such beliefs have been publicly disavowed.

Buren

Illustrating the principle that the "ideal Conceptual work," as artist Mel Bochner characterized it, could be experienced through its description and be infinitely repeatable—and thus able to transcend modernism's long-standing attachment to originality and uniqueness—the French

22.8 Fred Wilson, *Mining the Museum*, 1992. Installation detail, "Metalwork." Courtesy Contemporary Museum, Baltimore.

22.9 Daniel Buren, *Untitled*, 1973. Installation incorporating green and white stripes, Bleecker Street, New York (now destroyed).

artist **Daniel Buren** (b. 1938) reduced his painting to a uniform neutral and internal system of commercially printed vertical stripes, a formal practice that readily lent itself to infinite replication and exhibition in any environment (fig. **22.9**). The initial concept would never have to change, and variety came not in the form itself but rather in the context: city streets, public squares, museums, and galleries are all highlighted by Buren's stripes, indicating that the circumstances surrounding the display of art are as important as the work itself.

Extended Arenas: Performance Art and Video

Some artists found the material limitations of the written word confining and preferred the unboundedness of Performance art. Not only did Performance liberate artists from the art object, it also freed them to adopt whatever subject matter, medium, or material seemed promising for their purposes. Performance was not simply visual communication: it often incorporated words and called upon concepts of ritual and myth that had long been important to twentieth-century artists. Moreover, it enabled artists to offer their work at any time, for any duration, at any kind of site, and in direct contact with their audience. For some, this immediacy was crucial, providing a means of undermining the distinction between life and art. This was a dichotomy that some Conceptual artists sought to eliminate, believing that aesthetic distance permitted audiences to observe dispassionately rather than internalize the potentially transformative import of a performance or ritual.

Fluxus

The intuition that the personal was artistic, just a short step from being declared political, was at the heart of the Fluxus group, a loose international collective of sculptors, painters, poets, and Performance artists that began to form in 1962. That year, the group's *de facto* leader, the American artist George Maciunas (1932–78), asserted in one of his many manifestos, "Neo-Dada in Music, Theater, Poetry, Art," that "If man could experience the world, the concrete world surrounding him (from mathematical ideas to physical matter) in the same way he experiences art, there would be no need for art, artists and similar 'nonproductive' elements." That such a call for a new consciousness should be delivered at the height of the Cold War as the U.S. and the Soviet Union engaged in proxy wars in Asia, Africa, and Latin America is telling. Artists affiliated with Fluxus often understood their work in political terms while generally avoiding dogmatic pronouncements (see *The Situationists*, below).

Fluxus resisted transformations of life into art, believing that the two were already inseparable. Performance pieces served best to demonstrate the commingling of life and art, and Fluxus members staged various events ranging from

22.10 Yoko Ono performing *Cut Piece* at Carnegie Recital Hall, New York City, March 21, 1965.

Fluxus festivals, where many participants would convene for concerts and performances executed over several days, to intimate Happenings such as Fluxus divorces (in one case involving a group of participants who literally cut all of the couple's possessions in half), to Maciunas' 1978 "Fluxus Wedding" to artist Billie Hutching, in which the couple arrived in traditional wedding attire before ritually exchanging costumes. Wedding guests presented various impromptu actions and pre-orchestrated performances.

There was no discernible Fluxus style, though artists involved with the group shared a suspicion of art's role as a commodity. With the art market exerting ever greater pressure on the artistic process, some progressive artists felt that artworks had been drained of any but their commercial value. Performance pieces and Happenings were one way to subvert the market's duty to transform art objects into commodities. Another way to undermine the market was by producing unlimited editions of works that could be made available directly to those who wished to own them. Without an "original" object to which a dealer might attach the value-added condition of "authenticity," mass-produced works executed in series bypassed the gallery system (at least for a while—galleries soon adjusted to these strategies and now accommodate even works made expressly to defy their authority). Fluxus magazines and other publications appeared occasionally during the 1960s and 70s. Catalogues of Fluxus wares were also produced, in a direct-to-the-consumer gesture reminiscent of the Bauhaus.

The Fluxus approach is nicely summarized by the work of Japanese-born American artist **Yoko Ono** (b. 1933). She created the performances *Breathe Piece* and *Laugh Piece* (both 1966) by giving one-word instructions to her audience, as indicated by their titles. Her 1965 *Cut Piece* (fig. **22.10**), in which the artist sat on stage beside a large pair of scissors and wordlessly waited as the audience cut her clothes off, makes clear that the joyful whimsy apparent in much Fluxus work delivers politically astute commentaries on everyday life. This critical dimension would be pushed even further by activist artists, such as those discussed later in this chapter.

Beuys

No artist active in the 1970s realized the heroic potential of Performance more movingly than the charismatic and controversial German artist **Joseph Beuys** (1921–86). During World War II, Beuys was a radio operator serving on bombers. Shot down in 1943 and given up for dead in the blizzard-swept Crimea, he survived thanks to the aid of nomadic Tatars who nursed him for a week, wrapping him in warm felt and dressing his wounds with lard. He returned to peacetime existence determined to rehumanize both art and life by drastically narrowing the gap between the two. To achieve this, he employed personally relevant methods or materials in order to render form an agent of meaningful transformation. He began by piling asymmetrical clumps of animal grease in empty rooms and then wrapping himself in fat and felt, an act that ritualized the

22.11 Joseph Beuys, *How to Explain Pictures to a Dead Hare*, 1965. Performance at the Galerie Schmela, Düsseldorf.

22.12 Joseph Beuys, *The Pack*, 1969. Installation with Volkswagen bus and twenty sledges, each carrying felt, fat, and a flashlight. Staatliche Kunstsammlungen Kassel, Neue Galerie, Kassel, Germany.

healing techniques of the Tatars. Viewing his works "as stimulants for the transformation of the idea of sculpture or of art in general," Beuys intended them to provoke thoughts about what art can be and how the concept of artmaking can be "extended to the invisible materials used by everyone." He wrote about "Thinking Forms," concerned with "how we mold our thoughts," about "Spoken Forms," addressed to the question of "how we shape our thoughts into words," and finally about "Social Sculpture," meaning "how we mold and shape the world in which we live: Sculpture as an evolutionary process; everyone is an artist." He continued, "That is why the nature of my sculpture is not fixed and finished. Processes continue in most of them: chemical reactions, fermentations, color changes, decay, drying up. Everything is in a state of change."

In a Düsseldorf gallery in 1965 the artist created *How to Explain Pictures to a Dead Hare* (fig. 22.11), for which he sat in a bare room surrounded by his familiar media of felt, fat, copper, and wood, his face coated with honey onto which gold leaf had been applied. A dead hare lay cradled in his arms, and he murmured urgently to it, sometimes raising its limp paw to gently stroke a picture. To elucidate this piece, Beuys said that in his work "the figures of the horse, the stag, the swan, and the hare constantly come and go: figures which pass freely from one level of existence to another, which represent the incarnation of the soul or the earthly form of spiritual beings with access to other regions." In this seemingly morbid performance, Beuys pointed up the complex and ambivalent feelings aroused in us by works of art that try to deal directly with such intractably unaesthetic subjects as death. The natural human reaction to the harmless creature held by the artist overturned any notion of "aesthetic distance." And the gold mask Beuys wore made him seem not like an artist but rather a shaman or healer who, through magical incantation, could achieve a certain oneness with the spirits of animals.

Sculptural works such as *The Pack* (fig. **22.12**) drew on Beuys' personal experience in a different way, transforming inanimate objects by layering them with associations both positive and negative. The sleds in this work, for example, may be part of a rescue operation, like the one that saved the artist's life, since each one carries such emergency gear as a flashlight, in addition to the felt and the animal fat that Beuys specifically associated with his own rescue. But at the same time *The Pack* bears some resemblance to the equipment of a military assault force or commando unit and in this way might assume a decidedly more aggressive than pacifist character.

In 1962 Beuys joined Fluxus, but by the end of 1965 he had severed relations with the group, not finding the work sufficiently effective: "They held a mirror up to people without indicating how to change anything."

The Medium Is the Message: Early Video Art

By the early 1960s, television had been introduced to most of the developing world and was more or less ubiquitous in the industrialized West. This new medium was on its way to overtaking traditional newspapers and radio as the primary source of entertainment and information. Conceptual artists like Nam June Paik (see below) began experimenting with television as an art form in 1959, using magnets to disrupt and manipulate the screen image. The equipment needed to shoot video remained expensive and cumbersome until the introduction of comparatively cheap consumer video cameras and recorders in the 1970s. At that point, video art became central to Conceptual art practice.

Paik

A different kind of Performance artist whose chosen media are defined by change is **Nam June Paik** (1932–2006), who switched from straight electronic music composition to the visual arts when he discovered the expressive possibilities of video in all its forms. For Paik, television sets and their accompanying wires and antennas promised interesting sculptural possibilities just as the images and programs displayed on TV screens could be used to deliver limitless visual and aural experiences. Paik proclaimed that "as collage technique replaced oil paint, the cathode ray tube will replace the canvas." Witty, charming, and especially successful in collaboration, Paik was affiliated with Fluxus

22.13 Nam June Paik, *TV Bra for Living Sculpture* (worn by Charlotte Moorman), 1969. Television sets and cello.

for much of his career. He collaborated on several pieces with the classical cellist and performance artist Charlotte Moorman (1933–91). One of their pieces had the instrumentalist play the cello while wearing a bra made of two miniature TV sets, which took on a humanity by their association with one of the most intimate of personal garments (fig. **22.13**). When Paik and Moorman performed *Opera Sextronique* in New York in 1967, the cellist

removed all her clothing and was promptly arrested for, as the guilty verdict read, "an art which openly outrage[d] public decency." In contrast to his more provocative performance works, some of Paik's video installation pieces can be quite lyrical, even contemplative. In *TV Garden* (fig. **22.14**), the viewer is invited to stroll through a pastoral setting of potted plants, a garden decorated with television monitors. The glowing video images appear amid the foliage like blossoming flowers.

Nauman

Bruce Nauman (b. 1941) wittily made himself into a living pun on Duchamp's *Self-Portrait as a Fountain* (fig. **22.15**; see fig. 11.8). Over the years, his production has been an astonishingly diverse expression of his declaration: "I'm not interested in adding to the collection of things that are art, but [in] investigating the possibility of what art may be." Early in his career, Nauman created a number of films making use of all that the young artist had available: himself and his empty studio. The results, including *Walking in Contrapposto*, *Pacing Upside Down*, and *Slow Angle Walk*, the latter two filmed with the camera tipped and turned over, succinctly combine humor and art history with the uncanny. His sculptural work also fluctuates uneasily between levity and seriousness. Nauman has made works in neon, some of which blink on and off with disturbing imagery, such as before-and-after images of a hanged man. The familiarity and garishness of a flashing neon sign disarm the viewer, allowing the sinister content to make an especially strong impression once it is perceived. Nothing could more pointedly contrast with the austere, Minimal fluorescent light-fixture works of Dan Flavin (see fig. 20.36). Other of Nauman's neon signs, such as *Violins Violence Silence* (fig. **22.16**), depict only words and as such are related to Conceptual art. Asking the

22.14 Nam June Paik, *TV Garden*, 1974–78. Video monitors (number varies) and plants, dimensions variable. Installation view, Whitney Museum of American Art, New York, 1982.

22.15 Bruce Nauman, *Self-Portrait as a Fountain*, 1966–70. Color photograph, 19¾ × 23¾" (50.2 × 60.3 cm). Edition of eight.

22.16 Bruce Nauman, *Violins Violence Silence*, 1981–82. Neon tubing with clear glass tubing suspension frame, 62⅜ × 65⅜ × 6" (158 × 166.1 × 15.2 cm). Oliver-Hoffman Family Collection, Chicago.

viewer to read the neon lettering from either side, these signs juxtapose different words and flip them around, backward and forward, until their usual meanings are rendered confused and problematic; the letters become unfamiliar and operate more like collections of abstract shapes and bright colors. Unexpected relationships emerge, such as the odd similarity between "violence" and "violins."

Campus' Video Art

The ubiquity of television offered a rare combination of high-tech interest and utter banality. **Peter Campus**' (b. 1937) early video work included closed-circuit installations. Viewers approaching them, not realizing that they were on camera, would unexpectedly encounter projections of their own image: observers found themselves suddenly turned into performers. In such works, Campus explored how we come to see ourselves in unanticipated ways, not only physically but psychologically, and took as one of his main

themes the ever-shifting nature of the self-image. In the early 1970s he made a series of short videotapes, such as *Three Transitions* (fig. **22.17**), that pursue related ideas of transformation, usually focusing on himself as performer. Among other strange metamorphoses acted out on the tape, Campus applies make-up to his face, and the cosmetics appear to dissolve his features away. In another sequence he sets fire to a mirror reflecting his face; the mirror burns up, leaving a dark background. In such vignettes, the human face, the basis of our sense of identity, becomes little more than a changing mask that we can never see behind.

When Art Becomes Artist: Body Art

One form of performance, Body art, often induced a forced intimacy between the performer and the audience, with results that could be amusing, poetic, shocking, or discomfiting. Women artists were among those to contribute most profoundly to the development of Body art during the late 1960s and 70s. Feminism and the Women's Movement had exposed the cultural, political, and economic consequences of biology. Alternately confronting and embracing Freud's dictum that "biology is destiny," women artists looked to their own bodies for the most effective medium to express their desires, fears, and frustrations. Women were not, of course, the only ones to adopt their bodies as their media. Artists such as Vito Acconci and Chris Burden likewise contributed importantly to the development of Body art.

Schneemann and Wilke

Carolee Schneemann (b. 1939) and **Hannah Wilke** (1940–93) created some of the earliest and most affecting Body art pieces. In the 1960s, Schneemann's *Meat Joy*, a ritualistic, erotic romp between four men, four women, a serving maid, raw fish, chickens, paint, plastic, and sausages, drew on contemporary dance and Happenings to express something like the repressed unconscious of American Pop

22.17 Peter Campus, *Three Transitions*, 1973. Two-inch videotape in color with sound, five minutes.

and European abstraction. First performed in Paris in 1964, Schneemann's narrative and physical clutter challenged the directorial control exerted by Yves Klein in his *Anthropometries* (see chapter 19) and the classicism of her American peers. *Meat Joy* was about liberation, sensuality, and spirit rather than aesthetics.

By the 1970s, Schneemann's performances were focusing on the relationship between culture, meaning, and the female body. *Interior Scroll* (fig. **22.18**) is one of the most visceral performances of the decade. It included readings, the painting of a large figure, and concluded with Schneemann slowly unrolling a small scroll, which she had inserted in her vagina prior to the performance. As she unfurled the text she read it, telling the audience about a confrontation with a male filmmaker. The man told her that good art must avoid the graphic and personally revealing subject matter that interested her: "You are unable to appreciate the system of the grid," he exclaims. It is this ability to confound the aesthetic rules guiding the reception of contemporary art that continues to make work such as Schneemann's so challenging. With a sensitivity that avoids lapsing into simplistic opposition to masculinity, Schneemann gave serious thought to finding meaning in the experience of being a woman that was independent from male symbols. She explained, "I thought of the vagina in many ways—physically, conceptually: as a sculptural form, an architectural referent, the source of sacred knowledge, ecstasy, birth passage, transformation." From within her body, Schneemann described her life and challenged the codes of the art world.

Like Schneemann's, Hannah Wilke's performances reiterated her position as someone whose life is defined by playing the role of female artist. She took the portrait as the central document of her work, staging events for the camera as well as the audience. As she explained, even asleep she is posing. Unlike Schneemann, Wilke worked from within the expectations of society, casting herself as the beautiful woman posed to display her body and play the role of seductress. As she presented herself, she crafted the images so as to indicate the physical pleasure and the personal cost of such objectification. Concerned with "how to make yourself into a work of art instead of other people making you into something you might not approve of," Wilke encouraged viewers to enjoy the sensuality of the body—hers and theirs—but also to recognize that desire is not without cost.

A 1977 work *Intercourse with …* expresses the particular nature of Wilke's exposed body. The piece consisted of the artist striking poses as an answering machine played messages from her friends and family. The words shaped her body and defined her actions. She then undressed, and covering her body were the names of the speakers. The names were slowly removed, leaving her body without the protection of clothes or community. In *S.O.S. Starification*

22.18 Carolee Schneemann, *Interior Scroll*, 1975. Photographs of performance and scroll text, 48 × 72" (122 × 183 cm).

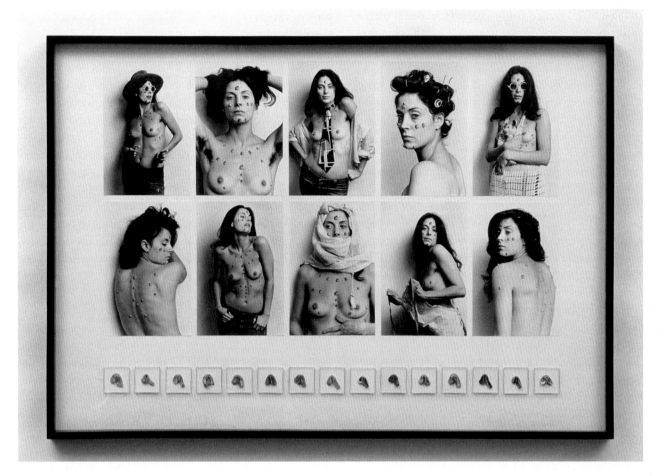

22.19 Hannah Wilke, *S.O.S. Starification Object Series*, 1974–82. Mixed media, 40½ × 58" (103 × 147 cm) framed.

Object Series (fig. **22.19**) she marked her body with signs of distress rather than care. The work consisted of an extended series of photographs that initially resemble fashion plates. Affixed to her body, however, were pieces of chewed gum folded to represent small vulvas. The gum sculptures disrupt the seductive quality of the pose and the photograph with external signs of what artists have referred to as "internal wounds." She intended the gum to suggest society's chewing up and spitting out, not only of women but also of minority ethnic groups.

Mendieta

The work of the Cuban-born artist **Ana Mendieta** (1948–85) centered on the drama of the body, treating female physiology as an emblem of nature's cycle of birth, decay, and rebirth. Her sculptural Process pieces evoke the aura of ancient fertility rituals. These works were often developed from the direct imprint of the body, as when Mendieta outlined her own silhouette on the ground in gunpowder and then sparked it off, burning her form into the soil. The resulting image was a way, the artist said, of "joining myself with nature." In a work for the *Fetish* series (fig. **22.20**), she created a mummy-shaped mound of mud

22.20 Ana Mendieta, *Untitled*, from *Fetish* series, 1977. Color photograph mounted on paperboard, 20 × 13¼" (50.8 × 33.7 cm). Whitney Museum of American Art, New York.

resembling a barely buried corpse and surrounded it with a shallow ditch, as if carrying out an archaic burial ceremony and returning the deceased to the earth. At the same time, the irrigation ditch and the small branches stuck into the figure's chest suggest that the body has been in a sense "planted" in the ground, to germinate and be resurrected in the spring.

Acconci

Body art was also exploited to tremendous effect by men, with similar questions about sexuality, intimacy, and power structures coming to the fore. In *Seedbed*, 1972, **Vito Acconci** (b. 1940) spent hours during each performance day masturbating beneath a gallerywide ramp, while visitors overhead heard via a loudspeaker the auditory results of his fantasizing. Here was the artist reintroducing into his work the element of personal risk that came from rendering himself vulnerable to the audience, as he engaged in an intensely personal activity and grappled with the potential audience alienation that such drastic strategies could produce.

Subsequently, Acconci made sculptural objects that can "perform" when activated by the viewer. The concerns reflected in these later works have become more political than psychological. His 1980 *Instant House* (figs. **22.21a**, **22.21b**) lies flat on the floor in its collapsed position. When the viewer sits on its swing, however, pulleys raise the house's walls, making a toy building that looks like a child's version of a military guardhouse. With the walls up, the viewer inside is surrounded by U.S. flags on the inner surfaces, while viewers outside see the red Soviet flag, with its hammer and sickle. In Acconci's ironic reduction of Cold War confrontation to the less intimidating proportions of a playground game, the underlying result was to point to the terrifyingly real implications of Cold War politics.

Burden

Some Body artists risked going beyond the by then expected, and accepted, shock factor in contemporary art into the realm of violent exhibitionism. **Chris Burden** (b. 1946) achieved international fame in 1971 with a performance in Los Angeles that consisted of having a friend shoot him in the arm: "In this instant, I was a sculpture." As was crucial to much of Conceptual art, the ephemeral performance was rendered permanent in photographic documentation. The straightforward factuality of the photographs, capturing critical moments in Burden's performance (fig. **22.22a**, **22.22b**, **22.22c**), makes the artist's ability to endure seem all the more harrowing.

Burden abandoned performance pieces involving extremes of physical endurance, taking up instead installations that, rather than enacting violence, sought to conceptualize it. He made *All the Submarines of the United States of America* (fig. **22.23**) during the centennial of the 1887 launching of the U.S. Navy's first submersible, the SS1. The work is made up of some 625 miniature models, representing each of the actual submarines launched by the navy during the ensuing hundred years, including its nuclear-missile-carrying Polaris submarines. The armada of tiny cardboard boats floats harmlessly in the gallery space, like a school of fish, but at the same time it enables the viewer to grasp a formidable reality—a fleet of warships capable of mass destruction. Shown just two years before the official end of the Cold War, Burden's piece speaks to the legacy of political engagement that has motivated much Conceptual art since the 1960s.

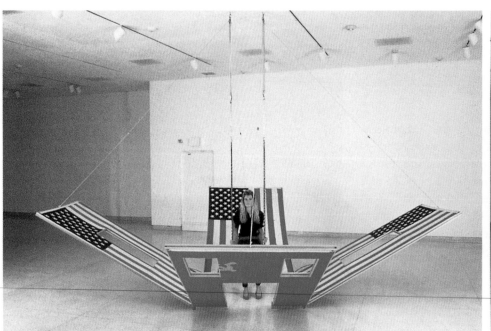
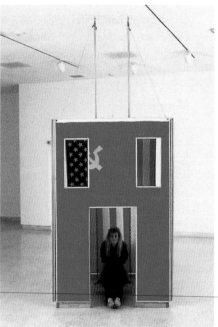

22.21a, 22.21b Vito Acconci, *Instant House*, 1980. Flags, wood, springs, ropes, and pulleys, open 8' × 21' × 21' (2.4 × 6.4 × 6.4 m), closed 8' × 5' × 5' (2.4 × 1.52 × 1.52 m). Museum of Contemporary Art, San Diego.

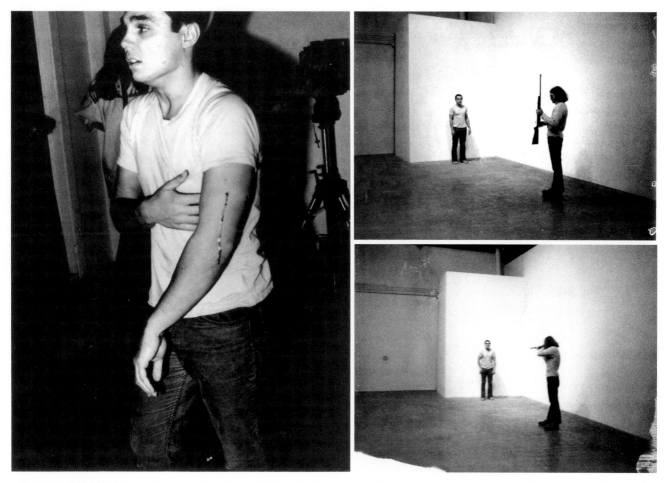

22.22a, **22.22b**, **22.22c** Chris Burden, *Shoot*, F Space, Santa Ana, California, November 19, 1971. The artist comments: "At 7:45 p.m. I was shot in the left arm by a friend. The bullet was a copper jacket .22 long rifle. My friend was standing about fifteen feet from me."

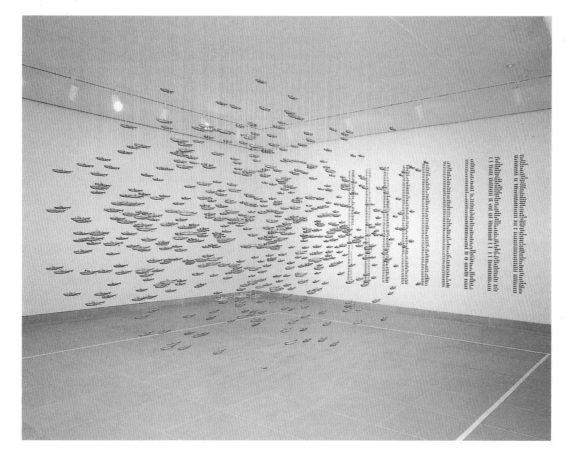

22.23 Chris Burden, *All the Submarines of the United States of America*, 1987. Installation with 625 miniature cardboard submarines, vinyl thread, typeface, 13' 2" × 18' × 12' (4 × 5.5 × 3.7 m), length of each submarine 8" (20.3 cm). Dallas Museum of Art.

Gilbert and George, Anderson, and Horn

In a lighthearted, though serious, response to the abstract and modernist tendencies of English sculpture of the 1960s still influenced by Moore, Hepworth, and Caro, a pair of London-based artists, Gilbert Proesch (b. 1943) and George Passmore (b. 1942), known simply as **Gilbert and George**, transformed themselves into "living sculpture" and brought to art and the world of the late 1960s a much-needed grace note of stylish good humor. Indeed, they would probably have been quite successful performing in an old-fashioned English music hall, which, like all the rest of their material, they simultaneously celebrated and parodied. For their performance *The Singing Sculpture* of 1971 (fig. **22.24**), they covered their faces and hands with metallic paint, adopted the most outrageously proper English clothing and hairstyles, placed themselves on a tabletop, and proceeded to move and mouth as if they were wound-up marionettes rendering the recorded words and music of the prewar song that gave the piece its subtitle.

A Performance artist who actually does appear in music halls and records with major record labels while successfully preserving her place in the world of contemporary art is **Laurie Anderson** (b. 1947). As a second-generation

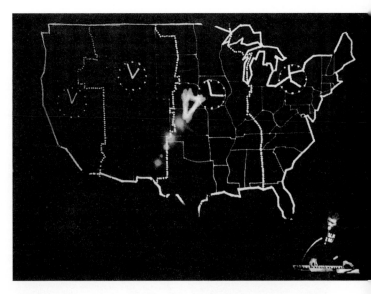

22.25 Laurie Anderson, *United States Part II*. Segment *"Let X = X,"* October 1980. Performance at the Orpheum Theater, New York, presented by the Kitchen.

Conceptualist and a child of the media age, Anderson proceeds from the intellectual rigor of her predecessors while wielding far more spectacular means of expressing it. For *United States Part II* (fig. **22.25**), a four-part epic composed and first presented over the years 1978–82, Anderson marshaled the full array of her accomplishments—drawing, sculpture, singing, composing, violin playing, electronic effects—to deal in half-hour segments with the themes of transportation, politics, sociopsychology, and money. Juxtaposing images and text, sound and technological inventions, she swept her audience through a series of ironical "talking songs." The journey turned into a joy ride, with such original devices as custom-made instruments, a slide show that magically came and went with the stroke of a neon violin bow, and red lips that suddenly floated in the dark. With humor, language, careful timing, style, and undeniable stage presence, Anderson has brought Conceptual art to a wide audience.

The German performance artist **Rebecca Horn** (b. 1944) has been active in creating sculpture, installations, and films. Horn explores the physical limits of the human body, which she often extends by using fantastic theatrical props, such as a mask of feathers, or gloves with yard-long fingers, or bizarre wing-like devices operated by the performer. The most ambitious of these props are conceived as machines, such as the mechanical sculpture *The Feathered Prison Fan* (fig. **22.26**), which appeared in Horn's first feature-length film, *Der Eintänzer* ("*The Gigolo*," 1978).

The film is set in a ballet studio. In one scene, the fan's two huge, rotating sets of ostrich plumes, one on either side, envelop a ballerina. Yet when the legs of the standing figure are exposed, the framework of feathers looks like a set of wings mounted on her seemingly headless torso, perhaps recalling the renowned Hellenistic sculpture the Nike or Winged Victory of Samothrace, or suggesting the feathered wings attached by the mythological master inventor

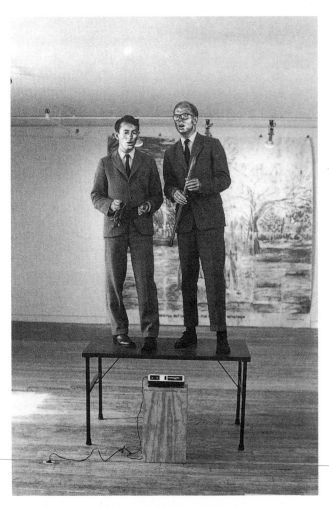

22.24 Gilbert and George, *The Singing Sculpture* (*"Underneath the Arches"*), 1969. Performance at the Sonnabend Gallery, New York, 1971.

22.26 Rebecca Horn, *The Feathered Prison Fan*, as it appears in the film *Der Eintänzer*, 1978. White ostrich feathers, metal, motor, and wood, 39⅜ × 32⅝ × 12⅝" (100 × 82.9 × 32.1 cm). Private collection.

22.27 Rebecca Horn, *Ostrich Egg Which Has Been Struck by Lightning*, 1995. Two brushes, ostrich egg, electric motor, 102 × 27½ × 12" (260 × 70 × 30 cm). Kunstmuseum, Bonn, Germany.

Daedalus to his son Icarus—that is to say, evoking figures capable of flight. And indeed elsewhere, as in *Ostrich Egg Which Has Been Struck by Lightning* (fig. **22.27**), the form of the egg calls to mind the most positive associations, symbolizing the artistic perfection sought by ballerinas as well as the formal absolutes of sculptors like Brancusi. The egg is placed between two soft brushes that move up and down but never come into contact with it; the spear-like forms threaten to pierce it and just barely miss. It is sensual and erotic and, at the same time, tantalizes viewers, whose expectations are titillated and then denied. Another influence is Max Ernst, whose Surrealist, masculinist fantasies are ironically evoked by Horn.

Radical Alternatives: Feminist Art

Conceptual art has always maintained a political and subversive vanguard. Among those most responsive to its political and social possibilities were those active in the feminist movements gaining ground in Europe and North America during the 1960s. As already discussed, feminist artists mobilized Body art for its ability to simultaneously challenge and assert sexual difference. Feminist artists also turned to other media, often choosing materials and techniques particularly associated with women's history or traditional domestic duties.

The Feminist Arts Program

Among the first organized efforts to produce a forthrightly feminist art was the Feminist Arts Program at California State University, Fresno. Founded by Miriam Schapiro (b. 1923) and **Judy Chicago** (b. Judy Cohen, 1939) in 1971, the program sought to address inequities in the

arts from an institutional position. Schapiro and Chicago's teaching redefined the creative process. Making art was not to be conceived as a private, introspective, mythic adventure. Instead, through public and private discourse, consciousness-raising sessions, personal confessions, and technical training, the program strove "to help women restructure their personalities to be more consistent with their desires to be artists and to help them build their art-making out of their experiences as women." The program moved to the California Institute of the Arts in 1972. There, faculty and students pursued the major artistic statement of the program, *Womanhouse*.

Womanhouse was one of the largest installations of the 1970s. Guests were invited into the traditional spaces of domestic femininity to discover that political analysis had replaced homemaking. A bride descended a staircase, her train getting dirty as she moved straight to the kitchen, itself decorated with brightly colored breasts that slid down into the frying pan to form two fried eggs. Here, earlier expositions on feminine domesticity and sexuality by artists like Duchamp and Magritte (see figs. 8.47,

15.24) are seized, transformed, and recontextualized to achieve feminist aims.

In another part of the house, a linen closet trapped a woman in a life defined, as one performance demonstrated, by an endless sheet endlessly ironed (fig. **22.28**). Perhaps the room most disturbing to audiences was the Menstruation Bathroom, which exposed the aspect of women's lives that is probably the most effectively hidden. In a white bathroom immaculately cleaned, a wastebasket sat under the sink overflowing with all the evidence of an impossibly heavy period. The excess of that small sculpture served as a metaphor for the explosive nature of the house itself. Performances, classes, consciousness-raising sessions, talks, readings, plays, and a documentary film about the project presented the often psychologically crippling pressures of being a middle-class woman in America. In doing so, *Womanhouse* provided ample evidence of the artistic potential of populations and subjects that had scarcely featured in art history textbooks and museums.

Womanhouse encouraged a generation of women artists to explore content and media marginalized in the art

22.28 Feminist Arts Program, *Womanhouse* (detail of linen closet) by Sandra Org, 1971. Mixed media.

22.29 Judy Chicago, *The Dinner Party*, 1974–79. White tile floor inscribed in gold with 999 women's names; triangular table with painted porcelain, sculpted porcelain plates, and needlework, each side 48' (14.6 m). Brooklyn Museum of Art.

world but central to many women's experiences. The most visible work to come out of this moment was Judy Chicago's *Dinner Party*, 1974–79 (fig. **22.29**). This elaborate celebration of women's history was executed, with intentional exaggeration, in such stereotypically feminine and decorative artistic media as needlework and china painting. The entire ensemble is organized as a triangle, a primor-dial symbol of womanhood as well as equality. Within its enclosed floor area are inscribed the names of 999 women in history and legend, from the ancient world to such modern figures as Isadora Duncan, Georgia O'Keeffe, and Frida Kahlo. Each side of the triangular table has thirteen place settings; in part this makes a wry comment on the Last Supper—an exclusively male dinner party of thirteen—and in part it acknowledges the number of witches in a coven. The thirty-nine settings pay tribute to thirty-nine notable women, and each name is placed on a runner embroidered in a style appropriate to its figure's historical era. In *The Dinner Party*'s most provocative gesture, the plates on the table display painted and sculpted motifs based on female genitalia. The dynamic designs of the plates transform the vagina into an energetic

counterpart to the ubiquitous phallic symbol. Such a reversal attracted criticism, first for essentializing and defining each woman by her anatomy, and secondly for visualizing female power as phallic energy in drag. The essentializing and binary nature of the work has made it as controversial as its politics and craft have made it central to the history of gender and the arts. In 2006, *The Dinner Party* was permanently installed in the Brooklyn Museum's Elizabeth A. Sackler Center for Feminist Art, confirming the work's central place in the expansion of artistic and institutional practices.

Erasing the Boundaries between Art and Life: Later Feminist Art

One of the lessons Miriam Schapiro took from her experience in the Feminist Arts Program was that "Merely to speak out, to describe the daily ways of your life, turns out to be political." Life was a performance, and its presentation was art and politics. By the late 1970s, feminists were shifting from descriptive projects to those examining how lifestyles are learned and knowledge is created.

Kelly

One of the most remarkable works of the period is **Mary Kelly**'s (b. 1941) *Post-Partum Document* (fig. **22.30**). American-born but at that time based in London, Kelly charted the early childhood development of her son in comparison to the psychological changes of herself as a new mother. Basing her work on the linguistic interpretation of Freud by the French psychoanalyst and writer Jacques Lacan, Kelly emphasized the role of language in identity formation, and the changes to the mother–child relationship as her son came to an understanding of his own selfhood and a command of language.

Post-Partum Document is a series of records: imprints of diaper stains, handprints, artwork, lists, medical and educational records, diagrams, and confessional notes. Some of the most striking pages record the boy's writing and the mother's interpretation on slates recalling both a schoolhouse chalkboard and the ancient Egyptian Rosetta Stone, and notes about her highly ambivalent attempts to provide day care, all displayed. The pages poignantly detail the incomplete translation of the son's acquisition of language and education into a sensible event for the mother. This is a moment when the relationship between mother and child begins to change. Significance for the child starts to be located out in the world, to be translated by him through language rather than given to him by the mother. Likewise, the role of the child as the primary bearer of meaning for the mother begins to fade in a confusing, often distressing manner. Kelly's striking foray into motherhood and psychology proposed content and form that combined Conceptual art, feminist politics, and psychoanalytic theory to examine aspects of female experience that were still taboo in the art world of the 1970s.

Guerrilla Girls

In 1985 a group of anonymous feminists who made public appearances disguised in gorilla masks began plastering streets and buses with advertisements that looked like public service announcements. The group, calling themselves the Guerrilla Girls (a pun on "gorilla" as well as a reference to their unorthodox tactics for consciousness raising), took on the mantle of the "conscience of the art world" and had grown frustrated at the small number of women represented in galleries, museums, and positions of power in that world. Though feminist activism in the 1970s had opened the door to such institutions, too few women had been allowed in. One early poster (fig. **22.31**) ironically listed the advantages to being a woman artist, beginning with "Working without the pressure of success." Another noted that the $17.7 million spent on a Jasper Johns work could have purchased one work each by sixty-seven major women artists, including Mary Cassatt, Frida Kahlo, Georgia O'Keeffe, and Artemisia Gentileschi. The Guerrilla Girls have co-opted a variety of forms of public address, including pasting posters around cities, renting space on billboards and buses, giving public lectures (in full ape attire), publishing an art history book, and operating a website (www.guerrillagirls.com).

FEBRUARY 28, 1974

08.30 HRS. 4½ OZS. SMA, 2 TSPS. CEREAL, 3 TSPS. EGG YOLK
10.20 HRS. 2 OZS. ORANGE
12.30 HRS. 7 OZS. SMA, 4 TSPS. CARROT, 6 TSPS. BEEF
14.30 HRS. 3 OZS. ORANGE
17.30 HRS. 7 OZS. SMA, 3 TSPS. CEREAL, 12 TSPS. APRICOT
20.00 HRS. 2½ OZS. RIBENA
21.00 HRS. 6 OZS. SMA

TOTAL: 34 OZS. LIQUIDS
30 TSPS. SOLIDS

2 8 FEB 1974 0 2

22.30 Mary Kelly, *Post-Partum Document: Documentation I Analysed fecal stains and feeding charts*, 1974. Perspex units, white card, diaper lining, plastic sheeting, paper, ink. Collection Art Gallery of Ontario.

THE ADVANTAGES OF BEING A WOMAN ARTIST:

Working without the pressure of success.
Not having to be in shows with men.
Having an escape from the art world in your 4 free-lance jobs.
Knowing your career might pick up after you're eighty.
Being reassured that whatever kind of art you make it will be labeled feminine.
Not being stuck in a tenured teaching position.
Seeing your ideas live on in the work of others.
Having the opportunity to choose between career and motherhood.
Not having to choke on those big cigars or paint in Italian suits.
Having more time to work when your mate dumps you for someone younger.
Being included in revised versions of art history.
Not having to undergo the embarrassment of being called a genius.
Getting your picture in the art magazines wearing a gorilla suit.

A PUBLIC SERVICE MESSAGE FROM **GUERRILLA GIRLS** CONSCIENCE OF THE ART WORLD
532 LaGUARDIA PLACE, #237• NY,NY 10012
www.guerrillagirls.com

Antoni

At first glance, *Gnaw* (fig. **22.32**), by **Janine Antoni** (b. 1964), appears to be a pair of Minimalist cubes slightly worn at the edges and emitting an odd organic smell; in fact one is made of fat and the other of chocolate. The degradation at the edges is the result of the artist gnawing at the sculptures, chewing off mouthfuls of lard and chocolate. In one performance, Antoni ate to the point of making herself vomit, summoning the specter of bulimia, one of the extreme measures taken by women to attain ideals of beauty largely manufactured by consumer culture. Antoni continued living with the two cubes until

22.32 Janine Antoni, *Gnaw*, 1992. 600 lb. cube of chocolate gnawed by the artist, 24 × 24 × 24" (61 × 61 × 61 cm). Collection of The Museum of Modern Art, New York.

22.33 Janine Antoni, *Lipstick Display*, detail, 1992. Lipstick made with pigment, beeswax, and chewed lard removed from *Lard Gnaw* and heart-shaped packaging tray for chocolates made from chewed chocolate removed from *Chocolate Gnaw*. Collection of The Museum of Modern Art, New York.

she had carved away enough material to reconstitute the masticated discharge into bright red lipstick and heart-shaped candy trays to be displayed in elegant mirrored cases worthy of any fine jewelers' (fig. **22.33**). Despite the complexity of the process and the installation, *Gnaw* is surprisingly succinct. Three familiar objects, lipstick, chocolates, and Minimalist cubes, are brought together through a performance that, although not seen by the viewer, is as physical and politically aware as those of Performance artist Carolee Schneemann and one that generates a feminist critique of art, fashion, and consumption—in every sense of the word.

Sylvie Fleury (b. 1961) produces work in which one is confronted with the commercial presumption that we are shaped by the things we buy—but leaving the viewer uncertain how to feel about it. Fleury has displayed the residue of shopping sprees, collections of designer shopping bags, shoes, and boxes. She has also created her own fashions including a series of Formula One dresses (fig. **22.34**) that

22.34 Sylvie Fleury, *Formula One Dress*, 1998.

turn the woman who wears them into the female equivalent of a corporate sponsored racing team. Using the adolescent and sexist comparison of a woman and a sports car, she creates a graphic illustration of a woman defined by social prejudices and commercial products. The woman who wears Fleury's dress is branded by the logos of global capitalism in a clear equation of fashion, sexism, capitalism, and sport. The irony, however, is that despite the clarity of Fleury's equation she seems to be having fun. She models the clothes with elan and continues to shop. Awareness of the forces of society does not lead to resistance as it might have even in the early 1980s. Rather, the artist seems to take the inevitable appeal of sex and commerce, whether at the racetrack or the mall, as a source of pleasure and even power.

The recent work of Antoni and Fleury is distinctly feminist, but few artists working today do not respond—either deliberately or unconsciously—to the influence of feminism on artistic practice and social conditions over the past four decades. The effects of gender—along with those of race, ethnicity, and even nationality—on the formation and reception of artworks are now acknowledged by most artists, many of whom have made these forces a central theme of their work.

Invisible to Visible: Art and Racial Politics

The visual arts were deployed by a number of artists to address issues of race that burst onto the political stage of postwar America with the Civil Rights Movement of the 1960s, which pressed for full civil and legal rights for black Americans. As often noted, the visual arts were slow to find a role in racial struggles. There was a feeling that art was a luxury to be indulged after more pressing political rights and economic goals had been achieved. As artists did incorporate their practice in the political movements, they gave a priority to communicating messages. While some artists, like Fred Wilson and Adrian Piper, adopted Conceptual practices, many drew from the figurative tradition in order to make plainly visible persons and ideas that had been rendered invisible by modern, Western society. Figurative art, with its historical role in political mural art and printmaking, provided a means of communication that could be manipulated while still maintaining maximum legibility.

OBAC, Afri-COBRA, and SPARC

One of the first major visual projects to address the issues of African-American experience was the *Wall of Respect* (fig. **22.35**) created in Chicago in 1967 by the Visual Arts Workshop of the Organization of Black American Culture (OBAC, pronounced o-BAH-cee to emphasize "oba," the Yoruba word for leader). OBAC was primarily a political and literary organ, but its experiment with the visual arts had an immediate and lasting effect. The *Wall* was a collaborative mural, created and conceived by artists and residents of the Southside neighborhood in which it was

22.35 OBAC (Organization of Black American Culture), *Wall of Respect*, 1967. Oil on brick, 30 × 60' (9.1 × 18.2 m). Chicago.

painted. Essentially a collection of portraits, the mural featured a cast of black political, artistic, and sporting heroes, including Malcolm X, Martin Luther King, Charlie Parker, Aretha Franklin, and Muhammad Ali. Upon completion, OBAC gave up all proprietary rights, deciding on principle that a mural in a community belonged to that community. The history of the Wall after that point is tragic. As it became a magnet for the news media seeking to document the creativity and blight of Chicago's Southside, it became a source of power. Local gangs competed for rights to the site and there was even a murder. The violence compelled the city of Chicago to demolish the mural and the building on which it was painted.

Despite the final debacle of the mural, the mission of the Visual Arts Workshop to use art to galvanize African-American communities continued. Several participants in the mural project, including Jeff Donaldson, Wadsworth Jarrell, Barbara Jones, and Carolyn Lawrence, formed Afri-COBRA, the African Commune of Bad Relevant Artists. Afri-COBRA provided a forum for discussing common aesthetic and political issues in the African and African-American experience. Determining that "Blackness

22.36 Wadsworth Jarrell, *Revolutionary*, 1971. Acrylic on canvas, 50½ × 63½" (128 × 161 cm).

contributed a specific quality to their visual expression," Afri-COBRA artists strove to articulate that quality. **Wadsworth Jarrell**'s (b. 1929) *Revolutionary* (fig. **22.36**) captures the group's aesthetic and philosophical principles. The image is a portrait of Angela Davis, philosopher and

Black Panther Party leader, at the time in hiding. She raises her fist into a field of text reading "Resist, Revolution, Black Nation time…." Afri-COBRA works aimed to be legibly programmatic on an individual and national level. Jarrell's figurative style uses brightly colored text—instructions, as it were—to build the figure of the revolutionary and contribute to the struggles of African peoples. The integration of text and image that Afri-COBRA called "mimesis at midpoint" was intended to join the objective and the non-objective, reality and revolution at a strategic point where the viewer was required to act: to read, see, and translate the image into the message. Using "Cool-Ade colors," "luminosity," and "shine," Afri-COBRA productions were designed to be easily reproducible, and images like Jarrell's were created in multiple screenprints to be widely circulated.

In Los Angeles in the mid-1970s, artist-activist **Judy Baca** (b. 1946) generated a political figurative art in the form of the world's longest mural, *Great Wall of Los Angeles* (fig. **22.37**), along one half-mile (0.8 km) of the Tujunga Wash drainage canal in the San Fernando Valley. Baca's project, begun in 1976 and initially finished in 1983 (it continued in a variety of formats into the 2000s), organized 450 local schoolchildren from diverse ethnic and racial backgrounds to paint the history of California from prehistory to the 1960s in a style reminiscent of the Mexican muralists of the 1930s (see chapter 16). Accompanying its creation, Baca also founded SPARC (the Social and Public Art Resource Center), a non-profit organization that "produces, distributes, preserves and documents community based public art works … that [reflect] the lives and concerns of America's diverse ethnic populations, women, working people, youth and the elderly." SPARC has since sponsored public mural projects throughout Los Angeles, creating images that respond to both local concerns and

22.37 Judy Baca, *Great Wall of Los Angeles*, 1976–83. Length one half-mile (0.8 km).

citywide issues, as well as portable works, an education and visual resource center, a website (www.sparcmurals.org), and interactive proposals for bringing the mural up to date. Baca has negotiated for funding from various branches of the city government to sponsor the conservation and continuation of the mural and related SPARC projects.

Ringgold and Folk Traditions

In the 1970s the New York-based artist **Faith Ringgold** (b. 1930) created two- and three-dimensional artworks presenting racially informed social analysis in forms that connected high art and folk traditions. Ringgold was committed to expressing the experiences of the African-American community, with particular attention to the experience of African-American women. In the 1960s she had painted flat figural compositions focusing on racial conflict in circumstances ranging from riots to cocktail parties. In the 1970s she began to draw on African and American folk traditions, crafting figural sculptures that she often made from beaded and painted fabrics to represent fictionalized slave stories and more contemporary

news accounts. Informed by a strong political conscience and sense of narrative complexity, her sculptural groups of weeping, speaking, shouting, and dying figures anticipated the painted story-quilts that have since become her signature works.

Ringgold began quilting as a means of "mixing art and ideas so that neither suffers" in a family tradition that extends to her great-grandmother, who had learned quilting as a slave. She began her first quilt, a collection of portraits called *Echoes of Harlem* (1980), with her mother Willi Posey. In 1983, a year after her mother's death, Ringgold created her first story-quilt, *Who's Afraid of Aunt Jemima?* (fig. 22.38), which told the story of Aunt Jemima, a matriarch restaurateur. The quilt and story weave together, describing the relations of the main character and her family as they compete with one another, meet and marry, and ultimately vie for the family business. Her characters are of different races and are compromised, sometimes morally upstanding, sometimes weak, always human. Ringgold has integrated quilts into performances and books, including several children's stories.

22.38 Faith Ringgold, *Who's Afraid of Aunt Jemima?* 1983. Printed and pieced fabric, 7' 6" × 6' 8" (2.29 × 2.03m).

Social and Political Critique: Hammons, Colescott

David Hammons (b. 1943) has used his art to present social and political issues in blunt terms. Among his first works were prints with intense and controversial content. His *Injustice Case* (fig. **22.39**) shows, in negative, a bound and gagged captive tied to a chair. The figure could be any political prisoner in the world, were the composition not framed by an American flag. The positive associations usually evoked by the flag are challenged, replaced by an implicit assertion that America does not offer "liberty and justice for all." The image also recalls the trial of Bobby Seale, accused as one of the original "Chicago 8" of conspiring to incite riots at the 1968 Democratic Convention. Unwilling to sit in silence during the trial, Seale was shackled and gagged during the proceedings by order of the presiding judge. The pose of the figure in Hammons' artwork is based on a widely circulated image of Seale executed by sketch artist Verna Sadock (photographers were not permitted to document the trial).

It seemed natural that Hammons would later turn to public sculpture, gaining a broader audience for his continuing critique of American icons. In *Higher Goals* (fig. **22.40**) he applied bottle caps by the hundreds to telephone poles. The patterns of shiny, repeated caps give this unlikely urban monument a sense of the energy of street life. But the work also implies concern for the well-being of the city's youth. At the tops of the telephone poles are another emblem of street life: basketball hoops, placed far higher than anyone could possibly reach. "It's an anti-basketball sculpture," Hammons comments. "Basketball has become a problem in the black community because the kids aren't getting an education. That's why it's called *Higher Goals*. It means that you should have higher goals in life than basketball." Hammons' installations have continued to challenge the politics of race in the U.S., as his works, especially his increasingly baroque basketball hoops, reach record prices. As an artist who began his career selling snowballs in a snowstorm, Hammons is now in the ironic position, rare among his peers from the 1970s, of creating cultural criticism in the form of art world commodities.

In 1997, when **Robert Colescott** (b. 1925) became the first African-American to represent the U.S. at the Venice Biennale, he joined David Hammons as an artist who had brought racial politics from the margins of the 1970s art world to the center in the 1990s. Colescott's career began with formal training at Berkeley and, from 1949 to 1950, in Paris under Fernand Léger. His breakthrough works,

22.39 David Hammons, *Injustice Case*, 1970.
Mixed-media print, 63 × 40½" (160 × 102.9 cm).
Los Angeles County Museum of Art.

22.40 David Hammons, *Higher Goals*, 1982.
Poles, basketball hoops, and bottle caps, height 40' (12.2 m).
Shown installed in Brooklyn, New York, 1986.

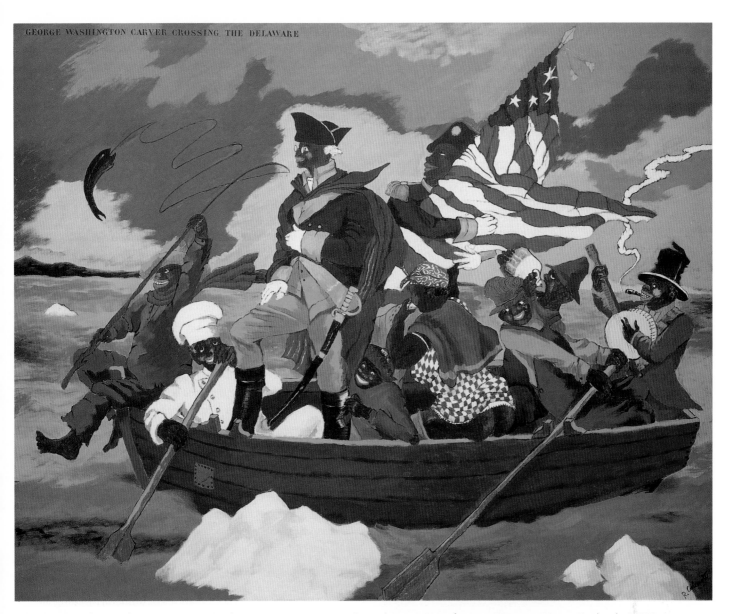

GEORGE WASHINGTON CARVER CROSSING THE DELAWARE

22.41 Robert Colescott, *George Washington Carver Crossing the Delaware: Page from an American History Textbook*, 1975. Acrylic on canvas, 4' 6" × 9' (1.37 × 2.74 m). Robert H. Orchard Collection, Cincinnati, Ohio.

done in the mid-1970s, drew on the European traditions in which Colescott had trained as a source for the satire of racial politics in history and art. *George Washington Carver Crossing the Delaware: Page from an American History Textbook* (fig. **22.41**) is an ironic reversal of the race of heroes depicted in Emanuel Leutze's (1816–68) 1851 *George Washington Crossing the Delaware* and a serious commentary on the relationship between race and history in America. Above the fray of drunken debauchery, depicted in the iconography of racist imagery, the sole figure of Carver stands, a token black admitted to history books.

Whether he is referring to Leutze's paintings or Van Gogh's, Colescott populates well-known masterpieces with "Aunt Jemimas" and other cultural stereotypes of black American identity. Even such figures as Carver cannot seem to enter into the Western canon without being

misrepresented. Colescott has commented on the role of racist images in his project of creating African-American figures: "Unfortunately stereotypical images are part of American heritage. I had to come to terms with it for myself, ultimately controlling the images by making them say some things for me." Colescott incorporated the free use of stereotypes in a painterly language that combines the abstracting impulse of Picasso with the cathartic stylistics of Expressionism. With striking emotional force, he transformed a range of Western representational approaches to depicting black bodies and lives. Like the descriptive projects of his feminist contemporaries, Colescott has made the exclusions of the past unavoidably apparent. In addition, his work is carefully attuned to the difference between the identity and the history of African-Americans: it is "not about race, [but] about perceptions," as he has explained.

Conceptualizing Race: Piper

Another artist to examine the disruptive lens of racism is **Adrian Piper** (b. 1948). Piper has explained that her art arises from a "compulsion to embody, transform, and use experiences as a woman of color in constructive ways, in order not to feel powerless." Drawing on her identity as a light-skinned black woman, and the insight into both black and white communities that this has provided, Piper's work examined the centrality of attitudes about race to the formation of personal and community identity in America. In her *Political Self-Portrait #2 [Race]* (fig. **22.42**), the text, an account of the prejudice she encountered while growing up, serves as a screen through which a divided image of the artist can be seen. The narrative of a life subjected to racial biases colors the view of the body. Like Colescott's use of stereotype, Piper's narrative of prejudice conveys the intrusions of language, particularly signifiers of race, on our perceptions of individuals and our creation of communities.

Piper's training and early work included Conceptual and Performance art as well as a doctorate in philosophy, which she continues to teach and practice. In the mid-1980s she brought together all three in *Calling Cards* (1986–90), a series of small note cards revealing the artist's identity as a woman of African descent. *Card #1 A Reactive Guerrilla Performance for Dinners and Cocktail Parties* was devised as a strategy for minimizing confrontation when she was compelled to challenge someone's racist behavior. Rather than staging a verbal and public confrontation, she handed the offender a card that begins, "Dear Friend, I am black. I am sure you did not realize this when you made/laughed at/agreed with that racist remark." And ends, "I regret any discomfort my presence is causing you, just as I am sure you regret the discomfort your racism is causing me." The passing out of the cards, when necessary, was followed by public sessions in which the action was explained and discussed. In the most successful Calling Card discussions, the defensive hostility initially felt by the largely white audience gave way to an uncomfortable contact upon hearing how devastating the "performance" was for the artist. Unlike more popular proclamations of humanity joining all races, Piper's work joined blacks and whites in a difficult social interaction based on awkward and painful regret. The performance takes up the Fluxus dictum that the world is art enough and informs it with the political attitude that the world must be transformed.

Conceptualism's unhesitating pursuit of political aims as a central part of artistic practice would shift decisively the outlook of artists coming of age in the final decades of the twentieth century. Even those artists who continued to see the fabrication of objects as central to their conception of artmaking would draw from Conceptualism's awareness of ideology and its influence on the production and reception of artworks.

22.42 Adrian Piper, *Political Self-Portrait #2 [Race]*, 1978. Photostat, 24 × 16" (61 × 40.6 cm). Collection Richard Sandor.

23
Post-Minimalism

Even as Conceptualism gained momentum during the 1970s, many artists still felt drawn to the expressive force of material objects. Giving physical embodiment to an idea, an emotion, or an experience remained essential to the practice of many young artists. Some even continued to negotiate the possibilities and problems raised by Minimalism. Not always content to restrict their aesthetic explorations to purely formal concerns, artists who came of age during the socially turbulent 1960s generally believed that artmaking could not be divorced from political or economic issues. In this way, most Post-Minimalists—as the artists whose work can be seen as a direct response to Minimalism were known—shared the social conscience of their Conceptualist contemporaries.

Post-Minimalism does not denote a single style. The term functions along the lines of Post-Impressionism, describing diverse artworks united by virtue of their makers' responsiveness to a previous movement. By the 1970s, some artists believed that Minimalism had thoroughly exhausted whatever formal and theoretical questions it

sought to address. This attitude was summarized in 1979 by New York critic John Perreault: "Presently we need more than silent cubes, blank canvases, and gleaming white walls. We are sick to death of cold plazas, and monotonous 'curtain wall' skyscrapers ... [as well as] interiors that are more like empty meat lockers than rooms to live in." Artists who shared Perreault's impatience adopted a variety of strategies to counter the cool, absolute abstraction of Minimalism, with some reviving the marginalized tradition of figurative art and others working to dismantle Minimalism through radical reformulations of abstraction.

Probably the most dramatic—and prophetic—announcement of an incipient rebellion against the earlier movement came from one of the artists most closely associated with it. **Frank Stella** (b. 1936) experimented in the 1970s with three-dimensional painted relief that confounded traditional designations of "painting" versus "sculpture" (fig. **23.1**). This project gave way in the mid-1980s to large, explosively dynamic wall pieces and sculptures that seem to disavow emphatically the cool restraint of his Minimalist

23.1 Frank Stella, Exhibition, 1971. Lawrence Rubin Gallery, New York.

23.2 Frank Stella, *The Pequod Meets the Jeroboam: Her Story, Moby Dick Deckle Edges*, 1993. Lithograph, etching, aquatint, relief, and mezzotint, 70 × 65¼" (177.8 × 165.7 cm). Printed and published by Tyler Graphics Ltd.

works (fig. **23.2**). If Stella's later art no longer retains obvious visual affinities with 1960s Minimalism, it nevertheless reflects the legacy of the shift in critical discourse marked by that movement as artists began to think as much about the spatial and psychological effects of their work as their form.

Process art was one approach taken by artists who, like Stella, retained an interest in the expressive possibilities of abstraction even as they abandoned Minimalism's pursuit of absolute formal clarity. Process art, as the term suggests, focused as much on the means and duration of production as on the final work. Related to Process art were "scatter works," consisting of raw materials dispersed over the gallery floor, a manifestation that opposed formalism with formlessness; and Earthworks, for which artists abandoned the studio and gallery world altogether and operated in open nature, to create art whose relationship to a particular site was an inseparable part of its existence.

Not all progressive artists abandoned the discipline of Minimalism. Many relished the movement's circumscription of formal problems, cherishing the clarity that could be derived from a practice demanding total submission to materials, the dictates of space, and the achievement of *Gestalt*. Minimalist sculptors like Donald Judd, Carl Andre,

and, especially, Richard Serra continued to produce important work, exerting a strong influence on young artists. Among those to expand most dramatically the limits of Minimalism's investigation of the observer's relationship to space and form were artists associated with site-specific and the Earthworks or Land art movements. Even some of the original Minimalists began to pursue allied concerns as these movements gained ground in the late 1960s.

Big Outdoors: Earthworks and Land Art

By the late 1960s, artists responding as much to the dramatic scale and physical impact of Minimalism as to Conceptualist experiments with erasing the bounds between art and life began to act on the idea of taking art out of both gallery and society and fixing it within far-off, uninhabited nature as huge, immobile, often permanent Land- or Earthworks. Insofar as pieces of this environmental character and scale were often not available to the general public, it was largely through documentation that they became known—which made such informational artifacts as photographs, maps, and drawings all the more important. Ironically, the documents often assumed a somewhat

surprising fine-art pictorial quality, especially when presented in a conventional gallery setting. Then again, while Land artists may have escaped the ubiquitous marketing system of traditional art objects, they became heavily dependent on engineers, construction crews, earth-moving equipment, and even aerial-survey planes, the field equivalent of the factory-bound industrial procedures used by Minimalists, with all the high finance that that entailed.

The possibility of taking art into the wilderness nevertheless held great meaning at the time. Just as Performance appeared to reintroduce an element of sacred ritual and mystery into a highly secularized modern society, Earth art seemed to formalize the revived interest in salvaging not only the environment but also what remained of such archeological wonders as Stonehenge, Angkor Wat,

and pre-Columbian burial mounds. The back-to-the-soil impulse may have first appeared in the post-studio works of Carl Andre, Robert Morris, and Richard Serra, who began to democratize sculpture by adopting the most commonplace materials—firebricks, logs, metal squares, styrofoam, rusted nails—and merely scattering them over the floor or assembling them on it. In Earth and Site works, the variables of selection and process inherent in the site took precedence over materials.

Site works—and other pieces considered site-specific—derive much if not all of their meaning from their placement. To relocate a site-specific artwork is often tantamount to destroying it. This focus on place is, of course, integral to much Land art. In its dialogue with natural forms and phenomena, Land art chimed with the burgeoning ecology movement of the late twentieth century, which called for more sustained and serious attention to be directed toward the dislocating effects of human intervention on the natural environment (see *Environmentalism*, left).

Monumental Works

One of the first to make the momentous move from gallery to wilderness was the California-born artist **Michael Heizer** (b. 1944), who, with the backing of art dealer Virginia Dwan and the aid of bulldozers, excavated a Nevada site to create the Earthwork *Double Negative* (fig. **23.3**). In the Nevada desert Heizer found what he called "that kind

23.3 Michael Heizer, *Double Negative*, 1969–70. 240,000-ton displacement in rhyolite and sandstone, 1,500 × 50 × 30' (457.2 × 15.2 × 9.1 m). Mormon Mesa, Overton, Nevada. The Museum of Contemporary Art, Los Angeles.

of unraped, peaceful religious space artists have always tried to put in their work." For *Double Negative*, Heizer and his construction team sliced into the surface of Mormon Mesa and made two cuts to a depth of fifty feet (15.2 m), the cuts facing one another across a deep indentation to create a site 1,500 feet (457.2 m) long and about fifty feet (15.2 m) wide. But at the heart of this work resides a void, with the result that, while providing an experience of great vastness, *Double Negative* does not so much displace space as enclose it. Here the viewer is inside and surrounded by the work, instead of outside and in confrontation with it.

For *Canceled Crop* (fig. **23.4**), a work created in 1969 at Finsterwolde, the Netherlands, **Dennis Oppenheim** (b. 1938) plowed an "X" with 825-foot (251.5 m) arms into a 709 by 422-foot (216 × 129 m) wheatfield. As if to comment on the binding artist-gallery-art cycle, Oppenheim said of his Dutch piece: "Planting and cultivating my own material is like mining one's own pigment. … I can direct the later stages of development at will. In this case the material is planted and cultivated for the sole purpose of withholding it from a product-oriented

system." In a work like this, Oppenheim emphasized the overridingly significant elements of time and experience in Conceptual art.

When the American artist **Walter de Maria** (b. 1935) initially felt the telluric pull, he responded by transporting earth directly into a Munich gallery. Once installed, *Munich Earth Room*, 1968, consisted of 1,766 cubic feet (50 cubic meters) of rich, aromatic topsoil spread some two feet (0.6 m) deep throughout the gallery space. At the same time that this moist, brown-black rug kept patrons at a definite physical remove, it also provided a light–dark, textural contrast with the gleaming white walls of the gallery and filled the air with a fresh, country fragrance, both of these purely sensuous or aesthetic experiences. Eventually De Maria would expand the boundaries of his site to embrace vast tracts of fallow land and the entire sky above.

In *Lightning Field* (fig. **23.5**) De Maria combined the pictorialness and ephemeral character of European Land art with the sublimity of scale and conception typical of American Earthworks. Here the natural force incited by the work is lightning, drawn by 400 stainless-steel rods standing over twenty feet (6 m) tall and arranged as a one-mile-by-one-kilometer grid set in a flat, New Mexican basin ringed by distant mountains. Chosen not only for its magnificent, almost limitless vistas and exceptionally sparse human population, but also for its frequent incidence of atmospheric electricity, the site offered the artist a prime opportunity to create a work that would involve both earth and sky, yet intrude upon neither, by articulating their trackless expanse with deliberately induced discharges of lightning. Few have ever been eyewitnesses to *Lightning Field* in full performance, but the photographic documentation

23.4 Dennis Oppenheim, *Canceled Crop*, 1969. Grain field, 709 × 422' (216 × 129 m). Finsterwolde, the Netherlands.

23.5 Walter de Maria, *Lightning Field*, 1970–77. A permanent Earth sculpture: 400 stainless-steel poles, with solid stainless-steel pointed tips, arranged in a rectangular grid array (sixteen poles wide by twenty-five poles long) spaced 220' (67.1 m) apart; pole tips form an even plane, average pole height 20' 7" (6.3 m); work must be seen over a twenty-four-hour period. Near Quemado, New Mexico.

23.6 Robert Smithson, *Chalk–Mirror Displacement*, 1969. Sixteen mirrors and chalk, approx. 10" (25.4 cm) in diameter. Art Institute of Chicago. Through prior gift of Mr. and Mrs. Edward Morris, 1987.277.

leaves little doubt about the sublime, albeit unpredictable, unrepeatable, and fugitive effects produced by a work designed to celebrate the power and visual splendor of an awesome natural phenomenon.

In 1968, the same year that De Maria created his *Munich Earth Room*, **Robert Smithson** (1938–73) relocated shards of sandstone from New Jersey to a New York City gallery and there piled them in a mirror-lined corner. In such gallery installations, including *Chalk–Mirror Displacement* (fig. **23.6**) of the following year, Smithson utilized strategically positioned mirrors to endow the amorphous mass of organic shards with a new form. Smithson's non-site works (that is, works made in a formal, gallery setting rather than out in the landscape) were a synthesis of unformed organic material from the landscape and such rigid, manufactured forms as mirrors. The juxtaposition of these materials represented the dialectic between entropy—the gradual degradation of matter and energy in the universe—and order. And just as the transferral from nature to gallery would seem to have arrested the natural process of continuous erosion and excerpted a tiny portion from an immense, universal whole, the mirrored gallery setting expanded the portion illusionistically, while also affirming its actual, and therefore infinite, potential for change in character and context. Fully aware of the multiple and contrary effects of his mirror pieces—of the dialectic set up between site and non-site—Smithson commented on these works' power as a metaphor for flux: "One's mind and the earth are in a constant state of erosion … ideas decompose into stones of unknowing."

Smithson moved from gallery installations back to site works and discovered a major inspiration in Utah's Great Salt Lake, which the artist saw as "an impassive faint violet sheet held captive in a stony matrix, upon which the sun poured down its crushing light." As this lyric phrase would suggest, the artist was a gifted and even prolific writer (see "*Cultural Confinement*," below), whose essays about his Great Salt Lake creation have made *Spiral Jetty*

SOURCE

Robert Smithson
from "Cultural Confinement," originally published in *Artforum* (1972)

Cultural confinement takes place when a curator imposes his own limits on an art exhibition, rather than asking an artist to set his limits. Artists are expected to fit into fraudulent categories. Some artists imagine they've got a hold on this apparatus, which in fact has got a hold of them. As a result, they end up supporting a cultural prison that is out of their control. Artists themselves are not confined, but their output is. Museums, like asylums and jails, have wards and cells—in other words, neutral rooms called "galleries." A work of art when placed in a gallery loses its charge, and becomes a portable object or surface disengaged from the outside world. A vacant white room with lights is still a submission to the neutral. Works of art seen in such spaces seem to be going through a kind of esthetic convalescence. They are looked upon as so many inanimate invalids, waiting for critics to pronounce them curable or incurable. The function of the warden-curator is to separate art from the rest of society. Next comes integration. Once the work of art is totally neutralized, ineffective, abstracted, safe, and politically lobotomized it is ready to be consumed by society. All is reduced to visual fodder and transportable merchandise. Innovations are allowed only if they support this kind of confinement.

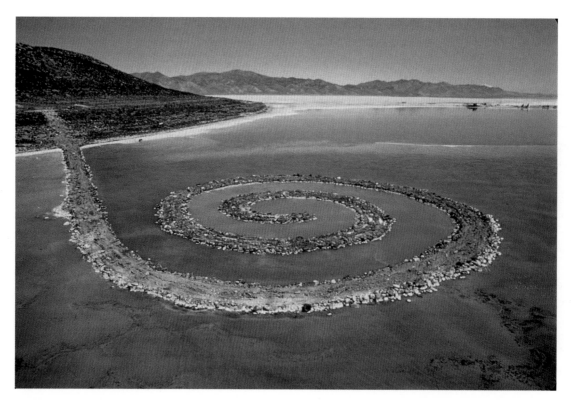

23.7 Robert Smithson, *Spiral Jetty*, 1969–70. Black rock, salt crystal, and earth, diameter 160' (48.8 m), coil length 1,500' (457.2 m), width 15' (4.6 m). Great Salt Lake, Utah.

the most famous and romantic of all the Earthworks (fig. **23.7**). He deposited 6,000 tons (6,096 tonnes) of earth into the lake, forming an enormous raised spiral. With its graceful curl and extraordinary coloration—pink, blue, and brown-black—the piece rewards the viewer with endless aesthetic delight, but the form, for all its purity, arose from Smithson's deep pondering of the site, combined with his fascination with entropy and the possibilities of reclamation.

At this particular point on the shore of the Great Salt Lake, Smithson found not only industrial ruin, in the form of wreckage left behind by oil prospectors, but also a landscape wasted and corroded by its own inner dynamism. As he wrote, the gyre does not expand into a widening circle but winds inward; it is "matter collapsing into the lake mirrored in the shape of a spiral." Prophetic words, for in the ensuing years *Spiral Jetty* has disappeared—and reappeared—periodically amidst the changing water levels of the Great Salt Lake. The films and photographs that document the piece now provide the only reliable access to it. Tragically, Smithson died in a plane crash during an aerial inspection of a site in Texas.

On a less monumental scale than her husband Robert Smithson's late projects, **Nancy Holt**'s (b. 1938) Land art involves site-specific architectural sculptures that are absolutely integral with their surroundings. Holt's involvement with photography and camera optics led her to make monumental forms that are literally seeing devices, fixed points for tracking the positions of the earth, the sun, and the stars. One of her most important works is *Stone Enclosure: Rock Rings* (fig. **23.8**), designed for and built

as a permanent outdoor installation on the campus of Western Washington University at Bellingham, Washington. It consists of two concentric rings formed of stone walls two feet (0.6 m) thick and ten feet (3 m) high. The inner wall defines a tubular space at the center and the outer one an annular space in the corridor running between the two rings; the smaller ring measures twenty feet (6.1 m) in diameter and the larger one forty feet (12.2 m). Piercing the walls are eight-foot (2.4 m) arches and twelve circular holes three feet four inches (1 m) in diameter. Together

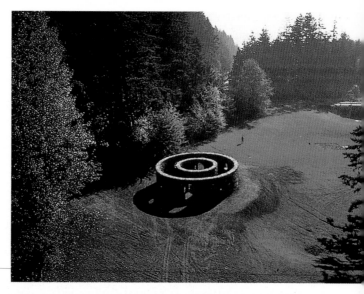

23.8 Nancy Holt, *Stone Enclosure: Rock Rings*, 1977–78. Brown Mountain stone, diameter of outer ring 40' (12.2 m), diameter of inner ring 20' (6.1 m), height of ring walls 10' (3 m). Western Washington University, Bellingham, Washington.

these apertures give the spectator both physical and visual access into and even through a structure whose circular presence and carefully calculated perspectives evoke Stonehenge, the prehistoric monument in Wiltshire, England, apparently constructed, at least in part, as a device for marking the solar year.

Landscape as Experience

In England, with its long history of the interrelationship of art and the natural environment in painting, poetry, and landscape gardening, a number of artists contemporary with Heizer and Smithson also looked to landscape as a means of creating art outside the market system. But these artists were confronted with very different issues—limited funds and a more intimate landscape that was densely populated, heavily industrialized, rigorously organized, and carefully protected. In response to these challenges, they chose to treat nature with a featherlight touch and, in contrast to the more interventionist Americans, to work on a decidedly anti-heroic scale.

In contrast to Holt, the American **Mary Miss** (b. 1944) builds deliberately fragile architectural sculptures as a means of stressing the ephemerality of experience. Common to both artists, however, is a preoccupation with time as it affects the perception of space, as well as a determination to create a viable public art by making the viewer more than a neutral receptor. In the publicly funded *Field Rotation* (fig. **23.9**), sited at Governors State University in Park Forest South, Illinois, Miss took her primary inspiration from the terrain, an immense, flat field with a gently curved mound at the center. To explore this space and unleash its potential for yielding both a personal and shared expression of cultural experience, Miss used lines of posts to pattern the field as a kind of giant pinwheel. Its spokes or arms radiate outward from, while also converging toward, a "garden"

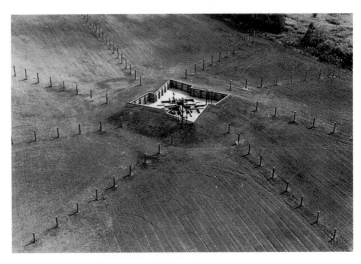

23.9 Mary Miss, *Field Rotation*, 1981. Steel, wood, and gravel, central structure 56' (17.1 m) square, depth 7' (2.1 m), sited on 4½ acres (1.8 hectares). Governors State University, Park Forest South, Illinois.

sunk within the central hub or mound. In it, there is a pit shaped like a fortress and built up inside as a reticulated, cross-timbered lookout rising above a "secret" well filled with water. At the same time that the posts and their fan-like movement articulate the vast openness of the American landscape, the sunken garden, which these paths lead both toward and away from, provides sanctuary and retreat from the surrounding barrenness.

Richard Long (b. 1945) "intervenes" in the countryside mainly by walking through it, and indeed he has made walking his own highly economical means of transforming land into art. Along the way he expresses his ideas about time, movement, and place by making marks on the earth, by plucking blossoms from a field of daisies, or by rearranging stones, sticks, seaweed, or other natural phenomena (fig. **23.10**). With these he effects simple, basic shapes:

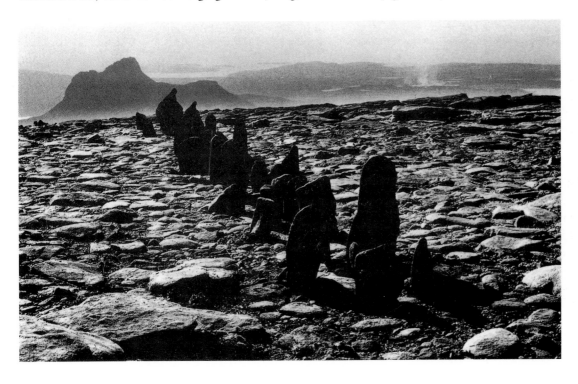

23.10 Richard Long, *A Line in Scotland*, 1981. Framed work consisting of photography and text, 34½ × 49" (87.6 × 124.5 cm). Private collection, London.

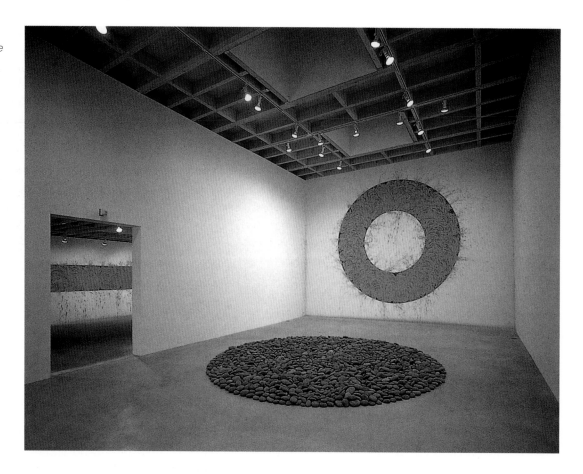

23.11 Richard Long, *Ocean Stone Circle*, 1990. Stones, diameter 13' (3.96 m).

straight lines, circles, spirals, zigzags, crosses, and squares that he documents with photographs. A token of human intelligence is thus left on the site—like the stone markers put in place by prehistoric peoples—and is then abandoned to the weather. "A walk is just one more layer," Long asserts, "a mark laid upon the thousands of other layers of human and geographic history on the surface of the land." Then, in a reversal of this practice, these landmarks can also be gathered up and displayed in a museum setting

23.12 Andy Goldsworthy, *Storm King Wall*, 1997–98. Field stone, approx. 5' × 2,278'6" (1.52 × 694.5 m) overall. Storm King Art Center sculpture park, Mountainville, New York.

(fig. **23.11**), as were Smithson's gallery installations. When the stones are arranged indoors, a token of the natural world is introduced into the human-made environment of buildings and communities. The walk through nature, which Long has now extended to a global enterprise, is completed as the walker returns home from the gallery.

The sculptures of British artist **Andy Goldsworthy** (b. 1956), site-specific installations of materials as transitory as ice and as lasting as stone, poetically acknowledge the role of humanity in the shaping of nature, yet respond to our desires for the restorative otherness of the natural world. Goldsworthy draws from the details of the local environment—stone walls in New England or sheepfolds in Cumbria—to bring the viewer into a relationship with the environment. In locations from Southern France to South Australia, Goldsworthy has assembled stone cairns, monumental variations on traditional trail markers, joining the history of exploration to the organic elegance of Brancusi or Arp (figs. 6.34, 15.2). Though often romantic in his reminders of our smallness within the sweeping vistas of nature, Goldsworthy consistently forces our attention to the landscape as a site of interaction between humanity and the environment.

Goldsworthy's *Storm King Wall* (1997–98) (fig. **23.12**), a site-specific installation for the Storm King Art Center sculpture park in Mountainville, New York, combines the themes of travel and integration of self and environment by transforming a fixture in the New England countryside, the old stone wall, into an anthropomorphic reminder of a walk in the woods. Built from local stones, the wall rises

up from the ground, winds around trees, dips into a lake, climbs out and continues to a nearby road. Stone walls of the region are physical evidence of the transformation of the American wilderness into a political landscape. In Goldsworthy's work this sign of power and possession becomes the expression of a journey that moves into and beyond our notions of private property.

Alice Aycock (b. 1946) too is less interested in building durable monuments than in siting and structuring her sculptures to induce us to move and thus intensify our experience of the environment, the work, and ourselves. But in a manner all her own, Aycock is concerned with the psychological implications of the architectural sites she creates for the sake of re-embracing nature. On a site she chose in Far Hills, New Jersey, Aycock built *A Simple Network of Underground Wells and Tunnels* (fig. **23.13**), a structure, as the title would suggest, hardly visible at eye level, but filled with implications for the spectator courageous enough to enter it. To realize the work, Aycock began by marking off a twenty-eight-by-fifty-foot (8.5 × 15.2 m) site with straight rows of cement blocks. Within this precinct she then excavated a twenty-by-forty-foot (6.1 × 12.2 m) area and installed two sets of three seven-foot-deep (2.1 m) wells connected by tunnels. After capping three of the shafts, the artist lowered ladders into two of the uncapped ones, thereby inviting the observer to descend and explore an underground labyrinth of dark, dank passages. Aycock uses Minimalism's cool, structuralist vocabulary but in distinctively novel, even surreal ways, the better to evoke such structural precedents as caves, catacombs, dungeons, or beehive tombs and to make them the expressive agents of her own work.

In celebrating the natural environment, **Alan Sonfist** (b. 1946) has sought to recreate a sense of an earlier, unspoiled time. Sonfist was born in the South Bronx, in

23.13 Alice Aycock, *A Simple Network of Underground Wells and Tunnels*, 1975. Concrete-block wells and tunnels underground, demarcated by a wall, 28 × 50' (8.5 × 15.2 m), area 20 × 40' (6.1 × 12.2 m). Marriewold West, Far Hills, New Jersey.

New York City, but happened to live near one of the area's few remaining wooded stretches. The compelling experience of seeing the vestiges of nature amid the gritty streets is reflected in his 1978 outdoor mural, *An American Forest*, at Tremont Avenue in the Bronx. The painting's marked contrast with the deteriorating buildings around it created a sharp sense of how different the American Eden had been before the land was settled and the cities built. In another, more Conceptual work, Sonfist put up memorial cardboard plaques at sites around the city where particular indigenous flora and fauna had long ago been displaced by sidewalks and office buildings. Some of his other work has a more international scope but still generally refers to an earlier, unspoiled state of nature. *Circles of Time* (fig. **23.14**), created for the city of Florence, is a circular

23.14 Alan Sonfist, *Circles of Time*, 1986–89. Bronze, rock, plants, and trees on three acres (1.2 hectares). Created in Florence, Italy.

23.15 Michael Singer, *First Gate Ritual* series, 1979. Bamboo and phragmites. DeWeese Park, Dayton, Ohio.

garden that allows the viewer to trace what Sonfist calls "the history of vegetation" in Tuscany. Like the rings of a tree trunk, each successive concentric circle of this work, from the center to the outer rim, represents a later era. In the center is the virgin forest, a time before human intervention. Farther out lies a band representing the herb gardens of the ancient Etruscans. Next are bronze casts of endangered or extinct trees, then a ring of laurels, referring

to the influence of Greece on Italy. A band of stones then demonstrates a historical Tuscan style of street pavement, and the present-day agriculture of the modern region is memorialized at the edges.

Like many sculptors during the early 1970s, **Michael Singer** (b. 1945) first worked in natural environments with the materials and shifting conditions they offered (fig. **23.15**). This took him from sites such as the beaver bogs near Marlboro, Vermont, to the saltwater marshes of Long Island, New York. Instead of imposing a preset idea on these sites in the manner of the Earth artists, however, he allowed nature and its laws to act on him and his work. In the mid-1970s, Singer returned to the studio and began making indoor pieces, confident that he could now maintain an aesthetic distance from such dominant trends as Minimalism and Conceptualism. By the 1980s, the resulting art had grown in complexity and poetic content, yet it preserved the essential qualities that Singer achieved almost from the start. Formally, his works contained rough stones and beams of diverse shapes assembled on the ground or on doors in self-contained, though visibly accessible, structures held in serene balance—a balance so delicate and precarious that it seems redolent of the mystery emanating from altars and ritual gates.

James Turrell (b. 1943) was associated at the beginning of his career with the Californian Robert Irwin (see fig. 20.38), founder of what is usually called light and space art. But Turrell's installations, to a greater degree than Irwin's, explore the mysteries of how we actually perceive light, the basis of all visual experience. Specifically, Turrell manipulates our perception of light in order to reveal our understanding of the space before us, and the way we see things within it, as fundamentally a kind of optical illusion. For example, in the early light sculpture *Afrum-Proto* (fig. **23.16**), he projected an intense beam of halogen light to form what appeared to be a three-dimensional, material object floating in the empty air. Turrell's most ambitious effort has been the site work called the *Roden Crater Project* (fig. **23.17**), begun in 1974 and still in progress. By moving hundreds of thousands of cubic yards of earth and slightly reshaping the bowl of this extinct volcano, he is enhancing its ability to create optical effects, transforming it into a vast "viewing space." Far from city lights, visitors look up from the bottom of the crater; they witness with remarkable clarity the subtle yet extraordinary phenomena

23.16 James Turrell, *Afrum-Proto*, 1967. Quartz-halogen projection.

23.17 James Turrell, Aerial view of *Roden Crater Project*, 1982. Cinder cone volcano, approx. height 540' (164.6 m), diameter 800' (243.8 m). Sedona, Arizona.

produced by changing atmospheric conditions in the clear Arizona sky. At times, the firmament over their heads can appear to solidify into an opaque disk that seems to rest on the rim of the crater. Under other conditions, the sky opens up as an illuminated dome of infinite depth, becoming what Turrell calls "celestial vaulting."

Abakanowicz's Site-Specific Sculpture

Unlike most sculptors interested in the nature of particular sites, the Polish artist **Magdalena Abakanowicz** (b. 1930) has focused on the human form. Her serial groups of figures owe some of their effectiveness to their complex surface textures, which give them each a certain organic, living quality, comparable to that of skin, as well as an individual identity. In the mid-1970s, Abakanowicz planned a series of seated figures cast from plaster molds, one mold for the front and one for the back, but wound up making only frontal figures. A few years later she decided to use the back

parts of the molds which had been set aside. The result was the sculptural ensemble called *Backs* (fig. **23.18**). Here, vulnerable-looking hunched-over forms, headless and with only remnants of arms and legs, gather in a crowd. The group produces an unsettling effect when installed at any site, whether landscape or museum. Outdoors, it may recall knots of dispirited refugees resting by the side of the road, a not uncommon sight in Central Europe during the artist's lifetime. When shown in the confines of a gallery, the *Backs* become patient captives put on display, turned away from the museum visitors who have come to look.

23.18 Magdalena Abakanowicz, *Backs*, 1976–80. Burlap and resin, eighty pieces, each approx. 25¾ × 21¾ × 23¾" (65.4 × 55.2 × 60.3 cm). Installed near Calgary, Canada, 1982. Collection Museum of Modern Art, Pusan, South Korea.

23.19 Magdalena Abakanowicz, *Zadra*, from the cycle *War Games*, 1987. Wood, steel, iron, and burlap, 4' 3" × 3' 3" × 27' 4¾" (1.3 m × 1 × 8.4 m). Hess Collection, Napa, California.

A sense of vulnerability is also evident in *Zadra* (fig. **23.19**), from the artist's cycle *War Games*. Working with huge tree trunks that foresters had cut down and left behind, Abakanowicz attacked the wood with an ax and chainsaw, hacking it into forms redolent of military aggression, such as cannon or projectile shapes. Yet she treated others of the dismembered trees as if they were war's helpless victims and compassionately bandaged them with burlap. (The bandage idea may owe something to the red-marked sackcloth collages made after World War II by Alberto Burri—see fig. 18.36—who had been a doctor.) In this way, concerns related to the body were made manifest through natural materials from a particular site.

Visible Statements: Monuments and Public Sculpture

The environmental impulse struck a deep, resonant chord in the consciousness of artists and patrons alike, and it continued to reverberate even as the trend developed away from interventionist procedures toward sculptural or architectural forms made independently of, but in relation to, the chosen site. Inevitably, public sculpture has produced conflicts, especially since much of it has been created under public commission or within the public domain, a situation that seems automatically to require that art strike some tenable balance between its own need for internal coherence and the needs of the immediate surroundings. At issue has been the degree of accommodation necessary between the essentially private, enigmatic character of modern art and the expectation that art placed in the public arena be accessible—that is, expressive and meaningful—to the public at large. A dramatic precedent for daring, monumental sculpture in an outdoor public setting had been provided by the aged **Picasso**'s (1881–1973) nearly sixty-six-foot-high (20 m) Chicago Civic Center sculpture of 1966 (fig. **23.20**). That huge work's conspicuous location and popular acceptance did much to certify the validity of urban site works, as well as provide encouragement to young artists. But if site sculpture represented a return to a variant of the very "aesthetic object" that Conceptualism had set out to eliminate from art, the actual objects now produced by environmentally minded artists nonetheless remained relatively free of a purist formal modernism.

Monumental sculptures spread across the American urban landscape, thanks largely to the United States General Services Administration's Art-in-Architecture program, which required one-half of one percent of the cost of constructing a new federal building to be allocated for the installation of artworks designed to enhance the new

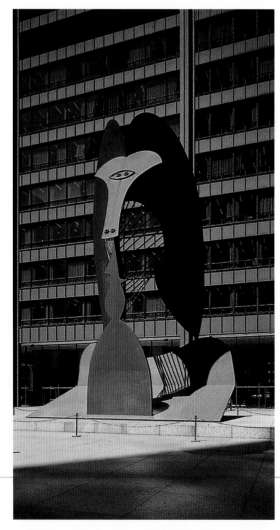

23.20 Pablo Picasso, *Chicago Monument*, 1966. Welded steel, height 65' 9" (20 m). Civic Center, Chicago.

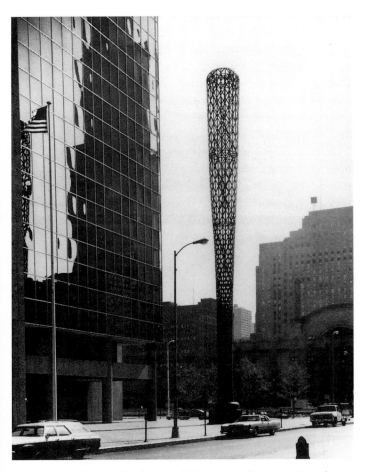

23.21 Claes Oldenburg and Coosje van Bruggen, *Batcolumn*, 1977. Welded steel bars painted gray, height 100' (30.5 m). United States Social Security Administration, Chicago.

structure and its site. One of the most successful of the federally sponsored public monuments is **Claes Oldenburg** (b. 1929) and **Coosje van Bruggen**'s (b. 1942) *Batcolumn* (fig. **23.21**). This large-scale project, as the collaborators prefer to call their monumental outdoor work, is a hundred-foot-tall (30.5 m) openwork, diamond-grid steel shaft erected in 1977 directly in front of the new Social Security Administration center in a former slum near the west end of Chicago's Loop. Oldenburg and Van Bruggen settled on the baseball-bat shape for the city of Chicago, an image evoking the many heroic columns in the city's older Beaux Arts architecture, the soaring towers of the skyscraper architecture Chicago invented, the countless smokestacks celebrated by Carl Sandburg, and the game played and cheered with such passion on Wrigley Field and Comisky Park. *Batcolumn* also makes a wry comment on art, specifically recalling Brancusi's *Endless Column* (see fig. 6.36) and Gabo's 1956–57 construction for the Bijenkorf department store in Rotterdam (see fig. 14.22). By recasting such a banal form on a monumental scale, the artists brought to fruition something of Oldenburg's earlier visionary "proposals" for revitalizing the urban world with familiar objects fantastically enlarged—immense baked potatoes, lipsticks, bananas, and Good Humor bars (see fig. 19.44). In the mid-1980s, the pair realized *Spoonbridge and Cherry* (fig. **23.22**) for the sculpture garden of the Walker Art Center in Minneapolis: an enormous aluminum spoon gracefully spans a pool of water, while a red cherry, serving as a counterpoint to the spoon's curve, spurts water from its stem in summer.

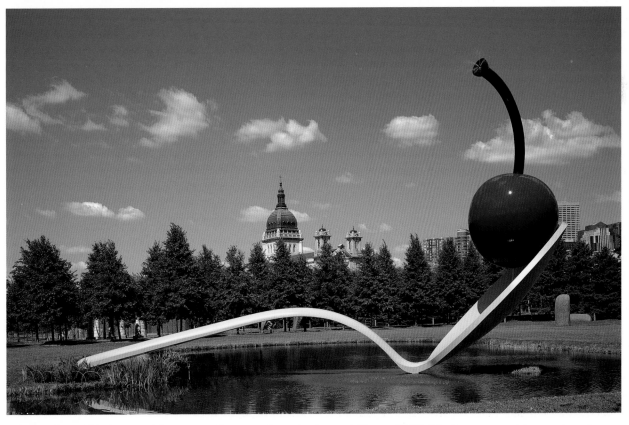

23.22 Claes Oldenburg and Coosje van Bruggen, *Spoonbridge and Cherry*, 1985–88. Aluminum, stainless steel, and paint, 29' 6" × 51' 6" × 13' 6" (9 × 15.7 × 4.1 m). Walker Art Center, Minneapolis.

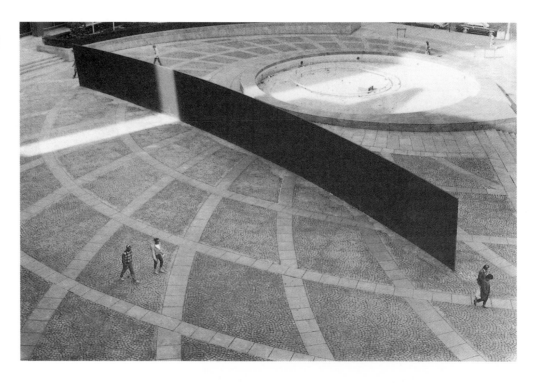

23.23 Richard Serra, *Tilted Arc*, 1981. Hot-rolled steel, height 12' (3.7 m), length 120' (36.6 m). Formerly at Federal Plaza, Foley Square, New York; removed in 1989.

The GSA program also commissioned the controversial *Tilted Arc* (fig. **23.23**) by **Richard Serra** (b. 1939), a 120-foot-long (36.6 m), twelve-foot-tall (3.7 m), seventy-two-ton (73 tonne) slab of unadorned curved and tilted steel for the federal building complex (Federal Plaza) in New York's Foley Square. Installed in 1981, the work was removed in 1989 in response to the demand of local civil servants, who objected to its imposing size and industrial-seeming character. It was called a "hideous hulk of rusty scrap metal" and an "iron curtain" barrier not only to passage across the plaza but also to other activities that once took place there, such as jazz concerts, rallies, and simple lunchtime socializing. The removal occurred in the face of heavy opposition mounted by the professional art community, which supported the artist in his contention that to relocate a piece he deemed utterly site-specific would be to destroy it, and that such action would constitute a breach of the moral, as well as legal, agreement the government made to maintain the work permanently as the artist conceived it.

During the heated public debate, little attention was given to the more positive, even lyrical, qualities of *Tilted Arc* as a physical object. For example, it could be argued that this surprisingly graceful sculptural "wall," with its elegantly leaning curvature, actually shielded the viewer from the barren vistas of Foley Square, at the same time helping to reshape what had surely been among the bleakest public plazas in New York City. And the worst insult hurled at the sculpture—"rusty scrap metal"—in fact pointed to one of its most distinctive characteristics, a feature related to Process art: a close examination showed that the steel's oxidizing surface was becoming more richly textured and complex as it aged and weathered (see *Minimalist Materials: Cor-Ten Steel*, chapter 20). By the time it was dismantled, *Tilted Arc* had begun to look like a homage to the expansive, dappled surfaces of late Monet—a kind of industrial *Water Lilies*.

In contrast to the dispute over Serra's *Tilted Arc*, few monuments created for urban sites have achieved such enthusiastic public acceptance as **Maya Ying Lin**'s (b. 1960) Vietnam Veterans Memorial (fig. **23.24**), commissioned in 1981. Since its completion, the memorial has been so highly acclaimed that it is difficult to remember how controversial the proposal originally was. In a competition to create a monument that would pay tribute to the 58,000 Americans killed in the Vietnam War and that would harmonize with its surroundings on the Mall in Washington, Lin daringly proposed two simple walls of polished black granite that would meet at an angle, an idea that at first seemed too abstract for some of the interested parties. Several veterans' groups wanted to add a realistic sculpture of soldiers at the apex of the structure, which would have drastically compromised the original concept; the figure sculpture was eventually added, but at a sufficient distance to allow both artworks to retain their individual integrity. In its finished state, the memorial's reflective black surface shows visitors their own faces as they search among the names of the casualties inscribed on the wall, an emotionally compelling effect that many have compared to an encounter between the living and the dead. In addition, visitors have the option of making pencil rubbings of the names of their loved ones.

The notion of site-specificity has assumed a compelling literalness in the work of British artist **Rachel Whiteread** (b. 1963). Her approach involves making direct casts of objects using materials as different as plaster, rubber, resin, plastic, and concrete. The resulting sculptures reveal the form of the negative space around objects as small and prosaic as bathtubs and mattresses and as large as a house itself. Evoking the geometric abstraction of both funereal

23.24 Maya Ying Lin, Vietnam Veterans Memorial, 1982. Black granite, length 500' (152.4 m). The Mall, Washington, D.C.

sculpture and Minimalist art, Whiteread's work, she says, "has to do with the way our culture treats death; other cultures celebrate it and we try to brush it under the carpet."

After several years of preparation, which included taking detailed measurements and estimates of equipment and materials, she created *Ghost* in 1990, a cast of the interior walls of a sitting room. Done in square panels of plaster, the sheets were assembled to become the positive form of the negative space of the room. Moldings and a mantelpiece forced shallow recessions into the form, while the fireplace left a slow spill of plaster. The structure conveys a palpable sense of loss and suggests a tomb, both in its size and in its emotional resonance.

In 1993, Whiteread was commissioned to create *House* (fig. **23.25**), the casting of the interior of an entire home in London's East End. Created from sprayed concrete,

23.25 Rachel Whiteread, *House*, 1993, destroyed 1994. Concrete. Commissioned by Artangel.

23.26 Rachel Whiteread, *Nameless Library*, 2000. Cast concrete, 30' × 23' × 12' 6" (10 × 7 × 3.8 m). Judenplatz, Vienna, Austria.

House stood in a low-income neighborhood that was being gentrified. Trading Victorian flourishes for concrete geometry produced an aggressive analogy for the demographic changes occurring in London. An aesthetically intrusive commentary on urban planning, *House* spurred immediate controversy. Though conceived as a temporary monument, plans for postponing its removal were stymied because of the uproar.

In 1996, Whiteread won the competition to design Vienna's first public monument to victims of the Holocaust. Like Lin, she provoked a maelstrom of controversy when her plans for *Nameless Library*—a concrete representation of the interior of a library, showing rows of shelves supporting books whose spines, and, hence, titles, cannot be seen because the cast books face away from the viewer—prompted many to fear that the monument would be too cold, ugly, and anonymous. Further delays were prompted by the discovery of the ruins of a medieval synagogue beneath the *Judenplatz* (Jewish Square) where Whiteread's monument was to stand. The site of a mass suicide by dozens of Jews during a brutal repression by the Catholic Church in the fifteenth century, the synagogue was seen by many to carry greater import than the new monument. Suggestions that Whiteread's memorial be built at a different site prompted the artist to explain that "I designed the memorial for Judenplatz and if it is to be moved elsewhere a new competition has to be launched." Eventually, a plan for Whiteread's monument to share the square with the remains of the synagogue was devised, and *Nameless Library* (fig. **23.26**) was revealed in 2000 to general acclaim, with most of its original critics persuaded of its success once in the presence of the piece. Whiteread's choice of books as a metaphor for Jewish culture and loss summons the idea of Jews as the "people of the book," the Jewish veneration of the Torah, and Israel's historic gift of books to libraries in remembrance of Holocaust victims. Yet the *Nameless Library* remains impenetrable, forever entombed with only traces of the lost volumes visible, along with an inscription at the base of the sculpture noting the names of the concentration camps where 65,000 Viennese Jews were systematically murdered by the Nazis.

Metaphors for Life: Process Art

Process art countered the timelessness and structural stability of Minimal art with impermanence and variability. Like the Earthworks and Land artist Robert Smithson, artists interested in Process took entropy as an all-important criterion in their choice of materials and allowed the transformative effects of time to become their principal means. The Process artist's action concludes once he or she has selected the substance of the piece—ice, grass, soil, felt, snow, sawdust, even cornflakes—and has "sited" it, usually in a random way, by scattering, piling, draping, or smearing. The rest is left to natural forces—time in tandem with gravity, temperature, atmosphere, and so forth—which suggests that now, in an art where creation and placement are an integral part of the same process, means, in the truest sense of the word, have become ends. Thus, as literal as Process art may be, it also constitutes a powerful metaphor for the life process itself.

The prolific and protean artist **Robert Morris** (b. 1931) subverted his own Minimalist sculptures (see fig. 20.50) by reinterpreting their Minimalist aesthetic in a heavy, charcoal-gray fabric that immediately collapses into shapelessness,

however precisely or geometrically it may be cut (fig. **23.27**). Soon Morris would be working with such insubstantial and transient materials as steam. He also countered the absolute, concrete clarity and order of his Minimal works with "scatter pieces," actually installations of what appear to be scraps left over from the industrial manufacture of metal as well as felt squares, cubes, cylinders, spheres, and grids. The order within this apparent disorder resulted from a "continuity of details," like that discernible in Pollock's allover gestural painting—an art unified by the generalized, holistic continuum of its endlessly repeated drips and dribbles.

German-born **Eva Hesse** (1936–70), who died at the young age of thirty-four, saw Process, especially as evidenced in such unconventional, malleable materials as latex, rubber tubing, and fiberglass, as a way of subjecting Minimalist codes—serial order, modular repetition, anonymity—to a broader, less exclusive range of human values than those inherent in cerebral, male-prescribed grandeur and monumentality. The cool distance and industrial aesthetic of much Minimalist sculpture is provocatively countered by Hesse's 1968 sculpture *Accession II* (fig. **23.28**). One of a series, this cube offers a more intimate, welcoming scale than Tony Smith's *Die*. As the viewer approaches the piece, its smoothly patterned sides begin to reveal their hand-crafted, time-consuming fabrication:

23.27 Robert Morris, *Untitled*, 1967–68. Felt, size variable. Installation view, 1968, Leo Castelli Gallery, New York. Private collection, New York.

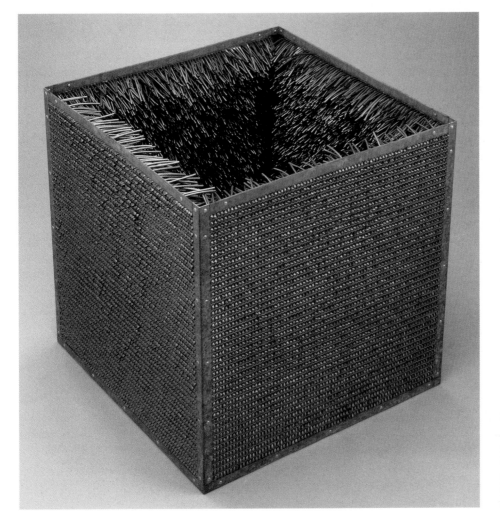

23.28 Eva Hesse, *Accession II*, 1968, galvanized steel vinyl, 30¾ × 30¾ × 30¾" (78.1 × 78.1 × 78.1 cm). Detroit Institute of Arts. Founders Society Purchase, Friends of Modern Art Fund, and Miscellaneous Gifts Fund, 1979.

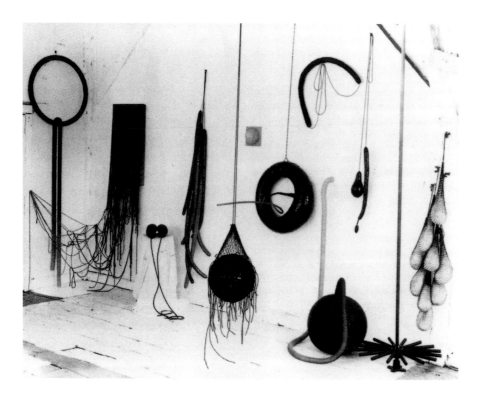

23.29 Photograph of Eva Hesse's Bowery studio in New York, 1966. Left to right: *Untitled*, 1965; *Ennead*, 1966; *Ingeminate*, 1965; *Several*, 1965; *Vertiginous Detour*, 1966; *Total Zero*, 1966; *Untitled*, 1966; *Long Life*, 1965; *Untitled*, 1966; *Untitled*, 1965; *Untitled or Not Yet*, 1966.

each of the panels is made of perforated steel through which Hesse has looped short lengths of rubber tubing. Thus the exterior of the cube is rendered smooth by the hundreds of rubber "stitches" on the surface. The top of the cube is uncovered, allowing the viewer to peer inside and see the ends of the tubing that forest the interior of the sculpture like cilia, endowing the cube with an organic sensibility. The rubber tubing conveys a soft, yielding quality, though its evenly cut ends maintain sharp edges, reminiscent of teeth, which transform the piece into a great maw or even the *vagina dentata* that so preoccupied the Surrealists (see chapter 15).

Taking memory, sexuality, self-awareness, intuition, and humor as her inspiration, Hesse allowed forms to emerge from the interaction of the processes inherent in her materials and such natural forces as gravity (fig. **23.29**). Thus, her pieces stretch from ceiling to floor, are suspended from pole to pole, sag and nod toward the floor, or hang against the wall. The works seem like dream objects, materializations of things remembered from the remote past, some even evoking the cobwebs that cling to old possessions long shut away in attics and basements. The pendulous, organic shapes of her sculptures provoke associations with gestation, growth, and sexuality, the kind of emotionally loaded themes that orthodox Minimalists cast aside.

The late piece called *Contingent* (fig. **23.30**), consisting of eight free-floating sections of cheesecloth covered with latex and fiberglass, takes the characteristic Minimalist concern with repeatable, serial objects and "humanizes" it.

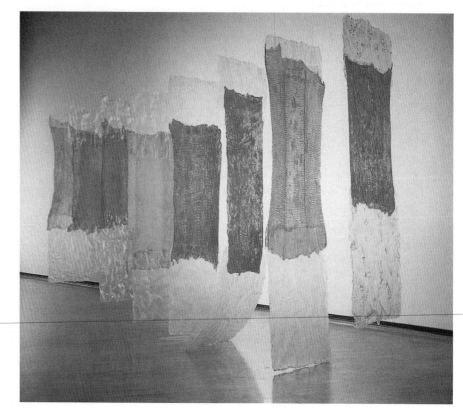

23.30 Eva Hesse, *Contingent*, 1969. Cheesecloth, latex, and fiberglass in eight panels. Installation, 12' ⅞" × 9' 4⅜" × 3' 2½" (3.7 × 2.9 × 0.98 m). National Gallery of Australia, Canberra.

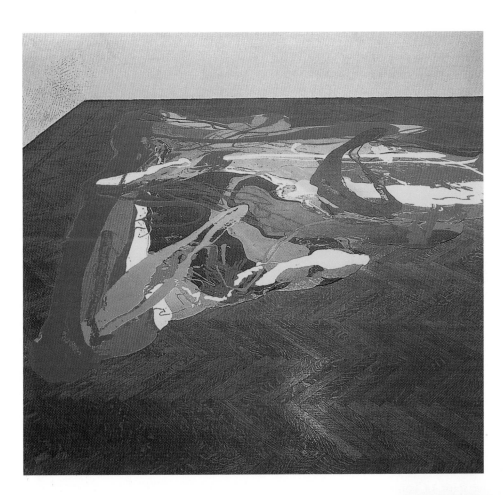

23.31 Lynda Benglis, *Bounce*, 1969. Poured colored latex, size variable. Private collection.

23.32 Lynda Benglis, *Excess*, 1971. Purified beeswax, dammar resin, pigments on Masonite and wood, 36 × 5 × 4" (91.4 × 12.7 × 10.2 cm). Walker Art Center, Minneapolis.

The luminous, translucent sheets function as both paintings and sculpture. Each of the hangings is allowed to become a distinct entity with its own texture and color, and each is suspended at a slightly different height; by these means, each one is given its own way of addressing the viewer who stands before it.

In the late 1960s, **Lynda Benglis** (b. 1941) became fascinated by the interrelationships of painting and sculpture and used Process as a route not only to new form but also to new content. She began to explore these issues by pouring liquid substances onto the floor, just as a sculptor might pour molten bronze (fig. **23.31**). But instead of shaping it with a mold, she allowed the material to seek its own form. The artist simply mixed and puddled into the flow a startling array of fluorescent oranges, chartreuses, Day-Glo pinks, greens, and blues.

A process of a different, more organic kind gave rise to the relief *Excess* (fig. **23.32**). Here the use of beeswax suggests an association between the making of the work and the natural process of bees building up a honeycomb. The relief, too, was built up over time, growing bit by bit as the artist applied the pigmented wax medium. The resulting form also displays unmistakable links with organic life: its incrustations recall the furrowed underside of some immense caterpillar. In subsequent works, the artist has pursued pictorial effects in wall reliefs with strong plastic, sculptural qualities. Often they have fan or bow-knotted shapes and are finished with some sumptuously decorative materials, such as gold leaf or a patina of rich verdigris.

Although he came to prominence among ambitious Minimalist sculptors, many of whom have created powerful works in steel and stone, **Richard Tuttle** (b. 1941) dared to give viewers what Bruce Nauman, an admirer of his work, called "a less important thing to look at." Working throughout his career with delicate and ephemeral materials, such as paper, string, and thin pieces of wire, Tuttle has been singled out for his work's unassertiveness, as when, for example, dyed pieces of cloth in geometric shapes are simply attached to the wall of a gallery.

When introduced into a specific venue, such works do not aggressively transform their surroundings, as do the more imposing sculptural works of some of Tuttle's peers. Instead, with their subtle nuances of texture and color, his modest constructions awaken a feeling for the sheer vulnerability of the domestic items around us, a sense of needing protection that can extend to ourselves as well. One critic has called his work a "meditation on the extreme fragility of existence." Tuttle gains our sympathy for these frail, decorative pieces (fig. **23.33**) by endowing them with much visual life: a finely gauged interplay of primary colors, the skillful intermixing of geometric with organic forms, and an elegantly balanced yet lively composition.

The Washington-based artist **Sam Gilliam** (b. 1933) fused painting and sculpture by flinging highly liquefied color onto stretched canvas, somewhat in the fashion of Jackson Pollock, though less in the spirit of controlled accident. He then suspended the support, minus its stretchers, from the ceiling (fig. **23.34**). Thus draped and

23.33 Richard Tuttle, *Monkey's Recovery for a Darkened Room (Bluebird)*, 1983. Wood, wire, acrylic, paint, mat board, string, and cloth, 36 × 22 × 6½" (91.4 × 55.9 × 16.5 cm). Private collection.

23.34 Sam Gilliam, *Carousel Form II*, 1969. Acrylic on canvas, 10' × 6' 3" (3 × 1.9 m). Installation view, Corcoran Gallery of Art, Washington, D.C. Collection the artist.

23.35a, **23.35b** Dieter Roth, Two screenprints from *Six Piccadillies*, 1969–70. Portfolio of six screen prints on board, each 19¾ × 27½" (50.2 × 69.9 cm).

swagged, the material ceased to do what would traditionally be expected of painted canvas and became a free-form, plastic evocation.

Associated for a time with the Fluxus group, German-born **Dieter Roth** (1930–98) lived in Switzerland, Iceland, Spain, and England. Roth became known for using food and other organic materials in unusual ways. In 1970 he had an exhibition of forty pieces of luggage, each filled with a different variety of cheese; during the show, the cheeses rotted and the suitcases leaked, attracting hordes of flies. As Roth said of another work of his made with foodstuffs, "Sour milk is like landscape, ever changing. Works of art should be like that—they should change like man himself, grow old and die."

While living in London, Roth became a friend of the British Pop artist Richard Hamilton (see fig. 19.19). This association informs *Six Piccadillies* (figs. **23.35a**, **23.35b**),

a portfolio of six prints based on a postcard view of Piccadilly Circus. In this instance, Roth explored a different kind of process—the technical act of making a reproductive print, which involves separating the colors of the original image into the four basic colors—cyan, magenta, yellow, and black—used for commercial printing, creating plates to hold the inks, and reworking the image through a series of press proofs. By these means, Roth produced a series of variations on the postcard image, letting it "decompose" itself through the printed medium.

Following a long tradition in Western civilization that can be traced from Plato through Cézanne to the Minimalists, Canadian-born **Jackie Winsor** (b. 1941) visualizes perfection in what the 1960s had learned to call Primary forms—simple squares, cubes, cylinders, spheres, and grids. Although her works do not, once finished, evince the process of their own making, that process is quite significant. It involves prolonged, ritualistically repetitive activity and materials chosen for their power to endow ideal geometry with a mysteriously contradictory sense of latent, primitive energy. In a 1971–72 work entitled *Bound Grid* (fig. **23.36**) that kind of energy was evident in the tension between a boldly simple grid form, made of crossed logs, and the slow, complex technique employed to lash them together. This entailed unraveling massive old ropes, returning them to their primary state as twine, and wrapping the crinkled, hairy strands round and round, for several days a week over months on end.

23.36 Jackie Winsor, *Bound Grid*, 1971–72. Wood and hemp, 7' × 7' × 8" (2.1 × 2.1 × 0.2 m). Fonds National d'Art Contemporain, Paris.

23.37a, **23.37b** Jackie Winsor, *Exploded Piece*, 1980–82. Wood, reinforced concrete, plaster, gold leaf, pigment, steel, and explosive residue, 34½ × 34½ × 34½" (87.6 × 87.6 × 87.6 cm). Private collection.

In 1980–82, Winsor set about activating energy in another, more startlingly dramatic manner. First she built a multilayered interior of plaster, gold leaf, and fluorescent pigment contained within a cube made of hand-buffed, black concrete reinforced with welded steel. After bringing the piece to the requisite degree of perfection, Winsor added a further element—dynamite—and exploded it (fig. **23.37a**). Later she gathered up the fragments, reinforced the interior, and restructured the outer layer (fig. **23.37b**). In its final state, *Exploded Piece* seems quiescent and contained, even though it bears the scars of the various stages—both the carefully measured and the immeasurably volatile—of its creation, destruction, and reconstruction. What physically happened to the form and its material constitutes the content of *Exploded Piece*.

Arte Povera: Merz, Kounellis

An interest in eliminating the distinction between art and life motivated much of the visual experimentation undertaken by the Arte Povera group in Italy. The name was coined by a critic in 1967 in response to the tendency of a group of Italian sculptors to use everyday materials—even old rags—as artistic media. Like those involved in Fluxus (see chapter 22), artists associated with Arte Povera used performance to further elide the distinctions between art and reality, and between artist and viewer. Committed to promoting social progress through their works, Arte Povera artists retained a stronger faith in the power of objects

to provoke political awareness than did many of their Fluxus contemporaries.

The Italian sculptor and painter **Mario Merz** (1925–2003) has always been fascinated by the way in which the world of nature and the world of modern civilization interact. Exploring this theme, he began making his "igloos" in 1968. Like much of his other work, the

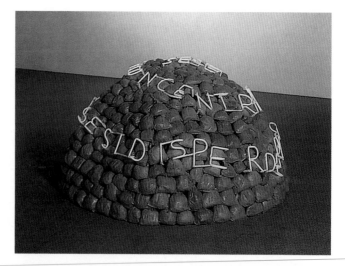

23.38 Mario Merz, *Giap Igloo—If the Enemy Masses His Forces, He Loses Ground; If He Scatters, He Loses Strength*, 1968. Metal tubes, wire mesh, wax, plaster, and neon tubes, height 3' 11¼" (1.2 m), diameter 6' 6¾" (2 m). Musée National d'Art Moderne, Centre d'Art et de Culture Georges Pompidou, Paris.

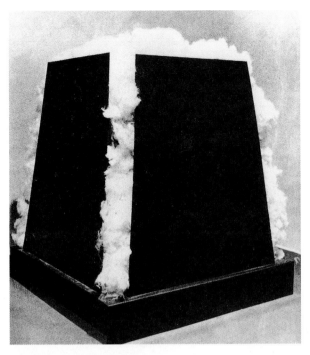

23.39 Jannis Kounellis, *Cotoniera*, 1967. Steel and cotton.

igloos fuse natural materials, such as mud and twigs, with industrial products, such as metal tubing and glass, to create rudimentary structures that look as if they were the shelters of some unknown nomadic people. The igloos' effect when shown in a museum is that their inhabitants have temporarily camped indoors. In the case of *Giap Igloo* (fig. **23.38**), Merz added modern neon signs to the outside, which spell out (in Italian) a saying by the eponymous North Vietnamese general: "If the enemy masses his forces, he loses ground; if he scatters, he loses strength." With its military proverb and conspicuous association with Vietnam, this particular igloo, made in 1968 at the height of the war, suggests an improvised guerrilla fortification of sandbags.

In one of his best-known works, **Jannis Kounellis** (b. 1936)—a Greek artist active in Italy with the Arte Povera group and deeply influenced by the Process-related *informel* works of the Italians Alberto Burri and Lucio

Fontana (see figs 18.36, 18.35)—stabled horses in a Roman art gallery as a way of dramatizing the contrast, and necessary relationship, between the organic world of nature and the human-created, artificial world of art. The same ideas inform *Cotoniera* (fig. **23.39**), a piece in which the soft, white, perishable fluffiness of cotton was combined with the dark, indestructible rigidity of steel to create a dialectic of nature and industry. In a later, untitled work of 1986, the world of human creation is all that is made manifest, represented by no more than forty-two toy trains endlessly orbiting the pillars of a vacant building.

Body of Evidence: Figurative Art

Figurative artists, too, in their turn, succeeded in overturning the dominance of Minimalist abstraction, and in the 1970s they created new kinds of illusionism. As they did so, however, they revealed their roots in the rejected Minimalist aesthetic by translating its stillness and silence into the frozen, stop-action image of the camera—an approach for which artists found sources in the work of Edward Hopper (see fig. 16.37). And this was true even in the work of many painters who adamantly excluded photography from their creative process. Given its markedly static character, almost all of what became known as the New Realism (not to be confused with European *Nouveau Réalisme*, see chapter 19) could be seen as a variety of still life, whatever its subject matter. Inevitably, therefore, genuine still-life motifs now made a stunning reappearance in painting, long after their early career in modernism, when artists favored inanimate, anonymous subjects as more conducive to cool, formalist manipulation or distortion than, for instance, the human image, with all its complicated moral and psychological associations.

Traditional Realism

In the United States, a pragmatic preoccupation with material reality, with the "old" realism, so to speak, had been too deeply ingrained to die out, even as Abstract Expressionism and its Minimal aftermath made American painting and sculpture more rigorously abstract than almost anything ever seen in the history of art. Throughout this very period, in fact, the most widely recognized of all living American painters was probably **Andrew Wyeth** (b. 1917), whose impeccably observed *Christina's World* (fig. **23.40**) long remained, during an era dominated by abstraction, the most popular painting in the collection of The Museum of Modern Art in New York. Another American artist who never lost the realist faith was **Alice Neel** (1900–84). After many years of subsisting on the fringes of mainstream

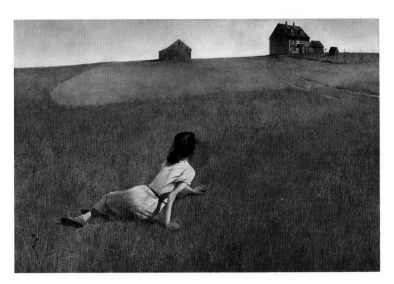

23.40 Andrew Wyeth, *Christina's World*, 1948. Tempera on gessoed panel, 32¼ × 47¾" (81.9 × 121.3 cm). The Museum of Modern Art, New York.

art, Neel came into late, but considerable, fame as a portraitist of such searching, psychologically penetrating power that she seemed to be "stealing" the very souls of her sitters (fig. **23.41**). In the same generation as Neel was **Fairfield Porter** (1907–75), who painted radiant, grandly composed intimist pictures (fig. **23.42**). Albeit thoroughly American, his works seem aesthetically and spiritually at one with the calm, coloristic art of Vuillard and Bonnard (see figs. 3.31, 3.33). Commenting on his luminous environments, Porter said: "I was never one to paint space. I paint air." Although committed to figuration in his own painting, Porter regularly wrote criticism that early and unflaggingly supported the American Abstract Expressionists. This posed no conflict for him, since, as he stated, "the important thing for critics to remember is the 'subject matter' in abstract painting and the abstraction in representational work." Happy to work in the traditional genres of still life, landscape, and interior, as well as portraiture, Porter was convinced that the uncommon could be found in the commonplace, that "the extraordinary is everywhere."

A cultured realist known for his almost monastic dedication and attention to craft is the Spaniard **Antonio López García** (b. 1936). His *Washbasin and Mirror* (fig. **23.43**)

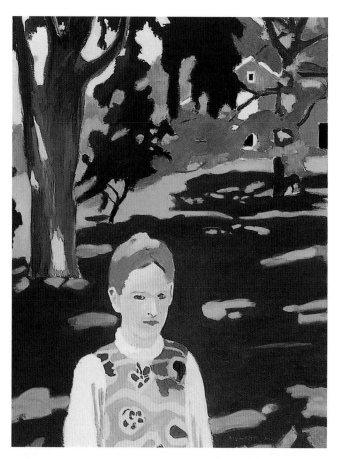

23.42 Fairfield Porter, *Under the Elms*, 1971–72. Oil on canvas, 62¹⁵⁄₁₆ × 46¼" (159.9 × 117.5 cm). Pennsylvania Academy of the Fine Arts, Philadelphia.

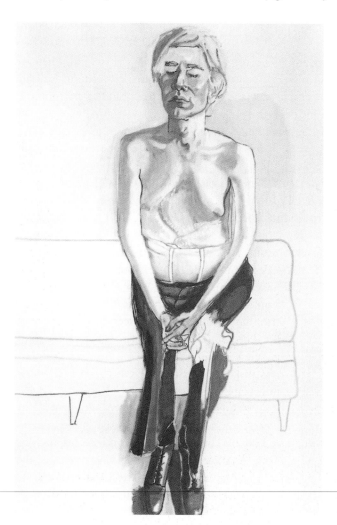

23.41 Alice Neel, *Andy Warhol*, 1970. Oil on canvas, 60 × 40" (152.4 × 101.6 cm). Whitney Museum of American Art, New York.

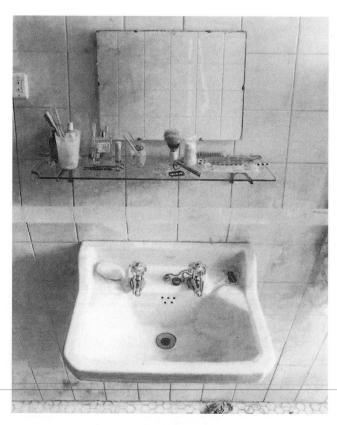

23.43 Antonio López García, *Washbasin and Mirror*, 1967. Oil on wood, 38⅝ × 32⅞" (98.1 × 83.5 cm). Private collection.

gives meticulous attention to the most mundane objects, inviting comparison with certain of the Photorealists about to be discussed. At the same time, the geometric lucidity of this work—with the lowly bathroom tiles providing a strict compositional grid—carries on a tradition of firmly constructed shelf- and tabletop still lifes that can be traced back to Cézanne.

Photorealism

Although he began as a late Abstract Expressionist, **Chuck Close** (b. 1940) sought to reconcile the conceptual ramifications of the artist's mark with the likeness of the sitter. The camera-made image imposed the discipline of a fixed model that told precisely what the painting should look like even before it had been started (fig. **23.44**). Furthermore, Close banished all color and worked exclusively from black-and-white images. He gave up thick, luxurious paint, and permitted himself only a few tablespoons of pigment for a huge, mural-size canvas. This was possible once he threw out his bristle brushes and adopted the airbrush, the better to eliminate all response to medium and surface; thus, his work achieves what appears to be the smooth, impersonal surface of a photographic print or slide.

At the same time that Close used photographs as his point of departure, in lieu of the drawings, studies, or time-consuming observation employed by traditional realists, he committed himself to the long, arduous labor of transferring the image and all its information onto the canvas by means of a grid, a uniformly squared pattern comparable to the screen that makes tonal variations possible in photo-mechanical printing. The grid has served painters for centuries as a device for transferring compositions from one surface to another, usually while also changing their scale, but only with Photorealism did the squares become so small that they could present the most minute facts, as well as overall form, so insistently as to become a dominant characteristic of the art. As though to counterbalance the mechanical impersonality of this process, Close decided to paint only the faces of himself and his friends, their heads full front and close up, and usually on a large scale. Trapped in a shallow, almost airless space and pitilessly exposed in all their physical imperfections, the subjects appear as

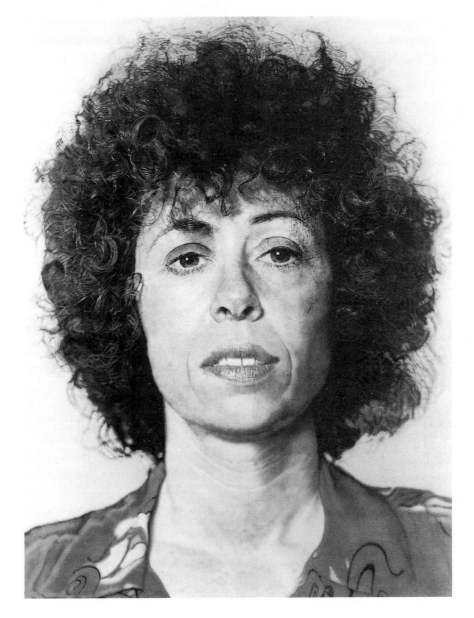

23.44 Chuck Close, *Linda*, 1975–76. Acrylic on linen, 9 × 7' (2.7 × 2.1 m). Akron Art Museum, Ohio.

much heroicized as exploited, as iconic as early American portraits, and as defiant as a police mug shot.

Eventually Close progressed toward color, at first by reproducing, one on top of the other, the four basic color separations used in photomechanical color printing. The more he experimented, however, the more he seemed to move away from realism toward greater involvement with process, which inevitably carried his art back toward the realm of abstraction where it first began. Such a development is especially evident in the Fingerprint paintings, for which the artist filled each unit of the grid with an impression of his own fingerprint inked on a stamp pad. Other works have each cell filled with ovals or lozenge forms (fig. **23.45**), breaking up the figure into geometric atoms in a manner reminiscent of portraits by Gustav Klimt (see chapter 5). While these devices heightened the desired tension between the mechanical and manual aspects of the technique, as well as the fluid and fixed elements of the image, they so tipped the balance between image and system that the former is all but subordinated to the dominant and voracious grid.

Because finger- and handprints convey such a strong sense of the physical presence of the artist, this technique can be exploited for its emotional impact. This was the intention of the British painter **Marcus Harvey** (b. 1963), whose large 1995 canvas *Myra* (fig. **23.46**) incited outrage

23.46 Marcus Harvey, *Myra*, 1995. Acrylic on canvas, 12' 8" × 10' 6" (3.9 × 3.2 m). Courtesy Saatchi Gallery, London © Marcus Harvey, 2008.

when it was first shown at an exhibition of deliberately provocative artworks called Sensation that was mounted at London's Royal Academy. At first glance, the painting appears to represent a rather ordinary-looking woman whose unremarkable features and tidy hairstyle suggest a matronly figure. For most British viewers, however, the face was recognizable as that of Myra Hindley, who participated in the sadistic torture-killings of several English children in the 1960s. As if the large size of the image were not enough to spark reaction, closer inspection of the painting reveals that the image is composed of tiny handprints. The suggestion that a child's hand might have been used to render an image of England's most notorious child murderer prompted some viewers to pelt the canvas with eggs and ink. Harvey explained that the work was essentially his meditation on the endlessly reproduced photograph of Myra Hindley. For Harvey, the serial repetition of the image had evacuated it of its significance. With his painted version of the iconic photograph—made using stencils of a child's hand—Harvey sought to restore the emotional content and original impact of the well-known image.

The art of **Richard Estes** (b. 1936) has the quintessential Photorealist look. Estes does not work from a single photo but rather from two or more, combining them in various ways (fig. **23.47**). Although his pictures have all the flat, planar qualities of broad sheets of reflective glass, those supposedly transparent surfaces reveal less what is

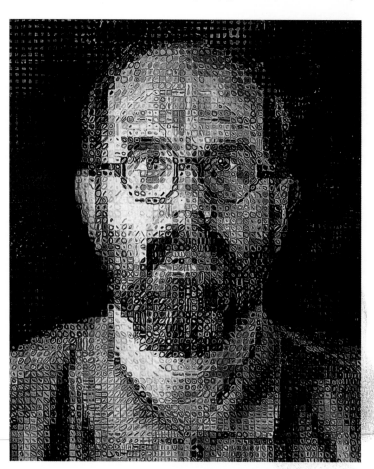

23.45 Chuck Close, *Self-Portrait*, 1991. Oil on canvas, 8' 4" × 7' (2.5 × 2.1 m). Collection Paine-Webber Group, Inc., New York.

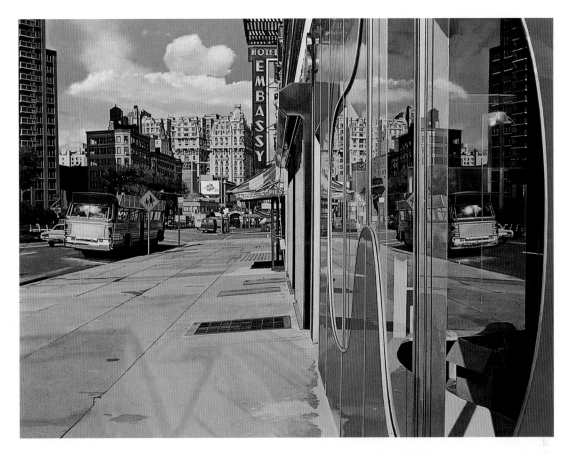

23.47 Richard Estes, *Bus Reflections (Ansonia)*, 1972. Oil on canvas, 40 × 52" (101.6 × 132.1 cm). Private collection.

depicted in depth than what is forward of the painting surface, achieving the effect of an inside-out world reflected from the viewer's own space. Reinforcing the sense of flatness is the uniformly sharp focus with which the artist, thanks to his photographic models, resolves the painting's two-dimensional surface, incorporating a vast quantity of visual information, however far or near. The richness of such an image reveals the importance of the camera to this new variety of realism, for never would a painter, however skilled, be able to render all that Estes has in a single work, or with such clarity and precision, merely by studying the subject directly. In the time required to complete the picture, everything would change—the light, the reflections, the weather, the season, the presence or absence of people and traffic, and certainly the commercial displays. The methods of traditional realism could not possibly freeze a modern urban jumble to one split second of time.

A mediating figure here is **Audrey Flack** (b. 1931), who, while credited with painting the first genuine Photorealist picture, also revived certain thematic concerns guaranteeing an emotional and psychological content remote from the cool detachment characteristic of Photorealist art. Departing from her early career as an Abstract Expressionist, Flack turned to illusionism, creating her own contemporary versions of the seventeenth-century *vanitas* picture (fig. **23.48**). These are still-life compositions positively heaped with the jewels, cosmetics, and mirrors associated with feminine vanity, mixed, as in old

master works, with skulls, calendars, and burning candles, those ancient *memento mori* symbols designed to remind human beings of their mortality and thus the futility of all greed and narcissism. Flack also composes in a traditional way, assembling the picture's motifs and arranging them to

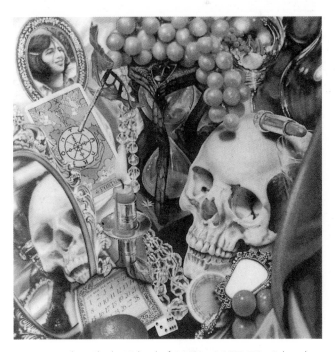

23.48 Audrey Flack, *Wheel of Fortune*, 1977–78. Oil and acrylic on canvas, 8 × 8' (2.4 × 2.4 m). Collection Louis, Susan, and Ari Meisel.

suit her purposes. Only then does she take up the camera, make a slide, project it onto the canvas, and paint over the image with an airbrush. Jammed with visual information and cropped like Baroque still lifes, Flack's pictures possess a striking lushness of color, a spatial complexity, and vastness of scale.

A British-born artist resident in New York since 1958, **Malcolm Morley** (b. 1931) had an early engagement with Photorealism, but, given his lack of interest in simulating the peculiar, glossy look of photographic images, he is only tangentially related to the style. In fact, Morley's unrelenting search for meaning has led him in a variety of fascinating but label-defying directions. One such avenue of exploration involved using photographic material in the form of a color illustration from a magazine or a travel brochure for his essential study or "drawing" for a painting (fig. **23.49**). After dividing up this image into numbered squares, Morley would enlarge and transfer them, one by one, to the canvas, often painting parts of the image upside down to emphasize the superiority of the abstract process. This process offered the dual advantage of distancing the artist from the standard tricks of *trompe-l'oeil* painting, while ensuring that the abstractly rendered image would

contain something of the reality reflected in its source. To acknowledge the artificiality of that source, Morley often retained the standard white border of the color reproduction or photographic print. Although he has denied overt political content, his choice of subject matter—for example Americans at play at a time of grave social unrest—is not without irony.

During the 1960s, the painter **Sylvia Plimack Mangold** (b. 1938) concentrated on rendering convincing images of ordinary floors, showing the lines of the floorboards receding into illusionistic space. The wit of these images arose from their being domestic, indoor versions of Renaissance *vedute*, or views of a city square, with schematic lines of perspective fanning out from the central vanishing point. Mangold began including mirrors in these works in 1972. *Opposite Corners* (fig. **23.50**) shows one corner but also depicts a leaning mirror reflecting the opposite corner of the same room. At first the mirror's frame appears to be a doorway leading into the space of some adjoining chamber. But after a moment, it becomes clear that this receding "space" is in fact an illusion, as of course is the rest of the picture. A few years later, Mangold began adding rulers to her images of floors. Some of these later works

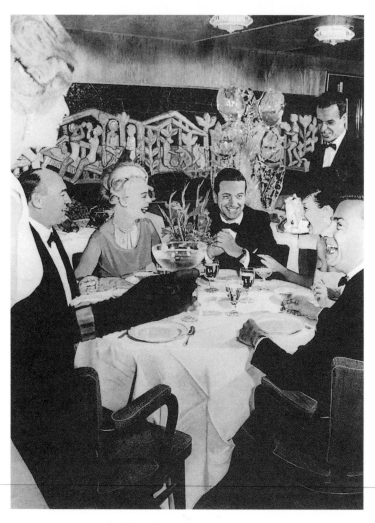

23.49 Malcolm Morley, *Ship's Dinner Party*, 1966. Magna color on canvas, 6' 11¾" × 5' 3¾" (2.1 × 1.62 m). Museum van Hedendaagse Kunst, Utrecht, the Netherlands.

23.50 Sylvia Plimack Mangold, *Opposite Corners*, 1973. Acrylic on canvas, 6' 6" × 5' 3¾" (2 × 1.62 m). Yale University Art Gallery, New Haven, Connecticut.

23.51 Vija Celmins, *Untitled (Big Sea No. 2)*, 1969. Graphite on acrylic ground on paper, 34 × 45" (86.4 × 114.3 cm). AT&T Art Collection.

show one ruler within the image proper—lying in perspective on a receding floor—and also a second ruler, apparently out in the viewer's own space and abutting the edge of the painting, as if fastened to the side of the canvas. Nothing could more economically demonstrate, and yet at the same time question, the laws of perspective that governed Western art from the Renaissance until modern times.

Born in Latvia, **Vija Celmins** (b. 1939) relocated via Germany to the United States in 1948. Her meticulously rendered, photograph-based drawings, paintings, and prints are related to Photorealism. In a series of dispersed, allover compositions, she worked from photographs of irregular natural surfaces—the desert, waves on the sea, and the craters of the moon. The surface depicted, often with richly textured graphite, becomes nearly identical with the picture plane itself, undermining any sense of objective "distance" from the thing being shown. The result is often to turn the source photograph into a near-abstraction. The wave crests of *Untitled (Big Sea No. 2)* (fig. **23.51**), for example, become so elaborately nuanced, through the thousands of individual marks made by the artist, that the camera's flat-footed realism is replaced by an infinitely complex pattern of surface incident. The surface becomes a vivid subject in its own right. Celmins also created portraits of individual objects, including World War II aircraft, based on found photographs, and combined quite distinct kinds of imagery in composite prints based on separate, seemingly unrelated photographs.

Hanson's Superrealist Sculpture

Nowhere has the ambiguity and tension between the realness of artificiality and the artificiality of reality yielded more bizarre effects than in the work of **Duane Hanson** (1925–96), whose life-size, free-standing sculptures (fig. **23.52**) seem, at first glance, to close the gap between art and life with a rude, decisive bang. To achieve such verisimilitude—in which artifice truly assumes the artlessness of literal reality—Hanson used direct casting from live models in the way Superrealist painters use photography, as a means of shortcutting the preparatory stages so that the artist can devote the maximum time and energy to virtually duplicating the look of the model. So successful is the resulting counterfeit that the delight it can produce in viewers may suddenly turn to horror when apparently breathing flesh and blood fails to breathe, remaining as stiff and static as death. Having cast the figure in fiberglass-reinforced polyester resin, Hanson adds, to the textured reality of pores, wrinkles, and bulges, the coloration of skin, veins, and even boils and bruises. Such waxworks literalism stands in fascinating contrast to the figural sculptures of George Segal (see fig. 19.39), who also casts from live models, but avoids confusion between reality and make-believe by using the white mold as the final form. Furthermore, Segal restricts his use of actual objects to environmental props, while Hanson adds them to the figure as clothing and accessories.

23.52 Duane Hanson, *Tourists*, 1970. Polychromed fiberglass and polyester, 64 × 65 × 47" (162.6 × 165.1 × 119.4 cm). National Galleries of Scotland, Edinburgh.

Stylized Naturalism

The illusionist revival that produced Photorealism in painting and Superrealism in sculpture also regenerated naturalistic painting based on the traditional method of direct and prolonged examination of the model or motif. But even there, much new art took on a distinctly photographic look, reflecting the dominance of camera-made imagery in an age increasingly saturated by the media. One of the preeminent masters of directly perceived, sharp-focus realism is **Philip Pearlstein** (b. 1924), a painter who belongs to the Pop, Minimalist, and Conceptual generation and even shares its preoccupation with banal subject matter and two-dimensionality, as well as cool, hard-edge handling. Pearlstein, however, reached his artistic maturity in about 1970, and did so with an art devoted to the nude figure represented as a solid form in simulated depth (fig. **23.53**). He set about integrating modernism's flatness and cropping, characteristics initially fostered by the influence of Japanese prints. Thus, at the same time that he reproduces his figures in all their sexual explicitness, he also robs them of their potential for expressionist content by a process of objectification, by rendering only one part of the anatomy at a time. This results in the loss of bodily context and, often, extremities, a further depersonalization that becomes especially acute when it involves the head. The painter calls his pictorial manipulation of the figure "a sort of still-action choreography." Pearlstein declared:

> I have made a contribution to humanism in 20th-century painting—I rescued the human figure from its tormented, agonized condition given it by the expressionistic artists, and the cubist dissectors and distorters of the figure, and at the other extreme I have rescued it from the pornographers, and their easy exploitation of the figure for its sexual implications. I have presented the figure for itself, allowed it its own dignity as a form among other forms in nature.

If some painters associated with realism were moving toward a more direct account of visual appearances, paradoxically some photographers were going in the opposite direction, treating their subjects in a manner increasingly formal and abstract. **Joel Meyerowitz** (b. 1938), who earlier in his career had earned recognition as a street photographer, now constructed images that, in their immaculately refined sensibility, seemed intent on portraying another world. Although *Porch, Provincetown* (fig. **23.54**) remains rooted in an actual time and place, it also brings to the fore highly abstracted elements, such as the conspicuously displayed trapezoid of the roof and the cleanly abutting planes of the sea and sky. The subtly graduated blush of twilight on the central column is so finely gauged as to

23.53 Philip Pearlstein, *Two Female Models with Regency Sofa*, 1974. Oil on canvas, 60 × 72" (152.4 × 182.9 cm).

make that cylindrical form look like a geometric sculpture, while the tinted atmosphere recalls painters of the sublime, even the Color Field art of Mark Rothko (see chapter 17). Finally, the porch is shot from an angle that makes it appear to be suspended, without ground support, over the sea, as if in a Surrealist painting by René Magritte (see chapter 15).

23.54 Joel Meyerowitz, *Porch, Provincetown*, 1977. Color photograph, 10 × 8" (25.4 × 20.3 cm). Courtesy the artist.

A reference to Surrealism can also be seen in the work of the Detroit-born photographer **Jerry Uelsmann** (b. 1934). Uelsmann combines two or more images into a composite work, bringing together ordinary representations in an unexpected way. The resulting image can have the disorienting, uncanny effect that the nineteenth-century French poet Lautréamont, admired by the Surrealists, compared to "the chance encounter on an operating table of a sewing machine and an umbrella." Uelsmann's *Untitled (Cloud Room)* (fig. **23.55**) creates just this effect of "defamiliarizing" the ordinary. The banal Victorian interior, taken on its own, would be quite unremarkable, and the cloudy sky, too, is part of the everyday world. But when storm clouds gather indoors, their unexpected presence creates a strangely disquieting scene, indebted to the works of painters like Magritte and Delvaux (see figs. 15.23, 15.25). Uelsmann's technical mastery in printing the composite photographs enhances the effect; he joins the disparate images together so seamlessly as almost to convince us for a moment that we are witnessing something impossible but true.

The painter **Alex Katz** (b. 1927) made an early choice of figuration and stuck with it throughout the heyday of American abstraction, turning some of abstraction's own sources of inspiration, such as Henri Matisse and Milton Avery, to his own purposes. Foremost among the formal abstract influences are broad fields of flat, clean color, elegantly brushed surfaces, radically simplified drawing, and epic scale. Selecting his portrait subjects from among family, friends, and art world personalities, Katz monumentalizes them not only by the sheer size of the painted image but also by the technique of representing the sitters only from the shoulders up, as if they were antique emperors or empresses presented to the public in the form of

23.55 Jerry Uelsmann, *Untitled (Cloud Room)*, 1975. Toned gelatin-silver print. Collection Jain and George W. Kelly, New York.

portrait busts (fig. **23.56**). But since the rendering has been done with a reductiveness reminiscent of movie billboards, a more apt association might be with the royalty of Hollywood rather than with that of monarchical Europe. Katz has declared, "I like to make an image that is so

23.56 Alex Katz, *The Red Band*, 1978. Oil on canvas, 6 × 12' (1.8 × 3.7 m). Private collection.

simple you can't avoid it, and so complicated you can't figure it out." To illustrate this quality of ambiguity, Katz here refers to *The Red Band*:

> The original background was green grass. But when I painted green, it just didn't have enough light in it. It didn't show the light that I was seeing. So I turned it to yellow, switched to violet, and then to orange. Finally, that was a plausible light, the light I was really seeing, instead of just a bunch of pretty colors. It was a glowing summer light.

Animated Surfaces: Pattern and Decoration

While some saw Minimalism's aloof stillness, silence, and simplicity as potent with rarefied meaning, others saw only a void, vast as the monumental scale of much mid- to late twentieth-century art, begging to be filled with a richly varied, even noisy abundance of pattern, decoration, and content. Here indeed was rebellion, for in the formalist's vocabulary of terms, the words "pattern" and "decoration" were fraught, still more than "illusionism," with pejorative connotations. This taboo prevailed, even though pattern— a systematic repetition of a motif or motifs used to cover a surface in a decoratively uniform manner—has an effect fully as flattening as any of the devices employed by the Minimalists. However, pattern and decoration, often abbreviated to P&D, was dismissively used to mean work by anonymous artisans, not individuals of known genius, usually done for the purpose of endowing mundane or utilitarian objects with an element of sensuous pleasure and delight. These qualities were thought to be secondary to the more intellectual concerns of high art. Thus, despite

Duchamp, whose readymades proved that the context can define what is, or is not, art, skeptical purists wondered how objects formed from designs, materials, and techniques associated with crafts, folk art, and "women's work" could be transformed into vehicles of significant content.

The answer lay in the sources of inspiration for the P&D movement, which began to stir in the early 1970s and coalesced as a major development in the second half of the decade. First of all there was Matisse, a proud "decorator" in the grand French tradition. Then there were the arabesques and fretwork of Islam's intensely metaphysical art, the pantheistic interlaces of ancient European Celtic art, and the symbol-filled geometries of Native American art, all recently brought into stunning prominence by important exhibitions or installations.

Finally, but perhaps most important of all, came the so-called craft works—carpets, quilts, embroidery, needlepoint, mosaic, wallpaper—not given much attention since Art Nouveau or the art of the Bauhaus. Apart from its irrefutable beauty, such patterned, decorative, and pragmatic folk art gained esteem for its content. Pattern painting, albeit based on the same grid as that underlying the formalist structures of Minimal art, appeared to resist self-containment in favor of an almost limitless embrace of surface. Because of its intrinsically more democratic character, P&D enjoyed broader and more enthusiastic support than did contemporaneous developments in Photorealism.

Initially, one of the strongest and most seasoned talents to transform traditionally undervalued decorative materials into ambitious, original art was **Miriam Schapiro** (b. 1923), energized by feminism as well as by a love of ornamental work, however "low" or "high" its origins. Schapiro drew her imagery and materials from the history of women's "covert" art, using buttons, threads, rickrack, sequins,

23.57 Miriam Schapiro, *Black Bolero*, 1980. Fabric, glitter, synthetic polymer paint on canvas, 6 × 12' (1.8 × 3.7 m). Art Gallery of New South Wales, Australia.

yarn, silk, taffeta, cotton burlap, and wool, all sewn, embroidered, pieced, and appliquéd into useful but decorative objects. Reassembling them into dynamic, baroque, almost exploding compositions, the artist created what she called "femmages," a contraction of "female" and "image" that connotes something of the découpage, photomontage, assemblage, and quilting techniques used to make these grandly scaled projects, without referring by name to the modernist male tradition of avant-garde collage. Moreover, her works are as large as an Abstract Expressionist painting, indicating also her desire to compete with modernist art and monumentalize "women's work."

Schapiro frequently articulated her new style—a synthesis of abstraction, images labeled by society as feminine (such as eggs, hearts, and kimonos), architectural framework, and decorative patterns—in the form of floral bouquets, lacy borders, and floating flowers. In one series she chose the fan shape—itself a decorative form—for wall-size canvases collaged with a wealth of patterned materials, ranging from cheap cotton to upholstery to luxurious Oriental fabrics, all combined to simulate the spreading folds of a real fan. *Black Bolero* (fig. **23.57**) is a potpourri of art and craft, structure and decoration, abstraction and illusion, public politics and personal iconography, thought and sentiment.

In 1975 **Robert Zakanitch** (b. 1935) met Miriam Schapiro during a term of guest teaching at the University of California in San Diego, and early the following year in New York the two painters jointly organized a group called the Pattern and Decoration Artists. The group held its first meeting in a SoHo loft space, signaling not only to the art world at large but also to the participating artists that a greater variety of painting was being done than Conceptualism had allowed anyone to believe.

This led to the Ten Approaches to the Decorative show in September 1976, sponsored by the Pattern and Decoration Artists themselves, and to a kind of collector interest that turned the recently opened Holly Solomon Gallery into a home for such P&D converts as Robert Kushner, Kim MacConnel, Valerie Jaudon, Ned Smyth, and Robert Zakanitch.

When Zakanitch took up decorative imagery, he had been working as a Color Field abstractionist faithful to the Minimalist grid as the structural system of his painting. Once employing decoration, he retained both his color sophistication and his respect for structure, but translated the latter into a free, often organic lattice pattern and the former into floral motifs rendered with a lush, painterly, lavender-and-plum palette (fig. **23.58**). Taken together, the painterliness, the opulent hues, the blooms, and the latticework invite obvious comparison with wallpaper designs, which in fact hold a pre-eminent place among the artist's acknowledged sources.

In 1974 **Robert Kushner** (b. 1949) went on an extended journey to Iran and Afghanistan. The experience was something of an epiphany for Kushner, who said: "On this trip, seeing those incredible works of genius, really master works which exist in almost any city, I really became aware of how intelligent and uplifting decoration can be." Although many of the masterworks happen to have been architectural, Kushner chose to express his love of arabesque fluency and grace not in mosaic or stone, but rather in loose, free-falling fabrics, decorated by their own "found" printed or woven patterns and Kushner's overpainting of leaf, vine, seed pod, floral, or, eventually, beast and human imagery. His preference was for a horizontal alignment of vertical panels, but instead of arranging his fabrics in a generally evenhanded sameness of length, he assembled

23.58 Robert Zakanitch, *Double Shirt*, 1981. Acrylic on canvas, 6 × 5′ (1.8 × 1.5 m). Private collection, Sweden.

them in whatever manner would produce a wearable costume, then hung them, unstretched, on the wall (fig. **23.59**). When donned, these richly patterned and colored pieces, often in original atonal harmonies, yielded an effect of barbaric splendor unknown since the heyday of the *Ballets Russes.*

Valerie Jaudon (b. 1945), a Mississippi-born artist with a cosmopolitan background, began in Color Field painting and, by concentrating on the decorative aspect of that style, continued to be a steadfast abstractionist throughout her work in P&D. To the degree that she is a purely non-objective artist, Jaudon has remained closer to her Islamic sources, mingled with Celtic interlaces, than any of the practitioners seen thus far in the P&D movement. However, her patterns are not copied but freshly reinvented, ribbon-like paths traced over and under one another along arcs and angles reminiscent of Frank Stella's work (see figs. 23.1, 23.2). With their symmetrical order and complex weave of clean lines, which invite the eye but immediately lose it in the indivisibility of the total configuration, Jaudon's earlier maze patterns also became something of a hard-edged counterpart of the allover, holistic, or non-relational compositions realized by Jackson Pollock. In subsequent work, Jaudon stabilized her interlaces within a solidly grounded architectural image, capped by round domes, pointed steeples, and ogival arches (fig. **23.60**). Adding to the sense of gravity and depth are the impastoed surfaces and the brilliant, strongly contrasted colors that distinguish one band or strap from another as well as from

23.59 Robert Kushner, *Blue Flounce* from *Persian Line*, 1974. Acrylic on cotton with miscellaneous fabrics and fringe, 7' 2" × 6' 3" (2.2 × 1.9 m).

23.60 Valerie Jaudon, *Tallahatchee*, 1984. Oil and gold leaf on canvas, 6' 8" × 8' (2 × 2.4 m).

23.61 Joyce Kozloff, *Mural for Harvard Square Subway Station: New England Decorative Arts*, 1984. Tiles, overall 8 × 83' (2.4 × 25.2 m). Cambridge, MA.

the background. Illusionism is denied, however, due to the emphatic linearity of the interlocking geometries and their resolutely flattened "folds" and "knots." Jaudon has said of her intricate art:

> As far back as I can remember, everyone called my work decorative, and they were trying to put me down by saying it. Attitudes are changing now, but this is just the beginning. If we can only get over the strict modernist doctrines about purity of form, line, and color, then everything will open up.

Feminism also encouraged **Joyce Kozloff** (b. 1942) in her decision to work in a decorative style. In her eagerness to dissolve arbitrary distinctions—between high and low art, between sophisticated and primitive cultures—Kozloff copied her sources more faithfully than most of her peers in the P&D movement, depending on her "recontextualization" of the motifs for the transformation necessary to create new art. At first, she sought her patterns in the late Baroque architecture of Mexico, but soon turned directly to its origins in Morocco and other parts of Islam. She then relocated them to independent picture or wall panels, composed of the most intricate, run-on, and totally abstract patterns, and executed them in gouache on paper or canvas or silkscreen on fabric. The architectural sources of her inspiration eventually drew the artist into large-scale environmental works such as public transport stations in San Francisco, Buffalo, Wilmington, and Cambridge, Massachusetts (fig. **23.61**). The imagery ranges from purely abstract quilt and wall-stencil patterns to representations of clipper ships, milltowns, farm animals, tombstones, and the flowers and trees of open nature, all stylized, in the naive manner of American folk art, to fit within the star shape of prefabricated tiles.

Figure and Ambiguity: New Image Art

In December 1978 the Whitney Museum of American Art in New York mounted an exhibition entitled New Image Painting. Though less than a critical triumph, the show provided a label for a number of emerging artists whose works had little in common other than recognizable but distinctly idiosyncratic imagery presented, for the most part, in untraditional, non-illusionistic contexts. Moreover, while honoring Minimalism's formal simplicity, love of system, and emotional restraint, they also tended to betray their roots in Conceptual art by continuing to be involved with elements of Process and Performance, narrative, Dada-like wit, and socio-psychological issues, sometimes even in verbal modes of expression. While all the latter may, quite correctly, imply a Post-Minimalist sensibility, the New Imagists have almost invariably produced works that tend to prompt a more immediate appreciation of form, with content more evocative than obvious or specific in meaning. The great progenitor of the New Imagists was Philip Guston (see fig. 17.18), who by 1970 had abandoned his famous Abstract Expressionist style for a rather raucous form of figuration.

By the time the New Imagists matured in the 1970s—painters like Nicholas Africano, Jennifer Bartlett, Jonathan Borofsky, Susan Rothenberg, Donald Sultan, Robert Moskowitz, and Joe Zucker, or the sculptors Joel Shapiro and Barry Flanagan—the artistic legacy they inherited was a heavy one indeed, consisting as it did not only of Abstract Expressionism, but also the whole incredibly dense and varied sequence of reactions and counteractions that had followed. To assimilate such cultural wealth and yet move beyond it posed an awesome challenge, but the artists eager to accept it proved to be a hardy, clever, immensely

well-educated lot—many of them graduates of Yale University's School of Art in the time of such directors as Josef Albers and the Abstract Expressionist painter Jack Tworkov—and could never have approached the problems of "how" or "why" in the comparatively free, unselfconscious way of the first-generation New York School. But, however complex and contradictory the scene, the younger artists who entered it were fortified with the competitiveness that came with an art market exploding from the effects of media hype. These artists satisfied the rising demand for imagery and collectible objects after the market's near demise under the impact of Minimalism and Conceptualism. Their striking originality lay not in style, which varied widely from practitioner to practitioner, but rather in the particular techniques and ideas appropriated from the recent past, with the result that something familiar or banal would become unexpectedly fresh and strange, possibly even magical, thereby engendering a whole new set of possibilities.

Rothenberg and Moskowitz

In conjuring the kind of eroded or fragmentary figuration last seen in the art of Giacometti or, more robustly, De Kooning, **Susan Rothenberg** (b. 1945) further defied Minimalism's immaculate, abstract surface by filling it with a dense, painterly, silver-gray facture reminiscent of Philip

Guston's probing Abstract Expressionist brushwork and sooty palette (see fig. 17.18). The motif with which she realized her first major success was the horse (fig. **23.62**), a massive form steeped in myth yet intimately involved with human history, obedient and faithful but also potent and wild, and often a surrogate in Romantic painting for human feeling. At a time in the Post-Minimal period when the more advanced among younger artists were not quite ready to deal with the human face and figure, "the horse was a way of not doing people," Rothenberg said, "yet it was a symbol of people, a self-portrait, really." Fundamentally, however, her concerns, like Giacometti's, were formal rather than thematic. In the case of Rothenberg, these centered, as in Minimal painting, on how to acknowledge and activate the flatness and objectivity of the painting surface, while also representing a solid, recognizable presence.

Robert Moskowitz (b. 1935) has said that "by adding an image to the painting, I was trying to focus on a more

23.63 Robert Moskowitz, *Red Mill*, 1981. Pastel on paper, 9' 3" × 4' ¾" (2.8 × 1.24 m). Museum of Contemporary Art, San Diego.

23.62 Susan Rothenberg, *Pontiac*, 1979. Acrylic and Flashe on canvas, 7' 4" × 5' 1" (2.2 × 1.55 m). Private collection.

central form, something that would pull you in to such an extent that it would almost turn back into an abstraction." His method is to isolate an image of universal, even iconic familiarity—natural or cultural shrines like Rodin's *Thinker*, New York's Flatiron Building, or Yosemite National Park's Seventh Sister—and then strip the form bare of all but its most basic, purified shape, making it virtually interchangeable with an abstract pictorial structure. "In all good work there is a kind of ambiguity, and I am trying to get the image just over that line," he said. By allowing it to travel no farther, however, the artist makes certain that, with the help of a clarifying title, the viewer feels sufficiently challenged to puzzle out and then rediscover the marvel of the monument long since rendered banal by overexposure (fig. **23.63**). Aiding the cause of regenerated grandeur and refreshed vision are his epic scale and his tendency to cut images free of the ground, so that they seem truly out of this world, soaring and mythic. This effect is achieved within the enchanted realm of the artist's pictorial surface, a gorgeous display of painterly craft, alternately burnished, flickering, or luminous, glorifying the flatness of the plane and seducing the eye into exploring the image.

Sultan and Jenney

In his break with Minimalism, **Donald Sultan** (b. 1951), like most of his New Image peers, did not so much want to reject the past as to make his art contain more of it. He wanted figuration with the monumental simplicity and directness of abstract art, an approach enabling him to find an image that would clearly metamorphose out of the materials and mechanisms of its own creation. While teaching himself to draw—a skill seldom imparted in the figure-averse academies of the 1960s and early 70s—and working as a handyman at the Denise René Gallery in New York, Sultan found himself retiling his employer's floor with vinyl. He immediately felt an affinity for the material's weight and thickness, as well as for its "found" colors and mottled patterns. Further, there was the unexpectedly sensuous way in which the cold, brittle substance became soft and pliant when warmed by cutting with a blowtorch, a process that, along with the medium and its special colors, would suggest a variety of new subject matter. Sultan also fell in love with the tar—called butyl butter—he used for fixing the tiles to their Masonite support, and began drawing and painting with it on the vinyl surface. This led to covering the plane with a thick layer of tar, which the artist would then paint on or carve into, in the latter instance achieving his image by revealing the vinyl color beneath. Process had indeed now served as a means of putting more and more elements back into the art of painting. And it again served when Sultan hit upon what, so far, has been his most memorable motif, a colossal yellow lemon (fig. **23.64**)—a luscious, monumental orb with nippled protrusions—whose color seems all the more dazzling for being imbedded in tar, traces of which make the fruit's flat silhouette appear to swell into full, voluptuous volume.

23.64 Donald Sultan, *Four Lemons, February 1, 1985,* 1985. Oil, spackle, and tar on vinyl tile, 8' 1" × 8' 1" (2.5 × 2.5 m). Collection the artist.

23.65 Neil Jenney, *Saw and Sawed*, 1969. Oil on canvas, 58½ × 70⅜" (148.6 × 178.7 cm). Whitney Museum of American Art, New York.

A key figure among the New Imagists was **Neil Jenney** (b. 1945), who integrated the strategies he first learned in Minimal, Pop, and Process art with beautifully illusionistic subject matter to achieve paintings of galvanic visual impact and chilling moral force. In such works as *Saw and Sawed*, 1969 (fig. **23.65**), for instance, Jenney rediscovered a version of the liquid Abstract Expressionist stroke and the cartoon-like drawing favored by the Pop artists, along with the visual-cum-verbal punning so beloved by both Pop and Conceptual artists (the work depicts a felled piece of timber), all set forth within a monochrome Color Field organization and a heavy, title-bearing frame that together betray a Minimalist consciousness of the painting as a literal object. In tension with this literalness is the witty ambiguity of the meaning implied by the juxtaposition of words and images.

Articulate and politically-minded, Jenney has spoken of art as "a social science," and as a language through which to convey "allegorical truths." Gradually, as the visual and verbal jokes interact to engage the mind, and the painterly fluidity seduces the eye, attentive viewers find themselves drawn, through a chain of unexpected relationships, into considering the consequences of human deeds, consequences of a serious environmental import. In subsequent paintings, Jenney reversed the relationship between his imagery and its enclosing frame until the latter—massive, dark, and funereal—allows a mere slit of an opening through which to glimpse a tantalizingly lyrical and illuminated nature (fig. **23.66**). Along with the monumentalization of the coffin-like frame has come a vast enlargement of the label. And when this spells out a title like *Meltdown Morning*, the image so segmentally revealed assumes the character of longing for a paradise already lost beyond recovery, as well as mourning for the old world as it may appear—like a rare fragment presented in a museum showcase—following nuclear armageddon or environmental catastrophe.

Borofsky and Bartlett

By his own admission, **Jonathan Borofsky** (b. 1942) has placed politics firmly at the center of his riotously pluralistic art, saying: "It's all about the politics of the inner self, how your mind works, as well as the politics of the exterior world." To express what has become an untidy multiplicity of concerns, Borofsky is at his most characteristic not in individual works but rather in whole gallerywide installations (fig. **23.67**), where he can spread over ceilings and windows, around corners, and all about the floor the entire contents of his mind, his studio, and even the history of his art, which began at the age of eight with a still life of fruit on a table.

The first time he mounted such a display, at Paula Cooper's SoHo gallery in New York in 1975, the show, Borofsky said, "seemed to give people a feeling of being inside my mind." Mostly that mind seems filled with dreams or with the free associations so cherished by the Surrealists, all of which Borofsky has attempted to illustrate with an appropriate image or object. A representative installation would contain a giddy mélange of drawing, painting, sculpture, audio work, and written words, all noisily and messily driving home certain persistent themes. The drawings typically begin with automatist doodles in which the artist discovers and then develops images, such as a dog with pointed ears, blown up by an opaque projector to

23.66 Neil Jenney, *Meltdown Morning*, 1975. Oil on panel, 2' 1⅜" × 9' 4½" (0.64 × 2.9 m). Philadelphia Museum of Art.

spill over and be painted onto walls and ceilings, as if a mythological monster were hovering above and threatening the whole affair.

Among the other presences activating the installations are the giant "Hammering Men" (visible, in two versions, at the left in fig. 23.67), the motorized up-and-down motion of their arms inspired by the artist's father, on whose lap young Borofsky sat while listening to "giant stories." Another character took the artist into the realm of sexual politics, where he conjured images of an androgynous clown dancing to the tune of "My Way." As a kind of interstitial tissue serving to link these disparate images, Borofsky littered the floor with crumpled fliers, which were in fact copies of an actual letter recounting the difficulties of ordinary life, a "found" work picked up by the artist from a sidewalk in California.

The artist has also imposed continuity on his output through his obsessive counting, a rational process of ordering, unlike the instinctual, random one seen elsewhere in his work, that he began in the late 1960s and has now taken beyond the three-million mark. Along the way he applies numbers to each of his pieces and sometimes even to himself, thus joining their separateness into one continuous, ongoing sequence. The record of this monotonous activity is displayed, in graph paper filled with numerals, stacked waist-high, and enshrined in Plexiglas, a project that testifies to the influence of Conceptual practices.

Another New Image artist with a voracious appetite for exhibition space and the creative energy to fill it is **Jennifer Bartlett** (b. 1941), whose vast 987-unit painting entitled *Rhapsody* (fig. **23.68**) became, upon its presentation in 1976, one of the most sensational works of the decade.

23.68 Jennifer Bartlett, *Rhapsody* (detail), 1975–76. Enamel and baked enamel silkscreen grid on 987 steel plates, each 12 × 12" (30.5 × 30.5 cm), overall 7' 6" × 153' 9" (2.3 × 46.9 m). Collection Sidney Singer, New York.

She simplified her painting process, eliminating wooden stretchers, canvas, and the paraphernalia of the oil paint, until she depended upon little more than the basic module of a one-foot-square (0.3 m) steel plate, a flat, uniform surface commercially prepared with a coat of baked-on white enamel and an overprinted silkscreen grid of light gray lines. When finally assembled on a large loft-size wall, hundreds of the enameled steel plates yielded multipart compositions filled with color-dot paintings in an eye-dazzling display of brilliantly decorative abstract patterns.

For *Rhapsody* Bartlett used a large repertoire of colors and, in a further attempt to include "everything," decided to have figurative as well as non-figurative images. For the former she chose the most "essential," emblematic forms of a house, a tree, a mountain, and the ocean, and for the latter a square, a circle, and a triangle—Cézanne's "cylinder, sphere, and cone" two-dimensionalized. She also had sections devoted purely to color, others to lines (horizontal, vertical, diagonal, curved), and some to different techniques of drawing (freehand, dotted, ruled). The painting finally climaxed in a 126-plate ocean sequence incorporating fifty-four different shades of blue. Bartlett went on to expand her basic themes in new directions, accommodating sculpture and undertaking large public and private commissions.

Chicago Imagists: Nutt and Paschke

A group of young figurative artists with a fondness for fantasy and grotesque exaggeration became known as the Chicago Imagists, since many of them studied at the school of the Art Institute of Chicago. **Jim Nutt** (b. 1938) began exhibiting in 1966 with a smaller group of these irreverent artists, which called itself the Hairy Who. At that time,

23.69 Jim Nutt, *It's a Long Way Down*, 1971. Acrylic on wood, 33⅞ × 24¾" (86 × 62.9 cm). National Museum of American Art, Smithsonian Institution, Washington, D.C.

23.70 Edward Paschke, *Duro-Verde*, 1978. Lithograph, 4 × 8' (1.22 × 2.4 m). Virginia Museum of Fine Arts, Richmond.

23.71 Pat Steir, *Cellar Door*, 1972. Oil, crayon, pencil, and ink on canvas, 6 × 9' (1.8 × 2.7 m). Collection Mr. and Mrs. Robert Kaye, New York.

Nutt's scribbly images of women were filled with adolescent aggressiveness. A more controlled work from a few years later, *It's a Long Way Down* (fig. **23.69**), still portrays a woman in anxious, if cartoonish, terms. Nutt says that the painting has to do with the movies, and the gigantic female here, so hugely out of proportion with the tiny inset figures at the upper left and the fleeing form at the lower right, does seem to come from 1950s science-fiction epics like *Attack of the Fifty-Foot Woman*. The headless torso (or is it a mannequin?) at the bottom and the severed head plummeting through the skylight complete this scene of comic mayhem.

Also initially associated with the Chicago Imagists is **Edward Paschke** (1939–2004). His figures of the 1970s may owe something to the particularity of Photorealism in their smoothly modulated contours, as with the exposed skin of the woman in *Duro-Verde* (fig. **23.70**). But even though that work may depict a recognizable event—presumably a high-society party or masked ball—the outrageous colors that Paschke employs nullify any sense of illusionistic fidelity. The artificial, electric green is akin to garish neon lighting, and it recalls as well the distortions of a poorly tuned color TV set. Also puzzling is his deliberate over-elaboration of the headgear and masks, perhaps intended to imply that this scene is more than it appears. Oddest of all are the dramatic poses of the figures.

The frowning, lance-wielding male on the left and the pensive couple on the right suggest nothing so much as a Postmodernist version of the Expulsion of Adam and Eve from the Garden of Eden.

Steir

The work of **Pat Steir** (b. 1940) reflects a consciousness that art always comes from older art, giving culture a vernacular of current forms, which each painter or sculptor reinvests with subtly or sharply different meanings. A clear demonstration of the principle can be found in *Cellar Door* (fig. **23.71**). The large, unmodulated black form at the left is a quotation of Malevich's *Black Square* (see fig. 10.31) of 1914–15, a key point of origin for subsequent geometric abstraction. As if to acknowledge Malevich's original challenge to traditional kinds of painting, Steir added a generic landscape to the right half of *Cellar Door* and then crossed it out, just as Malevich himself had once pasted a small reproduction of the *Mona Lisa* into one of his own works and marked an "X" across the face. Yet Steir also maintains a certain ironic distance from Malevich, not least by the title she gives her painting. The black square in *Cellar Door* is not a mysterious geometric icon like the one that Malevich made, but rather something from ordinary experience—just the doorway to an unlighted basement.

New Image Sculptors: Shapiro and Flanagan

In the context of the long figurative tradition of sculpture, **Joel Shapiro** (b. 1941) might conceivably have had less difficulty than painters when he determined to warm the chill perfection of Minimalism's cubic forms with some sense of an activated human presence. Even so, Shapiro found it necessary to proceed only gradually, moving toward the figure through the more abstract objectivity of its habitations in an early 1970s series devoted to the house (fig. **23.72**). Right away, however, Minimalism lost its monumentality as Shapiro miniaturized the image and pruned the form of all but its most primary or archetypal masses. As for the humanity excluded from these modest abodes, Shapiro so formed and inflected his figures that, on a larger scale, they share both the houses' clean lines and conflicted condition. His later stick figures, built of square-cut posts and cast in iron or beautiful reddish gold bronze—wood grain, knotholes, and all—display the economy of a Sol LeWitt sculpture, only to break free of constraints and seem to pivot, writhe, dance, collapse, and crawl, as if echoing in anti-heroic, Constructivist terms the tormented poses and gestures of Rodin's figures. Even more evocative

23.72 Joel Shapiro, *Untitled*, 1973–74. Cast iron, 3 × 27¼ × 2⅝" (7.6 × 69.2 × 6.7 cm); clipboard base, 14¾ × 29¾ × 5" (37.5 × 75.6 × 12.7 cm).

23.73 Joel Shapiro, *Untitled*, 1987. Charcoal and chalk on paper, 53⅛ × 42%₆" (134.9 × 108.1 cm). Whitney Museum of American Art, New York.

are some of Shapiro's drawings (fig. **23.73**), in which his ethereal smudging of the charcoal endows the geometric shapes with an aura of mystery, an effect enhanced by the use of deep colors. Beam-and-plank assemblages occupy a vast, atmospheric space that owes something to Romantic notions of the sublime.

The British sculptor **Barry Flanagan** (b. 1941) arrived at his New Imagist art by way of painting, dance, and various Conceptual installations produced with organic materials and processes. Throughout a highly varied oeuvre the consistent factors have been those of poetic association, inventiveness, and good humor. Flanagan favors substances such as hessian, rope, felt, steel, stone, ceramic, or bronze, which can be manipulated to "unveil" an image in the

course of handling and shaping. In the early 1980s, while squeezing and rolling clay, Flanagan found a hare "unveiling" itself in the material, and the image proved to have all the fecundity in art that the creature displays in life (fig. **23.74**). Leaping, strutting, dancing, balancing, or boxing, the slender, free-formed, but graceful bronze hare seems an emblem of Flanagan's own spontaneity, openness, and humor.

Humor, especially irony, would become the dominant tone in artworks produced by a number of architects and artists who emerged in the 1970s and 80s. It was then that the idea of Postmodernism expressed itself most forcefully, with artists focusing their attention on the consequences of modernism, not just for the art world but for society as well.

23.74 Barry Flanagan, *Hare on Bell with Granite Piers*, 1983. Bronze and granite, 7' 11½" × 8' 6" × 6' 3" (2.4 × 2.6 × 1.9 m). Number one of edition of five. Collection the Equitable Life Assurance Society of the United States, New York.

24
Postmodernism

The term "postmodern" had been creeping its way into the vocabulary of architects, artists, and critics throughout the twentieth century so that, by the 1980s, it was commonly deployed to describe current trends in visual culture. But what did it mean? Depending on the context, it seemed to denote a variety of ideas. Some used it disparagingly while others associated the term—now usually capitalized as Postmodernism—with fresh, innovative approaches to the visual arts. That the word Postmodern signaled some sort of relationship—either positive or negative—to modernism seemed to be the only idea held in common by those who cited it.

Postmodernism retains something of this flexibility in usage, though it is now understood generally to refer to forms of cultural expression that take modernism itself as a subject. Thus artworks that deliberately confront or undermine qualities associated with modernism—such as abstraction in painting and sculpture or the insistence that "form ever follows function" in architecture—are taken as examples of Postmodernism.

It is this continuing engagement with modernist ideas that has led cultural theorists, most notably Jürgen Habermas (b. 1929), to describe Postmodernism as simply a phase of modernism. This definition of Postmodernism derives from the understanding of modernism as a continually evolving, self-critical enterprise sparked by the Enlightenment. Modernism, this view holds, is always in the process of examining its own assumptions and aims.

Poststructuralism

To understand "Poststructuralism," it is necessary first to lay out the ideas associated with "Structuralism." Advances made in the natural sciences during the nineteenth century led historians and philosophers to look more closely at the methods of their counterparts in the sciences. Among the many differences between their disciplines was the adoption by natural scientists of rigorous, exhaustive systems by which phenomena could be categorized and analyzed. The rationale behind such an approach was simple: if all phenomena relating to a particular event or species could be classified according to a set of consistent formal criteria, meaningful comparisons could be made. These comparisons would then yield information about species development, geological activity, or astronomical occurrences. By the end of the nineteenth century, scholars seeking to understand human behavior and culture—including art—applied a similar approach, attempting to discern distinctive traits of behavior or appearance in order to make comparisons that might yield information about the history and development of a human activity. This, loosely, underlies a Structuralist approach.

Fundamental to Structuralism is the belief that the truth about a particular phenomenon can be determined if only the correct method is applied.

Poststructuralism takes a different view of things. Like Structuralism, Poststructuralism can be understood as a philosophy of knowledge (epistemology). But Poststructuralism advocates skepticism about claims to absolute truth, insisting that truths (whether scientific or cultural or religious) are always contingent, always subject to the biases and ideological blind-spots of the society that produces them. That is to say, Poststructuralism holds that the systems by which truth is discerned derive from precisely the arbitrary or subjective methods that Structuralism seeks to eradicate. The system is designed to produce the truth, so produce the truth it does. The wariness with which Post-structuralists approach scientific or social claims to truth contributed to Postmodernism. With its celebration of multiplicity, plurality, and hybrid rather than pure forms, Postmodernism is the cultural expression of the philosophic position of Poststructuralism.

Artists and critics sympathetic with Habermas' view embrace Postmodernism as simply a stage of modernism.

Not everyone sees Postmodernism in this way. The philosopher whose work is often counterposed against that of Habermas is Jean-François Lyotard (1924–98), who argued that Postmodernism cannot be characterized simply as a phase of modernism. For Lyotard, modernism is defined by a faith in absolutes, a belief that social and cultural progress can be achieved if only the correct course is found and followed. Determining a "correct" approach is itself, according to Lyotard, ultimately a matter of faith: social "truths" tend to be measured against other, previously settled conceptions of truth. Postmodernism, for Lyotard, simply admits that seemingly obvious points of social or even scientific fact may have no more claim to absolute truth than do forthrightly fictional narratives like novels or soap operas.

Both accounts agree that what is at stake in Postmodernism is the nature of truth itself (see *Poststructuralism*, opposite).

As the previous chapters have shown, the history of modern art can be understood as a continual renegotiation of the relationship between truth and visual representation. Marcel Duchamp succinctly summarized this vexed history with his *3 Standard Stoppages* (see fig. 11.10), in which he gives authoritative form to an arbitrary metric. The degree to which (living or inanimate) objects conform to his "standard" measure can be determined by using one of his rulers. The piece strikes the viewer simultaneously as ridiculous and chilling: to what extent are all social or even scientific judgments based on an arbitrary rule? At what point does an arbitrary standard assume the authority of time-tested "truth"?

Some art historians have suggested that Marcel Duchamp was, in fact, the first Postmodern artist. The critical position of Postmodernism would caution against seeking such authoritative moments of origination. Instead of offering a genealogy of Postmodernism, this chapter takes the chronology of Postmodernism's critical reception as its guide, presenting first the architectural theories and buildings that initially gained widespread notice as Postmodern.

Postmodernism in Architecture

The term "Postmodernism" originated not in the realms of painting or sculpture, but in the world of architecture. During the years of building and rebuilding after World War II, the International Style had an almost total hold on architects and clients. But in 1972, when the city of St. Louis dynamited Pruitt-Igoe (fig. **24.1**), a public-housing project built according to the best theories of modern architecture, the rule of Bauhaus took a great fall. All measures to save this monument to rational, utopian, Bauhaus planning had failed. Pruitt-Igoe had become an irredeemable social and economic horror scarcely twenty years after it had been built. The development, complete with "streets in the air"—safe from road traffic—and access to "sky, space, and greenery," which Le Corbusier had deemed the "three essential joys of urbanism," would, it had been hoped, inspire a sense of virtue in its inhabitants.

24.1 Minoru Yamasaki, Pruitt-Igoe public-housing project, St. Louis, at the moment of its demolition on July 15, 1972. Built 1952–53.

By the end of the 1960s, however, the multimillion-dollar, fourteen-story blocks had become so vandalized, crime-ridden, squalid, and dysfunctional that demolition seemed the best solution.

The demise of Pruitt-Igoe has been used by critics of modernism as proof that International Style architecture and urbanism were indifferent to the small-scale, personal requirements of privacy, individuality, context, and sense of place and were patronizing in their demands that residents adjust their lives to architecture. Pruitt-Igoe's architect, **Minoru Yamasaki** (1912–86), was blamed for failing to create viable homes for the people whose lives the project was meant to improve. The calamity in St. Louis was the "smoking gun" for critics who, since the mid-1960s, had attempted to indict Bauhaus modernism for alleged bankruptcy of both form and principle. These critics thought that the followers of Mies, Gropius, and Le Corbusier had created a movement far too narrowly ideological and impersonal—and certainly too self-referential in its inflexible insistence on formalism dictated purely by function and technology. Such a stance could not serve a society in which cultural and economic diversity would only increase.

The social context of modernism seems to have been ignored by early critics of Pruitt-Igoe who were too concerned with asserting the importance of new forms of architecture. Yamasaki's original plan had been for a mixed-height development that would correspond more logically to the neighborhoods from which its residents would be relocating. This was deemed too expensive, and the Public Housing Authority decided to erect thirty-three eleven-story structures. The density of the development was not part of the architect's plan. All demographic statistics were arrived at by government authorities and in the end even the materials, including doorknobs that broke and windows that were blown in by the wind, were determined by state-mandated financial limits rather than design choices. The shoddy materials and poor maintenance contributed to the physical degradation of the project and added to the all-black population's sense of grievance with the racial politics of St. Louis. The modernist style, with its rhetoric of uniform design and aesthetic reduction, became a convenient stylistic vehicle for the socially irresponsible (if not racist) public housing efforts of the city. For critics who were ready to see the style that had defined the pre-World War II years relegated to history, blaming the architect was a useful device that carried its own aesthetic and ideological message. Social dynamics outside the domain of style were, for a moment, dispensable in the pursuit of a new Postmodern architecture.

Postmodernists seek to build in relation to everything: the site and its established environment; the client's specific needs, including those of wit and adventure in living; any historical precedent relevant to current circumstance; and communicable symbols for the whole enterprise. The best Postmodern architects demonstrate that the tools, methods, materials, and traditions that architects, engineers, contractors, and even politicians and advertisers have always worked with are still valid.

Postmodernist architects resist the unifying aesthetic and corresponding faith in a single vision of architectural or urban design that was the keystone to modernist art and architecture. In contrast, they accept some modernist theories and reject others. Opposing the consistency of Bauhaus aesthetics, Postmodernism has a voracious appetite for an illogical and eclectic mix of history and historical imagery; for a wide variety of vernacular expression; for decoration and ornamentation; and for metaphor, symbolism, and playfulness. The new style would display a fascination with the products of society that resonated with the American Pop artists of the 1960s.

"Complexity and Contradiction": The Reaction Against Modernism Sets In

Among the first to declare affinity with Pop (Ed Ruscha in particular) and to voice and practice the revisionism that is Postmodernism was the Philadelphia architect and theorist **Robert Venturi** (b. 1925). Often called the father of Postmodernism, Venturi studied under the distinguished Beaux Arts professor Jean Labatu at Princeton University before traveling to Rome in 1954–56 as a Fellow at the American Academy. In Rome, he found not just a collection of great monuments but an urban environment characterized by human scale, sociable piazzas, and an intricate weave of the grand and the common. Supplemented by a period in the office of Louis I. Kahn, another admirer of the Roman model and a leading architect then moving from the International Style toward more rugged, expressionist, or symbolic buildings (see figs. 21.42, 21.43), Venturi's Roman experience served as the basis of a new philosophy that would culminate in his seminal book *Complexity and Contradiction in Architecture* (1966). Here, with scholarship and wit, Venturi worked back through architectural history to Italian Baroque and Mannerist prototypes and argued that the great architecture of the past was not classically simple, but was often ambiguous and complex. He held, moreover, that modern architects' insistence upon a single style of unrelenting reductivism was utterly out of synchrony with the irony and diversity of modern times. To Mies van der Rohe's celebrated dictum "Less is more," Venturi retorted "Less is a bore."

Complexity and Contradiction presented a broadside critique of mainstream modernism, at least as it had evolved in massive, stripped-down, steel-and-glass boxes that rose with assembly-line regularity throughout the postwar world. Even now, many critics consider Venturi's book the first and most significant written statement against the International Style. "Architects can no longer afford to be intimidated by the puritanically moral language of orthodox modern architecture," wrote Venturi.

I like elements which are hybrid rather than "clear," distorted rather than "straightforward," ambiguous rather than "articulated," … boring as well as "interesting," conventional rather than "designed," accommodating rather than excluding … inconsistent and equivocal rather than direct and clear. I am for messy vitality over obvious unity. I include the non sequitur and proclaim the duality. I am for richness of meaning rather than clarity of meaning.

With his wife, **Denise Scott Brown** (b. 1931), an architect and specialist in popular culture and urban planning and a partner in the firm of Venturi, Rauch, and Scott Brown, Venturi wrote an even more provocative book in 1972, *Learning from Las Vegas.* In it the authors declared that a careful study of contemporary "vernacular architecture," like that along the automobile-dominated commercial "strip" roadways of Las Vegas, may be "as important to architects and urbanists today as were the studies of medieval Europe and ancient Rome and Greece to earlier generations." Venturi and Scott Brown had sought to learn from such a landscape because for them it constituted "a new type of urban form, radically different from that which we have known, one which we have been ill-equipped to deal with and which, from ignorance, we define today as urban sprawl. Our aim [was] … to understand this new form and to begin to evolve techniques for its handling." The book was illustrated with photographs and film stills of the Strip; maps of the scale, purpose, and type of advertising; and theoretical, historical, and architectural analysis (fig. **24.2**). Since urban sprawl has come to stay, Venturi and Scott Brown are persuaded that architects should learn to love it, or at least discover how "to do the strip and urban sprawl well," from supermarket parking lots and hamburger stands to gas stations and gambling casinos. In their opinion, "the seemingly chaotic juxtaposition of honky-tonk elements expresses an intriguing kind of vitality and validity" (see *Learning from Las Vegas*, right).

SOURCE

Robert Venturi, Denise Scott Brown, and Steven Izenour
from Learning from Las Vegas (1972)

Learning from the existing landscape is a way of being revolutionary for an architect. Not the obvious way, which is to tear down Paris and begin again, as Le Corbusier suggested in the 1920s, but another, more tolerant way; that is, to question how we look at things.

The commercial strip, the Las Vegas Strip in particular—the example par excellence—challenges the architect to take a positive, non-chip-on-the-shoulder view. Architects are out of the habit of looking nonjudgmentally at the environment, because orthodox Modern architecture is progressive, if not revolutionary, utopian, and puristic; it is dissatisfied with *existing* conditions. Modern Architecture has been anything but permissive: Architects have preferred to change the existing environment rather than enhance what is there.

But to gain insight from the commonplace is nothing new: Fine art often follows folk art. Romantic architects of the eighteenth century discovered an existing and conventional rustic architecture. Early Modern architects appropriated an existing and conventional industrial vocabulary without much adaptation. Le Corbusier loved grain elevators and steamships; the Bauhaus looked like a factory; Mies refined the details of American steel factories for concrete buildings. Modern architects work through analogy, symbol, and image—although they have gone to lengths to disclaim almost all determinants of their forms except structural necessity and the program—and they derive insights, analogies, and stimulation from unexpected images. There is a perversity in the learning process: We look backward at history and tradition to go forward; we can also look downward to go upward. And withholding judgment may be used as a tool to make later judgment more sensitive. This is a way from learning from everything.

24.2 Robert Venturi and Denise Scott Brown, from *Learning from Las Vegas,* 1972.

In Praise of "Messy Vitality": Postmodernist Eclecticism

Venturi, Rauch, Scott Brown, and Moore

While such Pop taste and maverick views made Venturi the leading theoretician among younger architects, they also earned him the near-universal disdain of the modernist school and of critics such as Ada Louise Huxtable, who dubbed the quietly civilized Venturi the "guru of chaos." Venturi and Scott Brown's bold ideas also proved too much for arbiters of major architectural commissions. Thus, until 1986, when the firm of Venturi, Rauch, and Scott Brown won the coveted contract for the design of the extension to London's National Gallery on Trafalgar Square (see fig. 24.5), it had to content itself with relatively small projects. Still, the partners made the most of every opportunity, even while insisting that they deliberately designed "dumb" buildings or "decorated sheds." The decorated shed concept may have received its most salient expression in the highway store designed for the Best Products Company (fig. **24.3**). Its long, low façade rises above the parking lot like a false front on Main Street in a Western frontier town, while displaying huge, Andy Warhol-style gaily colored flowers. However, the prototypical Venturi building is one the architect built in 1962 for his mother in Chestnut Hill, Pennsylvania (fig. **24.4**), a work of exceptional humor, sophistication, and irony whose apparent ordinariness is just enough "off" to tell the alert viewer that something extraordinary has gone into its design.

In Chestnut Hill House, Venturi accepted the conventions of the "ugly and ordinary" American suburban crackerbox—its stucco veneer, wood frame, pitched roof, front porch, central chimney, and so forth—and parodied them so completely as to make the commonplace seem remarkable, enriching it with wit and light-hearted satire. The process of transformation began with the scale of the façade, which the architect expanded until it rose several feet above the roof, thereby creating another false front. He then divided it at the center to reveal the conceit and widened the cleft at the bottom to create a recessed porch. Visually joining the two halves together, yet simultaneously emphasizing their division, are the arch-shaped strip of molding and the stretched lintel above the entrance, both paper-thin like everything else about the façade (or like the crackerbox tradition itself, or even most modern curtain-wall construction). Meanwhile, the split in the front wall echoes the much older and more substantial stone architecture of the Baroque era, which in turn joins with the expanded height of the façade to create a certain illusionistic grandeur. Such complexity and contradiction extend deep into the structure, to the chimney wall, for instance, which spreads wide like a great central mass, only to project the chimney above it. Unity too has been honored with all the intricate ambiguities, as in the same size and number (five) of the asymmetrically disposed window panels on each side of the façade.

Hidden behind the deceptively simple exterior of Chestnut Hill House is a complicated interior, its rooms as irregularly shaped and small in scale as the façade is grand, in the Pop manner of Claes Oldenburg's giant hamburgers and baseball bats (see fig. 23.21). Yet the plan is tight and rational, not whimsical. For example, the crooked stairway is broad at the base but narrow at the top, reflecting, in Venturi's view, the difference in scale between the "public" spaces downstairs and the "intimate" ones upstairs. By its very irregularity, the interior accommodates the books, family mementos, and overstuffed furniture long owned by the client as well as it expresses her patterns of living. Unlike Corbusier's "machines for living" or Frank Lloyd Wright's Usonian houses, Chestnut Hill House does not suggest or impose a living pattern for its inhabitants. And herein lies the essence of the Venturi concept: the house makes no attempt to simulate a ship or an airplane, or to

24.3 Venturi, Rauch, and Scott Brown, Best Products Company, 1977. Oxford Valley, Pennsylvania.

24.4 Robert Venturi, Chestnut Hill House, 1962. Philadelphia.

become some organic device to commune with nature; instead, Venturi's design proclaims its "houseness" with historically relevant allusions that are not overt symbols. "We don't think people want 'total design' as it is given to them by most modern architects," Scott Brown once said. "They want shelter with symbolism applied to it."

In 1986, Venturi and Scott Brown won the commission to design a new wing for the National Gallery in London. They were to create a permanent exhibition space for the gallery's Early Renaissance collection, a large lecture hall, a computer information room, a video theater, a gift shop, and a restaurant. Located diagonally across from Trafalgar Square, their design for the Sainsbury Wing (fig. **24.5**) integrates both modern and classicist impulses. The main entrance is skewed to face Trafalgar Square, and the

classical details of the façade echo those of the adjacent main building. Although not easy to see from the square, these classical details have been subjected to subtle Postmodern idiosyncrasies and operations: the windows are blind and almost disappear into the stone façade, and, among the regularly spaced pillars, there is a single round column that imitates the monument to Lord Nelson in the square. The western-facing façade on Whitcomb Street is plain brick. The huge glass wall of the grand staircase at the east side of the wing offers a view of the exterior of the old gallery. The top floor's neutral-toned galleries, which permanently house the Renaissance collection, are respectful of both the old galleries and the artwork in their expertly scaled spaces. Natural and artificial lighting are adjusted every two hours by computer, according to the amount of natural light filtering in through the glass "attics." Venturi and Scott Brown's Sainsbury Wing demonstrates that the Postmodern style is flexible and capable of adapting to its site, its purpose, and other surrounding buildings.

Another student of Louis I. Kahn at the University of Pennsylvania and a close ally, if not an actual partner, of Venturi and Scott Brown was **Charles Moore** (1925–93), who looked not so much to Las Vegas for inspiration as to Disneyland, praising it as an outstanding public space as well as an embodiment of the American Dream. Concerned with the commercial or industrial sameness of the postwar world, and with it the lost "sense of place" that leaves so many American cities looking like Los Angeles, Moore became even more overtly historicist than Venturi and was fully committed to "the making of places." In this, he often favored the "presence of the past" found in a Roman or Mediterranean kind of environment. One of the

24.5 Robert Venturi and Denise Scott Brown, National Gallery, with Sainsbury Wing visible in the center of the photograph, to the left of the main gallery across Trafalgar Square, 1987–91. London.

most remarkable examples of how imaginatively he could develop this theme is the Piazza d'Italia in New Orleans (figs. **24.6**, **24.7**). Here he designed a public space to provide a small Italian-American community with an architectural focus of ethnic identity, a place exuberant enough to serve as the setting of the annual St. Joseph's festival, with its vibrant street life. Piazza d'Italia is an early example of the playful Postmodern use of classical forms. An entirely decorative and symbolic construction, it is architecture that abandons the aim for permanence. Collaborating with architects well versed in the local culture, Moore took into account not only the taste and habits of the area's inhabitants, but also the different styles of buildings around the new piazza. Thus, while the design incorporated the black-and-white lines of an adjacent modernist skyscraper in a graduated series of concentric rings, the circular form itself—essentially Italian Baroque in character—reflects the local community. Moore found the prototypes for his circular piazza in, among other places, Paris' Place des Victoires, the Maritime Theater at Hadrian's Villa near Tivoli, and the famed Trevi Fountain in Rome, an open-air scenographic extravaganza combining a classical façade, allegorical earth sculpture, and water.

At staggered intervals on either side of a cascading fountain at the Piazza d'Italia are various column screens representing the five classical orders, the outermost and richest one, Corinthian, crowned by polished stainless-steel capitals supporting an entablature emblazoned with dedicatory Latin inscriptions. Over the waterfall stands a triumphal arch, polychromed in Pompeiian hues and outlined in neon tubing. With its eclectic mixture of historical reference and pure fantasy, such as water coursing down pilasters to suggest fluting, water spouts serving as Corinthian leaves, and stainless-steel Ionic volutes sitting on neon necking, Piazza d'Italia combines archeology, modernism, commerce, and theater to provide something for everyone—and above all a sense of place unlikely ever to be confused with Cleveland, Los Angeles, Sicily, or even the French Quarter in New Orleans itself.

Hollein, Stern, and Isozaki

About the same time as Venturi and Scott Brown began to fill commissions, Austria's **Hans Hollein** (b. 1934) was in the American West, learning from Las Vegas and doing so in rebellion against the "Prussian dogma of modernism" at the Illinois Institute of Technology (where he had enrolled in 1958). Seeing all those open spaces and the expressive freedom they seemed to generate, Hollein had an epiphany, after which he designed with a pluralistic abandon worthy of his gaudy American models, but also with an exquisitely crafted, decorative elegance reflecting a subtle appreciation of Vienna's Secessionist tradition (see figs. 9.9, 9.11). Even more than the Americans, European Postmodernists such as Hollein found few opportunities to work on a large scale. The Austrian architect had to

24.7 Charles Moore with U.I.G. and Perez Associates, Inc., View from above, Piazza d'Italia.

24.8 Hans Hollein, Austrian Travel Bureau, 1978. Vienna.

contain his drive to invent and surprise within small jewel-box spaces—often old and refurbished interiors like that of the Austrian Travel Bureau in Vienna (fig. **24.8**) of 1978. For this project Hollein adopted topographical themes and scenographic methods similar to those of Charles Moore in Piazza d'Italia—and in the same metaphorical spirit—to make a pre-existing hall suggest the many places to which the Travel Bureau could send its clients: in other words, evoking the concept of travel. Thus, the assemblage of allusive forms and images found here includes: a grove of brass palm trees clearly based on those in John Nash's kitchen for the early nineteenth-century Brighton Pavilion (see fig. 4.9); a broken "Grecian" column and pyramids; a model of the Wright brothers' biplane; rivers, mountains, and a ship's railing. Lined up along the central axis, like a miniature Las Vegas strip, are such temptations as an Oriental pavilion, a chessboard seating area, and a ticket booth furnished with a cash window in the form of a Rolls-Royce radiator grille. Meanwhile, the hall itself has been styled to resemble a reconstruction of Otto Wagner's Post Office Savings Bank (see fig. 9.9), an ironic reference, since the whole purpose of the Travel Bureau is to encourage spending, not saving.

In 1972 Hollein was commissioned to design the Städtisches Museum Abteiberg in the North German town of Mönchengladbach (fig. **24.9**). The museum, which took ten years to complete, is a series of buildings that critic Charles Jencks called "a modern Acropolis." Located on a hill next to a Romanesque church, it provides, as Jencks suggested, a modern-day equivalent to the church's spiritual role. Declaring that he "was never afraid to use materials in new contexts—plaster or aluminum or marble, and all this together," Hollein designed the museum as a tiny town within a town, an agglomeration of distinct but

24.9 Hans Hollein, Städtisches Museum Abteiberg, 1972–82. Mönchengladbach, Germany.

24.10 Robert A. M. Stern, Pool House, 1981–82. Llewelyn, New Jersey.

compatible structures. With its undulating red-brick terraces snuggled against the slope, its relaxed and vaguely mock-ancient but non-abrasive Disneyland replicas, and its odd and delightfully particular cut-out corner and voluptuous semicircular marble stairs, the Mönchengladbach museum struck Jencks as "a beautifully detailed urban landscape dedicated to a form of collective belief we find valuable. Art may not be a very convincing substitute for religion, but it is certainly a suitable pretext for heroic architecture."

Another American architect profoundly influenced by Robert Venturi, as well as by Charles Moore (under whom he studied at Yale), is **Robert A. M. Stern** (b. 1939). Like his mentors, Stern had an active practice in Postmodern architecture as well as being a teacher, writer, and editor. Although as witty and sophisticated as Venturi and Moore, Stern is also more literal and fastidious in his use of historical precedents, and he is considerably more given to patrician sumptuousness. Indeed, he developed into a one-person equivalent of McKim, Mead & White (see fig. 4.1): he seems most truly himself when designing the sort of grand shingle-style country house or holiday retreat that the turn-of-the-century New York firm once produced with understated aristocratic bravura. Thus, while reveling in the decorative revival quite as joyously as Venturi and Moore, until his Walt Disney commission, Stern had worked less in the Pop spirit that animates Moore's Piazza d'Italia and Venturi's

Best Products Company's façade than in the fanciful manner of Hans Hollein's appropriations of Nash's Brighton Pavilion. This can be seen to splendid effect in the 1981–82 pool house (fig. **24.10**), part of an estate in northern New Jersey, where stainless-steel "palm columns" evoke the palm supports in Nash's Brighton kitchen, as had Hollein in his Travel Bureau in Vienna (see fig. 24.8). The glistening material of these uprights produces a "wet" effect appropriate to the setting, as do the polychrome wall tiles derived from a kind of décor favored by the Secessionist Viennese (see fig. 5.5). Further enhancing the bathhouse theme are the Art Deco figural quoins and the thick Tuscan columns, the latter reminiscent of Roman *terme*.

Stern's 1995 Feature Animation Building (fig. **24.11**) in Burbank, California, designed for the Walt Disney Company (which has also commissioned projects from

24.11 Robert A. M. Stern, Feature Animation Building, Walt Disney Company, 1995. Burbank, California.

Robert Venturi, Frank O. Gehry, and Arata Isozaki), offers a host of references both to the architecture of Los Angeles and to the fantasy architecture found in Disney animation. It is a highly complex building that in many ways resembles a converted warehouse, which is what Disney chief executive Michael Eisner had in mind when commissioning the project. Stern wanted the lobby—a tall oval space with one curved and tilted glass wall—to evoke the eccentric fast-food joints and donut shops of the 1940s, 50s, and 60s that are still to be found in and around Los Angeles. The building's profile—the entrance is tucked under a conical spire—is a reference to the cone-shaped hat worn by Mickey Mouse in a segment of the film *Fantasia*. Along the structure's south side is a narrow gallery with a high roof that slopes up toward the main façade, ending in a form like the prow of a ship. Stern called this "the Mohawk" because it resembles a punk haircut; it also alludes to the Mad Hatter in Disney's animated version of *Alice in Wonderland*. Visible from a nearby freeway, giant stainless-steel letters above the front entrance spell the word ANIMATION. The work space is accommodated in three vast, connected barrel vaults that form the main bulk of the building. Under the vaults, painted black with stainless-steel studs that twinkle like stars, are girders and air shafts, which have been left exposed and painted white so that their industrial forms stand out against the dark ceiling.

Another figure linked to Postmodern eclecticism is the Japanese architect **Arata Isozaki** (b. 1931). He began his career working for Kenzo Tange (see figs. 21.32, 21.33) but soon dispensed with any Corbusian influences he might have absorbed. A self-confessed "mannerist," Isozaki draws on a huge variety of sources—Eastern and Western, traditional and modernist—honestly quoting from and transposing them.

Situated in the old part of Mito, Japan, Isozaki's 1990 Art Tower is the cultural core of that city. The building accommodates four major features: a gallery of contemporary art, a concert hall, a theater, and the Mito centennial tower. The various parts are connected by a large square that occupies more than half the site. There is also a two-story conference hall and a museum shop, café, and restaurant. The museum space has three glass roofs (fig. **24.12**). A pyramid is set symmetrically at the center. The façades are set with porcelain tiles to give the plaza the feel of a European town. At the north end, a huge stone placed on the center axis of the square is suspended by thin cables. At the northwestern corner, sandwiched between the concert hall and the theater, is an entrance hall serving as a connecting chamber for the building's functions. This vertical space links the plaza to the street. A 328-foot-high (100 m) tower to the east of the plaza commemorates the centenary of the town. This Brancusian "endless" column is made of titanium-paneled tetrahedrons; stacked together, their edges create a DNA-like double helix.

24.12 Arata Isozaki, Gallery building, Art Tower, view of north end, 1990. Mito, Japan.

Ironic Grandeur: Postmodern Architecture and History

Johnson

In looking for the early signs of the Postmodern aesthetic, one finds an apparent scorn for a refined, stylistic consistency. This shift can be seen in the career of **Philip Johnson** (1906–2005), who was an associate partner with Mies van der Rohe on the Seagram Building (see fig. 21.17). By the mid-1950s, Johnson was turning against the order and rationalism of Miesian design. His efforts to overturn the Modernist movement found their greatest early success in association with John Burgee, when he designed the New York headquarters for American Telephone and Telegraph (see figs. 24.13, 24.14, 24.15). Heightening the shock value of this famously revisionist skyscraper, built between 1978 and 1983, is the fact that Johnson, together with architectural historian Henry-Russell Hitchcock, in 1932 had written a book that introduced the International Style to the English-speaking world and thus made it a true architectural *lingua franca*. By the late 1970s, Johnson was the virtual dean of American architects, and his immense prestige was very persuasive to the stolid AT&T officers when they committed more than $200 million to a Postmodern design of almost perverse irony and elegance.

The skyscraper was nicknamed the "Chippendale building" for the broken pediment at its top; its resemblance to a highboy chest in the Chippendale style was irresistible.

With hindsight, it is not so surprising that Johnson's witty mind, stocked with a vast and erudite range of aesthetic references, perceived in the skyscraper an analogy to the highboy, a colossal stack of "drawers" set in a chest supported by tall legs and topped by a scroll bonnet. Rising 647 feet (197 m) without setback, it is divided into base, shaft, and granite-clad cornice. The shaft provides "drawers," or stories; owing to their double height, there are only thirty-six "drawers" in what is a sixty-story tower. With the AT&T building, Johnson reintroduced "history" into the vocabulary of modern high-rise architecture, a history rendered compatible with the commercial world of the 1960s and 70s by reference not to palace or ecclesiastical structures, but to furniture. Herein may lie the essence of Postmodernism: the longing for symbolism and the grandeur of the past disembodied from the faith that inspired the original forms. Such design results in ingenious historical puns and self-mockery.

The AT&T building originally had a forest of "legs" at street level, which sheltered a capacious, open loggia some five or six stories high; it was dedicated as a public space until 1990, when the building was sold to the Sony Corporation. Within three years, Sony converted the loggia space to shops and renamed it Sony Plaza. In the original building, the historicism of the design produced a dizzying mix of themes. The façade (fig. 24.13), a central oculus-over-arch flanked by trabeated loggias, recalled the front face of the Pazzi Chapel, a Florentine Renaissance building known to every student of architecture and art history.

24.13 Philip Johnson and John Burgee, AT&T Headquarters building, 1978–83. New York.

24.14 Philip Johnson and John Burgee, Lobby, AT&T Headquarters building, 1978–83. New York.

Johnson and Burgee's interior, however, was a groin-vaulted Romanesque space (fig. **24.14**). The broken pediment that capped the building still endows it with its renowned and idiosyncratic profile (fig. **24.15**).

Stirling, Jahn, Armajani, and Foster

Already one of Britain's most important architects in the 1960s, when he worked in a somewhat Brutalist vein (see fig. 21.24), **James Stirling** (1926–94) seems to have been liberated by Postmodernism into full possession of his own expansive genius. This is best exemplified in the exciting addition to the Neue Staatsgalerie, or museum, in Stuttgart, built in 1977–84 (figs. **24.16**, **24.17**). Here, in

24.15 Philip Johnson and John Burgee, AT&T Headquarters building, 1978–83. New York.

24.17 James Stirling, Neue Staatsgalerie, 1977–84. Stuttgart, Germany.

24.16 James Stirling, Neue Staatsgalerie, 1977–84. Stuttgart, Germany.

24.18 Helmut Jahn, United Airlines Terminal of Tomorrow, O'Hare International Airport, 1987–88. Chicago.

association with Michael Wilford (b. 1938), Stirling took advantage of the freedom allowed by revisionist aesthetics to solve the manifold problems presented by a difficult hillside site, hemmed in below by an eight-lane highway, above by a terraced street, and on one side by the original Renaissance Revival museum building. With so many practical considerations to satisfy, Stirling decided to work in "a collage of old and new elements ... to evoke an association with a museum." And so, while the three main exhibition wings repeat the U-shaped plan of the nineteenth-century structure next door, the external impression is that of a massive Egyptian structure, ramped from level to level like the funerary temple of the Old Kingdom Queen Hatshepsut at Deir el-Bahri, but faced with sandstone and travertine strips more suggestive of medieval Italy. Visually, the ramps and the masonry unify a jumble of disparate forms clustered within the courtyard framed by the embracing U. Among these are an open rotunda

surrounding a sculpture court; the glazed and undulating walls of an entrance shaped rather like a grand piano; and a blue-columned, red-linteled, and glass-roofed high-tech taxi stand. Despite so many historical references and such diverse configurations, a sense of unity and distinctive place are real and even moving. The ramps convey the pedestrian along a zigzag path leading from the lower highway into and steeply halfway round the inner circumference of the rotunda, and finally through a tunnel in the cleft walls to the upper terraced street behind the museum. Adding to this heady mix of sophisticated, urbanistic pluralism is the keenly British sensibility of Stirling himself, who brought to the design the grace of the eighteenth-century Royal Crescent in Bath.

In the work of **Helmut Jahn** (b. 1940), Postmodernism's serious playfulness is articulated in large-scale projects. Jahn, a staunch admirer of Mies van der Rohe, emigrated from Germany to Chicago in 1966. In 1967 he joined a leading Chicago architectural firm, C. F. Murphy, and by 1981 was principal architect in the renamed firm Murphy/Jahn. The $500-million United Airlines Terminal of Tomorrow at Chicago's O'Hare International Airport (fig. **24.18**) is an example of Jahn's success in creating enormous public places that are interesting to experience, technically brilliant, yet not overwhelmingly futuristic. Awarded the A.I.A. Design Award of 1988, the building is an architectural echo of the past, reminiscent of the iron-and-glass structures of Victorian railway stations. One speeds through physically on people movers while being mentally transported to a previous era. As in Joseph Paxton's Crystal Palace of 1851 (see fig. 4.11), we see prefabricated metal and glass construction elevated to the scale of civic architecture. The corridors and departure/arrival gates are metal-framed, glass-paneled, and topped with soaring barrel vaults drenched with natural light. Yet Jahn's high-tech update on nineteenth-century engineering is a far cry from explicitly historicist buildings.

Siah Armajani (b. 1939), a self-described "architect/ sculptor" born in Tehran but long settled in Minnesota,

24.19 Siah Armajani, Irene Hixon Whitney pedestrian bridge. Bridge between Loring Park and Walker Art Center Sculpture Garden, 1988. Length 375' (114.3 m). Minneapolis.

24.20 Norman Foster, 30 St. Mary Axe, 2002. London.

creates sculptures and installations that suggest the history of architecture, engineering, and society and at times have even become works of architecture themselves. Since the late 1960s, Armajani has been interested in the functional and metaphoric in the architectural engineering of bridges. Among the works he has created is the Irene Hixon Whitney pedestrian bridge, which links the sculpture garden at the Walker Art Center with Loring Park in downtown Minneapolis (fig. **24.19**). Stretching over sixteen lanes of traffic, the bridge reconnects two parts of the city that were divided twenty years earlier by the construction of a superhighway. The bridge's design itself suggests a kind of symbolic unity: the two arches, one convex and the other concave, unite to form a single sine curve. Armajani enlists architectural design and engineering technology to articulate and, in a small way, compensate for the divisive, if expedient, effects of urban planning and civil engineering.

Just as cerebral and more celebratorily high-tech is the London high-rise at 30 St. Mary Axe (fig. **24.20**), the work of English architect **Norman Foster** (b. 1935). The design of the tower, built in 2002, follows the philosophy of Foster and Partners—that is, achieving maximum effect with minimal structural means, as well as achieving clarity and precision in the fitting together of components. Foster makes use of prefabricated components and uses recycled materials whenever possible. The tower's striking design (it is known to Londoners as the "Gherkin") facilitates the flow of fresh air through the building, and the entire structure aims to minimize waste and energy use. Utilities are gathered together inside the central core, making the most of the space available. Foster's effort to subsume mechanical and electrical needs to the occupants' benefit is reminiscent of the Pompidou Center, which his former architectural partner, Richard Rogers, designed with Renzo Piano. Yet for all its functionality, the design of 30 St. Mary Axe references an era of spaceship futurism with an innocent, almost playful, "World of Tomorrow" effect.

Pei and Freed

Historicism directed away from the futures imagined in the recent past and toward the ancient world was well developed when Chinese-American architect **I. M. Pei** (b. 1917) executed the commission for modernizing certain parts of the Louvre Museum in Paris. Pei is popularly known for

the controversy surrounding his Grand Louvre Pyramid (1988), constructed in the courtyard of the Louvre (fig. **24.21**). The Pyramid deliberately turns the tradition and concept of pyramid inside out. A pyramid is supposed to be solid, dark, and solitary—a mesmerizing symbol of the exotic world beyond the streets and cultures of Europe. Here, the pyramid is clear glass, almost immaterial, a vast skylight hovering over streams of museum visitors as they are channeled into the Louvre galleries through the below-ground entrance corridors. Besides its associations of timelessness and its brilliant ingenuity in lighting an underground space, the ensemble is a superb example of how new buildings in old settings do not always have to accommodate themselves to the style of their "found" surroundings.

The expansion of existing museums and the proliferation of new ones since the early 1980s have generated some of the most exciting architecture of recent times. Architect and curator attempt to bring the past into the present in flexible yet assertive form. Creating a museum to document one of the most atrocious crimes in history was an exceptional architectural challenge. The United States Holocaust Memorial Museum was chartered by a unanimous act of Congress in 1980 and opened in 1993. Architect **James Ingo Freed** (1930–2005), of Pei Cobb Freed & Partners, fashioned a relationship between the architecture of the building and the exhibitions within, creating in effect a work of art. Freed visited a number of Holocaust sites, including camps and ghettos, to examine structures and materials. While architectural allusions to the Holocaust are not specific, the building contains subtle metaphors and symbolic reminiscences. In Freed's words, "There are no literal references to particular places or occurrences from the historic event. Instead, the architectural form is open-ended." The building thus serves as a "resonator of memory."

At first glance, the exterior seems benign, which is part of the building's metaphoric message (fig. **24.22**). Yet throughout, Freed has incorporated physical elements of concealment, deception, disengagement, and duality. The curved portico of the 14th Street entrance—with its squared arches, window grating, and cubed lights—is a mere front, a fake screen that actually opens to the sky, deliberately hiding the disturbing architecture of skewed lines and hard surfaces of the real entrance behind it. This strategy of contrasting and juxtaposing appearance and reality is repeated throughout. Along the north brick walls, a different perspective reveals a roofline profile of camp guard towers, a procession of sentry boxes. Above the western entrance, a limestone mantel holds a solitary window containing sixteen solid "panes," framed by clear

24.21 I. M. Pei, Grand Louvre Pyramid, 1988. Paris.

24.22 Pei Cobb Freed & Partners, United States Holocaust Memorial Museum, 1993. Washington, D.C.

glass, reversing the normal order and obscuring the ability to look in or out. Inside, the physical layout ushers visitors through the exhibits in a sequence of experiences. The central, skylit, brick-and-steel Hall of Witness sets the stage of deadly efficiency that is echoed throughout this museum. The expansive use of exposed steel trusswork is an ever-present reminder of the death chambers. Vertically piercing the entire structure is the Tower of Faces, a chimney-like shaft lined with photographs of the people of a village that was essentially annihilated in the Holocaust. One passes through the Tower of Faces on a bridge, surrounded above and below by the faces of men, women, and children for whom the chimney was the ultimate symbol of fear. The personal detail of the faces is contrasted by the painting and sculptures commissioned for the museum from abstract artists—Ellsworth Kelly, Sol LeWitt, Joel Shapiro, and Richard Serra. From the main floor and on the way out, visitors climb an angled staircase to the second floor, which is highlighted by the hexagonal, light-filled Hall of Remembrance.

A very different structure is a Pei project of 1995, the Rock and Roll Hall of Fame and Museum in Cleveland, Ohio (fig. **24.23**). It is an elegant monument to the world's most subversive art form. All of Pei's work, from the East Building of the National Gallery of Art in Washington, D.C. (see fig. 21.45) to his Louvre Grand Pyramid in Paris (see fig. 24.21), reflects an obsession with Euclidean geometry, a system that analyzes the physical world in terms of the cube, the sphere, and the pyramid.

24.23 I. M. Pei, Rock and Roll Hall of Fame and Museum, 1995. Cleveland, Ohio.

Pei's fascination with the pyramid, which he explored in the Louvre project, carried over into the Rock and Roll Museum. A 117-foot-high (35.6 m) glass-and-steel tent leans at a forty-five-degree angle against a tower with cantilevered wings. The building is an architectural interpretation of the explosiveness of rock music. Pei himself has said that he took the explosion metaphor from rock's rebelliousness and energy.

The building has three major elements: the glass tent; the tower containing exhibition spaces; and a plaza with administrative offices, archives, storage, and more exhibition spaces. One wing houses a forty-four-foot-diameter (13.4 m) cylindrical space for viewing films supported by a single column that plunges into the lake. The other wing comprises a 125-seat, cube-shaped auditorium that juts above the water without any visible means of support.

Ando and Pelli

In any age, designing a house of worship requires the crafting of spaces that encourage and direct emotional and intellectual experience. Japanese architect **Tadao Ando** (b. 1941) has designed some of the most effective places of worship in the modern idiom, using precision-cast reinforced concrete—partly to make his buildings earthquake-safe—and siting the buildings and their precincts with extraordinary sensitivity to the surrounding topography. One such project is his 1988 Chapel-on-the-Water (fig. **24.24**). Located on a small plain in the mountains on the northern Japanese island of Hokkaido, this church is part of a year-round resort. The structure consists—in plan—of two overlapping squares. The larger, partly projecting out into an artificial pond, houses the chapel, and the smaller contains the entry and changing and waiting rooms. A free-standing L-shaped wall wraps around the back of the building and one side of the pond. The chapel is approached from the back, and entry involves a circuitous route: a counterclockwise ascent to the top of the smaller volume through a glass-enclosed space open to the sky, with views of the pond and mountains. In this space are four large concrete crosses. The wall behind the altar is constructed entirely of glass, providing a dramatic panorama of the pond with a large cross set into the water. The glass wall can slide like a giant shoji screen (the paper screens used to partition rooms in Japanese interior design), opening the interior of the chapel to nature. A 6,000-seat, semi-circular theater, northwest of the chapel, is designed to accommodate open-air concerts and other events. Set on a fan-shaped artificial pond, the amphitheater is intersected

24.24 Tadao Ando, Chapel-on-the-Water, 1988. Hokkaido, Japan.

24.25 Cesar Pelli, Petronas Towers, 1998. Kuala Lumpur.

by a long, bridge-like stage and a freestanding colonnade. A site wall points toward the church complex and turns at a sharp angle into the axis of the stage, tying the two structures together.

Internationally influential architect **Cesar Pelli** (b. 1926), dean of the Yale University School of Architecture from 1977 to 1984, expressed the importance of context in his assessment of the priorities of the architect: "A building is responsible to the place it occupies and takes in a city … the obligation is to the city. The city is more important than the building; the building is more important than the architect." Raised in Argentina, Pelli came to the United States in 1952 to study for a master's degree in architecture at the University of Illinois at Champaign-Urbana. His most visible buildings make stylish reference to their locales, often with motifs, and he is able to invest commercial buildings with a public and sometimes even spiritual presence by means of forms and open spaces, especially when designing public-space interiors.

No building reveals more characteristically Pelli's commitment to responding to local desires than the Petronas Towers in Kuala Lumpur (fig. **24.25**), at the time of completion the world's tallest buildings (they were first surpassed in 2004 by Taipei 101, designed by C. Y. Lee and Partners). The Towers, which are 1,483 feet (452 m) tall, respond in their design and detailing to the local Malaysian culture as well as declaring, through their great height, confidence in the strength of the Asian economy. The ground plan for the two towers is based on an Islamic design of overlaid squares and inset circles. The result is a sixteen-sided façade that alternates between curved and flat walls. As the towers ascend they are set back six times and tilt inward to accent the grace of the exterior lines. Sheathed in stainless steel and reflecting bands of fenestration, the massive towers appear to be decorated with the blue sky above Kuala Lumpur. The windows were designed for the climate: a system of panes and shades decreases the amount of light and heat that enters the rooms. Culturally as well as climatically sensitive, the architect decorated the interior spaces with traditional Malaysian arts. The centerpiece of the ground floor, set in between the towers, is a concert hall. The plan for the towers includes open space to accommodate future urban development. Pelli's concern

with creating architecture that interacts with the city can also be seen in projects such as the World Financial Center in New York, which houses the commercial development for the Battery Park neighborhood in Lower Manhattan, and in the Abandoibarra Master Plan for the Waterfront along the Nervión River in Bilbao, Spain.

What Is a Building?: Deconstruction

The work of the Iraqi architect **Zaha Hadid** (b. 1950) points in a very different direction from that of Stirling, Isozaki, Pelli, and Ando. Her buildings exploit the possibilities of deconstructionist theory, which challenges the standard functions, uses, and perceptions of a building, in much the same way as in the fields of literary criticism and art history (see *Deconstruction versus Deconstructivism*, p. 676). Deconstructionism and deconstructivist architects are a Postmodern phenomenon, although usually not regarded as mainstream Postmodernist. Born in Baghdad, Hadid studied mathematics in Beirut, was trained in architecture at the Architectural Association in London (1972–77), and

Deconstruction versus Deconstructivism

The theories that comprise Deconstructivism are loosely derived from Deconstruction, a philosophy associated most closely with the writings of French literary critic Jacques Derrida (1930–2004). Briefly, Deconstruction holds that the meaning of any text cannot be determined absolutely; words carry multiple associations, and these associations increase and shift with each new reading. Rather than grow frustrated in a futile pursuit of the definitive interpretation of any text, Derrida developed a strategy for reading that reveled in the wealth of possible interpretations. His mode of Deconstruction involved a word-by-word analysis of a text, exploring the multiplicity of signification contained in each word or, at times, in fragments of words or even letters. Peter Eisenman, one of the architects closely associated with Deconstructivism, collaborated for a time with Derrida. Others linked closely to Deconstructivism include Frank Gehry, Zaha Hadid, Rem Koolhaas, and Bernard Tschumi.

The process of realizing a work of architecture is complex and often protracted, whether because of design modifications or construction delays. Architects often work in teams and, unlike their counterparts who create sculptures or paintings or other portable artworks, they generally must accommodate the interests of their patrons. These conditions make architecture a process of negotiation where moments of creative clarity alternate with periods of distraction or outright interruption. Whereas the International Style of architecture valued purity and simplicity of form, pursuing designs that would appear inevitable and timeless, Deconstructivist architecture frankly asserts its status as something designed and fabricated over time. Time, in particular, is emphasized in Deconstructivist designs. Deconstructivist buildings often convey a sense of movement and of change. Architecture is temporal: to experience a work of architecture requires the viewer to move around and through it, an encounter that unfolds over time. This acknowledgement of architecture's temporal character stands in contrast to International Style tendencies to suppress time.

24.26 Zaha Hadid, *Vitra Fire Station*, 1993. Weil am Rhein, Germany.

The Vitra Fire Station shows a high sense of individual personality in its vigorous use of space. The architectural concept has been developed into a layered series of walls that alternate between void and volume, giving the impression of speed and escape. Constructed of exposed reinforced concrete—a very appropriate medium for Hadid to realize her sculptural expressiveness and ambitiously long spans and cantilevers—the whole building is movement suspended in time and space, expressing the firefighter's tension between being on the alert and the possibility of exploding into action at any moment. Special attention was given to the sharpness of all edges, and any attachments, such as roof edges or claddings, were avoided lest they detract from the simplicity of the prismatic form and abstract quality of the architectural concept. This same absence of detail informed the frameless glazing, the large sliding panes enclosing the garage, and the treatment of the interior spaces. The surrounding landscape seems to stream into the building, testimony to Hadid's reputation as an assertive sculptural architect and to her unique ability to transcend building mass with pure anti-gravitational energy. Yet the question inevitably arises whether such bold, sculptural anti-functionalism is suitable to the actual purpose of the building, or for that matter to anything else.

Also deconstructivist and neither a park nor a building in the traditional sense, Parc de la Villette (1982–91)—an open space in a working-class district of Paris that more closely resembles a large architectural and environmental sculpture—is the first built work of deconstructionist theorist and teacher **Bernard Tschumi** (b. 1944). His design for the master plan and structural elements of Parc de la Villette (*villette* means "little city") (fig. **24.27**) was selected from more than 470 entries in an international competition. The 125-acre (50.5 hectares) park includes walkways, gardens, and a canal, and thirty bright-colored, geometrical *folies*, small structures containing cultural and

established her own practice in 1979. She was one of the first experimental female architects to make a substantial reputation and impact in the second half of the twentieth century. Her Vitra Fire Station in Weil am Rhein (fig. **24.26**), from 1993, is a prime example of deconstructivist architecture. The work of painter Kazimir Malevich (see figs. 10.31, 10.32) has served as a basis for her work, and she says that her inspiration derives from the principles of Suprematism—a concept developed by Malevich and expressed by the reduction of the picture to Euclidean geometric arrangements of forms in pure colors, designed to represent the supremacy of pure emotion. Thus many of her projects exist as unbuilt, utopian investigations.

24.27 Bernard Tschumi, Plan, Parc de la Villette, 1982–91. Paris.

recreational facilities including a cinema, a video workshop, information and day-care centers, and a health club.

The organizing principle of the park's design is the superimposition of three independent ordering systems, each of which uses a separate vocabulary of either lines, points, or surfaces, so that there is no single or true master plan. In combination, the logic of each system loses its coherence, and accident and chance become determining factors in the resulting design. The most prominently ordered system, the 400-square-foot (37 m²) grid of points, is marked by the evenly spaced locations of the *folie* structures. Each *folie* is based on a cube, which is then "cut away," or reconfigured, transforming pure geometry into dissonance.

Tschumi, who was dean of the Graduate School of Architecture, Planning, and Preservation at Columbia University from 1988 to 2003, uses the tools of architecture to question the validity of its own rules. Employing multiple organizing principles, he sets them up to collide with one another, each one serving to cancel, interrupt, and undermine the others—asserting that there is no pure space, that activity necessarily and unapologetically violates architectural purity. The three ordering systems of the park allow for almost infinite variations on this theme.

During much of the twentieth century, the machine served as one of the most ubiquitous cultural metaphors, especially in regard to architectural form and theory. Designers have tried not only to emulate its aesthetic qualities but to envision an architecture whose relationship to its function corresponds as directly as that of a machine to its purpose. The spare beauty of Le Corbusier's Villa Savoye (see fig. 21.6), for example, is due to his resoluteness in applying the machine metaphor. Tschumi, on the other hand, proposes that architecture is continually transformed by the quotidian events taking place in and around it, events too varied and complex to be described by any one architectural program, such as the International Style. Rather than imposing a structure on the disorderliness of urban life, Tschumi's Parc de la Villette is emblematic of the metropolis and its inherent intricacies. It becomes a stage set for an infinite number of human activities, both planned and spontaneous, authorized and illicit, which momentarily form part of the metropolis. Parc de la Villette thus affirms the random disorderliness and vibrancy of the city. With its keen awareness of the importance of events that surround it, Tschumi's architecture aspires to an inclusivity reflecting the haphazard complexity of the modern metropolis.

The intellectual strain in the architecture of the 1980s and 90s achieves extreme form in the work of the American deconstructivist theoretician and architect **Peter Eisenman** (b. 1932). As a deconstructionist, Eisenman puts buildings together out of parts and elements that are not inherently unified or related, so that the realized structure may not serve the usual function or expectations for a building. Eisenman's first building to gain wide attention was the Wexner Center for the Visual and Performing Arts, a contemporary art museum at Ohio State University, Columbus, Ohio (fig. **24.28**). The center, built between 1983 and 1989, strikingly exemplifies Eisenman's commitment to architecture as an intellectual as well as a material art. The project is an intricate complex of construction and landscape, an "archeological earthwork" as Eisenman termed

24.28 Peter Eisenman, Wexner Center for the Visual and Performing Arts, Ohio State University, 1983–89. Columbus, Ohio.

it, that radically breaks with the predictable order of the traditional bucolic American academic campus. Conceptually and physically, the design connects the academic community with the Columbus civic community by mediating the historic plan of the campus, which was set at a 12.25-degree angle from the grid of the city (fig. **24.29**). By locating a center at this point of intersection between the civic and academic life of the city, Eisenman suggests that the metaphor of meeting place rather than repository best suits the contemporary museum. Symbolic of the act of collision and exchange is what the architect calls a "scaffolding" of square white steel pipes whose formation is a "metaphoric microcosm of the urban grid." The 140,000-square-foot (13,006 m²) building houses the experimental arts of computers, lasers, performance, and video as well as exhibition galleries, a café, a bookstore, and administrative offices. The most memorable image resulting from Eisenman's preoccupation with geometry and iconography is the rigorous coupling of architecture and landscape in a manner that revives, or at least harks back to, the formal geometric integration of garden and building of seventeenth-century European palaces. The Wexner Center marks a turning point in Eisenman's career that, as he has commented, "has conditioned everything that followed, because you begin to think, how do you build ideas, and not just project them?"

24.29 Peter Eisenman, Competition model for the Wexner Center for the Visual and Performing Arts and Fine Arts Library (plan view), 1983. Ohio State University, Columbus, Ohio. Frank Dick Studio.

Structure as Metaphor: Architectural Abstractions

Italian architect **Renzo Piano** (b. 1937) has been reimagining architectural metaphors for cultural and institutional power since his collaboration in the 1970s with English architect Richard Rogers in the design of the Centre Georges Pompidou, the controversial "inside-out" home of modern and contemporary art in Paris that showed his fascination and respect for the infrastructure of buildings (see fig. 21.26). More recently, Piano won the commission to design an all-new major airport, Kansai International Airport in Osaka, Japan, which opened in 1994. Over the years, Piano's work has become more refined and restrained without a loss of interest in technology and materials. The soaring waiting halls at the Kansai International Airport (fig. **24.30**) are examples of Piano's easy relationship with industrial-strength materials and his elegant use of them on a very grand scale.

Canadian-born American **Frank O. Gehry** (b. 1929) is another major figure whose approaches identify him with Postmodern design. His work, invariably witty, has generated variations on themes as refined as the modernist cube and as ordinary as a fish. His California Aerospace Museum

24.30 Renzo Piano, Waiting room, Kansai International Airport, 1994. Osaka, Japan.

(fig. **24.31**), completed in 1986, is a showcase for jet-age technology. Through its good-natured combination of disparate forms, materials, and scale, the structure clearly evokes the spirit of flight. Impaled on a cruciform strut above the forty-foot (12 m) "hangar" door is the most

24.31 Frank O. Gehry, State of California Aerospace Museum, 1982–86. Los Angeles.

24.32 Frank O. Gehry, Claes Oldenburg and Coosje van Bruggen, Chiat/Day Building and *Binoculars*, steel frame, concrete, and cement plaster painted with elastomeric paint, 45 × 44 × 18' (13.7 × 13.4 × 5.5 m), 1991. Venice, California.

24.33 Frank O. Gehry, Guggenheim Bilbao, 1991–97. Interior. Bilbao, Spain.

sensational aspect of the building's design: a Lockheed F-104 Starfighter plane. The gigantic, thematically appropriate aircraft does not upstage the museum—no small feat considering the drama of the spectacle. It is simply a bold ornament applied to a bold building.

Of a similarly allusive style is Gehry's good-humored Chiat/Day Building of 1991 on Main Street in Venice, California (fig. **24.32**). The headquarters for an advertising firm, the Chiat/Day Building is a collaboration between Gehry and the sculptors Claes Oldenburg and Coosje van Bruggen (see fig. 23.21). Oldenburg and Van Bruggen's mega-sized *Binoculars* forms the portal to an interior that is essentially open yet accommodating to impromptu meetings and plug-in work sites for its drop-in, drop-off employees.

By the 1990s, Gehry had modified his expressive language from the geometry and decoration of the Aerospace Museum and the Chiat/Day to a more organic architecture that evokes the breeze more than it does a fighter plane. Still working in a manner that he shares with Oldenburg and Van Bruggen, Gehry's late-style buildings start with blocks covered in gauze and crumpled paper. Using computer renderings, these architectural sculptures provide the source for one of the most ethereal and recognizable architectural styles of the century. Structures like the Guggenheim Museum in Bilbao, Spain (see fig. 27.39) provide another chapter in the history of expressive architecture begun with the theorized, though rarely built, work of Erich Mendelsohn and Antonio Sant'Elia.

The Bilbao museum is a monumental abstraction built in the capital of the Basque region. Gehry's design was inspired by Bilbao's industrial history and the curving Nervión River, which once supported thriving mills and shipyards. The building combines the geometry of classical modernism with the organic whimsy of Expressionism (fig. **24.33**). Gehry designed the museum to resemble a metal flower rising up from the riverfront. Designed with the aid of CATIA, a computer program created by the French aerospace industry to translate sculptural models into specifications for manufacture, the museum rises to a towering point of reinforced concrete at the north end that appears to hover impossibly in the sky. Undulating walls and ceilings sheathed in titanium open out from this peak like giant petals blown in the wind or floating on the river. To the east of the building is a huge exhibition space, 450 × 80 feet (137 × 24 m), for the display of large-scale sculpture. The organic and expressive design elements of the building are anchored by six Spanish limestone cubes that recall the severe geometry of the International Style. These elements house more traditional-style white box galleries, a library, auditorium, restaurant, and retail spaces. The cubes are arranged in two flanks that extend from the flower to the west and south. From the west, hints of the metallic flowers peek out from behind the stone walls, creating a sense of drama as one circles the building.

The design of the blossoming flower can be read as a metaphor for the political and economic ambitions of the Basque government to assert itself on an international stage. Intent on doing more than symbolizing the growth and stability of the region, Gehry responded to the needs of the city as well as the art collection, with the building combining the function of a museum with facilities for Bilbao's citizens. The restaurant, auditorium, and retail spaces are all accessible from the street independently of the museum. Likewise, a significant part of the collection will represent local art history. Gehry's Guggenheim has proven to be one of the signature works of the late twentieth century, not only because it is the pinnacle of a great architect's career, but also for its elegant summation of the collaborations possible in the increasingly international world of culture.

As late-twentieth-century cultural politics provided the impetus for the Guggenheim Bilbao, new technologies have inspired what may be one of the most surprising new museums of the twenty-first century. The architect team of Diller + Scofidio (**Elizabeth Diller**, b. 1954, and **Ricardo Scofidio**, b. 1935) has designed a multi-use building (fig. **24.34**) to house the production, exhibition, and education programs of Eyebeam, a foundation that sponsors digital art.

24.34 Elizabeth Diller and Ricardo Scofidio, Eyebeam Museum project, 2001.

24.35 Santiago Calatrava, Manrique Pedestrian Bridge, 1996–98. Murcia, Spain.

The museum of digital art is designed to rise from a standard rectilinear ground plan in Chelsea, New York, in the form of a ribbon looping across the plot, up to the next floor, and back over to divide the stories in an S-shaped curve to the top of the building. In addition to forming the floors, walls, and ceiling of the museum, the ribbon, a two-ply construction, will house the substantial electronic infrastructure required to power a collection of computer-based art. While providing the technological support absent from most museums, Diller + Scofidio's design creates an image for Eyebeam that looks like that of no other museum. Like the duo's projected exhibition hall Blur, a museum enveloped in an artificial cloud above Lake Neuchâtel, Switzerland, the Eyebeam building and the best of the art that it will house announce a new kind of aesthetic journey.

The sculptural basis for **Santiago Calatrava**'s (b. 1951) designs (for which he is both architect and engineer) presents itself most emphatically in his bridges (fig. **24.35**), which summon the exquisite balance and surprising formal relationships explored in Constructivist pieces by artists like Naum Gabo and El Lissitzky (see figs. 14.21, 10.33). While the elegant simplicity of form and forthright presentation of materials evince a modernist sensibility, the exuberance of Calatrava's designs far surpasses any reasonable conception of "form follows function." This is especially evident in his design for a Chicago skyscraper (fig. **24.36**). Calatrava envisions a spiraling 150-story residential complex that will corkscrew into the sky alongside Lake Michigan. Eight blocks away from Mies van der Rohe's Lake Shore Drive Apartments, Calatrava's Chicago Spire conveys a dizzying dynamism when compared with Mies' venerable and emphatically stolid rectilinear building.

24.36 Santiago Calatrava, Chicago Spire, 2007–. Chicago.

Flexible Spaces: Architecture and Urbanism

Modern art began at the intersection of cultural and urban change. Whether one discerns its origins in the nineteenth century, as we have, or in the eighteenth or seventeenth, as others have, modernism is rooted in the effects of industrialism, revolution, and economic transitions on the urban environment. Dutch Naturalism was generated in relation to the economic transformation of public and private life in the Netherlands during the second half of the seventeenth century; French Romanticism and Neoclassicism developed hand in hand with the configuring of Paris as an imperial center, revolutionary capital, and Napoleonic showcase; and realism, Impressionism, and photography were intimately related to demographic changes in Europe and the United States. In the Postmodern era, urbanism has also been central to cultural production. Venturi and Scott Brown's lesson in *Learning from Las Vegas* that "the order of the Strip includes" is an anthem for Postmodern artists and architects. Inclusion took on significance as it came to provide metaphors for the increasingly urban character of contemporary global society. In the west, two urban planning strategies developed to reckon with the chaotic heterogeneity that was coming to dominate daily experience. One, first described as neo-traditional planning when it arose in the early 1980s and then dubbed New Urbanism, attempted to recast early twentieth-century small towns to contain urban growth. The other strategy, practiced most spectacularly by Rem Koolhaas and his Office of Metropolitan Architecture (OMA) (see fig. 24.40), embraced the density, variety, and flux of existing late twentieth-century cities by building large-scale structures that, like much Postmodern art and architecture, sought to facilitate change within stable yet flexible architectural space.

Plater-Zyberk and Duany

Miami-based architects and planners **Elizabeth Plater-Zyberk** (b. 1950) and **Andres Duany** (b. 1949) are acknowledged leaders of the New Urbanists. They are contemporary architects who seek to reform America's communities. Their remedy is as much moral as it is aesthetic. They believe that traditional town planning—a grid of streets lined with trees and front porches, studded with shops and parks—can heal the nation's fragmented sense of community. In their 1991 book, *Towns and Town-Making Principles*, the authors champion a concern for the small-scale design decisions that make streets, blocks, and neighborhoods aesthetically pleasing. Since then, their firm, DPZ, has become much more heavily involved in urban planning.

At Seaside, DPZ's eighty-acre (32 hectares) resort town on the Florida Panhandle, it took ten years to build the hundred different houses and buildings, including a fire station, restaurant pavilion, and town hall (fig. **24.37**). It is one of the new "old" towns created as part of the New Urbanist movement. The tenets of the movement include creating pedestrian-oriented places organized around public open spaces—the antithesis of the postwar auto-oriented suburb. Residents are only a few minutes' walk from any part of the development. Ultimately, New Urbanists aim to design cohesive, environmentally sensitive places that look very much like traditional towns or big-city neighborhoods.

DPZ's experience in laying out Seaside, a prime example of a New Urbanist development, offers an idea of the opportunities that New Urbanism provides for architects. Each element is seen as a part of the whole, and architects are able to participate in town planning on a wide scale. They design not only the houses, but the streets, the blocks, the park—the whole community. In the most famous of the New Urbanist towns, the Walt Disney

24.37 Elizabeth Plater-Zyberk and Andres Duany, Seaside, aerial plan view, 1980s. Florida.

Company's Celebration, Florida (fig. **24.38**), regulations specified window size, curtain color, and placement of trees in the front yard. Celebration was opened to residents in 1996 and contains some of the most sought-after residential property in central Florida. Its residents are the most affluent and educated of the region. Forgoing the cul-de-sacs of many suburban developments, Celebration, like Seaside, brings back the grids that organize proto-typical small towns as well as major urban centers. Located next to Walt Disney World Resort, Celebration provides a case study of the role of New Urbanism in relation not only to city planning, but also to corporate relations. Faced with an excess of land, the Walt Disney Company created Celebration as a planning experiment. The city featured attractive homes, a good school, and a retail district within walking distance. The city was eligible for public money to make major improvements to the infrastructure of the region, which helped traffic flow in and around Disney's amusement parks.

Despite the attractiveness of Celebration to corporate and private interests in Florida, the New Urbanists' claims that the form of the gridded small town fosters cohesive communities have been contested. Several studies of Celebration showed that, while porches and well-traveled sidewalks foster a degree of community spirit, relationships tended to be formed over affiliations; that is, involvement in groups such as schools or other organizations based on shared interests or identity. These affiliations tended to exist independently of geographic proximity. Likewise, the presence of a downtown was not enough to create a centrally focused city. In Celebration, the high cost of buying property often meant that residents had less disposable income than they needed to be able to shop in the downtown boutiques and restaurants. Researchers found that residents saw the city's commercial services as more directed to visitors than to local people. Nonetheless, the residents have formed a civic bond as participants in a collective experiment. This bond may differ from old-fashioned town pride but has a similar effect.

The role of Disney as a corporate sponsor, designer, and majority owner of the town has introduced problems in the New Urbanist agenda, particularly the contradictory demographic influences exerted by the company in the region as a whole. While sponsoring the socially oriented Celebration, Disney was recruiting workers from Mexico and Puerto Rico who were not paid enough to live in the city. The influx of a low-paid and underemployed community aggravated the sort of urban problems New Urbanism sought to avoid. As seen in the case of Pruitt-Igoe (see fig. 24.1), form alone is not enough to transform urban life. Another tendency of New Urbanism that disturbs its critics is that many of its projects do not provide for existing buildings in their "new neighborhoods." Old buildings found on the sites of the new "community of neighborhoods" are tagged to be removed or razed. The objection to this is not that the new neighborhoods—with their planned roads, parks, and houses—are not attractive, but that they do not have a true history or an urban vibrancy, and that their lack of roots is disguised by a thin simulation of nostalgia and history. Though plans to fabricate a fictional history for Celebration were never executed, critics have claimed that New Urbanist planning often includes a troubling lack of physical or even intellectual mechanisms to allow for the kind of unexpected change that creates deep and individual urban histories.

24.38 Celebration, 1996. Florida.

Koolhaas and the OMA

An architect, urbanist, and theorist who has made the unexpected a central tenet of his practice on any scale (his most recent catalogue raisonné is called SMLXL) is **Rem Koolhaas** (b. 1944). Working in the deconstructionist tradition of Postmodernism, he collaborated with Zaha Hadid (see fig. 24.26) in 1978 on the design of the Dutch parliament building, The Hague, in his native Holland. The Netherlands Dance Theater (fig. **24.39**) is an example of Koolhaas' Postmodern vocabulary, from the huge, semi-abstract mural topping the main structure, to the mix of reinforced concrete, glass, metal, and masonry for the walls of its variously formed parts. The interior of the concert hall is constructed and detailed with aluminum, stucco, marble, and gold foil. The heterogeneous and often industrial materials serve as a metaphor for Koolhaas' conception that architecture is multipurpose. The theater caters to the multiple needs of urban life: municipal, cultural, economic, and architectural. In addition to the auditorium, the structure houses studios, offices, a sauna, a swimming pool, massage rooms, showers, and a restaurant. The entire building establishes relationships with an existing concert hall, parking garage, civic buildings, and a church square.

Koolhaas' concern with the context of architecture, demonstrated in the theater, lies at the center of his expansive studies of urban development, of which there are several volumes, beginning with 1978's *Delirious New York*. This took Manhattan as "the twentieth century's Rosetta Stone" and included analyses of major developing centers such as Lagos, Nigeria, and the Pearly River Delta, China. Like Venturi and Scott Brown, Koolhaas includes within the realm of architecture all manner of architectural, visual, urban, and popular culture. His studies give great weight to subjects as apparently different as Roman city planning and twenty-first-century shopping. Also like Venturi and Scott Brown, Koolhaas rejects the *tabula rasa* planning of either Le Corbusier or the New Urbanists. The solutions provided by Koolhaas' Office of Metropolitan Architecture (OMA) often revolve around "Megastructures"—centralized collections of multi-use spaces that concentrate all manner of civic activity within a single structure. Though similar in scale to the monumental projects of modernist city planning, these megastructures are constructed to respond to local metropolitan issues. The 1993 Euralille project in Lille, France, typifies the urbanistic flexibility that OMA practices. Lille is a hub for the high-speed train (TGV) as well as the major intersection for trains coming through the Channel Tunnel that connects Great Britain to the Continent. The location experiences one of the greatest volumes of traffic in Europe. OMA faced the challenge of creating an interface between the influx of visitors and the existing city. Their solution consists of a network of several huge structures that serve as monumental signposts and shelter for points of personal, geographical, economic, and artistic exchange, called "nodes" in OMA's terminology, existing in Lille. The railway station features sheet

24.39 Rem Koolhaas, The Netherlands Dance Theater, 1987. The Hague, the Netherlands.

24.40 Rem Koolhaas, Dutchtown, city center plan for Almere, the Netherlands.

glass walls that display the TGV, highlighting technology and transportation as the source of Lille's current character. This is an architecture that strives to be responsive to a society in flux.

Koolhaas' understanding of urbanism as "the staging of uncertainty" lies at the heart of OMA's design for the city center of Almere in the Netherlands. Almere, an enclave along the main artery from Amsterdam to its major airport, is the fastest-growing Dutch city. It has a number of significant buildings, but little overall character. With considerable foresight, Almere had been developed in four equal sections, with a fifth of the same size left relatively undeveloped. In this zone, OMA was asked to create a city center that would serve as a public destination and "logo" for the metropolis. Though conceived in commercial terms and with the requirement that it be attractive to investors, the downtown was also designed to give Almere an identity distinct from that of a dormitory community for people who work in Amsterdam.

OMA's strategy of urban design has been to create a center that contains a dense population and offers a diversity of functions and activities. The center joins municipal, commercial, and entertainment facilities with large-scale residences, all of which are readily accessible by automobile. In addition, the firm believes that the "position of the center must be visible and palpable throughout the city." In many ways, these strategies are the lessons learned in New York. The result, however, looks nothing like Manhattan. The plans (fig. **24.40**) detail a multilevel megastructure that contains veins for housing, retail areas, municipal purposes, offices, and parking spaces. There are levels and passages above and below ground. In addition to concentrating a variety of activities into several locations, OMA has left a considerable portion of the fifth zone open for future development.

Postmodern Practices: Breaking Art History

In the 1980s, a number of artists, and many more critics and theorists, declared a break with the modern era, identifying themselves as "Postmodernists." Postmodernism in art implied a dissatisfaction with the narrow confines of modernism, which apparently promoted the accomplishments of white, male artists of European descent at the expense of engaging political and social concerns, and non-majority and female artists. Postmodernism, by contrast, encouraged overtly polemical practices and an ironic distance from conventions of the past. At the same time that Postmodern critiques of art were being formulated, the audience and the market for new art were greater than ever. In this atmosphere, many younger artists were catalyzed to

reframe the history of art in a way that resonated with a Postmodern consciousness. The artists of the 1980s looked back to any number of historical styles, sometimes including several styles within one work, in order to recontextualize the achievements of modernism to give them significance in a Postmodern environment. Reclaiming the value of art premised on an authoritative position that was no longer valid was a difficult and contentious project. While some artists restated through appropriation the voices of the past in the company of the present, others created contemporary variations on styles of Expressionism, abstraction, installation, and assemblage. The sections that follow examine the aesthetic and political consequences of attempts in the 1980s to enlist traditions of historical modernism to speak to the present.

Appropriation: Kruger, Levine, Prince, and Sherman

Appropriation, the tactical borrowing and recontextualization of existing images, was one of the first identifying characteristics of an art that would be called Postmodern. Appropriation was most clearly evident in the work of a number of artists who, regardless of their training, relied on photography for their source material. Barbara Kruger, Sherrie Levine, Richard Prince, and Cindy Sherman, among others, presented photographs of photographs; photographs of television; photographs that looked like films; paintings of paintings; and paintings of photographs. These works all failed to assert any of the transformative effects expected of art. Like the citations made by Pop artists Roy Lichtenstein and Andy Warhol (see figs. 19.54, 19.57), Appropriation appeared to lack signs of creativity. As already discussed in this chapter, the appropriative strategy of pastiche was apparent in the work of the contemporary architects Robert Venturi and Philip Johnson, who seemed to be collaging historical styles to generate contemporary buildings. Forms appeared to be stolen and pasted together with little regard for the original context and, some worried, little regard for the immediate context either. This cut-and-paste procedure turned out to have great potential for visual practice.

To startled viewers of the late 1970s, Appropriation appeared to be a mean-spirited plagiarism that undermined the intuitive experience of looking at art. Appropriation artists did not intend to undermine the viewer, but they believed it was critical that viewers did not confuse the creativity of the artists' sources with the intention of the new work. They adopted devices for keeping the viewer aware of the mechanics of Appropriation and distanced from the traditionally expressive aspects of art, such as quoting easily recognizable sources like Mondrian or the Marlboro Man; adopting stylistically disruptive features such as collage or dramatic cropping; and creating titles that explained the appropriation. Like Duchamp or Fluxus (see figs. 11.8, 22.10), Appropriation artists insisted that the borrowed item was meaningful because of its position, and their creative act lay in framing it. In this way, Appropriation

may be understood as akin to sampling in popular music, which likewise became widespread during the 1980s.

Appropriation turned out to be an effective strategy for dealing with the power of the mass media and even stealing its thunder. By extracting images from their familiar original contexts and mixing them with other images from different sources, Appropriation strips iconography of its original import. At the same time, by putting borrowed images into a new context—that is, by "recontextualizing" them—it also endows those images with a new and often unsettling impact that encourages viewers to see the original sources in a new light. This startling effect—making us see familiar images afresh, as if for the first time—is the source of Appropriation's power as a critique. In the critical language of the day, this effect made Appropriation art "deconstructive"—setting in motion an analytical process that takes apart and exposes the image-maker's designs on us. Art of this kind gives us a more sophisticated awareness of how easily we can be manipulated by visual images.

Kruger

A notable example of the deconstruction process at work is found in the art of **Barbara Kruger** (b. 1945). Her picture-and-text combinations, such as the iconic *Untitled (Your Gaze Hits the Side of My Face)* (fig. **24.41**), reveal the most manipulative aspects of modern media culture. Kruger, who in the mid-1960s had worked as a graphic designer at *Mademoiselle*, appropriates the look of a glossy magazine layout (fig. **24.42**). Fashion magazines are an especially clear example of contrived visual meaning, since they freely crop and group their pictures and impose captions on them, in order to force the images into the particular "story" that the photo editor wants to tell. By borrowing these techniques, and by bringing them to the surface where we cannot miss them, Kruger makes it obvious that our response, not only to this picture—taken from a 1950s photo annual—but to any media image, is largely dictated by the editorializing of its presenter. Our understanding of what we see is not a simple, direct response to the optical facts; rather, it is something that has been "constructed" for us.

Work like Kruger's suggests that artists can also turn the tables. If the media can manipulate images in order to convey new meanings, so can artists—by taking such images back and giving them yet another new spin. In so doing, artists can open the viewer's eyes to the complex, ambiguous process by which the meanings of virtually all pictures are constructed. In fact, one can uncover a good deal about how a culture works and what it believes by "deconstructing" the way it uses visual images. This process of deconstruction reveals how certain images function to enforce social myths rather than any underlying truth. The force of continual scrutiny, for instance, experienced by women in a society that valorizes mythic standards of beauty, is captured in Kruger's image with the metaphor of a slap.

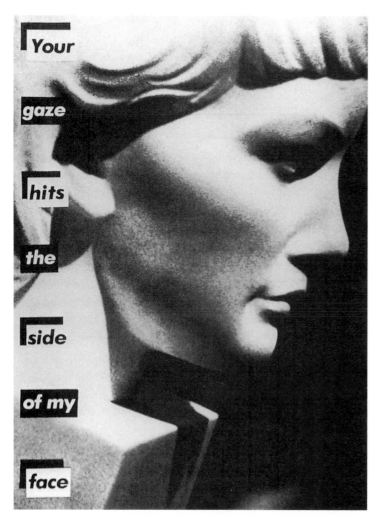

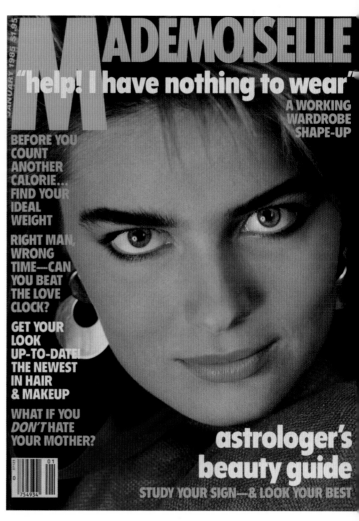

24.41 Barbara Kruger, *Untitled (Your Gaze Hits the Side of My Face)*, 1981. Photograph, 60 × 40" (152.4 × 101.6 cm). Collection Vijak Mahdavi and Bernardo Nadal-Ginard.

24.42 Cover of the January 1, 1985 issue of *Mademoiselle* magazine.

The quintessential Postmodernist among American artists may be **Sherrie Levine** (b. 1947), for her work most clearly represents familiar images from the canon of Western art history. Levine first startled the art world in 1981 with an exhibition of her own unmanipulated photographs of well-known, textbook examples of images taken by such master photographers as Edward Weston, Walker Evans, and Aleksandr Rodchenko (fig. **24.43**). Levine's replication of these iconic images pointedly undermined the ideals of modernism—originality, authenticity, and the unmediated link between the image and meaning. The presentation of familiar images—an interior of a poor Southern home by Evans for instance—authored by Levine forced the viewer to contemplate not the sublime geometry of the home and the corresponding moral rectitude of its inhabitant, as Evans intended, but the network of political, cultural, and commercial forces that sent Evans to the South and his work to the museum. Levine's copy confronts us with impurity, ambiguity, and politics in place of Evans' impeccable clarity.

After completing this series of photographs, Levine realized that her subversion of these traditional standards of artistic value could be accomplished not only through

photographic reproduction, but also through the insertion of her own touch. As a woman artist, deconstructing artworks by male artists by redoing them in watercolor carried its own feminist statement. Levine began hand-painting watercolors and gouaches "after" art-book reproductions of paintings by Léger, Mondrian, Lissitzky, and Stuart Davis—complete with printing flaws. Her *After Piet Mondrian* (fig. **24.44**) substitutes the measured tension and coloristic balance of Mondrian's painting with the slightly green imperfections of the textbook reproduction that is Levine's original. Like Polke's *Bunnies* (see fig. 25.7), Levine's copy of a mass-produced reproduction draws attention to the transformation of everything from sex to art into commodities traded in the cultural or political economy.

Levine pursued similar goals in a subsequent series consisting of what were less pure appropriations than "generic paintings," as the artist calls them. One series consists of small casein and wax panels offering two-color variations on a single theme of one narrow and three wide stripes. Here the model was a composite of all the great modernist stripe painters, again a pantheon of male artists, including Barnett Newman, Ellsworth Kelly, Brice Marden, Frank

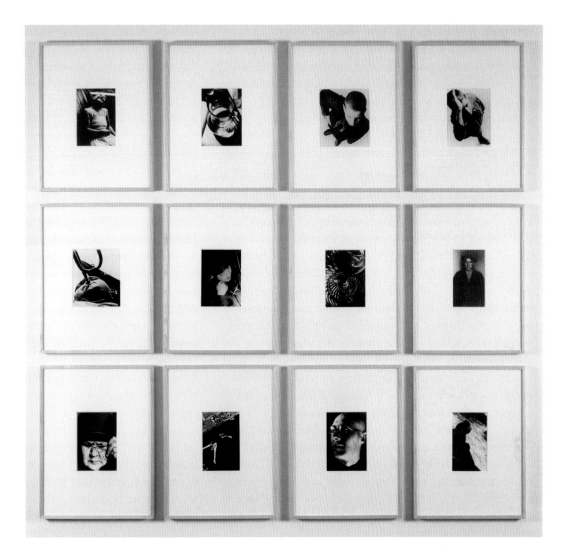

24.43 Sherrie Levine, *After Alexander Rodchenko, 1–12*, 1987–98. Twelve gelatin-silver prints A.P. I/I, edition of five, 8 × 6" (20.3 × 15.2 cm) each. Solomon R. Guggenheim Museum, New York.

Stella, and Daniel Buren. While the new works present the overall look of Minimal painting, they copy no one masterpiece or specific style. Instead, the artist takes on the male-dominated aesthetic of high modernism in a "generic" fashion. Despite Levine's evident iconoclasm, she is not without models, perhaps most significantly Marcel Duchamp, with whose readymades (see figs. 11.8, 11.9) the artist has acknowledged an affinity.

Like Duchamp's readymades or Pop icons such as Warhol's soup cans or Lichtenstein's comics, Appropriation was criticized because it failed to visibly transform its motif from reality into art. Artists countered this response in several ways. First, they insisted, like Duchamp, that art is not limited to those objects that render the appearance of reality in alternative forms or materials. Secondly, it was argued that transformation was in the mind of the artist, not the eye of the beholder. Kruger and Levine's work alone amply showed the efficacy of Appropriation as a transformative tool, as each radically recast our understanding of familiar objects. Finally, Appropriation was shown to be generative in rather old-fashioned terms as a form of drawing.

Richard Prince (b. 1949) developed a body of work that draws attention to the artifice underlying myths of American individuality and to Appropriation as a tool to

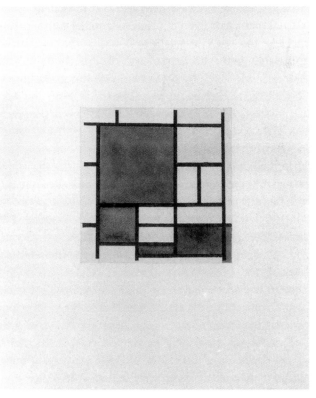

24.44 Sherrie Levine, *After Piet Mondrian*, 1983. Watercolor, 14 × 11" (35.6 × 27.8 cm). Private collection.

deconstruct them. In a series of works including *Untitled (Cowboy)* (fig. **24.45**) Prince re-presented the protagonist of televised cigarette ads. Avoiding the posture of "original" taken on by Levine's work, these photographs of television screens are self-conscious about their artificiality. They advertise the act of theft that is at the root of Appropriation and, unlike the myth of American manhood and tobacco consumption that they present, are clear about their misleading qualities.

Prince is distinguished by the clarity with which he conceived Appropriation as a formal tool. Early in his career, he enumerated different methods of appropriating that, like Sol LeWitt's instructions (see fig. 20.52) or Jasper Johns' repertoire of marks (see fig. 19.35), determine the appearance of the final works of art. With a list of eight different variations including the original copy, the rephotographed copy, the angled copy, and the out-of-focus copy, Prince showed Appropriation to be a form of mark-making related to art of the previous decades.

Beginning in 1978, **Cindy Sherman** (b. 1954) allied the arts of Performance and photography; she cast herself as the star of an inexhaustibly inventive series of still photographs called *Untitled Film Stills* sometimes characterized as "one-frame movie-making" (fig. **24.46**). Complete with props, lighting, make-up, wigs, costume, and script, most of the pictures exploited, with the eventual goal of subverting, stereotypical female roles appropriated from films, television shows, and commercials of the 1950s and 60s. Her characters ranged from a bored suburban housewife to a Playboy centerfold. In 1980–82 Sherman began working in color and in near-lifesize dimensions. As the pictures grew larger, the situations became more concentrated, focusing on specific emotional moments rather than implying the fuller scenarios seen earlier. Setting, background (supplied by a projector system), clothes, wig, make-up, and lighting combined with the performance

itself to create a unified mood: anxiety, ennui, flirtatiousness, or confidence. Sherman displays exquisite control over the tableaus, from the unified color schemes to disturbing details such as the black scuffs where a door has been kicked in (see fig. 24.46) or a piece of torn newspaper clutched by a plaid-skirted teenager sprawled on a linoleum kitchen floor. Like a Hitchcock heroine, the subject seems vulnerable to something outside the photographic frame.

Sherman's project, like Kruger's, is based on examining the notion that "woman" does not exist apart from socially constructed images of femininity and exploring the self-conscious assumption of that role by the woman herself. However near or distant the quoted source, Sherman and her fellow "image-scavengers" cause us to question our reliance on images and our relationship to the authority they wield. Integral to the role of images in the formation of feminine identity is the role of what has been theorized as the "gaze": the act of observation as it is implicated in power relations between those who observe and those who are observed. Traditionally, in both society and art history, women are most often objectified by the gaze; they are placed in the position of something to be possessed, enjoyed, and understood through vision. The centrality of female sex symbols in Western culture testifies to the conventional understanding that looking is different for men than for women, and it is no coincidence that those who do more of the looking have more power than those who are looked at. Sherman's imagery undermines the expected dynamic of the woman/model/subject being revealed through representation by the man/artist/observer. Not only is she the artist and the model—the watcher and the watched—but, as a subject, her identity is never secure. The question of "who is Cindy Sherman?" is made as unanswerable as it is inevitable. The *Untitled Film Stills* introduce an artist in possession of the gaze even while she is the object of it.

24.45 Richard Prince, *Untitled (Cowboy)*, 1991–92. Ektacolor photograph, 48 × 72" (122 × 183 cm).

24.46 Cindy Sherman, *Untitled Film Still #35*, 1979. Photograph, 10 × 8" (25.4 × 20.3 cm). Courtesy of the artist and Metro Pictures, New York.

In the late 1980s, Sherman's work shifted from the focused study of contemporary identity to an exploration of culture as the intersection between the social and psychological. One means of approaching this idea was through the notion of abjection, an idea drawn from the psychoanalytic theories of Julia Kristeva, who argues that the human psyche finds itself as attracted as it is repulsed by graphic scenes of horror. The horrible is that which cannot be explained, categorized, or controlled by society; it is cast off as inarticulate and disgusting. But in this realm of abjection is a kind of liberty, a means of expressing ideas and impulses that refuse to be managed by social norms. Laughter and sex along with vomiting were all linked by Freud with the abject, which he connected to the dangerous and polluting capacity of femininity; Kristeva mobilized this association to claim in the abject an expression of feminine power. Some artists and writers embraced the abject as a vehicle for giving rein to the distinctly feminine unconscious with its unique desires and anxieties. *Untitled #175* (1987) (fig. 24.47) presents the artist reflected in sunglasses dropped among the residue of incredible gluttony. It is no longer the violence of the gaze that is featured but the desire to look upon violence that

24.47 Cindy Sherman, *Untitled #175*, 1987. Colour photograph, 47½ × 41½" (120 × 105 cm). Courtesy of the artist and Metro Pictures, New York.

Sherman explores in all the baroque luxuriance allowed by photographic technology.

By 1990, Sherman had turned her aesthetic of entropy to unsettling the refined territory of art history: *Untitled #224 (after Caravaggio's Bacchus)* (fig. 24.48) presents the artist in the appropriated guise of Caravaggio's canonical figure, who straddles the boundaries between realism and fantasies of arcadia and homoerotica. By dressing

24.48 Cindy Sherman, *Untitled #224 (after Caravaggio's Bacchus)*, 1990. Photograph, 48 × 38" (122 × 96.5 cm). Courtesy of the artist and Metro Pictures, New York.

herself as Bacchus, god of wine, and her photography as seventeenth-century Baroque naturalism, Sherman collapses the history of realism. Her picture alludes to the collision of sensuality and reality at the roots of realism and photography, just as her abjection pictures suggested the same collision as the basis for Surrealism. By drawing our attention to the physical attraction of realist art, be it painting or photography, Sherman's work of the late 1980s and 90s explored the physical lives of the fragmented and multivalent identities depicted in her earlier work.

Holzer, McCollum, and Tansey

While most Appropriation artists copied existing images, a second group appropriated the means by which society transmits knowledge and exercises control. In an updated *trompe l'oeil*, artists such as Barbara Kruger, Jenny Holzer, and Allan McCollum reproduced the modes of communication seen in the streets, museums, or on television, and then infiltrated the expected content of the message. Images that looked like advertising or literature conveyed content regarding the politics of race, gender, healthcare, and sexuality, as well, of course, as issues of artmaking and collecting. Like their Conceptualist forebears—whose strategies provided direct inspiration—Appropriation artists in the 1980s appeared to dismantle the myths of originality, genius, and power that had been threatening to collapse since the 1960s. Moreover, the consequences of this lay within the worlds of practice as well as theory. Here was an art form with a high proportion of women practitioners.

In *Untitled (Your Gaze Hits the Side of My Face)* (see fig. 24.41), Kruger, as well as using a found image, copied the graphic clarity of magazine layout, thus using a means of communication created by the mass media to expose

the aggression of representation. With an even tighter focus on means of public address, **Jenny Holzer** (b. 1950) creates "language" works that appropriate the anonymous, often aggressive, manner in which messages of warning or instruction are transmitted from institutions such as police forces, the military, schools, or churches. Related to the language-focused Conceptualism of the 1970s (see fig. 22.1), Holzer's interventions are based on the pithy, often political, and sometimes cryptic sayings that she composes. She called these sayings "Truisms"; a typical example is the one-liner, "Abuse of power comes as no surprise." Some of the sayings sound like replies to the homespun wisdom of Benjamin Franklin in *Poor Richard's Almanac*. And although they can be as banal as fortune cookies, many have the punch of advertising slogans. At first, Holzer printed her aphorisms on posters and pasted them to the walls of public places, such as phone booths and bus shelters, but later she ran them on electric signboards in more prominent locations. In 1982 she obtained the use of the Spectacolor Board in New York's Times Square (fig. **24.49**), and flashed pointed remarks like "Private property created crime" and "Protect me from what I want" to throngs of surprised pedestrians. Her subsequent installation pieces in museums and galleries have generally been more meditative and subjective, notably *Laments* for the 1990 Venice Biennale, but at times they have been spectacular. At the Guggenheim Museum in 1989, a ribbon of her color signboards ran along the edges of Frank Lloyd Wright's great spiral ramp. The lights spinning around the helical curve of the architecture surrounded the visitor with such urgent phrases as "You are a victim of the rules you live by."

The work of **Allan McCollum** (b. 1944) interrogates contemporary attitudes toward art from within the galleries

24.49 Jenny Holzer, ~~Selection from *Truisms*,~~ 1982. Spectacolor Board, 20 × 40' (6.1 × 12.2 m). Installation, Times Square, New York. Sponsored by Public Art Fund, Inc., New York.

24.50 Allan McCollum, *20 Plaster Surrogates*, 1982–85. Enamel on hydrostone, twenty parts, various dimensions.

rather than in the streets and the media. McCollum's oeuvre consists of objects that function as signs of art. As one critic described them, they are like the shop signs of eyeglasses that an optician might hang in front of his shop. Called *20 Plaster Surrogates* (fig. **24.50**), McCollum's objects are plaster casts of framed pictures that he has painted black for the frames, white for the mat, and black for the picture. The thousands of *Surrogates* have slight inconsistencies of size and surface so that, while they lack any of the details that one expects from a work of art, each one serves as a place holder for the idea of a different work of art. In a politically and philosophically challenging question for those who study art, McCollum asks how anyone besides the wealthy can enjoy "souvenirs of that class of people who manipulate history to your exclusion." The issue of class and art continued to be a pressing one in the late twentieth century, when collectors with big bank accounts were buying out gallery shows, sponsoring exhibitions, promoting artists, and establishing "good taste." The *Surrogates* force one to consider whether it is the social status afforded by art or its content that matters most. McCollum's mass-produced objects, infiltrating museum and gallery exhibitions by speaking the language of art, answer in favor of the former. In a last caustic gesture reiterating the complicity of art and power, he created *Perpetual Photos* (1982–89), reproductions of the fleeting, indistinct artworks that adorned the fictional settings of television dramas, sitcoms, and soap operas. Starting off with a photograph of his television screen as it briefly contained

24.51 Allan McCollum, *Perpetual Photo, #209 B*, 1989. Gelatin-silver print, 45 × 52" (114.3 × 132.1 cm). The Metropolitan Museum of Art, New York. Purchase, The Horace W. Goldsmith Foundation Gift through Joyce and Robert Menschel, 1992.

a work hanging, for instance, on the wall of one of the fictional spaces presented on the popular 1980s television series *Dallas*, McCollum would then produce an enlarged print of the already indecipherable artwork and frame it, offering for the viewer's contemplation one of the thousands of unnoticed "artworks" that daily flood the visual field of most individuals living in industrialized societies (fig. **24.51**).

The importance of theory to artists of the early 1980s was immeasurable. It was as if the art-about-art impulse that defined formalism was taken far beyond the confines of the picture plane. The work of **Mark Tansey** (b. 1949), on the face of it traditional figurative realism, serves as evidence of the prevalence of theory and criticism. Painted in grisaille, Tansey's images resemble preparatory sketches for old master canvases, but illustrate, with great liberty, the recent history of art. In the monumental *Triumph of the New York School* (1984), Tansey transforms the military

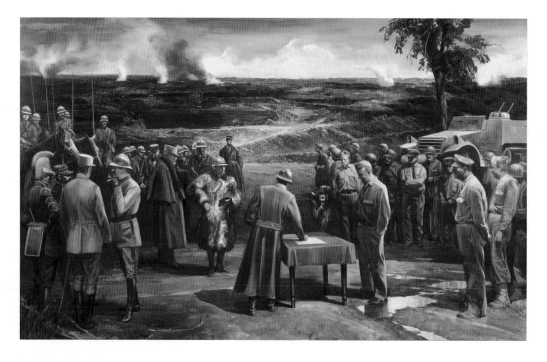

metaphor of "avant-garde" into an ironic variation on history painting based loosely on Velázquez's 1635 *Surrender at Breda* (fig. **24.52**). The painting depicts French artists, dressed in European military uniforms (save Picasso in a fur coat, Matisse in a cape and Duchamp in a robe) passing the baton of modernism to the Americans, who are dressed as GIs. In *Action Painting II* (fig. **24.53**), space flight provides the metaphor, as the space shuttle launch becomes the premise for a joke about the distance between the public and the modern (the Sunday painter and the action painter) and a more serious commentary on the transformation of Abstract Expressionism into a style. In the

late 1950s it was of great concern whether Abstract Expressionism had calcified into an academic style (see *Post Painterly Abstraction*, chapter 20). What might it mean to have turned the existential challenge and the expressive gestures of Pollock or De Kooning into a style? Posed another way, were artists, like those in Tansey's picture, not acting themselves but merely and ridiculously painting pictures of actions? By the mid-1980s and 90s, many artists turned to such ironic strategies to revitalize painting, while others took up painting with the same earnestness and passion that the earlier German Expressionists and American Abstract Expressionists had brought to the medium.

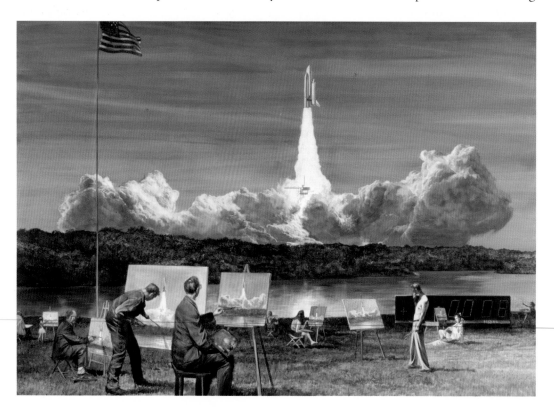

24.53 Mark Tansey, *Action Painting II*, 1984. Oil on canvas, 76 × 110" (193 × 279.4 cm).

25
Painting through History

Throughout the twentieth century, painting remained inextricably bound with the history and development of modern art. Histories of Western art tended to focus on the painterly origins of modernism, with Manet, Cézanne, or Picasso typically cast as progenitors. Painting was hailed as the modernist medium *par excellence* by admirers of Abstract Expressionism, who saw works by artists like Jackson Pollock or Willem de Kooning as fulfilling perfectly Clement Greenberg's concept of modernism. Even direct critiques of the conventions of easel painting—such as those by Marcel Duchamp or René Magritte—seemed to acknowledge the inevitability of the medium's endurance.

Challenges to the primacy of painting grew more frequent and emphatic during the second half of the century. Minimalism, Conceptualism, and Postmodernism had all questioned the relevance of traditional easel painting. For Minimalists, paintings could be accommodated only in terms of their status as objects. Whatever pictorial content or expressive facture a painting might deliver was no longer of interest. Sol LeWitt's wall drawings and Frank Stella's black paintings, for example, dispensed with narrative and bravura brushwork to assert their presence as objects capable of energizing a particular space just as a Minimalist sculpture might. Conceptualism, of course, held limited interest in the production of art objects, especially those as amenable to the marketplace as paintings. Postmodernism, though promoting a critical engagement with culture and history, nonetheless relied upon deliberate aesthetic distance. This approach to visual art tended to understand paintings primarily as vehicles for ironic iconography, as seen in Mark Tansey's work (see chapter 24).

Yet a number of artists working in the final decades of the twentieth century persisted in their pursuit of painting as an expressive medium, capable of achieving unique aesthetic and emotional effects. Generally classed as "Neo-Expressionists," artists who employed the vigorous brushwork and intense color of German Expressionism emerged in the 1970s and earned widespread acclaim in the following decades. Some Neo-Expressionists worked in abstraction, but many chose to pursue varying degrees of naturalism. Neo-Expressionism was not the only movement to affirm the continued interest in easel painting at the end of the century. Styles ranged from pure geometric abstraction to minute realism. Along with stylistic heterogeneity came a diversity of ideas about the significance of painting for modern art, with critics and collectors confirming the continued relevance of the medium.

What sustained this widespread interest in easel painting? One response to this question might be cynically to point to the art market boom of the 1980s: thanks to their portability and well-established status as markers of cultural attainment, paintings hold a special appeal for dealers and collectors. But artists had reasons other than marketability to turn to painting. One of these involves painting's position as an art form strongly associated with tradition. By the 1980s, many artists and viewers found themselves puzzling over the nature of art itself. After decades of distilling forms to their barest aesthetic essentials or blurring the boundaries between art and life and rejecting the category of "art" altogether, many felt called to reconsider the question "what is art?" Painting—an emphatically artful medium—offered a promising platform for this inquiry.

Of course, the relationship of painting to history—whether the history of art or the history of Western society since the Renaissance—attracted many artists who felt that the political events of the late twentieth century warranted scrutiny through a historically conscious aesthetic lens. The disintegration of the Soviet Union and the consequent release of the satellite "Eastern Bloc" countries from their political orbits affected not only Europe and Asia but the rest of the world as countries dependent on ideological guidance and economic assistance from the USSR were faced with their own social reorganization. It was through painting that many artists sought to understand the international realignment that would become known as globalization.

Primal Passions: Neo-Expressionism

With the beginning of the 1980s, the reaction against Minimalism assumed a new intensity, kindled in the United States by young painters with a love of bold gesture, heroic scale, mythic content, and rebellious figuration. Critics dubbed this movement Neo-Expressionism. European artists had been practicing Neo-Expressionism since the 1960s, when German artists in particular sought means to negotiate the cultural presence of the United States and the USSR in postwar Europe. On both sides of the Atlantic, Neo-Expressionists revived agitated, feeling-laden brushwork. Almost all of them generated content by exploiting imagery so taboo, primal, or vulgar that descriptive realism seemed to pass into the dislocated, surrealistic realm of dream, reverie, or nightmare. Yet even though the accessibility promised by identifiable subject matter was not quite as immediate as some might have hoped, collectors, museums, the media, and some critics rejoiced that here, at long last, were large, vigorously worked, color-filled, and clearly meaningful canvases. In an art world hungry as much for excitement as for imagery, this was an event. It was made all the more newsworthy because it had been spearheaded in Europe, where German and Italian artists were working with a self-confident strength and independence not seen since the original German Expressionists or the Italian Futurists and Metaphysical artists. For the first time in the postwar era, Continental artists could reclaim a full share of international attention and world leadership in new art, hand in hand with younger American painters.

The so-called Neo-Expressionists evinced a daring embrace of metaphor, allegory, narrative, surfaces energized by and packed with photographic processes, broken crockery, or even oil paint that made the New Image art of the 1970s (see chapter 23) seem yoked to modernist dogmas of emotional and formal reserve. Paradoxically, however, while previous avant-garde movements had tended to renounce the past, the Neo-Expressionists sought to liberate themselves from modernist restrictions by rediscovering those very elements of tradition most condemned by progressive, mainstream trends. For example, the Americans tended to look to the later, expressionist Picasso—the Picasso certain modernists had thought unimportant—instead of the cerebral, discriminating artist of the heroic Analytic Cubist era (see chapter 8). They flocked to the 1983 Guggenheim Museum exhibition devoted to the Spanish painter's final decade (1963–73), drinking in not only the liberated drawing and color, but also the unrestrained, autobiographical sexuality expressed by a still-vital octogenarian (fig. **25.1**). Not coincidentally, sexuality loomed large—often blatantly—in Neo-Expressionist art as well.

Beyond these broad, and highly provisional, generalizations, the Neo-Expressionists—a title almost none of them found appropriate—have little in common. Instead of forming a cohesive movement, they emerged, more or less independently, from their respective cultural and stylistic outposts. In the United States, those artists who came to the forefront of the movement did so with significant gallery support in the late 1970s and early 80s. The market that propelled the Americans inspired a retrospective

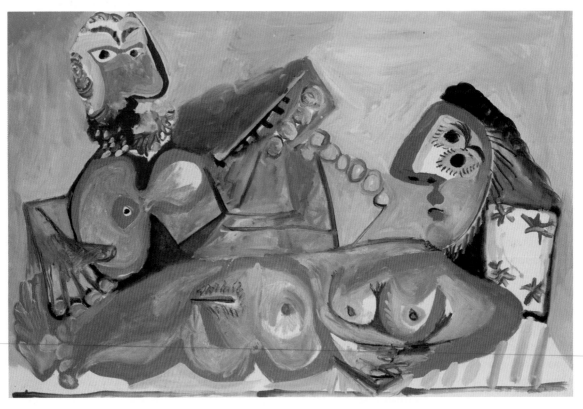

25.1 Pablo Picasso, *Reclining Woman and Man Playing Guitar*, 1970. Oil on canvas, 51⅛ × 76¾" (1.3 × 1.95 m). Musée Picasso, Paris.

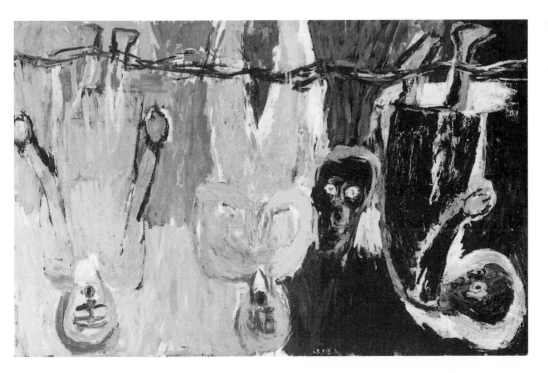

25.2 Georg Baselitz, *The Brücke Choir (Der Brückenchor)*, 1983. Oil on canvas, 9' 2½" × 14' 11" (2.8 × 4.5 m). Private collection.

interest in the many artists whose work had long shown characteristics of Neo-Expressionism. The celebration of paint did not come without criticisms, the strongest of which asserted that to reclaim modernist styles was to ignore postwar critiques of modernism. After conceptual art, feminism, and Appropriation, the step back to painting seemed to many to be a step too far.

German Neo-Expressionism: Baselitz, Lüpertz, Penck, and Immendorff

Among the German Neo-Expressionist painters, the senior artist is **Georg Baselitz** (b. 1938). His paintings are also perhaps the most distinctive, with the topsy-turvy orientation of their imagery—usually upside down—and their full, ripe color and powerful, liberated brushwork. In a gesture both nostalgic and nationalistic, Baselitz (born Georg Kern) renamed himself for the village where he was born, Deutschbaselitz in Saxony, after he moved out of what was then Russian-occupied East Germany and into West Berlin. Postwar West Germany, Baselitz discovered, was dominated by the cultural influence of the United States as East Germany had been by that of the Soviet Union. In 1958, the year after he emigrated, West Berlin hosted New American Painting, a show originating at The Museum of Modern Art, New York, which promoted artists including Pollock, De Kooning, and Kline. The propagandistic nature of the exhibition typified the policy for rebuilding Germany, which entailed an influx of economic and cultural goods from the United States. Artists wishing to assert creative and national independence could resist the impulse for abstraction but were wary of figurative painting because of its connections with Soviet Socialist Realism (see chapter 10). Baselitz's solution was to revive the kind of narrative and symbolic, emotive and rhapsodic art in which Germans had previously achieved greatness (see fig. 1.11).

During 1964–66, when international art was dominated by American Color Field painting (see chapter 20) and Pop (see chapter 19), Baselitz developed an iconography of heroic men—huge figures towering over devastated landscapes. The monumental human forms were personifications of the German psyche, homeless after the moral and physical devastation of the war. Baselitz eventually turned from the wandering heroes to figures left more or less intact but abstracted from reality by an upside-down posture and the disintegrating effects of brilliant color and aggressive painterliness (fig. **25.2**). Baselitz's treatment of his subjects, often friends in the midst of mundane activities such as talking, eating, or drinking, dramatized them by magnifying their size and manipulating their bodies through evocative distortions of anatomy.

Baselitz also made sculpture, hacking forms out of wood to register the medium's inherent qualities (fig. **25.3**). While this may be a tribute to the late works of Michelangelo, it also calls to mind the German Expressionists, who excelled in woodcut.

25.3 Georg Baselitz, *Untitled (Figure with Raised Arm)*, 1982–84. Limewood and oil, 8' 3" × 28" × 18" (2.5 × 0.71 × 0.45 m). Scottish National Gallery of Modern Art, Edinburgh.

In his rebellion against all authoritarian "norms," most particularly those inherent in the monolithic consistency and coolness of 1960s American abstraction, **Markus Lüpertz** (b. 1941) made intensity the driving force behind his search for artistic independence, variability the character of his style, imaginative reference to earlier artists his process, and politics the content of his art. Lüpertz saw Picabia as a precursor of his own stylistic restlessness and Picasso as a model of the obsessive quoter of established art. No less important, however, was Pollock, who for Lüpertz seemed a "Dionysiac" painter attuned to discovering the mysteries of his own personality within the unifying process of his art. Lüpertz uses abstracting means to invent objects that, while simulating the look of real things, remain totally fictitious, or what might be called "pseudo-objects." In the early 1970s, the artist executed a "motif" series in which he introduced such recognizable but taboo emblems as German military helmets, uniforms, and insignia, and combined them with palettes and other attributes of the painting profession. These works signified the need to confront history and the imperative that art be grounded in concrete reality (fig. **25.4**).

Having crossed from East to West Germany, **A. R. Penck** (b. 1939) struggled in his art not only with the cleft in German society but also with the need to come to terms with himself as an exile. The form that this self-taught artist found most effective for his purposes was a stick figure—Everyman reduced to a cipher—set in multiples or singly in a tapestry or batik-like pattern against a field of solid color, with figures and ground so counterbalanced as to lock together in a dynamic positive–negative relationship (fig. **25.5**). Mixing stick figures with a whole vocabulary of hieroglyphs, cybernetic symbols, graffiti signs, and anthropological or folkloric images, Penck expressed such personal and public concerns as the urgent need for individual self-assertion in a collective society. As a "crossover" himself, Penck often painted poignant versions of the lone stick man walking a tightrope or a burning footbridge suspended above an abyss separating two islands of barrenness.

Almost in counterpoint to Penck's radically depersonalized imagery, **Jörg Immendorff** (1945–2007) painted in a detailed, if highly conceptualized, realist style. Like Penck, he anguished over the theme of the individual entrapped by the contradictions of modern German life. In the *Café Deutschland* series, the central image is the artist himself, often seated between a pair of allegorical columns symbolizing the two halves of a polarized world (fig. **25.6**). While Baselitz, and to a great degree Lüpertz and Penck, adopted styles recalling the Expressionist painting of Die Brücke (see chapter 7), Immendorff looked to different sources. Taking from the *Neue Sachlichkeit* (New Objectivity; see chapter 11) examples of Georg Grosz, Otto Dix, and Max Beckmann, Immendorff evoked the moral poverty and political disgust that concerned these post-World War I painters in a style that, like theirs, bears more fidelity to realism than that of the

25.4 Markus Lüpertz, *Schwarz–Rot–Gold I*, 1974. Distemper on canvas, 102¼ × 78¾" (260 × 200 cm).

25.5 A. R. Penck, *The Red Airplane*, 1985. Oil on canvas, 3' 11" × 6' 10½" (1.19 × 2.1 m). Private collection.

25.6 Jörg Immendorff, *Café Deutschland I*, 1977–78. Acrylic on canvas, 9' 2" × 10' 10" (2.8 × 3.3 m). Ludwig-Forum für Internationale Kunst, Aachen, Germany.

prewar Expressionists. During and after his student days in Düsseldorf, where he studied with Joseph Beuys, Immendorff joined activist groups supporting tenants' rights and opposing the war in Vietnam and capitalist imperialism. His *Café Deutschland* paintings typify his political and aesthetic agenda. The relatively public, accessible style, the autobiographical subject, and the lurid disco scene, complete with heavy, forward-pitching perspective, express the sensibilities of a politically engaged, leftist artist who uncomfortably recognizes his own seduction by the art market.

Polke, Richter, and Kiefer

Sigmar Polke (b. 1941), along with Gerhard Richter, created an alternative to the nationalistic catharsis of their Neo-Expressionist peers. In the early 1960s, the international art community provided in Pop art its own alternative to American Abstract Expressionism and the European abstraction of *Art informel* and *Tachisme* (see chapters 18 and 19). Polke, Richter, and fellow student Konrad Leug created Capitalist Realism, an indigenous

form of Pop art that responded to American aesthetic hegemony. This new Pop art distorted what appeared to be an American infatuation with capitalism into an art sensitive to the unique complexities of contemporary German life. In the 1960s, Polke adopted the Benday process of mechanical reproduction not long after it had been integrated into painting by Roy Lichtenstein (see *Screenprinting*, chapter 19, and figs. 19.54, 19.55). But whereas the American artist aestheticized the dot system, not only by treating it as a kind of developed Pointillism (see chapter 3) but also by using it to depict established icons of high art, the German simply hand-copied— "naively"—a blown-up media image, complete with off-register imperfections and cheap tabloid subject matter (fig. **25.7**). The "imperfect" results draw attention to the means of reproduction, interfering with the seamless perfection that makes both classical Pop art and advertising so effective. In the context of postwar Germany, Polke's works constituted a critical commentary on the infiltration of American media imagery into German culture. Polke often worked on an allover grid or otherwise mechanically

25.7 Sigmar Polke, *Bunnies*, 1966. Acrylic on linen, 59 × 39½" (150 × 100 cm). Hirshhorn Museum and Sculpture Garden, Smithsonian Institution, Washington, D.C.

25.8 Sigmar Polke, *Hochstand*, 1984. Acrylic, lacquer, and cotton, 10' 8" × 7' 4" (3.3 × 2.2 m). Private collection, New York.

25.9 Gerhard Richter, *Scheune/Barn No. 549/1*, 1983. Oil on canvas, 27½ × 39½" (70.1 × 100.1 cm). Art Gallery of Ontario, Toronto.

patterned ground. Rauschenberg, of course, had incorporated ordinary textiles and photographs into his combine paintings, as a device for generating the shock effect once possible in the unorthodox juxtaposition of materials (see fig. 19.28). Polke, however, developed the painterly "naturally" out of the mechanical, thus demonstrating a disturbing synchronicity between subjective creativity and mass production.

By the 1980s, Polke was no longer creating Pop variations on advertising. In a further assimilation using photography, the artist developed his imagery by layering photographic reproductions onto underlying patterns of regularly repeating abstract motifs, often taken from textile designs (fig. **25.8**). Delineated like contour drawings and layered in a manner inspired by Picabia's *Transparencies* (see fig. 11.15), the images seem paradoxically to dematerialize at the same time that they emerge from the support upon which the artist has painted them, creating an illusionistically deep pictorial space that simultaneously seems independent of all perspective systems. Moreover, the figuration phases in and out of focus, as if it were the product of photographic or darkroom manipulations, or perhaps even of an accident with one of the substances Polke is known to have used in creating his curiously synthetic and characteristic colors. The impact of these visually stunning canvases is complicated when the premise for aesthetic

indulgence is as morally and historically ambivalent as the guard tower in *Hochstand* (see fig. 25.8).

Like his compatriot Penck, Dresden-born and -educated **Gerhard Richter** (b. 1932) found himself so in conflict with the social and aesthetic conditions of East Germany that he crossed over into the West in 1961. In 1962–63, he was in Düsseldorf and, with Polke, learning from Beuys, Fluxus, and exhibitions of American Pop artists. After his collaboration with Polke, Richter's work took a decisively more conceptual turn. Catalyzed by the iconoclasm of Fluxus, Richter declared, "I had had enough of bloody painting, and painting from a photograph seemed to me the most moronic and inartistic thing that anyone could do." This was an anti-art gesture that led to a challenging artistic career. Since 1962, the artist created scores of "photopaintings," all of them more distinctly "photographic" than Rauschenberg's transfers, and yet far more like real paintings than Warhol's appropriations of media imagery (see *Richter, "Notes 1964–1965,"* p. 702). In his later photopaintings, Richter felt freer to depart from the original, often a snapshot made by the artist himself, as long as he preserved something of a genuine photographic look, complete with such flaws as out-of-focus blurring, graininess, or exaggerated contrasts, all of which seem to be points of mediation between painting and photography. The calm, bucolic scenes of Richter's later work (fig. **25.9**)

In the apocalyptic paintings of **Anselm Kiefer** (b. 1945), German and Jewish history are frequently evoked symbolically through the motif and appearance of scorched earth. Kiefer's interest in exploring the consequences of German history began in a series of conceptual photographs that have little to do with the physical presence of his Neo-Expressionist canvases. In 1969, in a collection of photographs called *The Occupations*, Kiefer documented himself standing in Nazi uniform before monuments like the Colosseum in Rome, giving the Nazi salute. The scandal of enacting Hitler's imperialist desires in a confusing and often belittling way created an uproar that still colors the reception of Kiefer's work. The question of how to reckon with German history on personal, national, and international stages remains central to considerations of Kiefer's art.

In pursuing such themes, Kiefer exercises the freedom to exploit and mix images of Germany from the mythic realm of Valhalla (the mythological dwelling place of gods and heroes) to Nuremberg and the horror of Auschwitz, as well as biblical and historical themes. His media are equally diverse—straw and sand, overprocessed photographs, lacquer, and fire—and might serve the expressive purpose of simulating ancient fields charred and furrowed from centuries of battle and seeming to stretch into infinity. Kiefer's elegiac themes are seen in *Departure from Egypt* (fig. **25.11**), a grandiose landscape, rolling away majestically, yet held to the plane by the hook of Aaron's

show Central European landscape immersed in a soft, romantic atmosphere, a kind of filter that reveals as much about how painting and photography alike distort our vision of reality as it does about the world depicted.

In the late 1960s, Richter ran counter to the photo-paintings with a return to pure abstraction, first in a series of heavily impastoed monochrome works called Gray Pictures (*Graue Bilder*). By the beginning of the 1980s, after investigating many different styles, he came to concentrate on full-color, vigorously worked Expressionist abstractions (fig. **25.10**), painted as a series and complementary to the cooler, more objective "classicism" of the photo landscapes. Though apparently as free and gestural as their Abstract Expressionist antecedents, Richter's abstractions are based on photographs of details of his own work. Chromatically and gesturally similar to abstractions painted by De Kooning in the 1950s, Richter's non-representational works issue from a different critical process. They present a planar space layered in strata of relatively distinct elements, a structural conception already seen as characteristic of much Postmodern art. In executing these works, Richter drew upon a vast repertoire of painterly techniques—troweling, scraping, flinging, scumbling, and brushing—that recall the artistic procedures of Hans Hofmann (see fig. 17.2). In later work, Richter painted his abstractions directly, without the intervention of photography.

25.10 Gerhard Richter, *Vase*, 1984. Oil on canvas, 7' 4½" × 6' 6¾" (2.2 × 2 m). Museum of Fine Arts, Boston. Juliana Cheney Edwards Collection.

25.11 Anselm Kiefer, *Departure from Egypt*, 1984. Oil, straw, lacquer, and lead on canvas, 12' 5" × 18' 5" (3.8 × 5.6 m). Museum of Contemporary Art, Los Angeles.

rod. Even though appearing as if it had been swept by a firestorm, or mulched in blood and dung, tar and salt, the field rewards close inspection with a rich sense of tactility and texture.

Kiefer has also worked in sculpture. He has made immense "books" out of lead and gathered them on shelves; the resulting assemblages can weigh several tons (fig. **25.12**). Like Kiefer's paintings, his books contain the past, but as much through their material presence as through imagery or language. Indeed, these huge volumes have a massive solidity as physical objects that conveys a palpable sense of the weight of history upon us. The smaller versions often hold drawings by the artist along with sheets of charred paper, ashes, dirt, and sand, which scatter and even cling to the reader/viewer whenever the books are handled. In this way, the objects seem always to be disintegrating: whatever histories they may hold are disappearing even as they remain (physically as well as emotionally) with the viewer after the book has been closed. The artist's use of lead is also resonant with the centuries-long human desire to turn nature into wealth and power: lead is the material that alchemists sought to convert into gold in the Middle Ages. It is now used as a shield against the radioactivity of atomic devices—a modern transmutation of matter that in some sense has fulfilled the alchemist's dream, even with unforeseen consequences. After the unification of East and West Germany in 1991, Kiefer moved to southern France and stopped painting for a while. In the mid-1990s, he revealed canvases that take the romantic terrain of his new home as the source for a series of brilliant, light-filled landscapes. More recent projects have returned to the haunted landscape and bitter history of his native Germany.

25.12 Anselm Kiefer, *Breaking of the Vessels*, 1990. Lead, iron, glass, copper wire, charcoal, and aquatec, 16' × 6' × 4' ½" (4.9 × 1.8 × 1.23 m), weight 7½ tons. The Saint Louis Art Museum, Missouri.

Italian Neo-Expressionism: Clemente, Chia, and Cucchi

The second nation to foster a substantial Neo-Expressionist movement was Italy. Called the *transavanguardia*, Italian artists of the 1970s found in painting and Italian classicism, two traditions disregarded since World War II, the ingredients for a contemporary movement. Among the "three Cs" of Italy's *transavanguardia*—a group completed by Sandro Chia and Enzo Cucchi—who first came to international notice at the 1980 Venice Biennale, the Neapolitan-born **Francesco Clemente** (b. 1952) was the most prolific. Clemente maintained studio-residences in Rome, Madras, and New York, and each year spent time working in each country. While he absorbed and used the imagery, ideas, and techniques native to the environment of each city, the artist also allowed his disparate influences to overlap and cross-fertilize.

Clemente taught himself oil painting in New York. There, like Barnett Newman (see fig. 17.28), he created a series of works entitled *The Fourteen Stations*, interpreting the theme not with the traditional iconography of Christ's journey to the cross, but rather through a dream-like intermingling of personal psychology, cultural history, and religious symbolism. The artist's own naked body is ubiquitous throughout the series. In *Station No. IV*, the figure resembles a Roman-collared priest, screaming like Bacon's bishops (see fig. 18.44) and lifting his white surplice to reveal a dark, egg-shaped void just above an intact scrotum (fig. **25.13**). Behind the figure stands a bull,

painted with all the distorted energy of Pollock's *Guardians of the Secret* (see fig. 17.8). The animal recalls Nandi, Siva's bull, and provides a link between the Christian series and Clemente's Indian works.

Clemente's innumerable self-portraits present an image of selfhood and masculinity that is porous and flexible. Conventional expectations about male identity are undermined as are the boundaries of the body. The artist presents the human form doubling up on itself, as it mutates from a self-contained entity to a being mingled with others, in scenes that are sometimes ecstatic and sometimes painful. An elegant vision of the loss of self in a generative moment of creation is the 1983 *Semen* (fig. **25.14**). Suspended, with eyes closed, is a being loosely defined by a broken outline and incomplete shading. It resembles a kind of highly developed fetus, floating in amniotic fluid. The title, however, suggests a connection with swimming sperm. Together these clues create an ambiguous double sense of potential life awaiting fruition.

In his reaction to modernist conventions, **Sandro Chia** (b. 1946), a Florentine who subsequently relocated to New York, relied on Italian exuberance and a personal knowledge of the ersatz Neoclassicism practiced during the Fascist 1920s and 30s by artists such as Giorgio de Chirico (see fig. 10.5) and Ottone Rosai, who were themselves reacting against Futurism, Italy's first modernist style. Adopting the older painters' conventions—their absurdly muscle-bound nudes and self-consciously mythic situations—but inflating the figures to balloon proportions

25.13 Francesco Clemente, *The Fourteen Stations, No. IV*, 1981–82. Oil and encaustic on canvas, 6' 6" × 7' 4½" (2 × 2.2 m). Private collection.

25.14 Francesco Clemente, *Semen*, 1983. Oil on linen, 7' 9" × 13' (2.4 × 4 m). Private collection.

25.15 Sandro Chia, *The Idleness of Sisyphus*, 1981. Oil on canvas, in two parts: top 6' 9" × 12' 8¼" (2.1 × 3.9 m), bottom 3' 5" × 12' 8¼" (1.05 × 3.9 m), overall 10' 2" × 12' 8¼" (3.1 × 3.9 m). The Museum of Modern Art, New York.

while reducing the overblown narratives to the scale of fairytales, Chia parodies his sources while thumbing his nose at the authentic Neoclassical rigor that survived in Minimalism. Just as appealing as the comic amplitude of these harmless giants is the Mediterranean warmth of Chia's color and the nervous energy of his painterly surfaces—qualities of scale, palette, and touch that the artist also managed to translate into his heroic bronzes. Just how to take Chia's injection of contemporary citizens into classical themes, particularly the case of the bureaucrat in *The Idleness of Sisyphus* (fig. **25.15**), was central to debates over Neo-Expressionism in the 1980s. The reclamation of grand narrative painting even with the self-deprecating ineptitude of Chia's Sisyphus suggested to some that the deconstruction begun in the 1960s had been in vain.

Unlike the world travelers Clemente and Chia, **Enzo Cucchi** (b. 1950) remained solidly rooted in the soil of his native region near Ancona, a seaport on Italy's Adriatic coast. There, for generations, the Cucchi family has worked the land, a land whose circular compounds of farm buildings and catastrophic landslides often figured in the artist's paintings. Because of his doomsday vision and his love of richly textured surfaces, built up with what often seems a waxy mixture of rusted graphite and coal dust, Cucchi has sometimes been compared with Germany's Anselm Kiefer. What sets him unmistakably apart, however, is the Italian heritage that he brings to his dramas; he grew up amid paintings of saints and martyrs. In his *Entry into Port of a Ship with a Red Rose* (fig. **25.16**), austere yet emotively rendered crosses glide across the large fresco in graceful clusters, as purposefully as a fleet of sailboats.

25.16 Enzo Cucchi, *Entry into Port of a Ship with a Red Rose*, 1985–86. Fresco, 9' 2" × 13' 1" (2.8 × 4 m). Philadelphia Museum of Art.

Choosing Media

Contemporary painters have a range of new and historic media with which to work. Essentially, painting involves the mixture of pigment with some sort of binder, which allows the pigment to adhere to a support such as a canvas or a wall. Binders not only provide adhesion but also affect the appearance and durability of the resulting work. Among the oldest painting media still in use is fresco, in which pigments are applied to wet lime plaster. As the plaster dries, calcium carbonate crystals are formed in which the pigment is suspended. Thanks to this chemical process, frescos can be quite luminous, with rich, intense color. They are also quite durable because the image is bonded to its support, in most cases a wall or section of plaster. Fresco painting is a difficult process, though, and depends on exact formulations of slaked lime—a derivative of limestone. Frescos are also rarely portable, leaving them unsuited to modern exhibition practices. When artists like Enzo Cucchi adopt fresco, they can exploit not only the medium's unique material characteristics but its historical resonances as well. To work in fresco today is to invite consideration of the history of painting in antiquity and the Renaissance.

A similar gesture is undertaken by artists who work in encaustic, a medium used by ancient Romans that uses melted wax as a binder. Jasper Johns often worked in encaustic, taking advantage of its rich color as well as its translucency (see figs. 19.31, 19.32, 19.35). Johns often painted over collages made of newspapers or other fragments. These substrata are visible—just barely—beneath the surface of his encaustic paintings, providing attentive viewers with access to another, hidden level of signification in his work.

25.17 Julian Schnabel, *The Sea*, 1981. Oil on wood, with Mexican pots and plaster, 9 × 13' (2.7 × 4 m). Saatchi Collection, London.

he saw Antoni Gaudí's tiled mosaic benches in Güell Park (see fig. 5.9). However, rather than smooth and inlaid, Schnabel's shards project from the surface in an irregular, disjunctive arrangement that visually functions, edge to edge, as a field of enlarged Pointillist dots. At the same time that the china pieces serve to define shapes and even model form, they also break up the image and absorb it into the overall surface flicker like a primitive, encrusted version of the Art Nouveau figure-in-pattern effects of Gustav Klimt (see fig. 5.5), Gaudí's Austrian contemporary. By painting over, around, or even under the protruding ceramic, Schnabel created every kind of pictorial drama, from evocations of folkloric wit and charm to suggestions of mythic ritual. The emotive effect of his work arises less from the image, which is not immediately decipherable, than from an audacious stylistic performance, or process, that simultaneously structures and shatters both figure and surface. Since the 1990s, Schnabel has devoted himself largely to filmmaking, achieving critical success as director of feature-length, general-release movies.

Among the American Neo-Expressionists, one of the most controversial artists was **David Salle** (b. 1952), who forged an unpromising mix of secondhand, disassociated elements into a new, original conception. In the painting *Tennyson* (fig. **25.18**), the artist professed a Conceptual background by lettering out the title in capitals, across a field dominated on the left by a found wooden relief of an ear, and on the right by a nude woman with her back to the viewer. The name of a Victorian poet, a piece of erotica, and a severed ear—at first, the different images may seem to cancel one another out and erase all meaning, until one recalls that in 1958 Jasper Johns reproduced Tennyson's name across the bottom of an abstract canvas painted in sober gray on gray, as if in tribute to the artistic integrity and lyrical, high-minded spirit of England's

Such powerful compositional effects, achieved with the sparest of means, have led some critics to compare Cucchi's work with the early Renaissance frescoes of Giotto (see *Choosing Media*, above).

American Neo-Expressionism: Schnabel, Salle, and Fischl

The artist most often credited with catapulting into new life the 1980s art scene in New York was the Brooklyn-born, Texas-educated **Julian Schnabel** (b. 1951). For viewers starved by the lean visual diet of Minimalism and Conceptualism, Schnabel's grand-scale, thematic pictures—reviving the whole panoply of religious and cultural archetypes once the glory of traditional high art—had an electrifying effect.

In a move both innovative and violently expressive, Schnabel incorporated three dimensions into a flat surface in works such as *The Sea* by imbedding broken crockery in a reinforced wood support (fig. **25.17**). The idea for this process came to him during a visit to Barcelona, where

25.18 David Salle, *Tennyson*, 1983. Oil and acrylic on canvas, 6' 6" × 9' 9" (2 × 3 m). Private collection, New York.

"good gray poet." The connection to Johns is reasserted by the disembodied ear, which could also evoke the poet's "ear for words," or Van Gogh's self-imposed mutilation, but also, and more tellingly, Jasper Johns' *Target with Plaster Casts* (see fig. 19.32). Johns originally affixed a three-dimensional ear, among other anatomical parts, above the painting of a target. In Johns' work the uncomfortable relationship between the destination of an arrow or bullet and the exposed fragments of a naked body generated a range of personal and political content. Such correspondences were less clear in Salle's works, though supporters thought that paintings like *Tennyson* should be read as a commentary on the naked woman, the sexism such imagery represents, and the role of the nude in the history of art.

Salle's selection of poses typical of soft-core pornography (though copied from Salle's own photography rather than published sources), art-historical "masterpieces," found objects, and pop culture references encouraged the interpretation of his paintings as dustbins of American culture. To supporters, Salle was a deft practitioner of pastiche, the critical assemblage of existing cultural elements to elicit an analytical response from the viewer. If, by the 1980s, painting, with its grand tradition and canonical history, was understood to be a politically suspect medium, then Salle's casual combinations forced it to come down from its pedestal and sully itself with the mundane objects of everyday life. To critics in the 1980s, it was too early to presume as common knowledge the idea that painting had been compromised by its relationship to the elite of history. The image of themselves that many Neo-Expressionist painters put forward did nothing to assuage their critics. Complete with beautiful models, troops of assistants, and the ubiquitous cigar, they appeared to be more like clichés of the modernist genius than critics of modernism. Without such

a critique, Salle's imagery, like most Neo-Expressionist painting, appeared to many as naive and sexist, pining for the glory days of the great male painters.

Few of the Neo-Expressionist painters address their art totally to the figure, in all its naked physical and psychological complexity. Foremost among such painters is **Eric Fischl** (b. 1948), whose immense fleshscapes have an unusually high-voltage effect on viewers (fig. **25.19**). Created in tandem with a large body of photographs and

25.19 Eric Fischl, *The Old Man's Boat and the Old Man's Dog*, 1982. Oil on canvas, 7 × 7' (2.1 × 2.1 m). Collection Mr. and Mrs. Robert Lehrman, Washington, D.C.

fascinating preparatory sketches made of overlaid drawings on tracing paper, Fischl's presentation of nudity takes on a self-consciousness in form as well as content. Deliberately composed to occupy the spaces of alienation and Americana familiar from the work of American painters such as Winslow Homer and Edward Hopper (see figs. 2.50, 16.38), Fischl's subjects move beyond a fascination with either flesh or paint to become implicated in suggestions of alcoholism, voyeurism, onanism, homosexuality, and incest. This can be seen in paintings set in the gardens, on the beaches, in the well-appointed rooms, and on the yachts of affluent America, all populated by men, women, and children scattered about or clustered in scenes of boredom and isolation. Like the cathartic abstractions of his Neo-Expressionist peers, but in a style that referenced the traditions of American Realism, Fischl painted upper-middle-class angst. Awkward and half-embarrassed, self-absorbed and yet furtively, even intently, aware of one another's exposure, these figures communicate the individual's psychic as well as physical nakedness.

The paintings in Fischl's *India* series, a series of images based on scenes observed on a trip to northern India in 1988, have been described as the work of a "post-modern tourist." The series, like Clemente's work in the miniature tradition, implies a critique of the "Orientalism" and "exoticism" often featured in European images of Asia and Africa from the nineteenth century, just as Fischl's nudes are in part a critique of female nudes by Manet and others. Separating Fischl from his colonialist predecessors, however, is the fact that he works in an era in which Western imperialism most often takes the form of tourism and economic expansion rather than outright military conquest. Even if the beggars and the group of monkeys in *On the Stairs of the Temple* (fig. **25.20**) suggest little beyond a tourist's snapshot, the treatment of a woman at the center prompts a more complicated response. Clothed in pink and bathed in splendid light, she might at first seem to evidence at least some attempt by the artist to fathom another culture, with its different understanding of spiritual and physical beauty. Yet the draped figure communicates real ambivalence. The viewer's expectation that she be freely available as an object of visual delectation is at least partially confirmed by the subject's incarnation of the stereotype of veiled "Other of the East."

25.20 Eric Fischl, *On the Stairs of the Temple*, 1989. Oil on canvas, 11' 8" × 9' 7" (3.5 × 2.9 m). Private collection.

Regarding Representation: Painting and Photography in the 1980s

Neo-Expressionism was heralded by many as a return to painting and curators celebrated the fact that young artists "had returned to the painter's pots" (the reference to the pots of paint employed by ancient artists, who did not use palettes, emphasized the perception of painting as an especially venerable, classical medium). But many also took cameras into the studio. Eric Fischl's paintings were often the result of studying not just the model, but photographs of family, friends, and strangers. Salle generated many of his motifs by duplicating the compositions and the appearance of photographs. In the critical debates of the day, Neo-Expressionism figured as the return of the painterly, while Appropriation tapped into the potential of mass media, particularly photography. The issue was always complex and a number of artists juxtaposed the aesthetic bravado of the former with the sociocultural analysis of the latter.

Longo

The art of **Robert Longo** (b. 1953), which has been described as "apocalyptic Pop," features over-lifesize imagery taken from or inspired by film, television, comic books, and advertisements—a secondhand world of kitsch and high culture mixed and matched to provoke voyeuristic responses to such basic themes as love, death, and violence. No less dramatic is the serendipitous variety of media that Longo and his collaborators (usually named) have combined: sculpture (wood carving, stone intaglio, and bronze casting), painting (acrylic, spray paint, and gold leaf), drawing, silkscreen, and photography. Longo's practice put him in the company of Appropriation artists while his aggressive content, which has included black American flags, guns, and huge ocean waves, links his work to the Neo-Expressionist impulse.

Longo gained early recognition with a number of large black-and-white charcoal drawings, such as the 1979–82 series *Men in the Cities*. For these impressive works, the artist photographed single figures clad in sober business clothes and seized with the contorted throes of what could be either agony or ecstasy, dying or dancing (fig. **25.21**). But while any such condition should create a sense of heat, the figures are frozen—and perhaps all the more haunting for the tension that this ambiguity produces. Perhaps better than any of his peers, Longo captured the sense of corporate-induced frenzy that animated the art world in the early 1980s. His contorted and violent figures, in their business attire, express the uneasy combination of urgency and disregard that treating art as investments could produce. At a moment of escalating prices and famous art stars, the influence of money on artistic success felt as if it had never been greater, causing huge ambivalence in the art community. *Men in the Cities* was created by transferring photographs that Longo took of his friends leaping, dancing, and fighting on his roof. The images

25.21 Robert Longo, *Untitled* (*Men in the Cities* series), 1981. Charcoal and graphite on paper, 8 × 5' (2.4 × 1.52 m).

were projected and duplicated by means of emphatic and stylized charcoal and graphite drawings, which he executed with the help of assistants.

The Starns

The identical twins **Mike** and **Doug Starn** (b. 1961) produced work in collaboration. Although they have also painted, their principal medium is an elaborate variety of photocollage. In their work, they appropriate a photographic image and subject it to all manner of technical alterations. They might enlarge an image enormously, or make a toned print of it in the nineteenth-century manner. But they will also deliberately scratch the negative, or otherwise distress the image, crease or tear the print, stain it with glue, or cut it up. They will then complete the work by mounting and framing the separate pieces, or tape them directly to the wall. Often the resulting large-scale photocollages are as imposing as murals.

25.22 Mike and Doug Starn, *Double Mona Lisa with Self-Portrait*, 1985–88. Toned silver print and Ortho film, Scotch tape, and wood, 8' 9" × 13' 3½" (2.7 × 4.1 m). Museum of Fine Arts, Boston.

In *Double Mona Lisa with Self-Portrait* (fig. **25.22**) the Starns borrow an image often used by artists such as Duchamp and Warhol. Instead of using a photograph that documents the painting alone, however, as those artists did, the Starns took a picture of the *Mona Lisa* surrounded by its large, cumbersome vitrine at the Louvre in Paris, with the rest of the gallery and its visitors, including the two artists themselves, reflected in the glass. Even standing a few feet from Leonardo's painting, museum-goers see it twice removed, sealed behind a glaring barrier and obstructed by the reflected bodies of other visitors. The installation of the painting has the ironic effect of distancing the work from the very people who have come to experience it firsthand. In place of an original that is remote and out of reach, the photocollage substitutes its own complex aesthetic structure for that of the *Mona Lisa*. But the cut-up and painstakingly reconstituted version that the Starns create, with its patchwork grid of Scotch-taped panels, openly announces itself as a homemade, "constructed" copy—totally at odds with the mystique of the precious, irreplaceable masterpiece. The Starns create a dramatic, expressive comment on issues of originality and reproduction, art and meaning, devotion and power. Though clearly related to Appropriation, the Starns' aesthetic bravado places them comfortably in the company of the international Neo-Expressionists.

Gilbert and George

The English artist team of **Gilbert and George** (Gilbert Proesch, b. 1943, and George Passmore, b. 1942), known initially for turning their art school rebellion against modernism into comedic performances, found their monumental multipanel photographs included in group shows documenting the Expressionist movement in the 1980s. The pair's later work continued to push the limits of self-portraiture, as had their *Singing Sculptures* (see fig. 22.24), but now they featured images of themselves in large-scale

photographs, hand-dyed, mounted, and framed. The photoworks express aggressively political content, as in *Are You Angry or Are You Boring?* (fig. **25.23**), which combines the potential energy of alienated urban youth and images relating to the AIDS epidemic with decorative intuition that recalls Matisse. Gilbert and George designate everything they make as sculpture. They favor explicitly

25.23 Gilbert and George, *Are You Angry or Are You Boring?*, 1977. Color photograph, 7' 11" × 6' 7" (2.4 × 2 m). Stedelijk van Abbemuseum, Eindhoven, the Netherlands.

homoerotic content, often expressed emblematically through voluptuous flower and vegetable imagery, while presenting it within a religio-aesthetic structure of stained-glass-colored panels, and iconic cruciform patterns.

Searing Statements: Painting as Social Conscience

Frankly political painting had existed in the U.S. since the country's inception. As seen in chapter 16, the Ashcan and Regionalist painters continued to invest their works with ideological statements, often in support of social reform or democratic ideals. A number of artists likewise used their palettes and brushes as tools for consciousness-raising and calls for political action.

Golub and Spero

In a period of young artists' early success, the Chicago-born **Leon Golub** (1922–2004) stood in stark contrast. He was a moralist in the tradition of Daumier and Beckmann (see figs. 2.16, 11.38) who for some forty years stuck made figurative art suggestive of disconcerting narratives, all the while "famous for being ignored," until at last, in the early 1980s, the world's unhappy concerns had so evolved as to coincide with his own. These are the politics of power and the insidious, all-corrupting effects—violence and victimization—of power without accountability. The then sixty-year-old Golub had spent the long years of his exile—out of fashion and out of the country—steadily gathering his artistic and intellectual forces, so that by the time the first pictures in his *Mercenaries* series came before an astounded public in 1982, they presented, as did the later *White Squad* pictures, a hard-won but fixating, frozen unity of raw form and brutal content (fig. **25.24**).

By the time of the *Mercenaries*, Golub had begun to focus on the margins of society—the jungles of South America or Africa—where the emissaries of political power tended to be not anonymous armies or aloof public figures but "mercs," individual agents for hire. To bring home the evil of torture and terrorism, Golub hit upon the idea of making his political criminals all too human, fascinating and specific in their cowboy swagger and guilty satisfaction, while reducing the intimidated victim to a dehumanized, undifferentiated state almost beneath empathy. The better to authenticate his images of unfettered police authority, Golub pieced them together from photos of political atrocities, complete with the ungainliness of men exuberantly and sensually caught up in their daily work. He made his petty tyrants ten feet (3 m) tall, pressed them forward with a ground of Pompeiian oxide-red (itself a primary emblem of imperial, political power) and cropped the anti-heroes' legs off to spill the scene forward, as if into the viewer's own space. Far too committed and subtle to preach or sloganeer, Golub simply used his long-seasoned pictorial means—a congruence of image, form, process, and psychology—to induce feelings of complicity in a system that manipulates some individuals to destroy human life and others to ignore the fact that it is happening.

Since the beginning of her career in Chicago in the late 1940s, **Nancy Spero** (b. 1926), like her husband Leon Golub, pursued political and social themes. In the 1960s, her Vietnam drawings were among the most powerful statements against the war. *Search and Destroy* from 1967 shows one of the helicopters that saw much combat in Southeast Asia, but Spero imagines the aircraft in a fantastical, Goyaesque form, its nose like the lance of a huge swordfish, or perhaps a hypodermic needle, driven into the chest of a falling victim.

25.24 Leon Golub, *White Squad IV, El Salvador*, 1983. Acrylic on canvas, 10' × 12' 6" (3 × 3.8 m).

In subsequent work, Spero expanded her drawings into elaborate sequences. These she presented in the form of friezes or unrolled scrolls: panoramas of individual panels of print and collage, stretching up to 180 feet (55 m). These ribbons of images represent women from all eras and cultures. In *Goddess II* (fig. **25.25**), dancers from ancient Greek vases and cavorting goddesses appear again and again, amid earlier and later sources. The diversity of the figures' printed textures and colors from one appearance to the next makes the frieze richly inclusive in its unfolding graphic development. Spero said that her scrolls are "almost like a map. A map of the range of human experience from birth to aging, war, and rape, to a celebratory dance of life—but depicted through images of women."

Coe and Applebroog

Politically and socially committed, and as uncensored in her approach as Golub or Spero, the British-born artist **Sue Coe** (b. 1951) moved to New York in 1972. There she began aiming her agitprop collage-paintings at such targets as the CIA, male chauvinism, nuclear brinkmanship, apartheid in South Africa, and, ultimately, the policies of President Reagan (fig. **25.26**). Coe was inspired by the social and political inequities and righteous indignation expressed by artists such as Brueghel, Goya, Daumier, and Orozco. She is a true Expressionist, using art to indict an unjust world with the same passion that inspired earlier twentieth-century heroes of moral protest such as Käthe Kollwitz, George Grosz, Otto Dix, and Max Beckmann. Coe employed a whole battery of provocative techniques— a hellishly dark palette of graphite and gore; razor-sharp drawing; jammed, irrational spaces; collaged tabloid headlines—all of which she wielded with a seemingly unshakable faith in the rightness of her perceptions. But, however extreme or fanatical these works may seem to viewers of a less political persuasion, one cannot help being

moved by the poetic justice at work in a midnight world of evildoers metamorphosed into snakes and their hapless victims into angels, or in a painting overprinted with a banner like "If animals believed in God, then the devil

25.26 Sue Coe, *Malcolm X and the Slaughter House*, 1985. Oil on paper, collage, 59⅞ × 49¼" (152.1 × 125.1 cm). Hirshhorn Museum and Sculpture Garden, Smithsonian Institution, Washington, D.C. Partial Gift of Don Hanson and Joseph H. Hirshhorn, Purchase Fund, 1995.

25.27 Ida Applebroog, *Noble Fields*, 1987. Oil on canvas, five panels, overall 7' 2" × 11' (2.2 × 3.4 m). Solomon R. Guggenheim Museum, New York.

would look like a human being." As one critic wrote, "Sue Coe paints horror beautifully, ugliness elegantly, and monstrosity with precise sanity."

After making small drawings, artists' books, and videos in the 1970s, the New York artist **Ida Applebroog** (b. 1929) undertook a number of large, multipanel paintings in the 1980s, among them *Noble Fields* (fig. **25.27**). Applebroog's early work was marked by a feminist consciousness and an uncanny ability to generate expressive, intimate, and multidirectional narratives with the most schematic graphic means. A series of books from the late 1970s presents a single image repeated behind different headings evoking stages in tense, ambivalent stories. In her paintings, she pursued her thematic concerns with the forceful presentation of aggressive yet often highly ambiguous images. One critic, for example, saw in *Noble Fields* "a bald Medusa" who "sits for her portrait in an evening gown and arm cast, while little Oedy [Oedipus], nearby, eats a watermelon"—a description that some may find as puzzling as the painting. The mention of Oedipus is illuminating, however, since the stresses and hostilities within a troubled family are among Applebroog's notable subjects. Nonetheless, she speaks of them with a vocabulary of private symbols that the viewer cannot hope to decipher fully. Fixed against empty backgrounds that offer no clue to their meaning, her mysterious gatherings of figures are painted in thin, somewhat unearthly colors that give them the air of characters half-remembered from a distant, traumatic past. The multitude of seemingly unrelated images makes it impossible to offer a single, unified "reading" of the painting.

Applebroog delves into her substantial collection of personal and public imagery to generate what she has called "a chaos of possibilities within regimented formal designs." In *Noble Fields*, for instance, our attention is pulled back and forth by the strip of images symmetrically disposed across the horizontal panel at the top; by the injured, supported male, the line of high-kicking dancers, and the dining female in the right panel; by the delicately painted monster with a broken arm and a frilly dress in the left panel; and by the child gorging himself on massive watermelons in the stark, lunar landscape at the center. These competing areas of interest are as difficult to reconcile with one another as are the members of a fractious family, or the layers of guilt and pain that its members bear.

In the Empire of Signs: Neo-Geo

The term Neo-Geo refers to the work of artists impressed with the theoretical potential of Appropriation that used anything from Minimalist blocks to cigarette advertisements for their identity as bearers of content, though not necessarily that most readily associated with them. Recontextualization was key, but, unlike their Appropriationist peers, Neo-Geo artists were also interested in expression. At times objects that would seem to be important for their social function filled primarily expressive and aesthetic roles. The work of the most prominent of the Neo-Geo artists, Peter Halley, consisted of squares and rectangles whose form and meaning were determined by a set of social circumstances rather than formal ones. Halley associated his forms, called circuits, with the networks of communication and power in contemporary civilization. Neo-Geo artists intentionally enlisted the history and connotations of a form when they composed rather than hoping for a resonance between the shapes on the canvas and the soul of the viewer, as modernists often had. The understanding that there is specific meaning rather than generalized expression in abstract form was clearly articulated in the mid- to late 1980s, and continues to underlie presumptions about abstraction today.

Neo-Geo Abstraction: Halley and Bleckner

Peter Halley (b. 1953) was the undisputed leader of Neo-Geo. In a series of paintings based on Albers' *Homage to the Square* (see fig. 14.28), Halley treated the square, in his own words, "as a sign for certain kinds of regimented or confining structures in the social landscape." His emphasis on the restrictive nature of post-industrial society reflects the influence of Michel Foucault's essay on confinement, while his equation of a seemingly abstract sign with "the social landscape" derives from Jean Baudrillard's notion of "hyperreality." Halley and others took from Foucault the insight that the regulated geometries of modern society, from the calendar to the office building, were sites where modern ideas of geometric purity and authoritarian control coincided. The compatibility between modernist geometry and the regulation of nearly every part of our lives was, it was suggested, no coincidence. The intuition that modern art was connected to modern industry had informed machine-age art from between the wars on both sides of the Atlantic. In a deconstructive move, Foucault stripped the myth of progress from the relationship to reveal a more oppressive regime. Neo-Geo relied on this Postmodern insight, but resisted the impulse, so strong in modernist art, to transform a new idea into the foundation for an art of revelation.

The challenge for Halley was how to express content without substituting one deconstructed truth for another; how, in other words, we can tell that Halley's geometric conduits were different from the industrial abstractions of Charles Sheeler or Paul Strand (see figs. 16.29, 16.22). Halley used the writing of Baudrillard to explain that, though he relied on Foucault's insight, he, unlike the machine-age artist, did not claim to be presenting the connection between art and industry as a key to human nature. According to Baudrillard, two linked systems, international capitalism and mass media, force everyone to live in a glittering "empire of signs" where "hyperreal" images "simulate" and supplant ordinary reality. Paintings like *Two Cells with Circulating Conduit* (fig. **25.28**) "simulate" this "empire" by presenting the high-tech equivalent of its

"plumbing"—squares, to be understood as both battery and prison cells, connected by lines or "conduits" for the "circulation" of information and power. Halley, whose writings and interviews are often brought together with his paintings to form a single, pictorial–theoretical package, contends that his work collapses "the idea of the abstract and the representational" and gives abstraction a content. An important element in Halley's work is his use of Day-Glo paint, stucco surfaces, and, in more recent work, neon-colored wallpaper. These elements draw on an aesthetic of artifice that resists comparison to earlier modernists' quests for truth. Through such devices, Halley simulates traditional artist's color and evokes the dramatic beauty of the information age. Most importantly, through color and theory, Neo-Geo forced past styles of abstraction to signify new meanings rather than, as critics would claim of Neo-Expressionism, force contemporary minds to appreciate refound styles.

Ross Bleckner (b. 1949) was quickly associated with Neo-Geo by Halley and others for his use of vivid stripes to make large-scale, abstract paintings. His work is closely related to that of artists such as Sherrie Levine, who made "generic" versions of past styles in order to deconstruct modernist myths (see figs. 24.43, 24.44). However, Bleckner differed in his concentrated attempt to move beyond deconstruction to paint images about life and loss in contemporary America. His often obsessively repeated patterns do not simply allude to 1960s Op art; they simulate the hard-edged style in a way that critiques the modernist history of twentieth-century abstraction as a progressive unfolding of styles, each built upon the other, each "heroic and original" and unrepeatable. By throwing the "correct" sequence awry with the appropriation of an "incorrect" style such as Op, Bleckner showed that the past offers a variety of possibilities and has no fixed, necessary relationship to contemporary artistic practice or meaning.

As if to reinforce the point, in 1983 Bleckner started to exhibit somber paintings, such as *Two Knights Not Nights* (fig. **25.29**), in which evocations of spectral landscapes are combined with symbols—hands, torches, flowers, and

25.28 Peter Halley, *Two Cells with Circulating Conduit*, 1985. Acrylic, Day-Glo acrylic, and RollaTex on canvas, 5' 4" × 8' 8" (1.63 cm × 2.6 m). Collection Cooper Fund, Inc.

25.29 Ross Bleckner, *Two Knights Not Nights*, 1988. Oil and wax on canvas, 108 × 72" (274 × 182 cm). Mary Boone Gallery, New York.

urns—culled from the Baroque iconography of death and salvation. Such tenebrist paintings were among the earliest memorials to the victims of AIDS, which was first identified in 1982. Painted with wax and ground pigment rather than prepared paint, they are brilliant demonstrations of a return to old-master techniques, which Bleckner shared with Eric Fischl (see fig. 25.19), another artist trained at the California Institute of Arts. This school was founded in 1961 by Walt Disney, who hoped to prepare the next generation of animation artists for the film and television industries. Known as CalArts, the school quickly veered from the mission envisioned by Disney as its progressive faculty transformed it into the West Coast's leading school for experimental arts.

The Sum of Many Parts: Abstraction in the 1980s

Though overshadowed by the dramatic and sometimes shocking return of figuration in the conceptually challenging Appropriation or the emotionally wrenching Neo-Expressionism, a critical point had been reached in the

history of abstraction by the 1980s. As is clear from the work and writing of the Neo-Geo artists, if not in the polemical critiques of Neo-Expressionism, it could no longer be presumed that there was a direct connection between abstract forms on a canvas and either emotional responses or intuitive meaning. The time had passed when Kandinsky could talk about a direct connection between a color and the soul of the viewer or Pollock could place faith in the potency of his "get acquainted period" to result in painterly expressions that reached from his experience to that of mankind. Painting, as it has been said, was compromised. It was not, however, as some prematurely announced, dead. The 1980s, and 90s as well, witnessed a number of artists committed to working with the abstract tradition to articulate its boundaries and expressive as well as intellectual potential.

Murray

"All my work," the American painter **Elizabeth Murray** (1940–2007) asserted, "is involved with conflict—trying to make something disparate whole." In 1979–80 Murray realized a major breakthrough in her art. She began to break up not the image but rather the canvas, "shattering" it into separate shards or fragments (fig. **25.30**). Further compounding the conflict was the wall, revealed through the cracks as one more participant in the battle for the viewer's eye. To make such disintegration whole again, Murray, drawing on her academic background, reintroduced figuration, and imposed upon the entire archipelago of island canvases an image simple enough—brushes, palettes, cups, the painter's own hand—to be detected as a unifying factor. In addition, she adopted a painting style that was as

25.30 Elizabeth Murray, *Art Part*, 1981. Twenty-two canvases, overall 9' 7" × 10' 4" (2.9 × 3.1 m). Nelson-Atkins Museum of Art.

informed by cartoons as by the history of postwar abstraction. The cohesion of Murray's broken canvases could be experienced only by observers sufficiently attentive to "read" across the relief map of fractures and fields, visually and conceptually piecing the whole together like a puzzle.

Subsequently, Murray created large relief paintings with more unified imagery, even though fissures through the surface were still evident. These reliefs were generally based on such domestic items as old shoes with writhing shoelaces, or tables and cups, all given a certain awkwardness that made them seem vulnerable and even endearing. The objects become stand-ins for their human users, and are thus laden with psychological overtones.

Winters

It has been said that the American artist **Terry Winters** (b. 1949) "dreams science into art," a tendency that particularly extends to the science of biology. This is an interest not without precedents in modern art. After examining illustrations in scientific journals, Vasily Kandinsky (chapters 7, 10) near the end of his career portrayed microorganisms in a way that turned them into abstract shapes floating in space. Winters also painted shapes based on such organisms (along with botanical forms like buds, seeds, tubers, and spores), an interest, in both artists' work, that can be related to biomorphic Surrealism. But unlike the Russian, who generally focused in on one or two individual microscopic creatures, Winters suggests the dynamic interaction among the elements of a diverse community or colony as they grow, develop, and compete.

Winters spent three months working on the large painting called *Good Government* (fig. **25.31**), which he started without any particular title in mind. At the beginning, he struggled to bring coherence to its anarchic array of very different forms—from expansive blastulas to hard crystals to floating fragments of chromosomes. But at last, he said,

he "thought it looked like one of those maps you saw in grammar school and it said 'good government' and everything was working together." Like a system of checks and balances, these abstracted organic forms make up a complex compositional scheme, while the carefully modulated textures of this painting keep its contending shapes in an "organic" relationship with one another that threatens, like Malevich's black square (see chapter 10), not to be a composition at all.

Taaffe

Philip Taaffe (b. 1955) took abstract art as the source for his own abstract works. In a spirit akin to Appropriation, Neo-Geo, and even Richter's abstract painting, Taaffe used drawing, painting, printing, and collage to create what he calls "representations of abstract paintings." Drawing upon a nearly encyclopedic repertoire of decorative motifs from Western and non-Western sources, Taaffe is sometimes quite direct, recreating specific paintings by Barnett Newman and Clyfford Still, for instance. In other cases, genres of modernist abstraction are the general source of his inspiration. *Big Iris* (fig. **25.32**) is a curious union between Georgia O'Keeffe's big flower paintings and Op art of the 1960s, which joins the organic content of the former to the hypnotic visual effect of the latter. Collage, though linked to the avant-garde practice of Cubism, is also associated with craft traditions that were the aesthetic and feminist basis of Pattern and Decoration (see chapter 23) in the 1970s. Calling decorative art a "culturalized representation of nature," Taaffe has found in it a means to incorporate representation into his abstractions. The cultural breadth of his sources alludes to any number of artistic traditions. Taaffe's heterodox selection of motifs conspires to position his modernist sources as just one tradition among many with which artists may create historically conscious abstract painting.

25.31 Terry Winters, *Good Government,* 1984. Oil on linen, 8' 5¼" × 11' 5¼" (2.6 × 3.5 m). Whitney Museum of American Art, New York.

25.32 Philip Taaffe, *Big Iris*, 1986. Linoprint collage, acrylic on canvas, 5' 3" × 5' 3" (1.6 × 1.6 m).

Scully

Born in Dublin and educated in London, **Sean Scully** (b. 1945) moved to New York in 1973. Initially, the artist used stripes in large, densely woven "super-grids," painted in a style inspired by Mondrian, the English Vorticist David Bomberg, Agnes Martin, Brice Marden, and Sol LeWitt. Scully uses his stripes as the vehicles of an emotional or spiritual content much greater than anything obtainable from pure retinal stimulation. Beginning with his diptychs, Scully progressively elaborated his simple vocabulary of striped panels into a language of such breadth and subtlety that each painting emerged like "a physical event, a physical personality, just like people." His colors range from bril-

liant, clashing primaries to tawny mustards and creamy ochers, all warmed by long, sensuous strokes freely wavering over traces of contrasting oilstick color, the latter set down freehand. Scully moved from diptychs to immense eight-by-twenty-foot (2.4 × 6.1 m) polyptychs (fig. **25.33**), assembled from panels so various in their dimensions and depths, in their colors, widths, and directions of their banding, that they seemed like interactive social beings abstracted into iconic versions of processional figures in a classical relief, or geometric variations on Matisse's famous reliefs (see fig. 6.26). In this larger scheme, the colors and horizontal orientation assume the scale and atmosphere of landscape even as they recall monumental figural art.

25.33 Sean Scully, *Backs and Fronts*, 1981. Oil on canvas, 8 × 20' (2.4 × 6.1 m). Collection the artist.

Wall of Fame: Graffiti and Cartoon Artists

As Neo-Expressionism opened art to the many possibilities once banned by Minimalist purism, and Appropriation art drew on the commercial media, a number of even younger artists found themselves drawn into the energy and "authenticity" of one of the most "impure" of all graphic modes. This was graffiti, those "logos" (initials or nicknames) and scrawled "tags" (signatures) that their perpetrators called "writing" and had felt-tipped and spray-painted (or "bombed") all over New York City's subway trains since about 1960. For many passengers, this takeover of public walls by an indigenous, compulsive graphism simply constituted vandalism, but as a look back at the paintings of Jackson Pollock, Jean Dubuffet, and Cy Twombly indicates, graffiti-like marks have long been used by major artists (see figs. 17.8, 18.13). Not until the 1980s, however, did the underground world of self-taught graffiti writers, mainly from the Bronx and Brooklyn, interact with the above-ground, Manhattan-based realm of artists and art-school students. In 1983, the upwardly mobile graffiti artists received a boost when Rotterdam's Boymans van Beuningen Museum put on the first exhibition of graffiti art, and subsequently one of the world's premier dealers in modern art, Sidney Janis, put on his Post-Graffiti show. In the latter event, Janis displayed the canvases of graffiti writers in the very galleries where for years New Yorkers had viewed such blue-chip masters as Mondrian.

The graffiti artists and cartoonists who profited the most from the encounter between the uptown and downtown scenes, however, were not those who learned and practiced their art on the streets but those who brought the support of an art-school education to the experience. This equipped them with a basic pictorial language that was charged by their urge to communicate and their powerful calligraphic thrust, and allowed them to expand their own Pop-cartoon-TV vocabulary into a new, broadly expressive language. Their art-school backgrounds also made them more familiar with the commercial gallery system, then the primary means to achieve recognition and financial success. New York City's gritty East Village, with its affordable lofts and lively gallery scene, became the home and exhibition space for many of these young artists.

Haring and Basquiat

The dean of the art-school graffiti artists was **Keith Haring** (1958–90), who, with his School of Visual Arts preparation and love of working in public spaces, served as the all-important link between the subway world of self-taught graffiti "writers" and the younger "mainstream" artists responsive to the omnipresent, abrasive form of popular expression. At the same time that he made his presence felt in all the graffiti and cartoon forums, Haring was also traveling throughout New York City's subway system and leaving his artistic calling card on virtually every train platform. The ubiquitous format for his impromptu exhibitions was the black panel from which an advertising poster had been removed, providing a surface somewhat like that of a schoolroom blackboard. After 1980, Haring made thousands of chalk drawings "in transit," always quick, simple, strong, and direct, for the activity carried with it the risk of arrest for defacement of public property. He developed a distinctive vocabulary of cartoon figures—radiant child, barking dog, flying saucer, praying man—intermingled with universally readable signs like the cross, the halo, the pyramid, the heart, and the dollar, all rendered with such cheerfulness and generosity that their statements could be neither dismissed nor mistaken (fig. **25.34**). While in his commercial work Haring seemed to prefer drawing with black sumi ink or Magic Marker on paper, oaktag, fiberglass, or vinyl tarpaulin, he remained ready to unleash his prodigious capacity for graphic invention on almost any kind of surface, including those provided by pottery vases or plaster casts of such clichéd icons as Botticelli's *Venus*. On these, as well as on vast outdoor walls, he sometimes collaborated with genuine graffiti writers, most of whom otherwise preferred the moving, subterranean environment of the New York subway trains.

25.34 Keith Haring, *One-Man Show*, installation view, 1982. Tony Shafrazi Gallery, New York.

Though Haring garnered considerable respect in Europe, his contribution remained underappreciated in American museum circles during his lifetime. He aspired to have his work compared and exhibited with De Kooning and Matisse, but his populist and political activities seemed to work against art world recognition. Haring was politically active, creating posters and donating art for AIDS organizations in particular. In 1986 he opened the Pop Shop, which developed his project of bringing art to the masses who rarely ventured into SoHo galleries. At the Pop Shop, Haring sold low-cost merchandise such as pins and T-shirts with his signature motifs. The Pop Shop is still in operation. In 1997, seven years after his death from AIDS, Haring received a major retrospective at the Whitney Museum of American Art.

A key figure in the transformation of graffiti into painting in the 1980s was the Brooklyn-born Haitian-Hispanic artist **Jean-Michel Basquiat** (1960–88). A high-school dropout at seventeen, Basquiat was probably the most meteoric star among all the talents associated with graffiti. Like the other successful graffitists-turned-painters, Basquiat never actually "bombed" trains. Rather, while more or less living on the streets in Lower Manhattan, he formed a partnership with a friend named Al Diaz and began Magic Marking poetic messages, illustrated with odd symbols, all over the city. The pair signed their work SAMO© (standing for "same old shit"). Basquiat's tag reveals something of the frustration he felt as a black artist trying to assert his art within the context of a predominantly white gallery system. In the summer of 1980, SAMO© exhibited at the Times Square Show, a group exhibition produced by the artists' collective CoLab, praised for creating an environment within an abandoned building on 42nd Street

that mirrored the eclectic decay found in the city streets around it. Basquiat, along with Haring and others, contributed works that attracted favorable critical attention. Shortly thereafter, Basquiat struck out on his own, and his drawing soon revealed something more than graphic street smarts—what appeared to be a devotion to Picasso's *Guernica* (see fig. 15.39).

Basquiat's color-infused art is characteristically peopled by schematic figures with large, flattened, African-mask faces set against fields vigorously activated by such graffiti elements as words and phrases, arrows and grids, crowns, rockets, and skyscrapers. As in the work of Polke and Salle, the compositional force of Basquiat's work lies not in its fidelity to expected rules of composition, but rather in the poetic juxtaposition—sometimes abrasive, sometimes soothing—of a variety of images, signs, and symbols. Quite apart from his compelling sense of drawing, color, and composition, Basquiat seemed to be able to balance the contradictory demands expected of a young African-American in the art world of the early 1980s. His figural style suggested the simulated primitivism of much Neo-Expressionism, while his biography contributed further to the presumed authenticity of the work: the veil of irony that had shipped over much art of the 1980s seemed to fall away in the case of Basquiat, who allowed critics and dealers to believe that he was from a poor family. Basquiat was, in fact, the child of well-educated, middle-class Puerto Rican and Haitian parents. Even so, Basquiat's background was still far from the norm in the New York gallery scene, which presented the work of mostly white, male artists to a wealthy, white clientele. Politics aside, the rhythmic dirge of *Grillo* (fig. **25.35**) demonstrates that the artist was adept at coordinating graphic power with textual filigree to provide

25.35 Jean-Michel Basquiat, *Grillo*, 1984. Oil on wood with nails, 8' × 17' 6½" × 1' 6" (2.4 × 5.3 × 0.46 m). Stefan T. Edlis Collection, Chicago.

elements of formal grace and often brutal content. Basquiat's life and work have provided much scope for reconsidering the expectations of the art world and the role of expression, biography, race, money, and talent in the history and production of art, as in a 1996 feature film directed by Julian Schnabel. His early death from a drug overdose left a significant artistic potential untapped.

Wojnarowicz and Wong

Another alumnus of the East Village scene, **David Wojnarowicz** (1954–92), began his brief career scrawling politicized invectives and stenciled slogans in public places. An artist with a flair for drama to match the volatile life he led, Wojnarowicz developed a collage aesthetic that surrounded the viewer with the brutality of contemporary life. He was a prolific writer and photographer, as well as a painter, sculptor, video artist, musician, and performer. Wojnarowicz's installations recorded the personal pain of growing up gay in the United States and the continued cost of homophobia and AIDS. His graphic work effectively juxtaposed the romanticism of Arthur Rimbaud, one of Wojnarowicz's influences (and, in one series of photographs, his alter ego), with the landscape and mindscape of contemporary America. The results are harrowing assaults on the treatment of the individual that resonate with almost apocalyptic fervor. *Fire* (fig. **25.36**) was created the

year the artist was diagnosed with AIDS and the year his lover, the photographer Peter Hujar, died of the disease. The image contrasts manmade power with the power of nature and crime. In a comic and biting detail, the dung-beetle is shown to possess a human brain. *Fire*, and the *Four Elements Series* of which it is part, have been interpreted as an attempt to visualize a worldview that might bring sense to the loss and violence surrounding the artist.

Martin Wong (1946–99) was a painter who took public writing, including graffiti, sign language, and even charts of the constellations, as a foundation for his art. Wong began his career while working as a courtroom artist and there is a strong communicative element in his art. Though his work is figural—one of his most controversial paintings, *The Big Heat* (1988), represents two firemen wrapped in each other's arms as a building smolders behind them— Wong most often replaced the physiognomic detail required of a portraitist with a sensitivity to the expressive potential of the urban environment. *Attorney Street: Handball Court with Autobiographical Poem by Pinero* (1982–84) (fig. **25.37**) is a landscape of a Lower Manhattan playground with Wong's stylized sign language notation of a poem. Above the floating signs, graffiti adorns the urban playground, poetry fills the sky. The title of the painting is written in gold and black on simulated and constructed frames. The author of the poem, Miguel Pinero, stood at

25.36 David Wojnarowicz, *Fire*, 1987. Acrylic and mixed media on wood, 72 × 96" (1.83 × 2.44 m).

25.37 Martin Wong, *Attorney Street: Handball Court with Autobiographical Poem by Pinero*, 1982–84. Oil on canvas, 2' 11½" × 4' (0.90 × 1.22 m).

the center of the Nuyorican Poetry movement, a group of writers committed to creating literature at the intersection of Latino and U.S. cultures and languages. Pinero's work resonated with Wong's own commitment to an art responsive to the multi-ethnic, multicultural, and polyglot community in which he lived. Wong's painting, like that of Jasper Johns or Sigmar Polke, presents the viewer with a collection of different means of communication, though within the context of Lower Manhattan and with a romantic eye toward its residents. In a graceful mingling of poetry, painting, and the street itself, Wong gives form to the metaphor of the city as text.

Rollins and KOS

In 1979, **Tim Rollins** (b. 1955) co-founded Group Material, an artists' collective that developed curatorial strategies for creating what one critic called "the conditions necessary for making communication possible." For Group Material, this included shows like The People's Choice,

which featured treasured objects owned and displayed by their neighbors. Rollins completed the circuit of exchange from street to gallery by taking his social commitment into the classroom in the mid-1980s as a public school art teacher to low-income African-American and Latino teenagers in New York City. In 1984 he created a workshop with the students called KOS—"Kids of Survival."

The art created by Rollins and KOS took literature as its starting point and abstraction as the visual point of reference. Using texts such as *The Autobiography of Malcolm X*, Franz Kafka's *Amerika*, or Flaubert's *Temptation of Saint Anthony*, Rollins and the students sought to connect the themes of the books to events and concerns in their daily lives. These investigations were then used as the sources for abstract compositions that were painted onto the pages of the books. The results appropriate the text of the books as the literal and metaphoric support for an abstract art that came to be linked both to modernist concerns with the expressive potential of abstraction, and

to Neo-Geo insights into the relationship between abstract form and cultural contexts.

The Temptation of Saint Anthony—The Trinity (fig. 25.38) is a three-canvas work that covers the pages of Flaubert's novel, itself a meditation on the temptations of physical desire, with the suggestion through color and geometry of flesh and blood. A porous red ring sits off-center in the middle panel, recalling the targets of Jasper Johns and Kenneth Noland (see figs. 19.32, 20.20). The red and black of the ring are made from blood. On the left panel two red wounds appear in a gold monochrome while the righthand canvas seems to fill with blood, leaving an even red surface. The connection to AIDS becomes inescapable as the blood seems to flow from a body threatened, like Saint Anthony's, by temptations of the flesh. In a gesture of cultural democracy at its best, Rollins and KOS tear Flaubert's text and the language of modernist abstraction from their nineteenth- and early twentieth-century contexts to carry meanings relevant to urban life in the late twentieth century.

Painting Art History

In the 1990s, not only was the figure reassessed, but artists challenged the idea that before one painted or sculpted one had to interrogate the history and power of one's chosen medium. Self-consciousness toward the medium had been part of the legacy of modernism that artists from Jasper Johns and Gerhard Richter to Peter Halley and Barbara Kruger had turned into a critical tool of Postmodernism. By the end of the twentieth century, it was being taken for granted that the properties of painting, formal or political, had been exposed. A group of painters, Americans John Currin and Lisa Yuskavage among them, began generating imagery by using the old tools of realism in the new context of Postmodernism.

Currin and Yuskavage

Developing realism in the 1990s was, to **John Currin** (b. 1962), a form of "drag" in which figures, purely artificial in the contemporary mind, dressed as if they were

25.38 Tim Rollins and KOS, *The Temptation of Saint Anthony—The Trinity*, 1989–90. Blood on paper and linen, 5' 8" × 16' (1.73 m × 4.9 m).

mimetic representations of the real. Emphasizing the fact that bypassing the history of art since Courbet (see fig. 2.17) is a willful project, Currin fills his illusionistic spaces with exaggerated fantasies of middle-class white male America. Everything is sexualized.

The Cripple (1997) (fig. **25.39**), a deliberately provocative title for an image of a suggestive if somewhat disturbing young waif with a cane, exemplifies Currin's understanding of the male imagination. Other works are populated by young blondes with impossibly large breasts coddling a cast of helpless men. A more recent suite of paintings has swerved more acutely toward the frankly pornographic even as it retains Currin's fascination with the linearity, palette, and proportions of German Renaissance painting. Discussed as representing the masochism of hyperbolic male fantasy, Currin defends himself against charges of misogyny by asserting that though he uses the tools of realism, "the subject of painting is always the artist," never the objects that he or she paints. The reality being painted is a personal and psychological one.

Heightening the irony of realism by representing illogical figures with the logical devices of illusionism is also part of the art of **Lisa Yuskavage** (b. 1962), as is the use of exaggerated female anatomies. Unlike Currin's, however, Yuskavage's figures direct their attentions inward. Violets, pinks, and blues dominate scenes of erotic self-absorption. In *Honeymoon* (1998) (fig. **25.40**), Yuskavage rhymes the sensuous surfaces of flesh and nightgown with a view of mountains that look like a Chinese landscape seen through rose-colored glasses.

Yuskavage creates work that flirts with being insipid but is saved by flagrant exaggerations of both cliché and anatomy as well as creative painterly technique. In the context of decades of resistance, the creation of such oversexed female types painted in a style that seems to encourage objectification has been a confusing statement about art in the late 1990s. Figures have completely replaced bodies in this art and provide access to the suggestive and cathartic power of traditional tools such as perspective, chiaroscuro, illusionism, and paint. Yuskavage's insistence on analyzing and critiquing commercial pornography by sharply manipulating its own visual conventions testifies to the persistence of irony in contemporary art. Far from exhausted by Postmodernism, ironic interventions into the visual conventions of post-feminist, postcolonial, and post-global society characterize much of the art produced in the 1990s.

25.39 John Currin, *The Cripple*, 1997. Oil on canvas, 3' 8" × 3' (1.12 × 0.91 m).

25.40 Lisa Yuskavage, *Honeymoon*, 1998. Oil on linen, 6' 5½" × 4' 7" (1.97 × 1.4 m). Private collection.

26
Contemporary Art and the Renegotiation of Modernism

The 1990s began with a sudden and irrevocable fusion of art and politics. In Tiananmen Square, Beijing, the aspirations of thousands of protesters were summed up in a sculpture, a painting, and a harrowing performance. A model of the Statue of Liberty stood in the crowd; a portrait of Mao spattered with red paint hung before it; and as the protest ended a lone demonstrator stood in front of a military tank. In Europe, the unification of East and West Germany transformed the Berlin Wall from a military structure into a symbolic form as evocative in form and content as Maya Lin's Vietnam War Memorial (see chapter 23). In an iconic gesture of defiance, thousands of Germans from East and West celebrated the destruction of the wall by gathering at the Brandenburg Gate. In the U.S., art punctuated politics in a different fashion. The arts community, already mourning the death by AIDS of a growing number of artists, curators, and writers, was now being attacked by the government. Rightwing politicians appeared at museum openings to declare war on indecency and struck out at what they considered to be degenerate art.

Social conservatism had been quietly on the rise in the United States since the civil rights and anti-war demonstrations of the late 1960s and early 70s. Many found as much to fear as admire in the actions of students and other protesters willing to contest the authority of long-trusted institutions. Occasional violence on the part of protesters or by the police or soldiers called to subdue them was widely reported, for some giving the impression of an incipient insurrection. The global economic recession of the 1970s only made Americans warier. It was at this time that a new economic measure, "the misery index," was introduced to calculate the degree to which unemployment and inflation were lowering Americans' quality of life. The success of conservative candidates for public office during the 1980s testified to a widespread desire for a return to an imagined past of prosperity and civil order.

Once in power, conservative legislators began a concerted assault on government funding of art containing sexual or otherwise challenging content. The National Endowment for the Arts (NEA) came under particular scrutiny, and the agency's budget was severely cut (see *National Endowment for the Arts*, opposite). The debates surrounding the NEA controversy raised again issues that modern artists have been negotiating since the Whistler–Ruskin trial of 1878: to what extent should artworks be evaluated for their social versus their aesthetic merit? Some artists welcomed the decision by the U.S. Congress to curtail sharply the activities of the NEA, arguing that any public intervention in the arts undermines the freedom of artistic expression. Most observers, on the contrary, lamented the decision, predicting that the patronage vacuum left by the retreat of the NEA could only be filled by corporate interests with even narrower conceptions of what an artwork should be.

As it turns out, both sides were right. No event makes this plainer than the controversial exhibition Sensation, which appeared in London, Berlin, and New York between 1997 and 2000. The show consisted of works from the collection of British advertising magnate Charles Saatchi, who underwrote much of the exhibition's expense. As the title indicates, Sensation included many works intended to push the limits of aesthetic and social decorum, such as Marcus Harvey's *Myra* (see fig. 23.46). Many viewers and critics denounced the exhibition as sordid and voyeuristic. New York City's mayor even threatened to slash the Brooklyn Museum's budget in retaliation for hosting the show. Though the public generally agreed with the mayor's assessment of its merits, his threat to withhold funds was popularly denounced. Another point of contention was Saatchi's entrepreneurial approach to collecting; many noted that the value of works in the show would increase substantially because of the publicity it generated, a supposition that was confirmed when Saatchi sold several pieces during the show's tour at a considerable profit. Further muddying the interests of all those involved in the exhibition, Sotheby's, the auction house that handled the sale of Saatchi's Sensation works, donated $50,000 to the Brooklyn Museum. (For more on this subject, see *International Art Exhibitions*, opposite).

National Endowment for the Arts

Established by the United States Congress in 1965, the National Endowment for the Arts (NEA) provides support for the visual and performing arts as well as creative writing by allocating funds to individuals and to organizations. The vast majority of funds are awarded to arts education and outreach programs to underserved communities and to historical and conservation projects. Controversy over the role of the NEA erupted in 1989 when conservative lawmakers deemed offensive some works by a handful of artists who had received modest NEA support. Among the works to draw the loudest denunciations was a photograph by **Andres Serrano** (b. 1950) entitled *Piss Christ* (fig. **26.1**), which the artist made by placing a plastic crucifix into a jar of his urine before photographing it under dramatic lighting. Senator Alphonse d'Amato testified "that this is what contemporary art has sunk to, this level, this outrage, this indignity—some may want to sanction that, and that is fine. But not with the use of taxpayers' money. This is not a question of free speech. This is a question of abuse of taxpayers' money." Serrano's work, along with an exhibition of erotic photographs by the late Robert Mapplethorpe and a few performance pieces that addressed sexuality, fueled a Congressional assault on the agency. The NEA's chairman, John Frohnmayer, was forced to resign in 1992 and a systematic curtailing of the agency's budget was implemented. The NEA budget peaked in 1992 at nearly $176m. As the campaign against public funding for the arts gained ground, Congress decreased the agency's budget: by 2000 it had been cut by 45 percent, with annual expenditures reduced to $97m. Since then, the budget has risen annually, though it remains smaller than it was before the controversy.

26.1 Andres Serrano, *Piss Christ*, 1987. Cibachrome, silicone, Plexiglas, wood frame, 65 × 45⅛ × ¾" (165 × 115 × 1.9 cm) framed; 60 × 40" (152.4 × 101.6 cm) unframed. Edition of four.

International Art Exhibitions

Avant-garde artists have long relied on alternative venues for presenting their work. During the nineteenth century, progressive artists facing resistance from official institutions sometimes mounted their own exhibitions, as Courbet did when he staged his 1855 *Pavillon du Réalisme*. Within a few decades, audiences could view avant-garde art at places like London's Grosvenor Gallery or the jury-free Salon des Indépendants in Paris. Museums dedicated to showing modern art were proliferating by the mid-twentieth century, but even institutions dedicated to promoting modernism were eventually subject to some degree of conservatism, as taste inevitably lags behind aesthetic innovation. Museums also cannot respond to new developments as quickly as nimbler establishments like commercial galleries. Two types of exhibition have evolved to answer these conditions: large international surveys of current trends organized by curators; and art fairs, based in several cities around the world. The first approach includes the numerous biennials and triennials (including the Venice Biennale, São Paulo Biennial, Whitney Biennial, and Carnegie International) and Documenta, which takes place in Kassel, Germany, every five years and is known for ambitious site-specific and Conceptual artworks. Art fairs differ significantly in that programming is determined by dealers in concert with the artists they represent. While art fairs lack the thematic coherence or curatorial vision that defines an event like Documenta, they offer audiences in a variety of locations the opportunity to see work by hundreds of up-and-coming as well as established artists each year. Art fairs have shifted the locus of cultural exchange from major Western cities to Tokyo and Miami, which host fairs as noted as those held in Basel and London. Although art fairs are geared toward sales, they often include Performance, installation, or site-specific works that cannot be purchased, making the art fair into a cultural event as much as a marketplace.

Commodity Art

Artists have long been suspicious of the art market, as Duchamp's *Box in a Valise* and Manzoni's artist-inflated balloons demonstrate (see discussions in chapters 11 and 19). These concerns led some Conceptual artists to abandon the production of art objects altogether. But in the wake of Postmodernism, many artists decided to wrestle with the issue on its own terms, producing and trafficking in clearly marked consumer goods.

Jeff Koons (b. 1955) started showing elegant Minimalist arrangements of consumer goods in a small independent gallery with Peter Halley, Meyer Vaisman, and Ashley Bickerton in 1985. Within one year, he had graduated to a blue-chip operation in SoHo. *New Hoover* (fig. **26.2**) is typical of these early sculptures in its clear gridded composition and its commitment to leaving the new materials (similar to those Donald Judd had found so exciting in the early 1960s—see fig. 20.46) affixed to the commercial products for which they were intended. Here is a classical Minimalism of merchandise that brought together the economic and psychological satisfaction of fine art and the commodity. It was also clear that this ex-stockbroker had a refined aesthetic sense.

26.2 Jeff Koons, *New Hoover Quadraflex, New Hoover Convertible, New Hoover Dimension 900, New Hoover Dimension 1000*, 1981–86. Hoover vacuum cleaners, acrylic glass, and fluorescent light, 8' 3" × 4' 5½" × 2' 4" (2.5 × 1.36 × 0.71 m). Private collection.

Koons soon left the Minimalism frame and focused on the ambiguous potential of commodities of much lower form than vacuum cleaners. In an exhibition created as an ensemble and entitled The Banality Show, he presented exquisitely crafted porcelain renderings of kitsch, perhaps the one category of objects that had not yet been taken as a suitable subject for art. The effect was a composition of simulated desires in which Koons himself posed, with leather jacket and fashion-model looks, as its centerpiece. Koons, like the Appropriation artists discussed in chapter 24, seemed content to omit any obvious signs of his own creative act. Unlike Levine and others whose practice the Banality Show invoked, however, he did not critically reframe his selected forms. In discussing his art, he evinces a surprising commitment to a rather modernist belief in essences rather than a Postmodern conviction in the constructed. Claiming, with disarming innocence, "I think about my work every minute of the day," he has explained that he aims to reveal the true nature of his object by putting it in a place where that nature is exposed. He equates this with putting a shy person in public, where you can really see their shyness. The subjects of *Michael Jackson and Bubbles* (fig. **26.3**), it is supposed, revealed in the delicate finish of porcelain under the heat of the gallery lights, offer up the true and rather unsettling spirit of the pop star and his once ubiquitous pet chimpanzee. Koons capitalized on artifice, presenting objects that, while they reveal something of the fixations of American culture, suggest that the desires responsible for creating *Michael Jackson and Bubbles* are simulated and correspond to nothing more real than television.

Composing with commodities took a variety of forms. Perhaps the most elegant were the sparse organized collections of **Haim Steinbach** (b. 1944). On customized shelves, Steinbach arranged what looked like the results of a trip to the mall. Beside a field of six Dreammachine radio alarm clocks rises a tower of red pots looking like a Renaissance bell tower or, following the suggestion of the four lava lamps to its right, an erupting volcano. *Ultra Red #2* (fig. **26.4**) encourages the viewer to think in terms of countdowns and explosions, volcanoes and Italian landscapes, in a consumer reworking of the destruction of Pompeii, but, like Steinbach's work in general, it is more about color and form. In the early 1960s, Frank Stella (see fig. 20.42) professed that his goal as a painter was to permit the paint on his canvases to be as beautiful as it was in the can. Paint was conceived as a found object to be arranged but not transformed in the final work. Steinbach's palette is made up of consumer items rather than paint, but his aesthetic is strikingly similar.

If Steinbach used consumer goods to create abstractions that perhaps could be seen as landscapes, **Ashley Bickerton** (b. 1959) was best known for his portraits. Moving even farther from the realm of human experience, Bickerton chose not even desirable products but their brand names as his material. On rather overbuilt and mechanical-looking

26.3 Jeff Koons, *Michael Jackson and Bubbles*, 1988. Porcelain, 3' 6" × 5' 10½" × 2' 8½" (1.06 × 1.79 × 0.83 m).

26.4 Haim Steinbach, *Ultra Red #2*, 1986. Mixed media construction, 63 × 76 × 19" (160 × 193 × 48 cm).

apparatuses, Bickerton created ironic assemblages of logos that he then gave emotionally loaded titles like *Tormented Self-Portrait Suzie at Arles* (fig. **26.5**). One can construct a narrative out of the indicated products, imagining, perhaps, a romantic breakup on a road trip in Southern France to rationalize the title, but the work offers little support for this. Even the title and the artist's signature, the two human elements in the work, are emblazoned across its surface with all the superficiality of "TV Guide" and "MARLBORO." In Bickerton's ironic, if not cynical,

26.5 Ashley Bickerton, *Tormented Self-Portrait Suzie at Arles*, 1988. Mixed media construction with padded leather, 90 × 69 × 18" (2.29 × 1.75 × 0.46 m).

26.6 Damien Hirst, *The Physical Impossibility of Death in the Mind of Someone Living*, 1991 (refurbished in 2006). Tiger shark, glass, steel, 5% formaldehyde solution, 83⅞ × 204 × 83⅞" (213 × 518 × 213 cm). Steven A. Cohen Collection, Connecticut (on view in New York at The Metropolitan Museum of Art through 2010).

world, no one subject, Suzie or cigarettes, is any more substantial than another. The portrait suggests Postmodern ideas about the importance of social context in generating meaning and the fluid and impressionable nature of identity.

British artist **Damien Hirst** (b. 1965) has acknowledged not only the current role of art as commodity but also the long history of museum practices that have contributed to its condition. Both art and natural history museums have tended to display objects in a manner akin to goods presented in shop windows: artworks and specimens are often shown in glass vitrines and/or glass-fronted dioramas. In fact, the more precious the object, the more likely it is to be enclosed behind a glass barrier, as the presentation of the *Mona Lisa* at the Louvre Museum attests. Hirst made the way viewers encounter objects in a museum as much the subject of his work as the objects themselves.

Like Koons before him, Hirst has found the Minimalist vocabulary useful for creating a "clean, minimal, kind of acceptable look, with an intellectual splatter." The most notorious of Hirst's works is a Minimalist glass tank containing a shark in formaldehyde. In this work, titled *The Physical Impossibility of Death in the Mind of Someone Living* (fig. **26.6**), Hirst's morbidity and philosophical inclinations come neatly packaged with a Minimalist pedigree. The act of viewing an artifact preserved in a museum, whether for its aesthetic or social value, Hirst suggests, always involves a confrontation with loss. A painting executed by the hand of a long-dead artist, a tool used by an ancient hunter, a uniform worn by a soldier killed decades ago: to negotiate these works without plunging into psychic trauma, the viewer must constantly distance him- or herself from the fact of this overwhelming absence. In this way, Hirst's *Physical Impossibility of Death* functions in a manner akin to seventeenth-century Dutch *vanitas* still life paintings of skulls and nearly burnt-out candles, which served as reminders of the fleetingness of life.

Pharmacy, the final work in a series of installations addressing medicine, takes the sculptural dialogue with life and death to a high-class restaurant opened, with Hirst's involvement, in London in 1998. Travestying such restaurants as the Hard Rock Café, *Pharmacy* (fig. **26.7**) takes the multibillion-dollar pharmaceutical business as its theme, transforming so many "miracle" drugs into objects for the viewer's visual rather than corporeal consumption. Contemporary society's faith in drugs has superseded religion, Hirst suggests, as he presents pills and tonics enshrined like so many relics. Cabinets with aesthetically elegant displays of drugs filter the light as it falls on altar-like tables decorated with tablets and pills. A giant model of a DNA molecule adorns the dining room, while detailing suggests the hygiene of an operating room. An artist whose earlier work included bisected sheep and rotting carcasses displayed in large vitrines as well as oversized

26.7 Damien Hirst, *Pharmacy* (detail of restaurant windows with medicine), 1998.

and well-used ashtrays, Hirst here plays out his interest in the nature of sickness and death on the stage of London's social life.

Pharmacy is both an artistic confrontation with social space and a marketing strategy on a par with those of Andy Warhol or Keith Haring. Unlike such market-savvy artists before him, however, Hirst maintains a surprisingly high level of violence in his art. Speaking sentiments that could be uttered by Kara Walker (see fig. 26.23) and Raymond Pettibon (see fig. 26.21) or filmmakers such as Quentin Tarantino and Peter Greenaway, Hirst explained, "I am an artist. I use violence as a way to communicate." The success of *Pharmacy* reveals a certain comfort that we take in keeping company with death.

Postmodern Arenas: Installation Art

While much Postmodern art seems to maintain an ironic detachment, many artists working during the 1980s sought to avoid such critical distance in order to deliver an intense aesthetic experience. This intent manifested itself most forcefully through Installation art. Installations are specially constructed environments, designed to provoke a particular aesthetic sensation or to excite awareness of a specific idea or problem. Installation pieces were created throughout the 1960s and 70s by artists who also worked in Performance, such as Nam June Paik, Joseph Beuys, and Rebecca Horn, and by artists with links to Conceptual art, such as Jonathan Borofsky and Christopher Burden. The special potential of environmental works, however, came to the fore in the 1980s. Since we can walk around inside them, such works lend themselves to interpretation as scale models of the world at large, and installations made in this "retrospective" decade increasingly seemed like comments on the state of the Postmodern world. Some of these installations were specifically sites of memory, as in Christian Boltanski's work (see fig. 26.11)—places to reflect on the troubled history of the twentieth century and the role played by art within it. For many artists working in this mode, such as Ilya Kabakov (see fig. 26.10), the lofty aspirations of early modernist art had collapsed. Meanwhile, artists such as Bill Viola and Jenny Holzer, who turned to new electronic technologies, did so with a wary, skeptical irony, undercutting any great faith in the Brave New World of the future.

CoLab, Ahearn, and Osorio
In 1980, the CoLab collective of artists created the Times Square Show in an abandoned building on 42nd Street. The show kicked off the decade with an impulse to fill the interiors of the art world with the detritus of the streets, alleys, subway tunnels, peep shows, movie houses, studios, parks, and vacant lots of the city. The obsession with crime and degradation that filled the Times Square Show—simulated rats crawled through the rooms, and rape and other acts of violence were depicted again and

again—was relieved in a few notable works, such as those of CoLab organizer John Ahearn.

John Ahearn (b. 1951) was an upstate New York artist who, with his associate Rigoberto Torres, chose to live in the South Bronx and there portray its citizens in a series of relief sculptures. As did George Segal and Duane Hanson (see figs. 19.39, 23.52), Ahearn makes life casts that comment on human relationships and society at large. Their indomitable subjectivity is generated through realistically rendered faces, their intense gazes conveying ferocious dignity. The artist has said: "The basic foundation for the work is art that has a popular basis, not just in appeal, but in its origin and meaning. ... It can mean something here, and also in a museum." Certainly the reliefs communicate a great deal in gallery settings, but by "here," Ahearn means the exterior walls above the very streets in which his subjects live and work (fig. **26.8**). Even in the neighborhood, however, his placement is carefully selected to suggest content. *Homage to the People of the Bronx: Double Dutch at Kelly Street I: Freida, Jevette, Towana, Stacey* (1981–82) was installed on an exterior wall several stories above the ground. Ahearn applied a surrealist manipulation of the ordinary and rather straightforward symbolism to suggest that these children's footing as they navigate the complexities of life, expressed in the two ever-circling jump-ropes,

26.8 John Ahearn, *Homage to the People of the Bronx: Double Dutch at Kelly Street I: Freida, Jevette, Towana, Stacey*, 1981–82. Oil on fiberglass, figures life-size. Kelly Street, South Bronx, New York.

is far from stable. So popular are these open-air installations that the artist's neighbors compete to sit for twenty minutes with their heads covered by a fast-setting dental plastic. From the molds thus made, Ahearn then casts the form in fiberglass. But what brings the works to life is his immense gift for color, which allows him to evoke the ambient light and heat of skin itself. In a curious turn on dialectics akin to Robert Smithson's site/non-site (see fig. 23.6), Ahearn creates two copies of each work, one for collectors and museums and the other to stay rooted in the community, in the possession of the person represented.

Pepon Osorio (b. 1955) has found Installation to be a means to make art in, of, and for the Puerto Rican community. The enveloping nature of his format, often room-size environments bursting with all forms of decorative elements from beads and flowers to baseball cards and bicycles, mimics what Osorio understands to be a Puerto Rican aesthetic but one that embraces his viewers regardless of their background. During his early career, he worked as a caseworker in the New York City department of Children's Services and he is committed to an art of social conscience. Osorio defines artistic success as the unification of the individual, nation or larger community, and universal. *The Bed* (fig. **26.9**), a piece dedicated to the memory of Juana Hernandez, the woman who lived with his family and helped raise him, demonstrates the multiple references in his work. In the center of a room rests a large bed adorned with *capias*, souvenirs given at Puerto Rican weddings,

26.9 Pepon Osorio, *La Cama (The Bed)*, 1987. Mixed media installation; bed 75 × 67 × 78" (190 × 170 × 198 cm), room dimensions 450 × 450' (137 × 137 m). Collection El Museo del Barrio.

baptisms, and anniversaries. The installation presents loss—the loss of an important person in his life—through the lens of culturally specific rituals of celebration, thus inviting a nation of celebrants to comfort the artist and praise the dead. *The Bed* invites the artist's audience into a family experience in his own home: other installations focus on the choices and lives of fictionalized families. Often accompanied by performances, Osorio's art moves freely between fact and fiction, as well as personal and social realities, and always with an "aesthetics of abundance" that identifies his roots and his art.

Kabakov

Ilya Kabakov (b. 1933) grew up in the former Soviet Union during the harsh Stalinist era. Trained as an artist from an early age, for many years he earned his living as an illustrator of stories, most of them for children, while privately he made elaborate albums combining poetic, sometimes bizarre, tales and drawings. Kabakov began creating full-scale environmental pieces in the mid-1980s. They, too, contained elements of narrative, often revealing the difficulties and privations of Soviet daily life, but also conveying information through fantastical gatherings of objects, or what has been called Kabakov's "material poetry." After the collapse of the communist state, these works took on the character of archeological sites, where visitors could explore the cultural history of a vanished system.

In *The Man Who Flew into Space from His Apartment* (fig. **26.10**), the hardships of ordinary people are ironically juxtaposed with the grandiose projects of the state—in this case, apparently, the Soviet space program, which launched the first human being into orbit. About this fantasy work Kabakov said:

> The person who lived here flew into space from his room, first having blown up the ceiling and the attic above it. He always, as far as he remembered, felt that he was not quite an inhabitant of this earth, and constantly felt the desire to leave it, to escape beyond its boundaries. And as an adult he conceived of his departure into space.

The room we see, with a gaping hole in its roof, contains the debris left behind by the astronaut's improvised take-off: broken dishes, the remains of some simple furniture, and stray items of worn clothing. Glued to the walls are various political posters as well as the traveler's blueprints, flight plans, and calculations; from the ceiling hangs the catapult that flung him away from it all, up into outer space. On a small model of a city, which has a light bulb for a sun, a strip of curved metal rising from an apartment building shows the planned trajectory of "the one who flew away."

French installation artist **Christian Boltanski** (b. 1944) often deals with European memories of World War II.

26.10 Ilya Kabakov, *The Man Who Flew into Space from His Apartment*, 1981–88. From the installation *10 Characters*. Six poster panels with collage, furniture, clothing, catapult, household objects, wooden plank, scroll-type painting, two pages of Soviet paper, diorama. Room dimensions 8' × 7' 11" × 12' 3" (2.44 × 2.41 × 3.7 m).

Boltanski was born in Paris on Liberation Day (September 6, 1944), as the Allied armies entered the city, and his middle name is *Liberté*. He often created works for prisons, hospitals, and schools—institutional sites much concerned with the consequences, and the lessons, of the past. In a series of elegies that evoke the Holocaust, Boltanski hung up slightly blurred photographs of children and surrounded them with groups of small electric bulbs that cast a glow like candlelight in a place of worship (fig. **26.11**). Some of his other works evoke feelings that are considerably less overwhelming, and more mixed. *The Shadows*, for example, combines the macabre and the playful, suspending simple figurines in front of lights so that they cast large,

ominous shadows on the walls. Little paper dolls hung by the neck and skeletons dangling in mid-air start to look like the indeterminate shapes a small child might be afraid of in the dark. At the same time, they give a knowing twist to the tradition of the Balinese shadow puppet theater.

Viola

The American video artist **Bill Viola** (b. 1951) has also examined the theme of memory. Viola creates not just videotapes but entire installations that employ objects, video images, and recorded sound. He has long been interested in how the eye and brain process visual information, and he seeks to reveal their workings in his art.

26.11 Christian Boltanski, *Lessons of Darkness*, 1987. Twenty-three black-and-white photographs and 117 lights, overall approx. 6' 6¾" × 16' 4¾" (2 × 5 m). Kunstmuseum, Bern, Switzerland.

In *The Theater of Memory* (fig. **26.12**), an uprooted tree lies diagonally across the floor of a darkened room. In its branches are dozens of lanterns. A video image is projected against one wall. At intervals, white noise, mostly static, erupts from the speakers, separated by long periods of silence. Of this installation Viola said:

> I remember reading about the brain and the central nervous system, trying to understand what causes the triggering of nerve firings that recreate patterns of past sensations, finally evoking a memory. I came across the fact that all of the neurons in the brain are physically disconnected from each other, beginning and ending in a tiny gap of empty space. The flickering pattern evoked by the tiny sparks of thought bridging these gaps becomes the actual form and substance of our ideas.

His installation is a kind of working model of the brain's physiology, as if the viewer were standing inside the "theater" of a fantastically huge cranium. The lanterns are like the "tiny sparks of thought" that ignite along the branching "tree" of our intricate neural network; the projected video image evokes the "show" that memory replays before our mind's eye. It is a decidedly mechanistic, even clinical, view of how human consciousness operates, but a certain romantic sense of mystery is nonetheless supplied by the dramatically lit tree, the archaic lanterns, and the darkened theatrical space.

Strangely Familiar: British and American Sculpture

Like their counterparts working in Installation, sculptors found great potential in deriving abstract objects from narrative, representational, and found sources. Among a number of contemporary English sculptors of abstract tendency, **Tony Cragg** (b. 1949) has modified techniques of the Minimalist and Process artists, such as grids or scatter works, to exert control over content. A striking series of his works was created by carefully placing small discards, like airy mosaics, across the floor or wall in abstract patterns of color and shape that balance the effect of the whole with the specificity of the once-useful component parts. Like his fellow Britons Gilbert and George (see fig. 22.24), Cragg represents a generation of artists tired of the purity of English sculpture as represented by Anthony Caro, Henry

Moore, and Barbara Hepworth (see figs. 20.39, 18.50, 18.52). Cragg and the two sculptors most often discussed in relation to him, Richard Deacon and Bill Woodrow, find content in the Dada and Pop strategy of bringing into their works all things—including at times representation—considered to be outside the purview of abstraction. Scavenging and assembling bright fragments from the beaches and dustbins of England, Cragg makes newly relevant the once-useful but now broken, dysfunctional, and environmentally disfiguring products of industry. Often, as in *Britain Seen From the North* (fig. **26.13**), his compositions are as disorienting and politically suggestive as his process.

In 1978–79 **Richard Deacon** (b. 1949) read the German poet Rainer Maria Rilke's *Sonnets to Orpheus* and conceived a profound admiration for the manner in which "the objects that appear in Rilke's poetry, whilst taking on connotations, retain the quality of actuality." While the many implications of ears, horns, and mouths found in Deacon's sculptures derive ultimately, if obliquely, from Rilke's central metaphor of Orpheus' head, the forms remain too ambiguous to suggest clear, precise images. This dual sense of familiarity and strangeness can be seen in *Tall Tree in the Ear* (fig. **26.14**), where a large blue contour "drawing" in space seems to describe a very large dry bean, held upright by the silvery armature of what could be a pear. Together, the two- and three-dimensional forms conjure the shape and volume of the ear cited in the title, while their size evokes the immensity of the sound issuing from a tree, possibly one with branches full of noisy starlings or with leaves rustling in a strong wind. Mystery and poetry inform this art from beginning to end. Although he calls himself a "fabricator," Deacon employs simple methods, such as riveting; he uses unaesthetic materials, like steel and linoleum; and he prepares no preliminary drawings or models. Instead, he permits initial idea, material, and process to interact to produce sculptures that announce their presence even as they imply absence.

26.13 Tony Cragg, *Britain Seen From the North*, 1981. Plastic and mixed media, "figure" to left 66⅞ × 23" (170 × 58.4 cm), "Britain" to right 12' 1¼" × 22' 10¾" (3.7 × 7 m). Tate, London.

26.14 Richard Deacon, *Tall Tree in the Ear*, 1983–84. Galvanized steel, laminated wood, and blue canvas, 12' 3⅜" × 8' 2½" × 11' 11" (3.7 × 2.5 × 3.6 m). Saatchi Collection, London.

26.15 Martin Puryear, *Old Mole*, 1985. Red cedar, 61 × 61 × 32" (154.9 × 154.9 × 81.3 cm). Philadelphia Museum of Art.

Martin Puryear (b. 1941) accepted Minimalism's simplicity and gravity but went on to invest his art with a human scale and animistic quality generated by craftsmanly process. Time spent with the Peace Corps in Sierra Leone reinforced his desire for "independence from technology" and gave him an appreciation of the "magic"—the special meaning or content—that seems to emanate from hand-honed

objects. The resultant art is one in which modernist cerebration and tribal atavism, the traditions of Western high art and those of preindustrial craft, do not so much fuse as counterbalance one another in a dialectical standoff. The particular magic of *Old Mole* (fig. **26.15**), for example, is to keep several suggestive tensions unresolved: a form that at first looks solid reveals itself as a weave of relatively

weightless red cedar. And what appears to be an abstract shape quickly becomes in addition a kind of totem, a "mole"—a form that sits on the floor, looking alert and intelligent. Ultimately, the product of a craft technique is endowed with a sculptural presence, comparable to the transformation that occurs in the work of Brancusi (see chapter 6).

London-born, American-trained **Judy Pfaff** (b. 1946) is best known for her gallery-wide installations (fig. **26.16**), works related not only to those of Jonathan Borofsky and the "scatterwork" Conceptualists (see chapter 22), but also to the abstract illusionism of Al Held, her teacher at Yale. Walking into a Pfaff installation, viewers often sense that they have entered a giant Abstract Expressionist painting—one realized, in this case, as a lush, fluid underwater environment providing total immersion among all manner of strange, tropical flora and fauna, brilliantly colored and suspended in free-floating relationships. To produce her spectacular effects, Pfaff assembled a huge collection of non-art materials—plaster, barbed wire, neon, contact papers, woods, meshes—from junkyards and discount outlets, hardware, lumber, and paint stores. Having transported these "mixed media" to the gallery, along with a few artifacts prefabricated in her studio, Pfaff then worked in an improvisatory manner on site, first by setting up visual oppositions among painted and sculptural elements. With precariously counter-balanced rivalries as her guiding principle, she worked through the space, adding and adjusting,

26.16 Judy Pfaff, *Deepwater*, 1980. Installation view. Holly Solomon Gallery, New York.

establishing and upsetting formal relationships, all in a continuous flow of inspiration, editing, and fine-tuning.

After graduating from the Yale School of Art, the sculptor and painter **Nancy Graves** (1940–95) lived for a time in Italy. At a natural history museum in Florence, she happened upon a group of wax anatomical effigies made in the seventeenth century. In them she saw the possibility for a new kind of sculpture. She began making small stuffed animals and assembling them with the aid of found objects. In this menagerie she discovered her now-famous breakthrough image—the Bactrian, or double-humped, camel—a unique form that, because specific, left the artist "free to investigate the boundaries of artmaking." Graves made several series of full-scale camels, at first fabricating them from table legs, market baskets, polyurethane, plaster, and painted skins. Gradually, however, she progressed toward engineered, portable forms built of steel beams and covered with hide, finally producing the only camels she allowed to be used for museum exhibition. Although uncannily naturalistic, the Bactrians were not exercises in taxidermy but original creations made without reference to models and brought to life by the artist's own handwork and her meticulous regard for detail, texture, and proportion.

While investigating the form of the camel from the inside out, Graves discovered all manner of parts—fossils, skeletons, bones—that proved interesting in their own right as organic yet abstract forms, eminently suitable to aesthetic reordering. A commission for a bronze version of one of the resulting bone sculptures brought her together with the Tallix Foundry in Beacon, New York. Encountering a new technology launched the artist into a new phase of aesthetic experiment: open-form, polychrome, free-standing constructions combining natural and industrial shapes, often with a filigreed lightness (fig. **26.17**). Graves would arrive at the foundry with shopping bags filled with fern fiddleheads, squid and crayfish, palmetto and monstera leaves, lotus pods and warty gourds, Chinese scissors, pleated lampshades, Styrofoam packing pellets, and potato chips. At Tallix she expanded the repertoire of forms to include pieces of broken equipment, old drainage pipes and plumbing fixtures, or even spillages of molten metal. After a construction was assembled, she applied pigments either by patination or by hand-painting, with brushwork as freewheeling and extemporaneous as the structure it embellished.

For his sculpture, **Donald Lipski** (b. 1947) takes parts and makes wholes, but he imagines the whole only after finding—or scavenging—the parts and discovering a kind of surreal logic in some relationship among them. The artist's strategy is to raid junkyards, dustbins, dumpsters, and dime stores and then combine his gleanings in assemblages that astonish and delight with the perfect union of their incompatible parts. Thanks to his ingeniously associative mind, Lipski can easily grasp how the shape and clarity of a crystal ball render it ideal for nesting in the cradle of

an old telephone. Wrenched from their usual context and reordered in brilliantly dysfunctional ways, commonplace items become strange and wonderful objects of contemplation. While Lipski's work may recall Marcel Duchamp and his readymades, its lack of anti-art content and its lyrical obsessiveness give it a more certain kinship with the boxes of Joseph Cornell (see fig. 17.47).

Like his sculptures, Lipski's installation *The Starry Night* (fig. **26.18**) also presents ordinary things in unexpected ways. Here, nearly 25,000 double-edge razor blades were stuck directly into the Sheetrock walls of a gallery. Their swarming, swirling patterns across a large area resemble the cosmic vortex of the nocturnal sky in Van Gogh's famous painting (see fig. 3.29). At the same time, however, and more disturbingly, the thousands of dangerously sharp blades protruding toward the viewer remind us of Van Gogh's self-mutilation and his tortured mental state at that time. With its complex reference combining visionary pleasure and psychological pain, Lipski's *Starry Night* communicates a surprisingly affecting sense of the dangers in an intensely romantic art. Moreover, exhibited during the AIDS epidemic in an exhibition space in San Francisco known for its experimental installations, *Starry Night* would have suggested the far more immediate dangers of romance. Abstraction was defined in *Starry Night* by the geographical, temporal, and cultural context of its production and, like the most challenging art of the decade, was all the more powerful because of it.

26.17 Nancy Graves, *Wheelabout*, 1985. Bronze and steel with polyurethane paint, 7' 8½" × 5' 10" × 2' 8½" (2.3 × 1.8 m × 0.83 m). Modern Art Museum of Fort Worth, Texas.

26.18 Donald Lipski, *The Starry Night*. Razor blades on wall. Installation at the Capp Street Project, San Francisco, 1994.

Starry Night, a work of the 1990s, is deeply informed by the retrospective examination of modern visual languages in the 1980s, from the evocative, painterly vocabulary of Expressionism and the sublime attempts at purity in geometric abstraction to the forms of public address found in the mass media. After a decade of deconstructing visual communication, artists took on the task of rebuilding expressive and narrative forms that would respond to critiques of modernism as well as the continued desire of contemporary society to tell its stories and see its emotions, intuitions, hopes, and fears presented in art.

Reprise and Reinterpretation: Art History as Art

As is evident throughout this volume, art history has concerned nearly every artist in the modern era. Édouard Manet, perhaps the most art-historically conscious artist of the modern period, has been a particularly fertile subject for those seeking to understand their relationship to the Western tradition. Japanese photographer **Yasumasa Morimura** (b. 1951) has explored the history of art and the place that that history holds today by putting himself into recreations of canonical masterpieces. Associating himself with Cindy Sherman (see fig. 24.48)—he even recreated a Sherman work from the early 1980s—Morimura announces that his intentions are critical.

For *Portrait (Futago)* (1988–90) (fig. **26.19**), his commentary on *Olympia* (see fig. 2.24), Morimura constructed an elaborate set of Olympia's boudoir in which he posed both as the infamous courtesan and as her maid. In apparently gleeful modifications to the Manet painting, one can see serious intrusions into modern art history. As we know from recent scholarship on *Olympia*, Manet's painting was as much about class and race as gender and modernity. Morimura's addition of a bridal kimono casts Morimura/Olympia as a Japanese bride, and his transformation of the mysterious black cat into a figurine displayed by Japanese merchants as a totem of commerce and prosperity reiterates the class issues while adding those of race. Casting himself in the role of Olympia fuses the sexualized role of the prostitute with the vision, both feminized and eroticized, of the East still evident in Western discussions of Asian cultures.

Morimura/Olympia takes on the observer's gaze and directs it, controlling those things one is able to see. If artists of the 1970s and 80s examined the disturbing consequences of being the object of beauty, desire, and examination, in the 1990s Morimura and artists including Lisa Yuskavage (see fig. 25.40) explored the potential

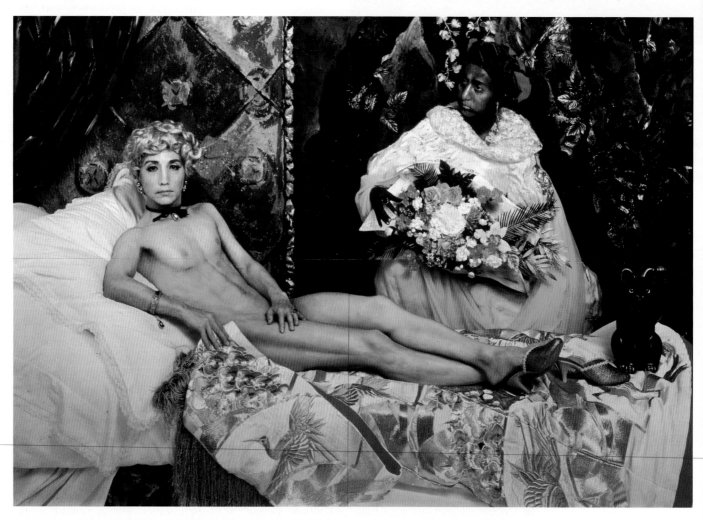

26.19 Yasumasa Morimura, *Portrait (Futago)*, 1988–90. Colour photograph, 6' 10¹¹⁄₁₆ × 9' 10⅛" (2.1 × 3 m).

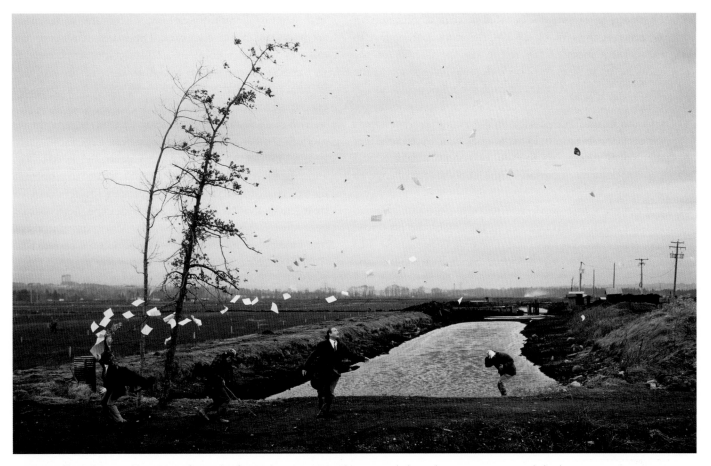

26.20 Jeff Wall, *A Sudden Gust of Wind (After Hokusai)*, 1993. Fluorescent light, color transparency, and display case, 7' 6⅜" × 12' 4⅞" (2.3 × 3.8 m). Tate, London.

for agency and power from the same position. Morimura's exploration has encompassed the personae and appearances of stars such as Greta Garbo, Marilyn Monroe, Jodie Foster, and Madonna.

As for Morimura, nineteenth-century painting provided the starting point for Canadian photographer **Jeff Wall** (b. 1946). Wall is part of a community of photographers in Vancouver whose interests coincide around the play of artifice and observation in narrative photography. As an art history student, Wall was interested in the transformation of history painting from a genre restricted to depicting the greatness of the past to one that, in the hands of such painters as Delacroix, Goya, or Manet, conveyed the gravity of contemporary life. In large light-boxes meant to mimic the propagandistic quality of history painting with the boldness of advertising, Wall presents scenarios of human activity including domestic quarrels, war, or just random accidents. To approach the scale and declarative quality of history paintings, he carefully designs his settings, sometimes in a studio, but often outside, and directs actors to play the scenes. Wall's process consists of digitalizing the negatives of numerous photographs and then combining them in a final transparency. The results give him even more compositional command and, as in *A Sudden Gust of Wind (After Hokusai)* (fig. **26.20**), impart gravity to the ambiguous activities depicted.

The narrative and appearance of *A Sudden Gust of Wind (After Hokusai)* (1993) were inspired by a woodblock print from the *Thirty-six Views of Mount Fuji* (1823–33) by Katsushika Hokusai (1760–1849). Taking the Japanese woodblock as his model for contemporary history photography, Wall alludes to both Eastern and Western nineteenth-century artistic traditions and the nineteenth-century European fascination with Asian visual culture. Using photography to transform the woodblock into a salon-style image of Canadian businessmen projects a certain irony onto the multicultural aspects of both the nineteenth and twentieth centuries.

One of the most persistent divisions maintained by art history is the distinction between "high" or "fine" art and popular forms of visual expression. Modern artists have alternately confirmed and rejected these categories, with Postmodernism delivering a strong blow against such hierarchization. The work of California artist **Raymond Pettibon** (b. 1957) likewise eschews this division, though he maintains that his position is less strictly theoretical than that of the East Coast Postmodernists who emerged in the 1980s. Pettibon has done so through a focused examination of the relationship between figural subjects, text, and time in narrative images. Narrative, of course, has been the implicit foundation of such archetypal Postmodern work as Cindy Sherman's untitled film stills (see fig. 24.46).

However, in Sherman's case, as in that of Simpson or Weems (see figs. 27.32, 27.30), the story is secondary to the consequences of the telling on the identity of the speaker. Artists like Pettibon maintained allegiance to the more traditional pleasures of narrative tension and resolve while transforming our ideas about the relationship of text and image. The passage on *No Title (The Translator's Have)* (1996) (fig. **26.21**) continues "attempted to satisfy themselves first as to the author's exact meaning …," thereby drawing attention to the impossible challenge of Pettibon's art.

Pettibon's first work was making illustrations aimed at Californian youth culture. In the 1980s, he produced his own illustrated magazine *Tripping Corpse* (1981–86) and did graphics for hardcore bands Black Flag, the Minutemen, and, later, Sonic Youth. By the 1990s, he was citing Henry James while appropriating figures such as Batman. Reiterating the disjunction between text and image, his drawing style is formally eclectic. Critics have found in his stylistic variation the kind of formal self-consciousness of Johns, Polke, and Twombly. Pettibon's decision to locate this heady research in the tradition of Comix—the genre of highly stylized cartoons usually focused on subcultural fascinations with sex and drugs and circulated in "zines" such as *Tripping Corpse*—rather than painting demonstrates how, where, and with whom art issues are being discussed. The irony that Pettibon's imagery was as at home in art history departments as it was at SST Records (the LA punk label of his brother) is indicative of the cross-cultural migrations that art encouraged in the 1990s.

The relationship between artist and model is a theme modern artists have self-consciously been negotiating since the mid-nineteenth century. Mary Cassatt, Berthe Morisot, and Suzanne Valadon were among those to confront directly and, to varying extents, subvert the tendency to treat female models as objects of a masculine, heterosexual gaze (figs. 2.27, 2.39, 3.37, 3.38). Morimura continued this inquiry, as has the American sculptor **Charles Ray** (b. 1953). *Most Beautiful Girl in the World*, 1993 snapshots taken by Ray that in their mundane settings attempt to make a supermodel look ordinary, further articulates the ambivalent relationship between artists and models in the 1990s. Branded a Conceptual Realist, Ray has used the figure to address the ironic relationship between our ideals and the realities of the psychic and material worlds. Characterized by immaculate craftsmanship and a surrealistic combination of the hyperreal and the fake, Ray's work relies on simple modifications of the ordinary or the expected to suggest emotional, psychological, even pathological states.

26.21 Raymond Pettibon, *No Title (The Translator's Have)*, 1996. Pen and ink on paper, 29¾ × 22" (75.6 × 55.9 cm).

26.22 Charles Ray, *Family Romance*, 1993. Mixed media, 4' 6" × 8' × 2' (1.37 × 2.44 × 0.61 m).

Self-Portrait (1990) shows a mannequin dressed in casual boating attire with a generalized portrait of the artist as its head. The portrait has an uncanny suggestion of a human personality even as it projects the vapid look of a department-store window display.

Family Romance (1993) (fig. **26.22**) relies on a sight gag as simple as *Self-Portrait*. In this family of four, the parents are scaled down by fifty percent and the children up by fifty percent. The resulting group is of approximately equal height but disparate build. The family looks distracted and a bit distressed, but there is no sense that they are responding to the physical transformation of their bodies. This family registers as figures whose reference is the artwork itself; their bodies are kept at a distance from the world. Though inspired by Ray's appreciation of Anthony Caro's command of scale (see fig. 20.40), the generalized antiseptic quality of Ray's distortions has led critics to see the work as addressing the idea of the nuclear family and its troubling late-century inconsistencies.

The exploration by American artist **Kara Walker** (b. 1969) of the brutalities of the past has led her to join together racial stereotypes and decorative arts in her work. Walker creates sado-masochistic variations of Romance novel plots, dramatizing sexualized violence among slaves and between slaves and slave-owners. Her medium is cut paper shaped with a rococo lyricism that gives scenes

of humiliation and violence elegant grace. These black silhouettes recall the cut-paper profile portraits so popular as middle-class American domestic decoration in the late eighteenth and the nineteenth centuries. Her decorative facility helps express her conviction that American identity, black as well as white, is rooted in finding pleasure in racist brutality. Walker's appeal to racist visual traditions and her pointed statements put her at the center of discussions of race and art in the 1990s.

Walker's characters have the physiognomy of "Black memorabilia," the pickaninnies and sambos that defined popular depictions of African-Americans created for a white audience. African-American artists since the 1920s have incorporated such racist stereotypes into their work. Harlem Renaissance painters Aaron Douglas and Palmer Hayden exaggerated the lips, brows, and hair to insist on the racial identity of their subjects. More recently, Robert Colescott has presented the black body as inseparable from the stereotypes that have described it (see fig. 22.41). To critics, Walker's imagery has none of the pride or critique of its predecessors and is a naive presentation of racist imagery for the delectation of racists. Walker's hyperbole severs the affinity between representation and reality on which its racist sources relied. Thus divorced from issues of realism, Walker's art is a quintessentially Postmodern engagement with the powers of representation.

26.23 Kara Walker, *Insurrection! (Our Tools Were Rudimentary, Yet We Pressed On)*, 2000. Cut paper and projection on walls, 11' 10" × 21' and 10' 8" × 32' 10" (3.6 × 6.4 and 3.28 × 10 m). Installation view of two walls. Collection of Solomon R. Guggenheim Museum, New York.

Work such as *Insurrection! (Our Tools Were Rudimentary, Yet We Pressed On)* (2000) (fig. **26.23**) applies Walker's elegant debasement to liberation scenes. Insurrection sacrifices the moral clarity of such tales by describing the revolt as a sexualized melee. Her exquisitely detailed outlines trace slaves and whites in states of uncompromised physical pleasure, apparently oblivious to the larger issues of liberty and justice. Typical of her generation, Walker exhibits a

readiness to complicate history with insights drawn from challenging the presumptions of the present.

In an exercise that illuminates the confluence of nature and culture, the Russian émigré duo of **Vitaly Komar** (b. 1943) and **Aleksandr Melamid** (b. 1945) also invoked the history of art as well as the history of taste by creating a series of most and least wanted paintings. They surveyed the public of several countries to determine what they

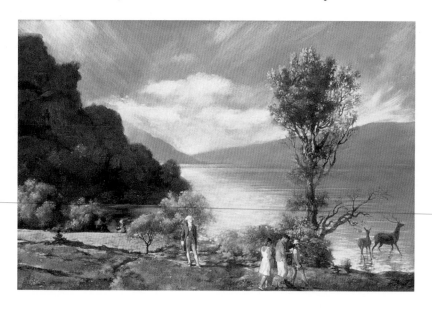

26.24 Vitaly Komar and Aleksandr Melamid, *USA's Most Wanted (Dishwasher Size)*, 1994. Oil and acrylic on canvas, dishwasher size.

liked and disliked in their art. In the United States, small angular abstractions in shades of brown and orange were the least appealing and historical landscapes in cool tones were ideal. They produced a series of artworks, the *Most Wanted Paintings,* scaled to conform to familiar objects: appliances, paperback books, and so on. *USA's Most Wanted: (Dishwasher Size)* (1994) (fig. **26.24**) was roughly the size of a dishwasher, as the title suggests. A combination of populism and irony, the *Most Wanted Paintings* serves as a reminder that art-historical genres are a way in which cultural demands define personal expression. Komar and Melamid's association of national and natural history makes it clear that even before the environment is experienced, its meaning has been defined in the realm of national, historical, and cultural expectations.

Meeting Points: Exploring a Postmodern Abstraction

Postmodern inquiries into the political as well as aesthetic resonances of art encompassed abstract art as well as figurative works. In abstraction, as in all forms of representation, the deconstructive lessons that began in the late 1960s were, by the 90s, leading to new approaches to artistic production. That all artistic languages compromise the myths and social conditions from which they emerge is now taken for granted and is no longer viewed as a barrier to artmaking.

American artist **Jonathan Lasker** (b. 1948) titled a 1989 painting *Euphoric Routine,* neatly expressing the irony that even as abstract art strives toward emotional immediacy, it is based on learned and repeated procedures. Lasker's paintings, which are rhythmic and visually engaging, but also oddly distant and mute, draw on a history of postwar painting concluding that, if abstraction communicated at all, it was because artists and viewers agreed that marks meant something. It was this linguistic quality of abstraction that Johns and Twombly examined (see figs. 19.34, 20.15) and the consequences of disregarding it that concerned Halley and Bleckner (see figs. 25.28, 25.29). Lasker's work demonstrates that one can respect the contrivance of abstraction while maintaining confidence in its expressive potential.

Lasker was particularly influenced by Brice Marden's calligraphic paintings (see fig. 20.64), but was troubled by the ease with which the viewer's mind is taken from canvas to the soul. To slow this process, Lasker devised studio practices that give a Postmodernist twist to modernist conventions. He began with automatic drawings on paper in the Surrealist mode. He then enlarged the drawings, carefully preserving both the shape of the mark and the quality of the pen that made them. These copied marks became the individual elements of a painting. In *To Believe in Food* (1991) (fig. **26.25**), they are the neutral scribbles and monotonous black lines that adorn the acid yellow field. By referring to the process as "editing my own subconscious," Lasker suggests that, in addition to critiquing conventional faith in abstraction, his work contains a plea to accept the emotional responses elicited by such painting. Self-consciously made with a compromised language, *To Believe in Food* argues that the impulses to edit, copy, quote, falsify, mislead, critique, assemble, travesty, mock, and honor, all evident in this painting, reveal much about personality and contemporary life as well as the history of art.

26.25 Jonathan Lasker, *To Believe in Food,* 1991. Oil on linen, 8' 4" × 6' 3" (2.5 × 1.9 m). Private collection.

26.26 Roni Horn, *When Dickinson Shut Her Eyes—For Felix; No. 886*, 1993. Plastic and aluminum, dimensions variable.

26.27 Fiona Rae, *Untitled (Sky Shout)*, 1997. Oil and acrylic on canvas, 108 × 96" (274.3 × 243.8 cm). Private collection.

The explorations into the phenomenology of sculpture proposed by American artist **Roni Horn** (b. 1955) can be likened to Lasker's dissection of abstract painting. Her earliest works, carefully crafted structures of a single material such as rubber or gold foil, highlight the specific properties of the different media. The title of her retrospective, Making Being Here Enough, captures the essence of her desire to "make sensible experience more present." "Sensible" can be understood as relating both to the senses and to finding meaning. In *Gold Mats, Paired—for Ross and Felix* (1994–95), the gold mats in two stacks seem to cling together and the floor even as the corners curl up from the ground, turning the consequences of layering sheets of gold into a memorial for Felix Gonzalez-Torres and his lover (see fig. 27.25).

Horn's sculpture resists our impulse to see sculptures as chiefly representations of or visual analogues for things or emotions. Seen in a photograph, the ambitious 1982–83 *Cobbled Lead(s)*, in which Horn replaced a 225-square-foot (20.9 m²) area of cobblestones in a museum courtyard with lead replicas, is an uneventful triangle. To understand the work demands that one pass over it and sense the changes in surface as one might physically register the walking from sidewalk to street. Horn's work suggests the rather thrilling variety of experience that can be initiated by the slightest change in our surroundings. In the 1990s, she created several geometric aluminum sculptures imbedded with fragments of poetry. The sculptures, including *When Dickinson Shut Her Eyes—For Felix; No. 886* (1993) (fig. **26.26**), reveal their poetry only if one moves around them. Again appealing to our sense and our senses, Horn's sculpture reveals poetic facets of the physical world.

Fiona Rae (b. 1963) and Ellen Gallagher, an African-American painter of the same generation, have created two very different oeuvres based on the conviction that abstraction has rich communicative potential despite, or because of, its compromised position. Rae's canvases posit a play between the gridded structure of Minimalist control and the expressive mark-making of Expressionist desire to signify competing aspects in a single personality. A work like *Untitled (Sky Shout)* (1997) (fig. **26.27**) gives the impression of a collage of brushstrokes stolen from the history of art. A Richter smear is repeated to build a geometric ground interrupted every few feet by a Kenneth Noland circle or a Kline-like stroke. Rae's archival aesthetics, as well as her own striking means of assembly, use the juxtaposition and connotations of past styles to convey content. In addition, her work has a sense of humor and contains passages in which the cathartic energy of the expressive marks is only just contained by the grids, reminding one of the sublime content that her predecessors swore they could reach.

Rae's paintings manipulate the connotations of historical styles. She uses the public meaning of abstraction to communicate private expressions. **Ellen Gallagher** (b. 1965) engages abstraction as a code bearing private content and resisting public interpretation. Abstract art has had a long and ambivalent relationship with the idea of code. Picasso's *Ma Jolie*, Malevich's *Black Square*, and Johns' targets all incorporated the idea that making modern art requires building a private cosmology and viewing it demands an act of deciphering. Gallagher's inclusion of even the smallest bit of representation into the abstract fields of her compositions infiltrates the coded structure of abstraction, placing the history of art in a very different context.

A close look at *They Could Still Serve* (2000) (fig. **26.28**) and a quick review of the artist's statements reveals a surprising source for the tiny biomorphic forms that dance across Gallagher's work: they are eyes from caricatures of African-Americans. In explaining her process Gallagher reveals "a willingness to play with something that is ugly. Making a cosmology out of these things that are so awful … ." Unlike Kara Walker (see fig. 26.23), Gallagher nearly hides her iconography in vast canvases, suggesting a different commentary on race. What rises to the surface as one loses one's self in the delicate tracery of gentle washes, rouge grids, and fragmented blackface, is a pertinent reminder of the persistence of racism, which continues to define much social interaction even in the current age of globalization and unprecedented cross-cultural exchange.

26.28 Ellen Gallagher, *They Could Still Serve*, 2000. Pigment, paper, and glue on linen, 10 × 8' (3.05 × 2.44 m).

27
Contemporary Art and Globalization

The word most frequently used to describe culture at the turn of the millennium is "global." For centuries, national boundaries determined, more or less absolutely, individuals' economic, political, and cultural experiences. As much a legacy of self-determinism as of colonization, national borders have a dubious relationship to individuals' everyday experience of cultural identity. With the dismantling of most Western as well as Asian empires in the twentieth century, dozens of former colonies assumed varying degrees of self-governance as they entered a postcolonial phase. Regions and peoples navigating a postcolonial existence have confronted issues of cultural identity, engaged in political reorganization, and negotiated economic opportunities as well as hardships.

Even as more countries experience political, economic, and cultural autonomy, the forces of globalization are knitting the world together more closely than ever. Current economic systems operate with little regard for national borders. Not only are goods exchanged easily from one part of the world to another, but the idea that a particular country is the producer of a specific product no longer obtains. The economic conception of globalization can be extended to account for contemporary cultural conditions as well. Just as the notion of an "American" or "Japanese" product is now largely obsolete, the idea of national cultures is also eroding. Communications technology, especially satellite television and the internet, is contributing to fluid, hybrid cultures that coalesce around those with shared interests, whether social, religious, artistic, or emotional. While some welcome globalization as a long overdue riposte to the nationalism that gave rise to two world wars and countless other violent conflicts, others fear that

CONTEXT

Modern Art Exhibitions and Postcolonialism

Postcolonial critiques have redirected the reception of modern art, especially primitivism (see chapters 3, 6, and 8), while also influencing the work of contemporary artists. The trajectory of postcolonial theory on the production and reception of art can be charted in a pair of important late twentieth-century exhibitions. The Museum of Modern Art's 1984 exhibition "Primitivism" in Twentieth-Century Art presented key modernist artworks displayed alongside examples of tribal visual culture believed to have influenced artists like Picasso and Matisse as well as more recent artists such as Jackie Winsor and Nancy Graves. While the show's organizers intended to accord to the tribal pieces the same aesthetic import given to the modernist pieces, the exhibition came under fire from many critics precisely because it did not attempt to establish the cultural, historical, or political specificity of the non-modernist works on view. For instance, critics noted that explanatory labels for the modernist pieces included precise language regarding the artist's nationality along with the work's date, medium, and

dimensions; tribal objects were exhibited with labels giving only vague information about the culture and period from which they originated. The failure to note the circumstances of tribal objects' acquisition or their original cultural significance and function was decried as evidence of the persistence of imperialist ideologies, which tend to treat colonized territories as ahistorical sources of material wealth or cultural curiosity. A sharp rejoinder to MoMA's approach was delivered by the 1993 Whitney Biennial, in which the roles of race, ethnicity, and gender in the production and reception of art were emphasized. Among the artists featured in that year's Biennial were Glenn Ligon, Lorna Simpson, Pepon Osorio, Janine Antoni, and the Guerrilla Girls (see figs. 27.31, 27.32, 26.9, 22.32, 22.31). The general tenor of the exhibition was apparent even as visitors entered the show. The buttons that most museums require visitors to wear as proof of paid admission were specially designed for the Biennial by Daniel Martinez and read "I CAN'T IMAGINE EVER WANTING TO BE WHITE."

it will level cultural difference to the point that some cultures, especially small or economically weak ones, will be eradicated entirely.

This tension reveals itself in often benign ways, with some countries stepping up cultural preservation programs and advocating the use of indigenous languages. In other cases, the fear of cultural dilution is so strong that it has contributed to violent attacks and uprisings. Artists have not ignored these conditions, and some of the most arresting recent artworks take postcolonialism and globalization as points of departure. Among the most persistent themes to emerge in contemporary art are questions of identity: the relevance of ethnicity, race, gender, sexuality, or nationality in understanding what makes us who we are. Of equal concern is the effect of globalization on the production, display, and acquisition of artworks. Are global or postcolonial audiences different from the audiences to which modern art has traditionally appealed? Is the nature of art changing to accommodate new cultural expectations? (See *Modern Art Exhibitions and Postcolonialism*, opposite).

Lines That Define Us: Locating and Crossing Borders

With the collapse of many national boundaries and the critique of nationalist ideologies at the end of the twentieth century, it is not surprising that some artists have addressed themselves to the theme of borders. A border circumscribes identity (whether individual or collective), containing what it surrounds just as it filters what may enter. Artists who root their art in an identifiable social group may then proceed to demonstrate how permeable the boundaries that contain subcultures in contemporary society actually are. Resisting claims to religious, racial, or ethnic purity, these artists capture the interwoven strands of national and international culture.

Art and the Expression of Culture

The visual arts have always expressed forms and ideas specific to particular cultures. While this offers a means of asserting cultural identity, the tendency to associate particular art forms with a single culture can also contribute to facile—and even denigrating—visual stereotypes. A number of artists working today navigate the shoals of cliché and "authenticity" in order to produce works that defy facile racial, national, or ethnic labeling.

The social analysis present in the work of **Jimmie Durham** (b. 1940) grew out of his commitment to political activism. Born to the

Wolf Clan of the Cherokee nation, Durham committed himself to challenging the government policies that were devastating the Native American community. Striving to "direct my rage at proper targets," Durham was active in the American Indian Movement and in 1973 was present at the Siege of Wounded Knee, an armed confrontation between U.S. federal forces and Oglala Sioux activists seeking rights established in treaties signed and broken by the U.S. government. The confrontation lasted for seventy-one days. Artmaking is, for Durham, a part of a life defined by an eclectic mix of activities and commitments: "I was raised as a political activist and carver and a good fisherman and blacksmith. I label myself an artist for convenience." Though in many ways playing up to the idea of the Native American living his or her art, Durham's response recalls the ideas of plurality and multiplicity that Jean-François Lyotard accorded to Postmodernism (see chapter 24) in the way he draws on personal experience to contest stereotypes of Native American art.

Durham's sculpture questions the notion that there is *a* Native American art. Typically associated with an uncomplicated animism and a naive connection to the land, Native American art is valued for its presumed authenticity yet also simultaneously associated with the mass-produced pottery and rugs sold at roadside stalls in the Southwest. An ironic display of 1984 called *On Loan* from the Museum of the American Indian featured Durham's "neo-primitive neo-conceptualism." His "Museum" lent out fake artifacts that challenged the authority of Western anthropology to define Native American culture. *Red Turtle* of 1991 (fig. **27.1**), handmade from a turtle shell, painted sticks, and paper, is a pastiche of the expected naturalism of Native American art and an assemblage of the detritus of daily life. The paper label affixed to the object reads:

27.1 Jimmie Durham, *Red Turtle*, 1991. Turtle shell, painted wood, paper, 61½ × 67½" (156.2 × 171.5 cm). Collection Dr. and Mrs. Robert Abel, Jr., Delaware.

We have tried to train them; to teach them to speak properly, to fill out forms. We have no way of knowing whether they truly perceive and comprehend or whether they simply imitate our actions.

Evoking the authoritative voice of the colonizer or the anthropologist, Durham offers a biting and humorous challenge to the teaching of history in schools, museums, and the marketplace, which requires Native Americans to remain frozen in a romantic and precolonial existence that obscures their far from Edenic reality in modern America. His sophisticated and elegant wall piece evokes the spare geometry of Constructivism as well as the witty play of signs typical of Dada. Anchored by a forceful "X," the piece invites readings as diverse as "X marks the spot" or a vehement cancellation.

Iranian filmmaker **Shirin Neshat** (b. 1957) creates from a position between two societies: in her case, Islamic and Western society. Though Neshat has lived and worked in the West since 1974, her films are highly choreographed events that explore the relationship between female identity and culture in an explicitly Islamic context. Richly produced, they present sweeping panoramas of desert and sea, textured scenes of old cities, and moving bodies often abstracted and identified by long veils. Borders and partitions such as walls, screens, curtains, and the *niqab* figure prominently in her work. The sensuality of her films is enhanced by multiscreen projections and the addition of music by composers including Iranian Sussan Deyhim for *Rapture* (1998) and American Philip Glass for *Passage* (2001).

Untitled (Rapture) (fig. **27.2**) explores the separation of men and women in fundamentalist Islamic culture. Presented on facing screens, men occupy a fortress while women move across a desert landscape to the sea. As the white-shirted men aggressively define the boundaries of their space, the women, veiled, watch. They shout once and the men look. Later, as several of the women board a boat, the men wave in an ambiguous gesture of farewell and warning. *Rapture* presents cultural divisions in choreographed movements in clearly articulated spaces. As we watch, alternating between screens mediating between the two sexes, we find our understanding of the film guided by similarly defined movements and spaces. Though tradition, culture, gender, and language may all appear threatening in Neshat's work, they do not overcome her female protagonists. Her work, she explains, is not about submission but rather the complexity of Islamic femininity that, to the artist, contains strength that is greater than men's because of its repeated suppression.

Born in Lahore, Pakistan, **Shahzia Sikander** (b. 1969) began her career learning the Pakistani and Indian tradition of miniature painting rather than the Western-style painting more popular among her peers. Her thesis project, however, turned the tables on expectations of Eastern and Western traditions. Demonstrating what Sikander calls the "vulnerability" of the miniature tradition to being inflected by the present even as it connotes the past, her work *The Scroll* (1992) was an illumination of the artist's daily life. Upon moving to the United States in 1993, she continued enlisting ancient techniques to respond to details of her life and her interest in postcolonial artistic and theoretical currents.

Pleasure Pillars (2001) (fig. **27.3**) is an illuminated page on which Sikander has layered decorative and figural imagery rooted in Eastern and Western art-historical traditions and popular culture. The image is meticulously crafted from sources including, but not limited to: twelfth-century Indian sculpture and sixteenth-century Italian Mannerist painting in the central figures; Modernist

27.2 Shirin Neshat, *Untitled (Rapture)*, 1998. Production still.

27.3 Shahzia Sikander, *Pleasure Pillars*, 2001. Watercolor, dry pigment, vegetable color, tea, and ink on hand-prepared wasli paper, 12 × 10" (30 × 25 cm). Collection of Purninder and Amita Chatterjee, New York.

abstraction in the circles repeated throughout the image (a motif also intended to suggest bombs falling from the warplanes that enter at the top); hunting imagery taken from miniature traditions; and popular arts, particularly sculpture, in the assorted animals and deities. Each formal element becomes part of a network of meanings that take the viewer in often surprising directions. The manuscript format alone, for instance, suggests how Sikander's art functions. In the most general Western context it reads simply as Indian, while to an informed, particularly South Asian, viewer it alludes to traditions pre-existing Pakistani independence in 1947. When the biography of the artist is considered, the form takes on a political tenor and an image such as *Pleasure Pillars*, created in response to life in New York in 2001, participates in a dialogue with another history.

Sikander has explained that she selects and manipulates her sources not so much to articulate a specific political position as to make her viewers aware that the "physical, emotional, geographical, cultural, and psychological boundaries" by which we define ourselves are flexible and porous. More recently, she has worked with short digital films presented in the format of an illuminated page. The work amplifies the visual effect of her layered aesthetic by revealing the process and setting the elements in motion, while maintaining the dialogue between arts and culture of the past and present.

Seduced by the transformative potential of costume, Japanese artist **Mariko Mori** (b. 1967) began her career as a model. She has continued to feature herself in attire of all kinds as she explores issues of desire and fantasy in performance, photography, and video. In a series of performance/photographs from the early 1990s, Mori became an incarnation of the ideal woman in the increasingly influential *anime* culture. *Anime*, Japanese animation, is a cross-cultural mixture of the Disney cartoons exported to Japan during and after World War II, and the Japanese animation industry, which has matured in the last few decades. Mori is one of several artists exploring the intersection of *anime* fantasy and Japanese reality.

27.4 Mariko Mori, *Play with Me*, 1994. Fuji super-gloss print, wood pewter, 10 × 12 × 3' (3.05 × 3.66 × 0.91 m).

Play with Me (1994) (fig. **27.4**) and the related *Tea Ceremony* from the same year featured Mori, dressed as a cyborg, attempting to interact with a Japanese audience. In *Tea Ceremony* she combined the ancient Japanese tradition with the sexualized yet anodyne feminine cyborg of the contemporary imagination. Mori's attempts at forcing the interaction of the ideal and the real met with awkward indifference. In *Tea Ceremony*, she served tea to businessmen on a city street, and they avoided her; in *Play with Me* her "real" cyborg was similarly overlooked.

Akin to the feminist analysis of the 1970s, Mori's work explores the ambivalence of cultural ideals. Her critique, though often barbed with a certain pleasure in revealing the inability of contemporary culture to locate its desires anywhere near reality, relishes aspects of the fantasy. Mori always seems to be enjoying herself. Her practice of shooting fantastic scenes in real locations, including Kansai International Airport, Osaka (see fig. 24.30), or La Défense, Paris, suggests the ironic possibility that our fantasies might not be so far removed from reality as they seem.

Anime has also influenced the painting and sculpture of Japanese artist **Takashi Murakami** (b. 1962). His work, like Mori's photography, takes history and popular culture as a means of examining the difficulty of satisfying one's desire with real life. Murakami sees the relevance of popular culture in terms distinct from the categories of high and low culture set in the West by either the Cubist, Expressionist, or Surrealist avant-garde or their Post-modern variations. In the 2000 essay *Superflat*, Murakami asserted that there were two observations about Japanese art history that informed his work. The first was that the idea of art as a category of cultural production distinct from popular culture is Western, imported to Japan during the Meiji era at the end of the nineteenth century. The

force with which Western and now international culture (which is heavily influenced by the Western capitalist worldview) instituted a binary fine/popular or high/low structure onto Japan's tradition of unified cultural production has caused, in Murakami's view, a crisis in Japanese culture. The way out of the crisis lay not in recombination of high and low after the model of Western avant-garde strategies such as those deployed in Cubism, Dada, or Pop, but in Murakami's second observation: that Japanese visual artists have historically been interested in the movement of objects across a flat surface, whether on screen, page, or film. *Anime* thus provides a means to revitalize Japanese visual culture, not as a source for "real" artists but as a legitimate point of departure for formal experimentation and intellectual content.

In a Japanese context, *Second Mission Project ko²* (*SMP ko²*) (1999–2000) (fig. **27.5**) agitates against what the artist sees as deep inconsistencies in Japanese culture. With the help of professional model-builders who specialize in three-dimensional *anime* figurines, Murakami created an anathema to the *otaku* (devotees of *anime*): a life-size, three-dimensional *anime* heroine. Once the object of *otaku* fantasy became too large, the physical, and—if one accepts even a modicum of feminist awareness—moral and political impossibility of realizing the *otaku* ideal became painfully apparent. Like Mori's *Play with Me*, the *SMP KO²*, a sexually provocative female superhero who transforms into a high-tech military spacecraft, reveals the distance between Japanese fantasy and reality. Murakami's figures mock human desire by confronting the fantasy narrative with the real world. John Currin (see fig. 25.39) used the language of realism, Murakami the scale of reality. Murakami considers his sculptures to be warnings of the alienation felt by thousands of people within Japan who have chosen, for the moment, to migrate from social reality into the realm of an emasculating fantasy.

In the context of Western traditions, the *anime*-influenced art from Japan, of which Murakami's is the most visible example, poses challenges to Western divisions of high and low art that echo those of *Nouveau Réalisme* and Pop art (see chapter 19). Murakami also has marketing savvy worthy of Warhol, though his studios in Tokyo and New York recall Rubens' closely managed workshop more than the casual atmosphere of the Factory. Murakami

27.5 Takashi Murakami, *Second Mission Project ko² (SMP ko²)*, 1999–2000. Oil, acrylic, synthetic resin, fiberglass, and iron. Human type 108 × 99 × 56½" (275 × 252 × 144 cm); jet airplane type 21 × 76 × 73" (55 × 193 × 186 cm).

and his staff have developed a creative and financial team that manufactures products from paintings to T-shirts and promotes them in all media and venues from the internet to museums, ultimately branding Murakami's work in the fashion of Warhol and Hirst, or Pepsi and Coca-Cola.

Growing into Identity

The physical and psychological condition of childhood has always been understood, in one way or another, to be a source of a later, mature identity. While cultures differ in their views regarding the exact nature of the relationship between the child and the eventual adult, all societies take pains to guide that transition in hopes of instilling desired physical abilities, emotional character, and moral values. Freud only heightened concerns about the effects of childhood experiences on an individual's mature identity, making childhood of particular interest to modern artists since the early twentieth century.

The presentation of even the most ordinary moments of childhood, suspended in time and transformed into aesthetic objects, takes on an uncanny quality. Though inspired by the fleeting glimpses of daily life, the photographs of **Sally Mann** (b. 1951) were the result of often-laborious re-enactments. Moreover, Mann's style, with its narrow depth of field, softened misty backgrounds, and rich details, belies a technique more deliberate than a snapshot.

The photograph *The New Mothers* (fig. **27.6**), an image of Mann's two daughters playing at motherhood, appears to juxtapose the demands placed by contemporary society on girls to become both sexual and nurturing. The elder daughter casually holds a candy cigarette between her fingers and squints aggressively at the camera, while the younger girl peers through heart-shaped sunglasses and petulantly places her fist on her hip. Depictions of children playing house have shown how girls are socialized into mothers since at least the seventeenth century. Mann's work of the time presented the psychological and moral dimensions of growing up in the twentieth century.

27.6 Sally Mann, *The New Mothers*, 1989. Gelatin-silver print, 20 × 24" (50.8 × 60.9 cm).

The artist faced censure from critics who took her work to be a vulgarization of the American family. Mann's 1992 *Immediate Family*, a portfolio of prints equal in their sensual command of surface and depth, presented, in her own words, "ordinary things every mother has seen: a wet bed, a bloody nose, candy cigarettes." Although only a fraction of the scenes in *Immediate Family* featured Mann's children in states of undress, to many the volume represented the threatening proximity of sexuality and childhood in contemporary American life.

Rineke Dijkstra (b. 1959) has also committed herself to exploring the socially difficult terrain of personal transformation. Dijkstra's portraits capture ordinary people with their flawed physiques and dated clothes, in states of flux—notably adolescence, although she has also captured the transitional moments of pregnant women, young mothers, and soldiers. Despite photographing subjects with whom she identifies for their often desperate failure to "have everything under control," Dijkstra makes them look like scientifically recorded specimens, evenly lit and isolated from their context. The work updates the integration of typographical and documentary traditions of photography that was begun earlier in the twentieth century in Germany with Sander and the Bechers (see figs. 11.36, 20.69).

Dijkstra built her reputation on an extended series recording teenagers at the beach. "More or less self-portraits," according to the artist, the images capture the often painful combination of the boldness and insecurity of adolescence. Taken in the Netherlands, Poland, Coney Island in New York, and Hilton Head in North Carolina, the series has an added anthropological element as it demonstrates how the character and class of the location affect the presentation of the subjects. Discussing Dijkstra's decision to address the passage from childhood to adulthood, critic Katy Siegel wrote: "This is a generation for whom the paradigm of adolescence (frustration, awkwardness, self-discovery) resonates louder than that of childhood (happiness, wonder, play) or adulthood (sophistication, responsibility, gravity)."

The Buzz Club, Liverpool, England/Mysteryworld, Zaandam, Netherlands (1996–97) (fig. **27.7**) extends to the medium of film Dijkstra's interest in the socially weighted transitions of adolescence. Presented in a side-by-side dual projection, *Buzz Club* presents images of kids at two nightclubs standing, dancing, and waiting. *Buzz Club* was filmed in storage rooms, thus keeping the subjects in the mood of the evening but far enough away to accent the awkwardness that Dijkstra felt dominated the environment. The results range from poignant and funny to awkward and boring.

Also interested in tracing the formation of social identity through children is **Marlene Dumas** (b. 1953), who began painting the figure in the mid-1980s while studying psychology in her adopted home of Amsterdam. Raised in South Africa under the apartheid system, Dumas has spoken of the painful awareness that her self-image as a

27.7 Rineke Dijkstra, *The Buzz Club, Liverpool, England/Mysteryworld, Zaandam, Netherlands*, 1996–97. Double projection, 35mm film with sound transferred to video or DVD.

"sweet young girl" was inseparable from her power and privilege as a white South African. The threatening dichotomy of innocence and power informs Dumas' series on children, sexuality, and South Africa.

The unsettling convergence of endearing childhood charm with the knowing power of a young girl is at the heart of *The Painter* (1994) (fig. **27.8**). Composed like a family snapshot, and perhaps based on one as well, *The Painter* makes details of childhood, such as dirty hands or a casual look, into signs of threat. Though the title and picture suggest that this girl was just making art on the floor, *The Painter* is often discussed as the record of a crime scene. Red paint can be seen to resemble blood and the charm of childhood is layered with fear. Dumas has used the format of *The Painter* to juxtapose themes of death and childhood and even describes the incipient aggression in her method.

Dumas uses found and photographed images as sources for her work. Translating the photograph into watercolor slows the speed of the camera to match the sensual flow of the painting medium. As intellectual in her appropriation as Richard Prince or Sherrie Levine (see chapter 24), Dumas' style reveals concern with the "trace of human touch" and the conflicts of human, particularly female, experience. Her method also poses a certain aggression,

27.8 Marlene Dumas, *The Painter*, 1994. Oil on canvas, 6' 6" × 3' 3" (1.98 × 0.99 m).

revealed in her explanation that "My people were all shot by a camera, framed before I painted them. They didn't know that I'd do this to them."

The Tracey Emin Museum (1995) by British sculptor, photographer, and performance and conceptual artist **Tracey Emin** (b. 1963) invokes the intensity and fragility of adolescence, a period of transformation that she places at the center of identity formation. Emin produces an excess of information in a style integrating apparent carelessness and colloquial text ("At age 13 why the hell should I trust anyone?" stitched on a quilt, "You forgot to kiss my soul" in neon). The sheer volume of personal information threatens to eliminate the sense of a private world revealed, and turns modernist introspection into Postmodern spectacle. Reversing Warhol's strategy of erasing the distinction between public and private lives by effacing his private life, Emin has merged the two realms by eliminating a censored public persona.

On the occasion of her nomination for the Turner Prize, Britain's most prestigious award for promising young artists, Emin displayed her unmade bed, complete with dirty underwear, KY Jelly, and a carton of Marlboros. Upon not winning the prize, she stormed off the stage drunk, creating a scene of adolescent rebellion for BBC TV to match the anxious sculpture *My Bed* (fig. **27.9**). Like her YBA peers ("young British artists" who came of age quickly and visibly in Britain in the early 1990s, spurred by the high-profile patronage of collector and advertising tycoon Charles Saatchi), Emin has made use of tabloids and TV even more than museums to forward her identity as a significant contemporary artist.

27.9 Tracey Emin, *My Bed*, 1998. Mixed media, dimensions variable.

Identity as Place

The connection between identity and a specific site or locale has long influenced artists' representations of the landscape. In some cases, a place as specific as a house can be seen as a source for an individual's sense of self or, as in the case of Tracey Emin's *Bed* installation, even one's bedroom can function as a metaphor for self. While the domestic realm offers one means of representing identity, landscapes defined by their physical specificity or their national borders present another conception of self.

The relationship between identity and a specific place motivates much of the work of **Emily Jacir** (b. 1970), a Palestinian artist who resides in Ramallah and in New York. Jacir has focused on the landscape of the contested West Bank in her explorations of personal, ethnic, and national identity. *Crossing Surda (a record of going to and from work)* (2002–03) is a video tape Jacir illegally recorded as she joined the hundreds of Palestinian students and workers who must daily contend with walking across a rugged and dangerous strip of land that serves as an Israeli checkpoint just to reach nearby businesses and schools (vehicles are not permitted). A trip that should take only minutes is extended to hours as individuals (including Jacir) are detained at gunpoint, interrogated, then (usually) allowed to continue their journeys. In a related piece called *Where We Come From*, Jacir takes advantage of her possession of an American passport to perform tasks or make visits on behalf of Palestinians who, because of immigration restrictions or the imposition of new borders and checkpoints, can no longer visit family members and friends or shop in once-familiar towns. This project consists of a series of framed texts and accompanying photographs (fig. **27.10**). Each text describes the request Jacir has been asked to fulfill, a short biography of the person on whose behalf she is traveling, and a brief report of the trip's outcome. One Lebanese man asked her to visit his parents' hometown of Haifa and "play soccer with the first Palestinian boy you see on the street." The related photograph shows

her playing soccer with a boy named Kamel in Haifa. Others asked her to visit friends and relatives or to eat on their behalf a longed-for local specialty. After the implementation of increased border security measures in 2003, Jacir now finds it impossible to carry out the requests she was able to fulfill previously.

Neighborhoods and—as a series of paintings by the American artist **Kerry James Marshall** (b. 1955) shows—housing projects are a potent source of identity. In an effort to challenge stereotypes about African-American life, Marshall has created a representational language incorporating expressive handling to match the Neo Expressionists, generalized figural types akin to comics or caricature, and the local details demanded of realism. Exceptional in his generation of African-American artists for his commitment to painting, Marshall has followed artists like Robert Colescott and Leon Golub (see fig. 22.41, 25.24) to take painting into the political arenas more often debated in photography and performance. Like Colescott, Marshall is well versed in the Western canon, often citing artists from Botticelli to Gauguin (see chapter 3), claiming their talents for his subjects.

Marshall's *Garden Project*, which includes *Better Homes Better Gardens* (1994) (fig. **27.11**), depicts scenes of life in public housing projects. Capitalizing on the myths and ironies that surround these projects (which often carry the word "garden" in their names), *Better Homes Better Gardens* appears to depict the project as an urban war zone: paint splashes evoke the spray of bullets. These signs of violence and the red HUD (the U.S. department of Housing and Urban Development) identification codes that abruptly label the surface of the canvas represent the dismal expectations most Americans have toward the projects despite the bucolic names they have. The violence, however, is conventional, and the irony is easy, and neither is the endpoint of Marshall's work.

The *Garden Project* series pushes past the competing clichés of tragedy and comedy that frame discussions of

27.10a, b Emily Jacir, *Where We Come From*, 2001–03. Detail *(Rizek)*: American passport, thirty texts, thirty-two C-prints, and one video text. 9½ × 11½" (24 × 29 cm); each photo 5 × 7" (12.7 × 17.8 cm).

poverty in the United States. Marshall was raised in a project like that depicted in *Better Homes*. The scene he paints is of ordinary pleasure. Unwilling to typecast the black experience as one of gritty desperation, he adopts a stylistic eclecticism to express its complexity. Figures detailed enough to suggest individuals, yet abstracted enough to stand as signs of African-American experience, are depicted going through both the trials and pleasures of life.

Robert Gober (b. 1954) has made a career of hand-crafting fragments of the American environment to suggest the complex intersection of psychic and social identity. Since the late 1970s, Gober has been isolating elements of the domestic realm that mark the initiation of individuals into society. He has crafted dollhouses, cribs, beds, doors,

wedding dresses, and newspapers. He has also embellished objects suggesting more ambiguous transitions like sinks, drains, tissues, and, starting in 1990, legs and torsos. His practice, with its attention to mimetic detail, can be likened to the Appropriation art of Cindy Sherman, Jenny Holzer, Sherrie Levine, and Barbara Kruger (see chapter 24), all of whom influenced Gober directly.

Since his earliest dollhouses, Gober has created environments. Even a single sculpture, a leg protruding from a wall, for instance, transforms the gallery into an environment defined by the piece. His 1992 installation at the Dia Center for the Arts, New York City (fig. **27.12**), serves as a transitional work that addresses the internal conflicts and external pressures of Western society. Stacks of handcrafted

27.12 Robert Gober,
Site-specific installation at
the Dia Center for the Arts,
New York, September 24,
1992–June 20, 1993.

newspapers, tied up like recycling, lie about the room. Sinks drip water to the recorded sounds of a babbling brook. The room is wallpapered with an artificial panorama of New England woods punctured by barred windows. These elements tell an ironic story about the transformation of nature into culture. Reading the newspapers reveals an even more upsetting story. Gober has juxtaposed the headlines "NOT GUILTY," "VATICAN CONDONES DISCRIMINATION AGAINST HOMOSEXUALS, CONCERN THAT GAY RIGHTS THREATEN MARRIAGE," and an ad featuring Gober in a wedding dress. The presence of the artist, a gay Catholic, cross-dressed for the forbidden ceremony, reiterates the repressive power of society at definitive moments in a person's life. Once in the installation, the viewer can walk behind the papered walls and see that they are temporary constructions, a hopeful metaphor for the artificial social constructions that the piece critiques.

In 1991, Californian artist **Shimon Attie** (b. 1957) began a five-year stay in Berlin where, among other things, he researched the Scheuenenviertel, a neighborhood that from the late nineteenth century to the 1930s was home to Eastern European Jewish immigrants. *The Writing on the Wall* series (1991–93) (fig. **27.13**) consists of site-specific events for which Attie matched archival photographs of the Scheuenenviertel with the locations as they existed in the 1990s. He then projected the photographs onto the existing buildings, many dilapidated from the war and years of neglect. The effect momentarily mixed pre- and post-World War II histories of Berlin. The images were primarily domestic scenes, although some were of populated exteriors. Viewing the projection, we seem to look through the ruins of the present to the activities of the past. Attie's work mediates the nostalgia of memory and old photographs by conflating three forms of destruction: the Jewish people by the Germans, the neighborhood by neglect, and the photograph by time. Intellectually layered, and visually rich, the series creates a forum for confronting an inhuman history with a living present.

The German work provided Attie with means to examine memory and history in other contexts. The most striking of his American projects was *Between Dreams and History* (1998), in which the personal narratives of residents from Manhattan's Lower East Side were projected onto the buildings of this historical immigrant neighborhood. Known as a site from which immigrants, first Jewish and then Latin American, arrived and moved on, *Between Dreams and History* made that history specific and personal: not a romantic vision of the past but a current reality.

Archival material and visions of the past projected onto objects of the present also provide the foundation for the work of **Whitfield Lovell** (b. 1959). Like Attie, Lovell strives to balance the nostalgia of old pictures with material, including architecture, that has historic bonds to the past and physical connections to the present. In a series of installations, Lovell has recreated the homes and insinuated the presence of African-Americans otherwise lost in the cover-ups and embarrassments of American history. *Whispers From the Walls* (1999) (fig. **27.14**), for example, was created at the invitation of the University of North Texas, Denton, Texas. Lovell learned that Denton had been home to a flourishing African-American neighborhood called Quakertown. In the early 1920s, a white women's

27.13 Shimon Attie, *Almstadtstrasse 43 (formerly Grenadierstrasse 7)*: slide projection of former Hebrew bookstore, 1930, Berlin, 1992, from the series *The Writing on the Wall*, 1991–93. 33 × 40" (84 × 102 m). Chromogenic photograph and on-location installation.

27.14 Whitfield Lovell, *Whispers From the Walls*, 1999. Installation view.

those who have suffered through the civil unrest of a country notable for its history of kidnappings and political murders, called "disappearances." The disappearances inflicted an abstract brutality on the lives of victims' families, who rarely learned the fate of loved ones. Salcedo incorporated in her work materials given to her by the people she interviewed, thus bringing in the material presence of their lives, characterized in the artist's perception by their fragility and precariousness. The sculpture echoes the emotional rhythms of people whose understanding of their own past is scarred with great absences in their memory, as in their nation's history. The clarity of Salcedo's objects, carefully stitched seams and juxtapositions of cement, wood, hair, and lace, for instance, when integrated into soft concrete and simple compositions, serves as an analogue for the poignancy of

college opened nearby and the Quakertown community was dispersed. Lovell's installation, a single room decorated in the style of the period, becomes home to portraits of Quakertown citizens. Lovell found photographs of these people in local archives and transcribed them onto the walls in black oilstick. His drawing is sensitive and in places abbreviated so as to leave large areas of wood uncovered by line. The material of the room thus forms the bodies of its former residents. Completing the installation are two soundtracks, one playing old blues tunes and the other barely audible voices, bits of conversation and shouts of children that become the whispers of the walls. Through similar methods Lovell has retold histories of a variety of figures in the story of African-American life, from railroad workers in Houston to slave traders in Italy.

Colombian sculptor **Doris Salcedo** (b. 1958) develops the expressive tradition of Minimalism while transforming its concern with universal experience to address local history. Salcedo clarifies her intentions by incorporating into her work materials, from clothing to furniture, that resonate with our daily life. *La Casa Viuda (Widowed House) IV* (1994) (fig. **27.15**) is one of a group of works in which bed frames, doors, chairs, fabric, zippers, bone, and wire are forced into geometric structures defined by the now illogical compression of once-useful furniture. Conceived for spaces such as hallways, entrances, and exits, *Widowed House* reiterates these transitional spaces in architecture, surrounding the viewer with a sense of physical and emotional change. Through her materials and compositions, Salcedo conveys confinement and occlusion in the physical experience of her work and, by extension, comments on the political landscape of Colombia.

Though she did graduate work in New York in the 1980s, Salcedo has remained in Colombia. She has interviewed

27.15 Doris Salcedo, *La Casa Viuda (Widowed House) IV*, 1994. Wood, fabric, and bones, 102½ × 18½ × 13" (260 × 47 × 33 cm). Private collection.

loss and the incomplete integration of death into the lives of those still living.

Jason Rhoades (1965–2006) provides a different commentary on globalism and the expansive possibilities of art, finding the locus of identity in America's carports and two-car garages. His installations enlist the formal properties of abstract painting and sculpture to explore the spaces of vision and experience with a particularly American perspective. His sculptures often illustrate myths of America and include narrative performances. *Cherry Makita—Honest Engine Work* (1993) (fig. **27.16**), an early work, is a tableau that explodes the traditional male space of the garage with a makeshift aesthetic of found objects, ephemeral materials, and overwhelming clutter only just unified by spatial containment and coloristic harmonies. *Cherry Makita* provided the set for a performance in which Rhoades worked in the garage with a Makita cordless drill hooked up to a car engine. As in his later pieces, which included elements of gun play and sexual bravado, *Cherry Makita* provided a phallic hyperbole at the centerpiece of the chaos.

Despite the expansive themes of mythic America, and the overflowing installations, Rhoades is intent on creating an intimate and contemplative environment. Built "for literally two or three people," Rhoades' work achieves a balance between grandiosity and intimacy. The spaceball that features in one installation is regularly cited as a metaphor for Rhoades' intentions. In the center of the installation, the spinning viewer finds himself weightless, at a physical loss in the face of overwhelming material display. In 2000 Rhoades shipped his car to Europe, reproducing the quintessential Los Angeles space, a large American car built to travel the endless L.A. highways, for him-self and a passenger. The car, *Impala (International Museum Project About Leaving and Arriving)*, like Rhoades' work in general, takes individual experience and confuses its limits, pushing past the confines of ego, exhibition space, national borders, and sometimes even gravity.

American **Ann Hamilton** (b. 1956) makes evocative, often ephemeral and site-specific work that addresses questions of identity and place. Her 1996 traveling exhibition was titled *The Body and the Object*, while her 1997 European show, *Present–Past*, invoked the context of history. Her juxtapositions of materials and history occur in installations that conjure magical-realist landscapes. Vistas with waterfalls, flowers, and people working are infused with smells of farmyards and orchards, and the activities of insects and birds. A student of Judy Pfaff (see fig. 26.16), Hamilton exerts control over large spaces and heterogeneous materials of natural as well as clearly manufactured origin.

Parallel Lines (1991) (fig. **27.17**), a key work of the early 1990s, was created as a historical landscape that responded to the artist's travels in Brazil. Invited to participate in the 1991 São Paulo Biennial, Hamilton began work by researching the area from the rainforest to urban industrial zones. She covered walls with copper tags and "painted" others with the carbon of burning candles, the remains of which were piled high on a cart in the room. In an annex she left a turkey carcass to be eaten by bugs. Hamilton presented the installation with a descriptive poem beginning:

> the entrance, a road encrusted
> with numbered copper tokens, emblems of exchange
> marred, marked, touched, tarnished, placed
> a cradle of freight, piled, mounded, stacked
> the laid sinew of candles
> burned and extinguished …

27.16 Jason Rhoades, *Cherry Makita— Honest Engine Work*, 1993. Garage renovation, New York, various materials; size varies according to installation, 141 × 130 × 180" (358.1 × 330.2 × 457.2 cm).

27.17 Ann Hamilton, *Parallel Lines*, 1991. Candles (lengths variable, 1 to 6' each, or 30 to 183 cm), steel basin, table, candle soot, glass and steel vitrines, turkey carcasses, Dermastid beetles, copper tags.

In presence and description, *Parallel Lines* evokes the intersection between rural and urban life, the same scenery that politicized landscape painting in the nineteenth century. Work and trade form a central theme in much of Hamilton's art. Often her pieces include people knitting, wrapping objects, or engaged in similarly simple tasks. Like-wise, the quantities of materials that she uses (*Parallel Lines* used 20,000 candles and 999 copper tags) connote the dour repetition of menial labor.

Skin Deep: Identity and the Body

As seen in chapter 22, many Conceptual artists adopted their own bodies as their primary medium. Some artists, such as Carolee Schneemann, used Body art to explore the nature of identity in physiological as well as psychological terms. Others, like Ana Mendieta, found a source of aesthetic and spiritual transformation through recourse to their own bodies. Christopher Burden presented his body

as a measure of human endurance, forcing the viewer to acknowledge the resilience as well as fragility of existence. Artists have continued to look to the body—their own and others'—in an effort to locate the sources and significance of personal, national, racial, and ethnic identity.

Body as Self

To negotiate the social and physical experience of the body, **Kiki Smith** (b. 1954) uses materials that convey malleability and fragility as well as power and strength. Wax, bronze, paper, glass, plaster, and photography all figure in her work. *Untitled* (1990) (fig. **27.18**) presents two figures, male and female, both naked, made of beeswax and raised

27.18 Kiki Smith, *Untitled*, 1990. Beeswax and microcrystalline wax figures on metal stand. Installed height of female figure: 6' 1½" (1.9 m). Installed height of male figure: 6' 4¹⁵⁄₁₆" (2 m). Female figure: 64½ × 17⅜ × 15¼" (163.8 × 44.1 × 38.7 cm). Male figure: 69⁷⁄₁₆ × 20½ × 17" (176.4 × 52.1 × 43.2 cm). Stand for female figure: 61⅞ × 13⅞ × 19¹¹⁄₁₆" (157.2 × 35.2 × 50 cm). Stand for male figure: 61¾ × 14⁹⁄₁₆ × 19¹¹⁄₁₆" (156.8 × 37 × 50 cm). Collection Whitney Museum of American Art, New York.

above the floor on metal poles. The bodies, soft and limp, seem overcome by gravity. White traces of fluid describe milk leaking from the woman's breasts over her torso and semen drying on the man's leg. Any sense of maternal nurturing or sexual catharsis is undermined by the figures' positions of collapse and display. These are bodies in a moment of physical exhaustion failing to contain themselves, and the spectacle is pathetic and embarrassing. A veteran of the CoLab collective (see chapter 26), Kiki Smith directs the physical unease generated by her work toward a social understanding of ourselves as well as the more physical and mystical experience that had interested her father Tony Smith (see chapter 20).

The Lebanese-born artist **Mona Hatoum** (b. 1952), now resident in London, began her career by staging intricate performances that placed her body in situations as extreme as some of Sherman's photographs. In one, Hatoum struggled for seven hours in a closet-sized Plexiglas box half full of mud. The performances, and much of her later work, comment on the history of the Middle East and the artist's life as a double émigré. Her parents had left Palestine in 1948 for Lebanon and in 1975, when war broke out in Beirut, she was studying in London and found herself stranded there. By the 1990s, she turned from performances that presented physical experiences to sculptures that created them.

Corps Étranger (1994) uses architecture and video to stimulate the awkward, almost painful, disjunctions in being human (figs. **27.19a, b**). Enlisting the predilection of Surrealist photography, described by Susan Sontag, to transform the everyday into art by deeming it important enough to record and display, Hatoum's work presents her own body as both horrifying and ordinary. On the floor of a small round room, she projected a film of the interior of her body taken with endoscopic and colonoscopic cameras. To the beating of a heart and the rumbling of a stomach, we peer into the artist's body while carefully trying not to step on it. Unlike equally graphic work of the 1970s, Carolee Schneemann's *Interior Scroll* for instance (see fig. 22.18), the body in *Corps Étranger* is so removed from its context that it remains foreign even as it is scrupulously examined. Rather, *Corps Étranger* is a situation of discomfort and alienation, resonant with themes of displacement and homelessness.

Filming the Body

The body has been central to video art since the work of Bruce Nauman or Nam June Paik in the 1960s (see chapter 22). As Hatoum's *Corps Étranger* demonstrates, video, when divorced from the television monitor, offers provocative possibilities for investigations into identity. The work of **Gary Hill** (b. 1951) has been central to the application of increasingly flexible video technology to address intersections of the body with social, physical, intellectual, and spiritual worlds.

Upon a first encounter with Hill's *Tall Ships* (1992) (fig. **27.20**), the video seems to be showing only an empty

27.19a, b Mona Hatoum, *Corps Étranger*, 1994. Video installation, 137¾ × 118 × 118" (350 × 300 × 300 cm). Musée National d'Art Moderne, Centre George Pompidou, Paris.

27.20 Gary Hill, *Tall Ships*, 1992. Sixteen-channel video installation: sixteen modified 4-inch black and white monitors with projection lenses, sixteen laserdisc players, sixteen laserdiscs, one computer with sixteen RS-232 control ports and pressure-sensitive switching runners, black or dark gray carpet and controlling software. Dimensions of corridor: 10 × 10 × 90' (3.05 × 3.05 × 27.43 m). Editions of two and one artist's proof.

corridor. As the viewer enters the passage, however, figures appear in the distance, come close enough to make eye contact, seem to initiate conversation, and then turn abruptly away. The figures are male and female and of different ages, races, and states of mind. Though the viewer initiates the interactions, the experience of deferred contact is defined by the projected figures. Like the Conceptual artists involved in the Art & Language group (see fig. 22.1), Hill's work

addresses the insufficiency of language to translate the thought, emotion, and sensations that make up consciousness. His work insists that the complexity of both video and the body extends far beyond any boundaries that either has been expected to respect.

Tony Oursler (b. 1957) has also pulled video from the confines of the monitor. Using miniature LCD projectors prominently displayed in his installations, Oursler projects onto stuffed bodies, isolated heads, and floating orbs, videos of crying, shouting, pleading, bullying, directing, and questioning faces, mouths, and eyes. Oursler examines the process by which human beings take on the attributes of the people and things around them, most importantly television. Much of his work explores Multiple Personality Disorder (MPD), which, to the artist, casts light on the Postmodern persona and the changing oeuvres of artists from Cindy Sherman to David Bowie. Works such as *Gateway 2* (1994), in which a female figure, her head stuck under a mattress, shouts out "Hey, you, get out of here, What are you looking at, I'll kick your ass," present, if not MPD, the radical separation of the conflicting qualities of impotence and aggression in a single character.

In 1996, Oursler reduced his sculptures from talking heads to watching eyes. In *Untitled (Eyes)* (fig. **27.21**), thirteen fiberglass balls support projections of a single eye. One cries, one is red and swollen, one appears to look quickly around the room, and all reflect what they are watching: TV. Two eyes watch the classic films on MPD, *The Three Faces of Eve* and *Sybil*. Another watches pornography, one MTV, and one a home video game. *Eyes* depicts the moment of media absorption when the eye, the window to the soul, swells and contracts as if, to quote Oursler,

27.21 Tony Oursler, *Untitled (Eyes)*, 1996. Installation view at Metro Pictures, New York, 1996. Video projection of eyes on thirteen painted fiberglass globes with soundtracks, dimensions variable.

it is "reflexively feeding on the light" of the TV. He has reduced the body to its visual receptors, to demonstrate the psychic formation of the human by the television.

Matthew Barney (b. 1967) uses his body along with video, film, and sculpture in his examination of "the kind of intuition that is learned through understanding a physical process." Specifically, he traces all forms of generation—whether aesthetic, procreative, or social—to an originating moment of resistance. Just as muscles are developed through resistance training, creative acts and social revolutions likewise depend upon initial resistance in order to develop the energy and the will necessary to produce change. This essential idea has led Barney to engage in performance pieces that test the limits of his physical strength, a project that he documents through sculpture and film. His expansive five-film suite called the *Cremaster Cycle* (1994–2002) explores resistance as the basis for personal, aesthetic, and social transformation. In one segment from *Cremaster 3* (2002), the artist assumes the character of the Apprentice (fig. **27.22**), who must overcome a series of harrowing physical and psychological tests in order to reach his full creative potential. Like most of the central characters in Barney's work, the Apprentice wears an elaborate costume (in this case evocative of a Scottish chieftain) and make-up or prostheses, which often symbolize the character's aspirations or limitations. *Cremaster 3* can be understood as an extended metaphor for the artist's own struggle. The final challenge faced by the Apprentice involves overpowering and killing the sculptor Richard Serra, who appears performing a variation on one of the renowned "splash pieces" he executed in the late 1960s by throwing molten lead against a gallery wall to form sculptures, in a method akin to Jackson Pollock's "drip" technique (fig. **27.23**; see fig. 17.9).

27.23 Matthew Barney, Richard Serra as "Fifth Degree," *Cremaster 3*, 2002. Video to film transfer, 182 mins.

Sensuality and selfhood have inspired a very different body of work by **Ghada Amer** (b. 1963), who was born in Egypt, raised in France, and now lives in New York. Explaining the character of her feminism, Amer has said, "I speak about women's pleasure. ... Women should use this power [of seduction] if necessary without being called frivolous snakes, witches, or prostitutes. ... I just wanted to take a typically feminine craft (sewing) and make of it a language with which to compete within the very masculine arena of painting." Amer transforms images taken from pornographic magazines into a form of feminism through a commitment to craft. Like the Pattern and Decoration movement of the late 1970s (see chapter 23), Amer recognized that the gendered and domestic history of textile production would necessarily politicize imagery drawing on its tradition. And, like P&D, Amer works on a scale and in styles that place her work clearly in a tradition of postwar abstract painting.

In 1998's *Untitled (Vert Kaki Figures en Bougainvilliers)* (fig. **27.24**), Amer embroiders line-drawn scenes of female autogratification. Her source is pornography. Throughout her imagery, Amer embellishes simple poses by repeating and overlapping them and allowing the ends of the threads to fall loosely over the surface of the canvas. Like many feminist artists of the 1990s, Amer sees herself taking back sensuality, in a sense stealing the image of the stereotypical sexualized woman to use as a source of empowerment

27.22 Matthew Barney, "The Apprentice," *Cremaster 3*, 2002. Video to film transfer, 182 mins.

27.24 Ghada Amer, *Untitled (Vert Kaki Figures en Bougainvilliers)*, 1998. Acrylic, embroidery, and gel medium on canvas, 30 × 40" (76 × 101 cm).

and pleasure. Amer's reclamation of "the female body [and] its power of seduction" does not always derive from compromised sources. In a project titled *The Encyclopedia of Pleasure* (2001), named for a collection of Muslim texts on sexual pleasure compiled in the eleventh or twelfth century, Amer stitched Islamic sources for expressing a liberated female sexuality.

The Absent Body

As modern artists as diverse as Marcel Duchamp and Eva Hesse have shown, one need not be depicting the body to be making art about the body; the metaphoric possibilities of the material world can be used to address states of consciousness typical of contemporary life. This has meant viewing the material work as the depository for our feelings

about being human. Whether dealing with the aftermath of World War I or the AIDS epidemic, in a real sense the body had gone missing and the artist discovered its memory in the world that once contained it.

Felix Gonzalez-Torres (1957–96) created a poetic oeuvre in which a pile of candy, or a string of lightbulbs, could interweave physicality, memory, biography, politics, and history. Deeply influenced by Minimalism and Conceptual art (see chapters 20 and 22), he found that the clarity and luxury of Minimalist art could be fashioned to push his audience from 1960s aesthetics to 90s politics.

Unlike the autonomy of Minimalist work, Gonzalez-Torres' sculpture directed attention to its creator and its audience. *Untitled (Portrait of Ross in L.A.)* (1991) (fig. **27.25**), for instance, appears to be a collection of elegant metallic units, a sculpture in the tradition of Donald Judd or Sol LeWitt (see figs. 20.46, 20.51). Its form, however, is the result of amassing the weight of Gonzalez-Torres' lover Ross in brightly wrapped pieces of candy. *Untitled (Portrait of Ross in L.A.)*, executed as its subject was dying of AIDS, is a meditation on the physical and emotional changes that occurred as the artist lost his lover. Viewers are invited to follow instructions and take a wrapped candy from the heap, the dwindling physical mass of the sculpture echoing the wasting away of Ross' body. Like all of Gonzalez-Torres' work, this sculpture is dependent on physical interaction with an audience. There are no viewers of the work, only participants, and taking part in Gonzalez-Torres' art demands that we alter it. Change is integral to both its form and its content. The artist's technique also suggests a shift in the political landscape as AIDS took its toll on American lives. Working, as he described it, "within the contradictions of the system," he examines both the public qualities of private experiences of love and death and the private consequences of such public events as viewing art or providing healthcare.

27.25 Felix Gonzalez-Torres, *Untitled (Portrait of Ross in L.A.)*, 1991. Multicolored candies, individually wrapped in cellophane, endless supply. Ideal weight, 175 lbs. (79.3 kg), dimensions vary with installation. Collection Howard and Donna Stone.

Mona Hatoum, whose visceral *Corps Étranger* (see fig. 27.19) placed the body literally and figuratively at the foundation of her work, has also addressed the political history of the body. In the early 1990s, she began to create an increasingly abstract, geometric, and violent body of work, including 1992's *Light Sentence* (fig. 27.26), which employed utilitarian objects such as bed frames, animal cages, and lightbulbs. The artists has explained that the sculptural works address the disjunction of her past while examining the structures of institutional power that she has observed in the West. *Light Sentence* is a U-shaped chamber made from walls of stacked chicken cages. In its center, a bare lightbulb slowly descends to the floor and rises again. The bulb, a surrogate for both object and agent of interrogation, shines through the cages, casting unsettling shadows on the gallery walls beyond. With simple means, Hatoum is able to create a physically demanding space that catches the human frame in a continually shifting mesh of metal and shadow. With the political clarity of her performances and the emotional suggestiveness of *Corps Étranger*, *Light Sentence* illustrates and effects the collision of bodily sensation and political history.

Approaching issues of self and society through the things that we embrace and the materials that cover us, sculptor and photographer **Yinka Shonibare** (b. 1962) has created a humorous and historically exacting body of work.

Shonibare's sculpture is based on a simple and historically implausible confusion of African and British fashion. *Girl/Boy* (1998) (fig. **27.27**) presents a mannequin dressed in Victorian costume tailored from fabrics associated with Africa. The juxtaposition is funny, providing an invitation to disruptive considerations of postcolonial consciousness.

While the fashion confusion itself draws attention to intercultural mixing, the history of the fabric complicates what appears to be a clear statement about the impossibility of sustaining an African identity in a British life. In interviews and statements, Shonibare makes an issue of relaying the history of the "Dutch print" fabric that he uses. Developed by the Dutch as a simulation of the batik textiles of colonial Indonesia, "Dutch prints" were copied a second time by British textile manufacturers in Manchester. The English then exported the fabrics to West Africa where, in the 1960s, they became symbols of anticolonial patriotism. In London in the 1990s, these materials were again being adopted by the Afro-British as signs of African cultural and political solidarity. Shonibare, himself raised in Lagos and London, has pinned notions of identity to an emblem of Africa with roots on several continents, in colonizing and colonized nations, and in colonial, postcolonial, continental, and diasporic African history. His sculptures mock notions of authenticity and singularity by insisting on the heterogeneous and international nature of both British

27.26 Mona Hatoum, *Light Sentence*, 1992. Wire-mesh lockers and motorized lightbulb, 6' 6" × 6' 1" × 16' 1" (2 × 1.9 × 4.9 m); installation space variable, minimum 15' 11" × 25' 11" (4.9 × 7.9 m); maximum 19' 2" × 28' 10" (5.8 × 8.8 m). Collection National Gallery of Canada, Ottawa.

27.27 Yinka Shonibare, *Girl/Boy*, 1998. Wax-printed cotton textile, mannequin 71 × 59 × 27½" (180 × 150 × 70 cm), plinth size 79 × 5½ × 79" (200 × 14 × 200 cm). The Speyer Family Collection, New York.

and African identity. Following the material clues of Shonibare's fashion, the answer to a question posed in the title of another work by him, *How Does a Girl Like You Get to be a Girl Like You?* (1995), is found in an international and polyglot heritage.

In the architectural projections of **Krzysztof Wodiczko** (b. 1943), the notion of site specificity is attached to both bodies and places. Wodiczko creates art that intrudes upon the built environment, insisting that viewers reckon with the social as well as individual impact of architecture on the day-to-day lives of individuals. The artist's *Homeless Projection* of 1987 (fig. **27.28**) consists of photographs of people displaced by the processes of urban development—in this case in Boston—which he projects onto prominent buildings. The socially invisible become all but inescapable. Wodiczko forces people to acknowledge the human cost of architecture by figuratively making buildings with them. Rather than presuming homelessness to be a problem in society that can be solved within the existing system,

Wodiczko's projections posit it as a fundamental part of society, as necessary to the shape of urban life as the investors and institutions that finance skyscrapers. In *Poliscar* (1991), the artist interviewed people living on the streets and created vehicles designed to meet their needs for shelter, storage, protection, and comfort. The vehicles were meant to function within the existing system, again making the invisible visible. Wodiczko was not seeking to change the behavior or even location of those people living on the streets, but rather to change the way homelessness is perceived and discussed by society.

A profoundly different meaning was generated by the columns of light that dominated the Manhattan skyline for thirty-four nights in the spring of 2002. Six months earlier, on September 11, 2001, a terrorist attack had destroyed the towering International Style skyscrapers that comprised part of the World Trade Center, killing 2,603 office workers, firefighters, police officers, and bystanders. Beginning the night of March 11, an architecture of light rose up from the site of the World Trade Center, replicating the geometry of

27.28 Krzysztof Wodiczko, *Homeless Projection: The Soldiers and Sailors Civil War Memorial*, December 1987. Public projection. The Common, Boston.

the two modernist towers in one of the most effective monuments since Lin's Vietnam Memorial (see fig. 23.24). The beacons were illuminated again on September 11, 2003 to mark the second anniversary of the attack, and the light memorial has recurred annually since then.

Several artists, architects, and engineers came up with the idea for the towers of light as they witnessed the tragedy of September 11. **Julian LaVerdiere** (b. 1971), **Paul Myoda** (b. 1967), John Bennett, Gustavo Bonevardi, Paul Marantz, and Richard Nash Gould were brought together to realize the project, titled *Tribute in Light*. The aim of the project was to direct attention away from the form of the buildings to the lives of those lost in them. The structure consisted of forty-four 7,000-watt xenon lightbulbs installed on a fifty-square-foot (4.64 m²) base adjacent to the excavation site. The lights projected almost a mile into the sky, creating the effect of a monumental memorial candle. The result could be seen by people over the entire metropolitan area, thus bringing the region together in a communal experience to mourn and gain strength through remembrance. As one of the architects explained, the lights by their visual presence and material absence "reconstruct[ed] the void as opposed to … the buildings." Rising above the chaotic expressions of grief that sprang up throughout the city—walls of photographs, letters, testimonies, mementoes, gifts, and flowers laid on street corners, parks, and firehouses—the *Tribute in Light* (fig. **27.29**) focused the emotional response into two centralized iconic forms. The work drew strength by combining the general symbolic iconography of the skyscraper with

27.29 Julian LaVerdiere and Paul Myoda, *Tribute in Light* over the Brooklyn Bridge, from the portfolio *Tribute in Light: Artists' Renderings*, 2001–02. Portfolio of twelve C-prints, matted in an archival box, 24" × 20", edition of 500 on behalf of the Tribute in Light Initiative produced by Creative Time.

the specific meaning of the World Trade Center. As Myoda remarked, "It is an irony, a kind of painful irony, that we looked at the towers the same way the terrorists apparently looked at them: as a symbol of communication, strength, and power."

The Art of Biography

Translating the experiences of one's life into a cogent story that responds to the needs of the teller and the demands of the audience has proved an acute challenge to contemporary artists. Some, like Tracey Emin, have attempted to push as much of their life into their art as possible, creating in a sense a real-time presentation of self. Others have sought to keep tighter control over the nature and content of personal revelation. Complicating the personal with the political, the majority of work discussed below addresses the specific problem of telling biographies of non-majority citizens in a language that is necessarily shaped by the majority. Using text, film, photography, and painting, this art interrogates the act of writing or picturing biography even as it attempts to achieve it.

Before becoming an artist, **Carrie Mae Weems** (b. 1958) studied folklore at the University of California, Berkeley. Her photographic work has focused her folkloristic convictions on the importance of narrative in the construction of identity and history. Weems attempts to tell stories faithful to the African-American experience in forms distinct from those of colonizing cultures. She has chronicled her family's migration from the deep South to Portland, Oregon, where she was born; written fictional stories of

contemporary life; and traced the migrations of people from West Africa to the U.S. Taken together, Weems' work weaves the biography, autobiography, fiction, and history of Africans and African-Americans into intricate photo, text, and sculpture installations. She uses photography and texts as pieces in conceptual projects aimed at constructing alternative means of discussing society. She is a storyteller, choosing to follow narratives through to their ending and filling them with a wealth of local detail.

Untitled (Kitchen Table series) of 1990–99 (fig. **27.30**) is a four-part tableau presenting characters in a domestic drama. Focusing on the intimate relationship of an educated working-class black woman and the space of the kitchen, the series addresses the themes of marriage, friendship, children, and loneliness. The images are accompanied by texts, told in different voices, about the perils of domestic life. By rewriting the drama of domestic life in a consciously scripted fashion, Weems directs the viewer to those aspects of African-American life that she deems important. Traditional documentary photography had been directive too, but it had hidden its agenda in the apparent realism of its imagery. Artifice, as well as the complicated arrangements of texts, images, and objects throughout her oeuvre, serve Weems' desire to be clear and present in her work.

Glenn Ligon (b. 1960) works, in large part, by formally manipulating text to explore the disjunction between lives lived and the words we use to talk about them. Using quotations, many of which describe the realities of growing up black in America, Ligon associates speaking of African-American experience with the Dada and Surrealist practice

27.30 Carrie Mae Weems, *Untitled* (outtake from the *Kitchen Table* series), 1990–99. Gelatin-silver print, 29¼ × 28¼" (74 × 72 cm).

of the readymade and the *objet-trouvé*. The texts of others, from James Baldwin to Mary Shelley, become the objects with which Ligon attempts to bypass the traps of institutionalized language, thereby conjuring up the experience of African-American people.

Combining the textual abstraction of Jasper Johns (see fig. 19.34) with a distinctly pictorial impulse, works like *Untitled (I Feel Most Colored When I am Thrown Against a Sharp White Background)* of 1990 (fig. **27.31**) illustrate Ligon's understanding of race in America in surprising ways. Ligon paints the words as though they were on a page from a book. Starting off in sharp focus on the white field, the words begin to bleed onto the panel around them, fading into the obscurity of a darker background. The painting reverses the increasing clarity described in the text. Ligon has not translated the metaphor of the text directly, but has used it to illustrate the deceptive clarity that race presents. In effect, Ligon is writing his own biography by making images with, not of, the writings of others.

Lorna Simpson (b. 1960), like Glenn Ligon, uses conceptual and pictorial devices to articulate and at least impart the difficulty of speaking about life as an African-American. Initially working in the tradition of documentary photography, Simpson, like many artists, began to question the assumed objectivity of the genre. Informed by Minimalist, Conceptualist, Feminist, and Identity art of the previous decades, Simpson questioned how the most fundamental properties of photography—repetition and framing—might complement her intentions as an African-American photographer.

Simpson's *Guarded Conditions* (1989) (fig. **27.32**) addresses racially and sexually directed violence, but uses none of the devices, expressive representation, and dramatic prose or poetry traditionally used to deal with such violence. The body of a standing black woman, her back turned to the viewer, is displayed in three framed photographs and repeated six times across the wall. Repeated below the figures are the phrases "SEX ATTACKS" and "SKIN ATTACKS."

Like Gonzalez-Torres or Hatoum, Simpson uses the history of Minimalism and Conceptual art to provide and infiltrate metaphors for the regulated nature of social space. Sentence fragments and cropped photographs of backs and turned heads become signs of social oppression and the coded means by which Simpson's subjects navigate and challenge it. Withholding as much if not more information than it provides, *Guarded Conditions* suggests both a generalized state of affairs and an intimation of specific events in a person's life. Though it is not an optimistic image, there is a sense in Simpson's art, as in Hatoum's and Gonzalez-Torres', of options within the "contradictions in the system."

In the introduction to her 1993 book *The Other Side*, a photographic celebration of cross-dressing, drag queens, and a spectrum of transgendered activity, **Nan Goldin** (b. 1953) wrote, "The pictures in this book are

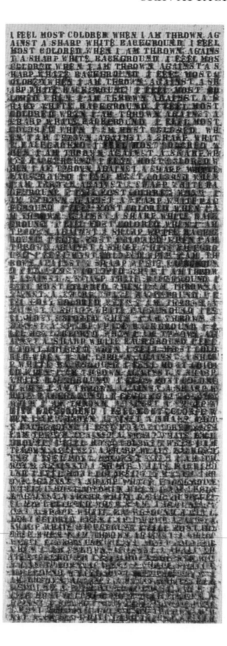

27.31 Glenn Ligon, *Untitled (I Feel Most Colored When I am Thrown Against a Sharp White Background)*, 1990. Diptych, oilstick and gesso on wood, each panel 6' 6" × 2' 6" (2 × 0.76 m). Collection the artist.

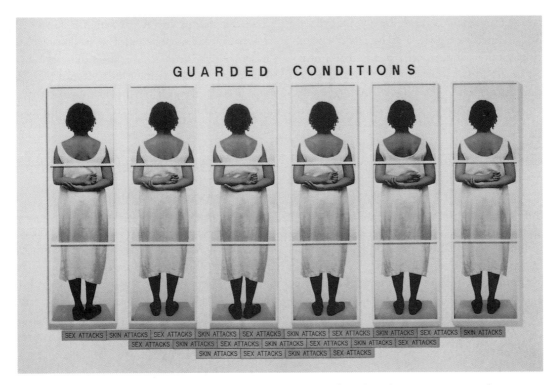

27.32 Lorna Simpson, *Guarded Conditions*, 1989. Eighteen color Polaroid prints, twenty-one plastic plaques, plastic letters, overall dimensions 7' 7" × 12' 11" (2.3 × 3.9 m). Collection Museum of Contemporary Art, San Diego.

not about people suffering gender dysphoria but rather expressing gender euphoria. This book is about new possibilities and transcendence." Goldin's work presents the intimate lives of people who make up her family of choice. *C Putting on Her Make-up at the Second Tip, Bangkok* (1992) (fig. **27.33**), from the series *The Other Side*, is one of Goldin's many presentations of alternative lives. Before the mirror, in bathrooms, dressing-rooms, and bedrooms, Goldin's subjects work on their faces, their bodies, and their clothes, transforming themselves into who they want to be. Goldin presents a world in which sexual, familial, social, and economic differences are impossible to define.

Goldin's earliest work employed the theatrics of glamour and the possibilities of fashion for the lives of her friends. She has continued to use the high-gloss printing that mimics the seductive brilliancy of fashion photography even if her subjects, denizens of sexual, social, and chemical subcultures, would seem to have little in common with supermodels and fashion designers. In 1981, she presented her signature work, *The Ballad of Sexual Dependency*, an ever-changing slide show documenting the people around her. *Ballad* depicts private scenes of men and women dressing, sleeping, or just bored, as well as showing an array of sexual activity, illicit drug use, and violent behavior.

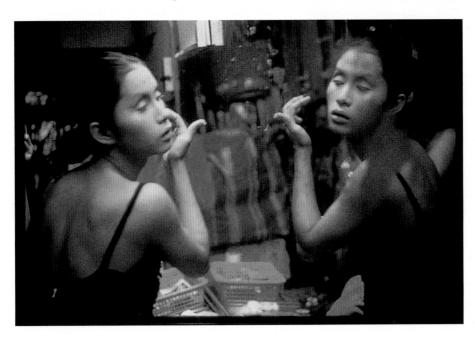

27.33 Nan Goldin, *C Putting on Her Make-up at the Second Tip, Bangkok*, 1992. Cibachrome print, 30 × 40" (76.2 × 101.6 cm).

In the late 1980s, Goldin became heavily addicted to drugs and documented her own descent and recovery. Though the themes of exclusion and brutality that infused *Ballad* remain strong in her work of the 1990s, the focus on personal transformation in *The Other Side* suggests the greater potential of its "new possibilities."

William Kentridge (b. 1955), like Weems, has used biography as a lens to view the relationship between history and the present. To do so he has essentially created his own medium—animation in which the traditional cells are replaced with charcoal drawings filmed at given moments of being drawn, erased, and altered. The results document images that seem to carry themselves across the surface of a single page of paper. Born, raised, and trained in Johannesburg, Kentridge considers all his art to be in one way or another about the city, and he uses his innovative medium to explore the conflation of his own biography as a white South African living through the end of apartheid with the fictionalized lives of two characters, Soho Eckstein and Felix Teitlebaum. Soho is an industrialist in the mode of George Grosz's ruthless caricatures of the 1930s (see fig. 11.32) and Felix is a nude everyman whose fragility seems to speak of a universal human condition. Throughout the films, the capitalist's cruelty becomes a foil for Felix's personal indiscretions, including an affair with Soho's wife and a flood of melancholy that in *Felix in Exile* (1994) (fig. **27.34**) threatens to drown him.

Kentridge displays the drawings from which each film was made together with the film itself. There are thus always two objects that make up his movies: an image frozen at the point where he decided to pause the history of erasures and additions; and the unstopping film. On a metaphoric level, the drawings are, like individuals and nations, marked by the passages of time and history.

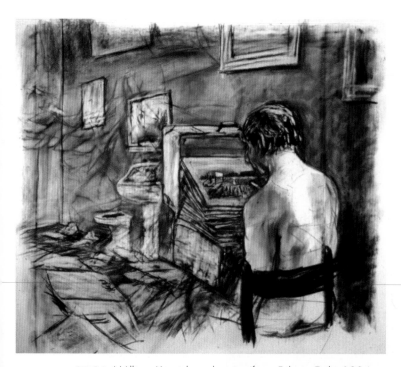

27.34 William Kentridge, drawing from *Felix in Exile*, 1994.

The contrast of the two combined media, between the intimacy of charcoal and the distance of film, further accents the difficult combination of biography and history. Like many works of the 1990s, Kentridge's films of Felix and Soho argue that history, in this case that of apartheid in South Africa, is only visible as it is filtered through the biographies of its witnesses.

Globalization and Arts Institutions

By the end of the twentieth century, the intertwined legacy of collecting and conquest was well appreciated. From Napoléon's Louvre in Paris to Alfred Barr's Museum of Modern Art in New York, the museum has expressed ideological positions through the selection and display of objects. The installations of Hans Haacke, Louise Lawler, and Fred Wilson had exposed the power and priorities of museums just as the activities of the Guerrilla Girls revealed the persistence of gender and racial bias in arts institutions (see chapter 22). A number of contemporary artists have extended this practice to address not only the consequences of feminism and the civil rights movement but also those of postcolonialism and globalization. Architects, too, are taking the economic and political consequences of these two developments into account when designing new museums and exhibition halls.

Interventions in the Global Museum

Lothar Baumgarten (b. 1944) began examining the relationship between institutional power and representation in the 1970s. Particularly concerned with how images became part of the process of colonization, Baumgarten scoured history and anthropology texts to investigate the renaming of the Americas. For instance, Venezuela in South America, meaning "little Venice," was given the name "Venezuola" by the Italian explorer Amerigo Vespucci, who accorded the region linguistic association with Europe. This association was forcibly asserted when the region was annexed by Spain during the sixteenth century. Such labeling of the non-Western world is the linguistic complement to the eighteenth- and nineteenth-century tradition of landscape painting and photography that fits foreign landscapes into familiar frameworks for assigning meaning to the world. In 1979, Baumgarten spent eighteen months living with and photographing the indigenous Amazonian Yanomami people. Subsequently, his work has integrated text and image to create deconstructive critiques of colonial exploration and constructive attempts at what might be called Post-modern anthropology.

A site-specific installation proposed by Baumgarten serves to clarify his critical use of text and image. He planned that the work should have the indigenous place names of Venezuelan cities engraved, with the letters reversed, in a public square in the capital, Caracas. This format would have politicized the text because it mimicked oppositional political slogans spray-painted in reverse throughout the

27.35 Lothar Baumgarten, *AMERICA, Invention I*, detail, 1988–93. Installation at the Guggenheim Museum, New York.

city. To accompany the exhibition, Baumgarten designed a volume of the *Guggenheim Magazine*, inviting art historians, anthropologists, and a poet to discuss issues raised by the work. At its center lay the heart of Baumgarten's project, a collection of photographs of objects on display at an ethnographic museum framed with words such as "questioned," "evaluated," "claimed," "obfuscated," and "fetishized," that

to the artist, in his own words, "describe the unsettled psyche of objects transported from one culture to another." Baumgarten's presentation, called *AMERICA, Invention I* (1988–93) (fig. **27.35**), joined together political and museum history by filling the rotunda of the Guggenheim Museum, New York, with the names of Native American tribes, some upside down in gray, some in bright red, which appear to ascend the spiral ramp defining the interior of the museum. In the side galleries radiating from the ramp, words by historians from the U.S. and Europe describing the treatment of those tribes are written in arcs that recall longitude lines on an atlas. A text on the floor reads, "Borrowed land for sale." The viewer stands in an art museum surrounded by the interwoven text of American history and its philosophical and moral dilemmas. Baumgarten's presentation suggests both the complicity and responsibility that cultural institutions have in the writing of history.

Several contemporary photographers have drawn on the practice of Bernd and Hilla Becher (see fig. 20.69) to create images of museums as penetrating as any installations that might appear in a museum. Two Becher students, **Candida Hofer** (b. 1944) and **Thomas Struth** (b. 1954), applied their professors' typological method to the institutions of learning and art history that developed them, using the camera to interrogate the forms and consequences of various types of artistic display.

Hofer has documented the empty interiors of museums, libraries, and schools that shape the semi-private, semi-public experiences of viewing art and internalizing culture. *Museum van Hedendaagse Kunst Gent III* (1995) (fig. **27.36**) presents the integration of the art, the exhibition space, and the dining room—all essential parts of a functioning museum. The curving atrium echoes the

27.36 Candida Hofer, *Museum van Hedendaagse Kunst Gent III*, 1995. Color photograph, 15½ × 23¼" (39 × 59 cm).

27.37 Thomas Struth, *Museum of Modern Art I*, 1994. C-print, edition of ten, 70⅞ × 93¾" (180 × 238 cm).

photography and furniture in it. Struth's series of museum interiors also presents the collusion between art and museum in shaping the physical, intellectual, and emotional experiences of the viewer, whom Struth includes in his photographs. *Museum of Modern Art I* (1994) (fig. **27.37**) presents seven or eight figures before Jackson Pollock's *One: Number 31* of 1950. An elegant image of the institutionalization of modern art, the photograph captures Pollock's painting in detailed, unmoving focus, while viewers move around and shift restlessly out of focus. Struth documents the transference of energy and behavior from the painting to the viewer. His image of Caillebotte's *Rainy Day, Paris* presents viewers judiciously positioning themselves before the painting. One woman begins to move her stroller from the streetside of Caillebotte's picture toward its vanishing point as a second woman stands securely by the sidewalk. Paintings, it seems, provide legible and convincing instructions about how to act in their presence. Hofer and Struth's museum images provide visually stunning evidence of the care with which we display art while posing vexing questions about who is in control as we look at it. Both artists participated in the 1999 exhibition Museum as Muse, held at the Museum of Modern Art, which celebrated that institution as a source of inspiration for artists.

In conjunction with this exhibition, Fred Wilson (see chapter 22) created an interactive website that allows visitors to navigate among images and texts drawn from the archives of the museum (www.moma.org/exhibitions/1999/wilson/index.html). By juxtaposing particular images and adding his own, often one-word, commentary to these archival records, Wilson makes clear that the historic processes of collecting, exhibiting, viewing, and analyzing art serve to establish and maintain ideologies, especially those ideologies that encourage a society to perceive cultures in hierarchical terms.

The *Advertising Castle* (fig. **27.38**) of **Cai Guo-Qiang** (b. 1957) is a clear statement of what was at stake in the

27.38 Cai Guo-Qiang, *Advertising Castle*, 1998. *In situ* at 1998 Taipei Biennial Sites of Desire.

current global art market. Raised in China and based first in Japan and then New York, Cai's personal experience put him in a good position to examine the global economies of culture and finance. He took the occasion of the 1998 Taipei Biennial, which, like all the biennials, aimed to inspire intellectual analysis, encourage cultural tourism and boost nationalism, to raise the issue of complicity between art and politics. In the political gamesmanship between China and Taiwan in the late 1990s, as well as in the cultural and economic competition that existed in Southeast Asia, Taiwanese nationalism was a volatile issue. Cai sheathed the Taipei Fine Arts Museum, host of the biennial, in a bamboo scaffold covered in advertisements. He highlighted the corporate interest in culture to such a degree that visitors had trouble finding the entrance to the show. In a double entendre leveled at the title of the biennial, Sites of Desire, the *Advertising Castle* proclaimed the exhibition as a desirable site to display corporate sponsorship and the advertisements to be sites where desire was generated in the citizen consumers attending the show. The *Advertising Castle* became a magnet for political debate, drawing complaints from the city council that it was serving commercial rather than artistic aims. The consequence of Cai hitting his mark so directly was that the council demanded that the work be removed. When the Taipei Fine Arts Museum refused, it lost NT$1 million in funding.

Designing a Global Museum

A number of architects have critically examined museum practices in order to design new exhibition spaces that will not propagate ideologies of cultural superiority or valorize the conquest of one culture by another. The difficulty of this effort is compounded by the simple history of Western conquest in the Americas, Africa, Asia, and the South Pacific. Part of this history involved the acquisition by trade or theft of the material culture of conquered peoples. Millions of items were relocated to Western museums, far from the regions where they were made and originally used. Many countries have petitioned for the return of cultural artifacts acquired during periods of colonization or conquest. International courts have generally ruled in support of such suits, forcing Western museums to repatriate artworks, ritual objects, and even human remains.

One way in which museum architecture has been used to diffuse the concentration of cultural power is by decentralizing the museum itself. If it can literally be taken apart and dispersed across national boundaries, perhaps the cultural authority it holds can likewise be shared by many nations. This is one of the rationales for the Guggenheim Museum's decision to establish venues at several satellite locations. Of course, the sites that the Guggenheim has chosen for its various offshoots testify as much to commercial as to ideological concerns.

In 1979, twenty years after Frank Lloyd Wright completed the Guggenheim Museum in New York, the Guggenheim Foundation opened the Venetian home of Peggy Guggenheim as its first international outpost. By the 1990s, the museum was expanding in size and mission. In New York there was a new addition to the Wright building; a SoHo museum; and plans for an enormous downtown complex. In 1997, branches were opened in Bilbao and Berlin. By 2001, Las Vegas was home to a Guggenheim exhibition space and a collaboration with the Russian Hermitage. Cyberspace had, of course, been occupied and there were plans for a new location in Brazil. The Guggenheim was also injecting its exhibition schedule with shows on fashion designers and motorcycles. Though criticized heavily for favoring marketing over curating and choosing to be popular instead of smart, the Guggenheim was crossing boundaries and welcoming audiences unapproached by traditional institutions (see *Avant-tainment*, below).

CONTEXT

Avant-tainment

The Guggenheim is only one of many museums worldwide to significantly expand or even multiply its venues. Museums of modern and contemporary art have been especially keen to increase gallery space along with adding restaurants, shops, and media centers. Among the first ambitious expansions was that undertaken between 1995 and 2004 by the Tate in London, which transformed a disused power station along the banks of the River Thames into a dramatic setting for the display of modern and contemporary art. Central to the design of the new Tate Modern were spaces for the public to relax and socialize away from the art galleries. Formerly regarded as a place for the conservation, display, and interpretation of artworks, museums are now conceived as entertainment complexes where visitors can shop, dine, and watch films and live performances as well as view the artworks. Critics have questioned the dilution of the museum's traditional mission, arguing that artworks are today serving merely as entertaining distractions or as spurs to consumers who now encounter several shopping opportunities during a typical museum visit. The fact that the avant-garde—with its history of resistance to consumer capitalism—might function as a lure to commerce strikes some critics as particularly galling. Others accept the fact that corporations have become stalwart patrons of the arts, reconciling themselves to the commercialization of the avant-garde. Certainly, corporate patrons recognize the value of their association with the art world: Prada commissioned Rem Koolhaas to design a boutique; Louis Vuitton collaborated with artist Takashi Murakami, allowing the artist to place a functioning store at the heart of a museum installation; and Chanel hired Zaha Hadid to design its portable, touring museum, filled with Chanel-themed artworks by twenty artists including Daniel Buren, Yoko Ono, and Sophie Fleury.

The **Frank Gehry** (b. 1929) structure in Bilbao (fig. **27.39**) (see chapter 24) captures the politics of the new museum as well as its traditional understanding of architecture and public image. Located in the Basque region of Spain and built by the Basque government, the museum was a centerpiece in a dramatic urban renewal campaign. Major infrastructure development, including a refurbished port, a new airport, and a riverfront complex designed by Cesar Pelli, have been planned for the city. The Guggenheim traded on its cultural capital, providing the Basque government with access to an international stage. The museum building, as much sculpture as architecture, is a destination for cultural tourism that facilitates the political and cultural ambitions of its host.

While the Guggenheim's efforts at international outreach have been denigrated as a form of cultural imperialism or as akin to the franchise economics of McDonald's (Guggenheim's international venues have been referred to as McGuggenheims), a number of other institutions are experimenting along similar lines. For instance, the Louvre Museum has plans to open another venue in Abu Dhabi in the United Arab Emirates. The new museum, scheduled to open in 2012, is being designed by Jean Nouvel (see discussion below).

Jean Nouvel (b. 1945) has already contributed significantly to ongoing debates about the nature of the museum in a postcolonial world with his Quai Branly Museum, which opened in 2006 and is devoted to the material culture of Asia, Africa, Oceania, and the Americas (see *Pritzker Prize*, right). Ethnographic museums, in particular, have come under sustained scrutiny through their inescapable relationship to Western colonization. Some have called for the dissolution of all institutions that retain or exhibit objects taken from societies under colonial rule. Others, including former French president Jacques Chirac, who strongly supported the establishment of the Quai Branly Museum, believe that cultural artifacts can transcend the often violent histories of their acquisition

to serve as testaments to the achievements and even unity of humankind.

Given the extreme positions taken by those on either side of the debate, Nouvel faced a difficult challenge in designing the Quai Branly. The building's exterior is distinguished by two main features. First, a "living wall" defines the western perimeter of the building (fig. **27.40**). Designed by **Patrick Blanc** (b. 1953), the living wall comprises a metal frame, perforated PVC pipe, and a layer of thick felt onto which plants can anchor, take root, and receive nourishment without soil. The result is a striking vertical plane of vegetation that changes in response

27.39 Frank O. Gehry, Guggenheim Bilbao, 1991–97. Bilbao, Spain.

assembled on the spot. The boxy modules resemble brightly colored shipping containers; the steel tubes that support the structure conjure discarded pipelines that have been hacked into sections and put to new use as stilts. The ingenuity of pre-industrial peoples in translating the "modern" materials of colonial expansion into unanticipated objects of striking appearance and utility has been theorized as *bricolage* ("do-it-yourself" or "odd jobs"; *bricoler* means "to tinker" in French; *bricole* refers to a small or insignificant thing). By making the green wall and his *bricolage* exterior the first things a visitor encounters, Nouvel insists that assumptions about non-Western cultures should be reconsidered.

The spectacular yet self-conscious character of the Quai Branly's exterior characterizes its interior spaces as well. Galleries are dimly lit, with dramatically illuminated cases. Instead of being arranged by strict geographic or chronological order, objects are dispersed throughout according to a variety of thematic relationships. The idea that unites one part of the installation may not be the same one used to circumscribe another, an arrangement that undercuts the impression of a single, authoritative presence within the museum. Pathways and corridors between and even within galleries meander and intersect unpredictably, contributing further to the visitor's impression of freedom: freedom of movement and of cultural expression.

Nouvel's Quai Branly Museum summarizes perfectly the challenges facing artists and architects working today. Even with the political and economic shifts that have ushered in this age of globalization, most arts institutions remain rooted to some extent in the national or colonial histories that defined late-nineteenth and twentieth-century history. As much as artists may wish to make works that transcend this history, contemporary art derives as much from the history as from the imagined future of those who make and observe it.

27.40 Patrick Blanc, *Living Wall (Vertical Garden System)*, 2006. Quai Branly Museum, Paris.

to the seasons and climate. Alongside the Quai Branly Museum, the living wall evokes the ecological vulnerability of much of the world and its populations, especially those cultures that live in pre-industrial conditions where the health of the natural environment is felt more acutely than in post-industrial, urban societies.

Apparent from the street is another of the building's signature characteristics. A series of conjoined boxes of varied size and color seems to rest atop drunkenly angled metal piers, creating the impression of a covered bridge hurriedly constructed of Tinker Toys (fig. **27.41**). The playful exterior draws on colonial history and postcolonial theory. Something aesthetically alluring and original that has been fabricated from the refuse of an abandoned Western occupation seems to have been

27.41 Jean Nouvel, Quai Branly Museum, 2006. Paris.

Bibliography

Art and architectural surveys reflect a wide range of critical discourse. Their bibliographies are, by necessity, selective. These suggestions for further reading strive for balance between canonical texts and recent scholarship published both as monographs and exhibition catalogues. Comprehensive research will benefit from a review of current periodical literature, but no attempt has been made to incorporate this vast and rapidly changing body of work here.

The bibliography is organized as follows:

I. General

A. Surveys, Theory, and Methodology
B. Dictionaries and Encyclopedias
C. Architecture, Engineering, and Design
D. Photography, Prints, and Drawings
E. Painting and Sculpture

II. Further Readings, Arranged by Chapter

Books and exhibition catalogues without discernible author(s) are listed alphabetically by title.

Abbreviations

HMSG	Hirshhorn Museum and Sculpture Garden, Washington, D.C.
LACMA	Los Angeles County Museum of Art
MMA	The Metropolitan Museum of Art, New York
MOCA	Museum of Contemporary Art, Los Angeles
MOFA	Museum of Fine Arts, Boston
MOMA	The Museum of Modern Art, New York
SFMOMA	San Francisco Museum of Modern Art
SMH	Studio Museum in Harlem, New York
SRGM	Solomon R. Guggenheim Museum, New York
WMAA	Whitney Museum of American Art, New York

Works cited here are in English, except for selected important sources, catalogues, and documents.

This bibliography was compiled by Mary Clare Altenhofen.

I. General

A. Surveys, Theory, and Methodology

Adamson, Walter L. *Embattled Avant-Gardes: Modernism's Resistance to Commodity Culture in Europe.* Berkeley, Calif.: University of California Press, 2007.

Arnheim, Rudolf. *Art and Visual Perception: A Psychology of the Creative Eye.* Enl. and rev. ed. Berkeley and Los Angeles, Calif.: University of California Press, 1974.

———. *To the Rescue of Art: Twenty-six Essays.* Berkeley, Calif.: University of California Press, 1992.

Art and Power: Europe Under the Dictators, 1930–45. Comp. D. Ades, et al. London: Hayward Gallery, 1995.

Art of the Twentieth Century. Trans. Antony Shugaar. 5 vols. Vol. 1. *1900–1919: The Avant-Garde Movements,* Vol. 2. *1920–1945: The Artistic Culture Between the Wars,* Vol. 3. *1946–1968: The Birth of Contemporary Art,* Vol.4. *1968–1999: Neo-Avant-Gardes: Postmodern and Global art,* Vol. 5. *2000 and Beyond: Contemporary Tendencies.* Milan: Skira; New York: Distr. Rizzoli, 2006.

Ashton, Dore. *Out of the Whirlwind: Three Decades of Arts Commentary.* Ann Arbor, Mich.: UMI Research Press, 1987.

———. *The Unknown Shore: A View of Contemporary Art.* Boston: Little, Brown, 1962.

Atkins, Robert. *Artspeak: A Guide to Contemporary Ideas, Movements, and Buzzwords.* 2nd ed. New York: Abbeville Press, 1997.

Baigell, Matthew. *A Concise History of American Painting and Sculpture.* Rev. ed. New York: Icon Editions, 1996.

Barasch, Moshe. *Modern Theories of Art.* 2 vols. New York: New York University Press, 1990–98.

Barr, Jr., Alfred H. *Cubism and Abstract Art: Painting, Sculpture, Constructions, Photography, Architecture, Industrial Arts, Theatre, Films, Posters, Typography.* Cambridge, Mass.: Belknap Press of Harvard University Press, 1986.

———. *Defining Modern Art: Selected Writings of Alfred H. Barr.* Eds. I. Sandler and A. Newman. New York: H.N. Abrams, 1986.

Battcock, Gregory. *Why Art: Casual Notes on the Aesthetics of the Immediate Past.* New York: Dutton, 1977.

Baudelaire, Charles. *Painter of Modern Life and Other Essays.* Trans. and ed. J. Mayne. 2nd ed. London: Phaidon, 1995.

Bearden, Romare. *A History of African American Artists: From 1792 to the Present.* New York: Pantheon Books, 1993.

Berger, John. *About Looking.* New York: Vintage International, 1991.

Bjelajac, David. *American Art: A Cultural History.* 2nd ed. Upper Saddle River, N.J.: Prentice Hall, 2005.

Blanshard, Frances. *Retreat from Likeness in the Theory of Painting.* 2nd ed. New York: Columbia University Press, 1949.

Boime, Albert. *The Academy and French Painting in the Nineteenth Century.* With new pref. and suppl. bibliography. New Haven, Conn.: Yale University Press, 1986

Bois, Yve-Alain. *Painting as Model.* Cambridge, Mass.: MIT Press, 1991.

Bolton, Richard, ed. *Culture Wars: Documents From Recent Controversies in the Arts.* New York: New Press, 1992.

Bowness, Alan. *Modern European Art.* New York: Thames & Hudson, 1972.

Broude, Norma, and Mary Garrard, eds. *The Expanding Discourse: Feminism and Art History.* New York: Harper & Row, 1992.

———, eds. *Feminism and Art History: Questioning the Litany.* New York: Harper & Row, 1982.

———, eds. *Reclaiming Female Agency: Feminist Art History After Postmodernism.* Berkeley, Calif.: University of California Press, 2005.

Brown, Milton W. *American Art: Painting, Sculpture, Architecture, Decorative Arts, Photography.* New York: H.N. Abrams, 1979.

Brunette, Peter, and David Wills, eds. *Deconstruction and the Visual Arts: Art, Media, Architecture.* New York: Cambridge University Press, 1995.

Bryson, Norman. *Calligram: Essays in New Art History from France.* New York: Cambridge University Press, 1988.

———, ed. *Vision and Painting: The Logic of the Gaze.* New Haven, Conn.: Yale University Press, 1983.

———, et al., eds. *Visual Theory: Painting and Interpretation.* New York: Cambridge University Press, 1991.

Bürger, Peter. *Theory of the Avant-Garde.* Trans. M. Shaw. Minneapolis, Minn.: University of Minnesota Press, 1984.

Cahn, Steven M. and Aaron Meskin, eds. *Aesthetics: a Comprehensive Anthology.* Malden, Mass.: Blackwell Publishers, 2008.

Cahn, Walter. *Masterpieces: Chapters on the History of an Idea.* Princeton, N.J.: Princeton University Press, 1979.

Canaday, John. *Mainstreams of Modern Art.* 2nd ed. New York: Holt, Rinehart and Winston, 1981.

Caws, Mary Ann. *The Eye in the Text: Essays on Perception, Mannerist to Modern.* Princeton, N.J.: Princeton University Press, 1981.

Celant, Germano, ed. *Architecture & Arts, 1900/2004: A Century of Creative Projects in Building, Design, Cinema, Painting, Sculpture.* 1st ed. Milan: Skira; New York: Distr. Rizzoli, 2004.

Cerutti, Toni, ed. *Ruskin and the Twentieth Century: The Modernity of Ruskinism.* Vercelli: Edizioni Mercurio, 2000.

Chadwick, Whitney. *Women, Art and Society.* 4th ed. New York: Thames & Hudson, 2007.

Cheetham, Mark et al. *The Subjects of Art History: Historical Objects in Contemporary Perspectives.* Cambridge, England; New York: Cambridge University Press, 1998.

Chu, Petra ten-Doesschate. *Nineteenth-Century European Art.* 2nd ed. Upper Saddle River, N.J.: Prentice Hall, 2006.

Clark, Kenneth. *Ruskin Today.* London: J. Murray, 1964.

Collingwood, R. G. *Essays in the Philosophy of Art.* Bloomington, Ind.: Indiana University Press, 1964.

Compton, Susan, ed. *British Art in the 20th Century: The Modern Movement.* Munich: Prestel, 1986.

Cone, Michèle. *The Roots and Routes of Art in the 20th Century.* New York: Horizon Press, 1975.

Crane, Diane. *The Transformation of the Avant-Garde: The New York Art World, 1940–1985.* Chicago: University of Chicago Press, 1987.

Crary, Jonathan. *Techniques of the Observer: On Vision and Modernity in the 19th Century.* Cambridge, Mass.: MIT Press, 1990.

Craven, Wayne. *American Art: History and Culture.* Madison, Wis.: Brown and Benchmark, 1994.

Crimp, Douglas. *On the Museum's Ruins.* Cambridge, Mass.: MIT Press, 1993.

Crow, Thomas. *Modern Art in the Common Culture.* New Haven, Conn.: Yale University Press, 1996.

Danto, Arthur C. *The Philosophical Disenfranchisement of Art.* New York: Columbia University Press, 2005.

———. *The Transfiguration of the Commonplace: A Philosophy of Art.* Cambridge, Mass.: Harvard University Press, 1981.

———. *Unnatural Wonders: Essays From the Gap Between Art and Life.* New York: Farrar, Straus and Giroux, 2005.

Dempsey, Amy. *Art in the Modern Era: A Guide to Styles, Schools, Movements, 1860 to the Present.* New York: H.N. Abrams, 2002.

Eisenmann, Stephen F., et al. *Nineteenth Century Art: A Critical History.* 2nd ed. New York: Thames & Hudson, 2002.

Ferguson, Russell, ed. *Discourses: Conversations in Postmodern Art and Culture. Documentary Sources in Contemporary Art.* Cambridge, Mass.: MIT Press, 1990.

Ferrier, Jean Louis, ed. *Art of Our Century: The Chronicle of Western Art, 1900 to the Present.* New York: Prentice Hall, 1989.

Fineberg, Jonathan. *Art Since 1940: Strategies of Being.* 2nd ed. Upper Saddle River, N.J.: Prentice Hall, 2000.

Fletcher, Valerie. *Dreams and Nightmares: Utopian Visions in Modern Art.* Washington, D.C.: HMSG, 1983.

Focillon, Henry. *The Life of Forms in Art.* New York: Zone Books, 1989.

Foster, Hal. *Return of the Real: The Avant-Garde at the End of the Century.* Cambridge, Mass.: MIT Press, 1996.

———, et al. *Art Since 1900: Modernism, Antimodernism, Postmodernism.* 2 vols. New York: Thames & Hudson, 2004.

———, ed. *The Anti-Aesthetic: Essays on Postmodern Culture.* Seattle: Bay Press, 1983.

Francis, Mark, ed. *Pop.* London; New York: Phaidon, 2005.

Frank, Patrick, ed. *Readings in Latin American Modern Art.* New Haven, Conn.: Yale University Press, 2004.

Frascina, Francis et. al. *Modernity and Modernism: French Painting in the Nineteenth Century.* New Haven, Conn.: Yale University Press in assoc. with the Open University, 1993.

Frascina, Francis, ed. *Pollock and After: The Critical Debate.* 2nd ed. New York: Routledge, 2000.

———, and Jonathan Harris, eds. *Art in Modern Culture: An Anthology of Critical Texts.* New York: Harper & Row, 1992.

———, and Charles Harrison, eds. *Modern Art and Modernism: A Critical Anthology.* New York: Harper & Row, 1982.

Fry, Roger. *Last Lectures.* Cambridge, England: The University Press, 1939.

———, *A Roger Fry Reader.* Ed. with introd. essays by Christopher Reed. Chicago: University of Chicago Press, 1996.

———. *Vision and Design.* Reprint. New York: Oxford University Press, 1981.

Gablik, Suzy. *Has Modernism Failed?* 2nd ed. New York: Thames & Hudson, 2004.

———. *Progress in Art.* London: Thames & Hudson, 1976.

Gage, John. *Color and Culture: Practice and Meaning from Antiquity to Abstraction.* Boston: Little, Brown, 1993.

Gaiger, Jason and Paul Wood, eds. *Art of the Twentieth Century: A Reader.* New Haven, Conn.: Yale University Press in assoc. with the Open University, 2003.

Goddard, Donald. *American Painting.* New York: MacMillan, 1990.

Goldwater, Robert. *Primitivism in Modern Art.* Enl. ed. Cambridge, Mass.: Harvard University Press, 1986.

Gombrich, Ernst H. *The Sense of Order: A Study in the Psychology of Decorative Art.* 2nd ed. Oxford: Phaidon, 1984.

Gordon, Donald. *Expressionism: Art and Idea.* New Haven, Conn.: Yale University Press, 1987.

Green, Christopher, ed. *Art Made Modern: Roger Fry's Vision of Art.* London: Merrell Holberton Publishers in assoc. with the Courtauld Gallery, Courtauld Institute of Art, 1999.

Greenberg, Clement. *Clement Greenberg: The Collected Essays and Criticism.* 4 vols. Chicago: University of Chicago Press, 1986–93.

Groïs, Boris. *The Total Art of Stalinism: Avant-Garde, Aesthetic Dictatorship, and Beyond.* Trans. C. Rougle. Princeton, N.J.: Princeton University Press, 1992.

Guilbaut, Serge, ed. *Reconstructing Modernism: Art in New York, Paris, and Montreal, 1945–1964.* Cambridge, Mass.: MIT Press, 1990.

Hamilton, George H. *19th and 20th Century Art: Painting, Sculpture, Architecture.* New York: H.N. Abrams, 1970.

Harris, Anne Sutherland, and Linda Nochlin. *Woman Artists: 1550–1950.* Los Angeles: LACMA, 1976.

Harris, Jonathan. *Writing Back to Modern Art: After Greenberg, Fried, and Clark.* London; New York: Routledge, 2005.

Harrison, Charles, and Paul Wood, eds. *Art in Theory, 1900–1990: An Anthology of Changing Ideas.* New ed. Malden, Mass.: Blackwell Publishers, 2003.

Hauser, Arnold. *The Social History of Art.* With an introd. by Jonathan Harris. 3rd ed. London; New York: Routledge, 1999.

Heartney, Eleanor et al. *After the Revolution: Women Who Transformed Contemporary Art.* New York: Prestel, 2007.

Heller, Nancy G. *Women Artists: An Illustrated History.* 4th ed. New York: Abbeville Press, 2003.

Herbert, Robert L. *From Millet to Léger: Essays in Social Art History.* New Haven, Conn.: Yale University Press, 2002.

———, ed. *The Art Criticism of John Ruskin.* Garden City, N.Y.: Anchor Books, 1964.

———, ed. *Modern Artists on Art.* Englewood Cliffs, N.J.: Prentice Hall, 1964.

Hertz, Richard. *Theories of Contemporary Art.* 2nd ed. Englewood Cliffs, N.J.: Prentice Hall, 1993.

———, and Norman Klein, eds. *Twentieth-Century Art Theory: Urbanism, Politics, and Mass Culture.* Englewood Cliffs, N.J.: Prentice Hall, 1990.

Hildebrand, Adolf von. *The Problem of Form in Painting and Sculpture.* Ann Arbor, Mich.: University Microfilms, 1979.

Hoffman, Katherine. *Explorations: The Visual Arts Since 1945.* New York: HarperCollins, 1991.

Hunter, Sam, and John Jacobus. *Modern Art: Painting, Sculpture, Architecture.* 3rd ed., rev. and expanded. Upper Saddle River, N.J.: Prentice Hall, 2004.

Jencks, Charles. *Critical Modernism: Where is Post-Modernism Going?* 5th ed. Chichester, England; Hoboken, N.J.: John Wiley, 2007.

Joachimides, Christos. *American Art in the 20th Century: Painting and Sculpture 1913–1933.* London and Munich: Royal Academy of Arts and Prestel, 1993.

———, et al. *German Art in the 20th Century: Painting and Sculpture 1905–1985.* London: Royal Academy of Arts and Weidenfeld & Nicholson, 1985.

———, ed. *The Age of Modernism: Art in the 20th Century.* Ostfildern-Ruit, Germany: Hatje Cantz; New York: Distr. D.A.P./Distributed Art Publishing, 1997.

Johnson, Ellen. *Modern Art and the Object.* London: Thames & Hudson, 1976.

———, ed. *American Artists on Art From 1940 to 1980.* New York: Harper & Row, 1982.

Johnston, Patricia, ed. *Seeing High & Low: Representing Social Conflict in American Visual Culture.* Berkeley, Calif.: University of California Press, 2006.

Joselit, David. *American Art Since 1945. World of Art.* London: Thames & Hudson, 2003.

Kemp, Martin. *The Science of Art: Optical Themes in Western Art from Brunelleschi to Seurat.* New Haven, Conn.: Yale University Press, 1990.

———. *Seen/Unseen: Art, Science, and Intuition From Leonardo to the Hubble Telescope.* Oxford, England; New York: Oxford University Press, 2006.

Kepes, Gyorgy. *The New Landscape in Art and Science.* Chicago: P. Theobald, 1956.

———. *Sign, Image, Symbol.* New York: G. Braziller, 1966.

Kern, Stephen. *The Culture of Time and Space: 1880–1918.* Cambridge, Mass.: Harvard University Press, 1980.

Kleinbauer, W. Eugene. *Modern Perspectives in Western Art History: An Anthology of Twentieth-Century Writings on the Visual Arts.* Reprint of the 1971 ed. Toronto: University of Toronto Press, 1989.

Kozloff, Max. *Renderings: Critical Essays on a Century of Modern Art.* London: Studio Vista, 1968.

Kramer, Hilton. *The Age of the Avant-Garde: An Art Chronicle of 1956–1972.* New York: Farrar, Straus and Giroux, 1973.

———. *The Triumph of Modernism: The Art World, 1987–2005.* Chicago: Ivan R. Dee, 2006.

Krauss, Rosalind. *The Optical Unconscious.* Cambridge, Mass.: MIT Press, 1993.

———. *The Originality of the Avant-Garde and Other Modernist Myths.* Cambridge, Mass.: MIT Press, 1986.

Kuh, Katharine. *The Artist's Voice.* New York: Harper & Row, 1962.

Kultermann, Udo. *The History of Art History.* New York: Abaris Books, 1993.

Kuspit, Donald B. *The Critic as Artist: The Intentionality of Art.* Ann Arbor, Mich.: UMI Research Press, 1984.

———. *The Cult of the Avant-Garde Artist.* New York: Cambridge University Press, 1993.

Langer, Cassandra. *Feminist Art Criticism: An Annotated Bibliography.* New York: G.K. Hall, 1993.

The Latin American Spirit: Art and Artists in the United States, 1920–1970. Essays by Luis R. Cancel et al. New York: Bronx Museum of the Arts in association with H.N. Abrams, 1988.

Levin, Kim. *Beyond Modernism: Essays on Art from the 70s and 80s.* New York: Harper & Row, 1988.

Lewis, M, T., ed. *Critical Readings in Impressionism and Post-Impressionism: An Anthology.* Berkeley, Calif.: University of California Press, 2007.

Lewis, Samella S. *African American Art and Artists.* Foreword by F. Coleman; new introd. by M. J. Hewitt. 3rd. ed., rev. and expanded. Berkeley, Calif.: University of California Press, 2003.

Liberman, Alexander. *The Artist in His Studio.* Rev. ed. New York: Random House, 1988.

Lippard, Lucy. *From the Center: Feminist Essays on Women's Art.* New York: Dutton, 1976.

Lucie-Smith, Edward. *ArtToday.* London: Phaidon, 1995

———. *Latin American Art of the 20th Century.* 2nd ed. *World or Art.* New York: Thames & Hudson, 2004.

Lynton, Norbert. *The Story of Modern Art.* 2nd ed. Oxford: Phaidon, 1989.

McCoubrey, John. *American Art, 1700–1960: Sources and Documents.* Englewood Cliffs, N.J.: Prentice Hall, 1965.

McShine, Kynaston. *An International Survey of Recent Painting and Sculpture.* New York: MOMA, 1984.

Meecham, Pam and Julie Sheldon. *Modern Art: A Critical Introduction.* 2nd ed. London; New York: Routledge, 2005.

Michalski, Sergiusz. *Public Monuments: Art in Political Bondage, 1870–1997.* London: Reaktion Books, 1998.

Miller, Angela L. et al. *American Encounters: Art, History and Cultural Identity*. Upper Saddle River, N.J.: Pearson Education, Inc., 2008.

Millon, Henry A., and Linda Nochlin, eds. *Art and Architecture in the Service of Politics*. Cambridge, Mass.: MIT Press, 1978.

Mitchell, W. J. T. *Picture Theory: Essays on Verbal and Visual Representation*. Chicago: University of Chicago Press, 1994.

———. *The Reconfigured Eye: Visual Truth in the Post-Photographic Era*. Cambridge, Mass.: MIT Press, 1992.

Nash, Steven A. *Arnason and Politics: A Commemorative Exhibition*. San Francisco: Fine Arts Museums, 1993.

Nelson, Robert, and Richard Shiff, eds. *Critical Terms for Art History*. 2nd ed. Chicago: University of Chicago Press, 2003.

Nochlin, Linda. *The Body in Pieces: The Fragment as a Metaphor of Modernity*. New York: Thames & Hudson, 1995.

———. *The Politics of Vision: Essays on Nineteenth-Century Art and Society*. New York: Harper & Row, 1989.

———. *Women, Art, and Power: and Other Essays*. New York: Harper & Row, 1988.

Norris, Christopher, and Andrew Benjamin. *What is Deconstruction?* 2nd ed. London: Academy Editions; Lanham, Md.: Distr. National Book Network, 1996.

Osborne, Harold, ed. *Oxford Companion to Twentieth-Century Art*. New York: Oxford University Press, 1981.

Papadakes, Andreas, et al., eds. *Deconstruction: The Omnibus Volume*. New York: Rizzoli, 1989.

Parker, Rozsika, and Griselda Pollock. *Old Mistresses: Women, Art, and Ideology*. New York: Pantheon, 1981.

Pevsner, Nikolas. *Academies of Art: Past and Present*. Reprint of the 1940 ed. New York: Da Capo Press, 1973.

Pincus-Witten, Robert. *Postminimalism into Maximalism: American Art, 1966–1986*. Ann Arbor, Mich.: UMI Research Press, 1987.

Podro, Michael. *The Critical Historians of Art*. New Haven, Conn.: Yale University Press, 1982.

Pohl, Frances K. *Framing America: A Social History of American Art*. 2nd ed, New York: Thames & Hudson, 2008.

Poggioli, Renato. *The Theory of the Avant-Garde*. Trans. G. Fitzgerald. Cambridge, Mass.: Belknap Press of Harvard University Press, 1968.

Pollock, Griselda. *Vision and Difference: Femininity, Feminism, and the Histories of Art*. With a new introd. London; New York: Routledge, 2003.

Powell, Richard. *Black Art: a Cultural History*. 2nd ed. London: Thames & Hudson, 2003.

———. *The Blues Aesthetic: Black Culture and Modernism*. Washington, D.C.: Washington Project for the Arts, 1989.

Preziosi, Donald. *Rethinking Art History: Meditations on a Coy Science*. New Haven, Conn.: Yale University Press, 1989.

———, ed. *The Art of Art History: A Critical Anthology*. Oxford; New York: Oxford University Press, 1998.

Prown, Jules, and Barbara Rose. *American Painting: From the Colonial Period to the Present*. New ed. New York: Rizzoli, 1977

———, et al. *Discovered Lands, Invented Pasts: Transforming Visions of the American West*. New Haven, Conn.: Yale University Press, 1992.

Rasmussen, Waldo, ed. *Latin American Artists of the Twentieth Century*. New York: MOMA, 1993.

Read, Herbert. *Art Now: An Introduction to the Theory of Modern Painting and Sculpture*. Rev. and enl. ed. London: Faber and Faber, 1960.

Rees, A. L., and Frances Borzello. *The New Art History*. London: Camden Press, 1986.

Risatti, Howard, ed. *Postmodern Perspectives; Issues in Contemporary Art*. 2nd ed. Upper Saddle River, N.J.: Prentice Hall, 1998.

Rodman, Selden. *Conversations with Artists*. New York: Capricorn Books, 1957.

Rose, Barbara. *American Art Since 1900*. Rev. ed. New York: Praeger, 1975.

———. *Readings in American Art Since 1900: A Documentary Survey*. New York: Praeger, 1968.

Rosen, Charles, and Henri Zerner. *Romanticism and Realism: The Mythology of Nineteenth-Century Art*. New York: Viking, 1984.

Rosen, Randy, and Catherine C. Brawer. *Making Their Mark: Women Artists Move Into the Mainstream, 1970–85*. New York: Abbeville Press, 1989.

Rosenberg, Harold. *The Tradition of the New*. New York: Horizon Press, 1959.

Rosenblum, Robert. *On Modern American Art: Selected Essays*. New York: H.N. Abrams, 1999.

Rubin, William, ed. *"Primitivism" in 20th-Century Art: Affinity of the Tribal and the Modern*. 2 vols. New York: MOMA, 1984.

Schapiro, Meyer. *Theory and Philosophy of Art: Style, Artist, and Society*. New York: G. Braziller, 1994.

Selz, Peter. *Art in Our Times: A Pictorial History 1890–1980*. New York: H.N. Abrams, 1981.

Shapiro, Theda. *Painters and Politics: The European Avant-Garde and Society: 1900–1925*. New York: Elsevier, 1976.

Sims, Lowery Stokes. *Challenge of the Modern: African-American Artists 1925–1945*. New York: SMH, 2003.

Smagula, Howard. *Currents: Contemporary Directions in the Visual Arts*. 2nd ed. Englewood Cliffs, N.J.: Prentice Hall, 1989.

Stangos, Nikos, ed. *Concepts of Modern Art: From Fauvism to Postmodernism*. 3rd ed. New York: Thames & Hudson, 1994.

Stich, Sidra. *Made in USA: An Americanization in Modern Art, the '50s and '60s*. Berkeley, Calif.: University of California Press, 1987.

Stiles, Kristine, and Peter Selz. *Theories and Documents of Contemporary Art: A Sourcebook of Artist's Writings*. Berkeley and Los Angeles, Calif.: University of California Press, 1996.

Storr, Robert. *Modern Art Despite Modernism*. New York: MOMA: Distr. H.N. Abrams, 2000.

Summers, David. *Real Spaces: World Art History and the Rise of Western Modernism*. London; New York: Phaidon, 2003.

Sylvester, David. *Interviews with American Artists*. New Haven, Conn.: Yale University Press, 2001.

Tagg, John. *Grounds of Dispute: Art History, Cultural Politics and the Discursive Field*. Minneapolis, Minn.: University of Minnesota Press, 1992.

Taylor, Joshua, ed. *Nineteenth-Century Theories of Art*. Berkeley, Calif.: University of California Press, 1991.

Tomkins, Calvin. *Post to Neo: The Art World of the 1980s*. New York: Holt, 1990.

Tuchman, Maurice. *The Spiritual in Art: Abstract Painting, 1890–1985*. New York: Abbeville Press, 1986.

Valéry, Paul. *Selected Writings*. New York: New Directions, 1964.

Varnedoe, Kirk, and Adam Gopnik. *High and Low: Modern Art and Popular Culture*. New York: MOMA, 1990.

———, eds. *Modern Art and Popular Culture: Readings in High and Low*. New York: H.N. Abrams, 1990. With essays by J.E. Bowlt, et al.

Wallis, Brian, ed. *Art After Modernism: Rethinking Representation*. Boston, Mass.: Godine, 1984.

———, ed. *Blasted Allegories: An Anthology of Writings by Contemporary Artists*. Cambridge, Mass.: MIT Press, 1987.

Walther, Ingo F., ed. *Art of the 20th Century*. 2 vols in 1. New York: Taschen, 2000.

Weiss, Jeffrey S. *The Popular Culture of Modern Art: Picasso, Duchamp, and Avant-Gardism*. New Haven, Conn.: Yale University Press, 1994.

Wheeler, Daniel. *Art Since Mid-Century: 1945 to the Present*. Englewood Cliffs, N.J.: Prentice Hall, 1991.

Whiting, Cécile. *Antifascism in American Art*. New Haven, Conn.: Yale University Press, 1989.

Wilkins, David G., Bernard Schultz, and Katheryn M. Linduff. *Art Past/Art Present*. 5th ed. Upper Saddle River, N.J.: Pearson Prentice Hall, 2005.

Wilmerding, John. *American Art*. Pelican History of Art. Harmondsworth: Penguin, 1976.

_____. *American Views: Essays on American Art*. Princeton, N.J.: Princeton Univeristy Press, 1991.

Witzling, Mara, ed. *Voicing Our Visions: Writings by Women Artists*. New York: Universe Books, 1991.

Wollheim, Richard. *Art and Its Objects*. With six suppl. essays. 2nd ed. Cambridge, England; New York: Cambridge University Press, 1992, 1980.

———. *Painting as an Art*. Princeton, N.J.: Princeton University Press, 1987.

Wood, Paul, et al. *Modernism in Dispute: Art Since the Forties*. New Haven, Conn.: Yale University Press, 1993.

Word as Image: *American Art, 1960–1990*. Milwaukee, Wis.: Milwaukee Art Museum, 1990.

Zegher, Catherine de, ed. *Inside the Visible: An Elliptical Traverse of 20th Century Art in of and From the Feminine*. Cambridge, Mass.: MIT Press, 1996.

B. Dictionaries and Encyclopedias

Benezit, Emmanuel. *Dictionary of Artists*. 14 vols. Paris: Gründ, 2006.

Chilvers, Ian, ed. *The Concise Oxford Dictionary of Art and Artists*. 3rd ed. Oxford, England; New York: Oxford University Press, 2003. Also available as an electronic database by subscription.

———. *A Dictionary of Twentieth-Century Art*. Oxford, England; New York: Oxford University Press, 1998. Also available as an electronic database by subscription.

Cummings, Paul. *Dictionary of Contemporary American Artists*. 6th ed. New York: St. Martin's Press, 1994.

Curl, James Stevens. *A Dictionary of Architecture and Landscape Architecture*. 2nd ed. Oxford, England; New York: Oxford University Press, 2006.

Dunford, Penny. *Biographical Dictionary of Women Artists in Europe and America Since 1850*. Philadelphia: University of Pennsylvania Press, 1990.

Encyclopedia of World Art. 17 vols. New York: McGraw-Hill, 1959–87.

Fleming, John. *The Penguin Dictionary of Architecture*. 4th ed. London; New York: Penguin Books, 1991.

Govignon, Brigitte. *The Abrams Encyclopedia of Photography*. New York: H.N. Abrams, 2004.

Hannavy, John, ed. *Encyclopedia of Nineteenth-Century Photography*. New York: Routledge, Taylor & Francis Group, 2007.

Heller, Jules, and Nancy Heller. *North American Women Artists of the Twentieth Century: A Biographical Dictionary*. New York: Garland, 1995.

Huyghe, Rene, ed. *Larousse Encyclopedia of Modern Art from 1800 to the Present Day*. Updated ed. New York: Excalibur, 1981.

Jervis, Simon. *The Penguin Dictionary of Design and Designers*. London: A. Lane, 1984.

Jones, Lois Swan. *Art Information and the Internet: How to Find It, How to Use It*. Chicago; London: Fitzroy Dearborn, 1999.

———. *Art Information: Research Methods and Resources*. 3rd ed. Dubuque, Iowa: Kendall/Hunt, 1990.

Julier, Guy. *The Thames & Hudson Dictionary of Design Since 1900*. 2nd ed. London; New York: Thames & Hudson, 2005.

Kort, Carol and Liz Sonneborn. *A to Z of American Women in the Visual Arts*. New York: Facts on File, 2002.

Lucie-Smith, Edward. *Lives of the Great Twentieth-Century Artists*. New York: Thames & Hudson, 1999.

Maillard, Robert, ed. *New Dictionary of Modern Sculpture*. New York: Tudor, 1970.

Marks, Claude, ed. *World Artists 1980–1990*. New York: H.W. Wilson, 1991.

Morgan, Ann Lee. *The Oxford Dictionary of American Art and Artists*. Oxford, England; New York: Oxford University Press, 2007. Also available as an electronic database by subscription.

Naylor, Colin, ed. *Contemporary Artists*. 3rd ed. Chicago: St. James, 1989.

Norman, Geraldine. *Nineteenth-Century Painters and Painting: A Dictionary*. Berkeley, Calif.: University of California Press, 1977.

Osborne, Harold. *The Oxford Companion to Twentieth-Century Art*. Oxford, England: Oxford University Press, 1981.

Pehnt, Wolfgang, ed. *Encyclopedia of Modern Architecture*. New York: H.N. Abrams, 1964.

Phaidon Dictionary of Twentieth-Century Art. Oxford, England: Phaidon, 1973.

The Prestel Dictionary of Art and Artists in the 20th Century. Munich, Germany; New York: Prestel, 2000.

Sennott, R. Stephen. ed. *Encyclopedia of 20th Century Architecture*. 3 vols. New York: Fitzroy Dearborn, 2004.

Spalding, Frances. *20th Century Painters and Sculptors*. Woodbridge, England: Antique Collector's Club, 1990.

Turner, Jane, ed. *The Dictionary of Art*. New York: Grove's Dictionaries, 1996. Also available as an electronic database by subscription.

Walker, John. *Glossary of Art, Architecture and Design Since 1945*. 3rd ed. Boston: G.K. Hall, 1992.

Warren, Lynne. *Encyclopedia of Twentieth-Century Photography*. New York: Routledge, 2006.

Woodham, Jonathan M. *A Dictionary of Modern Design*. Oxford, England; New York: Oxford University Press, 2004.

C. Architecture, Engineering, and Design

Arnheim, Rudolph. *The Dynamics of Architectural Form*. Berkeley and Los Angeles, Calif.: University of California Press, 1977.

Banham, R. *The New Brutalism: Ethic or Aesthetic?* London: Architectural Press, 1966.

———. *Theory and Design in the First Machine Age*. 2nd ed. New York: Praeger, 1960.

Behrendt, Walter. *Modern Building: Its Nature, Problems and Forms*. London: M. Kopkins, 1936.

Benevelo, Leonardo. *History of Modern Architecture*. 2 vols. Trans. H.J. Landry. Cambridge, Mass.: MIT Press, 1971.

Benton, Charlotte, et al. *Art Deco 1910–1939*. New York: Bulfinch Press, 2003.

Blake, Peter. *The Master Builders: Le Corbusier, Mies van der Rohe, Frank Lloyd Wright*. New York: Norton, 1976.

———. *No Place Like Utopia: Modern Architecture and the Company We Kept*. New York: Knopf, 1993.

Bouillon, Jean Paul. *Art Deco, 1903–1940*. New York: Rizzoli, 1989.

Brooks, H. Allen. *The Prairie School: Frank Lloyd Wright and His Mid-West Contemporaries*. Toronto: University of Toronto Press, 1972.

Coleman, Nathaniel. *Utopias and Architecture*. New York: Routledge, 2005.

Collins, Michael, and Andreas Papadakis. *Post-Modern Design*. New York: Rizzoli, 1989.

Conrads, Ulrich, and Hans Sperlich. *The Architecture of Fantasy*. New York: Praeger, 1962.

Conway, Patricia. *Art for Everyday: The New Craft Movement*. New York: Clarkson Potter Publishers, 1990.

Crook, J. Mordant. *The Dilemma of Style: Architectural Ideas from the Picturesque to the Post Modern*. Chicago: University of Chicago Press, 1987.

Curtis, William. *Modern Architecture Since 1900*. 3rd ed. Upper Saddle River, N.J.: Prentice Hall, 1996.

Dal Co, Francesco. *Figures of Architecture and Thought: German Architectural Culture, 1890–1920*. New York: Rizzoli, 1986.

———. *Transformations in Modern Architecture*. Greenwich, Conn.: New York Graphic Society, 1980.

Dean, Andrea Oppenheimer, ed. *Bruno Zevi on Modern Architecture*. New York: Rizzoli, 1983.

Dormer, Peter. *Design Since 1945*. World of Art. New York: Thames & Hudson, 1993.

Drexler, Arthur. *Transformations in Modern Architecture*. New York: MOMA, 1979.

Eldredge, H. W., ed. *Taming Megalopolis*. 2 vols. New York: Praeger, 1967.

Fitch, James. *American Building: The Historical Forces That Shaped It*. 2nd ed. Boston: Houghton Mifflin, 1966–72.

Frampton, Kenneth. *Modern Architecture: A Critical History*. World of Art. 4th ed. London; New York: Thames & Hudson, 2007.

Giedion, Sigfried. *Space, Time, and Architecture: The Growth of a New Tradition*. 5th ed., rev. and enl. Cambridge, Mass.: Harvard University Press, 1967.

Gössel, Peter. *Architecture in the Twentieth Century*. Köln, Germany; London: Taschen, 2001.

Heyer, Paul. *Architects on Architecture*. New York: Van Nostrand Reinhold, 1993.

Hitchcock, Henry-Russell. *Architecture: Nineteenth and Twentieth Centuries*. 4th ed., rev. Yale Univesity Press Pelican History of Art. Harmondsworth: Penguin, 1987, 1977.

Jencks, Charles. *Modern Movements in Architecture*. 2nd. ed. New York: Penguin, 1985.

Sources and Directions. Trans. J.C. Palmes. New York: Praeger, 1969.

Johnson, Philip. *Deconstructionist Architecture*. New York: MOMA, 1988.

Kostof, Spiro. *History of Architecture: Settings and Rituals*. 2nd ed. New York: Oxford University Press, 1995.

Kultermann, Udo. *Architecture in the Twentieth Century*. New York: Van Nostrand Reinhold, 1993.

Lampugnani, Vittorio. *Encyclopedia of Twentieth-Century Architecture*. New York: H.N. Abrams, 1986.

Leach, Neil. *Rethinking Architecture: A Reader in Cultural Theory*. New York: Routledge, 1996.

Le Corbusier (Charles-Édouard Jeanneret). *Toward an Architecture*. Introd. by J.-L. Cohen; trans. by J. Goodman. Los Angeles, Calif.: Getty Research Institute, 2007.

Lemaire, Sylvie, ed. *Looking at European Architecture: A Critical View*. Brussels: CIVA, 2008.

Lesnikowski, Wojciech G. *The New French Architecture*. New York: Rizzoli, 1990.

Loyer, François. *Architecture of the Industrial Age*. New York: Skira, 1983.

Maddex, Diane, ed. *Master Builders: A Guide to Famous American Architects*. Washington, D.C.: Preservation Press, 1985.

Manhart, Marcia, and Tom Manhart, eds. *The Eloquent Object: The Evolution of American Art in Craft Media Since 1945*. Tulsa, Okla.: Philbrook Museum of Art, 1987.

Meeks, Carol. *The Railroad Station: An Architectural History*. New Haven, Conn.: Yale University Press, 1995.

Middleton, Robin and David Watkin. *Neoclassical and 19th-Century Architecture*. 2 vols. *History of World Architecture*. New York: Electa/Rizzoli, 1987.

Mignot, Claude. *Architecture of the Nineteenth Century in Europe*. New York: Rizzoli, 1984.

Mumford, Lewis. *The Culture of Cities*. Reprint of the 1940 ed. London: Routledge/Thoemmes, 1997.

———. *Technics and Civilization*. New York: Routledge, 1934.

Nelson, George. *Building a New Europe: Portraits of Modern Architects: Essays by George Nelson, 1935–1936*. New Haven, Conn.: Yale University Press, 2007.

Ockman, Joan, ed. *Architecture Culture, 1943–1968: A Documentary Anthology*. New York: Rizzoli, 1993.

Pehnt, Wolfgang. *Expressionist Architecture*. London: Thames & Hudson, 1973.

Peter, John. *The Oral History of Modern Architecture: Interviews With the Greatest Architects of the Twentieth Century*. New York: H.N. Abrams, 1994.

Pevsner, Nikolaus. *Pioneers of Modern Design: From William Morris to Walter Gropius*. 4th ed. New Haven, Conn.; London: Yale University Press, 2005.

———. *The Sources of Modern Architecture and Design*. World of Art. New York: Thames & Hudson, 1985, 1968.

Pierson, William, and William H. Jordy. *American Buildings and Their Architects*. 4 vols. New York: Oxford University Press, 1986.

Pommer, Richard, ed. "Revising Modernist History: The Architecture of the 1920s and 1930s." *Art Journal* (Summer 1983) special issue.

Read, Herbert. *Art and Industry*. 5th ed. London: Faber, 1966.

Richards, J. M., ed. *The Anti-Rationalists and the Rationalists*. Oxford, England; Boston: Architectural Press, 2000.

Riesebero, Bill. *Modern Architecture and Design: An Alternative History*. Cambridge, Mass.: MIT Press, 1983.

———. *The Story of Western Architecture*. 3rd ed. Cambridge, Mass.: MIT Press, 2001.

Roth, Leland. *American Architecture: A History*. Boulder, Colo.: Westview Press, 2001.

———. *Understanding Architecture: Its Elements, History and Meaning*. New York: Harper & Row, 1993.

Rudofsky, Bernard. *Architecture Without Architects: An Introduction to Non-Pedigreed Architecture*. New York: MOMA, 1964.

Schafter, Debra, *The Order of Ornament, the Structure of Style: Theoretical Foundations of Modern Art and Architecture*. Cambridge, England; New York: Cambridge University Press, 2003.

Schuyler, Montgomery. *American Architecture and Other Writings*. Cambridge, Mass.: Belknap Press of Harvard University Press, 1964.

Scully, Vincent. *American Architecture and Urbanism*. Rev. ed. New York: H. Holy, 1988.

———. *Modern Architecture and Other Essays*. Princeton, N.J.: Princeton University Press, 2003.

———. *Modern Architecture: The Architecture of Democracy*. Rev. ed. New York: G. Braziller, 1974.

Sharp, Dennis. *Modern Architecture and Expressionism*. New York: G. Braziller, 1966.

———, ed. *Twentieth-Century Architecture: A Visual History*. Millennial ed. Mulgrave, Victoria, Australia: Images Publishing, 2002.

Silver, Nathan. *Lost New York*. Exp. and updated ed. Boston: Houghton Mifflin, 2000.

Smith, G. E. Kidder. *The New Architecture of Europe*. Cleveland and New York: World Pub. Co., 1961.

Steele, James. *Architecture Today*. London: Phaidon, 1997.

Tafuri, Manfredo. *Contemporary Architecture*. New York: H.N. Abrams, 1977.

———. *Modern Architecture*. 2 vols. *History of World Architecture*. New York: Electa/Rizzoli, 1986.

Thackara, John, ed. *Design After Modernism: Beyond the Object*. New York: Thames & Hudson, 1988.

Trachtenberg, Marvin, and Isabelle Hyman. *Architecture: From Pre-history to Post-Modernity*. 2nd ed. New York: H.N. Abrams, 2002.

Troy, Nancy. *Modernism and the Decorative Arts in France: Art Nouveau to Le Corbusier*. New Haven, Conn.: Yale University Press, 1991.

Tunnard, Christopher. *City of Man*. 2nd ed. New York: Scribner, 1970.

———, and Boris Pushkarev. *Man-Made America: Chaos or Control?* New Haven, Conn.: Yale University Press, 1963.

Vidler, Anthony. *The Architectural Uncanny: Essays in the Modern Unhomely*. Cambridge, Mass.: MIT Press, 1992.

———. *Histories of the Immediate Present: Inventing Architectural Modernism*. Cambridge, Mass.: MIT Press, 2008.

D. Photography, Prints, and Drawing

Adams, Clinton. *American Lithographs, 1900–1960: The Artists and Their Prints*. Albuquerque, N.Mex.: University of New Mexico Press, 1983.

Adams, Robert. *Beauty in Photography: Essays in Defense of Traditional Values*. 2nd ed. New York: Aperture, 1989.

Ades, Dawn. *Photomontage*. World of Art. Rev. and enl. ed. London: Thames & Hudson, 1986.

Badger, Gerry. *Collecting Photography*. London: Mitchell Beazley, 2003.

Barthes, Roland. *Camera Lucida, Reflections on Photography*. Trans. R. Howard. London: Vintage, 1993, 1981.

Benjamin, Walter. *The Work of Art in the Age of Its Technological Reproducibility, and Other Writings on Media*. Ed. M.W. Jennings, et al. Trans. E. Jephcott, et al. Cambridge, Mass.: Belknap Press of Harvard University Press, 2008.

Bolton, Richard, ed. *The Contest of Meaning: Critical Histories of Photography.* Cambridge, Mass.: MIT Press, 1989.

Braive, Michel. *The Photograph: A Social History.* New York: McGraw-Hill, 1966.

Bretell, Richard, et al. *Paper and Light: The Calotype in Great Britain and France 1839–1870.* Boston: D.R. Godine, 1984.

Buerger, Janet E. *The Era of the French Calotype.* Rochester, N.Y.: International Museum of Photography at George Eastman House, 1982.

———. *French Daguerreotypes.* Chicago: University of Chicago Press, 1989.

Bunnell, Peter C. *Inside the Photograph: Writings on Twentieth-Century Photography.* New York: Aperture Foundation; Distr. D.A.P., 2006

———, ed. *A Photographic Vision: Pictorial Photography, 1889–1923.* Salt Lake City: Peregrine Smith, 1980.

Burgin, Victor. *Thinking Photography.* London: MacMillan, 1990.

Campany, David, ed. *Art and Photography. Themes and Movements.* London: Phaidon, 2003.

Castleman, Riva. *Modern Art in Prints.* New York: MOMA, 1973.

———. *Modern Artists as Illustrators.* New York: MOMA, 1981.

———. *Prints from Blocks: From Gauguin to Now.* New York: MOMA, 1983.

———. *Prints of the Twentieth Century.* London: Thames & Hudson, 1988.

Clarke, Graham. *The Photograph.* Oxford, England; New York: Oxford University Press, 1997.

Coe, Brian. *Colour Photography: The First Hundred Years, 1840–1940.* London: Ash & Grant, 1978.

———, and Paul Gates. *The Snapshot Photograph.* London: Ash & Grant, 1977.

Coke, Van Deren. *The Painter and the Photograph: From Delacroix to Warhol.* Rev. ed. Albuquerque, N.Mex.: University of New Mexico Press, 1972.

———, ed. *One Hundred Years of Photographic History: Essays in Honor of Beaumont Newhall.* Albuquerque, N.Mex.: University of New Mexico Press, 1975.

Daval, Jean-Luc. *Photography: History of an Art.* New York: Rizzoli, 1982.

Davis, Keith F. *Hallmark Photographic Collection: An American Century of Photography: from Dry-plate to Digital: the Hallmark Photographic Collection.* 2nd ed., rev. and enl. Kansas City, Mo: Hallmark Cards in association with H.N. Abrams, 1999.

Doty, Robert, ed. *Photography in America.* New York: WMAA, 1974.

Edwards, Steve. *Photography: A Very Short Introduction.* Oxford, England; New York: Oxford University Press, 2006.

Evans, Martin Marix. *Contemporary Photographers.* 3rd ed. New York: St. James Press, 1995.

Fabian, Rainer, and Hans-Christian Adam. *Masters of Early Travel Photography.* New York: Vendome Press, 1983.

Fleischhauer, Carl, ed. *Documenting America, 1935–1943.* Berkeley, Calif.: University of California Press in association with the Library of Congress, 1988.

Freund, Gisele. *Photography & Society.* Boston: D.R. Godine, 1980.

Frizot, Michel. *A New History of Photography.* Köln, Germany: Könemann, 1998.

Galassi, Peter. *American Photography, 1890–1965, from the Museum of Modern Art, New York.* New York: MOMA: Distr. H.N. Abrams, 1995.

Galassi, Peter. *Before Photography: Painting and the Invention of Photography.* New York: MOMA, 1981.

Gernsheim, Helmut, *The History of Photography: From the Camera Obscura to the Beginning of the Modern Era.* 2 vols. 3rd rev. ed. London; New York: Thames & Hudson, 1982–88.

Gidal, Tim N. *Modern Photojournalism: Origin and Evolution: 1910–1933.* New York: Collier, 1972.

Gilmour, Pat, ed. *Lasting Impressions: Lithography as Art.* London: Alexandria Press, 1988.

Goldberg, Vicki, ed. *Photography in Print: Writings from 1816 to the Present.* New York: Simon and Schuster, 1981.

Golden, Reuel, comp. *Photojournalism, 1855 to the Present: Editor's Choice.* New York: Abbeville Press, 2006.

Goldschmidt, Lucien. *The Truthful Lens: A Survey of the Photographically Illustrated Book, 1844–1914.* New York: Grolier Club, 1980.

Gover, C. Jane. *The Positive Image: Women Photographers in Turn of the Century America.* Albany, N.Y.: SUNY Press, 1988.

Green, Jonathan, ed. *American Photography: A Critical History, 1945 to the Present.* New York: H.N. Abrams, 1984.

———. *Camera Work: A Critical Anthology.* Millerton, N.Y.: Aperture, 1973.

———, ed. *The Snapshot.* Millerton, N.Y.: Aperture, 1974.

Greenough, Sarah, et al. *On the Art of Fixing a Shadow: One Hundred and Fifty Years of Photography.* Chicago: Art Institute of Chicago, 1989.

Grundberg, Andy. *Crisis of the Real: Writings on Photography Since 1974.* 2nd ed. New York: Aperture, 1999.

———. *Photography and Art: Interactions Since 1946.* New York: Abbeville Press, 1987.

Hambourg, Maria Morris, et al. *The Waking Dream: Photography's First Century.* New York: MMA, 1993.

Harker, Margaret. *The Linked Ring: The Secession Movement in Photography in Britain, 1892–1910.* London: Heinemann, 1979.

Harnsberger, R. Scott. *Four Artists of the Stieglitz Circle: A Sourcebook on Arthur Dove, Marsden Hartley, John Marin, and Max Weber.* Westport, Conn.: Greenwood Press, 2002.

Hartmann, Sadakichi. *The Valiant Knights of Daguerre: Selected Critical Essays on Photography and Profiles of Photographic Pioneers.* Ed. H. W. Lawton and G. Knox. Berkeley, Calif.: University of California Press, 1978.

Harrison, Martin, *Appearances: Fashion Photography Since 1945.* London: J. Cape, 1991.

Hobgen, Carol, and Rowan Watson, eds. *From Manet to Hockney: Modern Artists' Illustrated Books.* London: Victoria and Albert Museum, 1985.

Homer, William I. *Alfred Stieglitz and the American Avant-Garde.* Boston: New York Graphic Society, 1977.

———. *Stieglitz and the Photo-Secession, 1902.* Ed. by C. Johnson. New York: Viking Studio, 2002.

Ives, Colta. *The Painterly Print.* New York: MMA, 1980.

Jammes, André, and Eugenia Janis. *The Art of French Calotype.* Princeton, N.J.: Princeton University Press, 1983.

Jeffrey, Ian. *Photography: A Concise History.* London: Thames & Hudson, 1981.

Johnson, William. *Nineteenth-Century Photography: An Annotated Bibliography, 1839–1879.* Boston: G.K. Hall, 1990.

Koetzle, Hans-Michael. *Photo Icons: The Story Behind the Pictures.* 2 vols. Köln, Germany; New York: Taschen, 2002.

Kozloff, Max. *Photography and Fascination: Essays.* Danbury, N.H.: Addison House, 1979.

———. *The Privileged Eye: Essays on Photography.* Albuquerque, N.Mex.: University of New Mexico Press, 1987.

———. *The Theatre of the Face: Portrait Photography Since 1900.* London; New York: Phaidon, 2007.

Lavin, Maud, et al. *Montage and Modern Life, 1919–1942.* Cambridge, Mass. and Boston: MIT Press and Institute of Contemporary Art, 1992.

Lenman, Robin, ed. *The Oxford Companion to the Photograph.* Oxford; New York: Oxford University Press, 2005.

Lewinski, Jorge. *The Camera at War.* London: W. H. Allen, 1978.

Maddow, Ben. *Faces: A Narrative History of the Portrait in Photography.* Boston: New York Graphic Society, 1977.

Marien, Mary Warner. *Photography: A Cultural History.* 2nd ed. Upper Saddle River, N.J.: Pearson Prentice Hall, 2006.

Mayor, A. Hyatt. *Prints and People: A Social History of Printed Pictures.* Rev. and updated. Princeton, N.J.: Princeton University Press, 1980, 1971.

Mellor, David, ed. *Germany: The New Photography, 1927–33.* London: Arts Council of Great Britain, 1978.

Naef, Weston. *Fifty Pioneers of Modern Photography: The Collection of Alfred Stieglitz.* New York: MMA, 1978.

———, and James N. Wood. *Era of Exploration: The Rise of Landscape Photography in the American West: 1860–1885.* Buffalo, N.Y.: Albright-Knox Gallery of Art, 1975.

Newhall, Beaumont. *The History of Photography from 1839 to the Present.* Completely rev. and enl. 5th ed. New York: MOMA; Boston: Distr. Bulfinch Press/Little, Brown and Company, 1999.

———, ed. *Photography: Essays and Images.* New York: MOMA, 1980.

Orvell, Miles. *American Photography.* Oxford, England; New York: Oxford University Press, 2003.

Osborne, Peter D. *Travelling Light: Photography, Travel and Visual Culture.* Manchester, England; New York: Manchester University Press; Distr. in the U.S. by St. Martin's Press, 2000.

Petruck, Peninah, ed. *The Camera Viewed: Writings on Twentieth-Century Photography.* 2 vols. New York: Dutton, 1979.

Phillips, Christopher, ed. *Photography in the Modern Era: European Documents and Critical Writings, 1913–1940.* New York: MMA, 1989.

Pyne, Kathleen A. *Modernism and the Feminine Voice: O'Keeffe and the Women of the Stieglitz Circle.* Berkeley, Calif.: University of California Press, 2007.

Roberts, Pam. *A Century of Colour Photography: From the Autochrome to the Digital Age.* London: Andre Deutsch, 2007.

Rose, Bernice. *Allegories of Modernism: Contemporary Drawing.* New York: MOMA, 1992.

Rosenblum, Naomi. *A World History of Photography.* 4th ed. New York: Abbeville Press, 2007.

Rotzler, Willy. *Photography as Artistic Experiment: From Fox Talbot to Moholy-Nagy.* Garden City, N.J.: Amphoto, 1976.

Sandler, Martin W. *Against the Odds: Women Pioneers in the First Hundred Years of Photography.* New York: Rizzoli, 2002.

Scharf, Aaron. *Art and Photography.* Harmondsworth and Baltimore: Penguin, 1974.

———. *Pioneers of Photography.* New York: H.N. Abrams, 1976.

Sobieszek, Robert A. *The Art of Persuasion: A History of Advertising Photography.* New York: H.N. Abrams, 1988.

Solomon-Godeau, Abigail. *Photography at the Dock.* Minneapolis, Minn.: University of Minnesota Press, 1991.

Sontag, Susan. *On Photography.* New York: Farrar, Straus and Giroux, 1973.

Stieglitz, Alfred. *Stieglitz on Photography: His Selected Essays and Notes.* Comp.and annotated by Richard Whelan. New York: Aperture, 2000.

———, ed. *Camera Work: A Photographic Quarterly.* Reprint. New York: A. Stieglitz, 1969.

Stott, William. *Documentary Expression and Thirties America.* Reprint. Chicago: University of Chicago Press, 1986.

Stryker, Roy, and Nancy Wood. *In This Proud Land: America 1935–1943 as Seen in FSA Photographs.* Greenwich, Conn.: New York Graphic Society, 1973.

Szarkowski, John. *Looking at Photographs.* New York: MOMA and New York Graphic Society, 1973.

———. *The Photographer's Eye.* New York: MOMA and Doubleday, 1977.

———. *Photography Until Now.* New York: MOMA, 1989.

Tagg, John. *The Burden of Representation: Essays on Photographies and Histories.* Amherst, Mass.: University of Massachusetts Press, 1988.

Tallman, Susan. *The Contemporary Print: From Pre-Pop to Postmodern.* London: Thames & Hudson, 1996.

Trachtenberg, Allan, ed. *Classic Essays on Photography.* New Haven, Conn.: Leeter's Island Books, 1980.

———. *Reading American Photographs: Images as History: Mathew Brady to Walker Evans.* New York: Hill and Wang, 1989.

Tsujimoto, Karen. *Images of America: Precisionist Painting and Modern Photography*. San Francisco: SFMOMA, 1982.

Waldman, Diane. *Twentieth-Century American Drawing: Three Avant-Garde Generations*. New York: SRGM, 1976.

Watrous, James. *American Printmaking: A Century of American Printmaking, 1880–1980*. Madison, Wis.: University of Wisconsin Press, 1984.

Weaver, Mike, ed. *The Art of Photography, 1839–1989*. New Haven, Conn.: Yale University Press, 1989.

Wells, Liz, ed. *Photography: A Critical Introduction*. 3rd ed. New York: Routledge, 2004.

E. Painting and Sculpture

[Albers, Arp, Bærtling, Herbin, Liberman, Lohse, Mortensen, Taeuber-Arp, Vasarely] *Hard Edge*. Paris: Galerie Denise René, 1964.

Alloway, Lawrence. *Topics in American Art Since 1945*. New York: Norton, 1975.

Andersen, Wayne. *American Sculpture in Process: 1930–1970*. Boston: New York Graphic Society, 1975.

Arnason, H. H. *Modern Sculpture from the Joseph H. Hirshhorn Collection*. New York: SRGM, 1962.

Art of Our Time: The Saatchi Collection. London and New York: Lund Humphries and Rizzoli, 1984.

Ashton, Dore. *American Art Since 1945*. New York: Oxford University Press, 1982.

Auping, Michael, ed. *Abstraction, Geometry, Painting*. New York: H.N. Abrams, 1989.

Barr, Jr., Alfred H., ed. *Painting and Sculpture in the Museum of Modern Art: 1929–1967*. New York: MOMA, 1977.

Barron, Stephanie and Sabine Eckmann. *Exiles + Emigrés: The Flight of European Artists from Hitler*. With contributions by Matthew Affron, et al. Los Angeles: LOCMA; New York: Abrams, 1997.

Beardsley, John, and Jane Livingston. *Hispanic Art in the United States: Thirty Contemporary Painters*. Houston and New York: Museum of Fine Arts and Abbeville Press, 1987.

Beattie, Susan. *The New Sculpture*. New Haven: Pub. for the Paul Mellon Centre for Studies in British Art by Yale University Press, 1983.

Braun, Emily, ed. *Italian Art in the 20th Century: Painting and Sculpture, 1900–1988*. Munich: Prestel, 1989.

Clement, Russell T. *A Sourcebook of Gauguin's Symbolist Followers: Les Nabis, Pont-Aven, Rose + Croix*. Westport, CT: Praeger, 2004.

Collins, Judith. *Sculpture Today*. London; New York: Phaidon, 2007.

Eitner, Lorenz. *An Outline of Nineteenth Century European Painting: From David to Cézanne*. Rev. ed. Boulder, Colo.: Westview Press, 2002.

Elsen, Albert. *Modern European Sculpture, 1918–1945: Unknown Beings and Other Realities*. New York: G. Braziller, 1979.

Farr, Dennis. *English Art: 1870–1940*. Oxford, England: Clarendon Press, 1978.

Fink, Lois Marie, and Joshua C. Taylor. *Academy: The Academic Tradition in American Art*. Chicago: University of Chicago Press, 1978.

Garlake, Margaret. *New Art, New World: British Art in Postwar Society*. New Haven, Conn.: Pub. for Paul Mellon Centre for Studies in British Art by Yale University Press, 1998.

Haftmann, Werner. *Painting in the Twentieth Century*. 2 vols. Rev. ed. New York: Praeger, 1979.

Hamilton, George H. *Painting and Sculpture in Europe, 1880–1940*. 6th ed. with a revised bibliography by R. Cork. New Haven, Conn.: Yale University Press, 1993.

Hammacher, A. M. *Modern Sculpture: Tradition and Innovation*. Enl. ed. New York: H.N. Abrams, 1988.

Hughes, Robert. *Shock of the New*. 2nd ed. New York: McGraw-Hill, 1991.

Hunter, Sam and John Jacobus. *Modern Art: Painting, Sculpture, Architecture*. 2nd ed. Englewood Cliffs, N.J.: Prentice Hall, 1985.

Ito, Norihiro, et al., eds. *Art in Japan Today II, 1970–1983*. Tokyo: Japan Foundation, 1984.

Janson, H. W. *Nineteenth-Century Sculpture*. New York: H.N. Abrams, 1985.

Joachimides, Christos, et al., eds. *German Art in the Twentieth Century: Painting and Sculpture, 1905–1985*. London: Royal Academy of Arts, 1985.

Johnson, Ellen, ed. *American Artists on Art from 1940 to 1980*. New York: Harper & Row, 1982.

Krens, Thomas. *Refigured Painting: The German Image, 1960–1988*. New York: SRGM, 1988.

Lane, John, and Susan Larsen, eds. *Abstract Painting and Sculpture in America: 1927–1944*. Pittsburgh: Museum of Art, Carnegie Institute, 1983.

Le Normand-Romain, Antoinette, et al. *Sculpture: The Adventure of Modern Sculpture in the Nineteenth and Twentieth Centuries*. New York: Rizzoli, 1986.

Lieberman, William S. *Painters in Paris, 1895–1950*. New York: MMA: Distr. H.N. Abrams, 2000.

———, ed. *Modern Masters: Manet to Matisse*. New York: MOMA, 1975.

Lucie-Smith, Edward. *Movements in Art Since 1945; Issues and Concepts*. World of Art. 3rd rev. and exp. ed. New York: Thames & Hudson, 1995.

Lynton, Norbert. *The Story of Modern Art*. 2nd ed. Oxford, England: Phaidon, 1989.

Meisel, Louis K. *Photorealism at the Millennium*. New York: H.N. Abrams, 2002.

Merewether, Charles, ed. *Art, Anti-art, Non-art: Experimentations in the Public Sphere in Postwar Japan, 1950–1970*. Los Angeles: Getty Research Institute, 2007.

Miller, Dorothy C., and William S. Lieberman. *The New Japanese Painting and Sculpture*. New York: MOMA, 1966.

Modern Sculpture Reader. Ed. Jon Wood, et al. Leeds, England: Henry Moore Institute, 2007.

Nairne, Sandy, and Nicholas Serota. *British Sculpture in the Twentieth Century*. London: Whitechapel Art Gallery, 1981.

Novak, Barbara. *American Painting in the Nineteenth Century: Realism, Idealism, and the American Experience*. 3rd ed. Oxford, England; New York: Oxford University Press, 2007.

———. *Nature and Culture: American Landscape and Painting, 1825–1875*. 3rd ed., with a new preface. New York: Oxford University Press, 2007.

Novotny, Fritz. *Painting and Sculpture in Europe, 1780 to 1880*. 2nd ed. New Haven, Conn.: Yale University Press, 1971.

Painting and Sculpture in the Museum of Modern Art: Catalog of the Collection: With Selected Works on Paper to January 1988. Ed. by Alicia Legg with Mary Beth Smalley. New York: The Museum, 1989, 1988.

Penny, Nicholas. *The Materials of Sculpture*. New Haven, Conn.: Yale University Press, 1993.

Potts, Alex. *The Sculptural Imagination: Figurative, Modernist, Minimalist*. New Haven, Conn.: Yale University Press, 2000.

Reynolds, Donald M. *Masters of American Sculpture: the Figurative Tradition from the American Renaissance to the Millennium*. New York: Abbeville Press, 1993.

The Rise of Modern Japanese Art. Greenwich, CT: Shorewood Fine Art Books, 1999.

Rosenblum, Robert. *Modern Painting and the Northern Romantic Tradition: Friedrich to Rothko*. New York: Harper & Row, 1975.

———, and H. W. Janson. *Nineteenth-Century Art*. Rev. and updated ed. Upper Saddle River, N.J.: Pearson Prentice Hall, 2005.

Russell, John. *The Meanings of Modern Art*. Rev. ed. New York: MOMA and HarperCollins, 1991.

Schapiro, Meyer. *Modern Art: 19th and 20th Centuries: Selected Papers*. New York: G. Braziller, 1978.

Selz, Jean. *Modern Sculpture: Origins and Evolution*. Trans. Annette Michelson. New York: G. Braziller, 1963.

Selz, Peter. *Art in Our Times: A Pictorial History, 1890–1980*. New York: H.N. Abrams, 1981.

Shone, Richard. *The Art of Bloomsbury: Roger Fry, Vanessa Bell, and Duncan Grant*. London: Tate, 1999.

———. *The Century of Change: British Painting Since 1900*. Oxford, England: Phaidon, 1977.

Soby, James T., and Alfred H. Barr, Jr. *Twentieth-Century Italian Art*. New York: MOMA, 1949.

Spalding, Frances. *British Art Since 1900*. London: Thames & Hudson, 1986.

Steinberg, Leo. *Other Criteria: Confrontations with Twentieth-Century Art*. New York: Oxford University Press, 1972.

Swiss Made: Precision and Madness: Swiss Art from Hodler to Hirschhorn. Texts by Markus Brüderlin, et al. Ostfildern-Ruit, Germany: Hatje Cantz, 2007.

Tomkins, Calvin. *The Bride and the Bachelors: Five Masters of the Avant-Garde*. Exp. ed. Harmondsworth, England; New York: Penguin, 1976.

Tuchman, Maurice. *The Spiritual in Art: Abstract Painting 1890–1985*. Los Angeles: LACMA, 1986.

Tucker, William. *The Language of Sculpture*. Reprint of the 1974 ed. New York: Thames & Hudson, 1985.

Varnedoe, Kirk. *Northern Light: Realism and Symbolism in Scandinavian Painting 1880–1910*. New York: Brooklyn Museum, 1982.

Waldman, Diane. *Collage, Assemblage, and the Found Object*. New York: H.N. Abrams, 1992.

———. *Transformations in Sculpture: Four Decades of American and European Art*. New York: Solomon R. Guggenheim Foundation, 1985.

Watson-Jones, Virginia. *Contemporary American Women Sculptors*. Phoenix, Ariz: Oryx, 1986.

Yamaguchi, Yumi. *Warriors of Art: A Guide to Contemporary Japanese Artists*. Trans. Arthur Tanaka. Tokyo; New York: Kodansha International, 2007.

II. Further Readings, Arranged by Chapter

1. The Origins of Modern Art

Adams, Steven. *The Barbizon School and the Origins of Impressionism*. London: Phaidon, 1994.

Ashton, Dore. *Rosa Bonheur: A Life and a Legend*. New York: Viking, 1981.

Baudelaire, Charles. *Eugène Delacroix: His Life and Work*. Trans. J. Bernstein. New York: Lear Publishers, 1947.

Boime, Albert. *Art in an Age of Civil Struggle, 1848–1871. A Social History of Modern Art*; vol. 4. Chicago: University of Chicago Press, 2007.

———. *Art in an Age of Counterrevolution, 1815–1848. A Social History of Modern Art*; vol. 3. Chicago: University of Chicago Press, 2004.

Bordes, Philippe. *Jacques-Louis David: Empire to Exile*. New Haven, Conn.: Yale University Press, 2005.

Bowness, Alan. *Gustave Courbet: 1819–1877*. London: Arts Council of Great Britain, 1978.

Brettell, Richard R. *Modern Art, 1851–1929: Capitalism and Representation*. Oxford, England; New York: Oxford University Press, 1999.

Brookner, Anita. *Jacques-Louis David*. London: Oxford University Press, 1980.

Bryson, Norman. *Tradition and Desire: From David to Delacroix*. Cambridge and New York: Cambridge University Press, 1984.

Chu, Petra T. D., ed. *Courbet in Perspective*. Englewood Cliffs, N.J.: Prentice Hall, 1977.

Clark, Timothy J. *Image of the People: Gustave Courbet and the 1848 Revolution*. Berkeley, Calif.: University of California Press, 1999.

Crow, Thomas. *Emulation: Making Artists for Revolutionary France*. New Haven, Conn.: Yale University Press, 1995.

[Delacroix] *Eugène Delacroix (1798–1863): Paintings, Drawings, and Prints from North American Collections*. New York: MMA, 1991.

[Delacroix] *The Journal of Eugène Delacroix*. New York: Garland Pub., 1972. Introd. by R. Motherwell.

Faunce, Sarah, ed. *Courbet Reconsidered*. New Haven, Conn.: Yale University Press, 1988.

Fermigier, André. *Jean-François Millet*. London: Hayward Gallery, 1976.

Fried, Michael. *Courbet's Realism*. Chicago: University of Chicago Press, 1990.

———. *Menzel's Realism: Art and Embodiment in Nineteenth-Century Berlin*. New Haven, Conn.: Yale University Press, 2002.

Harding, James. *Artistes Pompiers: French Academic Art in the 19th Century*. New York: Rizzoli, 1979.

Hargrove, June, ed. *The French Academy: Classicism and Its Antagonists*. Newark, N.J.: University of Delaware Press, 1990.

Hoozee, Robert, ed. *British Vision: Observation and Imagination in British Art, 1750–1950*. With introd. essays by John Gage and Timothy Hyman. Brussels: Mercatorfonds; Ghent: Museum voor Schone Kunsten; Distr. Cornell University Press, 2007.

Jansen, Leo. *Vincent Van Gogh: Painted with Words: the Letters to Émile Bernard*. New York: Rizzoli, in assoc. with the Morgan Library & Museum and the Van Gogh Museum, Amsterdam, 2007.

Johnson, Dorothy. *Jacques-Louis David: Art in Metamorphosis*. Princeton, N.J.: Princeton University Press, 1993.

Johnson, Lee. *The Paintings of Eugène Delacroix: A Critical Catalogue, 1816–1831*. 2 vols. Oxford: Clarendon Press, 1981.

Joll, Evelyn, et al. *The Oxford Companion to J .M.W Turner*. Oxford, England: Oxford University Press, 2001.

Landow, George P. *William Holman Hunt and Typological Symbolism*. New Haven, Conn.: Paul Mellon Centre for Studies in British Art, 1979.

Licht, Fred. *Goya*. Rev. ed. New York: Abbeville Press, 2001.

———, ed. *Goya in Perspective*. Englewood Cliffs, N.J.: Prentice Hall, 1973.

Murphy, Alexandra R. *Jean-François Millet*. Boston: MOFA, 1984.

Rosenblum, Robert. *Jean-Auguste-Dominique Ingres*. New York: H.N. Abrams, 1990.

Schnapper, Antoine. *David*. New York: Alpine Fine Arts Collection, 1980.

Stanton, Theodore, ed. *Reminiscences of Rosa Bonheur*. New York: Hacker Art Books, 1976.

Vigne, George. *Ingres*. Trans. J. Goodman. New York: Abbeville Press, 1995.

2. The Search for Truth: Early Photography, Realism, and Impressionism

Adler, Kathleen. *Manet*. Oxford, England: Phaidon, 1986.

———, and Tamar Garb. *Berthe Morisot*. Ithaca, N.Y.: Cornell University Press, 1987.

Barger, Susan M., and William B. White. *The Daguerreotype: Nineteenth-Century Technology and Modern Science*. Washington, D.C.: Smithsonian Institution Press, 1991.

Belloli, Andrea. *A Day in the Country: Impressionism and the French Landscape*. Los Angeles: LACMA, 1984.

Boggs, Jean Sutherland. *Degas*. Chicago: Art Institute of Chicago, 1996.

Boime, Albert. *The Art of the Macchia and the Risorgimento*. Chicago: University of Chicago Press, 1993.

Breeskin, Adelyn Dohme. *Mary Cassatt: A Catalogue Raisonné of the Oils, Pastels, Watercolors, and Drawings*. 2nd rev. ed. Washington, D.C.: Smithsonian Institution Press, 1979.

Brettell, Richard R. *Impression: Painting Quickly in France, 1860–1890*. New Haven, Conn.: Yale University Press in assoc. with the Sterling and Francine Clark Art Institute, Williamstown, Mass., 2000.

———, and Joachim Pissarro. *The Impressionist and the City: Pissarro's Series Paintings*. New Haven, Conn.: Yale University Press, 1992.

Broude, Norma. *Edgar Degas*. New York: Rizzoli, 1993.

———. *Impressionism: A Feminist Reading*. New York: Rizzoli, 1991.

Buckland, Gail. *Fox Talbot and the Invention of Photography*. Boston: D.R. Godine, 1980.

Callen, Anthea. *The Spectacular Body: Science, Method, and Meaning in the Work of Degas*. New Haven, Conn.: Yale University Press, 1995.

Casteras, Susan, et al. *John Ruskin and the Victorian Eye*. New York: H.N. Abrams, 1993.

Cikovsky, Jr., Nicolai and Franklin Kelly. *Winslow Homer*. Washington: National Gallery of Art; New Haven, Conn.: Yale University Press, 1995.

Clark, T. J. *The Absolute Bourgeois: Artists and Politics in France, 1848–1851*. Reprint of the 1973 ed. Berkeley, Calif.: University of California Press, 1999.

———. *The Painting of Modern Life: Paris in the Art of Manet and His Followers*. New York: Knopf, 1985.

Clarke, Michael. *Corot and the Art of Landscape*. London: British Museum Press, 1991.

Clayson, Hollis. *Paris in Despair: Art and Everyday Life Under Siege (1870–71)*. Chicago: University of Chicago Press, 2002.

Cooper, Suzanne F. *Pre-Raphaelite Art in the Victoria and Albert Museum*. London: V&A Publications; New York: Distr. H.N. Abrams, 2003.

Cox, Julian. *Julia Margaret Cameron: The Complete Photographs*. Contrib. Joanne Lukitsh and Philippa Wright. Los Angeles: Getty Publications in association with the National Museum of Photography, Film & Television, Bradford, England, 2003.

Cumming, Elizabeth, and Wendy Caplan. *Arts and Crafts Movement*. World of Art. New York: Thames & Hudson, 1991.

[Degas] *Pastels*. New York: G. Braziller, 1992. Texts by J. S. Boggs and A. Maheux.

Denvir, Bernard, ed. *The Impressionists at First Hand*. World of Art. New York: Thames & Hudson, 1987.

———. *The Thames & Hudson Encyclopedia of Impressionism*. World of Art. New York: Thames & Hudson, 1990.

Dorment, Richard. *James McNeill Whistler*. New York: H.N. Abrams, 1995.

Fried, Michael. *Manet's Modernism, or, the Face of Painting in the 1860s*. Chicago: University of Chicago Press, 1996.

Gernsheim, Helmut. *Julia Margaret Cameron: Pioneer of Photography*. 2nd ed. London and New York: Aperture, 1975.

———, and Alison Gernsheim. *L. J. M. Daguerre: The History of the Diorama and the Daguerreotype*. Reprint. New York: Dover Publications, 1968.

Getlein, Frank. *Mary Cassatt: Paintings and Prints*. New York: Abbeville Press, 1980.

Goodrich, Lloyd. *Thomas Eakins*. 2 vols. Cambridge, Mass.: Harvard University Press, 1982.

Gordon, Robert, and Andrew Forge. *Monet*. New York: H.N. Abrams, 1983.

Gosling, Nigel. *Nadar*. New York: Knopf, 1976.

Gotz, Adriani. *Renoir*. Cologne: Dumont; Distr. Yale University Press, 1999.

Gray, Michael, et al. *First Photographs: William Henry Fox Talbot and the Birth of Photography*. New York: PowerHouse Books in assoc. with the Museum of Photographic Arts, San Diego, 2002.

Griffin, Randall C. *Winslow Homer: An American Vision*. London; New York: Phaidon, 2006.

Haas, Robert B. *Muybridge's Man in Motion*. Berkeley and Los Angeles, Calif.: University of California Press, 1976.

Hambourg, Maria Morris. *Nadar*. New York: MMA: Distr. H.N. Abrams, 1995.

Hamilton, George. *Manet and His Critics*. Reprint of the 1954 ed. New Haven, Conn.: Yale University Press, 1986.

Hanson, Anne Coffin. *Manet and the Modern Tradition*. 2nd ed. New Haven, Conn.: Yale University Press, 1979.

Hendricks, Gordon. *Edward Muybridge—The Father of the Motion Picture*. New York: Grossmann Publishers, 1975.

Herbert, Richard. *Impressionism: Art, Leisure and Parisian Society*. New Haven, Conn.: Yale University Press, 1988.

Higonnet, Anne. *Berthe Morisot*. New York: Harper & Row, 1990.

———. *Berthe Morisot's Images of Women*. Cambridge, Mass.: Harvard University Press, 1992.

Hills, Patricia. *John Singer Sargent*. New York: WMAA, 1986. Texts by L. Ayres, A. Boime, W. H. Gerdts, S. Olson, G. A. Reynolds.

Hilton, Timothy. *The Pre-Raphaelites*. World of Art. Reprint of the 1970 ed. London: Thames & Hudson, 1985.

Hofmann, Werner. *Degas: A Dialogue of Difference*. London; New York: Thames & Hudson, 2007.

[Homer] *Winslow Homer and the New England Coast*. New York: WMAA, 1985.

House, John. *Monet: Nature into Art*. New Haven, Conn.: Yale University Press, 1986.

Jenkyns, Richard. *Dignity and Decadence: Victorian Art and the Classical Inheritance*. Cambridge, Mass.: Harvard University Press, 1992.

Johns, Elizabeth. *Thomas Eakins and the Heroism of Modern Life*. Princeton, N.J.: Princeton University Press, 1984.

———. *Winslow Homer: The Nature of Observation*. Berkeley, Calif.: University of California Press, 2002.

Kendall, Richard, and Griselda Pollock, eds. *Dealing with Degas: Representations of Women and the Politics of Vision*. New York: Universe Books, 1992.

Lemoine, Serge. *Paintings in the Musée d'Orsay*. Trans. T. Ballas. New York: H.N. Abrams, 2004.

Lipton, Eunice. *Looking into Degas*. Berkeley, Calif.: University of California Press, 1986.

Livingstone, Karen and Linda Parry, eds. *International Arts and Crafts*. London: Victoria and Albert; New York: Distr. H.N. Abrams, 2005.

Manet, Édouard. *Manet by Himself: Correspondence & Conversation, Paintings, Pastels, Prints & Drawings*. Ed. by J. Wilson-Bareau. Boston: Little, Brown, 1991.

[Manet] *Manet: 1832–1883*. New York: MMA, 1983.

Marsh, Jan. *The Pre-Raphaelite Circle*. London: National Portrait Gallery, 2005.

Mathews, Nancy M. *Mary Cassatt: A Life*. New York: Villard Books, 1994.

Mary Cassatt, *Modern Woman*. Org. Judith A. Barter; Contrib. Erica E. Hirshler, et al. New York: Art Institute of Chicago in assoc. with H.N. Abrams, 1998.

Miller, David, ed. *American Iconology: New Approaches to Nineteenth-Century Art and Literature*. New Haven, Conn.: Yale University Press, 1993.

Moffett, Charles S. *The New Painting: Impressionism, 1874–1886*. San Francisco: Fine Arts Museums, 1986.

Mosby, Dewey, and Darrel Sewell. *Henry Ossawa Tanner*. Philadelphia and New York: Philadelphia Museum of Art and Rizzoli, 1991.

Needham, Gerald. *19th-Century Realist Art*. New York: Harper & Row, 1988.

Nochlin, Linda. *Impressionism and Post-Impressionism, 1874–1904: Sources and Documents*. Englewood Cliffs, N.J.: Prentice Hall, 1976.

———. *Realism*. Harmondsworth: Penguin, 1972.

———. *Realism and Tradition in Art, 1848–1900: Sources and Documents*. Englewood Cliffs, N.J.: Prentice Hall, 1966.

———. *Representing Women*. New York: Thames & Hudson, 1999.

Ormond, Richard. *John Singer Sargent: Complete Paintings*. 4 vols. New Haven, Conn.: Published for the Paul Mellon Centre for Studies in British Art by Yale University Press, 1998–2006.

Orienti, Sandra. *Manet, Edouard. The Complete Paintings of Manet*. Intro. by P. Pool. New York: H.N. Abrams, 1985, 1967.

Pollock, Griselda. *Mary Cassatt: Painter of Modern Women*. New York: Thames & Hudson, 1998.

———. *Mary Cassatt*. London: Chaucer, 2005.

Parris, Leslie, ed. *The Pre-Raphaelites*. Reprinted with corrections. London: Tate, 1994, 1984.

Prettejohn, Elizabeth. *The Art of the Pre-Raphaelites*. Princeton, N.J.: Princeton University Press, 2000.

Prodger, Phillip. *Time Stands Still: Muybridge and the Instantaneous Photography Movement*. Stanford, Calif.: The Iris & B. Gerald Cantor Center for Visual Arts in assoc. with Oxford University Press, 2003.

Ratcliff, Carter. *John Singer Sargent.* New York: Abbeville Press, 1982.

Reff, Theodore. *Manet and Modern Paris.* Washington, D.C.: National Gallery of Art, 1982.

[Renoir] Texts by J. House, A. Distel, L. Gowing. London: Hayward Gallery, 1985.

Renoir, Jean. *Renoir: My Father.* Introd. by Robert Herbert. New York: New York Review Books, 2001.

Rewald, John. *The History of Impressionism.* 4th rev. ed. New York: MOMA, 1973.

———. *Degas's Complete Sculpture: Catalogue Raisonné.* New ed. San Francisco: Alan Wofsy Fine Arts, 1990.

Rilke, Rainer Maria. *Auguste Rodin.* Trans. Daniel Slager. Introd. by William Gass. New York: Archipelago Books, 2004.

———, and Frances Weitzenhoffer, eds. *Aspects of Monet: A Symposium on the Artist's Life and Times.* New York: H.N. Abrams, 1984.

Reynolds, Graham. *Victorian Painting.* Rev. ed. New York: Harper & Row, 1987.

Rosenblum, Robert. *Paintings in the Musée d'Orsay.* New York: Stewart, Tabori and Chang, 1989.

Rothkopf, Katherine, et al. *Pissarro: Creating the Impressionist Landscape.* Baltimore: Baltimore Museum of Art; London: Philip Wilson, 2006.

Rouart, Denis. *Renoir.* New York: Skira/Rizzoli, 1985.

Schaaf, Larry J. *Out of the Shadows: Herschel, Talbot and the Invention of Photography.* New Haven, Conn.: Yale University Press, 1992.

———. *The Photographic Art of William Henry Fox Talbot.* Princeton, N.J.: Princeton University Press, 2000.

Sewell, Darrel. *Thomas Eakins.* Essays by Kathleen A. Foster, et al. Philadelphia: Philadelphia Museum of Art in assoc. with Yale University Press, 2001.

Sheldon, James L. *Motion and Document, Sequence and Time: Eadweard Muybridge and Contemporary American Photography.* Andover, Mass.: Addison Gallery of American Art, 1991.

Spate, Virginia. *Claude Monet: Life and Work.* New York: Rizzoli, 1992.

Stuckey, Charles F. *Claude Monet, 1840–1926.* Chicago: Art Institute, 1995.

———, and William P. Scott. *Berthe Morisot, Impressionist.* New York: Hudson Hills Press, 1987.

Sutton, Denys. *Edgar Degas: Life and Work.* New York: Rizzoli, 1986.

Tinterow, Gary, and Henri Loyrette. *Origins of Impressionism.* New York: MMA, 1994.

Tucker, Paul. *Claude Monet: Life and Art.* New Haven, Conn.: Yale University Press, 1995.

———. *The Impressionists at Argenteuil.* Paul Hayes Tucker. Washington, D.C.: National Gallery of Art; Hartford, Conn.: Wadsworth Atheneum, 2000.

———. *Monet in the '90s: The Series Paintings.* New Haven, Conn.: Yale University Press, 1989.

———. *Monet in the 20th Century.* London: Royal Academy of Arts; New Haven, Conn.: Published in assoc. with Yale University Press, 1998.

Wadley, Nicholas. *Renoir: A Retrospective.* New York: Hugh Lauter Levin Assoc., 1987.

Weisberg, Gabriel. *Beyond Impressionism: The Naturalist Impulse.* New York: H.N. Abrams, 1992.

———. *The Realist Tradition: French Painting and Drawing, 1830–1900.* Cleveland: Cleveland Museum of Art, 1981.

White, Barbara Ehrlich. *Renoir: His Life, Art, and Letters.* New York: H.N. Abrams, 1984.

Wilmerding, John. *Winslow Homer.* New York: Praeger, 1972.

Wood, Christopher. *The Pre-Raphaelites.* New York: Viking, 1981.

3. Post-Impressionism

Adriani, Gotz. *Cézanne: A Biography.* New York: H.N. Abrams, 1990.

———. *Toulouse-Lautrec: Complete Graphic Works.* London: Thames & Hudson, 1988.

Bocquillon-Ferretti, Marina, et al. *Signac, 1863–1935.* New York: MMA; New Haven, Conn.: Yale University Press, 2001.

Brettell, Richard, et al. *The Art of Paul Gauguin.* Washington, D.C.: National Gallery of Art, 1988.

Broude, Norma. *Georges Seurat.* New York: Rizzoli, 1992.

Cachin, Françoise. *Cézanne.* Philadelphia: Philadelphia Museum of Art, 1996.

Denvir, Bernard. *Post-Impressionism.* World of Art. New York: Thames & Hudson, 1992.

Druick, Douglas W., et al. *Odilon Redon: Prince of Dreams, 1840–1916.* New York: H.N. Abrams, 1994.

Elsen, Albert, ed. *Rodin Rediscovered.* Washington, D.C.: National Gallery of Art, 1981.

———. *Rodin's Art: The Rodin Collection of the Iris & B. Gerald Cantor Center for Visual Arts at Stanford University.* Palo Alto, Calif.: The Iris & B. Gerald Cantor Center for Visual Arts at Stanford University in assoc. with Oxford University Press, 2003.

Gauguin, Paul. *Gauguin By Himself.* Ed. by Belinda Thomson. Boston: Little, Brown, 1993.

George, Waldemar. *Aristide Maillol.* London: Cory, Adams & Mackay, 1965.

Frèches-Thory, Clair. *The Nabis: Bonnard, Vuillard and Their Circle.* New York: H.N. Abrams, 1991.

Frey, Julia Bloch. *Toulouse-Lautrec: A Life.* London: Weidenfeld and Nicolson, 1994.

Fry, Roger. *Seurat.* 3rd ed. London: Phaidon, 1965.

Gauguin, Paul. *The Intimate Journals of Paul Gauguin.* Boston: KPI, 1985.

———. *Noa Noa: The Tahiti Journal of Paul Gauguin.* Trans. O. F. Theis. 1994 Océanie ed. San Francisco: Chronicle Books, 1994.

Gerhardus, Maly, and Dietfried Gerhardus. *Symbolism and Art Nouveau.* Trans. A. Bailey. Oxford: Phaidon, 1979.

Gogh, Vincent van. *The Complete Letters of Vincent van Gogh: With Reproductions of All the Drawings in the Correspondence.* 2nd ed. Boston: Little, Brown, 1978.

Goldwater, Robert. *Paul Gauguin.* New York: H.N. Abrams, 1984.

———. *Symbolism.* New York: Harper & Row, 1979.

Gotz, Adriani. *Henri Rousseau.* Trans. S. Kleager and J. Marsh. New Haven, Conn.: Yale University Press, 2001.

———. *Cézanne Paintings.* Trans. R. Stockman. Cologne: Dumont; New York: H.N. Abrams, 1995.

Gowing, Lawrence. *Cézanne, the Early Years, 1859–1872.* New York: H.N. Abrams, 1988.

Gray, Christopher. *Sculpture and Ceramics of Paul Gauguin.* Baltimore: Johns Hopkins Press, 1963.

Herbert, Robert L. *Georges Seurat, 1859–1891.* New York: MMA, 1991.

———. *Seurat and the Making of La Grande Jatte.* With an essay by Neil Harris, et al. Chicago: Art Institute of Chicago in assoc. with the University of California Press, 2004.

———. *Seurat, Drawings and Paintings.* New Haven, Conn.: Yale University Press, 2001.

Hulsker, Jan. *The New Complete Van Gogh: Paintings, Drawings, Sketches.* Rev. enl. ed. Amsterdam: J.M. Meulenhoff; Philadelphia: Distr. John Benjamins, 1996.

Jensen, Robert. *Marketing Modernism in Fin de Siècle Europe.* Princeton, N.J.: Princeton University Press, 1994.

Leen, Frederik. *Fernand Khnopff (1858–1921).* Brussels: Royal Museums of Fine Art of Belgium, 2004.

Leighton, John, et al. *Seurat and the Bathers.* London: National Gallery Publications: Distr. Yale University Press, 1997.

Lemoine, Serge. *Toward Modern Art: From Puvis de Chavennes to Matisse and Picasso.* New York: Rizzoli, 2002.

Lewis, Mary Tompkins. *Cézanne's Early Imagery.* Berkeley, Calif.: University of California Press, 1989.

Lorquin, Bertrand. *Aristide Maillol.* Trans. Michael Taylor. London; New York: Skira in association with Thames & Hudson, 1995, 1994.

Murray, Gale B. *Toulouse-Lautrec: A Retrospective.* New York: Hugh Lauter Levin Assoc., 1992.

Pierre Bonnard: *The Work of Art, Suspending Time: Musée d'art Moderne de la Ville de Paris, 2 February–7 May 2006.* Paris: Paris Musées; Gand: Ludion, 2006.

Rapetti, Rodolphe. *Symbolism.* Trans. D. Dusinberre. Paris: Flammarion; Distr. Rizzoli, 2005.

Rewald, John. *Paul Cézanne: The Watercolors, A Catalogue Raisonné.* Boston: Little, Brown, 1983.

———. *The Paintings of Paul Cézanne: A Catalogue Raisonné.* New York: H.N. Abrams, 1996.

———. *Post-Impressionism: From Van Gogh to Gauguin.* 3rd ed. rev. New York: MOMA, 1978.

———. *Seurat: A Biography.* New York: H.N. Abrams, 1990.

Texts by J. House, A. Distel, L. Gowing. *Studies in Post-Impressionism.* New York: H.N. Abrams, 1986.

Rubin, William, ed. *Cézanne: The Late Work.* New York: MOMA, 1977.

Schwartz, Dieter, ed. *Rosso Medardo, 1858–1928.* Düsseldorf: Richter Verlag, 2004.

Solana, Guillermo, ed. *Gauguin and the Origins of Symbolism.* London: Philip Wilson Publishers in assoc. with Museo Thyssen-Bornemisza and Fundación Caja Madrid, 2004.

Schapiro, Meyer. *Paul Cézanne.* Concise ed. New York: H.N. Abrams, 1988.

———. *Van Gogh.* Rev. ed. New York: H.N. Abrams, 1982.

Shiff, Richard. *Cézanne and the End of Impressionism: A Study of the Theory, Technique, and Critical Evaluation of Modern Art.* Chicago: University of Chicago Press, 1984.

———. *Toulouse-Lautrec.* World of Art. New York: Thames & Hudson, 1991.

Théberge, Pierre and Jean Clair. *Lost Paradise, Symbolist Europe.* Montreal: Montreal Museum of Fine Arts, 1995.

Thomson, Belinda. *Gauguin.* World of Art. New York: Thames & Hudson, 1987.

Thomson, Richard. *Toulouse-Lautrec and Montmartre.* Richard Thomson et al. Washington, D.C.: National Gallery of Art; Princeton, N.J.: In association with Princeton University Press, 2005.

Turner, Elizabeth H. *Pierre Bonnard: Early and Late.* Contrib. Nancy Colman Wolsk, et al. London: Philip Wilson Publishers in collaboration with the Phillips Collection, Washington, D.C., 2002.

Verdi, Richard. *Cézanne.* World of Art. New York: Thames & Hudson, 1992.

Walther, Ingo F., and Rainer Metzger. *Van Gogh: The Complete Paintings.* Cologne: Taschen, 1993.

4. The Origins of Modern Architecture and Design

Barthes, Roland. *The Eiffel Tower, and Other Mythologies.* Trans. Richard Howard. Berkeley, Calif.: University of California Press, 1997.

Charenbhak, Wichit. *Chicago School Architects and Their Critics.* Ann Arbor, Mich.: UMI Research Press, 1984.

Colquhoun, Kate. *"The Busiest Man in England": A Life of Joseph Paxton, Gardener, Architect & Victorian Visionary.* Boston: David R. Godine, 2006.

Crawford, Alan. *Charles Rennie Mackintosh.* New York: Thames & Hudson, 1995.

Floyd, Margaret Henderson. *Henry Hobson Richardson, a Genius for Architecture.* Photographs by Paul Rocheleau. New York: Monacelli Press, 1997.

Hitchcock, Henry-Russell. *The Architecture of H.H. Richardson and His Times.* New ed. Cambridge, Mass.; London: The M.I.T. Press, 1966.

Howarth, Thomas. *Charles Rennie Mackintosh and the Modern Movement.* 2nd ed. London: Routledge and Kegan Paul, 1977.

Kaplan, Wendy, ed. *Charles Rennie Mackintosh.* New York: Abbeville Press, 1996.

Kirk, Sheila. *Philip Webb: Pioneer of Arts & Crafts Architecture.* Photography by Martin Charles. Chichester, England; Hoboken, N.J.: Wiley-Academy, 2005.

Lethaby, William R. *Philip Webb and His Work.* New ed. London: Raven Oaks Press, 1979.

Loyrette, Henri. *Gustave Eiffel*. New York: Rizzoli, 1985.

Manieri-Elia, Mario. *Louis Henry Sullivan, 1856–1924*. Trans. A. Shuggar with C. Creen. New York: Princeton Architectural Press, 1996.

McKean, John. *Crystal Palace: Joseph Paxton and Charles Fox. Architecture in Detail*. London: Phaidon, 1994.

Mead, Christopher Curtis. *Charles Garnier's Paris Opera: Architectural Empathy and the Renaissance of French Classicism*. Cambridge, Mass.: MIT Press, 1991.

Morrison, Hugh. *Louis Sullivan, Prophet of Modern Architecture*. Introd. and revised list of buildings by T. J. Samuelson. New York: W. W. Norton & Co., 1998.

Pfammatter, Ulrich. *Building the Future: Building Technology and Cultural History from the Industrial Revolution Until Today*. Munich; New York: Prestel, 2008.

Sullivan, Louis H. *Kindergarten Chats and Other Writings*. New York: Dover Publications, 1979.

Szarkowski, John. *The Idea of Louis Sullivan*. Introd. by Terence Riley. New ed. Boston: Bulfinch Press/Little, Brown and Co., 2000.

Twombley, Robert, ed. *Louis Sullivan, the Public Papers*. Chicago: University of Chicago Press, 1988.

5. Art Nouveau and the Beginnings of Expressionism

Artigas, Isabel. *Antoni Gaudí: Complete Works*. Köln, Germany: Evergreen, 2007.

Arwas, Victor. *Art Deco*. Rev. ed. New York: H.N. Abrams, 1992.

———. *Art Nouveau: From Mackintosh to Liberty: The Birth of a Style*. London: Andreas Papadakis, 2000.

Brandstätter, Christian. *Wonderful Wiener Werkstätte: Design in Vienna, 1903–1932*. London: Thames & Hudson, 2003.

———, ed. *Vienna 1900: Art, Life & Culture*. New York: Vendome Press, 2006.

Calloway, Stephen. *Aubrey Beardsley*. New York: H.N. Abrams, 1998.

Chipp, Herschel B. *Viennese Expressionism 1910–1924*. Berkeley, Calif.: University Museum, University of California, 1963.

Comini, Alessandra. *Gustav Klimt*. New York: G. Braziller, 1975.

Duncan, Alastair. *Art Nouveau. World of Art*. New York: Thames & Hudson, 1994.

Eggum, Arne. *Edvard Munch: Paintings, Sketches, and Studies*. New York: C. N. Potter, 1985.

Escritt, Stephen. *Art Nouveau. Art & Ideas*. London: Phaidon, 2000.

Frehner, Matthias, et al. *Ferdinand Hodler*. Ostfildern-Ruit, Germany: Hatje Cantz, 2008.

Heller, Reinhold. *Munch: His Life and Work*. Chicago: University of Chicago Press, 1984.

Kallir, Jane. *Viennese Design and the Wiener Werkstätte*. New York: G. Braziller, 1986.

Lahuerta, Juan José. *Antoni Gaudí, 1852–1926: Architecture, Ideology, and Politics*. Milan, Italy: Electa Architecture; London: Phaidon, 2003.

Lemoine, Serge. *Vienna 1900: Klimt, Schiele, Moser, Kokoschka*. Paris: Editions de la Réunion des Musées Nationaux in association with Lund Humphries, 2005.

Nebehay, Christian M. *Ver Sacrum, 1898–1903*. Vienna: Edition Tuschi, 1975.

McShine, Kynaston, ed. *Edvard Munch: The Modern Life of the Soul*. Essays by Reinhold Heller, et al. New York: MOMA, 2006.

[Munch] *Edvard Munch: Symbols and Images*. Introd. by R. Rosenblum. Texts by A. Eggum, et al. Washington, D.C.: National Gallery of Art, 1978.

[Munch] *Munch in His Own Words*. Ed. by Poul Erik Tøjner. Munich; New York: Prestel Verlag, 2001.

The Origins of L'Art Nouveau: The Bing Empire. Ed. by Gabriel P. Weisberg, et al. Amsterdam: Van Gogh Museum; Paris: Musée des Arts Décoratifs; Antwerp: Mercatorfonds; Ithaca, N.Y.: Distr. Cornell University Press, 2004.

Partsch, Suzanna. *Klimt: Life and Work*. London: Bracken, 1993.

Permanyer, Lluis. *Barcelona Art Nouveau = Paseo por la Barcelona Modernista*. Trans. Richard Rees. New York: Rizzoli, 1999.

Pfeiffer, Ingrid and Max Hollein. *James Ensor*. Texts by Sabine Bown-Taevernier, et al. Ostfildern-Ruit, Germany: Hatje Cantz, 2005.

Price, Renée, ed. *Egon Schiele: The Ronald S. Lauder and Serge Sabarsky Collections*. Contrib. Alessandra Comini, et al. Munich; New York: Prestel, 2005.

———. *Gustav Klimt: The Ronald S. Lauder and Serge Sabarsky Collections*. Contrib. Ronald S. Lauder, et al. New York: Neue Galerie, New York; Munich; New York: Prestel Verlag, 2007.

Prideaux, Sue. *Edvard Munch: Behind the Scream*. New Haven, Conn.: Yale University Press, 2005.

Reade, Brian. *Aubrey Beardsley*. Rev. ed. Suffolk, England.: Antique Collectors's Club, 1998, 1987.

Rennhofer, Maria. *Koloman Moser: Master of Viennese Modernism*. London; New York: Thames & Hudson, 2002.

Riquer, Borja de, et al. *Modernismo: Architecture and Design in Catalonia*. New York: Monacelli Press, 2003.

Schmutzler, Robert. *Art Nouveau*. Abridged ed. Trans. E. Rodotti. London: Thames & Hudson, 1978.

Schorske, Carl. *Fin-de-Siècle Vienna: Politics and Culture*. New York: Vintage Books, 1980.

Selz, Peter and Mildred Constantine, eds. *Art Nouveau: Art and Design at the Turn of the Century*. Rev. ed. New York: MOMA, 1974.

Silverman, Deborah. *Art Nouveau in Fin-de-Siècle France*. Berkeley, Calif.: University of California Press, 1989.

Stansky, Peter. *Redesigning the World: William Morris, the 1880s, and the Arts and Crafts*. Princeton, N.J.: Princeton University Press, 1985.

Sweeney, James J. and Joseph L. Sert. *Gaudí*. Rev. ed. New York: Praeger, 1970, 1960.

[Van de Velde] *Henry van de Velde, 1863–1957*. Otterlo, the Netherlands: Kröller-Müller Rijksmuseum, 1964.

Varnedoe, Kirk. *Vienna 1900: Art, Architecture, and Design*. New York: MOMA, 1986.

———, and Elizabeth Streicher. *Graphic Work of Max Klinger*. New York: Dover Publications, 1977.

Vergo, Peter. *Art in Vienna, 1898–1918: Klimt, Kokoschka, Schiele and Their Contemporaries*. 3rd ed. London: Phaidon, 1993.

Weidinger, Alfred, ed. *Gustav Klimt*. With texts by Marian Bisanz-Prakken, et al. Munich; New York: Prestel, 2007.

Weisberg, Gabriel P. *Art Nouveau: a Research Guide for Design Reform in France, Belgium, England, and the United States*. New York: Garland Pub., 1998.

Whitford, Frank. *Klimt. World of Art*. London: Thames & Hudson, 1990.

Yearning for Beauty: The Wiener Werkstätte and the Stoclet House. Ed. by Peter Noever, et al. Vienna: MAK; Ostfildern-Ruit, Germany: Hatje Cantz; New York: Distr. D.A.P./Distributed Art Publishers, 2006.

6. The New Century: Experiments in Color and Form

Art of the Twentieth Century. Trans. Antony Shugaar. 5 vols. Vol. 1. *1900–1919: The Avant-Garde Movements*; Vol. 2. *1920–1945: The Artistic Culture Between the Wars*; Vol. 3. *1946–1968: The Birth of Contemporary Art*; Vol. 4. *1968–1999: Neo-Avant-Gardes: Postmodern and Global art*; Vol. 5. *2000 and Beyond: Contemporary Tendencies*. Milan: Skira; New York: Distr. Rizzoli International Publications, 2006.

Barr, Jr., Alfred H. *Matisse: His Art and His Public*. New York: MOMA, 1951.

Brodskaia, Natalia. *The Fauves: the Hermitage, St. Petersburg: the Pushkin Museum of Fine Arts, Moscow*. Trans. Paul Williams. Bournemouth, England: Parkstone; St. Petersburg: Aurora, 1995.

Clement, Russell T. *Les Fauves: A Sourcebook*. Westport, Conn.: Greenwood Press, 1994.

Crespelle, Jean–Paul. *The Fauves*. Trans. A. Brookner. Greenwich, Conn.: New York Graphic Society, 1962.

Duthuit, Georges. *The Fauvist Painters*. Trans. R. Mannheim. *Documents of Modern Art*. New York: Wittenborn, Schultz, 1950.

Elderfield, John. *Henri Matisse, A Retrospective*. New York: MOMA, 1992.

———. *The "Wild Beasts": Fauvism and Its Affinities*. New York: MOMA, 1976.

Ferrier, Jean Louis. *The Fauves: The Reign of Colour: Matisse, Derain, Vlaminck, Marquet, Camoin, Manguin, Van Dongen, Friesz, Braque, Dufy*. Paris: Terrail, 1995.

Flam, Jack D. *Matisse: The Man and His Art, 1869–1918*. London: Thames & Hudson, 1986.

———, ed. *Matisse: A Retrospective*. New York: Park Lane, 1990.

———, ed. *Matisse On Art*. Berkeley, Calif.: University of California Press, 1994.

———, ed. *Primitivism and Twentieth-Century Art: A Documentary History*. Berkeley, Calif.: University of California Press, 2003.

Flora, Holly and Soo Yun Kang. *George Rouault's Miserere et Guerre: This Anguished World of Shadows*. New York: Museum of Biblical Art, 2006.

Freeman, Judi. *The Fauve Landscape*. New York: Abbeville Press, 1990.

———. *Fauves*. Sydney: Art Gallery of New South Wales; London: Distr. Thames & Hudson, 1995.

Herbert, James D. *Fauve Painting: The Making of Cultural Politics*. New Haven, Conn.: Yale University Press, 1992.

Kosinski, Dorothy M., et al. *Matisse: Painter as Sculptor*. Baltimore, Md.: Baltimore Museum of Art; Dallas, Tex.: Dallas Museum of Art: Nasher Sculpture Center; New Haven, Conn.: Yale University Press, 2007.

Lee, Jane. *Derain*. Oxford, England: Phaidon; New York: Universe, 1990.

Leymarie, Jean. *Fauves and Fauvism*. Enl. ed. New York: Skira Rizzoli, 1987.

Masters of Colour: Derain to Kandinsky: Masterpieces From the Merzbacher Collection. London: Royal Academy of Arts; New York: Distr. in U.S. by H.N. Abrams, 2002.

Monod-Fontaine, Isabelle. *André Derain: An Outsider in French art*. Contrib. Sibylle Pieyre de Mandiargues, et al. Copenhagen, Denmark: Statens Museum for Kunst, 2007.

Muller-Tamm, Pia, ed. *Henri Matisse: Figure, Color, Space*. Texts by Gottfried Boehm, et al. Ostfildern-Ruit, Germany: Hatje Cantz, 2005.

Rewald, John. *Les Fauves*. New York: MOMA, 1952.

Rouault, Georges. *Miserere*. New and enl. ed. Paris: Le Léopard d'or; Tokyo: Zauho Press, 1991.

Sutton, Denys. *André Derain*. London: Phaidon, 1959.

Venturi, Lionello. *Rouault: Biographical and Critical Study*. Trans. J. Emmons. Paris: Skira, 1959.

Whitfield, Sarah. *Fauvism*. New York: Thames & Hudson, 1996.

Wright, Alastair. *Matisse and the Subject of Modernism*. Princeton, N.J.: Princeton University Press, 2004.

7. Expressionism in Germany

Art of the Twentieth Century. Trans. Antony Shugaar. 5 vols. Vol. 1. *1900–1919: The Avant-Garde Movements*; Vol. 2. *1920–1945: The Artistic Culture Between the Wars*; Vol. 3. *1946–1968: The Birth of Contemporary Art*; Vol. 4. *1968–1999: Neo-Avant-Gardes: Postmodern and Global art*; Vol. 5. *2000 and Beyond: Contemporary Tendencies*. Milan: Skira; New York: Distr. Rizzoli International Publications, 2006.

Bach, Friedrich Teja. *Constantin Brancusi, 1876–1957*. Philadelphia, Pa.: Philadelphia Museum of Art; Cambridge, Mass.: MIT Press, 1995.

Barnett, Vivian Endicott and Josef Helfenstein. *The Blue Four: Feininger, Jawlensky, Kandinsky, and Klee in the New World*. Cologne: Dumont; New Haven, Conn.: Distr. Yale University Press, 1997.

Barron, Stephanie, ed. *"Degenerate Art": The Fate of the Avant-Garde in Nazi Germany*. Los Angeles: LACMA, 1991.

———, and Wolf-Dieter Dube, eds. *German Expressionism: Art and Society*. New York: Rizzoli, 1997.

Behr, Shulamith. *Expressionism*. Movements in Modern Art. Cambridge, England: Cambridge University Press, 1999.

Benson, Timothy. *Expressionist Utopias: Paradise, Metropolis, Architectural Fantasy*. Los Angeles: LACMA, 1993.

Carey, Frances. *The Print in Germany, 1880–1933: The Age of Expression: Prints from the Department of Prints and Drawings in the British Museum*. With a section of illustrated books from the British Library by D. Paisey. 2nd ed. London: British Museum Press, 1993, 1984.

Chave, Anna. *Constantin Brancusi: Shifting the Bases of Art*. New Haven, Conn.: Yale University Press, 1993.

Dabrowski, Magdalena. *Kandinsky Compositions*. New York: MOMA. 1995.

Elsen, Albert E. *The Sculpture of Henri Matisse*. New York: H.N. Abrams, 1972.

Expressionism: A German Intuition. New York: SRGM, 1980.

Fischer, Hartwig and Sean Rainbird, eds. *Kandinsky: The Path to Abstraction*. Essays by Shulamith Behr, et al. London: Tate; New York: Distr. in U.S. and Canada by H.N. Abrams, 2006.

Geist, Sydney. *Brancusi: A Study of the Sculpture*. Rev. and enl. ed. New York: Hacker Art Books, 1983.

Gordon, Donald. *Ernst Ludwig Kirchner*. Cambridge, Mass.: Harvard University Press, 1968.

———. *Expressionism: Art and Idea*. New Haven, Conn.: Yale University Press, 1987.

———. *Oskar Kokoschka and the Visionary Tradition*. Bonn: Bouvier, 1981.

Grohmann, Will. *E. L. Kirchner*. Stuttgart: W. Kohlhammer, 1961.

———. *Karl Schmidt-Rottluff*. Stuttgart: W. Kohlhammer, 1956.

Helfenstein, Josef and Elizabeth Hutton Turner, eds. *Klee and America*. Houston, Tex.: Menil Collection: Ostfildern-Ruit, Germany: Hatje Cantz, 2006.

Heller, Reinhold. *The Art of Wilhelm Lehmbruck*. Washington, D.C.: National Gallery of Art, 1972.

Hess, Hans. *Lyonel Feininger*. Stuttgart: W. Kohlhammer, 1959.

Hinz, Renate, ed. *Käthe Kollwitz: Graphics, Posters, Drawings*. Foreword by Lucy R. Lippard. Trans. Rita and Robert Kimber. New York: Pantheon Books, 1982.

Hoberg, Annegret and Isabelle Jansen. *Franz Marc: The Complete Works*. 2 vols. in 3. London: Philip Wilson; New York: Distr. in the U.S. by Palgrave Macmillan, 2004–05.

Hofmann, Werner. *Wilhelm Lehmbruck*. London: A. Zwemmer, 1958.

Holst, Christian von. *Franz Marc, Horses*. Essays by Karin von Maur, et al. Trans. Elizabeth Clegg. Cambridge, Mass.: Harvard University Art Museums; Ostfildern-Ruit, Germany: Hatje Cantz, 2000.

Hultén, Pontus. *Brancusi*. New York: H.N. Abrams, 1987.

Jawlensky, Maria. *Alexej von Jawlensky: Catalogue Raisonné of the Oil Paintings*. London: Sotheby's Publications, 1991–98.

Jordan, Jim. *Paul Klee and Cubism*. Princeton, N.J.: Princeton University Press, 1984.

Kallir, Jane. *Egon Schiele*. With an essay by Alessandra Comini. New York: H.N. Abrams; Alexandria, Va.: Art Services International, 1994.

[Kandinsky] *Kandinsky in Munich: 1896–1914*. New York: SRGM, 1982.

Klee, Felix, ed. *The Diaries of Paul Klee: 1898–1918*. Berkeley and Los Angeles, Calif.: University of California Press, 1964.

Klipstein, August. *The Graphic Work of Käthe Kollwitz: Complete Illustrated Catalogue*. Reprint. Mansfield Center, Conn.: M. Martino, 1996, 1955.

Knesebeck, Alexandra von dem. *Käthe Kollwitz: Werkverzeichnis der Graphik*. Neubearb. des Verzeichnisses von A. Klipstein, 2 vols. + 1 CD-ROM with English translation of the text. Bern: Kornfeld, 2002.

Kokoschka: *A Retrospective Exhibition of Paintings, Drawings, Lithographs, Stage Design and Books*. London: Tate, 1962. Texts by E. H. Gombrich, F. Novotny, H. M. Wingler, et al.

[Kokoschka] *Oskar Kokoschka, 1886–1980*. New York: SRGM, 1986.

Kollwitz, Hans, ed. *The Diary and Letters of Käthe Kollwitz*. Evanston, Ill.: Northwestern University Press, 1988.

Lanchner, Carolyn, ed. *Paul Klee, His Life and Work*. Rev. ed. New York: MOMA; Ostfildern-Ruit, Germany: Hatje Cantz; New York,: Distr. D.A.P./Distributed Art Publishers, 2001.

Levine, Frederick S. *The Apocalyptic Vision: The Art of Franz Marc as German Expressionism*. New York: Harper & Row, 1979.

Lincoln, Louise, ed. *German Realism of the Twenties: The Artist as Social Critic*. Minneapolis: Minneapolis Institute of Arts, 1980.

Lindsay, Kenneth and Peter Vergo. *Kandinsky: Complete Writings on Art*. 2 vols. Boston: G. K. Hall, 1982.

Lloyd, Jill. *German Expressionism: Primitivism and Modernity*. New Haven, Conn.: Yale University Press, 1991.

———, and Magdalena M. Moeller, eds. *Ernst Ludwig Kirchner: The Dresden and Berlin Years*. London: Royal Academy of Arts, 2003.

———, and Michael Peppiatt, eds. *Van Gogh and Expressionism*. Ostfildern-Ruit, Germany: Hatje Cantz, 2007.

Long, Rose-Carol Washton, ed. *German Expressionism: Documents from the End of the Wilhelmine Empire to the Rise of National Socialism. Documents of Twentieth Century Art*. New York: G. K. Hall, 1993.

Lorenz, Ulrike and Norbert Wolf, eds. *Brücke*. Köln, Germany: Taschen, 2008.

Luckhardt, Ulrich. *Lyonel Feininger*. Munich: Prestel; New York: Distrib. in the U.S. and Canada by Te Neues, 1989.

Michalski, Sergiusz. *New Objectivity: Painting, Graphic Art and Photography in Weimar Germany, 1919–1933*. Köln, Germany: Taschen, 1994.

Miller, Sanda. *Constantin Brancusi: A Survey of His Work*. Oxford, England: Clarendon, 1995.

Modersohn-Becker, Paula. *Paula Modersohn-Becker, the Letters and Journals*. Ed.by Günther Busch and Liselotte von Reinken, et al. New York: Taplinger Pub. Co., 1983.

Neue Sachlichkeit and German Realism of the Twenties. London: Arts Council of Great Britain, 1978.

Painters of the Brücke. London: Tate, 1964.

Perry, Gillian. *Paula Modersohn-Becker: Her Life and Work*. New York: Harper & Row, 1979.

Prelinger, Elizabeth. *Käthe Kollwitz*. Washington, D.C.: National Gallery of Art, 1992.

Price, Renée, ed. *Egon Schiele: The Ronald S. Lauder and Serge Sabarsky Collections*. Contrib. Alessandra Comini, et al. Munich; New York: Prestel, 2005.

Richard, Lionel. *Phaidon Encyclopedia of Expressionism*. Trans. S. Tint. Oxford: Phaidon, 1978.

Roethel, Hans. *The Blue Rider*. New York: Praeger, 1971.

———, and Jean Benjamin. *Kandinsky. Catalogue Raisonné of the Oil Paintings*. 2 vols. Ithaca, N.Y.: Cornell University Press, 1982.

Sabarsky, Serge. *Egon Schiele*. New York: Rizzoli, 1985.

Samuel, Richard and R. Hinton Thomas. *Expressionism in German Life, Literature, and the Theatre (1910–1924)*. Cambridge, England: W. Heffer & Sons, Ltd., 1939.

Schvey, Henry. *Oskar Kokoschka, the Painter as Playwright*. Detroit: Wayne State University Press, 1982.

Shanes, Eric. *Constantin Brancusi*. New York: Abbeville Press, 1989.

Urban, Martin. *Emil Nolde: Catalogue Raisonné of the Oil Paintings*. 2 vols. London: Sotheby's Publications, 1987–90.

Vergo, Peter. *Art in Vienna, 1898–1918: Klimt, Kokoschka, Schiele, and Their Contemporaries*. London: Phaidon, 1975.

Vogt, Paul. *Erich Heckel*. Recklinghausen, Germany: Bongers, 1965.

———. *Expressionism: German Painting, 1905–1920*. Trans. A. Vivus. New York: H.N. Abrams, 1980.

Voices of German Expressionism, Comp, and ed, by Victor H. Miesel. London: Tate; New York: Distr. in North America by H.N. Abrams, 2003, 1970.

Weiler, Clemens. *Alexej Jawlensky*. Cologne: M. Du Mont Schauberg, 1959.

Whitford, Frank. *Expressionist Portraits*. New York: Abbeville Press, 1987.

Zigrosser, Carl. *The Expressionists: A Survey of Their Graphic Art*. New York: G. Braziller, 1957.

Zweite, Armin. *The Blue Rider in the Lenbachhaus, Munich: Masterpieces by Franz Marc, Vassily Kandinsky, Gabriele Münter, Alexei Jawlensky, August Macke, Paul Klee, Armin Zweite*. Commentaries and biographies by Annegret Hoberg. Munich: Prestel; New York: Distr. in the U.S. and Canada by Neues Publishing Co., 1989.

8. Cubism

Apollinaire, Guillaume. *The Cubist Painters*. Trans.with commentary by Peter Read. Berkeley, Calif.: University of California Press, 2004.

Arnason, H. H. *Jacques Lipchitz: Sketches in Bronze*. New York: Praeger, 1969.

Art of the Twentieth Century. Trans. Antony Shugaar. 5 vols. Vol. 1. *1900–1919: The Avant-Garde Movements*; Vol. 2. *1920–1945: The Artistic Culture Between the Wars*; Vol. 3. *1946–1968: The Birth of Contemporary Art*; Vol. 4. *1968–1999: Neo-Avant-Gardes: Postmodern and Global art*; Vol. 5. *2000 and Beyond: Contemporary Tendencies*. Milan: Skira; New York: Distr. Rizzoli International Publications, 2006.

Barr, Jr., Alfred H. *Cubism and Abstract Art: Painting, Sculpture, Constructions, Photography, Architecture, Industrial Art, Theatre, Films, Posters, Typography*. Reprint of the 1939. ed. Cambridge, Mass.: Belknap Press of Harvard University Press, 1986.

———, ed. Picasso: *75th Anniversary Exhibition*. New York: MOMA, 1957.

Bois, Yve-Alain. *Painting as Model*. Cambridge, Mass.: MIT Press, 1990.

Brooke, Peter. *Albert Gleizes: For and Against he Twentieth Century*. New Haven, Conn.: Yale University Press, 2001.

Brunhammer, Yvonne. *Fernand Léger: The Monumental Art*. Milan, Italy: 5 Continents, 2005.

Cogniat, Raymond. *Georges Braque: Rétrospective*. Saint-Paul: Foundation Maeght, 1994.

Clement, Russell T. *Georges Braque: A Bio-bibliography*. Westport, Conn.: Greenwood Press, 1994.

Cooper, Douglas. *The Cubist Epoch*. New York and London: LACMA, MMA, and Phaidon, 1970.

———, and Gary Tinterow. *Essential Cubism: Braque, Picasso and Their Friends, 1907–1920*. London: Tate, 1983.

———, ed. *Letters of Juan Gris (1913–1927)*. London: Lund Humphries, 1956.

Cowling, Elizabeth, and John Golding. *Picasso: Sculptor/Painter*. London: Tate, 1994.

———. *Visiting Picasso: The Notebooks and Letters of Roland Penrose*. New York: Thames & Hudson, 2006.

Esteban Leal, Paloma. *Juan Gris: Paintings and Drawings, 1910–1927*. Madrid: Museo Nacional Centro de Arte Reina Sofia, 2005.

FitzGerald, Michael C. *Picasso and American Art*. With a chronology by Julia May Boddewyn. New York: WMAA; New Haven, Conn.: Yale University Press, 2006.

Flam, Jack, ed. *Primitivism and Twentieth-Century Art: A Documentary History*. Berkeley, Calif.: University of California Press, 2003.

Gantefürher-Trier, Anne and Ute Grosenick. *Cubism.* Köln, Germany; Los Angeles: Taschen, 2004.

Golding, John. *Braque, the Late Works.* New Haven, Conn.: Yale University Press, 1997.

———. *Cubism: A History and an Analysis, 1907–1914.* 3rd ed. Cambridge, Mass.: Belknap Press of Harvard University Press, 1988.

Green, Christopher. *Cubism and Its Enemies.* New Haven, Conn.: Yale University Press, 1987.

———. *Juan Gris.* New Haven, Conn.: Yale University Press, 1992.

———. *Léger and the Avant-Garde.* New Haven, Conn.: Yale University Press, 1976.

———. *Picasso: Architecture and Vertigo.* New Haven: Yale University Press, 2005.

Harrison, Charles, Francis Frascina, and Gill Perry. *Primitivism, Cubism, Abstraction: The Early Twentieth Century.* New Haven, Conn.: Yale University Press, 1993.

Hicken, Adrian. *Apollinaire, Cubism and Orphism.* Aldershot, England; Burlington, Vt: Ashgate, 2002.

Hofmann, Werner, and Daniel-Henry Kahnweiler. *The Sculpture of Henri Laurens.* New York: H.N. Abrams, 1970.

Jacques Villon, Raymond Duchamp-Villon, Marcel Duchamp. New York: SRGM, 1957.

Kahnweiler, Daniel-Henry. *My Galleries and Painters.* With Francis Crémieux. Trans. by Helen Weaver; new material trans. by Karl Orend. ArtWorks. Boston, Mass.: MFA Publications, 2003.

———. *The Rise of Cubism.* Trans. Henry Aronson. New York: Wittenborn, Schultz, 1949.

Karmel, Pepe. *Picasso and the Invention of Cubism.* New Haven, Conn.: Yale University Press, 2003.

Krauss, Rosalind E. *The Picasso Papers.* New York: Farrar, Straus, and Giroux, 1998.

Lanchner, Carolyn, et al. *Fernand Léger.* New York: MOMA: Distr. H.N. Abrams, 1998.

Leighten, Patricia. *Re-Ordering the Universe: Picasso and Anarchism, 1897–1914.* Princeton, N.J.: Princeton University Press, 1989.

Les Desmoiselles d'Avignon. 2 vols. Paris: Musée Picasso, 1988.

Leshko, Jaroslaw. *Alexander Archipenko: Vision and Continuity.* New York: The Ukrainian Museum, 2005.

Lipchitz, Jacques. *My Life in Sculpture.* With H. H. Arnason. *The Documents of 20th-Century Art.* New York: Viking Press, 1972.

Michaelsen, Katherine J. *Alexander Archipenko, a Centennial Tribute.* Washington, D.C.: National Gallery of Art; Tel Aviv: Tel Aviv Museum; New York: Distr. Universe Books, 1986.

Monod-Fontaine, Isabelle, and E. A. Carmean, Jr. *Braque: The Papiers Collés.* Text by A. Martin.Washington, D.C.: National Gallery, 1982.

Nash, Steven A. and Robert Rosenblum, eds. *Picasso and the War Years, 1937–1945.* Contrib. Brigitte Baer, et al. New York: Thames & Hudson; San Francisco: Fine Arts Museums of San Francisco, 1998.

[Picasso] *Cubist Picasso: Musée National Picasso, Paris, September 19, 2007–January 7, 2008.* Curator, Anne Baldassari. Paris: Flammarion; Réunion des Musées Nationaux; New York: Distr. Rizzoli, 2007.

Picasso: Sixty Years of Graphic Works; Aquatints, Dry Points, Engravings, Etchings, Linoleum Cuts, Lithographs, Woodcuts. Los Angeles: LACMA, 1966.

Picasso's Paintings, Watercolors, Drawings and Sculpture: A Comprehensive Illustrated Catalogue, 1885–1973. 17 vols. San Francisco: Alan Wofsy Fine Arts, 1995–2008.

Robinson, William H., et al. *Barcelona and Modernity: Picasso, Gaudí, Miró, Dalí.* Cleveland, OH: Cleveland Museum of Art in assoc. with Yale University Press, 2006.

Rosenblum, Robert. *Cubism and Twentieth-Century Art.* New York: H.N. Abrams, 2001, 1976.

Rubin, William. *Les Demoiselles d'Avignon. Special Issue.* New York: MOMA; Distr. H.N. Abrams, 1994.

———, ed. *Pablo Picasso: A Retrospective.* New York: MOMA, 1980.

———, ed. *Picasso and Braque: Pioneering Cubism.* New York: MOMA, 1989.

———, ed. *"Primitivism" in 20th-Century Art: Affinity of the Tribal and the Modern.* 2 vols. New York: MOMA, 1984.

Schapiro, Meyer. *The Unity of Picasso's Art.* New York: George Braziller, 2000.

Schmalenbach, Werner. *Léger.* New York: H.N. Abrams, 1976.

Shoemaker, Innis H. *Jacques Villon and his Cubist Prints.* Philadelphia, Pa.: Philadelphia Museum of Art; New York: Distr. D.A.P., 2001.

Spate, Virginia. *Orphism: The Evolution of Non-Figurative Painting in Paris: 1910–1914.* Oxford; New York: Clarendon Press and Oxford University Press, 1979.

Steinberg, Leo. "The Philosophical Brothel." *October* 44 (Spring 1988): 7–74.

———. "The Polemical Part." *Art in America* 67:2 (March–April 1979): 114–127.

———. "Resisting Cézanne: Picasso's 'Three Women.'" *Art in America* (November–December 1978): 114–133.

Švestka, Jiří and Tomáš Vlček, eds. *Czech Cubism 1909–1925: Art, Architecture, Design.* Trans. Derek Paton, et al. Prague, Czech Republic: i3 CZ: Modernista, 2006.

[Villon] *Jacques Villon, Master of Graphic Art (1875–1963).* Text by P. A. Wick. Boston: MOFA, 1964.

Wallen, Burr, and Donna Stein. *The Cubist Print.* Santa Barbara, Calif.: University of California Art Museum, 1981.

Wight, Frederick. *Jacques Lipchitz: A Retrospective Selected by the Artist.* Los Angeles: UCLA Art Galleries, 1963.

Wilkin, Karen. *Georges Braque.* New York: Abbeville Press, 1991.

Wilkinson, Alan G. *Jacques Lipchitz: A Life in Sculpture.* Toronto: Art Gallery of Ontario, 1989.

Zelevansky, Lynn, ed. *Picasso and Braque, A Symposium.* New York: MOMA, 1992.

Zurcher, Bernard. *Georges Braque: Life and Work.* Trans. S. Nye. New York: Rizzoli, 1988.

9. Early Twentieth-Century Architecture

Anderson, Stanford. *Peter Behrens and a New Architecture for the Twentieth Century.* Cambridge, Mass.: MIT Press, 2000.

Bock, Ralf. *Adolf Loos: Works and Projects.* Trans. Lorenzo Sanguedolce. Milan, Italy: Skira, 2007.

Britton, Karla Marie Cavarra. *Auguste Perret.* London: Phaidon, 2001.

Gebhard, David. *Schindler.* Preface by Henry-Russell Hitchcock. 3rd ed. San Francisco: William Stout, 1997.

Gold, John Robert. *The Experience of Modernism: Modern Architects and the Future City 1928–53.* London; New York: E & FN Spon, 1997.

Haiko, Peter, ed. *Architecture of the Early XX Century.* Trans. G. Clough. New York: Rizzoli, 1989.

Hitchcock, Henry-Russell. *In the Nature of Materials: The Buildings of Frank Lloyd Wright, 1887–1941.* New foreword and bibliography by the author. New York: Da Capo Press, 1975, 1942.

Hudson, Hugh D. *Blueprints and Blood: the Stalinization of Soviet Architecture, 1917–1937.* Princeton, N.J.: Princeton University Press, 1994.

Larkin, David, and Bruce Brooks Pfeiffer. *Frank Lloyd Wright: The Masterworks.* New York: Rizzoli, 1993.

Mallgrave, Harry Francis. *Otto Wagner: Reflections on the Raiment of Modernity.* Santa Monica, Calif.: Getty Center for the History of Art and the Humanities, 1993.

McCarter, Robert, ed. *On and by Frank Lloyd Wright: A Primer of Architectural Principles.* London; New York: Phaidon, 2005.

Meyer, Esther da Costa. *The Work of Antonio Sant'Elia: Retreat into the Future.* New Haven, Conn.: Yale University Press, 1995.

Oechslin, Werner. *Otto Wagner, Adolf Loos, and the Road to Modern Architecture.* Trans. Lynette Widder. Cambridge, England; New York: Cambridge University Press, 2002.

O'Gorman, James F. *Three American Architects: Richardson, Sullivan, and Wright, 1865–1915.* Chicago: University of Chicago Press, 1991.

Riley, Terrence, and Peter Redd, eds. *Frank Lloyd Wright, Architect.* New York: MOMA, 1994.

Sarnitz, August. *Otto Wagner, 1841–1918: Forerunner of Modern Architecture.* Köln, Germany; Los Angeles: Taschen, 2005.

Schezen, Roberto and Peter Haiko. *Vienna 1850–1930, Architecture.* Trans. Edward Vance Humphrey. New York: Rizzoli, 1992.

Scully, Vincent. *Frank Lloyd Wright.* New York: G. Braziller, 1960.

———. *Modern Architecture and Other Essays.* Selected, with introductions by Neil Levine. Princeton, N.J.: Princeton University Press, 2003.

Taverne, Ed, et al. *J.J.P. Oud, 1890–1963: Poetic Functionalist; The Complete Works.* Rotterdam: NAi Publishers, 2001.

Tournikiotis, Panayotis. *Adolf Loos.* New York: Princeton Architectural Press, 1994.

Wright, Frank Lloyd. *The Essential Frank Lloyd Wright: Critical Writings on Architecture.* Ed. by Bruce B. Pfeiffer. Princeton; Oxford, England: Princeton University Press, 2008.

———. *Collected Writings.* Ed. Bruce B. Pfeiffer. 5 vols. New York: Rizzoli, 1992–95.

Zevi, Bruno. *Erich Mendelsohn: The Complete Works.* Trans. Lucinda Byatt. Basel, Switzerland; Boston: Birkhäuser, 1999.

10. European Responses to Cubism

Apollonio, Umbro, ed. *Futurist Manifestos.* Trans. Robert Brain, et al. With a new afterword by Richard Humphreys. Boston, Mass.: MFA Publications, 2001.

Art into Life: Russian Constructivism, 1914–32. New York: Rizzoli, 1990.

Art of the Twentieth Century. Trans. Antony Shugaar. 5 vols. Vol. 1. *1900–1919: The Avant-Garde Movements,* Vol. 2. *1920–1945: The Artistic Culture Between the Wars;* Vol. 3. *1946–1968: The Birth of Contemporary Art;* Vol. 4. *1968–1999: Neo-Avant-Gardes: Postmodern and Global art;* Vol. 5. *2000 and Beyond: Contemporary Tendencies.* Milan, Italy: Skira; New York: Distr. Rizzoli International Publications, 2006.

Baal-Teshuva, Jacob, ed. *Chagall, a Retrospective.* New York: Hugh Lauter Levin Assoc., 1995.

———. *Marc Chagall, 1887–1985.* Köln, Germany; New York: Taschen, 1998.

Baldacci, Paolo. *De Chirico: The Metaphysical Period, 1888–1919.* Trans. Jeffrey Jennings. Boston: Little, Brown, 1997.

Barron, Stephanie, and Maurice Tuchman. *The Avant-Garde in Russia, 1910–1930: New Perspectives.* Los Angeles: LACMA, 1980.

Basner, Elena, et al. Natalia Goncharova: *The Russian Years.* Trans. Kenneth MacInnes. St. Petersburg, Russia: State Russian Museum, Palace Editions, 2002.

Black, Jonathan, et al. *Blasting the Future!: Vorticism in Britain 1910–1920.* London: Philip Wilson; New York: Distr. Palgrave Macmillan, 2004.

Botar, Oliver A. I. *Technical Detours: The Early Moholy-Nagy Reconsidered.* New York: Art Gallery of the Graduate Center, the City University of New York: Salgo Trust for Education, 2006.

Bowlt, John E, and Matthew Drutt, eds. *Amazons of the Avant-Garde: Alexandra Exter, Natalia Goncharova, Liubov Popova, Olga Rozanova, Varvara Stepanova, and Nadezhda Udaltsova.* New York: SRGM: Distr. H.N. Abrams, 2000.

Bowlt, John, ed. and trans. *Russian Art of the Avant-Garde: Theory and Criticism, 1902–1934.* Rev. and enl. ed. New York: Thames & Hudson, 1988.

———, and Rose-Carol Washton Long, eds. *The Life of Vasilii Kandinsky in Russian Art: A Study of "On the Spiritual in Art."* Trans. J. Bowlt. Newtonville, Mass.: Oriental Research Partners, 1980.

Bown, Matthew Cullerne. *Socialist Realist Painting.* New Haven, Conn.: Yale University Press, 1998.

Bruni, Claudio, and Maria Drudi Gambillo, eds. *After Boccioni, Futurist Paintings and Documents from 1915 to 1919.* Trans. H. G. Heath. Rome: Studio d'arte contemporanea, La Medusa, 1961.

Cardullo, Bert and Robert Knopf, eds. *Theater of the Avant-Garde, 1890–1950: A Critical Anthology.* New Haven, Conn.: Yale University Press, 2001.

Chagall, Marc. *My Life.* New York: Da Capo Press, 1994, 1960.

Coen, Ester. *Umberto Boccioni.* New York: MMA, 1988.

Cork, Richard. *Vorticism and Abstract Art in the First Machine Age.* Berkeley, Calif.: University of California Press, 1976.

Dabrowski, Magdalena, et al. *Aleksandr Rodchenko.* New York: MOMA: Distr. H.N. Abrams, 1998.

Dabrowski, Magdalena. *Contrasts of Form: Geometric Abstract Art, 1910–1980.* New York: MOMA, 1985.

———. *Liubov Popova.* New York: MOMA, 1991.

D'Andrea, Jean. *Kazimir Malevich, 1878–1935.* Los Angeles: Armand Hammer Museum of Art, 1990.

Drutt, Matthew, ed. *Kazimir Malevich: Suprematism.* New York: SRGM; Distr. H.N. Abrams, 2003.

Edwards, Paul, ed. *Blast: Vorticism: 1914–1918.* Aldershot, England; Burlington, VT: Ashgate, 2000.

Elliott, David. *New Worlds: Russian Art and Society: 1900–1935.* London: Thames & Hudson, 1986.

———, ed. *Photography in Russia, 1840–1940.* London: Thames & Hudson, 1992.

Etlin, Richard A. *Modernism in Italian Architecture, 1890–1940.* Cambridge, Mass.: MIT Press, 1991.

Fagiolo del'Arco, Maurizio, et al. *De Chirico: Essays.* Ed. by William Rubin. New York: MMA, 1982.

Gauss, Ulrike, et al. *Marc Chagall, The Lithographs: La Collection Sorlier.* Ostfildern-Ruit, Germany: Hatje Cantz, 1998.

Gray, Camilla, and Marian Burleigh-Motley. *Russian Experiment in Art: 1863–1922.* Rev. ed. London; New York: Thames & Hudson, 1986.

The Great Utopia: The Russian and Soviet Avant-Garde. New York: SRGM, 1992.

Groys, Boris and Max Hollein, eds. *Dream Factory Communism: The Visual Culture of the Stalin Era = Traumfabrik Kommunismus: die visuelle Kultur der Stalinzeit.* Frankfurt, Germany: Schirn Kunsthalle; Ostfildern-Ruit, Germany: Hatje Cantz; New York: D.A.P./Distributed Art Publishers, 2003.

Guerman, Mikhail, ed. *Art of the October Revolution.* Trans. W. Freeman, D. Saunders, and C. Binns. New York: H.N. Abrams, 1979.

Haftmann, Werner. *Chagall.* Trans. H. Baumann and A. Brown. New York: Abradale Press, H.N. Abrams, 1998, 1973

———. *Marc Chagall: Gouaches, Drawings, Watercolors.* Trans. R. E. Wolf. New York: H.N. Abrams, 1984.

Hahl-Koch, Jelena. *Kandinsky.* New York: Rizzoli, 1993.

Hanson, Anne Coffin, ed. *The Futurist Imagination: Word + Image in Italian Futurist Painting, Drawing, Collage, and Free-word Poetry.* New Haven, Conn.: Yale University Art Gallery 1983.

———. *Severini Futurista, 1912–1917.* New Haven, Conn.: Yale University Art Gallery, 1995.

Harshav, Benjamin. *Marc Chagall and the Lost Jewish World: The Nature of Chagall's Art and Iconography.* New York: Rizzoli, 2006.

Hoffman, Katherine, ed. *Collage: Critical Views.* Ann Arbor, Mich.: UMI Research Press, 1989.

Hulten, Pontus. *Futurism and Futurisms.* New York: Abbeville Press, 1986.

Humphreys, Richard. *Futurism. Movements in Modern Art.* Cambridge, England; New York: Cambridge University Press, 1999.

Kandinsky, Vasily. *Complete Writings on Art.* Ed. K. Lindsay and P. Vergo. *Documents of Twentieth-Century Art.* 2 vols. Boston: G. K. Hall, 1982.

———. *Concerning the Spiritual in Art.* Original trans. Michael T. H. Sadler. With a new introd. by Adrian Glew and previously unpublished letters and poems by the author. Boston: MFA Publications, 2006.

Karasik, Irina, et al. *In Malevich's Circle: Confederates, Students, Followers in Russia, 1920s–1950s.* Moscow: The State Russian Museum; Palace Editions, 2000.

Khan-Magomedov, Selim. *Rodchenko: The Complete Work.* Cambridge, Mass.: MIT Press, 1986.

Lavrentiev, Alexander. *Aleksander Rodchenko: Photography is an Art.* Trans. Kate Cook. Mosdow: Interros, 2006.

Lissitzky, El and Sophie Lissitzky-Küppers. *El Lissitzky: Life, Letters, Texts.* Introd. by Herbert Read; trans. Helene Aldwinckle and Mary Whittall, New York: Thames & Hudson, 1992.

Lista, Giovanni. *Balla.* Modena, Italy: Galleria Fonte d'Abisso, 1982.

———. *Futurism & Photography.* London: Merrell in assoc. with the Estorick Collection of Modern Italian Art, 2001.

Lodder, Christina. *Constructive Strands in Russian Art, 1914–1937.* London: Pindar Press, 2005.

———. *Russian Constructivism.* New Haven, Conn.: Yale University Press, 1983.

Malevich, Kazimir Severinovich. *Essays on Art.* Trans. X. Glowacki-Prus and A. McMillin; ed. by Troels Andersen. 4 vols. Copenhagen: Borgen, 1968–78.

———. *Malevich on Suprematism: Six Essays 1915 to 1926.* Edited and introd. by Patricia Railing. Iowa City, Iowa: Museum of Art, The University of Iowa, 1999.

Mansbach, Steven A. *Modern Art in Eastern Europe: From the Baltic to the Balkans, ca. 1890–1939.* Cambridge, England; New York: Cambridge University Press, 1999.

———. *Visions of Totality: László Moholy-Nagy, Theo van Doesberg, and El Lissitzky.* Ann Arbor, Mich.: UMI Research Press, 1980.

Martin, Marianne. *Futurist Art and Theory 1909–1915.* Oxford, England: Clarendon Press, 1968.

———, and Anne Coffin Hanson, eds. *"Futurism."* Art Journal (Winter 1981) special issue.

Martin, Sylvia and Uta Grosenick. *Futurism.* Köln, Germany; Los Angeles: Taschen, 2005.

Milner, John. *Kazimir Malevich and the Art of Geometry.* New Haven, Conn.: Yale University Press, 1996.

———. *A Slap in the Face!: Futurists in Russia.* Exhib. organized by Estorick Collection of Modern Italian Art. London: Philip Wilson Publishers, 2007.

———. *Vladmir Tatlin and the Russian Avant-Garde.* New Haven, Conn.: Yale University Press, 1983.

Monferini, Augusta, Carrà, Carlo, 1881–1966. Milano: Electa, 1994.

Nakov, Andrei B. *Kazimir Malewicz: Catalogue Raisonné.* Paris: A. Biro, 2002

Ocheretianski, Aleksandr. *Literature and Art of Avant-Garde Russia (1890–1930): Bibliographical Index.* Newtonville, Mass.: Oriental Research Partners, 1989.

Petrova, Yevgenia and Jean-Claude Marcadâe, eds. *The Avant-Garde: Before and After.* Trans. Kenneth MacInnes. St. Petersburg, Russia: State Russian Museum, 2005.

Poggi, Christine. *In Defiance of Painting: Cubism, Futurism and the Invention of Collage.* Yale Publications in the History of Art. New Haven, Conn.: Yale University Press, 1992.

Rodchenko, Aleksandr Mikhalovich. *The Future is Our Only Goal.* Ed. by Peter Noever; essays by Aleksandr N. Lavrentiev and Angela Völker; trans. Mathew Frost, et al. Munich: Prestel; New York: Distr. Te Neues, 1991.

Rossi, Laura Mottioli, ed. *Boccioni's Materia: A Futurist Masterpiece and the Avant-Garde in Milan and Paris.* New York: The Solomon R. Guggenheim Foundation, 2004.

Rotzler, Willy. *Constructive Concepts: A History of Constructive Art from Cubism to the Present.* New ed. New York: Rizzoli, 1989.

Rowell, Margit. *The Planar Dimension: Europe 1912–1932.* New York: SRGM, 1979.

Rowell, Margit, et al. *The Russian Avant-Garde Book, 1910–1934.* New York: MOMA: Distr. H.N. Abrams, 2002

———, and Angelika Z. Rudenstine. *Art of the Avant-Garde in Russia: Selections from the George Costakis Collection.* New York: SRGM, 1981.

Schmied, Wieland. *Giorgio de Chirico: The Endless Journey.* Trans. Michael Robinson. Munich; New York: Prestel, 2002.

Taylor, Brandon. *Collage: The Making of Modern Art.* London: Thames & Hudson, 2004.

Tisdall, Caroline and Angelo Bozzolla. *Futurism.* New York: Oxford University Press, 1978, 1977.

Tolstoy, Vladimir, et al. *Street Art of the Revolution: Festivals and Celebrations in Russia, 1918–33.* London: Thames & Hudson, 1990.

Zhadova, Larissa A. *Malevich: Suprematism and Revolution in Russian Art.* Trans. A. Lieven. London: Thames & Hudson, 1982.

———, ed. *Tatlin.* New York: Rizzoli, 1988.

11. Picturing the Wasteland: Western Europe during World War I

Ades, Dawn, ed. *The Dada Reader: A Critical Anthology.* London: Tate, 2006.

———, et al., eds. *In the Mind's Eye: Dada and Surrealism.* New York: Abbeville Press, 1986.

——— *Surrealist Art: The Lindy and Edwin Bergman Collection at the Art Institute of Chicago.* Chicago: Art Institute of Chicago; New York: Thames & Hudson, 1997.

Afuhs, Eva. *Sophie Taeuber-Arp: Gestalterin, Architektin, Tänzerin = Designer, Dancer, Architect.* Zürich: Scheidegger & Spiess, 2007.

Andreotti, Margherita. *The Early Sculpture of Jean Arp.* Ann Arbor, Mich.: UMI Research Press, 1989.

Arnason, H. H. *Reality and Fantasy 1900–1954.* Minneapolis: Walker Art Center, 1954.

Arp, Hans. *On My Way: Poetry and Essays, 1912–1947.* New York: Wittenborn, Schultz, 1948.

Art of the Twentieth Century. Trans. Antony Shugaar. 5 vols. Vol. 1. *1900–1919: The Avant-Garde Movements*; Vol. 2. *1920–1945: The Artistic Culture Between the Wars*, Vol. 3. *1946–1968: The Birth of Contemporary Art*; Vol. 4. *1968–1999: Neo-Avant-Gardes: Postmodern and Global art*; Vol. 5. *2000 and Beyond: Contemporary Tendencies.* Milan: Skira; New York: Distr. Rizzoli International Publications, 2006.

Baker, George T. *The Artwork Caught by the Tail: Francis Picabia and Dada in Paris.* George Baker. Cambridge, Mass.: The MIT Press, 2007.

Barr, Jr., Alfred H., ed. *Fantastic Art, Dada, Surrealism.* Essays by Georges Hugnet. 3rd ed. New York: MOMA, 1947.

Borràs, Maria Lluïsa. *Picabia.* London: Thames & Hudson, 1985.

Bowers, Maggie Ann. *Magic(al) Realism.* London; New York: Routledge, 2004.

Camfield, William A. *Francis Picabia: His Art, Life, and Times.* Princeton, N.J.: Princeton University Press, 1979.

———. *Max Ernst: Dada and the Dawn of Surrealism.* New York: MOMA, 1993.

Caws, Mary Ann, et al. *Surrealism and Women.* Cambridge, Mass.: MIT Press, 1990.

Clair, Jean. *Marcel Duchamp: Catalogue Raisonné.* Paris: Musée National d'Art Moderne, Centre Georges Pompidou, 1977.

Compère-Morel, Thomas, et al. *Otto Dix: The War = der Krieg.* Milan: 5 Continents; Péronne: Historial de la Grande Guerre, 2003.

Dachy, Marc. *The Dada Movement, 1915–1923.* New York: Skira/Rizzoli, 1990.

———. *Dada: The Revolt of Art.* Trans. Liz Nash. New York: H.N. Abrams, 2006.

Dickerman, Leah. *The Dada Seminars.* Washington, D.C.: National Gallery of Art in assoc. with D.A.P./Distributed Art Publishers, 2005.

Dietrich, Dorothea. *The Collages of Kurt Schwitters: Tradition and Innovation.* New York: Cambridge University Press, 1993.

[Dix] *Otto Dix, 1891–1969.* London: Tate, 1992.

Duchamp, Marcel. *Marcel Duchamp, Notes.* Trans. P. Matisse. *Documents of Twentieth-Century Art.* Boston: G. K. Hall, 1983.

Dückers, Alexander. *George Grosz: das druckgraphische Werk = The Graphic Work.* Trans. Steven Connell. San Francisco: A. Wofsy Fine Arts, 1996.

Eberle, Matthias. *World War I and the Weimar Artists: Dix, Grosz, Beckmann, Schlemmer.* New Haven, Conn.: Yale University Press, 1985.

Elderfield, John. *Kurt Schwitters*. New York: MOMA and Thames & Hudson, 1985.

[Ersnt] *Max Ernst: Life and Work: An Autobiographical Collage*. Ed. Werner Spies. New York: Thames & Hudson, in assoc. with Dumont, 2006.

Foresta, Merry. *Man Ray, 1890–1976: His Complete Works*. Düsseldorf: Edition Stemmle, 1989.

——, et al. *Perpetual Motif: The Art of Man Ray*. Washington, D.C.: National Museum of American Art, 1988.

Grosz, George. *George Grosz: An Autobiography*. Trans. Nora Hodges; foreword by Barbara McCloskey. Berkeley, Calif.: University of California Press, 1998.

Hancock, Jane H, and Stefanie Poley. *Arp: 1886–1966*. Minneapolis: Minneapolis Institute of Arts, 1987.

Hannah Höch: Museo Nacional Centro de Arte Reina Sofía, Madrid. Madrid: Aldeasa; Museo Nacional Centro de Arte Reina Sofía, 2004.

Hess, Hans, George Grosz. New Haven, Conn.: Yale University Press, 1985, 1974.

Hopkins, David. *Dada and Surrealism: A Very Short Introduction*. Oxford, England; New York: Oxford University Press, 2004.

——. *Dada's Boys: Masculinity after Duchamp*. New Haven, Conn.: Yale University Press, 2007.

Jones, Amelia. *Postmodernism and the En–Gendering of Marcel Duchamp*. Cambridge, England and New York: Cambridge University Press, 1994.

Kachur, Lewis. *Displaying the Marvelous: Marcel Duchamp, Salvador Dali, and Surrealist Exhibition Installations*. Cambridge, Mass.: MIT Press, 2001.

Krauss, Rosalind. *Bachelors*. Cambridge, Mass: MIT Press, 1999.

Kuenzli, Rudolf, ed. *Dada*. London; New York: Phaidon, 2006.

——. *Dada and Surrealist Film*. Cambridge, Mass.: The MIT Press, 1996.

—— and Francis M. Naumann. *Marcel Duchamp: Artist of the Century*. Cambridge, Mass.: MIT Press, 1989.

Kuthy, Sandor. *Sophie Taeuber–Hans Arp*. Bern: Kunstmuseum Bern, 1988.

Lanchner, Carolyn. *Sophie Taeuber-Arp*. New York: MOMA, 1981.

Lavin, Maud. *Cut with the Kitchen Knife: The Weimar Photomontages of Hannah Höch*. New Haven, Conn.: Yale University Press, 1993.

Lewis, Beth Irwin. *George Grosz: Art and Politics in the Weimar Republic*. Rev. ed. Princeton, N.J.: Princeton University Press, 1991.

Makela, Maria. *The Photomontages of Hannah Höch*. Minneapolis: Walker Art Center, 1996.

Masheck, Joseph, ed. *Marcel Duchamp in Perspective*. Cambridge, Mass.: Da Capo Press, 2002.

Motherwell, Robert, ed. *The Dada Painters and Poets: An Anthology*. 2nd ed. Cambridge, Mass.: Belknap Press of Harvard University Press, 1989.

Müller-Alsbach, Annja and Heinz Stahlhut, eds. *Kurt Schwitters: MERZ, a Total Vision of the World*. Bern: Benteli, 2004.

Mundy, Jennifer, ed. *Duchamp, Man Ray, Picabia*. London: Tate, 2008.

Naumann, Francis M. *Conversion to Modernism: The Early Work of Man Ray*. With an essay by Gail Stavitsky. New Brunswick, N. J.: Rutgers University Press; Montclair, N. J.: Montclair Art Museum, 2003.

Neue Sachlichkeit: New Objectivity in Weimar Germany New York: Ubu Gallery, 2004.

Orchard, Karin and Isabel Schulz. *Kurt Schwitters, Catalogue Raisonné*. 3 vols. Ostfildern-Ruit, Germany: Hatje Cantz, 2000–06.

Paz, Octavio. *Marcel Duchamp: Appearance Stripped Bare*. New York: Viking Press, 1978.

Penrose, Roland. *Man Ray*. New York: Thames & Hudson: 1989, 1975.

Rau, Bernd. *Jean Arp: The Reliefs, Catalogue of Complete Works*. New York: Rizzoli, 1981.

Richter, Hans. *Dada, Art, and Anti-Art*. New York: Thames & Hudson, 1997, 1965.

Robertson, Eric. *Arp: Painter, Poet, Sculptor*. New Haven, Conn.: Yale University Press, 2006.

Rubin, William. *Dada, Surrealism, and Their Heritage*. New York: MOMA, 1968.

[Sander] *August Sander: Photographer of an Epoch, 1904–1959*. Millerton, N.Y.: Aperture, 1980.

Schulz-Hoffmann, Carla, and Judith Weiss. *Max Beckmann: Retrospective*. St. Louis and Munich: St. Louis Art Museum and Prestel, 1984.

Schwarz, Arturo, ed. *The Complete Works of Marcel Duchamp*. 3rd rev. and expanded ed. New York: Delano Greenridge Editions, 1997.

Selz, Peter. *Max Beckmann*. Modern Masters. New York: Abbeville Press, 1996.

Tatar, Maria. *Lustmord: Sexual Murder in Weimar Germany*. Princeton, N.J.: Princeton University Press, 1995.

Tzara, Tristan. *Seven Dada Manifestos and Lampisteries*. Trans. Barbara Wright. Illus. by Francis Picabia. New York: Riverrun Press, 1981.

Vögele, Christoph, ed. *Sophie Taeuber-Arp: Variations: Arbeiten auf Papier = Works on Paper*. Heidelberg: Kehrer, 2002.

Whitford, Frank, et al. *The Berlin of George Grosz: Drawings, Watercolours, and Prints, 1912–1930*. London: Royal Academy of Arts; New Haven, Conn: Yale University Press, 1997.

Wood, Ghislaine, ed. *Surreal Things: Surrealism and Design*. London: V&A Publications; New York: Distr. H.N. Abrams, 2007.

12. Art in France after World War I

Art of the Twentieth Century. Trans. Antony Shugaar. 5 vols. Vol. 1. *1900–1919: The Avant-Garde Movements*, Vol. 2. *1920–1945: The Artistic Culture Between the Wars*, Vol. 3. *1946–1968: The Birth of Contemporary Art*; Vol. 4. *1968–1999: Neo-Avant-Gardes: Postmodern and Global art*; Vol. 5. *2000 and Beyond: Contemporary Tendencies*. Milan: Skira; New York: Distr. Rizzoli International Publications, 2006.

Buffalo, Audreen, ed. *Explorations in the City of Light : African-American Artists in Paris, 1945–1965*. New York: SMH, 1996.

Golding, John, et al. *Braque, the Late Works*. New Haven, Conn.: Yale University Press, 1997.

Greenough, Sarah, et al. *André Kertész*. Washington: National Gallery of Art; Princeton: Princeton Univercity Press, 2005.

Kleeblatt, Norman L. and Kennesth E. Silver. *An Expressionist in Paris: The Paintings of Chaim Soutine*. Contrib. Romy Golan, et al. New York: Jewish Museum, 1998.

Klein, Mason, ed. *Modigliani: Beyond the Myth*. With essays by Maurice Berger, et al. New York: Jewish Museum; New Haven, Conn.: Yale University Press, 2004.

Mann, Carol. *Modigliani*. World of Art. New York: Oxford University Press, 1980.

——. *Paris Between the Wars*. New York: Vendome Press, 1996.

Modigliani, Jeanne. *Modigliani: Man and Myth*. New York: Orion, 1958.

Musée Utrillo-Valadon. *Maurice Utrillo, Suzanne Valadon: Catalogue du Musée*. Sannois: Musée Utrillo-Valadon, 2006.

Nacenta, Raymond. *School of Paris: The Painters and the Artistic Climate of Paris Since 1910*. New York: Alpine Fine Arts Collection, 1981.

Perez-Tibi, Dora. *Dufy*. Trans. S. Whiteside. London: Thames & Hudson, 1989.

Rose, June. *Modigliani, the Pure Bohemian*. London: Constable, 1990.

Sayag, Alain, et al. *Brassaï: The Monograph*. Trans. J. Brenton and H. Mason. Boston: Little, Brown and Company, 2000.

——. *Brassaï: "No Ordinary Eyes."* Trans. J. Brenton and H. Mason. London: Thames & Hudson, 2000.

Silver, Kenneth. *Esprit de Corps: The Art of the Parisian Avant-Garde and the First World War, 1914–1925*. Princeton, N.J.: Princeton University Press, 1989.

Turner, Elizabeth Hutton. *Americans in Paris (1921–1931) Man Ray, Gerald Murphy, Stuart Davis, Alexander Calder*. With essays by Elizabeth Garrity Ellis, and Guy Davenport. Washington, D.C.: Counterpoint, 1996.

Werner, Alfred. *Amedeo Modigliani*. New York: H.N. Abrams, 1985.

——. *Chaim Soutine*. New York: H.N. Abrams, 1977.

——. *Maurice Utrillo*. Commentaries by Alfred Werner and Sabine Rewald. New York: H.N. Abrams, 1981.

13. Clarity, Certainty, and Order: de Stijl and the Pursuit of Geometric Abstraction

Art of the Twentieth Century. Trans. Antony Shugaar. 5 vols. Vol. 1. *1900–1919: The Avant-Garde Movements*; Vol. 2. *1920–1945: The Artistic Culture Between the Wars*, Vol. 3. *1946–1968: The Birth of Contemporary Art*; Vol.4. *1968–1999: Neo-Avant-Gardes: Postmodern and Global art*; Vol. 5. *2000 and Beyond: Contemporary Tendencies*. Milan: Skira; New York: Distr. Rizzoli International Publications, 2006.

Bax, Marty. *Complete Mondrian*. Aldershot, England; Burlington, VT: Lund Humphries, 2001.

Blokhuis, Marleen, et al. *Theo van Doesburg, Oeuvre Catalogue*. Ed. by Els Hoek. Utrecht: Centraal Museum; Otterlo: Kröller-Müller Museum, 2000.

Blotkamp, Carel. *Mondrian: The Art of Destruction*. New York: H.N. Abrams, 1995.

Bulhof, Francis, ed. *Nijhoff, Van Ostaijen, "De Stijl": Modernism in the Netherlands and Belgium in the First Quarter of the Twentieth Century*. The Hague, the Netherlands: Nijhoff, 1976.

Doesburg, Theo van. *New Movement in Painting*. Delft: J. Waltman, 1971.

Jaffé, Hans Ludwig C. *De Stijl, 1917–1931: the Dutch Contribution to Modern Art*. Cambridge, Mass.: Belknap Press of Harvard University Press, 1986.

Langmead, Donald. *The Artists of De Stijl: A Guide to the Literature*. Westport, Conn.: Greenwood Press, 2000.

Mondrian, Piet. *The Complete Writings*. Ed. and trans. H. Holtzmann and M. James. *Documents of Twentieth-Century Art*. Boston: G. K. Hall, 1986.

Overy, Paul. *De Stijl*. World of Art. New York: Thames & Hudson, 1991.

Rudenstine, Angelika Z., ed. *Piet Mondrian, 1872–1944*. Boston: Little, Brown, 1994.

Straaten, Evert van. *Theo van Doesburg: Painter and Architect*. The Hague, the Netherlands: SDU, 1988.

Troy, Nancy. *The De Stijl Environment*. Cambridge, Mass.: MIT Press, 1983.

Warncke, Carsten-Peter. *The Ideal as Art: De Stijl, 1917–1931*. Köln, Germany: Taschen, 1991

White, Michael. *De Stijl and Dutch Modernism*. Manchester; New York: Manchester University Press, 2003.

14. Bauhaus and the Teaching of Modernism

Albers, Josef. *Interaction of Color*. Rev. and expanded ed. New Haven, Conn.: Yale University Press, 2006.

——. *Interaction of Color*. Computer file. Edition: Interactive CD-ROM ed., New Haven, Conn.: Yale University Press, 1994.

Art of the Twentieth Century. Trans. Antony Shugaar. 5 vols. Vol. 1. *1900–1919: The Avant-Garde Movements*; Vol. 2. *1920–1945: The Artistic Culture Between the Wars*; Vol. 3. *1946–1968: The Birth of Contemporary Art*; Vol. 4. *1968–1999: Neo-Avant-Gardes: Postmodern and Global art*; Vol. 5. *2000 and Beyond: Contemporary Tendencies*. Milan: Skira; New York: Distr. Rizzoli International Publications, 2006.

Bärmann, Matthias, et al. *Paul Klee: Death and Fire: Fulfillment in the Late Work*. German/English ed. Wabern/Bern: Benteli, 2003.

Bauhaus Photography. Cambridge, Mass.: MIT Press, 1985.

Baumann, Kirsten. *Bauhaus Dessau: Architecture, Design, Concept = Architektur, Gestaltung, Idee*. Berlin: Jovis, 2007.

Bayer, Herbert, Walter Gropius, and Ise Gropius. *Bauhaus, 1919–1928*. New York: MOMA, 1975.

Borchardt-Hume, Achim, ed. *Albers and Moholy-Nagy: From the Bauhaus to the New World*. New Haven, Conn.: Yale University Press, 2006.

Botar, Oliver A. I. *Technical Detours: The Early Moholy-Nagy Reconsidered.* New York: Art Gallery of the Graduate Center, the City University of New York; Salgo Trust for Education, 2006.

Curtis, Penelope. *Kandinsky in Paris: 1934–1944.* Text by V. E. Barnett. New York: SRGM, 1985.

Droste, Magdalena. *Bauhaus, 1919–1933.* Trans. Karen Williams. Köln, Germany: Taschen, 1998.

Fiedler, Jeannine, ed. *Photography at the Bauhaus.* Cambridge, Mass.: MIT Press, 1990.

——— and Hattula Moholy-Nagy. *László Moholy-Nagy: Color in Transparency: Photographic Experiments in Color, 1934–1946.* Göttingen: Steidl; Berlin: Bauhaus-Archiv, 2006.

Gabo, Naum. *Of Diverse Arts.* New York: Pantheon Books, 1962.

Gauss, Ulrike. *Willi Baumeister: Zeichnungen, Gouachen, Collagen.* German/English ed. Stuttgart: Edition Cantz, 1989.

———. *Willi Baumeister: Life and Work.* New York: H.N. Abrams, 1966.

Gropius, Walter. *The New Architecture and the Bauhaus.* Trans. P. Morton Shand, with an introd. by Frank Pick. Cambridge, Mass: M.I.T. Press, 1965.

Hammer, Martin and Christina Lodder. *Constructing Modernity: The Art & Career of Naum Gabo.* New Haven, Conn.: Yale University Press, 2000.

Hight, Eleanor. *Picturing Modernism: Moholy-Nagy and Photography in Weimar Germany.* Cambridge, Mass.: MIT Press, 1995.

Hochman, Elaine S. *Bauhaus: Crucible of Modernism.* Foreword by Dore Ashton. New York: Fromm International, 1997.

Isaacs, Reginald R. *Gropius: An Illustrated Biography of the Creator of the Bauhaus.* Boston: Little, Brown, 1991.

Itten, Johannes. *The Elements of Color; A Treatise on the Color System of Johannes Itten, based on his book The Arts of Color.* New York: John Wiley & Sons, 2001.

———. *Design and Form: The Basic Course at the Bauhaus and Later.* Rev. ed. New York: John Wiley & Sons, 2006.

Josef Albers, A Retrospective. New York: SRGM, 1988.

Kandinsky: Russian and Bauhaus Years, 1915–1933. New York: SRGM, 1983.

Kaplan, Louis. *László Moholy-Nagy: Biographical Writings.* Durham: Duke University Press, 1995.

Kentgens-Craig, Margret. *The Bauhaus and America: First Contacts, 1919–1936.* Cambridge, Mass.: MIT Press, 1999.

[Klee] *Paul Klee Notebooks.* Ed. by Jürg Spiller. 2 vols. Woodstock, N.Y.: Overlook Press, 1992.

———. *The Diaries of Paul Klee, 1898–1918.* Ed, with introd. by Felix Klee. Berkeley, Calif.: University of California Press, 1968, 1964.

Kudielka, Robert. *Paul Klee: The Nature of Creation: Works 1914–1940.* London: Hayward Gallery in assoc. with Lund Humphries, 2002.

Lane, Barbara Miller. *Architecture and Politics in Germany 1918–1945.* New ed. Cambridge, Mass.: Harvard University Press, 1985.

Lehman, Arnold and Brenda Richardson, eds. *Oskar Schlemmer.* Baltimore, Md.: Baltimore Museum of Art, 1986.

Long, Rose-Carol Washton. *Kandinsky: The Development of an Abstract Style.* Oxford Studies in the History of Art and Architecture. Oxford, England and New York: Clarendon Press and Oxford University Press, 1980.

Lupfer, Gilbert. *Walter Gropius, 1883–1969: The Promoter of a New Form.* Köln, Germany: Taschen, 2004.

Maciuika, John V. *Before the Bauhaus: Architecture, Politics and the German State, 1890–1919.* New York: Cambridge University Press, 2005.

Michalski, Sergiusz. *New Objectivity: Painting, Graphic Art and Photography in Weimar Germany, 1919–1933.* Trans. Michael Claridge. Köln, Germany: Taschen, 1994.

Moholy-Nagy, László. *The New Vision, and 1928: Abstract of an Artist.* 3rd rev. ed. New York: Wittenborn Schultz, 1949.

———. *Vision in Motion.* Chicago: P. Theobald, 1947.

Nash, Steven and Jörn Merkert, eds. *Naum Gabo: Sixty Years of Constructivism.* Munich and New York: Prestel, 1985.

Passuth, Krisztina. *Moholy-Nagy.* New York: Thames & Hudson, 1985, 1982.

Roskill, Mark. *Klee, Kandinsky, and the Thought of their Time: A Critical Perspective.* Urbana, Ill.: University of Illinois Press, 1992.

Roters, Eberhard. *Painters of the Bauhaus.* Trans. Anna Rose Cooper. New York: Praeger, 1969, 1965.

Schlemmer, Oskar. *The Theatre of the Bauhaus: László Moholy-Nagy, and Farkas Molnár.* Ed. by Walter Gropius. Trans. Arthur S. Wensinger. Baltimore, Md.: Johns Hopkins University Press, 1996.

Thöner, Wolfgang. *The Bauhaus Life: Life and Work in the Masters' Houses Estate in Dessau.* Leipzig: Seemann, 2003.

Verdi, Richard. *Klee and Nature.* New York: Rizzoli, 1985.

Whitford, Frank, ed. *The Bauhaus: Masters & Students by Themselves.* With additional research by Julia Engelhardt. London: Conran Octopus, 1992.

Wingler, Hans Maria. *The Bauhaus: Weimar, Dessau, Berlin, Chicago.* With additions and bibliographical suppl. Cambridge, Mass.: MIT Press, 1978, 1969.

Willett, John. *Art and Politics in the Weimar Period: The New Sobriety, 1917–1933.* New York: Da Capo Press, 1996.

15. Surrealism and Its Discontents

Abadie, Daniel, ed. *Magritte.* New York: Distr. Art Publishers, 2003.

Abbott, Berenice. *The World of Atget.* New York: Horizon Press, 1979.

Arbaïzar, Philippe, et al. *Henri Cartier-Bresson: The Man, the Image and the World: A Retrospective.* London; New York, N.Y.: Thames & Hudson, 2003.

Assouline, Pierre. *Henri Cartier-Bresson: A Biography.* New York: Thames & Hudson, 2005.

Ades, Dawn and Simon Baker. *Undercover Surrealism: Georges Bataille and 'Documents.'* Cambridge, Mass.: MIT Press, 2006.

Ades, Dawn, et al., eds. *In the Mind's Eye: Dada and Surrealism.* New York: Abbeville Press, 1986.

Alix, Josefina, et al. *André Masson, 1896–1987.* Madrid: Museo Nacional Centro de Arte Reina Sofía, 2004.

Arnason, H. H. *Reality and Fantasy, 1900–1954.* Minneapolis: Walker Art Center, 1954.

Art of the Twentieth Century. Trans. Antony Shugaar. 5 vols. Vol. 1. *1900–1919: The Avant-Garde Movements;* Vol. 2. *1920–1945: The Artistic Culture Between the Wars;* Vol. 3. *1946–1968: The Birth of Contemporary Art;* Vol. 4. *1968–1999: Neo-Avant-Gardes: Postmodern and Global art;* Vol. 5. *2000 and Beyond: Contemporary Tendencies.* Milan: Skira; New York: Distr. Rizzoli International Publications, 2006.

Barr, Jr., Alfred H., ed. *Fantastic Art, Dada, Surrealism.* Essays by Georges Hugnet. 3rd ed. New York: MOMA, 1947.

Blanc, Giulio V., et al. *Wifredo Lam and His Contemporaries.* New York: SMH, 1992.

Bonnefoy, Yves. *Giacometti.* New York: Flammarion/Abbeville Press, 1991.

Breton, André. *Manifestoes of Surrealism.* Ann Arbor, Mich.: University of Michigan Press, 1969.

———. *Surrealism and Painting.* Trans. Simon Watson Taylor; introd. by Mark Polizzotti. Boston, Mass.: MFA Publications; New York: D.A.P./Distributed Art Publishers, 2002, 1965.

———. *What Is Surrealism? Selected Writings.* Ed. and introd. by Franklin Rosemont. New York: Pathfinder, 2001, 1978.

Camfield, William. *Max Ernst: Dada and the Dawn of Surrealism.* Houston and Munich: The Menil Collection and Prestel, 1993.

Carter, Curtis L., et al. *Wifredo Lam in North America.* Milwaukee, Wis.: Patrick and Beatrice Haggerty Museum of Art, Marquette University, 2007.

Caws, Mary Ann, ed. *Surrealism.* London; New York: Phaidon, 2004.

Chadwick, Whitney, ed. *Mirror Images: Women, Surrealism, and Self-Representation.* Essays by Dawn Ades, et al. Cambridge, Mass.: MIT Press, 1998.

———. *Women Artists and the Surrealist Movement.* London: Thames & Hudson, 1985.

Christensen, Hans Dam, et al. *Rethinking Art between the Wars: New Perspectives in Art History.* Copenhagen: Museum Tusculanum Press: University of Copenhagen, 2001.

Dalí, Salvador. *The Collected Writings of Salvador Dalí.* Ed. and trans. by H. Finkelstein. Cambridge, England; New York: Cambridge University Press, 1998.

———. *The Secret Life of Salvador Dalí.* Trans. H. M. Chevalier. New York: Dover, 1993.

De Bock, Paul Aloïse. *Paul Delvaux.* Hamburg: J. Asmus, 1965.

Dervaux, Isabelle. *Surrealism USA.* Contrib. Michael Duncan, et al. New York: National Academy Museum: Ostfildern-Ruit, Germany: Hatje Cantz, 2004.

Descharnes, Robert. *Salvador Dalí, 1904–1989.* Trans. Michael Hulse. Köln, Germany; London: Taschen, 1997.

———. *Salvador Dali: The Work, The Man.* New York: H.N. Abrams, 1997.

Durozoi, Gérard. *History of the Surrealist Movement.* Trans. Alison Anderson. Chicago: University of Chicago Press, 2002.

Ernst, Max. *Beyond Painting, and Other Writings by the Artist and His Friends.* New York: Wittenborn, Schultz, 1948.

Fanés, Fèlix. *Salvador Dalí: The Construction of the Image.* New Haven, Conn.: Yale University Press, 2007.

Fer, Briony. *Realism, Rationalism, Surrealism: Art Between the Wars.* New Haven, Conn.: Yale University Press, 1993.

———, et al. *Transmission: The Art of Matta and Gordon Matta-Clark.* San Diego, Calif.: San Diego Museum of Art, 2006.

Foster, Hal. *Compulsive Beauty.* Cambridge, Mass.: MIT Press, 1993.

Foucault, Michel. *This is Not a Pipe.* With illus. and letters by René Magritte; trans. and ed. by James Harkness. 25th anniversary ed. Berkeley, Calif.; London: University of California Press, 2008.

Gablik, Suzy. *Magritte.* World of Art. Reprint. New York: Thames & Hudson, 1985.

Grant, Kim. *Surrealism and the Visual Arts: Theory and Reception.* Cambridge, England; New York: Cambridge University Press, 2005.

Haslam, Malcolm. *The Real World of the Surrealists.* Introd. by Barbara Rose. New York: Rizzoli, 1978.

Hohl, Reinhold. *Alberto Giacometti: A Retrospective Exhibition.* New York: SRGM, 1974.

Hopkins, David. *Dada and Surrealism: A Very Short Introduction.* Oxford, England; New York: Oxford University Press, 2004.

Klemm, Christian, et al. *Alberto Giacometti.* Zürich: Kunsthaus Zürich; New York: Distr. H.N. Abrams, 2001.

Krauss, Rosalind. *L'amour fou: Photography and Surrealism.* New York: Abbeville Press, 1985.

Kuenzli, Rudolf E., ed. *Dada and Surrealist Film.* Cambridge, Mass.: MIT Press, 1996.

Lanchner, Carolyn. *Joan Miró.* New York: MOMA, 1993.

Lewis, Helena. *The Politics of Surrealism.* New York: Paragon, 1988.

Lippard, Lucy R., ed. *Surrealists on Art.* Englewood Cliffs, N.J.: Prentice Hall, 1970.

Lord, James. *Giacometti, A Biography.* New York: Farrar, Straus and Giroux, 1985.

———. *Mythic Giacometti.* New York: Farrar, Straus and Giroux, 2004.

Magritte, René. *Magritte, the True Art of Painting.* Harry Torczyner, with the collaboration of Bella Bessard. Trans. R. Miller. New York: H.N. Abrams: distrib. by New American Library, 1985, 1979.

Maur, Karin von. *Yves Tanguy and Surrealism.* With essays by Susan Davidson. Trans. John Brownjohn and John S. Southard. Ostfildern-Ruit, Germany: Hatje Cantz; New York: Distr. D.A.P./Distributed Art Publishers, 2001.

Miró, Joan. *Joan Miró: Selected Writings and Interviews*. Ed. M. Rowell. Documents of Twentieth-Century Art. Boston: G. K. Hall, 1986.

Mundy, Jennifer, ed. *Surrealism: Desire Unbound*. Consultant ed., Dawn Ades; special adviser, Vincent Gille. Princeton, N.J.: Princeton University Press, 2001.

Nadeau, Maurice. *History of Surrealism*. Cambridge, Mass.: Harvard University Press, 1989.

Nesbit, Molly. *Atget's Seven Albums*. New Haven, Conn.: Yale University Press, 1992.

Ollinger-Zinque, Gisèle, et al. *Magritte, 1898–1967*. Ghent: Ludion Press; New York: Distr. H.N. Abrams, 1998.

———. *Paul Delvaux, 1897–1994: Royal Museums of Fine Arts of Belgium, Brussels*. Wommelgem: Blondé, 1997.

Picon, Gaëtan. *Surrealists and Surrealism: 1919–1939*. Trans. J. Emmons. New York: Rizzoli, 1977.

Roegiers, Patrick. *Magritte and Photography*. Trans. Mark Polizzotti. Aldershot, England: Lund Humphries; New York: D.A.P./Distributed Art Publishers, 2005.

Rowell, Margit. *Julio González: A Retrospective*. New York: SRGM, 1983.

Rubin, William S. *Dada, Surrealism, and Their Heritage*. New York: MOMA, 1968.

———. *Matta*. New York: MOMA, 1957.

Rubin, William S. and Carolyn Lanchner. *Andre Masson*. New York: MOMA, 1976.

Sims, Lowery Stokes. *Wifredo Lam and the International Avant-Garde, 1923–1982*. Austin, Tex.: University of Texas Press, 2002.

Spies, Werner. *Max Ernst: Life and Work: An Autobiographical Collage*. New York: Thames & Hudson, in assoc. with Dumont, 2006.

———, ed. *Max Ernst, Oeuvre-Katalog*. 7 vols. Houston, Tex.: Menil Foundation; Köln: M. DuMont Schauberg, 1975.

Spies, Werner and Sabine Rewald, eds. *Max Ernst: A Retrospective*. New York: MMA; New Haven: Yale University Press, 2005.

Spiteri, Raymond and Donald LaCoss, eds. *Surrealism, Politics and Culture*. Aldershot, England; Burlington, VT: Ashgate, 2003.

Stich, Sidra. *Anxious Visions: Surrealist Art*. New York: Abbeville Press, 1990.

The Surrealists Look at Art: Eluard, Aragon, Soupault, Breton, Tzara. Introd. by Pontus Hulten. Venice, Calif.: Lapis Press, 1990.

Sylvester, David. *Magritte: The Silence of the World*. New York: H.N. Abrams, 1994.

Szarkowski, John. *Atget. John Szarkowski*. New York: MOMA: Calloway, 2000.

———, and Maria Hambourg. *The Work of Atget*. 4 vols. New York: MOMA, 1981–84.

Walker, Ian. *City Gorged with Dreams: Surrealism and Documentary Photography in Interwar Paris*. Manchester, England; New York: Manchester University Press; New York: Distr. Palgrave, 2002.

Wilson, Laurie. *Alberto Giacometti: Myth, Magic, and the Man*. New Haven, Conn.: Yale University Press, 2003.

Worswick, Clark. *Berenice Abbott, Eugene Atget*. Santa Fe, N.Mex: Arena Editions, 2002.

16. American Art Before World War II

Abbott, Brett. *Edward Weston Photographs From the J. Paul Getty Museum*. Los Angeles: J. Paul Getty Museum, 2005.

Abstract Painting and Sculpture in America: 1927–1944. New York: H.N Abrams, 1984.

[Adams] *Ansel Adams: Images 1924–1974*. Boston: New York Graphic Society, 1974.

Adams, Henry. *Thomas Hart Benton: An American Original*. New York: Alfred A. Knopf, 1989.

———. *Thomas Hart Benton: Drawing from Life*. New York: Abbeville Press, 1990.

Alexander Calder: A Retrospective Exhibition. New York: SRGM, 1964.

Alinder, Mary Street. *Ansel Adams, a Biography*. New York: H. Holt, 1996.

Argenteri, Letizia. *Modotti Between Art and Revolution*. New Haven: Yale University Press, 2003.

Arnason, H. H., and Ugo Mulas, eds. *Calder*. New York: Viking Press, 1971.

Art of the Twentieth Century. Trans. Antony Shugaar. 5 vols. Vol. 1. *1900–1919: The Avant-Garde Movements*; Vol. 2. *1920–1945: The Artistic Culture Between the Wars*; Vol. 3. *1946–1968: The Birth of Contemporary Art*; Vol. 4. *1968–1999: Neo-Avant-Gardes: Postmodern and Global art*; Vol. 5. *2000 and Beyond: Contemporary Tendencies*. Milan: Skira; New York: Distr. Rizzoli International Publications, 2006.

Baigell, Matthew. *The American Scene: American Painting of the 1930s*. New York: Praeger, 1974.

Balken, Debra Bricker, et al. *Arthur Dove: A Retrospective*. Andover, Mass.: Addison Gallery of American Art; Cambridge, Mass.: MIT Press, in assoc. with the Phillips Collection, Washington, D.C., 1997.

Baker, Houston A., Jr. *Modernism and the Harlem Renaissance*. Chicago: Chicago University Press, 1987.

Bochner, Jay. *An American Lens: Scenes From Alfred Stieglitz's New York Secession*. Cambridge, Mass.: MIT Press, 2005.

Brandow, Todd and William A. Ewing. *Edward Steichen: Lives in Photography*. New York: W.W. Norton & Company, 2008.

Breeskin, Adelyn Dohme. *Roots of Abstract Art in America 1910–1930*. Washington, D.C.: Smithsonian Institution, 1965.

Brock, Charles. *Charles Sheeler Across Media*. Washington, D.C.: National Gallery of Art; Berkeley, Calif.: In assoc. with University of California Press, 2006.

Brown, Milton. *Story of the Armory Show: The 1913 Exhibition that Changed American Art*. 2nd ed. New York: Abbeville Press, 1988.

Calo, Mary Ann. *Distinction and Denial: Race, Nation, and the Critical Construction of the African American Artist, 1920–40*. Ann Arbor, Mich.: University of Michigan Press, 2008.

Carr, Carolyn Kinder. *Gaston Lachaise, Portrait Sculpture*. Washington, D.C.: National Portrait Gallery, Smithsonian Institution in assoc. with the Smithsonian Institution Press, 1985.

Conde, Teresa del, ed. *Tamayo*. Trans. Andrew Long and Luisa Panichi. Boston: Little, Brown, 2000.

Corn, Wanda. *Grant Wood: The Regionalist Vision*. New York: WMAA, 1983.

———. *The Great American Thing: Modern Art and National Identity, 1915–1935*. Berkeley, Calif.: University of California Press, 1999.

Craven, David. *Diego Rivera as Epic Modernist*. New York: G.K. Hall; London: Prentice Hall International, 1997.

Curtis, James. *Mind's Eye, Mind's Truth: FSA Photography Reconsidered*. Philadelphia: Temple University Press, 1989.

Danly, Susan. *Georgia O'Keeffe and the Camera the Art of Identity*. With an introd. by Barbara Buhler Lynes. New Haven, Conn.: Yale University Press; Portland, Me.: In assoc. with the Portland Museum of Art, 2008.

Davidson, Abraham. *Early American Modernist Painting: 1910–1935*. New York: Harper & Row, 1981.

Diego Rivera: A Retrospective. New York: Founders Society, Detroit Institute of Arts, in association with W.W. Norton, 1986.

Drohojowska-Philp, Hunter. *Full Bloom: The Art and Life of Georgia O'Keeffe*. New York: W.W. Norton, 2004.

du Pont, Diana, ed. *Tamayo: A Modern Icon Reinterpreted*. Santa Barbara, Calif. Santa Barbara Museum of Art, 2007.

Dwight, Edward. *Armory Show 50th Anniversary Exhibition 1913–1963*. Utica, N.Y.: Munson-Williams-Proctor Institute, 1963.

Eldredge, Charles C. *American Imagination and Symbolist Painting*. New York: Grey Gallery, New York University, 1980.

———. *Georgia O'Keeffe*. Library of American Art. New York: H.N. Abrams, 1991.

———. *Georgia O'Keeffe: American and Modern*. New Haven, Conn.: Yale University Press, 1993.

Fahlman, Betsy. *Chimneys and Towers: Charles Demuth's Late Paintings of Lancaster*. Fort Worth, Tex.: Amon Carter Museum; Philadelphia: Distr. The University of Pennsylvania Press, 2007.

Fávela, Ramón. *Diego Rivera: The Cubist Years*. Phoenix: Phoenix Art Museum, 1984.

Fine, Elsa. *John Marin*. New York and Washington, D.C.: Abbeville Press and National Gallery of Art, 1990.

Fine, Ruth. *The Art of Romare Bearden*. Contrib. Mary Lee Corlett, et al. Washington National Gallery of Art in assoc. with H.N. Abrams, 2003.

Folgarait, Leonard. *So Far From Heaven: David Alfaro Siqueiros' "The March of Humanity" and Mexican Revolutionary Politics*. New York: Cambridge University Press, 1987.

Frank, Robin Jaffee. *Charles Demuth: Poster Portraits, 1923–1929*. New Haven, Conn.: Yale University Art Gallery, 1994.

Frida Kahlo. 1907.2007. Trans. Gregory Dechant. Mexico: D.F. Instituto Nacional de Bellas Artes Editorial RM, 2008.

Furth, Leslie. *Augustus Vincent Tack: Landscape of the Spirit*. With essays by Elizabeth V. Chew and David W. Scott. Washington, D.C.: Phillips Collection, 1993.

Gaston Lachaise: Sculpture. Essay by Barbara Rose. New York: Salander-O'Reilly Galleries; Houston, Tex.: Meredith Long & Co., 1991.

Giménez, Carmen and Alexander S.C. Rower. *Calder: Gravity and Grace*. London; New York: Phaidon, 2004.

Glackens, Ira. *William Glackens and the Eight: The Artists who Freed American Art*. Rev. ed. New York: Horizon Press, 1984.

Goldberg, Vicki. *Margaret Bourke-White: A Biography*. New York: Harper & Row, 1986.

Greenough, Sarah. *Paul Strand: An American Vision*. New York: Aperture Foundation in assoc. with the National Gallery of Art, Washington, 1990.

Greenough, Sarah, and Juan Hamilton. *Alfred Stieglitz, Photographs and Writings*. Washington, D.C.: National Gallery of Art, 1983.

Haaften, Julia van, ed. *Berenice Abbott, Photographer: A Modern Vision: A Selection of Photographs and Essays*. New York: New York Public Library, 1989.

Hambourg, Maria Morris, et al. *Walker Evans*. New York: MMA in assoc. with Princeton University Press, Princeton, 2000.

Hammond, Anne. *Ansel Adams: Divine Performance*. New Haven, Conn.; London: Yale University Press, 2002.

Harnsberger, R. Scott. *Four Artists of the Stieglitz Circle: A Sourcebook on Arthur Dove, Marsden Hartley, John Marin, and Max Weber*. Westport, Conn.: Greenwood Press, 2002.

Harris, Jonathan. *Federal Art and National Culture: The Politics of Identity in New Deal America*. Cambridge, England; New York: Cambridge University Press, 1995.

Haskell, Barbara. *The American Century Art and Culture, 1900–1950*. New York: WMAA in assoc. with W.W. Norton, 1999.

———. *Burgoyne Diller*. New York: WMAA, 1990.

———. *Charles Demuth*. New York: WMAA; H.N. Abrams, 1987.

———. *Elie Nadelman: Sculptor of Modern Life*. New York: WMAA; Distr. H.N. Abrams, 2003.

———. *Joseph Stella*. New York: WMAA, 1994.

Herrera, Hayden. *Frida Kahlo: The Paintings*. New York: HarperCollins, 1991.

Heyman, Therese, et al. *Dorothea Lange: American Photographs*. San Francisco: SFMOMA and Chronicle Books, 1994.

Hobbs, Robert Carleton. *Milton Avery*. Introd. by Hilton Kramer. New York: Hudson Hills Press: Distr. Rizzoli, 1990.

Hole, Heather. *Marsden Hartley and the West: The Search for an American Modernism*. New Haven, Conn.: Yale University Press; Santa Fe, N.Mex.: Georgia O'Keeffe Museum, 2007.

Hunter, Sam. *Lachaise*. New York: Cross River Press, a division of Abbeville Press, 1993.

Hurlburt, Laurance P. *The Mexican Muralists in the United States*. Foreword by David W. Scott. Albuquerque: University of New Mexico Press, 1989.

Jaffe, Irma. *Joseph Stella*. Rev. ed. New York: Fordham University Press, 1988.

Johnson, Diane. *American Symbolist Art: Nineteenth-Century "Poets in Paint": Washington Allston, John La Farge, William Rimmer, George Inness, and Albert Pinkham Ryder.* Lewiston, N.Y.: Edwin Mellen Press, 2004.

Karlstrom, Paul J. *Turning the Tide: Early Los Angeles Modernists, 1920–1956.* Santa Barbara, Calif.: Santa Barbara Museum of Art, 1990.

Kornhauser, Elizabeth Mankin, ed. *Marsden Hartley.* Hartford, Conn.: Wadsworth Atheneum Museum of Art, in assoc. with Yale University Press, 2002.

Lane, John R., and Susan C. Larsen. *Abstract Painting and Sculpture in America 1927–1944.* Pittsburgh: Museum of Art, Carnegie Institute, 1984.

Levin, Gail. *Edward Hopper: A Catalogue Raisonné.* New York: WMAA, 1995.

———. *Edward Hopper: An Intimate Biography.* Updated and expanded ed. New York: Rizzoli, 2007.

———. *Synchromism and American Color Abstraction: 1910–1925.* New York: WMAA, 1978.

Lipman, Jean. *Calder's Universe.* New York: Viking Press and WMAA, 1977.

Longwell, Dennis. *Steichen: The Master Prints, 1895–1914.* New York: MOMA, 1978.

Lorenz, Richard. *Imogen Cunningham: Flora/Photographs.* Boston: Little, Brown, 1996.

Lorquin, Bertrand. *Maillol.* London: Thames & Hudson, 1995.

Lowe, Sarah M. *Tina Modotti: Photographs.* Philadelphia and New York: Philadelphia Museum of Art and H.N. Abrams, 1995.

Lozano, Luis-Martín, et al. *Diego Rivera Art & Revolution.* Mexico City: Instituto Nacional de Bellas Artes; Landucci Editores, 1999.

Lucic, Karen. *Charles Sheeler and the Cult of the Machine.* Cambridge, Mass.: Harvard University Press, 1991.

Lyden, Anne M. *Paul Strand: Photographs from the J. Paul Getty Museum.* Los Angeles: Getty Publications, 2005.

Lynes, Barbara Buhler. *Georgia O'Keeffe Museum Collections.* New York: H.N. Abrams, 2007.

———. *Georgia O'Keeffe and the Calla Lily in American Art, 1860–1940.* With essays by Charles C. Eldredge and James Moore. New Haven, Conn.: Yale University Press in assoc. with the Georgia O'Keeffe Museum, 2002.

Lynes, Barbara Buhler. *O'Keeffe, Stieglitz, and the Critics, 1916–1929.* Chicago: University of Chicago Press, 1991, 1989.

Lyons, Deborah, et al. *Edward Hopper and the American Imagination.* New York: WMAA in assoc. with W.W. Norton, 1995.

Maillol and America. New York: Marlborough Gallery, 2004.

Marter, Joan. *Alexander Calder.* Cambridge, England: Cambridge University Press, 1991.

———. *Beyond the Plane: American Constructions 1930–1965.* Trenton, N.J.: New Jersey State Museum, 1983.

Mellow, James R. *Walker Evans.* New York: Basic Books, 1999.

Meltzer, Milton. *Dorothea Lange: A Photographer's Life.* With a foreword by Naomi Rosenblum. Syracuse, N.Y.: Syracuse University Press, 2000.

Messinger, Lisa Mintz, et al. *African-American Artists, 1929–1945: Prints, Drawings, and Paintings in the Metropolitan Museum of Art.* New York: MMA; New Haven, Conn.: Yale University Press, 2003.

Milosch, Jane C., ed. *Grant Wood's Studio Birthplace of American Gothic.* Contrib. Wanda M. Corn, et al. Munich; New York: Prestel, 2005.

Mora, Gilles, ed. *Edward Weston: Forms of Passion.* New York: H.N. Abrams, 1995.

Morgan, Ann Lee. *Arthur Dove, Life and Work with a Catalogue Raisonné.* Newark: University of Delaware Press; London: Associated University Presses, 1984.

Nasgaard, Roald. *The Mystic North: Symbolist Landscape Painting in Northern Europe and North America, 1890–1940.* Toronto; Buffalo: Published in assoc. with the Art Gallery of Ontario by University of Toronto Press, 1984.

Newhall, Nancy. *Ansel Adams: The Eloquent Light.* Millerton, N.Y.: Aperture, 1980.

———. *From Adams to Stieglitz: Pioneers of Modern Photography.* Introd. by Beaumont Newhall. New York: Aperture, 1989.

———, ed. *The Daybooks of Edward Weston.* Foreword by Beaumont Newhall. 2nd ed. New York: Aperture, 1990.

Niven, Penelope. *Steichen: A Biography.* New York: Clarkson Potter, 1997.

Paul Strand: A Retrospective Monograph, the Years 1915–1968. 2 vols. Millerton, N.Y.: Aperture, 1971.

Peeler, David P. *The Illuminating Mind in American Photography: Stieglitz, Strand, Weston, Adams.* Rochester, N.Y.: University of Rochester Press, 2001.

Phillips, Stephen Bennett. *Margaret Bourke-White: The Photography of Design, 1927–1936.* Washington D.C.: The Phillips Collection in assoc. with Rizzoli, New York, 2003.

Photographs: Berenice Abbott. Foreword, Muriel Rukeyser; introd., David Vestal. Washington, D.C.: Smithsonian Institution Press, 1990.

Porter, James A. *Modern Negro Art.* With new introd. by David C. Driskell. Washington, D.C. Howard University Press, 1992, 1943.

Portrait of a Decade: David Alfaro Siqueiros, 1930–1940. Trans. Lorna Scott Fox. Mexico City: Instituto Nacional de Bellas Artes, 1997.

Powell, Richard J. and David A. Bailey. *Rhapsodies in Black Art of the Harlem Renaissance.* London: Hayward Gallery; Institute of International Visual Arts, Berkeley, Calif.: University of California Press, 1997.

Prather, Marla, et al. *Alexander Calder, 1898–1976.* Washington: National Gallery of Art; New Haven, Conn.: Yale University Press, 1998.

Rathbone, Belinda. *Walker Evans: A Biography.* Boston: Houghton Mifflin, 1995.

Ritchie, A. C. *Charles Demuth.* With a tribute to the artist by Marcel Duchamp. New York: MOMA, 1950.

Roberts, Brady, et al. *Grant Wood: An American Master Revealed.* Davenport, Iowa and San Francisco: Davenport Museum of Art and Pomegranate Art Books, 1995.

Robertson, Bruce. *Marsden Hartley.* Library of American Art. New York: Abrams in assoc. with the National Museum of American Art, Smithsonian Institution, 1994.

Rosenblum, Walter, et al. *America and Lewis Hine: Photographs, 1904–1940.* Millerton, N.Y.: Aperture, 1977.

Rosenthal, Mark. *The Surreal Calder.* With a chronology by Alexander S. C. Rower. Houston, Tex.: Menil Collection; New Haven, Conn.; London: Distr. Yale University Press, 2005.

Rubin, Susan Goldman. *Margaret Bourke-White: Her Pictures Were Her Life.* New York: H.N. Abrams, 1999.

Rylands, Phillip. *Stuart Davis.* Milan: Electa, 1997.

Schmidt Campbell, Mary. *Memory and Metaphor: The Art of Romare Bearden, 1940–1987.* New York: Oxford University Press, 1991.

Simpson, Marc, ed. *Like Breath on Glass: Whistler, Inness, and the Art of Painting Softly.* With essays by Wanda M. Corn, et al. New Haven, Conn.: Yale University Press, 2008.

Sims, Lowery Stokes. *Stuart Davis: American Painter.* New York: MMA, 1991.

Smith, Joel. *Edward Steichen: The Early Years.* Princeton, N.J.: Princeton University Press in assoc. with the MMA, 1999.

Smith, Terry. *Making the Modern: Industry, Art, and Design in America.* Chicago: University of Chicago Press, 1993.

Snyder, Jill. *Against the Stream: Milton Avery, Adolph Gottlieb, and Mark Rothko in the 1930s.* Katonah, N.Y.: Katonah Museum of Art, 1994.

South, Will. *Color, Myth, and Music: Stanton Macdonald-Wright and Synchromism.* Contrib. William C. Agee, et al. Raleigh, N.C.: North Carolina Museum of Art, 2001.

Spirn, Anne Whiston. *Daring to Look: Dorothea Lange's Photographs and Reports From the Field.* Chicago: University of Chicago Press, 2008.

Stebbins, Jr., Theodore E. *Weston's Westons: Portraits and Nudes.* Boston: MOFA, 1994, 1989.

———, and Karen Quinn. *Edward Weston, Photography and Modernism.* Boston: MOFA Bulfinch Press/Little, Brown, 1999.

———. *Weston's Westons: California and the West.* Boston: MOFA, 1994.

Stein, Judith E. *I Tell My Heart: The Art of Horace Pippin.* Philadelphia: Pennsylvania Academy of Fine Arts, 1994.

Steinorth, Karl, et al. *Lewis Hine: Passionate Journey, Photographs, 1905–1937.* Zurich: Edition Stemmle, 1996.

[Tamayo] *Rufino Tamayo: Myth and Magic.* New York: SRGM, 1979.

Troyen, Carol, and Erica Hirschler. *Charles Sheeler: Paintings and Drawings.* Boston: MOFA, 1987.

Troyen, Carol, et al. *Edward Hopper.* Boston: MFA Publications; New York: D.A.P./Distributed Art Publishers, 2007.

Wagner, Anne. *Three Artists (Three Women): Modernism and the Art of Hesse, Krasner, and O'Keeffe.* Berkeley, Calif.: University of California Press, 1996.

Wagstaff, Sheena, ed. *Edward Hopper.* Contrib. David Anfam, et. al. London: Tate, 2004.

Wheat, Ellen Harkins. *Jacob Lawrence, American Painter.* Contrib. Patricia Hills. Seattle: University of Washington Press in assoc. with the Seattle Art Museum, 1986.

Yglesias, Helen. *Isabel Bishop.* New York: Rizzoli, 1989.

Yochelson, Bonnie and Daniel Czitrom. *Rediscovering Jacob Riis: Exposure Journalism and Photography in Turn-of-the-Century New York.* New York: New Press; Distr. W.W. Norton, 2007.

Zurier, Rebecca. *Picturing the City: Urban Vision and the Ashcan School.* Berkeley, Calif.: University of California Press, 2006.

17. Abstract Expressionism and the New American Sculpture

Aaron Siskind 100. New York: PowerHouse Books, 2003.

Ad Reinhardt. *The Museum of Contemporary Art, Los Angeles and The Museum of Modern Art, New York.* Essay by Yve-Alain Bois. New York: Rizzoli, 1991.

Anfam, David. *Abstract Expressionism.* World of Art. New York: Thames & Hudson, 1990.

———. *Franz Kline: Black and White, 1950–1961.* Houston, Tex.: The Menil Collection, 1994.

———. *Mark Rothko: The Works on Canvas: Catalogue Raisonné.* New Haven, Conn.: Yale University Press; Washington: National Gallery of Art, 1998.

Arnason, H. H. *Abstract Expressionists and Imagists.* New York: SRGM, 1961.

———. *Robert Motherwell.* Rev. ed. New York: H.N. Abrams, 1982.

———. *Robert Motherwell: Works on Paper.* New York: MOMA, 1967.

Arshile Gorky: A Retrospective of Drawings. Essays by Janie C. Lee and Melvin P. Lader. New York: WMAA: H.N. Abrams. 2003.

Art of the Twentieth Century. Trans. Antony Shugaar. 5 vols. Vol. 1. *1900–1919: The Avant-Garde Movements*; Vol. 2. *1920–1945: The Artistic Culture Between the Wars*; Vol. 3. *1946–1968: The Birth of Contemporary Art*; Vol. 4. *1968–1999: Neo-Avant-Gardes: Postmodern and Global art*; Vol. 5. *2000 and Beyond: Contemporary Tendencies.* Milan: Skira; New York: Distr. Rizzoli International Publications, 2006.

Ashton, Dore. *About Rothko.* Cambridge, Mass.: Da Capo; London: Eurospan, 2003.

———. *The New York School: A Cultural Reckoning.* New York: Viking Press, 1973.

———. *Noguchi East and West.* Berkeley, Calif.: University of California Press, 1993.

———. *A Critical Study of Philip Guston.* Berkeley, Calif.: University of California Press, 1990, 1976.

Auping, Michael. *Abstract Expressionism: The Critical Developments.* New York: H.N. Abrams, 1987.

_____. *Philip Guston Retrospective*. Essays by Dore Ashton, et al. New York: Thames & Hudson; Fort Worth, Tex.: Modern Art Museum, 2002.

Balken, Debra Bricker. *Abstract Expressionism*. London: Tate; New York: Distr. in North America by H.N. Abrams, 2005.

Barañano, Kosme de and Matthias Bärmann. *Mark Tobey*. Madrid: Museo Nacional Centro de Arte Reina Sofía; Barcelona: Àmbit Servicios Editoriales, 1997.

Bonito Oliva, Achille. *Art Tribes*. Milan: Skira Editore; New York: Distr. Rizzoli through St. Martin's Press, 2002.

Bonk, Ecke. *Joseph Cornell/Marcel Duchamp—In Resonance*. Ostfildern-Ruit, Germany: Hatje Cantz; New York: Distr. in North and South America by D.A.P./Distributed Art Publishers, 1998.

[Bourgeois] *The Iconography of Louise Bourgeois*. New York: Max Hutchinson Gallery, 1980.

Castleman, Riva. *Art of the Forties*. New York: MOMA, 1991.

Caws, Mary Ann. *Robert Motherwell: With Pen and Brush*. London: Reaktion, 2003.

Cernuschi, Claude. *Jackson Pollock: Meaning and Significance*. New York: Icon Editions, 1992.

Christov-Bakargiev, Carolyn. *Franz Kline 1910–1962*. Milan: Skira, 2004.

Cohn, Marjorie B. *Lois Orswell, David Smith, and Modern Art*. Correspondence ed. by Sarah B. Kianovsky. Cambridge, Mass.: Harvard University Art Museums; New Haven, Conn.: Yale University Press, 2002.

Corris, Michael. *Ad Reinhardt. Itineraries*. London: Reaktion, 2003.

Duus, Masayo. *The Life of Isamu Noguchi: Journey Without Borders*. Trans. Peter Duus. Princeton, N.J.: Princeton University Press, 2004.

Engberg, Siri. *Robert Motherwell: The Complete Prints 1940–1991*. Minneapolis: Walker Art Center; New York: Distr. Hudson Hills Press, 2003.

Engelmann, Ines. *Jackson Pollock and Lee Krasner*. Trans. Stephen Telfer. Munich; New York: Prestel, 2007.

Flam, Jack D. *Motherwell*. New York: Rizzoli, 1991.

Fletcher, Valerie J. *Isamu Noguchi: Master Sculptor*. Contrib. Dana Miller and Bonnie Rychlak. London: Scala Publishers; Washington D.C.: Smithsonian Institution; New York: WMAA, 2004.

Gaugh, Harry F. *Franz Kline*. New York: Abbeville Press, 1994.

Giménez, Carmen. *David Smith: A Centennial*. New York: SRGM, 2006.

Godfrey, Mark. *Abstraction and the Holocaust*. New Haven, Conn.; London: Yale University Press, 2007.

Goodman, Cynthia. *Hans Hofmann*. With essays by Cynthia Goodman, Irving Sandler, and Clement Greenberg. Munich: Prestel-Verlag; New York: WMAA: Distr. in U.S. and Canada by Neues, 1990.

Greenberg, Clement. *Clement Greenberg: The Collected Essays and Criticism*. Ed. John O'Brian. Vol. 1. *Perceptions and Judgments, 1939–1944*; Vol. 2. *Arrogant Purpose, 1945–1949*; Vol. 3. *Affirmations and Refusals, 1950–1956*; Vol. 4. *Modernism with a Vengeance, 1957–1969*. Chicago: University of Chicago Press, 1986–93.

Guilbaut, Serge. *How New York Stole the Idea of Modern Art*. Chicago: University of Chicago Press, 1983.

_____, ed. *Reconstructing Modernism: Art in New York, Paris, and Montreal, 1945–1964*. Cambridge, Mass.: MIT Press, 1990.

Harrison, Helen, ed. *Such Desperate Joy: Imagining Jackson Pollock*. New York: Thunder's Mouth Press, 2000.

Hartigan, Lynda Roscoe. *Joseph Cornell: Navigating the Imagination*. Salem, Mass.: Peabody Essex Museum; Washington, D.C.: Smithsonian American Art Museum; New Haven, Conn.; London: In assoc. with Yale University Press, 2007.

Haskell, Barbara. *The American Century: Art and Culture, 1900–1950*. New York: WMAA in assoc. with W.W. Norton, 1999.

Herrera, Hayden. *Arshile Gorky: His Life and Work*. New York: Farrar, Straus, and Giroux, 2003.

Hess, Barbara. *Abstract Expressionism*. Köln, Germany; Los Angeles: Taschen, 2005.

Hirsch, Sanford, and Mary Davis MacNaughton, eds. *Adolph Gottlieb: A Retrospective*. Washington, D.C.: Corcoran Gallery of Art, 1982.

_____. *The Pictographs of Adolph Gottlieb*. Essays by Lawrence Alloway, et al. New York: Hudson Hills Press in assoc. with the Adolph and Esther Gottlieb Foundation, 1994.

Hobbs, Robert Carleton. *Lee Krasner*. Introd. by B. H. Friedman. New York: Independent Curators International in assoc. with H.N. Abrams, 1999.

_____, and Gail Levin. *Abstract Expressionism: The Formative Years*. Ithaca, N.Y.: Cornell University Press, 1981.

Jordan, Jim M., and Robert Goldwater. *The Paintings of Arshile Gorky: A Critical Catalogue*. New York: New York University Press, 1982.

Karmel, Pepe, ed. *Jackson Pollock: Interviews, Articles, and Reviews*. New York: MOMA. Distr. H.N. Abrams, 1999.

Kertess, Klaus. *Willem de Kooning: Drawing Seeing/Seeing Drawing, The Drawing Center*. Santa Fe, N.Mex.: Arena Editions; New York: Distr. D.A.P./Distributed Art Publishers, 1998.

Kingsley, April. *The Turning Point: The Abstract Expressionists and the Transformation of American Art*. New York: Simon & Schuster, 1992.

Krauss, Rosalind. *The Sculpture of David Smith: A Catalogue Raisonné*. New York: Garland Pub., 1977.

Landau, Ellen. *Jackson Pollock*. New York: H.N. Abrams, 1989.

_____, and Claude Cernuschi, eds. *Pollock Matters*. Chestnut Hill, Mass.: McMullen Museum of Art, Boston College; Chicago: Distr. University of Chicago Press, 2007.

Leja, Michael. *Reframing Abstract Expressionism: Subjectivity and Painting in the 1940s*. New Haven, Conn.: Yale University Press, 1993.

Lippard, Lucy R. *Ad Reinhardt*. New York: H.N. Abrams, 1981.

Lisle, Laurie. *Louise Nevelson: A Passionate Life*. New York: Summit Books, 1990.

McShine, Kynaston, ed. *Joseph Cornell*. New York: MOMA, 1990.

Morris, Frances, ed. *Louise Bourgeois*. With essays by Paulo Herkenhoff, et al. New York: Rizzoli, 2008.

Motherwell, Robert. *The Writings of Robert Motherwell*. Ed. by Dore Ashton with Joan Banach. Berkeley, Calif.: University of California Press, 2007.

Nixon, Mignon. *Fantastic Reality: Louise Bourgeois and a Story of Modern Art*. Cambridge, Mass.: MIT Press, 2005.

Obrist, Hans-Ulrich. *John Chamberlain*. Köln, Germany: Walther König; New York: Distr. D.A.P./Distributed Art Publishers, 2006.

O'Connor, Francis V., and Eugene V. Thaw, eds. *Jackson Pollock: A Catalogue Raisonné of Paintings, Drawings, and Other Works*. 4 vols. New York: Yale University Press, 1978.

_____. *Jackson Pollock: A Catalogue Raisonné of Paintings, Drawings, and Other Works*. Supplement ed. by Francis Valentine O'Connor; authorized by The Pollock-Krasner Authentication Board, Inc. New York: Pollock-Krasner Foundation, 1995.

O'Neill, John P. *Barnett Newman: Selected Writings and Interviews*. Text notes and commentary by Mollie McNickle; Introd. by Richard Shiff. Berkeley, Calif.: University of California Press, 1992.

Polcari, Stephan. *Abstract Expressionism and the Modern Experience*. New York: Cambridge University Press, 1991.

Prather, Marla. *Willem de Kooning/Paintings*. Washington: National Gallery of Art, 1994.

Preble, Michael. *William Baziotes: Paintings and Drawings 1934–1962*. Milan: Skira; New York: Distr. in North America by Rizzoli, 2004.

Puniello, Françoise S. and Halina R. Rusak. *Abstract Expressionist Women Painters: An Annotated Bibliography: Elaine de Kooning, Helen Frankenthaler, Grace Hartigan, Lee Krasner, Joan Mitchell, Ethel Schwabacher*. Lanham, MD: Scarecrow Press, 1996.

Rapaport, Brooke Kamin, ed. *The Sculpture of Louise Nevelson: Constructing a Legend*. Essays by Arthur C. Danto, et al. New York: under the auspices of the Jewish Theological Seminary of America; New Haven: Yale University Press, 2007.

Rosand, David, ed. *Robert Motherwell on Paper: Drawings, Prints, Collages*. New York: H.N. Abrams, 1997.

Rand, Harry. *Arshile Gorky: The Implications of Symbols*. Berkeley, Calif.: University of California Press, 1991.

Rose, Barbara, ed. *Art-as-Art: The Selected Writings of Ad Reinhardt*. Documents of Twentieth-Century Art. New York: Viking Press, 1991, 1975.

Rosenberg, Harold. *Art & Other Serious Matters*. Chicago: University of Chicago Press, 1985.

_____. *The Tradition of the New*. New York: Horizon Press, 1959.

Rosenthal, Stephanie. *Black Paintings: Robert Rauschenberg, Ad Reinhardt, Mark Rothko, Frank Stella*. Trans. Büro Sieveking. Munich: Haus der Kunst; Ostfildern-Ruit, Germany: Hatje Cantz; New York: D.A.P./Distributed Art Publishers, 2006.

Ross, Clifford. *Abstract Expressionism: Creators and Critics*. New York: H.N. Abrams, 1990.

Rothko, Mark. *Writings on Art*. Ed. by Miguel López-Remiro. New Haven: Yale University Press, 2006.

Salvesen, Britt. *Harry Callahan: The Photographer at Work*. Foreword by John Szarkowski with a contribution by Amy Rule. Tucson: Center for Creative Photography, in assoc. with Yale University Press, 2006.

Sandler, Irving. *The New York School: The Painters and Sculptors of the Fifties*. New York: Harper & Row, 1978.

_____. *The Triumph of American Painting: A History of Abstract Expressionism*. New York: Praeger, 1970.

Schreier, Christoph and Michael Semff, eds. *Philip Guston: Works on Paper*. Ostfildern-Ruit, Germany: Hatje Cantz; New York: Distr. in North America by D.A.P./Distributed Art Publishing, 2007.

Shiff, Richard, et al. *Barnett Newman: A Catalogue Raisonné*. Ed. by Ellyn Childs Allison. New Haven, Conn.: Yale University Press; New York: Barnett Newman Foundation, 2004.

Seitz, William. *Abstract Expressionist Painting in America*. The Ailsa Mellon Bruce Studies in American Art. Cambridge, Mass.: Published for the National Gallery of Art, Washington, by Harvard University Press, 1983.

Shapiro, David, and Cecile Shapiro, eds. *Abstract Expressionism: A Critical Record*. New York: Cambridge University Press, 1990.

Solomon, Deborah. *Utopia Parkway: The Life and Work of Joseph Cornell*. New York: Farrar, Straus and Giroux, 1997.

Something to Look Forward To: An Exhibition Featuring Abstract Art by 22 Distinguished Americans of African Descent: The Phillips Museum of Art, Franklin & Marshall College, Lancaster, Pennsylvania: March 26–June 27, 2004. Lancaster, Pa.: Franklin & Marshall College, 2004.

Stevens, Mark and Annalyn Swan. *De Kooning: An American Master*. New York: Alfred. A. Knopf, 2004.

Storr, Robert. *Louise Bourgeois*. London; New York: Phaidon, 2003.

Sylvester, Julie. *John Chamberlain: A Catalogue Raisonné of the Sculpture, 1954–1985*. New York: Hudson Hills Press, 1986.

Temkin, Ann. *Barnett Newman*. Philadelphia: Philadelphia Museum of Art, in assoc. with Yale University Press, 2002.

Tuchman, Maurice, ed. *New York School, The First Generation: Paintings of the 1940s and 1950s.* Los Angeles: LACMA, 1965. With statements by artists and critics.

———, and Carol S. Eliel. *Parallel Visions: Modern Artists and Outsider Art.* Contrib. Barbara Freeman, et al. Los Angeles, Calif.: Los Angeles County Museum of Art; Princeton, N.J.: Princeton University Press, 1992.

———. *The Spiritual in Art: Abstract Painting 1890–1985.* Los Angeles County Museum of Art. With the assistance of Judi Freeman, Carel Blotkamp, et al. New York: Abbeville Press, 1986.

Varnedoe, Kirk. *Jackson Pollock.* New York: MOMA; Distr. in the U.S. and Canada by H.N. Abrams, 1998.

Verderame, Lori. *An American Sculptor: Seymour Lipton.* With an introd. by Irving Sandler. University Park, Pa.: Palmer Museum of Art, Pennsylvania State University; New York: Distr. Hudson Hills Press, 1999.

Wagner, Anne. *Three Artists (Three Women): Modernism and the Art of Hesse, Krasner, and O'Keeffe.* Berkeley, Calif.: University of California Press, 1996.

Waldman, Diane. *Arshile Gorky 1904–1948: A Retrospective.* New York: SRGM, 1981.

———. *Joseph Cornell: Master of Dreams.* New York: H.N. Abrams, 2002.

———. *Mark Rothko in New York.* New York: SRGM, 1994.

———. *Willem de Kooning.* Library of American Art. New York: H.N. Abrams, 1988.

Wehr, Wesley. *Mark Tobey: Light Space.* Trans. Allison Plath-Moseley. Münster: Hachmeister, 2004.

Weiss, Jeffrey. *Mark Rothko.* Contrib. John Gage, et al. Washington: National Gallery of Art, 1998.

Yard, Sally. *Willem De Kooning: Works, Writings, Interviews.* Barcelona, Spain: Ediciones Polígrafa, 2007.

Yohe, James, ed. *Hans Hofmann.* New York: Rizzoli, 2002.

18. Postwar European Art

Agustí, Anna. *Tàpies: The Complete Works.* 8 vols. New York: Rizzoli, 1989.

Art of the Twentieth Century. Trans. Antony Shugaar. 5 vols. Vol. 1. *1900–1919: The Avant-Garde Movements;* Vol. 2. *1920–1945: The Artistic Culture Between the Wars;* Vol. 3. *1946–1968: The Birth of Contemporary Art;* Vol. 4. *1968–1999: Neo-Avant-Gardes: Postmodern and Global art;* Vol. 5. *2000 and Beyond: Contemporary Tendencies.* Milan: Skira; New York: Distr. Rizzoli International Publications, 2006.

Art Since Mid-Century: The New Internationalism. Werner Haftmann, et al. Vol. 1. *Abstract Art Since 1945;* Vol. 2. *Figurative Art Since 1945.* Greenwich, Conn., New York Graphic Society, 1971.

[Balthus] *Vanished Splendors: A Memoir: As Told to Alain Vircondelet.* Introd. by Joyce Carol Oates; trans. Benjamin Ivry. New York: Ecco, 2002.

Berthoud, Roger. *The Life of Henry Moore.* 2nd rev. updated and redesigned ed. London: Giles de la Mare, 2003.

Bonito Oliva, Achille. *Art Tribes.* Milan: Skira Editore; New York: Distr. Rizzoli through St. Martin's Press, 2002.

Bowness, Alan, ed. *Henry Moore: Complete Sculpture.* 6 vols. London: Lund Humphries, 1988.

Carandente, Giovanni, et al. *Eduardo Chillida: Open-Air Sculptures.* Barcelona: Ediciones Polígrafa; New York: Distr. in the U.S. and Canada by D.A.P./Distributed Art Publishers, 2003.

Casè, Pierre, ed. *Marino Marini.* Milan: Skira; New York: Distr. in North America and Latin America by Abbeville Press, 1999.

Ceysson, Bernard. *Soulages.* Trans. Shirley Jennings. New York: Crown Publishers, 1980.

Clair, Jean, ed. *Balthus.* New York: Rizzoli; Distr. St. Martin's Press, 2001.

Curtis, Penelope and Alan Wilkinson. *Barbara Hepworth: A Retrospective.* Liverpool: Tate, 1994.

Da Costa, Valérie. *Jean Dubuffet: Works, Writings and Interviews.* Barcelona: Polgrafa; New York: D.A.P., 2006.

Davis, Alexander. *Henry Moore Bibliography.* 5 vols. Hertfordshire, England: Henry Moore Foundation, 1992–94.

Demetrion, James T. *Francis Bacon, an Exhibition.* HMSG in assoc. with Thames & Hudson, 1989.

———. *Jean Dubuffet, 1943–1963: Paintings, Sculptures, Assemblages.* Essays by Susan J. Cooke, Jean Planque, and Peter Schjeldahl. Washington, D.C.: HMSG in assoc. with the Smithsonian Institution Press, 1993.

Farr, Dennis. *Francis Bacon, a Retrospective.* With essays by Dennis Farr, Michael Peppiatt, and Sally Yard. New York: H.N. Abrams in assoc. with the Trust for Museum Exhibitions, 1999.

Feaver, William. *Lucian Freud.* New York: Rizzoli, 2007.

Franzke, Andreas. *Tàpies.* Munich: Prestel; New York: Distr. in the USA and Canada by Te Neues Publishing Co., 1992.

Gisèle Freund, Photographer. Introd. by C. Caujolle. Trans. J. Shepley. New York: H.N. Abrams, 1985.

Gisele Freund: The Poetry of the Portrait: Photographs of Writers and Artists. With a preface by Gisele Freund. Munich: Schirmer Art Books, 1998.

Gimenez, Carmen. *Tàpies.* New York: SRGM, 1995.

Halem, Ludo van, ed. *CoBrA, the Colour of Freedom: The Schiedam Collection.* Rotterdam: NAi Publishers; Schiedam: Stedelijk Museum, 2003.

Harrison, Martin. *In Camera: Francis Bacon: Photography, Film and the Practice of Painting.* London: Thames & Hudson, 2005.

Hunter, Sam. *Marino Marini—The Sculpture.* New York: Abrams, 1993.

Ishaghpour, Youssef. *Antoni Tàpies: Works, Writings, Interviews.* Barcelona: Ediciones Polígrafa; New York: D.A.P./Distributed Art Publishers, 2006.

Lauter, Rolf, ed. *Lucian Freud, Naked Portraits: Works From the 1940s to the 1990s.* Ostfildern-Ruit, Germany: Hatje-Cantz; New York: Distr. in the U.S. by D.A.P./Distributed Art Publishers, 2001.

Leiris, Michel. *Francis Bacon.* Trans. John Weightman. London: Thames & Hudson, 1988.

Llorens, Tomàs. *Pierre Soulages: VII Premio internacional Julio González, Institut Valencià d'Art Modern.* Valencia: IVAM: Generalitat Valenciana, Conselleria de Cultura, Educació i Esport, 2007

Maizels, John. *Raw Creation: Outsider Art and Beyond.* With an introd. by Roger Cardinal. London: Phaidon, 1996.

Marino Marini, Catalogue Raisonné of the Sculptures. With an introd. by Giovanni Carandente. Milan: Skira, 1998.

Monnier, Virginie. *Balthus: Catalogue Raisonné of the Complete Works.* Trans. Michael Gibson and Ann Sautier-Greening. Paris: Gallimard; New York: Distr. H.N. Abrams, 1999.

Moore, Henry. *Henry Moore: Writings and Conversations.* Ed. and with an introd. by Alan Wilkinson. Berkeley, Calif.: University of California Press, 2002.

Peppiatt, Michael. *Francis Bacon: Anatomy of an Enigma.* New York: Farrar, Straus and Giroux, 1997.

———. *Francis Bacon in the 1950s.* New Haven, Conn.; London: Yale University Press; Norwich, England: in assoc. with the Sainsbury Centre for Visual Arts, University of East Anglia, 2006.

Permanyer, Lluís. *Tàpies and the New Culture.* Trans. K. Lyons. New York: Rizzoli, 1986.

Prat, Jean-Louis. *Nicolas de Staël.* Martigny, Switzerland: Fondation Pierre Gianadda, 1995.

Rathbone, Eliza E. *Nicolas de Staël in America.* Essays by Nicholas Fox Weber and John Richardson. Washington, D.C.: Phillips Collection, 1990.

Rewald, Sabine, ed. *Balthus: Time Suspended: Paintings and Drawings 1932–1960.* Munich: Schirmer/Mosel, 2007.

Rexer, Lyle. *How to Look at Outsider Art.* New York: H.N. Abrams, 2005.

Rhodes, Colin. *Outsider Art: Spontaneous Alternatives.* New York: Thames & Hudson, 2000.

Ritchie, Andrew. *The New Decade: Twenty-two European Painters and Sculptors.* New York: MOMA, 1955.

Russell, John. *Francis Bacon.* Rev. and updated ed. World of Art. New York: Thames & Hudson, 1993.

Selz, Peter, and James Sweeney. *Chillida.* New York: H.N. Abrams, 1986.

Smee, Sebastian. *Lucian Freud.* Köln, Germany; London: Taschen, 2007.

Stephens, Chris, ed. *Barbara Hepworth Centenary.* London: Tate; New York: Distr. in the U.S. and Canada by Abrams, 2003.

Stokvis, Willemijn. *Cobra: The Last Avant-Garde Movement of the Twentieth Century.* Aldershot, England; Burlington, VT: Lund Humphries, 2004.

Sylvester, David. *Looking Back at Francis Bacon.* New York: Thames & Hudson, 2000.

Thistlewood, David. *Barbara Hepworth Reconsidered.* Liverpool: Liverpool University Press and Tate Liverpool, 1996.

Velani, Lydia, ed. *Manzù.* Milan: Electa, 1987.

Weber, Nicholas Fox. *Balthus, a Biography.* New York: Knopf, 1999.

Weiss, Allen S. *Shattered Forms: Art Brut, Phantasms, Modernism.* Albany, N.Y.: SUNY Press, 1992.

Wheeler, Daniel. *Art Since Mid-Century: 1945 to the Present.* New York: Vendome Press; Distr. in the U.S. by Rizzoli International, 1991.

Wye, Deborah. *Antoni Tàpies in Print.* New York: MOMA, 1991.

Zweite, Armin, ed. *Francis Bacon: The Violence of the Real.* London: Thames & Hudson, 2006.

19. Nouveau *Réalisme* and Pop Art

Alloway, Lawrence. *Imagining the Present: Context, Content, and the Role of the Critic.* Ed. with a critical commentary by Richard Kalina. London; New York: Routledge, 2006.

———. *Roy Lichtenstein.* New York: Abbeville Press, 1983.

———, et al. *Christo and Jeanne-Claude: Early Works 1958–1969.* Lawrence Alloway, et al. Köln, Germany: Taschen, 2001.

———, et al. *Modern Dreams: The Rise and Fall and Rise of Pop.* Cambridge, Mass.: MIT Press, 1988.

Anaya, Rodolfo, et al. *Man on Fire: Luis Juimenz = El Hombre en Llamas.* Trans. Margarita B. Montalvo. Albuquerque, N.Mex.: The Albuquerque Museum, 1994.

Arbus, Doon, ed. *Diane Arbus.* 25th anniversary ed. New York: Aperture Foundation, 1997.

Armstrong, Richard. *Richard Artschwager.* New York and London: WMAA, 1988.

———, Laura Lisbon, and Stephen Melville. *As Painting: Division and Displacement.* Columbus, Ohio: Wexner Center for the Arts; Cambridge, MA: MIT Press, 2001.

Art of the Twentieth Century. Trans. Antony Shugaar. 5 vols. Vol. 1. *1900–1919: The Avant-Garde Movements;* Vol. 2. *1920–1945: The Artistic Culture Between the Wars;* Vol. 3. *1946–1968: The Birth of Contemporary Art;* Vol. 4. *1968–1999: Neo-Avant-Gardes: Postmodern and Global Art;* Vol. 5. *2000 and Beyond: Contemporary Tendencies.* Milan: Skira; New York: Distr. Rizzoli International Publications, 2006.

Art Since Mid-Century: The New Internationalism. Werner Haftmann, et al. Vol. 1. *Abstract Art Since 1945;* Vol. 2. *Figurative Art Since 1945.* Greenwich, Conn.: New York Graphic Society, 1971.

Aulich, James and John Lynch, eds. *Critical Kitaj: Essays on the Work of R.B. Kitaj.* New Brunswick, N.J.: Rutgers University Press, 2001.

Auping, Michael, et al. *Jess, a Grand Collage, 1951–1993.* Buffalo, N.Y.: Albright-Knox Art Gallery, 1993.

Avedon, Richard. *Woman in the Mirror.* Essay by Anne Hollander. New York: H.N. Abrams, 2005.

Axsom, Richard H. and David Platzker. *Printed Stuff: Prints, Posters, and Ephemera by Claes Oldenburg: A Catalogue Raisonné 1958–1996.* New York: Hudson Hills Press, 1997.

Baal-Teshuva, Jacob. *Christo & Jeanne-Claude.* Köln, Germany: Taschen, 1995.

————. *Christo: The Reichstag and Urban Projects.* Munich and New York: Prestel, 1993.

Bastian, Heiner, ed. *Andy Warhol: Retrospective.* With essays by Kirk Varnedoe, et al. Rev. ed. London: Tate; Los Angeles: MOCA, 2002.

Berggruen, Olivier, et al. *Yves Klein.* Contrib. Nuit Banai, et al. Ostfildern-Ruit, Germany: Hatje Cantz, 2004.

Bockris, Victor. *Warhol: The Biography.* 75th anniversary ed., 2nd Da Capo Press ed. New York: Da Capo Press, 2003.

Bosworth, Patricia. *Diane Arbus: A Biography.* New York: W.W. Norton, 2005.

Brett, Guy. *Force Fields: Phases of the Kinetic.* Barcelona: Museu d'Art Contemporani: Actar, 2000.

British pop: Museo de Bellas Artes de Bilbao. Ensayos a cargo de Marco Livingstone. Spanish/English ed. Bilbao, Spain: Museo de Bellas Artes de Bilbao, 2005.

Brodie, Judith. *Drawings of Jim Dine.* Washington: National Gallery of Art, 2004.

Broodthaers, Marcel. *Broodthaers: Writings, Interviews, Photographs.* Ed. by Benjamin H.D. Buchloh. Essays by Ranier Borgemeister, et al. Cambridge, Mass.: MIT Press, 1988, 1987.

Buchloh, B.H.D. and Judith F. Rodenbeck. *Experiments in the Everyday: Allan Kaprow and Robert Watts: Events, Objects, Documents.* New York: Miriam and Ira Wallach Art Gallery, Columbia University, 1999.

Carpenter, Elizabeth. *Jim Dine Prints, 1985–2000: A Catalogue Raisonné.* With an essay by Joseph Ruzicka. Minneapolis, Minn.: Minneapolis Institute of Arts, 2002.

Castleman, Riva. *Jasper Johns, A Print Retrospective.* New York: MOMA, 1986.

Celant, Germano. *Manzoni.* Milan: Electa, 2007.

————. *Super Warhol.* Milan: Skira: Monaco: Grimaldi Forum Monaco, 2003.

————, and Lisa Dennison, eds. *New York, New York: Fifty Years of Art, Architecture, Cinema, Performance, Photography and Video.* Milan: Skira; Monaco: Grimaldi Forum, 2006.

Cheim, John, ed. *Andy Warhol Nudes.* Essay by Linda Nochlin. New York: Robert Miller Gallery, 1995.

Chernow, Burt. *Christo and Jeanne-Claude: A Biography.* New York: St. Martin's Press, 2002.

Compton, Michael, et al. *Marcel Broodthaers.* Minneapolis: Walker Art Center and Rizzoli, 1989.

Corlett, Mary Lee. *The Prints of Roy Lichtenstein: A Catalogue Raisonné, 1948–1993.* New York: Hudson Hills Press in assoc. with the National Gallery of Art, Washington, D.C., 1994.

Danto, Arthur C., et al. *Redgrooms.* New York: Rizzoli, 2004.

Diane Arbus: Revelations: San Francisco Museum of Modern Art. New York: Random House, 2003.

Ferguson, Russell. *Hand-painted Pop: American Art in Transition, 1955–1962.* Los Angeles: MOCA, 1992.

Francis, Mark, ed. *Andy Warhol, the Late Work.* Munich: New York: Prestel, 2004.

Frank, Robert. *The Americans.* Introd. by Jack Kerouac. 3rd Scalo ed. New York: Scalo Publishers in assoc. with the National Gallery of Art, Washington: Distr. in North America by D.A.P., 1998.

Friedlander, Lee. *Lee Friedlander at Work.* New York: D.A.P./Distributed Art Publishers, 2002.

Geldzahler, Henry. *Making It New: Essays, Interviews, and Talks.* New York: Turtle Point Press, 1994.

Gianelli, Ida and Marcella Beccaria, eds. *Claes Oldenburg, Coosje van Bruggen: Sculpture By the Way.* Milan: Skira, 2006.

Glenn, Constance. *Time Dust: James Rosenquist. Complete Graphics: 1962–1992.* Long Beach, Calif. and New York: Cal State University and Rizzoli, 1993.

Goldman, Judith. *James Rosenquist: The Early Pictures, 1961–1964.* New York: Gagosian Gallery: Rizzoli, 1992.

Goldsmith, Kenneth, ed. *I'll Be Your Mirror: The Selected Andy Warhol Interviews: 1962–1987.* Introd. by Reva Wolf. New York: Carroll & Graf, 2004.

Goldstein, Ann and Anne Rorimer. *Reconsidering the Object of Art, 1965–1975.* Essays by Lucy R. Lippard, Stephen Melville, and Jeff Wall. Los Angeles: MOCA: Cambridge, Mass.: MIT Press, 1995.

Greene, Alison de Lima and Pierre Restany. *Arman 1955–1991: A Retrospective.* Houston, Tex.: The Museum of Fine Arts, 1991.

Greenough, Sarah, and Philip Brookman. *Robert Frank.* Washington, D.C.: National Gallery of Art, 1994.

Hackett, Pat, ed. *The Andy Warhol Diaries.* New York: Warner Books, 1989.

Haskell, Barbara. *Blam! The Explosion of Pop, Minimalism, and Performance: 1958–1964.* New York: WMAA, 1984.

Hess, Barbara. *Jasper Johns: "The Business of the Eye."* Köln, Germany: Los Angeles: Taschen, 2007.

Hockney, David. *Hockney on "Art": Conversations with Paul Joyce.* London: Little, Brown, 2002.

————. *That's the Way I See It.* Ed. Nikos Stangos. San Francisco: Chronicle Books, 1993.

Hockney's Pictures: The Definitive Retrospective. Comp. and with commentary by David Hockney. New York: Bulfinch Press, 2004.

Hopps, Walter and Sarah Bancroft. *James Rosenquist: A Retrospective.* New York: SRGM, 2003.

Howgate, Sarah and Barbara Stern Shapiro. *David Hockney Portraits.* Essays by Mark Glazebrook, Marco Livingstone and Edmund White. New Haven, Conn.: Yale University Press, 2006.

Hulten, Pontus. *Jean Tinguely: A Magic Stronger Than Death.* New York: Abbeville Press, 1987.

————. *Larry Rivers.* New York: Rizzoli, 1991.

————. *The Machine: As Seen at the End of the Mechanical Age.* New York: MOMA, 1968.

————. *Paris, New York, 1908–1968.* New ed. Paris: Editions du Centre Pompidou: Gallimard, 1991.

Hunter, Sam. *George Segal.* New York: Rizzoli, 1989.

————. *Robert Rauschenberg: Works, Writings and Interviews.* Barcelona, Spain: Ediciones Polígrafa: New York: Available in U.S. and Canada through D.A.P./Distributed Art Publishing, 2006.

Jim Dine: The Photographs, So Far. Paris: Maison Européenne de la Photographie, 2003.

Kaprow, Allan. *Assemblage, Environments, and Happenings.* New York: H.N. Abrams, 1966.

Kienholz: A Retrospective: Edward and Nancy Reddin Kienholz. New York: WMAA, 1996.

Kienholz: Tableau Drawings. Los Angeles: L.A. Louver, 2001.

Kostelanetz, Richard. *On Innovative Performance(s): Three Decades of Recollections on Alternative Theater.* Jefferson, NC: McFarland & Co., 1994.

Kotz, Mary Lynn. *Rauschenberg, Art and Life.* New ed. New York: H.N. Abrams, 2004.

Kozloff, Max. *Jasper Johns.* New York: H.N. Abrams, 1974.

Larry Rivers: Art and the Artist. Foreword by David C. Levy. Essays by Barbara Rose and Jacquelyn Days Serwer. Boston, Mass.: Little, Brown and Company, in assoc. with the Corcoran Gallery of Art, 2002.

Leggio, James, and Susan Weiley, eds. *American Art of the 1960s.* New York: MOMA, 1991.

Lisle, Laurie. *Louise Nevelson: A Passionate Life.* New York: Summit Books, 1990.

Lippard, Lucy. *Pop Art.* Contrib. Lawrence Alloway, Nancy Marmer, Nicolas Calas. World of Art. New York: Thames & Hudson, 1985.

Livingstone, Marco. *David Hockney.* New enl. ed. New York: Thames & Hudson, 1996.

————. *Jim Dine, the Alchemy of Images.* With commentary by Jim Dine. New York: Monacelli Press, 1998.

————. *Pop Art: A Continuing History.* New York: H.N. Abrams, 1990.

————. *R.B. Kitaj.* Rev. and exp. pbk. ed. New York: Thames & Hudson, 1992.

————. *Retrospective George Segal: Sculptures, Paintings, Drawings.* Montreal: Montreal Museum of Fine Arts, 1997.

————, ed. *Pop Art: An International Perspective.* Contrib. Dan Cameron, et al. New York: Rizzoli, 1992.

Lobel, Michael. *Image Duplicator: Roy Lichtenstein and the Emergence of Pop Art.* New Haven, Conn.: Yale University Press, 2002.

Loyall, Claudia, comp. *Richard Lindner: Catalogue Raisonné of Paintings, Watercolors, and Drawings.* Ed. Werner Spies. Munich; New York: Prestel, 1999.

Love and the American Dream: The Art of Robert Indiana. Portland, ME: Portland Museum of Art: Seattle, Wash.: Distr. University of Washington Press, 1999.

Luckhardt, Ulrich and Paul Melia. *David Hockney: A Drawing Retrospective.* San Francisco, Calif.: Chronicle Books, 1996, 1995.

Madoff, Steven Henry, ed. *Pop Art: A Critical History.* Berkeley, Calif.: University of California Press, 1997.

Mahsun, Carol Ann, ed. *Pop Art: The Critical Dialogue.* Ann Arbor, Mich.: UMI Research Press, 1989.

McCarthy, David. *Pop Art.* Cambridge, England; New York: Cambridge University Press; London: Tate, 2000.

McShine, Kynaston, ed. *Andy Warhol, A Retrospective.* New York: MOMA, 1989.

Mercer, Kobena, ed. *Pop Art and Vernacular Cultures.* Cambridge, Mass.: MIT Press; London: Iniva, Institute of International Visual Arts, 2007.

Meyer-Hermann, Eva, et. al. *Allan Kaprow: Art as Life.* Los Angeles: Getty Research Institute, 2008.

Monem, Nadine Käthe, ed. *Pop Art Book.* Contrib. Julia Bigham, et al. London: Black Dog, 2007.

Morphet, Richard, ed. *R. B. Kitaj.* London: Tate, 1994.

Museum Jean Tinguely, Basel: The Collection. Commentaries, Henriette Hahnloser, et al.; bio. Andres Pardey; biblio., Monica Wyss. Berne: Bentali, 1996.

Niki de Saint Phalle: Catalogue Raisonné, 1949–2000. 1 vol. Lausanne; Acatos; Wabern: Benteli, 2001.

Oldenburg, Claes, and Coosje van Bruggen. *Large-Scale Projects.* Contrib. Susan P. Casteras et al. London: Thames & Hudson, 2006.

Phillips, Lisa. *The American Century: Art & Culture, 1950–2000.* New York: WMAA in assoc. with Norton, 1999.

Pincus, Robert L. *On a Scale That Competes with the World: The Art of Edward and Nancy Reddin Kienholz.* Berkeley, Calif.: University of California Press, 1990.

Popper, Frank. *Origins and Development of Kinetic Art.* Trans. S. Bann. Greenwich, Conn.: New York Graphic Society, 1968.

Prather, Marla. *Unrepentant Ego: The Self-Portraits of Lucas Samaras.* New York: WMAA: Distr. H.N. Abrams, 2003.

Rapaport, Brooke Kamin, ed. *The Sculpture of Louise Nevelson: Constructing a Legend.* Essays by Arthur C. Danto, et al. New York: under the auspices of the Jewish Theological Seminary of America; New Haven, Conn.: Yale University Press, 2007.

Restany, Pierre. *Yves Klein: Fire at the Heart of the Void.* 2nd ed. rev. and enl. Putnam, Conn.: Spring Publications, 2005.

Rivers, Larry. *What Did I Do?: The Unauthorized Autobiography.* With Arnold Weinstein. New York: Aaron Asher Books, 1992.

Rondeau, James and Douglas Druick. *Jasper Johns: Gray.* Contrib. Mark Pascale, et al., and an interview with the artist by Nan Rosenthal. Chicago: Art Institute of Chicago; New Haven, Conn.; London: distr. Yale University Press, 2007.

Rosenthal, Nan, and Ruth Fine. *The Drawings of Jasper Johns.* Washington, D.C.: The National Gallery of Art, 1990.

Rowell, Margit. *Cotton Puffs, Q-tips, Smoke and Mirrors: The Drawings of Ed Ruscha.* New York: WMAA: Distr. H.N. Abrams, 2004.

Ruscha, Edward. *Edward Ruscha: Catalogue Raisonné of the Paintings.* 3 vols. New York: Gagosian Gallery; Göttingen: Steidl, 2003.

————. *Edward Ruscha, Editions, 1959–1999: Catalogue Raisonné.* Essays by Siri Engberg and Clive Phillpot. Minneapolis: Walker Art Center: New York: Distributed Art Publishers, 1999.

————. *Leave Any Information at the Signal: Writings, Interviews, Bits, Pages.* Ed. by Alexandra Schwartz. Cambridge, Mass.: MIT Press, 2002.

Russell, John, and Suzi Gablik. *Pop Art Redefined*. New York: Praeger, 1969.

Ryan, Susan Elizabeth. *Robert Indiana, Figures of Speech*. New Haven, Conn.: Yale University Press, 2000.

Sandford, Mariellen, ed. *Happenings and Other Acts*. New York and London: Routledge, 1995.

Sandler, Irving. *American Art of the 1960s*. New York: Harper & Row, 1988.

Schellmann, Jörg and Joséphine Benecke, eds. *Christo and Jeanne-Claude, Prints and Objects, 1963–1995: A Catalogue Raisonné = Christo und Jeanne Claude, Druckgraphik und Objecte 1963–95*. 2nd ed. New York: Edition Schellmann; München: Schirmer Mosel Verlag, 1995.

Schulz-Hoffmann, Carla, ed. *Niki de Saint Phalle*. Preface by Pierre Restany. Contrib. Pontus Hulten et al. New ed. Munich; London: Prestel, 2008.

Schwarz, Dieter, ed. *Richard Artschwager: Texts and Interviews*. Winterthur: Kunstmuseum Winterthur; Düsseldorf: Richter Verlag, 2003.

Seitz, William C. *Art in the Age of Aquarius, 1955–1970*. Comp. and ed. by Marla Price. Washington: Smithsonian Institution Press, 1992.

Shanahan, Mary, ed. *Evidence, 1944–1994: Richard Avedon*. Essays by Jane Livingston and Adam Gopnik. New York: WMAA, 1994.

Shirey, David. *Edward and Nancy Reddin Kienholz: Human Scale*. San Francisco: SFMOMA, 1985.

Siegel, Katy, ed. *High Times, Hard Times: New York Painting, 1967–1975*. Essays by Dawoud Bey, et al. New York: Independent Curators International: D.A.P./Distributed Art Publishers, 2006.

Slemmons, Rod. *Like a One-Eyed Cat: Photographs by Lee Friedlander*. New York and Seattle: H.N. Abrams and Seattle Art Museum, 1989.

Stack, Trudy Wilner. *Winogrand 1964: Photographs from the Garry Winogrand Archive, Center for Creative Photography, University of Arizona*. Santa Fe, N.Mex.: Arena Editions, 2002.

Stich, Sidra. *Yves Klein*. London: Hayward Gallery and Cantz, 1995.

Szarkowski, John. *Winogrand, Figments from the Real World*. New York: MOMA, 1988.

Taylor, Paul. *Post-Pop Art*. Cambridge, Mass.: MIT Press, 1989.

Tomkins, Calvin. *Off the Wall: Robert Rauschenberg and the Art World of Our Time*. Garden City, N.Y.: Doubleday, 1980.

Tuchman, Maurice, ed. *American Sculpture of the Sixties*. Los Angeles: LACMA, 1967.

Vanderlip, Dianne Perry and Deborah Jordy. *Lucas Samaras, Objects and Subjects, 1969–1986*. Essays by Thomas McEvilley, Donald Kuspit, and Roberta Smith. New York: Abbeville Press, 1988.

Varnedoe, Kirk. *Jasper Johns: A Retrospective*. New York: MOMA, 1996.

Violand-Hobi, Heidi E. *Jean Tinguely: Life and Work*. Munich; New York: Prestel, 1995.

Waldman, Diane. *Roy Lichtenstein*. New York: SRGM, 1993.

Weinhardt, Jr., Carl J. *Robert Indiana*. New York: H.N. Abrams, 1990.

Weiss, Jeffrey. *Jasper Johns: An Allegory of Painting, 1955–1965*. John Elderfield, et al. Washington: National Gallery of Art, in assoc. with Yale University Press, New Haven: 2007.

Whiting, Cécile. *Pop L.A.: Art and the City in the 1960s*. Berkeley, Calif.: University of California Press, 2006.

———. *A Taste for Pop: Pop Art, Gender and Consumer Culture*. Cambridge, England: Cambridge University Press, 1997.

Zilcrer, Judith. *Richard Lindner: Paintings and Watercolors, 1948–1977*. With an essay by Peter Selz and documentation by Claudia Loyall. Washington, D.C.: HMSG, Smithsonian Institution: Munich: New York, Prestel, 1996.

20. Playing by the Rules: Sixties Abstraction

Agee, William C. *Kenneth Noland: The Circle Paintings 1956–1963*. Houston, Tex.: Museum of Fine Arts, 1993.

———. *Sam Francis: Paintings, 1947–1990*. Los Angeles: MOCA, 1999.

Alison, Jane, ed. *Colour After Klein: Re-Thinking Colour in Modern and Contemporary Art*. Texts by Donald Judd, Yves Klein, and Hélio Oiticica. London: Barbican Art Gallery: Black Dog Publishing, 2005.

Alloway, Lawrence. *Imagining the Present: Context, Content, and the Role of the Critic*. Ed. with a critical commentary by Richard Kalina. London; New York: Routledge, 2006.

Andre, Carl. *Cuts: Texts 1959–2004*. Ed. with an introd. by James Meyer. Cambridge, Mass.: MIT Press, 2005.

Art of the Twentieth Century. Trans. Antony Shugaar. 5 vols. Vol. 1. *1900–1919: The Avant-Garde Movements*; Vol. 2. *1920–1945: The Artistic Culture Between the Wars*; Vol. 3. *1946–1968: The Birth of Contemporary Art*; Vol. 4. *1968–1999: Neo-Avant-Gardes: Postmodern and Global art*; Vol. 5. *2000 and Beyond: Contemporary Tendencies*. Milan: Skira; New York: Distr. Rizzoli International Publications, 2006.

Art Since Mid-Century: The New Internationalism. Werner Haftmann, et al. Vol. 1. *Abstract Art Since 1945*; Vol. 2. *Figurative Art Since 1945*. Greenwich, Conn., New York Graphic Society, 1971.

Armstrong, Richard and Richard Marshall, eds. *The New Sculpture 1965–1975: Between Geometry and Gesture*. With essays by Richard Armstrong, John G. Hanhardt, and Robert Pincus-Witten. New York: WMAA, 1990.

Axsom, Richard H. *The Prints of Ellsworth Kelly: A Catalogue Raisonné, 1949–1985*. New York: Hudson Hills Press in assoc. with the American Federation of Arts, 1987.

Baker, Kenneth. *Minimalism: Art of Circumstance*. New York: Abbeville Press, 1988.

Barker, Ian. *Anthony Caro: Quest for the New Sculpture*. Aldershot, England; Burlington, VT: Lund Humphries, 2004.

Bastian, Heiner, ed. *Cy Twombly: Catalogue Raisonné of the Paintings*. 4 vols. Berlin: Schirmer/Mosel, 1992–95.

Battcock, Gregory, ed. *Minimal Art: A Critical Anthology*. Berkeley, Calif.: University of California Press, 1995.

Berger, Maurice. *Labyrinth: Robert Morris, Minimalism, and the 1960s*. New York: Harper & Row, 1989.

Bois, Yve-Alain. *Ellsworth Kelly: Tablet, 1948–1973*. New York: Drawing Center; Lausanne: Musée cantonal des beaux-arts, 2002.

Bourdon, David. et al. *Jackie Ferrara Sculpture: A Retrospective*. Sarasota, Fla.: The John and Mable Ringling Museum of Art, 1992.

Colpitt, Frances. *Minimal Art: The Critical Perspective*. Ann Arbor, Mich.: UMI Research Press, 1990.

———, ed. *Abstract Art in the Late Twentieth Century. Contemporary Artists and their Critics*. Cambridge, England; New York: Cambridge University Press, 2002.

Crow, Thomas E. *The Rise of the Sixties: American and European Art in the Era of Dissent*. New Haven, Conn.: Yale University Press, 2004.

Davis, Hugh and Robert Irwin. *Robert Irwin: Primaries and Secondaries*. San Diego, Calif.: MOCA San Diego; New York: D.A.P./Distributed Art Publishers, 2008.

Del Roscio, Nicola, ed. *Cy Twombly: Catalogue Raisonné of Sculpture*. Text by Arthur Danto. 1 vol. Essen: Planco; München: Schirmer/Mosel, 1997.

———. *Writings on Cy Twombly*. Munich: Schirmer/Mosel, 2002.

Elderfield, John. *Morris Louis*. New York: MOMA, 1986.

Elger, Dietmar, ed. *Donald Judd, Colorist*. Ostfildern-Ruit, Germany: Hatje Cantz; New York: Distr. in the U.S. by D.A.P./Distributed Art Publishers, 2000.

Feldman, Paula, et al., eds. *About Carl Andre: Critical Texts Since 1965*. London: Ridinghouse, 2006.

Fine, Ruth. *Helen Frankenthaler Prints*. Washington, D.C. and New York: National Gallery of Art and H.N. Abrams, 1993.

Follin, Frances Marie. *Embodied Visions: Bridget Riley, Op Art and the Sixties*. London: Thames & Hudson, 2004.

Foster, Hal, ed. *Richard Serra*. Essays by Benjamin H.D. Buchloh, et al. Cambridge, Mass.: MIT Press, 2000.

Fried, Michael. *Art and Objecthood: Essays and Reviews*. Chicago: University of Chicago Press, 1998.

Fuchs, Rudi and Donald Judd. *Donald Judd: Large Scale Works*. New York: The Pace Gallery, 1993.

The Future of the Object!: A Selection of American Art, Minimalism and After. Essay by Kenneth Baker. Antwerpen, België: Galerie Ronny Van de Velde, 1990.

Garrels, Gary. *Plane Image: A Brice Marden Retrospective*. New York: MOMA, 2006.

———, ed. *Sol LeWitt: A Retrospective*. With essays by Martin Friedman, et al. San Francisco: SFMOMA; New Haven: Yale University Press, 2000.

Geldzahler, Henry, et al. *Jules Olitski*. New York: Salander-O'Reilly Galleries, 1990.

Goldberger, Paul. *Frank Stella: Painting into Architecture*. New York: MMA; New Haven, Conn.: Yale University Press, 2007.

Greenberg, Clement. *Clement Greenberg: The Collected Essays and Criticism*. Ed. John O'Brian. Vol. 1. *Perceptions and Judgments, 1939–1944*; Vol. 2. *Arrogant Purpose, 1945–1949*; Vol. 3. *Affirmations and Refusals, 1950–1956*; Vol. 4. *Modernism with a Vengeance, 1957–1969*. Chicago: University of Chicago Press, 1986–1993.

Greene, Alison de Lima. *Kenneth Noland: The Nature of Color*. With an essay by Karen Wilkin. Houston, Tex.: Museum of Fine Arts, 2004.

Grenier, Catherine. *Robert Morris: Musée national d'art moderne, Centre de création industrielle, Centre Georges Pompidou. Contemporains monographies*. Paris: Le Centre, 1995.

Guberman, Sidney. *Frank Stella: An Illustrated Biography*. New York: Rizzoli, 1995.

Harrison, Charles and Paul Wood, eds. *Art in Theory, 1900–2000: An Anthology of Changing Ideas*. New ed. Malden, Mass.: Blackwell Publishers, 2003.

Harrison, Pegram. *Frankenthaler: A Catalogue Raisonné: Prints, 1961–1994*. New York: H.N. Abrams, 1996.

Haskell, Barbara. *Agnes Martin*. New York: WMAA, 1992. Texts by B. Haskell, A. Chave, and R. Krauss.

Houston, Joe. *Optic Nerve: Perceptual Art of the 1960s*. London; New York: Merrell; Columbus, Ohio: Columbus Museum of Art, 2007.

Jimenez, Ariel. *Conversaciones con Jesus Soto = Conversations with Jesus Soto*. Caracas, Venezuela: Fundacion Cisneros, 2005.

Jones, Kellie. *Energy, Experimentation: Black Artists and Abstraction 1964–1980*. Frank Bowling, et al. New York: SMH, 2006.

Judd, Donald. *Complete Writings, 1959–1975*. Halifax and New York: Press of the Nova Scotia College of Art and Design and New York University Press, 1975.

———. *Complete Writings, 1975–1986*. Donald Judd. Eindhoven: Van Abbemuseum, 1987.

Kertess, Klaus. *Brice Marden: Painting and Drawings*. New York: H.N. Abrams, 1992.

———. *Joan Mitchell*. New York: H.N. Abrams, 1997.

Koshalek, Richard and Kerry Brougher. *Robert Irwin*. With essays by Robert Irwin, et al. Ed. by Russell Ferguson. Los Angeles: MOCA; New York: Rizzoli, 1993.

Krauss, Rosalind, et al. *Robert Morris: The Mind/Body Problem*. New York: SRGM, 1994.

Leggio, James, and Susan Weiley, eds. *American Art of the 1960s*. Studies in Modern Art. New York: MOMA, 1991.

Leider, Philip. *Stella Since 1970*. Fort Worth, Tex.: Fort Worth Art Museum, 1978.

Livingston, Jane. *The Art of Richard Diebenkorn*. With essays by John Elderfield, Ruth E. Fine, and Jane Livingston. Berkeley, Calif.: WMAA, New York, in assoc. with University of California Press, 1997.

————. *The Paintings of Joan Mitchell*. With essays by Linda Nochlin, Yvette Lee, and Jane Livingston. New York: WMAA; Berkeley, Calif.: in assoc. with University of California Press, 2002.

Marzona, Daniel. *Minimal Art*. Köln, Germany; Los Angeles: Taschen, 2004.

McShine, Kynaston, et al. *Richard Serra Sculpture: Forty Years*. New York: MOMA; London: Thames & Hudson, 2007.

Moorhouse, Paul, ed. *Anthony Caro*. With essays by Michael Fried and Dave Hickey. London: Tate, 2005.

Morgan, Robert C. *Vasarely*. Naples, Fla.: Naples Museum of Art; New York: George Braziller, 2004.

Morris Louis Now: An American Master Revisited. Atlanta: High Museum of Art, 2006.

Morris, Robert. *Have I Reasons: Work and Writings, 1993–2007*. Ed. and with an introd. by Nena Tsouti-Schillinger. Durham: Duke University Press, 2008.

Popper, Frank. *Agam*. 3rd ed. rev. New York: H.N. Abrams, 1990.

————. *Origins and Development of Kinetic Art*. Greenwich, Conn.: New York Graphic Society, 1968.

Rickey, George. *Constructivism: Origins and Evolution*. Rev. ed. New York: G. Braziller, 1995.

Robert Mangold: Early Works, 1963–66. Essays by Robert Storr, Lucy Lippard, and Mel Bochner. New York: Peter Freeman, 2004.

Rosenthal, Mark. *Abstraction in the Twentieth Century: Total Risk, Freedom, Discipline*. New York: SRGM, 1996.

Rosenthal, Stephanie. *Black Paintings: Robert Rauschenberg, Ad Reinhardt, Mark Rothko, Frank Stella*. Trans. Büro Sieveking. Munich, Germany: Haus der Kunst; Ostfildern-Ruit, Germany: Hatje Cantz; New York: Distr. D.A.P./Distributed Art Publishers, 2006.

Rowley, Alison. *Helen Frankenthaler: Painting History, Writing Painting*. New Encounters. London; New York: I.B. Tauris; New York: Distr. in U.S. by Palgrave Macmillan, 2007.

Rubin, Lawrence. *Frank Stella: Paintings 1958 to 1965: A Catalogue Raisonné*. Introd. by Robert Rosenblum. New York: Stewart, Tabori & Chang, 1986.

Rubin, William. *Frank Stella*. New York: MOMA, 1987.

Sandler, Irving. *Al Held*. New York: Hudson Hills Press, 1984.

————. *American Art of the 1960s*. New York: Harper & Row, 1988.

Schiff, Richard, et al. *Robert Mangold*. London: Phaidon, 2000.

Schwarz, Dieter and Michael Semff, eds. *Brice Marden, Work Books, 1964–1995*. Winterthur, Switzerland: Kunstmuseum Winterthur; Cambridge, Mass.: Harvard University Art Museums, 1997.

Serota, Nicolas, ed. *Donald Judd*. New York: Published in North America by D.A.P./Distributed Art Publishers, 2004.

Serra, Richard. *Writings, Interviews*. Chicago and London: University of Chicago Press, 1994.

Soto: A Retrospective Exhibition. New York: SRGM, 1974.

Stoops, Susan L. ed. *More than Minimal: Feminism and Abstraction in the '70s*. Contrib. Whitney Chadwick, et al. Waltham. Mass.: Rose Art Museum, Brandeis University, 1996.

Storr, Robert. *Robert Ryman*. New York: MOMA, 1993.

————. *Tony Smith: Architect, Painter, Sculptor*. New York: MOMA; Distr. H.N. Abrams, 1998.

Temkin, Ann and Briony Fer. *Color Chart: Reinventing Color 1950 to Today*. New York: MOMA; London: Thames & Hudson, 2008.

Tuchman, Maurice. *American Sculpture of the Sixties*. Los Angeles: LACMA, 1965.

Upright, Diane. *Morris Louis: The Complete Paintings, a Catalogue Raisonné*. New York: H.N. Abrams, 1985.

Varnedoe, Kirk. *Cy Twombly, A Retrospective*. New York: MOMA, 1994.

Waldman, Diane., ed. *Ellsworth Kelly: A Retrospective*. New York: SRGM, 1996.

Weinhardt, Martina and Max Hollein, eds. *Op Art*. German/English ed. Frankfurt: Schirn kunsthalle; Köln: König, 2007.

Weiss, Jeffrey, ed. *Dan Flavin: New Light*. Essays by Briony Fer, et al. New Haven, Conn.: Yale University Press; Washington, D.C.: National Gallery of Art, 2006.

Wilkin, Karen. *Kenneth Noland*. New York: Rizzoli, 1990.

Wood, Paul, et al. *Modernism in Dispute*. New Haven, Conn.: Yale University Press, 1993.

Zevi, Adachiara, ed. *Sol Lewitt, Critical Texts*. Rome: Libri de AEIUO, 1994.

21. Modernism in Architecture at Mid-Century

Alvar Aalto Archive. *The Architectural Drawings of Alvar Aalto: 1917–1939*. 11 vols. New York: Garland, 1993–94.

Art of the Twentieth Century. Trans. Antony Shugaar. 5 vols. Vol. 1. *1900–1919: The Avant-Garde Movements*; Vol. 2. *1920–1945: The Artistic Culture Between the Wars*; Vol. 3. *1946–1968: The Birth of Contemporary Art*; Vol. 4. *1968–1999: Neo-Avant-Gardes: Postmodern and Global art*; Vol. 5. *2000 and Beyond: Contemporary Tendencies*. Milan: Skira; New York: Distr. Rizzoli International Publications, 2006.

Baltanás, José. *Walking Through Le Corbusier: A Tour of His Masterworks*. London; New York: Thames & Hudson, 2005.

Bettinotti, Massimo, ed. *Kenzo Tange, 1946–1996: Architecture and Urban Design = Kenzo Tange, 1946–1996: architettura e disegno urbano*. Milan: Electa, 1996.

Blake, Peter. *No Place like Utopia: Modern Architecture and the Company We Kept*. New York: Knopf, 1993.

————. *Philip Johnson*. Basel and Boston: Birkhäuser Verlag, 1996.

Bogner, Dieter and Peter Noever. *Frederick J. Kiesler: Endless Space*. Ostfildern-Ruit, Germany: Hatje Cantz; New York.: Distr. in the U.S. by D.A.P./Distributed Art Publishers, 2001.

Boesiger, Willy and Hans Girsberger, eds. *Le Corbusier 1910–65*. Boston: Birkhäuser Verlag, 1999.

Boulton, Alexander. *Frank Lloyd Wright, Architect: An Illustrated Biography*. New York: Rizzoli, 1993.

Brillembourg, Carlos, ed. *Latin American Architecture, 1929–1960: Contemporary Reflections*. New York: Monacelli Press, 2004.

Brownlee, David Bruce. *Louis I. Kahn: In the Realm of Architecture*. Introd. by Vincent Scully. Condensed ed. New York: Universe Pub.; Los Angeles: MOCA, 1997.

Cannell, Michael T. *I.M. Pei: Mandarin of Modernism*. New York: Carol Southern Books, 1995.

Curtis, William J. R. *Le Corbusier: Idea and Forms*. New York: Rizzoli, 1986.

Drexler, Arthur, ed. *The Mies van der Rohe Archive*. With introd. notes by Arthur Drexler and Franz Schulze. 20 vols. New York: Garland Pub., 1986.

Fox, Stephen. *The Architecture of Philip Johnson*. Boston: Bulfinch Press, 2002.

Frampton, Kenneth. *Le Corbusier: Architect of the Twentieth Century*. New York: H.N. Abrams, 2002.

————. *Richard Meier, Architect: Buildings and Projects, 1966–1976*. New York: Oxford University Press, 1976.

Gatje, Robert F. *Marcel Breuer, a Memoir*. Foreword by I. M. Pei. New York: Monacelli Press, 2000.

Girouard, Mark. *Big Jim: The Life and Work of James Stirling*. London: Chatto & Windus, 1998.

Hausen, Marika, et al. *Eliel Saarinen: Projects, 1896–1923*. Cambridge, Mass.: MIT Press, 1990.

Hays, K. Michael and Dana Miller, eds. *Buckminster Fuller: Starting with the Universe*. With essays by Antoine Picon, Elizabeth A. T. Smith, and Calvin Tomkins. New York: WMAA, in assoc. with Yale University Press, 2008.

Hertz, David. *Frank Lloyd Wright in Word and Form*. New York: G. K. Hall, 1995.

Hines, Thomas S. *Richard Neutra and the Search for Modern Architecture*. New York: Rizzoli, 2005, 1982.

Hitchcock, Henry Russell. *The International Style*. With a new foreword by Philip Johnson. New York: W.W. Norton, 1996.

Hyman, Isabelle. *Marcel Breuer, Architect: The Career and the Buildings*. New York: H.N. Abrams, 2001.

Jencks, Charles. *Le Corbusier and the Continual Revolution in Architecture*. New York: The Monacelli Press, 2000

————. *Le Corbusier and the Tragic View of Architecture*. Rev. ed. Harmondsworth, England: Penguin, 1987.

Johnson, Philip. *Mies van der Rohe*. 3rd ed. rev. New York: MOMA: Distr. New York Graphic Society, 1978.

Jornod, Naïma. *Le Corbusier (Charles Edouard Jenneret): Catalogue raisonné de l'oeuvre peint*. 2 vols. Milan: Skira, 2005.

Kahn, Louis I. *Louis I. Kahn: Writings, Lectures, and Interviews*. Ed. A. Latour. New York: Rizzoli, 1991.

Kato, Akinori, ed. *Pier Luigi Nervi*. Tokyo: Process Architecture; Westfield, N.J.: Distr. in U.S. by Eastview Editions, 1981.

Khan, Hasan-Uddin. *International Style: Modernist Architecture From 1925 to 1965*. Köln, Germany: Taschen, 1998.

Lambert, Phyllis, ed. *Mies in America*. Essays by Werner Oechslin, et al. New York: H.N. Abrams, 2001.

Lamprecht, Barbara Mac. *Richard Neutra: Complete Works*. Ed. by Peter Goessel, et al. Köln, Germany; New York: Taschen, 2000.

Le Corbusier. *Essential Le Corbusier: L'esprit nouveau articles*. Oxford; Boston: Architectural Press, 1998.

Levine, Neil. *The Architecture of Frank Lloyd Wright*. Princeton, N.J.: Princeton University Press, 1996.

Lewis, Hilary and John O'Connor. *Philip Johnson: The Architect in His Own Words*. New York: Rizzoli, 1994.

Loud, Patricia. *The Art Museums of Louis I. Kahn*. Durham, N.C.: Duke University Press, 1989.

Louis de Malave, Florita Z. *Work and Life of Pier Luigi Nervi, Architect*. Monticello, Ill. Vance Bibliographies, 1984.

The Louis I. Kahn Archive: Personal Drawings: The Completely Illustrated Catalogue of the Drawings in the Louis I. Kahn Collection. 7 vols. Garland Architectural Archives. Philadelphia and New York: University of Pennsylvania, Pennsylvania Historical and Museum Commission, and Garland: 1987.

Merkel, Jayne. *Eero Saarinen*. London; New York: Phaidon, 2005.

Murray, Irena Z., ed. *Moshe Safdie: Buildings and Projects, 1967–1992*. Montreal and Buffalo, N.Y.: Canadian Architecture Collection et al., 1996.

Newhouse, Victoria. *Wallace K. Harrison, Architect*. New York: Rizzoli, 1989.

Niemeyer, Oscar. *The Curves of Time: The Memoirs of Oscar Niemeyer*. Trans. I. M. Burbridge. London: Phaidon, 2000.

Okrent, Daniel. *Great Fortune: The Epic of Rockefeller Center*. New York: Viking, 2003.

Pallasmaa, Juhani, ed. *Alvar Aalto, Architect*. Vols. 6–7. Helsinki: Alvar Aalto Foundation, Alvar Aalto Academy, 2003.

Pelkonen, Lisa and Donald Albrecht, eds. *Eero Saarinen: Shaping the Future*. New Haven, Conn.: Yale University Press; New York: In assoc. with The Finnish Cultural Institute in New York; Helsinki: The Museum of Finnish Architecture; Washington, D.C.: The National Building Museum; New Haven, Conn.: Yale University School of Architecture, 2006.

Pfeiffer, Bruce Brooks. *Frank Lloyd Wright: The Masterworks*. Ed. D. Larkin and B. B. Pfeiffer. New York: Rizzoli, 1993.

Phillips, Lisa. *Frederick Kiesler*. New York: WMAA, 1989.

Prown, Jules David. *The Architecture of the Yale Center for British Art*. 2nd ed. New Haven, Conn.: Yale University, 1982, 1977.

Ray, Nicholas. *Alvar Aalto*. New Haven, Conn.; London: Yale University Press, 2005.

Reed, Peter and William Kaizen, eds. *The Show to End All Shows: Frank Lloyd Wright and the Museum of Modern Art, 1940*. New York: MOMA, 2004.

Richard Meier, Architect. Essays by Kenneth Frampton and Joseph Rykwert. 4 vols. New York: Rizzoli, 1984–2004.

Riley, Terrence, and Peter Reed, eds. *Frank Lloyd Wright, Architect*. New York: MOMA, 1994.

Román, Antonio. *Eero Saarinen: An Architecture of Multiplicity*. New York: Princeton Architectural Press, 2003.

Ronner, Heinz, and Sharad Jharen. *Louis I. Kahn: Complete Works, 1935–74*. 2nd ed. rev. and enl. Basel and Boston: Birkhäuser Verlag, 1987.

Schildt, Göran. *Alvar Aalto, His Life*. Jyväskylä, Finland: Alvar Aalto Museum, 2007.

Schildt, Göran. *Alvar Aalto: The Complete Catalogue of Architecture, Design, and Art*. New York: Rizzoli, 1994.

Schulze, Franz. *Mies van der Rohe: A Critical Biography*. Chicago: University of Chicago Press, 1985.

———, ed. *Mies van der Rohe: Critical Essays*. Cambridge, Mass.: MIT Press, 1990.

———. *Philip Johnson: Life and Work*. New York: Knopf, 1994.

Schumacher, Thomas. *Surface & Symbol: Giuseppe Terragni and the Architecture of Italian Rationalism*. New York: Princeton Architectural Press, 1990.

Scully, Vincent Joseph. *Louis I. Kahn*. New York: G. Braziller, 1962.

———. *Modern Architecture and Other Essays*. Selected and with introd. by Neil Levine. Princeton, N.J.: Princeton University Press, 2003.

Smith, Elizabeth A. T. *Case Study Houses*. Epilogue and photography by Julius Shulman. Ed. by Peter Goessel. New York: Taschen, 2002.

Stern, Robert A. M. *Raymond Hood*. New York: Institute for Architecture and Urban Studies: Rizzoli International Publications, 1982.

Storrer, William Allin. *The Architecture of Frank Lloyd Wright: A Complete Catalog*. 3rd ed. Chicago: University of Chicago Press, 2002.

———. *The Frank Lloyd Wright Companion*. Rev. ed. Chicago; London: University of Chicago Press, 2006.

Tegethoff, Wolf. *Mies van der Rohe: The Villas and Country Houses*. New York: MOMA, 1985.

Terragni, Attilio Alberto. *The Terragni Atlas: Built Architectures*. Milan: Skira, 2004.

Underwood, David K. *Oscar Niemeyer and Brazilian Free-Form Modernism*. New York: Braziller, 1994.

Vegesack, Alexander von, et al. *Le Corbusier: The Art of Architecture*. Weil am Rhein, Germany: Vitra Design Stiftung, 2007.

Weston, Richard. *Alvar Aalto*. London: Phaidon, 1995.

Whitney, David and Jeffrey Kipnis, eds. *Philip Johnson: The Glass House*. New York: Pantheon Books, 1993.

Wiseman, Carter. *The Architecture of I.M. Pei: With an Illustrated Catalogue of the Buildings and Projects*. Rev ed. London: Thames & Hudson, 2001.

———. *I.M. Pei: A Profile in American Architecture*. Rev. ed. New York: H.N. Abrams, 2001.

Wright, Frank Lloyd. *Frank Lloyd Wright, Collected Writings*. Ed. by Bruce B. Pfeiffer. 5 vols. New York: Rizzoli, 1992.

———. *Letters to Apprentices*. Selected and with commentary by Bruce B. Pfeiffer. Fresno, Calif.: Press at Cal State University, 1982.

———. *Modern Architecture: Being the Kahn Lectures for 1930*. With a new introd. by Neil Levine. Princeton, N.J.; Oxford: Princeton University Press, 2008.

22. Conceptualism and Activist Art

Ackerman, Marion and Hans Werner, eds. *Rebecca Horn: Moon Mirror: Site-Specific Installations, 1982–2005*. With essays by Richard Cork, Steven Henry Madoff, Doris von Drathen and texts by Rebecca Horn. Ostfildern-Ruit, Germany: Hatje Cantz; New York: D.A.P./Distributed Art Publishers, 2005.

Adriani, Götz, Winfried Konnertz, and Karin Thomas. *Joseph Beuys*. Neuaufl. Köln, Germany: DuMont, 1994.

Albero, Alexander and Blake Stimson, eds. *Conceptual Art: A Critical Anthology*. Cambridge, Mass.: MIT Press, 1999.

Alloway, Lawrence. *Imagining the Present: Context, Content, and the Role of the Critic*. Ed. with a critical commentary by Richard Kalina. London; New York: Routledge, 2006.

Ana Mendieta: A Retrospective. New York: New Museum of Contemporary Art, 1987.

Anderson, Laurie. *Stories from the Nerve Bible: A Retrospective 1972–1992*. New York: Harper Perennial, 1994.

Armstrong, Elizabeth, and Joan Rothfuss. *In the Spirit of Fluxus*. Minneapolis: Walker Art Center, 1993.

Art of the Twentieth Century. Trans. Antony Shugaar. 5 vols. Vol. 1. *1900–1919: The Avant-Garde Movements*; Vol. 2. *1920–1945: The Artistic Culture Between the Wars*; Vol. 3. *1946–1968: The Birth of Contemporary Art*; Vol. 4. *1968–1999: Neo-Avant-Gardes: Postmodern and Global art*; Vol. 5. *2000 and Beyond: Contemporary Tendencies*. Milan: Skira; New York: Distr. Rizzoli International Publications, 2006.

Ayres, Anne, et al, eds. *Chris Burden: a Twenty-Year Survey*. Essayist, Donald Kuspit, et al. Newport Beach, Calif.: Newport Harbor Art Museum, 1988.

Baker, Kenneth. *The Lightning Field*. With a preface by Lynne Cooke. New Haven: Yale University Press, 2008.

Baldessari, John. *This is Not That*. Manchester, England: Cornerhouse, 1995.

Battcock, Gregory, ed. *New Artists Video: A Critical Anthology*. New York: Dutton, 1980.

Benson, Cynda L. and Audrey Flack. *Audrey Flack: Reinventing the Goddess*. Savannah, Ga.: Savannah College of Art and Design, 2008.

Berger, Maurice. *Adrian Piper: A Retrospective. Issues in Cultural Theory*, 3. Baltimore, MD: Fine Arts Gallery University of Maryland, 1999.

———. *Fred Wilson: Objects and Installations, 1979–2000. Issues in Cultural Theory*, 4. Baltimore, MD: Center for Art and Visual Culture, University of Maryland; New York: Distr. D.A.P./Distributed Art Publishers, 2001.

Beuys, Joseph. *Joseph Beuys: The Reader*. Ed. and trans. Claudia Mesch and Viola Michely; foreword by Arthur C. Danto. Cambridge, Mass.: MIT Press, 2007.

Bochner, Mel. *Solar System & Rest Rooms: Writings and Interviews, 1965–2007*. Cambridge, Mass.: MIT Press, 2008.

Boettger, Suzaan. *Earthworks: Art and the Landscape of the Sixties*. Berkeley, Calif.: University of California Press, 2002.

Borer, Alain. *The Essential Joseph Beuys*. Ed. by Lothar Schirmer. Cambridge, Mass.: MIT Press, 1997.

Bourdon, David. *Designing the Earth: The Human Impulse to Shape Nature*. New York: H.N. Abrams, 1995.

Broude, Norma, and Mary D. Garrard, eds. *The Power of Feminist Art: The American Movement of the 1970s, History and Impact*. New York: H.N. Abrams, 1994.

Bruggen, Coosje van. *John Baldessari*. New York: Rizzoli, 1990.

Burnham, Linda Frye and Steven Durland. *The Citizen Artist: 20 Years of Art in the Public Arena: An Anthology from High Performance Magazine, 1978–1998*. Gardiner, N.Y.: Critical Press, 1998.

Burton, Johanna. *Mel Bochner: Language, 1966–2006*. Contrib. Mel Bochner, James Meyer, and James Rondeau. Chicago, Ill.: Art Institute of Chicago; New Haven, Conn.: Yale University Press, 2007.

Celant, Germano. *Michael Heizer*. Milan: Fondazione Prada, 1997.

Celant, Germano, et al. *Rebecca Horn*. Texts by Rebecca Horn. New York: SRGM, 1993.

Chicago, Judy. *Beyond the Flower: The Autobiography of a Feminist Artist*. New York: Penguin Books, 1996.

———. *The Dinner Party: From Creation to Preservation*. London; New York: Merrell, 2007.

———, and Edward Lucie-Smith. *Women and Art: Contested Territory*. New York: Watson-Guptill, 1999.

Chris Burden. Texts by Fred Hoffman, et al. Newcastle upon Tyne, England: Locus Plus, 2007.

Cooke, Lynne, et al.eds. *Robert Smithson: Spiral Jetty: True Fictions, False Realities*. With texts by George Baker, et al; and an interview with Robert Smithson by Kenneth Baker. New York: Dia Art Foundation; Berkeley, Calif.: University of California Press, 2005.

———. *Beuys, Joseph. Where Would I Have Got If I Had Been Intelligent!* New York: Dia Center for the Arts, 1994.

Baker, Kenneth. *Robert Smithson*. New York: Dia Art Foundation; California: University of California Press, 2005.

Cottingham, Laura. *Seeing Through the Seventies: Essays on Feminism and Art*. Amsterdam: G+B Arts International, 2000.

Darboven, Hanne. *Urzeit/Uhrzeit*. New York: Rizzoli, 1990.

Elwes, Catherine. *Video Art: A Guided Tour*. London; New York: I.B. Tauris; London: In assoc. with University of the Arts; New York: Distr. Palgrave Macmillan, 2005.

Fairchild, Patricia A. *Primal Acts of Construction/ Destruction: The Art of Michael Heizer, 1967–1987*. Ann Arbor: UMI Research Press, 1994.

Farrington, Lisa E. *Faith Ringgold*. San Francisco: Pomegranate, 2004.

Finkelpearl, Tom. *Dialogues in Public Art: Interviews with Vito Acconci, John Ahearn, David Avalos, Denise Scott Brown, Rufus L. Chaney, Mel Chin, Douglas Crimp*. Cambridge, Mass.: MIT Press, 2000.

Flügge, Matthias and Robert Fleck, eds. *Hans Haacke: For Real: Works 1959–2006*. Düsseldorf: Richter, 2006.

Friedman, Ken ed. *The Fluxus Reader*. Chichester, England; New York: Academy Editions, 1998.

Gilbert & George. *Gilbert & George: The Complete Pictures, 1971–2005*. With an introd. by Rudi Fuchs. New York: Aperture Foundation, 2007.

Godfrey, Tony. *Conceptual Art*. London; New York: Phaidon, 1998.

Goldberg, RoseLee. *Laurie Anderson*. New York: H.N. Abrams, 2000.

———. *Performance: Live Art Since 1960*. Foreword by Laurie Anderson. New York: H.N. Abrams, 1998.

Goldie, Peter and Elisabeth Schellekens, eds. *Philosophy and Conceptual Art*. Oxford, England: Clarendon Press; Oxford; New York: Oxford University Press, 2007.

Goldstein, Ann, ed. *Lawrence Weiner: As Far as the Eye Can See*. Essays by Kathryn Chiong, et al. Los Angeles: MOCA; New York: WMAA; New Haven: Distributed by Yale University Press, 2007.

———, and Anne Rorimer, eds. *Reconsidering the Object of Art, 1965–1975*. Essays by Lucy R. Lippard, Stephen Melville, and Jeff Wall. Los Angeles: MOCA; Cambridge, Mass.: MIT Press, 1995.

Gouma-Peterson, Thalia. *Miriam Schapiro: Shaping the Fragments of Art and Life*. Foreword by Linda Nochlin. New York: H.N. Abrams Publishers, in assoc. with the Polk Museum of Art, 1999.

———, ed. *Breaking the Rules: Audrey Flack, A Retrospective 1950–1990*. New York: H.N. Abrams, 1992.

Grande, John K. *Art Nature Dialogues: Interviews with Environmental Artists*. Foreword by Edward Lucie-Smith. Albany: State University of New York Press, 2004.

Guerrilla Girls. *Confessions of the Guerrilla Girls*. New York: HarperCollins, 1995.

Haacke, Hans. *Hans Haacke*. 2 vols. Oxford: Museum of Modern Art; Eindhoven: Van Abbemuseum, 1978–1984.

Hanhardt, John G. *The Worlds of Nam June Paik*. New York: SRGM: Distr. H.N. Abrams, 2000.

Hendricks, Jon. *Fluxus Codex*. With an introd. by Robert Pincus-Witten. Detroit, Mich.: Gilbert and Lila Silverman Fluxus Collection in assoc. with H.N. Abrams, New York, 1988.

Herzogenrath, Wulf and Barbara Nierhoff, eds. *Peter Campus: Analog + Digital, Video + Foto, 1970–2003: Kunsthalle Bremen*. German/English ed. Bremen: Kunstverein in Bremen; New York: Distr. outside Europe, D.A.P./Distributed Art Publishers, 2003.

Higgins, Hannah. *Fluxus Experience*. Berkeley, Calif.: University of California Press, 2002.

Holton, Curlee Raven. *Faith Ringgold: A View From the Studio*. Boston: Bunker Hill Pub. in assoc. with Allentown Art Museum, 2004.

Iversen, Margaret, Douglas Crimp, and Homi K. Bhabha. *Mary Kelly*. London: Phaidon Press, 1997.

Jackie Winsor: Sculpture: P.S. 1 Contemporary Art Center, New York. New York: Paula Cooper Gallery, 1998.

John Baldessari. 2 vols. Köln, Germany: König; New York: Distr. outside Europe, D.A.P., 2005.

Jones, Amelia and Andrew Stephenson, eds. *Performing the Body/Performing the Text*. London; New York: Routledge, 1999.

Kaprow, Allan. *Essays on the Blurring of Art and Life*. Ed. by Jeff Kelley. Expanded ed. Berkeley, Calif.: University of California Press, 2003.

Kastner, Jeffrey, ed. *Land and Environmental Art. Themes and Movements*. London: Phaidon, 1998.

Ketner, Joseph D. *Elusive Signs: Bruce Nauman: Works with Light*. Essays by Joseph D. Ketner II, Janet Kraynak, and Gregory Volk. Milwaukee, Wis.: Milwaukee Art Museum; Cambridge, Mass.: Distr. MIT Press, 2006.

Kosuth, Joseph. *Joseph Kosuth: Interviews, 1969–1989*. Stuttgart: Edition P. Schwarz, 1989.

Kozloff, Joyce, and Linda Nochlin. *Patterns of Desire*. New York: Hudson Hills, 1990.

Kurtz, Bruce D. *Contemporary Art, 1965–1990*. Englewood Cliffs, N.J.: Prentice Hall, 1992.

Lailach, Michael. *Land Art*. Köln, Germany; London: Taschen, 2007.

Lelong, Guy. *Daniel Buren. La Création Contemporaine*. Paris: Flammarion, 2001.

Lippard, Lucy R., et al. *Judy Chicago*. Ed. by Elizabeth A. Sackler. New York: Watson-Guptill Publications, 2002.

———. *Six Years: The Dematerialization of the Art Object from 1966 to 1972*. New York: Praeger, 1973.

Livingstone, Marco. *Gilbert & George*. London: Tate; New York: Distr. in the U.S. and Canada by Abrams, 2007.

Lucie-Smith, Edward. *Art in the Seventies*. Ithaca, N.Y.: Cornell University Press, 1980.

Lustig, Suzanne. *How and Why Did the Guerrilla Girls Alter the Art World Establishment in New York City, 1985–1995*. Internet resource: http://womhist.alexanderstreet.com/ggirls/intro .htm. Binghamton, NY: State University of New York, 2002.

Martin, Sylvia. *Video Art*. Köln, Germany; Los Angeles: Taschen, 2006.

Marzona, Daniel. *Conceptual Art*. Köln, Germany; Los Angeles: Taschen, 2005.

Michael Heizer: Double Negative. Foreword by Richard Koshalek and Kerry Brougher. Essay by Mark C. Taylor. Los Angeles: MOCA; New York: Rizzoli, 1991.

Miss, Mary. *Mary Miss*. Essays by Daniel M. Abramson, et al. New York: Princeton Architectural Press, 2004.

Morgan, Robert C. *Art into Ideas: Essays on Conceptual Art*. Cambridge; New York: Cambridge University Press, 1996.

———. *Conceptual Art: An American Perspective*. Jefferson, N.C.: McFarland, 1994.

Moure, Gloria, ed. *Ana Mendieta*. With texts by Donald Kuspit, et al. Santiago da Compostela, Spain: Centro Galego de Arte Contemporánea; Barcelona: Ediciones Polígrafa, 1996.

———. *Vito Acconci*. Barcelona: Ediciones Polígrafa; New York.: D.A.P./Distributed Art Publishers, 2001.

Nauman, Bruce. *Please Pay Attention Please: Bruce Nauman's Words: Writings and Interviews*. Ed. by Janet Kraynak. Cambridge, Mass.: MIT Press, 2003.

Norvell, Patricia. *Recording Conceptual Art: Early Interviews with Barry, Huebler, Kaltenbach, LeWitt, Morris, Oppenheim, Siegelaub, Smithson, Weiner*. Ed. by Alexander Alberro and Patricia Norvell. Berkeley, Calif.: University of California Press, 2001.

Onorato, Ronald J. *Douglas Huebler: La Jolla Museum of Contemporary*. La Jolla, Calif.: The Museum, 1988.

———. *Vito Acconci: Domestic Trappings*. La Jolla, Calif.: La Jolla Museum of Contemporary Art, 1997.

Osborne, Peter, ed. *Conceptual Art*. London; New York: Phaidon, 2002.

Piper, Adrian. *Out of Order, Out of Sight*. 2 vols. Cambridge, Mass.: MIT Press, 1996.

Reynolds, Ann Morris. *Robert Smithson: Learning from New Jersey and Elsewhere*. Cambridge, Mass.: MIT Press, 2003.

Ringgold, Faith. *We Flew Over the Bridge: The Memoirs of Faith Ringgold*. Boston: Little, Brown, 1995.

Roberts, Jennifer L. *Mirror-Travels: Robert Smithson and History*. New Haven, Conn.: Yale University Press, 2004.

Robins, Corinne. *The Pluralist Era: American Art 1968–1981*. New York: Harper & Row, 1984.

Rose, Bernice. *Allegories of Modernism: Contemporary Drawing*. New York: MOMA, 1992.

Rosenblum, Robert. *Introducing Gilbert & George*. London; New York: Thames & Hudson, 2004.

Rosenthal, Mark, et al. *Joseph Beuys: Actions, Vitrines, Environments*. Houston, Tex.: Menil Collection; New Haven, Conn.: Distr. Yale University Press, 2004.

Rothkopf, Scott. *Mel Bochner Photographs, 1966–1969*. New Haven, Conn.: Yale University Press; Cambridge, Mass.: Harvard University Art Museums, 2002.

Rush, Michael. *Video Art*. Rev. ed. London: Thames & Hudson, 2007.

Sandford, Maryellen, ed. *Happenings and Other Acts*. London; New York: Routledge, 1995.

Sandy Skoglund: Reality Under Siege: A Retrospective. New York: Smith College Museum of Art, in assoc. with H.N. Abrams, 1998.

Sayre, Henry M. *The Object of Performance: The American Avant-Garde Since 1970*. Chicago: University of Chicago Press, 1989.

Schneeman, Carolee. *More than Meat Joy: Performance Works and Selected Writings*. 2nd ed. Kingston, New York: McPherson & Co., 1997.

Senie, Harriet F., and Sally Webster. *Critical Issues in Public Art: Content, Context, and Controversy*. With a rev. introd. Washington, D.C.: Smithsonian Institution Press, 1998.

Shapiro, Gary. *Earthwards: Robert Smithson and Art after Babel*. Berkeley, Calif.: University of California Press, 1995.

Shearer, Linda. *Vito Acconci, Public Places*. New York: MOMA, 1988.

Simon, Joan. *Ann Hamilton*. New York: H.N. Abrams, 2002.

———, ed. *Bruce Nauman: Exhibition Catalogue and Catalogue Raisonné*. Essays by Neal Benezra, et al.; Minneapolis: Walker Art Center; New York, N.Y.: Distributed Art Publishers, 1994.

Smithson, Robert. *Robert Smithson, the Collected Writings*. Ed. Jack Flam. Berkeley, Calif.: University of California Press, 1996.

Sobel, Dean. *Jackie Winsor*. With essays by Peter Schjeldahl and John Yau. Milwaukee, Wis.: Milwaukee Art Museum, 1991.

Sonfist, Alan, ed. *Art in the Land: A Critical Anthology of Environmental Art*. New York: Dutton, 1983.

Stimson, Blake and Gregory Sholette, eds. *Collectivism after Modernism: The Art of Social Imagination After 1945*. Minneapolis: University of Minnesota Press, 2007.

Storr, Robert. *Dislocations*. New York: MOMA, 1991.

Suderburg, Erika, ed. *Space, Site, Intervention: Situating Installation Art*. Minneapolis: University of Minnesota Press, 2000.

Summerbell, Deirdre, ed. *Mary Kelly, Interim: Corpus, Pecunia, Historia, Potestas*. New York: New Museum of Contemporary Art, 1990.

Temkin, Ann. *Thinking Is Form: The Drawings of Joseph Beuys*. New York: MOMA, 1993.

Tomkins, Calvin, and David Bourdon. *Christo's Running Fence*. Photography by G. Gorgoni. New York: H.N. Abrams, 1978.

Townsend, Chris, ed. *The Art of Bill Viola*. New York: Thames & Hudson, 2004.

Tsai, Eugene and Cornelia Butler. *Robert Smithson*. Essay by Thomas Crow; texts by Alexander Alberro, et al.; interview with Robert Smithson by Moira Roth. Los Angeles: MOCA; Berkeley, Calif.: University of California Press, 2004.

Tufnell, Ben. *Land Art*. London: Tate; New York: Distr. in U.S. by H.N. Abrams, 2006.

Viso, Olga M. *Ana Mendieta: Earth Body: Sculpture and Performance, 1972–1985*. With essays by Guy Brett, Julia P. Herzberg, and Chrissie Iles. Washington, D.C.: HMSG, Smithsonian Institution; Ostfildern-Ruit, Germany: Hatje Cantz, 2004.

Walker, John A. *Left Shift: Radical Art in the 1970s*. London; New York: I.B. Tauris, 2002.

Zweite, Armin, Katharina Schmidt, and Doris von Drathen. *Rebecca Horn: Bodylandscapes: Drawings, Sculptures, Installations 1964–2004*. Including a dialogue between Rebecca Horn and Joachim Sartorius; poems by Rebecca Horn. Ostfildern-Ruit, Germany: Hatje Cantz, 2005.

23. Post-Minimalism

50 Years Documenta, 1955–2005: Kunsthalle Fridericianum. 2nd ed. Göttingen: Steidl, 2005.

Alex Katz: Unfamiliar Images. Interview by David Salle. Texts by Enzo Cucchi and Vincent Katz. Milan: Alberico Cetti Serbelloni Editore, 2002.

Allara, Pamela. *Pictures of People: Alice Neel's American Portrait Gallery*. Hanover, NH: University Press of New England; Brandeis University Press, 1998.

Anderson-Spivy, Alexandra. *Robert Kushner: Gardens of Earthly Delight*. With an essay by Holland Cotter. New York: Hudson Hills Press, 1997.

Andrews, Richard and John Beardsley. *Maya Lin: Systematic Landscapes*. Foreword by Lawrence Weschler. Seattle: Henry Art Gallery, University of Washington; New Haven, Conn.: Yale University Press, 2006.

Armstrong, Philip, Laura Lisbon and Stephen Melville. *As Painting: Division and Displacement*. Columbus, OH: Wexner Center for the Arts; Cambridge, Mass.: MIT Press, 2001.

Armstrong, Richard and Richard Marshall, eds. *The New Sculpture 1965–1975: Between Geometry and Gesture*. With essays by Richard Armstrong, John G. Hanhardt, Robert Pincus-Witten. New York: WMAA, 1990.

Art of the Twentieth Century. Trans. Antony Shugaar. 5 vols. Vol. 1. *1900–1919: The Avant-Garde Movements*; Vol. 2. *1920–1945: The Artistic Culture Between the Wars* Vol. 3. *1946–1968: The Birth of Contemporary Art*; Vol. 4. *1968–1999: Neo-Avant-Gardes: Postmodern and Global Art*; Vol. 5. *2000 and Beyond: Contemporary Tendencies*. Milan: Skira; New York: Distr. Rizzoli International Publications, 2006.

Ashbery, John, and Kenworth Moffett. *Fairfield Porter: Realist Painter in an Age of Abstraction*. Boston: MOFA, 1982.

Auping, Michael. *Susan Rothenberg: Paintings and Drawings*. New York: Rizzoli; Buffalo, N.Y.: Albright-Knox Art Gallery, 1992.

Barilleaux, René Paul. *Valerie Jaudon*. Introd. essay by Anna C. Chave. Jackson, Miss.: Mississippi Museum of Art, 1996.

Bartman, William, ed. *Vija Celmins*. New York: Art Press, 1992.

Beardsley, John. *Earthworks and Beyond: Contemporary Art in the Landscape*. 4th ed. New York: Abbeville Press, 2006.

Benezra, Neal. *Ed Paschke*. Chicago: Art Institute of Chicago, 1990.

Binstock, Jonathan P. *Sam Gilliam: A Retrospective*. Forewords by Walter Hopps and Jacquelyn D. Serwer. Berkeley, Calif.: University of California Press, 2005.

Bowman, Russell. *Philip Pearlstein: The Complete Paintings*. New York: Alpine Fine Arts, 1983.

Bradley, Fiona, ed. *Rachel Whiteread*. Text by R. Krauss, et al. London: Tate, 1996. Braun, Christian, ed. *Eye Infection*. Essay by Robert Storr. Amsterdam: Stedelijk Museum; Düsseldorf: Richter, 2001.

Brutvan, Cheryl. *The Paintings of Sylvia Plimack Mangold*. New York and Buffalo, N.Y.: Hudson Hills Press and Albright-Knox Art Gallery, 1994.

Buchsteiner, Thomas and Otto Letze, eds. *Duane Hanson: More Than Reality*. Ostfildern-Ruit, Germany: Hatje Cantz; New York: Distr. in U.S. by D.A.P./Distributed Art Publishers, 2001.

Carr, Carolyn Kinder. *Alice Neel: Women*. New York: Rizzoli: Distr. St. Martin's Press, 2002.

Castagnoli, Pier Giovanni, Ida Gianelli, and Beatrice Merz. *Mario Merz*. Turin: Fondazione Merz, 2006.

Cathcart, Linda. *American Painting of the 1970s*. Buffalo, N.Y.: Albright-Knox Gallery, 1979.

———. *American Still Life, 1945–1983*. Houston, Tex.: Contemporary Arts Museum; New York; London: The Museum in assoc. with Harper & Row, 1983.

Celant, Germano. *Arte Povera*. New York: Praeger, 1969.

———. *Mario Merz*. New York: SRGM, 1989.

Chase, Linda. *Hyperrealism*. Introd. by Salvador Dalí. New York: Rizzoli, 1975.

Christo: Surrounded Islands, Biscayne Bay, Greater Miami, Florida, 1980–1983. Trans. S. Reader. New York: H.N. Abrams, 1985.

Cooper, Helen, ed. *Eva Hesse: A Retrospective*. New Haven, Conn.: Yale University Press, 1992.

Corn, Wanda. *The Art of Andrew Wyeth*. San Francisco: Fine Arts Museums, 1973.

Cuno, James B. *Subject(s): Prints and Multiples by Jonathan Borofsky, 1982–1991*. Essay by Ruth Fine. Hanover, N.H.: Hood Museum of Art, Dartmouth College, 1992.

Dennison, Lisa and Craig Houser. *Rachel Whiteread: Transient Spaces*. New York: SRGM: Distr. H.N. Abrams, 2001.

D'Oench, Ellen. *Sylvia Plimack Mangold: Works on Paper 1968–1991: With a Catalogue Raisonné of the Prints*. Middletown, Conn.: Davison Art Center, Wesleyan University; Ann Arbor, Mich.: University of Michigan Museum of Art; Distr. University of Washington Press, 1992.

Dobke, Dirk. *Dieter Roth: Unique Pieces*. With an introd. by Laszlo Glozer. London: Edition Hansjorg Mayer; New York: Distr. in U.S. and Canada by Thames & Hudson, 2002.

Drathen, Doris von. *Pat Steir: Installations*. Milan: Charta, 2006.

Dunlop, Ian. *Donald Sultan*. Chicago: Museum of Contemporary Art; New York: H.N. Abrams, 1987.

Eisenberg, Deborah. *Air: 24 Hours—Jennifer Bartlett*. New York: H.N. Abrams, 1994.

Enyeart, James. *Jerry N. Uelsmann: Twenty-Five Years—A Retrospective*. Boston: Little, Brown, 1985.

Feinstein, Stephen C. Ed. *Absence/Presence: Critical Essays on the Artistic Memory of the Holocaust*. Syracuse, N.Y.: Syracuse University Press, 2005.

Finch, Christopher. *Chuck Close: Work*. Munich; New York: Prestel, 2007.

Flood, Richard and Frances Morris. *Zero to Infinity: Arte Povera, 1962–1972*. Minneapolis: Walker Art Center; New York: Distr. D.A.P./Distributed Art Publishers, 2001.

Friedman, Martin L. *Close Reading: Chuck Close and the Art of the Self-Portrait*. New York: H.N. Abrams, 2005.

Friedman, Terry and Andy Goldsworthy, eds. *Hand to Earth: Andy Goldsworthy Sculpture, 1976–1990*. New York: H.N. Abrams, 2004, 1990.

Fry, Edward F. and Donald B. Kuspit. *Robert Morris: Works of the Eighties*. Chicago: Museum of Contemporary Art, 1986.

Fuchs, Rudolf Herman. *Richard Long*. London: Thames & Hudson, 1986.

Goldsworthy, Andy. *Andy Goldsworthy: A Collaboration with Nature*. New York: H.N.Abrams, 1990.

———. *Andy Goldsworthy: Sheepfolds*. London: Michael Hue-Williams Fine Art, 1996.

———. *Wall at Storm King*. Essay by Kenneth Baker. New York: H.N. Abrams, 2000.

Goldwater, Marge. *Jennifer Bartlett*. 2nd ed. Minneapolis: Walker Art Center; New York: Abbeville Press, 1990.

Goodyear, Jr., Frank H. *Contemporary American Realism Since 1960*. Boston: New York Graphic Society and the Pennsylvania Academy of the Fine Arts, 1981.

Grynsztejn, Madeleine, ed. *The Art of Richard Tuttle*. With essays by Cornelia H. Butler, et al. San Francisco: SFMOMA: New York: In assoc. with D.A.P./Distributed Art Publishers, 2005.

Hills, Patricia. *Alice Neel*. New York: H.N. Abrams, 1983.

Hobbs, Robert Carleton. *Alice Aycock: Sculpture and Projects*. Cambridge, Mass.: MIT Press, 2005.

Hornstein, Shelley and Florence Jacobowitz, eds. *Image and Remembrance: Representation and the Holocaust*. Bloomington, Ind.: Indiana University Press, 2003.

Inglot, Joanna. *The Figurative Sculpture of Magdalena Abakanowicz: Bodies, Environments, and Myths*. Berkeley, Calif.: University of California Press, 2004.

Jim Nutt. Milwaukee: Milwaukee Art Museum, 1994.

Juncosa, Enrique, ed. *Barry Flanagan: Sculpture 1965–2005*. Dublin: Irish Museum of Modern Art, 2006.

Knutson, Anne Classen. *Andrew Wyeth: Memory & Magic*. Introd. by John Wilmerding. Essays by Christopher Crosman, Kathleen A. Foster, *Michael R. Taylor*. Atlanta: High Museum of Art; Philadelphia: Philadelphia Museum of Art in assoc. with Rizzoli, 2005.

Krane, Susan. *Lynda Benglis: Dual Natures*. Atlanta, Ga.: High Museum of Art, 1990.

Krauss, Rosalind, et al. *Rachel Whiteread: Shedding Life*. New York: Thames & Hudson, 1997.

Kurtz, Bruce D. *Contemporary Art, 1965–1990*. Englewood Cliffs, N.J.: Prentice Hall, 1992.

Lippard, Lucy. *Get the Message? A Decade of Art for Social Change*. New York: Dutton, 1984.

Lista, Giovanni. *Arte Povera*. Milan: 5 continents, 2006.

Long, Richard. *Richard Long: Selected Statements & Interviews*. Ed. by Ben Tufnell. London: Haunch of Venison, 2007.

Lucie-Smith, Edward. *American Realism*. New York: H.N. Abrams, 1994.

Lumley, Robert. *Arte Povera*. London: Tate, 2004.

Lyons, Lisa and Robert Storr. *Chuck Close*. New York: Rizzoli, 1987.

Marshall, Richard. *Alex Katz*. Text by Robert Rosenblum. New York: WMAA, 1986.

———. *American Art Since 1970: Painting, Sculpture, and Drawings from the Collection of the Whitney Museum of American Art*. New York: WMAA, 1984.

———. *Developments in Recent Sculpture*. New York: WMAA, 1981.

———. *New Image Painting*. New York: WMAA, 1978.

Malpas, William. *The Art of Andy Goldsworthy: Complete Works*. 3rd ed. Maidstone, England: Crescent Moon, 2005.

———. *The Art of Richard Long: Complete Works*. 2nd ed. Maidstone England: Crescent Moon, 2007.

McEvilley, Thomas. *Pat Steir*. New York: H.N. Abrams, 1995.

Meisel, Louis K. *Photo-Realism*. New York: Abradale Press; H.N. Abrams, 1989.

———. *Photorealism Since 1980*. New York: H.N. Abrams, 1993.

———. *Photorealism at the Millennium*. Essay by Linda Chase. New York: H.N. Abrams, 2002.

———. *Richard Estes: The Complete Paintings 1966–1985*. New York: H.N. Abrams, 1986. With an essay by J. Perreault.

Meyerowitz, Joel. *Cape Light: Color Photographs*. Foreword by Clifford S. Ackley. Interview by Bruce K. MacDonald. New exp. ed. Boston: MOFA: Bulfinch Press, 2002.

Mitchell, W. J. T. *Art and the Public Sphere*. Chicago and London: University of Chicago Press, 1992.

Mullins, Charlotte. *Rachel Whiteread*. Modern Artists. London: Tate, 2004.

Petzinger, Renate, ed. *Eva Hesse: Catalogue Raisonné*. 2 vols. Wiesbaden: Museum Wiesbaden; New Haven, Conn.: Yale University Press, 2006.

Pincus-Witten, Robert. *Postminimalism*. New York: Out of London Press, 1977.

———. *Postminimalism into Maximalism: American Art, 1966–1986*. Ann Arbor, Mich.: UMI Research Press, 1987.

Pollock, Griselda and Vanessa Corby, eds. *Encountering Eva Hesse*. Munich: New York: Prestel, 2006.

Real, Really Real, Super Real: Directions in Contemporary American Realism. San Antonio: San Antonio Museum Association, 1981.

Relyea, Lane, Robert Gober and Briony Fer. *Vija Celmins*. Contemporary Artists. London; New York: Phaidon, 2004.

Rippner, Samantha. *The Prints of Vija Celmins*. New York: MMA; New Haven, Conn.: Yale University Press, 2002.

Robert Morris: The Mind/Body Problem. Essays by Rosalind Krauss, et al. New York: SRGM, 1994.

Rose, Barbara. *Magdalena Abakanowitz*. New York: H.N. Abrams, 1994.

Sandler, Irving. *Alex Katz: A Retrospective*. New York: H.N. Abrams, 1998.

Simon, Joan. *Susan Rothenberg*. New York: H.N. Abrams, 1991.

Smagula, Howard J. *Currents: Contemporary Directions in the Visual Arts*. Englewood Cliffs, N.J.: Prentice Hall, 1983.

Spring, Justin. *Fairfield Porter: A Life in Art*. New Haven, Conn.: Yale University Press, 2000.

Storr, Robert. *Philip Pearlstein Since 1983*. New York: H.N. Abrams, in assoc. with Robert Miller Gallery, 2002.

———, Carter Ratcliff, and Iwona Blazwick. *Alex Katz*. London; New York: Phaidon, 2005.

Tannenbaum, Judith. *Vija Celmins*. Philadelphia: Institute of Contemporary Art, 1992.

Teicher, Hendel. *Joel Shapiro, Sculpture and Drawings*. With an introd. essay by Michael Brenson. New York: H.N. Abrams, 1998.

Temkin, Ann, ed. *Alice Neel*. With essays by Ann Temkin, Susan Rosenberg, and Richard Flood. New York: H.N. Abrams in assoc. with Philadelphia Museum of Art, 2000.

Townsend, Chris., ed. *The Art of Rachel Whiteread*. New York: Thames & Hudson, 2004.

Uelsmann, Jerry. *Jerry Uelsmann: Other Realities*. New York: Bulfinch Press, 2005.

———. *Jerry Uelsmann: Photo Synthesis*. Gainesville, Fla.: University Press of Florida, 1992.

Varnedoe, Kirk. *Duane Hanson*. New York: H.N. Abrams, 1985.

Vischer, Theodora and Bernadette Walter, eds. *Roth Time: A Dieter Roth Retrospective*. Baden, Switzerland: Lars Müller Publishers, 2003.

Wagner, Anne. *Three Artists (Three Women): Modernism and the Art of Hesse, Krasner, and O'Keeffe*. Berkeley, Calif.: University of California Press, 1996.

Waldman, Diane. *Michael Singer*. New York: SRGM, 1984.

Walker, Barry. *Donald Sultan, a Print Retrospective*. New York: Rizzoli, 1992.

Weergraf-Serra, Clara, and Martha Buskirk, eds. *The Destruction of "Tilted Arc": Documents*. Cambridge, Mass. and London: MIT Press, 1991.

Westerbeck, Colin. *Joel Meyerowitz*. Rev. ed. in new format. London; New York: Phaidon, 2005.

Whiteread, Rachel. *House*. Ed. by James Lingwood. London: Phaidon, 1995.

Wilmerding, John. *Richard Estes*. New York: Rizzoli, 2006.

Young, James E. *At Memory's Edge: After-images of the Holocaust in Contemporary Art and Architecture*. New Haven, Conn.: Yale University Press, 2000.

24. Postmodernism

50 Years Documenta, 1955–2005: Kunsthalle Fridericianum. 2nd ed. Göttingen: Steidl, 2005.

Adjimi, Morris, ed. *Aldo Rossi: Architecture, 1981–1991*. New York: Princeton Architectural Press, 1991.

Ando, Tadao. *The Colors of Light*. London: Phaidon, 1996.

————. *Interview with Tadao Ando*. Interviewed by Betty Blum. Rev. ed. Chicago: Art Institute of Chicago, 2002.

Arata Isozaki: Four Decades of Architecture. Preface by Richard Koshalek. Essay by David B. Stewart. Rev. ed. New York: Universe Pub.; Los Angeles: MOCA, 1998.

Art of the Twentieth Century. Trans. Antony Shugaar. 5 vols. Vol. 1. *1900–1919: The Avant-Garde Movements*; Vol. 2. *1920–1945: The Artistic Culture Between the Wars*; Vol. 3. *1946–1968: The Birth of Contemporary Art*; Vol. 4. *1968–1999: Neo-Avant-Gardes: Postmodern and Global Art*; Vol. 5. *2000 and Beyond: Contemporary Tendencies*. Milan: Skira; New York: Distr. Rizzoli International Publications, 2006.

Berger, Maurice, ed. *Postmodernism: A Virtual Discussion*. Contrib. Maxwell Anderson, et al. Baltimore, Md.: Center for Art and Visual Culture, University of Maryland; Santa Fe: Georgia O'Keeffe Museum Research Center; New York: Distr. D.A.P./Distributed Art Publishers, 2003.

Brownlee, David B., David G. DeLong, and Kathryn B. Hiesinger. *Out of the Ordinary: Robert Venturi, Denise Scott Brown and Associates: Architecture, Urbanism, Design*. Philadelphia, Pa.: Philadelphia Museum of Art in association with Yale University Press, 2001.

Burton, Johanna, ed. *Cindy Sherman*. Essays by Craig Owens, et al. Cambridge, Mass.: MIT Press, 2006.

Cesar Pelli: Buildings and Projects, 1965–1990. Introd. by Paul Goldberger. New York: Rizzoli, 1990.

Cindy Sherman, Retrospective. Essays by Amada Cruz, Elizabeth A. T. Smith, and Amelia Jones. New York: Thames & Hudson; Chicago: MOCA; Los Angeles: MOCA, 1997.

Crosbie, Michael J. *Cesar Pelli: Recent Themes*. Basel; Boston: Birkhauser, 1998.

Cruells, Bartomeu. *Ricardo Bofill*. Barcelona: G. Gili, 1992.

Cuito, Aurora, ed. *Tadao Ando*. Düsseldorf: New York: Te Neues, 2003.

Dal Co, Francesco, and Kurt W. Forster. *Frank O. Gehry: The Complete Works*. Milan: Electaarchitecture; London; New York: Distr. Phaidon Press, 2003.

Dannatt, Adrian. *The United States Holocaust Memorial Museum: James Ingo Freed*. London: Phaidon, 1995.

Danto, Arthur C. *Cindy Sherman: History Portraits*. New York: Rizzoli, 1991.

Davidson, Cynthia, ed. *Tracing Eisenman: Peter Eisenman: Complete Work*. With essays by Stan Allen, et al. London: Thames & Hudson, 2006.

Davis, Douglas. *Artculture: Essays on the Postmodern*. New York: Harper & Row, 1979.

————. *The Museum Transformed: Design and Culture in the Post-Pompidou Age*. New York: Abbeville Press, 1990.

Dixon, Peter Morris, ed. *Robert A.M. Stern: Buildings and Towns*. Essay by Vincent Scully. New York: Monacelli Press, 2007.

Dobney, Stephen, ed. *Eisenman Architects: Selected and Current Works*. Mulgrave, Vic.: Images Pub. Group, 1995.

Dodds, George and Robert Tavernor., eds. *Body and Building: Essays on the Changing Relation of Body and Architecture*. Cambridge, Mass.: MIT Press, 2002.

Ebony, David. *"Towers of Light for New York City,"* Art in America 11, Nov 2001, p.35.

[Eisenman] *Re-working Eisenman*. London and Berlin: Academy Editions and Ernst & Sohn, 1993.

Ferguson, Russell, ed. *Discourses: Conversations in Postmodern Art and Culture*. Foreword by Marcia Tucker. Photographic sketchbook by John Baldessari. New York: New Museum of Contemporary Art; Cambridge, Mass.: MIT Press, 1990.

Fineberg, Jonathan David. *Art Since 1940: Strategies of Being*. 2nd ed. New York: H.N. Abrams, 2000.

Foster, Hal, ed. *The Anti-aesthetic: Essays on Postmodern Culture*. New York: New Press: Distr. W.W. Norton, 1998.

Frampton, Kenneth. *Labour, Work and Architecture: Collected Essays on Architecture and Design*. London; New York: Phaidon, 2002.

Frantz, Douglas, and Catherine Collins. *Celebration, USA: Living in Disney's Brave New Town*. New York: Henry Holt & Co., 1999.

Gehry, Frank. *The Architecture of Frank Gehry*. New York: Rizzoli, 1986.

Goldstein, Ann. *Barbara Kruger*. With essays by Rosalyn Deutsche, et al. Los Angeles: MOCA; Cambridge, Mass.: MIT Press, 1999.

Harrison, Sylvia. *Pop Art and the Origins of Post-Modernism*. Cambridge, England; New York: Cambridge University Press, 2001.

Hays, K. Michael, and Carol Burns, eds. *Thinking the Present: Recent American Architecture*. New York: Princeton Architectural Press, 1990.

Heartney, Eleanor. *Postmodernism*. Cambridge, England; New York: Cambridge University Press, 2001.

James, Warren A., ed. *Ricardo Bofill/Taller de Arquitectura: Buildings and Projects: 1960–1985*. New York: Rizzoli, 1988.

Jencks, Charles. *Architecture Today*. 2nd ed. London: Academy Editions, 1993.

————. *Critical Modernism: Where is Post-Modernism Going?* 5th ed. Chichester, England; Hoboken, N.J.: John Wiley, 2007.

————, ed. *Frank O. Gehry: Individual Imagination and Cultural Conservatism*. With a critical discourse by Robert Maxwell and Jeffrey Kipnis London: Academy Editions, 1995.

————. *The New Paradigm in Architecture: The Language of Post-Modern Architecture*. 7th ed. New Haven, Conn.: Yale University Press, 2002.

Jenkins, David, ed. *Norman Foster: Works*. Contributors, Chris Abel, et al. Vols. 1–2, 4 Munich; New York: Prestel, 2002.

Jenson, Robert, and Patricia Conway. *Ornamentalism: The New Decorativeness in Architecture and Design*. New York: C.N. Potter, 1982.

Joselit, David. *Jenny Holzer*. London: Phaidon, 1998.

Kipnis, Jeffrey. *Perfect Acts of Architecture*. Introd. by Terence Riley. New York: MOMA; London: Thames & Hudson, 2001.

Klotz, Heinrich. *The History of Postmodern Architecture*. Trans. R. Donnell. Cambridge, Mass.: MIT Press, 1988.

Koolhaas, Rem. *Delirious New York: A Retroactive Manifesto of Manhattan*. New York: Oxford University Press, 1978.

————, and Bruce Mau. *Small, Medium, Large, Extra-large: Office for Metropolitan Architecture*. Ed. J. Sigler. Rotterdam: 010 Publishers, 1995.

Kraft, Elizabeth, ed. *Robert A.M. Stern: Buildings and Projects, 1987–1992*. Introd. by Vincent Scully. New York: Rizzoli, 1992.

Krauss, Rosalind E. *Cindy Sherman, 1975–1993*. With an essay by Norman Bryson. New York: Rizzoli, 1993.

Krier, Rob. *Rob Krier on Architecture*. New York: St. Martin's Press, 1982.

————. *Town Spaces: Contemporary Interpretations in Traditional Urbanism: Krier-Kohl-Architects*. Introd. by Michael Graves. Essays by Hans Ibelings, Philipp Meuser, and Harald Bodenschatz. 2nd rev. ed. Basel; Boston: Birkhauser, 2006.

[Kruger] Nixon, Mignon. "You Thrive on Mistaken Identity." *October 60* (Spring 1992): 59–81.

Kurtz, Bruce D. *Contemporary Art, 1965–1990*. Englewood Cliffs, N.J.: Prentice Hall, 1992.

Linker, Kate. *Love for Sale: The Words and Pictures of Barbara Kruger*. New York: H.N. Abrams, 1990.

Lucan, Jacques. *OMA Rem Koolhaas: Architecture 1970–1990*. New York: Princeton Architectural Press, 1991.

McShine, Kynaston, ed. *Berlinart, 1961–1987*. With essays by René Block, et al. New York: MOMA; Munich: Prestel, 1987.

Meyhöfer, Dirk, ed. *Architectural Visions for Europe: Hans Hollein, Austria; Sir Norman Foster, England; Dominique Perrault, France; Romuald Loegler, Poland; Hans-Ullrich Bitsch and Niklaus Fritschi, Germany; Matteo Thun, Italy*. Braunschweig: Vieweg, 1994.

Moos, Stanislaus von. *Venturi, Rauch, and Scott Brown: Buildings and Projects, 1960–1985*. New York: Rizzoli, 1987.

————. *Venturi, Scott Brown & Associates: Buildings and Projects, 1986–1998*. Interview by Mary McLeod. New York: Monacelli Press, 1999.

Nichols, Karen, ed. *Michael Graves: Buildings and Projects, 1995–2003*. Essay by Francisco Sanin. New York: Rizzoli, 2003.

Norberg-Schulz, Christian. *Ricardo Bofill*. New York: Rizzoli, 1985.

Obrist, Hans-Ulrich. *Rem Koolhaas. The Conversation Series*, 4. Köln, Germany: Walther König, 2006.

Obrist, Hans-Ulrich. *Zaha Hadid. The Conversation Series*, 8. Köln, Germany: Walther König, 2007.

Patteeuw, Véronique, ed. *Considering Rem Koolhaas and the Office for Metropolitan Architecture: what is OMA*. Rotterdam: NAi Publishers, 2003.

Phillips, Lisa. *Richard Prince*. New York: WMAA, 1992.

Portoghesi, Paolo. *Postmodernism: The Architecture of the Post-Industrial Society*. Trans. E. Shapiro. New York: Rizzoli, 1983.

The Presence of the Past: First International Exhibition of Architecture—Venice Biennale 1980. New York: Rizzoli, 1980.

Provoost, Michelle. *Dutchtown: A City Centre Design by OMA/Rem Koolhaas*. Rotterdam: NAi Publishers, 1999.

Ragheb, J. Fiona, ed. *Frank Gehry, Architect*. New York: SRGM, 2001.

Risatti, Howard, ed. *Postmodern Perspectives: Issues in Contemporary Art*. 2nd ed. Upper Saddle River, N.J.: Prentice Hall, 1998.

Ross, Andrew. *The Celebration Chronicles: Life, Liberty, and the Pursuit of Property Value in Disney's New Town*. New York: Ballantine Books, 1999.

Rossi, Aldo. *Architecture of the City*. Trans. D. Ghirardo and J. Ockman. Rev. ed. Cambridge, Mass.: MIT Press, 1982.

Rugoff, Ralph. *Psycho Buildings: Artists Take on Architecture*. London: Hayward Gallery; New York: Distr. D.A.P./Distributed Art Publishers, 2008.

Rykwert, Joseph. *The Judicious Eye: Architecture Against the Other Arts*. Chicago; London: University of Chicago Press, 2008.

Sandler, Irving. *Art of the Postmodern Era: From the Late 1960s to the Early 1990s*. New York: Icon Editions, 1996.

Schneider, Eckhard, ed. *Jenny Holzer: Truth Before Power*. Köln, Germany: Walther König; New York: Distr. D.A.P./Distributed Art Publishers, 2004.

Schumacher, Patrik and Gordana Fontana Giusti, eds. *Zaha Hadid: Complete Works*. London: Thames & Hudson, 2004.

Spector, Nancy. *Richard Prince*. New York: SRGM, 2007.

Steele, James. ~~*Schnabel House: Frank Gehry*. London:~~ Phaidon, 1993.

Stern, Robert A. M. *New Directions in American Architecture*. Rev. ed. New York: G. Braziller, 1977.

Tadao Ando: 1983–2000. Madrid: El Croquis Editorial, 2000.

Tschumi, Bernard. *Event-Cities: Praxis*. Cambridge, Mass.: MIT Press, 1994.

Venturi, Robert. *Complexity and Contradiction in Architecture.* Introd. by Vincent Scully. New York: MOMA, 1966.

———, *Denise Scott Brown, and Steven Izenour. Learning from Las Vegas: The Forgotten Symbolism of Architectural Form.* Robert Venturi, Denise Scott Brown, Steven Izenour. Edition: Rev. ed. Cambridge, Mass.: MIT Press, 1996, 1977.

Waldman, Diane. *Jenny Holzer.* 2nd ed. New York: SRGM: Distr. in U.S. and Canada by H.N. Abrams, 1997.

Wallis, Brian, ed. *Art after Modernism: Rethinking Representation.* New York: The New Museum, 1984.

Yudell, Buzz. *Moore Ruble Yudell: Making Place.* Mulgrave, Australia: Images Pub., 2004.

25. Painting through History

50 Years Documenta, 1955–2005: Kunsthalle Fridericianum. 2nd ed. Göttingen: Steidl, 2005.

Ammann, Jean-Christophe. *Francesco Clemente: Works 1971–1979.* New York: Deitch Projects; Milan: Distr. Edizioni Charta, 2007.

Applebroog, Ida and Benjamin Lignel. *Ida Applebroog: Are You Bleeding Yet?* New York: La Maison Red, 2002.

Arasse, Daniel. *Anselm Kiefer.* New York: H.N. Abrams, 2001.

Art of the Twentieth Century. Trans. Antony Shugaar. 5 vols. Vol. 1. *1900–1919: The Avant-Garde Movements;* Vol. 2. *1920–1945: The Artistic Culture Between the Wars;* Vol. 3. *1946–1968: The Birth of Contemporary Art;* Vol. 4. *1968–1999: Neo-Avant-Gardes: Postmodern and Global Art;* Vol. 5. *2000 and Beyond: Contemporary Tendencies.* Milan: Skira; New York: Distr. Rizzoli International Publications, 2006.

Bailey, David A. Ian Baucom, & Sonia Boyce, eds. *Shades of Black: Assembling Black Arts in 1980s Britain.* Durham, England: Duke University Press; 2005.

Barnes, Lucinda, ed. *Between Artists: Twelve Contemporary American Artists Interview Twelve Contemporary American Artists.* With an introduction by Dave Hickey. Los Angeles: A.R.T. Press; New York: Distr. D.A.P./Distributed Art Publishers, 1996.

Becker, Jürgen and Claus von der Osten. *Sigmar Polke: The Editioned Works, 1963–2000: Catalogue Raisonné.* Trans. David Britt. Ostfildern-Ruit, Germany: Hatje Cantz; New York: Distr. D.A.P./Distributed Art Publishers, 2000.

Bee, Susan and Mira Schor, eds. *M/E/A/N/I/N/G: An Anthology of Artists' Writings, Theory, and Criticism.* Durham, NC: Duke University Press, 2000.

Berger, Maurice. *Adrian Piper: A Retrospective.* Contrib. Jean Fisher, et al. Baltimore, Md.: Fine Arts Gallery, University of Maryland; New York: Distr. D.A.P./Distributed Art Publishers, 1999.

Bird, Jon, ed. *Other Worlds: The Art of Nancy Spero and Kiki Smith.* Gateshead, England: BALTIC; London: Reaktion Books, 2003.

———, et al. *Nancy Spero.* London: Phaidon, 1996.

Boris, Staci and Rochelle Steiner. *John Currin.* Essays by Robert Rosenblum, et al. Chicago: Museum of Contemporary Art; London: Serpentine Gallery; New York: In assoc. with H.N. Abrams, 2003.

Bradley, Laurel. *Tragic and Timeless Today: Contemporary History Painting.* Chicago: Gallery 400, College of Architecture, Art and Urban Planning, University of Illinois at Chicago, 1987.

Bright, Deborah, ed. *The Passionate Camera: Photography and Bodies of Desire.* Ed. Deborah Bright. London; New York: Routledge, 1998.

Cameron, Dan, et al. *Fever: The Art of David Wojnarowicz.* New York: Rizzoli, 1998.

Celant, Germano. *Anselm Kiefer.* Milan: Skira; New York: Distr. Rizzoli, 2007.

———, ed. *Keith Haring.* Munich: Prestel, 1992.

Chiappini, Rudy. Ed. *Jean-Michel Basquiat.* Milan: Skira; Lugano: Museo d'Arte Moderna, Citta di Lugano, 2005.

Clark, T. J. *Farewell to an Idea: Episodes from a History of Modernism.* New Haven, Conn.: Yale University Press, 1999.

Coe, Sue. *Dead Meat.* Introd. by Alexander Cockburn. New York: Four Walls Eight Windows, 1995.

———. *Pit's Letter.* New York: Four Walls Eight Windows, 2000.

Cowart, Jack. *Expressions: New Art from Germany, Georg Baselitz, Jörg Immendorff, Anselm Kiefer, Markus Lüpertz, A. R. Penck.* St. Louis, Mo.: St. Louis Art Museum, 1983.

The Creation: Tim Rollins + K.O.S. at Pyramid Atlantic. Silver Spring, Md.: Pyramid Atlantic, 2005.

Danto, Arthur C. *Eric Fischl: Masterworks From the Early Eighties.* Zurich: Thomas Ammann, 2006.

———. *Mark Tansey: Visions and Revisions.* Ed. C. Sweet. New York: H.N. Abrams, 1992.

David Wojnarowicz: A Definitive History of Five or Six Years on the Lower East Side. Interviews by Sylvère Lotringer. Ed. by Giancarlo Ambrosino, et al. New York: Semiotext(e); Cambridge, Mass.: Distr. MIT Press, 2006.

Dennison, Lisa. *Clemente.* New York: Solomon R. Guggenheim Foundation: Distr. H.N. Abrams, 1999.

———. *Ross Bleckner.* New York: SRGM; Distr. H.N. Abrams, 1995.

Documenta (9th: 1992: Kassel, Germany) Documenta IX: Kassel, June 13–September 20, 1992. Stuttgart: Edition Cantz in assoc. with H.N. Abrams, New York, 1992.

Dunitz, Robin J. *Street Gallery.* Los Angeles, Calif.: RJD Enterprises, 1993.

Eccher, Danilo, et al. *Sean Scully: A Retrospective.* New York: Thames & Hudson; Barcelona: In assoc. with the Fundació Joan Miró, 2007.

Endgame: Reference and Simulation in Recent Painting and Sculpture. Boston: Institute of Contemporary Art, 1986.

Eric Fischl, 1970–2000. Essays by Arthur C. Danto, Robert Enright, and Steve Martin. New York: Monacelli Press, 2000.

Eric Fischl: Paintings and Drawings 1979–2001. Ostfildern-Ruit, Germany: Hatje Cantz; New York: Distr. D.A.P./Distributed Art Publishers, 2003.

Finkelpearl, Tom. *Dialogues in Public Art: Interviews with Vito Acconci, John Ahearn, David Avalos, Denise Scott Brown, Rufus L. Chaney, Mel Chin, Douglas Crimp.* Cambridge, Mass.: MIT Press, 2000.

[Fischl] *Scenes and Sequences: Recent Monotypes by Eric Fischl.* Hanover, N.H.: Hood Museum of Art, 1990.

Fleischman, Stephen. *Donald Lipski: A Brief History of Twine.* Essay by Terrie Sultan. Madison, Wis.: Madison Art Center; New York: Avail. through D.A.P./Distributed Art Publishing, 2000.

Fox, Howard N. *Avant-Garde in the Eighties.* Los Angeles: LACMA, 1987.

———, ed. *Robert Longo.* New York: Rizzoli, 1989.

Francesco Clemente: A Portrait. Photographs by Luca Babini. Essay by Rene Ricard. New York: Aperture, 1999.

Freeman, Judi. *Mark Tansey.* Los Angeles and San Francisco: LACMA and Chronicle Books, 1993.

Garrels, Garu, ed. *Amerika: Tim Rollins—K.O.S.* New York: Dia Art Foundation, 1990.

Gilmour, John. *Fire on the Earth: Anselm Kiefer and the Postmodern World.* Philadelphia: Temple University Press, 1990.

Godfrey, Tony. *The New Image: Painting in the 1980s.* New York: Abbeville Press, 1986.

Golub, Leon. *Leon Golub: Do Paintings Bite? Selected Texts 1948–1996.* Ed. by Hans-Ulrich Obrist. Ostfildern-Ruit, Germany: Hatje Cantz; New York: Distr. D.A.P/Distributed Art Publishers, 1997.

Gould, Claudia. *Lisa Yuskavage.* With essays by Katy Siegel and Marcia B. Hall. Philadelphia: Institute of Contemporary Art, University of Pennsylvania, 2000.

Gronert, Stefan. *Gerhard Richter: Portraits.* With an essay by Hubertus Butin. Ostfildern-Ruit, Germany: Hatje Cantz, 2006.

Gruen, John. *Keith Haring: The Authorized Biography.* New York: Prentice Hall, 1991.

Grundberg, Andy. *Mike and Doug Starn.* Introd. by Robert Rosenblum. New York: H.N. Abrams, 1990.

Harper, Glenn, ed. *Interventions and Provocations: Conversations on Art, Culture, and Resistance.* Albany, N.Y.: State University of New York Press, 1998.

Hentschel, Martin. *Sigmar Polke, the Three Lies of Painting.* Ostfildern-Ruit, Germany: Hatje Cantz; New York: Distr. D.A.P./Distributed Art Publishers, 1997.

Herrera, Hayden. *Joan Snyder.* With an essay by Jenni Sorkin. Introd. by Norman L. Kleeblatt. New York: H.N. Abrams, 2005.

Hockney, David and Lawrence Weschler. *Cameraworks: True to Life.* New York: Knopf, 1984.

Hollein, Max, ed. *Julian Schnabel: Paintings 1978–2003.* With essays by Maria de Corral, et al. Ostfildern-Ruit, Germany: Hatje Cantz, 2004.

Howard Hodgkin: Paintings. Essays by Michael Auping, John Elderfield, and Susan Sontag. New York: H.N. Abrams, 1995.

Ida Applebroog: Nothing Personal, Paintings 1987–1997. Essays by Terrie Sultan, Arthur C. Danto, and Dorothy Allison. Washington, D.C. Corcoran Gallery of Art; New York: D.A.P./Distributed Art Publishers, 1998.

Jenkins, Tamara. *Lisa Yuskavage: Small Paintings, 1993–2004.* New York: H.N. Abrams, 2004.

Joachimides, Christos. *A New Spirit in Painting.* Texts by Norman Rosenthal and Nicholas Serota. London: Royal Academy of Art, 1981.

Kellein, Thomas. *Mark Tansey.* Basel: Kunsthalle, 1990.

———, ed. *Robert Longo, Magellan.* Köln, Germany: Dumont, 1997.

Kiefer, Anselm. *The High Priestess.* With an essay by Armin Zweite. New York and London: H.N. Abrams and Anthony d'Offay, 1989.

Kuspit, Donald B. *Leon Golub: Existentialist/Activist Painter.* Rutgers, N.J.: Rutgers University Press, 1985.

Lane, John R. ad Charles Wylie, eds. *Sigmar Polke: The History of Everything: Painting and Drawings, 1998–2003.* Dallas, Tex.: Dallas Museum of Art; New Haven, Conn.: Yale University Press, 2003.

Levick, Melba. *The Big Picture: Murals of Los Angeles.* Boston: Little, Brown, 1988.

Lisa Yuskavage. Philadelphia: Institute of Contemporary Art, 2000.

Littmann, Klaus, ed. *Keith Haring, Editions on Paper 1982–1990: The Complete Printed Works.* Stuttgart: Cantz, 1993.

Longo, Robert. *Men in the Cities, 1979–1982.* With and introd. and interview by Richard Proce. New York: H.N. Abrams, 1986.

Lucie-Smith, Edward. *Art in the Eighties.* Oxford: Phaidon, 1990.

Marshall, Richard. *Jean-Michel Basquiat.* New York: WMAA, 1992.

Mayer, Marc, ed. *Basquiat.* Essays by Fred Hoffman, et al. Brooklyn, N.Y.: Brooklyn Museum; London; New York: Merrell, 2005.

McShine, Kynaston, ed. *Berlinart, 1961–1987.* With essays by René Block, et al. New York: MOMA; Munich: Prestel, 1987.

———. *An International Survey of Recent Painting and Sculpture.* New York: MOMA, 1984.

Mercurio, Gianni, ed. *Enzo Cucchi.* Milan: Electa, 2002.

———. *The Keith Haring Show.* Milan: Skira; London: Distr. Thames & Hudson, 2005.

Mignot, Dorine. *David Salle.* Trans. Beth O'Brien. Ghent: Ludion, 1999.

Moure, Gloria. *Sigmar Polke.* Trans. Graham Thomson. Barcelona: Polígrafa; New York: D.A.P./Distributed Art Publishers, 2005.

Obrist, Hans Ulrich. *Nancy Spero. The Conversation Series,* 11. Köln, Germany: Walther König; New York: Distr. D.A.P., 2008.

Olsen, Richard, ed. *Julian Schnabel.* New York: H.N. Abrams, 2004.

Percy, Ann, and Raymond Foye. *Francesco Clemente: Three Worlds*. Philadelphia: Philadelphia Museum of Art, 1990.

Pincus-Witten, Robert. *Entries (Maximalism): Art at the Turn of the Decade*. New York: Out of London Press, 1983.

Prat, Jean-Louis, et al. *Jean-Michel Basquiat*. 3rd ed. 2 vols. Paris: Galerie Enrico Navarra, 2000.

Price, Marla. *Howard Hodgkin: The Complete Paintings: Catalogue Raisonné*. Introd. by John Elderfield. London: Thames & Hudson; Fort Worth, Tex.: In assoc. with the Modern Art Museum of Fort Worth, 2006.

Ratcliff, Carter. *Komar & Melamid*. New York: Abbeville Press, 1988.

Reynolds, Cory, ed. *Peter Halley, Maintain Speed*. Essays by Rudi Fuchs, et al. New York: D.A.P./Distributed Art Publishers, 2000.

Richter, Gerhard. *Gerhard Richter: Atlas*. Ed. by Helmut Friedel; Trans. Michael Eldred. New ed. New York: D.A.P., 2006.

Rifkin, Ned. *Sean Scully: Twenty Years, 1976–1995*. Contrib. Victoria Combalia, Lynne Cooke, Armin Zweite. New York: Thames & Hudson; Atlanta: High Museum of Art, 1995.

Rose, Barbara. *American Painting, the Eighties: A Critical Interpretation*. New York: Grey Art Gallery and Study Center, New York University, 1979.

Ross Bleckner: Watercolor. Sante Fe, N.Mex.: Arena; New York: Distr. D.A.P, 1998.

Schor, Mira. *Wet: On Painting, Feminism, and Art Culture*. Durham: Duke University Press, 1997.

Scully, Sean. *Sean Scully: Resistance and Persistence: Selected Writings*. Ed. by Florence Ingleby. London; New York: Merrell, 2006.

Serota, Nicholas, ed. *Howard Hodgkin*. With an essay by James Meyer. London: Tate, 2006.

Serwer, Jacquelyn Days. *American Kaleidoscope: Themes and Perspectives in Recent Art*. Contrib. Johnathan P. Binstock, et al. Washington, D.C.: National Museum of American Art; New York: Distr. D.A.P./Distributed Art Publishers, 1996.

Sigmar Polke. San Francisco: Museum of Modern Art, 1990.

Sims, Lowery Stokes. *Ida Applebroog: Happy Families: A Fifteen-Year Survey*. Houston, Tex.: Contemporary Arts Museum, 1990.

Sims, Patterson. *Mark Tansey: Art and Source*. Seattle: Seattle Art Museum, 1990.

Sollins, Susan. *Eternal Metaphors: New Art From Italy*. Essays by Alessandra Mammì and Susan Sollins. New York: Independent Curators, 1989.

Solomon, Deborah. "Elizabeth Murray: Celebrating Paint." *New York Times Magazine*. (March 31, 1991): 20–25, 40, 46.

Spero, Nancy. *Codex Spero: Nancy Spero: Selected Writings and Interviews 1950–2008*. Ed. by Roel Arkesteijn. Amsterdam: Stichting Roma Publications 2008.

Starn, Mike. *Attracted to Light*. New York: PowerHouse Books, 2003.

Storr, Robert. *Elizabeth Murray*. New York: MOMA: Distr. in U.S. and Canada by D.A.P./Distributed Art Publishers, 2005.

———. *Gerhard Richter: Doubt and Belief in Painting*. New York: MOMA: Distr. D.A.P./Distributed Art Publishers, 2003.

Sussman, Elisabeth. *Keith Haring*. Contrib. David Frankel, et al. New York: WMAA, 1997.

———, et al. *Nan Goldin: I'll Be Your Mirror*. New York: WMAA: Scalo, 1996.

Taylor, Mark C. *The Picture in Question: Mark Tansey and the Ends of Representation*. Chicago: University of Chicago Press, 1999.

Thistlewood, David, ed. *Sigmar Polke: Back to Postmodernity*. Liverpool, England: Liverpool University Press: Tate, 1996.

Tuchman, Maurice, and Stephanie Barron. *David Hockney, A Retrospective*. New York: H.N. Abrams, 1988.

Wacker, Kelly, ed. *Baroque Tendencies in Contemporary Art*. Newcastle, England: Cambridge Scholars, 2007.

Waldman, Diane. *Enzo Cucchi*. New York: SRGM, 1986.

———. *George Baselitz*. New York: SRGM, 1995.

———, ed. *Italian Art Now: An American Perspective*. New York: SRGM, 1982.

Weg, Kara vander and Rose Dergin, eds. *John Currin*. With essays by Norman Bryson, Alison M. Gingeras, and Dave Eggers. New York: Gagosian Gallery: Distr. Rizzoli International, 2006.

Weiss, Evelyn, ed. *Komar & Melamid: The Most Wanted, The Most Unwanted Painting*. Ostfildern-Ruit, Germany: Hatje Cantz, 1997.

Whitney, David, ed. *David Salle*. Text by Lisa Liebmann. New York: Rizzoli, 1994.

Wojnarowicz, David. *Memories That Smell Like Gasoline*. San Francisco: Artspace Books, 1992.

Zweite, Armin. *Gerhard Richter*. Ed. by Kunstsammlung Nordrhein-Westfalen. With an essay by Armin Zweite and the catalogue raisonné, 1993–2004. Düsseldorf: K20K21 Kunstsammlung Nordrhein-Westfalen, 2005.

26: Contemporary Art and the Renegotiation of Modernism

50 Years Documenta, 1955–2005: Kunsthalle Fridericianum. 2nd ed. Göttingen: Steidl, 2005.

Adams, Brooks, et al. *Sensation: Young British Artists From the Saatchi Collection*. London: Thames & Hudson, 1997.

Alexander, Julia Marciari and David Scrase, eds. *Howard Hodgkin Paintings 1992–2007*. With essays by Richard Morphet, Anthony Lane. New Haven, Conn.; London: Yale University Press, 2007.

Allan McCollum. Interview by Thomas Lawson. Los Angeles: A.R.T. Press; New York: Distr. Distributed Art Publishers, 1996.

Annear, Judy. "Peepshow: Inside Yasumasa Morimura's Looking Glass," *Art Asia Pacific 13* (1997): 42–47.

Armstrong, Carol and Catherine de Zegher, eds. *Women Artists at the Millennium*. Cambridge, Mass.: MIT Press, 2006.

Art of the Twentieth Century. Trans. Antony Shugaar. 5 vols. Vol. 1. *1900–1919: The Avant-Garde Movements*; Vol. 2. *1920–1945: The Artistic Culture Between the Wars*; Vol. 3. *1946–1968: The Birth of Contemporary Art*; Vol. 4. *1968–1999: Neo-Avant-Gardes: Postmodern and Global Art*; Vol. 5. *2000 and Beyond: Contemporary Tendencies*. Milan: Skira; New York: Distr. Rizzoli International Publications, 2006.

Baigell, Matthew. *Artist and Identity in Twentieth-Century America*. Cambridge, England; New York: Cambridge University Press, 2001.

Benezra, Neal. *Martin Puryear*. Chicago: Art Institute of Chicago, 1991.

———, and Olga Viso. *Regarding Beauty: A View of the Late Twentieth Century*. With an essay by Arthur C. Danto. Washington, D.C.: HMSG; Ostfildern-Ruit, Germany: Hatje Cantz, 1999.

Biggs, Lewis, et al. *A New Thing Breathing: Recent Work by Tony Cragg*. Liverpool, England: Tate Liverpool; London: Distributed by Tate, 2000.

Bonami, Francesco, ed. *Jeff Koons*. With a conversation between Jeff Koons and Lynn Warren. Chicago: Museum of Contemporary Art, Chicago; New Haven, Conn.: Yale University Press, 2008.

Bright, Deborah, ed. *The Passionate Camera: Photography and Bodies of Desire*. London; New York: Routledge, 1998.

Brougher, Kerry. *Jeff Wall*. Los Angeles: MOCA, 1997.

Bryson, Norman. "Three Morimura Readings," *Art + Text 52* (1995): 67–78.

Benjamin H.D. Buchloh, et al. *Gabriel Orozco*. Los Angeles: MOCA; Mexico City: Consejo Nacional para la Cultura y las Artes, 2000.

Cameron, Dan, Carolyn Christov-Bakargiev, and J.M. Coetzee. *William Kentridge*. Contemporary Artists. London: Phaidon, 1999.

Carrie Mae Weems: The Louisiana Project. New Orleans: Newcomb Art Gallery, Tulane University, 2004.

Carmean, E. A., et al. *The Sculpture of Nancy Graves: A Catalogue Raisonné*. New York: Hudson Hills Press in assoc. with the Fort Worth Art Museum, 1987.

Celant, Germano. *Tony Cragg*. New York: Thames & Hudson, 1996.

———. *Unexpressionism: Art Beyond the Contemporary*. New York: Rizzoli, 1988.

Christov-Barkagiev, Carolyn. *William Kentridge*. Milan: Skira, 2004.

Colpitt, Frances, ed. *Abstract Art in the Late Twentieth Century*. Cambridge, England; New York: Cambridge University Press, 2002.

Crone, Rainer, and David Moos. *Jonathan Lasker: Telling the Tales of Painting; About Abstraction at the End of the Millennium*. Stuttgart: Édition Cantza, 1993.

The Decade Show: Frameworks of Identity in the 1980s. New York: Museum of Contemporary Hispanic Art, The New Museum of Contemporary Art, SMH, 1990.

Documenta X: Short Guide. Texts, Paul Sztulman, et al. Ostfildern-Ruit, Germany: Hatje Cantz, 1997.

Duve, Thierry de, et al. *Jeff Wall*. 2nd ed. rev. and exp. London: Phaidon, 2002.

Elderfield, John, et al. *Martin Puryear*. New York: MOMA; 2007.

Enwezor, Okwui. *Archive Fever: Uses of the Document in Contemporary Art*. New York: International Center of Photography; Göttingen: Steidl Publishers, 2008.

———. *Lorna Simpson*. Foreword by Helaine Posner; essay by Hilton Als; conversation with the artist, Lorna Simpson, Isaac Julien, and Thelma Golden. New York: H.N. Abrams, in assoc. with the American Federation of Arts, 2006.

Finley, Karen. *A Different Kind of Intimacy: The Collected Writings of Karen Finley*. New York: Thunder's Mouth Press; Distr. Publishers Group West, 2000.

Foster, Hal. *Return of the Real: The Avant-Garde at the End of the Century*. Cambridge, Mass.: MIT Press, 1996.

Freeman, Phyllis, et al., eds. *New Art*. New York: H.N. Abrams, 1984.

Gablik, Suzy. *Has Modernism Failed?* 2nd ed, New York: Thames & Hudson, 2004.

Gabriel Orozco. México: Turner; Museo del Palacio de Bellas Artes, INBA, 2006.

Gaensheimer, Susanne and Nicolaus Schafhausen, eds. *Liam Gillick*. Trans. Brigitte Kathoff. Köln, Germany: Oktagon, 2000.

Galassi, Peter and Neal Benezra. *Jeff Wall*. Interview with Jeff Wall by James Rondeau. New York: MOMA: Distr. D.A.P./Distributed Art Publishers, 2007.

Gillick, Liam and Lilian Haberer. *Factoriesinthesnow*. Zurich: Jrp/Ringier; New York: D.A.P./Distributed Art Publishers, 2007.

Glee: Painting Now. Organized by the Aldrich Museum of Contemporary Art and Palm Beach Institute of Contemporary Art. Ridgefield, Conn.: Aldrich Museum of Contemporary Art, 2000.

Goldstein, Richard. *South Bronx Hall of Fame: Sculpture by John Ahearn and Rigoberto Torres*. Houston, Tex.: Contemporary Arts Museum; Seattle, Wash.: Distr. University of Washington Press, 1991.

Goodman, Cynthia. *Digital Visions: Computers and Art*. New York: H.N. Abrams, 1987.

Gumpert, Lynn and Mary Jane Jacob, eds. *Christian Boltanski: Lessons of Darkness*. Chicago: Museum of Contemporary Art, 1988.

Gumpert, Lynn. "Glamour Girls." *Art in America* 84:7 (July 1996): 62–65.

Heartney, Eleanor, et al. *After the Revolution: Women Who Transformed Contemporary Art*. With a foreword by Linda Nochlin. Munich; New York: Prestel, 2007.

Helter Skelter: L.A. Art in the 1990s. Los Angeles: MOCA, 1992.

Hickey, Dave. *Air Guitar: Essays on Art & Democracy*. Los Angeles: Art Issues. Press; New York: Distr. D.A.P. 1997.

———. *The Invisible Dragon: Four Essays on Beauty*. Los Angeles: Art Issues Press, 1993.

Hirst, Damien. *I Want to Spend the Rest of my Life Everywhere, with Everyone, One to One, Always, Forever, Now*. New York: Monacelli Press, 1997.

———, and Gordon Burn. *On the Way to Work*. London: Faber and Faber, 2001.

———, and Millicent Wilner. *Corpus: Drawings, 1981–2006*. New York: Gagosian Gallery; Other Criteria, 2006.

hooks, bell. *Art on My Mind: Visual Politics*. New York: The New Press, 1995.

Horn, Roni. *Earths Grow Thick*. Columbus, OH: Wexner Center for the Arts, 1996.

———. *Making Being Here Enough: Installations from 1980 to 1995*. Hannover: Kestner-Gesellschaft, 1995.

Johnstone, Mark. *Contemporary Art in Southern California*. North Ryde, Sydney, Australia: Craftsman House: G+B Arts International, 1999.

Jones, Kellie, Thelma Golden and Chrissie Iles. *Lorna Simpson*. London; New York: Phaidon, 2002.

Kellein, Thomas, ed. *Jeff Koons: Pictures, 1980–2002*. New York: Distributed Art Publishers, 2002.

Kentridge, William. *William Kentridge*. Chicago: Museum of Contemporary Art, 2001.

Kirsch, Andrea, and Susan Fisher Sterling. *Carrie Mae Weems*. Washington, D.C.: National Museum of Women in the Arts, 1993.

Kleeblatt, Norman L., ed. *Mirroring Evil: Nazi Imagery/Recent Art*. New York: Jewish Museum, 2001.

———, ed. *Too Jewish: Challenging Traditional Identities*. New York: The Jewish Museum, 1996.

Koether, Jutta. "The Nonchalance of Continuous Tenseness," *Parkett* 58 (2000): 104–115.

Koons, Jeff. *The Jeff Koons Handbook*. Introd. by Robert Rosenblum. New York: Rizzoli, 1992.

Linker, Kate. "Went Looking for Africa: Carrie Mae Weems." *Artforum* 31 (February 1993): 79–82.

Lippard, Lucy. "Andres Serrano: The Spirit and the Letter." *Art in America* (April, 1996): 239–245.

[Lipski] Princenthal, Nancy. "Reweaving Old Glory." *Art in America* (May 1991): 137–140.

Maraniello, Gianfranco, ed. *Art in Europe 1990–2000*. Trans. Language Consulting Congressi. Milan, Italy: Skira; New York: Distr. Rizzoli through St. Martin's Press, 2002.

Masheck, Joseph. *Modernities: Art-Matters in the Present*. University Park, Pa.: Pennsylvania State University Press, 1993.

Matt, Gerald and Thomas Miessgang. *Raymond Pettibon*. Trans. Wolfgang Astelbauer. Wien, Germany: Kunsthalle Wien; Nürnberg, Germany: Verlag für moderne Kunst; New York: Distr. D.A.P./Distributed Art Publishers, 2006.

Modernism and Modernity: The Vancouver Conference Papers. Ed. by Benjamin H.D. Buchloh, Serge Guilbaut, and David Solkin. 2004 ed. Halifax, N.S.: Press of the Nova Scotia College of Art and Design, 2004.

Mullins, Charlotte. *Painting People: Figure Painting Today*. New York: D.A.P./Distributed Art Publishers, 2006.

Moos, David. *Jonathan Lasker: Selective Identity: Paintings From the 1990s*. Birmingham, Ala.: Birmingham Museum of Art, 1999.

Morgan, Jessica, ed. *Ellen Gallagher*. Interview with the artist, text by Greg Tate and Robert Storr. Boston: Institute for Contemporary Art, Boston, 2001.

Murphy, Patrick T., ed. *Andres Serrano: Works 1983–1993*. Texts by R. Hobbs, W. Steiner, M. Tucker. Philadelphia: Institute of Contemporary Art, 1994.

Nead, Lynda. *The Female Nude: Art, Obscenity and Sexuality*. New York: Routledge, 1992.

Neri, Louise, et al. *Roni Horn*. London: Phaidon, 2000.

Ohrt, Roberto, ed. *Raymond Pettibon: The Books 1978–1998*. Trans. Warren Niesluchowski. New York: D.A.P./Distributed Art Publishers, 2000.

Osorio, Pepon. *Con to 'los Hierros: A Retrospective of the Work of Pepon Osorio*. New York: El Museu del Barrio, 1991.

Owens, Craig. *Beyond Recognition: Representation, Power, and Culture*. Berkeley, Calif.: University of California Press, 1992.

Padon, Thomas. *Nancy Graves: Excavations in Print: A Catalogue Raisonné*. With a foreword by J. Carter Brown. New York: H.N. Abrams in assoc. with the American Federation of Arts, 1996.

Perry, Gill and Paul Wood, eds. *Themes in Contemporary Art*. New Haven, Conn.: Yale University Press in assoc. with the Open University, 2004.

[Pettibone] Rugoff, Ralph. "Surfing with Raymond: Nobody Rides for Free." *Parkett* 47 (1996): 82–87.

Piché, Thomas and Thelma Golden. *Carrie Mae Weems: Recent Work, 1992–1998*. New York: George Braziller; Syracuse, N.Y.: in assoc.with Everson Museum of Art, 1998.

Piper, Adrian. *Out of Order, Out of Sight*. 2 vols. Cambridge, Mass.: MIT Press, 1996.

Pollock, Griselda and Joyce Zemans, eds. *Museums after Modernism: Strategies of Engagement*. Malden, Mass.: Blackwell, 2007.

Popper, Frank. *From Technological to Virtual Art*. Cambridge, Mass.: MIT Press, 2007.

Pressplay: Contemporary Artists in Conversation. London; New York: Phaidon, 2005.

Price, Marla. *Howard Hodgkin: The Complete Paintings: Catalogue Raisonné*. Introd. by John Elderfield. London: Thames & Hudson; Fort Worth, Tex.: In assoc. with the Modern Art Museum or Fort Worth, 2006.

Rice, Shelley, ed. *Inverted Odysseys: Claude Cahun, Maya Deren, Cindy Sherman*. Contrib. Lynn Gumpert, et al.; also including "Heroines," a fictional text by Claude Cahun, trans. by Norman MacAfee. Cambridge, Mass.: MIT Press, 1999.

Richards, Judith Olch, ed. *Inside the Studio: Two Decades of Talks with Artists in New York*. New York: Independent Curators International: Distr. D.A.P./Distributed Art Publishers, 2004.

Rosenblum, Robert. *The Jeff Koons Handbook*. New York: Rizzoli, 1992.

Rubinstein, Raphael. *Polychrome Profusion: Selected Art Criticism 1990–2002*. Lenox, Mass.: Hard Press Editions, 2003.

Saltz, Jerry. *Seeing OutLoud: The Voice Art Columns, Fall 1998–Winter 2003*. Great Barrington, Mass.: The Figures, 2003.

Sandler, Irving. *From Avant-Garde to Pluralism: An On-the-Spot History*. Lenox, Mass.: Hard Press Editions, 2006.

———. *Judy Pfaff*. Introd. by Russell Panczenko. New York: Hudson Hills Press, in assoc. with Elvehjem Museum of Art, University of Wisconsin-Madison; Lanham, Md.: Distr. National Book Network, 2003.

Schimmel, Paul. *Tony Cragg: Sculpture 1975–1990*. Text by Lucinda Barnes, et al. London; New York: Thames & Hudson in assoc. with Newport Harbor Art Museum, 1991.

Schwabsky, Barry. "A City of Bricks and Ciphers," *Art in America* (September 1998): 100–105.

———. *The Widening Circle: The Consequences of Modernism in Contemporary Art*. Cambridge, England; New York: Cambridge University Press, 1997.

Semin, Didier, Tamar Garb, and Donald Kuspit. *Christian Boltanski*. London: Phaidon, 1997.

Senie, Harriet. *Contemporary Public Sculpture: Tradition, Transformation, and Controversy*. New York: Oxford University Press, 1992.

Serrano, Andres. *America and Other Work*. Contrib. Julie Ault, Dian Hanson, and Eleanor Heartney. Köln, Germany; Los Angeles, Taschen, 2004.

Siben, Isabel, ed. *Ilya & Emilia Kabakov: Installation & Theater*. Contrib. Boris Groys, Hans-Peter Riese. Munich: Prestel, 2006.

Stahel, Urs and Roni Horn. *If On a Winter's Night ... Roni Horn ...* . Gotingen: Steidl, 2003.

Stiles, Kristine, and Peter Selz, eds. *Theories and Documents of Contemporary Art: A Sourcebook of Artists' Writings*. Berkeley, Calif.: University of California Press, 1996.

Storr, Robert. "Anxious Spaces," *Art in America* 86 (November 1998): 101–5, 143–4.

———. "Setting Traps for the Mind and Heart." *Art in America* 84:10 (January 1996): 70–77ff.

———, et al. *Raymond Pettibon*. New York: Phaidon, 2001.

Temkin, Ann, and Hamza Walker, eds. *Raymond Pettibon: A Reader*. Philadelphia: Philadelphia Museum of Art, 1998.

Townsend, Chris, ed. *The Art of Bill Viola*. New York: Thames & Hudson, 2004.

Vischer, Theodora and Heidi Naef, eds. *Jeff Wall: Catalogue Raisonné, 1978–2004*. Basel: Schaulager; Göttingen: Steidl, 2005.

Viso, Olga. *Distemper: Dissonant Themes in the Art of the 1990s*. Washington, D.C.: HMSG, Smithsonian Institution, 1996.

Wacker, Kelly, ed. *Baroque Tendencies in Contemporary Art*. Newcastle, England: Cambridge Scholars, 2007.

Walker, Hamza. "Nigger Lover or Will There Be Any Black People in Utopia," *Parkett* 59 (2000): 152–161.

Wallach, Amei. *Ilya Kabakov, 1969–1998*. Annandale-on-Hudson, N.Y.: Center for Curatorial Studies, 2001.

———. *Ilya Kabakov: The Man Who Never Threw Anything Away*. New York: H.N. Abrams, 1996.

Wallis, Brian ed. *Democracy: A Project by Group Material. Discussions in Contemporary Culture*, 5. Seattle: Bay Press, 1990.

Walsh, John, ed. *Bill Viola: The Passions*. With essays by Peter Sellars and a conversation between Hans Belting and Bill Viola. Los Angeles: The J. Paul Getty Museum in assoc. with The National Gallery, London, 2003.

Warr, Tracey, ed. *The Artist's Body*. Survey by Amelia Jones. Themes and Movements. London: Phaidon, 2000.

Wollen, Peter. *Paris/Manahttan: Writings on Art*. London; New York: Verso, 2004.

Yoko, Hayashi, ed. *Morimura Yasumasa: Self-Portrait as Art History*. Tokyo: Asahi Shimbun. 1998.

Zegher, M. Catherine de. *Inside the Visible: An Elliptical Traverse of 20th Century Art in, of, and From the Feminine*. Cambridge, Mass.: MIT Press, 1996.

Zelevansky, Lynn. *Sense and Sensibility: Women Artists and Minimalism in the Nineties*. New York: MOMA, 1994.

27: Contemporary Art and Globalization

1993 Biennial Exhibition. New York: WMAA, 1993.

Albertini, Claudia. *Avatars and Antiheroes: A Guide to Contemporary Chinese Artists*. New York: Kodansha America, 2008.

Altschuler, Bruce, ed. *Collecting the New: Museums and Contemporary Art*. Princeton, N.J.: Princeton University Press, 2005.

Always Remember: The NAMES Project AIDS Memorial Quilt. Washington, D.C.: National Museum of American History, 1996.

Anastas, Rhea and Michael Brenson, eds. *Witness to Her Art: Art and Writings by Adrian Piper, Mona Hatoum, Cady Noland, Jenny Holzer, Kara Walker, Daniela Rossell and Eau de Cologne*. Annandale-on-Hudson, N.Y.: Center for Curatorial Studies, 2006.

Archer, Michael, Guy Brett and Catherine de Zegher. *Mona Hatoum*. Contemporary Artists. London: Press, 1997.

Art of the Twentieth Century. Trans. Antony Shugaar. 5 vols. Vol. 1. *1900–1919: The Avant-Garde Movements*; Vol. 2. *1920–1945: The Artistic Culture Between the Wars*; Vol. 3. *1946–1968: The Birth of Contemporary Art*; Vol. 4. *1968–1999: Neo-Avant-Gardes: Postmodern and Global Art*; Vol. 5. *2000 and Beyond: Contemporary Tendencies*. Milan: Skira; New York: Distr. Rizzoli International Publications, 2006.

Baerwaldt, Wayne and Thelma Golden. *Glenn Ligon: Some Changes*. Essays by Darby English, et al.; interview by Stephen Andrews. Toronto, Ont.: Power Plant, 2005.

Baigell, Matthew. *Artist and Identity in Twentieth-Century America*. Cambridge, England; New York: Cambridge University Press, 2001.

Baigell, Matthew. *Jewish-American Artists and the Holocaust*. New Brunswick: Rutgers University Press, 1997.

Bailey, David A. and Gilane Tawadros, eds. *Veil: Veiling, Representation, and Contemporary Art.* Cambridge, Mass.: MIT Press, 2003.

Bartman, William S., and Miyoshi Barosh, eds. *Mike Kelley.* New York: Art Press, 1992. Interview with the artist by J. Miller.

Baumgarten, Lothar. *America.* New York: SRGM, 1993.

Beil, Ralf, ed. Boltanski: *Time.* Ostfildern-Ruit, Germany: Hatje Cantz; Darmstadt: Mathildenhöhe Darmstadt, 2006.

Benezra, Neal David. *Distemper: Dissonant Themes in the Art of the 1990s.* Washington D.C.: HMSG, Smithsonian Institution, 1996.

Blessing, Jennifer, ed. *Rrose is a Rrose is a Rrose: Gender Performance in Photography.* New York: SRGM, 1997.

Boeri, Stefano, et al. *Jimmie Durham.* Milao: Charta; Como: Fondazione Antonio Ratti, 2004.

Bolton, Richard, ed. *Culture Wars: Documents from the Recent Controversies in the Arts.* New York: The New Press, 1992.

Boogerd, Dominic van den, Barbara Bloom and Mariuccia Casadio. *Marlene Dumas.* London: Phaidon, 1999.

Broeker, Holger, et al. *Gary Hill: Selected Works + Catalogue Raisonne.* Köln, Germany: Dumont, 2002.

Bronx Museum of the Arts. *Collection Remixed.* Essays by Marysol Nieves, et al. Bronx, N.Y.: Bronx Museum of the Arts, 2005.

Brougher, Kerry and Russell Ferguson. *Open City: Street Photographs Since 1950.* Oxford, England: Museum of Modern Art Oxford; Ostfildern-Ruit, Germany: Hatje Cantz; New York: D.A.P./Distributed Art Publishers, 2001.

Buchloh, Benjamin H.D. *Thomas Struth: Photographs.* Chicago: The Renaissance Society, 1990.

Bussard, Katherine A. *So the Story Goes: Photographs by Tina Barney, Philip-Lorca Dicorcia, Nan Goldin, Sally Mann, Larry Sultan.* Chicago: Art Institute of Chicago; New Haven, Conn.; Distr. Yale University Press, 2006.

Butler, Cornelia. *Marlene Dumas: Measuring Your Own Grave.* Los Angeles: MOCA, 2008.

Button, Virginia and Charles Esche. *Intelligence: New British Art 2000.* London: Tate, 2000.

Cai Guo-Qiang: Cultural Melting Bath: Projects for the 20th Century. Essays by Jane Farver. New York: Queens Museum of Art, 1997.

Castello Di Rivoli Museo d'Arte Contemporanea. *Shirin Neshat.* Milan: Charta, 2002.

Chambers, Kristin. *Threads of Vision: Toward a New Feminine Poetics.* Cleveland, OH: Cleveland Center for Contemporary Art; New York: D.A.P./Distributed Art Publishers, 2001.

Chu, Marjorie. *Understanding Contemporary Southeast Asian Art.* Singapore: Art Forum, 2003.

Coles, Alex, ed. *Site-Specificity: The Ethnographic Turn.* Contrib. Lothar Baumgarten, et al. London: Black Dog Press, 2000.

"A Conversation on Recent Feminist Art Practices: Silvia Kolbowski, Mignon Nixon, Mary Kelly, Hal Foster, Liz Kotz, Simon Leung and Ayisha Abraham." *October* 71 (Winter 1995): 48–69.

Cooke, Lynne and Karen Kelly, eds. *Diana Thater Knots + Surfaces.* New York: Dia Center for the Arts, 2002.

Cooper, Emmanuel. *The Sexual Perspective: Homosexuality and Art in the Last 100 Years in the West.* 2nd ed. London: Routledge, 1994.

Cruz, Amanda, et al. *Takashi Murakami: The Meaning of the Nonsense of Meaning.* Annendale-on-Hudson: Center for Curatorial Studies, 1999.

Dannatt, Adrian. "From Lacan's Drive to Rodeo Drive: Marketing and Minimalism in Fleury's Femininity," *Parkett* 58 (2000): 76–88.

Danto, Arthur C. *The Wake of Art: Criticism, Philosophy, and the Ends of Taste.* Amsterdam: G+B Arts International, 1998.

Deitch, Jeffrey. *Form follows Fiction.* Milan: Charta, 2001.

DeMonte, Claudia. *Women of the World: A Global Collection of Art.* Foreword by Arlene Raven. San Francisco: Pomegranate, 2000.

Drucker, Johanna. *Sweet Dreams: Contemporary Art and Complicity.* Chicago: University Of Chicago Press, 2005.

Dumas, Marlene. *Sweet Nothings: Notes and Texts.* Amsterdam: De Balie, 1998.

Durant, Alice, Laura Mulvey, and Dirk Snauwaert. *Jimmie Durham.* London: Phaidon, 1995.

Eklund, Douglas, et al. *Thomas Struth 1977–2002.* Dallas, Tex.: Dallas Museum of Art; New Haven, Conn.: Yale University Press, 2002.

Engberg, Siri. *Kiki Smith: A Gathering, 1980–2005.* Contrib. Linda Nochlin, Lynne Tillman, and Marina Warner. Minneapolis: Walker Art Center, 2005.

Engelbach, Barbara and Wolf Herzogenrath, eds. *Diana Thater: Keep the Faith: A Survey Exhibition.* Köln, Germany: Salon Verlag, 2004.

English, Darby. *How to See a Work of Art in Total Darkness.* Cambridge, Mass.: MIT Press, 2007.

Enwezor, Okwui. *Archive Fver: Uses of the Document in Contemporary Art.* New York: International Center of Photography; Göttingen: Steidl Publishers, 2008.

————. *Lorna Simpson.* Foreword by Helaine Posner; essay by Hilton Als; conversation with the artist, Lorna Simpson, Isaac Julien, and Thelma Golden. New York: Abrams, in assoc. with the American Federation of Arts, 2006.

Farrell, Laurie Ann, ed. *Looking Both Ways: Art of the Contemporary African Diaspora.* Contrib. Valentijn Byvanck, et al. New York: Museum for African Art; Gent: Snoeck, 2003.

Ferguson, Russel. "Given: 1: The Caprice 2. The Ferrari," *Parkett* 58 (2000): 122–128.

————. *The Undiscovered Country.* Los Angeles: Hammer Museum, 2004.

Fibicher, Bernard and Suman Gopinath. *Horn Please: Narratives in Contemporary Indian Art.* Ostfildern-Ruit, Germany: Hatje Cantz; New York: D.A.P./Distributed Art Publishers, 2007.

Fogle, Douglas. *Painting at the Edge of the World.* Minneapolis: Walker Art Center, 2001.

Friis-Hansen, Dana, Octavio Zaya, and Serizawa Takashi. *Cai Guo-Qiang.* Contemporary Artists. London; New York: Phaidon, 2002.

Fusco, Coco. *English is Broken Here: Notes on Cultural Fusion in the Americas.* New York: The New Press, 1995.

————, and Brian Wallis, eds. *Only Skin Deep: Changing Visions of the American Self.* New York: International Center of Photography: H.N. Abrams, 2003.

Gablik, Suzy. *Has Modernism Failed?* 2nd ed. New York: Thames & Hudson, 2004.

Gerz, Jochen. *Jochen Gerz: res publica: The Public Works 1968–1999.* Ostfildern-Ruit, Germany: Hatje Cantz, 1999.

Gillick, Liam. *Literally No Place: Communes, Bars and Greenrooms.* London: Book Works, 2002.

————. "Literally No Place: An Introduction," *Parkett* 61 (2001): 56–63.

Gilman, Larry, ed. *Threads of Vision: Toward a Feminine Poetics.* Cleveland: Cleveland Center for Contemporary Art, 2001.

Goetz, Ingvild, et al. *Matthew Barney.* München: Sammlung Goetz, 2007.

Golden, Thelma. *Black Male: Representations of Masculinity in Contemporary American Art.* New York: WMAA, 1994.

————. *Chris Ofili: Afromuses, 1995–2005.* Text by Hilton Als and Beth Coleman. New York: SMH, 2005.

Goldin, Nan. *The Ballad of Sexual Dependency.* New York: Aperture, 1996.

————. *Nan Goldin: I'll Be Your Mirror.* New York: WMAA, 1996.

————, and John Jenkonson. *The Devil's Playground.* London: Phaidon, 2003.

González, Jennifer A. *Subject to Display: Reframing Race in Contemporary Installation Art.* Cambridge, Mass.: MIT Press, 2008.

Gott, Ted, ed. *Don't Leave Me This Way: Art in the Age of AIDS.* Melbourne: National Gallery of Australia, 1994.

Groom, Simon, Karen Smith and Xu Zhen. *The Real Thing: Contemporary Art From China.* London: Tate; New York: Distr. H.N. Abrams, 2007.

Grosenick, Uta and Burkhard Riemschneider, eds. *Art Now: 137 Artists at the Rise of the New Millennium.* Texts by Kirsty Bell, et al.; trans. Monica Bloxam, Isabel Varea, Karen Waloschek. Köln, Germany: Taschen, 2002.

————. *81 Artists at the Rise of the New Millennium.* 25th Anniversary ed. Köln, Germany; London: Taschen, 2005.

Guldemond, Jaap, Gabriele Mackert, and Barbera van Kooij, eds. *Yinka Shonibare: Double Dutch.* Rotterdam: Museum Boijmans Van Beuningen; Vienna: Kunsthalle Wien; Rotterdam: NAi Publishers, 2004.

Haase, Amine and Friedhelm Mennekes. *Gregor Schneider: Cubes: Art in the Age of Global Terrorism.* Milan: Charta, 2006.

Hamilton, Ann. *The Body and the Object: Ann Hamilton, 1984–1996.* Columbus, OH: Wexner Center for the Arts, 1996.

Hamilton, Ann. *Mneme.* Ed. by Judith Nesbitt. London: Tate, 1994.

Hamilton, Ann. *Ann Hamilton: Present-Past, 1984–1997.* Milan: Skira, 1998.

Hanor, Stephanie, et al. *TRANSactions: Contemporary Latin American and Latino Art.* La Jolla: Museum of Contemporary Art, San Diego, 2006.

Heinrich, Christoph, et al. *Mona Hatoum.* Ostfildern-Ruit, Germany: Hatje Cantz, 2004.

Heon, Laura Steward, ed. *Mona Hatoum Domestic Disturbance.* North Adams, Mass.: Massachusetts Museum of Contemporary Art, 2001.

Hornstein, Shelley and Florence Jacobowitz, eds. *Image and Remembrance: Representation and the Holocaust.* Bloomington, Ind.: Indiana University Press, 2003.

Hsu, Wer-rwei. "Subject of Desire: The 1998 Taipei Biennial," *Art Asia Pacific* 22 (1999): 25–27.

Janus, Elizabeth and Gloria Moure, eds. *Tony Oursler.* Barcelona: Ediciones Polígrafa; New York: D.A.P./Distributed Art Publishers, 2001.

Jeffrey, Celina and Gregory Minissale, eds. *Global and Local Art Histories.* Newcastle: Cambridge Scholars Pub., 2007.

Jhaveri, Amrita. *A Guide to 101 Modern & Contemporary Indian Artists.* Mumbai: India Book House, 2005.

Jones, Amelia. *Body Art: Performing the Subject.* Minneapolis: University of Minnesota Press, 1998.

Jones, Kellie, Thelma Golden, and Chrissie Iles. *Lorna Simpson.* London; New York: Phaidon, 2002.

Kelley, Mike. *Interviews, Conversations, and Chit-Chat, 1986–2004.* With A. A. Bronson, Larry Clark, Kim Gordon, Thurston Moore, Jutta Koether, Harmony Korine, Tony Oursler, Richard Prince, Jim Shaw, Michael Smith, Jeffrey Sconce, John Waters, and John C. Welchman. Ed. by John C. Welchman. Zurich: JRP/Ringier; Dijon: Les presses du réel; New York: D.A.P./Distributed Art Publishers, 2005.

Kemal, Salim and Ivan Gaskell, eds. *Politics and Aesthetics in the Arts.* Cambridge, England; New York: Cambridge University Press, 2000.

Kim, Elaine H., et al. *Fresh Talk, Daring Gazes: Conversations on Asian American Art.* Berkeley, Calif.: University of California Press, 2003.

Kissone, Seán, ed. *Shahzia Sikander: Sharing Space.* Dublin, Ireland: Irish Museum of Modern Art, in assoc. with Charta, 2007.

Krens, Thomas and Alexandra Munroe. *Cai Guo-Qiang, I Want to Believe.* New York: SRGM; London: Thames & Hudson, 2008.

Lippard, Lucy, et al. *The Art of Whitfield Lovell: Whispers From the Walls.* Rev. ed. San Francisco, Calif.: Pomegranate, 2003.

Lippard, Lucy. "Jimmie Durham: Postmodernist 'Savage,'" *Art in America* (February 1993): 62–68.

————. "Out of the Safety Zone." *Art in America* 78:12 (December 1990): 130–139ff.

Luard, Honey and Peter Miles, eds. *Tracey Emin: Works 1963–2006.* New York: Rizzoli, 2006.

Mann, Sally. *At Twelve: Portraits of Young Women.* New York: Aperture, 1988.

———. *Immediate Family.* New York: Aperture, 1992.

———. *Second Sight: The Photographs of Sally Mann.* Contemporary Photographers Series; 4. Boston: D.R. Godine, 1983.

———. *Still Time.* New York: Aperture, 1994.

———. *What Remains.* Boston, Mass.: Bulfinch Press, 2003.

Mannoni, Laurent, Werner Nekes, and Marina Warner. *Eyes, Lies and Illusions: The Art of Deception: Drawn From the Werner Nekes Collection: With Contemporary Works by Christian Boltanski, Carsten Höller, Ann Veronica Janssens, Anthony McCall, Tony Oursler, Markus Raetz, Alfons Schilling, Ludwig Wilding.* London: Hayward Gallery; Aldershot; Burlington, VT: in assoc. with Lund Humphries, 2004.

Marcoci, Roxana. *Comic Abstraction: Image-Breaking, Image-Making.* New York: MOMA: Distr. D.A.P./Distributed Art Publishers, 2007.

Marshal, Kerry James. *Kerry James Marshall.* New York: Abrams, 2000.

McFadden, David Revere, and Ellen Napiura Taubman, eds. *Changing Hands: Art Without Reservation.* London: Merrell; New York: In assoc. with the American Craft Museum, 2002–05 Vol. 1: *Contemporary Native American Art from the Southwest.* Vol. 2: *Contemporary Native American Art from the West, Northwest, & Pacific.*

McShine, Kynaston. *The Museum as Muse: Artists Reflect.* New York: MOMA, 1999.

Morgan Jessica, ed. *Portraits: Rineke Dijkstra.* Boston: Institute for Contemporary Art, Boston, 2001.

Morgan, Robert C., ed. *Gary Hill.* Baltimore, Md.: Johns Hopkins University Press, 2000.

Mori, Mariko. *Mariko Mori.* Chicago: Museum of Contemporary Art, London: Serpentine Gallery, 1998.

———. *Mariko Mori.* Ostfildern-Ruit, Germany: Hatje Cantz, 2008.

———. *More Details: Mariko Mori.* New York: H.N. Abrams, 1998.

Muir, Gregor and Clarrie Wallis. *In-a-gadda-da-vida: Angus Fairhurst, Damien Hirst, Sarah Lucas.* London: Tate, 2004.

Murakami, Takashi, ed. *Little Boy: The Arts of Japan's Exploding Subculture.* New York: Japan Society; New Haven, Conn.: Yale University Press, 2005.

Murakami, Takashi. *Takashi Murakamo: Kaikai Kiki.* Interview with Takashi Murakami by Hélène Kelmachter. Paris: Fondation Cartier pour l'art contemporain; London: Serpentine Gallery, 2002.

Murphy, Patrick T., ed. *Andres Serrano: Works 1983–1993.* Texts by Robert Hobbs, Wendy Steiner, Marcia Tucker. Philadelphia: Institute of Contemporary Art, 1994.

Nead, Lynda. *The Female Nude: Art, Obscenity and Sexuality.* New York: Routledge, 1992.

Neri, Louise, et al. *Roni Horn.* London: Phaidon, 2000.

Neshat, Shirin. *Rapture.* Paris: Galerie Jerome de Noirmont, 1999.

———. *Shirin Neshat.* Milan: Charta, 2002.

Njami, Simon, ed. *Africa Remix: Contemporary Art of a Continent.* With essays by Lucy Duran, et al. Ostfildern-Ruit, Germany: Hatje Cantz; New York: D.A.P., 2005.

Obrist, Hans Ulrich, ed. *Matthew Barney: Drawing Restraint.* Vols 1–2. Köln, Germany: Walther König, 2005.

Oguibe, Olu, and Okwui Enwezor, eds. *Reading the Contemporary: African Art from Theory to the Marketplace.* Cambridge, Mass.: MIT Press, 1999.

Perry, Gill and Paul Wood, eds. *Themes in Contemporary Art.* New Haven, Conn.: Yale University Press in assoc. with the Open University, 2004.

Phelan, Peggy, Hans Ulrich Obrist, and Elisabeth Bronfen. *Pipilotti Rist. Contemporary Artists.* London; New York: Phaidon, 2001.

Point of View [video recording]: *An Anthology of the Moving Image.* New Museum of Contemporary Art; Bick Productions. New York: New Museum of Contemporary Art, 2003.

Pollock, Griselda and Joyce Zemans, eds. *Museums After Modernism: Strategies of Engagement.* Malden, Mass.: Blackwell, 2007.

Posner, Helaine. *Kiki Smith.* Interview by Christopher Lyon. New York: Monacelli Press, 2005.

Princenthal, Nancy, et al. *Doris Salcedo.* Interview by Carlos Basualdo. Contemporary Artists. London: Phaidon, 2000.

Ramadan, Khaled D., ed. *Peripheral Insider: Perspectives on Contemporary Internationalism in Visual Culture.* Copenhagen: Museum Tusculanum Press/University of Copenhagen, 2007.

Ravenal, John B. *Outer & Inner space: Pipilotti Rist, Shirin Neshat, Jane & Louise Wilson, and the History of Video Art.* With essays by Laura Cottingham, Eleanor Heartney, and Jonathan Knight Crary. Richmond, VA: Virginia Museum of Fine Arts; Seattle, Wash.: Distr. University of Washington Press, 2002.

Rhoades, Jason. *Jason Rhoades: Volume, a Rhoades Referenz.* Nurnberg: Kunsthalle Nurnberg, 1998.

———. *PeaRoeFoam: The Impetuous Process, My Special Purpose and the Liver Pool.* Vienna: MUMOK, 2002.

Robert Gober: the United States Pavilion, 49th Venice Biennale, June 10–November 4, 2001. Chicago: Art Institute of Chicago; Washington, D.C.: HMSG; New York: Distr. D.A.P., 2001.

Rothschild, Deborah. *Tony Oursler: Introjection: Mid-career Survey 1976–1999.* Williamstown, Mass.: Williams College Museum of Art, 1999.

Rubinstein, Raphael, ed. *Critical Mess: Art Critics on the State of Their Practice.* Lenox, Mass.: Hard Press Editions, 2006.

Said, Edward W. and Sheena Wagstaff. *Mona Hatoum: The Entire World as a Foreign Land.* London: The Tate, 2000.

Schimmel, Paul. *Gregor Schneider.* Milan: Charta, 2003.

Seigel, Katy. "Nurture Boy," *Artforum* (Summer 1999): 132–35.

Seijdel, Jorinde, et al., eds. *Art as a Public Issue: How Art and its Institutions Reinvent the Public Dimension.* Rotterdam: NAi Pub., 2008.

Serrano, Andres. *America and Other Work.* Contrib. Julie Ault, Dian Hanson, Eleanor Heartney. Köln; Los Angeles, Taschen, 2004.

Shaw, Gwendolyn Dubois. "Final Cut," *Parkett* 59 (2000): 129–132.

———. *Seeing the Unspeakable: The Art of Kara Walker.* Durham: Duke University Press, 2004.

[Shonibare] *Yinka Shonibare.* New York: The Studio Museum, Harlem, 2002.

Sikander, Shazia. *Shahzia Sikander.* Chicago: Renaissance Society, University of Chicago, 1999.

Simon, Joan. *Ann Hamilton: An Inventory of Objects.* New York: Gregory R. Miller; D.A.P./Distributed Art Publishers, 2006.

———. *Robert Gober.* Paris: Éditions du Jeu de Paume and Réunion de Musées Nationaux, 1991.

Smith, Elizabeth A. T. and Tricia van Eck. *Kerry James Marshall: One True Thing, Meditations on Black Aesthetics.* Chicago: Museum of Contemporary Art; New York: D.A.P./Distributed Art Publishers, 2003.

Soutter, Lucy. "By Any Means Necessary: Document and Fiction in the Work of Carrie Mae Weems." *Art and Design* 11 (November/December 1996): 70–75.

Spector, Nancy. *Barney, Beuys: All in the Present Must be Transformed.* New York: Solomon R. Guggenheim Foundation: Avail. through D.A.P./Distributed Art Publishers, 2006.

Sterling, Bruce and Philippe Parreno. *Rirkrit Tiravanija: A Retrospective (Tomorrow is Another Fine Day).* Rotterdam: Museum Boymans Van Beuningen, 2004.

Tallman, Susan. "Kiki Smith: Anatomy Lessons." *Art in America* 80 (April 1992): 146–153ff.

Thomas Struth: Museum Photographs. Essays by Hans Belting, Walter Grasskamp, Claudia Seidel. 2nd expanded ed. Munich: Schirmer/Mosel, 2005.

Vergne, Philip. *Kara Walker: My Complement, My Enemy, My Oppressor, My Love.* With texts by Sander L. Gilman, et al. Minneapolis: Walker Art Center, 2007.

Vischer, Theodora, ed. *Gary Hill: Imagining the Brain Closer Than the Eyes.* Texts by Hans Belting, et al. Ostfildern-Ruit, Germany: Cantz and Museum für Gegenwartskunst, 1995.

———. *Robert Gober: Sculptures and Installations, 1979–2007.* Basel, Switzerland: Schaulager; Göttingen: Steidl, 2007.

Visser, Hripsimé. *Rineke Dijkstra: Portraits.* München: Schirmer/Mosel, 2004.

Wakefield, Neville et al. *Matthew Barney: Pace Car for the Hubris Pill.* Rotterdam: Museum Boymans-van-Beuningen, 1995.

Wallis, Brian, ed. *Body and Soul/Andres Serrano.* Texts by bell hooks, Bruce Ferguson, and Amelia Arenas. New York: Takarajima Books, 1995.

Weitman, Wendy. *Kiki Smith: Prints, Books and Other Things.* New York: MOMA; Distr. D.A.P., 2003.

Welchman, John C, Isabelle Graw, and Anthony Vidler. *Mike Kelley.* London: Phaidon, 1999.

Wright, Beryl J. and Saidiya V. Hartman. *Lorna Simpson: For the Sake of the Viewer.* New York and Chicago: Universe Pub. and Museum of Contemporary Art, 1992.

Yamaguchi, Yumi. *Warriors of Art: A Guide to Contemporary Japanese Artists.* Trans. Arthur Tanaka. Tokyo; New York: Kodansha International, 2007.

Young Artists in Italy at the Turn of the Millennium: Behind and Beyond the Italian Studio Program at P.S. 1. MoMA. A Project by Giulio Di Gropello. Milan: Charta, 2005.

Zuhur, Sherifa, ed. *Images of Enchantment: Visual and Performing Arts of the Middle East.* Cairo: American University in Cairo Press, 1998.

Glossary

Abstract art The term has two main applications:
1. Art that is non-representational, purely autonomous and makes no reference to an exterior world, e.g. Suprematism, Abstract Expressionism (known as "strong" abstraction); 2. Art that "abstracts" its images from the visible world, e.g. Cubism (referred to as "weak" abstraction).

acrylic paint A synthetic medium developed in the 1930s and in wide use by the 1960s, quick-drying and retaining brightness. It permits effects of transparency and **impasto** but is generally used for work in flat color.

aerial perspective A technique for indicating spatial recession on a two-dimensional surface by making crisp and clear those objects intended to be perceived close to the viewer, while objects meant to be understood as further away are represented as hazy or less distinct.

airbrush A device that uses compressed air to spray fine droplets of paint, producing a smooth, even surface. Most often associated with commercial art but also employed by Hard Edge abstract painters and other. Airbrush effects do not show brushmarks or other evidence of the artist's touch.

aisle Part of a church or hall parallel to the main span and divided from it by an arcade of piers or columns or in rare cases by a screen wall.

aleatory The use of chance or random elements (from the Latin *aleatorius*, a dicer).

all-over composition Painting that treats the whole surface of the canvas in a uniform manner, in contrast to suggesting a compositional center or main focal point. The term is applied to the work of Jackson Pollock and the Color Field painters.

allegory A type of artistic symbolism in which abstract entities, such as Truth or Love, are portrayed as figures or objects.

altarpiece A devotional painting or sculpture placed on, above, or behind an altar, peculiar to Catholic Europe, where it was introduced in the early thirteenth century when priests began to celebrate Mass with their backs to the congregation. Many depict multiple scenes and are on several panels (*see* **polyptych**, **triptych**), hinged so that they can be concealed or revealed as required.

appropriation The copying of images for purposes different from those for which they were originally intended, e.g. the reproduction of a famous work of art in a commercial advertisement. From the early 1980s appropriation has also been adopted as a means of challenging the premium put on artistic originality.

apse Vaulted semicircular termination of a building, usually a church.

arabesque Intricate surface decoration of plant forms, spirals, knots, etc. without human figures.

Arcadia A mountainous region of Greece that gave its name to a mythical land of rustic peace and plenty, frequently evoked in classical, Renaissance, and later art and literature.

armature Framework on which sculpture in clay is supported.

assemblage An artwork composed of three-dimensional objects, either natural or manufactured, often junk.

atelier French term for a studio or workshop. In nineteenth-century France "ateliers libres" provided non-academic, studio-based teaching.

automatism An artistic approach in which the artist relinquishes conscious, rational control, enabling unconscious impulses to direct the form of the work. Automatism is most closely associated with the Surrealists and Abstract Expressionists.

avant-garde Literally, the vanguard; more loosely, those in advance or ahead of their time—or thought to be so.

balustrade A series of balusters (short posts or pillars) supporting a rail.

barrel-vault *see* **vaulting**.

basilica An ancient Roman colonnaded hall for public use, later adopted as a building type for Early Christian churches. The Christian basilica had acquired its essential characteristics by the fourth century: oblong plan, longitudinal axis, timber roof either open or concealed by a flat ceiling, and a termination either rectangular or apsidal. It is usually divided into a nave and two or more aisles, the former higher and wider than the latter, lit by clerestory windows and with or without a gallery.

bas-relief *see* **relief**.

Benday A process of shading by means of small uniform dots, invented by the New York printer Benjamin Day (1838–1916) for cheap photographic reproductions; also imitated by Pop artists, notably Lichtenstein.

biomorphic A type of abstract art in which—as in much of Arp's work—the forms relate to organic shapes (in contrast to geometric abstraction).

Body art The use of the artist's own body as a medium for artistic expression.

canon A list of works that sets the standard for artistic achievement (originally, the books of the Bible accepted by the Jewish or Christian faiths). In the late twentieth century the concept of the canon came increasingly to be challenged on the basis that it represents a relatively narrow spectrum of Western art and is defined as much by what it excludes as by the works that are included.

cantilever A horizontally projecting architectural element such as a beam or canopy that has no external bracing and appears to be self-supporting. Such an element is, in fact, anchored at one end by the structure from which it projects. Closely associated with the designs of Frank Lloyd Wright.

caricature A type of portraiture in which the subject's features are distorted for comic, often satirical, effect.

chiaroscuro In painting, the manipulation of light and shade to give the effect of modeling.

chromolithography A type of lithography in which color prints are produced by printing each color using a different stone or plate.

collage A composition made by gluing pieces of paper, cloth, etc. on a canvas or other ground.

color The sensation produced on the eye by light waves. The seven main wavelengths that make up the visible spectrum are subdivided into three primary colors or hues—red, yellow, and blue—each of which has a complementary color composed of the other two. Color *values* are determined by the amount of light reflected by different hues (yellow has a high, blue a low value), irrespective of the *saturation* or purity of the hue.

combination printing A photographic technique in which the final print is created by combining two or more negatives.

contrapposto A pose developed in classical antiquity. The figure is shown resting his or her weight on one leg, allowing the other leg to bend slightly and the hip to drop. This gives the figure a slight S-curve, and suggests a moment of repose between actions.

curtain wall The outer enclosing wall of a medieval castle or, especially with reference to twentieth-century architecture, a non-load-bearing wall applied to the exterior of a structure.

cyanotype An early photographic technique that uses iron salts to produce a deep blue image.

daguerreotype Photographic process invented by L.-J.-M. Daguerre and patented in 1839 for fixing positive images on silver-coated metal plates; widely used, especially for portraits, until the 1860s. Each daguerreotype is unique and the process was superseded by developments from the calotype process by which numerous prints may be made from a single negative.

diptych A picture or **relief** on two hinged panels.

Divisionism The technique of painting with small areas of unmixed pigments juxtaposed so that they combine optically when seen from a certain distance. Although employed empirically by several artists, notably Watteau, Delacroix, and the Impressionists, it was first adopted as a stylistic term by Paul Signac and, independently, by the Italian Post-Impressionists in the 1880s.

drypoint Technique of **print**making by which the copper plate is scratched with a sharply pointed tool, which creates a soft, feathery line when printed. Drypoint is often used in combination with other methods of **engraving** and **etching**.

earthwork A large-scale artwork for which the surface of the earth is the medium.

encaustic An ancient technique of painting with pigmented wax fused with the support by the application of hot irons.

engraving An incised design, also a **print** made from an engraved metal plate; *see also* **etching** and **woodcut**.

environment art The creation by the artist of a three-dimensional space in which the viewer is directly involved in the work of art.

etching A **print** from a metal plate on which the design has been etched or eaten away by acid.

façade The architecturally emphasized front or face of a building.

ferro-concrete A modern development of concrete reinforced by the insertion of steel mesh or rods. Also called **reinforced concrete**.

figurative Art depictions of the visible world, not necessarily including human or animal figures.

folk art A term loosely applied to decorative or functional art produced in rural communities, either by specialist craftspeople or in the home, in contrast to the urban, academic or elite milieu of much Western fine art.

foreshortening Application of **perspective** to a single form, e.g. a foot represented as pointing out of, not in line with, a pictorial plane.

formalist An approach to art analysis that emphasizes qualities of visual form, color, composition, above other aspects of the work of art, such as narrative meaning, or biographical, social, and political context.

found images, materials or **objects** Those found in an everyday environment and **appropriated** for artworks, especially **assemblages**.

fresco Wall and ceiling painting on fresh (*fresco*) moist lime plaster with pigments ground in water so that they are absorbed into the plaster. Pigments added after the plaster has dried are said to be applied *a secco*.

frieze The middle division of an entablature, also loosely any sculptured or decorated horizontal band.

frottage French term meaning "rubbing" used for the technique of placing paper over a textured material and rubbing with a chalk or pencil until an image of the texture is formed. In the twentieth century Max Ernst exploited the suggestive power of images produced by frottage as a starting point for many works, and the technique was adopted by other Surrealists.

functionalism The theory that a building, piece of furniture or other object should be designed primarily to fulfill its material purpose and use and that its form should be determined exclusively by its function.

genre painting A picture of everyday life.

genres The various categories of painting, e.g. history, landscape, portrait, **still life**, etc.

Gesamtkunstwerk Term used by the German composer Richard Wagner (1813–83) to mean a unified work of art in which music, drama, painting, and poetry should be combined.

golden section or **mean** An irrational proportion, probably known to the ancient Greeks and much taken up by Renaissance art theorists. It may be defined as a line cut in such a way that the smaller section is to the greater as the greater is to the whole. This cannot be worked out mathematically, hence its fascination. Approximately it would be 5:8.

grisaille Painting in tones of gray, sometimes suggesting low **relief**.

Happening An unscripted performance, usually in an ordinary open space (e.g. street or parking lot) in which one or more artists, using materials without fine art associations, encourage the spontaneous participation of spectators who condition its development; sometimes recorded by photography.

history painting In European academic theory a **figurative** painting of a scene from classical mythology, the Bible, the lives of saints or a historical event.

icon A small, portable panel painting of Christ, the Virgin and Child or the saints, produced for Greek or Russian Orthodox Christians from the sixth century to the present day. Also: one of the three classes of signs designated by philosopher C.S. Peirce, an icon is a sign that looks like the thing it represents.

iconography The study of the meaning of visual images whether conveyed directly or by symbols, allegories, etc.

ideogram A written character or symbol that represents a thing itself, rather than a word or sound.

impasto Thickly applied **oil paint**.

index One of the three classes of signs designated by philosopher C.S. Peirce, an index is a sign made through the direct action of its referent.

installation A designed environment set up as an artwork, usually multimedia, in a gallery or outdoor location, and always **site-specific**.

kinetic sculpture A three-dimensional artwork that moves, usually by a mechanism.

land art *see* **earthwork**.

linear perspective A technique for indicating spatial recession on a two-dimensional surface in which literal or implied lines converge at one or two points in the distance.

linoleum cut A print made from a piece of linoleum by the **woodcut** process.

lintel A horizontal beam or stone bridging an opening.

lithography A process of printmaking from a drawing in oily crayon on stone. Invented c. 1798.

mandorla An upright almond shape, especially a glory of this form surrounding the figure of Christ in medieval art.

maquette A small preliminary model for a larger work of sculpture.

mobile A three-dimensional artwork, parts of which can be moved by a current of air, as distinct from **kinetic sculpture** with mechanically controlled movement.

monochrome A painting in tones of a single color, e.g. **grisaille**.

monotype A print made from an image painted (not **engraved**) on a metal or glass plate. As the plate must be partly repainted each time it is used, each of the usually rather few prints made from it is unique.

mosaic A pictorial composition made of small colored stones (*pebble mosaic*) or cubes of stone, glass, etc., set in plaster.

naturalism An approach to art that emphasizes likeness to observable nature. Like "realism" it is used in a non-specific sense of representational art that achieves lifelike effects. Neither naturalism nor realism should

be confused with the term Realism (with a capital R), which has specific connotations. Nineteenth-century French Realism, for example, combined an unidealized view of actual people and places with a strong element of social commentary that can be found later in the work of American Social Realist painters of the Depression era of the 1930s.

nave The congregational area of a church, flanked by **aisles**.

oculus A circular opening in a wall or dome.

odalisque A female slave or concubine in a harem. Odalisques frequently appear, both nude and clothed, as a subject of Western painting from Ingres to Matisse.

oil paint Pigment mixed with an oil (usually linseed) which hardens when dry into a transparent film. Oil paint is normally applied opaquely but it can be used as a colored translucent or semi-translucent film over opaque ground colors. Its use was developed in the fifteenth century in Flanders and Italy and it was soon taken up for easel paintings throughout Europe.

old master A non-specific term for any great European painter or painting of pre-nineteenth-century date.

papier collé A **collage** composed of pieces of variously colored paper glued to a ground.

pastoral A type of subject that evokes a more-or-less idealized vision of rural surroundings and pursuits (from the Latin *pastor*, shepherd). (*See also* **Arcadia**.)

pentimento (pl. **pentimenti**) Italian term for part of a picture that has been painted over by the artist but which is visible beneath the top layer of paint.

Performance art A live-action piece in which the artist is typically present, either directing or participating in the event.

peristyle A colonnade around the inside of a court or room, also the space surrounded by such a colonnade.

perspective Systems of representing objects in spatial recession, either *linear* or *aerial*.

photomontage A term coined in Berlin c. 1918 for a **collage** composed of fragments of photographs, newsprint, etc., but later used also for a composite picture made by printing from several negatives on a single sheet.

pier A solid masonry support, as distinct from a column.

pilotis French term for pillars on which a building is raised, leaving it open at ground level. Le Corbusier, in particular, made extensive use of pilotis.

plein-air **painting** A painting executed out of doors rather than in a studio.

Pointillism *see* **Divisionism**.

polyptych A painting or **relief**, usually an **altarpiece** on more than three panels, *see* **triptych**.

post-and-beam or **post-and-lintel** *see* **trabeated**.

primitive Term formerly used to denote much of the art produced outside the spheres of Western or Asian civilization. It is also used of self-taught and so-called naive artists such as Henri Rousseau.

Primitivism Tendency of Western artists to emulate motifs or techniques associated with so-called "primitive" cultures. Artists such as Paul Gauguin believed that non-Western and pre-industrial cultures were more authentic than industrialized Europe and North America.

prints A generic term for all images made in multiple copies from woodblocks, metal plates, inked stone, photographic negatives, etc., *see* **woodcut**, **etching**, **engraving**, **lithograph**, **silkscreen**.

Process art Artworks whose subject matter is the process of their creation, which the spectator is invited to reconstruct. Many were executed in the 1960s and 1970s.

reinforced concrete *see* **ferro-concrete**.

relief Sculpture with forms projecting from a ground, called *high relief* when they are at least half in the round, otherwise *low relief* or *bas-relief*.

repoussé relief Decoration on metal (mainly gold, silver and copper) produced by hammering from the underside.

Romanesque refers generally to medieval European culture produced roughly between 1000 CE and 1250 CE. More specifically, Romanesque denotes a style of medieval architecture that immediately preceded the Gothic, characterized by monumental scale along with the use of barrel vaults and rounded arches.

rustication Massive blocks of masonry with roughened surfaces and sunk joints, often simulated in plaster.

Salon French word for a formal room such as the Salon d'Apollon in the royal palace of the Louvre (Paris). Exhibitions of work by the Royal Academy of painters and sculptors were held there from the late seventeenth century and the word 'Salon' thus acquired a special meaning. It was used in this

sense for official exhibitions in other rooms in the Louvre and from the mid-nineteenth century to cover exhibitions held elsewhere in Paris.

screenprint *see* **silkscreen**.

scumble An upper layer of opaque or semi-opaque pigment used in **oil painting**, applied irregularly so that areas of the color underneath remain visible, giving a broken or veiled effect, softening hard lines.

semiotics The study of signs, in particular the analysis of language as a system of signs proposed by the Swiss pioneer of modern linguistics, Ferdinand de Saussure. Semiotic interpretation has been extended to other cultural arenas such as mythology and clothing.

sfumato A soft, misty effect attained in **oil painting** mainly by the use of glazes to create delicate transitions of color and tone.

shoji A type of partition in Japanese domestic architecture made by covering a wooden framework with paper.

silkscreen A process of making prints by squeezing paint through a piece of silk, parts of which have been masked, exploited by commercial artists since the 1930s. One impression can be made to differ from another by varying the density of paint. Also called *serigraphy*.

silverpoint A small silver rod with a pointed end for drawing on an abrasive surface (specially prepared paper or parchment or a primed panel), first used in medieval Italy, elsewhere from the fifteenth century, but generally superseded by the graphite pencil in the seventeenth century.

site-specific A term used for an **installation**, sculpture or other artwork designed for, and in reference to, a specific location.

socle A base or pedestal.

staffage Figures or animals introduced as accessories in landscape painting.

still life A representation of such inanimate objects as flowers, fruit, dead animals, or household articles.

stucco Various types of plaster used as a protective and decorative covering for walls. A mixture including lime and powdered marble has been extensively used for **relief** decorations on ceilings and interior walls since the sixteenth century in Europe.

symbol An object or representation that stands for a specific thing or idea. One of the three classes of signs designated by philosopher C.S. Peirce, a symbol carries meaning by virtue of social consent. Linguistic signs are examples of symbols.

tenebrism Painting with a dominant dark tonality.

tesselation A pattern composed like a mosaic out of small shapes (*tesserae*) that fit closely together.

trabeated Construction based mainly on upright members supporting horizontals, as in an ancient Greek temple. Also called *post-and-lintel*. To be distinguished from arcuated.

transept The tranverse arms of a cross-shaped church.

transverse arch An arch separating one bay of a **vault** from another in Romanesque and Gothic architecture.

triptych A painting on three panels.

trompe l'oeil An illusionistic painting intended to "deceive the eye."

typography The art of letter design and printing.

Value *see* **color**.

vanitas An allegorical **still life** often incorporating a skull as a reminder of mortal transience.

vaulting A masonry roof or ceiling constructed on the principle of the arch. The simplest form is a *tunnel* or *barrel vault* of continuous semicircular or pointed section unbroken by *cross-vaults*. The intersection of two tunnel vaults of identical shape produces a *groin vault*. A *rib vault* has a framework of arched diagonal ribs between which the cells are filled with lighter stone. It is called *quadripartite* if each bay is divided into four quarters or cells, *sexpartite* if divided transversely into two parts so that each bay has six compartments. A *dome* is a vault of even curvature on a circular plan and of segmental, semicircular, pointed or bulbous section. The simplest form is constructed by corbeling. If a dome is erected on a square base, pendentives or squinches must be interpolated at the corners to mediate between square and circle.

woodcut A print made from a block of wood from the surface of which all areas not intended to carry ink have been cut away. The block is cut from a smoothed plank of fairly soft wood with the grain running parallel to the surface. A print made from a block of very hard wood cut across the grain and worked with a graving tool is called a *wood engraving*.

ziggurat A rectangular mound built in stepped-back stages and crowned by a temple. These structures were first developed in the Ancient Near East by the Sumerians.

Index

Credits

Courtesy of the artist and Gagosian Gallery, NY; 22. 23 Dallas Museum of Art, purchase with funds donated by the Jolesch Acquisition Fund, The 500, Inc., The National Endowment for the Arts, Bradbury Dyer III, Mr. and Mrs. Bryant M. Hanley Jr., Mr. and Mrs. Michael C. Mewhinney, Mr. and Mrs. Edward W. Rose and Mr. and Mrs. William T. Solomon; 22.25 © DACS 2009; 22.26 © DACS 2009; 22.27 © DACS 2009; 22.28 Miriam Schapiro; 22.29 Donald Woodman, © ARS, NY and DACS, London 2009; 22.30 Mary Kelly; 22.31 © Guerilla Girls; 22.32 Artist and Luhring Augustine, photograph Brian Forest, Digital image © 2009 MOMA/Scala, Florence; 22.33 Artist and Luhring Augustine, photograph John Bessler, Digital image © 2009 MOMA/Scala, Florence; 22.34 Artist and Galerie Hauser & Wirth & Presenhuber, Zurich; 22.35, 22.36 Wadsworth A. Jarrell; 22.37 Social and Public Art Resource Center, Venice, CA; 22.38 © Faith Ringgold 1983; 22.39 LACMA, Museum Acquisition Fund, photograph © 2009 Museum Associates/ LACMA; 22.40 Dawoud Bey; 22.41 Phyllis Kind Gallery, NY

Chapter 23: 23.1 Courtesy of Leo Castelli Gallery, NY; © ARS, NY and DACS, London 2009; 23.2 Steven Sloman, © ARS, NY and DACS, London 2009; 23.3 Gift of Virginia Dwan, courtesy of Xavier Fourcade Gallery, NY; 23.5 John Cliett; 23.6 © Estate of Robert Smithson, DACS, London/VAGA, NY 2009; 23.7 Estate of Robert Smithson/VAGA, NY/DACS, London 2009; 23.8 Courtesy of John Weber Gallery, © DACS, London/VAGA, NY 2009; 23.9 Max Protetch Gallery, NY; 23.12 Storm King Art Center, Mountainville, NY, photograph by Jerry L. Thompson; 23.13 Courtesy of John Weber Gallery, NY; 23.14 © C. Johnson; 23.15 Susan Zurcher; 24.53. Janet Borden, Inc.; 23.17 Courtesy of the artist; 24.55. Courtesy of the artist; 23.19 Jan Kosmowski, © DACS 2009; 23.20 Courtesy of the artist; 23.21 Balthazar Korab, Michigan, © Succession Picasso/DACS 2009; 23.22 Leo Castelli Gallery, NY, © Claes Oldenburg and © Coosje van Bruggen; 23.23 Gift of Frederick R. Weisman in honor of his parents, William and Mary Weisman, 1988, Walker Art Center, Minneaopolis, © Claes Oldenburg and Coosje van Bruggen, © ARS, NY and DACS, London 2009; 23.25 © Esto; 23.26 Courtesy of the artist and Luhring Augustine, NY; 23.27 © ARS, NY and DACS, London 2009; 23.28 © The Estate of Eva Hesse. Hauser & Wirth Zürich London, photograph © 1998 The Detroit Institute of Arts, © ARS, NY and DACS, London 2009; 23.30 Robert Miller Gallery, NY/Gretchen Lambert; NY, © Estate of Eva Hesse; 23.31 Robert Miller Gallery, NY, © Estate of Eva Hesse; 23.32 Courtesy of the artist, © DACS, London/VAGA, NY 2009; 23.33 © DACS, London/VAGA, NY 2009; 23.35 Courtesy of Middendorf Gallery, Washington, D.C.; 23.37 eeva-inkeri, Courtesy of Paula Cooper Gallery, NY; 23.38 Geoffrey Clements, Paula Cooper Gallery, NY, © Mario Merz/SIAE/DACS, London 2009; 23.39 Philippe Migeat © Centre Georges Pompidou, Paris; 23.41 © Andrew Wyeth, digital image © 2009 MOMA/Scala, Florence; 23.42 Whitney Museum of American Art, NY, gift of Timothy Collin; 23.43 Gift of Mrs. Fairfield Porter; 23.44 Robert E. Mates; 23.45 Courtesy of the Pace Gallery, NY; 23.46 © Marcus Harvey, 2009. Photograph by Stephen White. Courtesy Jay Jopling/White Cube (London); 23.48 Courtesy of Louis K. Meisel Gallery, NY; 23.49 Bruce C. Jones, courtesy of Louis K. Meisel Gallery, NY; 23.50 Eric Pollitzer, NY; 23.51 Yale University Art Gallery, New Haven, Susan Morse Hilles Fund; 23.52 © Estate of Duane Hanson/VAGA, NY/DACS, London 2009; 23.53 National Gallery of Scotland, © Estate of Duane Hanson/VAGA, NY/DACS, London 2009; 23.55 Courtesy of the artist; 23.56 © Jerry Uelsmann, © DACS, London/VAGA, NY 2009; 23.58 George Roos, courtesy of Marlborough Gallery, NY, © Alex Katz/VAGA, NY/DACS, London 2009; 23.59 eeva-inkeri, Robert Miller Gallery, NY; 23.60 D. James Dee, © DACS, London/VAGA, NY 2009;

23.61 Allan Finkleman, © DACS, London/VAGA, NY 2009; 23.62 Cymie Payne, courtesy of Barbara Gladstone, NY, © ARS, NY and DACS, London 2009; 23.63 Roy M. Elkind, courtesy of the Willard Gallery, NY, © ARS, NY and DACS, London 2009; 23.64 Philipp Scholz Ritterman; 23.65 Courtesy of the BlumHelman Gallery, NY; 23.67 Eric Mitchell; 23.68 Geoffrey Clements, NY; 23.69 Geoffrey Clements, NY; 23.70 Art Resource, NY; 23.71 Gift of the Sydney and Frances Lewis Foundation, © ARS, NY and DACS, London 2009; 23.72 Bevan Davies, © ARS, NY and DACS, London 2009; 23.73 Geoffrey Clements, courtesy of Paula Cooper Gallery, NY, © ARS, NY and DACS, London 2009; 23.74 Robert E. Mates, N.J., © ARS, NY and DACS, London 2009; 23.75 Bill Jacobson Studio

Chapter 24: 24.1 Courtesy of Skidmore, Owings & Merrill; 24.2 Venturi, Scott Brown and Associates; 24.3 Courtesy of Venturi Rauch & Scott Brown, Philadelphia; 24.4 Rollin R. La France; 24.6 © Norman McGrath, NY; 24.7 © Norman McGrath, NY; 24.8 Courtesy of Hans Hollein, Vienna; 24.9 Franz Hobman, courtesy of Hans Hollein, Vienna; 24.10 © Norman McGrath, NY; 24.11 Peter Aaron/Esto, © Walt Disney Enterprises; 24.12 Yasuhiro Ishimoto, Tokyo; 24.13 Courtesy of Johnson/ Burgee Architects, NY; 24.14 Courtesy of Johnson/Burgee Architects, NY; 24.15 © Norman McGrath, West Germany; 24.16 © Jorg Maucher, West Germany; 24.17 Marvin Trachtenberg; 24.18 Timothy Hursley; 24.19 Courtesy of Walker Art Center, Minneapolis; 24.20 Grant Smith/View Pictures; 24.21 Sautereau/Cosmos/Woodfin Camp and Associates; 24.22 Edifice; 24.23 Timothy Hursley; 24.24 Shinkenchiku-sha, Tokyo; 24.25 Powerstock; 24.26 Richard Bryant/Esto/ Arcaid; 24.27 Bernard Tschumi, Paris; 24.28 Eisenman Architects; 24.29 Frank Dick Studio, courtesy of Eisenman Architects; 24.30 Shinkenchiku-sha; 24.31 © Timothy Hursley; 24.33 © FMGB Guggenheim Bilbao Museoa, photograph by Erika Barahona Ede. All rights reserved. Total or partial reproduction is prohibited; 24.34 Diller and Scofidio; 24.35 Photograph by Barbara Burg/Oliver Schuh/ www.palladium.de; 24.36 Santiago Calatrava Archive; 24.37 Alex S. MacLean; 24.38 © The Celebration Company; 24.39 Office for Metropolitan Architecture, Rotterdam; 24.40 Office for Metropolitan Architecture, Rotterdam; 24.42 Photograph by Bill King. King/ Mademoiselle; © Conde Nast Publications; 24.43 © S. Levine. Courtesy of the Paula Cooper Gallery, NY. Photograph by Adam Reich; 24.52 Copy photograph © The Metropolitan Museum of Art; 24.44 Courtesy of Baskerville & Watson Gallery; 24.45 Barbara Gladstone; 24.46 Courtesy of Metro Pictures, NY; 24.47 Artist and Metro Pictures, NY; 24.49 Barbara Gladstone © ARS, NY and DACS, London 2009; 24.50 Lisson Gallery, London; 24.53 Gagosian Gallery, NY

Chapter 25: 25.1 © RMN/Jean-Gilles Berizzi, © Succession Picasso/DACS 2009; 25.2 Courtesy of Mary Boone/Michael Werner Gallery, NY; 25.3 Zindman/Fremont, © ARS, NY; 25.4 Michael Werner Gallery, NY and Cologne; 25.6 Anne Gold, Aachen; 25.8 Courtesy of Mary Boone Gallery, NY; 25.9 © Gerhard Richter, 2009; © Art Gallery of Ontario, Toronto; 25.10 © Museum of Fine Arts, Boston; 25.11 Anthony J. Oliver, NY, purchased with funds provided by Douglas S. Cramer, Beatrice and Philip Gersh, Lenore S. and Bernard A. Greenberg, Joan and Fred Nicholas, Robert A. Rowan, Pippa Scott, and an anonymous donor; 25.13 Courtesy of the artist; 25.15 Digital image © 2009 MOMA/Scala, Florence, © Sandro Chia/VAGA, NY/DACS, London 2009; 25.16 Gift of Mr. and Mrs. David N. Pincus; 25.18 Zindman/Fremont, Courtesy of Mary Boone Gallery, NY, © DACS, London/VAGA, NY 2009; 25.19 Geoffrey Clements, courtesy of Mary Boone Gallery, NY; 25.20 Courtesy of Mary Boone Gallery, NY; 25.21 Pelka/Noble, NY; 25.22 Gift of Charlene Engelhard, Vijak Mahdavi and

Bernardo Nadal-Ginard, © Museum of Fine Arts, Boston, © ARS, NY, and DACS, London 2009; 25.24 Courtesy of Ronald Feldman Fine Arts, NY, © DACS, London/VAGA, NY 2009; 25.25 Mary Boone Gallery, NY, © DACS, London/VAGA, NY 2009; 25.26 Adam Reich, Sally Baker, NY; 25.27 Myles Aronowitz; 25.29 Steven Sloman, Courtesy of Washburn Gallery, NY; 25.30 Photograph by Ellen Page Wilson, © Elizabeth Murray, courtesy of PaceWildenstein, NY; 25.31 Bill Jacobson Studio, NY; 25.32 Gagosian Gallery NY; 25.33 Courtesy of David McKee Gallery, NY; 25.34 Ivan Dalla Tana, courtesy of Tony Shafrazi Gallery, NY; 25.35 Zindman/Fremont, courtesy of Mary Boone Gallery, NY, © ADAGP, Paris and DACS, London 2009; 25.36 Artist and PPOW, NY; 25.39 © John Currin, courtesy of Andrea Rosen Gallery, photograph by Fred Scruton; 25.37 Courtesy of the Estate of Martin Wong and PPOW, NY; 25.38 Courtesy of Mary Boone Gallery, NY; 25.39 Courtesy of Andrea Rosen Gallery, NY, photograph by Fred Scruton; 25.40 Marianne Boesky Gallery

Chapter 26: 26.1 Courtesy of Paula Cooper Gallery, NY; 26.3 Sonnabend Gallery, NY; 26.4 Sonnabend Gallery, NY; 26.5 Sonnabend Gallery, NY; 26.6 Courtesy DACS, © Damien Hirst. All rights reserved, DACS 2009; 26.7 Science, © Damien Hirst. All rights reserved, DACS 2009; 26.8 Courtesy of Alexander & Bonin; 26.9 El Museo del Barrio and DACS, London 2009; 26.10 Courtesy of Ronald Feldman Fine Arts, NY, © DACS 2009; 26.11 © ADAGP, Paris and DACS, London 2009; 26.12 Kira Perov/Squidds and Nunns, 26.13, 26.20 © Tate, London 2009; 26.15 Prudence Cumming Associates Ltd., London; 26.16 Julius Kozlowski, courtesy of Holly Solomon Gallery, NY; 26.17 Gift of Mr. and Mrs. Sid R. Bass, © Nancy Graves Foundation/ DACS, London/VAGA, NY 2009; 26.18 Ben Blackwell; 26.19 Artist and Luhring Augustine, NY; 26.22 Regen Projects, Los Angeles; 26.24 Ronald Feldman Fine Arts, NY, photograph by D. James Dee; 26.26 © Dorothy Zeidman; 26.27 Artist and Timothy Taylor Gallery, London; 26.28 Gagosian Gallery, NY

Chapter 27: 27.1 Fred Scruton; 27.2 Barbara Gladstone; 27.3 Brent Sikkema, NY; 27.4 Artist and Dietch Projects, NY; 27.5 © 1999–2000 Takashi Murakami/Kaikai Kiki Co., Ltd. All rights reserved. Courtesy of Blum & Poe, Los Angeles; 27.6 © Sally Mann. Edwynn Houk Gallery, NY; 27.7 Artist and Marian Goodman Gallery, NY; 27.8 Jack Tilton/Anna Kustera Gallery, NY; 27.9 © the artist. The Saatchi Gallery, London. Courtesy Jay Jopling/White Cube (London); 27.10 Photograph by Bill Orcutt. Courtesy of Alexander & Bonin, NY; 27.11 Jack Shainman Gallery, NY; 27.12 Bill Johnson/© Dia Center for the Arts; 27.13 Jack Shainman Gallery, NY, © DACS 2009; 27.14 Artist and DC Moore Gallery, NY; 27.15 Alexander & Bonin, NY, photograph by D. James Dee; 27.16 Artist and David Zwirner, NY; 27.17 Sean Kelly, NY; 27.19a and b photograph © CNAC/MNAM, Distr. RMN/ © Philippe Migeat; 27.20 Donald Young Gallery, Chicago; 27.24 Artist and Dietch Projects, NY, © ADAGP, Paris and DACS, London 2009; 27.26 National Gallery of Canada, Ottowa; 27.27 Stephen Friedman Gallery, London; 27.28 Artist and Galerie LeLong, NY; 27.29 On behalf of the Tribute in Light Initiative produced by Creative Time and Municipal Art Society. Courtesy of the artists and Lehmann Maupin, NY; 27.30 Artist and PPOW, NY; 27.32 Philipp Scholz Ritterman; 27.34 Artist and Marian Goodman Gallery, NY; 27.35 Artist and Marian Goodman Gallery, NY, © DACS 2009; 27.36 Sonnabend Gallery, NY; 27.37 Artist and Marian Goodman Gallery, NY; 27.38 © Taipei Fine Arts Museum; 27.39 © FMGB Guggenheim Bilbao Museoa, photograph by Erika Barahona Ede. All rights reserved. Total or partial reproduction is prohibited; 27.40, 27.41 © Musee du Quai Branley, photograph by Nicolas Borel/Scala, Florence, © ADAGP, Paris and DACS, London 2009